MODERN ARTS CRITICISM

ISSN 1052–1712

VOLUME 1

MODERN ARTS CRITICISM

A Biographical and Critical Guide to Painters, Sculptors, Photographers, and Architects from the Beginning of the Modern Era to the Present

Joann Prosyniuk
Editor

Thomas Ligotti
Sean R. Pollock
Laurie Sherman
Associate Editors

Gale Research Inc. · DETROIT · NEW YORK · LONDON

STAFF

Joann Prosyniuk, *Editor*

Thomas Ligotti, Sean R. Pollock, Laurie Sherman, *Associate Editors*

Stephen B. Barnard, James P. Draper, Tina N. Grant, Grace N. Jeromski, Michael W. Jones,
David Kmenta, Jelena O. Krstović, Marie Lazzari, Michelle L. McClellan, Zoran Minderović,
Ronald S. Nixon, James E. Person, Jr., Joseph C. Tardiff, Debra A. Wells, *Assistant Editors*

Jeanne A. Gough, *Permissions and Production Manager*
Linda M. Pugliese, *Production Supervisor*
Suzanne Powers, Maureen A. Puhl, Linda M. Ross, Jennifer E. VanSickle, *Editorial Associates*
Donna Craft, James G. Wittenbach, *Editorial Assistants*

Victoria B. Cariappa, *Research Manager*
H. Nelson Fields, Judy Gale, Maureen Richards, *Editorial Associates*
Paula Cutcher, Alan Hedblad, Jill M. Ohorodnik, *Editorial Assistants*

Sandra C. Davis, *Permissions Supervisor (Text)*
Josephine M. Keene, Kimberly F. Smilay, *Permissions Associates*
Maria L. Franklin, Michele Lonoconus, Camille P. Robinson, Shalice Shah,
Denise M. Singleton, Rebecca A. Stanko, *Permissions Assistants*

Patricia A. Seefelt, *Permissions Supervisor (Pictures)*
Margaret A. Chamberlain, *Permissions Associate*
Pamela A. Hayes, Lillian Quickley, *Permissions Assistants*

Mary Beth Trimper, *Production Manager*
Evi Seoud, *Assistant Production Manager*

Arthur Chartow, *Art Director*
C. J. Jonik, *Keyliner*

Laura Bryant, *Production Supervisor*
Louise Gagné, *Internal Production Associate*
Yolanda Y. Latham, *Internal Production Assistant*

Since this page cannot legibly accommodate all copyright notices, the Acknowledgments section constitutes an extension of the copyright notice.

While every effort has been made to ensure the reliability of the information presented in this publication, Gale Research Inc. does not guarantee the accuracy of the data contained herein. Gale accepts no payment for listing; and inclusion in the publication of any organization, agency, institution, publication, service, or individual does not imply endorsement of the editors or publisher. Errors brought to the attention of the publisher and verified to the satisfaction of the publisher will be corrected in future editions.

The paper used in this publication meets the minimum requirements
of American National Standard for Information Sciences—Permanence
Paper for Printed Library Materials, ANSI Z39.48-1984. ∞™

Printed in the United States of America

Published simultaneously in the United Kingdom by Gale Research
International Limited
(An affiliated company of Gale Research Inc.)

Contents

Preface vii

Acknowledgments ix

Preface

Modern Arts Criticism has been created in response to the need for a comprehensive, convenient source of biographical, critical, and bibliographical information on world artists. Although a vast amount of such information exists, no other reference source compiles and organizes all of the diverse types of materials presented in this series.

Scope of the Series

Modern Arts Criticism is designed as an introduction to major painters, sculptors, photographers, architects, and multimedia artists of the modern period. Commentators most often identify the advent of photography as the first of the many formative influences in the development of modern art; this series therefore includes artists active after the emergence of that medium as a form of artistic expression, which occurred in the mid-nineteenth century. Because the number of such artists is extremely large, *Modern Arts Criticism* focuses only on those whose works have been the subject of significant commentary.

In presenting discussions of major artists by leading commentators and art historians, *Modern Arts Criticism* helps students develop valuable insight into art history and sparks ideas for papers and other assignments. In addition, by including a wide spectrum of critical opinion, the series fosters an awareness of the dynamism and diversity of the visual arts and their impact on modern life.

Highlights of Each Entry

An entry in *Modern Arts Criticism* consists of the following elements: artist heading; biographical and critical introduction; excerpts of criticism (each preceded by explanatory notes and followed by a bibliographic citation); illustrations; and a bibliography of further reading.

●The *artist heading* consists of the name by which the artist is most commonly known, followed by the birth date and, where applicable, death date. If an artist consistently used a pseudonym, the pseudonym will be listed in the artist heading and the real name will appear in the first line of the introduction, as will any other important variations of an artist's name.

●The *biographical introduction* outlines the artist's life and career, as well as critical response to the works.

●Whenever possible, *criticism of three types* has been included in entries: artists' statements concerning their works or aesthetic ideas, introductory overviews, and criticism of more specific issues or phases in an artist's career arranged in chronological order to convey a sense of the development of critical opinion.

All titles of works featured in the criticism are printed in boldface type to enable the user to easily locate discussion of particular works. Also for purposes of easier identification, the critic's name and the publication date of the essay are given at the beginning of each piece of criticism. Unsigned criticism is preceded by the name of the journal in which it appeared.

Some of the excerpts in *Modern Arts Criticism* also contain translated material. Unless otherwise noted, translations in brackets are by the editors; translations in parentheses or continuous with the text are by the critic. Publication information (such as publisher names and book prices) and parenthetical numerical references (such as footnotes or page references) have been deleted at the editors' discretion to provide smoother reading of the text.

●Critical excerpts are prefaced by *annotations* providing the reader with information about both the critic and the criticism that follows. Included are the critic's reputation, approach to art criticism, and particular expertise. Also noted are the relative importance of a work of criticism, the scope of the excerpt, and the growth of critical controversy or changes in critical trends regarding an artist. In some cases, these annotations cross-reference excerpts by critics who discuss each other's commentary.

●A complete *bibliographic citation* designed to facilitate location of the original essay or book follows each piece of criticism.

●Whenever possible, two types of *illustrations* have been included in artist entries. These include *artist portraits* and *reproductions of selected works* discussed in the text.

●An annotated list of *further reading* appears at the end of each entry. Included are writings by the artist, interviews, bibliographies (both primary and secondary), biographies, critical studies and reviews, and sources of reproductions of the artist's works. These categories of primary and secondary readings are clearly labeled to facilitate location of specific types of material.

Cumulative Indexes

Each volume of *Modern Arts Criticism* will include *a cumulative medium index* listing artists who have appeared in the series arranged according to the primary medium with which they are identified. The *cumulative title index* will list the titles of all works that have been discussed in the series. Beginning with the second in the series, each volume will also include a *cumulative index of artists.*

A Note to the Reader

When writing papers, students who quote directly from any volume in the *Modern Arts Criticism* series may use the following general forms to footnote reprinted criticism. The first example pertains to material drawn from periodicals, the second to material reprinted from books:

[1] R. Gordon Taylor, "Ansel Adams 1902–1984," *The British Journal of Photography* 131 (September 28, 1984), 1014–16; excerpted and reprinted in *Modern Arts Criticism,* Vol. 1, ed. Joann Prosyniuk (Detroit: Gale Research, 1991), pp. 11–13.

[2] Lionello Venturi, *Impressionists and Symbolists* (Charles Scribner's Sons, 1950); excerpted and reprinted in *Modern Arts Criticism,* Vol. 1, ed. Joann Prosyniuk (Detroit: Gale Research, 1991), pp. 255–72.

Suggestions Are Welcome

Readers who wish to suggest artists to appear in future volumes, or who have other suggestions, are cordially invited to write the editors.

Acknowledgments

The editors wish to thank the copyright holders of the excerpted criticism included in this volume, the permissions managers of many book and magazine publishing companies for assisting us in securing reprint rights, and Anthony Bogucki for assistance with copyright research. We are also grateful to the staffs of the Detroit Public Library, the University of Detroit Library, the Library of Congress, the Wayne State Unversity Purdy/Kresge Library Complex, and the University of Michigan Libraries for making their resources available to us. Following is a list of the copyright holders who have granted us permission to reprint material in this volume of *MAC*. Every effort has been made to trace copyright, but if omissions have been made, please let us know.

COPYRIGHTED EXCERPTS IN *MAC*, VOLUME 1, WERE REPRINTED FROM THE FOLLOWING PERIODICALS:

Afterimage, v. 3, January, 1976. ©Visual Studies Workshop 1976. Reprinted by permission of the publisher.—*American Artist,* v. 25, March, 1961; v. 37, June, 1973; v. 44, February, 1980. Copyright © 1961, 1973, 1980 by Billboard Publications, Inc.—*American Film,* v. V, November, 1979. Copyright 1979 by *American Film.*—*Aperture,* n. 86, 1982. Copyright © 1982 by Aperture Foundation Inc. Reprinted by permission of the publisher.—*Apollo,* v. LXXIV, June, 1961. © Apollo Magazine Ltd. 1961. Reprinted by permission of the publisher.—*Architectural Digest,* v. 41, July, 1984.—*Art and Artists,* v. 9, April, 1974; v. 9, June, 1974. © copyright Hansom Books, 1974./ v. 5, December, 1970 for "Botero: Sensuality, Volume, Colour" by Jacqueline Barnitz. © copyright Hansom Books, 1970. Reprinted by permission of the author.—*Art in America,* v. 63, January-February, 1975 for an interview with Alex Katz by Gerrit Henry. Copyright © 1975 by Art in America, Inc. Reprinted by permission of the publisher and Gerrit Henry./ v. 1, September-October, 1973 for "Ralph Goings at O.K. Harris" by Peter Schjeldahl; v. 64, November-December, 1976 for "Ed Moses' Absolutist Abstractions" by Nancy Marmer; v. 65, July-August, 1977 for "Diane Arbus at Helios" by Donald B. Kuspit; v. 66, January-February, 1978 for "Report from Pittsburgh: Alechinsky at the Carnegie" by Alfred Frankenstein; v. 67, January-February, 1979 for "Looking at Giacometti" by Michael Brenson; v. 68, May, 1980 for "Ralph Goings at O.K. Harris" by Pepe Karmel; v. 69, November, 1981 for "Photography: Garry Winogrand, Public Eye" by Pepe Karmel; v. 73, May, 1985 for "Back to Arcady" by Paul Brach; v. 73, December, 1985 for "Ed Moses at L.A. Louver" by Frances Colpitt; v. 74, November, 1986 for "Alex Katz: First Painter of Character" by Bill Berkson; v. 76, March, 1988 for "Our Kiefer" by Peter Schjeldahl; v. 76, October, 1988 for "The Witness" by Kenneth E. Silver; v. 76, November, 1988 for a review of exhibits at the Malborough and the Massimo Audiello Galleries by Donald B. Kuspit. Copyright © 1973, 1976, 1977, 1978, 1979, 1980, 1981, 1985, 1986, 1988 by Art in America, Inc. All reprinted by permission of the publisher and the respective authors./ v. 60, November-December, 1972; v. 61, March-April, 1973; v. 61, September-October, 1973; v. 72, March, 1984. Copyright © 1972, 1973, 1984 by Art in America, Inc. All reprinted by permission of the publisher.—*Art International,* v. VII, September 25, 1963; v. XIII, Christmas, 1969; v. XIV, November 20, 1970; v. XVI, December, 1972; v. XVII, December 15, 1973; v. XVIII, December 15, 1974; v. XXII, February, 1978; v. XXII, March, 1978; v. XXIII, April, 1979; v. XXIV, March-April, 1981; v. XXVI, July-August, 1983. All reprinted by permission of the publisher.—*Art Journal,* v. XXVI, Spring, 1967; v. XXXIV, Fall, 1974; v. XXXV, Summer, 1976; v. 41, Spring, 1981. Copyright 1967, 1974, 1976, 1981, College Art Association of America, Inc. All rights reserved. All reprinted by permission of the publisher.—*Art Magazine,* v. 7, May-June, 1976.—*Artforum,* v. XIII, October, 1974 for "Incisions in History/Segments of Eternity" by Hollis Frampton. © 1974 Artforum International Magazine, Inc. Reprinted by permission of the publisher and the Literary Estate of Hollis Frampton./ v. IV, September, 1965 for an interview with Matta by Max Kozloff. © 1965 Artforum International Magazine, Inc. Reprinted by permission of the publisher and Max Kozloff./ v. XVIII, May-June, 1980 for "Essential Differences: A Comparison of the Portraits of Lisette Model and Diane Arbus" by Shelley Rice. © 1980 by Shelley Rice. Reprinted by permission of the publisher and the author./ v. IV, May, 1966 for "A Georgia O'Keeffe Retrospective in Texas" by Peter Plagens; v. IX, November, 1970 for "Georgia O'Keeffe: The Paintings of the Sixties" by Barbara Rose; v. X, March, 1972 for "Ed Moses: The Problem of Regionalism" by Peter Plagens; v. XI, June, 1973 for a review of an exhibit at Ronald Feldman Fine Arts by Bruce Boice; v. XI, June, 1973 for "The Uncanny Portrait: Sander, Arbus, Samaras" by Max Kozloff; v. XII, May, 1974 for a review of an exhibit by Jeremy Gilbert-Rolfe; v. XV, December, 1976 for "Night Light: Brassai and Weege" by Colin L. Westerbeck, Jr.; v. XXI, September, 1982 for "Swallowing Dali" by Carter Ratcliff. © 1966, 1970, 1972, 1973, 1974, 1976, 1982 Artforum International Magazine, Inc. All reprinted by permission of the publisher and the respective authors./ v. XVI, December, 1977; v. XVII, March, 1980; v. XXIII, May, 1985. © 1977, 1980, 1985 Artforum International Magazine, Inc. All reprinted by permission of the publisher.—*ARTnews,* v. 81, April, 1982. © 1982 ARTnews Associates./ v. 78, March, 1979 for "Oskar Kokoschka: Empathetic Interpreter of Human Feelings" by Benjamin Forgey; v. 77, April, 1978 for "Adams' Landscapes, Weston's Nudes" by Gerrit Henry; v. 77, November, 1978 for "What Remains of Man Today?" by Michael Gibson; v. 78, Summer, 1979 for "Alex Katz: 'I See Something and Go Wow!'" by Ellen Schwartz Harris; v. 79, April, 1980 for "Autobiographical Erasers" by Melinda Wortz; v. 83, May, 1984 for

Ansel Adams

1902-1984

American photographer.

Celebrated as a pioneer of modern photography, Adams was a pivotal figure in the evolution of that medium from its technically unsophisticated nascent state to its current status as a highly respected artistic medium. Adams, along with several colleagues, sought an alternative to the pictorialist style of photography, in which both composition and technique were stylized to resemble paintings, and embraced what he called "straight" photography, using the camera to capture clearly defined, realistic images. In his own works, Adams concentrated on natural scenes, and his majestic, black-and-white landscapes, with their well-modulated tones, are considered among the finest photographs ever produced.

Adam's immense respect for his artistic subject was fostered by his upbringing in the mountainous region surrounding the city of San Francisco. Although he proved himself a quick study at the piano, becoming an accomplished player, he bridled at the regimentation of public education. His father responded by purchasing a season pass to the Panama-Pacific Exposition for Ansel, who visited the exhibition nearly every day in place of school, admiring in particular the Post-Impressionist art works displayed there. In 1916, Adams persuaded his parents to vacation in Yosemite National Park. There he took his first photographs, inaugurating two enduring relationships, one with photography, and one with Yosemite, where he would return at least once every year for the remainder of his life.

Throughout the 1920s, Adams's interest in photography grew. Nevertheless, he had decided to become a concert pianist, going so far as to purchase a Mason and Hamlin grand piano, the finest available, in 1925. In the summers, he participated in Sierra Club outings in Yosemite and continued his self-education in photography. In 1927, Adams achieved his first "visualization," a pre-exposure vision of the final print and determination of the camera settings necessary to capture and convey the emotion felt by the photographer; to attain the dramatic tonal range Adams beheld before him, he also employed a red filter, rather than the conventional yellow, to accentuate the contrast in light. The result was one of his finest photographs, *Monolith, The Face of Half Dome.* This "visualization" process would become a central feature of Adams's technique.

Despite this early success, the private publication of his first folio, *Parmelian Prints of the High Sierras,* in the fall of 1927, an appointment as an official photographer for the Sierra Club, and an exhibition of his photographs at the Sierra Club in San Francisco, Adams hesitated to abandon his musical aspirations. Then, in 1930, Adams met photographer Paul Strand, whose collection of negatives (he had no prints to show Adams) and commitment to creative photography convinced Adams that the medium of photography offered a means of creative expression

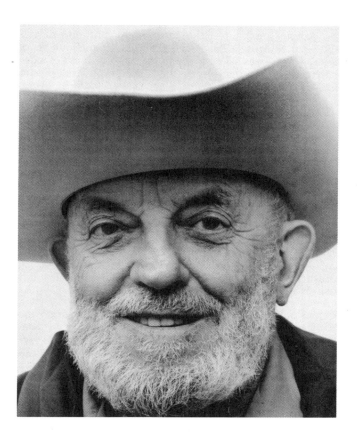

equal to that of music; shortly thereafter, Adams decided to pursue a career in photography. Solo exhibitions in San Francisco and at the Smithsonian in Washington, D. C. encouraged Adams to make a pilgrimage to An American Place, the New York gallery run by the eminent patron and innovator of photography, Alfred Stieglitz. Adams often acknowledged the debt he owed Stieglitz for his doctrine of Equivalence, which stated that the finished print ought to represent the emotional state of the photographer, making photography an expressive medium akin to the other fine arts. Throughout his career, Adams never deviated from the aesthetic principles governing creative photography that he derived in large part from the clear, well-composed, natural images of Paul Strand and Stieglitz's doctrine of Equivalence.

In 1932, Adams and several of his colleagues, including Edward Weston and Imogen Cunningham, founded Group f/64, a name derived from the smallest lens aperture on cameras then in use, which yields the greatest depth of focus and therefore the sharpest image. The name was intended to suggest the group's commitment to sharp-focus, or "straight," photography, as opposed to the pictorial school. Although Group f/64 was an informal circle that remained intact for only a year, their ideas were high-

ly influential in the development of photographic aesthetics. In their manifesto, they identified themselves as artists "who are striving to define photography as an art form by a simple and direct presentation through purely photographic methods. . . . Pure photography is defined as possessing no qualities of technique, composition or idea, derivative of any other art form." The emergence of straight photography as an art form was further advanced by Adams's exhibit—"the most important one of my life"—at Stieglitz's American Place in 1936. Four years later, Adams was asked to aid in the establishment of a department of photography at the Museum of Modern Art in New York.

Over the course of the next thirty years, Adams produced many spectacular landscape prints, as well as articles and books dedicated to illuminating the technical aspects of creative photography, including the widely-used, instructional Basic Photo Series. In 1941, while teaching at the Art Center School in Los Angeles, Adams developed his Zone System, a technique intended to afford the creative photographer greater control of the range of tones in the finished print by dividing the spectrum of light, from white to black, into ten gradations or zones before making an exposure. He also founded the Department of Photography at the California School of Fine Arts in San Francisco, and conducted annual Yosemite workshops. At his death in 1984, Adams was one of the most popular and widely-recognized photographers in the world.

Critics have occasionally rebuked Adams for ignoring the social ills of his era and focusing instead on natural scenery. Adams defiantly replied that photography is "a creative art, not a socio-political platform," and he challenged the implication "that unless photography has a socio-political function it is not of value to people at large." Adams contended that art attains social worth according to its ability to illuminate beauty and affirm life, and need not engage in social commentary. To those critics who objected that Adams's prints included no human figures, Adams sardonically rejoined that every one of his photographs involved at least two people, the photographer and the viewer. Although he supported the work of Dorothea Lange and other documentary photographers, Adams rarely strayed far from images of the wilderness. His lone foray into photo-documentary came in 1943 when he and Lange photographed a Japanese-American relocation camp; however, even here Adams's photographs appeared void of any overt socio-political criticism. When Adams later collaborated with Lange on a *Life* photo-essay on the Mormons in Utah, he chided her "doctrinaire attitudes, which sucked dry the potential spirit" of the piece.

If Adams lacked the political agenda of many of his professional peers in focusing on visions of scenic splendor rather than social ills, he was nevertheless a fervent crusader for conservation of the American wilderness. He served on the Board of Directors of the Sierra Club from 1934-71 and lobbied presidents to preserve wilderness areas. Moreover, his startlingly clear, painstakingly composed, and tonally rich natural images—including *Moon and Half Dome, Aspens, Northern New Mexico* (1958), *Clearing Winter Storm* (1940), *Mt. McKinley and Wonder Lake* (1947), and his best known photograph, *Moonrise, Hernandez, New Mexico* (1941)—not only furthered

awareness of the unrealized technical and artistic potential of his medium, but also, in their affirmation of the redemptive powers of natural beauty, argued for the necessity of land preservation. For his contributions to photography and the conservation movement, Adams won numerous fellowships, including the Guggenheim, and awards, including the United States Presidential Medal of Freedom.

ARTIST'S STATEMENTS

Ansel Adams (essay date 1943)

[*In the following excerpt from his essay "A Personal Credo," Adams describes the elements necessary to produce a fine, creative photograph: precision, patience, visualization, and the simplest equipment necessary to render the image with the utmost clarity.*]

I have been asked many times, "What is a great photograph?" I can answer best by showing a great photograph, not by talking or writing about one. However, as word definitions are required more often than not, I would say this: "A great photograph is a full expression of what one feels about what is being photographed in the deepest sense, and is, thereby, a true expression of what one feels about life in its entirety. And the expression of what one feels should be set forth in terms of simple devotion to the medium—a statement of the utmost clarity and perfection possible under the conditions of creation and production." That will explain why I have no patience with unnecessary complications of technique or presentation. I prefer a fine lens because it gives me the best possible optical image, a fine camera because it complements the function of the lens, fine materials because they convey the qualities of the image to the highest degree. I use smooth papers because I know they reveal the utmost of image clarity and brilliance, and I mount my prints on simple cards because I believe any "fussiness" only distracts from and weakens the print. I do not retouch or manipulate my prints because I believe in the importance of the direct optical and chemical image. I use the legitimate controls of the medium only to augment the *photographic* effect. Purism, in the sense of rigid abstention from any control, is ridiculous; the logical controls of exposure, development and printing are essential in the revelation of photographic qualities. The correction of tonal deficiencies by dodging, and the elimination of obvious defects by spotting, are perfectly legitimate elements of the craft. As long as the final result of the procedure is *photographic*, it is entirely justified. But when a photograph has the "feel" of an etching or a lithograph, or any other graphic medium, it is questionable—just as questionable as a painting that is photographic in character. The incredibly beautiful revelation of the lens is worthy of the most sympathetic treatment in every respect.

Simplicity is a prime requisite. The equipment of Alfred Stieglitz or Edward Weston represents less in cost and variety than many an amateur "can barely get along with." Their magnificent photographs were made with intelli-

gence and sympathy—not with merely the machines. Many fields of photography demand specific equipment of a high order of complexity and precision; yet economy and simplicity are relative, and the more complex a man's work becomes, the more efficient his equipment and methods must be.

Precision and patience, and devotion to the capacities of the craft, are of supreme importance. The sheer perfection of the lens-image implies an attitude of perfection in every phase of the process and every aspect of the result. The relative importance of the craft and its expressive aspects must be clarified; we would not go to a concert to hear scales performed—even with consummate skill—nor would we enjoy the sloppy rendition of great music. In photography, technique is frequently exalted for its own sake; the unfortunate complement of this is when a serious and potentially important statement is rendered impotent by inferior mechanics of production.

Of course, "seeing," or visualization, is the fundamentally important element. A photograph is not an accident—it is a concept. It exists at, or before, the moment of exposure of the negative. From that moment on to the final print, the process is chiefly one of *craft;* the pre-visualized photograph is rendered in terms of the final print by a series of processes peculiar to the medium. True, changes and augmentations can be effected during these processes, but the fundamental thing which was "seen" is not altered in basic concept.

The "machine-gun" approach to photography—by which many negatives are made with the hope that one will be good—is fatal to serious results. However, it should be realized that the element of "seeing" is not limited to the classic stand-camera technique. The phases of photography which are concerned with immediate and rapid perception of the world—news, reportage, forms of documentary work (which may not admit contemplation of *each* picture made) are, nevertheless, dependent upon a basic attitude and experience. The instant awareness of what is significant in a rapidly changing elusive subject presupposes an adequate visualization more general in type than that required for carefully considered static subjects such as landscape and architecture. The accidental contact with the subject and the required immediacy of exposure in no way refutes the principles of the basic photographic concept. Truly "accidental" photography is practically nonexistent; with preconditioned attitudes we *recognize* and are arrested by the significant moment. The awareness of the *right moment* is as vital as the perception of values; form, and other qualities. There is no fundamental difference in the great landscapes and quiet portraits of Edward Weston and the profoundly revealing pictures of children by Helen Leavett. Both are photographic perceptions of the highest order, expressed through different, but entirely appropriate, techniques.

Not only does the making of a photograph imply an acute perception of detail in the subject, but a fine print deserves far more than superficial scrutiny. A photograph is usually looked *at*—seldom looked *into*. The experience of a truly fine print may be related to the experience of a symphony—appreciation of the broad melodic line, while important, is by no means all. The wealth of detail, forms, values—the minute but vital significances revealed so exquisitely by the lens—deserve exploration and appreciation. It takes *time* to really see a fine print, to feel the almost endless revelation of poignant reality which, in our preoccupied haste, we have sadly neglected. Hence, the "look-through-a-stack-of-prints-while-you're-waiting" attitude has some painful connotations.

Sympathetic interpretation seldom evolves from a predatory attitude; the common term "*taking* a picture" is more than just an idiom; it is a symbol of exploitation. "*Making* a picture" implies a creative resonance which is essential to profound expression.

My approach to photography is based on my belief in the vigor and values of the world of nature—in the aspects of grandeur and of the minutiæ all about us. I believe in growing things, and in the things which have grown and died magnificently. I believe in people and in the simple aspects of human life, and in the relation of man to nature. I believe man must be free, both in spirit and society, that he must build strength into himself, affirming the "enormous beauty of the world" and acquiring the confidence to see and to express his vision. And I believe in photography as one means of expressing this affirmation, and of achieving an ultimate happiness and faith. (pp. 13-16)

Ansel Adams, "A Personal Credo, 1943," in The American Annual of Photography, *Vol. 58, 1944, pp. 7-16.*

Ansel Adams with Tom Cooper and Paul Hill (interview date 1976)

[*In the following excerpt, Adams discusses some of his early influences, the impetus behind his technical innovations, and his own artistic vision.*]

[Cooper and Hill]: *Mr. Adams, can you remember the first photograph that you ever took?*

[Adams]: Well, that would be hard because the family had an old 3½ by 3½ Kodak Bullseye and we'd just take pictures. I think the first photograph I was conscious of really trying to make was a picture taken whilst I was sitting on a rotten stump near Camp Curry. The stump gave way and I descended. I clicked the shutter and in some miraculous way I got the picture. When the film was developed at the local photofinishers, he said: 'You must have held the camera upside down when you did this one.' I was wracking my brains to figure out how I did do it. He showed me the whole roll and I thought that it must have happened when I fell off the stump. That was in the Yosemite Mountains during 1916 and as I became more and more interested in the mountains, my natural impulse was to have a visual diary. The excitement of Yosemite became strong and filtered through me into some aesthetic experiences which probably were supported by similar experiences I was having in music study. I think my very first visualized image was on a 4000 ft climb, a lot of it through snow. The photograph was an impressive scene halfway up the cliff. I did it in the conventional way. I had two glass plates and a 2-filter and then I began to think now what's this going to look like. I realized that the sky and the shadow of the rock would pull together and I could see that the print wouldn't have the feeling of grandeur that I was certainly experiencing. I had a very strong red filter and I took it with that. It's the equivalent of how I

felt. It was the first time I can say that I anticipated how a photograph was really going to look.

Was there any art background in your family at all?

No, not in the family.

Did you see any other photographs or magazines at about that time?

Oh I'd seen many. Picture magazines, though I never thought of them as art. There was *Camera Craft,* that was the magazine published in San Francisco; but we didn't see photographs. There weren't very good photographs available. It wasn't considered as an art. The pictorialist camera club people were dreadful. You could sense their taste right away as not amounting to anything. I don't know why, but it was camp, terrible stuff.

Why did you have a prejudice against that pictorialist soft focus approach?

I think it was because of a lack of aesthetic intensity. It isn't that it was soft focus or fuzzy, because there's nothing worse than a sharp image of a fuzzy concept! What they would try to do was to get to a pseudo art feeling; the feeling of an etching or a pencil sketch. The straight photograph was just not considered art.

Had you seen any of the Camera Work *publications?*

No, we hadn't seen those. I don't know whether there were any out. I suppose there must have been. The only people who were contemporary at that time were Imogen Cunningham and Dorothea Lange. I would imagine that Imogen would have the greatest knowledge, being the oldest.

Why did you study music instead of photography?

I studied music when I was about 8 or 9. I forgot the exact date, but I was very young. So I'd worked with music years before I even thought of using the camera.

So, in fact, you ended up being a self-taught photographer?

That's all you could be then as there was no school. I learned some sort of bread and butter things. In the summer of 1917 I learned a lot about developing, picture washing, the 'nuts and bolts' as we call it.

Why did you choose Nature as being your predominant subject matter at that time?

Well, I was surrounded by it. I lived by the sand dunes near the Golden Gate and Santa Cruz, so I've always had the nature experiences. I've never had any unpleasant experiences except when I was delivering pick-me-up film for this photo finisher—then I was involved with the seamier side of life. In the 1915 Fair my father took me out of school and got me a season ticket and I went every day to the Great Exposition. In 1915 they had an extraordinary art exhibit—the Armory show. I don't remember any photographs, but I do remember the Picassos—an amazing show. Nothing like that had happened at that time and nothing happened like it for years afterwards. Oh, yes, some show! The San Francisco International Exhibition was one of the really great expositions—the architecture, the unity, the fantastic technology, the wonderful music programmes, and the main art collection.

Do you feel that the Armory show, and seeing all the modern artists' work, had any effect on your photography?

It must have had some latent effect. I reacted to it very strongly, and as a kid I didn't have any prior knowledge at all, and some of it I just could not comprehend. I used to argue with the curator and the people who were there. It became quite amusing because obviously I didn't know what I was talking about, but I was just saying what I felt. But after 2 months I began to have a sense of what they were doing, that was the first feeling. It wasn't just silly, this was a rich experience. I remember the collages. I forget whether Picasso was just entering a blue period then or not. I can see the paintings very clearly in my memory, but I can't remember who they were by. (p. 15)

Can you remember the first creative photographer you ever met?

I believe it was Paul Strand. Well, no, I met Edward Weston before that, but just passing. I didn't realize what Edward was trying to say. I liked him and we got along fine. Then I didn't see him for a couple of years. I went to New Mexico in 1929 or 30 and I met Paul Strand at Taos. He didn't have any prints but he showed me the negatives that he had made then and developed. Immediately you realize that this is another concept! I came home and realized what I had not done and tried to print some of the old negatives, and they wouldn't take it. It was quite a revolution.

What was in Strand's work that you had not seen before?

Well, even in the negative form there was this wonderful sense of organization. Everything was right. Although I was a young photographer I could still read negatives. Beautiful 4 × 5s and each one was an absolute gem. The thing that was impressive was that he didn't follow the rules of composition. I was still under the thumb then of rules, that certain things should balance, and so on. I got away from that pretty quick after seeing Strand. I realized what Weston said about composition being the strongest way of seeing. If you see a thing strongly and convey that—that's composition. . . .

What was it then that finally made you go fully into photography as a career?

Well, that again is a very difficult thing. I had two groups of people who were friends. One was saying: 'You can go anywhere you want in photography' and the others were saying: 'Photography does not express the human soul—stay with music'. So I did have this problem of making a decision. It took 2 or 3 years. . . .

What started your interest in photographic science?

The crux of that is that I was trained as a musician. My teacher never played anything for me, it was all discussion and answering questions like 'Do you really think you shaped that phrase', or 'Did you know your notes' or 'You are out of unison'. Never any domination of style. It was all trying to bring it out of you. Whenever I taught I tried to do that same thing because I realize how easy it is to imitate. Beware of piano teachers with two pianos—that's one of the worst things! So I had worked up sufficient technique for myself when I got to teaching in Los Angeles at the Art Centre School. I realized I had nothing to teach but the way *I* did it, and that of course went against the grain right away. I hadn't realized, but somebody would

say 'What do I do' and I would say 'Well I did . . . ' I just realized that if I kept to the basic sensitometry principle and codified that in some way so that it was easily understood, then a person using that system would be liberated to express himself. That was the beginnings of the Zone System which was based on visualization of the image.

From the Hurder and Drifield experiments.

Well, Hurder and Drifield were the first ones of consequence. I think there had been attempts but never so complete as their attempts to create a rationalization effect on exposure and development measurable in density. They founded the science of sensitometry and they plotted the results of exposure and density. I can think in logarithms fairly well, but a lot of people have difficulty. Well anyway, we worked out the system and I gave full credit to everybody, especially Fred Archer, who was a director of the Department of Portraiture. He was a pretty good photographer and an awfully nice man and a helpful teacher. He really helped me along and we worked it out. But the confidence to do it came from an article by Davenport in the *US Camera* magazine. He had shown how you could, by changing development time, create the same density with different exposures. Now the only difference between that and my Zone System was that he never presented visualization, to him it was just a physical fact. With half the exposure and so much more development you get the same density. A student would see something and see it his way and this system gave him the control and development to get it. All I did was to codify the system—I didn't invent it. It is sensitometry—simple physics. But it is extremely complex if you want to get into the physical chemistry and the mathematics involved.

Did you have a vision of sorts, like the Annunciation, that confirmed the propriety of a move towards photography?

I think I probably got that from Strand. I think I realized that he was a great artist. Yes, it would be almost like an annunciation. It was very strong. But remember, regarding the Zone System, there have been hundreds of millions of photographs made without the benefit of it, or even exposure meters! When I worked in Yosemite I learned by trial and error concerning what the exposures were. Then I went to the South West and I fell flat on my face because the conditions were totally different and I had to resensitize myself. Then I went to New England and I had trouble again. That isn't really visualization because unless I make a stupid arithmetic error there's no reason why I should ever fail. I might have a feeble visualization or a weak idea, but as far as getting the exposure right there isn't any reason why I shouldn't hit it every time. You have that exposure scale and you know that shows you what the film will actually do. Now I can see you sitting there and I can see ten different ways of creating an image. I find myself, from force of habit, always looking for pictures.

Do you think it's important to have a thorough grounding in photographic science to become a successful photographer?

No. In black and white photography, though, I think a working knowledge of the Zone System, practical backroom chemistry, and knowing how to control development is useful. But it's a relatively simple thing. Now toning with selenium toner is simple, but to understand the chemistry of selenium toning is very complicated, and it wouldn't help you a bit, anymore than I'd have to build up a piano to be a pianist. Now if I was doing colour work I'd really have to know more—but again that is useful chemistry rather than abstract.

Can you remember when you had your first exhibition?

I think the very first one was in 1932 at the De Young Museum. Then I had one in New York in '34, and in Yale School of Fine Art also in '34, and then I had the most important one of my life at the Stieglitz gallery, (An American Place,) in '36. Now that was very important, and was the one that put me at a highly responsible level. I had been accepted as an artist. (p. 21)

Can you indicate why there was a need for such a grouping as f/64 at that time?

Yes—a few of us had become conscious of 'straight' photography: Edward Weston, Willard Van Dyke, Imogen Cunningham, John Paul Edwards and myself. We were all thinking of the quality 'straight' photograph. After a couple of years we thought we ought to have a manifesto—a visual manifesto. Van Dyke had a little gallery in Berkeley where he was showing some of his things, and Edward was propagandizing for the 'straight' photograph. One day Willard called up and said: 'We must go ahead. I've got a wonderful name—Group f/64.' Well, it has to be a small 'f' number to be mathematically right. But it was significant, symbolic of the great depth of field and illusion of sharpness. We only kept the group together for a year. It was very informal and we didn't want it to develop into a cult—but it did anyway. It was quite wise because this could have gone on and on. We accomplished what we set out to do and caused a real revolution. Then Van Dyke went East and went into the documentary movie work, and he became the Director of the Film Department of the Museum of Modern Art. . . .

How did you first come to meet Stieglitz?

Well, we made our first trip East in 1933. It was the time of the Depression and on the way we were stuck in Santa Fé for 6 weeks with no money. They wouldn't cash travel cheques. Everyone was in the same boat. It wasn't too amusing. When we arrived in New York I went right over to see Stieglitz. I had a letter of introduction from Sigmund Stern—who was related to Stieglitz's first wife. The Place was on Madison Avenue and had just opened. There was a table and an army cot, no chairs and nothing on the walls. He had this glowering look, you know, 'what do you want?', and I said: 'I have a letter of introduction.' He put the letter in his pocket and said: 'All that woman has got is money and if this mess keeps up much longer she won't even have that. What do you want?' I said: 'I'd like to show you some prints', and he said: 'I can't see you now, come back at 2.30', and walked off. I hadn't been used to being treated that way, it really was a very brutal business. I had a sense of chivalry, and I didn't like anybody making fun of it. I didn't realize the difference between the western spirit and the eastern in those days. A thing like that wouldn't happen out west. Well, I went back. I paced up and down Madison Avenue and I thought: 'Well, am I going to see the bastard or am I going back to California.' I wanted to go home, but I thought: 'No. I've come all this way and I've got to go and see him.' I went and he told

me to sit down. Well, the only place I could sit was a radiator, a steam radiator, and it was on just enough to create a slight corrugation. He was sort of sitting in this cot with the portfolio. He opened it up and he looked at every print. I leaped forward to talk about my work but he waved me aside. He put them all back in the portfolio and tied the string. Then he looked at me. I shifted over to the next order of corrugation—I didn't know what to do. Then he took all the prints out and looked at every one again. 'Well', he said in very complimentary terms, 'that's photography. I'm very happy to see you.' Well, I nearly fell off the radiator! And from that time on we were very fast friends. He just put me through the third degree in the morning. If he hadn't liked them he would have told me. There was no question, he could be very brutal. Well, I felt pretty good about it, and from then on I saw other photographers. Anton Bruhl was very fine, very cordial, but quite a number were superior. Steichen was the only one I never got along with. Bruhl said: 'I'm terribly busy this morning, just sit down and look at anything you want and I'll take you out to lunch.' During lunch he said: 'I'm doing a colour ad this afternoon, would you like to watch?' It was so important to me at that time to have this assistance. Later when we founded the Department of Photography at the Museum of Modern Art things really began to escalate then!

What did you gain from Stieglitz's comments at that time?

Affirmation of my approach was one thing. I mean I was obviously on a good track. There was nothing that I could feel unhappy about; no basis for fundamental criticism, and great confirmation on the technique. In fact, he said that this was the finest technical work he'd ever seen up to that time. Of course, I worked my tail off and they were quite beautiful prints. When I saw other people's prints I knew what he meant. When Stieglitz saw Edward Weston's work he liked the early nudes and Weston liked Stieglitz's nudes. But Stieglitz wasn't very warm to the cold, hard print. Anyway, Weston left with a feeling of mutual appreciation, but that was the end of it because Stieglitz just wouldn't show Weston. I guess Weston felt that he should be shown. He asked Stieglitz why, and I think Stieglitz told him bluntly that he didn't like the work. He just said: 'It's not in my field, you're working in another world.' . . .

Did Stieglitz talk to you about what it meant to him for you to be really the first contemporary photographer that he had shown since Strand?

There was Eliot Porter too. Stieglitz thought he had a great vision, but his prints weren't all that they should be—they were a little bit on the muddy side. But Eliot does have a very fine sense of perception. What was interesting about Stieglitz was that he had a very mystical outlook on life and on himself, but he couldn't verbalize. He would talk incessantly, but as far as describing what he wanted to put into the photograph, it was impossible, he just couldn't. He'd say the only thing I can say is: 'I go out into the world to make a photograph, and I need to photograph. If I observe something that excites me and gives me an emotional and spiritual reaction, I see it as a photograph and I make it, and then I show it to you as the equivalent of what I felt.' But sometimes he'd say: 'You may reject it, or if you know me very well you might say, "I think I know what was in Alfred's mind."' You're

probably wrong though, but the important thing is that if the photograph is strong enough it excites the spectator to do something intense on his own.' And to him that was the greatest effect that he could have. But the image itself had the prime meaning. (p. 27)

How did you get involved with the Japanese Americans towards the end of the war?

Because of the potential danger that the Government thought they had of invasion they got all of the Japanese living on the West Coast and put them out in camps. This was unconstitutional because they were American citizens. Now they didn't do it in Hawaii. Then it turned out that many of their children went into the Army and into the crack divisions. It was a pitiful thing to see these young soldiers visit their parents. When the soldiers were on leave they had to go in this place with barbed wire to see their parents who were American citizens and very loyal. Well, I came there after the exodus. Dorothea Lange photographed it as well. It was all very tragic, it was terrible, just awful for these people. Then Ralph Merritt came and I said I can't do anything, and Steichen called me up and wanted me to run his darkrooms (for the war effort) and I said at last I can do something. But somebody else did that. Well, I did some teaching at Ford Ord whilst trying to get into something more useful. I was a little too old to be in the Army, but I could have done a great deal. So I decided that here was a contribution I could make by going down and making a record of this camp. The important thing is how these people had developed a life for themselves; the beginnings of a society in the face of the toughest situation you can imagine. They took it logically and they took it philosophically, and they literally built an enclosure, a social thing. It was really marvellous. They had their own newspaper and they would go out and get beautiful rocks for their Japanese gardens, right in the middle of the blazing desert with the big Sierra behind them. It was pretty impressive. They had a choral society, bathing societies, and they farmed. They literally created a microcivilization. I spent quite a lot of time there, and someone decided to publish it. But the American public couldn't tolerate the fact that the Japanese, who were the enemy, were seen in this light, and they had to destroy the books. The book was called *Born Free and Equal*.

So they were actually printed?

Thousands and thousands, but nobody would sell them. They were ashamed to sell them. Oh, what letters I got. 'I've lost two sons in the Pacific and you are supporting the enemy.' So I'd have to write back and say: 'I have to remind you that these are American Citizens. I presume you are and I know I am.' I almost had a formal letter. It was wrong and unconstitutional and I tried to point this out. For a while I was a little worried I was going to be beat up. They'd sit down and write letters: 'Traitor! You should be in Leavenworth.'

Was it this involvement with social concerns that eventually got you connected with the Photo League?

Yes. After the war it became a society of photographers and critics. Then it was taken over by the Commies. Barbara Morgan telephoned me and said: 'I've just come from a meeting and about half the Board are Party members and it's all being switched to politics.' I said: 'Well, if you want to be a Communist, fine, but I don't want to join a

political organization. I joined a photographic organization.' Then she called in a while later and said: 'Now the majority are, and I'm getting out.' So I called my lawyer and I said: 'Now, what do I do?' He said: 'I'd just say that you are objecting because you don't want to be associated with any political movement. You write them a letter and you ask what is the emphasis now. Is it becoming a political organization with political motives or are you really interested in photography in a social sense generally?' He said: 'Then send a copy to the FBI.' I never got a reply, so his instructions then were to send a letter of resignation. I said: 'I'm not protesting against what you're doing, I'm just simply saying I don't want to be involved in a political movement of any kind.' I sent that to the FBI. That got me out of an awful lot of trouble, because I was automatically on the black list. A lot of fine people couldn't get jobs in certain industries. I was doing a lot of work for Polaroid, and I said to Dr. Land: 'I'm worried because I know I'm on the black list because I was a member of this organization.' He said: 'We'll get you cleared.' It took a year and the investigation was something terrific. They looked into all my friends, my school, and my family. In spite of these letters two FBI men finally called on me in San Francisco. They said: 'We have to tell you Mr. Adams that we've been on your clearance along with many others and we are very happy to say that you are completely cleared.' I said: 'Well, thank you.' They said: 'You know it is very fortunate that you wrote those letters because in writing those letters you have established your position. But we had to check that those were completely valid and they weren't a subterfuge. You'll have to bear with us in the sense that there was a great deal going on, in terms of national security, that had to have attention.' I still was ruffled and I felt injured as an American. Just because I'd belonged to an organization like that I'd been under suspicion. Then I had official secret clearance but I didn't get 'Top Secret'. I got very close to it but that would have required another investigation.

You say that at that time you were working for Polaroid?

About 1950 I became a consultant.

What were you doing between the end of the war and 1950?

Writing books and finishing a Guggenheim. Also I was involved in putting on an exhibition, with Nancy Newhall, on conservation. It was called 'The American Earth'. It became very popular and there were several editions made of it. Well, then the next step was to do a book. This was the first one in the Exhibit Format series of the Sierra Club and it was pretty conservative. We had to raise the money, so I got a $15,000 donation from the McGraw foundation and a loan of $12,000, and that enabled us to put out the books. The first thing we did was to pay back that loan. It became an amazingly successful book, the paperback sold 100,000 copies, and it started a whole Exhibit Format series which, unfortunately, deteriorated financially, which was a disaster.

What did you receive your Guggenheim for?

You see I had been a photo muralist for the Department of the Interior. In 1941 my job was to get photographs of all the parks and the monuments and install these big things in the Interior Building. Then came Pearl Harbour. I got a Guggenheim to continue this theme after the war and out of that came 'My Camera in the National Park'.

Then I had another Guggenheim to catch up with printing.

Were you the first one to receive three Guggenheims?

Yes, I guess so. Well, its really not three. There was one and a renewal, and then a second one.

Also after the war you got involved in teaching. How did this come about?

We had a photographic session in Yosemite called the Yosemite Photographic Festival, with Edward Weston, Dorothea Lange, and a kind of a cross section of different workers. *US Camera* in 1939 did a magnificent folder for it you know. I guess it was the first thing we called a workshop. We had big cancellations so it wasn't a driving success. But still it started a pattern. Then a year or so after the war I started up the Ansel Adams Yosemite Workshop again and that gradually developed into much broader things. Now we have many workshops a year, but I'm only there in June.

How did you get involved with 'formal' teaching?

Edward Adams (no relation) invited me to come to the Art Centre and teach. I thought it was a good opportunity, but I'll never forget the trauma when we were packing up the station wagon in Yosemite to leave. Everything tremendous, waterfalls, morning star, the north wind, and I was going to that 'blankety-blank' Los Angeles. I almost pulled the cameras out of the car and turned the job down, but I said I'd do it, so I had to go. It was a very important thing because out of that came the Zone System.

When you went to the California School of Fine Arts (later, The San Francisco Art Institute), and started the photography programme there, was that the first formal photography programme of its kind?

It probably was. You see I'd taught before the war, and during the war at the Art Centre. After the war I was asked to found a Department of Photography. I worked like a dog, but we had good staff. I was supposed to teach three mornings a week and ended up teaching 8 days a week! You have to admit teaching is not casual! We turned out some very fine people. Then Minor White came. I said: 'I'm going nuts. I'm losing assignments. I'm going broke.' They paid relatively little—25 dollars a morning or afternoon session. I was making 200 a week. But I had a job for *Fortune* in Western Canada and I couldn't do it. I think I turned down four assignments and each one was up in the thousands you know. They were also creative opportunities. I directed and taught at the school for two years I think, and during the last year Minor White attended the last session and helped teach. Then I asked him to take it over. So I got back into pretty intense photography.

Then I got on a lecture tour and went to all the colleges along the Pacific coast. That went on for years and it was very tiring. I wasn't getting any printing done and I had a lot of exhibits to do. I did a great many assignments for big developments because I liked project ideas. I did one on the University of Rochester and later on I did the University of California. I also began to sell prints, particularly from Yosemite.

What were your thoughts on photographic education at that

time; and what are your thoughts on photographic education today?

Well, that's a very important subject, and a very difficult one. I was trained as a musician with intense discipline. And whenever I taught photography I taught it on that basis. Subsequently, photographic education has lost the feeling of craft; it either went to the social domain or it became subjective. Now Minor White is a superb photographer—but his whole approach is highly subjective; I call it centrifical. Instead of going out into the world, the camera is being used as a therapy, and as a psycho-analytical tool to heal people who are disturbed. This can be dangerous if someone is terribly disturbed. There's a lot of work done without rhyme and reason except as a personal indulgence, and I don't like that. Then the other branch is sociological with the human situation as the prime thing. Photography is in there just to record it. It's very important, but there aren't many photo-journalists who are artists. Eugene Smith is absolute tops and Cartier-Bresson is good too. But we do have quite a number whose photographs are really observations of the external world. What we call the fine print, with all its subtilties, is of secondary importance.

Was it because you felt some sort of dissatisfaction with the lack of craft in a photographer's work that you were attracted to writing manuals on photographic technique?

Yes. I felt that there was some need to express a technique. Now I've never done it to a point where I've indicated an exclusively technical approach. People say that there is another way. Of course there is, but I'm just saying that there is a system that I know works and if you've got a better one then fine. I'm delighted when people interpret their own system. Minor has done some fine interpretations, and also some very confused ones. You see a lot of people think they can teach, and they write what they think they can teach, but they don't do it.

What were the first portfolios that you published?

One was dedicated to Stieglitz, and each print is equivalent to something I felt about Stieglitz.

What kind of images were they? Were they of the land?

They followed the war up to '48. There were 12 prints. I just allowed myself to be very subjective in the pictures that represented Stieglitz. Stieglitz died, and the prints died too. And I refused to talk about them. I just can't, and I can't say why. You've seen these pictures, it's an equivalent thing. . . . The cloud going up to the peak of the mountain in Golden Canyon.

Then the second portfolio was really the Guggenheim, and the third one was the Yosemite Valley. I produced it, and the Sierra Club published it. And now portfolio seven is due in 1976 sometimes and it's selling for an unbelievable amount of money. They've already sold more than 20 and I haven't even set the subject yet!—That's one of my jobs now. I have to get right down and pick out the 30 that I would like to go in. The publishers and I choose them because I've always said that the artist cannot really make the selection of his work. I mean he can't be that objective. But he has a right to say whether something goes or not. (pp. 37-9)

What does the concept of the 'straight' photograph mean to you?

It means just using photographic methods to achieve the result with no drawing in or retouching. But then again, take the famous portrait of Lincoln: he had a mole and it catches your eye as a black speck. It doesn't read as a mole. So I think you'd be privileged to take that out.

You've always been very much influenced by the large panoramic view of nature. How do you think this influence came about?

I think we do have large panoramic views of nature, and they are very difficult to photograph because their largeness or their majesty is not just geometric. It is a mood and it affects you in a certain way. Photographically you expand, you enrich, and you give them monumental qualities which overcome the geometric limitations of scale. I also have a picture of a 6 feet wide stump, which is in one of my books, and this is also monumental. The trouble with average scenic images is that stuff is out there and the eye can see it. To render that most effectively with a camera you have to have total control.

It's been said that your view of the American natural scene has become every American's view of America's natural scene.

I think that's an exaggeration. What I've seen I've seen in my own way and I'm not conscious of any influence. But you never know where the influence comes from. I imagine that some of the early paintings and some of the early photographs had something to do with it. You see, the American Scene becomes very dramatic up to the Rockies and from there on it becomes another kind of scene. The East Coast is another kind of scene, and so on.

Nancy Newhall and I were planning a book and I wish we had had the time and energy to do it because it would have been magnificent. The title would have been the 'Far Horizon', the story of the western migration, with the text of the explorers, the writers, the surveying people, and then stylized photographs. Now imagine if you take a book on the development of America towards the west and bring in these images, it would be a colossal thing.

Those things can be so moving and so important compared to the hideous dryness of the Bi-Centennial. I'm scared to death of this pipe and drum stuff for two hundred years. They forget that the good old times are a product of a poor memory. Watergate wasn't the first awful scandal we had in this country you know. So I say the Bi-Centennial should be the celebration of the next 200 years. The new American Centre of Creative Photography is going to say: 'This is the next 200 years.' We're going ahead instead of going back and digging up all these old replicas, which please Chambers of Commerce and Disneyland.

You haven't photographed many people in your life. Is there any reason why this is?

I *have* photographed many people! I did a lot of portraiture on demand, which I don't consider my best work at all. You do portraits to make a living. Edward Weston did a lot of portraits and that's the way he made a living, but they're not his top work. I must have 100 very fine portraits, most of which haven't been printed.

Sometimes when you photograph people, it has been said that they turn out more like rocks, whereas your rocks and landscapes seem more humanistic, more alive.

No, I don't take it that way. One of Stieglitz's finest portraits was one of two minutes exposure. He and I agreed, individually, that more of the person comes through with the static analysis of his face. The candid photographer has upset this because he thinks that a slice of time is *it*, but that isn't you at all. Now if I did a picture of you it would be a very different and a very quiet thing: magic would happen with the lighting and all.

What in your opinion have been the major influences on the aesthetic development of photography in the twentieth century?

Well, it would be very presumptuous to say that I was a great influence, but I can't deny the fact that I've been an influence along with many others. Perhaps in a way I've had the opportunity, through associations, to have more effect on the art than many people. But it's not an intentional fact, and I have never attempted to manipulate. That is a thing that you have to be very careful of. There have always been people who have dictated trends, and the terrible thing about the museums is that the people that run them are self-appointed taste-makers. When a big museum does something it establishes a line of acceptance and profoundly influences taste. Major influences have been Weston and Strand and people like Beaumont Newhall, the historian, and Nancy, with her editorial capacity. (p. 39)

What has been your dominant philosophical concern throughout your photographic career?

Well, you see now you're asking me to verbalize and I can't. I think the photographs have to say that. Externally speaking, I've always been extrovertal. In other words if I do something, I want it to work. So, from a philosophic point of view, I have a feeling that photography is a visual language. I want to communicate, but I want to help other people to communicate with themselves and with others. . . .

Is it your feeling though that a photograph exists primarily as a work of art?

No, I've never been able to say that. O'Sullivan was one of the best of the western photographers. He had an eye and took beautiful images, but they weren't done with the art intention. You have to be very careful now that you are not reading in intention. One example I have in my own work is the picture of Long Beach Cemetery and the Angel of Death, an Italianate marble carving with, in the background, the Signal Hill oil derricks. That was done in 1937 and we were very much interested in getting almost absurd juxtapositions. Well, I sold some prints of it at the time but now it has suddenly become the symbol of pollution—the Angel of Death and the oil wells. This is totally and completely divorced from any concept I'd had when I made it.

Your photography is full of life. Do you see photography as a means of affirmation?

Exactly, as Stieglitz said: 'Art is the affirmation of life', and that would be a basic philosophy. It's the affirmation of something, not the denial; it's not the negative without

the alternative. That's one of the problems now with the environment. Anybody can say no, but they don't really have a right to say no, unless they have an alternative. (p. 40)

<div align="right">

Ansel Adams with Tom Cooper and Paul Hill, in an interview in Camera, *Vol. 55, No. 1, January, 1976, pp. 15, 21, 27, 37-40.*

</div>

Ansel Adams with Mary Street Alinder (essay date 1984)

[*In the following extracts from his autobiography, Adams recalls the circumstances behind his photograph,* Monolith, The Face of Half Dome (*1927*) *and describes the founding of the f/64 group.*]

One bright spring Yosemite day in 1927 I made a photograph that was to change my understanding of the medium. My soon-to-be wife, Virginia, our friends Cedric Wright, Arnold Williams, and Charlie Michael, and I started out quite early that morning on a hike to the Diving Board. A magnificent slab of granite on the west shoulder of Half Dome, the Diving Board overlooks Mirror Lake thousands of feet below. Several years before I had climbed to the Diving Board with Francis Holman, and since then I had thought of that staggering view of Half Dome and knew it would make a good photograph.

We decided to climb via the LeConte Gully, just north of Grizzly Peak. This route would be relatively free from snow though it is very steep and rough, and much easier to ascend than to descend, as I had discovered with Bill Zorach in 1920. My camera pack alone weighed some forty pounds, as I was carrying my Korona view camera, several lenses, two filters, six holders containing twelve glass plates, and a heavy wooden tripod.

At the top of the gully, we removed our packs for the difficult final climb of several hundred feet to the summit of Grizzly Peak. This craggy rock tower gave us a rather startling panorama: four waterfalls, the great mass of Glacier Point, Half Dome rising thousands of feet higher, and the many peaks of the Sierra, dominated by Mount Florence and Mount Clark. Everything above seven thousand feet was covered with snow. I regretted leaving my camera below the summit.

We returned to the intermediate base, took up our packs and proceeded up the long, partially snowy rise of Half Dome's shoulder. I stopped often to set up and compose pictures. I had several failures, but did get one rather handsome telephoto image of Mount Galen Clark. By the time I had finished that picture, which took two exposures, added to the six errors I had already made, I had only four plates left for my prime objective of the trip.

We reached the Diving Board at about noon, tired and hungry. It was beautiful, but the enormous face of Half Dome was entirely in shade, and I felt I must wait a few hours until the sun revealed the monolith. It was one of those rare occasions when waiting was justified.

Following lunch washed down with water from melting snowbanks, I made a picture of Virginia standing on one of the thrusts of the Diving Board. The camera was pointed to the west, and with the first plate I forgot to shield

the lens from the direct sun. I made a second plate to be sure. I now had only two plates left for one of the grandest view-experiences of the Sierra, the face of Half Dome itself.

At about two-thirty I set up the camera at what seemed to be the best spot and composed the image. My 8½-inch Zeiss Tessar lens was very sharp but, as usual with lenses of this design, did not have much covering power; the image formed by the lens was just large enough to cover my glass plate when centered thereon. I had to use the rising-front of the camera, as tilting the camera up more than a small amount would create the unwanted effect of convergence of the trees. Over the lens I placed a conventional K2 yellow filter, to slightly darken the sky. I finally had everything ready to go. The shadow effect on Half Dome seemed right, and I made the exposure.

As I replaced the slide, I began to think about how the print was to appear, and if it would transmit any of the feeling of the monumental shape before me in terms of its expressive-emotional quality. I began to see in my mind's eye the finished print I desired: the brooding cliff with a dark sky and the sharp rendition of distant, snowy Tenaya Peak. I realized that only a deep red filter would give me anything approaching the effect I felt emotionally.

I had only *one* plate left. I attached my other filter, a Wratten #29(F), increased the exposure by the sixteen-times factor required, and released the shutter. I felt I had accomplished something, but did not realize its significance

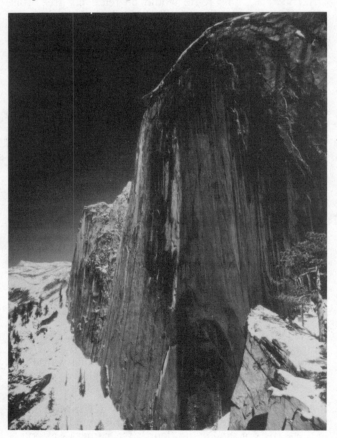

Monolith, The Face of Half Dome (1927)

until I developed the plate that evening. I had achieved my first true visualization! I had been able to realize a desired image: not the way the subject appeared in reality but how it *felt* to me and how it must appear in the finished print. The sky had actually been a light, slightly hazy blue and the sunlit areas of Half Dome were moderately dark gray in value. The red filter dramatically darkened the sky and the shadows on the great cliff. Luckily I had with me the filter that made my visualized image possible.

The date was April 17, 1927 and the results of this excursion were three very good plates: *Monolith, The Face of Half Dome, Mount Galen Clark,* and the one of Virginia on the edge of the Diving Board, *On the Heights.*

Monolith has led a charmed life. It survived my darkroom fire in 1937 with only charred edges that are cropped from the final print anyway. I have not dropped the glass plate nor sat on it. It rests in my vault, still printable, and represents a personally historic moment in my photographic career.

Visualization is not simply choosing the best filter. To be fully achieved it does require a good understanding of both the craft and aesthetics of photography. I was asked by *Modern Photography* to write an article about creative photography for their 1934-5 annual. This was my definition of visualization.

> The camera makes an image-record of the object before it. It records the subject in terms of the optical properties of the lens, and the chemical and physical properties of the negative and print. The control of that record lies in the selection by the photographer and in his understanding of the photographic processes at his command. The photographer visualizes his conception of the subject as *presented in the final print.* He achieves the expression of his visualization through his technique— aesthetic, intellectual, and mechanical.

The visualization of a photograph involves the intuitive search for meaning, shape, form, texture, and the projection of the image-format on the subject. The image forms in the mind—is visualized—and another part of the mind calculates the physical processes involved in determining the exposure and development of the image of the negative and anticipates the qualities of the final print. The creative artist is constantly roving the worlds without, and creating new worlds within. (pp. 73-8)

.

During the first two years of [my] marriage I juggled two professions: music and photography. By 1930 I was wracked by indecision because I could not afford either emotionally or financially to continue splitting my time between them. I decided to return to New Mexico to complete the Taos book [*Taos Pueblo*], hoping the Southwest summer sunlight and towering thunderclouds would inspire a decision.

Arriving unannounced at Los Gallos, I found it so crowded that Mabel [Dodge Luhan] had not one guest room left. I was introduced to Paul and Becky Strand, who invited me to stay with them in the extra bedroom of the small adobe guest house that Mabel had given them for the summer. I knew photographer Paul Strand by creative reputation, and I had seen his photographs in handsome photo-

gravure reproductions in Stieglitz's great photographic journal, *Camera Work*. Paul was a buoyant spirit and Becky a serene and beautiful woman.

That first evening I dined with the Strands and Georgia O'Keeffe. Strand inquired politely about my Taos Pueblo project, then I inquired if he had any prints to share. He asked if I would like to see his negatives, since he had made no prints that summer nor had he brought prints from New York. Of course I would!

The next afternoon Paul took a white sheet of paper and set it in the sunlight streaming through a south window. He placed me squarely in front of the paper and opened a box of 4 × 5-inch negatives. He handed them to me, admonishing, "Hold them *only* by the edges."

They were glorious negatives: full, luminous shadows and strong high values in which subtle passages of tone were preserved. The compositions were extraordinary: perfect, uncluttered edges and beautifully distributed shapes that he had carefully selected and interpreted as forms— simple, yet of great power. I would have preferred to see prints, but the negatives clearly communicated Strand's vision.

My understanding of photography was crystalized that afternoon as I realized the great potential of the medium as an expressive art. I returned to San Francisco resolved that the camera, not the piano, would shape my destiny. Virginia was very supportive of my decision; my mother and aunt reacted differently, pleading, "Do not give up the piano! The camera cannot express the human soul!"

I replied, "Perhaps the camera cannot, but the photographer can."

Though committed, I was uncertain what Ansel Adams's direction in photography should be. Increasingly, I detested the common pictorial photography that was then in vogue and also questioned the more sophisticated work of some San Francisco photographers because it clung to those pictorial skirts. There was nothing I responded to in this mannered style of photography. In fact I had seen little photography that I felt was art. My knowledge of the important people in the history of photography and the work of other creative photographers was abysmal.

With high energy I began to explore a personal photographic direction based on the inherent qualities of the photographic process itself. I abandoned my textured photographic papers and began using the same smooth, glossy-surfaced papers used by Paul Strand and Edward Weston to reveal every possible detail of the negative. I am unsure how much this change in paper affected my photographic "seeing," but I suddenly could achieve a greater feeling of light and range of tones in my prints. I felt liberated; I could secure a good negative born from visualization and now consistently progress to a fine print on glossy paper.

One evening in 1932 there was a remarkable collection of sympaticos gathered at the Berkeley home of Willard Van Dyke, a University of California student and photographer: Van Dyke, Imogen Cunningham, Edward Weston, Henry Swift, Sonya Noskowiak, John Paul Edwards, and myself. I presented, with extroverted enthusiasm, my new sense of direction in photography. The response was im-

mediate, striking powerful sparks of accord from the others, some of whom had already embarked on the same journey.

We agreed with missionary zeal to a group effort to stem the tides of oppressive pictorialism and to define what we felt creative photography to be. Perhaps most importantly, our efforts provided moral support for each other. Though we actually met together very few times as a group, I have found records that show that we paid dues, at least once, of ten dollars each.

On another evening at Willard's, we bantered about what we should call ourselves. The young photographer Preston Holder was present that night, and he suggested we call ourselves "US 256," the designation of a very small lens aperture many of us used to achieve greater sharpness and depth. Afraid that people would confuse us with a highway, I followed his line of thought, picked up a pencil, and drew a curving *f*/64. The graphics were beautiful and the symbol was apt—*f*/64 was the new aperture marking system identical to the old system number US 256.

Group *f*/64 became synonymous with the renewed interest in the philosophy of straight photography: that is, photographs that looked like photographs, not imitations of other art forms. The simple, straight print is a fact of life— the natural and predominant style for most of photography's history—but in 1932 it had few active proponents.

The members of Group *f*/64 decided that our first goal would be to prepare a visual manifesto. Our work was varied but shared a fresh approach that stirred the wrath of the salonists, perplexed many in our local art world, and delighted a few pioneers including Lloyd Rollins, director of the M. H. de Young Memorial Museum in San Francisco. Lloyd had come to one of our gatherings at Willard's where we had a small display of the group's work. After looking at our photographs, he immediately offered us an exhibition. This was an important event for each of us; for me it was my third major museum exhibition. I had had a solo show in 1931 at the Smithsonian Institution, and both Edward and I had already had exhibits at the de Young earlier in 1932. For this exhibition the seven members of Group *f*/64 invited four others to show with us: Preston Holder, Consuela Kanaga, Alma Lavenson, and Brett Weston, knowing that they represented the same photographic philosophy. The exhibition dates were November 15 through December 31, 1932. There were a total of eighty photographs in the show, from four to ten prints per photographer, with prices that now seem ridiculous: Edward charged fifteen dollars per print and the rest of us charged ten.

At the exhibit we handed out a written manifesto to accompany the visual one. I was one of the authors and feel that it explains quite clearly what we were about.

GROUP *f*/64 MANIFESTO

The name of this Group is derived from a diaphragm number of the photographic lens. It signifies to a large extent the qualities of clearness and definition of the photographic image which is an important element in the work of members of this Group.

The chief object of the Group is to present in frequent shows what it considers the best contempo-

rary photography of the West; in addition to the showing of the work of its members, it will include prints from other photographers who evidence tendencies in their work similar to that of the Group.

Group *f*/64 is not pretending to cover the entire field of photography or to indicate through its selection of members any deprecating opinion of the photographers who are not included in its shows. There are a great number of serious workers in photography whose style and technique does not relate to the metier of the Group.

Group *f*/64 limits its members and invitational names to those workers who are striving to define photography as an art form by a simple and direct presentation through purely photographic methods. The Group will show no work at any time that does not conform to its standards of pure photography. Pure photography is defined as possessing no qualities of technique, composition or idea, derivative of any other art form. The production of the "Pictorialist," on the other hand, indicates a devotion to principles of art which are directly related to painting and the graphic arts.

The members of Group *f*/64 believe that photography, as an art form, must develop along lines defined by the actualities and limitations of the photographic medium, and must always remain independent of ideological conventions of art and aesthetics that are reminiscent of a period and culture antedating the growth of the medium itself.

Our exhibition and accompanying statement created considerable attention and invigorating discussion, much of it negative. The de Young Museum received many letters of protest, mostly from artists and gallery people, complaining that valuable space at a public museum had been given to photography *which was not Art!* Concerned, Rollins requested the opinion of the board of trustees of the museum, who supported him by saying, "You are our director; if you think exhibits of photography are appropriate for the museum, by all means present them." Rollins telephoned me to describe the meeting and his great relief at its outcome. I have wondered what might have been the effect on the progress of West Coast photography if the Group *f*/64 exhibit had been rejected by the de Young. (pp. 109-12)

Ansel Adams with Mary Street Alinder, in his Ansel Adams: An Autobiography, *Little, Brown and Company, 1985, 400 p.*

INTRODUCTORY OVERVIEW

R. Gordon Taylor (essay date 1984)

[*In the following excerpt, Taylor chronicles the prolific career and achievements of Ansel Adams.*]

Ansel Easton Adams was born on 20 February 1902 in San Francisco, the only child of Charles and Olive Adams, being named after a brother-in-law of his father. When he

was four years old he suffered a fall during the great San Francisco earthquakes and damaged his nose, which remained slightly misshapen for the rest of his life. In 1914 he started piano playing seriously and this competed with photography in his interests for a great number of years, as he became good enough to give concerts and intended for some time to make it his career. His interests in the natural world were encouraged by his first visit to Yosemite Valley in 1916, where he took photographs with a Box Brownie—the camera with which so few photographers seem not to have started. He visited the valley every year after that, sometimes being taken camping by an uncle who was a member of the Sierra Club, whose members at that time were a relatively small group of conservationists. By the time he was eighteen he had decided to make music his career, although he obtained a summer job as custodian of the Club's HQ in the valley in 1919 and did the same for the next three summers. He met his wife-to-be, Virginia Best, in the valley when he used their family piano for the hours of practice needed in between his Club duties. A less well known side of Adams is that he was also a poet and composed quite a quantity of verse over the years.

On the photographic side he progressed from the Brownie camera, and photographs taken on trips in the valley were first published in the *Sierra Club Bulletin* in 1922, to be followed by some hundreds in the following years up to 1971 when he resigned the directorship he had held from 1934. He was encouraged in his photography by several people and in the autumn of 1927 a portfolio of eighteen photographs, printed by Adams was produced: as the publisher objected to the plain word 'photographs', the black grosgrain, satin-lined case in which they were presented proclaimed **Parmelian Prints of the High Sierras.** In 1928 he became official photographer in the Sierra Club and a member of its outings committee, helping to plan routes safely for up to 200 people with accompanying pack train.

Ansel and Virginia were married in January 1928, to move into a house he had built overlooking the Golden Gate two years later. This was designed for both music and photography but at this period he felt he had to decide between the two for his future profession, for although he had given a few recitals he was also recognised as a serious photographer. A meeting with Paul Strand while on a return visit to Taos helped him make the decision to be a professional photographer—as he had been advised, although not unanimously, by friends. Music remained a pleasure and relaxation for the rest of his life—he was seen playing Bach at the beginning of a TV interview shown in Britain within the last year or two.

Another book followed in 1930 as a limited edition (108 copies) of his photographs, **Taos Pueblo,** with text by Mary Austin. At $75 a copy it nevertheless soon sold out and like other early works of his is sought by collectors. At the beginning of 1931 he had his first exhibition in Washington, where the Smithsonian Institution showed 'Pictorial Photographs of the Sierra Nevada Mountains.' Nancy Newhall has pointed out that this was the last time that he allowed the word pictorial to be associated with his name. He first met Edward Weston in 1927 and admired the clarity of the prints Weston was then making on glossy paper—a surface that 'pictorialists' then abhorred. Although some of his early photographs were in soft-focus and he even tried some bromoils, from about

1930 onwards his style was clear and sharp. In 1931 Adams stopped using textured paper 'for the simple dignity of the glossy print' even though it showed every defect. This was really the beginning of the Adams style of photograph for which he was eventually to become so famous.

When in 1931 he was asked to contribute a column on photography in an arts review *The Fortnightly,* he took it seriously and his first column in November concerned Eugene Atget whose smooth paper surface and clear images he praised. His second concerned a one-man show by Edward Weston which he recommended to painters and other readers, but some later exhibitions, such as one of the work of Moholy-Nagy, he castigated.

The famous—but short-lived—f/64 Group (a figure not intended to be taken literally) was formed in November 1932, in which Imogen Cunningham, John Paul Edwards, Sonya Noskowiak, Willard Van Dyke, Edward Weston and Henry Swift joined informally with Adams (all being relatively young and hot blooded) to promote 'straight' photography (in which the camera was not a substitute for the brush) as distinct from the pictorialism of that time. Later Dorothea Lange became a member but it was dissolved quietly in 1935, its work done. In 1933 Adams started a gallery in San Francisco, which opened with a Group f/64 exhibition, to be followed by one of a mixture of paintings and drawings. He also gave lectures and private tuition. He gave up the gallery in 1934 to concentrate on what he considered his real work.

A trip to New York in 1933 led to a visit to An American Place where Alfred Stieglitz admired his prints, this resulting in an Adams exhibition there in 1936, the first there of work by a young photographer for nearly 20 years.

One of his best-known early books was *Making a Photograph,* published by The Studio in the USA and Britain in 1935. As a book with first-class illustration quality and clear expounding of ideas, this, and its subsequent editions in 1939 and 1948, was studied by a great number of students and photographers who considered a good technique and fine black-and-white prints worth working for. The technical manuals for which he is best known are contained in the Basic Photo series of five books: *Camera & Lens* (1948), *The Negative* (1948), *The Print* (1950), *Natural Light Photography* (1952) and *Artificial Light Photography* (1956). A sixth volume in the series, Twelve Photographic Problems, was projected but did not appear. In 1963 he was appointed consultant to the Polaroid Corporation and produced a comprehensive *Polaroid Land Manual* in that year, with a revised edition in 1978 to deal with different materials and other changes in the system. The first volume of the Basic Photo series was updated in a revised and expanded edition in 1970, to be followed more recently by The New Ansel Adams Photography Series (with the collaboration of Robert Baker): *The Camera* (1980), *The Negative* (1981) and *The Print* (1983), which are completely revised and re-written to include up-to-date apparatus and materials. Adams contributed to the Hasselblad magazine and one of that manufacturer's own series of instructional/promotional booklets is by Adams and based on the Basic Photo series. (pp. 1014-15)

Articles on conservation, photography, other photographers, technique and places were contributed throughout his photographic life to magazines and annuals. Although known by most people for his clear landscapes, he photographed most other subjects, too, notably during his time as a commercial photographer.

In 1940 Adams helped Beaumont Newhall establish at the Museum of Modern Art the first department of photography as a fine art and he was vice-chairman of its advisory committee. Much later he was to make a $250,000 gift to MOMA to establish a photographic curatorial fellowship. He founded the first Department of Photography at the California School of Fine Arts in 1946 and in that year received his first Guggenheim Fellowship.

He began holding photographic workshops in Yosemite in 1955 and these continued until 1981 when he transferred the summer workshop to the Monterey peninsula, where it is now administered by The Friends of Photography of which he was one of the founders and served on its board of trustees from its inception in Carmel in 1967.

Adams has defined 'my basic approach to photography depends on visualisation of the final print before the exposure is made' and this led to his well-known Zone System which, he said, 'is nothing more than simplified sensitometry'. This system, which he devised in 1940, once it is understood, can help serious workers improve their technique and make production of 'the fine print' much easier, although some disciples have wrapped the system in too much verbiage and led to discouragement or even hostility to the system.

As a teacher he has pointed out that 'there is no question that a 4 × 5 or 8 × 10 view camera calls for a different kind of "seeing" than a hand-held 35mm camera . . . a photographer who uses several different camera types will often find that his very perception changes when he is carrying a small camera instead of a large one, and vice versa'. He used cameras of all sizes, although best known as a large-format worker. In the 1930's he wondered if the miniature camera would make photography too easy and that standards would be lowered but in 1935 started using a Contax after seeing work taken on 35mm by Peter Stackpole, a late member of the f/64 Group. By one of life's coincidences, his first Box Brownie gave him negatives 2¼ × 2¼ in and this is the size he used most frequently in his last years. Among his cameras was a lightweight 10 × 8 model of duralumin which came from an arctic explorer. At one time he had a special large roof-rack or platform on top of his large estate car to take himself and 10 × 8 camera when a high vantage point was needed. As his collection of negatives grew he had a special fireproof concrete building made for them, with humidity and temperature control.

By his landscape work, Adams aroused an awareness in many people of the scenic heritage of the USA and of the camera's ability to show it at its best. When taking his views he did not take just the one negative of each. Insurance against damage advises more than one and it is sometimes possible to see slight variations, such as in the position of clouds, in some of his most often reproduced works, showing that the negative was different although the title might be the same. This must not be confused with a common photographic malady of today—bracketing 'to be on the safe side'. As with other well-known photographers, some of his images are seen almost

too frequently in various books and magazines but this is probably the fault of the picture editors who either know of these only or have not investigated the photographer's work thoroughly. (pp. 1015-16)

It has been said that Adams celebrated the sublime in nature with visions of America as paradise, and he has not been without his critics, exemplified in the article by Gerry Badger [see excerpt dated 1976] and the subsequent correspondence. Are his landscape photographs too good? too technically perfect? too full of 'glee—just look at that!'? too much a literal view of what was in front of the camera, however grand, and yet with something missing? As was mentioned in the review of *Images 1923-1974* 'in general his landscapes are usually brilliant and quite different to the moody views of Albert Renger-Patzsch, the compassion of Josef Sudek, the undramatic but sincere outlook of Paul Strand, or Edward Weston's contemplative kind of photography'. Nevertheless his photographs will continue to be admired, as they were in an exhibition of 125 of his prints in Shanghai earlier this year, as well as in another which travelled through India, Saudi Arabia, Morocco, Cairo and other countries in 1982.

In 1959 Adams was a 'protagonist' in a series of TV films *Photography: The Incisive Art* and he took part in a TV commercial for Datsun. He received doctorates, fellowships and other awards from 1960 onwards, including the Progress Medal of the Photographic Society of America and an Honorary Fellowship of the Royal Photographic Society. When approaching 80 he was given the Hasselblad Award and Gold Medal and on his 80th birthday received the French decoration of *Commander* in the Order of Arts and Letters, France's most prestigious cultural honour given to a citizen of another country. A Californian Wilderness Bill has been proposed to preserve nearly two million acres of wilderness: if passed, a hundred-acre area of it will be named after Adams. In 1980 he received the Presidential Medal of Freedom from President Carter at the White House.

The number of negatives he leaves has been estimated at between 30,000 and 40,000, although he once said 'twelve photographs that matter in a year is a good crop for any photographer'. Postcard sets of his landscape photographs have been issued in the USA, with reproduction quality quite high. A visitor to the USA 25 years ago mentioned seeing coffee tins with an Adams landscape on the label.

Although known for his black-and-white work, Adams also took colour, mainly of commercial subjects although including some 5 × 4in Kodachromes soon after it started its relatively short life in that size in the mid-late 1930's.

As he and mainly his landscapes became more and more well-known, Adams original prints became increasingly in demand and reached high prices in galleries and auctions,with prints realising from $800 up to $1200 (which Adams thought was crazy). About 10 years ago he announced that he would take no more orders for prints after the end of December 1975. Dealer Harry Lunn then ordered 1000 prints, for which Adams was paid $400,000. He had his own agent who arranged publication deals.

As a person, Adams had the knack of becoming known, not only through his appearance and the stetson-type hats he wore outdoors, but also by being lively and sometimes noisy when with friends and not taking photographs. As

well as being fortunate in the acquaintances and friends of his early years, he seems to have been a better businessman, or received and acted on much better advice, than many photographers, who tend generally to have an image of being lax in financial matters, and more adept at self-promotion (although there are some obvious exceptions today). Joe Munro described him in *Infinity* (of the American Society of Magazine Photographers) as 'a gentle, twinkling, quick, educated, cultured, sometimes vague but enormously disciplined, energetic, aesthetically aware and earnest man—who just loves to make sharp, poetic, rich-toned photographs of the western outdoors'. It is interesting that his assistants' names have often been seen subsequently as significant photographers themselves—but not necessarily with his style or outlook.

Ansel Adams was one of many long-lived photographers. They, like conductors in the world of music, seem to add extra years to their life span: is it from the satisfaction gained from the work they do? or in order to do what they do, have they to have a certain mental outlook which produces, or is allied to, the factors controlling longevity? . . . Prophetically he said in 1938 'What I will be at sixty, seventy and eighty remains to be seen. Probably I will be a photographer'. (p. 1016)

R. Gordon Taylor, "Ansel Adams 1902-1984," in The British Journal of Photography, *Vol. 131, No. 6478, September 28, 1984, pp. 1014-16.*

SURVEY OF CRITICISM

Anita Ventura (essay date 1963)

[*In the following review of an exhibition at the De Young Museum, Ventura notes that Adams's conservationist impulse is manifest in each of his prints.*]

Forty years of the work of Ansel Adams is being shown currently . . . at the De Young Museum. Adams has become by now a figure both institutional and (he would object) legendary in American photography. As a practitioner and a teacher he has stood for what in common parlance is the straight approach to photography: available light and the full use of available technique (Polaroid, for instance); the uncropped print. This splendid gathering, originating at the De Young and directed by Nancy Newhall, who is also the author of his . . . biography, *The Eloquent Light,* brings a point about Adams quite home, in both senses. It is this, and it may be now available because the photographs are seen in his own stamping grounds: Adams is a conservationist first, a man who handles superbly a medium that best states his message about conservation—whether it be a stand of redwood or the face of the scientist Russel Varian. He records exactly identity apart from himself; he is a genius at it. His approach is a non-art approach: a tree in snow that at first glance looks like the December photograph in a lumber-company calendar. But look again, and see how by his skill there is something beyond: a frieze of jagged rock,

faint but there in every detail. You are off the calendar and onto the map. It is this detail, this "warts and all" that he always asks of himself (not for him are Steiglitz's high-flown equivalents)—absolute identification, from the early Parmelian prints to the latest views of the Sierra, that gives his work a moral quality. There is something double-edged in this kind of morality, and it can lead to the sour remarks about contemporary art that we are used to from, say, Ben Shahn (this may be the artist rearing his ugly head). But there is an extraordinary generous gift, too: the preservation, as he rightly states, of "endless moments of the world."

Anita Ventura, "The Bay Climate," in Arts Magazine, *Vol. 38, No. 3, December, 1963, p. 33.*

William D. Case (essay date 1972)

[*In the following review of an exhibition at New York's Witkin Gallery, Case notes that light is Adams's ultimate subject.*]

"Ansel Adams at 70" celebrates one of the world's greatest photographers, a man whose contributions to both the art and technique of this medium were enormously influential in shaping the work of more than a generation. Since the beginning of his career, at the age of twenty-five, he has continued not only to document the extraordinary beauty of the American wilderness, but to develop the technical means and the aesthetic criteria necessary to record them with the minimum loss of impact.

Light is Adams's primary obsession, to a degree that suggests comparison with Caravaggio or De la Tour—except that Adams's is concerned with a far broader study of it. He does not limit himself to using light as a means of enhancing a particular subject, but makes it the subject itself, reminding us that it is not only the life's blood of photography, but virtually as substantial as the air it shapes.

William D. Case, in a review of "Ansel Adams at 70," in Arts Magazine, *Vol. 47, No. 2, November, 1972, p. 77.*

Sanford Schwartz (essay date 1972)

[*In the following review, Schwartz lauds Adams's technical expertise but suggests that he lacks a pervasive style or point of view.*]

"Ansel Adams at 70" (at the Witkin Gallery) is a small-sized retrospective—75 prints—of this very well-known photographer's work. The show concentrates, in what is probably the right proportion, on Adams's nature photographs, which have primarily been done in our national parks. These are grand views, more in keeping with the enormous vistas of the 19th century landscape painters than contemporary photographers (such as Weston, Stieglitz, or Strand), who have been interested in photographing nature only in small parts, and even then with the aim of finding complex formal patterns in the things they shoot, such as pieces of seaweed, scattered rocks, or clouds. Compared to these photographers, Adams's interests are not so essentially esthetic, and part of his reason for always having photographed nature in its most re-

splendent, stirring moments is his desire, as a conservationist, to make a broad public aware of the *American Earth* (as he called one of his books). He has also been a crusader for photography, generously giving his time and energy not only in aiding institutions (the University of California, the Museum of Modern Art, etc.) to establish departments of photography, but in helping to edit, publish, and preserve the work of his contemporaries, and, maybe most importantly, in remaining totally open to the problems of many younger photographers. He has picked up were Stieglitz left off, although there's a crucial difference between the two men in that where Stieglitz was obsessed with photography being taken seriously as a fine art, on a par with painting, Adams has tended to stress, as a basic first, the science of photography. His interest in showing the intense beauty of our wilderness has coincided with his pedagogic impulse to demonstrate the possibilities of his medium.

The effect of looking at so many prints by Adams in the Witkin show, which was my first large exposure to this photographer outside of his books, was a little staggering. To borrow and twist a famous line, I found it hard to bear so much reality. Adams's views of valleys, forests, mountain ranges, seashores—and after looking at many of his pictures it gets to feel as if he's putting in all of these things at once—are equally brilliant in every point of depth, so that a bit of bark, a twig, a leaf, a stone, and a cloud seven miles away from where you began are all dazzlingly sharp. The experience of these photographs is very different from actually being in nature, where it's impossible to take in so much at one time, and where the light is rarely as transparent—as empty-looking—as Adams gets it. And yet when you're looking at these pictures you're always conscious of the actual places, of being thrust into real landscapes. His vistas and his closeups are inviting the way the interiors in the paintings of the Flemish magic realists are, where your impulse is to inspect the settings as real rooms. In these paintings the fastidiously detailed execution makes everything seem like an enlargement of life even though, in actual dimensions, the pictures are miniatures. The Flemish masters, in their blinding realism, take us outside the realm of art, and Adams does too; when we think of the hand that made these paintings and photographs we're aware of the artist not in terms of his powers of transforming things, but in his incredible skill and patience.

Although many of Adams's photographs show his awareness of the stylistic devices of photographers such as Weston and Stieglitz, and also of a number of painters, I don't feel that his work derives too much strength from these artists' more complex compositional sense. In Weston's case, for example, decisions about the composition are inseparable from feeling for the object being photographed, and sometimes it's in his awkward-looking pictures, in those pictures that at first appear offhand or graceless, that we come to see his deepest feeling. When an Adams print occasionally looks awkward, you want to set it right. When a Weston looks awkward, exactly what would make it "right" is never apparent; in time either the picture will create its own kind of rightness, or else the photographer's intentions will never be made clear. Randall Jarrell wrote that Carl Sandburg's poems "are improvisations whose wording is approximate; they do not have the exactness, the guaranteeing sharpness and strangeness of a real

style". It's not my intention to compare Adams to Sandburg, but I think Jarrell's point can be made of most of Adams's "artful" photographs (the ones of shapely rivulets on the sand, or jagged forms of water catching the light, etc.). Unlike Weston (some of whose subject matter overlaps Adams's), Adams doesn't have what Jarrell described as the marks of a real style; his passion for nature has produced many glorious views, but the "exactness" and the "sharpness" of his work has more to do with his enormous technical finesse than a point of view that, from picture to picture, is necessarily his. His work never has that "strangeness of a real style"; you never feel in his work "this could be done in no other way". His best pictures are the absolutely direct, head-on shots, and preferably those, like the photograph of the porch post from Columbia, California, that aren't too densely detailed. In these pictures the viewer doesn't have to get so literally involved in the place being shot (as is the case with his grand vistas), and savoring Adams's great craftmanship becomes a pleasing end in itself. (pp. 61-2)

Sanford Schwartz, in a review of "Ansel Adams at 70," in Art International, *Vol. XVI, No. 10, December, 1972, pp. 61-2.*

Gerry Badger (essay date 1976)

[*In the following review of an Ansel Adams exhibition at London's Victoria and Albert Museum, Badger asserts that Adams's undisputed technical perfection and virtuosity constitute his greatest strength and weakness, giving his images an impressive, picturesque quality but failing to convey a sense of the artist's personal vision.*]

To walk into [a show] by a famous, indeed almost legendary master photographer, and to view original prints of images that one has known for perhaps years in reproduction can be an overwhelming experience, or it can be an almighty letdown. That it often tends to be the latter is usually due to our higher expectations of an original print vis-à-vis reproduction, expectations unfulfilled by so many photographers; but whatever our reactions, it does indicate the possible dangers of making total judgements based on reproductions, and exemplifies the very real differences not only between actuality and image but between image and image.

Of course, one need not be in any doubt that in the case of Ansel Adams one is going to be overwhelmed, for Mr. Adams is in the business of overwhelming—of impressing our sensibilities by the sheer scale, sharpness and tonal magnificence of his prints, those precisely etched facsimiles of a generally unspoilt landscape, a landscape imbued with a spectacular and rugged grandeur. So, when one looks at such well-known and well-loved images as *Monolith, Half Dome* (c1926), or *Winter Sunrise, Sierra Nevada, from Lone Pine* (1944), or *Mount Williamson, Sierra Nevada, from Manzanar* (1944), and especially the marvellous *Aspens, Northern New Mexico* (c1958) and *Moonrise, Hernandez, New Mexico* (c1944), one's breath is almost taken away.

We look at *Aspens* and marvel at the infinite subtleties of the dark grey scale going on and on in to the depths of the print, or we look at *Hernandez,* where the interplay of tones in the line of clouds and low hills is one of the most

beautiful things in all photography, and where one would not be surprised to spot a lizard under a stone from two miles, such is the sharpness.

Yet, for all this virtuosity, and Adams is *the* master of the 20 × 16in virtuoso statement, I personally find something fundamental lacking. And here I hesitate, for Adams is a universally recognised and widely acclaimed photographer, and he has so many qualities which I wholeheartedly admire—he has worked unceasingly and unselfishly for so many causes, for photography itself, for the environment, for the plight of interned Japanese-Americans during the War, for Dorothea Lange, for the recognition of Timothy O'Sullivan: in all he has made an immense contribution—as populariser, teacher, technician, theorist, historian, and iconographer. Yet, with the few exceptions such as *Aspens* and *Moonrise,* his photographs simply just do not *move* me.

And before anyone thinks how can one properly use or rather define such an amorphous term as 'move' in a responsible critical essay, let me say that I would not admit so readily to my doubts about Adams' imagery—I recognise that I have my critical 'blind-spots' and idiosyncrasies like anyone else—if it were not for the fact that my opinion is quite definitely shared, and shared by people who know about the medium. And although that opinion may be admittedly a minority one, it is the opinion I would say, of a sizeable minority.

The root of this negative attitude towards Adams lies in the undoubted fact that he is a virtuoso. And this virtuosity, as well as being his greatest strength, is his greatest weakness. He is the coloratura of the grey scale, and analagous to that particular breed of operatic singer, noted for a virtuoso, florid, somewhat ostentatious vocal technique, must be open to the criticism that the bravura technical display, however dazzling, is not a vehicle capable of expressing deeper and more lasting emotions.

However, this kind of critical argument is more often than not merely a personal expression of distaste for a certain opulence of style, and I would not contend categorically that the flamboyance of Adams necessarily should preclude true achievement. Yet I do believe that an overconcentration upon the technical aspects of the medium has prevented Ansel Adams from being as great a photographer as he might have been.

It was noticeable that in all the talks he gave when in this country recently—and I personally attended two of them—he emphasised the craft aspects of his work, to the extent of largely evading any questions regarding his philosophical and aesthetic attitudes. One perhaps may surmise that this is because he does not have any philosophical tenets other than at craft level, but I think that the answer is more complex. I would indeed, think it quite likely that this emphasis on technique has been forced upon him over the years by his admiring public: after all, everyone can accept that *what* is done is the artist's mystery, *how* it is done is accessible to anyone with persistence—so that's what everyone wants to know about. I think that Adams to an extent has been trapped into the situation of high-priest of photographic technique, a situation undoubtedly partly of his own making, but also, as they say, by public demand.

Thus I believe that, even if he doesn't realise it, he is turn-

ing out a predictable artistic product—a product perhaps unconsciously but nontheless firmly directed towards a public, and a popular audience. As Ian Jeffrey has noted, it is remarkable that a lot of Adams' best-known and best-loved images are of popular tourist sights and noted landmarks, obviously subject to much bad photography and reduced to cliché in the process. Adams' photographs, says Jeffries, are re-interpretations, technically perfect, dramatically acceptable reworkings of popular imagery—in other words, out-clichéing the cliché.

So Adams—and here his taste and mine do quite definitely diverge—reflects a romantic, picturesque and essentially escapist landscape. It is certainly a dramatic landscape, but the drama again seems carefully manipulated—as if out of a bottle, or rather a red filter—verging on the melodramatic, and like everything in his meticulously controlled vision, is funnelled to us in those immaculate, brilliant tones of black and white and grey. It is all so dazzling, so sanitised, and so unreal. Struggle is acknowledged, but encapsulated and therefore banished. There is beauty, grandeur, even great dignity in Ansel Adams' view of nature, but there is also an aura of smugness and sentimentality. It is perhaps unfair to use his own words, written in 1940, against him, but I feel that he himself can sometimes ignore them—'true beauty does *not* mean mere *prettiness.*' There is no doubt that Adams' imagery is a popular one: it is also a thoroughly public imagery, thus negating for me a true feeling of individuality, in the sense that I look in vain for Adams in the work—the presence of the truly expressive, creative and passionate artist.

Adams' mode of expression is essentially technical. The hyper-reality of his vision is created by the huge depth of sharpness, the great tonal range and the size of his prints. All this we are asked to admire, and we may indeed admire it. But photography is a strange medium: for all the supposed objectivity of the camera it never ceases to startle us by reflecting, and reflecting often with uncanny accuracy the psyche of its user. So if you 'see' a mountain as a series of tonal values, the chances are that the photograph will speak more of 'tonal sense.' Therefore by channelling the expression of his vision almost solely through technique—and the overwhelming response of most viewers to Adams, be they photographers or not, is to the technical aspects on one level or another—he has left himself out, and so his photographs seem rather one-dimensional if compared with, say Edward Weston's. I find an interesting, and I would say perhaps revealing statement in an interview conducted by Mark Hayworth-Booth and Diane Lyon, published earlier this year in *The Photographic Journal.* Talking about the differences between Weston and himself, Adams stated that he thought Weston was connected with creating and imposing his own sense of form upon the world, whereas he—Ansel—is trying to reveal form in the world but not let it dominate his imagery. If I understand the full implications of this statement it would seem to be not only a negation of overt formalism—a quite proper sentiment—but also a relegation of form. He has, partly consciously but also unconsciously, tended to weaken his vision.

Not that Adams' pictures are not perfectly composed—they are—but his inherent sense of form tends to be monumental, static, obvious if you like. And despite the heightened drama of filtered sky and starkly defined blacks and

whites, misses the intuitive feeling for those subtle, underlying rhythms which would imbue his images with the formal tension necessary to fully animate them and thus render a more complete view of nature. I do not find in Adams that instinctive sense for the dynamic, formal undercurrents which, as in Weston, imply not only the beauties of nature but also the forces and struggles which shape it. And therefore by implication I miss in Adams' work the underlying life in metaphor, the reflection of the persona and struggles of the artist himself. It is in the sense of struggle which perhaps I miss most of all: Adams shows no sign of the artist's struggle—for vision, for technique: passion has been sublimated for perfection of means.

It sounds as if I am criticising Adams for being technically perfect—better than me, and you, and everyone else—and in a sense I am, for it seems to me that he has, if you like, neglected the formal side of his vision in favour of technique. Of course this is true only to an extent, for form, content and technique are all interdependent and inextricably mixed, but I do believe that an over-obsessive concern in the technical area can inhibit development and growth in other areas. It is perhaps unfortunate that whereas other photographers can employ Adams' techni-

Adams on photography:

Ever since 1927 I have tried to visualize all my pictures before taking them. I think all photographers do that but it takes a long time to be in total command of the technique. There are different ways of 'seeing' a picture. The subject is squeezed into the mind somewhere. Some photographers, however, don't understand the way that the lens 'sees' and the film 'sees'. Eventually you learn how to manage the film, the exposure and the development and how to get the information on to the negative and print. But like any art it takes time.

.

I can always control the picture unless I make a plain, ordinary arithmetical mistake, which happens quite often, or if I forget to figure a lens extension. Or again I may visualize the picture and turn the colour into poorly separated black-and-white values, and so miss the full intensity of the visualization. That doesn't occur too often now, but it happened all the time in the beginning. In those days I didn't have what I call 'image management'. The idea is to control the image on the ground glass—to 'see' things from the point of view of the lens. You just have to 'look' at the world like this or you are lost.

Ansel Adams, in an interview with Pat Booth, in Master Photographers: The World's Great Photographers on Their Art and Technique, *edited by Pat Booth, Macmillan, 1983, p. 10.*

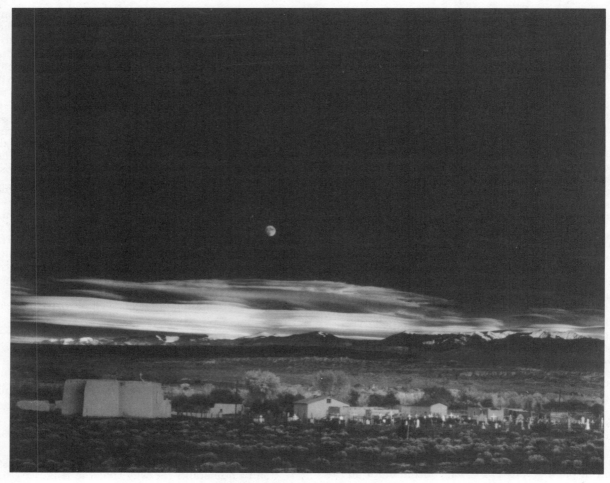

Moonrise, Hernandez, New Mexico (1941)

cal achievements to the full, learn the Zone System and then 'forget' about it in the search for greater expressiveness, its inventor is 'stuck' with it—a straitjacket ironically of his own making.

I think that it is partly in reaction to this and to the kind of criticism he constantly gets, of 'monumentality' and 'coldness,' that he has so readily taken to the Polaroid system which, although a highly technical process, does offer the possibilities of loosening up his vision. But even here, the exquisite, jewel-like quality of the prints themselves tends, as with the larger prints, to blind one to the other virtues—or possibly vices—of the imagery. Some are indeed, quite ordinary, particularly the portraits, although there are also a few truly beautiful images. One wonderful example, of two poplar trees, a shadow and a gravestone—a quiet, simple yet intense statement—proves that at his finest, Adams can be superb and rank with anyone.

I am very conscious that in writing from this rather critical viewpoint, it is so much easier to be excessively negative, certainly so much more so than to actually *do*. Despite my criticisms, there is no doubt, amply proved in this exhibition, that Ansel Adams is a very fine photographer and has made an immense contribution to the medium. His place in photography's pantheon is assured, but it is important that the doubts be aired.

For my part, I would like to see some of Adams' images where he was so excited by the subject that the Zone System went out of the window, or where he forgot his box of red filters. In other words, what we are presented with is—as with any artist—a carefully controlled and filtered view of himself, determined by himself and his advisers. I have the nagging feeling that some of his potentially finest images have been left, and will be left, in his files. (pp. 883, 895)

> *Gerry Badger, "Ansel Adams—A Critical View," in* The British Journal of Photography, *Vol. 123, No. 6063, October 8, 1976, pp. 883, 895.*

John Szarkowski (essay date 1977)

[*Szarkowski discusses Adams's artistic achievement, noting that the importance of his work lies not only in his depiction of evanescent moments in nature but also in his recording of the vanishing wilderness.*]

In the history of modern photography Ansel Adams is something of an anomaly—a triumphant one, but an anomaly nevertheless. In a period when most ambitious photographers have felt fortunate to win the support of one parochial segment of the total audience, Adams has

been admired by a constituency so large and diverse that it could, one would have assumed, agree on nothing.

The spectrum of Adams' admirers has extended from the great Alfred Stieglitz, who gave the impression that he abhorred the popular, to successful advertising executives, who are thought to live in terror of the esoteric. Between these poles, Adams' supporters have included an impressive list of critics and historians, younger photographers of high talent, politicians, curators, conservationists, and an army of photographic hobbyists, who are ordinarily interested in no one's work but their own, and who tend to believe that the art of photography is a matter of better lenses or exotic chemical formulae.

The reasons for this almost catholic acclaim are not completely clear, but surely they are based largely on general intuitions that Adams has some privileged understanding of the meanings of the natural landscape, and that through his pictures he has given the rest of us some hint or glimpse of what we also once knew.

Adams would object to being described specifically as a landscape photographer. Like all good artists he distrusts categories, and it is true that he has made many splendid photographs of other sorts of subjects. Nevertheless, it is our prerogative to define the reasons for our own gratitude, and I think we are primarily thankful to Adams because the best of his pictures stir our memory of what it was like to be alone in an untouched world.

It does not advance us very far to note that Adams has made elegant, handsomely composed, technically flawless photographs of magnificent natural landscapes, a subject which, like motherhood, is almost beyond reproach. These attributes are surely virtues. For many they are sufficient virtues, and these many need not wonder what the precise difference is between the best of Adams' pictures and uncounted other neat, clean, and dramatic photographs of the glorious American West.

The difference presumably depends from the fact that Adams understands better the character and significance of his subject matter, and thus is especially alert to those details, aspects, and moments that are most intensely consonant with the earth's own tonic notes. We must remind ourselves, however, that all we know of Adams' understanding of the earth comes to us not from any direct view into his mind or spirit, but only from photographs, little monochrome substitutes for his ultimately private experience. To the best of our knowledge, he knows no more than he has shown us. As with any artist, his intuitions are finally no better than his prowess.

What Adams' pictures show us is different from what we see in any landscape photographer before him. They are concerned, it seems to me, not with the description of objects—the rocks, trees, and water that are the nominal parts of his pictures—but with the description of the light that they modulate, the light that justifies their relationship to each other. In this context it is instructive to compare Adams' photographs with those of his older friend and neighbor Edward Weston, who photographed much of the same country that Adams has photographed, but who found there a very different species of picture. The landscape in Weston's pictures is seen as sculpture: round, weighty, and fleshily sensuous. In comparison, Adams' pictures seem as dematerialized as the reflections on still water, or the shadows cast on morning mist: disembodied images concerned not with the corpus of things but with their transient aspect.

From the standpoint of craft, Adams' problem is more difficult than Weston's, dealing as it does less with eternal verities than with quicksilver. Those who have wondered whether Adams' legendary technique is in fact altogether necessary, or whether it might be a kind of showy overkill, reveling in an unnecessary perfection, have perhaps not understood the content of Adams' pictures, which describe phenomena as ephemeral and evanescent, in an unpeopled world, as those of his contemporary, Cartier-Bresson, describe in a world of human events. To describe in a small monochrome picture the difference between the twilight of early morning and that of evening, or between the warm sun of May and the hot sun of June, requires that every tone of the gray scale be tuned to a precise relationship of pitch and volume, so that the picture as a whole sounds a chord that is consonant with our memories of what it was like, or our dreams of what it might be like, to stand in such a spot at such a moment.

Adams would perhaps say that it comes down to a question of good description, which is doubtless true but which has caused a good deal of misunderstanding, since the thing being described is not (for example) a mountain but a concept of one way in which a mountain might be transposed into a photograph.

The particular variety of precision which is essential to the success of an Adams photograph is not graphic but tonal. A diagram of the composition of a first-rate Adams would be largely irrelevant. Adams is not much interested in the traditional concept of composition, which is a way of relating the discrete parts of a picture in terms of mass, torque, inertia, and other similar mechanical notions. He has what is for him a better system. His pictures are unified by the light that describes a coherent space, in which individual objects play only supporting roles.

The skill with which Adams translates the anarchy of the natural world into these perfectly tuned chords of gray creates a sense of heightened order that is often mistaken by nonphotographers for sharpness. In fact Adams' photographs are no sharper—no more optically acute—than those of any other competent technician using similar tools. They are more *clear*—a matter not of better lenses but of a better understanding of what one means. (pp. vii-ix)

Serious photographers believe that photography is something larger and more inclusive than the sum of all photographs made thus far, larger even than all those that will be made in the future, and that the chief adventure of the medium lies not in using what is known but in learning more. It seems clear that the best, most interesting photographers have indentured themselves to this ideal, and that this generic artistic ambition has taken precedence over the claims of the specific subject matter with which they have chosen to work. To some degree, the mountain, or the historic human event, has been a pretext for picture-making.

Nevertheless, artists, unlike philosophers, must deal with physical specifics. The photographer especially, being least able of all artists to achieve synthesis, must depend on its opposite: symbol. Large issues must be inferred from

trivial data. One family picnic on the banks of the Marne, clearly seen, may stand for civilization; one unfolding fern, for freedom.

If this suggests the game that photographers play, it should be added that the game can be played well only in an environment in which the photographer is knowledge-able and at home, and in which the subtle distinctions of meaning inherent in subject matter are understood and ap-preciated.

In the specific case of Ansel Adams one might guess that he is even more committed to the ideal of making one per-fect photograph than he is to the goal of expressing the beauty and meaning of the wild landscape. But if he does not love and wish to understand the wild landscape, where will he find the energy and tenacity needed to see his sub-ject, coldly and clearly, as a picture?

Ansel Adams was born in 1902, in San Francisco. He began to photograph the landscape of the American West more than fifty years ago, before the Model A had begun to replace the Model T. At that time there were no super-highways, no motels, and no passenger airlines. San Fran-cisco and New York were, by crack train, four splendid days apart.

In those days the world was still a reasonably commodious place, and it was natural to assume that its various parts would retain their discrete, articulated character if they could be protected from the depredations of the lumber, mineral, and water barons. Conservation then was a mat-ter of seeking the support of the people against the en-croachment of the powerful few. If one could describe in photographs how much like Eden was Yosemite Valley the electorate would presumably save it from its exploit-ers. It was not foreseen that the people, having saved it, would consider it their own, nor that a million pink-cheeked Boy Scouts, greening teenage backpackers, and middle-aged sightseers might, with the best of intentions, destroy a wilderness as surely as the most rapacious of lumbermen, who did his damage quickly and left the land to recover if it could.

It has developed, in other words, that to photograph beau-tifully a choice vestigial remnant of natural landscape is not necessarily to do a great favor to its future. This prob-lem is now understood, intuitively or otherwise, by many younger photographers of talent, who tend to make land-scapes of motifs that have already been fully exploited and that have therefore nowhere to go but up. It is difficult today for an ambitious young photographer to photo-graph a pristine snowcapped mountain without including the parking lot in the foreground as a self-protecting note of irony.

In these terms Adams' pictures are perhaps anachronisms. They are perhaps the last confident and deeply felt pic-tures of their tradition. It is possible that Adams himself has come to sense this. The best of his later pictures have about them a nervous intensity that is almost shrill, a Ber-nini-like anxiety, the brilliance of a violin string stretched tight.

It does not seem likely that a photographer of the future will be able to bring to the heroic wild landscape the pas-sion, trust, and belief that Adams has brought to it. If this is the case, his pictures are all the more precious, for they

then stand as the last records, for the young and the fu-ture, of what they missed. For the aging—for a little while—they will be a souvenir of what was lost. (pp. xi-xii)

> *John Szarkowski, in an introduction to* The Portfolios of Ansel Adams, *edited by Tim Hill, New York Graphic Society, 1977, pp. vii-xii.*

Gerrit Henry (essay date 1978)

[*In the following excerpt from his review of* The Portfo-lios of Ansel Adams, *Henry asserts that Adams's land-scapes are distinguished by their technical expertise and deft treatment of light.*]

From 1948 to 1976, the American photographer Ansel Adams produced seven limited-edition portfolios, each containing ten to 16 original prints. The portfolios are owned by a handful of individuals and institutions. Now, all 90 prints have been made available to the public in re-production in *The Portfolios of Ansel Adams.*

Adams is perhaps best known as a nature photographer and conservationist; he was director of the Sierra Club of California from 1936 to 1970. The *Portfolios* are a valu-able reminder that Adams saw his works not as docu-ments of the American landscape, but as "creative photo-graphs of the natural scene," with an emphasis on "cre-ative." The prints in each portfolio were not arranged in chronological order, nor are the portfolios unified by any one subject matter. Instead, each of the seven collections stands as a kind of sampler of Adams' most masterful prints. The art-minded readers of the *Portfolios* will be as handsomely rewarded as those in search of scenic won-ders.

They may, in fact, be better rewarded. Although Adams' studies of Yosemite Valley in California or the Sierras in Nevada or Tennessee's Great Smoky Mountains are epic, and often sublime in vision, it is Adams' extraordinary technical abilities that distinguish his work from more or-dinary "America the beautiful" kinds of landscape pho-tography. Through his use of sharp, brilliant contrasts of light and dark and infinitely subtle black and white tonali-ties, Adams was, from an early date, attaining to a thor-oughly modern photographic art, with a number of the landscapes in the *Portfolios* exhibiting a deeper under-standing of the two-dimensional picture plane than many of Adams' contemporaries in painting. (p. 138)

> *Gerrit Henry, "Adams' Landscapes, Weston's Nudes," in* ARTnews, *Vol. 77, No. 4, April, 1978, pp. 138-39.*

Ainslie Ellis (essay date 1984)

[*In the following review of an Adams exhibition at Lon-don's Victoria and Albert Museum, Ellis asserts that Adams has not received the critical respect his work truly deserves primarily, the critic contends, because of his popularity.*]

There was a rare but all too brief opportunity to view some superlative photographs by Ansel Adams at the [Victoria and Albert Museum] recently. A lull in the exhibitions

schedule in the Photo Gallery, between 19 August and the third week in September, could have meant that visitors would have found the wall-cases empty and might well have felt disappointed, if not annoyed. Instead, advantage was taken of this gap and 22 prints by Ansel Adams were installed as a brief tribute to him. These were a joy to examine.

The death of Ansel Adams closes a monumental chapter in American photography. It raises too, inevitably, the question of his relative importance in photography's brief history. If his work is the only proper measure of this, and I am sure that it is, then it is by his photographs that he ought to be judged. And I for one was extremely grateful for the opportunity to look closely at even this tiny sample of his output. One has seen too much of it only in reproduction. Yet his photography is, in every sense, too big for the page. For, together with its dominant subject matter, it deserves one fitting word: elemental.

Unhappily, in my opinion, there was a tiresome and rather hasty attempt in the Henry Cole Wing to relate Adams' prints to a wider and prior landscape tradition. If the two watercolours that were on view, by J. R. Cozens and George Fennel Robson, were to be taken as true examples of this tradition then any relationship is pure fiction. It may fit the thesis of some art historian but it offends all the canons of common sense. Edmund Burke's 'A Philosophical Enquiry into the Origins of our Ideas of the Sublime and the Beautiful' no doubt suited the eighteenth century. And it may well have set in motion 'a cult of the sublime that extolled vastness of extent and greatness of dimension as true measures of sublimity.' But to claim that Ansel Adams' *Winter Sunrise, Sierra Nevada, from Lone Pine* or *Moon and Half-Dome, Yosemite National Park,* let alone *Pipes and Gauges, West Virginia,* have a whit in common with any of that fine talk is plainly hooey.

Ansel Adams was not only a marvellous photographer and a master craftsman of the highest order, he was above all a splendid observer of the natural scene and celebrated in his work the elemental strengths and massiveness, the heroic and the elegiac forms of Planet Earth. Yet in spite of these virtues (or even in some contrary fashion because of them) Ansel Adams has not received the critical esteem his work truly deserves.

A critic who is highly perceptive and whose work I respect, A. D. Coleman, is less than just. Writing twelve years ago in *Village Voice* . . . he says this:

> . . . nothing a critic can say can hamper the future of a man who has wrapped his landscapes around Hills Bros. coffee cans, hidden them on the inner sleeves of record albums, sold four 16 × 20s of his *Moonrise* at 200 dollars a clip in just the first week of his show at the Witkin Gallery—and who, on some channel of some TV set somewhere even as I write this, is tramping through Yosemite trying to persuade someone that the planting of a tree more than compensates for the pollution generated by test-driving a Datsun.

Smart talk indeed but fully as trite and empty as Coleman appears to find Adams' work.

> His prints are the supreme examples in photography of the result of one-track technical perfectionism, and they exist in limited enough numbers that their value cannot help but rise. Emotionally and intellectually, they fall in the same plane as the works of Rockwell Kent and Andrew Wyeth; they are almost aggressively accessible, demanding very little and returning more than they demand. I have never had a bad time in an Adams print . . . Adams has learned well some key lessons from Strand, from Weston, and from Stieglitz, and has created a body of work which I must respect for its phenomenal extent and consistently rigorous standards of craftsmanship, but I am obliged to state also that it is a body of work to which, in the normal course of events, I never turn for solace, exaltation, insight, inspiration, or even argument's sake.

You can scarcely be more dismissive than that. In course of the same piece he took John Szarkowski severely to task for:

> . . . we are told that Adams has not been making perfectly printed oversized picture postcards, but mordant studies of a grim and implacable universe—that he is the Lee Friedlander of the High Sierras, in short, the Garry Winogrand of the view camera.

The criticism implicit in these remarks is aimed at three things and more besides. The three objections appear to be: first, Ansel Adams landscapes are used in advertising (Hill Bros. coffee and record sleeves); second, that his prints sell well in the market place; third, on account of their almost aggressive accessibility to the viewer (i.e. it is a photograph about what it appears to be about rather than about something else). If to be involved in either of the first of these two, advertising and prints fetching good prices, is something despicable or heinous, it tars rather too many photographers to make any sense. The third objection is a criticism varnished with élitism or else it is a general dislike of the natural order.

Turning to *The Magic Image* by Cecil Beaton and Gail Buckland to discover how this work strikes another type of sensibility one finds this:

> Adams perfected new ways of exposing and developing and felt he had produced the supreme negative. This technical mastery has been the foundation upon which he has built a great business, selling his pristine, impeccable prints throughout America, where they can be seen on the walls of motels or in popular galleries . . .

> An essentially outdoor type, with an atmosphere of spume and sea-spray about him, he is never involved in magic. He is the direct honest-to-God photographer whose influence in the States, both as a teacher and as a conservationist, cannot be exaggerated.

The sting lies in that phrase, 'he is never involved in magic.' This is quite untrue. The problem is surely this, that we are so used to having something *worked-up,* in whatever medium you please, that we reject being asked to look directly, to look for ourselves. On the opposite page to that cutting remark, 'he is never involved in magic' there is a full-page reproduction of *Sunrise, Dunes, Death Valley National Monument, 1948* which is pure magic. And certainly not to have found this also in many of the photographs too briefly shown at the V&A would have been sad indeed. Not sad in terms of what Ansel Adams had done but in terms of the nature and being of the be-

holder who failed to perceive the magic before him. (pp. 1016-17)

Ainslie Ellis, "All Too Brief," in The British Journal of Photography, Vol. 131, No. 6478, September 28, 1984, pp. 1016-17.

Andy Grundberg (essay date 1984)

[In the following essay, Grundberg undertakes a critical reassessment of Adams's aesthetic ideals and achievements.]

When Ansel Adams died in April 1984 he was the best-known and most widely admired photographer in the United States, if not the world. In the last decade of his life he maintained the high profile of a public figure—appearing on television in automobile advertisements and in print on the cover of Time, being interviewed by Playboy, having a private audience with President Reagan—and his photographs took on the status of public monuments. His 1941 image *Moonrise, Hernandez* became the hit of the auction and collecting world in the late Seventies, but public taste gravitated equally to his classic images of Yosemite valley, including *Monolith, The Face of Half Dome* of 1927 and *Clearing Winter Storm* of 1944. For all the popular acclaim and critical plaudits during his lifetime, however, the exact nature of his aesthetic achievement is remarkably unresolved.

Adams was not innocent of aspiring to be the world-famous photographer he became. His celebrity was no doubt enhanced by his having cultivated an image as the grand old man of the West, complete with Gabby Hayes visage and frontier demeanor, and by his lifelong efforts at publicizing and promoting the medium in which he worked. He befriended historian Beaumont Newhall and Newhall's wife, Nancy, a writer, early on, helped them and David McAlpin found the photography department of the Museum of Modern Art in 1940, established a department to teach photography at the San Francisco Art Institute after World War II, and in 1967 founded the Friends of Photography near his home in Carmel, California. In 1977 he provided the funds to endow the Beaumont and Nancy Newhall Curatorial Fellowship at the Museum of Modern Art.

In addition, Adams was the author of more than thirty-five books, some devoted to his pictures and some purely technical, and of a substantial number of articles and reviews, dating back to the 1930s, that advance the cause of the "photographic" in photography. He also was a figure in conservation circles, serving as a Sierra Club director from 1936 to 1970 and advocating the preservation of wilderness areas and national parks. Given such a record of activity, it is not surprising that he managed to be a respected senior figure in the photography community. Still, what made Adams so popular in the public mind first and foremost was his photography—especially those images that show the natural site as a majestic and indomitable force impervious to the depredations of weather and tourism alike.

These pictures are among the most visually imposing, dramatically printed images of twentieth-century photography. (Ironically, they are most often seen as reproductions, in books and magazines and on posters and post-cards.) They reveal a dedication to the craft of photographic printmaking that finds its nearest equivalent in the turn-of-the-century Pictorialist era, when hand-applied emulsions and arcane toners were employed to achieve a misty, painterly "look." Yet Adams's photographs are otherwise diametrically opposed to the values of Pictorialism. If they have any precedent in the medium's tradition, it is the straightforward, richly detailed early Western frontier views of William Henry Jackson, Timothy O'Sullivan and Carleton Watkins. They are minutely descriptive in a way that seems transparently documentary, and they depict a topography that has yet to show the traces of human occupation.

But unlike those nineteenth-century pioneers of American landscape photography, whose views more often than not suggest that the natural world is totally alien and inhospitable, Adams pictured nature as *scenery*. In his landscape images, the natural world presents itself for human delectation; whatever threatening quality its sharp cliffs, precipitous gorges and compacted thunderheads may have had is by and large neutralized and neutered. As I had occasion to observe in reviewing the Museum of Modern Art's 1979 exhibition "Ansel Adams and the West," in Adams's universe the moon seems always to be rising and storms always to be clearing—symptoms, it would seem, of Adams's essentially modernist optimism about the future of the human spirit.

There is, however, another aspect to Adams's landscape photography: It shows us a natural world so precisely ordered and so cleansed of ills that we might suspect it had been sanitized by a cosmic disinfecting agent in advance of the photographer's appearance on the scene. This fundamentally hygenic conception of the world is apparent not only in Adams's pictures but also in the ways in which he discussed the particular style of photography to which he was devoted. While he disliked the term "Purist" to describe this style, purity was essential to it. Writing in the photography magazine Camera Craft in 1940, he spoke of his commitment to "a clean, straightforward approach to photography." Elsewhere he wrote of the need for "clean standards" to capture the "vigor" and "virility" of the natural world.

That this yearning for the hygenic also extended to nature is clear from a 1922 letter to his future wife, Virginia, in which he wrote, "I long for the high places—they are so clean and pure and untouched." In the same letter, which is quoted in Nancy Newhall's admiring 1963 biography The Eloquent Light, Adams complains about the crowds in the Yosemite valley—crowds that are never seen in his photographs—and says: "How I wish that the Valley could be now like it was forty years ago,—a pure wilderness, with only a wagon road through it, and no automobiles nor mobs."

A similar desire for purity may lie behind his almost fetishistic concentration on craft, which in the 1930s led him to develop a systematic procedure for "pre-visualizing" the final printed image while the exposure was being made. Called the Zone System, it enabled Adams to adjust his exposure and development times to produce negatives ideally suited for enlargement—and, most important for Adams, negatives that contained within them the germ of his original "vision" of the subject. Adams was not the first photographer to place a high value on visualizing the

final image in advance, any more than he was the first to swear allegiance to sharply focused and finely detailed prints (his friend Edward Weston, for one, preceded him on both counts), but he was the first to combine the science of sensitometry with the aesthetic of the expressive photograph.

Vision, for Adams, was what transcended technique and justified calling photography an art form. "A great photograph," he wrote in a document called "A Personal Credo" [see Artist's Statements, above], "is a full expression of what one feels about what is being photographed." To rationalize the notion that a straight, unmanipulated print could express the personal vision of its maker as fully as any picture or painting made entirely by the hand of an artist, Adams drew upon the already existing aesthetic of the Equivalent, as conceived by Alfred Stieglitz. Stieglitz held that photographs, besides being documents of what they are of, are expressions of something else—that something else being the vision or feeling of the photographer.

For all its virtues in making us engage photographs more closely and complexly, the aesthetic of the Equivalent as it developed from Stieglitz through Adams and Minor White has one major shortcoming: after asserting that an apparently transparent image of the world is imbued with an individual vision or feeling, it has difficulty defining what that vision or feeling is. Used as a critical instrument, the theory of Equivalence is unable to determine any intended meaning in a photograph. But as a credo, it has served as the dominant aesthetic of American photographic modernist practice. Its assumptions are enshrined not only in the photography of Adams, Stieglitz, Strand, Weston *et al.* but also in Beaumont Newhall's *The History of Photography from 1839 to the Present* (1937), which serves as today's gospel of the photographic tradition.

Not surprisingly, Adams throughout his life refused to speak of the meanings of his pictures—preferring, presumably, to let them speak for themselves. But if Adams's pictures are expressive, as he made clear he intended them to be, the criticism of modernist photography has yet to describe what they are expressive of. If they are equivalents of the artist's deepest feelings, what are those feelings? As the photographer Robert Adams has written in regard to Minor White's imagery, "Sooner or later, one has to ask of all pictures what kind of life they promote."

Mr. Newhall, in the 1964 edition of his history, has this to say about Adams's accomplishment: "Mr. Adams, in his photography, his writing and his teaching, has brilliantly demonstrated the capabilities of straight photography as a medium of expression." Of the Adams images shown at Stieglitz's American Place gallery in 1936, Mr. Newhall says that they "had sensitivity and direct, honest integrity that were rare" (sic). Today, these efforts at getting to Adams's importance seem not unlike the kind of evasions ambivalent critics sometimes undertake. But Mr. Newhall, a longtime ally of Adams's, is not alone in stopping short of telling us what Adams achieves in his pictures. One can search all the panegyrical commentary on the photographer's work and not find a single description of the meaning of Adams's vision of the natural world—or, for that matter, any clue as to what his unmatched technical brilliance allowed him to express.

The silence, coupled with the absence of any body of criti-

cism that takes issue with the work, is what has left Adams's place in the art of this century surprisingly unsettled. One sign of this was the large degree of misinformation that accompanied the tributes marking his death this spring. Some obituary writers hailed him as the inventor of "straight" photography, others as the pioneer of Purist style, still others as the originator of the crisply delineated "f/64" style. More than one editorial claimed that he had revealed the splendors of Yosemite to us for the first time. Even so circumspect an historian as Peter Bunnell let hyperbole exceed clear judgment when he wrote that Adams "fundamentally altered our conception of photographic picture making in the twentieth century." (This last appeared in the newsletter of the Friends of Photography, an organization Adams founded, so Mr. Bunnell might be excused.)

The truth is, Adams came on the scene too late to pioneer the style in which he worked. "Straight" photography was already being discussed as early as 1901 by the critic Charles Caffin, a member of Stieglitz's early circle. "Purism" was first developed in the years following World War I by Paul Strand and Edward Stiechen and was arrived at more or less independently by Edward Weston in Mexico in the mid 1920s—at a time when Adams was deciding to devote himself full time to photographing Yosemite National Park. As was clear from the Museum of Modern Art's 1979 exhibition of Adams's Yosemite work, "Ansel Adams and the West," Adams's early silver prints (which he called "Parmelian prints") have a small, self-consciously arty look to them; it was only in 1930, the year Paul Strand showed Adams his photographs, that Adams's pictures began to acquire the dramatic contrasts and expansive scale of his mature work. Through the Thirties and Forties he worked in close proximity to Weston, whose more abstractionist dramatic style no doubt strengthened Adams's commitment to Purist practice.

As for who first showed the splendors of Yosemite to the American public, we have to go back to the mid-nineteenth century, when wet-plate photographers such as C. L. Weed, Carleton Watkins, and Eadweard Muybridge made the arduous journey into what then was unsurveyed territory. Watkins in particular was devoted to the Yosemite landscape, visiting it several times throughout his career with both mammoth-plate and stereo cameras. Adams himself recognized their precedents, claiming allegiance to them as a way of rejecting his immediate Pictorialist inheritance. In Adams's photographs, however, we see Yosemite *as if* for the first time—his conception of it is so different from that of the nineteenth-century landscape photographers that Yosemite seems remade.

Perhaps the person who has come closest to suggesting the nature of Adams's accomplishment as a picture maker is John Szarkowski, director of the Department of Photography at the Museum of Modern Art and the curator of "Ansel Adams and the West." In his wall label for that exhibition he wrote, "He is the last of those Romantic artists who have seen the great spaces of the wilderness as a metaphor for freedom and heroic aspirations." Here we can begin to see the outlines of Adams's vision, the limitations of its usefulness in describing today's world, and the widespread appeal it continues to have in the face of its obsolescence.

Today, the experience of Yosemite depicted in Adams's

photographs is no longer ours, nor even available to us—as anyone who has visited the park in the last ten years surely knows. Our present-day experience is more like that depicted in Bruce Davidson's 1965 photograph of a crowded campsite on the valley floor, all folding lawn furniture and cars among the trees. Here, the democratic nature of the photographic image finds its counterpoint in the democracy of the national park system, with none of Adams's rarefied isolation and elegance. This isn't to say that Davidson is Adams's equal as a photographer, merely that he is—like most of us—beyond the reach of the romantic imagination. What is interesting to us in retrospect are the lengths to which Adams went in his time to avoid quotidian reality both in his choice of subject matter and in his printing style, which became increasingly theatrical and hyperbolic over the course of his career.

Clearly, however, there still exists a longing for the "clean and pure and untouched" spaces that Adams's landscapes depict in such loving detail. This longing may be rooted in the trailings of the nineteenth-century notion of the sublime, which elevated landscape imagery to the status of religious icon, but it just as likely reflects an urge to escape the depredations and disillusionments of late-twentieth-century life. In the sanitized, immaculate arena of Adams's West, its frontier virginity seemingly intact, there is comfort of a kind entirely lacking in the "man-altered" or "New Topographic" landscape photography practiced today by the likes of Robert Adams, Joe Deal, Lee Friedlander, and Frank Gohlke. Adams's photographs are valued—and I mean the word in both its senses—because they function as surrogates of pristine, uncultured experience at a time when the domain of culture seems unbreachable. And inasmuch as the prints themselves are also clean and pure and un(re)touched, they now function in lieu of the scenic wilderness as artifacts of a lost contentment. (pp. 48-52)

Andy Grundberg, "Ansel Adams: The Politics of Natural Space," in The New Criterion, *Vol. III, No. 3, November, 1984, pp. 48-52.*

Peter C. Bunnell (essay date 1984)

[*Bunnell, professor of the History of Photography and Modern Art at Princeton University and president of the Friends of Photography, describes Adams's nature and achievements on the occasion of the artist's death.*]

How might we characterize [Ansel Adams]? Ansel was passionately in love with passion, and coldly determined to seek the means of expressing it in the most visible way. An immense passion, reinforced with a formidable will—such was the man. In this duality we find the two signs that mark the most substantial geniuses.

It is evident that for Ansel the imagination was the most precious gift, the most important faculty, but that this faculty remained impotent and sterile if it was not served by a resourceful skill which could follow it in its restless and imperious ways. He certainly had no need to stir the fire of his always incandescent imagination, but the day was never long enough for his study of the material means of expression. It is this never-ceasing preoccupation that seems to explain his endless investigations into technique and the quality of photographic representation, his lively

interest in matters of chemistry and physics and his work with the manufacturers of photographic materials. In this respect he comes close to Leonardo da Vinci, who was no less possessed by the same obsessions and who sought to see everything without shadow.

Ansel was a curious mixture of skepticism, politeness, dandyism, burning determination, craftiness, despotism and, finally, of a sort of personal kindness and tempered warmth that always accompanies extraordinary capacity. There was much of the romantic in him. This was in fact the most precious part of his soul, the part that was entirely dedicated to the photographing of his dreams and to the worship of his art. There was also much of a man of the world; that part was destined to disguise the other. It was, I think, one of the great concerns of his life to conceal the rages of his heart and not to force his larger-than-life demeanor. His spirit of dominance, which was quite legitimate and even a part of his destiny, sometimes almost entirely disappeared beneath a thousand kindnesses. He owed to himself, that is to say to his genius and the consciousness of his genius, a sureness, a marvelous ease of manner, combined with a politeness which, like a prism, admitted every nuance, from the most cordial good nature to the most irresponsible crudeness or inanity. He was all energy, energy that sprang from the nerves and from the will.

The morality of his works—if it is permissible to speak of ethics in photography—is visibly marked with the understanding of the heroic in our lives, of the choices we must make between right and wrong, of our searching out of the reasons for life itself. He occasionally found it possible to concentrate his camera on the expression of tender and voluptuous feelings, for certainly he was not lacking in tenderness; but even into these images, as in all of his works, he infused an incurable rightness in strong measure. Carelessness and whimsy—the usual companions of simple pleasure—were absent from them.

Ansel's legacy will, of course, be his incomparable photographs—both as a demonstration of his brilliant technique, which has so fundamentally altered our conception of photographic picture making in the twentieth century, and also because of their style and content. They tell us not only of his concern for our land but of his concern for everything about us. They are timeless and expressive with the haunting quality of the deeply felt. Today we surely sense that it is the end of an era, of a career concluded, but I do not believe that this is the way he would wish us to think. He was too positive and too forward-looking.

If you consider his most famous photograph—*Moonrise, Hernandez, New Mexico*—you realize after a moment of thought that this is really a sunset picture. The moon is reflecting received light, the light striking the adobe church and the crosses in the cemetery is from the sun. Crop away the top portion of the picture and there is no ambiguity; it is a heliograph pretending to be a lunagraph. This special achievement in pictorial virtuosity is, I believe, emblematic of Ansel's essential ideology. The factuality and, moreover, the meaning of the setting sun were rejected by him in favor of the expressive symbolism of the rising moon; of the shining luminescence ablaze with greatness in its primal mystery, dramatically isolated in the infinity of darkness. Like all poets, he transported us

into a world that is vaster and more beautiful than our own, where reality echoed the dream. (pp. 53-6)

Peter C. Bunnell, "An Ascendant Vision," in Ansel Adams 1902-1984, *edited by James Alinder, The Friends of Photography, 1984, pp. 53-6.*

John Szarkowski (essay date 1986)

[*In assessing Adams's artistic achievement and contribution to the art of photography, Szarkowski views Adams as a transitional figure whose work can be divided into an "open, lyric style" evident in his early years, and later, a more "declamatory and epic" style.*]

The love that Americans poured out for the work and person of Ansel Adams during his old age, and that they have continued to express with undiminished enthusiasm since his death, is an extraordinary phenomenon, perhaps even one unparalleled in our country's response to a visual artist.

It is reasonable to regard the extraordinary with a degree of skepticism, and to look for the invisible wires or mirrors by which the trick was turned, or (on a more sophisticated level) to seek the confluence of anonymous cultural forces that might pick up the bark of an individual artist and carry it and him to fame and esteem. Adams was indeed in his latter years the right man in the right place. For the first time a substantial public had been educated to appreciate what he had done in his youth and middle age; his work as a conservationist was finally in tune with the intuitions of a substantial minority of his countrymen; the machinery that could intermediate between an independent photographer and his potential public—museums and galleries dedicated to the importance of the art of photography, skilled printers who could transpose a fine photograph into ink on paper, and imaginative publishers—was finally in place. Without these supporting structures Adams would not, I suppose, have become a hero to his countrymen, even though no less an artist.

Still, these structures were available to other photographers of exceptional achievement, some of whom also served the causes of conservation and ecological intelligence, and although some of these have been well served by the new circumstances, none has been granted the affection and trust of so broad a spectrum of his fellows as Adams.

I have in the past attempted to explain the nature of Adams' achievement in terms that could be encompassed within the broad thrust of photography's history:

"One might say that the great landscape photographers of the nineteenth century approached the natural world as if it were a collection of permanent and immutable facts, which might be objectively recorded and catalogued, given adequate time. Ansel Adams discovered that the natural world is infinitely varied in aspect, constantly potential, evanescent; that its grand vistas and its microcosms are never twice the same; that the landscape is not only a place but an event.

"Trained as a musician, Adams understood the richness of variation that could be unfolded from a simple theme.

As a young mountaineer in Yosemite, he learned from intimate experience and faithful attention the rhythms, structures and special effects of that delicately flamboyant place. In order to describe exactly his perceptions of the landscape, he had to develop a technique of extraordinary suppleness and precision, capable of evoking the specific quality of a given moment in the natural history of the world."

These observations still seem to me just and useful, but they do not seem adequate to explain the special esteem in which he came to be held by those countless many who could not have known, in rational, critical terms, how good an artist he was, but who sensed that he believed in something that they believed in: not the high sentiment of conservation, or the science of ecology, or the art of photography, but the deeply romantic idea that the great vistas and microcosmic details of the wilderness could be seen as metaphor for freedom and heroic aspiration. Adams' photographs seem to demonstrate that our world is what we would wish it was—a place with room in it for fresh beginnings. During Adams' lifetime it became progressively difficult to hold faith in this idea, and as he advanced toward old age the open, precise, lyric style of his youth gave way to one that was declamatory and epic.

In terms of the central ambitions of modern photography this change did not seem an advance, but in terms of the requirements of Adams' own intuitions it was necessary, and he was faithful to those intuitions. We can now be grateful that he was, for he has left us both the classic Adams of his youth and the romantic, magniloquent Adams of the later years.

In historical terms, we might see Ansel Adams as a bridge that links two traditions. He was perhaps the last important artist to describe the vestigial remnants of the aboriginal landscape in the confident belief that his subject was a representative part of the real world, rather than a great outdoor museum. He was certainly among those who sketched the outlines of a new sense of the meaning of the natural landscape, an understanding based on the earth's intimate details, its unnoted cases, its ephemeral gestures.

It seems unlikely that we will see again an artist like Adams. Younger photographers of integrity will presumably form their view of the world on the basis of their own experience, and they will have seen Yosemite not as a surviving fragment of Eden, but as a recreational center. If this is the case, Adams' work is all the more to be cherished. For those who share his memory of a world that seemed not yet quite fully used, it is a precious souvenir. For the young and for the future, it will define something of great value from a former time, now lost, that must be retrieved and reformed in different terms. (pp. 5-6)

John Szarkowski, in an introduction to Ansel Adams: Classic Images *by James Alinder and John Szarkowski, Little, Brown and Company, 1986, pp. 5-6.*

FURTHER READING

I. Writings by Adams

"Creative Photography." *Art in America* 45, No. 4 (Winter 1957-58): 33-7.
> Essay in which Adams asserts that photography, analogous to other artistic mediums, relies on the artist to elevate the process from mere documentation or record-making to the realm of art.

"The Conservation of Man." *AIA Journal* XLV, No. 6 (June 1966): 68-74.
> Adaptation of a speech Adams delivered at the 1965 convention of the California Council AIA in which he exhorts his audience of architects to conceive of structures that embody the highest aesthetic and functional values and stand in complete harmony with their environment.

"Sixty Years in Photography." *The Photographic Journal* 117, No. 3 (May-June 1977): 128-33.
> Adaptation of a lecture Adams delivered to the Institution of Electrical Engineers in London in 1976. Adams reflects anecdotally on his career, noting the principal influences on his work and the evolution of his aesthetic ideal.

"I Am a Photographer." In *The Camera Viewed: Writings on Twentieth-Century Photography,* edited by Peninah R. Petruck, pp. 25-39. New York: E. P. Dutton, 1979.
> Discussion of technique and clarification of photographic terminology. Adams's remarks were first delivered as a lecture at the International Museum of Photography at George Eastman House in Rochester, New York in 1958 and were originally published in the journal *Image* (March 1959).

Ansel Adams: An Autobiography [with Mary Street Alinder]. Boston: New York Graphic Society, 1985, 400 p.
> Adams's memoirs illustrated with dozens of his prints and published one year after his death in 1984.

II. Interviews

Adams, Ansel and Booth, Pat. Interview in *Master Photographers: The World's Great Photographers on Their Art and Technique,* edited by Pat Booth, pp. 8-21. London: Macmillan, 1983.
> Reflects on various aspects of his life and career, including the techniques involved in producing some of his most famous photographs.

Adams, Ansel and Esterow, Milton. "Ansel Adams: the Last Interview." *ARTnews* 83, No. 6 (Summer 1984): 76-89.
> Discusses a variety of topics and issues, including the status of contemporary photography, the "zone system," "visualization," memorable personal events, and influential relationships.

Silver, Anita. "Editorial." *The Journal of Aesthetics and Art Criticism* XXXIX, No. 3 (Spring 1981): 243-47.
> Addresses a number of aesthetic issues regarding photography in general and Adams's own artistic vision.

III. Biographies

Newhall, Nancy. *Ansel Adams: The Eloquent Light.* San Francisco: The Sierra Club, 1963, 175 p.
> Sympathetic, noncritical biography that chronicles the years 1902-38 and quotes extensively from letters of Adams, Stieglitz, Weston, and others.

IV. Critical Studies and Reviews

"Exhibition: Ansel Adams." *Camera* 59, No. 1 (January 1980): 41.
> Review of an Adams retrospective exhibition at the Museum of Modern Art. The critic commends Adams for his ability to endow his subject with "an almost tangible sense of poetry and spirituality," as well as the artist's evocation and manipulation of light.

Cohen, Ronny H. Review of *Ansel Adams: Yosemite and the Range of Light* and *Ansel Adams: 50 Years of Portraits. Art in America* 67, No. 7 (November 1979): 27, 29.
> Asserts that both works under review "stress the importance of communicating to others the sublime beauty of the American wilderness so that steps may be taken to protect it." Regrettably, in the critic's estimation, neither work undertakes a critical assessment of Adams's prints, especially in relation to the artistic renderings of his peers, accentuating the need for such analysis.

Fisher, John. "Editorial." *The Journal of Aesthetics and Art Criticism* XLII, No. 3 (Spring 1984): 751-53.
> Briefly assesses Adams's aesthetic principles and deems his work "a classic example of the humanistic approach," involved in the elevation of the human spirit rather than the quotidian world of socio-political phenomena.

Hill, Paul. "Ansel by Himself." *The British Journal of Photography* 133, No. 6546 (17 January 1986): 78-9, 81.
> Descriptive, appreciative review of Adams's autobiography. Although Hill concedes that Adams was perhaps not "much of an art innovator," he also asserts that Adams "has left an indelible impression on photography and the culture of America."

Hughes, Robert. "Master of the Yosemite." *Time* (3 September 1979): 36-44.
> Biographical essay that highlights Adams's contributions to the art of photography, especially in terms of popularizing the medium and winning acceptance from the artistic community.

Jacobs, David L. "Blindness and Insight." *Afterimage* 13, No. 10 (May 1986): 8-9.
> Evaluates Adams's autobiography, concluding that Adams obfuscates rather than illuminates this crucial period in the history of photography: "Unfortunately a great opportunity was lost in turning what could have been a revealing account into yet another self-aggrandizing exercise in autobiography."

Kennedy, Clarence. "Photographs in Portfolio." *Magazine of Art* 43, No. 2 (February 1950): 68-9.
> Brief appraisal of Adams's *Portfolio One, Yosemite, California.*

Laurent, Amy. "Ansel Adams." *New Art Examiner* 11, No. 1 (October 1983): 18.
> Describes a 1983 Adams exhibition at the Corcoran Gallery of Art in Washington, D. C., that sought to reprise Alfred Stieglitz's 1936 Adams show at An American Place.

Mellon, James R. "Reviews and Previews." *ARTnews* 71, No. 6 (October 1972): 75-6.

Includes a cursory review of an Adams retrospective at New York's Witkin Gallery, commendable, in the critic's view, for depicting the scope of Adams's interests.

Newhall, Nancy. Review of *My Camera in Yosemite Valley. Magazine of Art* 43, No. 8 (December 1950): 309.

Commends the "unusual combination of power, light and space" captured in these twenty-four photographs, as well as the expansive range of moods and subjects. The critic also praises Adams's accompanying essay on mountain photography.

Spencer, Ruth. "Ansel Adams." *The British Journal of Photography* 123, No. 6057 (27 August 1976): 728-32.

Provides a concise overview of the photographer's life and career with references to Adams's own writings and interviews.

Taylor, R. Gordon. Review of *Ansel Adams: Images 1923-1974. The British Journal of Photography* 123, No. 6037 (9 April 1976): 306-09.

Affirms that if there is a weakness in this 115-print selection from the artist's life work, "it is in the close-ups, whether of rocks or plants, where the 'seeing' was lacking and the viewer is left with just a photograph of the object, and no more." However, the critic commends the thoughtful and technically superior design and reproduction of the bold, well-defined, "really stunning" landscapes.

Thornton, Gene. "Adams: His Legacy Endures." *The New York Times* (25 April 1984): C15.

Commemorates and describes the principal contributions Adams made to the art of photography, including previsualization, his advocacy of straight photography, and his celebrated "zone system."

Wood, Jim. "The Gentle Crusader: Ansel Adams." *Historic Preservation* (January-February 1981): 32-9.

Sketches Adams's career with special emphasis on his conservation efforts.

V. Selected Sources of Reproductions

Adams, Ansel. *My Camera in Yosemite Valley.* Yosemite National Park: V. Adams, 1949, 69 p.

A privately published collection of prints with an essay on mountain photography.

Adams, Ansel. *Images, 1923-1974.* Boston: New York Graphic Society, 1974, 127 p.

An extensive collection of prints with a foreword by Wallace Stegner.

Adams, Ansel. *The Portfolios of Ansel Adams.* Boston: New York Graphic Society, 1977, 124 p.

Includes the introduction by John Szarkowski excerpted above.

Adams, Ansel. *Yosemite and the Range of Light.* Edited by Tim Hill. Boston: Little, Brown and Co., 1979, unpaged.

Collection of 116 photographs taken in the Sierra Nevadas, including Yosemite, with a foreword by Adams and an introduction by Paul Brooks relating the emergence of the Sierra conservation movement.

Adams, Ansel. *Examples: The Making of 40 Photographs.* Boston: New York Graphic Society, 1983, 177 p.

Forty of Adams's best-known photos, each with detailed background information provided by Adams.

Adams, Ansel. *Photographs of the Southwest.* Boston: Little, Brown and Co., 1984, 128 p.

Collection of 109 photographs made from 1928-68 in Arizona, California, Colorado, New Mexico, Texas, and Utah with a statement by Adams and "An Essay on the Land" by Lawrence Clark Powell.

DeCock, Liliane. *Ansel Adams.* Boston: New York Graphic Society, 1972, unpaged.

Photos by Adams with a foreword by Minor White.

Gray, Andrea. *Ansel Adams: An American Place, 1936.* Tucson: Center for Creative Photography, University of Arizona, 1982, 37 p.

Chronicles the 1982 recreation at the San Francisco Museum of Modern Art of the original 1936 exhibition of Adams's prints at Alfred Stieglitz's New York gallery, with 45 plates.

Pierre Alechinsky

1927-

Belgian painter and graphic artist.

Alechinsky is primarily noted for highly expressionistic paintings that have often been described as phantasmagorical, violent, and, in a positive sense, disordered. While recognized as highly individualistic, his style and sensibility evolved to a significant extent from his early years as a member of Cobra, a group formed in Paris in 1948 and named for the native cities of its founding artists—COpenhagen, BRussels, and Amsterdam. Of the tenets of this group, Alechinsky has written: "Cobra means spontaneity; total opposition to the calculations of cold abstraction, the sordid or 'optimistic' speculations of socialist realism, and to all forms of split between free thought and the action of painting freely." It is this spirit of creative freedom, which has been compared to that of primitive myth and childhood imagination, that commentators have found especially characteristic of Alechinsky's work.

Alechinsky was born in Brussels, the only child of a Russian father and a Belgian mother. He studied at the National College of Architecture and Decorative Arts, and in 1947 held his first exhibition of paintings, which he described as "portraits of girls whom I monstrified." Two years later he joined the Cobra group, whose membership also included noted artists Karel Appel, Asger Jorn, Corneille, and Jean Atlan. Reflecting the group's central ambition of unfettered expression of the unconscious, their works often featured fantastic images and mystical symbols derived from mythology and folklore. After the Cobra members went their separate ways in 1951, Alechinsky settled in Paris, where he studied engraving and associated with such artists as Surrealist painter Joan Miró and sculptor Alberto Giacometti. He also developed an interest in oriental calligraphy, a discipline that ultimately led him to travel to Japan in 1955 to film a documentary on the subject. Since that time Alechinsky has worked prolifically in a variety of artistic materials and media, including oils, watercolor, and acrylic painting; ink drawings; lithography; and book illustration. He has exhibited his works in major galleries and museums throughout the world, and in 1976 was the first recipient of the Andrew W. Mellon prize, awarded by the Carnegie Institute's Museum of Art in Pittsburgh.

While Alechinsky has been acclaimed for his turbulent style, critics are quick to assert that the distorted, often monstrous figures and representations in his works are not emblems of social or psychological turmoil but rather the result of a vital and energetic artistic imagination. Alechinsky has confirmed that "as for the monsters that so frequently make their appearance in my work, they are benign monsters—they're not meant to scare anybody. For some reason it gives me pleasure to paint them." This explanation of the impulse behind these particular images may also illuminate the prime motive of Alechinsky's art, which, as the artist himself has stated, "has always been to paint or draw that which gives me pleasure, the princi-

ple being that if an artist is not happy with his work then others will not be happy with it either."

ARTIST'S STATEMENTS

Pierre Alechinsky with Michael Gibson (interview date 1986)

[*In the following excerpted interview, Alechinsky discusses various aspects of his work.*]

[Gibson]: *Let's talk about your marginal comments.*

[Alechinsky]: I pass. No I don't after all. I'll trump with one of Henri Matisse's remarks: "I always start from the frame."

What do you make of that statement?

28

Beyond the frame there is . . . well, all the rest! The roving hordes, the outside world, so powerful when you compare it to a small rectangle of paper or canvas. I sense then how urgent it is, not only to concentrate on the composition of the rectangle itself, but also on that of its frontiers, on the *margins.*

Progressively, as I produced my paintings with margins (I have been painting such works episodically, ever since I did **Central Park** in 1965, I found myself stressing the rectangle, underscoring it even, whether by means of a fringe of pictures around the *center,* or by materializing a border.

You did this with the idea of defining a separate space in which a different order of event occurs. Right?

And at the same time to annex the frame, to make it part of the picture, rather (let's say in passing) in the manner that an engraver uses a border in his woodcut to prevent the roller from touching areas that have been hollowed out. This is the sort of limitation that can turn out to be an aesthetic advantage—depending on the engraver's talent. I started out as a printer and I have made use of some of the craftsman's notions, tricks or habits in my painting. *Marginalia*—in the form of notes, addenda, subtitles, summaries—have existed ever since the invention of the book. Proof corrections find their proper place in the margin too; they indicate and countermand alongside the column of type. Authors use the margin to modify the text on which they are working. It can be quite spectacular at times. Lithographers use it to test a tool and try their hand before setting to work. In doing so they trace minute and often charming preparatory sketches, which are erased before the actual printing, once the first test print has been run off. Some rare proofs of this kind are occasionally to be found, described in print and book collector's catalogues in such terms as: ". . . despite a few rust spots, this is a fine proof of the first state with marginal comments." A term I appropriated.

Your own modus operandi also includes the assembling and mounting on canvas of the work you initially painted on paper. This is at once an additional business of composition and a manual task.

Which invites a detour. It is a fortunate thing, really, that painting should demand such a wide range of chores. One would be rather ill-advised to tackle literature head on! But the very act of painting requires a whole ritual of incantatory approach. It is this specific mixture, three parts chores to one part creation, that yields a painting.

Let's talk about the work that stands before us: **After Us,** *1980.*

The center, both mineral and aquatic, says: color. The border composed of black and white drawings confirms that the subject of the central part is cascades and moving vapors that fall back into water. The viewer's eye is led on through a gyratory movement, a cycle. The subject dealt with in the middle of the painting was less apparent: just a deluge of blue. . . . This impelled me to add some clarifications outside the field. And so I painted one rectangle after another, around the big one in the middle, and then adding the comments within their individual frames, each one with its own problems of composition (**After Us**).

It might conceivably evoke the way a sixteenth-century tapestry is organized—or even an oriental carpet.

The image in itself is isolated and forsaken, therefore vulnerable. From time to time it requires protection. The access border, the commentaries reassure. The painting must stand alone in its struggle against indifference. The viewer is soon enough inclined to turn his eyes to other sights! The image is not always self-sufficient. It needs a specific body of reference to catch and hold the passing glance.

All this work of composition prompts the eye to come and go.

From the larger to the smaller. These paintings are intended to be seen in two ways—both from a distance and close-up. Just as I made them: first the center, then the margins.

First the center, yes. I suppose you allow yourself a pause between the two?

Once the center is done I grant myself a moment of respite. I float around or turn to other tasks; the break can last several days, after which I begin working on the border; but it can also last several weeks or months. In exceptional cases, even several years. No schedule, no deadline. No obligation either. **Agoraphobia Square** (a painting, done in 1966, that gives a good idea of where I stood after the twenty years I had remained faithfully wedded to oil painting) waited for three years before receiving, in acrylic at last, the developments on its frame. In any event, I observe the center before venturing into the margins. But, as you know, I have also painted and I still paint a lot of images without marginalia. Evidently they are not a necessity each and every time.

What is your understanding of the notion of "spontaneity" which played such an important role in the theories of the Cobra *movement?*

Spontaneity was the rallying cry of *Cobra* in contrast to the "pure psychic automatism" favored, no doubt with some extra charge of idealism, by André Breton. (pp. 15-18)

The action of painting leads the painter to an awareness of the material nature of his craft, much more so than a writer who is never sufficiently conscious of the material act of writing, of the tracing of words. This notion was significantly amplified by Christian Dotremont, who derived his logograms from it. Marcel Havrenne spoke of a poetry "in which the script itself has its word to say." Both of them referred to the impact of the physical act of writing on the imagination. Implicit in this attitude is a mistrust of any idea that is too precise at the outset: it can blind one to new ideas that might otherwise appear *while* work is in progress. Everything significant occurs within this creative "meanwhile" (which is one of the mysteries of art). *Before* is irrelevant, we are told. And *after,* we stand before a *fait accompli,* a definite result, definitely locked into its own moment in time, and which we call a painting.

So that, in this view, the term "spontaneity" refers to a form of interaction between conception and execution, the manner in which the physical act of painting inflects the actual result. It implies a readiness to welcome whatever may yet, quite unpredictably, occur. But I also notice, in actual fact, beyond the polemical slogan "spontaneity," a manner of

paradoxical tension: on the one hand this openness, availability, "spontaneity," and on the other a demanding attitude, an order, a discipline. Spontaneity, in this sense, does not imply a surrender to mere impulse. . . .

The less demanding, the less visual person will indeed surrender—the temptation is too great.

And he will invoke spontaneity.

As an extenuating circumstance!

I bring this up because I gave the matter some thought a few years ago, after a conversation I had with Dotremont. It occurred to me then that there was an abyss between what he actually meant by spontaneity and the vulgar, unthinking meaning the term usually is given. In Dotremont's case this "spontaneity" was coupled with a considerable discipline. When he drew his logogram he never allowed the idea of the text to precede by any great length of time the actual act of setting it down on paper. And not only that: if the result did not satisfy him, he rarely made use of the same text a second time but went on to invent another one. His "spontaneity," consequently, was never devoid of self-discipline, and his craft was the result of an interaction between openness and stricture.

It's a strange thing: we create limits for ourselves. We invent a game called "painting," governed by disciplines which, all told, are extremely demanding. The artist-legislator is also his own judge. He cannot, however, easily lie to himself, to the extent that he can only feel pleased or displeased by the line he has just drawn. So he has no other choice but to strive after a perfection that cannot exist—"perfection is death," said Jorn. And only in the long run can we measure the scope of the disciplines we have imposed upon ourselves. Discipline! An extravagant word to be coupled with such spacious freedom!

As for the openness or availability we mentioned, it is apparent in the very act by which the line is drawn.

And which the eye trails.

And this is why we can easily recognize a line drawn by Alechinsky. Your draftsman's script, like your handwriting, belongs to you alone. And your graphic idiom can also be recognized in the choice of a certain format, a way of "centering," of organizing the work as a whole.

This concern with composition is the result of a handicap I have. I am left-handed. Educators ordered me to hold my pen in my right hand, the awkward one, but fortunately allowed me to clutch a pencil or brush in my left one. Painting and drawing, as you can see, do not enjoy the same status as writing. I was soon aware of the flow that runs from right to left instead of in the direction followed by a reader's eye. Yet this is the direction in which a viewer surveys a painting. Consequently the situation, as far as I am concerned, is the following: I must allow a free rein to my reverse dynamics, while making allowances for a few features that will permit the viewer (myself included) to return to the cursive flow derived from the act of reading. Hence my predilection for the printer's shop, where I have spent so many hours looking into Alice's mirror where all that has been reversed is again set right.

So the eye runs in a set direction, not only when it reads a text, but also when it takes in a picture.

This direction is perceptible in the way the brush settles on the paper, rests there and leaves it. Painters discover this if they are curious enough to look at their painting in a mirror. On the other hand, being quite accustomed to seeing our own features reversed, we dislike ourselves in a photograph. A photograph is shocking to its subject.

Have you, in any way, taken advantage of your handicap?

I would never have been so attentive to composition if I had the blinding good fortune of being right-handed!

My own adventures with writing have made me aware of script in general. I often view a painting as a mass of information. I discover the hand and personality, hesitant or determined, sensitive or dreary, pretentious, measured, captivating, precise, brutal, compassionate, refined, open, flustered, sovereign, adorable, etc. All that, and much more besides, is to be read in the lines of a painting.

Do you perceive an affinity between your artistic script and the Far Eastern technique of calligraphy?

Our perception of Far Eastern script doesn't go beyond its graphic aspect. We don't understand what it is saying. But we discover a comparable graphic serpentine (our own manner of tying and untying a line), if we take the trouble of holding a page we have written to the light, and looking at it from behind, reversed, so that we can no longer make out the written text. I sometimes write backwards with my left hand. In 1955 I traveled to Japan to study the calligraphers and film them at work on sheets of paper laid out on the floor or placed flat on a low table. In any event, I have chosen to use the same equipment and have acquired a passionate love for paper.

But the precepts of a master must necessarily be disappointing. "What should one do to become a great calligrapher?" And the immediate answer is: "Sit upright and breathe properly." And Bonnard too, advising a young painter, says no more than: "Always have a clean rag."

A calligrapher or a writer can get a kind of satisfaction from tracing an entire sentence or text at one go. Their state of mind is different from that of a painter who traces a form here or there on his canvas, then stands back to judge the effect before continuing. The calligrapher does not pause. He writes cursively and appreciates the formal beauty arising out of his tool, his paper, the movement of his hand inflected by the literary content. A painter does not transmit words; his drawings have no connection with syntax.

Have you noticed a change in your script as time goes on?

Indeed, a hand armed with a brush acquires practice, encounters surprises and improves with time. A line that expresses at once the artist's idea, his moments of hesitation, the shortcuts of his thoughts and of his decisions, his energy with its phases of acceleration and of subsiding pleases me more than any exaggeratedly neutral one.

And all of this is apparent before us, here in a broken line, or there in the hatchmarks that define a frame.

In vital chaffings, pauses, wrenches that are, one must hope, perceptible, in the imprint of the brush that reveals the power of a forceful gesture or the delicacy of a caress. (pp. 18-22)

Central Park (1965)

Looking at such works as **Chromatic Buoy,** *based on the rubbing of a circular bench, or* **Street Pepper,** *based on rubbings of a cast-iron manhole cover, a question comes to mind: Just what kind of interest do you take in the symbolic value of, say, the circle or the wheel?*

A painting can evoke different associations each time we look at it—and consequently different ideas. Dotremont said: "A painting is a ventriloquist's doll." This leads us to the literary problem of choosing titles.

When it comes to thinking up a title, the general impression, a detail, some circumstance unrelated to pictorial matters can provide a clue. Each unknown painting must provoke its own title. This explains why the "entitling painter" has almost more experience than a writer. I have had to find titles for several dozen drawings at a go. "Be more specific, please," says the title to the painter.

I have published several books with the word "title" on the cover. The matter obviously preoccupies me. I wrote *Titres et pains perdus* in 1965; then *Le test du titre,* in which I published the responses of sixty-one personalities I had asked to think up titles for six of my drawings. And finally *Le bureau du titre,* a sequence of titles presented without any corresponding pictures, so that they might be savored on their own. As for my *titreurs d'élite,* many of

whom are now dead (René Magritte, Jean Paulhan, François Truffaut . . . and so recently Joyce Mansour), most of them, quite independently of one another, had found some sort of common denominator. Much to my surprise!

My question about symbolic or mythic content was prompted by the fact that you quite recently chose to produce a series of paintings dealing with circular forms.

I've been involved with wheels for a long time, and making rubbings of them too. I even wrote a book entitled *Roue libre* for Albert Skira in 1969. At that time I had not yet noticed the cast-iron manhole covers in the streets, but I had painted ***Star and Disaster*** based on a pattern of concentric circles.

As far as content is concerned, there are obviously . . . I was about to say, "universal symbols." When someone draws a circle he brings about, how shall I put it, a sort of . . .

Statement.

I was thinking more of a state of mind. We collect ourselves, our thoughts or feelings, inside a circle with a certain degree of fascination. Stage directors are aware of this and make good use of the inclination. So there is some irony in the act of taking manhole covers and turning them into mandalas.

Derision, yes, but marked with a touch of admiration. A distortion of derision. My admiration for the anonymous work of the foundrymen has its share in this. I have been attentive to the variety of decorative motives on these cast-iron plates which the French administration refers to as *"pièces du mobilier urbain"* ["pieces of urban furniture"]. This leads me back to recollections of childhood (rubbing a coin with a pencil) or to Max Ernst (Max, that lucid child). They are technically rubbings. As it happens, they are also evocative both of childhood and of China.

Is it so unusual to pay attention to these covers shaped like mandalas? A man walking, Jean Dubuffet once observed, is more inclined to look at the ground than straight ahead. Gravity plays its part. I took those extremely heavy plates that communicate with the catacombs of New York, out of whose infernal depths gray fumaroles arise, and turned them into solar wheels: suspended gates of hell!

Other enigmatic forms have come to squat in my paintings. "Universal symbols" I am sometimes told, that also occur in sacred art. But in fact, my own art is profane. I am an atheist, and insistent upon this fact, though I do feel an affinity for such things, and am always stirred, for instance, by Johann Sebastian Bach's *Saint Matthew Passion*—stirred, but without hope. And hopelessly so.

You keep your distance from content.

It's more a matter of reserve.

Of irony, perhaps, masking a modesty which in turn masks a content?

Long ago I elaborated a vocabulary made of images. I drew from things laid out on my table next to the paper and the ink bottle—exceedingly humble things (if you will forgive the pathetic fallacy, of attributing an attitude such as modesty to pebbles, roots and orange peels). And then, emerging from them, like sequences of free associations or like puns, I saw all my lady-loves appear, and also the feathered headgear of the Gilles dancers of the Carnaval de Binche (suddenly so close to those of the Mayas), and volcanic eruptions, spirals, volutes, the meanders of a river turning into a lane, a shoelace, a necessary snake.

About this matter of content, I would rather say that we are dealing with a symbolic material inherent in society itself, of which a highly elaborate and formalized version is found in the various religions. But this fund of images is already present in the language we are taught, in education and even in good manners. This thing we call "culture" is a free and creative elaboration, by all human societies, of a fund inherited from the animal societies from which we are descended. (I have no use for sociobiology, by the way, which Marshall Sahlins has devastatingly criticized.) These societies also have their symbolic order, as any ethologist can tell, rooted in behavior. No society can function without it, but in our own case it assumes much vaster proportions because it takes the shape of a symbolic language which refers to the meaning and value of all things.

This aspect can easily be neglected, no doubt because our way of describing the world has favored the individual self-perception, taking it in isolation and artificially placing it under glass. As Gavroche might have said, it is, in a sense, la faute à Descartes ["Descartes's fault"]—for Descartes (but Locke too), based his philosophy on individual self-

awareness and thus sent into eclipse those aspects of this awareness which arose out of the prehuman collectivity, although they are, in fact, quite as fundamental as the individual aspect. This has always been so, of course, because we inherited this social ground, with its basic behavioral symbolism (which has been studied by Konrad Lorenz, among others) from our prehuman ancestors. We inherited it as a basic pattern, but we also elaborated it (and continue to elaborate it) in a way that allows us to designate goals and values beyond the immediate and tangible ones that alone concern animal societies. And it is primarily this ordering of a society and its goals (inevitably through symbolic terms) that constitutes the material of culture. . . .

The collective order of culture has its inhuman aspect because it often commands a blindly tribal assent, but it is also that which, in an entirely positive sense, goes beyond the individual and represents the things for which the individual is willing to give all of himself, and even his life if necessary. It consequently commands both the most immoral and the most ethical forms of behavior. In the latter case, it refers us to the values that give life a substantiality and a meaning. And all of these can ultimately be condensed into, and signified by an entirely rudimentary symbol, a circle, for instance. It is far too easy to treat such things as though they were mere speculative theory. Yet when someone draws a circle before us, under certain (theatrical or religious) circumstances, it can call to mind something that has a bearing on a community or a communion—or again, with negative implications, a casting of spells, a separation or, in a better sense yet, a reserved space, a "passage" towards transcendence, in other words towards "what is not there" or "not yet there," though it is of momentous importance to us: our life goal. And when a person deals with forms, as you do, he is constantly making use of such things, be it a circle, or a sequence of images that suggest a narrative, even if the narrative, as it happens in your work, has no definable content.

I was recently showing a friend some paintings composed of rubbings, **Chromatic Buoy** among them. And he declared that the trace of these cast-iron entities appeared more important than the objects themselves, in the same way the hollow imprint of a vanished fossil becomes more affecting than the actual fossil. The fossil is gone, the trace remains. The negative concept is more intense than the positive one. Whereupon he began to talk about Tantrism. I replied that as soon as we see a circle anywhere Tantrism will inevitably be mentioned.

Yet walking through the flea-market years ago I had, despite my own fathomless unknowing, been drawn to a Tantric image which I found so beautiful that I carried it home with me. Had it been hanging on my studio wall for so long that I no longer could *see* it? When people recognize "universal symbols" in my work I sometimes recoil, as though the association were undeserved. A reflex. As if to say: "I have nothing to do with this."

You are perhaps a bit wary of any interpretation that might be suggestive of mysticism?

The truth is that I enjoy coincidences. Nature and culture, in bits and pieces, run through us with their symbols and obscurities, thus producing various beneficial short-circuits.

One might suppose that the "sacred symbols," at the outset,

refer to a form of experience that does not necessarily derive from any set theory, nor any dogma. . . .

Looking at the Apocalypse tapestries in Angers I tell myself that in those days I would have enjoyed (illusion!) drawing clouds and monsters as crude and elegant as those. I recognize these same lines in my own work. And when, for instance, I depict a sort of fortress wall from another age, I should not be surprised if others begin to think of more specific subjects I might not willingly touch upon myself, but which appear according to the fancies of my brush. . . .

A painting is a revealing slip! (pp. 23-8)

Your marginalia have, a bit too easily, been compared to the comic-strip form. I would prefer to see an affinity with the narrative idiom of the quattrocento frescoes.

If any comic-strip style did influence me, it was the black and white variety of yesterday, or even before: the medieval woodcut or again the *Dreams and Lies of Franco* by Pablo Picasso, the father of us all. An admission which should only make orphans sneer! (p. 28)

We were discussing the interpretation of a painting a while ago and you mentioned the "ventriloquist's dummy." Does this metaphor imply that one should not listen to what the dummy has to say?

The definitions we add to an indefinite, indefinable yet to be defined or already (momentarily) more or less identified image are derived from daydreams, and each of us does not dream in the same way every time. You cannot bathe twice in the same image. Rather, it is the bather who changes—but let's not go into that.

There is a tree, a quasi-landscape. Great lava flows, a mask in profile, a torso wrapped in bandages. Have I sufficiently respected, sufficiently clarified the intent of the line? Working in the labyrinth, I clutched the thread which (as I perceived it) would lead me to the plausible dome of a skull, or a slow spilling over of lava or of molten iron. *Walkway* is the title that occurred to me after having finished the border of a painting that reminded me of a suspended walkway. This refers to a twofold reminiscence: one, a visit to the Pont-à-Mousson Foundry in Lorraine, and two, the viewing of Fellini's *E la nave va*. Micky [Alechinsky] and I had been to a dinner party and there we stood, both of us rather ridiculously overdressed, on the walkway beside a foundry Director in a double-breasted suit, like the tourists in the movie looking down on the engine room—on the inferno. (I had gone to Pont-à-Mousson in the hopes of finding some nineteenth-century manhole covers, but in a foundry every scrap of metal is melted down again.) This is merely intended to suggest where a painting's title may be found, and by what devious ways. Another day, I might only have distinguished a tree: *Tree* or *Walkway,* one or the other can *nonetheless* impel one to say: "What do you know, a myth!" (p. 30)

Pierre Alechinsky with Michael Gibson, "Bordering on Something Central," in Pierre Alechinsky: Margin and Center, *Solomon R. Guggenheim Museum, 1987, pp. 15-30.*

INTRODUCTORY OVERVIEW

Dore Ashton (essay date 1978)

[Ashton is an American educator and critic who has written extensively on modern artists and art movements. In the following essay, written on the occasion of a retrospective exhibition of Alechinsky's work at the Carnegie Institute, Ashton provides an overview of Alechinsky's career.]

My goodness, Ionesco exclaims in his introduction to Alechinsky's catalogue, what a labyrinth!

Impossible to know just what Ionesco is referring to. Does he mean Alechinsky's gadabout mind, roving here and there in history and winding the paradoxes he discerns through his life? Does he mean to tell us—and I think this is quite likely—that this fifty-year-old young man has poured out a volume of thoughts and feelings that defy criticism, so tortuous has been their course?

Because it is quite possible that to define Alechinsky's œuvre, it would be necessary to regard him not as a painter at all but as a culture. Valéry told us in his introduction to "Monsieur Teste" that "it is impossible to conceive, at the beginning of a reflective life, that only arbitrary decisions enable man to *found* anything at all: language, societies, knowledge, works of art." It does appear that Alechinsky, while still quite young, made a number of arbitrary decisions to which he has clung ever since. He obviously decided that to paint was not enough. No single step along his way has been exclusively in the path of painting. Although the walls of the Carnegie Institute in Pittsburgh were replete with thirty years' results of his drawing and painting impulse, even these objects always allude to the other impulses that have kept Alechinsky faithful to his decisions. Impulses to write, to document, to make commentaries, to compose books, to correspond with poets, to remark on the bizarre events of his interior life, and to govern what is written about him. Undoubtedly it is this extensive drive to found a private culture that has kept Alechinsky vivid and interesting to so many other artists—above all, poets.

In his own copious commentaries, Alechinsky has told us where it all came from—his *furor* to write, draw, paint, travel, talk, talk, talk. But of course, he cannot tell us everything, even though, like Valéry, who said he saw himself seeing, Alechinsky has claimed:

> The top spins. It did not see itself being spun nor its cord being wound. Never does it measure the skill, or lack of skill, of the person who spins it. It did not have the power to move; it does not have the power to stop. It spins. Amidst the cigarette stubs, brushes and tubes, before a canvas stretched and waiting, I become a top, a top that sees itself. I can, I must wind the cord.

Spinning out his life's trajectory . . . , he does tell—without emphasis—where some of it came from. For instance, he tells of a bombing raid on Brussels in 1944 near the Gare du Nord. There he helped to clear the rubble. "The amalgamation of the inhabitants with their balconies, extracted from the hills of bricks, will determine his refusal to use horror in painting for edifying ends." He has remained true to this early refusal. Although he himself

insists that when he paints, he liberates monsters, no one scanning his life's work could be fooled into believing that these are indeed monsters. Certainly not the monsters Goya meant when he said the sleep of reason produces them. Alechinsky's sorties into the monstrous are so jolly, so gay, that perhaps monsterism is not a useful term at all in considering his work.

For all that, he is very much concerned with the sleep of reason. Everything in his background pointed him in that direction. At his grandmother's house, there were engravings by James Ensor—an irascible who more than once turns up in Alechinsky's most serious meditations, and whose unreasonable imagery and queer painting palette left a permanent imprint on Alechinsky. At art school, immediately after the war, he encountered the veterans of Belgium's strong pre-war surrealist movement, and before he was twenty knew most of the Belgian stars including Magritte and the poet Achille Chavée. The shadow of André Breton begins to dog his tracks even then, and grows larger and larger as years go by. All these enemies of unreasonable adherence to reason thronged Alechinsky's youthful imagination and marked him forever as a child of the *revolution sans revolution* that was, and is, Surrealism.

Alechinsky on his art:

I am very much influenced by my Belgian heritage, especially the carnival costumes and traditional pageantry. I see a natural link between the smoke of a volcano—I draw a lot of volcanoes—and the sumptuous plumes on the headdress of a famous figure in Belgian folklore. . . . My first view of New York was of Central Park, laid out like a map far below with winding paths, mounds and valleys, and I had to paint it right away. That painting of Central Park was the first time I used drawings as marginal comments around the main theme, so it is a work I see as a landmark in my art.

Another subject I found irresistible was the river, with ice floes floating up it and then pulled back down by the tide. I could look down and watch the water slipping along in wide bends and curves, carrying great chunks of ice formed in these strange shapes, and the whole scene seemed familiar from my own paintings. Yet there's no river in Brussels, and you don't see ice floating up the Seine in Paris.

I write a bit as well as paint, but literary work is harder. It means covering an unknown space—with no limits set and no mind visions to follow—whereas painting is all visual; you see images and your space is exactly defined by the size of the paper. It has limits.

From "Conversations with Six Belgian Artists," in ARTnews, Vol. 81, No. 4, April, 1982, pp. 144-47.

Accordingly, it was quite natural for Alechinsky to find common cause with the group that called itself Cobra which, as he has often repeated, was his "school". He dates his adherence to Cobra views to 1949, when he encountered the surrealist poet Christian Dotremont who introduced him to the work of the Dutch artists Corneille and Appel and the older Scandinavian artists Pedersen and Jorn. This international ingathering of expressionist temperaments raged briefly through Europe, resurrecting the sacred principles of the old Surrealist pantheon. But, since Alechinsky, Corneille and Appel, at least, were extremely youthful, their own attitudes were somewhat more exuberant, less brooding than the older generations'. Alechinsky said that the Cobra artists were trying to be "happily unselfconscious", while Corneille saw their effort as a response to the geometric art that had dominated pre-war Europe, Holland in particular, and reflecting a need to start "a gigantic disorder". What Cobra meant to Alechinsky apparently was an opportunity to participate in a congenial international group where he could fully exercise his temperamental need to be "unspecialized"; where, through the group's magazine, and in verbal encounters, he could fulfill his need to both talk and write.

During the hectic Cobra period Alechinsky's energies were dispersed, and his painting evolved slowly. The works from 1949-1951 are mostly sorties into the new language that was overtaking all of Europe. The simple imagery of children transposed with the remnants of Picassoesque figure distortion suggests his concourse with Appel and Corneille rather than with the older expressionists. But his thoughts charged ahead, and circled in areas that Jorn had been exploring for many years. Jorn's artistic ethic, nurtured in the 1930s when he had spent some time in France, harked back to the rebellion of Surrealism. He wrote in *Cobra* magazine that "intelligence and creative thought are ignited in their encounter with the unknown, the unexpected, the accidental, disorder, the absurd and the impossible." He constantly admonished the younger Cobra artists to bear in mind that the free artist must be a professional amateur and not a professional artist. One suspects that Jorn's passions registered deeply with Alechinsky, and turned him definitively in the direction he has followed ever since.

It was not until 1951, when Alechinsky got a grant from the French government to study engraving (which he did in Hayter's Atelier 17) that he settled in Paris and concluded his term as Cobra promoter. Then commenced a period of intense work combined with a broadening of his associations in the art community. In the early works at the Carnegie retrospective there are echoes of Parisian enthusiasm for Dubuffet, as well as echoes of the more refined abstraction which, in principle, Cobra had defied. Most notable is Alechinsky's hint of admiration for the Cuban painter, Wifredo Lam. The 1951 *Les hautes herbes* with its bone-like grid, and eyes peering through jungles of small forms; and the 1955 ***Montagne regardant*** both suggest Lam's influence. The latter painting, one of the best of the early period, also indicates Alechinsky's interest in some of Ensor's more eccentric techniques, such as scraped lines, and paint thinned and handled almost like finger paint. For several years Alechinsky wielded two palettes: one hot, in the pink-to-orange range, and one cool in the blue-through-green range. With these alterna-

tions of mood, Alechinsky explored zoomorphic and anthropomorphic references.

The prevailing climate in Paris during the 1950s was favorable to Alechinsky's inclinations. There was considerable enthusiasm for the new defiance called "l'art informel"; much discourse concerning free form, free spirit, free technique, free thought, free everything provided it did not refer back to any of the pre-war canons. Edouard Jaguer founded the magazine *Phases* in the spirit of pre-war surrealist publications, but devoted its columns to the work of those painters who had sprung themselves free both from figurative allusion and technical restriction. It was in *Phases* that Alechinsky published one of his most serious articles, "Au delà de l'écriture", in which he summarizes his deep interest in oriental calligraphy. Noting that the experiments of the automatist painters of Europe have certain formal resemblances with the calligraphies developed in post-war Japan, Alechinsky's exposition stresses certain tendencies that are "in the air". His mind was engaged above all by the fact that Japanese calligraphy is paradoxical: the child learning calligraphy is submitted to a rigorous muscular discipline in order that he may produce a free and spontaneous expression. He recognizes that such a fusion of thought and action is rare in the Occident, but suggests (with unconscious surrealist fervor) that "if we have found by purely automatistic means certain spectacular aspects of Japanese expressivity, isn't that an indication of the hoped-for return to the sources destroyed in us, perhaps in spite of us, of the Imaginary and the Marvelous?"

His own return becomes evident in the late 1950s when increasingly he has recourse to the calligrapher's free brush in the manner he discovered while watching his friend, the Chinese painter Walasse Ting at work. Unquestionably the physical mobility that Oriental techniques permit, and the emphatic character of the predominant blacks in many of Alechinsky's ink paintings of the 1950s and 1960s freed his imagination. The metamorphic polymorphous characters pour out without effort, and Alechinsky's need to be "happily unselfconscious" is assuaged. At the same time, his works in oil also benefit. The old references—Ensor's masked mummers and the amoeboid heads and figures shared by Cobra with Dubuffet—are sublimated in the buoyant rhythms of his calligraphy. Color, as is often the case with Alechinsky, is used to provide exclamation rather than to compose the picture-plane. Such a narrative of his labyrinthine impulses, so closely related to the writing impulse, would certainly engage the imagination of an Ionesco, and of the many other international writers who have responded in print to Alechinsky. It can be found in his key work of the early 1960s, **Alice Grandit.** Here Alechinsky gives full expression to his desire to embed forms in a flowing matrix. Amongst the scribbles and scrubbed surfaces nest a host of allusions—to eyes, to Pinocchio, to children's drawings, to fingers—all wafted upward in an unending flow, accented gaily with primary colors.

Somewhere along the line, in the mid-1960s, Alechinsky abandoned oil paints. He had been moving away from them for years, working often in inks on paper on the floor. The transition for him was easy, and ensured that he would stay in touch with the imaginative sources that poured metamorphoses into the work at a congenial speed. Many of the larger works of the 1960s were painted on paper on the floor with acrylics, then mounted on canvas. Since paper and writing are so closely identified, it is not surprising that he gave way to the writing impulse with ardor. A key work of 1965, **Central Park,** fully exploits the water medium. The "park", a kind of ambiguous groundplan in bright colors, which can also be read as a goggle-eyed head or coiled figure, is surrounded by what Alechinsky calls commentaries. These are small ink drawings of carefully evolved monsters that have some reference to Alice in Wonderland (according to the artist) but that are clearly the product of a very free association of images. Their comic-strip character refers more to the searing imagery of Picasso's *Dream and Lie of Franco* than to the benign Sunday supplement comic strips. The pleasure Alechinsky derives from these visual footnotes can be sensed in a huge painting of 1967, **Le théâtre aux armées.** Here the large central screen is filled with a colored drawing of rather light intensity while the surrounding frame of comments is stressed, shifting the emphasis always to the edges. Clearly the *sotto voce* remark delights Alechinsky far more than the protagonists' speeches from center stage. This can be seen in one of his more decorative works of 1969, bearing as its title a characteristic pun, **Astre et désastre.** A sumptuous blue-green mandala, buoyed up by water, sits above a suite of black-and-white commentaries to which the eye is insistently drawn. The cinematic movement of the drawings of spheres (so many frames) reads alternately as a strip and as a piece of calligraphy in which symbols must be read in succession.

In all of Alechinsky's varied activities—his book illustrations, etchings and murals, his collaborations with writers such as Michel Butor, Christian Dotremont and Joyce Mansour, his own writings—there is an implicit belief in magical moments when thoughts and intuitions coincide. In his texts there is a constant search for confirmation of his initial surrealist conviction that these moments of magic can in fact arrive. For instance, he records that Ikouma Arishima visited Matisse in 1928 and was "shaken by a scarlet panel from the Shin dynasty. Upon it four gold ideograms stood out: Purity Screen South River. Without access to their meaning Matisse had placed them opposite the window looking out over the sea: Through a pure screen seeing the water at midday". In Alechinsky's wild scrawls, his freest effusions, we sense that he expects such miracles to occur in his own creative life. Certainly his ceaseless wandering amongst cultures has the earmarks of a quest. If he alludes to history (Satie, Ensor, Artaud and even Magritte) and if he alludes to personal history (his early years as the child of a Russian Jewish father transplanted into the bourgeois stolidity of Belgium), there are always probes into a possible future act of magic that will emerge as he stands over his papers, his pig-bristle Japanese brush poised to capture the flow of his associations. (There are countless fascinating cross-lines in Alechinsky's accounts of his life, not the least being a familial connection with the Russian writer Isaac Babel.) Even in the splendid overflow of imagery that makes up the bright rooms of the Carnegie retrospective, there is a sense of ever-present underlying impatience—an impatience that seeks to spend itself, like the spinning of a top, in a quest for what he once called the Imaginary and the Marvelous. If Cobra was, as he says, his "school", its ideals remain unchallenged for Alechinsky. (pp. 22-9)

Dore Ashton, "Alechinsky at Large," in Art

International, *Vol. XXII, No. 3, March, 1978, pp. 22-9.*

SURVEY OF CRITICISM

George Wallace (essay date 1962)

[*In the following excerpt from his review of an exhibition of works by members of the Cobra group at the Art Gallery of Toronto, Wallace unfavorably assesses this group of artists while finding Alechinsky's contributions to the show relatively praiseworthy.*]

This exhibit of sixteen works . . . provided a useful, if limited, opportunity to view and assess [Alechinsky and the Cobra group of European Expressionists]. For in many respects these artists, while influenced by recent American painting, continue the development of earlier Expressionism. They have in fact inherited all of its limitations, while they have few of its virtues. They, too, carry a self-conscious emotionalism to the borders of the merely sentimental; are devoted to a needlessly assertive and violent handling, and too frequently reduce colour to the crude simplification of a few primaries. These aspects reach their disastrous apogee in Karel Appel's turgid and repetitive impasto. They are present also in Corneille's *Entre soleil et sable II* and in Asgar Jorn's *Fascination*. . . . This pictorial muscle-flexing is often described as "spontaneous" or "vigorous." I wonder if it is anything more than the inept and unimaginative use of a mannerism.

In this exhibition, Alechinsky is much the most accomplished painter and he is most successful in three small pictures, particularly in a small water colour of a metamorphosed head. Generally speaking, the smaller pictures are more successful than the larger. This I think is due to two related factors. Much of this work both in iconography and style, relates to the drawings of four- or five-year-old children. These gross-headed monsters with matchstick limbs are not without their macabre fascination, but they become merely pretentious when inflated to a larger scale. Again these pictures have only the most tenuous pictorial organization. At their best they show the tumbling lively disorder of a child's drawing, but expanded in scale, they disintegrate into an almost complete lack of articulation.

While this "child art" has something in common with the work of Klee and Jean Dubuffet, it entirely lacks their wit or irony. The paranoia of the Expressionist artist has often led him to take himself more seriously than he need and it is perhaps this lack of wit that is most depressing. In this sense Alechinsky's world of grimacing monsters is a declension from the larger humanism of Nolde or Kokoschka and from the whole European tradition. Maybe we are all Babes in the Wood crawling towards Nemesis, but need that distract the artist from attempting to stand up and keep his diaper and pinafore as neat as possible. (pp. 396, 398)

George Wallace, "Alechinsky and the Cobra Group," in Canadian Art, Vol. XIX, No. 6, November-December, 1962, pp. 396, 398.

Jane Harrison (essay date 1964)

[*In the following review, Harrison offers a negative appraisal of Alechinsky's works featured in an exhibition at the Lefebre Gallery.*]

[This] exhibition comprises oil paintings and a series of large brush-and-ink drawings on rice paper mounted on a linen support. Alechinsky's main claim to fame, apart from what I consider to be a slight but pleasant talent, is his association with the Cobra Group (Appel, Corneille, Jorn, etc.). In the present exhibition the over-all tangle of skeins and loops which carried, in his earlier work, the hint of human forms and faces has almost entirely given place to the kind of spectral, Ensor-like figures which also recur throughout Asger Jorn's work. Jorn's influence, in fact, has become more and more apparent over the past few years. Alechinsky's paintings display a willful, almost petulant, lack of design, color sense and coherency; they smack too much of a painter who has been canonized at an early age (Alechinsky is thirty-five). The brushwork is scrubby and aimless, and the poverty of color—mostly mint green, browns and flesh pink—which attempts to perform some emotive function, simply makes the paintings the more negligible. Initially the brush-and-ink drawings are stronger, due largely to the appeal of the medium itself and the scale of the drawings (average 64″ by 52″). Alechinsky uses a free, broad line which has a slightly moth-eaten look where the ink does not take to the rice paper. The surface is partitioned into loose patterns and schematic figures and faces. Certainly these provide a momentary pleasure, but here again there is precious little to bite on.

Jane Harrison, "Pierre Alechinsky," in Arts Magazine, Vol. 38, No. 4, January, 1964, p. 30.

Paul Waldo Schwartz (essay date 1970)

[*In the following excerpt, Schwartz discusses the relationship between images and ideas in Alechinsky's work, quoting the artist at length.*]

[There are two sides to Alechinsky's] thinking, drawing, his brushstrokes, his words, his intentions; on the one hand, the immediate celebration of colour, sensual harmonics, instinctive balance and the sonority of a work of art immune to critical context, and, on the other hand, an intellectual, often metaphysical search for meaning, or hidden meanings unintended. To this second end Alechinsky is eager to join images and words, his own images and words, or his own images and words of others. The possibilities of magic are never far from his consciousness. If the image is precise, its reverberations are elusive and mysterious. . . .

[Alechinsky comments]:

I can't stop in my path. The current continues. Where determinations come from or to what they ascribe is not always evident at first. The title of the London works, **Astres et désastres,** comes from a

Agoraphobia Square (Original composition 1966; marginal drawings added 1970)

poem of Guillaume Apollinaire's. I look for the same sonority. That is, if I say "aster", I think "disaster". There is a phrase of Jacques Prévert's, for example, in *Quai des brumes:* "When I see a swimmer, I think of a drowning man." I like that. But here is the passage from Apollinaire: "Je ne chante pas ce monde, ni les astres/Je chante toute les possibilités de moi-même hors de/ce monde et des astres." So the implication is surely there already. Surely he intended that reverberation of sound.

I write a great deal now. It's difficult for me. When I paint I make the rules. When I write I have to accept the rules. Words take me to a deep pessimism. But I can't hide the fact that to paint is a delight, quite the opposite. But as soon as I touch words, pessimism quickly takes over. Painting is therapeutic. Painting is my drug, and I manufacture my drug myself.

The daily condition is always more disaster than aster. But to paint is to forget. For example, I am altogether an atheist. But Matisse remarked that, "I only believe while I am painting." . . .

As to current sensibility or anti-sensibility? I am for rich art, against impoverished art. Children don't make impoverished art because they are rich. As for Pop or Neo-Dada, I'm all for it. For me the strongest, most admirable man going today is Claes Oldenburg. But he knows how to draw, he does exactly what he wishes.

Among his current projects, Alechinsky has done two anti-editions with Arman, called *Les infeuillables,* the word being parallel to *Les incunables.* In each case, the entire edition of prints, handsomely boxed in the grand manner, is encased in one of Arman's plastic blocks. The presence of the prints below the first 'page' is revealed but only the first sheet is visible—for the 'book' cannot be opened. 'It's to deny the idea of "the edition" ', Alechinsky explained. It may also, in fact, champion the cause of desire in the face of satiety. (p. 180)

Paul Waldo Schwartz, "London Commentary," in Studio International, *Vol. 179, No. 921, April, 1970, pp. 180-82.*

Nicolas Calas (essay date 1976)

[*In the following excerpt, Calas discusses some of the artistic techniques Alechinsky used at various points in his career.*]

Certain artists who used Masson's and Miró's process of

automatic writing to produce a formless kind of abstract painting were later to generate an imagery from formless patterns. Unlike the expressionist paintings of Munch, Nolde, or Soutine that distort physical reality to express a mood, de Kooning and Alechinsky produce images by fusing the expressionist needs with the gestural process. By means of this fusion, Alechinsky developed a method to produce images that conform to what Breton called an inward image. Writing to the artist, Breton noted: "What I enjoy most in art is that quality which you possess, the power to interlace curves, the evidently organic rhythm, the felicitous feminine surrender that you obtain from light and color."

The Belgian Pierre Alechinsky was the youngest member of the short-lived but influential Cobra group (1948-1951). In 1955 he went to Japan to follow the work of its painter-writers. He learned from them that the artist acquires his total freedom of gesture by mastering the traditional technique of calligraphy. The Japanese would paint the body bent forward above the paper spread on the ground. From then on the problem Alechinsky set himself was to form a pictorial writing that could transform an inkblot into a labyrinth of images worthy of Ariadne. The title of *Les grands transparents,* given to a work of the late fifties, suggests that Alechinsky shared Breton's conviction that the invisible could manifest itself to the initiate. His treatment of the subject, however, indicates that in contradistinction to Matta, he avoided depicting these transparent beings.

In the late sixties, using acrylics, Alechinsky produced an idiomatic series of Surrealist images. By that time he had mastered the very difficult art of handling colors and lines so that the relation of figure and ground could be caught in a mesh of positive and negative spaces. The viewer can at will shift his attention from the rich and inventive ballet of colors to the serpentine design, and to the flowing fantasy of an untold narrative.

Since the mid-sixties, Alechinsky has framed some of his paintings with sets of drawings and often comments on the subject described in the picture. According to Chris Yperman, by means of this method Alechinsky was able to show us his picture from within. The theory is ingenious. However, since the margins are filled with pictorial notes designed after the picture was completed, they turn out to be poetic elaborations of the central theme. Visually, these bands of drawings remind one of the designs with which the medieval artists adorned the appearance of the handwritten page. But Alechinsky, by emphasizing the calligraphic character of his imagery, adds as it were a weighty argument in favor of those who, like the Surrealist, are interested in painting when it becomes poetic writing.

After the pictures have been read, the eye retains their song of color; intense greens support an explosion of blood-like specters gazing through cobalt skies, emerald grounds are metamorphosed into a cobra, a Rorschach of red trumpets once again man's insatiable desire for revelations.

In a new series, *The Color of Time,* the antithesis between marginal drawings and polychrome visions has given way to a horizontal division, the top half being of abstract design, the one below of animistic lines and varied colors. The duality of sky and earth gives life to the picture, light to the celestial sphere, gravity to its support. With delight

he reinterprets the Franco-Flemish Book of Hours. Despoiled of mythology his zodiacs wheel, often counter-clockwise, while genii, as yet unsullied by classification, await change or metamorphose themselves hour after hour with the liberty Alechinsky so amiably grants them.

Alechinsky is predestined to play with light. In the series named *Washpaints,* he brushes the black to heighten the intensity of whiteness and deals with fractioned triadic spaces in which volcanoes erupt into trees, highways wind skyward, sea monsters rock the night. Alechinsky turns humor into a diabolic joie de vivre.

Nicolas Calas, "Pierre Alechinsky," in Arts Magazine, *Vol. 50, No. 7, March, 1976, p. 13.*

Eugène Ionesco (essay date 1977)

[*A Rumanian-born French dramatist, Ionesco is a major exponent of the Theater of the Absurd, a dramatic form which attempts through various techniques to portray the essential meaninglessness of human existence. One of Ionesco's primary concerns is the impossibility of communication between human beings, and his plays often convey that idea through bizarre distortions of language, creating dialogue that is significant in its semantic vapidity. Incomprehensible on any superficial level, Ionesco's works create a darkly comic vision in which the grotesque and the mundane are both exaggerated to the point of surrealism to reveal the complacency with which human beings confront their absurd, collective situation. In the following excerpt, Ionesco reflects on Alechinsky's paintings.*]

A difficult thing, stepping into the world of an artist. His is an autonomous language. You don't explain or analyze a painting; you describe it. But even then, it's a superfluous endeavor. Anyone can describe a painting. Anyone? Yes, provided that—and this is no easy prerequisite—one is able to forget oneself, forget preconceived notions about painting. It means saying the unexpected, it means not talking about form, volume, value, rhythm, static versus dynamic, or depth. It means telling the truth. How then do we approach this painting, *Network?*

The goal of painting is to discover, to invent forms, views, visualizations, unprecedented visual worlds. A different criterion must be adopted for each painter. Criterion? No. A different viewpoint. But let's not 'narrate' painting. There is no need to duplicate the painter: criticism is just so much pointless labor. A new language has to be created each and every time.

What then is this distorted world?

Seeking to copy the world, to imitate its creator, has he ended up with a caricature of it? Or, on the contrary, has he unveiled its true meaning?

Towards the Future: what a mess! You mean to say that's *us?* Nothing better than that? The beautiful siren without tail or head. But what beautiful eyes.

Rorschach. So then, everything is subjective? Arbitrary? No: consensus. Unless one is mad—removed from the real world—one winds up in objectivity again. Reactions and discoveries look alike, cluster together.

My goodness, what a labyrinth! I'm not very keen on wandering about in there. But I am already here: I'm inside it. The perspective shown me by the painter (what shall we call him: artist, poet, sorcerer, gentleman?); there's the end of my trail.

I am in the trail.

Art: meeting of man and universe. Collision: neither emerges intact. They've smashed, softened, undermined each other. They've given in to each other. (p. 9)

God pulls the world out of nothingness. The artist would like to do likewise; he does his best. He does what he can. He reworks shapes that already exist: clearly, they are not created out of nothingness. It's just scrawl. He doesn't transform, he deforms. We are only men, we do what we can. We are not made in God's image: we're only His caricature. Clumsiness—that's man's contribution to creation. The materials are there, given. Impossible to see beyond the walls, beyond the doors, beyond the roof that closes us in. Prohibited. We're dumbfounded: let's make a nice mess of it. That's why I like Alechinsky; but it's pointless for him to put four eyes on a head inscribed in a head. Inscribed in a circle. Why not call that an ideogram?

I had come to realize that what counts in literature is not what one says, but how one says it. I was mistaken. What counts is what is used to say what one has or hasn't got to say. The interesting thing about painting is not the subject, values, or drawing. What's interesting is to know what is used to make or not make what is made. Alechinsky himself supplies the information: an ideal medium—spring water, a support—a simple sheet of pelure paper, a Japanese brush and some bowls, half-transparent, half-opaque matters and ideas, a restaurant tablecloth, some drops of wine, the fingertip, good morale, well-sharpened pencils, an eraser, a pen, some acrylic, some turpentine, an atomizer. All that. What you do with it doesn't matter much, or at all. We've already seen so many things.

It's not just a question of caricaturing natural and divine forms; one must caricature what man has done by caricaturing natural and divine forms.

As I look at Alechinsky's extraordinary world, I ask myself: from form to the formless? Or the formless in search of its form? But *Micky* is quite beautiful, snake with the head of a woman.

I haven't really familiarized myself with his work.

If I see a canvas, a painting by Alechinsky, I have no desire to incorporate myself into it, I don't want to walk into it from the other side and become part of his world. It's not that he's not kind. He's not mean either, or severe. But he still frightens me. I'm afraid of irony; I'm afraid of forms that move, that are unstable. There are people who think they like painting when, in fact, they actually don't. They're the ones who say, when confronted with a Picasso or Van Gogh or Cézanne or Matisse or Tanguy, 'I wouldn't have that in *my* house.' I, on the other hand, would gladly hang an Alechinsky on my wall; but I wouldn't care to step into it. His is an adventure in form that I dare not join.

Alechinsky's paintings, more than any others, take in the outside world, transform it by passing it through an inner world, then throw it back into the real world. But that's what all art is about, you may say. Obviously. But in the case of Alechinsky, this process is both unrestrained and intentional. Ever since Kant's proposition that we perceive and transform the outside world according to the structure of our intellect, we haven't known what the outside world really is. And our feelings add their interpretations over and above this intellectual transformation. In short, the transformation is due to the incarnation or concretion of the inner vision.

And yet, we're able to recognize each other because there is a consensus of feelings. My feelings are akin to Alechinsky's; they are awakened by his. I do indeed recognize these figures. Alechinsky is making fun of the world. That's right: the world, in other words, creation. True, he does copy it, but he mixes in clumsiness, irony, and affection.

How does one go about discussing painting? Every work of art is approximate, a rough estimate. It's only more or less what the painter himself has seen, for there is a distance or gap that arises from the conflict between the thing to be incarnated or substantized and the material that the painter struggles with to give the forms substance. Every work of art is a compromise. God alone is capable of determining to what extent the painter has succeeded in illustrating his world view.

For the person who is inhibited, serious-minded, strait-laced, an authority on even post-surrealist painting, Alechinsky is a painter only insofar as he applies layers of color to canvas, paper, cloth, or walls. He doesn't paint landscapes or people. He doesn't paint: he coats with paint, he covers with loud color. He has no desire to depict things; he has no meaning whatsoever to give them. In this respect, he is the most objective artist or craftsman on earth. He lets exterior or interior phenomena arrange, act upon, and paint themselves, so to speak. He doesn't draw or paint in order to 'mean' something; he lets meanings and phantasms link up of their own accord. His is not a premeditated vision. Of course, his phantasms are depicted just the same. But these visions get hooked by spatial baits and traps laid for them. Alechinsky is like an angler who has no idea what kind of fish his hook will catch.

That's not quite right. Alechinsky is the painter-fisherman, the rod, the hook, the water flowing in the river, and the fish, all rolled up in one. Now, it's struck me that I just stated quite simply that his work synthesizes—no, I don't like that word—brings together the interior and the exterior. Rather, interior and exterior collide in his work, and both seem to come out of it battered. And these 'bruises', so to speak, are what the mixing process yields.

Hallucinations, illusions, dreams, you might say. Not so, for these images don't belong to a dream world. They're not hallucinations; yet it does seem to be an hallucinatory world. At times, one could even say that Alechinsky is a realist. His work really springs from a conflict between reality and himself. True, the world is labyrinthine. True, the labyrinth is a snake biting, or not biting, its tail. True, mythic meaning is involved here. Myth is an expression of thought subject to the real world. Myth has no need to be demystified because it is *not* a mystification, as is stated in certain modern dictionaries influenced by Roland Barthes (who decrees his definitions to them like a dicta-

tor). Myth is a structure, that is, a real phenomenon, an indisputable fact. If it be an expression of thought, then it is a universal expression. Myth does not have to be de-mystified; it can be clarified and explained, to the extent that it's feasible to do so. Myth is a phenomenon that manifests itself to consciousness. In another sense, it is startling, abnormal, or extraordinary only to the extent that reality itself, the world itself, the Manifestation itself is an abnormal, startling occurrence, emerging from the nothingness that is the usual state of things, the usual state of everything. (It can't be put this way; but it can't be put any other way, either.)

The world: disturbing, astonishing, caricatural, ironic, mad, useless, amusing if you can distance yourself from it. This is how it appears as painted by Alechinsky. What awesome power man has: to be able to distance himself from the world, to criticize it, laugh at it, parody it, question it, question the Creator, even his own existence!

Is painting a structured language (*langue*) or individual expression (*langage*)? If it's the former it can be translated. If it's the latter—namely, a thought- or utterance-system that is wholly autonomous—then it is untranslatable. In any event, trying to understand is predicated on knowledgeability. Art critics are more knowledgeable than painters themselves. Museum coordinators are even more knowledgeable than critics. One should beware of knowledgeability: it always goes too far and ends up as obfuscating erudition. Of course, one must try to see; but if you describe what you've seen, then you've already got literature. And as we know, literature is not painting. What's more, one may be able to explain without understanding; one may understand, but not be able to explain.

Regarding the painting *Central Park:*

It is easy to draw poorly. It's more difficult to draw well. It's even more difficult for someone who knows how to draw well to draw poorly. By drawing 'poorly,' Alechinsky expresses his childhood, his obsessions, his terrors, his humor. Joker and ontologist—Alechinsky is both. After all, isn't creation a joke that God has played on man? That is how Alechinsky sees it.

In the center of *Central Park* we see a layout of the park. 'A twelve-year-old child could have done it,' a high-school drawing teacher once told me as he spoke about some apples painted by Cézanne. That's true, I replied, a twelve-year-old child with the technique of a forty-year-old man. Or perhaps a forty-year-old man with the soul of a twelve-year-old painter. Encircling the map of *Central Park,* a sequence of cartoons based on *Alice in Wonderland.* But Alice's monsters prompt Alechinsky to create others beyond those associated with Alice: the rabbit, hand placed serenely in the monster's mouth, meeting with a peculiar-looking woman. In the lake of *Central Park,* we discover birds accustomed to living only in an aquatic environment; but there is also the lion, the lion of the deep, and even some fish, such as this dolphin with several mouths. Along park walks or in the waters of the lake or in both, we see shellfish walking on the heads of women and men drowned long ago; all that remains of them are skeletons and skulls. A curious phenomenon, Alechinsky's painting: it's not aggressive, but neither is it accommodating. It frequents familiar fears.

Is it the same woman? Certainly, but unsettling. Here she is: a snake with the head of a woman with no hair, a woman with snakes instead of hair. But who are they for, these snakes hissing on your heads? The beautiful siren without tail or head, but what beautiful eyes. *Micky,* again.

To come back to *Central Park.* This medusa on the grass or in the water. Amazement of a man standing in front of a bicycle twisted by a woman with bare breasts who's turning her back to him. That woman is going to stretch out nude on the grass or on the sand at the bottom of the water.

Network:

'It's a tree, I tell you.'

'No, it's an upside-down volcano.'

'Same thing,' I tell him. 'It's a plastic pun,' he replies, quoting Raymond Queneau.

My earlier notes did not match the above description. One might see in it a duel between man and woman. Third alveolus: I rise up from the stem. Seventh alveolus: let's spit like a watering can to extinguish it. Alveolus eight: quite small before her, I see myself, she is a fish, she's a snake, she's an enormous fish from Far Eastern waters, alive in the living air. Nine: I make myself a huge frog, carry it, bird with plume. Ten: Embarked, woman and siren. Thirteen: legs, bodies, breasts. Fourteen: maximum sexuality. Fifteen, sixteen: separation. (pp. 10-14)

Alechinsky rejects prowess. This is painting that is both pure and impure. It may seem impure in the sense that it is narration, pure because it is the interplay of transformations. (p. 16)

> *Eugène Ionesco, "Three Approaches," translated by I. Mark Paris, in* Pierre Alechinsky, *Harry N. Abrams, Inc., Publishers, 1977, pp. 9-16.*

Alfred Frankenstein (essay date 1978)

[*Frankenstein was an American educator and critic who summarized his principal interests as "American painting and music, historic and contemporary, cultivated and folkloristic." In the following excerpt from his review of a major exhibition of Alechinsky's work at the Carnegie Institute, Frankenstein examines the visual style and thematic content of Alechinsky's work.*]

Once an artist has been a member of a group, he is likely to be identified with it forever, even though the group may not have lasted very long. This is true of Alechinsky, who was the "BR" in COBRA. COBRA was a group of young artists in Paris who had come there from COpenhagen, BRussels and Amsterdam. During its brief heyday, 1949-51, it seems to have had numerous members, but those most widely recognized today are the late Asgar Jorn of Denmark, Karel Appel of Holland, and Alechinsky who, for all his Russian name—he is the son of a Russian refugee doctor—was born, raised and educated in Belgium. At 22, he was the youngest member of COBRA, and perhaps the one most strongly affected by its principles.

"COBRA was my school," says he, and . . . he defines the ideas of the movement as follows:

COBRA means spontaneity, total opposition to the calculations of cold abstraction, the sordid or "optimistic" speculations of socialist realism, and all forms of split between free thought and the action of painting freely: it also means a step toward internationalism and a desire for despecialization. (Painters write, writers paint.)

Observe that Alechinsky speaks of COBRA in the present tense; although as a group it broke up a quarter of a century ago, its principles still command his fullest allegiance. Observe also the reference, which can scarcely be accidental, to Harold Rosenberg's "action painting." Much of the painting of the Cobrists is Abstract Expressionist—except that it isn't abstract. Some imagery of the world "out there" is always present—a human figure, a landscape, an object or combination of objects—sometimes quite easily legible, often implied rather than specifically stated. So it is, at least, with Alechinsky.

Alechinsky has written a great deal more than any of the other painters of the COBRA group. [*Alechinsky: Paintings and Writings*] begins with anecdotes, odd commentaries and philosophical one-liners by the artist, which are strikingly like the sort of thing John Cage has published both in print and in recorded form. The subtitle of one section of the book will give you the idea: "Notes on disappearances, losses of meaning, transmission difficulties, blanks, wants, and useless persistences." The book also contains a detailed, often hilarious autobiography.

For Alechinsky, writing and painting are closely linked activities. Writing instruments and the fluids they employ lie at the center of his work as a painter. He was trained originally in a school for typographers and book designers, and he is as fascinated by paper and ink as any Japanese calligrapher. In a section of the catalogue called "The Means at Hand," Alechinsky says:

Oil painting no longer holds the slightest temptation for me. Drawn to it without knowing what I was about, I ended up using the wrong material for 20 years. Here follows, topsy-turvy, an incomplete list of all that I now loathe: lead tubes concealing the true colour of their contents, whence the decision, the obligation, to open them; hard pig-bristle brushes good for putting a first coat of paint on a door; the sludge at the bottom of the pot; the all too often fatal step forward; the ever-repeated three steps backwards; the position of assailant on his feet; the immaculate canvas—ready for conception—waiting white and sly on the easel, an instrument which resembles Guillotin's invention; the tussle with gravity, the fluid color flowing like jam from on high; the heavy paste not letting itself be directed; the knife that has scraped too much of it; waiting for days, for weeks, before it dries; subsequently noting cracks and signs of age; all too seldom discovering in it (in oil painting) the freshness of the ink sketch or the cadence and narrative flow of the drawing that comes out right.

My first acrylic painting dates from 1954. I executed it on a sheet of paper in Walasse Ting's studio in New York and took that piece of paper away with me to France. I set about observing it, stuck up on the wall, while drawing images one after the other on long strips of Japanese vellum. These I pinned up around it; *Central Park,* my first painting with marginal remarks. I stuck the whole thing on a canvas: first re-mount. I was soon to break myself of the habit of oil painting. It had never allowed me such rearrangements, alliterations, comings and goings.

The artist goes on to describe "spring water galore" as the ideal medium. The support he favors is a thin paper used for patterns in the garment trade. The acrylic pigments and the water rest on the floor, as does the paper. He uses a Japanese brush, held in his left hand. "With it, with them (water, color, bowl, brush, paper), I pass from drawing to painting through successive layers of semi-transparent, semi-opaque agents and ideas; some revealing as though grudgingly the shadow of that which was, others exhibiting, sparing, that which will finally be saved."

All this means, of course, that Alechinsky is essentially a draftsman, but being an artist of line does not preclude his being a brilliant colorist when he wants to be. His color goes on in thin washes of watercolor or water soluble acrylic; in this he stands at the opposite pole from Appel and his thick, tortured, convoluted lava flows of oil paint.

Although many of his paintings are very large, they are made up of relatively small elements. A large canvas intimidates him, says Alechinsky; for years his work has been done on pieces of paper glued to the canvas after the painting has been completed. His paintings are often framed in small, boxed-off drawings in black and white like those of a comic strip; sometimes an entire work will consist of an assemblage of such drawings. They are frequently done on old documents where detached words and phrases are left legible—the literary interest again.

The literary interest also leads Alechinsky to great lengths in the matter of titles: *I am Free, Yells the Glow-Worm: The Future of Property: With Eyes Closed.* A title like *Astres et désastres* is worthy of Duchamp. *L'or du rien* goes Duchamp one better; it plays on the title of Wagner's *Das Rheingold* as translated into French and it also contains, hidden, the work *ordure.* Whether or not this expresses Alechinsky's view of Wagner he does not say, but Wagnerian grandiloquence is not in keeping with his style. His visual world is full of people, ghosts, animals, flowers, volcanos, seas, clouds and monsters. It may at times convey tragic connotations, but its total effect is of a kind of heroic whimsicality.

One sometimes finds Alechinsky compared to Bosch and Ensor because they are, or were, all fantasists and all Belgians, but the parallel is forced. Alechinsky himself invokes the "primitive" Flemish masters in insisting that acrylic has restored the transparency and limpidity of color characteristic of their egg tempera; but the best parallel of all would be to the method of his friend Walasse Ting. As Alechinsky describes it, "He crouches before his paper. I follow the movement of the brush, the speed. Very important, the variations in the speed of a line. Acceleration, braking, immobilization. The light fixed blob, the heavy fixed blob. The whites, all the grays, the black. Slowness and lightning speed. Ting hesitates, then out of the blue comes the solution, the fall of the cat onto its feet. Last graceful figure taken beyond the paper."

And that's how a pussycat can become a tiger. (pp. 52-3)

Alfred Frankenstein, "Report from Pittsburgh: Alechinsky at the Carnegie," in Art in Ameri-

ca, *Vol. 66, No. 1, January-February, 1978, pp. 52-3.*

Lorraine Karafel (essay date 1986)

[*The following is Karafel's review of a thirty-year retrospective exhibition of Alechinsky's work at the Lefebre Gallery.*]

From his abstract, spontaneous canvases of the 1950s, works that reflect the artist's study of calligraphy in Japan as well as his affiliation early in that decade with the CoBrA group, to his collagelike reuse in the '60s of old documents with their formal, decorative handwriting, to his most recent works on paper. Alechinsky declares his passion for the visual qualities of writing. This exhibition, surveying the Belgian artist's work from the past 30 years, brought this fascination to light.

In 1965, after having worked in oils for several years, Alechinsky discovered the materials—rice paper, ink, acrylic paint—he would use to create such classic works as the expressionistic **Death and the Young Girl** (1966-67), a version of a subject common in early northern painting, whose central image is surrounded by "marginal notes," cryptic ink drawings that narrate the story. Marginal notes encircling intensely painted centers or predellas running along the bottoms of paintings have dictated Alechinsky's compositions since.

In his recent work, Alechinsky not only paints on the paper but also uses it as a sort of participatory agent in the creative process, picking up rubbings of manhole covers and smaller water-pipe covers on the streets of French cities and New York. These transferred circular forms with their geometric patterns become focal images in painted compositions, works like **Ville d'Arles** or **25th Street and Second Avenue** (both 1985), that again suggest Alechinsky's link with writing: linear images move frantically over the surface, calligraphy gone mad, let loose from the restraints of framed words to untangle itself and surround the machine-stamped covers marked with the names of cities. A narrow border of color, reminiscent of the marginal notes, edges these monumental, emotive pages. Most satisfying is the sense of the mysterious, reached through exploration and discovery, that Alechinsky has over the years made his own. (pp. 119, 121)

Lorraine Karafel, *"Pierre Alechinsky,"* in ARTnews, *Vol. 85, No. 7, September, 1986, pp. 119, 121.*

Octavio Paz (essay date 1986)

[*An author of works on literature, art, anthropology, culture, and politics, Paz is primarily recognized as one of the greatest modern Spanish-American poets. Early in his career he met André Breton, founder of Surrealism, and Paz's work shares the Surrealist quest for personal freedom and the high value placed on love relationships. Paz's poetry is characterized as visionary and experimental, and his critical writings on literature are regarded with respect. The following poem by Paz, entitled "Central Park," refers to Alechinsky's painting of the same name.*]

The Argument: Some say that, given the exterior world exists, one must deny it; others say that, given the world does not exist, one must invent it; and still others, that only the inner world exists. Pierre Alechinsky turns his head and, saying nothing, paints a rectangle in which he encloses Central Park in New York, in the late afternoon, seen from the window of his closed eyes. The rectangle surrounds the four sides of the park, and is divided into irregular spaces, themselves rectangles, like the boxes in a theater, the cells in a convent or the cages in a zoo. Inside each box swarm bizarre creatures that are somehow vaguely familiar: Are they *they* or *us?* Do we look at them, or are they looking at us? Inside the rectangle, Central Park has been transformed into a green, black and golden Cobra: Is it an anamorphosis of Alice, the Queen of Diamonds in our sleepwalking deck? The painting is not a vision but a spell.

Green and black thickets, bare spots,
leafy river knotting into itself:
it runs motionless through the leaden buildings
and there, where light turns to doubt
and stone wants to be shadow, it vanishes.
Don't cross Central Park at night.

Day falls, night flares up,
Alechinsky draws a magnetic rectangle,
a trap of lines, a corral of ink:
inside there is a fallen beast,
two eyes and a twisting rage.
Don't cross Central Park at night.

There are no exits or entrances,
enclosed in a ring of light
the grass beast sleeps with eyes open,
the moon exhumes razors,
the water in the shadows has become green fire.
Don't cross Central Park at night.

There are no entrances but everyone,
in the middle of a phrase dangling from the telephone,
from the top of the fountain of silence or laughter,
from the glass cage of the eye that watches us,
everyone, all of us are falling in the mirror.
Don't cross Central Park at night.

The mirror is made of stone and the stone now is shadow,
there are two eyes the color of anger,
a ring of cold, a belt of blood,
there is a wind that scatters the reflections
of Alice, dismembered in the pond.
Don't cross Central Park at night.

Open your eyes: now you are inside yourself,
you sail in a boat of monosyllables
across the mirror-pond, you disembark
at the Cobra dock: it is a yellow taxi
that carries you to the land of flames
across Central Park at night.

(pp. 10-11)

Octavio Paz, *"Central Park,"* translated by Eliot Weinberger, in Pierre Alechinsky: Margin and Center, *Solomon R. Guggenheim Museum, 1987, pp. 10-11.*

FURTHER READING

I. Writings by Alechinsky

Pierre Alechinsky. New York: Harry N. Abrams, 1977, 258 p.

> Includes essays, aphorisms, poetry, and autobiography by Alechinsky, along with reproductions of his paintings and drawings.

II. Critical Studies and Reviews

Beck, James H. "Pierre Alechinsky." *ARTnews* 64, No. 3 (May 1965): 12.

> Describes characteristics of Alechinsky's works, stating that he "is an Expressionist, but within the heritage of his native Belgium (especially close to Ensor, though by comparison he is somewhat more restrained). Indeed, despite his manifest vigor, there is a tenderizing intellect, one that prefers not the frontal smash on the head, but a more subtle and gradual emergence of images with straightforward color."

Benedikt, Michael. "Pierre Alechinsky." *ARTnews* 62, No. 8 (December 1963): 50.

> Descriptive summary of Alechinsky's second U. S. exhibition.

Browne, Rosalind. "Pierre Alechinsky." *ARTnews* 64, No. 5 (September 1965): 60.

> Review of an exhibition of forty-three oils, watercolors, and drawings by Alechinsky at the Jewish Museum. Browne concludes that Alechinsky "appears to choke the weird, amoebic skulls, birds and animals haunting his panoramas with Niagaras of automatic painting that cascade with more passion than force. However, when he does hit, he convinces that with sufficient joyous wallowing in paint and esoteric imagery, he can carry his sensation across to the public."

Gruen, John. "The Man Who Grew up to Be a Child." *ARTnews* 77, No. 1 (January 1978): 50-1, 53-4.

> Biographical sketch and interview with Alechinsky.

Larson, Kay. "Heir Heads." *New York* 20, No. 13 (30 March 1987): 94-5.

> Unfavorable review of the exhibition "Pierre Alechinsky: Margin and Center" at the Guggenheim Museum.

Raynor, Vivien. "Alechinsky." *Arts Magazine* 39, No. 9 (May-June 1965): 66-7.

> Positive review of an exhibition at the Lefebre Gallery.

Stark, D., and Flomenhaft, E. *A Cobra Portfolio: Selection of Abstract Artists in Europe Post World War II.* New York: Emily Lowe Gallery, 1981, 70 p.

> Annotated catalog to an exhibition of works by twelve members of the Cobra group, with an introduction outlining the history and doctrines of the movement, an essay explaining the roots of the movement, and brief biographical summaries of Cobra artists.

Winter, Peter. "Left-Handed Fantasy." *Art International,* No. 4 (Autumn 1988): 99-100.

> Discusses the evolution of Alechinsky's style. Winter concludes: "Alechinsky's exorcising forms are aimed at a spectator who is willing to be patient and give his full attention. Only in this way does the work open up fully to the viewer. Otherwise his images are like a fugitive decor, a Mardi Gras parade that hurriedly slips by."

III. Selected Sources of Reproductions

Pierre Alechinsky: Margin and Center. New York: Solomon R. Guggenheim Museum, 1987, 176 p.

> Reproduces a broad range of Alechinsky's paintings and drawings.

Diane Arbus

1923-1971

American photographer.

Considered a key figure in contemporary documentary photography, Arbus is best known for her spare, realistic portraits of unusual subjects—dwarfs, female impersonators, triplets, giants, and hermaphrodites—that emphasize their self-acceptance as well as their alienation from society. Her photographs immediately captured the attention of the viewing public and engendered a critical debate that still continues. Yet these portraits of "freaks," as Arbus referred to them, constitute only a part of her total output; she produced, in addition, intriguing pictures of commonplace scenes and ordinary people, who, as a result of her technique, are made to appear grotesque or sinister. Arbus has achieved an international reputation for her uncompromising integrity, her compassion for her subjects, and her highly individual style.

Arbus was born in 1923 into a wealthy Jewish family in New York City. Her father, David Nemerov, was the owner of Russek's, a fashionable Fifth Avenue clothing store. Arbus later said that she and her siblings, Howard—the noted poet—and Renee, were so overprotected as children that they did not even know they were Jewish. She attended the progressive, private Ethical Culture and Fieldston schools in New York, and upon graduating in 1941 married Allan Arbus, an advertising clerk in her father's store. Assisted by her father, Diane and Allan established their own photography studio and began specializing in fashion advertising, producing layouts for Russek's and for such magazines as *Glamour* and *Harper's Bazaar*. Allan took the photographs and Diane worked on the styling. As she became increasingly interested in the art of photography, Arbus enrolled in a course with the well-known photographer Alexey Brodovitch. Her pursuit of a separate career, however, strained the highly successful professional team of Arbus and Arbus, which eventually broke up in 1956. The Arbus's marriage, too, was ending around this time, and they separated in 1959. Diane moved with her two daughters, Doon and Amy, into an apartment in Greenwich Village. After nearly twenty years in fashion photography, she now devoted her attention to developing her own skills as a photographer.

In 1957, Arbus attended a series of workshops on photography taught by Lisette Model. These proved pivotal for the fledgling photographer, who quickly discovered her capabilities and learned to experiment with the medium under Model's direction. In search of subjects who interested her, Arbus became a frequent visitor at Hubert's Museum (a freak show in New York's Times Square) and at Club 82, a meeting place for female impersonators. She later commented that she was looking for a side of life she had not known in childhood and that she was prepared to go anywhere and do anything for a good photograph. Willing to wait days or months for a portrait she really wanted, Arbus was able to develop unusual rapport with her subjects. During this period, her work began receiving more and more attention, and she took on magazine as-

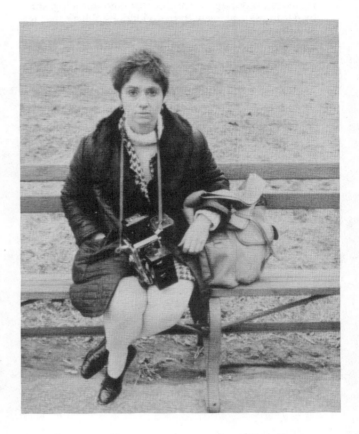

signments for *Esquire, Sunday Times Magazine, Nova, New York,* and others.

Arbus's head-on, unadorned portraits of people on the fringe of society, and her photos of ordinary people that skillfully reveal the pretension and alienation of everyday life, received both high praise and sharp criticism. Her detractors wrote that photographing the unusual was mere sensationalism, or that her photographs were less portraits of others than externalized images of her own neuroses. Other critics, however, extolled Arbus's wit, humanity, and experimentation with photographic conventions in her work. Reviewers noted that one of Arbus's main strengths was her fusing of portraiture and documentary methods. Thomas W. Southall wrote: "The merging of these disparate techniques seemed truly revolutionary at the time. Many of her portraits appeared to be simultaneously as artless and innocent as a snapshot and as factual and unequivocal as an x-ray." Recognition came, too, in the form of two Guggenheim Fellowships—in 1963 and 1966—for documentary projects she had proposed.

In 1967, the Museum of Modern Art in New York mounted an exhibit entitled "New Documents" featuring the photographs of Arbus, Lee Friedlander, and Garry Winogrand. The show polarized opinion on Arbus's work

even further, making her a cult figure on the one hand and an outcast on the other. The Museum's librarian, Yuben Yee, was quoted as saying that he had to come every morning "to wipe the spit off the Arbus portraits." Arbus was shocked by this reaction but continued to photograph subjects that captured her attention. However, magazine assignments and interest in her work declined after 1969. Her last series of photographs, taken in 1970 and 1971 in a mental institution in New Jersey, indicates a change in her style and techniques: set against a bleak autumn landscape, the photographs emphasize the absurdity and pathos of the inmates, dressed in Halloween costumes and masks, and seem to call into question the whole concept of normalcy. Arbus died by suicide in the summer of 1971.

Arbus's death brought renewed interest in her photographs and her reputation again soared. Since she had allowed only a small number of her photographs to be seen during her lifetime, the Museum of Modern Art mounted a major retrospective of her work in 1972 which travelled the United States for three years. Also in 1972, Arbus became the first American photographer to have her work shown at the Venice Biennale. Her photographs are now part of permanent collections in major museums in the United States and Europe. Commending her originality and independence, Richard Avedon remarked that Arbus "has taken photography away from the sneaks, the grabbers, the generation created by *Life, Look* and *Popular Photography* and returned it to the artist."

INTRODUCTORY OVERVIEW

Howard J. Smagula (essay date 1983)

[*Smagula offers a retrospective of Arbus's career, assessing her style and themes while praising her courage and sensitivity in documenting the tenuous nature of human existence.*]

Arbus' camera plunges us into a dark afterworld where the maimed wander cut off even from an awareness of their aloneness. Some of the characters in Arbus' photographic dramas assume frightening mythical roles: Giants, midgets, prostitutes, pimps, and mentally retarded individuals stand before us. What saves all of these subjects from cheap sensationalism and lurid exploitation is the implied presence and vulnerability of the photographer herself. Diane Arbus enters into an intimate, sympathetic dialogue with all of her subjects. She views them as individuals strangely ennobled by the burden of humanity they carry and the isolation they feel. Although she avoided a condescending attitude of pity towards her subjects she did see elements of herself in many of their lives. They shared a tragedy but not the *same* tragedy. At the same time, she was in love with the *idea* of who and what they were and how her world and background were totally different from theirs. These misshapen individuals and social misfits allowed Arbus to feel something she felt she had

been cheated out of as a child: misfortune. "One of the things I felt I suffered from as a kid was I never felt adversity," she once remarked. "I was confirmed in a sense of unreality which I could only feel as unreality."

In part, Arbus photographed in order to feel. It was not a question of experiencing joy or pleasure, but of dealing with the horror of feeling nothing at all. For her even pain was preferable to this existential nightmare. Arbus' images are travel photographs of a sort, mementoes she has gathered on a trip, reminders of where she has been and whom she has visited. One of her favorite things, she was quoted as saying, is to go where she has never been before.

In terms of craft, one might almost say that Arbus was uninterested in technical means—at least the aspects of the medium that center around equipment, film emulsions, and darkroom techniques. She is anything but a photographic Formalist; clever composition, meticulous craft, and printing tricks were never what interested her most. Her photographs, however, are stunning and masterful examples of straightforward and effective visual and thematic organization. Rather than approaching her art from a background of design and formalized aesthetics—where everything is artfully posed and camera angles are carefully chosen—Arbus approaches the subject directly and unerringly.

She was first and foremost a "subject" photographer; the content of the picture was always much more important than visual and compositional elements. For her the camera was a legitimate means of reaching what really interested her, people. In this sense she is a documentarist like Eugene Atget and August Sander, the great German cataloguer of human archetypes. At the same time, she is a different kind of notetaker, very much interested in recording the inner psychological terrains of particular individuals as well as their outer appearances. (pp. 197-98)

Despite the great notoriety and fame of her "freak" photographs, it is important to note that these subjects represent only a fraction of Arbus' total output. In fact, one reviewer—speaking of the Arbus monograph—wrongly states that, "the majority of the photographs [in the book] are of midgets, giants, a hermaphrodite and transvestites." Exactly nine such individuals appear in a book that features almost eighty portraits. A simple majority are of physically ordinary people; the rest of the photographs feature topless dancers, circus performers, or devotees of nudism. This gross misperception can only be explained by the mind's attempt to preserve a threatened image of itself. Arbus hits dangerously close to home when she witnesses and records the freakish overtones of so-called "normal individuals."

Witness the solid majority of ordinary people who turn up in her photographs revealed and transformed by the uncompromisingly harsh light of her flash-gun: an outlandish woman in a strange, feathered bird mask; the blue-jeaned couple sitting on a park bench in Washington Square Park; two Brooklyn girls in oddly matching bathing suits; a heavily made-up blond with iridescent lipstick; a pudgy couple happily dancing.

The truly deformed souls who appear in Arbus' photographs function as "plants," placed there to lull us into complacency and give us a false sense of security—thank God we do not look like them. But after viewing a retro-

spective selection of Arbus photographs the line between us and them begins to break down. By the end of the exhibit we feel as if we have witnessed scores of "freaky" and deformed people, whereas we may have only seen a handful. This then is the basis for the profoundly disquieting nature of her work, the recognition that when anything is looked at long and hard enough it becomes strange and foreboding. Arbus depicts both the deformed and the "normal" as unwitting victims of life. In *Woman on a Park Bench on a Sunny Day, New York City* . . . , a woman gazes at us with a disturbing look that becomes more frightening the longer we stare at the print. Through the unerring directness and selectivity of her vision Arbus reveals an unseen world. "I mean if you scrutinize reality closely enough," she said, "if in some way you really, really get into it, it becomes fantastic. You know it really is totally fantastic that we look like this and you sometimes see that very clearly in a photograph."

One of Arbus' best-known photographs in the category of the physically odd is her portrayal of Eddie Carmel. The photograph is titled *A Jewish Giant at Home with His Parents in the Bronx, N.Y. 1970*. . . . There is an almost scientific and anthropological tone to the title that belies the amazing vision Arbus presents to us in the picture: a mythical apparition, amusing and tragic at the same time. The verbal description pretends to present us with the necessary biographical data one would need to decode the image. Nothing makes it easy to interpret, explain, or even "see" this incongruous scene. The picture refuses to fit any previous category of photograph we may have encountered—family snapshot, fashion illustration, or newsphoto. There is no "fine-arts" look to this piece, no tasteful composition, no beautiful subject matter, no lush natural light—just the brilliant glare of a flash-gun that illuminates the trio. The harshness of the artificial light reveals with minute detail every aspect of this ordinary-extraordinary scene: the shrouded sofa and armchair, the cellophane-covered lampshades, his mother's delicate printed dress, scraps of paper on the couch, framed reproductions of classical paintings, his father's formal attire (no doubt donned for the photograph), and, of course, the enormous height and little-boy look of Carmel himself. His mother looks up at him in self-conscious puzzlement and wonder; his father gazes abstractly into the distance past him.

The photograph looks suspiciously out of kilter; it appears to have been taken in a specially constructed room, the kind one finds at science expositions that change and distort perspective. The longer we look at this documentary photograph, the stranger things become. In fact, with no great mental gymnastics it is quite easy to turn the picture around and envision a normal-sized Eddie Carmel juxtaposed with Lilliputian furniture and tiny parents.

One is struck with the remarkable consistency and continuity in all of Arbus' pictures; even though she photographs the broadest range of individuals, she seems to be showing us the same thing. Perhaps this uncanny ability to reveal the hidden and frightening nature of humanity is the reason she has gained the reputation of mainly documenting "freaks." The irony is that quite often in Arbus' work these deformed people appear to have an acceptance of themselves and life that often surpasses the attitude of her "straight" subjects. Witness the confident assurance

of a carnival hermaphrodite at home in his trailer or the perfectly cozy scene of the Russian midgets in their apartment on 100th Street in New York City.

One of the most haunting photographs of Arbus' career is the widely reproduced *Identical Twins, Roselle, N.J. 1967*. . . . There is nothing overtly grotesque about these two handsome girls. They stand at attention before us like dual apparitions—immovable, inexplicable. Most viewers are captivated by this striking image yet cannot determine just what affects them. Perhaps part of their fascination lies in the mind's inherent love of comparison. Their similarity compels us to study them and note the slightest nuance of dissimilarity. For instance, the girl on the right subtly smiles, the girl on the left does not. Despite their genetic sameness there are significant differences that reveal themselves the more we study this odd duo.

Inevitably, this photograph functions on a level beyond conscious perception, entering us swiftly and incomprehensively. If one looks at it deeply enough, the innocent girls take on a frightening appearance—they become twin messengers from a mythical *Village of the Damned* about to tell us something we would rather not hear.

Despite their Siamese-twin similarity—Arbus even visually fuses their dark corduroy dresses together—they seem worlds apart psychologically. Arbus' own words hauntingly seem to comment on this study of sameness. "What I'm trying to describe is that it's impossible to get out of your skin into somebody else's and that's what all this is a little bit about." Perhaps our uneasiness in the presence of this photograph stems from Arbus' depiction of the ultimate psychological isolation: to be so physically close to an identical copy of yourself yet mentally miles apart.

The underlying theme of aloneness—especially in photographs that feature couples—is present throughout Arbus' entire body of work. She shows us, with compassion and truth, the tremendous odds we face trying to find comfort and solace in a less-than-perfect world. Nowhere is this attitude expressed more touchingly than in *Teenage Couple on Hudson Street, N.Y.C. 1963* . . . ; in this photograph she captures something at once brave and sad. The diminutive body size, adolescent features, and awkward posture of the posing couple is juxtaposed with their adult demeanor and attire. The boy is dressed in a sports jacket, tie, overcoat, and dress shoes with his hair rakishly combed in the style of the day; his eyes shyly avoid confrontation with the camera. She, half repressing a nervous smile, looks at us directly, proud to be photographed with her man. Her clothes are also "grown-up"—camel hair coat, print dress, hose, and stylish shoes. Arbus captures this couple out on a date. Everything about them, their look, attitude, and stance, suggests a valiant effort to mimic the adult world they want so desperately to enter. Hand gestures play an important role in this teenage narrative: His right hand clutches her shoulder, holding her near; his other hand is insecurely thrust into the pocket of his overcoat. She has her hidden arm around his waist; the other is awkwardly held to her side.

The environmental context in which they are immersed adds to the picture of brave optimism in the face of sociological and economic adversity. The brick wall with its cryptic graffiti messages from individuals with no social standing, the edge of a dark doorway that obliquely juts

into the picture, and, above all, the street debris—cigarette butt, soda-straw wrapper, and crumpled paper—are all important details in this dark prognostication of the couple's socioeconomic fate. Arbus seems to ask, "What lies before them?" Their attitude, half-aware and half-oblivious, makes the scene all the more touching. Arbus is no social documentarian, however, preferring to invent her own vision of reality rather than capture it. "Lately," she said in her monograph, "I've been struck with how I really love what you can't see in a photograph. An actual physical darkness. And it's very thrilling for me to see darkness again."

Reading Arbus' words, one is struck with the degree to which her aesthetic sensibility is reminiscent of the character of Holden Caulfield, the teenaged hero of J. D. Salinger's *Catcher in the Rye.* The piercing sensitivity and alternately amused-horrified outlook on life show up regularly in all of Arbus' photographs. Like the adolescent, Holden Caulfield, Arbus saw things simultaneously from two conflicting points of view: the idealistic, wide-eyed wonder of a child and the oppressive, "adult" vision of diminishing possibilities and rapidly fading hopes.

Every stranger who might be encountered on the street had for Arbus an unfathomable potential for both innocence and evil. Arbus captured both of these qualities in one of her most provocative and disturbing images, *Child with a Toy Hand Grenade in Central Park, N.Y.C. 1962. . . .* Despite the benign context of the piece the young child playing in the park appears demonic and almost supernatural. The terror-stricken eyes and distorted mouth transform him into a "possessed" individual. As in most of Arbus' photographs, the subject is simply placed in the center of the composition and is allowed to incongruously contrast with the background—in this case, a sun-dappled and tree-lined walkway. Somehow he becomes all the more evil in appearance because of this innocent environment. His mother or nanny peeks out fuzzily from behind his head and patiently waits in the background; a toddler and a baby in a carriage approach, completely unaware of the hellish drama taking place in front of them. Only Arbus sees the horrible truth of this particular moment; as she once stated, a good photograph, " . . . is a secret about a secret."

Again the details of the print hammer home Arbus' message of hidden despair and reveal the tawdry underpinnings of human existence: his cutesy print shirt and little-boy shorts with the loose shoulder strap; one hand holding a plastic hand grenade, the other tensely clutching, claw-like, an imaginary one; his no-doubt normally angelic face distorted and transformed beyond normal bounds; and, again, a litter-strewn ground of scrap papers, wooden ice-cream spoon, and straw wrapper. Innocence and horror commingle in ways that seem to go far beyond rational explanation. Because facial expressions are so mobile and fleeting we often miss them. But using the instantaneous recording ability of the camera is a way of fixing these moments of short-lived reality that pass before us, usually unrecognized. Arbus uses this instrument as a means of breaking through to another world, a world physically close but conceptually distant from our ordinary perception. "I really believe," she said, "there are things which nobody would see unless I photographed them." (pp. 198-203)

Arbus changed the parameters and territory of photographic art and her influence in this area is indisputable.

Although some critics and commentators have observed that [her] tragic fate was inevitable in view of her work—she went too far and looked too deeply—this attitude seems too patronizing and glib. In a significant way her photography stands apart from her final self-destructive act. All of her pictures connect her, and us, to a revelatory perception of humanity that optimistically links us to life.

Those who knew her remember her as a shy, perceptive, trim woman of extraordinary grace and charm who had the courage to look closely at the things most of us avoid. Diane Arbus will be remembered as an adventurous artist who held up her camera in wonder and amazement to the broadest range of humanity possible—courageous giants, crying babies, and bewildered adults. (pp. 203-04)

> *Howard J. Smagula, "Photography: Landscape to Narrative," in his* Currents: Contemporary Directions in the Visual Arts, *Prentice-Hall, Inc., 1983, pp. 181-220.*

SURVEY OF CRITICISM

Marion Magid (essay date 1967)

[*In the following excerpt, Magid characterizes Arbus's "wit" and describes the effect that viewing her photographs has on her audience.*]

Diane Arbus is attracted to the darker aspects of the human comedy. Most of the photographs in this extraordinary show are of human oddity in one form or another: oddities of birth (twins, triplets, midgets); psychological oddities (homosexuals, transvestites); or those great American ritual oddities that so fascinated Nathanael West (beauty contests, dance marathons, movie premiers). In one haunting instance, she even combines two of these peculiarly American aberrations to produce—in *Beauty Contest in a Nudist Camp—Pennsylvania 1963*—a weird lament, an elegiac tribute to the uncertain life of the body with echoes of the Fourth of July.

Yet, as in the fiction of West, the tension in Diane Arbus' photography is at bottom a tension of wit. Her most unforgettable portraits are those which juxtapose with terrifying precision the realm of the ordinary with the realm of the aberrated and absurd; thus, the stout, middle-aged couple taking its ease in a comfy suburban living-room is 'normal' down to the last detail—except that both man and woman are stark naked. Similarly, when she restricts her gaze to the more 'ordinary' subjects of photography—lovers, women alone, teenagers—Mrs. Arbus invests in them an air of extraordinary mystery. By some curious foreshortening and stunting, her adolescent couple is made to seem like the two last survivors in a world not their own; the Puerto Rican woman on a park bench betrays the terror and passion of some mythic Cassandra; a glossy girl in toreador pants with an improbable cotton-

candy hairdo seems to await, in her livingroom in New Orleans, some ultimate encounter. By virtue of her art, even the meanest objects—the overstuffed toy poodles, the banjo-shaped clocks, the shepherdess lamps for the boudoir, and all the rest of the discount-house rubbish by which we are surrounded—take on a sacramental look.

Because of its emphasis on the hidden and the eccentric, this exhibit has, first of all, the perpetual, if criminal, allure of a sideshow. One begins by simply craving to *look* at the forbidden things one has been told all one's life not to stare at. One peeks guiltily at the titles of the magazines on a transvestite's coffee-table; one tries to make out the family photos (also naked, as it turns out) on top of a nudist's television set.

Then a reversal takes place. One does not look with impunity, as anyone knows who has ever stared at the sleeping face of a familiar person, and discovered its strangeness. Once having looked and not looked away, we are implicated. When we have met the gaze of a midget or a female impersonator, a transaction takes place between the photograph and the viewer; in a kind of healing process, we are cured of our criminal urgency by having dared to look. The picture forgives us, as it were, for looking. In the end, the great humanity of Diane Arbus' art is to sanctify that privacy which she seems at first to have violated.

> Marion Magid, "Diane Arbus in 'New Documents'," in Arts Magazine, *Vol. 41, No. 6, April, 1967, p. 54.*

Walker Evans (essay date 1969)

[*A photographer, author, editor, and educator, Evans is best known for his innovative photographs taken during the Depression while he worked for the Farm Security Administration. His works are included in permanent collections at the Smithsonian Institute, the Metropolitan Museum of Modern Art, and the Art Institute of Chicago. In the following excerpt, he briefly discusses Arbus's* Young Boy in a Pro-War Parade, *praising her artistry.*]

The subject [of **Young Boy in a Pro-War Parade**] was discovered in a parade, in 1967, by Diane Arbus. This artist is daring, extremely gifted, and a born huntress. There may be something naïve about her work if there is anything naïve about the devil.

Arbus's style is all in her subject matter. Her camera technique simply stops at a kind of automatic, seemingly effortless competence. That doesn't matter: we are satisfied to have her make her own photography speak clearly. Her distinction is in her eye, which is often an eye for the grotesque and gamey; an eye cultivated just for this—to show you fear in a handful of dust.

This picture is a quick, brilliant comment; aside; in passing. Arbus's work as a whole is not propaganda. There is more of wonder than of politico-social conviction in her gaze. In any event, be it said (if in persiflage) that art ought not to be propaganda, which is useless; it ought to have purpose and a function. (p. 172)

> Walker Evans, "Photography," in Quality: Its Image in the Arts, *edited by Louis Kronenberger, Atheneum, 1969, pp. 169-211.*

Shelley Rice, on Arbus's inversion of social norms:

[The] irony of Arbus' work is that she tried to undermine the social order while working very much within its dictates; indeed, the very impact of her pictures depends on the existence of the norms she purports to challenge. Although the accepted social standards of normalcy are not immediately evident in her photographs, they are everywhere by implication; they function as the source of her vision and as the framework within which her rebellion achieves its meaning. These norms provided the negative impetus against which Arbus created—and against which she defined her vision of the world. And, most important, they provided her with the negative standards by which she judged the worth—or lack thereof—of human lives. These inverted social definitions allowed her to make blanket assessments of whole classes and types of people that were startlingly simplistic and naive, that had little to do with individual personality or situation and everything to do with the external mannerisms or appearances that defined position within the social order. By perceiving outcasts as "aristocrats" and the bourgeoisie as a sideshow of oddities, Arbus created new standards that were as shallow—and as stereotypic—as those that she despised.

> Shelley Rice, "Essential Differences: A Comparison of the Portraits of Lisette Model and Diane Arbus," in Artforum, *Vol. XVIII, No. 9, May-June, 1980, pp. 66-71.*

Doon Arbus (essay date 1972)

[*Doon Arbus is Arbus's elder daughter and the executrix of her estate. In the excerpt below, she recounts her mother's unusual rapport with her subjects and her quest for perfection.*]

Diane Arbus was my mother so I am not entirely to be trusted. Like anyone who knew her, I have too much at stake. Recollections are inextricably bound up with what one needs to believe. Which is probably as it should be. Since her death I have gone looking for her in what I remember and in the memories of those who knew her. I find scraps that don't quite fit together. Those I recognize thrill me. Others are jarring to what I know and I try to discredit them. The hardest things to recapture are the jokes. All I mean to say is that no one can be a reliable authority on her. The closer they were to her, the more prejudices they have. I will tell some of what I have learned and remember but it must not be mistaken for the truth.

She must have known thousands of people, literally thou-

sands. They include almost everyone she photographed because, whether she was only with them for several hours or many times over a period of years, she exchanged secrets with them. Often what they told each other, neither had shared with intimate friends. And on her part, this is not to say that she was guarded with her friends but that there was a special intensity in the moments when she was working that made something pertinent which had never been so before. It was as much what people drew from her that excited her as what she was able to draw out of them. (p. 22)

I was often frightened by her capacity to be enthralled, by her power to give herself over to something or to someone, to submit. But it was the very thing that made her photographs possible. They were the products of a kind of mutual seduction which she instigated by being herself seduced. And she was very hard to resist as it is always hard to resist someone you've captivated without even trying. Everyone wants to be recognized. (pp. 22, 41)

She had begun as a huntress and it seemed that the more she discovered, the more she became her own prey. She was like someone pursued, pursued as much by what she had already done as by what it had enabled others to do. She was always trying to carve out a place for herself where nobody else had ever been, in short, to be the best. It was for her like a duty which seemed to have come hand-in-hand with being any good at all. (p. 42)

> *Doon Arbus, "Diane Arbus," in* Camera, *Vol. 51, No. 11, November, 1972, pp. 22, 41-2.*

A. D. Coleman (essay date 1972)

[*Coleman is a lecturer, art critic, and the author of many books on photography, including* Light Readings: A Photography Critic's Writings, 1968-1978 (*1979*) *and* Estimations: Fifteen Photographers of the Twentieth Century (*1982*). *In the following excerpt from the former work, he emphasizes the fact that Arbus's own moral code is an integral part of her photographic style and that it enabled her to present her subjects truthfully.*]

In some rare cases a body of creative work is not primarily a statement of esthetic sensibility or an intellectual feat of strength or a sermon or anything abstractable and removed, but rather the naked manifestation of the artist's own moral code in action. There are ethical decisions involved in all forms of creative work, of course, but they are perhaps closest to the surface in still photography. A photographic image is a transformation of reality; when selected with consciousness and an intention beyond the recording of surface, it is inevitably a remaking of an event into the photographer's own image, and thus an assumption of godhead.

The ethical issues inherent in the photographic medium are most fully exposed in the act of portraiture, by which I refer specifically to portraits of other people. (It is, of course, possible to make a portrait of a tree—another life form—or even of a rock; it is also possible to exploit these two non-human subjects, and all others as well. But that is another discussion, and less pertinent to ourselves.) There are no hard and fast rules for ethical portraiture. Most photographers, no matter what their subject, take

photographs; a few, to use Minor White's distinction, *make* photographs; fewer still (as Robert Leverant puts it) *give* photographs.

Diane Arbus *gave* portraits—an astonishing number of them. . . . She was able to do so by virtue of her absolute and intransigent insistence on documenting what I can only term the truth concerning an interaction which demanded her own self-revelation as the price for the self-revelation of her subject. This process is by necessity intuitive, for it cannot be systematized, dependent as it is on the constantly fluctuating state of one's finally secret soul.

John Szarkowski . . . indicates that her work "challenged the basic assumptions on which most documentary photography of the period had been predicated" by being "concerned primarily with psychological rather than visual coherence, with private rather than social realities, with the prototypical and mythic rather than the topical and temporal. Her true subject was no less than the interior life of those she photographed." And, he might have added, of herself as well, for her portraits are self-portraits.

She gravitated to subjects we group under the label "freaks"—midgets, giants, hermaphrodites, twins, lesbians—not out of any decadent search for the outré but because she saw them as heroes who had already passed their individual trials by fire while most people stood around pleading for theirs to be postponed. It is not surprising that her work was often misunderstood—though that should be more infrequent now that a large body of it, most of which has never been shown before, is readily available—nor that it had its greatest impact on a generation which followed Bob Dylan into the same territory.

Without disagreeing with the impeccable distinctions made by Szarkowski in the statement quoted above, I would like to point to one specific area of current cultural consciousness and change to which her work is particularly relevant, prophetically though not intentionally so. Like the German photographer August Sander—to whom her work is linked but not beholden—Arbus explored her subjects' roles. But where Sander concerned himself principally with the roles imposed by class and occupation, Arbus dealt with those imposed by body and gender.

As Marvin Isreal has commented, she made no nudes, "only pictures of naked people." They are all freaks—as are we all, equal in our differentness. Some happen to be physically abnormal while others are more average, some happen to be male and some female. Her images are never concerned with how these individuals appear, only with their relationship to their physical and sexual selves—what they've done with what they were given. Look at such images as **Hermaphrodite and Dog, Girl Sitting on Her Bed with Her Shirt Off, Woman with Veil on Fifth Avenue, Two Friends at Home,** and **A Naked Man Being a Woman**—especially the last one. . . .

There is more, much more, to talk about; her humor, for example, and her tenderness—in which regard the untitled series made in a home for the retarded merits a lengthy discussion all to itself. There is time for analysis later; right now while it is still fresh and uncategorized is our last opportunity to stand before her work and try to match its nakedness. Let us not permit ourselves to assume—pretty as it may be to think so—that when she committed suicide over a year ago she had no idea of how

important her work already was to so many and would become to so many more. Consider instead the possibility that she did know—and that such knowledge was not enough. Diane Arbus once said, "Somebody else's tragedy is not the same as your own." Janis Joplin once said, "I'm going to write a song about making love to 25,000 people in a concert and then going back to my room alone." (pp. 125-27)

A. D. Coleman, "Diane Arbus (II): Her Portraits Are Self-Portraits," in his Light Readings: A Photography Critic's Writings, 1968-1978, *Oxford University Press, Inc., 1979, pp. 125-27.*

Robert Hughes, on Arbus's photographing of her subjects:

Before her death she was beginning to be recognized in art circles as the photographer who had subjected the hallucinated blankness of urban life, mostly in and around New York, where she was born and lived, to a uniquely truthful scrutiny, like Eurydice with a lens in the tunnel to Hades. . . . Arbus did what hardly seemed possible for a still photographer. She altered our experience of the face.

Arbus' vision was exactly opposite to the flabby Family of Man attitude that still governs most photographic responses to the human animal. Everyman is a poor subject. There is compromise in the very act of shooting a person as if he or she were "really the same as me"; it means a flattening of human experience, a generality that amounts to well-meant condescension. In brief, it is sentiment. In her passion for "not evading facts, not evading what it really looks like," Diane Arbus became perhaps the least sentimental photographer who ever caught a face in the view finder. She refused to generalize. There was no family, and the unshared particularity of her subjects was recorded as it lay, dense, mediocre and impenetrable. "What I'm trying to describe," she declared, "is that it's impossible to get out of your skin into somebody else's. And that's what all this is a little bit about. That somebody else's tragedy is not your own."

Robert Hughes, "To Hades with Lens," in Time, *New York, Vol. 100, No. 20, November 13, 1972, pp. 83-4.*

Richard Schickel (essay date 1973)

[*Schickel is a respected writer and critic whose film criticism has appeared regularly in* Time *magazine since 1972. In the following excerpt, he lauds the discipline, self-effacement, and freedom from pretension he finds*

in Arbus's photographs, asserting that she accomplished "a radical purification of the photographic image."]

Until recently it seemed that photography as a serious art (not as an adjunct to fashion and advertising) would be confined to two major traditions. On the one hand there was the salon tradition, that of the print composed as carefully as a painting and dealing in the same conventionalized subject matter—nudes, still lifes, landscapes, etc. On the other, there was photo-journalism, the art of what Cartier-Bresson, one of its great practitioners, called "the decisive moment." In this tradition, the photographer armed with lightweight equipment and fast film intruded (generally as unobtrusively as possible) on our public—and even our private—lives, hoping to catch us unaware at some moment of high drama and, by recording the physical manifestations of our emotional responses, both to particularize and (if he was very lucky) to summarize in human terms the meaning of large events and universal experiences. (p. 73)

Given the limits (and the recent decline) of these two traditions, the importance of the work of the late Diane Arbus cannot be overestimated, though it may seem to some that it *has* been, the recent exhibition of her work at the Museum of Modern Art in New York and the publication of a book based on that show having resulted in the most extraordinary outburst of publicity and criticism I can ever remember being accorded to a single photographer's work. As Hilton Kramer quite boldly but accurately stated, Mrs. Arbus "was one of those figures—as rare in the annals of photography as in any other medium—who suddenly, by a daring leap into a territory formerly regarded as forbidden, altered the terms of the art she practiced."

Still, it seems to me that most of the talk about her has centered around her gothic subject matter and around the mysteries of her personality, while ignoring the question of technique, which is to me the realm where she made her most exciting (and, I would guess, her most lasting) contribution. To begin with, it only *seems* that her principal subjects were the physical and psychological misfits of the world—midgets, transvestites, the mentally ill—probably because these photographs, amounting to fewer than half of those published in the book, have the greatest immediate impact. (One cannot say they are the most arresting, since a first glance at many of them has the opposite effect—one's hand fairly flies to turn the page.) For the most part, though, her photographs are of quite ordinary people whom she encountered at the beach, in the park, at parades, dances, weddings. They often look crazy or vacuous or just plain worn down, but one gets no sense that the photographer was doing them dirt—catching them unawares or, conversely, manipulating them into self-divestation. On the contrary, the evidence is that upon seeing subjects who interested her she carefully went about gaining their confidence, enlisting their cooperation, getting them to pose in their homes or against other backgrounds that felt natural to them. The results, viewed as a group, are moving precisely because she appears to have treated everyone so even-handedly. "I work from awkwardness," she once said. "By that I mean I don't like to arrange things. If I stand in front of something, instead of arranging it, I arrange myself." In short, she opened herself up as well as her lens and therefore her photographs

of persons we are ordinarily pleased to think of as exotic have a kind of sweetness, an innocence, that is unavailable in any other graphic representations of them that I know.

In a similar fashion Mrs. Arbus's "normal" subjects have a singularity that is simply not revealed in the work of photographers consciously committed to the liberal, humanist line most often used to justify their work and most forcefully enunciated in the famous *Family of Man* exhibit over fifteen years ago. Indeed, Mrs. Arbus had something very good to say on this matter: ". . . when I first began to photograph I thought, there are an awful lot of people in the world and it's going to be terribly hard to photograph all of them, so if I photograph some kind of generalized human being, everybody'll recognize it. It'll be like what they used to call the common man or something. It was my teacher, Lisette Model, who finally made it clear to me that the more specific you are, the more general it'll be."

To her great credit, Mrs. Arbus did not replace that familiar rationale for the photographer's work with something more up to date. She was not, for instance, an R. D. Laing with a camera, romanticizing the insane at the expense of the ordinary. Nor did she imply that her subjects, sane or insane, were the victims of an unjust social or political order. Her works make no special plea of any kind. She knew, and cheerfully admitted, what every photographer should know, that photography is the most accidental of arts, just because of the subtle, indiscernible time lapse between the decision to snap the shutter and the instant of its accomplishment—just time enough, as inevitably happens, for the subject to alter his expression in some way he doesn't know and the photographer cannot observe. That is why we are always so anxious to know how our pictures "came out." And why Mrs. Arbus could say, "I never have taken a picture I intended. They're always better or worse." And, "I would never choose a subject for what it means to me or what I think about it. You've just got to choose a subject, and what you feel about it, what it means, begins to unfold if you just . . . do it enough."

Her subjects—that is, the human beings who posed for her—were more varied, as I've said, than most critics have noted. But her *subject*—her central concern—was unvarying. It was not so much loneliness or alienation, but the range of our attempted defenses against them: the widow in her bedroom, for instance, subtly distanced from the amazingly ornate desk crammed with her obviously treasured collection of *objets d'art,* which look to the camera like junk, completely incapable of assuaging the unnamable pain we sense in their owner's pose and gaze. All her portraits of individuals suggest an alienation from their possessions, from the very furnishings of their homes, from the things they hoped would console them.

But it is in her pictures of group efforts at community that Mrs. Arbus's work is most poignant and troubling. The king and queen of a senior citizens' dance, bedecked in the costumer's paste-jewel crowns and phony ermine robes, sit on widely separated thrones and gaze solemnly into and through the camera as if hoping it might teach them the meaning of their coronation. Nudists stare unblinking into the camera, and we wonder if the fellowship that is supposed to be the reward for their nakedness is sufficient recompense for their absurd exposure. The inmates of an insane asylum caper on its lawns in masks and costumes fulfilling, one imagines, some social worker's idea of a "good time," which incidentally parodies and illuminates all the other "good times" Mrs. Arbus recorded in the outside world, our world.

Yet one does not want to make too much of this, if only because Diane Arbus appears not to have. Because she chose to look upon things others had not, because she was a well-bred middle-class woman who turned away from a flourishing career in fashion photography, and because, finally, she died a suicide, there is a tendency to want to make her into a cult figure on the order of Sylvia Plath. But it is not a role she would have wanted. Surely she understood that her sensibility was a unique one and equally surely this sense of her own uniqueness drew her toward people who were singular in other ways. ("Most people go through life dreading they'll have a traumatic experience. Freaks were born with their trauma. They've already passed their test in life.") But the introduction to [*Diane Arbus*], from which I've been quoting, is drawn from remarks she made to students and interviewers and they reveal her as a mostly cheerful, even chipper, ironist who appeared to have passed her own self-imposed test and to be justly, but not overbearingly, proud of so doing (". . . I really believe there are things nobody would see unless I photographed them"). It was, indeed, her lack of pretentiousness that prevented her pictures from becoming exercises in the fashionable grotesque, prevented the imposition of alien ideological interpretations on them, and was, I'm certain, the basis on which she established her inimitable technique.

What she did in this area amounted to a radical purification of the photographic image. On the one hand she stripped away all reference to the "painterly" in her prints, on the other she abandoned any effort at capturing the height of an action or an emotion, "the decisive moment." Nearly all of her subjects are in repose, and nearly all actively, consciously collaborate with her in the creation of the photograph. In effect, she turned her back on professionalism, on all the established notions of what constituted a proper aesthetic for a serious photographer. And thereupon she recreated herself in the oldest, humblest tradition available, that of the documentarian. Actually, what her photographs most remind us of compositionally are snapshots—the subjects carefully centered, looking straight into the camera, the photographer careful to include as much of the background as possible.

Mrs. Arbus consciously acknowledged what Aunt Emma and Uncle Stu instinctively understand when they group the family for a birthday or anniversary pose—that the places we choose (or make) say something significant about us, are a legitimate part of the record. Similarly, the act of involving the subject with the camera, of making him conscious of the need to present an image to the lens, to those perfect strangers who may see the shot later, leads, paradoxically, to greater revelation than in a picture taken unawares. Even the attempt to hide a flaw or emphasize some good point tells volumes. As Mrs. Arbus once said, "Everybody has that thing where they need to look one way but they come out looking another way and that's what people observe. You see someone on the street and essentially what you notice about them is the flaw . . . there's a point between what you want people to know

about you and what you can't help people knowing about you . . . the gap between intention and effect."

Her manner is easy enough to emulate—millions of snapshot amateurs, after all, employ it endlessly. The question is whether other photographers, burdened with the necessity of proving to an essentially hostile artistic community that they deserve membership, burdened also with the breed's powerful desire for self-assertion, to "interpret" reality and thus "make a statement," can achieve the kind of selflessness she achieved. "For me the subject of the picture is always more important than the picture," she said. "And more complicated. . . . I mean it has to be *of* something. And what it's of is always more remarkable than what it is." Which is to say, I suppose, that her style amounts to no style in the conventional sense, her technique no technique at all. But the attainment of this radical simplification, especially for a well-schooled professional photographer, must have required the most determined self-discipline. In a time of undisciplined art, when many, in all media, have lusted after the large, general comment about the wretched of the earth, it is her self-effacing manner—not, as she may have thought, her subjects—that sets her apart. It is the austerity and specificity of her technique that makes her an exemplary figure, her loss a major one. (pp. 73-5)

Richard Schickel, "The Art of Diane Arbus," in Commentary, *Vol. 55, No. 3, March, 1973, pp. 73-5.*

Amy Goldin (essay date 1973)

[*Goldin discusses Arbus's technique, noting that "the clash of artifice . . . against nature . . . is the key to [her] special poignancy."*]

By the commonest standards of art, Diane Arbus is an artist. Her photographs get to us and we acknowledge it. In the good old-fashioned way of audiences, we are moved, and grateful for it.

The thing that sends me up the wall is that it ends there. The odd and interesting things she has made, and what they do to our minds and feelings, all that stays in its gift wrappings, unopened. Faced with figurative art, sixty years of abstraction, sixty years of artistic intelligence made tangible, have won us, apparently, nothing. The Museum of Modern Art's Arbus exhibition was welcomed, in a dry season, as a major event. It was extensively criticized and discussed, yet all there is to show for it is ancient artistic ritual—the social habits and Victorian fog of Art for Art's Sake. Arbus's work is interpreted with the flashing acuity of Maureen O'Hara telling Tarzan about Christianity. Only it is esthetic, instead of theological baby talk.

The Arbus show was a winner and the experts handed out both their ultimate laurels. Laurel wreath A is the expanding frontiers of art bit (Blue Ribbon, all classes) and laurel wreath B is the Revelation of Inner Reality prize (Gold Medal, previously awarded to everybody from Michelangelo to Magritte). She "altered the terms of the art she practiced" (Kramer); "challenges the basic assumptions on which most documentary photography has been thought to rest" (Szarkowski). Moreover, she investigated the "deepest recesses and best-kept secrets of the psyche" (Rose); "gets very close to her subjects, far closer than is

comfortable for most people" (Thornton); she "records the outward signs of inner mysteries" (Szarkowski again). Ultimately she "altered our experience of the face" (Hughes, in *Time*). None of this has anything to do with Arbus. Her whole action involves playing with conventions, not dissolving them. Moreover, by insisting on her compassion and sympathy for her terrifying subjects, the critics clean everything up. Where we might have to face the possibility of being involved with something humanly dirty or dishonorable, they reassure us.

The facts are quite different. We are all taught to feel sorry for freaks, and not to stare at them. Arbus photographed lots of stigmatized people—female impersonators, dwarfs, madmen, idiots—and we stare, measuring our distance from them, and our closeness. We taste the horror of our fellowmen, the dread of being touched by them, and gratitude for the distance, and every reviewer absolves us of guilt. They tell us we have nothing to be ashamed of because Arbus loved them enough, and makes us feel pity enough.

We are supposed to be purified by the artistry of it all, just as Victorian critics assured their readers that the artists' high-mindedness purified the naked, absolving the viewers from prurience. Arbus is not even allowed her risks. As if, in fact, there *were* no moral risk, and nothing more serious was at stake than the possibility of being snubbed or rejected. In fact, the psychological and moral dangers of courting temporary intimacy are considerable. Every deliberate encounter violates one's own privacy, as well as the other person's. One may be asked to give more, for a longer time, than one wishes. As strong capacities entail responsibility, freedom carries its guilts, and empathy its dislocations of self.

I think these photographs cannot begin to be seen unless we admit, immediately, that the risk was real. Arbus may indeed have exploited her subjects, made artistic capital out of their hunger for friendship and acceptance. The desire to be documented in conventional ways is a normal human wish; to be counted, to leave proof of having existed, like everyone else. But people want to be seen on their own terms, and I think it must be admitted that Arbus cheated, and knew she cheated. She saw her subjects *her* way, and they are invariably consumed. The "documents" became her vision of them, not their own, and certainly nobody else's. The "straight" photos, the ones of ordinary people and places, demonstrate this, and it is there, I believe, that we can see exactly what has been done.

To begin we must ask how, after all, Arbus's subjects stand in the world. It seems to us that they stand precariously. Their attitudes vary; they may be brave, sullen, defiant, yearning or complacent, but for *us* the dominant impression is pathos. For us her people are all losers, whether they know it or not.

This is an amazingly subtle effect to achieve time after time. The slightest loss of composure would ruin everything. Her subjects must not seem to feel too much, lest they destroy the delicate superiority we gain from knowing more of their vulnerability than they do. Nor can they be heroic; we must admire ourselves for respecting them. *They* must be both gallant and doomed, just as the Victorian nudes had to be both willing and ashamed to show us

their bodies. Accounting for the gallantry is easy. The doomed part is harder.

Her subjects' gallantry lies in their willingness to face us. They are usually disengaged from work or any emotional preoccupation and devote themselves to meeting our gaze. They present themselves according to the conventions of portrait photography, with the deliberate face and body masking that we assume when we arrange ourselves for the camera's encounter. Gravely, they offer themselves to be recognized. They make the claim to personal identity and social acceptance implicit in the studio portrait. But formal portraiture is combined with the intimacy of locale that comes from snapshots and documentary photographs. We are given all the contingencies of place, the *unchosen* quality of the site and its props. The people expect us; the situation does not. Thus we see both: an identity that the sitter has chosen to be seen and an environment that we accept as true. An environment that undercuts that choice and turns it into artifice and delusion. As her dominant mood is pathos, Arbus's central theme is the futility of artifice, the distance between what has been chosen and what is given. Think of the photographs of nudists. How bizarre that these people, with their visible timidity or vanity, should dream of being children of nature! The clash of artifice (carried by poses, clothing, cosmetics) against nature (the unwanted hair and wrinkled skin, the clutter or bareness of urban settings) is the key to Arbus's special poignancy.

Steadily and subliminally, she says that whatever is artificial is a sad, romantic lie. An iconoclastic Puritanism turns the photomural in *A Lobby in a Building, NYC, 1966* or *A Castle in Disneyland, Cal., 1962* into emblems of the pathos of illusion.

Consider one of the most subtle of her accomplishments, the shot called *Xmas Tree in a Living Room in Levittown, L.I., 1963.* Notice first that Arbus's titles regularly stress the objective documentary dimension of the image. She never gives personal names, and always supplies precise data about time and place. What is personal and social is presented as if it were abstract and sociological. (Though surely here "Xmas" instead of "Christmas" is editorializing!) The interpenetration of documentary and portrait conventions depends on violations of the lighting and focal length normal for each genre. Where the stigmatized subjects are usually shot with a harder light and from a closer-than-normal point of view, the unlit Christmas tree is here unexpectedly distant and photographed in even, diffuse daylight. A sense of desolation is created by the absence of people (elementary), but also by one of the artist's favorite devices, a low-angle shot that shows an edge of ceiling and lots of naked wall. It turns the interior space into a bare cube that locks in a trapped central image. (*Girl in a Coat Lying on Her Bed, N.Y.C. 1968, Transvestite at Her Birthday Party, N.Y.C. 1969, Four People at a Gallery Opening, N.Y.C. 1968, The Junior Interstate Ballroom Dance Champions, Yonkers, N.Y. 1962*).

Faintly skewed right angles, bare walls and a dominant compositional symmetry invariably suggest an impersonal, mechanical order, a world in which humanity is alien, or, at least, messy. It is to Arbus's credit that she doesn't allow herself to make a mannerism of this almost foolproof technique. Her eye is carefully attuned to finding the visually powerful elements of a banal setting—the ele-

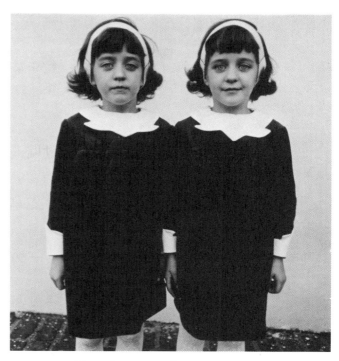

Identical Twins, Roselle, New Jersey (1967)

ments that will drain off the psychic force of the portrait subjects. In *Man at a Parade on Fifth Avenue, N.Y.C. 1969,* for instance, it is the massive trash container that gives an unexpected flimsiness to the flatly lit, raincoated man at its side who holds a black hat over his heart. In *Triplets in Their Bedroom, N.J. 1963* it is the expanse of patterned wallpaper and bedspread that mimics the repetition of the identically dressed little girls.

The "secret" here, as with the identically dressed pairs in several other photos, is that we read the separateness of the figures as something they reject. By their dress and posture they choose to be identical, indistinguishable from one another, but their separate faces betray them. Similarly, the sexually ambiguous pairs are also betrayed, for those who choose the woman's part are always bigger or stronger-looking than their partners.

What is universal in Arbus's vision is that we all support illusions about ourselves, and we're all afraid the disparity shows. She threatens us all. We are afraid because we know we lie, and we think the camera never does. Arbus's stiff-upper-lip pathos is finally based on our own naïve notions, the popular naïveté that supposes all "bare facts" are true and all artifices are lies. With the traditional realism of the Jewish mother, she takes our aspirations to be childish fantasies, and tries to strip us of them for our own good. If we submit, however, it is not reality that overpowers us; it is art. Her images are *constructions,* the result of will, choice and artifice, just as we are ourselves. Nothing is more savagely natural than the use of dress, scarification, body and facial ornament to assert the identity of the bearer. Of necessity, we are all artists, creating our intuitions out of biologically and socially given materials. If we are appalled by the Mexican dwarf who wears his derby in bed, there is finally nothing there worse than a

failure of taste. Perhaps Arbus was showing us that, too. (pp. 73-5)

Amy Goldin, "Diane Arbus: Playing with Conventions," in Art in America, *Vol. 61, No. 2, March-April, 1973, pp. 72-5.*

Max Kozloff (essay date 1973)

[*Kozloff is a highly esteemed art critic and author and the winner of a Pulitzer Prize for his work in the* Nation *magazine. His works include, among others,* Photography and Fascination *(1979) and* The Privileged Eye *(1987). In the following excerpt, he analyzes Arbus's approach to her subjects, finding that she focused on their pathos, oddity, and loneliness.*]

As the German [photographer August Sarder] compiled a rogue's gallery of the pillars of society, [Diane Arbus] studied its rejects and dropouts. Always emotive where he was circumspect (compare their portraits of circus artists), she apparently could not "ennoble" her subjects without feeling she was condescending to them. They are worldly people whom she approaches, for the most part, but the goods of their world are reduced to the rock tunes on transistors, the TV in rest homes or squalid hotels, and the stale tastes of the flesh. She is the Nathaneal West of photography, equipped, when she wants, with a flashgun. . . . Arbus presents glittering tinsel and social anomie with corrosive exhilaration, and the very sweat and pores of several models are textured as if they are news. At the same time, we realize that fashion can be like news photography, in quest of the novel or sensational, a turn of fortune that separates individuals, if only for an instant, from average experience. That most people might want to emulate the aristocratic artifices of high fashion, and would want to avoid being exposed as a news event, are feelings jarringly projected by a gamut of anonymous portraits, neither newsworthy nor fashionable—in fact quite the contrary. Sander, no doubt, would have been paid for his commissioned photos; a few of Arbus' sitters give the impression they would have taken pay for being filmed. In the older artist, hierarchical themes that tie people together are work, family, and money; for the American, it is sex. Yet, with what sad, disabused glamor she proposes it, and how pitiable it is in the inspiringly mangled contexts of the art she achieved before her suicide in 1971.

> The slightest loss of composure would ruin everything. Her subjects must not seem to feel too much, lest they destroy the delicate superiority we gain from knowing more of their vulnerability than they do. Nor can they be heroic; we must admire ourselves for respecting them.

To bring off this composure, well observed here by Amy Goldin [see excerpt dated 1973], required the most tactful brutality. A new situation was, for Arbus, "a blind date," but at the same time, having her camera, "everyone knows you've got some edge." The result of her contacts shows itself as the accidental pose or expression becoming hyperformalized, the decisive catching of annoyance, wariness, laughter, or curiosity before it might go soft into embarrassment and spoil her aim. A *Seated Man in a Bra and Stockings,* just ceasing to be as bemused as his counter-

part, the topless dancer in San Francisco, reveals how fine are her photographic tolerances.

So, her characters cooperate in the portrait enterprise, may even look straight out at us, but, once again, are caught off guard and found out. How do they relate to the artist herself, or she to them? Is she a nominal member of the scene? Yes, in the nudist camp. Is she a confidante? Yes, with the queens and transvestites. Could she be an outside observer who is given casual sanction? Yes, in the park episodes. And can we say, finally, that she is a presence of no particular account to the subjects? Yes, once more, on the playgrounds of a madhouse. All this enriches and variegates the expressive moods of her work, induces the nuances of tension and relaxation we feel before it. (Not incidentally because we equate our own eye with that of the camera.) The same, of course, goes for the reflexes caused by her forbidding subjects in themselves. For some of them get defined by their class or social situation, others by their compulsions, and several by their abnormal physical condition. Thirty-three years after he played in Tod Browning's *Freaks,* a Russian midget poses among friends for Diane Arbus. Yet, despite the spectrum of social contacts invoked by her work, it seems, by and large, a witness of great loneliness.

For if human features as matter are not that pliable to the lens, the space that encloses or opens around them can tell of their plight—and with Arbus, that space is frightening and oppressive. Sometimes, then, the face is brought excruciatingly close up, giving us no relief from nose-rubbing confrontation. At other moments, people are seen in just the reverse, as if through the wrong end of a low power telescope, so that they look diminished and surrounded by an emptiness of barren room or smoky field. *Four People at a Gallery Opening,* an example, is neatly handled as a combined news and fashion item, but with what a difference! In either case, the normal canons of distance in portraiture are violated, and men and women appear to live in a world visited by some glandular disturbance. The fascination of twins or look-alikes, the plethora of masks these subjects wear, the tattooed man and the carnival sword swallower, the mongoloids and the malignant children, what are these if not some weird inflection of that disturbance? (p. 65)

Max Kozloff, "The Uncanny Portrait: Sander, Arbus, Samaras," in Artforum, *Vol. XI, No. 10, June, 1973, pp. 58-66.*

Susan Sontag (essay date 1973)

[*Sontag is among the most influential contemporary American critics. Her works, which stress the use of a new sensibility in evaluating a work of art, include* Against Interpretation and Other Essays *(1966),* Styles of Radical Will *(1969), and* Illness As Metaphor *(1978). In the following excerpt from her* On Photography *(1973), she analyzes the artistic or moral intent of Arbus's photographs, placing her work in a cultural and historical perspective.*]

The most striking aspect of Arbus's work is that she seems to have enrolled in one of art photography's most vigorous enterprises—concentrating on victims, on the unfortunate—but without the compassionate purpose that such

a project is expected to serve. Her work shows people who are pathetic, pitiable, as well as repulsive, but it does not arouse any compassionate feelings. For what would be more correctly described as their dissociated point of view, the photographs have been praised for their candor and for an unsentimental empathy with their subjects. What is actually their aggressiveness toward the public has been treated as a moral accomplishment: that the photographs don't allow the viewer to be distant from the subject. More plausibly, Arbus's photographs—with their acceptance of the appalling—suggest a naïveté which is both coy and sinister, for it is based on distance, on privilege, on a feeling that what the viewer is asked to look at is really *other*. Buñuel, when asked once why he made movies, said that it was "to show that this is not the best of all possible worlds." Arbus took photographs to show something simpler—that there is another world.

The other world is to be found, as usual, inside this one. Avowedly interested only in photographing people who "looked strange," Arbus found plenty of material close to home. New York, with its drag balls and welfare hotels, was rich with freaks. There was also a carnival in Maryland, where Arbus found a human pincushion, a hermaphrodite with a dog, a tattooed man, and an albino sword-swallower; nudist camps in New Jersey and in Pennsylvania; Disneyland and a Hollywood set, for their dead or fake landscapes without people; and the unidentified mental hospital where she took some of her last, and most disturbing, photographs. And there was always daily life, with its endless supply of oddities—if one has the eye to see them. The camera has the power to catch so-called normal people in such a way as to make them look abnormal. The photographer chooses oddity, chases it, frames it, develops it, titles it.

"You see someone on the street," Arbus wrote, "and essentially what you notice about them is the flaw." The insistent sameness of Arbus's work, however far she ranges from her prototypical subjects, shows that her sensibility, armed with a camera, could insinuate anguish, kinkiness, mental illness with any subject. Two photographs are of crying babies; the babies look disturbed, crazy. Resembling or having something in common with someone else is a recurrent source of the ominous, according to the characteristic norms of Arbus's dissociated way of seeing. It may be two girls (not sisters) wearing identical raincoats whom Arbus photographed together in Central Park; or the twins and triplets who appear in several pictures. Many photographs point with oppressive wonder to the fact that two people form a couple; and every couple is an odd couple: straight or gay, black or white, in an old-age home or in a junior high. People looked eccentric because they didn't wear clothes, like nudists; or because they did, like the waitress in the nudist camp who's wearing an apron. Anybody Arbus photographed was a freak—a boy waiting to march in a pro-war parade, wearing his straw boater and his "Bomb Hanoi" button; the King and Queen of a Senior Citizens Dance; a thirtyish suburban couple sprawled in their lawn chairs; a widow sitting alone in her cluttered bedroom. In *A Jewish Giant at Home with His Parents in the Bronx, NY, 1970,* the parents look like midgets, as wrong-sized as the enormous son hunched over them under their low living-room ceiling.

The authority of Arbus's photographs derives from the contrast between their lacerating subject matter and their calm, matter-of-fact attentiveness. This quality of attention—the attention paid by the photographer, the attention paid by the subject to the act of being photographed—creates the moral theater of Arbus's straight-on, contemplative portraits. Far from spying on freaks and pariahs, catching them unawares, the photographer has gotten to know them, reassured them—so that they posed for her as calmly and stiffly as any Victorian notable sat for a studio portrait by Julia Margaret Cameron. A large part of the mystery of Arbus's photographs lies in what they suggest about how her subjects felt after consenting to be photographed. Do they see themselves, the viewer wonders, like *that?* Do they know how grotesque they are? It seems as if they don't.

The subject of Arbus's photographs is, to borrow the stately Hegelian label, "the unhappy consciousness." But most characters in Arbus's Grand Guignol appear not to know that they are ugly. Arbus photographs people in various degrees of unconscious or unaware relation to their pain, their ugliness. This necessarily limits what kinds of horrors she might have been drawn to photograph: it excludes sufferers who presumably know they are suffering, like victims of accidents, wars, famines, and political persecutions. Arbus would never have taken pictures of accidents, events that break into a life; she specialized in slow-motion private smashups, most of which had been going on since the subject's birth.

Though most viewers are ready to imagine that these people, the citizens of the sexual underworld as well as the genetic freaks, are unhappy, few of the pictures actually show emotional distress. The photographs of deviates and real freaks do not accent their pain but, rather, their detachment and autonomy. The female impersonators in their dressing rooms, the Mexican dwarf in his Manhattan hotel room, the Russian midgets in a living room on 100th Street, and their kin are mostly shown as cheerful, self-accepting, matter-of-fact. Pain is more legible in the portraits of the normals: the quarreling elderly couple on a park bench, the New Orleans lady bartender at home with a souvenir dog, the boy in Central Park clenching his toy hand grenade.

Brassaï denounced photographers who try to trap their subjects off-guard, in the erroneous belief that something special will be revealed about them. In the world colonized by Arbus, subjects are always revealing themselves. There is no decisive moment. Arbus's view that self-revelation is a continuous, evenly distributed process is another way of maintaining the Whitmanesque imperative: treat all moments as of equal consequence. Like Brassaï, Arbus wanted her subjects to be as fully conscious as possible, aware of the act in which they were participating. Instead of trying to coax her subjects into a natural or typical position, they are encouraged to be awkward—that is, to pose. (Thereby, the revelation of self gets identified with what is strange, odd, askew.) Standing or sitting stiffly makes them seem like images of themselves.

Most Arbus pictures have the subjects looking straight into the camera. This often makes them look even odder, almost deranged. Compare the 1912 photograph by Lartigue of a woman in a plumed hat and veil (*Racecourse at Nice*) with Arbus's *Woman with a Veil on Fifth Avenue, NYC, 1968.* Apart from the characteristic ugliness of

Arbus's subject (Lartigue's subject is, just as characteristically, beautiful), what makes the woman in Arbus's photograph strange is the bold unselfconsciousness of her pose. If the Lartigue woman looked back, she might appear almost as strange.

In the normal rhetoric of the photographic portrait, facing the camera signifies solemnity, frankness, the disclosure of the subject's essence. That is why frontality seems right for ceremonial pictures (like weddings, graduations) but less apt for photographs used on billboards to advertise political candidates. (For politicians the three-quarter gaze is more common: a gaze that soars rather than confronts, suggesting instead of the relation to the viewer, to the present, the more ennobling abstract relation to the future.) What makes Arbus's use of the frontal pose so arresting is that her subjects are often people one would not expect to surrender themselves so amiably and ingenuously to the camera. Thus, in Arbus's photographs, frontality also implies in the most vivid way the subject's cooperation. To get these people to pose, the photographer has had to gain their confidence, has had to become "friends" with them.

Perhaps the scariest scene in Tod Browning's film *Freaks* (1932) is the wedding banquet, when pinheads, bearded women, Siamese twins, and living torsos dance and sing their acceptance of the wicked normal-sized Cleopatra, who has just married the gullible midget hero. "One of us! One of us! One of us!" they chant as a loving cup is passed around the table from mouth to mouth to be finally presented to the nauseated bride by an exuberant dwarf. Arbus had a perhaps oversimple view of the charm and hypocrisy and discomfort of fraternizing with freaks. Following the elation of discovery, there was the thrill of having won their confidence, of not being afraid of them, of having mastered one's aversion. Photographing freaks "had a terrific excitement for me," Arbus explained. "I just used to adore them."

Diane Arbus's photographs were already famous to people who follow photography when she killed herself in 1971; but, as with Sylvia Plath, the attention her work has attracted since her death is of another order—a kind of apotheosis. The fact of her suicide seems to guarantee that her work is sincere, not voyeuristic, that it is compassionate, not cold. Her suicide also seems to make the photographs more devastating, as if it proved the photographs to have been dangerous to her.

She herself suggested the possibility. "Everything is so superb and breathtaking. I am creeping forward on my belly like they do in war movies." While photography is normally an omnipotent viewing from a distance, there is one situation in which people do get killed for taking pictures: when they photograph people killing each other. Only war photography combines voyeurism and danger. Combat photographers can't avoid participating in the lethal activity they record; they even wear military uniforms, though without rank badges. To discover (through photographing) that life is "really a melodrama," to understand the camera as a weapon of aggression, implies there will be casualties. "I'm sure there are limits," she wrote. "God knows, when the troops start advancing on you, you do approach that stricken feeling where you perfectly well can get killed." Arbus's words in retrospect describe a kind of combat death: having trespassed certain limits, she fell in a psychic ambush, a casualty of her own candor and curiosity.

In the old romance of the artist, any person who has the temerity to spend a season in hell risks not getting out alive or coming back psychically damaged. The heroic avant-gardism of French literature in the late nineteenth and early twentieth centuries furnishes a memorable pantheon of artists who fail to survive their trips to hell. Still, there is a large difference between the activity of a photographer, which is always willed, and the activity of a writer, which may not be. One has the right to, may feel compelled to, give voice to one's own pain—which is, in any case, one's own property. One volunteers to seek out the pain of others.

Thus, what is finally most troubling in Arbus's photographs is not their subject at all but the cumulative impression of the photographer's consciousness: the sense that what is presented is precisely a private vision, something voluntary. Arbus was not a poet delving into her entrails to relate her own pain but a photographer venturing out into the world to *collect* images that are painful. And for pain sought rather than just felt, there may be a less than obvious explanation. According to Reich, the masochist's taste for pain does not spring from a love of pain but from the hope of procuring, by means of pain, a strong sensation; those handicapped by emotional or sensory analgesia only prefer pain to not feeling anything at all. But there is another explanation of why people seek pain, diametrically opposed to Reich's, that also seems pertinent: that they seek it not to feel more but to feel less.

Insofar as looking at Arbus's photographs is, undeniably, an ordeal, they are typical of the kind of art popular among sophisticated urban people right now: art that is a self-willed test of hardness. Her photographs offer an occasion to demonstrate that life's horror can be faced without squeamishness. The photographer once had to say to herself, Okay, I can accept that; the viewer is invited to make the same declaration.

Arbus's work is a good instance of a leading tendency of high art in capitalist countries: to suppress, or at least reduce, moral and sensory queasiness. Much of modern art is devoted to lowering the threshold of what is terrible. By getting us used to what, formerly, we could not bear to see or hear, because it was too shocking, painful, or embarrassing, art changes morals—that body of psychic custom and public sanctions that draws a vague boundary between what is emotionally and spontaneously intolerable and what is not. The gradual suppression of queasiness does bring us closer to a rather formal truth—that of the arbitrariness of the taboos constructed by art and morals. But our ability to stomach this rising grotesqueness in images (moving and still) and in print has a stiff price. In the long run, it works out not as a liberation of but as a subtraction from the self: a pseudo-familiarity with the horrible reinforces alienation, making one less able to react in real life. What happens to people's feelings on first exposure to today's neighborhood pornographic film or to tonight's televised atrocity is not so different from what happens when they first look at Arbus's photographs.

The photographs make a compassionate response feel irrelevant. The point is not to be upset, to be able to confront the horrible with equanimity. But this look that is

not (mainly) compassionate is a special, modern ethical construction: not hardhearted, certainly not cynical, but simply (or falsely) naïve. To the painful nightmarish reality out there, Arbus applied such adjectives as "terrific," "interesting," "incredible," "fantastic," "sensational"— the childlike wonder of the pop mentality. The camera— according to her deliberately naïve image of the photographer's quest—is a device that captures it all, that seduces subjects into disclosing their secrets, that broadens experience. To photograph people, according to Arbus, is necessarily "cruel," "mean." The important thing is not to blink.

"Photography was a license to go wherever I wanted and to do what I wanted to do," Arbus wrote. The camera is a kind of passport that annihilates moral boundaries and social inhibitions, freeing the photographer from any responsibility toward the people photographed. The whole point of photographing people is that you are not intervening in their lives, only visiting them. The photographer is supertourist, an extension of the anthropologist, visiting natives and bringing back news of their exotic doings and strange gear. The photographer is always trying to colonize new experiences or find new ways to look at familiar subjects—to fight against boredom. For boredom is just the reverse side of fascination: both depend on being outside rather than inside a situation, and one leads to the other. "The Chinese have a theory that you pass through boredom into fascination," Arbus noted. Photographing an appalling underworld (and a desolate, plastic overworld), she had no intention of entering into the horror experienced by the denizens of those worlds. They are to remain exotic, hence "terrific." Her view is always from the outside.

"I'm very little drawn to photographing people that are known or even subjects that are known," Arbus wrote. "They fascinate me when I've barely heard of them." However drawn she was to the maimed and the ugly, it would never have occurred to Arbus to photograph Thalidomide babies or napalm victims—public horrors, deformities with sentimental or ethical associations. Arbus was not interested in ethical journalism. She chose subjects that she could believe were found, just lying about, without any values attached to them. They are necessarily ahistorical subjects, private rather than public pathology, secret lives rather than open ones.

For Arbus, the camera photographs the unknown. But unknown to whom? Unknown to someone who is protected, who has been schooled in moralistic and in prudent responses. Like Nathanael West, another artist fascinated by the deformed and mutilated, Arbus came from a verbally skilled, compulsively health-minded, indignation-prone, well-to-do Jewish family, for whom minority sexual tastes lived way below the threshold of awareness and risk-taking was despised as another goyish craziness. "One of the things I felt I suffered from as a kid," Arbus wrote, "was that I never felt adversity. I was confined in a sense of unreality. . . . And the sense of being immune was, ludicrous as it seems, a painful one." Feeling much the same discontent, West in 1927 took a job as a night clerk in a seedy Manhattan hotel. Arbus's way of procuring experience, and thereby acquiring a sense of reality, was the camera. By experience was meant, if not material adversity, at least psychological adversity—the shock of

immersion in experiences that cannot be beautified, the encounter with what is taboo, perverse, evil.

Arbus's interest in freaks expresses a desire to violate her own innocence, to undermine her sense of being privileged, to vent her frustration at being safe. Apart from West, the 1930s yield few examples of this kind of distress. More typically, it is the sensibility of someone educated and middle-class who came of age between 1945 and 1955—a sensibility that was to flourish precisely in the 1960s.

The decade of Arbus's serious work coincides with, and is very much of, the sixties, the decade in which freaks went public, and became a safe, approved subject of art. What in the 1930s was treated with anguish—as in *Miss Lonely-Hearts* and *The Day of the Locust*—would in the 1960s be treated in a perfectly deadpan way, or with positive relish (in the films of Fellini, Arrabal, Jodorowsky, in underground comics, in rock spectacles). At the beginning of the sixties, the thriving Freak Show at Coney Island was outlawed; the pressure is on to raze the Times Square turf of drag queens and hustlers and cover it with skyscrapers. As the inhabitants of deviant underworlds are evicted from their restricted territories—banned as unseemly, a public nuisance, obscene, or just unprofitable— they increasingly come to infiltrate consciousness as the subject matter of art, acquiring a certain diffuse legitimacy and metaphoric proximity which creates all the more distance.

Who could have better appreciated the truth of freaks than someone like Arbus, who was by profession a fashion photographer—a fabricator of the cosmetic lie that masks the intractable inequalities of birth and class and physical appearance. But unlike Warhol, who spent many years as a commercial artist, Arbus did not make her serious work out of promoting and kidding the aesthetic of glamour to which she had been apprenticed, but turned her back on it entirely. Arbus's work is reactive—reactive against gentility, against what is approved. It was her way of saying fuck *Vogue,* fuck fashion, fuck what's pretty. This challenge takes two not wholly compatible forms. One is a revolt against the Jews' hyper-developed moral sensibility. The other revolt, itself hotly moralistic, turns against the success world. The moralist's subversion advances life as a failure as the antidote to life as a success. The aesthete's subversion, which the sixties was to make peculiarly its own, advances life as a horror show as the antidote to life as a bore.

Most of Arbus's work lies within the Warhol aesthetic, that is, defines itself in relation to the twin poles of boringness and freakishness; but it doesn't have the Warhol style. Arbus had neither Warhol's narcissism and genius for publicity nor the self-protective blandness with which he insulates himself from the freaky nor his sentimentality. It is unlikely that Warhol, who comes from a working-class family, ever felt any of the ambivalence toward success which afflicted the children of the Jewish upper middle classes in the 1960s. To someone raised as a Catholic, like Warhol (and virtually everyone in his gang), a fascination with evil comes much more genuinely than it does to someone from a Jewish background. Compared with Warhol, Arbus seems strikingly vulnerable, innocent—and certainly more pessimistic. Her Dantesque vision of the city (and the suburbs) has no reserves of irony. Although

much of Arbus's material is the same as that depicted in, say, Warhol's *Chelsea Girls* (1966), her photographs never play with horror, milking it for laughs; they offer no opening to mockery, and no possibility of finding freaks endearing, as do the films of Warhol and Paul Morrissey. For Arbus, both freaks and Middle America were equally exotic: a boy marching in a pro-war parade and a Levittown housewife were as alien as a dwarf or a transvestite; lower-middle-class suburbia was as remote as Times Square, lunatic asylums, and gay bars. Arbus's work expressed her turn against what was public (as she experienced it), conventional, safe, reassuring—and boring—in favor of what was private, hidden, ugly, dangerous, and fascinating. These contrasts, now, seem almost quaint. What is safe no longer monopolizes public imagery. The freakish is no longer a private zone, difficult of access. People who are bizarre, in sexual disgrace, emotionally vacant are seen daily on the newsstands, on TV, in the subways. Hobbesian man roams the streets, quite visible, with glitter in his hair.

Sophisticated in the familiar modernist way—choosing awkwardness, naïveté, sincerity over the slickness and artificiality of high art and high commerce—Arbus said that the photographer she felt closest to was Weegee, whose brutal pictures of crime and accident victims were a staple of the tabloids in the 1940s. Weegee's photographs are indeed upsetting, his sensibility is urban, but the similarity between his work and Arbus's ends there. However eager she was to disavow standard elements of photographic sophistication such as composition, Arbus was not unsophisticated. And there is nothing journalistic about her motives for taking pictures. What may seem journalistic, even sensational, in Arbus's photographs places them, rather, in the main tradition of Surrealist art—their taste for the grotesque, their professed innocence with respect to their subjects, their claim that all subjects are merely *objets trouvés*.

"I would never choose a subject for what it meant to me when I think of it," Arbus wrote, a dogged exponent of the Surrealist bluff. Presumably, viewers are not supposed to judge the people she photographs. Of course, we do. And the very range of Arbus's subjects itself constitutes a judgment. Brassaï, who photographed people like those who interested Arbus—see his *La Môme Bijou* of 1932—also did tender cityscapes, portraits of famous artists. Lewis Hine's *Mental Institution, New Jersey, 1924* could be a late Arbus photograph (except that the pair of Mongoloid children posing on the lawn are photographed in profile rather than frontally); the Chicago street portraits Walker Evans took in 1946 are Arbus material, as are a number of photographs by Robert Frank. The difference is in the range of other subjects, other emotions that Hine, Brassaï, Evans, and Frank photographed. Arbus is an *auteur* in the most limiting sense, as special a case in the history of photography as is Giorgio Morandi, who spent a half century doing still lifes of bottles, in the history of modern European painting. She does not, like most ambitious photographers, play the field of subject matter—even a little. On the contrary, all her subjects are equivalent. And making equivalences between freaks, mad people, suburban couples, and nudists is a very powerful judgment, one in complicity with a recognizable political mood shared by many educated, left-liberal Americans. The subjects of Arbus's photographs are all members of

the same family, inhabitants of a single village. Only, as it happens, the idiot village is America. Instead of showing identity between things which are different (Whitman's democratic vista), everybody is shown to look the same. (pp. 33-47)

Susan Sontag, "America, Seen Through Photographs, Darkly," in her On Photography, *Farrar, Straus and Giroux, 1977, pp. 27-48.*

Alan Levy, from a tribute to Arbus, his friend and fellow artist:

Nothing about her life, her photographs, or her death was accidental or ordinary. They were mysterious and decisive and unimaginable, except to her. Which is the way it is with genius.

Alan Levy, "Working with Diane Arbus: 'A Many-Splendored Experience'," in ARTnews, *Vol. 72, No. 6, Summer, 1973, pp. 80-1.*

Ian Jeffrey (essay date 1974)

[*Jeffrey discusses some of Arbus's most famous photographs and asserts that they constitute "a mocking denial of the American archetypes we have learned to recognize."*]

Many successful modern photographers are intermediaries, explorers and reporters on our behalf. They take unfamiliar and often disquieting societies as their subjects. Until fairly recently these societies were safely distant, in Russia, in Africa, or, particularly, in China. Of late these aliens have been detected nearer to home; photographers have turned their attention increasingly to the poor, to cult and interest groups and to ethnic minorities. This was a distinct feature of American photography in the 1960s and its most complete expression is to be found in the work of Diane Arbus. . . .

With Diane Arbus it was no longer a case of documenting the squalid and dangerous sectors of American urban life, but of identifying and photographing its more eccentric inhabitants, of seeking out the veritable curiosities. Her subjects range from the disturbed and mongoloid through the ranks of transvestites and hermaphrodites to the near-normality of burlesque entertainers and topless dancers. In the resultant portrait gallery there is a stress on the grotesque; many of the figures are ugly, their settings are mundane and their actions perturbing. . . .

Although she concentrates on eccentricities of appearance, on 'freaks' as she calls them ('Freaks was a thing I photographed a lot'), she notes a lot of other things too. Virtually everything she pictures is strange and in the course of being fixed as a photograph it becomes stranger: 'I mean if you scrutinize reality closely enough, if in some way you really, really get to it, it becomes fantastic'. (p. 133)

There are a number of pictures in [a recent monograph de-

voted to her work] which have no possible connection with freaks, yet they are undeniably strange. In a very puzzling late picture, *A Family on Their Lawn One Sunday in Westchester, NY 1968,* a couple sprawl on deckchairs, sunbathing, whilst their son plays on the lawn in the background: a row of trees cuts out most of the sky and closes the picture. This could epitomize middle-class normality, but for the sombre gothic cast of the bank of trees and the unalleviated leaden intricacies of the wide stretch of lawn. The boringly normal has become sinister in this photograph. Just as mundane is an image of an *Elderly Couple on a Park Bench, NYC 1969:* they look sour and tired, admittedly, but far from odd: there is, however, an element of the 'fantastic' in the heavy black labyrinthine pattern of the woman's astrakhan coat and the accidental alignment of neck and shirt which makes the man's head into a continuation of his shirt front. More discreetly 'fantastic' is a picture of *A Woman with Pearl Necklace and Earrings, NYC 1967;* the cord fabric of her hat makes a pattern of parallel lines which looks very like a blow-up of a crude wirephoto and this is curious above the detailed description of her face, but it is no more than a witty demonstration of the resources of photography. As she said, one of her great preoccupations was with the differentiation of substances: 'I wanted to see the difference between flesh and material, the densities of different kinds of things: air and water and shiny'. This interest in the substance and the texture of things often goes no further than a delight in differences of material.

More often than not this preciseness about substances serves a more complex intention. *Patriotic Young Man with a Flag, NYC 1967* offers a range of matte and reflective surfaces, delicately modulated half tones and the clarities of an emblematic badge and a flag, a richly beautiful setting for the youth's blotched and pustular face. She had it in her power to ridicule and it was a power she did not refrain from using. There is something of George Grosz in her occasional savagery, but where he revealed the lusts and brutalities of a rampant middle class she attends to anyone who has been to the trouble to prepare a face or posture for the world. In the public faces of ordinary people there is the greatest discrepancy between the intended ideal and the actual. In *Blonde Girl with Shiny Lipstick, NYC 1967,* for instance, the right-hand side of the girl's face is as perfect as the heavily made-up girl could wish: to the left though, shadow and raking light distort the features and reveal a pitted skin texture. She can achieve the sort of generalizing caricature typical of Grosz at his best, as in the extraordinary *Man Dancing with a Large Woman, NYC 1967,* but she is also capable of the petty coarseness of *A Jewish Couple Dancing, NYC 1963* where in a parody of a party photograph the smiling man shows his discoloured and malformed teeth and his partner her craggy elbow. As she says: 'Our whole guise is like giving a sign to the world to think of us in a certain way but there's a point between what you want people to know about you and what you can't help people knowing about you'. It is as though she is obsessed by the peculiarities which arise from this distance between invention and effect, and having established this as her particular insight documented it where and whenever it was to be found. The ethical system which might be expected to attend or even to precede such an insight appears to be quite absent; what results easily looks like a promiscuous involvement in grotesquerie.

Arbus was attracted to performers. Many of her characters are public figures whether they like it or not. The dwarves and the Jewish giant would be objects of curiosity anywhere and the same applies to the twins and the triplets she photographs. Less public perhaps, but equally objects of curiosity, are the transvestites and hermaphrodites; this accounts for their evident composure in front of her camera. At times this composure is genial and obliging: the *Tattooed Man at a Carnival, Md. 1970* knew what was expected of him, and the *Hermaphrodite and a Dog in a Carnival Trailer, Md. 1970* could hardly have been more charming and gracious. In fact, through this whole compilation of portraits there is a curious inversion of normality; the more her people are drawn from everyday life the more disturbed they appear.

Merely by being photographed her subjects became, even if only for a moment or two, performers. It seems that she hardly ever took pictures of people unawares; they were allowed time to arrange themselves according to their own conceptions of their roles. An undernourished *Teenage Couple on Hudson Street, NYC 1963* pose half heartedly as true lovers and in *Man and a Boy on a Bench in Central Park, NYC 1962* whilst the boy stares with open curiosity at the camera the man has had time to deploy a whole repertoire of debonaire gestures. Generally she shows isolated individuals and when she does show people together it is to demonstrate some remarkable contrast bearing on the gulf between intention and actuality. An epic in this genre is *A Young Brooklyn Family Going for a Sunday Outing, NYC 1966* in which the young husband seems to have stepped leadenly out of Dorothea Lange's 1930s and his wife from the aftermath of *Cleopatra.*

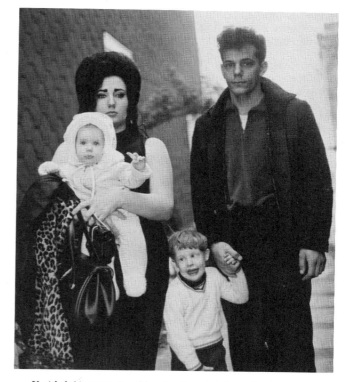

Untitled (A young Brooklyn family going for a Sunday outing, 1966)

She pictures those moments in our culture when self-images are under strain, where the young man and his wife labouring under the exigencies of the present still retain some brief hold on a prepared and public face.

In some of her work, then, she does no more than to record the visible signs of certain cultural incongruities. More usually, however, she forces the pace as a parodist of stock photographic types. Her pictures of babies are revealing; not only does she favour close-ups but uses a sort of directed Leonardesque lighting which gives them a sombre plasticity unusual in the genre. *A Child Crying, NJ 1967* is a counter-example to all those pleasant children of the professional photographer and the gifted amateur; the forehead close to the lens shoots upwards and shadow smears the lips.

Before turning to this sort of art Diane Arbus worked as a fashion photographer and the work in this collection shows that she attended closely and critically to its modes. In her commercial work she pictured the ideal and here she pictures the after-effects of such myth making, as the advertised product passes into common circulation. *Two Girls in Identical Raincoats, Central Park, NYC 1969* alludes clearly to an advertising idyll: it has all the ingredients of a picture by Clarence White, the slender forms of the girls and the dappled lighting of the parkland trees, the still discernible stylish cut of the coats but the girls stand lumpish and puzzled staring morosely at the tilted camera. In a grotesque parody of elegant hauteur a half-naked transvestite decked in feathers and pearls looks arrogantly past the camera. *Woman in Her Negligee, NYC 1966* features an ideal bedroom and an artful diaphanous garment but there is no avoiding the dilapidation of the flesh and a sadness of age. It is as though Arbus was composing variations on the themes of advertising, switching around the personnel, reenacting the time-honoured scenes with an amateur and uncertain cast.

As improvisations on well-established photographic types these pictures are unquestionably interesting, and Diane Arbus's alertness to the 'fantastic' ensures that a surrealist strangeness of setting or material is constantly in evidence. Yet other photographers have been as effective in their parody and quite as alert as this without achieving even a fraction of Arbus's fame and notoriety. (pp. 133-34)

It is not simply a question of a unique sensibility imposing its style on heterogeneous subject matter but of a programmatic interpretation of American life, amounting to a perverse parody of a social structure. It is a hierarchical society which she identifies, and it is dominated by an imposing set of stone-faced matriarchs. At one level we have *Woman with a Fur Collar on the Street, NYC 1968,* the visual equal to any of Curtis's lapidary Indians, and further up the social scale the massive confidence of *Woman with a Veil on Fifth Avenue, NYC 1968.* Many of the other women she photographs may be unsettling, near savage in one or two cases, but they are positive and certain in their femininity where the Arbus men are almost without exception pathetic and ludicrous. If not actually intimidated many of the men dress and act as women. If they appear in a conventional male role they are rendered preposterous; her patriots are gauche, ugly and stupid (*Boy with a Straw Hat, Patriotic Young Man* and *Man in an Indian Headdress* respectively).

It is a world turned upside down where the truck driver paints his nails and wears a slip whilst the *Lady at a Masked Ball with Two Roses on her Dress, NYC 1967* has the build and the charm of an all-in wrestler. As a composite picture of American people it is a mocking denial of the American archetypes we have learned to recognize, of the weathered masculinity in the Westerns and the cigarette ads, of the trim Beauty refreshed by a Coke. Pop art went some way in the promotion of parody; it ensured that it could be an acceptable mode in contemporary art, but it dealt in fragments, in pastiches and enigmas. Now in this collection the scope of 60s irony has produced a sort of totality in Diane Arbus's perversely structured world. Equally these are pictures for an art context; for a context, that is, which has gone through an unprecedentedly hermetic phase of art for artists with society nowhere. With Diane Arbus's collected pictures contemporary society re-enters the avant-garde forum to massive effect. (p. 134)

Ian Jeffrey, "Diane Arbus and American Freaks," in Studio International, *Vol. 187, March, 1974, pp. 133-34.*

William Packer (essay date 1974)

[*In the following excerpt, Packer praises the directness and objectivity of Arbus's photographs.*]

Because photographs have subjects recognisable, whether pathetic or powerful, funny or shocking, their interpretation so easily becomes little more than an exercise in iconography. The images are read superficially, their immediate appearance being all that matters. And thus glib motives are assumed to inform the photographer's work, which is seen as an essay in compassion, perhaps, or social comment, political commitment, or anger, love or wit. Such an over-literary approach inhibits consideration of what the images actually are, and through them of what the reality which the photographer confronts actually is. Where the images are especially powerful so this danger increases, as is true of Mrs. Arbus' photographs. Some shock, some terrify, and, because we respond so strongly, we assume mistakenly that this is what she intended. The truth is, I am sure, that nothing was further from her mind. She would have given it no thought whatsoever. Her concern was to take a photograph that was true; not simply an accurate record, but a true equivalent of her experience of that particular moment in that particular situation. Our response to what she did is entirely our responsibility. And this is true of all Art.

Diane Arbus regarded her subjects unblinkingly, dispassionately, with a close and searching scrutiny. The simplicity of her work is striking, its uncompromising, and even brutal, directness unnerving. The stark confrontation with areas of experience, and facts of life, from which we usually insulate ourselves behind a hedge of taboo, transmits that same shock that one receives upon first exposure to hardcore pornography, except that here there is no ulterior intention, no prurient curiosity to satisfy. Instead we are made to face the ungarnished truth, and come to terms with our own guilts and prejudices.

Her subjects fall easily into categories. More often than not they gaze steadily straight into the eye of the camera, static, almost at ease. Many seem at first even unremark-

able, ordinary, normal . . . ; a woman with pearl neck-lace and ear-rings, woman on a park bench on a sunny day, man at a parade on Fifth Avenue, blonde girl with shiny lipstick. And so they are, but the detail, the close and specific attention to detail, which we gradually pick up, at length establishes the inalienable individuality of each person; and so they do indeed become utterly re-markable. The sequence of portraits goes on, the details, marks of identification, becoming increasingly and more openly strange and peculiar: a woman in a bird mask, child with a toy hand grenade in Central Park, nudist lady with swan sunglasses, masked woman in a wheelchair, girl, sitting on her bed with her skirt off. All treated with the same straight-forwardness and honesty, preserve their dignity. There is no question of humiliation. Everyone is seen as he is, however tragic his situation might be. So we are able to take the more extreme, the more shocking con-frontations in the same way, the dwarves, transvestites and mongols, and others: a naked man being a woman, a woman with her baby monkey, seated man in a bra and stockings, hermaphrodite and a dog in a carnival trailer, a Jewish giant at home with his parents in the Bronx, Mex-ican dwarf in his hotel room. What we come to realise is our common reality. These people present themselves as they wish to be seen; we see them, with their vanity, and vulnerability, ambitions and illusions, and are able to ac-cept them. More extreme perhaps, but their problems are close to our own. We all live out our own tragedies. (pp. 14-15)

[Arbus'] is the attitude of the artist, using rather than being dominated by technique, examining rather than in-terpreting her view of the world. The photographs which result from this clear eyed and unfalteringly honest intro-spection are frequently beautiful, and always impressive. They may be bleak and a pessimistic presentation of the more dreadful aspects of the human condition, the dark side of the moon, but they are undidactic, free of moralis-ing and propaganda. (p. 17)

> *William Packer, "Positive Images," in* Art and Artists, *Vol. 9, No. 1, April, 1974, pp. 14-17.*

Toni del Renzio (essay date 1974)

[*Del Renzio criticizes Arbus's style as a "gimmick" and observes that her photographs are a "pathetic externali-sation of her own neurosis."*]

In spite of some pompous pronouncements . . . by pho-tographers and critics, Diane Arbus made no comment upon society. She tells us nothing about her subjects, and reveals herself to be a case, ripe for study. She compels us to speculate about what it was in her New York, Jewish, middle class, rag trade background that drove her to this pathetic externalisation of her own neurosis. She convert-ed a gimmick into a style, but then that is what magazine photography so often is. (p. 38).

> *Toni del Renzio, "London," in* Art and Art-ists, *Vol. 9, No. 3, June, 1974, pp. 38-40.*

Judith Goldman (essay date 1974)

[*Goldman analyzes what she perceives as flaws in*

Arbus's technique, claiming that her "focus on a narra-tive statement instead of on a visual one"—on her own "obsessive vision"—prevented her from creating com-plete pictorial statements.]

The recent articles on Diane Arbus' photographs all falter in the same private, indulgent way. The writings have been homages to suicide, eulogistic tributes, and noncritical memoirs. Diane Arbus, who was a very good photogra-pher, deserves better. Not that the abundance of essays are not well done or interesting. The nature of the subject pre-determines at least voyeuristic interest and they are com-petent, if strikingly similar. (p. 30)

In most of the writings, visual perceptions dissolve into self-revelations, as if the task of the assignment were too much for the writer. The effect, like a potent drink, turns the critical prose into boozey private musings, more about the writer than Arbus the photographer. The critical reac-tion is redundant—and the diffuseness of its praise sug-gests the power of Arbus' photographs as well as their in-herent problems. Her photographs unleash the observer's private despair and their back-alley secrets are offered as explication as if her own statement were not mean enough.

Cultism is easy and hard to avoid. The "Sylvia Plathisms" that now decorate the Arbus legend and hang from it like purple hearts are harder still to circumvent. The fault is not critical but cultural: Diane Arbus died heroically in action. And an assumption that where she chose to travel contributed to her death makes viewers look away from the art. If you look too hard, you take your life in your hands; isn't that, after all, what Arbus did? What's more, it is better taste to place laurels at the shrine. But those flowers wilt into literary trivia, and no one is well served. Who after all remembers, or cares, that Sarah Teasdale drowned herself in a bathtub; this is the cult of poetry, not the stuff of it. Sylvia Plath and John Berryman are not bet-ter poets because they took their lives nor is Diane Arbus a better photographer for that fact.

The mesmerizing power of Arbus' photographs is also the problem. That power derives from her choice and, more importantly, from her handling of subject. Each picture acts like a visual boomerang; freaks and lonely people scare us into looking first at them and then back at our-selves. Arbus' camera reflected the visual confrontations we choose not to have, the appearance of horrors that stop us but are hard to see. That is never easy. Yet should it be as difficult as her pictures seem to make it? We come away from an Arbus photograph never having seen the whole picture. The visual statement is strangely unre-solved and incomplete, not because we get stuck in our own frame, but because her handling of subject prevents it. Something about her honesty is dishonest.

I do not think this happens because she chose to photo-graph freaks. Though trained not to admit it, we are fasci-nated by the aberrant, the violent, and the perverse. When we are assured no one is watching, we stare at cripples and auto wrecks. Although the sensationalism of Arbus' sub-jects offers a cogent, if superficial, explanation of why her pictures are hard to see, the fact that they are freaks is sec-ondary to the larger problem of how she saw them and elected to present them.

We are, remember, a third party to the photographic re-cord. The observer and creator was Arbus and the photo-

graph captures her past encounter. The docile subjects were participants, who worked with her in a picture-taking process that was active. What is disturbing about her photographic record is its ceaseless consistency. Identical compositions repeat to the same effect. Subjects are almost always presented dead-center in the foreground of the square picture plane against a soft-focused ground, or in the enclosed space of a room. The uneven edges and the occasional black line that borders the abstract ground literally and figuratively frame the subject and push them out to confront and envelop us. Her camera's invariable focus was on the subject's eyes. In photograph after photograph, they stare out with frozen despair. The eyes of a Mexican dwarf in a hotel room carry the same wistful vision as a woman on a park bench. Their dulled expectation is that of the Junior Interstate ballroom dancers, the tattooed muscle man, and the young man in curlers. Each suggests endless replays of an original confrontation.

Arbus fixes her subject's eyes in an additional symmetry that nears contrivance and often precludes a composition's successful completion. In a photograph of a nudist lady, breasts, vulva, knees, and peeping teatlike toes reiterate the shape of her winged sunglasses. This alignment freezes the preening woman into a naked statue, and makes her adornments of the clothed—a bracelet, a necklace, and a coy towel—suggest nakedness, not nudity. They act as a reference and judgment on a way of living. The camera has stripped bare the nudist's freedom. Immobile and lifeless, the lady as object is seemingly the picture's subject. In fact, she is the whole picture, a more than adequate conception; but pictorially, it doesn't work. The nudist lady sits on the picture's surface, while her breasts push out of the frontal plane and break the surface, causing the background to literally fall off. The picture reads in one dimension—as a visual narrative fact. But the narrative, in overwhelming the visual, subverts it. The photograph does not read as a whole picture. It is as if Arbus became so caught up in the storytelling that she forgot about her picture. The technique employed is conventional portraiture, yet the camera does not portray qualities about the subject that are in and of it, but a suspiciously prearranged storyline from outside the picture plane. Successful photographs combine plastic qualities with literary narrative. When the two break down, when the narrative is not about the picture, or when it overwhelms the picture, something goes awry, and a photograph cannot hold together as a whole.

In Arbus' photographs, narrative and visual facts splinter into a strange and twisted moral tale. The *Topless Dancer In Her Dressing Room* (1968), sequined and centered in the picture plane, is balanced by the dressing table on either side, a mirror and the three lights behind her. The shabby background of empty glasses, scrambled clothes, and a decaying wall documents the picture's point about a transient, plastic life. The dancer is equated to her background. The picture almost works, but the composition's well-planned artifice divides the visual and narrative facts. The eye reads the background as an indictment against the subject, while the subject's alignment makes the background hard to see, almost visually extraneous. There are countless other examples of Arbus's symmetry: a curtain, reinforcing stage center, parts to reveal a naked man being a woman; the woman with pearl earrings is further cen-

tralized and mimicked by her rounded jewelry, and the twins echo each other.

The obsessive nature of Diane Arbus' vision is revealed by the repetition of compositional technique. Both form and metaphor are familiar, the simple snapshot suggests a happy "instamatic" life. And because similar groupings fill our own picture albums, we misconstrue Arbus' evenness for fairness. By turning a known convention inside out, Arbus captured the fears, taboos, and fragmentation of 20th-century life. The brilliance of her invention explains our fascination and discomfort, for her camera exposed a despair that was not, like Dorothea Lange's, the result of an economic condition, but rather the result of an emotional famine and interior drought. Arbus' use of the snapshot transformed the nature of photography; yet if her achievement was great in a general sense, it was also extremely problematic.

Light is crucial to the narrative of the frontal compositions Arbus favored. Where light hits sets and activates the scene, controlling the picture's story. And it was, I think, Arbus' handling of light that made her narrative so dark and overpowering. In picture after picture, light falls on the surface: the shimmer of a transvestite's pearls, the cold, outdoor light on a woman's cheek. Often when it is not light, a white object draws the eye to the frontal plane: the tangled and unmade sheets of the sexually ambiguous friends, a chair in the foreground of the man being a woman. In reinforcing the surface, Arbus' use of light stymied the narrative's movement. Her frontal compositions remain static in their symmetry and repeat the same story, forcing subject and viewer into a predetermined mental set of despair. (pp. 30-3)

Her frontal approach carried with it a compositional failing that pulled the picture apart. The inability of the subjects to hold the picture plane kept them from having lives of their own. For Arbus, the crucial balance of an aesthetic distance seems to have been off.

Arbus' pictures read as one. Their intention is never clear. That is the irony of Arbus' hunt and unquestionable talent. Masquerading as documentation, the same fantastic quality of the emotional netherland pervades each image and contradicts any reality. That is their flaw. To use Arbus' own words, that flaw is a "gap between intention and effect."

> Everybody has this thing where they need to look one way but they come out looking another way and that's what people observe. You see someone on the street and essentially what you notice about them is the flaw. It's just extraordinary that we should have been given these peculiarities. And, not content with what we were given, we create a whole other set. Our whole guise is like giving a sign to the world to think of us in a certain way, but there's a point between what you want people to know about you and what you can't help people knowing about you. And that has to do with what I've always called the gap between intention and effect. . . . You know it really is totally fantastic that we look like this and you sometimes see that very clearly in a photograph. Something is ironic in the world and it has to do with the fact that what you intend never comes out like you intend it.

There is every reason to think Diane Arbus liked her sub-

jects. She followed their lives and worked hard at becoming their intimate. Her pictures seem honest and meticulous, if condescendingly sympathetic. When her friend Marvin Israel described her contact sheets, he revealed a life:

> There are hundreds of sheets where the same face never appears more than once, all very close-up. It's like some strange catalogue. And then there would be a contact sheet from several years later with one of those same faces in which you can trace Diane's progress from the street to their home, to their living room, to their bedroom. These are like a narrative, a slow process leading up to some strange intimacy.

But there is something dishonest about Arbus' intimacy. An air of complicity and misplaced trust escapes from the framed subjects. That dishonesty was neither moral nor even intended, but a kind of compulsive cheating, made by someone who had the upper-hand. It has to do with not being completely straight, with surreptitious intentions that were very likely as hidden from herself as from her subjects. The pictures finally sell their strange intimates out. Diane Arbus once said that "a photograph is a secret about a secret." Her secret was not the ostensible one—the intrigue of other people's lives—but that she was a double agent, always in the act of betraying her subjects and her art. The betrayal was not intentional; it was an obsessive vision that isolated each subject in despair. The effect was an aesthetic boomerang. Arbus' camera reflected her own desperateness in the same way that the observer looks at the picture and then back at himself. Her focus on a narrative statement instead of on a visual one too often prevented her from making a complete pictorial statement.

Diane Arbus took care to present her pictures as facts. Her head-on compositions are clinical in their directness. The accompanying captions add a further documentary quality by citing date, place, and subject. Accordingly Arbus has been classified as a "new documentarian" who changed the nature of photography by focusing on interior truths. But the similarity of despair in Arbus' pictures cancels their credibility as objective statements. The captions further discredit the documents' objectivity by telling us how to see the picture. The nudist of the swan-winged glasses is a *lady,* not a woman; the young man with a flag is needlessly dubbed *patriotic:* The caption for the photograph of the now famous giant reads: "A Jewish Giant at home with his parents in the Bronx, N.Y. 1970." With or without the caption, the photograph is spectacular; a young man towers over two tiny people, stooping to avoid the enclosing ceiling. The curtain seems *trompe l'oeil.* The giant's youth exaggerates the sterility of slip-covered furniture. The picture smells from stale cigars. The caption tells us to read this picture a certain way. The giant is Jewish and he lives in the Bronx with his parents. A non-Jew will see this differently than a Jew, a non-New Yorker from a New Yorker. Regardless, Arbus has made David into Goliath and brought the wrath of the Old Testament God to the Bronx. That wrath is the artist's wrath and fortunately this photograph is strong enough to withstand Arbus' inability to keep herself out of the picture.

Diane Arbus took many good photographs, but a basic deceptiveness that grew out of her failure to get past a private narrative make them less good than they first appear. Her very best pictures like *Xmas Tree in a Living Room*

in Levittown, L.I. 1963 are peopleless or, like the Jewish giant or the transvestite at a birthday party, are contained by the structured space of a room. Often, her balanced view fixes excellent formal compositions like the *Identical Twins* (1967) or the *Mexican Dwarf* (1970) and others, too, particularly those like the *Elderly Couple on a Park Bench* (1969) where the subjects' eyes are not directed at the camera. Among the very best pictures are the very last taken in 1970 and 1971. Dressed in Halloween clothes, institutionalized subjects cavort and play for the camera, depicting a change of vision. Backgrounds are in evidence. With the exception of three, action no longer takes place in the center of the picture plane. The subjects' eyes have changed as well; they are no longer frozen in futile expectation, and the masked subjects, unlike the earlier masked man and woman, do not peer out from their charade as unknowing accomplices to the event. In the end, Arbus seemed to be leaving her own psychological mise-en-scene to go elsewhere. (pp. 33-5)

> *Judith Goldman, "Diane Arbus: The Gap between Intention and Effect," in* Art Journal, *Vol. XXXIV, No. 1, Fall, 1974, pp. 30-5.*

Hollis Frampton (essay date 1974)

[*Frampton was a photographer, filmmaker, and art critic. In the excerpt below, he lauds the lyrical quality of Arbus's images and her capacity to show through them the "doubling, . . . duality, and duplicity" of life.*]

Diane Arbus has left us images that affirm, in ways as various as themselves, [the] doubling, and duality, and duplicity, of our every experience. She made them, as she once found words to say, "because they *will* have been so beautiful."

She shows us identical twins, for instance, who might personify our twin minds, nine years old and already at war; or a brawny, tattooed circus performer, obviously a tough customer, whose paramount trait is a surface filigreed in elegance; or a standing naked man, his genitals tucked away between his thighs, "being" a woman as if the verb *to be* were somehow made transitive; or a lonely Victorian mansion that is nothing but a facade. Freaks, nudists, transvestites, masked imbeciles, twins and triplets, inhabit an encyclopedia of ambiguities buried so far beneath language that we feel a familiar vague terror at the very suggestion of being asked to speak of them . . . an irrational suspicion that, should we ever find and utter a name for what these images mean to us, we would so profane them that they might vanish like Eurydice, or fall to dust.

Now, in this moment, as I see, once again, the photographs of Diane Arbus, these words that I drop behind me consume themselves as if by fire, evacuating the pathway of my thought as it is drawn to what is before it: namely, the images themselves. So that the phrase, 'in this moment' dissolves, in an obliteration of *all* moments into my accustomed unspeakable fascination by images that seem to possess the vertiginous stability of dream, of déjà vu . . . or of those artifacts of the seeing mind, glimpsed before light broke upon the eyes, that coinhabit with palpable matter the whole space of the world. And after that dissolution of a phrase, the adverb 'once again' is annihilated, in my seeming surprise as these images, time and

again, suggest that only a vicissitude of words segments their eternity into a mensurable time, invented, once, to resemble articulate space, that now no longer seems to matter.

These images, then, which offer me everything but words, enclose or apostrophize the exquisite stasis of a *tableau vivant* . . . tinted, to my disturbance and satisfaction, by my own lenses . . . divided by an interminable abyss, or, better, by an impenetrable membrane that is neither quite gauze nor caul nor screen nor window nor yet mirror, within which, or through which, or upon which, two personifications fix one another in endless regard. In a posture of easy attention, image and word, *eros* and *thanatos,* eternity and time, multitudes of partnerships at once open and secret, stare each other and themselves into existence. Diane Arbus and I, more or less in focus, may even be among them: because she is gone, but never, to my pleasure, quite entirely absent . . . and I am here, but never, to my pain, quite entirely present.

Within our tableau, now, all these personages bear toward one another an archaic expression which we cannot quite comprehend. Sometimes it looks to us like a smirk of angry conceit . . . or again, as briefly, a vacuous grin of confusion. But sometimes, for an instant that will outlast us, we animate upon these ancient faces, suddenly as a veil of an aurora, a smile of triumphant happiness. (p. 50)

Hollis Frampton, "Incisions in History/Segments of Eternity," in Artforum, Vol. XIII, No. 2, October, 1974, pp. 39-50.

Donald B. Kuspit (essay date 1977)

[*Kuspit is a professor of philosophy and art and the author of several works of art criticism. In the following excerpt, he discusses Arbus's attempt to bridge the gap between photographer and subject in her work.*]

Arbus did all she could to strike down the border between art and humanity—to make her art an invisible means of entry into horrific static lives. The Coney Island (1957-60) and South Carolina Appalachia (1968) photographs . . . are in their different ways climactic statements of this intention. At first glance, the former have a Reginald Marsh look, and the latter seem documentary. But on further inspection, what is crucial is the emergence of the individual from the crowd, in all his grotesque givenness. This, indisputably, is real, Arbus seems to say, and it is dreadful just because of that. It is no fantasy, even though it looks like one. The Appalachia photographs bring this idea to a head. There is no point being appalled by the reality exhibited, because one's emotions won't change a thing. They can only be an acknowledgement of sheer fact, confronting us and turning us back on our own facticity.

There is another idea that is capsuled in a 1958 Coney Island photograph showing a vigorously striding old man emerging from the cluster of figures on the beach, an admonishing prophet moving, so it seems, toward the photographer—although still a great distance away, greater than in the usual Arbus photograph. He may not be aware of her, but he is heading in her direction, and will eventually "engage" her. Here we see a key Arbus theme: the moment of engagement between photographer and her subject, and how it can destroy the boundaries between

them. There is a pathos in this, which I think helps give Arbus her power: she creates the illusion that the borders are down, but of course they are not, because she is different from her subjects, not only because she has not suffered appalling poverty or does not need outlandish means—transvestite dress, circus life—to realize herself, but also because she is on one side of the camera and they on the other. She is the artist, they the subject matter, and so she is already in a different class, with a different consciousness. But it is this difference in consciousness Arbus tries to bridge, not by empathy, but by sheer force of recognition—as though the photographer, by basic recognition, can become her own subject matter.

We might call this the big lie; it is the moment of fiction. Arbus is interested in people who cater to other people's need for fiction—impersonators and other kinds of "performers"—and in the process express their own reality, as well as in people who seem fictions in themselves, such as circus freaks. Her art exploits a sideshow effect and a tendency to perform for the camera, an exhibitionism revelatory of reality—and a thin line between monstrousness and banality. Such fictionalizing for Arbus is not a sign of intractable irrationality, but of a logic chosen to create and express the personal. Most of her creatures lose their nightmarishness (but not the Appalachians and freaks, because they have not chosen their condition) when one realizes that however demented they appear, they are in fact acting out their fantasies openly because to do so is their only means of finding satisfaction in life. Their abnormality is an expression of their idealism.

For Arbus only illusions can fully satisfy expectations, and she studies the real details of surfaces that carry illusions. Thus her charged photographs of a Disneyland castle (1962); a burnt out fun house (n. d.), and a Hollywood mansion (1963), which to me epitomize her art more than the familiar pictures of people. She depicts the facades (one violated by fire) in a Potemkin's village of happiness, which everyone knows is fictional. Yet disbelief is willingly suspended because of the belief it generates; it is believing which is in and of itself satisfying. Arbus depicts true believers—the real monsters—those who have hardly begun to question their condition. This is why they freely show themselves to her. They have mastered the art of self-belief, which teaches that there is nothing to be embarrassed about. They are not afraid that the camera will steal their souls, since part of their naiveté is that one's soul can be shown openly—an implicit expectation of intimacy, of boundaries dropping. It is this that in the end makes them grotesque, and all too creaturely.

Donald B. Kuspit, "Diane Arbus at Helios," in Art in America, Vol. 65, No. 4, July-August, 1977, p. 95.

Geoffrey Williams (essay date 1980)

[*Williams reviews the exhibit of Arbus's photographs at the Centre Georges Pompidou in Paris, noting that her works often embody "an atmosphere of menace."*]

I cannot say that I like the photographs of Diane Arbus— like and dislike are not the correct terms, these images defy such a simple judgment, they stand as a pure photographic statement of fact. Much of her work concerned the malformed, the midgets and freaks, an aspect of humanity we prefer not to see, our dislikes arising out of a

Howard Nemerov, in a poem on his sister's suicide:

To D—, Dead by Her Own Hand
My dear, I wonder if before the end
You ever thought about a children's game—
I'm sure you must have played it too—in which
You ran along a narrow garden wall
Pretending it to be a mountain ledge
So steep a snowy darkness fell away
On either side to deeps invisible;
And when you felt your balance being lost
You jumped because you feared to fall, and thought
For only an instant: That was when I died.
That was a life ago. And now you've gone,

Who would no longer play the grown-ups' game
Where, balanced on the ledge above the dark,
You go on running and you don't look down,
Nor ever jump because you fear to fall.

Howard Nemerov, in a poem from his The Collected Poems of Howard Nemerov, *The University of Chicago Press, 1977, p. 431.*

deep unconscious fear of the mentally or physically handicapped. Other works exhibited are simply street portraits, or taken at home or in social functions. They all however share a sense of alienation.

In all, thirty photographs were on show [in the exhibit at the Centre Georges Pompidou]. . . .

To understand [photography] it is necessary to enter into a relationship with the images, and those of Diane Arbus seem to stand out, both demanding and defying the viewer to do so. Many appear menacing, the malformed **Child with a Toy Grenade** seems to threaten although the twisted face expresses no real emotion. **Puerto Rican Woman with a Beauty Mark** presents the face as a form of twisted snarling mask, an impenetrable mask, from which only the eyes are alive. In **Woman in a Bird Mask** it is a real barrier, anonymous eyes forming the only point of contact with the viewer. It is here that the menace lies, the eyes beckon, but we cannot see behind. The image hiding the real person is strengthened by the false glitter of the theatrical world such as that of the **Hermaphrodite with a Dog in a Carnival Trailer** and the **Topless Dancer in Her Dressing Room.** The sitters are always relaxed, aware but undisturbed by the camera. However, a sense of falseness pervades their world, freaks in a fairytale land. The false façade is everywhere, from the faces of the people to the swan lake mock-up castle in Disneyland; an ephemeral never-never land, a mere false front like that of the **House on the Hill** in Hollywood; barriers we erect; voluntary or involuntary against the world.

On the other hand, the picture of the **Retired Man and His Wife in a Nudist Camp One Morning** has none of these

overtones. It is a relaxed welcoming atmosphere, there is no feeling of voyeurism, they are natural, smiling and confident. This is the only one of this collection that does not carry an atmosphere of menace although, as in all her works, the situation is not usual. There is a sense of pretence, a lifestyle that is close to nature but as real as that of a theatrical world.

Diane Arbus was concerned with humanity, her subjects were of primary importance to her and this reflects in her works. All her subjects dominate in the photographs calling for us to consider them and to try to relate with them. Only by involvement could these images be achieved, only by involvement can they be understood.

Geoffrey Williams, "Diane Arbus at the Centre Georges Pompidou, Paris," in The British Journal of Photography, *Vol. 127, No. 6247, April 18, 1980, p. 371.*

Jim Jordan (essay date 1987)

[*Jordan comments on Arbus's last series of photographs, taken at a home for the retarded in New Jersey. He posits that they reveal Arbus at "some penultimate point in her search for photographic integrity."*]

[Arbus] produced a body of photographs that reformulated a whole generation's attitudes toward portraiture and the documentary image, and not solely among photographers. Since her suicide in 1971 at the age of forty-eight, Arbus has become a figure of myth, an artist whose life story, like that of van Gogh, has become so interwoven with her work that the two can no longer be considered separable. Her work, now, must be viewed as a chronicle—perhaps *saga* is the more appropriate word. It is a record of her own protracted struggle to come to terms with a society so immersed in illusion that verisimilitude, whether physical or emotional, was considered a form of fantasy. As Marvin Israel once commented, she produced no nudes, "only pictures of naked people." Nowhere was that lack of pretense so evident as in the *Untitled* series, a group of photographs made at a home for retarded adults in Vineland, New Jersey, during the last two years of her life. . . .

In an age accustomed to the brutal excesses of artists such as Robert Mapplethorpe and Joel-Peter Witkin, one would expect to find even Arbus somewhat staid in comparison. Yet there is an electric tension in this small group of images that would be difficult to duplicate, even with Witkin's horror-chamber props. In these portraits of retarded individuals (mostly women) at play and participating in the Halloween ritual of masking and begging for treats, Arbus produced something more than a parable about humanity; the series reads like an anthropological record rather than a metaphor. As if this were a documentary about Homo sapiens produced by some extraterrestrial visitor, the photographs capture a range of personal interactions, social structures, leisure activities and work (of a sort). The Halloween pieces are set under gray skies, and the masks seem quite incidental, since without them the faces that are recorded are also masks, set into habitual expressions by the condition of each individual's mental condition. Witless glee, paranoia and vacant stares are most common.

The other images in the series are of a pair and, once, a trio of young (?) retarded women. The photographs are casually composed and intended to convey a family-snapshot quality. There is great tenderness here, which heightens the underlying sense of frenzy characterizing the series as a whole. It appears that Arbus had reached some penultimate point in her search for photographic integrity: having stripped away the maximum amount of esthetic assumptions, she is left with only camera and film, shooting her images almost randomly and certainly with little thought given to final appearances. The photographer, in these works, was as defenseless as her subjects. These pictures are self-portraits, more than a record of others. For Arbus, neither the tragedy nor the tenderness, not even the probable knowledge that her work was about to become extremely important artistically, was enough to compensate for the conflict between what she wanted to believe and what she thought she *knew* about people—and herself.

Jim Jordan, "The Naked and the Masked," in Artweek, *Vol. 18, No. 4, January 31, 1987, p. 11.*

FURTHER READING

I. Biographies

Bosworth, Patricia. *Diane Arbus: A Biography.* New York: Alfred A. Knopf, 1984, 366 p.
> Unauthorized biography, sometimes criticized for its lack of documentation, which purports to reveal many controversial facts about Arbus's "dark side."

II. Critical Studies and Reviews

Deschin, Jacob. "People Seen As Curiosity." *The New York Times* (5 March 1967): 21.
> A positive review of Arbus's photographs in the "New Documents" exhibit at the Museum of Modern Art in New York. Deschin notes that Arbus "seems to respond to the grotesque in life."

Gross, Jozef. "Diane Arbus: Life and Death." *British Journal of Photography* 132, No. 6503 (22 March 1985): 321-24.
> Overview of Arbus's life, career, and photographic style. Gross suggests that toward the end of her career "Arbus had lost the clarity of her vision."

Lieberson, Jonathan. "Snapshots of the Photographer." *The New York Review of Books* XXXI, No. 13 (16 August 1984): 9-10, 12.
> Critique of Bosworth's biography of Arbus. Lieberson also discusses Arbus's style, comparing it to that of the photographer Weegee.

Melville, Robert. "Intrinsic Meanings." *The Architectural Review* CIV, No. 928 (June 1974): 373-76.
> Review of Arbus's exhibit at the Hayward Gallery in New York, emphasizing her "special feeling" for the deformed and handicapped.

"Telling It As It Is." *Newsweek* (20 March 1967): 110.
> Very favorable review of the "New Documents" exhibit at the Museum of Modern Art in 1967.

Oille, Jennifer. "Review." *Art and Artists* 9, No. 1 (April 1974): 38-9.
> Generally favorable review of the exhibit of Arbus's photographs at the Hayward Gallery in New York.

Rice, Shelley. "Essential Differences: A Comparison of the Portraits of Lisette Model and Diane Arbus." *Artforum* XVIII, No. 9 (May/June 1980): 66-71.
> Detailed comparison of Arbus's technique, themes, and attitude with those of her teacher Lisette Model.

Roth, Evelyn. "Oeuvre View." *American Photographer* XVIII, No. 2 (February 1987): 82.
> Positive review of an exhibit of Arbus's late photographs at the Frankel Gallery in San Francisco.

Smith, C. Zoe. "Audience Reception of Diane Arbus' Photographs." *Journal of American Culture* 8, No. 1 (Spring 1985): 13-28.
> Statistical study and analysis of viewers' responses to Arbus's photographs.

III. Selected Sources of Reproductions

Arbus, Doon and Israel, Marvin, eds. *Diane Arbus.* Millerton, N.Y.: Aperture, 1972, 184 p.
> Large-format reproductions of many of Arbus's photographs, prefaced with a compilation of her remarks and writings.

———. *Diane Arbus: Magazine Work.* Millerton, N.Y.: Aperture, 1984, 175 p.
> Reproduces photographs taken and articles written by Arbus for various magazines between 1960 and 1971. Includes an essay detailing Arbus's magazine career by Thomas W. Southall and a bibliography of her magazine pieces.

Jean Arp

1887-1966

(Also called Hans Arp) German-born sculptor, painter, mixed-media and graphic artist.

While Arp worked in a wide variety of visual media, producing drawings, collages, graphics, and reliefs, he is best known for his simple, gracefully curved sculptures which suggest human and organic forms. Viewing imagination and spontaneity as the most important elements of art, Arp attempted to create works that would offer an alternative to what he deemed the "inherited prejudices" of traditional modes of expression. Although Arp's work also reflects to some extent his involvement in several major avant-garde movements of the twentieth century, including Dadaism and Surrealism, critics suggest that early in his career he established a unique personal style that remained consistent as he experimented with and sometimes invented new forms and techniques.

Arp was born in the Alsatian city of Strasbourg, his lineage and bilingualism reflecting the mixed German and French culture of the Alsace region. He began drawing at an early age and at fourteen left high school to study at the Strasbourg School of Decorative Arts. Arp later attended the Academy of Fine Arts in Weimar, Germany, and the Académie Julian in Paris, but he found traditional art instruction uninspiring and his periods of formal study were very brief. He was, however, inspired by the Modernist aesthetic theories that were then taking hold in Europe, and after 1910 he began experimenting with abstract painting. By 1914, his canvases were being exhibited throughout Europe with those of other Modernists, most notably Wassily Kandinsky, Paul Gauguin, Henri Matisse, and Pablo Picasso. None of these early paintings are extant, having been judged unsatisfactory and destroyed by Arp at a later date.

Living in Zurich during World War I, Arp played an increasingly active role in the European avant-garde, meeting with other artists and writers at the renowned Cabaret Voltaire. In 1916, he took part in the founding of the Dadaist movement along with Tristan Tzara, Hugo Ball, Emmy Hennings, Richard Huelsenbeck, and Marcel Janco. Repelled by the folly and brutality of the war, Arp and his Dadaist associates vehemently rejected the kind of conventional thinking they believed had rationalized such a catastrophe, and, viewing traditional modes of artistic expression as servants of those archaic ideas, they sought to create new art forms. The Dadaists' preferred form was the "event," wherein nonsense poetry was read and nonsense plays were staged, often with lavishly bizarre costumes and sets. In addition to writing poetry and designing sets for these productions, Arp created a number of Dadaist collages during this period, often in collaboration with Sophie Taeuber, a young avant-garde artist and dancer whom Arp later married. Like his earlier works, Arp's Dadaist collages were entirely abstract, composed of geometric shapes arranged randomly so as to incorporate the element of accident so favored by the Dadaists.

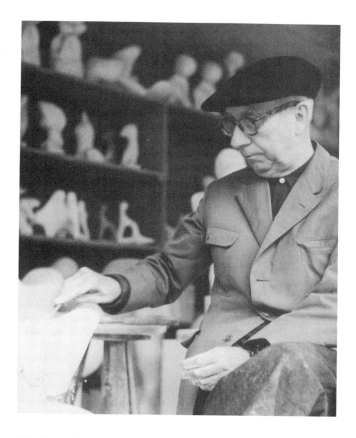

The Dadaist contempt for inherited art forms was reflected in Arp's creation of an entirely new medium, the painted wood relief, sometime after 1915. Composed of simple shapes arranged on a plain background and usually painted with bright primary colors, Arp's earliest relief sculptures feature the abstract geometric images characteristic of his earlier paintings and collages. About 1920, however, he adopted what he described as an "object language," using simplified yet clearly representational shapes to create enigmatic yet poetic images. In particular, Arp favored the juxtaposition of randomly selected forms, as demonstrated in the titles of some well-known examples of his wood reliefs of the 1920s: *Shirt Front and Fork* (1922); *Egg Board* (1922); *Plate, Fork, and Navel* (1923); and *Mountain, Table, Anchors, Navel* (1925).

Following the slow demise of the Dadaist movement after the war, many of its participants, including Arp, moved to Paris, where they formed the core of the Surrealist movement during the 1920s and 1930s. Although Arp was closely associated with the Surrealists and showed his works with theirs, critics note that his style was not greatly affected by their aesthetic tenets, which focused primarily on the exploration of the unconscious mind. Arp did, however, collaborate on drawings and writings with other Sur-

realist artists, sometimes using the Surrealist technique known as automatism, in which the artist attempted to surrender control of the creative process to the unconscious mind.

After 1930, Arp concentrated on the production of freestanding sculptures, transferring the evocative quality of his simplified yet highly suggestive organic forms to the three-dimensional medium. Although he created large compositions in stone, wood, and bronze, he favored the medium of plaster for its particularly smooth finish, in which all traces of the artist's hand could be obliterated. Critics note that in Arp's later sculptures, images of gestation, growth, and vitality predominate, often rendered in smoothly flowing shapes that suggest the continual metamorphosis involved in such processes. In 1954 Arp was awarded the International Sculpture Prize at the Venice Biennale, and during the final decade of his life he received a number of important commissions, including the large relief *Human, Lunar, Spectral* (1950) for the Harvard Graduate Center, the bronze relief mural *Constellation* (1957) for the UNESCO building in Paris, and several large pieces for the University of Caracas in Venezuela. He died of heart failure in 1966.

Discussing what he described as Arp's "profound interest in simple objects," James Thrall Soby wrote: "Commonplace components of the tangible world have inspired him continuously to achieve an art in which inconography is rid of all storytelling purpose and from which a new visual order emerges." Critics agree that this new visual order constitutes Arp's primary contribution to modern art as well as the fulfillment of his endeavor to free himself from the traditional language of the plastic arts.

ARTIST'S STATEMENTS

Jean Arp (essay date 1948)

[*In the following excerpt, Arp discusses his liberation from traditional art, his avant-garde works of the 1910s in which he sought to express himself in a tidy, unspoiled medium, and his eventual acceptance of the mortality of art, which led him to compose his torn-paper collages.*]

Between 1908 and 1910 I made my first attempts to transcend inherited art forms, inherited prejudices. This was a time of torment. I was living in solitude between Weggis and Greppen in Switzerland, at the foot of the Rigi. In winter I saw no one for months. I read, sketched and looked out of the window of my little room into the mountains immersed in snowclouds. It was an abstract landscape that surrounded me. I had leisure for philosophizing. In December 1915 in Zurich, I met Sophie Taeuber, who had already liberated herself from traditional art. In our work, we first suppressed the playful and the charming. We also regarded the personal as burdensome and useless, since it had grown in a rigid lifeless world. We searched for new materials, which were not weighted down with tradition. Individually and in common we embroidered, wove, painted, pasted geometric, static pic-

tures. Impersonal, severe structures of surfaces and colors arose. All accident was excluded. No spots, tears, fibres, imprecisions, should disturb the clarity of our work. For our paper pictures we even discarded the scissors with which we had at first cut them out, since they too readily betrayed the life of the hand. From this time on we used a paper-cutting machine. In the embroideries, woven fabrics, paintings, collages that we did together, we humbly strove to approach the pure radiance of reality. I should like to call these works the art of silence. This art turns from the outward world of silence to inner being, reality. From right angles and squares we erected radiant temples to the deepest grief and the highest joy. Our works were intended to simplify, transform, beautify the world. But our art did not disturb the bourgeois in their overcrowded madhouses, where they continued to wallow in their original oil paintings. . . . Today even more than in my youth I believe that a return to an essential order, to a harmony, is necessary to save the world from boundless confusion.

I further developed the collage by arranging the pieces automatically, without will. I called this process "according to the law of chance." The "law of chance," which embraces all laws and is unfathomable like the first cause from which all life arises, can only be experienced through complete devotion to the unconscious. I maintained that anyone who followed this law was creating pure life.

About 1930 the pictures torn by hand from paper came into being. Human work now seemed to me even less than piece-work. It seemed to me removed from life. Everything is approximate, less than approximate, for when more closely and sharply examined, the most perfect picture is a warty, threadbare approximation, a dry porridge, a dismal moon-crater landscape. What arrogance is concealed in perfection. Why struggle for precision, purity, when they can never be attained. The decay that begins immediately on completion of the work was now welcome to me. Dirty man with his dirty fingers points and daubs at a nuance in the picture. This spot is henceforth marked by sweat and grease. He breaks into wild enthusiasm and sprays the picture with spittle. A delicate paper collage or watercolor is lost. Dust and insects are also efficient in destruction. The light fades the colors. Sun and heat make blisters, disintegrate the paper, crack the paint, disintegrate the paint. The dampness creates mould. The work falls apart, dies. The dying of a picture no longer brought me to despair. I had made my pact with its passing, with its death, and now it was part of the picture for me. But death grew and ate up the picture and life. This dissolution must have been followed by the negation of all action. Form had become unform, the Finite the Infinite, the Individual the Whole.

It was Sophie Taeuber who, through the example of her clear work and her clear life, showed me the right way, the way to beauty. In this world there is a fine balance between Above and Below, light and darkness, eternity and transitoriness. And so the circle closed. (pp. 76-7)

Jean Arp, in an excerpt, translated by Ralph Manheim, from his On My Way: Poetry and Essays, 1912 . . . 1947, *edited by Robert Motherwell, Wittenborn, Schultz, Inc., 1948, pp. 76-7.*

Jean Arp (essay date 1958)

[In the following excerpt, Arp comments upon his formative years, his encounters with various modernist art groups, and his works of the 1930s. He also assesses his own contribution to modern art.]

To open my eyes, to see, to look, to contemplate the world, to watch clouds and trees, to behold cities and buildings, to look works of art in the eye, to look men in the eye, to see, to look—ever since my childhood this has been my greatest joy. I have seen many magnificent buildings in Switzerland, France, Italy, and Greece. But the most beautiful thing of all is the interior of the Strasbourg cathedral with its great jewels, the miracle of its stained-glass windows. I will write a thousand and one poems about those windows. In 1958, after many years, I revisited Strasbourg, my birthplace. I visited the house where I was born, a Renaissance structure. Here I spent the first years of my life. I clearly remember my consternation, in that house, at my brother's arrival in the world. It was there that I began to draw. But by the time I was sixteen the everlasting copying of stuffed birds and withered flowers at the Strasbourg School of Applied Art not only poisoned drawing for me but destroyed my taste for all artistic activity. I took refuge in poetry. My old love of the German Romantics, Novalis, Brentano, Arnim is still with me. At that time I discovered Rimbaud's *Illuminations* and Maeterlinck's *Serres Chaudes* in a French bookstore, and soon I was surrounded by mountains of books.

From Strasbourg I moved to Switzerland where I lived in great isolation on Lake Lucerne. Gradually I began to draw again. I tried to be "natural," in other words, the exact opposite of what the drawing teachers call "faithful to nature." I made my first experiments with free forms. I looked for new constellations of form such as nature never stops producing. I tried to make forms grow. I put my trust in the example of seeds, stars, clouds, plants, animals, men, and finally in my own innermost being. But later on, in Weimar as well as Paris, the teachers seemed determined to spoil the visible and invisible world for me. They kept trying to make me copy, imitate. But I refused to be confused or led astray, and in 1915 I produced my first "essential" picture. I believe that I was playing with some children's blocks at the time. My "first successful picture" grew out of this playing and building with elementary forms. It contains both the crucifixion and the head of Christ crucified, which form independent pictures within the picture. And I dreamed of pictures that would combine innumerable pictures within them. I might add that forty-three years were to pass before the second figure was discovered in this "first successful picture." What Christopher Columbus did for America, Marguerite Hagenbach did for my "first successful picture." It was she who discovered the head in it.

In 1915 I met Sophie Taeuber and her work encouraged me in constructing pictures. Sophie Taeuber was one of the first to construct pictures. It was not until 1919 that we received a few numbers of the Dutch review *De Stijl* and became acquainted with the work of Theo van Doesburg and Piet Mondrian. In the last few years Sophie Taeuber's work has begun to come in for the appreciation it deserves. Dr. Georg Schmidt, the far-sighted director of the Basel museum, called attention to her work many years ago.

In 1914 Marcel Duchamp, Francis Picabia, and Man Ray, then in New York, had created a *dada* (hobby-horse) that left nothing to be desired. But great was their distress, for they found no name for it. And because it was nameless, we in Zurich knew nothing of its existence. But when in 1916 we engendered our Dada and it was born, we—Hugo Ball, Tristan Tzara, Richard Huelsenbeck, Emmy Hennings, Marcel Janco, and I—fell rejoicing into each other's arms and cried out in unison: "Da, da ist ja unser Dada" ("There, there's our Dada"). Dada was against the mechanization of the world. Our African evenings were simply a protest against the rationalization of man. My gouaches, reliefs, plastics were an attempt to teach man what he had forgotten—to dream with his eyes open. Even then I had a foreboding that men would devote themselves more and more furiously to the destruction of the earth. The choicest fruits on the tree of Dada, gems from top to toe, were those raised by my friend Max Ernst and myself in Cologne. A little later we moved to the Tyrol and Tristan Tzara joined us in the good work. In Cologne Max Ernst and I founded the great enterprise of "Fatagaga" under the patronage of the charming Baroness Armanda von Duldgedalzen and the well-to-do Herr Baargeld (Mr. Cashmoney). Overcome by an irresistible longing for snakes, I created a project for reformed rattlesnakes beside which the insufferable rattlesnake of the firm of Laocoön and Sons is a mere worm. At the very same moment Max Ernst created "Fata." My reformed rattlesnake firm and Max Ernst's Fata firm were merged under the name of Fatagaga, and can be brought back to life at any time on request. The important thing about Dada, it seems to me, is that the Dadaists despised what is commonly regarded as art, but put the whole universe on the lofty throne of art. We declared that everything that comes into being or is made by man is art. Art can be evil, boring, wild, sweet, dangerous, euphonious, ugly, or a feast to the eyes. The whole earth is art. To draw well is art. Rastelli was a wonderful artist. The nightingale is a great artist. Michelangelo's *Moses:* Bravo! But at the sight of an inspired snow man, the Dadaists also cried bravo.

The building of the Aubette in Strasbourg in 1926 is another milestone in my life. Sophie Taeuber, Theo van Doesburg, the architect and painter, and I, were able, thanks to Messrs. Horn, our far-sighted patrons and their enlightened understanding of art, to carry through one of the first syntheses of architecture, painting and sculpture. The ten rooms, on which we worked for two years, have meanwhile been destroyed by a microcephalic owner, a deed worthy of Hitler. If the Aubette were still standing, it would be one of the most notable sights in Strasbourg, for there is probably nothing like it in modern architecture. One of the destroyed reliefs was reconstructed last year for the university of Caracas, by Villanueva, from Sophie Taeuber's original drawings.

In 1927 Sophie Taeuber and I moved to Meudon in the outskirts of Paris. Gradually, very gradually, the first art dealers in Paris and Brussels began to take an interest in my work. In Switzerland, which I had regularly revisited, I found my most faithful friends, who were also collectors, Mr. and Mrs. Giedion-Welcker, Mr. and Mrs. Hoffmann-Stehlin, Mr. and Mrs. Oscar Müller-Widmann, Mr. and Mrs. Friedrich, and Miss Marguerite Hagenbach. Kurt Schwitters came from Germany to see me and we worked together on his novel, since vanished, *Franz Müllers*

Drahtfrühling (Franz Müller's Wire Springtime). In 1925 I exhibited at the first surrealist group show and contributed to their magazines. They encouraged me to ferret out the dream, the idea behind my plastic work, and to give it a name. For many years, roughly from the end of 1919 to 1931, I interpreted most of my works. Often the interpretation was more important for me than the work itself. Often it was hard to render the content in rational words. Here are a few of the titles, interpretations, poems of my "dreamed plastic works" of those years: "The Eggboard"—"Paolo and Francesca"—"Bird Mask"—"Navel"—"Navel Bottle"—"Moon Frog"—"Mountain, Table, Anchors, Navel"—"Semicolon"—"Rhymed Stones"—"Navel and Two Thoughts"—"Church Clock"—"Delivered Flame"—"Pregnant Amphora"—"Three Walking Canes"—"Shadows Enjoying a Black View." These titles were often abbreviated little stories such as this one for **Mountain-Table-Anchors-Navel** in my book *Unser täglicher Traum (Our Daily Dream)*: "A dreamer can make eggs as big as houses dance, bundle up flashes of lightning, and make an enormous mountain, dreaming of a navel and two anchors, hover over a poor enfeebled table that looks like the mummy of a goat." At that time Theo van Doesburg's magazine *De Stijl* published a long poem of mine, "The Eggboard." This poem was about my egg game and its rules. My relief **The Eggboard** was the game's coat-of-arms, so to speak. I was particularly fascinated by time, watches, tower clocks. In the end my interpretations, my names for my plastic works, gave rise to poems. Here is a little poem in which clocks are a vital element: "A lump of masculine air disguised as an old Egyptian made himself two clocks, one from tortoises for the slow days, one from swallows for the fast days."

Suddenly my need for interpretation vanished, and the body, the form, the supremely perfected work became everything to me. In 1930 I went back to the activity which the Germans so eloquently call *Hauerei* (hewing). I engaged in sculpture and modeled in plaster. The first products were two torsos. Then came the "Concretions." Concretion signifies the natural process of condensation, hardening, coagulating, thickening, growing together. Concretion designates the solidification of a mass. Concretion designates curdling, the curdling of the earth and the heavenly bodies. Concretion designates solidification, the mass of the stone, the plant, the animal, the man. Concretion is something that has grown. I wanted my work to find its humble, anonymous place in the woods, the mountains, in nature. Sophie and I now exhibited at the *Cercle et Carré* group, founded by Michel Seuphor. We were also active in founding *Abstraction-Création*. Both groups were dedicated to abstract painting and sculpture. The sessions in the cafés were endless. I attended gatherings in the most unlikely corners of Paris, where still more unlikely speeches were made in the most elegant style and accompanied by gestures which had no doubt been carried to a still higher degree of perfection by Louis XIV. The literary gatherings in the cafés weren't bad either. Eighteenth-century Satanism was still a favorite dish in certain literary circles. In other groups every speaker was expected to invoke the Hegelian dialectic at least once a minute. Since it was no longer possible to send *lettres de cachet* meting out sentences of exile and imprisonment, the groups had to content themselves with letters of sadistic vilification.

But I never had the pleasure of hearing Breton, Eluard, or Péret read their wonderful poems.

The search for an unattainable perfection, the delusion that a work could be completely finished, became a torment. I cut the papers for my *collages* with extreme precision and smoothed them down with a special sandpaper. The slightest loose thread or fiber was intolerable to me. The tiniest crack in a bit of paper often led me to destroy a whole *collage*. This frenzy ended in a tragedy when I was asked to exhibit some old *collages* I had done in collaboration with Sophie Taeuber. This accident taught me the true meaning of perfection and finish. The word perfection means not only the fullness of life but also its end, its completion, its finish, and the word "accident" implies not only chance, fortuitous combination, but also what happens to us, what befalls us. We brought down the *collages* from the attic where they had been exposed for years to heat, cold, and dampness. Some of the papers had come unstuck, they were covered with spots, mould, and cracks, and between paper and cardboard blisters had formed that looked more loathsome to me than the bloated bellies of drowned rats. When after many weeks of confusion I had calmed down a bit, I began to tear my papers instead of cutting them neatly with scissors. I tore up drawings and carelessly smeared paste over and under them. If the ink dissolved and ran, I was delighted. I stuck my *collages* together with a wad of newsprint instead of pressing them carefully with blotting paper, and if cracks developed, so much the better; as far as I was concerned, it made my work more authentic. I had accepted the transience, the dribbling away, the brevity, the impermanence, the fading, the withering, the spookishness of our existence. Not only had I accepted it, I had even welcomed transience into my work as it was coming into being. These torn pictures, these *papiers déchirés* brought me closer to a faith in things other than earthly. I exhibited them for the first time in 1933 in Jeanne Bucher's gallery in Paris, and most of them found their way to the United States. I believe that they represent the transition from abstract painting to "liberated painting," as I should like to call the new American painting. The divine dream is a bridge between too much and too little. This dream is a fundamental part of my plastic search; similarly Sophie Taeuber created her luminous dream between coming-into-being and passing-away.

In 1941 Sophie and I fled from Paris to Grasse, whence we planned to leave for the United States. In Grasse we joined our friends Sonia Delaunay, Alberto and Susi Magnelli. For two years we lived in that wonderful place, surrounded by trembling crowns of light, gliding flower wings, ringing clouds, and tried to forget the horror of the world. We did drawings, watercolors, and lithographs together, and so produced one of the most beautiful of books [*Les Nourritures Terrestres*] Every possibility of work in common was tried out in this book. . . . Despite the horrors of those years, I look back on this period of work with my friends as one of the finest experiences of my life. Never was there a trace of vanity, arrogance, rivalry.

When Christopher Columbus, my pet, tried to sail to the East Indies "the other way round," he discovered America. When we tried to paint "the other way round," we discovered modern painting. It now seems incredible to me that I should have taken so long to realize that the art of our century and that of the preceding centuries are entire-

ly different things. The beauty of Rembrandt's engravings, Giotto's frescoes, or the statuary of the Gothic cathedrals has little relation to that of the painting and sculpture of our day. They are as different from one another as the beauty of the nightingale's song and the beauty of the Gregorian chant. Even more so, in fact. They are incommensurable, like the beauty of the murmuring spring and the beauty of the rose, the beauty of a poem composed by the trees and the beauty of a snowflake. (pp. 12-16)

> *Jean Arp, "Looking," translated by Ralph Manheim, in* Arp *by Jean Arp and others, edited by James Thrall Soby, Doubleday & Company, Inc., 1958, pp. 12-16.*

INTRODUCTORY OVERVIEW

James Thrall Soby (essay date 1958)

[*In the following excerpt from a monograph occasioned by an exhibition of Arp's works at the Museum of Modern Art in New York City, Soby offers an appreciative critical and biographical overview of the artist's career to 1957.*]

"A one-man laboratory for the discovery of new form," Alfred Barr once called Jean (Hans) Arp. The description seems accurate when one considers the variety of Arp's plastic innovations in many media. (p. 7)

To a number of his works Arp has applied the title, "objects arranged according to the laws of chance," and there can be no doubt that the occasional miracles of accident have had particular meaning for him, as when he makes his string compositions, his *papiers déchirés* and his automatic drawings. His alertness to subconscious sources of inspiration is swift and apparently inexhaustible, a fact which once attracted him, though briefly, to the surrealist movement. Whatever he touches carries the mark of strong personality and estimable skill. One assumes that he considers spontaneity a primary asset of art. What cannot easily be explained is how he retains this spontaneity when reworking some of his sculptures in varying dimensions and materials, so that each version has the look of new wonder.

The automatism of many of Arp's works has tended to obscure the importance of his capacity for acute observation in viewing the tangible world around him. The truth is that he is among other things a naturalist of the very finest order, stripping human and animal forms to a magic essence that far transcends realism to arrive at subtle evocation. Consider, for example, the allusive cogency of the *Owl's Dream,* wherein the silent bird is wreathed in sleep. Or consider the swelling, slithering vitality of his *Snake Movement II,* epitomizing the coiling of serpents. The word "abstract" becomes almost meaningless when applied to some of Arp's sculptures, though the discipline of abstraction has engaged him persistently, notably in his many brilliant *collages.* And it must be added that Arp is one of the few contemporary artists whose contribution to

psychological explorations has been just as important as his contribution to problems of formal order.

Arp was born in Strasbourg on September 16, 1887. Extremely precocious, he drew at a very early age. But then . . . he tired of "the everlasting copying of stuffed birds and withered flowers," and turned to poetry for relief, leaving the Strasbourg School of Applied Art to read avidly the German Romantic, Clemens Brentano, and the poetry of the members of the *Sturmer* group. In 1904 he was exposed to modern painting on a visit to Paris, and within a few years again became an art student, first at the Weimar Art School, later (1908) at the Académie Julian in Paris. His rare visual sensitivity made it possible for him to appreciate the more advanced aspects of Parisian art even in youth, and by 1911 he had organized with friends an exhibition at Lucerne, under the title *Moderne Bund,* which showed works by Gauguin, Hodler, Matisse, Picasso, Arp himself, and others today less eminent. The same year he visited Kandinsky, came into contact with the artists of the famous *Blaue Reiter,* and soon was contributing to their exhibitions and to the publication bearing the group's name.

By the time he was twenty-five Arp had emerged as a poet and a painter of marked distinction. The dual role, which Arp has continued to play to this day, has its pitfalls, and we are all aware of its debilitating effect on the lesser members of the Romantic movement in both France and Germany, the two countries which between them supply Arp's intellectual patrimony as an Alsatian. But Arp, unlike the Romantics, has never confused or over-stepped the boundaries which separate literature from the fine arts. His writings and his visual works have a comparable intensity and richness of analogy, yet each is faithful to its own identity and neither pre-empts the function of the other. For how many other leading painters and sculptors of our day can we claim so decided and intrinsic a literary talent?

In 1915, . . . Arp created his first "essential" picture. He . . . was playing with children's blocks at the time. The statement will sound weird and even frivolous to those puritans for whom art is a matter of unyielding solemnity. But it characterizes Arp's profound interest in simple objects. "My 'first successful picture,'" he says, "grew out of this playing and building with elementary forms." Throughout his career Arp has been nourished by plain objects which could never have potential meaning in the creative sense for artists of less lively imaginative powers. Moustaches, forks, navels, eggs, leaves, clouds, birds, shirt fronts—these and other commonplace components of the tangible world have inspired him continuously to achieve an art in which iconography is rid of all storytelling purpose and from which an invaluable new visual order emerges.

One might say that Arp's regard for everyday objects is essentially metaphysical and that his aim is to restore to these objects their preternatural mystery. In this connection his art may be compared with some profit to that of the Surrealists who, following the example of Giorgio de Chirico, have disrupted the logic of ordinary associations by combining in their pictures objects of totally disparate meaning, so as to arrive at a provocative, new and unforeseen scenario derived from subconscious dictation. The difference, however, is obvious. Arp does not admire in-

congruity for its shock value. Rather his aim is to give a penetrating dignity to familiar forms, both animate and inanimate, through a reappraisal of their metabolic capacity. Similarly, the "double image," a persistent surrealist device for obviating reality, has seldom if ever interested him. His statements about reality are unequivocal on the surface, but they revive a long-buried archaeology of the human spirit to which many other artists have since turned with profit and to which many more undoubtedly will turn in the future.

In 1914 Arp lived in Paris, where he became the friend of Picasso, Apollinaire, Max Jacob, Modigliani, Delaunay, and other leaders of the modern movement in the arts. The following year he moved to Zurich, and exhibited his first mature *collages* and tapestries. His interest in these two media is typical. The first, invented by Picasso and Braque only a few years before, had the appeal of a revolutionary departure from the authority of the hand-painted oil; the second had descended over the centuries from a position of august skill and eloquence to one of academic handicraft. Arp must have liked the challenge inherent in both. There followed the superb group of *collages,* tapestries, and fabrics through which he won a more and more influential following. His revolutionary fervor found support and encouragement when he joined Hugo Ball, Emmy Hennings, Richard Huelsenbeck, Marcel Janco, and Tristan Tzara in founding Zurich's Dada movement. At this time, too, he met Sophie Taeuber, who became his wife and with whom he often collaborated on works of art, one of his cherished beliefs being that creative activity should be a shared rather than a solitary process.

In 1916 and 1917 Arp produced the first of those painted wood reliefs to which he has since turned his attention consistently. The authority of his very first reliefs such as the *Portrait of Tzara,* the *Forest,* and *Plant Hammer* is remarkable, and within a few years he had progressed to works as supremely inventive as the *Birds in an Aquarium, Shirt Front and Fork* and *Plate, Fork, and Navel.* By then he had been active in the Dada movements of Cologne, Berlin, and other Central European cities. He had also become the friend of Kurt Schwitters and, above all, of Max Ernst, with whom he collaborated in painting a series of "Fatagaga" pictures—"guaranteed to be gasometric." The playfulness and insolence of the Dada movement obviously appealed to him, yet it did nothing to contaminate his unflinching integrity as an artist. As the Dada movement waned he gravitated with many of his colleagues toward Surrealism, and in 1925 took part in the first group exhibition of the surrealist artists at the Galerie Pierre in Paris.

The 1920s were especially fertile years for Arp and during that decade he finished many of his beguiling string compositions and some of his finest wooden reliefs, among them the *Shirt and Tie, Arranged According to the Laws of Chance,* and *Two Heads.* Yet during the 1930s he was to broaden his expressive range still further. At this time, disgusted with the fading neatness of his earlier *collages* . . ., he began to produce his torn-paper drawings, impetuously and often with violence. He continued to make wooden reliefs, of course. But sculpture in the round interested him more and more. We see him moving toward it in the *Hand Fruit* of 1930, one of the earliest of his free-standing pieces.

By 1931 Arp had progressed to the *Bell and Navels,* still executed in wood, his favorite material up to that point. In 1932, however, he began to produce his sculptures in bronze and various kinds of stone, the latter, of course, being mostly carved pieces. That same year he joined the *Abstraction-Création* group on whose other members his influence was considerable. He was then often interested, as was Henry Moore a few years later, in assembling several independently executed sculptural forms within a given work of art, as in *Human Concretion on Oval Bowl,* and in *To Be Lost in the Woods* whose pedestal is as thoughtfully conceived as the object it sustains.

It must be added that Arp, whose early (1916-18) *collages* had been concerned with geometric shapes, particularly squares and rectangles, had long since become a leading and persuasive advocate of the biomorphic and had written his celebrated dictum, "Art is a fruit that grows in man, like a fruit on a plant, or a child in its mother's womb." As this advocate, he has had a deep effect on artists slightly younger than himself such as Moore and Calder and, quite possibly, Miró, though Arp with characteristic modesty feels that the last-named, who lived in the same building as he at number 22, rue Tourlaque, Montmartre, during the years 1925 and 1926, arrived at his mature vision by quite another route. Moreover, Arp's influence on the arts of design, not excluding architecture, has been of vast importance. He as much as anyone brought about the revolt against the geometric preoccupations of a great number of preceding artists from the cubists to Mondrian. The shift in his own direction is glaringly apparent if we compare his *Rectangles Arranged According to the Laws of Chance* of 1916 with such a work as *Color Tear* of 1947 or *Bird and Necktie* of 1954.

By the middle and later 1930s Arp had reached his full stature as a sculptor in the round, creating such masterworks as the *Human Concretion* in cast stone, the *Stone Formed by the Human Hand* in Jura limestone, the *Shell Crystal* in granite and the *Homage to Rodin* in granite. The last-named piece is a touching reminder that Rodin's significance was not lost on his heirs in sculpture even during those years when professional art historians and critics tended to find his work too grandiose and dramatic. It may be, too, that Rodin's mastery of bronze surfaces led Arp to use this hardy, traditional material more and more often. One must add as a matter of personal opinion that Arp usually seems more at ease with stone than with bronze, possibly for the very reason that the former is a more "natural" material. It is no accident that one of the sculptures mentioned above is entitled *Stone Formed by the Human Hand.* In many of Arp's . . . stone sculptures, whether cast or carved, there is an intimacy between artist and material which metal sometimes obscures.

During the Second World War Arp took refuge in Switzerland, where he continued to work in the many media which have made him one of the most versatile of contemporary artists. In 1949 and again in 1950 he came to America and on the second of these journeys completed a monumental wood relief for Harvard University's Graduate Center at Cambridge. His search for new form was . . . unrelenting, and both this relief and the one he executed in metal on cement for Ciudad Universitaria at Caracas, Venezuela, (1956) make clear his knowledgeability in questions of scale. It may be, nevertheless, that his

greatest achievement of the past twenty years has been his sculpture in the round. At any rate, outstanding sculptures from his hand have followed one another with admirable profusion: the intensely tactile little **Snake Bread** of 1942; the **Chimerical Font** of 1947; the almost mystical **Head with Claws** of 1949; the exquisite **Configuration in Serpentine Movements** of 1950; the frighteningly real **Cobra-Centaur** of 1952; **Oru;** the majestic **Ptolemy** of 1953, with its breath-taking balance of solids and voids; the enigmatically sensual **Seated** [1957].

Since the Second World War, in addition to his sculptures, bas reliefs, *collages* and drawings, Arp has designed several fine tapestries. His interest in textiles is of very long standing; in 1915 at the Tanner Gallery in Zurich, as briefly noted, he had included in his first important exhibition tapestries and embroidery, partly in protest against what he considered to be the tyranny of oil painting as the preferred medium for serious artists. The range of Arp's technical facility, as noted before, is most impressive. He turns from one form of expression to another with startling rapidity and conviction—from *papiers déchirés* to the recent drawings done with an engraver's precision, from *collages* to bas reliefs, from woodcuts to paintings, from paintings to sculpture in the round. He gives absolute credence to those falling-stars of inspiration which veer into his artist's consciousness, blazing, sometimes irregular and quite often, one assumes, uninvited.

A word must be said about Arp's emotional and intellectual flexibility. His works may have the solemnity of a sacred oath, and then again he delights in a guffaw, as when he invented his eggboard game: "An indefinite number of gladiators open the game in goosestep . . . and deeming themselves the winners, march busily smashing eggs with the eggboard through the goal . . . the use of hardboiled eggs is unfair." At times his absorption in his art is pious; at times he becomes deliciously irreverent, though always within the discipline of a firm creative conscience. Like all fine artists he is never completely predictable. But one thing even now may be foretold with certainty: that Arp's high and unique place in our century's art will remain indisputable. (pp. 7-11)

James Thrall Soby, "Introduction: The Search for New Forms," in Arp *by Jean Arp and others, edited by James Thrall Soby, Doubleday & Company, Inc., 1958, pp. 7-11.*

SURVEY OF CRITICISM

Robert Motherwell (essay date 1948)

[*An American painter best known for his monumental abstract collages, Motherwell first became familiar with members of the Surrealist movement beginning in 1940. The following excerpt consists of Motherwell's personal response to Arp's work.*]

Shadowy figure in a low, modern doorway; marble white, precisely carved biomorphic eggs; light blue and white jig-saw puzzles, cleanly painted like fishermen's buoys or toy boats; full of satires ("man is a pot the handles of which fell out of his own holes"); loving "nature but not its substitute," representation; a modern man who hates for art or the world to wear the costumes of the past, a man who loathes the intrusion of the social world.

The "world of memory and dreams is the real world"; there Arp would live as a private citizen, but thought of the social world arouses his rage; his invective equalled only by that of his friend Max Ernst and of Picasso and Wyndham Lewis among modernist artists; his words explode at the workings of modern society, costumed fraud; he cannot bear that the "daily black joke" exists beside the "real world"; the Dadaist in him is aroused, and he writes true poetry, spontaneous and unforced, without desire to "be" a poet.

The emotion in his sculpture is prolonged; it is carved from hard stones; rage never enters his plastic work. Even the torn papers in his collages "arranged according to the laws of chance" which might, to the innocent, seem angry rebellion against traditional art are serene, an effort to find a natural order, like that of leaves fallen on the ground (an order like any other when perceived as such, and relaxed and uninsistent). He finds correspondences for the volumes and rhythms of the surface of the human body, quiet and living, in bed, in the studio, and on the bank of the river, wherever it moves slowly or rests stationary.

Imagine coming upon one of Arp's sculptures of "stone formed by human hand" in midst of a wood. Few artists in modern times enhance nature, perhaps only Arp. Brancusi's outdoor works are monumental stone tables and columns on the scale of the elements, settings for a modern Oedipus or Lear; Alberto Giacometti's recent figures are pervaded with anguish, the "I" seen from distance, untouched, a stranger in the world of nature and man. Arp is a true pastoral artist ("my reliefs and sculptures fit naturally in nature"); his scale derives from adjusting the human body to its surroundings, garden or field; his process is slow and even as nature's, carving that has the effect of water run over human stones ("the empty spaces in the marble nests . . . were fragrant as flowers"). No wonder predatory man nauseates him! His love is permanent.

The sky is August blue. Green skins dangle from the wild cherry trees. Its hair scorched, the ground drowses. If an Arp sculpture were present, it too would sleep in the sun ("I work until enough of my life has flowed into its body").

Robert Motherwell, in a prefatory note to On My Way: Poetry and Essays, 1912 . . . 1947 *by Jean Arp, edited by Robert Motherwell, Wittenborn, Schultz, Inc., 1948, p. 6.*

Thomas B. Hess (essay date 1949)

[*Hess was a highly respected art critic known for his passionate advocacy of modern painting, particularly in the field of Abstract Expressionism. In the following favorable review of Arp's first American exhibition, Hess points to the importance of mysticism and humor in the artist's works.*]

"A picture or a sculpture," Arp writes, "without any object for a model is just as concrete and sensual as a leaf or a stone . . . to me the conception of art that has upheld the vanity of man is sickening." In Arp's first American exhibition the spectator will see how this artist has succeeded in creating sculpture in and of nature. These objects are unhuman and anonymous in that they seem to possess a curious freedom of self-contemplation and self-satisfaction. But yet all show the mark of their creator—each fillup of stone or turn of bronze is like a signature—and so they do "uphold the vanity (but a better word would be 'dignity') of man." In this, fortunately, Arp has failed to live up to his written philosophy, and in this is his greatness as an artist.

To most Americans, he is known only as one of the most articulate and intelligent of the dadaists and as the creator of witty bas-reliefs whose titles usually include the word "navel." With this show, and with the publication of his book *On My Way* Arp emerges as a much more complex and original artist and as one of the great modern sculptors.

There is a certain element of mysticism in Arp's works, even in those made during his most radical dada experiments. He arranged cylinders of wood "according to the laws of chance" on planks. But the mathematical formulas of combination and permutation had little to do with the actual construction of these graceful reliefs. The "laws of chance" obeyed a highly developed aesthetic will, and it is significant that Arp considers these reliefs to be symbolic of his concept of destiny. In the more recent sculptures and reliefs, Arp's mysticism is even more apparent. If the objects are to be as independent "as a leaf," then the artist must work like some sort of demiurge. The care and precision which Arp lavishes on his hard stones, finishing them so the smooth texture retains a rocky quality of mass but still crisply moves under contours, is like the care and precision Carolingian scribes devoted to their illuminations. Morphological forms brood over chunky bases with a sort of generalized pantheism not unlike that found in the texts of Indian and Christian mystics—authors much admired by Arp. If this sounds like irrational, murky sculpture, it is because no mention has been made of Arp's balancing force, wit. It combines with all his philosophies to set up an equilibrium and tension of form and content. Ponderous stalks of metal nonchalantly wave little breasts at the spectator; a massive, introspective chunk of marble is also a slightly pompous little owl. It is, in Jean Arp's phrase, "the laughter of diamonds." (p. 21)

Thomas B. Hess, "Arp: Well-Rounded Mystic," in ARTnews, *Vol. XLVII, No. 9, January, 1949, pp. 20-1.*

Carola Giedion-Welcker (essay date 1957)

[*An art critic and collector, Giedion-Welcker was also a close friend of Arp and his first wife, Sophie Taeuber-Arp. In the following excerpt, Giedion-Welcker discusses the development of the artist's style in a variety of mediums, including sculpture and three-dimensional relief.*]

Zurich was the first center of the [Dada] movement, because this neutral island had become a meeting place of a generation of Europeans, who after a period of considerable material prosperity had been driven into the criminal

Arp on the Dadaist movement:

Dada aimed to destroy the reasonable deceptions of man and recover the natural and unreasonable order. Dada wanted to replace the logical nonsense of the men of today by the illogically senseless. That is why we pounded with all our might on the big drum of Dada and trumpeted the praises of unreason. Dada gave the Venus de Milo an enema and permitted Laocoon and his sons to relieve themselves after thousands of years of struggle with the good sausage Python. Philosophies have less value for Dada than an old abandoned toothbrush, and Dada abandons them to the great world leaders. Dada denounced the infernal ruses of the official vocabulary of wisdom. Dada is for the senseless, which does not mean nonsense. Dada is senseless like nature. Dada is for nature and against art. Dada is direct like nature. Dada is for infinite sense and definite means.

Jean Arp, in an excerpt, translated by Ralph Manheim, from his On My Way: Poetry and Essays, 1912 . . . 1947, *edited by Robert Motherwell, Wittenborn, Schultz, Inc., 1948, p. 48.*

disaster of a world war. It was clear-sighted youth that anticipated the defeat of the idea of rule by force, and at an early date recognized the demonic effects of the power neurosis and the divorce between technical ingenuity and wisdom. Arp felt spiritually akin to these "outsiders," who were actually the best representatives of their epoch. These poets, *diseuses, conférenciers,* painters, dancers, and architects were in rebellion against the prevailing moral standards and the "official" taste; at the same time they derided and parodied their own complicated and pointless everyday life, while the bloated nationalism that surrounded them only led to crises and wars. But they did not confine themselves to the game of *épater le bourgeois,* which was their version of the romantic struggle against Philistinism; these knights-errant of nonsense were also constructive, and strove for a new art and a new life, spiritualized and simplified. They radically repudiated "universal progress"; according to them, culture was to be found among the so-called barbarian primitives, and there was real barbarism in our over-organized, bureaucratic and mechanized civilization. They summoned the elementary force of "thought sprung from fantasy" in opposition to a view of the world originating in so-called common sense, and satirized the latter in poetic and pictorial manifestations. The growing opposition between the ideas of Vico and of Descartes, which is so topical today, was intuitively sensed even then. For what was the Dada movement but a revolt against a rationalistic universal system that had become untenable, against the superficial ideal of beauty on the classical model, against moral hypocrisy? "We must destroy, so that the lousy materialists may recognize in the ruins what is essential," Jean Arp wrote in retrospect, and to these words that sound like a manifesto

he added that in his view the purpose of Dada was "to destroy the swindle of reason perpetrated on man in order to restore him to his humble place in nature." Thus, behind the allegedly nihilistic Dadaist attitudes lay a profound belief in long-forgotten beauty and humanity. The authentic *vox humana,* as Hugo Ball called it, was to make itself heard again, and come out against stifling materialism and intellectualization.

The artists who gathered in Zurich to form the *Cabaret Voltaire* (1916-1918) represented a cross section of European youth: Tristan Tzara and Marcel Janco came from Rumania; Hugo Ball, Emmy Hennings, and Richard Huelsenbeck from Germany; Otto and Mme. van Rees from Holland; Arp from Alsace and Paris; only Sophie Taeuber was a native of Zurich. All of them were anxiously seeking "the true, buried face of their time, its basic, essential features, the cause of its affliction and the possibility of its awakening." Art should be only "an occasion, a method" toward such an end, Hugo Ball says in *Die Flucht aus der Zeit* (*Escape from Time*). The Muse had come down from her pedestal; art was the expression of a profound spiritual vision, flowing from the unconscious life, and works of art could be created out of the humblest materials. In any event, there was no room here for the cult of genius. The Dadaists, for all their apparent absurdities, for all the deliberate shabbiness that characterized their artistic and literary output, had a clear and honest insight into the nature of their movement. According to Hugo Ball, Dada was "a fool's play originating in nothing, but in which all higher problems were involved." Spontaneous imagination launched an offensive, at once gay and serious, against stale routine and artificial virtuosity.

Such were the guiding ideas of the Dadaists and of their *Cabaret Voltaire,* situated in the narrow Gothic Spiegelgasse of the old quarter in Zurich; they were also the ideas of the young Arp throughout his extremely active Zurich period. His works—reliefs, woodcuts, collages, tapestries, masks, and stage décors—bear the stamp of their time, but they also disclose a quest for primordial simplicity, for the essential, as well as an urge toward artistic anonymity. "Works of art should remain as anonymous in the great workshop of nature as are the clouds, the mountains, the seas, the animals, and man himself. Yes! Man should once again become part of nature, and artists should work collectively, as did the medieval artists." Thus Arp spoke, reflecting the atmosphere of those years. He himself seemed in those days something between a late-medieval "fool of God" and a modern dandy. His art, his thinking, his very being emanated relaxation, spontaneous wit, and charm. Hence his radical rejection of the hectic emotional pathos and theatricalism of the German Expressionists (although their participation in contemporary expression was evident) emerged from the spirit of the time, and marked a definitive repudiation of all pseudo-artistic attitudes, which had been officially cultivated in the preceding Wilhelmian era, and which now were criticized and ridiculed. The young Klee, too, had desperately resorted to satire in his early graphic works in order to launch an attack on his period and society, and in doing this he preferred a grim and grotesque style to that of sugar-coated *bellezza.* The young Italian Futurists had similarly discarded their Italian *bellezza* in favor of an expressive *anti-grazioso.*

Arp's reliefs, woodcuts, and collages thrived in this Zurich

Dadaland, in a soil fertilized and stimulated by the most various cultural influences. There, too, his roguish poetry was first heard, in a language that sent up words like rockets. But to the Zurich public, and during the turbulent disputes within the Dada group, these facetious poems were also relaxing lyrical oases. As his friend Otto Flake said, "they thrust aside all psychological problems, and inaugurated a fantastic game, eliminating causality, and boldly skipping all intermediate links." In this animated verbal world of "silver balls and fountains," of winged words and sonorous images, simultaneity was the trump card. The domains of the visible and the audible witnessed the birth of quite unusual things—strange symbioses and symbols, alluding equally to thoughts and things. The banal instruments of everyday life, which constitute our small world, now emerged as fragments, detached from their practical contexts to form other, purely pictorial or linguistic associations, in a new existence. Elements of sound, rhythm, and proportion were dominant in Arp's pictorial and poetic works. A concise sign language, developed from forms and words, served to construct a detached, hovering universe, in which nothing was defined logically, but in which irrational zones open up with great suggestive force. Both the pictorial works and the poems repeatedly disclose the tragi-comic conflict between human smallness and cosmic infinity—a conflict to which our poor world is constantly exposed. Hence the dimensional contrasts in Arp, which draw their expressive force from both intellectual and formal elements. Peculiar formal entities arise—one might call them *Formlinge* (Frobenius' term for archetypal form-beginnings). Here, too, primeval shapes seem to come to life again and to act out a burlesque of today. For instance, a lone umbilical form floats like a tiny island in the cosmos of an enormously large page, as did once the legendary island of Calypso in the mysterious center of the sea. Or a gigantic black **Arrow Cloud** threatens dot-like white entities that swirl around it. But the fact that from this new pictorial world *Constellations* and *Configurations* arise is the most important. For Arp is less interested in the fixed individual case than in the animated play of relationships, the sounds and echoes within that dynamic order in which everything fluctuates and is eternally subject to change and transformation.

In addition to this profoundly meaningful buffoonery or drollery, related in spirit to the marginal decorations of medieval Bibles and permeating the morality plays of those times, Jean Arp now developed another aspect of his being. It was an intensive listening to the central stillness of the inner world. His growing interest in Laotse's philosophy and Jakob Boehme's mystical writings points in the same direction. In his diary Arp speaks of "the infernal phantom of earthly confusion, disorder, futility and stupidity," against which one should "proceed with beating drums in order to make apparent the inconceivable madness of human activities"; and he adds in a distinctly religious vein: "We were attracted by the radiant brilliance of the mystical poems in which man is released from joys and sorrows. This was the 'carefree' ground of being, as the mystic Tauler called it." To the overactive busyness, the senseless turmoil of his epoch, the young Arp thus opposed inwardness, eternity. He recorded this inner absorption and spiritual asceticism, this turning away from the glitter of outward phenomena, in severe constructions composed of pure elements of form and color. Problems of content and of form merged; the early Zurich *Collages*

(1915-1916) are actually pictorial meditations, expressions of that absorption. They are geometric compositions, almost solemnly constructed, made of silver-gray or black-and-white papers, or held to Franciscan tones of gold, brown, and white. Everything is cut by machines in order to eliminate the human hand, which had been wielding "the brush stroke of genius" with such painful virtuosity. In their architectonic clarity and rhythmicality, these works have points of contact with Mondrian's creations, which Arp at that time had not seen. It should also be noted that, unlike Kandinsky, Arp did not call his works "compositions," but *"architectural formations"*: "Our works are constructions of lines, surfaces, forms, colors. They attempt to approach reality. They hate artifice, vanity, imitation, tight-rope walking . . . Art should lead to spirituality, to a mystical reality."

With this credo Arp defined the course he was to follow, and pointed to the deeper regions where he was later to anchor ever more resolutely. These *Collages,* with their austerity and ascetic rectangular design, were in striking contrast to the fluid, organic forms of his contemporary "objects reliefs," spontaneous creations full of witty associations, which were ordered according to "the laws of chance." Just as "elementary" as the collages, the reliefs are above all characterized by their softly undulating organic forms and a burlesque quality, which we also find in many of his poems at that time, abounding in humorous attitudes, concentrated expressions, linguistic deformations, and grotesque verbal images. Their source is banal everyday life, but the words in the poems, just as the forms in the pictures, acquire rich new meanings. Here, too, for all the facetiousness, the way led through nonsense to that mysterious primal sense that slumbers deep below the world of phenomena and that can be approached—whether linguistically or pictorially—only in symbols that have many significations. Richard Huelsenbeck, whom Arp met in the Dada period and who has remained his friend to this day, regarded Arp's role as an artist within the modern movement as crucial. He wrote in the heyday of Dada: "Hans Arp's art is the first that—since the Cubist transvaluation—has discovered a dogma to resolve all difficulties, spasms, and convulsions . . . A new will to spirituality has appeared."

The two essential features of the entirely new method of artistic creation that Arp conceived at that time—organic form flowing from the depths of the irrational and abstract articulation by means of elementary geometric figures—implied rejection of the predominance of the material world, and of an artistic expression by the means of a virtuoso-like illusionism. In both respects the new art asserted the *inner image,* which was to be grasped by unprecedented methods, deliberately simple and austere—*les moyens pauvres,* as Stravinsky called them referring to the domain of music. This double orientation toward organic form and abstract articulation—we might also speak of an intimate interweaving of classical and romantic "climates"—was to define the basic directions of modern art. Arp as early as 1916 anticipated developments to come.

Like Klee, the painter-poet Arp used captions for his visual creations to add a voice from another realm and to do away with the rigid demarcation line separating the word from the image, and at the same time to point a way to their interpenetration. Indeed, the very fact of his own

parallel activities contributed to the merging of the normally separate domains of art. Merely by reading the poetic titles of Arp's works in chronological order, we can follow his artistic path and his successive changes of emphasis. At first he is concerned with paradoxical and unusual configurations, with oppositions and connections between symbols of human and of inanimate things. The captions always refer to "magic fragments," to bizarre formations that are detached from their usual contexts, splinters of a great all-pervading being and becoming, which are brought into new, unusual relationships and strange new combinations. His *Eye and Navel Dress* stretches triangularly, bends into a double arc, and is in fact the pictorial version of his lyrical *Pyramidal Petticoat.* Curved mustaches, floating neckties, and fluttering lips seem to perform their undulating movements on a cosmic scale, as if they were great elemental forces. Swooping umbilical forms, masks of men and of birds leer at us, church clocks beat time with oval pestles. The specific form here is not the straight, but the organic, wavy line. Everything is vibrating in a world where man, closely interwoven with the cosmos and with things, has lost his uniqueness and exists only as an absurd fragment. Along with all else, man is drawn into eternal change, like natural forms, and like the latter, is animated by the all-comprehensive "universal spirit" of the romantics. The long-buried primeval pattern of the human seems to re-emerge, as though out of a deep recollection, as a torso or vase form.

Arp restores essential mythical existence to man and things. That is why man, in his works, is not a rational being enthroned above all else, but himself an element of nature, a thing, a part of one great fate, a solitary leaf adrift in the space of worlds and times. Therewith a bridge is thrown out leading from inwardness to mythical forms. All around us there is an all-comprehensive net of relationships involving things large and small, important and unimportant, and a bubbling fantasy and irony are at work perpetually destroying the bombastic illusion of man's supremacy. Man is identified with things, while things are identified with man. New spiritual and formal proportions have made their appearance, and a new world of unity and interrelatedness arises from disunion and separateness. (pp. vii-xvii)

Since his Dada period in Zurich, and even earlier, from his participation in the *Blaue Reiter* movement in Munich, Arp has been *both* a poet and a plastic artist, producing imaginative and disciplined poems, graphic works, and reliefs. We are reminded of Kandinsky, who said that each time he switched from poetry to painting or vice versa, he "merely changed instruments." No Dada publication appeared without Arp's many-sided contributions in the form of humorous verse, woodcuts, and cover designs. His visual creations are sometimes fluid and mobile, and sometimes symmetrically articulated with architectonic severity. These two orientations—toward the natural and toward the urban—were even then expressed very intensively. His burlesque poems are illustrated by his rhythmic black and white forms, and words and forms have equal force. Never is his poetic creation a mere accompaniment to his pictorial work; the life of the former is always as full, as rich, and as joyous as that of the latter. Throughout that period Arp's compositions are often like kinds of written images that emerge from the depths of a fantastic world, constructed with lines and planes, or moving seismically

to the pulsations of an inner rhythm. Arp spontaneously rediscovers Novalis' "marvelous and secret code of nature" and embodies it in a modern artistic form. This is often suggested by his captions, such as ***Objets placés comme écriture (Objects Arranged as Writing)***, and many similar ones. Such an intimate relationship with written characters can often be detected in modern art, for instance in the symbolic or formally expressive part played by letters and words in Cubist pictures, or in Paul Klee, who developed a hieroglyphic language, and invented a pictorial "plant script," "picture script," and "abstract script," while Arp composed "string reliefs" in "written" forms and rhythms.

If only because of his dual talents, Arp has always been inclined to place the word in a pictorial setting, and to decorate books, the vehicles of the word. Even after the Zurich period, during his Surrealist years in Paris, and down to the present, he has always invented fantastic, yet amazingly simple pictorial accompaniments to his own and his friends' poetic texts. In Zurich, Arp provided the manifestoes and poems of the Dadaists with vignettes and full-page illuminations. Large-scale individual forms and interwoven groups of forms here carry on their roguish play, or are articulated as solemn black-and-white rhythms, serving as visual support to the text. This, for instance, is the case with Richard Huelsenbeck's *Phantastische Gebete* (*Fantastic Prayers*, 1916), in which the author's drum-beating language is matched by Arp's sonorous

Infinitely Bound Form (1923)

"chords"—abstract, often severely symmetrical compositions. The veins of the wood on which they are engraved lend them an irregular natural quality, and at the same time make us constantly aware of the presence of the material which helped to shape them. In Tristan Tzara's *Cinéma calendrier du coeur abstrait* (*Film Calendar of the Abstract Heart*) of 1920 entire pages are covered with irrationally flowing dreamy forms, which spread out like a moving black web—these are no doubt maturer versions of his early attempts at Weggis. The passive, unconscious following of the inner flux, which the Surrealists later named *automatisme psychique,* is here kept in control and balanced by a perpetually alert sensibility. The cover for the periodical *Der Zeltweg* is an outstanding example of monumental clarity and nobility in its sure arrangement of planes, forms, and letters, where playful jagged lines are fused with softly flowing ones into a tightly-knit unity.

In tracing the sources of Arp's idiom, we may assume that his early graphic works were to some extent influenced by Kandinsky who, in 1912, in his book *Über das Geistige in der Kunst* (*On the Spiritual in Art*), in his collection of lyrical poems *Klänge* (*Sonorities*), and in the *Blaue Reiter* yearbook presented modern graphic works of an entirely new character. Arp, who contributed to that yearbook, was stimulated by Kandinsky's engravings to develop his own method of graphic "illumination" on an identical non-illustrative basis. In retrospect we recognize that Arp anticipated many things that were to be realized on a large scale, in book production and advertising, only in the course of the following decades. His drawings in the periodicals, books and manifestoes, which were then printed in limited editions by W. Heuberger in Zurich, and which today are collector's items, are characterized by breadth of treatment, and sure typographic instinct in harmonizing text and pictures. This new plastic language expressed a profoundly original vitality. Whereas Kandinsky's wood engravings suggest an explosive, flaming handwriting, Arp's signs flow smoothly despite their firm structure. Significantly, he himself at that period called these works "pictorial constructions." Moreover, Arp's quieter, lyrical tone stands out clearly from the dramatic passion of Kandinsky's early creations.

The intensive interplay of forms, and of forms and surfaces, has remained a constant feature of Arp's works and is present in his reliefs as well as in his sculptures in the round. He achieves a mysterious correspondence between external and internal movement, between active structuring and elastic yielding, and between black and white tones. The combination of the organic and the constructive, the "vegetative" and "planned" principles, which pervades his entire *oeuvre,* was present even then, and to this day it has been the hallmark of his art. We rediscover it in his *Geometric-Ageometric* sculptures and reliefs, which he assigns to an "intermediate realm," and many of which he entitles *Interregnum,* no doubt suggesting that here the most various languages of form interpenetrate.

His conception of the pedestal also makes use of both expressive potentialities. In his early period Arp provides no base for his sculptures, which are as though lost in nature, or he gives them organically undulating bases, which grasp the sculptural parts and hold them together, as might also happen in nature. This method is consistent with his idea that art should be anonymous and integrated

with nature as a whole. On the other hand, we see that his treatment of the base, particularly in his later works, is carried out in an architectonic language: the base becomes a terminal point, a boundary, or a mediating element between the sculpture and the constructed environment. The treatment of the base has today become an extraordinarily difficult and important problem in the presentation of a sculpture, and the base is to an increasing extent conceived of as a peripheral component of the work itself. Arp has often used parts of earlier sculptures as bases for new ones; in their new subordinate function they appear with completely changed proportional and tensional contrasts.

The general "elementarism" and the clear mathematical structure of Arp's compositions enabled him (as well as Miro) to keep aloof from literary description even during the years of his active participation in the Surrealist movement (1924-1928) in Paris, and assert the primary pictorial relationships, while his subject matter continued to suggest recollection and mythical elements. Accordingly the response to his art was dual, too, and he gained recognition in opposing camps. Piet Mondrian, the Dutch painter who was imbued with mathematical discipline, saw in Arp's creations "neutral, completely indeterminate forms against a neutral background"; in a broader sense, he considered Arp's method a variation and confirmation of his own purely geometric and universal "neo-plastic" paintings, which eliminated every suggestion of figurative representation, and in which the character of the picture was decided only by the austere counterpoising of pure colors in balanced relationships. This was "the new culture of pure relations," as Mondrian put it. On the other hand, Max Ernst reacted positively and affirmatively to the elements of content in Arp's work: he underlined Arp's "hypnotic language which takes us back to a lost paradise, to cosmic secrets, and teaches us to understand the language spoken by the universe." Arp's creations conjure up the most mysterious depths of nature, as Novalis had experienced them.

After his Dada years, the poet Hugo Ball turned toward religion, and found a deepened inner culture, opposed to the superficial civilization of progress, in the Christian-romantic spirit of Novalis. Arp, who in 1926 had moved to Meudon near Paris, after joining the newly rising Surrealist movement, gradually turned from his early burlesque interpretations of life to the fusion of natural and human substance into a new sculptural unity. He produced anonymous forms, symbols of life, in which the tragic rifts, dividing the human, the natural, and the artificial were bridged. They were objectivized and self-contained entities whose universal and elementary forms logically continued the earlier reliefs. The title *Concrétion humaine*, which emerges at the beginning of the series, and is often repeated later, evokes the comprehensive natural process of condensation, of dynamic convergence: "Concretion is the result of a process of crystallization: the earth and the stars, the matter of the stone, the plant, the animal, man, all exemplify such a process. Concretion is something that has grown."

While in his early period he expressed the tension between man and the world through the shock of unusual forms and proportions—an approach that both in form and content often survives in the grotesque designs of his sculptures—he now formulates the mysterious life and fusion

of nature and man with ever greater vigor and breadth in a daring and joyful plastic language.

> Art is a fruit that grows in man, like a fruit on a plant, or a child in its mother's womb. But whereas the fruits of the plant, of the animal, of the mother's womb assume autonomous and natural forms, art, the spiritual fruit of man, usually resorts to forms that are ridiculously like other things. Only in our time has plastic art freed itself from reproducing mandolins, presidents in cutaway suits, battles or landscapes. I love nature, but not its substitutes. Naturalistic, illusionist art is a substitute.

It is noteworthy that Arp came to sculpture in the round by way of reliefs. He began to make these in his early period, and even today he devotes part of his interest to them. We can follow him as he gradually detaches the relief from the wall, places it in free space, rounds it more and more, and in the end transforms the relief elements into fully rounded sculptural configurations, displaying again the most impressive form relationships. The elementary shapes and the intricate relationships are as crucial here as they were in the reliefs. In 1935 he begins to produce sculptures that summarize and synthesize his previous experiments. These monumental works, revealing a distinguished and sublimated sense for treatment of the expanded volumes, are found side by side with works that are playfully burlesque in their capricious formations. The humorous, bizarre goblin and elf play continues throughout all periods of his creation from 1917 on, producing fairytale beings, hybrid and magic, but his symbols of nature occupy a far greater place in his *oeuvre*. What is nature for Arp? An immense vital process, both extraordinarily simple and complex, a cycle evolving between birth and death, constantly changing and growing, and hence to be grasped only dynamically, never statically in the field of art.

Arp's genetic orientation, his untiring search for the "archetype," and his deep aspiration to penetrate into the innermost original shape and structure of creation are suggested also by his personal confessions and diary entries. He, too, was drawn to that original cause of all formative powers in nature, which for the painter Paul Klee was the home and starting point of authentic art. We can detect in Arp the same profound experience of life, which conceives of creation as an eternal process, as permanent transformation and growth, not as being, not as a ready-made product of nature. This is why Arp's initial forms strike us as being so ready to be transmuted, so filled with inner organic tension. Whereas Brancusi emphasizes an almost religious element of worship in his sculptures, and pursues the ideal of extracting purest form from matter—in a sense that is perhaps a modern revival of antiquity—Arp's sculptures, for all their arbitrariness, usually retain an anonymous quality: they are lost in space and in dream, and are directly connected with stones and trees. But in a certain respect, his art, like Brancusi's, is sometimes characterized by a Mediterranean self-sufficiency and harmony, which clarify and expose form in its splendor and beauty. He creates well-balanced, joyful pieces alongside those others that mysteriously emerge from long-buried forests and fairylands. This fantastic world includes "stones that are as though formed by human hand" or stones that are "exposed" in the landscape like foundlings,

and he speaks of these stones as of fabulous beings, which are nevertheless intimately connected with him:

> A dead stone suddenly opens its eyes, and sends out swarms of singing glances. Sometimes stones are like children. They babble on and on, and the sculptor is only too willing to believe what they are saying. To enlarge a stone is difficult work. Stones that cling to the sculptor are dangerous: they obstruct his path to God.

Here once again Arp deliberately turns his back on so-called "creative genius" in favor of artistic anonymity, and thus comes close to the oriental conception of quietly radiating things—including those that have not been touched or changed by human hand, as they can be seen in Japanese gardens or markets where stones are sold like choice fruit. But this is also the language of a certain contemporary romantic spirit, which is not tied to the period or the hour, but seeks to penetrate to the authentic vital core of things. How close this poetic world of Arp's dreams and creations comes also to the sphere of natural science may be seen from the fact that the English biologist Waddington, according to whom growth and individuation of form are characteristic of organic life, uses Arp's sculptures as supplements to his scientific illustrations.

Arp's sculpture in the round starts from the self-contained volume. But just as in his woodcuts he discloses an interplay of positive and negative forms, so in his sculptures, he often permeates his mass with light and air, and obtains striking effects by allowing air to circulate freely around the forms. Brancusi applies the same principle only in his wood sculptures, and Henry Moore occasionally achieves the same effect by "enshelling" his surfaces. Arp's **Snake Bread,** smooth, without joints, curls around a well-like hollow. The upward-striving **Garland of Buds** (1936) and **Star** (1939) spread out into space and are articulated by their encircling of it, while the significant **Ptolemy** (1953) in its serpentine, homogeneously flowing circumscription of airy zones describes a circling in space, which suggests both in form and content the philosopher's system that was built around a cosmic center of the world. Here too Arp achieves in the transmutations or in the synthesis of the "vegetative" and "constructive" principles a sculptural form that, like his reliefs, can exist *within* and harmonizes *with* architecture. The fact that all his creations fit in easily with their environment—even though the forms are sometimes purely organic—is shown by the early murals in the Aubette nightclub at Strassburg (1927-1928). We can also understand why his gigantic and grotesque organisms, thanks to their elementary clarity and rhythm, disclosing essential proportional contrasts, can find their place in Theo van Doesburg's and Sophie Taeuber's geometric interior architecture and decoration. His burlesque shapes—masks and mustached heads, torsos and giant-navels on a dark ground, or friezes of enormous mushroom caps running under the edge of the ceiling—do not seem to dissolve the severe architecture, but animate it with new natural rhythms. Surely those who had the good fortune to dance in this modern prehistoric cavern moved not merely to the sounds of jazz, but were also inspired by the visual vitality and rhythms of Arp's creations, which articulated the walls and the space, reaching out like monumental tentacles full of facetiousness and relaxation.

The same is true of sculptures such as **Shepherd of Clouds**

(1949-1953) with its abundant floating shapes. When it was temporarily exhibited in the square of the old town of Yverdon (in 1954), it fitted in easily with the old tower and the Baroque houses; now, in front of the library of the University of Caracas (Venezuela), its actual destination, this fantastic being placed among plants, architecture, and various structures is effective, independent and yet not isolated, in full harmony with this entirely different environment.

The wood reliefs that Arp created for the bar of the Graduate Center at Harvard (Cambridge) in 1950 seem less facetious than the Strassburg mural; yet they brighten the surroundings with a penetrating lyrical accent. Like passing stars, clouds, birds and leaves, the forms move along the regularly veined wooden wall, broadening finally into "constellations." It is relaxed poetic interplay of motions, forms and surfaces. Arp's fantastic world is here incorporated into the daily life of a young generation, which lives in this environment. Walter Gropius, by coupling with his building these irrational spheres that transcend its spatial and functional tasks, gave proof of an especially sensitive understanding of our present needs.

The most recent reliefs, at the University of Caracas, are precisely cut and roundly undulant forms which describe their movement before great wall surfaces in a script-like manner. The hovering interplay of open and closed forms, perforated and continuous surfaces, is executed in the language of a fantastic geometry, which reminds one of Oriental calligraphy or shadow puppets. Arp seems to come ever closer to those domains. Already his india-ink drawings, the black cadences accompanying Richard Huelsenbeck's *New York Cantata* (1952), came close to a monumental pictorial language. But even apart from the works directly connected with and planned for architecture, Arp's graphic productions seem predestined for interiors and walls, adding a human note and at the same time rhythmic accents harmonizing with the architectural whole. His magnificently soaring simple forms are just as much at home in a wood-panelled peasant house as in a modern city bar or café.

The basic aspiration of the art that for more than four decades has been called "modern" is perhaps to make an invisible reality visible—to discover a visual language capable of capturing the spiritual spheres beyond the world of phenomena. Such an inner vision has been embodied in various ways in the works of Kandinsky, Klee, Mondrian, Brancusi, and Pevsner, to name only a few. Arp, who took this path at an early date, has also been led to a completely new conception of matter. At first, matter was for him a primary element of tension, an autonomous conglomerate whose silent language the artist was to awaken pictorially. In the course of the years he has gradually shifted the emphasis onto the spiritual forces of man, in the feeling that only they have continuous existence. Now matter is subject to the artist's free choice, and is interesting only as a medium for expressing a higher reality. Arp regards this higher reality alone as indestructible and eternal, and everything material as inevitably fragile and transient. His *papiers déchirés*—"torn papers" mark the introduction of the tragic element of transitoriness, of death, into his work: this element is anticipated, included in the composition in advance. This new attitude toward time, and the presence of death in life, was furthered in Arp by a person-

al tragedy—the sudden death (in 1943) of his wife, whose inner light and clarity contributed a quality of faith to his life and creative struggle. The clear and firmly structured *Collages* which he composed, partly in collaboration with her, in his early Zurich period yielded to compositions of pieces of torn material, on which lies the shadow of transience. Thus the spiritual attitude flows from the *process* of work itself. In this connection it may be interesting to quote a remark by which the Danish writer Alexander Partens qualified Arp's artistic methods: "It was the distinction of Jean Arp," he said, "to have at a certain moment discovered that the craft itself is a problem. He was no longer concerned with improving a given aesthetic system, he wanted direct production." Thus the mode of production, the artistic form, and the spiritual attitude were woven into a higher unity. (pp. xvii-xxxiii)

Arp in all his periods is spiritually akin to the German romantics: like them, he endows the created world with a soul, and seeks to establish an essential unity between man and nature. His ironic wit, which reflects a characteristic intellectual freedom and alertness, is also a feature of German romanticism. The fact that along with daring fantasies he creates almost classically pure structures, and that among his works we find joyful marble fruits, illumined by an inner sun, side by side with nocturnal forms, enigmatic and dreamy, may well be rooted in his Franco-Alemanic origin. In 1941-1942 his production was stimulated by the serene beauty that surrounded him at Grasse where he enjoyed a last Arcadian idyll with his wife. But the Mediterranean features of his art are not merely due to external influences, such as his stay at the French coast, or his trips to Greece, where he was deeply impressed by the prehistoric and archaic epochs of Hellenic sculpture. It was within himself that he bore those shapes of simple harmony, such as those primordial vase contours and torso forms that he transmuted into the idol-like image of man, or developed into torso-trees such as the *Daphne.*

The motif of the torso-vase or humanized amphora emerges repeatedly from his earliest period on, and occupies a dominant place in his work, both in two- and three-dimensional treatments. Things and man are fused in simple and pure forms that are reminiscent of the Cycladic idols. Both Paul Klee and Oskar Schlemmer have in this sense brought the vase and man into unity, whereas the undulant body of the guitar, which continually appears in Picasso's work, reawakens only remote and formal—rather than mythical—associations with the primeval human type. But in Arp, after his long wanderings through the world of objects in his Dada period and the world of natural symbolism in the later periods, the slumbering archetype of the human seems to come back to life from the depths of memory. As early as 1916, Hugo Ball had written prophetically: "If I understand him well, he is concerned less with richness than with simplification . . . To form, means for him to delimit himself against the indefinite and the nebulous. He strives to purify the imagination, and concentrates less on exploring its treasure of images than on discovering the basic pattern of these images." These words remain true today. By freely adopting an austere expressive method, Arp has brought about a renascence of essential form in many domains of art. That is why his interest is repeatedly directed toward the early periods of art and thinking, and time and again he returns to the ideas of primitive Christianity and

the pre-Socratic philosophy of nature, to that eternally changing cosmos of Heraclitus, and the *theos agenetos,* the most primitive divine being, which Thales of Miletus describes as "the still unborn God." And like those early ascetics, thinkers, and poets, Arp dreams (with burlesque undertones) cosmic dreams, connections and transmutations. Thus he writes:

> From a sailing cloud a leaf emerges to the surface. The leaf changes into a vase. An immense navel appears. It grows, it becomes larger and larger. The sailing cloud dissolves in it. The navel has become a sun, an immense source, the fountainhead of the world. It radiates. It has become light. It has become the essential.

(pp. xxxiii-xxxiv)

Carola Giedion-Welcker, in her Jean Arp, *translated by Norbert Guterman, H. N. Abrams, 1957, 122 p.*

William Rubin (essay date 1958)

[*The following excerpt is from a highly favorable review of a retrospective of Arp's works at the Museum of Modern Art in New York City. Here, Rubin asserts that the artist's sculptures represent his most important work.*]

The most important works of Arp's early years as a Dadaist in Zurich are the wood reliefs, made by gluing flat cutouts one on top of another. Wood relief, like tapestry and collage, appealed to Arp because it was less linked than painting to realism and illusionism. Tied to the tradition of artisanship and to the notion of the precise machine-made object (important later in Arp's sculpture, as it was in Brancusi's), sawn wood was his antidote to what he considered the excesses of painterly virtuosity. The earliest reliefs, like the *Forest* and the *Portrait of Tzara* (somewhat disfigured by what appears to be a . . . repainting), are less conventional than many which came later in their rejection of the notion of the field. By the word "relief" we ordinarily infer an a priori geometrically shaped field or "ground" from which the "figure" is relieved. In the elimination of the ground and the acceptance of an irregular outer contour Arp's early reliefs move farther away from illusionism and closer to the state of pure objects. Such reliefs were rarer in the twenties, when they tended to be replaced by arrangements set against a conventional rectangular background, sometimes even reinforced by a framing device.

The "automatic drawings" of the Dada years were among the most prophetic of Arp's works. Their starting point was the notion of vitality, the movement of the creative hand. There was no preconceived subject matter, but as the black patterns formed on the surface, they released for Arp a series of poetic associations. Suggestions of plant life, animal forms, human physiognomies and organs began to emerge but were never brought to a literal level, the artist preferring then, as always, the ambiguous form that suggests much but identifies nothing. Many of these drawings appear to us wholly nonfigurative, but for Arp they always implied some relationship, however tenuous or elliptical, to the world of objects. Yet in their uncompromising flatness they are comparable to Mondrian's works of that time and represent a more complete rejection of illusionistic pictorial space than had yet been

achieved by Picasso or Kandinsky. When we compare these drawings with the "automatic" sketches of Miró and Masson made in the following decade, we become aware of their less casual, less accidental character; their contours are firmly and carefully drawn, and the black ink is evenly filled in. It seems that for Arp the data of automatism could not be accepted as freely as it later was by the Surrealists and, even more heroically, by Jackson Pollock. For Arp it was a starting point, but the image was always brought to a level of scrupulous "finish."

It was natural that, on moving to Paris, Arp should have been caught up in the Surrealist movement. In many ways Surrealism constituted a formalization and extension of values implicit in Dadaism. Arp had anticipated Surrealism during World War I by making "automatic" poems as well as drawings, and it might be more correct to say that Surrealism was drawn to him rather than he to Surrealism. He met Breton around the end of 1923 and became a regular member of the group, participating in the first Surrealist exhibition at the Galerie Pierre in 1925. "Surrealism supported me, but did not change me," Arp recalls. "It perhaps emphasized the poetic, associational side of my work." But Arp's development was too self-motivated to be altered by external movements, and it is difficult to perceive any break in his work between the Dada and Surrealist phases or, for that matter, during his later career.

The years 1925-29 were the heroic period of Surrealism, when the ideal of a spontaneous and imaginative art had not yet given way to the Daliesque notion of "hand-painted dream photos." Masson, Giacometti and especially Miró were doing some of their finest work, the last-named assimilating much from Arp into his own style. Around 1930 Surrealism and Arp moved off in different directions. As the rest of the Surrealists surrendered to the new illusionism, only Miró and Arp persisted in the affirmation of the flat picture. Though he continued to show with Surrealists up to their last exhibition, organized by Duchamp and Breton in Paris in 1947, and under their banner at the Venice Biennale, Arp ceased to be an active and intimate member of the group.

While Surrealism made a cult of the dream image, Arp, who curiously never remembers his dreams, preferred to "dream with his eyes open" on the world of natural objects. His turning to free-standing sculpture in 1930 was the natural outcome of his flight from illusionism and the concomitant desire to make his art-work an "object." There is nothing tentative even in the earliest sculptures, the inevitable transition having been in preparation ever since the first wood reliefs. The biomorphic forms remain largely the same, only now they are carved or modeled. Among the less characteristic of his early sculptures, only *Bell and Navels* (1931) is reminiscent of the Surrealist constructions with which Giacometti was occupied. But the possibilities of this direction for free-standing sculpture did not seem to interest Arp.

In both structure and title the *Human Concretions* of 1935 fully confirmed Arp's own direction as a sculptor. "Concretion," he writes, "designates curdling, the curdling of the earth and the heavenly bodies. Concretion designates solidification, the mass of the stone, the plant, the animal, the man. Concretion is something that has grown." This last remark is the key to the great gap that separates Arp and Brancusi, in spite of the superficial resemblance between their work. Brancusi's ascetic sculptures are true abstractions, purified and distilled to the absolute essence of the subject; Arp is less interested in condensing the subject than in discovering its poetic relationships to other things through formal ambiguities. Brancusi's sculptural process is centripetal, demanding reduction to the simplest and most economical forms; Arp's is centrifugal, the work growing outward from a nucleus and incorporating the sensuous and transient in its metamorphoses.

As Arp's concretions expand, they often surround and shape open space. These "holes" give the finished sculpture a more organic character and also intensify the mass. There is no linear contouring or cagelike containment of three-dimensional space such as is explored by metal sculptors like Smith, but rather a classical alternation of solid and void. Only once did Arp experiment with surrounding a three-dimensional spatial core: the forms of the extraordinary *Ptolemy,* an entirely atypical work curiously chosen as the focal point of the museum installation, wind smoothly around its center, rather than grow out from it. The difficulty here lay in making the forms narrow enough to allow the spectator to measure the space in the middle and yet massive enough so that they appeared not simply as frames for that space, but as independent sculptural entities. The solution could only be achieved by perfectly balancing the width of the surrounding forms with the spaces contained by them. The result is an unusual work in which the outer contour of the mass forms a simple and regular symmetrical silhouette, static and absolute in character, while the inner edges of the same mass define biomorphic and asymmetrical spaces, implying change and movement.

The more purely abstract, metaphysical order of these oppositions separates *Ptolemy* from most of Arp's other sculptures, which are charged with allusions, however remote, to the world of real objects. (The name of the ancient astronomer was attached later as a title, simply in reference to its metaphysical theme.) But while *Ptolemy* represents Arp's perfect solution to the problem of containing three-dimensional space, it also represents the *only* solution possible, given the constants of his style. This, I believe, accounts for its uniqueness in his *oeuvre*. His best possibilities of development lay elsewhere.

Arp has created perhaps the last sculptural style deriving from a tradition leading back through Brancusi to the Greeks. As opposed to many forms of modern sculpture introduced by painters (Degas, Boccioni) or translated by sculptors from previously established painting styles (Lipchitz' Cubism), it is inherently sculptural. However, like the style of Brancusi, it is cut off from the new directions of sculpture in the last decade or so. The essential process of the new sculpture, it seems to me, is not carving or modeling, but *manipulating*. While this is patent in metal sculpture (Smith and Stankiewicz), it applies equally to much work in traditional materials like wood (Nevelson and Kohn). The antecedents of the new sculpture are not to be found in the classical tradition of Brancusi and Arp, but in Piccaso's relief constructions of 1914, Arp's early wood reliefs, Giacometti's early sculptures and objects, and Surrealist *objets-trouvés-aidés*. The new sculpture is closer to Picasso's *Bull's Head* (bicycle seat and handle bars) than to his Cubist sculpture.

While a perfect fulfillment of Arp's creative personality,

and perhaps for that very reason, his sculpture, like the mature painting of Mondrian, represents a dead end for the history of art. Unlike "break-throughs" such as the Cubism of 1911-14 or Pollock's work of 1949-51, it cannot serve as a starting point for others. Arp's immediate heirs (Viani, Signori and Gilioli), like the depressing followers of Mondrian, have mistakenly tried to incorporate quantitative elements of his plastic language divorced from the deeply personal poetic sensibility from which they sprang, with cliché-like results.

The smooth, anonymous "finish" of Arp's sculptures reveals nothing of the dialogue with the material expressed by chisel marks, thumb prints or evidences of the blow-torch. In thus submerging the traces of the hand, he counters the main flow of modern art. Even **Stone Formed by Human Hand** seems the impersonal creation of elements. The *papier déchiré* collages, which Arp began in the early thirties, constitute the primary exception to his insistence on finish, and open directly upon the aesthetic concerns of recent painting. "I believe that they represent a transition," says Arp, "from abstract painting to 'liberated' painting, as I should like to call the new American painting." But whatever the place of these torn papers in the immediate heritage of Abstract Expressionism, their role in Arp's *oeuvre* is quite secondary to the stones and bronzes that have been the glory of his recent years. His emphasis on these collages reflects a natural desire to feel attached to the advanced work of younger men. But though his sculptures are remote from the taste of recent avant-garde art, they have a higher *actualité*—the contemporaneity shared by the masterpieces of every epoch, which transcend their moment in history and remain forever fresh and alive. (pp. 49-51)

William Rubin, "Month in Review," in Arts, *Vol. 33, No. 2, November, 1958, pp. 48-51.*

Robert Melville (essay date 1958)

[*In the following excerpt, Melville comments on the consistency of Arp's work and analyzes his wood reliefs of different periods.*]

There is no sharp division between Arp's Dada and surrealist work. It is true that the beginning of the period of his active collaboration with the Surrealists (he participated in the first surrealist exhibition, held at the Galerie Pierre in 1925) coincided with a new informality in the disposition of the forms in his reliefs which was probably provoked by the most famous of surrealist texts—Lautréamont's "as beautiful as the chance meeting of an umbrella and a sewing-machine on an operating table"—but the "chance meetings" were between anonymous forms which only assumed identities after Arp had given them names. He was already constructing pictographs of the world in some of his Dada reliefs, and in his surrealist period these pictographs tended to become more simple in appearance and more economical in the use of expressive symbols.

By the same token, it is not possible to put a precise date to the end of his surrealist period. There is no break in the continuity of his work that can be linked with the year, generally put at 1928, in which he severed his connection with the surrealist group. The reliefs became even more simple and economical after that date, but the spirit in which the surrealist reliefs were conceived was never stronger than in certain examples made in 1931 and 1932. I think it can be said, however, that when he became pre-occupied by sculpture in the round he began to assume that the product of the artist's creative faculty proved itself to be a natural conception if it bore a kind of family resemblance to objects formed by natural processes: he has not been rigid or fanatical about it, but it leaves a mark of sensual solemnity upon even those works which are not noticeably biomorphic, and his later reliefs, which are often very beautiful, have a certain sculptural sumptuousness which was not attained, and certainly not sought, in the reliefs made before 1932.

Arp once said: "My reliefs and sculptures fit naturally in nature." This is true of the sculpture, and I can think of no twentieth-century works which sit more snugly in a patch of grass than his "human concretions" made in 1935; but the painted reliefs are very far from being at home in nature. Their profoundly human qualities are inseparable from the fact that they are highly unnatural-looking objects, and if one came across one of them in a Nature Reserve it would declare that it carried a human message as boldly and intransigently as the painted notice boards that tell one how to get out again.

According to Hans Bolliger, Arp did not begin to make painted wood reliefs until 1917, but Carola Giedion-Welcker assigns the relief called **Forest** to the previous year, and I think it must be a very early example because, unlike the other reliefs of the period, it makes formal allusions to a predetermined subject matter. The tree, the moon, and the dark forest floor were clearly in mind at the time they were shaped, and the work as a whole may well have been conceived as a concretion of the overlapping forms and shallow planes in Rousseau's jungles.

In a larger work called **Plant Hammer,** dated 1917, which was made like the **Forest,** with one piece of wood impacted upon another, the profiles follow a more arbitrary course, and it is evident from the curious and rather strained title, that Arp discovered the subject after examining the finished work. The forms are ambiguous, and I suspect that Arp was attempting through the title to exercise control over the suggestiveness of the image: by identifying the curvilinear silhouettes with plant life he was perhaps hoping to distract attention from their even stronger resemblance to reptilian life. Arp was highly conscious of the magic of words and the weight of associations they carry, and it was his preference for understatement in his titles that turned his reliefs into object-poems. If he had brought the reptilian aspect of the shapes in **Plant Hammer** into the title it would have translated the image into a somewhat banal emblem of good and evil. At all events, he seems to have put a curb on his curvilinear gestures in other Dada reliefs; the curves of **Madame Torso with Wavy Hat** and the superbly inventive raggedness of **Bird Mask** exemplify his ability to exercise some control over shape-making actions which remained essentially arbitrary.

There is a macabre element in **Bird Mask** which he could undoubtedly have nurtured and developed if he had wished. He was on terms of intimacy with Dadas and Surrealists who were practising various kinds of pictorial terrorism and he must have been tempted at every turn. As

a northern artist, he would have been following the line of least resistance if he had allowed the scarifying image to flourish in his work, but macabre and horrific elements play only a minor and scarcely perceptible role in his beliefs.

In the early twenties, he began to devise reliefs composed of several pieces of wood cut into simple shapes and scattered over an irregular or rectangular backboard like a crazy game of checkers. Among the first were the "clock" reliefs in which the hands part company, wander across a face which has lost all its numerals, and "register" biological time by changing their shape and laying eggs. In many that followed, he adopted the convention of the enigmatic encounter, which was being used by other Surrealists for the production of brutal or fantastic relationships in the manner of Lautréamont's famous image. But even those examples which most obviously disclose Arp's use of this system, such as the painted wood **Shirt Front and Fork** and the painted cardboard **Eye and Navel Dress** acknowledge Surrealism more in the relationship between image and title than in the relationship between the forms. The forms are too ambiguous and too remote from illusionism to display outré disruptions of reality: their relationships are never established by perverse interferences; on the contrary, they reflect Arp's vision of a smiling world of elementary forms where nothing is incongruous.

The shirt front in **Shirt Front and Fork** is just as distinctly a human mask, and the fork is equally suggestive of a human arm, but Arp obtains his most far-reaching effects from forms which are neutral and innocuous rather than ambiguous. These wooden blanks or counters look rather like discarded cutouts from simple fretwork panels, and at their most complicated are shaped like bits of kindergarten jigsaw puzzles or fancy biscuits. They are never "readymades" however, and even the plain discs which he has so frequently called navels are always slightly but tellingly out of true, and as soon as he places them on one of his "carefree" grounds they become, in the language of the numinous side of existentialism, rich noughts. His sense of the validity of such forms was probably influenced by Kandinsky's ideas about the spirituality of non-figurative art, and the painted wood relief called **Infinite Amphora** shows how brilliantly he could transform one of Kandinsky's "geometrical situations."

The **Infinite Amphora** is one of Arp's greatest and most poetic works and is achieved by almost farcically simple means. A small, roughly circular disc, painted grey, with two little bulges at opposite points of its circumference, stands for an amphora with a neck at each end; it has been stuck on to a rectangular board painted light blue; the blue ground is broken by two areas of flat white paint which appear to be issuing from the necks of the amphora; they broaden into misshapen triangles as they stream away in opposite directions. The configuration brings to mind Kandinsky's contention that "the impact of the acute angle of a triangle on a circle produces an effect no less powerful than the finger of God touching the finger of Adam in Michelangelo," but Arp does not think in catastrophic terms, and Kandinsky's vision of an overwhelmingly expressive geometry has been re-cast into a marvellous genetical image. In effect, it is a purification of Tintoretto's famous anthropomorphic image of the milky way: it emblemizes a sharper comprehension of the vastness of the universe and a more profound awareness of the mystery of creation. It is an example of what Arp himself once referred to as "games of wisdom and clairvoyance which were to cure human beings of the raging madness of genius and return them modestly to their rightful place in nature."

The **Infinite Amphora** is one of a number of works which might be described as the relief maps of a poetic cosmogony: they appear to relate to Arp's avowed interest in the Pre-Socratic philosophers, and in particular to their speculations upon the originative material of things and the coherence of the natural world.

The ease with which the elementary forms in the reliefs called **Flight of Birds** and **Constellation of Leaves** refer to larger and vaguer entities than those he names, can be partially accounted for by his response to some of the cosmogonical conceptions of the Pre-Socratics. It does not seem to me to be incongruous to relate Arp's simple counters to those "whole-natured forms" which in the cosmogony of Empedocles, had no distinction of parts and represented a stage in both the cosmic cycle and the evolution of living things; and if we permit ourselves to see Arp's counters as the first issue of the originative substance, the board on which he raises them becomes the originative substance itself—the primeval waters of Thales, or the Indefinite of Anaximander, or the void of the Pythagoreans, which had the function of keeping things apart.

Arp usually refers to the simplest of his forms as navels, but they are also "other worlds," and this range of allusiveness is a reminder that Pre-Socratic speculations upon the origins of the universe were colored by analogies with genetics.

His extraordinary ability to scatter forms over a surface "according to the laws of chance" and turn the unexpected into the inevitable is intuitive, unique, and unassailable: nevertheless, he takes a philosophical view of chance, and indicates clearly enough in the following quotation from *On My Way* that he thinks of it as something immensely superior to the merely accidental: *The law of chance, which embraces all laws and is unfathomable like the first cause from which all life arises, can only be experienced through complete devotion to the unconscious.* He is thus able to treat the activity which brings about his "constellations" of forms as a very small and very large event. It is a gambler's throw that obeys the same law which, in the atomic theories of Leucippus and Democritus, causes the intervals between the "innumerable worlds" to be unequal. Arp's sense of placing creates a great stirring and rustling among the forms, as if they were leaves in a summer gale and as if they were stars blown into random clusters by cosmic winds. He is a humorous and undemonstrative deviser of vast conceptions.

We admire in others the evidence of tensions and anxieties and heroic labors that have sustained their venturesomeness, but in Arp we admire a venturesomeness that has involved a surrender to simple states of goodness and happiness and raised his work to the plane of leisure. (pp. 28-33)

Robert Melville, "On Some of Arp's Reliefs," in Arp *by Jean Arp and others, edited by James Thrall Soby, Doubleday & Company, Inc., 1958, pp. 27-33.*

Arp on art:

Art is a fruit that grows in man, like a fruit on a plant, or a child in its mother's womb. But whereas the fruit of the plant, the fruit of the animal, the fruit in the mother's womb, assume autonomous and natural forms, art, the spiritual fruit of man, usually shows an absurd resemblance to the aspect of something else. Only in our own epoch have painting and sculpture been liberated from the aspect of a mandolin, a president in a Prince Albert, a battle, a landscape. I love nature, but not its substitutes. Naturalist, illusionist art is a substitute for nature.

I remember a discussion with Mondrian in which he distinguished between art and nature, saying that art is artificial and nature natural. I do not share his opinion. I believe that nature is not in opposition to art. Art is of natural origin and is sublimated and spiritualized through the sublimation of man.

> *Jean Arp, in an excerpt, translated by Ralph Manheim, from his* On My Way: Poetry and Essays, 1912 . . . 1947, *edited by Robert Motherwell, Wittenborn, Schultz, Inc., 1948, pp. 50-1.*

Herbert Read (essay date 1968)

[*A prominent English novelist, poet, and art historian, Read was best known as an outspoken champion of avant-garde art. Several convictions are central to his aesthetic stance, the foremost being his belief that art is a seminal force in human development and that a perfect society would be one in which work and art are united. Read presented his theories in numerous highly-regarded studies, including* The Meaning of Art *(1931),* Education through Art *(1943),* Icon and Idea *(1958), and* The Forms of Things Unknown *(1960). In the following excerpt, Read analyzes Arp's evolving style in his various reliefs, collages, sculptures, and torn-paper compositions.*]

Generally speaking, Arp's reliefs are made by the superimposition of two or more layers of material (wood or metal). That is to say, with a few exceptions such as the **Schematic Composition** of 1943, they are not reliefs carved from a single solid material, as are, for example, the reliefs of Ben Nicholson. They are, strictly speaking, 'assemblages' of plywood or sheet metal.

The earliest surviving reliefs of this kind are two examples in the collection of François Arp, the **Stag** of 1914 and the **Abstract Configuration** of 1915; their extreme incongruity of style shows Arp still groping towards an appropriate use of the medium. This he achieves in the **Forest** of 1916, four pieces of painted wood cut (presumably by a fret-saw) into forms that suggest leaves and a tree, glued together in a compact mass. A **Portrait of Tzara** of the same year is similar in technique and form.

It is necessary to make a distinction between the technique used in these reliefs and the better-known technique of 'collage'. Collage is a technique first introduced by Picasso (inspired perhaps by Braque's use of certain 'graining' or 'combing' techniques) and first took the form of gluing a piece of oil-cloth to his *Still-Life with Chair-Caning* in 1911-12 (the oil-cloth is printed with a pattern of chair-caning). Thereafter Picasso began to use a variety of materials (especially paper and cardboard), generally glued to a canvas base, and this is what constitutes the technique of collage. Arp also used this technique, as we shall see presently. Although the general idea of assembling ready-made materials in a composition came from the Cubists, Arp seems to have perfected his reliefs independently. Picasso's *Mandoline* of 1914, which is nearest in technique, is a construction made from rough pieces of coloured wood glued together, but if it is not to be called a 'construction', it is an 'assemblage' rather than a relief. The difference is that Picasso leaves his raw materials in their rough and 'ready-made' condition and seems to throw them together with superb nonchalance, whereas Arp seeks precision of form and masks the raw material in paint. In some of his reliefs Arp respects the prime nature of the material—for example, in the **Torso,** a relief in wood of 1920, or later still in the **Summer Metope** of 1946, a relief which beautifully exploits the graining of oak. But from the beginning there is a strain of perfectionism in Arp's nature that has no sympathy for the 'rough and the ready'. Dada, Arp once wrote in a letter to Brzekowski, is for nature and against 'art'. Dada is, like nature, 'direct', and seeks to give everything its essential place in nature. 'Dada is for infinite sense and definite means.' All Arp's early reliefs have the precision of natural forms (such as leaves, flowers, fruits, seeds, etc.). But between the natural form and the work of art there is the play of Arp's imagination.

Arp continued to make reliefs all his life—the monumental **Constellation** at the Harvard Graduate Center (1950) is a wood relief. He used relatively simple configurations such as the **Forest,** and complex assemblies such as the **Plant Hammer** (1917). The most precise and yet the most evocative of the early reliefs are the **Mask** of 1918 and the **Bird Mask** of the same year and the rococo **Madame Torso with Wavy Hat** (1916). In these three pieces the grain of the wood is fully exploited.

The **Egg Board** of 1917 and two **Clocks** of 1924 show a development, perhaps under Surrealist influence, towards the grotesque, using human forms or features. This phase reaches its extreme limit in the **Shirt Front and Fork** of 1924 and the **Mountain Table Anchors Navel** of 1926 (which is painted on cardboard with cut-outs, so not perhaps strictly speaking a relief). Then Arp begins to return to his original organic simplicity—the **Forks and Navel** of 1927, the **Shirt and Tie** of 1928 (not organic subjects, but given organic form), the beautiful **Infinite Amphora** of 1929, which Robert Melville has rightly described as 'one of Arp's greatest and most poetic works . . . achieved by almost farcically simple means' [see excerpt dated 1958], and the **Flight of Birds** and the **Constellation of Leaves** (both of 1930), the **Mythical Composition** of 1929-52—a simplicity he was never afterwards to abandon. Indeed, there is not much point in carrying this analysis of the wood reliefs any further, because though from this time until the end of his life Arp continued to make reliefs in-

cluding some in materials other than wood such as 'pavatex' (a plastic), bronze and aluminum, and though these reliefs have infinite variety, they do not depart from the simplicity of basic organic forms. There are one or two exceptions which seem to be inspired by the *papiers déchirés* (e.g. *Tournament* of 1940 and a relief of 1948), but these are experiments which were not pursued. Also exceptional but closely identified with the wood reliefs are the string reliefs of 1928-30, the *Dancer* of 1928, the *Head and Leaf* of 1930. They consist of string shaped to follow in outline configurations similar to those already evolved in the wood reliefs. The string shapes are glued or sewn to a canvas background. Arp seems to have abandoned this experiment after 1930. (pp. 56-76)

The transition from relief-sculpture to sculpture 'in the round' took place in the years 1930-31, by way of two pieces which are in effect reliefs mounted on a pedestal, in itself another relief. *Shell Profiles* (1930) consist of two almost identical bird-like profiles in painted wood joined together, standing on a base of similar configuration. *Hand Fruit* of the same year, also in painted wood, has a similar configuration though presumably the title indicates its origin in fruit-shapes (as the title *Shell Profiles* may have some connection with shells rather than birds— the shapes in both cases do not differ much from what Arp was later to call 'neutral forms' (e.g. *Constellation of Neutral Forms,* 1953). Arp acknowledged the ambiguity of his forms and of his titles in such a piece as *Bird-Like Cloud* (1943). Titles, as in the case of Paul Klee, belong to verbal poetry: shapes evolve, in art as in nature, without predetermined names. Arp himself explains the process:

> Often some detail in one of my sculptures, a curve or a contrast that moves me, becomes the germ of a new work. I accentuate the curve or the contrast and this leads to the birth of new forms. Among these, perhaps two of them will grow more quickly and more strongly than the others. I let these continue to grow until the original forms have become secondary and almost irrelevant. Finally I suppress one of the secondary or irrelevant forms so that others may become more apparent. Sometimes it will take months, even years, to work out a new sculpture. I do not give up until enough of my life has flowed into its body. Each of these bodies has a definite significance, but it is only when I feel there is nothing more to change that I decide what this is, and it is only then that I give it a name.

This statement explains how a form originally suggested by a bird or a shell can slowly be transformed into a form suggesting a fruit or a cloud. This process of transfiguration is based on a philosophy of nature, a morphology, which assumes that all the forms in nature are modifications of a few basic forms, a doctrine which Arp almost certainly took from Goethe. (pp. 85-9)

The next stage in the transition to sculpture 'in the round' is represented by several works of the years 1930-32 to which Arp was afterwards to give the general description of 'Concretions'. The plaster *Head with Annoying Objects* (1930) is the first of these. It suggests a flattened skull to which three leeches are clinging, though no doubt the 'germ' of this work had pleasanter associations. *To Be Lost in the Woods,* a bronze in three separate assembled forms, is very similar but comes two years later. Somewhat different, and nearer to the reliefs, are the *Figures,*

One Large and Two Small and the *Bell and Navels* of 1931. Both these are in painted wood and are not so unified in composition as the two groups just mentioned: the 'figures' still require a base, as in the *Shell Profiles* of the previous year. Though his works are generally shown on a pedestal of some kind, from 1930 onwards Arp was working towards a conception of sculpture as a free form with its own centre of gravity and often reversible.

There follow, throughout the thirties, a series of figures in which the form is unified or integrated into a single *Gestalt* (configuration). The *Torso* of 1931, of which there are versions in plaster, marble and bronze (an edition of three) is the prototype of these pieces, and indeed the prototype of what was to remain Arp's characteristic sculptural form for the rest of his life. In a similar style are the *Human Concretions* of 1934 and 1935. . . . Arp attached a special importance to this word 'concretion':

> In 1930 I went back to the activity which the Germans so eloquently call *Hauerei* (hewing). I engaged in sculpture and modelled in plaster. The first products were two torsos. Then came the 'Concretions'. Concretion signifies the natural process of condensation, hardening, coagulating, thickening, growing together. Concretion designates the solidification of a mass. Concretion designates curdling, the curdling of the earth and the heavenly bodies. Concretion designates solidification, the mass of the stone, the plant, the animal, the man. Concretion is something that has grown. I wanted my work to find its humble place in the woods, the mountains, in nature.

Metamorphosis (Shell-Swan-Swing) follows in 1935—a plaster original, five bronzes, and another version of the same theme in an edition of three bronzes. The sub-title suggests the progressive stages of the metamorphosis, of the process of concretion. (pp. 91-3)

The limestone *Giant Seed* (nearly five feet high) is a transformation by enlargement: the seed is magnified until it becomes a giant reservoir of vital energy. The *Crown of Buds* (1936) is a transformation by proliferation: the vital energy presses outwards through several breast-like protuberances. There is a second version in cast cement and an edition of three bronzes. *Giant Pip* (limestone) in the Musée d'Art Moderne is another version of the idea embodied in *Giant Seed. Stone Formed by the Human Hand* (1937-38), carved in Jura limestone, and *Shell* (1938) and *Shell Crystal* (1938), both bronzes, are relatively small, compact representations of organic form. *Marital Sculpture* (1937) and *Landmark* (1938) are lathe-turned pieces executed in collaboration with Sophie Taeuber.

The most distinctive piece of this decade is perhaps the *Growth* of 1938, a white marble original in the Solomon Guggenheim Museum with three bronze versions (one in the Philadelphia Museum of Art). This is a subtler variation of the embodiment of vital energy already noted in the *Crown of Buds:* the energy no longer turns in on itself in endless repetition, but thrusts upwards into the light in rhythmic curves. *Awakening,* of the same year, is a simpler version of the same theme.

The sculpture of the remaining twenty-five years of Arp's active life does not show any violent departure from the prototypes established in the thirties. There are pieces which revert to an almost geometrical severity, such as

Mediterranean Sculpture I, also called *Orphic Dream,* of 1941, and pieces of almost rococo exuberance such as the *Human Lunar Spectral* of 1960 (a carving in marble). If I were asked to choose a representative piece which seems to concentrate all Arp's formal invention in one coherent image, it would be the *Ptolemy* of 1953 (limestone; three versions in bronze). I do not know which of the many Ptolemys Arp had in mind when giving this title to the piece—perhaps Ptolemy II (Ptolemacus Philadelphus), the patron of Euclid and Theocritus. The organic rhythm which it embodies is no longer reminiscent of a particular natural phenomenon—bud or breast, leaf or shell; it takes the form of a re-entrant coil and is perhaps suggestive of the ventricles of the heart more than anything else. It seems to beat with an inner life, and at the same time to rest in eternal stillness.

Arp had always liked to see his sculpture in a natural setting. Towards the end of his life, in his garden in the Ticino, he carved large slabs of stone into circular shapes like millstones, pierced with his characteristic motives. They were made in this shape so that they could be rolled from one position to another, to vary the natural background from time to time. The Ticino is a region that makes inspired use of the stone from its mountains for walls, posts, pergolas, etc. Arp loved this stone country, where his work merged insensibly into the natural background. There the organic growth of his work came to a final fruition. (pp. 93-102)

Arp tells us that it was in 1914, at Paris, rue du Mont-Cenis, that he made his first collages.

> They were very different from the *papiers collés* of the Cubists. All that remains of these collages are some small photographs my brother made of them. Herbin, who lived near-by in the *Bateau-Lavoir,* place Ravignan, introduced me to Léonce Rosenberg of the Galerie l'Effort, 19, rue de Beaune. He showed an interest in my collages and spoke vaguely of a contract. Events were to bring to an end these vague projects. These collages were static constructions, symmetrical, porticos of pathetic vegetation, an entry into the kingdom of dreams. They were executed in coloured papers of even black, orange or blue. Although Cubist paintings interested me a great deal, there is no trace of their influence in my collages.
>
> In 1915, at Zürich, I made a series of abstract collages, or rather *concrete* collages, because there is not a vestige of abstraction in these collages. In making use of printed paper, printed fabrics, papers and fabrics of every colour that chance—I assure you that chance is also a dream—put in my way, these multi-coloured materials were disposed in tumultuous diagonals that already announced the boum-boum of the big fantastic drum of Dada. The joy of destruction, to explain which would lead me too far astray, let very few of them escape.

An *Abstract Composition* of 1915 is the earliest of these collages to survive. It is made of paper, cardboard and fabric and is similar in composition to the collages that Picasso and Braque made from 1912 onwards; it is even closer to the collages of Juan Gris of 1913-15. (p. 107)

Chance, as I have already pointed out, played a fundamental part in Arp's philosophy of art. In a conversation with Bryen, held on All Saints' Day, 1955, and published in the

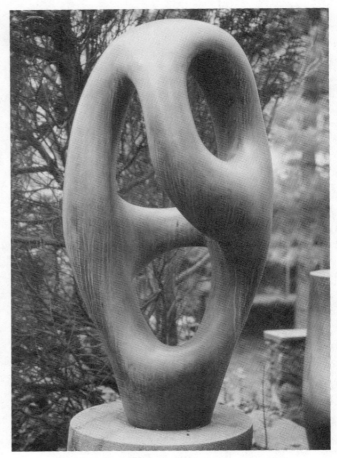

Ptolemy I (1953)

January, 1956, issue of *XXe Siècle,* Arp confesses that his first collages were made for 'un ami occultiste' ["an occultist friend"], and in the statement already quoted [immediately above] which dates from the same year speaks again of these occult influences.

> The absolute haunted me. I stuck together, unstuck, began again and destroyed, destroyed and began again, but the decomposition, the eventual decay of all human effort, led me, in 1930, to tear my papers instead of cutting them with a guillotine. It was in 1930 that I made the 'papiers déchirés' that Jeanne Bucher exhibited for the first time. Among these torn-up papers, these bits of paper, there were some that lifted a finger in the air, Zen papers, papers outside time and space. All this development took place without my knowledge. The tearers of paper were to become legion, and were the forerunners of tachism.

Arp here shows himself familiar with Zen Buddhism, presumably thanks to the unnamed 'ami occultiste'. This friend would no doubt be familiar with the *I Ching,* the Chinese *Book of Changes,* which might be called the great classic of the philosophy of chance. It has been a vital influence in China for more than three thousand years (though no doubt its oracular wisdom does not appeal to the dialectical materialists who dominate that country

now). The Book is based on the belief that the chance aspect of events is significant.

> What we call coincidence seems to be the chief concern of this peculiar (Chinese) mind, and what we worship as causality passes almost unnoticed. . . . The matter of interest seems to be the configuration formed by chance events in the moment of observation, and not at all the hypothetical reasons that seemingly account for the coincidence. While the Western mind carefully sifts, weighs, selects, classifies, isolates, the Chinese picture of the moment encompasses everything down to the minutest nonsensical detail, because all of the ingredients make up the observed moment.

These sentences are quoted from Jung's Foreword to the English translation of the *I Ching,* and a further passage must be quoted because it exactly describes the philosophy behind Arp's *déchirages:*

> This assumption involves a certain curious principle that I have termed synchronicity, a concept that formulates a point of view diametrically opposed to that of causality. Since the latter is a merely statistical truth and not absolute, it is a sort of working hypothesis of how events evolve one out of another, whereas synchronicity takes the coincidence of events in time and space as meaning something more than mere chance, namely, a peculiar interdependence of objective events among themselves as well as with the subjective (psychic) states of the observer or observers.

To consult the *Book of Changes* (for its oracular wisdom upon any particular occasion) the consultant throws a bundle of yarrow-sticks of varying lengths or three coins *at random,* and is directed to a particular part and section of the Book by the position into which the sticks or the coins fall. The procedure is somewhat complicated and does not concern us here; what is significant is the philosophy behind the procedure, for Arp assumed in his *papiers déchirés* that a work of art could be made in exactly the same way. Tear up the paper and throw the pieces on the floor, and the position they assume will have some occult significance.

Whether this significance is aesthetic or not we need not stop to consider: it is sufficient that the chance composition is meaningful, and this supposition agrees with all those theories of art, from Leonardo to Jackson Pollock, that attach importance to inarticulate form-experiences— the theory that certain art forms are *'gestalt free'*—that is to say, essentially formless or inarticulate but nonetheless significant at an unconscious level of the psyche.

A further point to emphasize, of which Arp was well aware, is that works of art produced by these means are *impersonal.* For this reason Arp would usually not sign them.

(pp. 109-14)

Arp also treated his *papiers collés* as expendable. He says that in this respect he followed the example of the Oceanic people who never, in making their masks, worried in any way about the durability of their materials, using perishable things such as shells, blood and feathers. There are no rules, no limits; any kind of material can be used, and these materials can be used inconsequentially, as pictures or as reliefs, in colour or in black and white (which Arp said he preferred because it is like writing, the usual medium of communication between human beings).

There is a certain kind of mysticism in this attitude to the artist's materials, and Arp, in another statement, relates his collages to his poems, his 'automatic writing'. He discovered that in tearing up a piece of paper or a drawing one could open the way to the very essence of life and death.

> I allow myself to be guided by the work at the time of its birth, I have confidence in it. I don't reflect. The forms come, pleasing or strange, hostile, inexplicable, dumb or drowsy. They are born of themselves. It seems to me that I have only to move my hands. These lights, these shadows that 'chance' sends us, should be welcomed by us with astonishment and gratitude. The 'chance', for example, that guides our fingers when we tear paper, the forms that then take shape, give us access to mysteries, reveal to us the profound sources of life. . . . Very often, the colour which one selects blindly becomes the vibrant heart of the picture. . . . It is sufficient to close one's eyes for the inner rhythm to pass into the hands with more purity. This transfer, this flux is still easier to control, to guide in a dark room. A great artist of the Stone Age knew how to conduct the thousands of voices that sang in him: he drew with his eyes turned inward.

Though chance and indeterminacy are of the essence of Arp's *papiers déchirés* and collages, nevertheless they fall into three or four distinct groups—the collages as invented by Braque and Picasso (though as Arp pointed out, the collage was not a new invention—Byzantine mosaics are essentially collages); the 'rectangles arranged according to the laws of chance' which are made of cut paper; the *papiers déchirés* made from 'clean' paper; the *papiers déchirés* made from paper which had previously been drawn on; and finally what might be called *collages en relief,* of which the best example is the **Mutilé et apatride** of 1936.

When Bryen once asked Arp if his collages were a visual poetry, he replied: 'Yes, it is a poetry made by plastic methods.' (pp. 115-18)

> *Herbert Read, in his* The Art of Jean Arp, *Harry N. Abrams, Inc., 1968, 216 p.*

William S. Rubin (essay date 1968)

[*In the following excerpt, Rubin assesses Arp's works and discusses his involvement in the Dadaist movement.*]

[If Marcel Duchamp] originated the *mentalité* and much of the iconography of Dada and Surrealism, Jean Arp was the first major contributor to its specifically formal vocabulary. He confirmed the possibility of a *peinture-poésie* by charging his work with allusive subject matter and at the same time preserving a nonillusionist formal purity uncompromised by the forced and self-conscious literary complications that vitiate some Dada and Surrealist art. His work seemed equally at home with the Surrealists and with the Abstraction-Création group; it was alone in appealing equally to Mondrian (who saw Arp's reliefs as "neutral," pure plastic forms "against a neutral background") and Ernst (who spoke of Arp's "hypnotic language" that "takes us back to a lost paradise" and reveals "cosmic secrets"). (p. 75)

Though many Dadaist and Surrealist artists were practicing poets, Arp is one of the very few whose poetry stands in both quality and quantity as an important contribution in its own right. The involvement of the painters of these movements with poetry produced a variety of rapports between the two arts, some of which endowed their *peinture-poésie* with new and unexpected dimensions, but others of which tended to vitiate their painting through a dilution of esthetic modes. Arp's collages, reliefs, and sculpture share with his poetry an iconography—e.g., navels, mustaches, and clouds—a gentle whimsy, and a feeling of naturalness, but nowhere is their plasticity compromised.

Arp's definitive pictorial language did not emerge until 1915, and it is difficult to study its earlier phases because very little work of his youth is extant. His disdain for this early work led him to destroy much of it and allow the rest to be lost, so that the only evidence we possess of his style in the immediately prewar years are some small portrait drawings and nudes reproduced in *Der blaue Reiter* (1912) and in various spring and fall numbers of *Der Sturm* for 1913. These drawings are all naturalistic; the contours are loose and sketchy and the spotting of darks unsure. Those reproduced in the autumn of 1913 are completely linear and more open in their sketchiness, identical in style with engravings of horses done the following year and later used as illustrations for a book by Huelsenbeck. From this it is evident that both the rectilinear and biomorphic styles of Arp's Zurich period were the result of a radical conversion during the winter of 1914-15 rather than of a long process of gestation.

Arp's first art studies were at the School of Applied Arts in Strasbourg, which he attended in 1904; that same year, he visited relatives in Paris, where he had his first contact with modern painting. Then followed two years at the Weimar Art School and a year at the Académie Julian in Paris. Between 1903 and 1912, his family sojourned frequently in Weggis, Switzerland, where he worked in the studio of Franz Huf. There he made the only sculptures he was to do before the age of forty-three, when, already a major figure in modern art, he began again to work in the round. On his return to Switzerland in 1915, Arp carefully sought out and destroyed all these early sculptures—or at least he thought he destroyed them all. One very small portrait has recently come to light, and was in his atelier during the years before his death. It shows him working, as in his drawings, in a figurative vein, with a slight flattening of the planes and a tendency to exaggerate and twist the features in a manner related to the early *Brücke* phase of German Expressionism.

In his crucial formative years just before World War I, Arp was deeply impressed by the painting of the Cubists and Kandinsky—which somewhat explains the bipolarization of his work during 1915 and 1916, just after he had relinquished Expressionist naturalism. He had been a student in Paris when the first Analytic Cubist pictures were being painted, and in subsequent years he continued to follow the development of Cubism closely. His rectilinear collages and paintings of 1915-16 suggest that the Cubists (particularly Picasso) gave him the idea of an architectural grid pattern and encouraged him to press forward radically in the direction of greater abstraction (his meeting with Apollinaire in 1914 was important in this regard). Analytic Cubism contained much that Arp felt constrained to re-

ject: vestiges of luminous illusionistic space, suavity of brushwork, and refined "cuisine." Synthetic Cubism, which began to emerge in the wake of the collage late in 1912, was more to his liking, for it flattened the space of the picture, carried it evenly to the edges (in contrast to the dissolving or "fadeout" in earlier Cubism), and suppressed niceties of brushwork and impasto. Collage, however, interested him even more, providing as it did a still better means of eliminating "cuisine" and rendering execution more impersonal. But by the outbreak of World War I, Arp was searching for something still more anonymous and collective, still more ascetic and even antiseptic than anything he could find in Cubism.

In the catalogue of an exhibition of his geometrical *papiers collés* and tapestries (and works by his friend Otto van Rees) held at the Tanner Gallery shortly after his arrival in Zurich in 1915, Arp describes his work in terms of simple constructions of "lines, surfaces, forms, and colors." They strive, he continues, to "surpass the human and attain the infinite and eternal. They are a negation of man's egotism." It was natural that this desire for an impersonal, communal art should have led Arp to collaborate with other artists . . . and to media more associated with artisanship than with fine art. Throughout his Zurich period, and for many years after, he abstained not only from sculpture but from easel painting. His wood reliefs, tapestries, and collages required, if not the mediation of another party (the weaver or the carpenter), at least that of a mechanical operation:

> We searched for new materials which were not weighted down with tradition. . . . We embroidered, wove, painted and pasted static geometric pictures. Impersonal severe structures of surfaces arose. All accident was excluded. No spots, tears, fibres, imprecisions, should disturb the clarity of our work. For our paper pictures we even discarded the scissors with which we had first cut them out since they too readily betrayed the life of the hand. From this time on, we used a paper-cutting machine.

But even as Arp was cutting these rectilinear collages, he had begun to explore another, less geometrical, more organic language of forms, the antecedents of which were to be found not in Cubism but in Kandinsky and, to a lesser extent, in Art Nouveau. By the end of 1916, biomorphism had triumphed in Arp's work, and rectilinear forms, associated with his collaboration with Sophie Täuber, disappeared except as framing devices.

Except for the work of Henry van de Velde, Arp has had nothing but disdain for Art Nouveau. It was the plastic language of his parents' generation, and he found its fluency abhorrent, wanting for himself something simpler and more abstract. Arp's own position notwithstanding, we cannot overlook a certain affinity of forms. And it is unquestionable that Arp digested certain elements of Art Nouveau, if only unconsciously; a young artist who was thirteen at the turn of the century and who traveled widely in the next decade could not have escaped being exposed to Art Nouveau in a variety of forms. Moreover, it is probable that a visit during his student days in Weimar to an exhibition of works by van de Velde had a special effect on him. No other artist connected with Art Nouveau used its stylistic resources in a manner so like that biomorphism which crystallized in Arp's work some eight years later.

Arp's mature work bears the same elliptical relationship to the uncomplicated, highly abstract organic language of van de Velde as Miró's painting does to the more prolix and ornamented Art Nouveau of his Spanish compatriot Antoni Gaudí. (pp. 75-8)

[Arp's] earliest extant relief, *The Stag,* defines quite clearly the major parts of the animal's body, including its antlers. However, the contours have been transformed and the masses assimilated in a manner that is very abstract and wholly in character with Arp's subsequent Zurich work. Markedly biomorphic shapes make their first appearance in *Forest* of 1916, but here they are still specifically identifiable as the moon and its halo. Only in the reliefs that follow does the biomorphic shape become ambiguous and the motif indeterminate and allusive.

The Stag and *Forest* are good examples of the two ways Arp has handled the wood relief throughout his career. In *The Stag* the animal's shape is an empty space *cut out* of the wood panel, while in *Forest* the moon and trees are independent shapes of wood, *on top* of the rear plane, that advance toward the spectator. The outside contours of both these reliefs, like most of those done in Zurich, are irregular and meandering. This rejection of the conventional rectangular field gives them a fresher, more unexpected air than most of the reliefs of the 1920s, and at the same time brings them closer to sculptural objects than to paintings.

Arp's first relief free of the pointed naturalistic references still manifest in *Forest* is *Portrait of Tzara,* which he did late in 1916. In this work only parts of the outer contour and the shape on the right (perhaps derived from an eyebrow) have even an elliptical relationship to identifiable subject matter. The same is true of *Plant Hammer* (1917), which is built on an opposition of blunt, straightedged forms (vaguely recalling hammers) and meandering plantlike contours. All these reliefs were painted in bright flat colors taken from Synthetic Cubism, in a technique that, except for occasional stippling, displays no nuances and leaves no trace of the brush.

One of the earliest unpainted reliefs is the haunting *Bird Mask* of 1918, which contains a macabre element rare in Arp's work. He might have developed this element had he so wished, for, as Robert Melville observes, "he was on terms of intimacy with Dadas and Surrealists who were practising various kinds of pictorial terrorism and he must have been tempted at every turn. As a northern artist, he would have been following the line of least resistance if he had allowed the scarifying image to flourish in his work." But it was not to be, and the macabre has remained for him something marginal.

Simultaneously with the reliefs, Arp executed a series of "automatic drawings" that are among the most prophetic works of his Dada years. Their starting point was the notion of vitality, the movement of the creative hand. There were no preconceived subjects, but as the patterns formed on the surface, they provoked poetic associations. Intimations of plant life, animal forms, human physiognomies and organs began to emerge but were never brought to a literal level, the artist preferring always the ambiguous form which suggested much but identified nothing. The pencil outlines once drawn, he filled in the contours with black ink, often changing and adjusting them, and even

eliminating shapes as he brought the drawing to completion. Arp has given us an insight into this associational and improvisational methodology as it functioned in connection with the work [*Vegetation*]:

> The black grows deeper and deeper, darker and darker before me. It menaces me like a black gullet. I can bear it no longer. It is monstrous. It is unfathomable. As the thought comes to me to exorcise and transform this black with a white drawing, it has already become a surface. Now I have lost all fear and begin to draw on the black surface. I draw and dance at once, twisting and winding, twining, soft, white flowery round. A snakelike wreath . . . turns and grows. White shoots dart this way and that. Three of them begin to form snakes' heads. Cautiously the two lower ones approach one another.

Many of these drawings appear nonfigurative to us, but for Arp they always implied some relation, however tenuous, to the world of recognizable things. In their uncompromising flatness they are comparable to Mondrian's works of that time, and they represent a more complete rejection of illusionistic pictorial space than either Picasso or Kandinsky had yet considered. (pp. 79-80)

William S. Rubin, "Jean Arp: The Dada Years," in his Dada and Surrealist Art, *Harry N. Abrams, Inc., 1968, pp. 75-81.*

Janet Landay (essay date 1984)

[*In the following excerpt, Landay uses three plaster sculptures donated to the Detroit Institute of Arts—* Pistil *(1950),* Entre Lys et défense *(1956), and* Demeter *(1961)—to assess possible influences on Arp's evolving style and the capacity of his works to evoke multiple associations.*]

In 1974, the Detroit Institute of Arts received a gift of three plaster sculptures by Jean (Hans) Arp: *Pistil, Entre lys et défense,* and *Demeter.* These works were generously donated to the museum by the artist's widow, Marguerite Hagenbach-Arp, who decided to give to public collections many of the plaster pieces that remained in Arp's studio at the time of his death in 1966. (p. 15)

By the very nature of their forms, subjects, and materials, these plasters from the last period of Arp's career exemplify all the major characteristics of the artist's style in freestanding sculpture. Although he began to make fully realized three-dimensional sculpture only after 1930, prior to that time Arp had experimented with the relatively flat form of sculptural relief in works such as *Têtestabile,* 1926. His move to freestanding sculpture marked a transferral of ideas to another dimension rather than any break with earlier aesthetic premises formulated during the preceding two decades. Throughout his long career, Arp was committed to the continual exploration of fundamental forms, natural growth, and metamorphosis—an approach that led him to a concept of the reintegration of man and nature. In the spirit of the Dada movement he helped to found in 1915, Arp also believed in and celebrated the irrational rather than the rational and was devoted to the synthesizing of unlike things.

The Surrealists' fascination with the realm of dreams was

also essential to Arp, who wrote a great deal of both poetry and imaginative prose throughout his life. A statement of 1955 reveals that these same concerns remained central to him during the period in which the Detroit plasters were made:

> I dream of the flying skull, of the umbilical gate and the two birds that form it. Or a leaf that turns into a torso, of yellow spheres, of yellow planes, of yellow, green, and white time, of the essential clock without hands and face. I dream of the inner and of the outer, of above and below, here, there, today, tomorrow, increase, interweave, disintegrate. This transcending of frontiers is the path that leads to the essential.

The three Detroit plaster sculptures are all biomorphic forms, undulating with a pulsating rhythm and creating a vibrant equilibrium and self-contained harmony. Their representational content establishes visual metaphors for biological growth and the creative process. Because all living things continually grow and evolve, Arp worked to create an art of new and constantly changing forms. All three sculptures are about growth, rebirth, and transformation. Their subjects are those of fertility and regeneration, and their forms derive from a morphological system which maintains that all things in nature, including human beings, grow out of a few basic shapes.

The medium of plaster is well-suited to Arp's concerns. Although we are accustomed to seeing his finished work in bronze or stone, most of his three-dimensional sculpture was originally made in plaster. Arp first learned the technique of plaster-modeling from the Swiss artist Fritz Huf in 1910-11. When he began sculpting in the round in 1930, he returned to plaster because of its great versatility. He would begin his work by building up shapes with wet plaster, then carving and smoothing the forms when dry. The alteration between modeling and carving was continually repeated until the piece reached completion. The process was both addictive and reductive, allowing for large alterations of form (Arp occasionally used a saw to lop away whole sections of a piece) as well as more subtle changes. This process of continual adjustment imitates nature's process of continual change, thereby contributing to the alliance between art and nature that is central to Arp's work. And the stress on nature is entirely in keeping with Arp's Dada roots: "Dada is for nature and against 'art.' "

Once the plaster was completed, Arp would keep it in his studio until he wished to exhibit it or until a collector expressed interest in it, at which time he would have it fabricated in a more durable material. Most of Arp's sculpture has been created in multiple versions, with a particular form varying both in size and medium. With the exception of soft stone, which he enjoyed carving himself, he appears to have had little preference for one material over another. Arp retained the original plasters in his studio, sending out a new plaster cast of the form for translation into bronze or stone. Thus the three plasters discussed here are in fact more "original" than his sculptures in other materials, because they were made entirely by his own hand.

The earliest of the Detroit sculptures is *Pistil;* it dates from 1950. The title is characteristic of Arp's choice of words to associate with his works. A pistil—consisting of stigma, style, and ovary—is part of the reproductive system of the flower. At the simplest level, this work relates to floral reproduction, as indeed the overall vertical configuration of the piece suggests the appearance of a pistil. If one looks further, however, additional layers of meaning are revealed. One of the characteristics of the flower's reproductive system is that it contains both the male and female functions (the stamen and the pistil) within each plant. Another look at *Pistil* reveals a similar possibility in its suggestion of human sexuality. The vertical form of the piece easily suggests a phallic image and, simultaneously, the curvilinear oval shape at the top of the piece, with its central indentation, can also be read as a vaginal form. When viewed from the opposite side, the sculpture may also be interpreted as a twisted human torso. This combination of human and vegetal imagery in the same forms affirms the commonality between man's nature and that of plants: both are part of the natural world, both develop from fertilized seeds, both grow, evolve, and die.

Arp has often been counted as one of the primary Surrealist artists, and it is clear that the Surrealist style of the 1930s was an important element in his sculpture. While the three-dimensional medium did not originally lend itself to the "automatic" techniques espoused by André Breton in the early years of Surrealism, the illusionistic painting styles of Yves Tanguy, René Magritte, and Salvador Dali in the late 1920s all suggested ways of rendering unsettling metaphoric images in concrete form. By 1930 some artists were making "Surrealist objects," which were three-dimensional collages of incongruous found objects, but others, notably Alberto Giacometti, sculpted haunting, disturbing works based on suggestive juxtapositions of semi-abstract forms. If one looks at the sculptures Arp created between 1930 and 1932, it is apparent that his efforts were in keeping with the Surrealist endeavor. *Head with Annoying Objects,* 1930, for example, suggests the disconnected body parts and potent sexual imagery characteristic of so much Surrealist art.

By 1932, however, overt Surrealist content in Arp's sculpture had already waned and he began to make semi-human, semi-vegetal abstractions which he called "concretions." At the same time he became involved with a number of artists in the group *Cercle et Carré,* founded by Michel Suephor in 1929, as well as those in *Abstraction-Création,* a movement led by August Herbin and Georges Vantongerloo. Both groups were dedicated to abstract painting and sculpture, and Arp remained friends with many of these artists for the rest of his life.

The potential for a single form to assume a number of different identities is an assumption underlying all of Arp's art. It corresponds to his working method, in which new shapes are "discovered" out of essential biomorphic forms. This assumption also corresponds to a philosophy which holds that all natural shapes are modifications of a few basic forms. This doctrine originated with Johann Wolfgang von Goethe, the eighteenth-century naturalist and artist who was one of the first to theorize about the nature of cellular growth. Goethe developed a view of the world based on dynamic change, in which process, growth, and development determine the identity of living organisms. Arp would have found a kinship of ideas with Goethe in, for example, the following passage:

> the organic parts of a plant—leaves and flowers, stamens and pistils, the great variety of covering tissues and whatever else strikes the senses—they

are all identical organs which a succession of vegetative operations modifies and transforms beyond recognition.

> The same organ can fan out into a compound leaf of the utmost complexity and contract to form the simplest stalk. Depending on circumstances, the same organ can develop into a flower bud or an infertile twig. The calyx, forcing its development, can become a corolla; and the corolla can undergo a regression in the direction of the calyx.

In a similar fashion the shapes that make up *Pistil* can be seen as human sexual organs, or they can appear to grow into a human torso, or indeed, they can simply grow, to become an oversized embodiment of a flower's pistil. The final metamorphosis that Arp achieves is, of course, through the scale of the sculpture: the large size of the piece considered together with the inherently small size of an actual pistil effects a disarming contrast that jolts the viewer's perception of the sculpture. The viewer's associations with the pistil increase as his perception of the subject enlarges and clarifies, thus creating a final pun, or twist, directed at the viewer of the work.

Entre lys et défense (Between Lily and Tusk) presents a more complex set of images. Like *Pistil,* it explores growth and transformation; however, in this instance the sculpture fixes on the darker manifestation of death and rebirth rather than the celebratory context of birth and fertility. The title suggests a Surrealist fantasy, not unlike the juxtaposition of the umbrella and sewing machine in Lautréamont's famous image, and Arp's lily and tusk reveal hidden similarities which function as a Surrealist metaphor for the reconciliation of opposites. Typically, this title suggests both the visual configuration of the piece and a string of metaphoric images based on the dream-like resonances between lilies and tusks. Arp's abstracted biomorphic forms, created according to the laws of chance, thus reveal more specific Surrealist concerns, among them the idea that the forced conjunction of unlike things leads to the perception of a higher reality, a psychic state where all contradictions cease to exist. It is rewarding to consider *Entre lys et défense* in this context.

An initial look at the sculpture suggests that the title offers two possible identities for the piece. The pointed projection at the top of the sculpture can be read as an animal tusk or the overall shape can be seen as a lily. The most obvious similarity between either object and the sculpture itself is that all three are primarily white, a color that fascinated Arp. All apparent similarities seem to end here. Lilies are small, intricate, and fragile; tusks are large, simple, and strong. In European art lilies have traditionally been used as symbols of the Virgin Mary's purity and Christ's Resurrection. As early spring flowers, they are also symbols of rebirth. A tusk is a very different natural object. As an animal's means of defense, it is a deadly weapon and would seem to represent aggression, death, and survival. The two images are apparent opposites and create a certain resonance by their very strongly contrasting properties. However, tusks are ivory and in Christian iconography ivory is symbolic of purity, a reference to the incorruptibility of Christ's body and thus also to the Resurrection. Suddenly the image of lily and tusk are not so dissimilar. Their identities begin to converge, and the sculpture takes on multiple layers of meaning. It is at once about violence and purity, aggression and sacrifice, death

and rebirth. The whole range of meanings here is greater than the sum of the parts, a fact indicated by the structure of the title itself. *Entre lys et défense* could be interpreted to represent either a lily or an animal's tusk or a completely new entity somewhere between the two. It is this new entity, an abstraction hovering only in the mind's eye, that enlarges and enriches the meaning of the work.

The titles Arp gave his sculptures are evidence of his playfulness and his attraction to the poetic qualities of the words, as they allowed him to extend the visual response to his work into the verbal and mental realm. While the titles do provide intriguing possibilities for the interpretation of the works, they are not intrinsic to the plastic configuration of the piece, for Arp sometimes gave more than one title to a particular form. Another version of *Entre lys et défense,* for example, is called *Bust of Gnome.* . . . (pp. 15-19)

The most recent of the Detroit plasters is *Demeter.* Completed in 1961, this is one of the most classical of Arp's works. With a minimal number of shapes and no individualizing detail, Arp has created the essence of an elegant female torso. As the Greek goddess of fertility and agriculture, Demeter provided a fitting subject for Arp. According to mythology, Demeter controlled the growth of crops. During the winter months when her daughter Persephone was kept underground by her captor Hades, Demeter mourned and no crops grew. But each spring, when Persephone was allowed back on earth to visit her mother, Demeter rejoiced and the earth abounded with fertility.

Demeter, like other torsos in Arp's oeuvre, portrays only the most simplified and basic forms of the human body. Arp never included arms, legs, or facial features in these works, believing that the fundamental character of human beings is found in their essential form. But Arp did not ignore the particular in the pursuit of the general. There are whole works devoted to such specific features as mustaches, navels, and mouths.

By dividing the human body into sundry parts and giving them equal attention, Arp placed humanity on the same level as the innumerable creations of nature that surround us. Like the morphology at work in *Pistil,* the transformation that produced a torso from an indeterminate shape appears to have occurred by chance. The simple modification of one or two forms could result as easily in one part of the human body as another, or even in a non-human form of life. The uncertain outcome neutralizes man's assumed dominance over the natural world, replacing that hierarchy with an egalitarian view of man's place in nature.

In the early 1950s, Arp and Marguerite Hagenbach traveled to Greece, where they saw ancient sculptures of Demeter and other goddesses. These rounded torsos, fragmented and weathered to a smooth finish by the centuries, were clearly one of the sources for Arp's modern-day version of this venerable goddess.

It was from the 1930s onward that Arp created his greatest sculptural works. While he continued to make two-dimensional forms and also devoted considerable time to writing poetry and collaborating on group projects, particularly with his first wife, Sophie Taeuber-Arp, it was with his freestanding sculpture that Arp achieved a balance between the many sources of his work and the many sides

of his imagination. ***Pistil, Entre lys et défense,*** and ***Demeter*** offer a lively combination of abstract and natural imagery informed by a rich metaphoric content. These strikingly beautiful plasters are entirely characteristic of Arp's major work and embody his desire to create an art that reunites man and nature into a harmonious whole. (pp. 19-20)

> Janet Landay, *"Between Art and Nature: The Metamorphic Sculpture of Jean Arp," in* Bulletin of the Detroit Institute of Arts, *Vol. 61, No. 4, 1984, pp. 14-21.*

FURTHER READING

I. Writings by Arp

On My Way: Poetry and Essays, 1912 . . . 1947. New York: Wittenborn, Schultz, 1948, 147 p.
 Incorporates Arp's poems and the original and translated texts of his essays from 1912 to 1947. Includes an extensive bibliography.

Arp on Arp: Poems, Essays, Memories. Edited by Marcel Jean. Translated by Joachim Neugroschel. New York: Viking Press, 1969, 574 p.
 Includes Arp's poems, criticism, statements of artistic intent, recollections of his career, and a selected bibliography.

II. Interviews

Schneider, Pierre. "Arp Speaks for the Law of Chance." *ARTnews* 57, No. 7 (November 1958): 34-5, 49-51.
 Interview in which the artist discusses his involvement in various twentieth-century art movements and his opinions of other artists, including American painters, Mark Rothko and Jackson Pollock.

III. Critical Studies and Reviews

Bois, Yve-Alain. "Report from Paris: Jean Arp, Chance and Necessity." *Art in America* 71, No. 8 (September 1983): 41-3.
 Review of an exhibition of Arp's collages and torn-paper works. Includes five reproductions.

Foster, Stephen C., ed. *Dada/Dimensions.* Ann Arbor: UMI Research Press, 1985, 292 p.
 Contains two essays on Arp: "Arp's Chance Collages," by Jane Hancock, focusing on the artist's early Dadaist works, and "Periods and Commas: Hans Arp's Seminal Punctuation," by Harriett Watts, comparing Arp's use of punctuation marks in his poetry and reliefs.

Giedion-Welcker, Carola. "Contemporary Sculptors." *Horizon* 14, No. 82 (October 1946): 232-39.
 Analysis of Arp's sculptures completed prior to World War II.

Grieve, Alastair. "Arp in Zurich." In *Dada Spectrum: The Dialectics of Revolt,* edited by Stephen C. Foster and Rudolf

E. Kuenzli, pp. 175-205. Madison, Wis.: Coda Press, Inc.; Iowa City: University of Iowa, 1979.
 Overview of Arp's activities within the Dadaist circle in Zurich, Switzerland during World War I.

Hancock, Jane H. "Jean Arp's *The Eggboard* Interpreted: The Artist as a Poet in the 1920s." *The Art Bulletin* LXV, No. 1 (March 1983): 122-37.
 Analysis of the relationship between Arp's poetry and visual art as manifested in his poem and relief of the same title. Hancock concludes: "Arp believed that an artistic idea once executed could continue to live and grow in the imagination, and take shape in words. These in turn could confer further meaning upon the work of art."

Rubin, William. "Arp: 'The World of Memory and Dreams'." *Art Digest* 29, No. 11 (1 March 1954): 14-15, 24-5.
 Analysis of Arp's use of fantasy forms, particularly in his sculptures.

Seuphor, Michel. "Profile of Jean Arp." *Art Digest* 28, No. 18 (1 July 1954): 16-17.
 A brief memoir written by a friend.

Wight, Frederick S. "Notes on Jean Arp (and Herbert Read)." *Art International* XIII, No. 5 (20 May 1969): pp. 17-20.
 Article occasioned by art critic Herbert Read's posthumous exhibition catalog *Jean Arp Memorial Exhibition* (1969). Wight evaluates Arp's relationship to art critic Herbert Read, particularly focusing on the difficulty of assessing Arp's work in light of the artist's statements of intent.

IV. Selected Sources of Reproductions

Cathelin, Jean. *Jean Arp.* Translated by Enid York. New York: Grove Press, 1959, 64 p.
 Contains forty black-and-white illustrations, seven color plates, a biographical and critical overview of Arp's career, and a bibliography.

Fauchereau, Serge. *Arp.* Translated by Kenneth Lyons. New York: Rizzoli International Publications, 1988, 128 p.
 Contains numerous reproductions and illustrations from Arp's work, with a biographical essay by Fauchereau.

Hancock, Jane, and Poley, Stefanie, eds. *Arp: 1886-1966.* Cambridge, England: Cambridge University Press, 1986, 317 p.
 Catalog to a large retrospective of Arp's works. Offers a wide variety of essays, interviews, and reminiscences as well as a list of selected exhibitions, a bibliography, and numerous reproductions.

Soby, James Thrall, ed. *Arp.* New York: The Museum of Modern Art, 1958, 126 p.
 Monograph compiled on the occasion of a retrospective exhibition of Arp's work held at the Museum of Modern Art in New York City. Features articles by Soby, Arp, Richard Huelsenbeck, Carola Giedion-Welcker, and Robert Melville (see excerpt above), as well as 113 illustrations and a selected bibliography.

Ernst Barlach

1870-1938

German sculptor and graphic artist.

An Expressionist primarily known for sculptures blending elemental power and passionate spirituality, Barlach was also a graphic artist and a writer of recognized merit. As a German patriot and believer in tolerance and justice, Barlach incurred the wrath of Germany's Nazi rulers in the 1930s, but simultaneously earned wide admiration for his courageous condemnation of Nazism. Critics indicate that Barlach's oeuvre cannot be divorced from his personal philosophy, which fused humanism and spiritualism, defining human destiny as a quest for God.

Born in Wedel, Holstein, Barlach studied art in Hamburg, Dresden, and Paris, devoting his energies to sculpture and ceramics. In 1904, the artist's ceramics and drawings were exhibited in Berlin. Two years later, Barlach traveled to Russia; this journey marked a turning-point in his career, for Barlach, deeply moved by the profound religiosity of Russian peasants, began depicting humble subjects in his works and turned to the study of medieval German carving, which provided a foundation for his personal style. Barlach's wood carvings, the earliest of which date from 1908, are more than the result an antiquarian interest in a neglected medium: for Barlach, the return to the material of anonymous medieval artists meant the discovery of an artistic language, which, although infused by the spirit of a particular historical period, included universal and timeless symbolism.

In 1910, Barlach established himself permanently in the town of Güstrow, Mecklenburg, some 100 miles north of Berlin, dedicating the remainder of his life to art and literature. There, in the solitude of his studio, he drew, sculpted, and wrote, isolated from the world but keenly aware of its political and spiritual agony. Barlach's response to the decay of civilization consisted of a carefully-wrought comprehensive philosophy of humanization through spiritual and religious reawakening. This worldview underlies his 1912 play, *Der tote Tag* (*The Dead Day*), which describes a man's desperate struggle to free himself from the pull of telluric forces, symbolized by his mother, and embark on a quest for his lost father, who represents the Spirit, or God.

Barlach flourished during the Weimar republic (1919-1933), receiving commissions for artworks and honors, including the 1924 Kleist Prize for literature. He produced, in addition to sculptures, numerous woodcuts, lithographs, and drawings. In these works, he drew inspiration from grotesque aspects of everyday life, while introducing disquieting hints of the supernatural. Barlach's ability to transform seemingly irreconcilable elements, such as terrestrial despair and divine grace, into a meaningful whole comes to the fore in his book illustrations. In addition to illustrating his own writings, Barlach produced a memorable series of twenty woodcuts for the Walpurgisnacht episode of Johann Wolfgang Goethe's *Faust* (1808), as

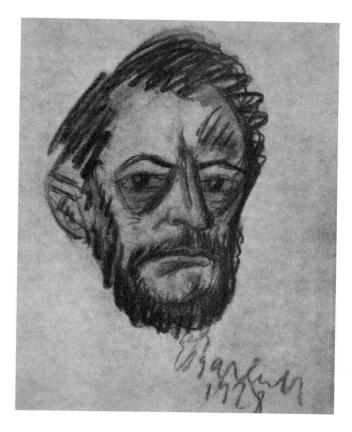

well as nine for Friedrich Schiller's celebrated "Ode to Joy" (1827).

During the 1920s, Barlach executed several imposing commemorative works, including the War Memorial for the Nikolai Church, the Memorial for the University Church (*Champion of the Spirit;* 1928) both in Kiel, as well as the War Memorial for Güstrow (*Hovering Angel;* 1927). Crystallizing Barlach's hope for a world of peace and freedom, these sculptures depict a "champion of the spirit," struggling to protect his country from decadence and barbarization. And precisely because of their explicit, and sometimes even pathetic, appeal to humankind's latent spirituality, Barlach's works, especially his powerful religious compositions, provoked the animosity of the ascending Nazi party. The Nazis, who loathed Barlach's humanistic worldview, accused the artist of glorifying Slavic, and therefore—to the Nazi mind—racially inferior, physiognomies, thus betraying the Fatherland. The Nazi regime branded Barlach's art as "degenerate," showing many of his works at the "Entartete Kunst," or degenerate art, exhibition in Munich in 1937, only four years after he received the Order Pour le Mérite, a high military decoration also given to deserving civilians. Ironically, the Nazis failed—or refused—to perceive the profound influence of

93

medieval German art, which they considered racially "pure," in Barlach's sculptures. In Barlach's words, 1937 was a "terrible year": the *Champion of the Spirit* and the *Hovering Angel* were removed or obscured; and not only did the Prussian Academy of Arts request his resignation but the authorities forbade him to exhibit his works. Ostracized from public life, the artist voiced his opposition to the Nazi regime in letters and conversations with friends. The following year, Barlach, who had been suffering from a heart ailment, died; only close friends, including the noted artist Käthe Kollwitz, attended his funeral.

After the collapse of the Third Reich, Barlach's art gradually assumed the status of a national treasure: the artworks, such as the *Hovering Angel,* were restored, his studio in Güstrow became a permanent museum, and another museum, the Barlach-Haus, was built near Hamburg. An outstanding figure in the cultural history of twentieth-century Germany, Barlach is part of the great humanistic tradition in German culture, which includes Schiller, Goethe, and Ludwig van Beethoven, artists with whom he felt a strong affinity. Furthermore, his remarkable civic courage, exemplified by his decision to stay in Germany during the Nazi terror, and to live in a kind of inner exile, added an aura of saintliness to his reputation. Barlach's great theme is the human condition, and he developed it not as distant observer but as a kind, serious, and empathetic participant, whose principal ambition was, as Carl Dietrich Carls wrote, to depict humankind's "forlornness between heaven and earth, its spiritual barrenness, its joys and sorrows."

INTRODUCTORY OVERVIEW

Bernard S. Myers (essay date 1963)

[*Myers is an American art historian, educator, and editor whose writings include* Mexican Painting of Our Time *(1956),* Art and Civilization *(1957), and* The German Expressionists *(1957; rev. ed. 1963). In the following excerpt from the last-named work, he assesses Barlach's artistic and literary oeuvre, praising the artist's ability to eloquently express the universal spiritual aspirations of humankind.*]

The best known of modern German sculptors, Ernst Barlach was equally important as graphic artist and as Expressionist dramatist. Born in 1870, he derived from northern Germany, like Nolde with whom he might be compared in some respects. Barlach studied in Hamburg, at the Dresden Academy, and in Paris; to his Dresden period he probably owed the flowing, curvilinear quality of many figures that may be allied to the general *Jugendstil* development of the late nineties.

Barlach's early interest in Millet and Meunier—exponents of a Romanticized proletarian art—was reinforced by a visit to Paris in 1895-1896 when he was acquainted with the art of Van Gogh, whose more powerful emotions of sympathy and suffering influenced the German further along the path of his natural development. The supposed similarities between Barlach and Rodin are rather superficial at best, since the French master remained naturalistically Romantic while Barlach went on to rhythmically conceived, flowingly designed, and semi-abstract symbols of human feeling. Where Rodin suggests the Baroque, Barlach evokes the Middle Ages in the intensity and deliberate harshness of many of his forms.

His trip to Russia in 1906 had considerable effect on his point of view. In the endless Russian plains, in the simplicity and profundity of the Russian peasant and his primitive religiosity, Barlach seemed to have found the spiritual direction of his art. As in the case of the symbolist poet Rainer Maria Rilke, Barlach's contact with Russia was decisive, although with both men it is not clear exactly how the change came about. Barlach represented, however, a concrete instance of the general influence of Russian symbolism and mysticism on the nascent Expressionist attitude at the beginning of the century.

His early figures, especially some of the porcelain sculptures, showed Russian types: beggars, wanderers, etc., in a generalized and symbolic portrayal of the typical rather than the individual, expressing in almost mystical fashion the ideas of suffering, helplessness, poverty, and futility which occupied the Russian intellectual world. Many of these concepts remained permanent parts of Barlach's ideology in his plastic and literary works, just as they had their influence on the whole Expressionist movement. In contrast to this vivid Russian experience, Barlach's trip to Italy in 1909 left him relatively untouched, a not uncommon phenomenon with Germans of that time, judging by the experience of Nolde and Beckmann.

As with other artists of the era, Barlach achieved the aesthetic realization of his natural emotional bent through the Gothic art of his own country, differing only in that he leaned toward an earlier phase than most, the fourteenth and early fifteenth centuries. Yet, as was often the case with Expressionists, this material was used for the sake of the mood it suggested—the mingling of factual and spiritual—rather than for technical procedures. In some instances, it is true, we do feel an actual borrowing of methods, as in *The Beggar,* a crippled figure with a medieval Christ-like face and form shown verticalized on its crutches. Elsewhere, however, this modern artist was attracted by the spirit of the Middle Ages which elevated the material and brought the spiritual closer to the human. Working in the monastic loneliness of his studio at Güstrow, Barlach produced the stirring works that betokened his reaction to the unrest and disquiet of the age.

His *Seated Shepherds* of 1907 and his *Listeners Frieze,* on which he was working as late as 1934, express the remarkable combination of exaltation and earthiness, the apparently paradoxical longing to escape from the world, that is felt so strongly by these earth-derived creatures. Here again it would seem that Barlach was part of a general movement in which these qualities were fairly typical, but one should distinguish between his closeness to nature and that of Nolde with whom he has so often been compared.

Barlach managed by the force of exaltation to raise his peasants and his poor into symbols of universal feeling, always arousing our sympathy by the strength of his own compassion. However mean or evil the circumstances of

existence, the poet-sculptor evoked some strong humanistic response of indignation, hopefulness, or similar emotion. To Nolde, life meant evil, terror, cruelty, and other fear-arousing ideas. A true primitive in its literal meaning, Nolde felt himself and, by analogy, mankind hemmed in by the forces of darkness from which he tried in varying ways to retreat. His response to life was altogether pessimistic and even hateful, and much as we might be impressed by the fury and power of his inhuman terror, there was scarcely ever the element of hope, of aspiration toward something better. In effect, Barlach was concerned with the world of people and their fate, Nolde with himself and his own sufferings.

In the wood forms through which he best expressed himself, Barlach has left us vibrant testimony of the powerful feelings that animated him, the sublimation of the suffering of his time and even the prophecy of greater evil to come. The *Freezing Girl* of 1917 and the frightening face of the *Weeping Woman* of 1923 symbolize the war and postwar periods; the Magdeburg monument to the dead of the war (1929) implies the futility of that sacrifice. Barlach's protest was universal, meaningful for all of humanity at all times.

This uncorrupted prophet was early proscribed by the Nazis, and by 1935 he was isolated in the Güstrow studio where he had lived since 1908. Photographs of his remarkable **Listeners Frieze** were secretly circulated among the artist's friends in 1936 by Hermann F. Reemtsma of Hamburg-Othmarschen, for whom the gigantic work had been executed. After this, however, Barlach sat alone in his studio, without work or recognition. He died in October 1938. Today there is no question of the overwhelming contribution of Barlach the sculptor; in this study our concern is mainly with his somewhat less known graphic work. In this area his favorite medium, as might be expected, was the woodcut with its decisive outlines, emotional possibilities, and primitively direct expressiveness. Most interesting in many ways are Barlach's illustrations for his own writings, such as 'The Poor Cousin' and the drama *The Foundling*, since they present a homogeneous creation. Also important are portfolios like *The Manifestations of God (Die Wandlungen Gottes)* and the woodcut illustrations for Goethe's 'Walpurgisnacht' and Schiller's 'Ode to Joy'. For the most part Barlach's woodcuts have a free and individual quality that distinguishes them even from his own sculptural aesthetic, perhaps less stylized and not dependent on decorative ideas. A parallel between Barlach the sculptor and Barlach the graphic artist is found in the lithographic series done to illustrate his early play *The Dead Day (Der tote Tag)*, 1912, a realistic-symbolic piece dealing with the violent emotions of a mother who loses her child. Barlach executed these plates in a loosely stroked manner which emphasized the naturalistic bulk of the individual figure rather than the more violent black-and-white contrasts of the woodcuts.

A similar technique may be seen in the various independent charcoal or chalk drawings, such as the *Anno Domini MCMXVI Post Christum Natum* charcoal of 1916. Here we find a terrifying spectacle in which an emaciated Christ (very much like the figures in **The Listeners Frieze**) is shown before an endless landscape covered with tiny crosses. His tempter is one of the characteristically short, squat, grotesque peasants seen so often in the sculpture—

types whom the pre-1933 Nazis already described as non-German, inferior racial individuals, i. e. Slavic. The anger of this brutish form in contrast to the bewilderment of the Prince of Peace symbolizes the resentment of humanity and its revolt.

Barlach has left us at least a thousand drawings of this and other kinds, some done for their own sakes and others as preparations for his sculpture. The drawings for *The Listeners Frieze,* for example, must be looked upon as more than mere sketches, in spite of their relation to the finished forms. Their elasticity and spontaneity, in the opinion of some critics, make them even more effective emotionally. In these remarkable graphics we feel the dematerializing quality of Barlach's art far more keenly than in the sculptures; a lithe tenseness and an inspirational sketchiness convey the ultimate essence of the artist's purpose.

Die Wandlungen Gottes, a set of seven woodcuts, offers another Barlach with an entirely different technique. De-emphasizing the contrast possibilities of the medium, Barlach used a series of short incisive strokes which bespoke the lithographic artist and draughtsman, rather than the conventional broad contrast manner of the woodcut artists of the time. We may take the plate showing God resting from His labors (*The Seventh Day,* 1922) as typical of the technique of this series.

Schiller's 'Ode to Joy' was the inspiration for a series of nine woodcuts by Barlach that comes closest to the ecstatic style of his sculpture and to the spirit of the Expressionist woodcut with its strong contrasts. We may note that the subject choice here was not altogether accidental, since the same poetry had inspired a great work by another of Barlach's heroes, Beethoven (for whom the sculptor planned a magnificent monument).

The first plate illustrating Schiller's hymn to human brotherhood shows a generalized smiling figure in boldly cut black and white tones raising a cup against a blank white sky. Beneath, a dark sea moves horizontally left in the same direction as the outstretched arm, while the mountain descending from the upper right cuts across the powerful form of the man leaning forward out of the lower right. Barlach's ecstasy and prayer, his yearning toward another, higher sphere, as shown in this print, exceed in some ways the ordinary Expressionist feeling, which is similarly powerful but undirected. It is not merely *Sturm und Drang,* any more than Schiller himself is; this picture represents the hopeful and exciting pledge of a better world, for which German intellectuals like Barlach have perpetually yearned but which the historical situation in that country has constantly thwarted.

The grotesque element, so evident in the work of Expressionists (cf. Nolde), emerges also in the sculpture and graphics of Barlach. In the twenty plates for his drama *Der Findling (The Foundling)* we find good examples of Barlach's grotesque and often macabre humor. These plates have the straight-from-the-soil horror of Grimm's fairy tales; but they have, too, a pictorial quality which is quite unique, and a cursive graphic effectiveness that separates them from the many mannered efforts of his contemporaries. In the illustrations for 'Die Walpurgisnacht,' the grotesquerie (which in the foregoing instance was part of Barlach's own play) is exaggerated far beyond the intentions of Goethe.

Perhaps the best and most genuine example of this side of Barlach's work is to be found in his ten woodcut illustrations for an Expressionist poem by Walter von Reinhold called 'Der Kopf' ('The Head'), published by Cassirer in Berlin, 1919. One effective passage is entitled "Petrograd, 1918"; in this the poet achieves a genuine Expressionist atmosphere combining the naturalistic and the symbolic, eminently suitable to the style of the sculptor-illustrator. Describing the scarred and half-destroyed city of revolution, Reinhold says:

> She is a sunken city
> The stormbird visits her.
> There across the river
> Thundering into emptiness, her bells sound,
> And her beggars are her dukes.
>
> Look. There on that step a beggar stands.
> He is a colossus.
> He has rags on his body.
> He is covered with dirt.
> He is one of those blind ones,
> In whose eyes the whites gleam.
> He carries a wooden platform.
> It reaches to his shoulder:
> A stick, on it a narrow board—
> There lies a head.
> Its carcass is dwarflike.
> The withered arms hang down.
> The pale dirty legs are twisted.
> The miserable head is gigantic,
> It raises itself like a mountain
> In the broken valley of the shoulders.
> It lies on the board as though cut off.

Barlach's illustration is as close in spirit to the mood of the verse as it is possible to be. Few other illustrators of the period might have been as suitable for this task.

The grotesque element so clearly marked in his graphic works is also part of Barlach's sculptural expression. Nowhere does it emerge as clearly and emotively as in the famous **War Memorial at Magdeburg** (1929). Here the mingling of material and spiritual elements runs parallel with a macabre horror; we are reminded forcibly of the medieval inspiration for so much Expressionist sculpture and graphic art.

An underlying vein of Barlach's expression was the religious feeling that appeared in his work in varied ways. Like most Expressionists he was not interested in religion for its own sake but for its ecstatic possibilities. Even the specifically religious subjects became part of an over-all visionary attitude. Nevertheless, Barlach was not concerned merely with emotion and nothing else, as were so many lesser Expressionists who conceived it as a kind of revolt in itself; he utilized spirituality and lesser emotive forms as means of aspiration toward something higher. His was a world in a constant state of motion and emotion.

One can understand the religious undertone in Barlach's work by considering specific examples such as **The Beggar**, 1930, or **Death**, bronze, 1925, which convey strong medieval religious feeling mingled with the artist's own human sympathy and spiritual quality. In the graphic works we observe that, except as they relate directly (i. e. as sketches) to sculpture, they tend to take on a different form and meaning in which the religious element plays a smaller role.

It follows almost inevitably that Barlach's art, in whichever medium, is basically narrative in form and humanistic in approach. Perhaps no other artist of that period except Käthe Kollwitz expressed the sufferings of humanity as Barlach did. His people are unfortunate creatures philosophically as well as socially, because circumstances have overwhelmed them and damned them to suffering.

Barlach was not an artist who took an occasional "fling" at writing. His dramas occupied as high a place in the evolution of Expressionist literature as those of any other author. He was among "the anxious dreamers and the seekers after God" produced by the age and stood near Kokoschka in that sense as both artist and dramatist. Both men revealed a restlessness, a seeking character (in Kokoschka's case it became hunted) that was part of the total Expressionist movement.

Barlach took a stand as a mighty fighter against the middle-class point of view, in both his art and his writing. The bitterness of his feeling about the bourgeoisie in its very violence underscored this quality as one of the animating forces of Expressionism, e. g. *The Poor Cousin,* 1918, and *The Real Sedemunds,* 1920. His mingling of religiosity and social consciousness (cf. Van Gogh) was by no means unusual in this period. Barlach mixed mysticism, suffering, and striving for a visionary light and otherworldliness in a somewhat confusing fashion. This very mixture, however, was one of the interesting and attractive features of his work, both dramatic and plastic.

Barlach's writings are not dramas in the conventional sense. They run to a looseness of form that gives the predominantly legendary content an unusual, individual quality. What interests the auditor of the dramas (which are better read than performed) is a strange kind of *double entendre* in which things are symbolized rather than recounted, in which form and expression have that same cloudy appearance we meet so often in the works of other Expressionist dramatists, German and non-German. Here, as in his plastic works, Barlach was distinctly pioneering.

The dramas are of two general types: one a predominantly tragic problem play exemplified in *Der tote Tag,* 1912, *Die gute Zeit,* and *Die Sintflut,* 1924; the other a more grotesque expression in which earnestness is mixed with an almost diabolic humor. The latter type is illustrated by *Der arme Vetter* (*The Poor Cousin*) and *Die echten Sedemunds* (The Real Sedemunds). These two works emphasize the effect of unbalanced people on the community; while plays like *Die gute Zeit* (*The Good Time*) are more specifically Expressionist in their theme of regeneration through sacrifice, an old Dostoievskian favorite of German writers. The dramas may introduce God in a disguised form so that He appears as a beggar, pilgrim, or stranger. Like Unruh, Werfel, Edschmid, and Kafka, Barlach was concerned with the relations of man and God. His characters are often symbolic in their generalized names, e. g. Alb, or Nightmare, in *Der tote Tag* who symbolized human fear; they sum up the various qualities and feelings of humanity.

Like other Expressionist dramatists, Barlach tried to clothe an idea in dramatic form; similarly, he dealt not only with the man and God problem but, even more typical, with the mother problem, as in *Der tote Tag.* There

was also an implication that the so-called facts are merely superficial appearances of reality; this was paralleled by denial of the reality of people, who were often considered as ghosts. As in other Expressionist dramas, man was caught in the toils of an imperfect world and in trying to improve the state of things his soul was awakened. Barlach's whole creativeness partook of this soul-awakening.

It was not inconsistent with the character of German Expressionism that this most Germanic of artists (accused by the Nazis of portraying inferior races), whose emotive power and exaltation were in the historical stream of his country's creative expression, was also in the best tradition of German liberalism. In him the echoes of Goethe's humanism, Schiller's liberalism, and Beethoven's Romantic rebellion were clearly and powerfully heard. (pp. 70-7)

> *Bernard S. Myers, "Ernst Barlach," in his* The German Expressionists: A Generation in Revolt, *revised edition, McGraw-Hill Book Company, Inc., 1963, pp. 70-7.*

SURVEY OF CRITICISM

Alfred Werner (essay date 1961)

[*Werner is an Austrian-born American art critic and editor whose writings include* Modigliani the Sculptor *(1962),* Ernst Barlach *(1966),* Chaim Soutine *(1977), and* Edvard Munch *(1978). In the following excerpt, he discusses the humanistic spirit of Barlach's art, remarking that Barlach "stands for everything that is noble and good and lasting in modern German art."*]

Every critic can point to one artist who fulfills all the demands that can be made upon a practitioner of the plastic arts: that he be superbly skilled in his medium, or media; that he perform his task without being swayed from his proper path by religious, national or racial bias, by party politics, or unscrupulous commercialism; and that he have a philosophy, an esthetic of his own that enables him to speak for those millions who have no articulate language to voice their pain or joy.

My own favorite is Ernst Barlach, the poet, printmaker and sculptor who, in my opinion, stands for everything that is noble and good and lasting in modern German art. He is the most significant personality of German Expressionism, that powerful phenomenon which arose a few years prior to the first World War and was stamped into extinction by Hitlerism a few years before the second world conflagration. But while the painters of this northern branch of a world-wide movement—such as Kirchner, Nolde and Schmidt-Rottluff—have become known here in the last decade through exhibitions and books, Barlach's name still fails to evoke the fervent response that it deserves. But I would choose him to represent Germany in a Hall of Fame, were each nation to have only one artist to epitomize the glory of its achievement. (pp. 22-3)

While Barlach is now widely appreciated all over Europe—his sword-yielding *Avenger* could be seen in 1958 at the "50 Years of Modern Art" exhibition of the Brussels World's Fair—too many people here have never heard of him. Many Americans, incidentally, hold the notion that German art, especially Expressionism, is utterly lacking in compositional strength, that the proper balance between the formal and the expressive aspects is missing, that, whatever its subjective, emotional, passionate, aggressive appeal, it is inferior to, say, French art which, on the whole, always manages to retain a healthy minimum of calculation and logic. Actually, German Expressionism started out as a revolt against the vague formlessness into which Impressionism had degenerated. Several of the German rebels of the 1900's turned to the woodcut and other graphic media for the very reason that they demanded strict discipline, to protect them, as it were, from an escape into fuzzy indecision. Barlach, in particular, proves through his work that impulse can very well go along with discipline, eloquence with restraint, and that a sculpture or print can be powerfully charged with expression while maintaining a firm equilibrium between form and content.

Barlach is primarily known as a sculptor, yet what he wrote about his approach can be applied to his achievements in any medium of expression:

> I do not represent what I, on my part, see or how I see it from here or there but what *is* the real and truthful, which I have to extract from what I see in front of me.

What he saw around himself was a dishonest society in which crude egotism often prevailed over the nobler sentiments of the heart. Barlach could have reacted to this phenomenon of an irresponsible mankind with the pungent satire of a George Grosz, had not his striking characteristic been pity rather than scorn, commiseration rather than anger. In this respect he closely resembled his idol, Van Gogh, who was still little known in Germany when Barlach became enthusiastic about him. His emphasis is on suffering rather than on evil. The symbolic figures which he carved out of wood are, for the most part, people in doubt, confusion or pain; people suffering from hunger, cold, sickness, the ravages of old age; individuals such as he would rarely encounter even in the slum quarters of German cities, but who stand as unchallengeable symbols of agonized humanity irrespective of time, nationality, race or creed.

Barlach rediscovered the intrinsic beauty, the color and texture of wood, that material which, in the Middle Ages, had been put to such excellent use by Gothic carvers of the images of Christ and the Virgin. His generally small single figures are "abstract" in the sense that every detail that is not absolutely necessary is omitted. No attempt is made to duplicate natural textures such as skin, hair, or woolen garments, the entire object being treated in a homogeneous style of chip carving. Sometimes the hands are hidden under the garments, while other figures may have a cloak drawn over the head, revealing nothing but a pair of bony hands. There is nothing conventionally beautiful about these figures—heavy and even clumsy monolithic blocks that are generally in a state of deep repose, though occasionally they may express violent excitement. They are real pieces of sculpture, self-contained closed forms, with arms often kept close to the body or concealed by

Hovering Angel (1927)

drapery so that the esthetic dramatic conflict is confined to subtle opposition of concave and convex forms.

Though his graphic work consists of more than two-hundred prints, they are less widely known than his sculptures. Some of these lithographs and woodcuts illustrated Barlach's own poetic plays, while others decorated new special editions of works by other poets. Kaethe Kollwitz admired him fervently as a printmaker. In a diary entry of June 25, 1920 she writes of a show in Berlin: " . . . I saw something that knocked me over: Barlach's woodcuts." (It was his example that made her turn to this medium.) These are characterized by the same rugged strength that we admire in his sculptures, the same bold, massive forms permeated with passion. Although he has left us numerous lithographs, I find that the more resisting wood was better suited to his nature. "The woodcut," he wrote in a letter, "demands complete avowal, an unequivocal precipitation of what one really means. It dictates a certain universal expression and rejects an amiable or easy solution." Indeed, Barlach is often more convincing, esthetically, in the medium of the woodcut than in anything else he produced. Instinctively he knew that a metaphysical message should be presented like a piece of writing, in black and white, to avoid distortion by the impact of color. While the medium imposes certain limitations upon the artist, it also allows great emotional tensions through the contrasts between heavy blacks and stark whites; it affords severity and clarity through a direct and simple statement.

Notable, in particular, are the twenty woodcuts to "Walpurgis Night" (a scene in the second part of Goethe's *Faust*), the ten woodcuts to Schiller's Ode to Joy (the poem which Beethoven used in his Ninth Symphony) and the eight woodcuts, **The Manifestations of God** (published in an album without text). In his autobiography, Barlach, an eloquent writer, speaks of the astounding realization that came over him:

> That you may dare without reserve to give out your very own—the innermost as well as the outermost, the gesture of blessing or the blast of wrath—since expression of everything is possible, whether it be a hellish paradise or a heavenly hell.
>
> (pp. 27, 60-2)

Alfred Werner, "The Universal Humanism of Ernst Barlach," in American Artist, Vol. 25, No. 3, March, 1961, pp. 22-7, 60-2.

Horace Shipp (essay date 1961)

[*In the following excerpt from his review of a London exhibition of Barlach's works, Shipp offers a positive assessment of the artist's mature style.*]

The exhibition of Ernst Barlach's sculptures and drawings at the Arts Council Galleries has reminded us how fine and how human an artist this man was. Hitherto in Britain we have only had opportunities, and those rare enough, of seeing a few of his sculptures. . . . Barlach comes back as something of a classic. His work, deeply rooted in the Gothic wood-carving sculptural tradition of his country, modernist in its acceptance of a simplification of the forms and an emphasis of the rhythmic elements, is also full of tragic feeling for the sadness of humanity. At the end of his life, as his country rushed down the steep place of Nazism, this feeling for the poor was interpreted by German officialdom as committal to the Left; and Barlach's works were declared "decadent", were proscribed, and one by one confiscated by the authorities. . . .

[Barlach] is too individual an artist to give him labels. "Expressionist" conveys the sense of the deep feeling with which he invested everything he did, but there is in his work none of the undiscipline with which we cannot but associate Expressionism. As Dr. Wolf Stubbe says in his understanding introduction to the catalogue [of this exhibition]: "it was never his own grief, his own joy finding noisy relief in tormented expression; his are rather universal concerns which have raised his expression to the level of poetic intensity. The wonder is that his art is at once so controlled yet so full of vitality—vitality alike of the artist in his technical mannerism and of the subject. Every piece is perfectly finished, yet it is a sketch; it is poised, yet it is swiftly moving." He himself spoke of his "crystallization of the human figure", and that is a right word. Steeped in the Northern Gothic tradition he nevertheless discovered his true way when, at the age of 36 he went to Russia and found the unsophisticated Russian peasantry and the poor.

I found the most satisfactory piece in the whole exhibition to be the **Russian Beggarwoman** of 1907; and the white porcelain figures resultant from this visit are superb. As it happens his art is perfectly suited to ceramic treatment: the simplification of the planes and masses, the absence of

all fussiness (once he had escaped his first Art Nouveau period). But fundamentally it belongs to wood-carving and bronze, for there is always something a little frivolous about pottery, even the most earnest. So, after 1906, where this exhibition practically begins, he never looked back, and he remained consistent to one method all his life. Not for Barlach the art for art's sake theories which spread from Paris to the whole western world. He was, in this sense, a "committed" artist. He was not afraid of being "literary", of conveying a message, of being old fashioned. (p. 169)

Horace Shipp, "Current Shows and Comments: Commitment and Escape," in Apollo, Vol. LXXIV, No. 436, June, 1961, pp. 169-70.

Alfred Werner (essay date 1967)

[*In the following excerpt, Werner comments on the principal characteristics of Barlach's work as a draftsman, noting that many of his "drawings are 'sculptural' rather than linear."*]

What might be called the German national genius has, through the centuries, found its appropriate outlets in drawing rather than in any other artistic media. . . .

The draftsman Ernst Barlach is now favored by the current emphasis on the spontaneous and informal. Whether or not this love for the "unfinished" is a dangerous fad, it causes the post-Barlach generation to prefer the master's sketches that appear to have emerged rapidly from some dark cranny below the threshold of consciousness to his more carefully and even meticulously executed creations, particularly to his sculptures. Were he still alive, Barlach, of course, would have been deeply disappointed to observe that so much of what he had created in metal, stone or wood is regarded with mild respect rather than deep admiration. Yet he would have approved of the important place his own drawings have been given in all exhibitions since 1945. (p. 234)

If the practitioners of art can be divided into realists and surrealists, the mature Barlach clearly belongs with the latter. If asked to choose between Courbet who said, challengingly, "I'll paint an angel when you can show me one," and Blake who sang, "I hear a voice you cannot hear . . . I see a hand you cannot see," Barlach would have chosen Blake. Redon's statement that his originality consisted in "making incredible beings live according to credible laws, in placing the logic of the possible at the service of the invisible" might very well be applied to the graphic work of Barlach, too. . . . In his autobiography he explained how he was out to transcend the material, to give concrete form to man's soul rather than to everyday ordinariness:

A mighty realization burst upon me, and this is what it was: To you it is given to express, without reserve, all that is within you—the uttermost, the innermost, the gentle gesture of piety and the rude gesture of rage—because for everything, be it paradise, hell, or one in the guise of the other, there is expressive form.

Barlach was haunted with visions. Witches, furies, and a variety of other startling phenomena of the spirit world—such as Dances of Death—abound in his graphic work, in his drawings as well as his lithographs and woodcuts (his prints are based on sketches in charcoal and other media). Demons may press an artist, but he does not succumb to them. Instead, he may vanquish them by his craft, just as the pre-historic hunter killed his fear of powerful wild animals by drawing their likenesses on cave walls. Through his drawings—often entirely spontaneous, as if completely unpremeditated—he was able to release inner images, to free his subconscious mind from havoc-wreaking tormentors.

"Grotesque" may be applied to characterize many of his drawings. But he did always dwell in the "grottoes" of darkness from which this term is derived. With a tenderness and humility not surprising in one whose Christianity was close in spirit to that of the early followers of Christ, he drew scenes inspired by episodes from the Old and the New Testament. Moreover, while the sculptor rarely permitted friends to sit for portrait busts, and never made one of himself, in his graphic work portraits and self-portraits abound. There is, of course, nothing "photographic" about them. Barlach always insisted that the outward appearance of a man was only a mask, and that he had to look behind it; he wanted to show what he felt and sensed rather than what he actually saw. His self-portraits (drawings and lithographs) concentrate on the ascetic face surrounded by an unruly beard, with large, unforgettably sad eyes above dark hollow pouches and with a melancholy, severe mouth—the picture of a saint, an ideal model for El Greco.

Many of the drawings are "sculptural" rather than lineal: strokes inside and outside the contour, cross-hatchings, shading give the illusion of three-dimensionality. This is particularly true of those that are *Vorzeichnungen* (sketches for work in other media, especially sculpture). From a sculptor one will, of course, expect numerous drawings, since his work demands the making of preparatory sketches on paper. Sculpture requires planning in advance because, like an edifice, it must not be allowed to break or to topple. The print-maker, too, generally sketches his basic ideas on paper before approaching metal, wood, the lithographic stone or transfer paper which do not permit the making of corrections. In Barlach's case, however, there is often only a very loose connection between a particular drawing and the sculpture for which it appears to prepare. The numerous sketches for the bronze **Geistkaempfer (Champion of the Spirit)** demonstrate that only after a long search did Barlach arrive at the final version. On the other hand, many of his drawings have a historical value because they document a sculpture known to have existed but now irretrievably lost. At the same time, sculptures which never saw the light of day exist at least in the "Urbild," in preparatory drawings, especially the World War I memorial which would have stood in the Pomeranian town of Malchin, had not right-wing opposition canceled the project, or some of the sculptures for the façade of the St. Catherine's Church in Luebeck (the victory of Nazism prevented the completion of the ambitious project).

How much Barlach valued his drawings is demonstrated by the fact that he made a selection for a friend, the publisher Reinhold Piper of Munich, to issue in a book—. . . *Zeichnungen*—prefaced by an appreciation from the literary critic, Paul Fechter. Nothing "political" was in *Zeich-*

nungen. But it appeared in November 1935, after thirty months of the Nazi regime, and by that time the more sophisticated Nazis, who had wanted to salvage Barlach, Emil Nolde and others as decidedly "Nordic" artists, had lost the battle against the extremists who were preparing the final death blow for all "degenerate art." This radical wing condemned *Zeichnungen* for the absence of the blind optimism and deluded self-confidence that the Nazi state had to propagate. For there are many unhappy people in Barlach's dramatis personae: men and women starving, freezing, ailing, mourning; lonely individuals filled with melancholy, with doubt. In Nazi-approved drawings, people smile or show off enormous muscles in heroic determination to fight for victory. Helmuth Lehmann-Haupt correctly states [in *Art under a Dictatorship*] that it was not only Hitler's primitive approach to art in general, but also his demand that the arts conjure up the vision of a healthy, successful society that prompted the persecution of Barlach and like-minded artists:

> The dictator wants his artists to promote a feeling of belonging; they must promise security through identification with the community, they must glorify the collective aims of society and propagate complete faith in the methods of the totalitarian leaders".

(pp. 237-39)

Alfred Werner, "The Draftsmanship of Ernst Barlach," in Art Journal, *Vol. XXVI, No. 3, Spring, 1967, pp. 234-39, 245.*

Peter Meech (essay date 1973)

[*In the following excerpt, Meech analyzes the function of music as a motif and a source of inspiration in Barlach's artistic and literary work, noting that it "provides an insight both into his* Weltanschauung *and . . . into his understanding of the expressive potential of the different media at his disposal."*]

As a recurring motif in Barlach's work, music appears relatively insignificant in comparison with others. Certainly it has received little attention from critics. And yet it is invaluable in that it provides an insight both into his *Weltanschauung* and . . . into his understanding of the expressive potential of the different media at his disposal. An ostensibly artless story told by Barlach to his son serves as a convenient starting-point for an analysis of these topics. According to the writer Hans Franck, the boy Nikolaus was puzzled one day as to how a frog and a (reflected) star could inhabit the same puddle. The child's curiosity prompted the following explanation from his father:

> Der Frosch im Wasser sah den Stern am Himmel und fragte: Ist es da oben schön? Der antwortete: Ja, schön! Spring doch herauf! Da sprang der Frosch hinauf, aber er fiel wieder herunter, und da sitzt er noch heut. Da fragte der Stern: Ist es im Wasser schön? Ja, schön! antwortete der Frosch, spring doch herunter! Da sprang der Stern herunter, und da sitzt er noch heut.

> [Since the frog could not jump high enough to join the star, the star descended and joined the frog in the puddle.]

Venturing beyond the simple surface, it is possible to interpret this fable as having a metaphysical significance. The puddle can be taken to represent the material world—the "vale of tears" in another aqueous metaphor—the frog stands as a cipher for mankind, and the reflection of the star becomes a representative in this world of a distant and inaccessible realm of perfection. Additional evidence to support what may appear at first sight to be a far-fetched interpretation is provided by Barlach himself in another, quite distinct context. Writing in 1923 to his publisher Reinhard Piper, he first confesses his antipathy to the work of Max Beckmann, then expresses his own contrasting attitude:

> Mich verlangt instinktiv, elementar nach dem Anzeichen, daß über diesem Pfuhl ein Himmel ist, möchte über dem Schauder einen Reflex der ewigen Harmonie spüren.

> [My instinctive longing for a heaven above this sink, a wish "to feel a reflection of eternal harmony beyond all this dreadfulness."]

In letters and in the diary written during his self-imposed isolation in the little Mecklenburg town of Güstrow he makes clear that he regarded Classical and sacred music as just such a reflection or hieroglyph. Listening to it, he was able to divert his attention from everyday concerns to the contemplation of the sublime, to merge his individual identity with something ineffably greater, suprapersonal. . . . [Classical music] can be seen to have fulfilled for Barlach a similar function to that of the reflected star in the fable, for which reason it will henceforward be referred to as "star-music". In contrast, other varieties, such as popular music, drinking songs and dancing will be classed as "frog-music". . . . The distribution of these two aspects of the tonal art is of particular interest. While instances of "frog-music" are found in the dramas, the graphic work and drawings, examples of "star-music" feature almost exclusively in the visual media.

To take the former category first: from his second play *Der arme Vetter* (1918) onwards crude snatches of song or grotesque and tasteless dancing are employed to portray the depravity of a wholly egoistic, worldly outlook. In this work, which invites comparison in terms of developmental significance with Goethe's *Die Leiden des jungen Werthers,* a young man, Hans Iver, escapes through suicide from a world that has become intolerable to him because of its crass materialism. But this neurotic idealist, while himself sinking ever deeper into an all-pervading gloom, nevertheless manages to bring about a spiritual awakening in one Fräulein Isenbarn, which culminates in her breaking off her engagement to the boorish Siebenmark in the presence of the corpse. (pp. 24-6)

It will suffice to mention . . . two further examples of "frog-music" in the dramas. The figure of the organ-grinder in *Die echten Sedemunds* (1920) forms a link between the singing and dancing in this work, in which, through a bogus report that a lion has escaped from a menagerie, a North German provincial community is temporarily driven into a panic of soul-searching and self-criticism. The jangling notes of his instrument firstly lend emphasis to the sarcastic lyrics of a song aimed at the local militia and the ensuing criticism of the entire community for their hypocrisy. And later, as the leader of a grotesque, hysterical procession to the local cemetery—immediately before the discovery of the hoax allows the majority to re-

sume their old identities—he is described as the "Musik-trabant der Höllenreise" ["musical follower of the infernal journey"]. In this role he strengthens the character of the procession as an evocation of the medieval Dance of Death, expressive of human vanity and transience.

The conclusion of this section is provided by Barlach's only drama to incorporate extensive verse passages, the mystery play *Der Findling* (1922). In this work the miraculous transformation of the deformed, diseased and deserted child of the title into an object of radiant beauty results from the love of a young couple, Elise and Thomas, the only ones to manifest an attitude of concern for others. The remaining characters, including their parents, are refugees in flight, but are presented as a totally unsympathetic group, scornful of youthful ideals and absorbed in their own predicament to the extent of indulging in cannibalism. At the end of the work, immediately following the mystical testimony of the *Beter* [The Man at His Prayers], the essence of which is that truth cannot be approached or expressed through language, Sauerbrei makes a final statement of his own attitude to life. Having enthused about the simple existence of the mole and scratched out a hole in the earth into which to put his head, he sings "ein Lied in der zufriedenen Maulwurfsweise" ["a song in the manner of a satisfied mole"]. This seven-line song of praise, in being addressed to the *Muttererde* or *Mutterboden,* combines the ideas of the physical soil and the conventionally anthropomorphic Mother Earth (normally *Mutter Erde*). According to Sauerbrei, this composite object displays a maternal solicitude both for the living . . . and for the dead. . . . But the comfort that he preaches *im Singsangton* is only for those whose concerns are wholly worldly and physical, for whom in short there is no problem of reconciling the rival claims of the spirit. If God exists for Sauerbrei, then he is nothing but a *Gott der Würmer,* as another character puts it, a chthonic entity to be sought in the ground underfoot rather than in contemplation of the firmament. (pp. 27-8)

In the visual media there are a number of equivalent examples of ["frog-music"]. **Die Wandlungen Gottes,** a cycle of seven woodcuts depicting the transformations that God undergoes at the hands of mankind, was produced in 1920-1 and published in 1922, the same year as *Der Findling.* Just as in the play Thomas and Elise are surrounded by abuse, so in the print entitled **Totentanz** a young couple walk hand in hand, shielding themselves with a blanket from a hostile crowd behind. This *verlästertes Paar,* as Barlach himself described them, are taunted among others by two musicians, one playing a flute, the other a concertina. Here music functions as an agent of division, uniting one group in aggressive opposition to another, as in the case of many children's and soldiers' songs, and national anthems. Barlach's first three plays all appeared together with his own illustrations: 27 lithographs in the case of *Der tote Tag* (1912), 34 lithographs for *Der arme Vetter* and 20 woodcuts for *Der Findling.* In the second of these series there is a print, entitled **Verzweifelter Abtanz,** . . . in which Siebenmark performs a callous, if somewhat premature dance of triumph around the dead Hans Iver, his rival for the attentions of Fräulein Isenbarn. The clumsy inappropriateness of the dance is expressed in the print by the awkward stance of the figure. In particular, the left leg is drawn straight across the bent right leg and the elbows shown flung up and out to their limit, as each hand lifts

a coat-tail. The overall angularity, its jagged outline, is a feature this graphic figure has in common with the sculpture **Tanzende Alte.** Although the tone here is more light-hearted, even comic, a similarly grotesque character is projected, here not unlike the Dame of traditional British pantomime. There is an exaggeration in the length of the toes and fingers, and a low centre of gravity emphasized by the solid support section between the feet. Of special interest are the suggestion of a centrifugal force at work, scattering areas of detail and interest (face, fingers, raised foot) out to the periphery, and the enclosed space on each side of the body, similar to the previous figure, resulting from the lateral movement of the arms. These features are distinctive for the group and contrast markedly with those of the "star-music" group of figures. Apart from the series of prints for his own plays, Barlach only published one other set of illustrations for a dramatic work: the 20 woodcuts based on the "Walpurgisnacht" scene from Goethe's *Faust.* On the whole they interpret the literary text with a much greater licence than previous attempts, with Barlach's visual imagination creating often fantastic figures, as in the case of the bizarre **Reitender Urian,** springing from the slightest of textual hints. As regards **Faust, tanzend mit den Jungen,** however, the print is a straightforward graphic realization of a stage direction. A greater sense of movement, appropriate for the mood of lecherous abandon, is suggested here than in either **Verzweifelter Abtanz** or **Tanzende Alte.** Faust's cloak swirls round his shoulders. Feet, "frozen" in mid air and foreshortened in the case of the young witch, are emphasized by the contrasting white area alongside. The hatching on the naked female body, which continues across the background and appears too on the first fold of Faust's cloak, strengthens the diagonal and forward movement inherent in the composition as a whole. Another interesting feature is that, except for her legs which appear not without significance between Faust's, the outline of the woman's body is contained within his. Thus the line of her back continues into his right leg, while his left leg is an extension of her arm. The effect is to streamline the triangular form of their seemingly integrated torso, so throwing into sharper contrast the zig-zag configuration of their legs and feet. With this woodcut is concluded an examination of some examples from the dramatic and visual works that express a negative attitude of irresponsibility, vulgarity and self-satisfaction, the products, for Barlach, of a wholly secular outlook.

In turning to the topic of "star-music", it will be remembered that the star in the puddle was in reality simply a reflection of a star in the sky. One interpretation makes of this a symbol in the physical world of a sphere of perfection for ever beyond man's grasp; and evidence was adduced to suggest the analogous role of certain kinds of music in Barlach's works. The contrasting category of "frog-music" has been shown to find expression in all fields, which distinguishes it further from "star-music", a feature almost entirely limited to the sculptures, woodcuts, lithographs and drawings. Here Barlach was faced by the perennial problem of rendering in visual and spatial terms something that is essentially abstract and temporal. In common with other artists, he attempts to realize in a metaphor of line and volume (though not of colour) his emotional response to a particular musical work or his conception of the symbolic, metaphysical character of music in general. As might be expected, it is the figure of

the singer or instrumentalist that is most frequently chosen to fulfill this function. On the other hand there are several examples too where the connection with music is far less overt. To the first group belongs the small figure of *Der singende Mann,* one of his best known bronzes. A strong rhythmic movement is created by a series of triangles in various planes, e.g. knee—feet—knee; shoulder—hands—shoulder, head—hands—waist. Bold vertical and horizontal forms hold in check the diagonal emphases, so that the work achieves a balance of expressive rhythms and overall restraint. The broad stylized folds of the drapery are arcs of concentric circles, whose centre is located in the figure's head. Similarly, the long straight arms lead the eye to the focal point of the work: the slightly reclining head with its closed eyes and open mouth, suggesting a complete absorption in the activity of singing. The vigour, coupled with self-control, with which the song is produced, in contrast to the impetuous dancing . . . , reveals itself on the one hand in the flowing movements of the constituent parts, and on the other in a detail such as the modelling and set of the toes. Based on an original drawing of 1919/20 is the bronze sculpture *Der Flötenbläser* made in 1936, two years before his death and one year before the infamous *Ausstellung der entarteten Kunst* in Munich, which included work by Barlach. So compelling did he find the earlier design of the rustic flautist during the period in which he fell victim to official Nazi censorship, that he produced in addition a teak and an oak version in the course of the same year. These works can be considered as at once an escape from current persecution into a timeless world of tranquillity and as an affirmation of a belief in the symbolic significance of music. A diagonal movement up to the head, whose eyes are once again closed, links them with *Der singende Mann.* But in contrast to the previous work, they exhibit a closed form, a fusion of individual parts, with no space between them. To this end, the knees are drawn towards each other and the flute itself held close to the chest. In addition, the outline is softly contoured, with the width of the shoulders reduced and the left arm and elbow minimized. Thus the calm, relaxed playing of the man, the source of whose inspiration seems to lie entirely within, finds its appropriate expression in a compact design of gentle, sweeping curves.

Perhaps more than any other sculptural work of Barlach's the clinker figure *Singender Klosterschüler* (also called *Der Sänger*) best represents the category of "star-music". This work, one of only three which were able to be completed by Barlach for the series *Die Gemeinschaft der Heiligen,* was restored in 1947 to its original niche position on the facade of St. Katharine's Church, Lübeck, after a dozen years of concealment from unsympathetic and hostile forces. Finished in a matt violet-grey and a little over life-size, the figure is of a simple construction, since its site requires it to be seen from afar and from below. With the exception of the hair, the work is almost perfectly symmetrical. As in the case of *Der Flötenbläser,* the form is of a closed variety, with the limbs contained within the overall shape of the garment. On this occasion, however, the standing figure thus composed is lent the compactness and concentrated strength of a pillar. Yet, despite this somewhat monumental character, the main quality that is projected is one of sublime composure. . . . The collective name of the group to which it belongs, the site they occupy, and the title of the figure itself all suggest that it is a hymn that is being sung. Whether this is ad-

dressed directly to God as an act of worship, or sung in His praise to all men, it would appear that it has become so much a part of the singer that he need no longer refer to the score. Despite the general avoidance of specific characteristic detail, there is evidence on the brow and in the throat of the energy needed to project the voice. However, this does not substantially impair the serenity and control of the figure, exemplified by its symmetrical form. An extension of this attitude is to be found in the nine oak figures constituting the *Fries der Lauschenden.* Originally planned as reliefs decorating the vase of a memorial bust of Beethoven, they were eventually commissioned for a music room by the tobacco magnate Hermann Reemtsma, so that a musical context was always the intention. Once again, each figure is column-like, exhibiting little outward movement and a tendency to the symmetrical. They themselves do not sing or perform music, but are shown rather in the act of listening. This activity may concern itself simply with terrestrial music, or it may involve an extrasensory contact with the sublime, with God, through the agency of such music. . . . Barlach's reference to the figures of the *Fries der Lauschenden* as "Heiligen und Andachtsgestalten" ["sacred and devotional figures"] suggests that, through their outward silence, they at least are in communion with the "melodies and silences of Heaven". In comparison with these melodies, even those of Bach and Beethoven lose their semblance of perfection, to reveal a relationship as of the reflection to the brilliant star.

In a letter of 1924 Barlach speaks for the first time of illustrating Schiller's ode *An die Freude,* [stating that joy is "the meaning, purpose, and essence of the world," and a notion "transcending time and space"]. The resulting series of nine woodcuts was completed during the following winter, though not published till 1927. "Lied an die Freude", the title by which the series is referred to in his letters, indicates Barlach's conception of this work as "musical" (in the "star-music" sense). An exemplary print from the series is *Engelreigen.* Round a small, but intense light source, whose rays inform and enliven the whole picture, hover angelic figures in an arc formation. While those in the foreground are linked by the outstretched arms of one of them, the rest, who are made to appear to extend beyond the limits of the print, are depicted as separate, though contiguous. The floating figure, an abiding preoccupation of Barlach's in all the visual media, expressing a release from mundane concerns and anxieties, here finds its most vivid statement. All reference to the physical world, to the *Mutterboden* of Sauerbrei's song, is excluded. Instead, the myriad shafts of light radiating from the star-like source stress the other-worldly joy of the angels' song. Thus Barlach, in supplying a visual equivalent for Schiller's poetry and Beethoven's music, achieves a form of synthesis of the arts, which, since Romanticism, has been regarded as an expression of the unity of all creation.

Absolute perfection, whether of beauty, truth, goodness or love, is not confined by the limitations of time or space. In its unchanging condition it remains a sublime ideal which man can only aspire to, never attain. Acknowledging this, Barlach nevertheless recognized in music the closest approach to this ideal, through its being at the one time the most abstract of the arts and the one most able to express directly the emotions experienced in contem-

plating the absolute. However, even music cannot escape the category of time, but must continually unfold and develop in a sequence of elusive sounds. In sculpture, however, in addition to the other visual media, Barlach had a mode which permitted him to suggest at least a sense of "stasis", of removal from time, one of the qualities of the absolute. This he emphasizes, for instance, in the quoted examples of visual "star-music", by an anti-realist avoidance of the particular and the characteristic in his figures, depersonalizing them both in form and title. In addition, he inclines, especially in his later years, towards representations of contemplative states in preference to depicting figures in action. Thus the inward experience of blissful self-forgetfulness through music lends itself particularly, for Barlach, to being realized visually in motionless figures of a generalized character. In contrast to the ideal of timeless perfection, the inherent imperfections of humanity manifest themselves above all in conflict and change. Individual traits of character or appearance, in reality unique constellations of imperfections, may be the features which distinguish human beings, giving them "personality", but this particularizing is also the source of tensions. These tensions, or dissonances, have been labelled "frog-music" and identified as such, especially in the dramas. Here the need for proper names and speech forms befitting the personality of the speaker serve to individualize and set apart one character from another. But these are merely the surface expressions of a deep-rooted aggressive instinct, which reveals itself in its most extreme form dramatically in murder, suicide and mutilation. Related, although less extreme, are the immoderate singing and impetuous dancing of the dramas and visual works, in the latter case performed by similarly individualized figures. Above all, the drama, being the art-form at Barlach's disposal that is dependent on chronological time, becomes the means to expression of the fundamental characteristic of the human condition: transience. The contrast with sculpture is clear.

Unlike his literary cousins in Aesop, La Fontaine or Luther, Barlach's fabulous frog acquires a self-knowledge that enables him to accept the patent inadequacies of his existence. Moral sustenance is provided by the stellar image, a constant reminder of a desired, but unattainable perfection. As has been shown, Classical music can be similarly sustaining, particularly for those who perceive in it a distant echo of the music of the spheres. (pp. 28-34)

> *Peter Meech, "The Frog and the Star: The Role of Music in the Dramatic and Visual Works of Ernst Barlach," in* Literature and the Plastic Arts, 1880-1930: Seven Essays, *edited by I. Higgins, Scottish Academic Press, 1973, pp. 24-34.*

Albert E. Elsen (essay date 1974)

[*Elsen is an art critic whose books include* Purposes of Art *(1962) and* Pioneers of Modern Sculpture *(1973). In the following excerpt, he identifies what is sometimes termed the "primitivism" of Barlach's sculptural style as the artist's elemental yearning for spiritual illumination.*]

Ernst Barlach's subjects are backward people in a second-class rural environment near the Baltic, one that the artist felt put man closer to the capricious moods of God. In form and subject, this self-styled "Low German" sculptor cherished his own type of primitivism that involved places and people he knew, and which encouraged his life-long epic of the spirit's travail. In the costumes of Baltic peasants and townspeople, Barlach discovered the evidence through "masked movement" of true feeling. Folk types provided him with "problematic characters," the grotesque in form and conduct, demoniacal reactions, uninhibited ecstasy, all in genuine rude gestures that mimed human insecurity, perversity, and endurance. These were people who satisfied Barlach's need to feel pity and to give the world an art of consolation. (pp. 24-5)

> *Albert E. Elsen, in an excerpt from his* Origins of Modern Sculpture: Pioneers and Premises, *George Braziller, 1974, pp. 24-5.*

Renée Riese Hubert (essay date 1983)

[*Hubert is a poet, literary scholar, and art critic whose writings include* La Cité borgne *(1953) and* Le Berceau d'Eve *(1957), both collections of poems, and* Apollinaire et Picasso *(1966). In the following excerpt, she analyzes Barlach's illustrations for Goethe's* Faust, *pointing out that the artist remained faithful to the spirit of Goethe's great work, while not subordinating his imagination to the text.*]

We may wonder why so many Expressionists, and Barlach in particular, would illustrate *Faust*. Dissatisfied with the reigning political, social, and economic principles, eager for change and for artistic forms which would adequately express protest, why would they turn to *Faust* rather than to works which belong unilaterally to *Sturm und Drang*? Yet Goethe was one of the authors most frequently quoted by the Expressionists whose interests, in addition to painting and illustrations, were also displayed in Murnau's 1925 film, *Faust* (based on both Goethe's and Marlowe's *Faust* in addition to popular legends), Rudolf Steiner's creation of the Goethenäum, Gustav Mahler's references to Faust motives in his symphonies, Gottfried Benn's reading of Goethe as a pre-expressionist writer, amply documented with quotations. Expressionists endorsed Goethe's belief in the spiritual qualities of man and nature, his implicit mysticism, his stylistic versatility. They hardly were concerned with his role as civil servant and his lofty social status.

These comments may account for Barlach's illustrations of poems rather than those of "Walpurgisnacht". However, . . . [Barlach], in his choice of poems, was strongly attracted to the uncanny. . . . [He clearly] favoured the visionary and the mystical rather than the mimetic and the realistic. In order to overcome triviality and to move to the essential, he aimed to create figures, not to copy them, and he tried to elevate them above the conventional. His struggle, which encompassed destruction as well as reconstruction, could well be represented by his graphic reading of a scene in which antagonistic, though unacknowledged, forces were made visible.

Barlach, by situating his series in the Middle Ages, does not suggest overt references to modern times, be it those of Goethe or his own. His multiple figures, clad in medieval attire, reveal affinities with Gothic sculpture and wood carving, insisting more on the foolish rather than on

the wise, on the grotesque rather than on the sublime. (pp. 76-8)

The striking title page where slightly irregular Gothic letters seem to repeat the linear design of the woodcut appearing above can serve as a model for the entire series. The lines formed by the pleats of the woman's skirt, the gestures of her hand, the outlines of the shell that frame her, synchronize with the succession of round and jagged lines of the letters. Woodcuts refer to passages of varying length with varying descriptive qualities. Although Goethe's characters are usually recognizable, so much so that the reader hardly requires identification, the artist refrains at the outset from establishing unequivocally the relation of text and image. At times, Barlach represents characters as if they were performing their parts, at others he expatiates on a single line of the text. He neglects narrative so as to give free rein to his imagination. However, when his own fantasies extend the text, he carefully refrains from doing violence to Goethe's words or disrupting his own series. Woodcuts such as **Spielleute, Schneckenhexe,** and **Der Bischof** have only peripheral relations to the text. The snail, a slimy creature traditionally related to the Sabbath and named in the text, is transformed by Barlach into a new species of witch characterized by snail-like features. The relationship of **Die Spielleute** to the text appears even more remote, for . . . it derives not from Goethe's but from Grimmelshausen's *Simplizius Simplizissimus,* whose description impressed Barlach strongly. (pp. 78, 80)

Barlach, aware of the dramatic and even theatrical nature of the text, represents creatures in constant motion, though not necessarily responsible for their gestures and expressions. Two figures next to one another assert their differences and yet are subjected to the same influences. In the fifth woodcut, Faust and Mephisto come under the spell of the same tempestuous forces whose overpowering relations are inscribed in the sky. Mephisto seems better adapted to a space where all forms of stability are threatened. We shall attempt to read Barlach's [woodcut] in conjunction with Delacroix's corresponding illustration. Whereas the Romantic lithograph stresses painterly qualities, notably a strong sense of spatial depth, Barlach's woodcut, in which the hardness of the wood asserts itself, reduces spatial elements to a single plane and suppresses colour shading, eschews the picturesque so favoured by Delacroix. . . . The romantic painter dramatizes Faust's and Mephisto's temperamental differences; he shows that they incarnate opposing forces. Mephisto, an evil power, indigenous to the Brocken, assumes a dynamic posture as though to make visible the rhetoric with which to entice a reluctant Faust to follow him. Threatening evil manifests itself not only in Mephisto's demeanor, but also by the presence of snakes. During the witches' Sabbath, Mephisto need not make concessions by disguising or muting his diabolical origins. Here he comes close to the supernatural being that Delacroix depicted in the "Prologue in Heaven", although he does appear wingless in the presence of witches.

Barlach, on the other hand, far from dramatizing a rift, represents the struggle against overwhelming circumstances, where man is threatened by loss of control and mastery. He echoes the Expressionists' anguish at succumbing to disproportionate forces. Mephisto with his skeletal hands, protruding elbows, and bare head appears more exposed than Faust whose clothes help to shelter him. Characters and atmosphere willy-nilly obey the same laws and whirling motion encompasses everything. Solid objects, incapable of resistance, seem to be transformed into the spirals of the clouds. . . . These tendencies emerge all the more strongly since Barlach curtails open spaces, increases the density of the atmospheres, establishes analogies between the outer and inner worlds, and asserts the simultaneous presence of the cosmic and the ordinary, the unity of the universe on the other side of chaos. The disturbances of the world order do not exclude a potential reversal toward equilibrium, for Barlach also situates the scene in a redemptive context in the series as a whole. The manifestation of violence does not refer to a specific hostility between man and the outer world or nature in particular. Rather, Barlach's depiction corresponds to trends in Expressionism which stress that renewal may transcend instability and victimization.

As Klaus Lazarowicz [stated in his *Expressionismus als Literatur*], Barlach had already mastered the representation of "Hexensgenossen" and "Teufelsbruder" when he undertook his Faust illustrations. We may wonder whether the artist, who so effectively relates man to his environment, makes any basic distinctions between witches and human protagonists, between the supernatural and the ordinary. From the title page on, where a rustic and amply clothed witch raises her skirts and displays her protruding womb, the viewer can surmise that Barlach will underplay the daemonic or Satanic, but emphasize vulgarity and sensuality. He thus gives a fairly literal reading of a salient aspect of Goethe's "Walpurgisnacht", for the scene brings Faust into contact with the lowest forms of temptation as evidenced by one of the earliest visions:

> Die alte Baubo kommt herein
> Sie reitet auf einem Mutterschwein.
>
> [Old Baubo approaches riding on a sow.]

The powerful image of the ugly and repulsive witch seated on a sow, the sow heavy in her maternity, attracted . . . Barlach. . . . Barlach emphasizes the intimate relationship between the witch and the sow. Far from exaggerating the sensuality of the pig, he transforms her into a sort of emblem endowed with the noble characteristics of a heraldic lion. She rushes at the onlooker, but her forward thrust, rather than uncluttering the space, curtails it even further, for her jagged bristling outline inscribes itself everywhere. The viewer cannot separate the sow from the surroundings which she generates and by which she is generated. The witch, like other protagonists of the series, fails to maintain control. Though seated on her sow, thus assuming an almost embryonic posture, she struggles throughout to set herself free. This tension between shelter and prison corresponds to equivocations detectable in the text. But the woodcut also provides a grotesque vision based on the disruptions of the death and birth cycle which certainly goes beyond textual metaphors.

Barlach portrays a wide range of perversion with his witches, all of them contrasting with the figure of Gretchen. The witches epitomize the triumph of the grotesque, capable of distorting the myriad forms of nature and producing derision without laughter. In the plate entitled **Hexenritt** Barlach introduces a landscape both more familiar and more autonomous than in his other plates. Over

forbidding darkness with sharp-edged tree tops, witches move at high speed, each one executing different gestures. Their flight, belonging to a space incompatible with ordinary perceptions and natural laws, generates by its profusion a labyrinth of movements, which graphically parallels and parodies the dangerous path all along which the Goethean protagonist is forced to travel.

The *Trödelhexe* seems to differ from other witches by a semblance of stability, for she kneels on the cloth on which she displays her goods. But in producing her merchandise, she also knows it to be false. She thus provides a metaphoric key which links various strata of the scene. . . . The witch can be considered the visual equivalent of Goethe's verbal display. Her raised hands underscore her bargaining and further dramatize her strong facial expression. The multiple folds in her clothes, the mountainous, labyrinthine contours, hint at instability and restlessness. Goethe does not enumerate the objects that the *Trödelhexe* displays and tries to sell. He hints at their perniciousness without naming any of them. Barlach shows perniciousness in his expressionist "Vanitas" skulls, snakes and double-headed monstrous figures. His repulsive inventory represents the Sabbath in miniature. In addition, he does not overlook the ambiguity of the dramatic text. The witch's skeletal fingers, her kneeling posture, and her facial expression all reveal the unrelieved suffering of the damned, a suffering as contagious as it is perverse. The woodcut refers to the paradox whereby container and contained, actor and victim, have become inseparable, a device which can forestall or introduce the reversibility of any protagonist's fate.

Barlach's *Der Proktophantasmist und anderes Gelichter* fittingly interprets dramatic characters who assert ineffective philosophical beliefs out of touch with reality. The illustrator's ridiculous cortège reveals a complicity between these false luminaries and the "regular" population of the Brocken festivity; almost Brechtian encounters are produced. (pp. 80-4)

Barlach further amplified the social and satirical dimensions of his illustrations by introducing a bishop . . . , for which the text provides no precedent. The juxtaposed figures may derive just as strongly from Brecht's *Verfremdungseffekt* as from Goethe's "Walpurgisnacht". Traditionally, as Barlach shows here, there are close connections between pagan and Christian elements in the Sabbath. The ritually clad bishop, representing the establishment, moves in proximity to a nude satanic creature, half man, half beast. In parallel fashion, they attempt to climb the Brocken, but the ascent seems to turn into a descent into an underworld during which the bishop struggles to save appearances.

Promiscuity does not exclude solitude, as Faust states at the beginning of Goethe's scene. . . . When Barlach's Faust dances with a young witch, Barlach emphasizes the separation of partners both by the sloping body of the witch and the out-of-step pacing of the dancers. Isolation is suggested by physical separation in the woodcut *Gretchen.* Gretchen, facing the viewer, seems infinitely distant from the double circle of dancers in the background, chained by their common addiction to the Sabbath. She faces away, not only from the witches, but also from Mephisto and Faust who, according to the text, see her in a vision. Though physically absent from the scene, she

therefore provides the focal point of a circular structure. Statue-like and transfixed, she combines earth-bound imprisonment with spiritual elevation. Barlach, the expressionistic dramatist, inscribes tension and reversibility almost into each moment he evokes, even the almost static vision of Gretchen. (pp. 84-6)

> *Renée Riese Hubert, "Art and Perversity: Barlach's and Dali's Views of 'Walpurgisnacht',"* in Journal of European Studies, *Vol. 13, Nos. 49 & 50, March-June, 1983, pp. 75-95.*

FURTHER READING

I. Critical Studies and Reviews

Carls, Carl Dietrich. *Ernst Barlach.* New York: Praeger, 1969, 216 p.
 Discusses Barlach's life and career, with emphasis on his literary works. A translation of a revised edition of a 1931 essay on Barlach.

Chipp, Herschel B. "German Expressionism in Los Angeles." *Art Journal* 44, No. 1 (Spring 1984): 82-5.
 Review of an exhibition of German Expressionist artists; discusses Barlach's sculptures, with particular emphasis on his 1914 work the *Avenger.*

Hooper, Kent W. *Ernst Barlach's Literary and Visual Art: The Issue of Multiple Talent.* Ann Arbor, Mich.: UMI Research Press, 1987, 202 p.
 Relates Barlach's iconography to his literary symbolism.

Kuspit, Donald B. "An Appeal for Empathy." *Art in America* 72, No. 10 (November 1984): 114-22.
 Includes a brief discussion of Barlach's religiosity. Kuspit asserts that Barlach recognized "the tragic character of human existence, an outlook preserved in religion."

Matteson, Lynn R. "Hirshhorn Museum and Sculpture Garden Smithsonian Institution Exhibition: German Expressionist Sculpture." *Bruckmanns Pantheon* (April-June 1984): 200-01.
 Review of an exhibition which included Barlach's early sculptures in plaster and wood, as well as later porcelain copies. In Matteson's view, the copies constitute an unsuccessful transformation, "for much of the strength of Barlach's style . . . is lost in the icy fragility of the porcelain."

Strauss, Michel. "Current and Forthcoming Exhibitions." *The Burlington Magazine* CIII, No. 699 (June 1961): 288-91.
 Includes an appreciative review of the exhibition of Barlach's work at Arts Council Galleries in London. Sums up Barlach's artistic oeuvre as "a synthetic vision of human shapes and gestures which express with the utmost clarity and sincerity the true basic nature of man's feelings."

Werner, Alfred. Introduction to *Ernst Barlach: Sculptures and Drawings.* New York: Galerie St. Etienne, 1962.
 Discusses Barlach's works in the context of twentieth-century European art. Werner observes that Barlach's

art, despite some affinities with the metaphysical preoccupations of Expressionism, essentially strives to directly represent the tragic condition of humankind. Catalog for the March-April 1962 Barlach exhibition at the Galerie St. Etienne.

————. "Homage to Barlach." *Arts Magazine* 37, No. 4 (January 1963): 64-6.
 Presents the historical background of the Barlach-Haus, near Hamburg. Werner discusses the works displayed, concluding that the museum is "a place for contemplation where one can enjoy and admire the creations of a profound, solitary man who made no compromise in his effort to find an adequate plastic expression for the invisible."

————. *Ernest Barlach.* New York: McGraw-Hill, 1966, 176 p.

An overview of Barlach's artistic oeuvre with references to his writings.

II. Selected Sources of Reproductions

Jackson-Groves, Naomi. *The Transformations of God: Seven Woodcuts by Ernest Barlach with Selections from His Writings.* Hamburg: Kulturabteilung des Auswärtigen Amtes der Bundesrepublik Deutschland, 1962, 52 p.
 Reproductions of Barlach's acclaimed series of seven woodcuts *The Transformations of God* are complemented by selections from his writings.

————. *Ernst Barlach, Life in Work: Sculpture, Drawings and Graphics, Dramas, Prose Works and Letters in Translation.* Königstein (Germany): Langewiesche, 1981, 120 p.
 Includes a representative selection of Barlach's literary output.

Romare Bearden

1914-1988

American painter and mixed-media artist.

Bearden was one of the foremost American artists working in the photomontage and collage media. His vibrant depictions of black American life, both rural and urban, juxtapose fragmented images that resonate Christian and African archetypes and demonstrate a mastery of modernist formal concerns. Marked by the innovative repetition of motifs and color patterns, Bearden's art is especially lauded for adapting the improvisational techniques of jazz and blues music.

Bearden was born in Charlotte, North Carolina, but grew up in Harlem, where his mother was a well-known journalist and political figure. Following high school, Bearden enrolled in Boston University, but he transferred to New York University after two years, majoring in mathematics. During his college career, Bearden also drew political cartoons for student humor magazines and for a national periodical, the Baltimore *Afro-American.* He graduated in 1935, after which he abandoned plans for medical school, made in deference to his parents' wishes, to devote himself to the visual arts. Bearden subsequently attended the Art Students' League in New York, where he studied under German-born American painter and caricaturist George Grosz. Grosz encouraged him to analyze in-depth the elements of composition in the works of major European artists, particularly Flemish painter Pieter Bruegel and the seventeenth-century Dutch masters, and Bearden later wrote, "It was during my period with Grosz . . . that I began to regard myself as a painter rather than a cartoonist."

Although Bearden took a position as a welfare caseworker in New York in 1938, he continued to paint and to participate in the rich cultural milieu of Harlem in the late 1930s. Among his friends were painter Charles Alston, poet Claude McKay, and prominent jazz musicians whose music would heavily influence Bearden's later work. Following three years in the army during World War II, he held his first solo exhibition, and subsequent appearances of Bearden's art in New York galleries earned him critical recognition. While his earliest efforts had reflected the influence of Depression-era social realism, his watercolor paintings of this period, as epitomized by the series *The Passion of Christ* (1945), are characterized by a Cubist-influenced, nonrepresentational style. In 1950 Bearden went to Paris to study philosophy at the Sorbonne. There he read widely in Western literature and art history, and met Romanian-born sculptor Constantin Brancusi and French Cubist painters Fernand Léger and Georges Braque. Upon his return to New York in the following year, Bearden experienced a period of artistic uncertainty during which he wrote jazz music. However, by the mid-1950s he had resumed painting, producing a series of highly abstract works that are noted for their striking colors, varied textures, and skillful use of Oriental compositional principles.

In the early 1960s Bearden began to experiment with the photomontage medium, juxtaposing pictures from popular magazines which he enlarged photostatically. As in his highly-regarded series *Projections* (1964), Bearden's works of this period conflate fractured images to depict urban street scenes, Southern landscapes, and both secular and religious rituals. Human figures in his photomontages typically feature distorted hands and facial features, reminiscent of African sculpture. Bearden's technique in these works is lauded for the use of overlapping visual planes as found in works by Pablo Picasso and the Cubist painters. His photomontages are also praised for structural and imagistic allusions to paintings by major seventeenth-century Dutch artists. Drawing on the rich narrative potential of black American culture, Bearden's photomontage works were an aesthetic breakthrough in his career and earned him wide critical acclaim.

From the early 1970s until the end of his career, Bearden concentrated his efforts on a more conventional approach to the collage medium, using cut-up, repainted sections of paper and other materials to create Cubistically flattened images similar to those conveyed by his photo fragments. This technique allowed him to create colorful, finely delineated images, and Bearden's collages feature some of his

best-known depictions of subjects that preoccupied him throughout his career. The series *Of the Blues* (1974) and later works that treat themes related to jazz and blues music are acclaimed for incorporating the improvisational techniques of these musical media through recurrent motifs, patterns of color, and visual distortions that suggest musical phrases. Commentators also praise Bearden's ability to draw from his personal past images that symbolize significant aspects of black culture. The collages *Maudell Sleet's Magic Garden* (1978), *Sunrise-Moonrise with Maudell Sleet* (1978), and several versions of *Conjur Woman,* for example, portray characters based on women Bearden knew whom critics view as black female archetypes.

During the years just prior to his death in 1988, Bearden focused on subjects inspired by his childhood memories of Mecklenburg County, North Carolina, most notably in the mural *Quilting Time* (1986), a tile mosaic commissioned by the Detroit Institute of Arts. Because of the rich diversity of Bearden's art, commentators concur that he depicted black American life in a manner both highly personal and universally significant. As novelist Ralph Ellison concludes, "Through an act of creative will, [Bearden] has blended strange visual harmonies out of the shrill, indigenous dichotomies of American life and in doing so reflected the irrepressible thrust of a people to endure and keep its intimate sense of its own identity."

ARTIST'S STATEMENTS

Romare Bearden (essay date 1934)

[*What follows is a discussion by Bearden, written at the beginning of his career, in which he suggests that black American artists have failed to evolve authentic styles of expression.*]

For the moment, let us look back into the beginnings of modern art. It is really nothing new, merely an expression projected through new forms, more akin to the spirit of the times. Fundamentally the artist is influenced by the age in which he lives. Then for the artist to express an age that is characterized by machinery, skyscrapers, radios, and the generally quickened cadences of modern life, it follows naturally that he will break from many of the outmoded academic practices of the past. In fact every great movement that has changed the ideals and customs of life, has occasioned a change in the accepted expression of that age.

Modern art has passed through many different stages. There have been the periods of the Impressionists, the Post Impressionists, the Cubists, the Futurists, and hosts of other movements of lesser importance. Even though the use of these forms is on the decline, the impression they made in art circles is still evident. They are commendable in the fact that they substituted for mere photographic realism, a search for inner truths.

Modern art has borrowed heavily from Negro sculpture.

This form of African art had been done hundreds of years ago by primitive people. It was unearthed by archaeologists and brought to the continent. During the past twenty-five years it has enjoyed a deserved recognition among art lovers. Artists have been amazed at the fine surface qualities of the sculpture, the vitality of the work, and the unsurpassed ability of the artists to create such significant forms. Of great importance has been the fact that the African would distort his figures, if by so doing he could achieve a more expressive form. This is one of the cardinal principles of the modern artist.

It is interesting to contrast the bold way in which the African sculptor approached his work, with the timidity of the Negro artist of today. His work is at best hackeneyed and uninspired, and only mere rehashings from the work of any artist that might have influenced him. They have looked at nothing with their own eyes—seemingly content to use borrowed forms. They have evolved nothing original or native like the spiritual, or jazz music.

Many of the Negro artists argue that it is almost impossible for them to evolve such a sculpture. They say that since the Negro is becoming so amalgamated with the white race, and has accepted the white man's civilization he must progress along those lines. Even if this is true, they are certainly not taking advantage of the Negro scene. The Negro in his various environments in America, holds a great variety of rich experiences for the genuine artists. One can imagine what men like Daumier, Grosz, and Cruickshanks might have done with a locale like Harlem, with all its vitality and tempo. Instead, the Negro artist will proudly exhibit his "Scandinavian Landscape," a locale that is entirely alien to him. This will of course impress the uninitiated, who through some feeling of inferiority toward their own subject matter, only require that a work of art have some sort of foreign stamp to make it acceptable.

I admit that at the present time it is almost impossible for the Negro artist not to be influenced by the work of other men. Practically all the great artists have accepted the influence of others. But the difference lies in the fact that the artist with vision, sees his material, chooses, changes, and by integrating what he has learned with his own experiences, finally molds something distinctly personal. Two of the foremost artists of today are the Mexicans, Rivera and Orozco. If we study the work of these two men, it is evident that they were influenced by the continental masters. Nevertheless their art is highly original, and steeped in the tradition and environment of Mexico. It might be noted here that the best work of these men was done in Mexico, of Mexican subject matter. It is not necessary for the artist to go to foreign surroundings in order to secure material for his artistic expression. Rembrandt painted the ordinary Dutch people about him, but he presented human emotions in such a way that their appeal was universal.

Several other factors hinder the development of the Negro artist. First, we have no valid standard of criticism; secondly, foundations and societies which supposedly encourage Negro artists really hinder them; thirdly, the Negro artist has no definite ideology or social philosophy.

Art should be understood and loved by the people. It should arouse and stimulate their creative impulses. Such is the role of art, and this in itself constitutes one of the

Negro artist's chief problems. The best art has been produced in those countries where the public most loved and cherished it. In the days of the Renaissance the towns-folk would often hold huge parades to celebrate an artist's successful completion of a painting. We need some standard of criticism then, not only to stimulate the artist, but also to raise the cultural level of the people. It is well known that the critical writings of men like Herder, Schlegel, Taine, and the system of Marxian dialectics, were as important to the development of literature as any writer.

I am not sure just what form this system of criticism will take, but I am sure that the Negro artist will have to revise his conception of art. No one can doubt that the Negro is possessed of remarkable gifts of imagination and intuition. When he has learned to harness his great gifts of rhythm and pours it into his art—his chance of creating something individual will be heightened. At present it seems that by a slow study of rules and formulas the Negro artist is attempting to do something with his intellect, which he has not felt emotionally. In consequence he has given us poor echoes of the work of white artists—and nothing of himself. (pp. 371-72)

[The] Negro artist . . . must not be content with merely recording a scene as a machine. He must enter wholeheartedly into the situation which he wishes to convey. The artist must be the medium through which humanity expresses itself. In this sense the greatest artists have faced the realities of life, and have been profoundly social.

I don't mean by this that the Negro artist should confine himself only to such scenes as lynchings, or policemen clubbing workers. From an ordinary still life painting by such a master as Chardin we can get as penetrating an insight into eighteenth century life, as from a drawing by Hogarth of a street-walker. If it is the race question, the social struggle, or whatever else that needs expression, it is to that the artist must surrender himself. An intense, eager devotion to present day life, to study it, to help relieve it, this is the calling of the Negro artist. (p. 372)

> *Romare Bearden, "The Negro Artist and Modern Art," in* Opportunity, *Vol. XII, No. 12, December, 1934, pp. 371-72.*

Romare Bearden (essay date 1968)

[*In the following essay, Bearden elaborates on his compositional techniques and aesthetic objectives as a painter and photomontagist.*]

When I first started to make pictures I was particularly interested in using art as an instrument of social change. As far as I was concerned at the time, which was in the mid-1930s, art techniques were simply the means that enabled an artist to communicate a message—which, as I saw it then, was essentially a social, if not a political one. My original objective as an artist was to become a political cartoonist. I was an undergraduate majoring in mathematics at New York University when I started producing a steady stream of caricatures and satirical sketches for *The Magpie,* the campus magazine of humor; by the time I received my degree I had already become something of a semi-professional cartoonist with a weekly feature in the Baltimore *Afro-American,* a Negro newspaper of nationwide reputation and circulation.

It was my search for better ways of getting a social message into my cartoons which led me to the works of Daumier, Forain and Kathe Kollwitz, to the Art Students League and to George Grosz. The artists in the 1930's were deeply conscious of social problems, and Diego Rivera, José Orozco and David Siqueiros in Mexico, and Thomas Hart Benton, John Steuart Curry and Grant Wood in the United States were then at the height of their popularity. But what impressed, engaged and challenged me most were the corrosive line drawings and the watercolors of Grosz.

It was during my period with Grosz, under whom I began studying several months after graduating from New York University, that I began to regard myself as a painter rather than a cartoonist. The drawings of Grosz on the theme of the human situation in post World War I Germany made me realize the artistic possibilities of American Negro subject matter. It was also Grosz who led me to study composition, through the analysis of Brueghel and the great Dutch masters, and who in the process of refining my draftsmanship initiated me into the magic world of Ingres, Dürer, Holbein and Poussin.

I had decided that I wanted to make painting, not mathematics, my life's work, but it was not until several years after leaving the League that I managed to do a group of paintings with any stylistic continuity. The subject matter of almost all of these paintings was drawn from Negro life. This is also true of my painting now, but at that time my emphasis was more on the rural south of the United States, than the urban north. Everything that I have done since then, has been, in effect, an extension of my experiments with flat painting, shallow space, Byzantine stylization and African design.

All of my first paintings were done in tempera. I completed about 20 before going into military service in 1942. When I returned to civilian life in 1945, I began a series of watercolors based on such themes as the Passion of Christ, the Bullring and the Iliad. My temperas had been composed in closed forms and the coloring was subdued, mostly earthy browns, blues and green. When I started working with watercolor, however, I found myself using bright color patterns and bold, black lines to delineate semi-abstract shapes. I never worked long on a painting with this method or made many corrections. I had not yet learned that modern painting progresses through cumulative destructions and new beginnings.

When I started to paint in oil, I simply wanted to extend what I had done in watercolor. To do so, I had the initial sketch enlarged as a photostat, traced it onto a gessoed panel and with thinned color completed the oil as if it were indeed a watercolor.

Later on I read Delacroix's *Journal* and felt that I too could profit by systematically copying the masters of the past and of the present. Not wanting to work in museums, I again used photostats, enlarging photographs of works by Giotto, Duccio, Veronese, Grünewald, Rembrandt, De Hooch, Manet and Matisse. I made reasonably free copies of each work by substituting my own choice of colors for those of these artists, except for those of Manet and Matisse when I was guided by color reproductions. The Rembrandt I chose, *Pilate Washing His Hands,* gave me the most difficulty. While studying this masterpiece, I found

so many subtle rhythms and carefully planned relationships that I finally surrendered the work, having learned that there are hidden, mysterious relationships which defy analysis.

In 1950, I went to Paris on the G.I. Bill, for 18 months. During that time, however, I was much too busy visiting museums, galleries, and studios to get any actual painting done. But I was undergoing a change in my thinking nevertheless, and when I returned to New York I began experimenting in a radically different way. I started to play with pigments, as such, in marks and patches, distorting natural colors and representational objects: I spent several years doing this, until I gradually realized the tracks of color tended to fragment my compositions. That was when I went back to the Dutch masters, to Vermeer and De Hooch, in particular, and it was then I came to some understanding of the way these painters controlled their big shapes, even when elements of different size and scale were included within those large shapes. I was also studying, at the same time, the techniques which enable Chinese classical painters to organize their large areas, for example: the device of the open corner to allow the observer a starting point in encompassing the entire painting; the subtle ways of shifting balance and emphasis; and the use of voids, or negative areas, as sections of pacivity and as a means of projecting the big shapes.

As a result, I began to paint more thinly, often on natural linen, where I left sections of the canvas unpainted so that the linen itself had the function of a color. Then in a transition toward what turned out to be my present style, I painted broad areas of color on various thicknesses of rice paper and glued these papers on canvas, usually in several layers. I tore sections of the paper away, always attempting to tear upward and across on the picture plane until some motif engaged me. When this happened, I added more papers and painted additional colored areas to complete the painting.

When I begin a work now, I first put down several rectangles of color, some of which, as in a Rembrandt drawing, are of the same proportion as the canvas. I next might paste a photograph, perhaps of a head, in the general area where I expect a head to be. The type of photograph does not matter, as it will be greatly altered. At this stage I try only to establish the general layout of the composition. When that is accomplished, I attempt ever more definite statements, superimposing other materials over those I started with. I try to move up and across the surface in much the same manner as I had done with the torn papers, avoiding deep diagonal thrusts and the kind of arabesque shapes favored by the great baroque painters. Slanting directions I regard as tilted rectangles, and I try to find some compensating balance for these relative to the horizontal and vertical axes of the canvas.

I do not burden myself with the need for complete abstraction or absolute formal purity but I do want my language to be strict and classical, in the manner of the great Benin heads, for example. In that sense, I feel my work is in the tradition of most of all the great exponents of flat painting. I have drawn on these styles, which I feel are timeless and historically durable, to control my images in pictorial space. I have incorporated techniques of the camera eye and the documentary film to, in some measure, personally involve the onlooker. Without going too far beyond select-

ed aspects of reality, I try to transform them, often as they are perceived conventionally, into an intense aesthetic statement.

Some observers have noted that the apparent visual basis of my current work, through the use of overlapping planes and of flat space, is similar to Cubism. In the actual process of composition, however, I find myself as deeply involved with methods derived from De Hooch and Vermeer, as well as other masters of flat painting, including the classic Japanese portrait artists and the pre-Renaissance Siennese masters, such as Duccio and Lorenzetti. What I like most about the Cubism of Picasso, Braque and Léger is its primary emphasis on the essentials of structure. Nevertheless I also find that for me the Cubism of these masters leads to an overcrowding of the pictorial space. This accounts for the high surface of the frontal planes, so prevalent in some of the most successful early works of the Cubists. In fact, such exceptions as the collage drawings of Picasso in which emptier areas are emphasized, only point up what is otherwise typical. Much of the agitation in Juan Gris' *Guitar and Flowers,* for instance, is the result of the violent diagonal twist of his planes away from the stabilizing rectangle of the surface. Even the early Cubism of Mondrian, who was in many ways a descendant of De Hooch and Vermeer, contains a number of small brick-like, rectangular shapes which strike me as being more a concession to the manner of the time, than essential to his austere conception of space and structure.

Although I find I am increasingly fascinated by the possibilities of empty space on a canvas, in **The Dove** and **The Street** I was working for maximum multiplicity, without the surface fragmentation which I object to in the early Cubists paintings. Both of these works, which I call **Projections,** were first done in a size not much larger than a sheet of typing paper, then the original was enlarged photographically and dry mounted on masonite board. The subjects are drawn from crowded urban street-scenes but in **The Dove** the variety of the scale in the human figures is such that some of the faces really function as areas of pacivity. The robes in **The Baptism** fulfill a similar function in the counterpoint of occupied and empty areas. Zurburan, in some of his great figural compositions, employed flatly modeled drapery for the same purpose. **The Baptism** is a recollection of the fact that during the warm weather the shallow streams in the Southern states were frequently used for baptismal purposes. In this picture, the train represents the encroachment of another culture.

One of the technical problems with which I am now involved is the interplay between a photograph and an actual painting so that I find myself adjusting color to the grays of the black and white photograph. This adjustment to an over-all gray is, of course, not new to the art of painting. Even in what remains of some Pompeian frescos it appears apparent that in spite of the orange-red backgrounds, the figures and drapery were painted in tones of black, white and gray, with the flesh tints glazed over this gray range of colors. The deep browns and reds, which we associate with the great frescos of the Casa Misteria in Pompeii, actually emanate from a merging of the background with the grayed figures and objects. Before full color methods of printing were established in the early decades of this century, the old two-color process had a

more extensive range of color than one would have thought possible because of a similar interaction of colors.

In many of my paintings I use either a blue-gray or a green color to harmonize with the gray, since I feel both of these colors are intimately related to gray. Sometimes, in order to heighten the character of a painting, I introduce what appears to be a dissonant color, as in **The Approaching Storm,** where the reds, browns and yellows disrupt the placidity of the blues and greens. I found, when I was working on this painting, in which various colored papers were mounted directly onto masonite, that these dissonant colors gave an entirely new significance and character to the other colors and forms. Therefore, in order to unify the composition, I was obliged to both emphasize certain colours and shapes and to mollify others.

Similarly, the heavy red in the ground and upper right-hand areas in **The Folk Musicians** was called for by the brightly colored orange guitars of the musicians. The figures in this painting are, for the most part, painted in oil. The relations of the other colors and shapes to the bright orange, which is certainly the most dominant color, produced some unusual effects. The figure on the far right is quite ghost-like, probably because of the contrast with the red brick wall and, also, because of the opposition of the more solid appearing central figure, which is both light and dark in value.

On the other hand, the simple whites of the blouses on the two figures in the gray, white and blue painting, **The Old Couple** hold their place in a decidedly more reticent manner. I think it is worth observing that most of the background in **The Old Couple** is painted in oil and that throughout the painting there is an interchange between the photographic material and what is painted.

This is also true in **Conjur Woman as an Angel,** where the nude figure of the young woman was freely painted and the photographic components were imposed afterwards. A conjur woman was an important figure in a number of southern Negro rural communities. She was called on to prepare love potions; to provide herbs to cure various illnesses; and to be consulted regarding vexing personal and family problems. Much of her knowledge had been passed on through the generations from an African past, although a great deal was learned from the American Indians. A conjur woman was greatly feared and it was believed that she could change her appearance.

Much of the material used in the abstract elements of my paintings (particularly in the construction of faces) are often parts of photographs as in **Illusionists at 4 p.m.,** where the faces of the women are related to African masks.

Two fundamental assumptions underlie my attitude to my work. First, I feel that when some photographic detail, such as a hand or an eye, is taken out of its original context and is fractured and integrated into a different space and form configuration, it acquires a plastic quality it did not have in the original photograph. In most instances in creating a picture, I use many disparate elements to form a figure, or part of a background. I rarely use an actual photograph of a face but build them, for example, from parts of African masks, animal eyes, marbles, corn and mossy vegetation. In such a process, often something specific and particular can have its meaning extended toward what is

more general and universal but never at the expense of the total structure. In this connection, the thumb of the woman on the far left in [**Illusionists at 4 p.m.**] has as much to do with integrating the painting as a whole, as with representing the 'handness' of hands. And in **Two Women in a Courtyard,** I try to show that the courtyard was as important to American southern life, as indeed it was in the Holland of De Hooch, Terborch and Vermeer.

Also involved in the process of fracturing, as I conceive it, is its purpose in extending the larger rhythms of the painting. For instance, also in [**Illusionists at 4 p.m.**], the way the lower section of the standing woman's face is cut, corresponds to the horizontal rhythms that stretch across the top of the painting.

Secondly, I think a quality of artificiality must be retained in a work of art, since, after all, the reality of art is not to be confused with that of the outer world. Art, it must be remembered, is artifice, or a creative undertaking, the primary function of which is to add to our existing conception of reality. Moreover, such devices of artificiality as distortion of scale and proportion, and abstract coloration, are the very means through which I try to achieve a more personal expression than I sense in the realistic or conventionally focused photograph. The initial public reaction to my work has generally been one of shock, which appears to rise out of a confrontation with subject matter unfamiliar to most persons. In spite of this, it is not my aim to paint about the Negro in America in terms of propaganda. It is precisely my awareness of the distortions required of the polemicist that has caused me to paint the life of my people as I know it—as passionately and dispassionately as Brueghel painted the life of the Flemish people of his day. One can draw many social analogies from the great works of Brueghel—as I have no doubt one can draw from mine—my intention, however, is to reveal through pictorial complexities the richness of a life I know.

I am afraid, despite my intentions, that in some instances commentators have tended to overemphasize what they believe to be the social elements in my work. But while my response to certain human elements is as obvious as it is inevitable, I am also pleased to note that upon reflection many persons have found that they were as much concerned with the aesthetic implications of my paintings as with, what may possibly be, my human compassion. (pp. 11-18)

Romare Bearden, "Rectangular Structure in My Montage Paintings," in Leonardo, *Vol. 2, No. 1, January, 1969, pp. 11-19.*

SURVEY OF CRITICISM

Dore Ashton (essay date 1964)

[*Ashton is an American educator and critic who has written extensively on modern artists and art move-*

ments. In the following essay, she discusses Bearden's first series of photomontages, Projections.]

Romare Bearden chooses his terms cautiously, never overtaxing the function of his images. He wryly observes that to change the world you might need something more than a painting. His new suite of photomontages, **Projections,** is, he says, "the consolidation of some memories, of some direct experiences from my childhood to the present."

But that is a characteristic understatement, for these memories and experiences emerge in a form that is more commanding than mere reminiscence. Circumstance is all-important: these harrowing images have surged into Bearden's consciousness with enough force to displace, temporarily, his usual preoccupation with abstract lyrical painting. They arrived at a particular moment in American history and cannot be seen—at least not for the moment—as divorced from the crisis. They are direct responses to the groundswell of awareness that brought white Americans finally into a confrontation with their crimes. They are, as Bearden himself acknowledges, "about something outside of just the structure of the works."

The mordant technique of photomontage answered a need. Bearden cites Braque's "you can't do everything the same way" to explain his departure from abstract painting, and adds that his photomontages are "very pure plastically." They are, in fact, strongly structured, plastically sound compositions, but they go beyond elementary design problems. Necessity was their source just as the photomontage technique itself derived from a specific necessity.

Although Bearden sees his projections in the cubist tradition, his images relate as much to the activist photomontages that gained currency during the First World War. It is quite possible, writes Peter Selz in an article on John Heartfield, that the photomontage principle was discovered by soldiers on the Western Front who, "unable to get their reports of butchery past the censors, turned to pasting together photographs and cutouts from illustrated papers to tell their tale of horror to their families and friends". From these graphic accounts such artists as John Heartfield and George Grosz (who was Bearden's teacher years later) derived a medium which they turned into a vigorous protestant tool.

In his own terms, Bearden has done no less. His tale of horror, drawn from his own history, is told in the inescapably plain terms of the photograph—the eye-witness whose testimony cannot be shaken. Even though Bearden has scissored and pasted with the skill of a long-standing, powerful graphic artist, and even though he alludes constantly to Art, or the history of art, Bearden ultimately arrives at a piercing, activist bill of particulars of intolerable facts. As a background to the works, Bearden's lean autobiography gives only a few essential clues:

> I was born in Charlotte, North Carolina, on Sept. 2, 1914. I went to public school and high school in New York City and Pittsburgh . . . After I graduated from New York University I went to the Art Students' League and studied with the great German artist George Grosz . . . I got a studio. Mine was over that of Jacob Lawrence's at 33 West 125th Street. . . .

125th Street: The main thoroughfare of New York City's ghetto Harlem—site of overwhelming squalor and despair. As an indication of how remote and confined ghetto life is, Bearden's next few lines in his autobiography are revealing. He explains how his education was supplemented when a friend of his took him "downtown" where he met such artists as Paul Burlin and Stuart Davis. "Downtown" where the white artist seeks his destiny is very different from uptown, from Bearden's studio over the Apollo Theatre on 125th Street. In another context Bearden has written that as a Negro, "I do not need to go looking for 'happenings', the absurd, or the surreal, because I have seen things that neither Dali, Beckett, Ionesco or any of the others could have thought possible."

What Bearden had seen from youth on did not recede—not while he was in the United States Army, not while he was working in Paris, not while he was developing a distinctive abstract idiom, not while he was, for a time, a professional song writer. It was there, waiting for the appropriate moment and means, and emerged in time to become one of the strongest statements in an art form of the central scandal of America.

Bearden in his photomontages takes us into many climates, many places—some literally described, some allegorically indicated in allusions to Art. Yet even when he introduces an almost-familiar figure from a Renaissance painting, as he does at the extreme right of **Mysteries,** or in the Velasquez-like group in **Evening, 9:10, 461 Lenox Avenue,** the image functions as more than an esthetic quotation. For each of Bearden's compositions is dominated by the eyes of real people, eyes that look out at the spectator with relentless steadiness, eyes that can only be seen as accusing.

Bearden doesn't depend, as would the surrealist, on startling juxtaposition. Rather, he focuses on significant details from which the nature of his experiences can be constructed by the beholder. Of his early memories, there are compositions alluding unmistakenly to the South. Quite aside from the fact that they would naturally fall into the past (he was born in 1914, after all), these Southern images have a quality of ancientness. They are at once quiet and disquieting. They recall African customs and colonial vices.

In **Prevalence of Ritual, Tidings** for instance, the ancient train is moving through a pale, stripped landscape haunted by birds, while the specific place is indicated by the clapboard house. The black angel bearing tidings is, like most of Bearden's creatures, masked, and only the large eye is animate.

The pendant composition, **Conjur Woman** carries an interesting commentary by the artist:

> Only the conjur woman, alone in the woods, seems unaffected by her solitude; therefore no train defaces her woods. A conjur woman, they say, can change reality, but for the rest of us, it is too late. The World is without her kind of mystery now.

Yet the mystery, coupled with ineffable despair, does extend itself into Bearden's images of urban life. One of the strongest pictures in the series, **Pittsburgh Memory** deliberately invokes African associations. The two workers, frontally seen in closeup, are like participants in a sober

ritual. Their faces are given as masks and the displacement of feature is not distortion, but rather, abstraction of the essential feelings involved.

This curious effect, by the way, runs consistently throughout the series. Any individual face when examined closely is basically distorted, with features of varying types and ages brought together in one startling visage. Yet the total effect is not one of deformity—not the exacerbated dislocations of Bacon, or the disfigurations of Richier. Rather, Bearden's compendia of features can be read as the multiple profiled heads in Picasso's paintings can be read: as vital descriptions of salient characteristics. They are not expressionist at all in tenor, but rather sadly analytical.

In the sweep of Bearden's life several epochs are commemorated. His views of jazz, for instance, are the views of the 1930s when jazz was "hot" and not "cool" and when jazzmen grinned and were transported wildly, rather than introspectively and deadpanned as they are today.

Bearden's metropolitan ghetto is today's ghetto however, its bricks and pavements closely figured, its denizens exasperated and sullen. In **The Dove** Bearden gives much of his message in the ballet of hand gestures—from a raised fist to the folded hands of resignation. In others pertaining to urban misery, childrens' faces often serve as the dread counterpoint for Bearden's accretions of telling detail. Inescapably the "real" speaks.

Although Bearden's stress is insistently on art, it is in the artlessness of the "real" that the power of these photomontages lies. The times and places he depicts are unmistakeable, no matter how much regulated by his plastic manipulations. In this sense, Bearden's photomontages may be compared with the best film documentaries which, through their uncompromising severity, their strict adherence to visual fact, transcend reportage and become art. Depth of feeling and discipline are the keys. (pp. 100-10)

Dore Ashton, "Romare Bearden: Projections,"
in Quadrum, *No. 17, 1964, pp. 99-110.*

Ralph Ellison (essay date 1968)

[*An American novelist and essayist, Ellison is best known as the author of the highly acclaimed novel* Invisible Man (*1952*). *Considered among the most significant works of postwar American fiction,* Invisible Man *concerns a black American's search for identity as an individual as well as his struggle against racial prejudice. The following essay was written as an introduction to a 1968 exhibition of Bearden's paintings and photomontages, which was held at the the State University of New York at Albany. Here, Ellison examines the relationship between artistic expression and the portrayal of black American identity in Bearden's works.*]

This series of collages and projections by Romare Bearden represent a triumph of a special order. Springing from a dedicated painter's unending efforts to master the techniques of illusion and revelation which are so important to the craft of painting, they are also the result of Bearden's search for fresh methods to explore the plastic possibilities of Negro American experience. What is special about Bearden's achievement is, it seems to me, the manner in which he has made his dual explorations serve one

another, the way in which his technique has been used to discover and transfigure its object. For in keeping with the special nature of his search and by the self-imposed "rules of the game," it was necessary that the methods arrived at be such as would allow him to express the tragic predicament of his people without violating his passionate dedication to art as a fundamental and transcendent agency for confronting and revealing the world.

To have done this successfully is not only to have added a dimension to the technical resourcefulness of art, but to have modified our way of experiencing reality. It is also to have had a most successful encounter with a troublesome social anachronism which, while finding its existence in areas lying beyond the special providence of the artist, has nevertheless caused great confusion among many painters of Bearden's social background. I say *social,* for although Bearden is by self-affirmation no less than by public identification a Negro American, the quality of his *artistic* culture can by no means be conveyed by that term. Nor does it help to apply the designation "black" (even more amorphous for conveying a sense of cultural complexity) and since such terms tell us little about the unique individuality of the artist or anyone else, it is well to have them out in the open where they can cause the least confusion.

What, then, do I mean by anachronism? I refer to that imbalance in American society which leads to a distorted perception of social reality, to a stubborn blindness to the creative possibilities of cultural diversity, to the prevalence of negative myths, racial stereotypes and dangerous illusions about art, humanity and society. Arising from an initial failure of social justice, this anachronism divides social groups along lines that are no longer tenable while fostering hostility, anxiety and fear; and in the area to which we now address ourselves it has had the damaging effect of alienating many Negro artists from the traditions, techniques and theories indigenous to the arts through which they aspire to achieve themselves.

Thus in the field of culture, where their freedom of self-definition is at a maximum, and where the techniques of artistic self-expression are most abundantly available, they are so fascinated by the power of their anachronistic social imbalance as to limit their efforts to describing its manifold dimensions and its apparent invincibility against change. Indeed, they take it as a major theme and focus for their attention; they allow it to dominate their thinking about themselves, their people, their country and their art. And while many are convinced that simply to recognize social imbalance is enough to put it to riot, few achieve anything like artistic mastery, and most fail miserably through a single-minded effort to "tell it like it is."

Sadly however, the problem for the plastic artist is not one of "telling" at all, but of *revealing* that which has been concealed by time, by custom, and by our trained incapacity to perceive the truth. Thus it is a matter of destroying moribund images of reality and creating the new. Further, for the true artist, working from the top of his times and out of a conscious concern with the most challenging possibilities of his form, the unassimilated and anachronistic—whether in the shape of motif, technique or image—is abhorrent, an evidence of conceptual and/or technical failure, of challenges unmet. And although he may ignore the anachronistic through a preoccupation with other

Carolina Shout (1974). Mint Museum of Art, Charlotte, North Carolina. Museum Purchase: National Endowment for the Arts Matching and the Charlotte Debutante Club Fund.

pressing details, he can never be satisfied simply by placing it within a frame. For once there, it becomes the symbol of all that is not art and a mockery of his powers of creation. So at best he struggles to banish the anachronistic element from his canvas by converting it into an element of style, a device of his personal vision.

For as Bearden demonstrated here so powerfully, it is of the true artist's nature and mode of action to dominate all the world and time through technique and vision. His mission is to bring a new visual order into the world, and through his art he seeks to reset society's clock by imposing upon it his own method of defining the times. The urge to do this determines the form and character of his social responsibility, it spurs his restless exploration for plastic possibilities, and it accounts to a large extent for his creative aggressiveness.

But it is here precisely that the aspiring Negro painter so often falters. Trained by the circumstances of his social predicament to a habit (no matter how reluctant) of accommodation, such an attitude toward the world seems quite quixotic. He is, he feels, only one man, and the conditions which thwart his freedom are of such enormous dimensions as to appear unconquerable by purely plastic

means—even at the hands of the most highly trained, gifted and arrogant artist.

"Turn Picasso into a Negro and *then* let me see how far he can go," he will tell you, because he feels an irremediable conflict between his identity as a member of an embattled social minority and his freedom as an artist. He cannot avoid—nor should he wish to avoid—his group-identity, but he flounders before the question of how his group's experience might be given statement through the categories of a non-verbal form of art which has been consciously exploring its own unique possibilities for many decades before he appeared on the scene; a self-assertive and irreverent art which abandoned long ago the task of mere representation to photography and the role of story-telling to the masters of the comic strip and the cinema. Nor can he draw upon his folk tradition for a simple answer. For here, beginning with the Bible and proceeding all the way through the spirituals and blues, novel, poem and the dance, Negro Americans have depended upon the element of narrative for both entertainment and group identification. Further, it has been those who have offered an answer to the question—ever crucial in the lives of a repressed minority—of who and what they are in the most simplified and graphic terms who have won their highest

praise and admiration. And unfortunately there seems to be (the African past notwithstanding) no specifically Negro American tradition of plastic design to offer him support.

How then, he asks himself, does even an artist steeped in the most advanced lore of his craft and most passionately concerned with solving the more advanced problems of painting as *painting* address himself to the perplexing question of bringing his art to bear upon the task (never so urgent as now) of defining Negro American identity, of pressing its claims for recognition and for justice? He feels, in brief, a near-unresolvable conflict between his urge to leave his mark upon the world through art and his ties to his group and its claims upon him.

Fortunately for them and for us, Romare Bearden has faced these questions for himself, and since he is an artist whose social consciousness is no less intense than his dedication to art, his example is of utmost importance for all who are concerned with grasping something of the complex interrelations between race, culture and the individual artist as they exist in the United States. Bearden is aware that for Negro Americans these are times of eloquent protest and intense struggle, times of rejection and redefinition—but he also knows that all this does little to make the question of the relation of the Negro artist to painting any less difficult. And if the cries in the street are to find effective statement on canvas they must undergo a metamorphosis. For in painting, Bearden has recently observed, there is little room for the lachrymose, for self-pity or raw complaint; and if they are to find a place in painting this can only be accomplished by infusing them with the freshest sensibility of the times as it finds existence in the elements of painting.

During the late Thirties when I first became aware of Bearden's work, he was painting scenes of the Depression in a style strongly influenced by the Mexican muralists. This work was powerful, the scenes grim and brooding, and through his depiction of unemployed workingmen in Harlem he was able, while evoking the Southern past, to move beyond the usual protest painting of that period to reveal something of the universal elements of an abiding human condition. By striving to depict the times, by reducing scene, character and atmosphere to a style, he caught both the universality of Harlem life and the "harlemness" of the national human predicament.

I recall that later under the dual influences of Hemingway and the poetic tragedy of Federico Garcia Lorca, Bearden created a voluminous series of drawings and paintings inspired by Lorca's *Lament for Ignacio Sanchez Mejias*. He had become interested in myth and ritual as potent forms for ordering human experience, and it would seem that by stepping back from the immediacy of the Harlem experience—which he knew both from boyhood and as a social worker—he was freed to give expression to the essentially poetic side of his vision. The products of that period were marked by a palette which in contrast with the somber colors of the earlier work and despite the tragic theme with its underlying allusions to Christian rite and mystery, was brightly sensual. And despite their having been consciously influenced by the compositional patterns of the Italian primitives, and the Dutch masters, these works were also resolutely abstract.

It was as though Bearden had decided that in order to possess his world *artistically* he had to confront it *not* through propaganda or sentimentality, but through the finest techniques and traditions of painting. He sought to recreate his Harlem in the light of his painter's vision, and thus he avoided the defeats suffered by many of the aspiring painters of that period who seemed to have felt that they had only to reproduce out of a mood of protest and despair the scenes and surfaces of Harlem, in order to win artistic mastery and accomplish social transfiguration.

It would seem that for many Negro painters even the *possibility* of translating Negro American experience into the modes and conventions of modern painting went unrecognized. This was, in part, the result of an agonizing fixation upon the racial mysteries and social realities dramatized by color, facial structure, and the texture of Negro skin and hair. And again, many aspiring artists clung with protective compulsiveness to the myth of the Negro American's total alienation from the larger American culture—a culture which he helped to create in the areas of music and literature, and where in the area of painting he has appeared from the earliest days of the nation as a symbolic figure—and allowed the realities of their social and political situation to determine their conception of their role and freedom as artists.

To accept this form of the myth was to accept its twin variants, one of which holds that there is a pure mainstream of American culture which is "unpolluted" by any trace of Negro American style or idiom, and the other (propagated currently by the exponents of *Negritude*) which holds that Western art is basically racist and thus anything more than a cursory knowledge of its techniques and history is to the Negro artist irrelevant. In other words, the Negro American who aspired to the title "Artist" was too often restricted by sociological notions of racial separatism, and these appear not only to have restricted his use of artistic freedom, but to have limited his curiosity as to the abundant resources made available to him by those restless and assertive agencies of the artistic imagination which we call technique and conscious culture.

Indeed, it has been said that these disturbing works of Bearden's (which virtually erupted during a tranquil period of abstract painting) began quite innocently as a demonstration to a group of Negro painters. He was suggesting some of the possibilities through which commonplace materials could be forced to undergo a creative metamorphosis when manipulated by some of the non-representational techniques available to the resourceful craftsman. The step from collage to projection followed naturally since Bearden had used it during the early Forties as a means of studying the works of such early masters as Giotto and de Hooch. That he went on to become fascinated with the possibilities lying in such "found" materials is both an important illustrative instance for younger painters and a source for our delight and wonder.

Bearden knows that regardless of the individual painter's personal history, taste or point of view, he must, nevertheless, pay his materials the respect of approaching them through a highly conscious awareness of the resources and limitations of the form to which he has dedicated his creative energies. One suspects also that as an artist possessing a marked gift for pedagogy, he has sought here to reveal a world long hidden by the cliches of sociology and

rendered cloudy by the distortions of newsprint and the false continuity imposed upon our conception of Negro life by television and much documentary photography. Therefore, as he delights us with the magic of design and teaches us the ambiguity of vision, Bearden insists that we *see* and that we see in depth and by the fresh light of the creative vision. Bearden knows that the true complexity of the slum dweller and the tenant farmer require a release from the prison of our media-dulled perception and a reassembling in forms which would convey something of the depth and wonder of the Negro American's stubborn humanity.

Being aware that the true artist destroys the accepted world by way of revealing the unseen, and creating that which is new and uniquely his own, Bearden has used cubist techniques to his own ingenious effect. His mask-faced Harlemites and tenant farmers set in their mysterious, familiar, but emphatically abstract, scenes are nevertheless resonant of artistic and social history. Without compromising their integrity as elements in plastic compositions his figures are eloquent of a complex reality lying beyond their frames. While functioning as integral elements of design they serve simultaneously as signs and symbols of a humanity which has struggled to survive the decimating and fragmentizing effects of American social processes. Here faces which draw upon the abstract character of African sculpture for their composition are made to focus our attention upon the far from abstract reality of a people. Here abstract interiors are presented in which concrete life is acted out under repressive conditions. Here, too, the poetry of the blues is projected through synthetic forms which, visually, are in themselves tragi-comic and eloquently poetic. A harsh poetry this, but poetry nevertheless; with the nostalgic imagery of the blues conceived as visual form, image, pattern and symbol—including the familiar trains (evoking partings and reconciliations), and the conjur women (who appear in these works with the ubiquity of the witches who haunt the drawing of Goya) who evoke the abiding mystery of the enigmatic women who people the blues. And here, too, are renderings of those rituals of rebirth and dying, of baptism and sorcery which give ceremonial continuity to the Negro American community.

By imposing his vision upon scenes familiar to us all Bearden reveals much of the universally human which they conceal. Through his creative assemblage he makes complex comments upon history, upon society and upon the nature of art. Indeed, his Harlem becomes a place inhabited by people who have in fact been *resurrected,* re-created by art, a place composed of visual puns and artistic allusions and where the sacred and profane, reality and dream are ambiguously mingled. And resurrected with them in the guise of fragmented ancestral figures and forgotten gods (really masks of the instincts, hopes, emotions, aspirations and dreams) are those powers that now surge in our land with a potentially destructive force which springs from the very fact of their having for so long gone unrecognized, unseen.

Bearden doesn't impose these powers upon us by explicit comment, but his ability to make the unseen manifest allows us some insight into the forces which now clash and rage as Negro Americans seek self-definition in the slums of our cities. There is a beauty here, a harsh beauty which

asserts itself out of the horrible fragmentation which Bearden's subjects and their environment have undergone. But, as I have said, there is no preaching; these forces have been brought to eye by formal art. These works take us from Harlem through the south of tenant farms and northward-bound trains to tribal Africa; our mode of conveyance consists of every device which has claimed Bearden's artistic attention, from the oversimplified and scanty images of Negroes that appear in our ads and photojournalism, to the discoveries of the School of Paris and the Bauhaus. He has used the discoveries of Giotto and Pieter de Hooch no less than those of Juan Gris, Picasso, Schwitters and Mondrian (who was no less fascinated by the visual possibilities of jazz than by the compositional rhythms of the early Dutch masters), and has discovered his own uses for the metaphysical richness of African sculptural forms. In brief, Bearden has used (and most playfully) all of his artistic knowledge and skill to create a curve of plastic vision which reveals to us something of the mysterious complexity of those who dwell in our urban slums. But his is the eye of a painter, not that of a sociologist and here the elegant architectural details which exist in a setting of gracious but neglected streets and the buildings in which the hopeful and the hopeless live cheek by jowl, where failed human wrecks and the confidently expectant explorers of the frontiers of human possibility are crowded together as incongruously as the explosive details in a Bearden canvas—all this comes across plastically and with a freshness of impact that is impossible for sociological cliche or raw protest.

Where any number of painters have tried to project the "prose" of Harlem—a task performed more successfully by photographers—Bearden has concentrated upon releasing its poetry, its abiding rituals and ceremonies of affirmation—creating a surreal poetry compounded of vitality and powerlessness, destructive impulse and the all-pervading and enduring faith in their own style of American humanity. Through his faith in the powers of art to reveal the unseen through the seen his collages have transcended their immaculateness as plastic constructions.— Or to put it another way, Bearden's meaning is identical with his method. His combination of technique is in itself eloquent of the sharp breaks, leaps in consciousness, distortions, paradoxes, reversals, telescoping of time and surreal blending of styles, values, hopes and dreams which characterize much of Negro American history. Through an act of creative will, he has blended strange visual harmonies out of the shrill, indigenous dichotomies of American life and in doing so reflected the irrepressible thrust of a people to endure and keep its intimate sense of its own identity.

Bearden seems to have told himself that in order to possess the meaning of his Southern childhood and Northern upbringing, that in order to keep his memories, dreams and values whole, he would have to recreate them, humanize them by reducing them to artistic style. Thus in the poetic sense these works give plastic expression to a vision in which the socially grotesque conceals a tragic beauty; and they embody Bearden's interrogation of the empirical values of a society which mocks its own ideals through a blindness induced by its myth of race. All this, ironically, by a man who visually at least (he is light-skinned and perhaps more Russian than "black" in appearance) need never have been restricted to the social limitations im-

posed upon easily identified Negroes. Bearden's art is thus not only an affirmation of his own freedom and responsibility as an individual and artist, it is an affirmation of the irrelevance of the notion of race as a limiting force in the arts. These are works of a man possessing a rare lucidity of vision. (pp. 673-80)

Ralph Ellison, "The Art of Romare Bearden," in The Massachusetts Review, *Vol. XVIII, No. 4, 1977, pp. 673-80.*

Michael Brenson (essay date 1987)

[*In the following excerpt, Brenson reviews the exhibit "Romare Bearden: Origins and Progressions," evaluating major paintings and collages by Bearden.*]

Romare Bearden's intimate tapestries are about memory and forgetting, wisdom and laughter, silence and song. His human comedy is pieced together with the hard, racy, broken rhythms of New York City, where he has spent most of his life, and the communal rhythms of Mecklenburg County, N.C., where he spent the summers of his youth. Bearden has said that he wanted in his collages to "bring the Afro-American experience into art and give it a universal dimension." In "Romare Bearden: Origins and Progressions," a 40-year survey at the Bronx Museum of the Arts, it is clear that he has succeeded.

Bearden is a great collagist. He took the medium invented by Picasso and Braque and made it a very particular narrative and expressive tool. Musicians play; eyes accuse or wink; bodies glide across the surface with no more urgency than the procession across Keats's Grecian urn; ancestral shadows illuminate and haunt the present. Bearden turns faces in and out, combines photographs with paint, puts big hands on small bodies and small hands on big bodies. By making each object and each head and hand a different material, he almost obliges us to see details independently and as part of a whole.

The collages can be poignant and raucous. *Morning Work Train,* with a naked black woman standing alone in her home as a train pulls in outside her door, has the bittersweetness of the blues. In *Night Song* a black woman, as composed and stately as a queen, waits in her freshly cleaned room. In the next room, a woman in cleaning clothes faces the open door through which we see, feel and almost hear the southern night. Amidst this expectation and mystery, an unexpected pink shape jumps out, in the bedroom with the regal woman is a chicken.

In the 1974 *At Connie's Inn* Bearden has taken the nightclub scene identified with Post-Impressionism and given it a different syntax and texture. A jazz band plays. Women dance. The crowd near the stage sits still. A man in the back yells. Spread over the work, seemingly inside the work, is a hot yellow. We are far here from the cool distance of Degas. We are inside the work, alongside the pianist who is controlling the scene like an organist in church, playing the scene like the artist himself.

Although any full retrospective would have to start in the 20's and 30's, where Bearden's jazz-age rhythms entered his blood and his mural ideal took shape, this is the first exhibition that allows the career of the 74-year-old artist to unfold. The focus is not the collages for which he is best

known, but the work of 1945 to 1962, when Bearden was exploring literary themes and experimenting with abstraction. The abstractions alone are worth a visit.

The show originated at the Detroit Institute of Arts. The inspiration was *Quilting Time,* a 9-foot-tall and 14-foot-wide mosaic mural commissioned by the Detroit museum, whose tradition of commissioning populist works began in the early 1920's with Diego Rivera's *Detroit Industry* mural. Both the Rivera and the Bearden are permanent installations and cannot travel. The Rivera is a grandiose, utopian hymn to urban industry, the Bearden an ode to the memory and imagination woven into the handiwork of the rural south. Wanting to provide a context in which the mosaic mural could be understood, the Detroit Institute organized an exhibition of 57 works. There are just enough collages after 1970, including the maquette for *Quilting Time,* to sustain the momentum and demonstrate the fullness of Bearden's artistic statement. (p. 33)

The earliest water colors and paintings in the show were inspired by religion and literature. Bearden served in the Army during World War II, and in its aftermath he struggled with big themes. He made works based on the cosmic farce of Rabelais's *Gargantua and Pantagruel,* the battlefield of Homer's *Iliad,* and the hypnotic mourning of Garcia Lorca's *Lament for a Bullfighter.* From 1945 the insistence on light and rhythm is clear. So is the dialogue between transparency and opaqueness that can make some parts of Bearden's works as dense as mud and others as luminous as stained-glass windows.

But if these subjects are familiar, their treatment can be ironic and brash, particularly in 1945 scenes drawn from the *Passion of Christ.* In the *Last Supper,* Christ is prostrate, and Judas may be the one behind the table eating. In *Mary Supporting Christ,* Christ and Mary seem like lovers, and he seems to be consoling her for his fate.

In the 1945 *Madonna and Child,* the Christian story is told in the meeting of eyes in which the fate of the child seems already understood. But Bearden has superimposed outlines over the figures that give the Madonna the large breasts and generalized shape of a fertility goddess. The Christ figure now becomes almost sacklike, and he appears to be resting on her back, like many children in mother-and-child images in tribal sculpture.

While much has been written about Bearden and music, there is almost as much to say about him and the written word. It is clear from this show that not only has he read widely in epic literature, but his water colors can have the quality of medieval illuminations. Bearden also has a deep feeling for paper. Its white delivers more light to him than he can ever coax out of canvas. If he is a musician in the way he approaches tones and intervals, he is also a storyteller, and paper is as much his element as color and line.

In the abstractions of the 1950's, Bearden found a new freedom and experimented with a larger scale. If previous works in the show suggest Picasso, Matisse and the School of Paris, the abstractions belong to a decade marked by Abstract Expressionism and Chinese painting, which Bearden studied. Previously he worked with specific subjects. From this point on, Bearden allowed the artistic process to guide him. As his work began to follow something like a natural process, his subject matter moved closer to nature.

The movement in the abstract paintings can be slow, as in *Leafless Garden,* where the paint seems to ooze across the canvas like a mudslide. Or it can be fast as in *The Heart of Autumn,* where everything seems to be sucked into or shot out of a vortex. There are intimations of landscape everywhere. *River Mist* seems like a collage of natural forces. The blue expands like the sky and crashes like a waterfall. In these works Bearden plays with cut-out shapes, which in his hands seem like pieces of a primal jig-saw puzzle.

On an art-historical level, the abstractions are among the richest works Bearden has done. *The Heart of Autumn,* with its rich play of textures and materials, suggests a bridge between the early 20th century abstract paintings of Augusto Giacometti and the recent alchemical paint-ings of Sigmar Polke. *Number 9* and *Number 12,* both from 1961, suggest a link between the blocklike sculptural strokes of Cézanne and the cross-hatchings of Jasper Johns.

Number 12 crosses cultures. Bearden has allowed paint to soak into rice paper. If the cut-out sheets are organized in ways that suggest the all-over approach of Abstract Ex-pressionism, the shift in perspectives is reminiscent of Chi-nese art. And the head that seems to be taking shape in the bottom half of the work has the ferocity and frontality of tribal art. One sign of Bearden's pictorial intelligence is that the scale of this painting, and of almost every work in the show, feels right.

Bearden's pact with his creative process has been essential. "Painting is like a man being in love," he has said, "an ad-venture one plunges into without knowing how you will fare." He is convinced of the importance of listening to his work rather than imposing an idea or concept upon it. Often shapes, lines and colors will lead him to content, di-rect him to what he wants to say. He does not force the issue. His tendency to proceed from the inside out is one reason why his work has continued to grow and deepen.

By the time the civil-rights movement inspired Bearden to make the Afro-American experience his subject his work already had a universal dimension. The more concrete and specific his content became, the more everything he had seen, read and listened to came together. Even in a rela-tively simple work like the 1970 *Black Mother and Child,* in which a mother and child are nestled cheek to cheek as they might be in a Byzantine icon or an altarpiece by Duc-cio, different cultures intersect.

There are attempts at big statements. The 1968 *Family Dinner* is one of several works in which Bearden is attract-ed to the theme of the ages and family of man. The 1972 *Study for Block II* is a small mural about tenement life. Facades of buildings become actors in a drama filled with bewilderment and danger. We see the facades, and we see the faces behind the facades. Bearden's sense of the dis-junctiveness and incongruity of modern life was surely born in part of these buildings. In the center of the paint-ing, looking at us, is an eye.

In the mid-1970's Bearden began tapping memories of North Carolina; he did not actually return to Mecklen-burg County until 1979. The maquette for the mosaic mural *Quilting Time,* includes different generations of black people gathered together at dusk or dawn for a "quilting bee." They are in a courtyard that seems to be

in time and outside it, part of the landscape and a pocket that looks like a frame seen through a zoom lens. The ubiquitous guitar player is seated at the right, ready to play, presiding over the scene like the sun over the sky and hills. His chair is his throne, the quilting family is his court. Its members, young and old, are kings or queens. They are weaving together disparate moments, present and past. We can hear Bearden's song, and it is about time. (pp. 33-4)

Michael Brenson, "A Collagist's Mosaic of God, Literature and His People," in The New York Times, *January 11, 1987, pp. 33-4.*

Huston Paschal (essay date 1988)

[*In the following excerpt, Paschal examines the influ-ence of jazz and blues on the form and content of Bear-den's collage works.*]

[Bearden's] "finger-snapping, head-shaking enjoyment" of . . . music translates into our eye-catching, soul-satisfying reward. There is fascination and benefit in studying how one of the nation's distinguished painters has made artistic use of the blues indigenous to his native South and the vanguard jazz he heard in New York City's Harlem from his boyhood on. . . . [Bearden's collages, exemplified by those in] the *Jazz* and *Of the Blues* series, showcase such legendary performers as Jelly Roll Morton, Billie Holiday, and Charlie Parker as well as the palaces and hangouts that played host to them, places like Min-ton's, Connie's Inn, and the Lafayette Theater. Paraphras-ing in visual form the back-and-forth riffs familiar to the world of jazz, these works of art reveal Bearden's gift for inventing an original melody from a variation. They also demonstrate the artist's ability to locate the profound in the profane and to draw together the common bonds of humanity from its fragmented diversity.

Bearden is a consummate collagist. The medium was thrust into the modern consciousness in 1912 by Picasso and Braque in an extension of their revolutionary experi-ments with Cubism, and Bearden has made it into a partic-ularly personal and expressive tool. It was through his ini-tial efforts in collage and the resulting *Projections* of the early 1960s that he first came to national prominence. Be-fore that breakthrough, Bearden had already invested thirty years in formulating his artistic ideas. The transi-tions over those three decades can be traced from stylized figuration through semi-abstraction to the nonrepresenta-tional. Throughout, his preference for flat painting asserts itself alongside a persisting preoccupation with the prob-lem of composition, how to arrange pictorial space. These continuing concerns also permeate the collages he has concentrated on for the last twenty-five years.

Though largely a self-taught artist, Bearden profited indel-ibly from two painters he encountered early in his career. During his brief time at the Art Students League in the late thirties, Bearden worked with George Grosz. It was Grosz who introduced him to the study of composition through the analysis of the Flemish and Dutch master-pieces of Brueghel and Vermeer, among others. Investi-gating the structure of old master—and modern—paintings is a learning device to which Bearden has often returned throughout his development as an artist. Fur-

ther, it was Grosz who helped Bearden realize the potential subject matter the American black experience offered him, an insight Bearden would not fully exploit until much later. Of more immediate application was that which he absorbed from Stuart Davis's example and instruction.

Beginning in 1940, Bearden made regular visits to the studio of the pioneer modernist notable for his Americanization of Cubism. Bearden was attracted to Davis because they shared the opinion that decoration and design are the primary objectives of contemporary painting. Equally significant for Bearden was Davis's interest in jazz; he was one of the first artists to appreciate jazz as a distinctly American idiom and to recognize its visual implications.

Davis explained how his own use of color intervals had been influenced by the way Earl Hines used space as an element in building structures of sound on the piano. Encouraging the younger artist to seek visual analogues for the inimitable instrumentalist's playing, Davis drew Bearden's attention to what Hines was leaving out as well as putting in. . . . Bearden describes how he lost himself in Hines's music, listening until he no longer heard the melody but only the silences between the notes. He credits the interpretive technique of the paramount black pianist—the delicate and precise phrasing and expressive use of intervals—with teaching him a great deal about pictorial composition.

Furthermore, in the same way that jazz and the blues depend on improvisation, Bearden adopts impromptu invention in the construction of his collages. But just as jazz generally contains improvisation within a structural framework, there is discipline of organization within the shifting planes, chromatic separations, and interacting rectangles in a Bearden collage. Without insisting on any strict correlation, the analogy can be extended. The way Bearden orchestrates fractured colors and forms can be compared to ideas behind jazz riffs and rhythms. This method, by the way, informs Bearden's entire body of work, not just the music-related subjects. The free forms of jazz—for example, riffs in which motifs are repeated and varied, leapfrog sequences, and call-and-response patterns in which one instrument carries on a conversation with another or with the ensemble—and the insistent rhythm that overwhelms the melody find visual equivalents in the striking juxtapositions spliced together by Bearden. The music and his art, sharing as they do the abandonment of a fixed perspective, achieve a climax of stunning, reverberating synthesis, like that found in *Alto Composite.*

This collage, with its intricately interlocking composition, could almost be a blueprint for the sophisticated architectonics behind the jazz sound. Impulse and counterimpulse intersect in provocative conjunction. Crashing diagonals cut across emphatic verticals. Splintered planes in rich, dark-hued colors interact like the faceted glass of a kaleidoscope in an effect that has often been compared to the interplay of a jazz band. The precision-cut paper is lapped ply upon ply, and washes are stippled, splattered, and sponged onto the surface. In spite of the dappled texture and layered depth, the collage still retains the integrity of its flatness. The assertive two-dimensional activity, as well as the vibrant impression of the musician immersed in the waves of sound splashing around him and arching up out

of his saxophone, are controlled and contained. Bearden has locked the image in by framing it with wide bands of largely undifferentiated, muted color on all four sides, punctuated at the lower right by his name, which he has stacked in single syllables, almost like a closing chord.

Jazz can be feverishly hot or cooly cerebral, plaintive or affirmative. It mixes disparate elements from improbable sources. But the smoky warmth and earthy rawness along with the spiritual background of the blues have enriched jazz immeasurably, as they have Bearden's art. *Carolina Shout* illustrates both the blues' crude strength and jazz's blend of religion and ragtime. This collage, like *Alto Composite,* is from Bearden's 1974 *Of the Blues* series, a group that does not pretend to portray the history of jazz and the blues. Rather, the series evokes the aspirations behind the creation of the music and its essential, driving force tinged with a blue tonality. Echoing emblems, the collages also recapitulate the cultural contribution these black musicians have made.

In *Carolina Shout,* Bearden has convened a complex congress. Heads that are too big for their bodies and hands as big as the heads appear as sharp-edged silhouettes. In the abbreviated space Bearden has designated, the foreground and background merge and separate constantly. The dark, flattened forms of the heads and hands might be notes on a staff, spelling out either the stride-piano piece that gives the collage its name or some more sacred song suggested by the throbbing intensity of this congregation.

Indeed, *shout* refers to a *ring shout,* a vestige of the West African circle dance adapted by the black faithful as a manifestation of religious fervor. The figures at fever pitch in Bearden's collage do seem to fit the description of this dance-chant phenomenon—the worshipers move in a circle, caught up in an ever-intensifying rhythm while the preacher shouts song after song to which they respond in mounting frenzy. Bearden adroitly uses this galvanized gathering, indulging in uninhibited enjoyment of James P. Johnson's rag, to send multiple signals.

With a clear idea of structure on which to build, Bearden facilely creates collages of iridescent intensity and exuberant variety. Isolated figures, like the saxophone player in *Tenor Spot* or the duo in *Jazz Rhapsody,* have all the lushness and luminosity found in the far more complicated *At Connie's Inn* and *Wrapping It Up at the Lafayette.* The nightclub scene, often associated with the art of Degas or of Toulouse-Lautrec and other Post-Impressionists, is given a fired-up Jazz Age treatment by Bearden. *Wrapping It Up at the Lafayette* amounts to a vertical cross section of the theater. Its compressed composition—band in the pit, stage show of smooth, in-step quartet and shimmying chorus girls, exotic scrim, and scalloped proscenium arch—is laid out schematically, one flattened width of frozen activity on top of another. Bearden plays the animated two-dimensional design of the painted backdrop off against the dancing line of human figures, suspended in action in his frontal-plane format. The careful calculations do not seem contrived, and fitting every element into this shallow, snug arrangement does not deplete the energy. The colors—lemon yellow and violet, cerulean and grass green—dazzle, and the forms set up zigzagging, syncopated movement.

Bearden revamps Synthetic Cubist collage, stylizing its vocabulary and enlarging its meaning. With assured legerdemain, he teases pieces of dyed and painted papers, snippets of photographs, and scraps of fabric into playful conspiracy. Such control of cut and torn paper recalls Matisse, as does Bearden's fluent use of the highly saturated, sequiny colors with which he drenches his surfaces. Bearden conducts the dialogue between opacity and transparency with a masterful skill, and he obscures and reveals with the touch of the poet. He so effectively integrates his materials that he camouflages their identifying characteristics. Photographic fragments, less and less of a presence in the more expansive recent work, infiltrate the composition with surpassing subtlety and lend suggestive evidence of tangible reality. Moreover, Bearden charges content with consequence. Collage has often been considered only for its decorative effects, but Bearden has grasped the possibilities of the medium to express humanistic as well as aesthetic concerns. For the Cubists, collage was a means of analysis and interpretation of objects in space; they intentionally withdrew the narrative associations. Bearden drains his images of any sapping sentimentality but his feeling for the human experience—the lamentations and laughter—is fully apparent.

In his maturity, Bearden has taken to heart the cue from Grosz and reconstructed his own and his people's history in his art. Staging them in series, he has addressed the themes emerging from the rich heritage and scarred existence of black Americans: the role of the land, the beauty and power of black women, masks and magic cults, and the protective presence of the dead, as well as the consolations of song and the jubilation of jazz. He deals with daily events and common exchanges and elevates these to the level of ritual, finding in a family's roots the remedy for their tribulations. While the figures are given recognizably Negroid features, they transcend their ethnic identity. Bearden's art nourishes us all with his unshakable vision, that the acts of retrieval and commemoration sustain the search for self and place.

Bearden, close listener, knows that a beat has breadth. There is the back of the beat, its center, and that which is ahead of it, "on top of the beat." Extrapolating from that realization, he uses collage—perhaps the ideal medium for this purpose—to isolate either a custom or a ceremony, to paste it down, like gluing a treasured snapshot in a family album. He thus reminds us to acknowledge the breadth of that moment's importance, its resonance as symbol. In teaching himself to hear the spaces between the notes in Earl Hines's playing, he extends this understanding to his collages, establishing breathing room around the incident he has extracted and enshrined. Bearden confers a special status upon each of life's episodes and enhances their cumulative effect. He drives home the need for making the connections between the past and the present, which are crucial to the process of defining ourselves.

Sensitive to the tempo of the times, Bearden is simultaneously attuned to the timeless. Just as a jazz musician dominates the piece he is playing, Bearden imposes himself—and his belief in an art that binds people together—on the topic at hand. Out of the intimate and personal, the artist projects the universal, and he has transformed the decorative cutout into an eloquent archetype. Bearden's specialty is the synthesis of form and meaning, which he

nurses to life. His inquiring mind and dedication to craft have led him to an astonishing array of sources for inspiration and information, from the poetry of Homer and García Lorca to the techniques of cinema and Byzantine mosaics. Crossbreeding Cubism and African sculpture, he derives the shadowy, masklike face that recurs in his work; refashioning the planes of light and rectangles of space of Vermeer and Mondrian, he incorporates them into his singular syntax. With wit and gravity, he has smoothly assimilated this range of aesthetic allusions into a highly individual and literate style. Relying on instinct combined with intellect, fusing the sensual and spiritual, he conjures a modern epic. Unabashed by the unknown and the incongruous, he expresses his durable faith in continuity and coherence.

If jazz, with its dissonance and dynamism, seems scored to accompany the disjunctiveness of modern life, it performs the further function of diagraming by its daring use of improvisation, the potent value of imaginative response. The lessons—more basic—of the blues are about survival. In the music collages, this buoyant humanist celebrates the rite honoring resilience. His good will toward his fellow man is palpable, and his is a good-news sermon. The note sounded on Bearden's trumpet is triumphant, and noble threnody is transmuted into exultant anthem. (pp. 5-10)

Huston Paschal, Riffs and Takes: Music in the Art of Romare Bearden, *North Carolina Museum of Art, 1988, pp. 5-10.*

FURTHER READING

I. Writings by Bearden

The Painter's Mind: A Study of the Relations of Structure and Space in Painting. [With Carl Holty.] New York: Crown Publishers, 1969, 224 p.
 Analyzes structural elements and principles of composition in the painting process, using examples from major works in art history and stressing "that visual judgment needed to make a free choice about space and structure."

"Artists in Focus: Romare Bearden." *American Artist* 50, No. 527 (June 1986): 12.
 Brief statement by Bearden on his self-education as an artist.

II. Critical Studies and Reviews

Andre, Michael. "Romare Bearden (Cordier & Ekstrom)." *ARTnews* 75, No. 3 (March 1976): 131-32, 134.
 Favorable review of an exhibition of Bearden's series *Of the Blues: Second Chorus* in New York.

Berman, Avis. "Romare Bearden: 'I Paint Out of the Tradition of the Blues'." *ARTnews* 79, No. 10 (December 1980): 60-7.
 Discussion of Bearden's art and career. Berman emphasizes techniques that Bearden's collage work shares with blues and jazz music, and his treatment of figures and motifs from his personal past.

Brenson, Michael. "Romare Bearden: Epic Emotion, Intimate Scale." *New York Times* (27 March 1988): H41, H43.
 Tribute to Bearden that offers an appreciative overview of his career, asserting that "no postwar artist poured more epic feeling into intimate content and scale."

Campbell, Mary Schmidt. "Romare Bearden: Rites and Riffs." *Art in America* 69, No. 10, December 1981): 134-41.
 Addresses Bearden's treatment of myth and ritual in his collages, focusing on the "woman-in-a-garden" motif.

Childs, Charles. "Bearden: Identification and Identity." *ARTnews* 63, No. 6 (October 1964): 24-5, 54, 61-2.
 Offers an overview of Bearden's career in the context of black American culture.

Hooton, Bruce Duff. "Odyssey of an Artist." *Horizon* 22, No. 8 (August 1979): 16-25.
 Biographical essay that lauds Bearden's art for combining classical and modern techniques to comment on American society and to "bridge that furrow in our heritage, from country to city, youth to sophistication."

Markus, Julia. "Romare Bearden's Art Does Go Home Again—To Conquer." *Smithsonian* 11, No. 12 (March 1981): 70-4, 76-7.
 Preview of the traveling exhibition "Romare Bearden, 1970-1980." Markus stresses the works' shared theme of the homecoming.

Pomeroy, Ralph. "Black Persephone." *ARTnews* 66, No. 6 (October 1967): 44-5, 73-5.
 Review of Bearden's 1967 exhibition of photomontages at the Cordier & Ekstrom gallery in New York. Pomeroy praises his evocative presentation of archetypes and legend.

Princenthal, Nancy. "Romare Bearden at Cordier & Ekstrom." *Art in America* 75, No. 2 (February 1987): 149.
 Favorable review of a 1986 exhibit of Bearden's collages in New York. Princenthal particularly acclaims works inspired by Bearden's childhood memories of Mecklenburg County, North Carolina.

Riffs and Takes: Music in the Art of Romare Bearden. Raleigh: North Carolina Museum of Art, 1988, 13 p.
 Exhibition catalog offers personal reminiscences by Bearden on the role of music in his life and collage work, a selected bibliography, small-format reproductions, and an essay by Huston Paschal, excerpted above.

Romare Bearden: The Prevalence of Ritual. New York: Museum of Modern Art, 1971, 24 p.
 Exhibition catalog features an essay by Carroll Greene on Bearden's art, a selected bibliography, and reproductions of several works exhibited.

Russell, John. "Jazzy Collages by Romare Bearden at the Brooklyn." *The New York Times* (2 October 1981): C1, C28.
 Review of the traveling exhibition "Romare Bearden, 1970-1980" lauding Bearden's diverse approach to the collage medium.

Schwartzman, Myron. "Of Mecklenburg, Memory, and the Blues: Romare Bearden's Collaboration with Albert Murray." *Bulletin of Research in the Humanities* 86, No. 2 (Summer 1983): 140-61.
 Addresses Bearden's collaboration with writer and essayist Albert Murray during the 1970s, outlining their shared experiences and aesthetic concerns.

——————. "Romare Bearden Sees in a Memory." *Artforum* XXII, No. 9 (May 1984): 64-70.
 Describes how "the people and places of Bearden's memory have become elemental to his art."

Sims, Lowery S. "The Unknown Romare Bearden." *ARTnews* 85, No. 8 (October 1986): 116-20.
 Evaluates the 1986 exhibition "Romare Bearden: Origins and Progressions" at the Detroit Institute of Arts and elaborates on the significance of Bearden's abstract paintings executed between 1953 to 1963.

Smagula, Howard J. "Contemporary Painting: Personal Mythology, Object, and Illusion—Romare Bearden." In his *Currents: Contemporary Directions in the Visual Arts,* pp. 72-81. Englewood Cliffs, N.J.: Prentice-Hall, 1983.
 Overview of Bearden's life and works, focusing on his *Of the Blues* series and on his collages inspired by Christian and mythological motifs.

Stavis, Barrie. "Intimations of Immortality." *ARTnews* 87, No. 6 (Summer 1988): 40-2.
 Contains personal reminiscences of Bearden's life and art in an excerpt from a eulogy given by Stavis, an American dramatist.

Tomkins, Calvin. "Profiles: Putting Something Over Something Else." *The New Yorker* LIII, No. 41 (28 November 1977): 53ff.
 Offers extensive autobiographical recollections by Bearden and charts the development of major styles and themes in his work.

III. Selected Sources of Reproductions

Ashton, Dore. "Romare Bearden: *Projections.*" *Quadrum,* No. 17 (1964): 99-110.
 Includes nine reproductions from the *Projections* series. For Ashton's evaluation of the works, see the excerpt above dated 1964.

Fogliatti, Cynthia Jo, ed. *Romare Bearden: Origins and Progressions.* Detroit: Detroit Institute of Arts, 1986, 48 p.
 Exhibition catalog includes numerous large-format reproductions of works in the exhibit, excerpts from Bearden's journal entries that address aesthetic issues, and an essay by Lowery S. Sims focusing on the development of his paintings from 1946 to 1962.

Washington, M. Bunch. *The Art of Romare Bearden: The Prevalence of Ritual.* New York: Harry N. Abrams, 1973, 230 p.
 Contains 91 large-format reproductions of Bearden's paintings, photomontages, and collages from 1942 to 1971. The oversize book also features an introduction by American novelist and editor John A. Williams and an essay by Washington that presents personal impressions of Bearden's art.

Fernando Botero

1932-

Colombian painter and sculptor.

The most renowned of contemporary Colombian artists, Botero has gained international recognition for his unique figurative style, in which subjects appear as though hugely inflated. Although his work is sometimes viewed as grotesquely satirical, Botero explains that his intent is rather to celebrate the robust sensuality of life by fully exploiting the element of three-dimensionality, or plasticity, in his work. Citing early Renaissance masters—most notably Piero della Francesca, Paolo Uccello, and Andrea Mantegna—as his primary stylistic influences, Botero also acknowledges his indebtedness to the Latin American tradition of figurative distortion that dates back to the pre-Colombian period.

Born to a family of modest means in Medellín, Botero decided at an early age to become an artist. By the time he was sixteen, he was contributing illustrations to the local newspaper, and in June of 1951, only five months after graduating from high school, Botero held his first solo exhibition. His earliest paintings, done in the style of Mexican muralists Diego Rivera and José Clemente Orozco, were favorably received and sold well. In 1952, after winning a 7,000-peso prize for his entry in Colombia's annual salon, Botero traveled to Europe to continue his art studies.

When Botero arrived in Spain, his first stop in Europe, he was interested primarily in Modernist art. However, while studying at the Academia San Fernando in Madrid, he developed an appreciation for the work of earlier European masters that deepened into reverence during his subsequent stay in Florence. In particular, Botero became fascinated with the naturalistic, lushly colored Italian paintings of the early Renaissance, or quattrocento, period. He later noted: "What fascinates me about Italian art is that through the approach that they had it was possible to give color and form equal importance." Although Botero's exposure to the plasticity of quattrocento works played a major role in shaping his approach to art, it was not until after his return to Colombia in 1955 that he discovered what would become the distinctive feature of his style. In an often-recounted anecdote, Botero has explained that while making a drawing of a mandolin one day in 1956, he placed a small dot where the sound hole was to be and found that the illusion thus created greatly enhanced the plasticity of the composition. He soon realized that by inflating and rounding his subjects, he could take full advantage of this effect, and in 1958 he painted the first of his works in this style, *Homage to Mantegna*.

Although Botero's style was quickly accepted in Europe, his work was for many years either ignored or condemned in the United States, where he lived from 1960 to 1973. Reviewing Botero's first New York show in 1962, Jack Kroll described his figures as monstrous, disgusting, and vile. Nevertheless, Botero continued to utilize and refine his unique style, creating brightly colored portraits of

enormously fat human beings and animals, as well as voluptuously rounded still lifes. For subject matter, he drew primarily upon his memories of Colombian village life, but he also painted inflated versions of the works of the great masters. Among the latter, the portrait *Alof de Vignancourt (After Caravaggio)* (1974) has been described by Cynthia Jaffee McCabe as "Botero's tour de force" for its skillful duplication of the sculptural effects of the knight's armor. In the mid 1970s, Botero's interest in three-dimensional effects led him to experiment with the medium of sculpture, casting bronzes and molding polyester resins into characteristic pneumatic-looking figures. Since returning to oils in the late 70s, he has added numerous depictions of bullfights and matadors to his panoramic view of Colombian life.

While Botero now enjoys enormous popularity throughout much of the world, critical response to his work remains mixed. Often applauded as visually satisfying and whimsically appealing, his style has also been dismissed as a simplistic answer to his aesthetic aims and is viewed by some critics as nothing more than caricature. However, several recent critics have noted that Botero's primary contribution to modern art lies not in the unique plasticity

of his forms but in the consistency of his vision and in his creation of a complete, uniquely Boteroesque world.

ARTIST'S STATEMENTS

Fernando Botero with Ingrid Sischy (interview date 1985)

[*In the following interview, Botero discusses his aesthetic aims and comments on his attitude toward the most common criticisms of his style.*]

[Sischy]: *You are surrounded by the cheers of fans and the virtual silence of American art critics. To some you're a household name, to others you're the lone sign of Latin America's presence in the international arena of art. Your work's been called a parody of the bourgeoisie, but it's also been dismissed as a bourgeois parody. There are worlds of different opinions on the subject of your work. At the eye of the storm is your obsession with the full shapes that most of us moderns try to stay away from, even if it's just through mental abstinence. What about these swollen forms? Why have you chosen them?*

[Botero]: This formation is not something that just came to my mind one day. It has been built through years of meditation. From the very beginning, I had some kind of inclination toward it, then gradually, through experience and knowledge of art history, I was able to rationalize my position, to know why I am doing it.

Can you remember the first time you painted something in the scale and proportions that we have come to expect from your work?

It was a few years after my travels of art-historical detective work in Europe. I was in Mexico. One day I was drawing a mandolin, and I was going to make the hole in the middle of it. I did one little hole that was not in relation to the size of the instrument and to my surprise I saw that now the mandolin had two monumental dimensions—volume and scale. There was something exciting about the dynamic of plasticity in these wild proportions. This was the actual beginning of what I am doing now, but I had been looking for a way to create a language of plasticity that would be effective and that people would be touched by since I decided to be an artist.

I'm always curious about the decisions we make to be something, and especially about the decision to be an artist. It seems to me it always involves some kind of battle—either familial, societal, internal, or through a host of other tests and obstacles. What were some of yours? Let's start where it starts, with your family, in Medellín, Colombia.

My mother was a sensible woman; she had great sensitivity without being an intellectual at all. My family never tried to stop my decision. There were three or four painters in our town making a living teaching drawing to high school students. When one decided to be a painter, it was like deciding to be a priest.

In my town were no museums, no galleries, no information about art whatsoever. We had a painting of the Virgin Mary in the living room. That was it. The only other art I saw when I was a child were the pictures hanging in the church, which were from the colonial period. They were copies of European prints or paintings. Perhaps my interest in this period comes from the fact that when I went to church I was transfixed by how smooth these pictures looked. For years that was what art was for me. Pre-Columbian art was there, of course, but you didn't see it. Now everyone has pre-Columbian art, but at that time no one had it. No one could care less. Now there are museums for pre-Columbian objects and people collect pre-Columbian. I didn't see it. I only saw these smooth figures in church. Now, of course, I study pre-Columbian art a lot because of its history and its element of originality. We Latin American artists have a need to find our own authenticity—some position that is not colonial. Culturally, we have been colonized by the United States and by Europe for centuries. This effort to find our own art has been attempted in many different ways.

The question is, what is Latin American art today. One way to answer that question would be to take those colonial paintings in the church and compare them with the European paintings they are copied from. When you put the two together, there is a difference, and this big or little difference is in essence 20th-century Latin American art. I have tried to understand what this difference is, to see what is in there, because I want my paintings to have roots. These roots give truth to what you do. You can't take from the air; you have to go from the ground. At the same time, I don't want to feel as if I'm only allowed to paint peasants. I want to paint anything I feel like. So I paint Marie Antoinette, but with the hope that everything I do will be touched by this Latin American spirit.

I believe I was elected to do this work. Perhaps I had more than most people in Colombia do, and that's why I was selected for the responsibility of making art today. But it is too easy to do peasants and say this makes me a Latin American artist. The problem is more complicated. I don't want to be colonized by anyone, to feel that Latin American art is being defined *for* me. Art should be independent. This is the beginning of real independence; only then can one have independence in thinking, in position, in language.

Why did you leave Colombia and go to Europe?

I was making my living in my home town as an illustrator for a literary magazine, a supplement for the Sunday paper in Medellín, painting and spending time with some people I had met through the magazine. They knew about poetry and spoke of painters like Picasso and Braque, and had such a good time doing so. I thought, I'm going to do the same, and left with the idea of learning. First I went to Spain because of the language similarity and because it was so inexpensive.

One night when I was in Madrid I was walking past a bookstore and there in the window was a book about Piero della Francesca. When I saw the painting on the cover—*Meeting of Solomon and the Queen of Sheba*—it was as if someone had finally shown me the definition of what painting was all about. Everything was there—the most fantastic color—it was the most beautiful spiritual expres-

sion of a group I had ever seen. The drawing was incredible, so full, so generous. It was everything you dream of. I went the next morning and bought the book. I'd planned to go to Paris, but I only stayed there a short time because I had to get to Italy to see the paintings. Through Piero della Francesca, I discovered the Renaissance. Once I knew about him I wanted to know about Uccello—I needed to know how all this came about. It was like detective work about the reformation of form in art history.

I know I'm not bringing you news when I point out that the response to your continuation of this tradition is often to assign you the role of satirist.

Why don't people laugh at the proportions when they see Romanesque art or pre-Columbian art? For centuries there was this kind of form, and now all of a sudden it is necessarily a satire. In the very beginning, some of my paintings were done with a satirical idea. But these were almost exclusively in the beginning, as when I did the presidential family, and the dictators. My deeper interest is in the sensual, plastic language of painting and in the expansion of form.

When you eventually came to New York in 1960 there was a very different interest in what you call the language of painting, and yet certain of the developments of the time, particularly Pop art, overlap in a fascinating way with your investigations of scale and your relationship to European art history. Did you feel more connected to Pop than to abstract painting, which was also committed to the idea of a language of painting?

I felt outside it all. The attitude of Pop art was completely different, even in the repainting of art history that went on. When I did it I was saying, I want to belong to the tradition but I need to find the essence of how I belong, how I'm different, and how I can transform form. Pop art was saying that it didn't want the tradition, didn't need it, and that it wanted something radically new.

When you are from a provincial country you are in a way handicapped. When you're American, you're given internationality as an artist when you are born. Everything you do is international because you are American. Your subject matter is universal. If you do Coca-Cola, for example, it's universal. If you are from a Third World country you have to find your feeling of universality. It's not a gift you have when you are born.

Regarding the Abstract Expressionist painters I remember one incident in my studio that should tell something about the period. No one ever came to my place and I started thinking, what difference does it make if I'm doing the greatest paintings in the world and no one sees them. So I invited a group of artists I'd met at the Cedar Bar to come and see my work. One of them brought his son, who was four or five. As I took out my work the man would point to the paintings and say in an infantilizing voice, "a-p-p-l-e, p-e-a-r," to the child. He said absolutely nothing to me.

Things got more sensitive only when Dorothy Miller, from the Museum of Modern Art, came down to my studio in 1961. The next day she sent a truck to pick up a painting, **Mona Lisa, Age 12** (1959), she'd seen, liked, and bought. They hung it in a great position, and it received tremendous comment. After that my work was seen a lit-

tle, but my first big gallery show was not until 1972. This was the last time I received serious critical response from the New York press. From then on when I did shows there was complete silence. It was like I was a leper. One critic in particular came to see my work and had to stand in front of it without looking because he said it made him sick. From the public I got the opposite attention.

What do you think causes this schism between the public and the critics?

I don't know. I just make paintings and sculptures the way I like. I have to be the one taken by my work. Some people say to artists that they should change. Change what? It's like saying, why don't you walk differently or talk differently. I can't change my voice. That's the way I am. I work every day because I have never found anything that gives me more pleasure than painting. Once, when my ideas weren't clear, when I didn't know exactly what I was doing or what I wanted to do, it was very painful. When I didn't have the technical resources to put on the canvas exactly what was in my mind, it was painful, but now it is a great, great pleasure, and provides my stability. It is my continuum.

Do you work from models?

No, for me a model is a limitation, and although I've done some portraits I don't really like to because I'm not able to be as free with them as when I work completely from my imagination. I've only made a few portraits; they're all of people I know so well that even when I have a photograph I already have them in my mind.

You seem to work with objects and people the way an abstract painter uses color and form. How are your decisions of size and scale made?

My paintings start like a cloud. I don't make anything precise. I just let the thing out onto an uncut roll of canvas until I find the relationships I'm looking for. And when the moment is right, I start to tighten here and there. Basically, the image is an explosion. In the small paintings it is exactly the same as in the big ones: I want to fill the room with one. The force in a painting doesn't come from its size. You see so many large, empty paintings today, which look overblown because the right scale and proportions haven't been found.

One of the most intriguing aspects of the dramas of scale in your work is that even when they are reproduced tiny the tension about monumentality remains. Everything and everyone still looks inflated to the viewer but normal in relation to the rest of the picture. These are inflationary times, and as others have pointed out, you've come up with that perspective in your figures; but there's more to it. You've been doing the same thing for too long for that to be the whole understanding.

I didn't choose to make art the way I do with the idea of astonishing people. Such a notion would quickly turn into a cliché and lose the ability to touch honestly and communicate personally and directly, which is what I'm trying to do. (pp. 72-4)

Fernando Botero and Ingrid Sischy, in an interview in Artforum, *Vol. XXIII, No. 9, May, 1985, pp. 72-4.*

SURVEY OF CRITICISM

Michael Peppiatt (essay date 1969)

[*In the following review of an exhibition at the Galerie Claude Bernard in Paris, Peppiatt assesses the visual impact of Botero's technique of inflation.*]

[Fernando Botero's] interests lie with a startling change of dimension. Although every human being, as well as the cats and dogs, is fat in this strange portrait gallery, the element of surprise never vanishes, for Botero fashions a universe where everything joins in astonishment at their corpulence. This curiously poetic world has something both of a nineteenth-century science fiction and *Alice in Wonderland;* smooth-fleshed, passive and nostalgic, its inhabitants exist in a langour of time, as though being fat were an end in itself. Yet they appear pestered by their volume, for—unless this is the comparatively slender spectator's subjectivity—within their gentle eyes, one can see the proverbial thin man struggling to get out. They are pestered, too, by flies—minute specks that unreasonably magnify the characters' bulk, and to some extent by objects, whose size dwindles beside their own, so much so that a coffee cup becomes as a thimble in their fatly delicate grasp. This constancy of human scale also becomes slightly claustrophobic: where everybody is fat, fatness is the state of normality. With this mountainous flesh there comes sexlessness: their outsize world is circumscribed by eating, sleeping and above all dreaming, contact with the other sex being limited to a comfy kind of "understanding"—at most, the kind of relationship one might expect Oliver Hardy to sublimate on film. Naked, they are even less sexed than dressed; the impression of soft reverie within boredom is further defined. Gradually, Botero's field of vision takes on a date and a milieu: one supposes oneself in the physically stifled latter half of the 19th century, among an amorphous bourgeoisie which includes respectably "bohemian" poets and overdressed ladies. Moreover, given Botero's country of birth and that one of the portraits is of a dictator, possible geographical locations easily come to mind. (p. 77)

Michael Peppiatt, in a review of an exhibit at the Galerie Claude Bernard, in Art International, *Vol. XIII, No. 10, Christmas, 1969, pp. 77-8.*

Jacqueline Barnitz (essay date 1970)

[*In the following essay, Barnitz discusses the development of Botero's style, praising its visual appeal and symbolic complexity.*]

Fernando Botero's **Madonna** has a traditional pyramidal composition culminating at its apex with the virgin's head. A self-portrait of the artist—another traditional touch—appears beneath her to the right. The colours are soft and warm like those found in Latin American painting of the Colonial period.

Then one begins to notice certain absurd deviations. A snake—symbol of evil on which Colonial Madonnas are shown standing—is coiled around the figure of the artist who is preposterously tiny in proportion to the bloated, towering virgin. She is giving him some money. Paint

brushes lay at her feet. In an ex-voto to her left, the artist begs her to grant him first prize (at the 1970 Medellín Biennale where it was shown). A minuscule angel holds up the Colombian flag so it forms a back drop for the virgin. Everything in the picture seems curiously out of context.

Although this painting is somewhat more explicit than others, its satire is characteristic. Sinfully fat religious and political figures, family groups on Sunday picnics and still-lifes bursting at the seams share in these whimsical details. One of Botero's peculiarities is that he makes no differentiation between hard and soft substances. The metal body of a tea kettle and the flesh of a human being are equally resilient. Both look as if made of rubber. Yet there is something impenetrable about their surfaces. These voluminous masses do not yield to an imaginary touch. Background and subject alike push forward. There is no feeling of space in the traditional sense, only positive and negative form. But more than anything, one is struck by the delicious glowing colour.

The stepped up delight in the use of colour apparent in Botero's recent work might well have its source in Impressionism. Picasso may be responsible for the strong design, solidity of volume and frontality of his paintings. Squat forms sit or stand squarely and convincingly on the ground or table from which they literally seem to grow like plants. Botero may also owe a debt to Diego Rivera for a certain clarity of form and colour. But more than anything he absorbed the techniques of Velázquez and Goya at the Prado and the Italians of the Quattrocento during a study trip to Florence.

Botero's discovery of the Florentine painters established the direction his painting was to take. Piero della Francesca made a particularly strong impact. Botero learnt to integrate colour and form into an organic whole. He also found that he could obtain volume without the need of chiaroscuro simply by adjusting colour and line in a certain way. This led to the dilation of form that has become so typical of his painting. He had discovered the key to sensuality, volume and colour, and has made them his primary concern ever since.

While he applies techniques learnt from the old masters, his paradoxical blend of wickedness and naive charm has its roots in the Colonial and folk painting of his native Colombia. His bishops sleeping and bathing, all have a touch of the profane. They impart a pagan sense of pleasure rather than mystical exaltation. *The Supper* (1966) shows five tightly grouped assorted religious figures seated around a small table tilted to form a truncated pyramid with nothing but an absurdly small plate at the head. The plump figures follow the pyramidal composition like the Madonnas. Everything in the painting directs the attention to the central figure. The rich red background and warm magenta and earth tones of the two front figures contribute to a pervasive atmosphere of sinfulness.

In each painting the choice of colour and symbols establishes its particular mood. Among Botero's favourite symbols are snakes, lit cigarettes, Colombian flags, insects. These witty touches also introduce an element of surprise because of their sometimes ridiculous proportions or absurd context. In *The First Lady* (1967), a massive female in a mink coat holds a minuscule flag. Family groups are

Botero's favourite ground for those subtle twists. *Family* (1967) shows three figures all clad in blue, a mother and two children with a monstrously large dog on a leash. The soft foliage in the background is painted with the innocent loving care of a Henri Rousseau. A blue snake emerging from the trees on the right provides a vital and unifying spot of colour. A lit cigarette lying menacingly on the ground, insignificant and whimsical as it may seem, contributes considerably to colour balance. In a 1967 still-life with pineapples, two flies provide strategic dark accents over the soft golden yellows and ochers of the fruit. They also stabilise the weight created by a dark cutting board on the opposite side. Without that detail, the painting would lack cohesion.

In the late 'sixties, Botero proved his talent for gentle mockery with a series of paintings and drawings done after well-known works of art. Far from being mere entertainment, some of these provided him with interesting new problems. Rubens' Baroque form offered him a particular challenge since his own painting is deliberately static. In a series of 12 works entitled *Mrs. Rubens,* after Rubens' portrait, *Chapeau de paille,* Botero sought to stabilise the diagonal movement in his version while indulging in exuberant Baroque colour and brushwork. He found a solution by restraining himself along the figure's outline and giving in to free brush play on her arms and folded hands where it could be most effective without disturbing the static order of the painting. Only once did he attempt to use Baroque movement in a large charcoal drawing on canvas, *Louis XVI and His Family in Prison,* done after an 18th century print. Not only did Botero emulate the strokes of the burin but he allowed the composition to flow freely. The looseness of this drawing, although a feat in its own right, makes one aware of what strength and tension are packed into his static works.

Not only does this tension depend on total stability but also on carefully calculated relationships between subject and canvas dimensions. The importance of these relationships shows best in simple still-lifes. In one of these, a watermelon on a table all but fills the canvas. A disproportionately small grey knife and fork lie on its left, and to the right, a minuscule shocking pink wedge of fruit cut from the top from where it is flagrantly missing, create startling effects of design and colour. The strong impact and tension created by the surreal relationship between the massive watermelon and the picture's boundaries remind one of some of Magritte's strange contrasts of size or Peter Dechar's huge pears cramped into small spaces. The use of old master techniques makes Botero's painting all the more paradoxical since his treatment is as contemporary as Oldenburg's oversized objects in absurd contexts.

Botero succeeds in obtaining the most effective dimensions by cutting the canvas only after it is almost finished. In this way he can adjust colour and shape without the unnecessary limitation of predetermined boundaries. He works from the inside out on a canvas stapled onto a temporary frame. The final step is a vital one. The difference of a single inch more or less on any of the painting's four sides would destroy its strength and balance. When he cuts, he sometimes allows so little background to remain that the subject seems compressed. But the tensile force

and compression created by the resulting relationships are essential.

Botero's new work follows the same direction as his work of the past four years except for an expanding repertoire of ideas. The subjects exist more than ever within the confines of their compressed environment but with added impact. They seem more alive and for this reason the figures are all the more pathetic in their ridiculous state. *The Melancholic Transvestite* (1970) has a touching warmth which was not as strongly expressed in *Sleeping Bishops* with its inert mass of rubbery figures. A more delicate treatment of pigment, a new softness around the edges, and an even greater delight in colour give the work a warm glow. Botero conveys the pleasure he finds in every detail. The brocade of a cushion, the collar of a dress provide him with a welcome excercise in still-life. Nowhere is this delight more apparent than in a recent painting with flowers in a pot. The luscious reds, pinks, flesh tints, blues and greens of the flowers share all the sensual gaiety of Renoir's robust nudes.

Botero says 'the problem is not to change but to keep going deeper', and that is what he is doing. By repeating himself, he is achieving the opposite. Each new solution opens the way to another step into the great experience of painting. Painting is not dead! Long live Botero! (pp. 51-2)

> *Jacqueline Barnitz, "Botero: Sensuality, Volume, Colour," in* Art and Artists, *Vol. 5, No. 9, December, 1970, pp. 50-3.*

Tracy Atkinson (essay date 1970)

[*In the following essay, Atkinson discusses Botero's work and his formative influences.*]

The work of Fernando Botero represents a view of the world which is not only highly personal, but which largely sets him aside from his contemporaries. His effulgent, inflated images are at once astonishing and compelling, and one cannot help responding to them. We are not used to his approach. He paints ordinary, even traditional subjects in such a completely extraordinary way that it accomplishes rather startlingly the ends of all art—to draw the viewer out of his own world and into another, especially created one, where the artist is in control and bends everything to his will. This is entirely in accord with Botero's conception of the artist and his role—to create a total vision which encompasses all things.

Botero's world is peopled with a cast of characters who are generally absurd and a little pathetic, doing mostly very ordinary things. But there is a warmth of approach and a human sympathy which saves them from the ugly and once seen they are never forgotten. So intense and consistent is his attitude too, that it does indeed embrace all things, so that a watermelon, for instance, assumes the same kind of personality as a fat lady on a picnic in the mountains. It is a world inflicted with gigantism, but full of primal innocence and the best of good will. Behind it all lies a quality of painting which is exceptional in its skill, for Botero's pictures are above all beautifully painted. He has selected a traditional approach to his work, but so modified is it by his personal vision that it becomes unique to him alone.

Botero comes from Latin America where he was born in Medellín, Colombia, in 1932. He is a Latin American artist in the sense that his roots are there and in the fact that many of the things he paints and at least part of his attitude stem from the tradition of his homeland. He is unique among contemporary Latin American artists however in that he stands apart from the general international abstractionist trend recently prevalent there. Like all artists in our century, too, the development of his work has international references.

Medellín is a conservative, industrial city, physically separated from the rest of the country by high mountains, but it is by no means isolated or backward in terms of that awareness of ideas current in the rest of the world which is a necessary prerequisite for the growth of an artist. Although the painters with whom he first came into contact were hardly avant-garde, there was a group of intellectuals even in Medellín who were well acquainted with what was going on elsewhere in all creative areas and Botero early frequented these circles. His interest in art manifested itself well before he was twenty and at seventeen he was already professionally engaged in his career. His early influences were primarily from the Impressionists and Post-Impressionists not unusual for a young artist at the time, but there was also an awareness of Picasso's work and of that of other more recent artists. It is perhaps significant in terms of his later work that among his first paid works were some stage sets copied after the Surrealist Magritte, and that he was very early aware of the work of the Mexican muralist Diego Rivera whose influence pervaded the whole of Latin America. Both artists were concerned with a largeness and simplicity of form, but from entirely disparate points of view and within a context largely unrelated to Botero's own specific later developments.

The one thing absolutely necessary for an artist which Colombia could supply only to a most limited extent was the direct experience of original works of art, for there are few museums there. Botero's knowledge of the art of the rest of the world was mostly second-hand, through reproductions, and it was largely to correct this want that he went to Europe in 1952. The proceeds from a very successful exhibition of his work in Bogotá, where he had moved the previous year, financed the trip, and this show also contributed toward establishing his reputation in Colombia where he has since risen to the top in recognition.

He went first to Madrid, where the Prado was a real revelation in terms of the direct experience of paintings he was seeking. He was convinced of the validity of the old masters whose work he first saw there in the original and this reinforced a direction which his work was soon to take. He went on to Paris where he was disappointed by the examples of modern art in the "Musée de l'art moderne" and this confirmed the direction set by the Prado. After this point there were for him in his own words " . . . no more revelations in modern art". He found much that was of interest in French painting of the 17th Century in the Louvre, but it was neither Spain nor France, however, but northern Italy which provided the crucial experience and in particular the Florentine artists of the quattrocento, especially the work of the great 15th Century master Piero della Francesca. He had already discovered Piero in Madrid. He found his work reproduced in a book and was so fascinated that he lingered in the bookshop for an hour over it, finally returning the next day to buy it. It opened a new world for him. In the work of Piero there was a simplicity of form and a thorough integration of form and color and a poetry which was incipient in his earlier work and was to be a central concern for Botero from that day on. He rejected the chiaroscuro of the later Renaissance artists as a means of creating form and now concerned himself with line and the creation of mass with line and color alone. A visit to north Italy largely by motorcycle, including stops in Florence, Pisa, Sienna, Arezzo, Bologna and Venice confirmed his conviction that his painting should come to terms with the venerable problems of the Renaissance masters. He sees himself today as an "old-fashioned" painter, immersed in problems of painting which don't exist for most of his contemporaries. It is a negation of the generally accepted values of his time which creates in him a certain personal sense of isolation, in that it is difficult to talk in common terms with other painters, but it undoubtedly contributes greatly to the power of his work.

On his return to Colombia in 1955 there followed a period of uncertainty and consolidation. To try to paint in the way of the old masters presented many problems not the least of which was a lack of acceptance of his work. But the direction continued and from about this time until today there has been a steady progression in the direction of painting solid, impenetrable forms conceived of in terms of line and color resulting in a monumentality of a kind which has little equal.

He did not escape the influence of Picasso in all this, as hardly anyone of his generation or before did, but it is slight and disappears with time. A visit to Mexico in 1956 renewed his acquaintance with the work of Rivera and Orozco, but his own attitudes were so well formed by this time that whatever ideas he gained from the Mexican muralists at this time were probably confined purely to the kind of brushwork necessary to the fresco technique wherein a simplicity of form somewhat like Botero's is mandatory.

His arrival in the United States in 1957 precipitated another period of crisis in his work. It was the moment when Abstract Expressionism was at its peak, when this American style was assuming hegemony throughout the world, and when the movement was the focus of all attention. Abstract Expressionism with its great emphasis on immediacy of effect, total abstraction, and absolute vehemence of statement was totally opposed to everything Botero was doing. He was however much impressed by the "presence" of pictures in the Abstract Expressionist style, by its directness and immediacy of impact. The importance of painting in large scale of Abstract Expressionism reinforced a direction in which he was already going, but for the rest its influence initiated a period of hesitancy and uncertainty. There were temporary influences from various Abstract Expressionists within the confines of his already established figurative style, for instance from de Kooning and Kline, Raymond Parker and even the Dutchman, Karel Appel, and elements which were inappropriate to his style—such as a heavy impasto applied on his simple forms—entered his work. He was completely conscious of these influences as well as of a temporary confusion on his part. His old directions finally reasserted themselves however and he continued to work toward a refined, patient

and clearly painted figurative style, a style of delicious surfaces to which he refers appropriately as "la pintura comestible" ["edible painting"].

His subjects during this decade were very much as they are today, but his color shows a progression toward increasingly subtle tonalities, and his forms change from flatter to rounder. Large simple shapes are a consistent aspect of his work as is a composition held within a very narrow foreground space which does much to create the burgeoning, overwhelming bigness of everything. There is also, now, a new play of large, effulgent forms against small ones in a new, impudent whimsy. The plastic quality of his work, this very monumentality, and the successful integration of form and color, underlie the impact of his work, supplying its potency and its conviction. It is this aspect of his work of which Botero himself is most conscious and on which he most concentrates when he speaks of his work, which he frequently does well and at length.

The other side of his work, its content, to which the viewer more immediately responds is less overt, less rationalized. Perhaps this is because it speaks more for itself and gains nothing from repetition and redundancy, perhaps because Botero is so much an artist that the visual statement stands alone without verbal reinforcement. His work is witty, satirical and with an infectious, ingenuous humor. His is a gentle attitude of sophisticated innocence which takes the sheerest delight in the things his world hands him. His subjects are people, both singly and in happy family groups; churchmen, saints and madonnas which his Colombian predecessors have painted for centuries and which are a normal part of life for a Latin American artist; still-lifes of the most outrageous and impudent fruits and cooking utensils which look as if they themselves had overeaten as much as his people. A constant theme has been a series of variations on pictures by old masters like **Mrs. Rubens** a transformation into his own terms of a well-known portrait of his wife by the 17th Century Flemish painter Peter Paul Rubens. The form which the title takes, with the inappropriately formal "Mrs.", is as ingenuously innocent as the visual statement. The landscapes are a new theme in 1966 and characteristically these appear in the form of traditional tales, **The Mystic Trip** (of St. Xavier) and **St. George and the Dragon** in which the protagonist is relatively insignificant and the real subject is the obtrusive form of the buildings. The qualities of color in these two pictures, dramatic and forceful in the one and subtle and poetic in the other, span the gamut of his development in this sense in 1966. The long, narrow **Kidnapping** is unusual in its narrative subject—performing a cathartic function in his work.

The utilization of lesser details is often crucial to the humor. The pathetic little wisp of vapor steaming from the spout of the enormous pot in **Still Life with Boiling Water** is the final fillip which saves the day in what otherwise might have been much too serious an effort. There is a Spanish word for this, "el duende" which is difficult to translate in this context, but which literally means "ghost or spectre", and Botero is a master of it. It is a gesture added at the last minute and it appears over and over in his recent work.

Our Lady of New York, undoubtedly one of Botero's masterpieces, well represents the unbridled innocence of the man when he approaches a religious subject, which he fre-

quently does. Not particularly religious personally, nor equally not anti-religious, such a subject seems a normal part of his heritage and of his everyday frame of reference. The picture is absolutely traditional stemming from Latin American colonial painting, the crowned Virgin, the Queen of Heaven, standing on a snake—trampling the symbol of Evil—and surrounded by a glory of flowers, the symbols of life and Heaven. Even the inclusion of a self-portrait of the artist has ample precedent in a long tradition of European painting, his subordinate position and diminutive size expressive of his dedication. In all of this Botero continues the ways of his Colombian antecedents including the innocence of their primitive vision, in a very knowing and sophisticated way and creates a delightful picture.

In terms of the content of his work Botero stands in the tradition of Paul Klee and Dubuffet, but differs markedly from the one in the monumentality of his forms and from the other in the gentleness of his expression. He remains unforgettable. (pp. 3-12)

> *Tracy Atkinson, in an introduction to* Botero *by Fernando Botero, Edition Galerie Buchholz, 1970, pp. 3-12)*

Gustav René Hocke (essay date 1974)

[*In the following excerpt, Hocke discusses Botero's paintings as a reflection of both Latin American culture and the artist's personal literary and artistic influences.*]

Latin America has always been a mystery to many people. Some things there seem larger than life, others puny in the extreme. Creative writers still count the continent among the parts of our planet where miracles occur and myths are in the making. Social scientists view it as a corner of the world where oppression grows more and more rampant. South America begets dreams and satire, venturesome voyages of discovery and critical evaluations. Imagination still runs riot, harking back to the dawn of history and clashing head-on with modern technology. Each superlative is contradicted by another.

The Colombian painter Fernando Botero . . . captures this titanic scene as though under a magnifying glass, with the same scientific detachment that once animated an Alexander von Humboldt in exploring his homeland. As an artist, however, he enjoys far greater freedom. He puffs his people up into monstrous balloons of horrendous obesity—these members of a society of "law and order" who have lost touch with the grandiose prehistory of their vast spaces without gaining any contact with the equally grandiose future predicted for them.

The balloon people provide the initial shock when one looks at Botero's pictures, but on a closer look they turn out to be done with superlative craftsmanship. Botero has obviously studied Dürer. On one occasion he was asked why he painted his figures so fat. "They seem on the slim side to me", he replied, adding that there was nothing wrong with his eyes, but that, like El Greco, he painted with his "mind's eye".

With his own lips Botero thus identifies himself with the sixteenth century subjective Mannerism of Spain and Italy; but his distortions do more than capture beneath the

lens of satire the transitional society of South America with its uncertain history; nor is he merely a Mannerist latecomer, victim to the blandishments and the reckless pseudo freedom of that style. Like a child, he likes to play with absurdity for its own sake.

He sticks to his personal inventory, the things of South America, living or dead—people, animals, plants, rocks— in part because this enables him to solve problems of form by intuition; and this is precisely what has made him a much-noted artist among the younger figurative painters of our time. Even his still lifes reveal his dynamic powers of subjective transformation, which already far transcend obsolescent distortion as such. A new herald of the objective, Botero is haunted by mysteries, dreams, demons, the grotesque, and overwhelmed by sadness, a kind of world *angst*. He is one of the neo-figurative artists of our time who can turn a mere thing into a vision, who can make balloons inflated with poison gas of certain types of people. He clearly gives deep thought to his work and organises his space shrewdly. His palette is at once aggressive and delicate. He is concerned with the mystery of mankind, not merely of one particular person.

The Italo-German humanist and philosopher Ernesto Grassi, one of Europe's last philosophers of "body .and mind", recently published a book entitled *Departure without Arrival—A Confrontation with South America*. In it he writes that there are regions on earth where history seems inconsequential. In South America, for example, distance is often beyond all measurement.

> [In South America] one rests in the shadow of a house and the hours simply drift by while realities undreamt-of begin to obtrude. Shadows on the wall, designs in the floor tiles, folds in the bed sheets, footfalls fading along a hallway—they are all signals for which we had no time in that other world. Time? It dissolves in the rhythms of the shadows in the room, shadows that move imperceptibly. Time no longer passes. We are no longer concerned with what the hands of the clock show.

It is precisely this sense that informs the deeper backgrounds of Botero's work. Elsewhere in his book, Grassi writes: "Individual acts are no longer lost in the corridors of time but simply become signposts within an all-embracing present."

Viewing Botero's pictures, one has an instant feeling of being at home in all four chambers of the heart of this still unknown giant continent. Yet numberless questions are posed at once, for the element of mystery, the sense of utter strangeness and the power to amaze all remain intact and hidden, despite the many tangible messages. Some things do look familiar, others odd and confusing, but the fundamentally alien nature always shines through. Thus *Verfremdung* à la Brecht—alienation—is no literary monopoly. In terms of their content, most of Botero's works elicit an initial astonishment bordering on incomprehension. This response is enhanced by the fact that he is so obviously an excellent painter, a master of form—*his* forms, which may well be archetypal Colombian. How explain all this?

I asked Botero to list his favourite writers for me. Among the poets Pablo Neruda, García Lorca and the Colombian Barba Jacob headed the list. Miguel Angel Asturias was named among the novelists. Of North Americans he had read mainly Faulkner, Salinger and Hemingway, a significant aggregation combining satire and the imagination. He had also studied the works of art historians like Berenson and Longhi, mainly Italians.

The road traversed by Botero may indeed be viewed as a "departure without arrival", an unfinished journey in the direction of the heart of a continent that still poses many puzzles, especially in human terms. He observes and records with an inspired acumen not unlike Alexander von Humboldt—although the German was describing a world not his own.

It should be noted, of course, that there is not the slightest connection between Botero and the Nazi *Blut und Boden* ("blood and soil") painters or the dogmatic painters of Socialist Realism in the Soviet Union. He is far too clever, independent and imaginative for such lapses. His work is more accurately described as a kind of collection of South American fairytales written by a combination of Brecht and Neruda. Botero, furthermore, is anything but parochial in outlook. He views his country with the detachment of a cosmopolite. Born in Medellín, Colombia, in 1932, he studied in Paris and Florence, lived for a time in Mexico and settled in the end in New York and Paris. He has travelled widely, among other places to Germany, where Dürer's work fascinated him. Yet his country of origin always remains a medium, so to speak, that invests him with figurative ideas and power of form. "I do prefer to view my country from afar", he says. "This enables me to transform it more successfully, to dream about it with greater freedom. Actuality can sometimes overwhelm."

Botero's actuality is indeed all-embracing, even though he sees it on occasion through the magnifying glass of caricature and satire. It is certainly not the petty actuality of Socialist Realism. Like Grassi, among others, Botero is convinced that Latin America is one of the few regions where the world can become transmogrified into myth. "Myth is a pretentious term", he says, "a term that is often abused." In Botero's own work? In what way? What his work does manifest is a specifically South American unreality, still tinged with prehistory, confronting a society infected with an often spectral and pseudo historical ideology. Botero's people, especially members of the ruling classes, thus grow monstrous and larger than life, whether they are generals or bishops, ladies of the upper middle-class, so-called, in their bath, tricked-out lovers or Sunday poets and the like.

They seem about to burst at any moment, these curiously puffed-up creatures, often posed against endless landscape backgrounds. Their own time is out of joint, and their failure is a failure in the face of true timelessness.

Perhaps the mythology of Botero might be thus summarised: He seeks to depict the failure of man, poised between the infinite and a falsely conceived finite. It is an up-to-date and indeed dramatic mythology, not of and for South America alone, for according to the school of Carl Gustav Jung, the Swiss psychiatrist, it concerns all of us. It unmasks the timeless philistine in all of us, Flaubert's Bouvards and Pecuchets who are by no means confined to the South American scene with its abundant contrasts. According to Grassi, it is a mythology that is perhaps best concretised within South America in poetic terms, be-

cause of the vast residue of prehistory, as vast as the ample figures of Botero, working away in stoic self-control. The painting of revolutionary posters is as foreign to him as is the lack of nuance in pop art with its frequent lapses into vulgarity. Botero's mythology shares its intellectual subtlety with, say, the myths of the late Hellenistic age with their Mannerist tinge. It has passed through the filter of Europe, like the poetry of Pablo Neruda.

Let us look at a few of the works displayed recently at the Marlborough Gallery, Zurich. Take, for example, *The Spinster,* which shows us an interior in pseudo historical style. A dim mirror reflects what looks to be a female breast—a hint of Mannerist *trompe l'œil?* The whole philistine ambiance is dominated by a bespectacled woman whose hips are almost as wide as she is tall. Her thin, faded, blond hair is crowned with a light blue, thoroughly Surrealist hair ribbon à la Max Ernst, betokening the subject's infantilism. For the rest, everything about her is tiny—eyes, nose, mouth, breasts, hands, feet. How she keeps her footing is a mystery. Her apple-cheeked visage reflects the dreadful emptiness that characterises so many of Botero's figures. Jung might have said they are people who lack a metabiological umbilical cord.

This is true also of the rather horrifying *Man Smoking,* apparently representing a (possibly Mafia-affiliated) "pillar of society" in Ibsen's sense. The characteristics are similar to those that served Botero in depicting his *Spinster*—but this "boss" is no bachelor, he wears a wedding ring. Even so, both of them squint, which may be meant to symbolize a disturbed balance of mind. Both figures display the mock elegance of the hopelessly provincial-minded. The tiny moustache of our horse trader—or whatever his calling may be—is razor-sharp, as is his tight-lipped evil little mouth. Our *Man Smoking* might well qualify for a part in Brecht's *Threepenny Opera.* He is shown against a background of sombre gloom.

The Bed shows a couple of this ominous genre in a dungeonlike room. A single small picture hangs on the wall. What is it? Who is it? A self-portrait of the artist? Pillows and mattresses swell and billow. They reveal only the back of a man's head and a barely visible woman's face in half-profile. The cell is mysteriously lighted. Are they making love? Are they asleep? What accident washed up these two in this monstrous bed? The questions remain unanswered. They are people in a wasteland and the last thing they are having is fun—although it must be said that Botero's pictures are never unchaste.

We come, lastly, to a still life titled *Oranges.* A still life is defined as "a representation of inanimate or motionless objects in an arrangement created by the artist rather than by nature." Well now, Botero's oranges are anything but "dead". They muster their last resources of fermentation towards the goal of ultimate ripeness, in the golden twilight shimmer of Colombia. To be sure, they are motionless, like all that is cut off from its vital juices, yet their immobility is oddly, almost Surrealistically rigid, like most of Botero's figures. A fly on the wall, one of his favourite items, seems almost like a fossil. A thread dangles from a barely open drawer. Another symbol? We do not know. The Mannerists, in any event, were given to the trick of eliciting surprise and consternation by means of detail easily overlooked. And here, once again, we note an admirable precision of craftsmanship that never lapses into

grandstand virtuosity. Something unknown beckons from the picture. The mystery of death? Answer comes there none—perhaps the painter himself does not know, which would provide the best evidence of his "archetypal" imagination. We return to the primal theme: life versus ossification, the temporal versus the everlasting.

A word about the palette of this unusually talented European South American. His pigments combine pastel tones with the yellowed garishness of old frescoes. They join nocturnal deep purple with dazzling sunlight, the discreet gold-blue of Greece with the harsh colours typical of South American folk art. Botero is no painter of the erotic, but there is a wild abandon in the connubial blending of the full spectrum of his nuances. In terms of his tints he is an eroticist par excellence—in other words, here too the archetypal Latin American.

In sum, Botero paints the kind of "monsters" that might peer from the pages of Herodotus, adding the elements of love, grace, insight and restraint. In Botero figurative art, in the last trimester of the twentieth century, has regained the kind of significance, mythological and human, if you will, in which Europe's greatest historian of the past hundred years, Arnold Toynbee, never lost faith.

I ask for indulgence for awakening such echoes. They stem from the vantage-point of an observer who, as the German poet Platen put it, "beholds beauty with his eyes". Hölderlin, one of Germany's greatest poets, commended the "sanctity of detachment", that is innate in Botero, in contrast to far too many painters of his generation. (pp. 19-21, 34)

> Gustav René Hocke, "Fernando Botero—A Continent under the Magnifying Glass," translated by Heinz Norden, in Art International, Vol. XVIII, No. 10, December 15, 1974, pp. 19-21, 34.

Judy Heviz (essay date 1976)

[*In the following review of an exhibition at the Marlborough Godard gallery in Montreal, Heviz praises the implicit satire of Botero's work.*]

Fernando Botero's oeuvre has an arresting ambiguity; under the veils of a pretended bucolic naivety the viewer soon discovers the amusing irony of a social satirist. His characters and the objects of his still-lifes (painted in the style of a meticulous realism) are seemingly the reflections of a megalomanic view of nature. There is a proliferation of opulent fleshy forms in his human figures, matched by the same profusion of oversized fruits and other edibles, as though his subject matter were descended from a Gargantuan feast.

The associations his work brings to mind range from the voluptuous corpulence of female nudes of a Rubensian or Renoiresque facture, to the irreverent criticism of Goya's royale portraits or Georg Grosz' unpardoning social criticism. But, no matter what the influences have been, prevailingly imposing is Botero's own creative vision that filtered and decanted them.

The gigantesque female nude, for instance, featured in his 1975 triptych, *Bathers,* is the carrier of an ambivalent in-

National Holiday (1982)

terpretation. It could be an earthbound fertility symbol or a sort of sensuous eternal Eve holding the apple of temptation. Instead the character becomes a vehicle to ridicule the obese deformity and to reveal her domineering animal nature.

This tendency of mercilessly exposing the brutish features of humans is obviously evident in the porcine faces his models wear and in the disproportions he mostly imposes on them to emphasize their grotesque corpulence.

The best example, perhaps, is the portrait of an armored nobleman flanked by his page boy, after Caravaggio's *Alof de Vignancourt.* The grandeur that ought to be the essential characteristic of a gala portrait is diminished and degraded by the enhanced incompatibility between the importance the hero is claiming for himself and the incongruous physical self.

The purposeful juxtaposure of out-of-scale objects also serves as an instrument to underline greediness and lust. This is evident, for example, in his 1974 charcoal on canvas *Still Life* towards which a small, plump hand is greedily reaching out, or the pencil drawing of the same year titled *A Painter,* with father and son sitting at a lavishly set table. In both cases the human presence is overwhelmed in size and importance by the elements of still life, underlining the meanness of human weakness.

Botero's satiric touch does not pardon even the closest and

dearest to him—his family. His late son Pedro appears in several drawings with a cherubic, chubby face, or in a large composition domineering, like a toy soldier, his toy world in which allusions to his death are made by an inertly laying small figure and his equally miniatural begrieved parents.

Royalty, noblemen, politicians, family, morality and clergy are not spared by Botero's brush. *New Born Nun,* a 1975 oil on canvas, disrespectfully identifies a nun with a well-fed baby innocently asleep in a basket, as such depriving her from any connotations of ascetic sainthood.

The originality of his style (in spite of so many sources of reference) assembles in a complex unity an imposing sophistication of vision and a pretence of naive purity that makes the work of Fernando Botero intriguing, stimulating and highly enjoyable at the same time. (p. 60)

Judy Heviz, "Goodridge Roberts, Fernando Botero," in Art Magazine, *Vol. 7, Nos. 26-27, May-June, 1976, pp. 57-60.*

Duane Stapp (essay date 1981)

[In the following exhibition review, Stapp expresses a preference for Botero's street scenes, suggesting that they avoid the tendency toward caricature present in his figurative works.]

Fernando Botero has been conveniently categorized by most as an artist who simply "paints fat people." His rotund figures are as immediately recognizable as Kewpie dolls, and share a similar popularity because they are so consistently stylized. Botero's efforts continue to be gargantuan; his latest paintings feature figures as well padded as ever, along with bulbously exaggerated still lifes and landscapes. He paints the world as a child might see it, with all its contents puffed up to intimidating proportions. *Mother Superior,* for example, is a single imposing figure of a nun shaped like a giant marshmallow, clutching two tiny crosses in her hands. She stands in solemnity, her piggish face in a pious stare, oblivious to her awkward size. The same fat that makes her a fear-inducing authority figure also gives her a certain vulnerability, like a punchable roly-poly toy.

But a closer look at Botero's work reveals that his true concern is not with fat itself. Botero seeks to isolate individual elements in his paintings, and he utilizes fat as a method to separate them in space. The face of his *Mother Superior* is a huge pinkish sphere dotted with miniscule features. The eyes, nose, and mouth are only encountered as one scans the long expanses of flesh between them. Instead of melding together to form a familiar pattern of a face, they stand isolated like outposts, each to be separately considered as it is seen.

The same method is evident in Botero's street scenes which do not totally depend upon his plump figures and are more successful because of it. Most of the surface of *The White Street* is apparently blank, a rectangular void depicting the blanched wall of an adobe-like building. Along the right-hand edge is a thin band of activity as a rosy-cheeked head pops out from behind a shutter on an adjoining side of the building, and a few tiled rooftops are visible. Again, minute details are isolated against a larger

field, in this case, an expanse of wall rather than a globe of facial flesh. This isolation is the essence of Botero's work and is better realized in these street scenes which cannot be misinterpreted as mere portraits of cutely fattened figures. (pp. 33-4)

Duane Stapp, in a review of an exhibit at the Marlborough Gallery in Arts Magazine, *Vol. 55, No. 5, January, 1981, pp. 33-4.*

Carter Ratcliff (essay date 1981)

[*In the following essay, Ratcliff discusses the aesthetic implications of Botero's style.*]

First, one sees Fernando Botero's wit. By means of a sober tie, a neatly arranged pocket handkerchief and a cane, he raises a provincial Latin American to the status of a man-about-town. This social promotion so inflates the chap's sense of himself that he undergoes a physical transformation. His body swells to grossness. Consequently, his badges of social rank are miniaturized—tie and handkerchief, especially. These are absorbed by his immense presence, as are the features of his face and the bland pomposity they express. The figure's bulk absorbs satire as well. Bulk itself—massively rendered volume—dominates the artist's treatment of his subjects' every other aspect. Botero gives prim nuns and high-heeled, half-dressed women the same treatment he gives his smoking boulevardier. This is not the strategy of a painter who wants to sit in satirical judgment. The anatomical details which distinguish his Adams from all their Eves are miniaturized as thoroughly as those which set his field marshals apart from their civilian counterparts in the ministerial offices of Botero's imaginary South America.

Botero's art guides human form towards androgeny, so his subjects appear less as particular individuals than as instances of sheer mass. This blurs boundaries between people and things. A pair of lovers lie in bed much as apples and oranges lie in Botero's fruit bowls. The artist's most recent New York show included a version of Mantegna's *Camera degli sposi.* Botero had drawn on this source before, in 1958, when his figures were just beginning to take on that massiveness which has made them so striking for nearly two decades. This second treatment of themes from Mantegna's *Camera* solidifies a challenge that was still tentative in 1958. Throughout his career, Botero has set his style the task of remaking the images of masters— many besides Mantegna, among them Caravaggio, Rubens, Manet and Bonnard. And yet, once made, Botero's art-historical references are engulfed, incorporated like earrings, wristwatches and rosaries. Still, when asked why he paints fat figures, Botero says, "I don't. They look rather slim to me."

If we must somehow learn to see Botero's people as "slim", then we must also find a way past his satirical effects. And we must ignore the fact that many of Botero's figures look, quite simply and overwhelmingly, grotesque. Their hugeness can be horrifying, especially when it is unclothed. Equal masses of flesh in Rubens's art affected Mark Twain and Thomas Eakins in the same manner, presumably because they belonged to the age of American Victorianism. In our times, Rubensian voluptuousness is out of date but perfectly acceptable. We tend not to be upset by nudity, even great expanses of it. Nonetheless, Botero's undraped figures have the power to shock. The seventeenth-century reflection of this discomfiting force is not in Rubens's Flemish abandon but in the paintings of dwarves by the Spaniard, Juan Carreño de Miranda. The best known are in the Prado, a pair of canvases showing a female dwarf or, in the idiom of the time, a monster. In one rendering, she wears a dress much like that of the Infanta Margarita, who stands at the center of Velázquez's *Las meniñas.* In Carreño's other canvas, the "monster" is unclothed and the evocation of Botero's art is strong. This seventeenth-century personage is so squat she nearly achieves the proportions of Botero's people, who, in turn, come to look like gigantic dwarves. Ultimately, though, Botero is no more interested in freakishness than in satire.

He says: "Art is deformation. There are no works of art that are truly 'realistic'. Even painters such as Raphael who are considered realistic are not. People would be shocked to see in real life one of his figures coming down the street. What I think is wrong is deformation for deformation's sake." If Botero's people are not monsters— gigantic dwarves or freakish updatings of Rubensian amplitude—it is because he deforms them for the sake of something other than horror or satire. A clue to what that might be is offered by Botero's observation that he treats oranges and bananas the way he treats people, and, he adds: "I have nothing against these fruits." His vision applies to all the world's contents. He doesn't single out field marshals, presidential wives or inmates of whorehouses. Still, Botero's people are so very strange at first sight that doubt lingers. Perhaps, after all, he does paint human grotesquerie.

It is hard to deny that some of the inhabitants of his world are monstrously voluptuous—especially the single-minded eaters and drinkers who appear from time to time. Bowls of soup and beans, bottles of beer and soft drinks, loaves of bread, watermelons—all are miniaturized by the presence of human figures. Yet, when compared to their counterparts in the ordinary world, these objects show a massiveness of their own. Volumetric inflation is a constant in Botero's art, and yet it is adjusted to give the greatest weight to the most important forms in a scene. A drinker is more fully expanded than the bottle from which he drinks. In a still life centered on a bottle, that object would be granted a full degree of expansion. Thus Botero never shows immense people overwhelming objects of ordinary size. In their own world, his men and women share some of their immensity with pets and place settings, tables and chairs. Even the smallest object, a fork or a berry, achieves massiveness on occasion, and that is why Botero can say his people are "slim". In their own world, their proportions are close to ordinary. What sets that world apart is the principle of expansion that pervades it. Every volume is touched to some degree by a strangely powerful style of plasticity. Botero's subjects undergo deformation for the sake of increasing the fullness, the weight, of that style.

This is not a matter of self-expression. Botero rejected German expressionist deformations and abstract expressionist spontaneities on his way to a mature style. Further, he rejects all psychological readings of his art—or, at least, he does when questioned directly on the matter. And he goes on to point out with approval that the human form

struggles toward complete conventionality in the art of Egypt, classical Greece and the early Renaissance. The same occurs in pre-Columbian and Latin American folk traditions, both of which send massively full-bodied figures to lurk at the edges of Botero's vision. Turning to modernist art, he is impressed by Henry Moore's tendency to reduce the face to a simple mask or even to a featureless extension of the neck. "I include facial features", says Botero, "but I always make them as small as possible. I would do without them if I could, because I'm not interested in the personalities of my figures."

Here is a psychological—or anti-psychological—reading of the shrunken details which embellish Botero's people. With eyes, noses and mouths reduced to miniature stereotypes, personality is forbidden to distract from plasticity. Not that these forms are completely lacking in human character. A few traits persist, meekly. The artist acknowledges this in his rare comments on the satirical import of his paintings. When he points to the pompous bulk of a pie-faced stroller, he draws attention to the disparity between character and role. A point about social pretentions has been made. For the most part, though, Botero denies that his people are collective portraits or that any of his forms are to be read as symbols. He directs his paintings not at Latin American provinciality and corruption but into the very nature of his medium: its power to create three dimensions from two, and thus endow the flat surface of the canvas with volume and depth.

Even Botero's satirical points reinforce plasticity, for they are made with human figures who owe their poses and pretentions to a super-abundance of self-sufficient bulk. The smugness and dimmed awareness of each personage add up to the psychological equivalent of volumetric fullness. These are thick, solid, inward-turning attributes. And they are ultimately negligible, like a field marshal's epaulettes or a demimondaine's earrings. The more clearly his figures' massiveness is figured forth, the more efficiently, in his words, "the incidental details of a mass are subordinated to the idea of mass".

For Botero, the play of light and dark tones, the modeling, which produces mass is not merely a means to an end. It joins with its product, volumetric form, to constitute an end in itself—and here is the essence of Botero's style. Intimately blended, plastic effects and the means of creating them provide his art with its animating "idea", a word the artist uses in something close to a Platonic sense.

Plato's Ideas are eternal archetypes which, taken together, form an ultimate and unchanging reality. Graspable only by reason, these Ideas are the models for the mutable, imperfect world experienced by the senses. Ordinary things are flawed copies of their Ideal counterpart, and so, for Plato, art can only be a copy of a copy. It was Plotinus who, in the third century A.D., first claimed that painting and sculpture could elevate the soul above ordinary reality to Plato's realm of immutable essences. Thus when Botero says that his "idea" of plasticity is a "conception of mind that creates a mental world", he is less a Platonist than a Neoplatonist. For him, as for Plotinus, art represents not a debased reality but one of our few hopes for an experience of the absolute.

On their surfaces, Botero's forms are satirical and grotesque. Just past those immediate effects he elaborates his

"idea" of plasticity in hopes of creating works which image forth volumetric shape with ultimate certitude. He speaks of "the joy, the mystery, of plastic form", which he feels when two dimensions are transformed into three. If the process can only be full and authoritative enough, it will intimate the nature of vision, of thought, of being. Botero's imagination is so caught up in the seventeenth-century of Velázquez and Rubens, it is not surprising to find that his Neoplatonism is echoed closely by the theoretical writing of that period. In his introduction to his book on *The Lives of Modern Painters, Sculptors and Architects* (1672), Giovanni Pietro Bellori begins by describing the origins of our world:

> When that high and eternal intellect, the creator of nature, made his marvelous works by reflecting deeply within himself, he established the first forms called *Ideas*. Each species was derived from that *Idea,* and so was formed the admirable web of created things . . . Noble painters and sculptors imitate that first creator, and form in their minds also an example of superior beauty and, reflecting on it, improve upon nature until it is without any fault of color or of line.

To make a work of art, according to Bellori, is to give visible form to that inward reflection, that ultimate "Idea", whether it be of Jupiter or Minerva or of the tables and chairs that might surround them in a painting. From Plotinus's time to the present, painters have employed plastic modeling, among other devices, in the attempt to make their Ideas visible. Only Botero has raised plasticity to the status of an Idea in its own right. Still, if any pictorial means is able to sustain such treatment, it is this one. Modeling with light and shade has been basic to Western painting for so long it could hardly help taking on spiritual import.

By raising plasticity from a means to an Idea, Botero claims a (or possibly *the*) basic device of painting for his own. Having made the appropriation, he is free to impose his version of plasticity at will upon the contents of the world and art history. This renders his subjects captive to his Idea and the "mental world" of his art. The chief result is that it installs Botero himself in the role of the Neoplatonic first creator. After all, he stands toward the world of his art as Bellori's god stands toward our world.

It was once routine to call original artists godlike in their creative powers, yet such rhetoric was never intended to obscure their humanity. To name Raphael "the divine", as his contemporaries did, is not to claim that his inspiration descended directly from heaven. Few denied then or deny now that an artist's development enmeshes him in a down-to-earth process of give and take with other artists, with history, and with the culture at large. And, of course, no one denies that in Botero's case. Nonetheless, his strangely Neoplatonic idea of plasticity has led him to an isolation so extreme that it seems natural to see Botero as the primary cause, the demiurge, of a world that exists full-scale only in his mind. Just as in his satirical comments on the world we all share, he creates an alien reality according to the rules of his style. He knows there are risks in following those rules as closely as he does. Recently he said: "To be mad and to have a style are the same thing."

Yet Botero isn't mad. His world does touch on ours, for his paintings present sheer being prior to any nuanced un-

certainties of vision. His concern is the existence we have in common with one another, with plants and animals, and even with inanimate things. In a desire to present being with ever greater authority, Botero pushes his "Idea" as far as he can. Plasticity becomes difficult to distinguish from the subject it captures for his art. Existence begins to blend with the painter's means of offering it to view. The closer he gets to achieving this deep unity, the more secure his sense of his own existence, of his own place in the world. (pp. 9-19)

Carter Ratcliff, "Fernando Botero," in Art International, *Vol. XXIV, Nos. 7-8, March-April, 1981, pp. 9-19.*

Jasia Reichardt (essay date 1983)

[*In the following essay, Reichardt analyzes the elements of Botero's style, focusing on the effect of his technique of inflation.*]

Many artists have marshalled art history to lead inevitably and inexorably to the point where their own innovations begin. Necessity for this is not always clear, but in the case of Fernando Botero there are good reasons for starting with history in coming to appreciate his work, if only because he has openly paid homage to the great masters from the Quattrocento to the present, throughout his career as an artist. Botero has expressed this homage in three specific ways: firstly, by repainting some of the works of these great artists in his own style; secondly, by making variations on themes they have used; and thirdly, by taking elements from their paintings and incorporating them in his pictures. Thus, for example, Botero has come to terms with Van Eyck and Ingres, in the first instance, by copying them; with Manet and Bonnard, in the second instance, by making his own versions of paintings such as the *Déjeuner sur l'herbe* and *Nude in the Bath;* and finally, with Pollock and the Abstract Expressionists, for instance, in maintaining a unified all-over intensity throughout the area of the painting.

So Botero is almost prodigal by the standards of others in acknowledging his fundamental allegiances and particular debts to the work of other artists. Paradoxically, his work is so personal and idiosyncratic in its vision and its language, that it remains very difficult for us to assess its place in either the chronology of other art or in a common hierarchy of values.

Botero's breakthrough to a personal style came in mid-1950s with his first inflated figure. He said later that it was like walking through a door beyond which he found possibilities that had evaded him before. He had always considered style to be an obsession. Now he found a style of his own which, on the face of it, manifested all the characteristics of an obsession and, was remote from other art. Through it, he was able to come to terms with not only the great masters of the past whose work had impinged upon him so forcibly, but also with his Latin American background and the human/animal/vegetable nature to which his paintings are dedicated.

The device of inflation has been central to his painting for more than 25 years and, not surprisingly, it has led to some obvious misunderstandings. When Botero is asked time and again why he paints fat people he resorts to some stock responses intended more to silence the interrogator than to deal with the question, to which there is no real answer anyway. Sometimes Botero would say that to him the people he paints are thin; sometimes he would explain that by puffing them up they would be rendered increasingly sensual; at other times he would answer that deformation is the function of all art including his own, and leave it at that. Even so the process of inflation remains puzzling. If attempted explanation is beside the point, it is at least worth defining its particular effects. For instance, when the inflationary process is applied to people, animals, fruit or objects it affects each of these three categories differently.

The compositions of fruit, flowers, musical instruments and other still lifes are rendered very formal, monumental and sedate when they are blown up. This effect is particularly visible when a disturbance in the serenity of these arrangements suddenly occurs through an incident such as a small bite taken out of an enormous pear, a miniscule worm disappearing inside a gigantic apple, or even an unexpected invasion of the tranquil scene by wasps, flies, or a predatory cat. The still life, or rather its vocabulary, is repeated in painting after painting through the introduction of the same or very similar objects: cutlery, fruit, jugs, a casually placed, somewhat crumpled tablecloth. The fruit provide the greatest variety in their colour and form but the more time Botero has spent outside his native Colombia, the more readily he discards fruits from temperate climates, declaring apples to be for snobs. Even so, apples persist (as do pears and all the other fruits which have invaded his picnics from the very beginning) and inflation magnifies their importance and their formidable presence.

Expressions of friendship, pleasure, aggression, horror or amusement are reserved for animals. Dogs and cats may not be endowed with greater expressiveness than Botero's human subjects, but it is precisely because they have been treated in the same way as the people in these pictures that they appear to us as more animated. This effect is the direct result of the evenness, sameness, lack of accentuation with which everything in the picture is shown. Within the course of inflation the features of the animals appear to become more concentrated, with the humans it is just the opposite.

Only very exceptionally do the figures depicted look at one another. They stare in front of them even if they are engaged in making love. They behave generally as if the artist had arranged them in front of a camera—either looking straight ahead or very deliberately to one side, and usually as if at nothing, without focus. Their relationships are determined by the artist for whom they are now posing. When a smart looking man in his Sunday best meets a lady decked out in frills, in the street on a ***National Holiday,*** we do not know whether he is raising his hat to her, or to the painter painting the picture, or to us, the viewers. Only when these characters have their eyes closed do they cease to stare. Botero discloses their separateness, the "ownness" of their individual worlds all the more emphatically because the figures are so enormous and at the same time so delicate, with tapering fingers and carefully manicured nails. By contrast with them, their beds, chairs, balconies, houses and belongings appear small, almost inadequate.

These vacant, staring eyes which convey a melancholic impression go together with slightly raised shoulders and

arms which articulate their buoyancy in suspended animation. However, there are exceptions. There are important differences between Botero's anonymous individuals which populate most of the pictures and to which I have been referring, and the portraits which he has painted of particular people, e.g. Mr & Mrs Thomas Messer, F. K. Lloyd and family, and Claude Bernard. These are recognisable likenesses shown as corpulent or even gigantic characters but their features are those of the sitters translated into fat people, with completely individual expressions, with details and wrinkles. They are specific people painted in a fat mode while the other Botero characters, the anonymous ones, are puppets or prototypes.

The prototypes are altogether different. They are blown up rather than fat, and through the process of inflation the wrinkles and facial features have been ironed out. As such they become interchangeable. It is the clothing and decorations which give these personages identity. The President becomes a Poet when he takes off his glasses and a Transvestite when he dons a dress. The Spinster, the Art Collector, the Youngest Sister are all identified with gold-rimmed glasses framing a cross-eyed stare and above, a large bow surmounting a mass of frizzy ginger hair. The presence of recurring characters lends the paintings a serial familiarity and narrative quality. The repertoire of accessories is interchangeable. The snake which is about to sting the Chief of Police in one painting takes aim at a Cardinal in another, or a naked man at a picnic elsewhere. Botero has developed his own obsessional iconography which sustains and is sustained by the repetitions and patterns he weaves from one picture to the next. The narrative always deals with incidents of a town or countryside (inevitably in Colombia) featuring characters who are bishops, generals, tarts, aunts, and ordinary citizens according to their insignia. Sometimes the spotlight falls on a single figure, but more often we meet the population in couples or groups.

Occasionally, within the illusion of normality of the Botero world, something surprising happens in one of the pictures, something out of character in relation to the main group of protagonists. For instance, an enormous leg descends from above with a tapering foot and a child's sock resting lightly on the step of a ladder leaning against an apple tree and held fast by a man much smaller in scale; sometimes a face appears in a window above the main scene which directs its gaze deliberately and quite untypically at what is going on below. Meanwhile in between the main characters of these *tableaux vivants,* there is a great activity where spaces are occupied by apples, flowers, toys, cigarette butts, pools of water, patterned carpets, animals and birds. The floor is often very dull and has to be animated, as Botero once explained in his enigmatic way to someone who asked him about the frequent incidence of cigarette butts.

Although Botero's copies of paintings by others have been discussed often, the artist to whom he owes a very special allegiance has not featured in the list. It is Henri Rousseau to whom Botero seems much the closest in spirit and ideas among the many great artists he has honoured with gestures of homage. Rousseau, too, devised means of animating and occupying the areas in between his principal and often inactive subjects. Often these in-between areas were more agitated than the inert group in the centre posing as

if for a camera. But it is Rousseau's portraits of individual children that share the unreal atmosphere so recognisable in Botero's paintings. Rousseau, in the portraits of his young sitters (whose parents often failed to recognise them), painted the isolation of a child within an enormous and often hostile landscape. The *Child of the Rocks* at the National Gallery in Washington, which Botero must have seen when he was there in the early 1960s, shows a boy with a doll-like body without much detail and with the face of an old man, as if impaled in the middle of a group of rocks, with the sea in the distance. In his other paintings of children, also positioned in the centre of the picture, holding a flower or a doll, they sit atop landscapes, isolated and looking like outsize puppets. In Botero's paintings the child-cum-doll-cum-balloon is also placed centrally, quite separate and self contained, a small immature being shown against the immensity of the outside. The jagged rocks in Rousseau's paintings become the Andes in Botero's, but the mountains, like the children themselves are inflated into curves. Rousseau's boy of the rocks finds its parallel in Botero's girl of the volcano or the boy riding a bike over the soft contours of the marshmallow Andes below.

In Botero's land-town-mountain-scapes, the middle distance is often contracted or eradicated altogether. The Andes, like sugar loaves, and the regular lines of the red brick roofs like a grid dividing space, are brought close to the events in the foreground so that the disparity between the figures in front and the scape behind is that of scale rather than size. This is typical because Botero assembles together not so much the disparate elements as the distinct or different ways of looking at them. In the **National Holiday,** mentioned before, it is not the strangeness of the man, or the woman and the dog finding themselves in a narrow cobbled street which is hardly wide enough to accommodate them, but the way the street rises up behind them like a backcloth.

Transition, transformation, distortion, spatial disorientation, are constant elements of Botero's visual language. Another constant is that his paintings are pervaded by the atmosphere of a dream—a state of suspended animation which is unreal and yet has hypnotic clarity. His world is not regulated by the gravity of the real world. Furthermore, there is a sameness about the light, tone, weight, colour, texture, movement, of everything in the pictures and we see it all as if through a haze of a single tone of an opaque coloured glass.

Botero's paintings have another particular quality which makes them memorable and this is their timelessness because nothing belongs very specifically to a particular moment. Consider the immutability of the ubiquitous iron bedsteads, screeching birds, scorched landscape, and decorated women; dignitaries, picnics and succulent fruit. Because of these qualities, they sometimes touch the same essential chord that is struck by legendary, apocryphal stories, handed down through generations. We may not know why they are being told nor why we enjoy so much to listen to them, but the sense of continuity they convey is important and their authority and identity is immediately recognisable to us. (pp. 18-24)

Jasia Reichardt, "Botero's Blow-Ups," in Art International, *Vol. XXVI, No. 3, July-August, 1983, pp. 18-24.*

FURTHER READING

I. Critical Studies and Reviews

Aberbach, J. Jean. "On Fernando Botero." *Yale Literary Magazine* 149, No. 3 (December 1981): 5-13.
>Brief appreciation written by a collector of Botero's work.

Dreiss, Joseph. "Fernando Botero." *Arts Magazine* 50, No. 3 (November 1975): 5.
>Positive assessment of Botero's style.

McPherson, Hugo. "Fernando Botero." *ArtsCanada* 33, No. 204-05 (April-May 1976): 57.
>Brief appreciation of Botero's work.

Moorman, Margaret. "A Gift for Being Different." *ARTnews* 85, No. 2 (February 1986): 71-9.
>Biographical essay derived in part from the author's meeting with Botero in 1986.

Pau-Llosa, Mario. "Botero and the New Folklore." *Art International* XXVI, No. 3 (July-August 1983): 59-63.
>A negative assessment of Carter Ratcliff's 1980 study, *Botero,* (see Selected Sources of Reproductions). Pau-Llosa affirms Botero's link with native Latin American culture and suggests that the real value of his work lies in its blending of symbolic and iconographic functions, although Botero himself fails to realize this.

II. Selected Sources of Reproductions

Arciniegas, Germán. *Fernando Botero*. Translated by Gabriela Arciniegas. New York: Harry N. Abrams, 1977, 223 p.
>Large-format color reproductions with a biographical essay by Arciniegas and a brief interview with Botero.

Botero, Fernando. *Fernando Botero: La Corrida, the Bullfight Paintings.* New York: Marlborough Gallery, 1985, 54 p.
>Color reproductions of Botero's later bullfight series.

Galerie Buchholz. *Botero.* Munich: Galerie Buchholz, 1970, 117 p.
>Small-format color and black-and-white reproductions with essays by Tracy Atkinson (excerpted above), Klaus Gallwitz (in German), and Alvaro Mutis (in Spanish).

Gallwitz, Klaus. *Fernando Botero.* Translated by John Gabriel. London: Thames and Hudson, 1976, 77 p.
>Small-format color reproductions with text by Gallwitz.

McCabe, Cynthia Jaffee. *Fernando Botero.* Washington: Smithsonian Institution Press, 1979, 119 p.
>Numerous color reproductions with a comprehensive biographical essay by McCabe.

Ratcliff, Carter. *Botero.* New York: Abbeville Press, 1980, 272 p.
>Large-format color reproductions with critical commentary by Ratcliff.

Restany, Pierre. *Botero.* Translated by John Shepley. New York: Harry N. Abrams, 1984, unpaged.
>Large-format color reproductions with an appreciation by Restany.

Sullivan, Edward J. *Botero Sculpture.* New York: Abbeville Press, 1986, 171 p.
>Photographs of Botero's sculptures with explanatory text by Sullivan.

Brassaï

1899-1984

(Born Gyula Halász) Hungarian-born French photographer, painter, and sculptor.

Brassaï is best known for his nighttime photographs of Paris in the 1930s. His two major picture collections, *Paris de nuit* (1933) and *Le Paris secret des années 30* (1976; *The Secret Paris of the 30's*), contain night scenes of prewar cafe, bar, and street life in the French capital. Brassaï himself defined his artistic mission in *The Secret Paris of the 30's:* "During my first years in Paris, beginning in 1924, I lived at night, going to bed at sunrise, getting up at sunset, wandering about the city from Montparnasse to Montmartre. And even though I had always ignored and even disliked photography before, I was inspired to become a photographer by my desire to translate all the things that enchanted me in the nocturnal Paris I was experiencing. So *Paris de nuit,* . . . was born."

Brassaï was born Gyula Halász in Brasso, Transylvania, which was at that time part of the Austro-Hungarian Empire and is now part of Romania. He received most of his primary education locally and served in the Austro-Hungarian Army from 1917 to 1918. By his own account, Brassaï originally wanted to be a painter. He studied at the Academy of Fine Arts, Budapest, from 1918 through 1919 and at the Akademische Hochschule, Berlin-Charlottenburg, from 1921 through 1922. He came to Paris in 1924 as a journalist. For the remainder of the decade, he painted, sculpted, and wrote pieces for newspapers and magazines. He became the intimate of leading Paris-based artists and thinkers of the period: Pablo Picasso, Georges Braque, Salvador Dalí, Henry Miller, Alberto Giacometti, and others. He was a talented painter, but found the medium taxing and time-consuming. Encouraged by fellow expatriate André Kertész, Brassaï began experimenting with photography in 1930. He found the immediacy of the medium irresistibly seductive. Soon he was regularly selling his pictures of Paris to such magazines as *Minotaure, Verve,* and *Harper's Bazaar.* In 1933 he mounted his first individual exhibition, "Paris de nuit," at the Arts et Metiers Graphiques in Paris. The show was a resounding success, the photographs acclaimed for their realism and technique. In these works Brassaï drew back the curtain on Paris after dark. Opium dens, brothels, prostitutes, street fairs, cesspool cleaners, the criminal underworld, public urinals, homosexual parties, the wings of the Folies-Bergère—these and similar subjects all figured strongly in the "Paris de nuit" series. Typical images of this period are *Two Apaches in Paris, Young Toughs in a Bistro Near the Place d'Italie, The Bum with His Cat, The Human Gorilla with His Son Peterchen, Two Girls Looking for Tricks, Boulevard Montparnasse, Homosexual Ball at Magic City, Rue Cognacq-Jay, An Opium Smoker Asleep,* and *A Gas Company Employee Extinguishing One of the Last Remaining Gaslights, Boulevard Edgar-Quinet.*

Characteristically, Brassaï's photographs are determinedly nonjudgmental. According to Henry Miller, "Brassaï has that rare gift which so many artists despise—*normal*

vision. He has no need to distort or deform, no need to lie or to preach. He would not alter the living arrangement of the world by one iota; he sees the world precisely as it is and as few men in the world see it because seldom do we encounter a human being endowed with normal vision. Everything to which his eye attaches itself acquires value and significance, a value and significance, I might say, heretofore avoided or ignored."

Brassaï's documentary excursions into nighttime Paris diminished in 1940 during the German occupation. For the duration of the war, he returned to an earlier interest, drawing. He also worked on a novel, *Histoire de Marie* (1948), and photographed sculptures for Picasso in the artist's studio. The latter experience provided material for Brassaï's 1964 book *Conversations avec Picasso* (*Picasso and Company,* 1966). Another collection of Brassaï's photographs, *Camera in Paris,* was published in 1949. From about 1945 to 1963, Brassaï regularly contributed photographs to *Coronet, Labyrinthe, Lilliput, Picture Post, Plaisirs de France,* and *Réalités.* During the 1950s, he struck out in a new direction, photographing Parisian graffiti. These pictures were shown in two major exhibitions, "Graffiti" (Museum of Modern Art, New York, 1957) and "The Language of the Wall: Parisian Graffiti Photo-

graphed by Brassaï" (Institute of Contemporary Arts, London, 1958). Commenting on the graffiti project, Brassaï wrote: "The *graffiti* strike one by their extreme austerity, their primitive simplicity, the strictness of their composition. . . . The emblems of love and death predominate. Numberless hearts, pierced by a line, marked with the loved one's initials—how often are they found pitted with holes, ravaged in a fit of fury or revenge! Does this not recall the cave-man's painted bison, studded with arrows, by means of which the prehistoric hunter wanted to express his magical power, his 'seizing'?" During the 1960s and 1970s, Brassaï concentrated as much on painting, sculpture, and drawing as on photography. A major retrospective of his photographs was presented at the Museum of Modern Art, New York, in 1968. In 1975 he published an important study of the life and work of his friend Henry Miller, entitled *Henry Miller: Grandeur Nature.* Brassaï's last major exhibition, "The Secret Paris of the 30's," was mounted in 1976 by Marlborough Gallery, New York. The book of the same name was widely acclaimed. Brassaï died in Nice, France, in 1984.

Brassaï turned his camera on some of the most colorful and mysterious aspects of 1930s Paris. Writing in 1976, he stated of the photographs in *The Secret Paris of the 30's:* "To the present generation, some of these pictures will certainly seem as exotic as if they were of pygmies or Zulus. Even more so. This is because in our century's mad rush, style, morals, customs, art itself, have all been subjected to an unprecedented acceleration. Everything changes in a few years, and in a half-century everything has become far away, unrecognizable." Brassaï's photographs, critics agree, are therefore an invaluable record of an age now lost.

ARTIST'S STATEMENTS

Brassaï (essay date 1958)

[*In the following statement, Brassaï considers the origin and purpose of his photographs of Parisian graffiti.*]

Why should it be that in an age dominated, as ours is, by the exact sciences, there is so tremendous an interest taken in primitive art, be it stone or iron age, prehellenic or Mexican, Peruvian or Asiatic? Why are we more excited by the beginnings of art than by masterpieces produced in the great ages? The reason is that the earliest impulses in art seem to spring up from a deeper stratum, from a purer source, which seem better able to illuminate for us the fact of artistic creation which so preoccupies us today. We are always hoping to discern beneath the carved or painted figures of primitive art the true being of man, the essence of the human spirit.

Apart from the Primitives, the madmen and the *naïfs*—those who have lost their reason or who have not yet acquired it—it is children who enable us to participate most closely in the birth of art. The early years of a human being are perhaps not unlike the early stages of the human race. With its heroes, monsters, myths and legends, childhood

has something of the candour and innocence, the strange and disturbing quality, of the world of early man. Psychologists have in all seriousness attempted to mark off each of the 'periods' of child-artists, from their prehistoric scribblings to their classic phase of patterns and symbols, down to the age of narrative and finally to the decline which sets in at the age of ten when the child's fragile creative gift usually fades for ever.

Children's drawings and paintings are in fashion, and are now even to be found in museums; but there remains another branch of child-creativeness (whether actually by children or by those with childish minds), which, because it is less observed and therefore less influenced and controlled, is all the more authentic: wall scratchings, or *graffiti.* The art of the wall has been almost entirely neglected. Yet it is *graffiti* which, from the Neolithic caves to the cities of classical antiquity, have supplied the most exact and the most unsophisticated evidence on the character and intimate nature of a civilization.

They have been discovered abundantly on the house walls of Rome and Pompeii; and even in our own day this genuine "mural" art, with its odd world of signs, figures and symbols, continues to exist. In the year 1956 *graffiti* resembling those in the Dordogne caves, in the ancient Nile valley or in Mesopotamia, were still appearing on walls within a stone's throw of the Paris Opéra, in the heart of the city. I myself have for twenty years now been gathering the wild and frail blossoms of this art as they sprout up throughout the *faubourgs* of Paris.

The things about children's drawings that please us are their dreamlike fantasy, their naïvety, their humour, their closeness to the world of fairy tale, the happiness of their graphic inventions, their innate sense of colour. But there is a change of expression with the change of surface from paper to wall. By taking away the facility of pencil-on-paper the wall seems to obtain from the child-artist a quite different style—more astringent, harder, more expressive and, elaborations of detail being suppressed, less sweet.

As an area of blotches, cracks, coarse or decaying surfaces, crazing and damp patches, the texture of a wall is particularly apt to suggest images and to excite the imagination. Like the forms of rocks, of knots in wood and of mountains, which have always done so, wall surfaces are richly suggestive of shapes to the eye of man. Leonardo da Vinci had already perceived the *maieutic* properties of a wall, able unconsciously to conceive and deliver in the minds of beholders the forms which are inherent in it, when he wrote the celebrated passage in the *Treatise of Painting:*

> A variety of compositions may be seen in such spots, according to the disposition of the mind with which they are considered; such as heads of men, various animals, battles, rocky scenes, seas, clouds, woods, and the like. It may be compared to the sound of bells, which may seem to say whatever we choose to imagine.

A child who at first had all his pleasure in scoring the wall with an old, blunt pen-knife and covering it with a chaos of meaningless lines will suddenly grow serious in his fun once he has recognized a *face* in a chance outline. This recognition is enough for a form to isolate itself from the scratchings and become the object of the child's vision. He

needs only to give a *name* to the outline and he will feel he possesses, intoxicatingly, his own magic power as a creator of forms. One of my examples shows just one of these amorphous patches in which a child has recognized some sort of monster. By simply ringing it round he has lawfully taken possession of it—it has become his own creation. We are here looking at creation caught in the act.

We can also see how the growth and identification of the image of the human being in the child's mind is based on *cavities,* and not on *ovals,* as generally held by psychologists, who solidly maintain that the 'sausage-man' is the fundamental representation of a human. Again and again on the walls of Paris a *pair of holes* has been recognized by children as human eyes. Just two holes, but for the child it's a complete man, and his complete facial expression. More sinister than Melanesian masks, these dark pits watch us as it were from the depths of time. Later a third hole will be added to serve as a nose, and later still a fourth for the mouth. The final oval to enclose the manikin's moonlike face usually comes a good deal later, and is added by another hand. It is surprising that the same three or four holes can be given such a vast range of expression. It may, according to the child's own character that is being revealed, be anything between the extremes of jollity and tragedy. It is these solid and sombre works of art, cut down to essentials, in which the child has identified man at the same moment as for the first time expressing himself, which are perhaps the most moving of all, for they sweep us instantly into the uneasy world in which the soul of a child has its being.

The *graffiti* strike one by their extreme austerity, their primitive simplicity, the strictness of their composition. A child who on paper may fill up his scenes and stories with crowded detail is forced by the character of the wall to use a minimum of lines. He may also be helped by the freedom and impersonality of a wall to let himself go, to confess, to unburden himself of his troubles and anxieties, fears and obsessions. Like his far-distant ancestors the child struggles alone, in the darkness. Even now, the wall is a place preordained for ecstasies, for 'possession' by *Doppelgänger.* The emblems of love and death predominate. Numberless hearts, pierced by a line, marked with the loved one's initials—how often are they found pitted with holes, ravaged in a fit of fury or revenge! Does this not recall the cave-man's painted bison, studded with arrows, by means of which the prehistoric hunter wanted to express his magical power, his 'seizing'?

These same distresses and fears in early youth have given rise to a whole language of symbols. The widespread pierced-heart motif sometimes turns into a bow-and-arrows, or again the hammer-and-sickle, or a formalized version of the genital organs. Elsewhere the arrow may become a dagger, and the heart the thighs of a woman. Likewise, aeroplanes, torpedoes, pistols, streamlined motor cars may change into phallic emblems. We thus witness on the walls an unceasing transposition and transmutation of forms, disguising or altering themselves or sometimes reducing themselves to secret ideograms. We can follow almost step by step the birth of writing—for example, the ultimate simplification of the pierced-heart into a straight line intersecting a curved one. Or again, two lines making an X stand for death—are they the last vestiges of the skull and crossbones? It was in this way that at the end of the

Magdalenian period the pictures of a horse's head, a bison or a fish passed into geometrical outlines so abstract as to become unrecognizable as such.

The current language of the walls offers other analogies with the prehistoric past. It was surprising to discover in a squalid street the 'sister' of the well-known witch-doctor of the cave paintings, half man, half beast—the ancestor of later ages' fabulous monsters. There was a woman-headed bird, or better, a bird-headed woman, related to the beaked deities of the Assyrians and the ram, lion and hawk-headed gods of Egypt, who had been re-invented by some boy, probably because he had heard a woman called 'une poule' (a chicken, as prostitutes are popularly called in France). How ingeniously, too, had another artist, under the spell of the name 'Hilter' [*sic*], conjured a fully armed and helmed Teuton warrior, terrible to behold, goose-stepping a crude swastika into life.

It is also surprising to note to what degree the idea of death occupies the imagination of children. A vast variety of death's heads dominates the walls, but of course these also symbolize adventure, seafaring and piracy, and poison. There are a great many demons, sorcerers, fairies, ghosts and imaginary animals. To the war and the occupation are owed the warriors and the gallows.

The greater number of *graffiti* suggest the vanished civilizations of Central and South America, or still earlier epochs, such as the horned cattle found in the rue du Temple, which could easily have come from a cave in the Vallée d'Eyzie. Some *graffiti,* on the other hand, recall great artists of our own times; Picasso is brought to mind by an amusing version of the death's head. A magician recalls Klee, and others Mirô, while some of the tragic, mask-like faces have affinities with Rouault. (pp. 237-40)

Brassaï, "The Art of the Wall," translated by James Clark, in The Saturday Book, *Vol. 18, 1958, pp. 236-49.*

Brassaï (essay date 1976)

[*In the following statement from his collection* The Secret Paris of the 30's, *Brassaï describes the genesis of his nighttime photographs of Paris.*]

During my first years in Paris, beginning in 1924, I lived at night, going to bed at sunrise, getting up at sunset, wandering about the city from Montparnasse to Montmartre. And even though I had always ignored and even disliked photography before, I was inspired to become a photographer by my desire to translate all the things that enchanted me in the nocturnal Paris I was experiencing. So **Paris de nuit,** published in 1933, was born.

Sometimes I would be accompanied on my excursions by a friend or bodyguard. I strolled with Henry Miller through the XIIIth and XIVth arrondissements we both loved. On many evenings, Léon-Paul Fargue, the self-styled "Pedestrian of Paris," led me to discover the hidden areas of Ménilmontant, Belleville, Charonne, the Porte des Lilas, which he knew so well. I remember a late-night outing with Raymond Queneau, whom I took to a street dance in the suburbs. I also spent several nights in the neighborhoods around the Bassin de la Villette with Jacques Prévert, where we reveled in the "beauty of sinis-

ter things," as he used to call the pleasure those deserted quays, those desolate streets, that district of outcasts, crawling with tarts, full of warehouses and docks, gave us.

More often, however, I wandered alone in unsavory, ominous areas where I wouldn't dare go today. Sometimes, impelled by an inexplicable desire, I would even enter some dilapidated house, climb to the top of its dark staircase, knock on a door and startle strangers awake, just to find out what unsuspected face Paris might show me from their window. This is how, once, around midnight, I got to photograph the street fair which had set up its merry-go-rounds, booths, its tiny circus, in the Place d'Italie. My intrusion frightened the inhabitants as much as my purpose: in those days, no one had heard of night photography. But oddly enough, doors were almost always opened to me, and I never got shot at, as might have happened, for disturbing a nocturnal household. I was hauled off to the police station by the patrol squad on only three occasions. The police refused to believe that anyone might want to take pictures by the canal at three A.M., and were more inclined to think I had been dumping a body into the greenish water. To show any possible interrogators it could be done, I usually carried with me some photographs I had taken at night.

Sometimes the inhabitants surprised me more than the view from their window could have. One winter's night, having spotted a seventh-story attic window in a decaying house across from the church of Saint-Séverin, I climbed the dark stairs, lit only by two small lamps. At the very top, I knocked on the last door. It swung open. A man and a woman in nightgowns were standing in the middle of the small room, like the figures in Millet's *Angelus*. It was dark. Their somber, expressionless faces were lit by the faint reflection from the pink sky of Paris outside. "What do you want?" the man asked, without turning toward me. "I'd like to see Paris from your window. You'd be doing me a great favor." "I'm glad I can still do a favor for someone," he replied. "Go on, look . . . we don't know what it's like. We're both blind." I left, ashamed, heartsick. Two blind people living there, in that poor attic room! One could enter a dwelling at random and discover the strange, the tragic.

Just as night birds and nocturnal animals bring a forest to life when its daytime fauna fall silent and go to ground, so night in a large city brings out of its den an entire population that lives its life completely under cover of darkness. Some once-familiar figures in the army of night workers have disappeared: the repairers of the streetcar tracks, whose acetylene torches made fireworks, showers of violet sparks; the cesspool cleaners, who zealously pumped the septic tanks in the older neighborhoods; the porters and market gardeners, the agents, the butchers of La Villette, before Les Halles moved to Rungis.

The real night people, however, live at night not out of necessity, but because they want to. They belong to the world of pleasure, of love, vice, crime, drugs. A secret, suspicious world, closed to the uninitiated. Go at random into one of those seemingly ordinary bars in Montmartre, or into a dive in the Goutte-d'Or neighborhood. Nothing to show they are owned by clans of pimps, that they are often the scenes of bloody reckonings. Conversation ceases. The owner looks you over with an unfriendly glance. The clientele sizes you up: this intruder, this new-

comer—is he an informer, a stool pigeon? Has he come in to blow the gig, to squeal? You may not be served, you may even be asked to leave, especially if you try to take pictures . . . And yet, drawn by the beauty of evil, the magic of the lower depths, having taken pictures for my "voyage to the end of night" from the outside, I wanted to know what went on inside, behind the walls, behind the façades, in the wings: bars, dives, night clubs, one-night hotels, bordellos, opium dens. I was eager to penetrate this other world, this fringe world, the secret, sinister world of mobsters, outcasts, toughs, pimps, whores, addicts, inverts. Rightly or wrongly, I felt at the time that this underground world represented Paris at its least cosmopolitan, at its most alive, its most authentic, that in these colorful faces of its underworld there had been preserved, from age to age, almost without alteration, the folklore of its most remote past.

The half-dressed girl strutting along the Rue des Lombards, picking up passers-by, murmurs the same "Want to come with me?" as the streetwalkers murmured to the rakes in the fourteenth century. She walks the same sidewalks as they did, the same pavement, stands on the same corners. The pimps, hatching shady deals and keeping a businesslike eye on their stables of girls, play endless games of cards or dice in the same cafés, the same cheap restaurants, as did the rogues of long ago, the *Coquillards* with whom François Villon hung out, or the companions of that other shady ex-convict, François-Eugène Vidocq, who became the chief of police.

Maybe my fascination with the underworld in those days was inspired by the infatuation with outcasts I had derived from some of my favorite writers: Stendhal, Mérimée, and above all Dostoevsky, Nietzsche. Enthralled by outlaws living outside the conventions, the rules, they admired their pride, their strength, their courage, their disdain for death. "Extraordinary men," wrote Dostoevsky in *The House of the Dead*, "perhaps the most richly endowed, the strongest of all our people. . . ." And let there be no mistake. The admiration expressed by the author of *Crime and Punishment* was not for revolutionary intellectuals or for political prisoners, but for real criminals: thieves, murderers, convicts—his own prison companions. These criminals cast out by society became his mentors, their doctrine of life—never written, but clear nonetheless—became his ideal. There was no pity in this. Dostoevsky consciously adopted the convicts' code: to live life according to one's own passions, to create one's own laws! Thus, more than a quarter of a century before Nietzsche, Raskolnikov had already removed himself "beyond good and evil." The author of *The Brothers Karamazov* admired these criminals so much that during his prison term he put up with the contempt with which they treated him. Was he not an outsider, a stool pigeon? "How is it," he wondered, "that they seemed then, they still seem, right to have despised me, and why is it that against my will I feel so weak, so insignificant, so—how terrible to say it—*ordinary,* compared to them?" For me too, or rather, for that other me of forty years ago, this infatuation for low places and shady young men was doubtless necessary. Could I otherwise have torn these few images from the strange Parisian nights of the thirties before they sank into nothingness? For me, fascination with a subject was always an indispensable stimulus.

To the present generation, some of [the pictures in *The Secret Paris of the 30's*] will certainly seem as exotic as if they were of pygmies or Zulus. Even more so. This is because in our century's mad rush, style, morals, customs, art itself, have all been subjected to an unprecedented acceleration. Everything changes in a few years, and in a half-century everything has become far away, unrecognizable. Pierre Mac Orlan has already complained that nothing remained to testify to the experiences of his youth. "The almost total disappearance of everything picturesque," he wrote, "which formed the most touching part of life in 1900, is a fact." Raymond Queneau believes that these destroyed areas, these forgotten customs, live on in the work of the author of *Chant de l'équipage*. "This vanished world of hoods and underworld characters will take its place alongside the common folk and unscrupulous heroes of Petronius: time changes nothing. Any writer worthy of the name gives his era a certain image, at once true and poetic, lasting and evanescent; this is what Mac Orlan has done" (Preface to the *Collected Works of Pierre Mac Orlan*). Forty years ago, when I was planning the publication of the photographs in this book, I asked Pierre Mac Orlan to write the accompanying text. He came to Paris to meet me in a bistro near the Gare de l'Est. And he agreed with pleasure to write that text: my whores and crooks, my sailors, seemed to him to have come out of his own world. The collection was not published at that time. Now that the pictures are to appear accompanied by my own text, and not the one he wanted to write for me, I must include here a friendly thought for Pierre Mac Orlan.

In order to get into those suspicious, closed circles, so wary of witnesses, I had to employ both trickery and diplomacy. I usually tried to get friendly with someone who belonged. During the time a film was being made in a studio in Montmartre, I got acquainted with a young electrician, a member of the underworld. One evening, he took me to the Bal des Quatre Saisons in the Rue de Lappe. He introduced me to the owner, saying, "He's a friend." Not a word more. According to the custom and usage of the place, "friend" was like a password, a total guarantee. Having been introduced into one of the oldest and most authentic of the popular dance halls—no tourists, no bourgeois visitors among these toughs: hoods, thieves, small-time pimps—I hung out there for a time, just to make myself known and to become as invisible as possible. But it was very difficult to overcome their distrust of me. Despite the owner's acceptance, in the eyes of some of them I was still an informer. What I wanted was for the suggestion to take photographs not to seem to come from me, but from them. Having made a few friends among them, both men and women, I showed them my photographs, and finally I succeeded in getting what I wanted. For a couple of evenings I was allowed to work without any trouble. Then suddenly . . . On that evening, the atmosphere was extraordinary. Such couples! Such faces! I worked in a kind of fever, sure that I was capturing the most wonderful underworld images. In those days, I was still using sheathed plates. My leather case held two dozen. Around midnight, I had only one unexposed plate left. I went to get it out of the bag, which I had left on a table. No bag. Stolen! Someone had lifted the whole take! The owner of the Quatre Saisons, his pride wounded, was more upset than I was. "That, to a friend!" He even put up a reward for whoever got back my bag, or turned in the

thief. All in vain. I never found my leather bag, with its twenty-three marvelous, forever latent, images . . . It was probably tossed into a garbage can or into the gutter. And I understood: one never knew where one stood with these guys. They were capable of killing you for having taken their picture—most of them had reasons for protecting their anonymity, for staying unnoticed—or for having ignored them. All in all, I got out of that adventure rather well. They were very quick at settling scores! They could have ganged up on me with knives as I left the hall, instead of just stealing my twenty-three plates.

Photographing the girls and young toughs in the streets, in cafés, in whorehouses, I always ran the same risks. But my passion for capturing these pictures made me almost oblivious to danger. I escaped with a couple of pursuits and two broken cameras. The only time I was actually threatened with death was one morning when I was peacefully asleep in my hotel room. Someone knocked on the door. Waking with a start, I opened it. Before me stood a giant brandishing a crime magazine. I recognized him: a marvelous mobster I had photographed in a bar in the Saint-Merri quarter. He thrust a picture in the magazine under my nose. The caption, which had been added by the editors, read something like: "This murderer who . . . that murderer who . . . " "So I'm a murderer, am I?" he said, pulling his cap down over his forehead and brandishing a switchblade. "Then I'm going to kill you!" I was in bed, unarmed, in a real fix. I didn't even dare yell for fear of provoking him. What do you do when threatened with a knife? Luckily, I was able to wriggle out of it. Taking all my money, he left. My life had been spared. This experience still did not stop me from becoming linked one day with a gang from the Place d'Italie—"Big Albert's" gang. A huge strapping fellow, a gang leader, surrounded by six more or less colorless lieutenants who worshiped him unreservedly and obeyed him without scruple. This guy had three whores working for him. I accompanied them on some of their nighttime rambles. Although I succeeded in taking photographs of these toughs, one day they managed to lift my wallet, even though I had already paid them handsomely for their favors. I didn't lodge a complaint, however. Thievery for them, photographs for me. What they did was in character. To each his own. (pp. iii-ix)

Brassaï, in a preface to his The Secret Paris of the 30's, *translated by Richard Miller, Pantheon Books, 1976, pp. iii-ix.*

SURVEY OF CRITICISM

Henry Miller (essay date 1941)

[*An American novelist, essayist, and critic, Miller was one of the most controversial authors of the twentieth century. The ribaldry and eroticism of such works as* Tropic of Cancer (*1935*) *and* Tropic of Capricorn (*1939*) *made him perhaps the most censored major writer of all time. An expatriate in Paris during the 1930s,*

Miller often accompanied Brassaï on his nighttime walks through the streets of the French capital. In the following excerpt, he argues that Brassaï's genius as a photographer stems from his "normal vision."]

Brassai has that rare gift which so many artists despise—*normal vision.* He has no need to distort or deform, no need to lie or to preach. He would not alter the living arrangement of the world by one iota; he sees the world precisely as it is and as few men in the world see it because seldom do we encounter a human being endowed with normal vision. Everything to which his eye attaches itself acquires value and significance, a value and significance, I might say, heretofore avoided or ignored. The fragment, the defect, the commonplace—he detects in them what there is of novelty or perfection. He explores with equal patience, equal interest, a crack in the wall or the panorama of a city. Seeing becomes an end in itself. For Brassai is an eye, a living eye.

When you meet the man you see at once that he is equipped with no ordinary eyes. His eyes have that perfect, limpid sphericity, that all-embracing voracity which makes the falcon or the shark a shuddering sentinel of reality. He has the eyeball of the insect which, hypnotized by its myopic scrutiny of the world, raises its two huge orbs from their sockets in order to acquire a still greater flexibility. Eye to eye with this man you have the sensation of a razor operating on your own eyeball, a razor which moves with such delicacy and precision that you are suddenly in a ball room in which the act of undressing follows upon the wish. His gaze pierces the retina like those marvelous probes which penetrate the labyrinth of the ear in order to sound for dead bone, which tap at the base of the skull like the dull tick of a watch in moments of complete silence. I have felt the penetration of his gaze like the gleam of a searchlight invading the hidden recesses of the eye, pushing open the sliding doors of the brain. Under that keen, steady gaze I have felt the seat of my skull glowing like an asbestos grill, glowing with short, violet waves which no living matter can resist. I have felt the cool, dull tremors in every vertebra, each socket, each nodule, cushion and fiber vibrating at such a speed that the whole backbone together with my rudimentary tail is thrown into incandescent relief. My spine becomes a barometer of light registering the pressure and deflection of all the waves which escape the heavy, fluid substance of matter. I feel the feathery, jubilant weight of his eye rising from its matrix to brush the prisms of light. Not the eye of a shark, nor a horse, nor a fly, not any known flexible eye, but the eye of a coccus newborn, a coccus traveling on the wave of an epidemic, always a millimeter in advance of the crest. The eye that gloats and ravages. The eye that precedes doom. The waiting, lurking eye of the ghoul, the torpid, monstrously indifferent eye of the leper, the still, all-inclusive eye of the Buddha which never closes. The insatiable eye.

It is with this eye that I see him walking through the wings of the Folies-Bergère, walking across the ceiling with sticky, clinging feet, crawling on all fours over candelabras, warm breasts, crinolines, training that huge, cold searchlight on the inner organs of a Venus, on the foam of a wave of lace, on the cicatrices that are dyed with ink in the satin throat of a puppet, on the pulleys that will hoist a Babylon in paint and papier-mâché, on the empty seats which rise tier upon tier like layers of sharks' teeth. I see him walking across the proscenium with his beautiful suede gloves, see him peeling them off and tossing them to the inky squib which has swallowed the seats and the glass chandeliers, the fake marble, the brass posts, the thick velvet cords and the chipped plaster. I see the world of behind the scenes upside down, each fragment a new universe, each human body or puppet or pulley framed in its own inconceivable niche. I see the lovely Venus prone and full athwart her strange axis, her hair dipped in laudanum, her mouth bright with asphodels; she lies in the neap of the tide, taut with starry sap, her toes tinctured with light, her eyes transfixed. He does not wait for the curtain to rise; he waits for it to fall. He waits for that moment when all the conglomerations artificially produced resolve back into their natural component entities, when the nymphs and the dryads strewing themselves like flowers over the floor of the stage gaze vacantly into the mirror of the tank where a moment ago, tesselated with spotlights, they swam like goldfish.

Deprived of the miracle of color, registering everything in degrees of black and white, Brassai nevertheless seems to convey by the purity and quality of his tones all the effects of sunlight, and even more impressively the effects of night light. A man of the city, he limits himself to that spectacular feast which only such a city as Paris can offer. No phase of cosmopolitan life has escaped his eye. His albums of black and white comprise a vast encyclopaedia of the city's architecture, its growth, its history, its origins. Whatever aspect of the city his eye seizes upon the result is a vast metaphor whose brilliant arc, studded with incalculable vistas backward and forward, glistens now like a drop of dew suspended in the morning light. The Cemetery Montmartre, for example, shot from the bridge at night is a phantasmagoric creation of death flowering in electricity; the intense patches of night lie upon the tombs and crosses in a crazy patchwork of steel girders which fade with the sunlight into bright green lawns and flower beds and graveled walks.

Brassai strikes at the accidental modulations, the illogical syntax, the mythical juxtaposition of things, at that anomalous, sporadic form of growth which a walk through the streets or a glance at a map or a scene in a film conveys to the sleeping portion of the brain. What is most familiar to the eye, what has become stale and commonplace, acquires through the flick of his magic lens the properties of the unique. Just as a thousand diverse types may write automatically and yet only one of them will bear the signature of André Breton, so a thousand men may photograph the Cemetery Montmartre but one of them will stand out triumphantly as Brassai's. No matter how perfect the machine, no matter how little of human guidance is involved, the mark of personality is always there. The photograph seems to carry with it the same degree of personality as any other form or expression of art. Brassai is Brassai and Man Ray is Man Ray. One man may try to interfere as little as possible with the apparatus, or the results obtained from the apparatus; the other may endeavor to subjugate it to his will, to dominate it, control it, use it like an artist. But no matter what the approach or the technique involved the thing that registers is the stamp of individuality.

Perhaps the difference which I observe between the work

Untitled (Group of men at the bar of a bistro, Rue de Lappe; c.1932). From The Secret Paris of the 30's.

of Brassai and that of other photographers lies in this—that Brassai seems overwhelmed by the fullness of life. How else are we to explain that a chicken bone, under the optical alchemy of Brassai, acquires the attributes of the marvelous, whereas the most fantastic inventions of other men often leave us with a sense of unfulfillment? The man who looked at the chicken bone transferred his whole personality to it in looking at it; he transmitted to an insignificant phenomenon the fullness of his knowledge of life, the experience acquired from looking at millions of other objects and participating in the wisdom which their relationships one to another inspired. The desire which Brassai so strongly evinces, a desire *not* to tamper with the object but regard it as it is, was this not provoked by a profound humility, a respect and reverence for the object itself? The more the man detached from his view of life, from the objects and identities that make life, all intrusion of individual will and ego, the more readily and easily he entered into the multitudinous identities which ordinarily remain alien and closed to us. By depersonalizing himself, as it were, he was enabled to discover his personality everywhere in everything.

Perhaps this is not the method of art. Perhaps art demands the wholly personal, the catalytic power of will. *Perhaps.* All I know is that when I look at these photographs which

seem to have been taken at random by a man loath to assert any values except what were inherent in the phenomena, I am impressed by their authority. I realize in looking at his photos that by looking at things aesthetically, just as much as by looking at things moralistically or pragmatically, we are destroying their value, their significance. Objects do not fade away with time: *they are destroyed!* From the moment that we cease to regard them awesomely they die. They may carry on an existence for thousands of years, but as dead matter, as fossil, as archaeologic data. What once inspired an artist or a people can, after a certain moment, fail to elicit even the interest of a scientist. Objects die in proportion as the vision of things dies. The object and the vision are one. Nothing flourishes after the vital flow is broken, neither the thing seen, nor the one who sees. (pp. 173-78)

Henry Miller, "The Eye of Paris," in his The Wisdom of the Heart, *New Directions Books, 1941, pp. 173-86.*

Karl Shapiro (essay date 1955)

[*An American poet and critic, Shapiro won the Pulitzer Prize for poetry in 1945. In the following exhibition re-*

There have been photographic salons for a century—for as long as the art has existed—and there have been notable and even famous showings of individual and group collections. But the treatment of photography as a fine art, and not merely as a technique or craft or by-product of optical science, is still a matter for debate. Photography, which progressed largely through amateur experimentation, suffers from the success of amateurs. And it suffers from the camera itself. The camera, after all, has a mind of its own; being one of the more sensitive, most human, of machines, it picks up every commonplace, ponders every cliché. The camera has an enormous literary appetite; it takes a strong hand to keep it from dawdling or browsing or chattering about trivia. One sometimes can see the struggle between the photographer of genius and his gossiping machine. The wittiness of the finest photography is one of the results of this tussle.

The Brassai exhibition (which opened at the Chicago Art Institute, and is now at the Walker Art Center, Minneapolis) proves the point admirably. Nothing is humorous, obvious or cute: everything criticizes itself. The pictures in this collection are mostly Parisian subjects, among them some of Brassai's best work and some of the outstanding photographs of our period. Brassai's range is carefully organized, not in theme but in what might be called the use of his palette. The majority of the pictures, whether interiors or landscapes, covers the whole spectrum of visible color. Translated into black and white, this total use of color gives his pictures a personality and a frame. There is hardly one in which there is not a spot of the blackest black and the whitest white. What happens in between is the subject of the individual work. In a sequence of pictures, of course, such as the documentary *Séville en fête,* the tones are carefully equalized in order to build up a single progress: all the pictures are interpretations of the same scene, and the palette is limited. But in the individual pictures (and these are the most impressive) the subject determines the massing of color, the extremes of emphasis, and the structuring.

Few of the best modern painters use the camera at all. This, let us hope, is a high compliment to the camera. On the other hand, one of the most common dangers of photography is the imitation of art. The temptation to outpaint the painter, merely by clicking the shutter, is irresistible. Brassai, too, plays Degas and Mondrian and, I think, Delacroix, for whom he has a kind of secret affinity. Sometimes he glances in the direction of the scientists of photography, journalists, guidebook illustrators and movie cameramen. But not for long. His wit, his happy intelligence easily move beyond these snares.

The picture called *Côte d'Azur,* for instance, is the obverse of a travel poster. As the poster leaves one with the desire to discover the reality, so the Brassai opens a window on the Côte d'Azur which prevents the mind from wanting to be there. Not that anything painful is presented. On the contrary: the picture shows an aging man huddled under a blazing white umbrella. Behind him is the "grey" sea and the "toneless" sky—both unbearably blue. The man is drenched in black from his collar to the bat-like shadow shed by his umbrella. Dominating the background is a section of white iron grill fence, boring rather than ugly;

below that a band of gravel beach, and finally a tiny white wave inaudibly curling on the shore. And, as a last impression, the straight black spike of the umbrella, like a splinter in the memory.

This is not the best Brassai, however; nor the many others, like the plane tree on the Paris street. Here the subject concerns the texture of the peeling spotted tree rising in a vertical panel that fills one-third of the frame. The rest is white sky, typical Paris houses, etc. Nor the river pictures by day and night. When a writer (say, Henry Miller) talks about the Seine, he tries to think of it as a place where a derelict can drown himself. The trouble with the river is that it is more a Chamber of Commerce river, and there is very little one can do to express it otherwise, even by showing barges and tramps sleeping on the embankment.

The best Brassais, and there are enough of them to fix this artist in one's mind permanently, are what appear to be chance, still shots. *Passage clouté,* a woman in raincoat waiting at a brilliantly wet crossing; on her right an ascending line of white crossing-discs; the whole dominated by a triangulated reflection of light. *Façade,* black, broken-out windows of ascending-diminishing sizes; straight horizontal whitewashed lines; vertical rainspout bisecting the design; vacancy, abstraction; the whole an inverted L in white, shading off into grey in the descent. *Heads or Tails,* the night-view (one from the front, one from the rear) of a square-built female tough, standing on a design of square cobblestones, against a background so drab that it barely exists. In the rear view of the woman there is little more than a silhouette; the light falls on the street. In the front view the points of concentration are the cigarette-in-mouth and two planes of the face and neck. One can say no more about this picture than one can say about a fine poem. What is said is indescribably rich in the poverty of the model; here Brassai is so objectively sympathetic and beyond sentimental contact that one can look at the picture forever.

And many more as good; many failures; many on the border. But abundant proof of the genius of the camera and of its user. (pp. 46-7, 69-70)

Karl Shapiro, "Brassaï: Poetic Focus on France," in ARTnews, *Vol. 53, No. 10, February, 1955, pp. 46-7, 69-70.*

Colin L. Westerbeck, Jr. (essay date 1976)

[*In the following excerpt, Westerbeck discusses the subject matter and technique of Brassaï's photographic studies of 1930s Paris.*]

The city that emerges [in both *Paris de nuit* and *The Secret Paris of the 30's*] is a rather deserted one, many of the pictures capturing familiar parks, boulevards and landmarks at an hour when no one is around. Moreover, when people do appear, they are often glimpsed only at a distance and are subordinated to the graphic elements of the scene. Lovers kissing on a park bench blend into the background of a picture whose power comes from the way a strong sidelight picks up the slats of the bench like the keys of a xylophone. A man pissing against a wall, or perhaps carving grafitti, is dwarfed in the far background of a picture by the box-work of pillars and riveted beams on the underside of an elevated train line. Can-can dancers

doing high kicks, the feet of girls in two facing rows meeting overhead, are of interest mainly for the pattern their legs make against the herringbone of the parquet floor on which they dance. Even the derelicts whose portraits crowd the pages of *The Secret Paris* are known in *Paris de nuit,* in one of its most beautiful and magical pictures, only by their fire flickering far down an embankment in counterpoint with the lone street lamp on the bridge over their heads.

Though seven of the photographs in *Paris de nuit* depict the same scenes obviously on the same nights as pictures in *The Secret Paris,* none of the pictures in the later book is actually in the earlier one. In general *Paris de nuit* differs from *The Secret Paris* as much in substance as it does in style. Over a third of *Paris de nuit* is high-angle shots, many of them panoramic, while only about one-tenth of *The Secret Paris* was made from a vantage point. The distinct character of *Paris de nuit* makes me wonder, in fact, whether many of the photographs in it were not taken during the period 1929-1931, when Brassai was first beginning photography and before he was capable of the cafe and street pictures of 1931-32.

We know that André Kertesz loaned Brassai his first camera in 1929, and indeed a shot of the Eiffel Tower in *Paris de nuit* was clearly made that year since the date is emblazoned on it in lights, apparently to celebrate the 40th anniversary of the tower's construction. Brassai has also said, according to Jean Reissman in *Miniature Camera World,* that it took him quite awhile to solve the problem of halation from street lamps at close range. In the meantime, he may have concentrated on longer shots, where, he said, the long exposure times required for night photography simply suffused the light. Whether this is so or not, certainly everything done those first couple of years must have been done at the more respectful distance so apparent in *Paris de nuit.* In our conversation, Brassai stressed that it took him several years to cultivate the friendship of the criminals and other habitués of Montmartre sufficiently to be permitted to photograph them at all.

All these high-angle cityscapes in *Paris de nuit* suggest that Brassai was at that time poised on the brink of the city, ready to descend and become a part of it in a way no photographer had. The two photographs accompanying the first chapter of the reminiscence in *The Secret Paris,* seem to pick up where those high-angle shots in *Paris de nuit* leave off, and to suggest that that descent into the city was in effect a kind of descent into hell. Both pictures were made atop Notre Dame, where the suffused light drifts up from below as if born aloft on a sulphurous cloud from brimstone pavements. In the foreground of each photograph a gargoyle in silhouette or a winged demon with horns dominates half the picture space. The lighting coming up from below makes the demon look that much more sinister. But the casual, almost languid way his head is cupped in his hands as he contemplates the city is really comical, and offsets any fear we might have. Indeed, if this is a vision of hell, it is a very attractive and tempting one. It is, in brief, just the sort of vision we might expect from this noctambulant Transylvanian, this countryman of Count Dracula.

From these heights *The Secret Paris* descends first into the streets, then into the cafes and music halls, and finally into the brothels, private "houses of illusion" and opium parlors. The photographs from the dens of iniquity which have not been seen before are wonderful, as are Brassai's remembrances of those places. But without taking anything away from this new material, I still feel that the finest of all Brassai's pictures are the ones he took in the mirror-lined cafes and dance halls of Montmartre. It is appropriate that he should have taken his best photographs halfway between the public settings of *Paris de nuit* and the private ones seen for the first time in *The Secret Paris.* Those cafes were clearly very ambiguous spaces. They opened onto the street and anyone was free to come in; yet if a stranger should happen to do so, he was at once made to feel uneasy and unwelcome. The cafes straddled the private and public extremes of *The Secret Paris* and combined elements of both. It is therefore right that Brassai should have made his best photographs in them because the quality of those photographs is their power of synthesis—the unity they achieve of sentiment and esthetics, form and content.

The graphic element so strong in *Paris de nuit* is not really absent from the cafe pictures. It has just become implicit. It has insinuated itself in the reality of cafe life. The cafe pictures are in fact a marvellous sort of *trompe l'oeil* in which Brassai's graphic sense and the self-images of his subjects combine. They combine to become the underpinnings of a vision which at first seems the opposite of graphic and studied, a vision that seems candid and spontaneous. I think most of us take it for granted that these pictures are unposed, and Brassai himself confirmed this to me. He never arranged a scene or instructed his subjects like a movie director, he said, "Never!" In one sense this is obviously quite right, too. The most important insight I gained by talking to Brassai came not from his answer to any question so much as from just being in the presence of the man. It was apparent that his genius for photography lay in his disarming personality, not in any photographic technique. Along with the exceptional peripheral vision his very prominent eyes undoubtedly give him, his energy and charm must have allowed him to catch any subject off guard.

But there were still limitations on his equipment that he must have been obliged to compensate for. The Bergheil Voigtlander camera he used in the '30s, a 6 × 9 cm plate camera, had to be mounted on a tripod and, under the available light in the cafes, would usually have required exposures of three or four seconds or more, sometimes much more. When such long exposures were not needed, it was only because Brassai had a magnesium-powder flash fired by an assistant. This means that Brassai's subjects were either keyed to his taking of a picture by his signals to his assistant synchronizing the flash, or else the subjects were asked to hold during a prolonged exposure some attitude into which they had happened. When you look closely at Brassai's pictures, the telltale signs of these impositions the camera must have made on the scene are apparent. In a brothel the flash gun is reflected in a mirror as an assistant extends it into the scene from the next room. Lovers stand idly at the bar in a lesbian cafe, but the bartender stares into space instead of watching where he is pouring a cocktail, and on closer inspection the cocktail shaker looks empty. A sailor at a table with a girl leers bug-eyed to one side, as if told not to watch the birdie, but not to blink, either, during the long exposure.

In addition, slightly different versions of photographs published over the years make it clear that Brassaï often took a series of exposures, frequently with the aid of the flash on each. It cannot then be doubted that his subjects were as a rule aware of the camera and had to accommodate it in some way, performing for the lens even if Brassaï himself did not prompt that performance. The reason these contrivances do not register with us in the cafe pictures is that Brassaï had found in the habitués of Montmartre the perfect subjects for his peculiar art. For the world Brassaï photographed was, after all, that of the apache dancer—a world of poseurs and studied toughness, a world whose inhabitants were trying to wear their emotions on their rolled-up sleeves. Or so we assume, at any rate, and Brassaï's photographs get the benefit of that assumption. We take it for granted that the "natural" behavior of these cafe and dance-hall types was full of artifice, and the photographs themselves trade on our belief in their subjects' paradoxical behavior. We accept the candor of the attitudes being struck in these photographs because Brassaï's sense of the art of photography is deftly baffled behind his subjects' sense of the art of living. Such bafflement is what the illusions of all art are for.

This grand illusion which underlay all Brassaï's photographs is also overlaid in many of them by other, more transparent illusions. The latter play across the surface of these photographs in order to distract us from noticing the former, on which our acceptance of the photographs' candor and authenticity depends. Frequently Brassaï turned the limitations of his equipment into his advantage, relying on imperfect camera technology to perfect his own art. For instance, a photograph of two smiling prostitutes abruptly changes its mood when we notice that some crockery on the shelf behind them can be seen right through them. This occurs only because they moved slightly during the long exposure, but the effect is to make their youth, their prettiness and their gaiety into something painfully ephemeral. The same effect is achieved in a photograph of a beautiful carnival dancer named Conchita. As her performance at the middle of the stage effaces itself in a blur of diaphanous costuming and movement, two other dancers on the stage's edge are, though oafish and unattractive, also in far sharper focus because they are still. Thus will the mystery that Conchita represents endure only as long as she can continue her dance, turning the moment she stops into the reality of the other girls.

Brassaï's real opportunity for such illusion, though, lay in those mirrors omnipresent on the walls of the Parisian cafes and dance halls. It was in his use of them that his sense of composition worked most effectively. Consider the way in which the alternation of moods in the pictures just discussed is also achieved in a photograph taken at "la Boule rouge" in 1933. . . . In this picture a man smirks suggestively at a girl who smiles back at him in obvious enjoyment of his company, but reflected somewhat uncertainly over their heads—perhaps in a mirror and through a plate-glass window as well—appears another, more dour-looking couple who are dancing. It is as if the unfocussed and partly obscured mirror image were anticipating in its dancers' embrace both the lovemaking the foreground couple will soon get down to, and the disappointment their present expectations will no doubt suffer when they do.

Of course no visual artist since Impressionism, and particularly not an artist who spent his time in Parisian cafes, has been able to ignore the imagery of mirrors. The mirror's duplication of the real world in an illusion is central to the iconography of modern art. We must keep in mind, too, that it was as a painter Brassaï first came to Paris. Arriving in the early '20s, he felt intensely the aftershocks of Cubism and even the lingering influence of Impressionism itself. His own sense of pictorial space, at least in the cafe pictures, owes as much to the traditions of modern painting playing themselves out around him as it does to any potential that inhered in the camera alone. Brassaï became a friend of Picasso's at just the time that he was taking these cafe pictures, and the influence of Picasso's mind on Brassaï was surely considerable.

In a sense the camera was the ideal instrument to achieve the goal Monet had set for himself, which was to arrest light. Even before the introduction of color film, the camera promised to achieve by mechanical means that spontaneous grasp of the world Impressionism strove for. Yet it seems clear from the beginning of his career that Brassaï also wanted to achieve something contrary to this. He wanted to extend this spontaneous, intuitive act of taking pictures, *instantanes,* in a way that would reconcile it with a more structural, more analytical perception of space. The cafe pictures taken before mirrors do this, too. The figures reflected in the mirrors, whether they are the subjects seated before the mirror or someone out of the camera's field, always seem to appear from a different perspective. Profiles reflect away from themselves at skew angles, different planes of the composition intersect as if in a labyrinth, and lines of vision disperse in an oblique, controlled geometry just as they might in the most premeditated Cubism.

Brassaï's photographs are, then, the product of a variety of cross-currents—cross-currents between Impressionism and Cubism, painting and photography, analysis and instinct within the photographer himself, oblivion and self-consciousness in his subjects. They are the result of cross-currents between a graphic sense of esthetics and the sentimentality he felt for the people he photographed. In the best of his pictures, moreover, one can almost see all these oppositions writ large. They seem virtually to cross each others' paths along the photographs' alternate diagonals, holding each other in a kind of suspension. The photograph in which all these elements perhaps fall together more perfectly than any other is one Brassaï took in a cafe on the Place d'Italie. Two lovers huddle at a table in a corner from which mirrors issue in both directions, reflecting not only the lovers but each other. The two figures, which are so intimate in the middle of the frame, are isolated from one another out on the edges. There their reflections are imprisoned in darts of glass that meet point to point. The way they gaze into each other's eyes in reality is belied by the two reflections, which render their heads parallel rather than facing, and thus suggest solipsism instead of love. The woman's hand moves to her ear in a gesture that is at once both casual and affected. She seems lost in the attentions of her lover, and yet not so lost that she is unmindful of the camera.

The intersection of form and content that occurs in this picture is in fact found everywhere in Brassaï's work during this period. It can be seen not only in the cafe pictures,

but also in those made out on the street. There Brassai characteristically placed himself so that a wall forming a street corner was at 45 degrees from him. The flash, masked by the corner, was then fired by his assistant along one diagonal of the picture while the action—the solicitation, necking, prowling or whatever—took place at right angles to the light. That counter-thrust of light or space or mirror imagery that gives form to Brassai's embrace of Paris night life in these pictures is no accident either. That Brassai was aware of it and purposely created it then, when he took the pictures, is attested now in what he says about them. Although he began photography simply out of the desire to record what he saw in Montmartre and Montparnasse, he never thought of photography itself as an indifferent tool or of his work as mere reportage. In our interview he told me,

> I don't like snapshots. I like to seize hold of things, and the form is very important for this. Of course, all photography presents chances to relate things of interest, but it lacks often a sense of form. Form is very important not only in order to create art, but because only through form can the image enter into our memory. It's like the aerodynamics of a car, don't you see? For me, form is the only criterion of a good photograph. One doesn't forget such a photograph and wants to see it again.

It is hard to imagine a better apology than this for the synthesis, the unity, that the cafe pictures achieve. They have indeed entered into our memory, and for just the reason Brassai said. Nevertheless, in recent years Brassai seems to have moved even further away from the sensibility of *Paris de nuit* and toward a kind of naturalism in his valuing of his photographs. This is noticeable in the way he has come to crop certain of his most widely published pictures. The graphic tendency of *Paris de nuit,* which was subsumed as form in the cafe pictures, is now consumed away altogether in his recropping of some of those pictures. This seems especially significant in two photographs made in 1932 at the Bal des Quatre Saisons.

The first of these is perhaps Brassai's most famous photograph and depicts two lovers who are turned sullenly away from each other, just having had an argument. In the original version a woman's face, unfocussed but strikingly like the face of the female lover, is reflected in the mirror over the couple's heads. A little, star-shaped cleat holding the mirror in place appears where the reflected face's eye should be, and this disfigurement turns the mirror image into a kind of fantasy that might be going on right at this moment in the man's mind. (An eye that is masked or blinded from the camera is a constant motif in Brassai's photographs.) Crucial as that face in the mirror is to the coherence of the picture, however, Brassai has cropped it out for years now. The whole photograph appears in the Focal Press edition of Brassai's work done in London of 1949, but in the 1952 Paris edition, and in each subsequent publication of the picture Brassai could control, including *The Secret Paris,* the picture has been cropped.

When I asked Brassai about the cropping of this photo and the other one from the Bal des Quatre Saisons, he claimed to be surprised, as if he had never really noticed it before. "You know my photographs better than I," he declared with playful mockery in his voice. In the other picture at the Bal des Quatre Saisons, a glum-looking man sits flanked by two women before a mirror in which there appears another man, who is smiling, also flanked by two women. The photograph was originally taken in a horizontal format and included two large, empty areas in the upper left and lower right portions—one, the wall, is light in tone, while the other, the seat cushion, is nearly black. Precisely because nothing in the arrangement of the figures necessitates the inclusion of these empty areas, the fact that they were included seems significant. They are an intentional part of the composition.

Yet in *The Secret Paris* Brassai cropped the picture vertically, eliminating those areas (and one other extraneous figure). When I pointed this out, his response was, as he indicated the two groups of figures, "The eye should fall here, and it is necessary not to chase after things which distract it." But I do not agree. The recropping eliminates one of those opposing diagonals and so relaxes the tension its contrast between light and dark introduced. Form and feeling almost literally travel along the alternate diagonals in this photo because of the way the empty spaces oppose the clusters of smiling, frowning people. Taking away those spaces, therefore, takes away the form itself to too great an extent. When the photograph is horizontal, we seem to be farther away from the figures, and this gives us a little perspective on their experiences. That diagonal of empty spaces holds back the emotion a bit. It holds the melodrama in check, and this is the reason it is necessary.

The reason that Brassai has eliminated it anyway may have something to do with growing old. His own motives for going over all those pictures from the '30s again may not be so different from the motives of many who went to his exhibition and read the text of his book. That is, Brassai too may be moved by simple nostalgia, which usually prefers sentiment unmitigated by art. But there is no need to trivialize the changes that may have occurred over the years in Brassai's attitude toward his work. It is fair to say, rather, that his sense of his work has just become more human as time passed.

Photographers both great and ordinary often begin with the kind of heavily graphic sensibility seen in *Paris de nuit.* Seeing the world as an abstract pattern rather than a human comedy excuses one from having to confront people at close range. But as time goes on, and the photographer becomes both deft and curious enough to overcome his initial standoffishness, he may also pay less attention to esthetics. In Brassai's best work, I have said, the esthetics do not disappear; they are merely assumed and become implicit. But it is understandable, particularly in old age, that an artist should ultimately want to concentrate on humanity, on the feeling alone, and exclude all else. This is what happened to Wordsworth too, when he revised *The Prelude* almost half a century after first publishing it. The second version of the poem is less concerned with the grand design of Nature, and more concerned with the purely human pleasures of memory. Perhaps it is only natural that Brassai's revision of *his* prelude should be the same. (pp. 36-40)

Colin L. Westerbeck, Jr., "Night Light: Brassaï and Weegee," in Artforum, *Vol. XV, No. 4, December, 1976, pp. 34-45.*

Brassaï on photographic composition:

The composition of a photograph is most important, not because of any aesthetic considerations, but because only a picture that is well composed can enter into the memory. Composition is as important to photography as aerodynamics is to the design of an airplane. My ambition was never to capture the "interesting" things about Paris, but to capture things as they were, to immobilize them in some definitive, final way. What characterizes a good photographer is that he has both a journalistic sense and, at the same time, that crucial sense of form. For me, there is only one criterion for a good photograph: that it be unforgettable.

Brassaï, in a 1982 interview with Avis Berman.

Nancy Newhall (essay date 1976)

[*In the following essay, first published in its entirety in 1976, Newhall describes a visit with Brassaï in Paris in 1952, noting especially the artist's own impressions of his work.*]

81 Rue du Faubourg St.-Jacques, Paris—a tall apartment house on a corner. In the square below, a street fair stood melancholy in the late afternoon light. The flying carousel, with a huge metal dove among its boats, the immense, undulating serpent on which to rush round and round, the alley lined with shooting galleries, the little automobiles on trolleys, bright as Christmas balls—all were deserted. The carnival people were going back under the autumn trees to their painted carts drawn up on the cobbles; there were voices and a tinkle of crockery, a door slammed, a washtub was hung out to dry. The dribble of daytime customers was over; the fair awaited the night.

As in the entries of most Paris apartment houses, there was only the gray light from the street and a dim glimmer within the lodge of the concierge. "M. Brassaï . . . ? Au fond, à gauche, prenez l'ascenseur, cinquième étage!" By groping, the little elevator was found and the frantic little doors pushed back; under the weight of a foot the floor sank—and a light went on. Slowly, creakingly, the little cage rose beside the circling stairs and came shakingly to a stop. I can never escape soon enough from French elevators, nor from the feeling that somehow one ought to pat them for their labors, like aged but faithful donkeys.

Years ago, fleetingly, we had met Brassaï, like a ball of energy, and kind. He had given us the photograph, of climbers on an icy mountain slope, with which we had begun our personal collection. The door opened. A dark vivid girl—Gilberte, Mme. Brassaï, or, dropping the pseudonym, Mme. Gyula Halász. And Brassaï himself—the same ball of energy, with the same extraordinary eyes. The eyes of great photographers are often extraordinary; Stieglitz's deep and dark, as though you were looking through a lens into the darkness beyond; Weston's, hot, slow, absorbing; Adams's, brilliant under the wild flying brows

that see everything at once like a 180 degree lens. Brassaï's eyes are black, sparkling, enormous; he seems able to throw them at anything that interests him. Henry Miller once called him "The Eye of Paris" [see excerpt dated 1941]—

> Brassaï has that rare gift which so many artists despise—*normal vision*. He has no need to lie or to preach. He would not alter the living arrangement or the world by one iota; he sees the world precisely as it is For Brassaï is an eye, a living eye . . . the still, all-inclusive eye of the Buddha which never closes. *The insatiable eye* . . . the cosmologic eye, persisting through wrack and doom, impervious, inchoate, *seeing only what is.*

Brassaï's little room for thinking and talking is a magpie's nest, a room formed by a boundless curiosity and amusement. During its mutations through the years, probably anything could have been found here, even the dull and the conventional suddenly transformed by association. Jumping jacks and playing cards and posters and a calendar on which he has pasted his photograph of a cat's eyes gleaming in the dark; a cluster of masks hung on the corner of a bookcase; a statue of St. Sebastian with holes for arrows into which he has stuck cigarettes; a row of primitive paintings under the ceiling, and under them a row of daguerreotypes; then a jungle of pharmacists' vases with electric lights shining behind them and past the silhouettes of strange buds and branches; small sculptures from Mexico and Africa; tiny skulls; shells of mother-of-pearl; a horrifying fiesta figure from Seville, dead white, faceless, with a tall peaked hood reminiscent of the Inquisition; soap made with the water from the holy spring at Lourdes. Boxes of negatives; a glass case full of Brassaï's own sculptures on pebbles, meant to be held and seen in the hand. The back wall, topped by large earthen pots, crammed with dummies of incipient books with boxes of prints marked *Picasso I, Picasso II, Paris de jour, Nus, Portraits,* etc. From the balcony, over pots mantled with ivy, you look across the square and the chimneypots of Paris.

Brassaï brought out a flood of photographs, all 11 × 14-inch glossies. We spread them on the couch, on the floor, we stacked them against the chair and the table legs. Paris by day and by night—the Paris that has obsessed untold numbers of men like a dream, like a passion, the imperceptible men and the famous ones, the frugal, the acquisitive, the spendthrift; the humble little gatherer of information for the city directory, Victor Barthélemy, who began his great collection of photographs by asking everywhere he went if they had old photographs of Paris; Atget, drinking his tea and going forth under his 8 × 10 down the dark alleys and misty boulevards of a Paris still asleep; Daumier, with his savage insight and rending pity; Toulouse-Lautrec, mordantly observing the death-in-life night world; Balzac—whom Brassaï vaguely resembles—preoccupied with his Comédie Humaine.

Brassaï is not Paris-born; he is not French. "I was born in Transylvania on September 9, 1899, at nine at night. Nothing but nines or multiples of nines in my birthdate. This figure has pursued me all my life. I live always at no. 81. . . . " Brasso, the medieval town on the edge of the Orient, where he was born and whence he takes his pseudonym, he first left when he was four; his father, a professor of French literature, came back to his beloved Paris to refresh himself for a year at the Sorbonne. For that year lit-

tle Gyula (Jules) Halász and his brother lived the enchanted life of little Parisians. In 1924 he came back again, after studying art in Budapest and Berlin. And Paris, the huge, the manifold, began to call him, especially down its vistas through the night.

"For a very long time I had an aversion to photography," wrote Brassaï in his 1952 album. "Up to my thirtieth year I did not know what a camera was." One dark night, standing on the Pont Neuf with his old friend and fellow countryman, the photographer André Kertész, he found out. Kertész's camera was up on its tripod, and it seemed to Brassaï that they had been talking near it or over it for a very long time. "Well, take your picture and let's go." "It's being taken," Kertész said with a smile. "Wait another fifteen minutes and we'll have it." Brassaï was fascinated. "Open a little box in the middle of the night and half an hour later you have a photo?" Brassaï went to see that negative developed. And the next day he bought the camera Kertész advised, a little Voigtländer, 6½ × 9 cm., with Heliar 4.5 lens. "I had a whole profusion of images to bring to light, which during the long years I lived walking through the night never ceased to lure me, pursue me, even to haunt me, and since I saw no method of seizing them other than photography, I made a few tries." These obsessive images, about to be made into Brassaï's first book, *Paris de nuit,* 1933, seemed to Henry Miller "the illustrations to my books. . . . I beheld to my astonishment a thousand replicas of all the scenes, all the streets, all the walls, all the fragments of that Paris wherein I died and was born again. There on his bed, in myriad pieces and arrangements, lay the cross to which I had been nailed. . . ." The walls of Paris, eroded by rain, age and man, and scratched by him with his own weird obsessive symbols of death and sex; its roofs, windows, cobbles, incised by daylight or illumined against the night and the mist. The immense and endless panorama of its people: the concierges and their cats, the cafés, the brothels, the curious oldsters with their pitiful trades, the shadowy parks and the glittering Metro, the lighted fountains and the powerful confusion of the dim market.

And beyond Paris: the medieval hospital at Beaune, with nuns in white coifs; the Rabelaisian feasts of Burgundy, with whole hogs in jelly, decorated, miles of banquet tables hemmed with wineglasses, chefs and gourmets in academic robes. Midnight mass on Christmas in a remote village, with a young shepherd holding a lamb in his arms. The strange rock-borne town of Baux-en-Provence, where the sheep emerging from crags and grottoes in the pumice seemed to Brassaï like souls summoned up from Purgatory. Holy Week in Seville—the medieval hoods among baroque splendor and the dancing skirts. The Côte d'Azur, and a white boat like a dream on the sand.

But always and forever Paris again. And his friends, Picasso, Rouault, Braque, Matisse, Eluard, Breton, Prévert.

Brassaï is not, like Henri Cartier-Bresson, an invisible man. People look at him and his camera naturally and comfortably. He can go along any street into any life from top to underside of society and become, by osmosis, accepted into it. What Cartier-Bresson sees with a shock or a tingle to heart or intellect, Brassaï sees as part of the Human Comedy; where Cartier-Bresson watches for the all but invisible instant, the almost incredible accident that turns the world inside out, Brassaï watches for the mo-

ment devoid of *transience,* the moment when character is totally visible, with its roots down into time and place. Brassaï has a huge gusto and an unshakeable objectivity; he can see without revulsion or exaggeration the whole horror and wonder of humanity. Towards the flow of reality around him, he has the humility that marks the great photographer. " . . . The object is absolutely inimitable; the question is always to find that sole translation that will be valid in another language. And now, immediately, there is the *difficulty of being faithful to the object,* the fear of betraying it (for all literal translation is treason), which obliges us to recreate it or reinvent it. The compelling pursuit of *resemblance,* of representation (whatever may be said about it today) *leads us far, much farther than "free" imagination or invention. It is what excites in art those pictorial, verbal, or other discoveries that constantly renew expression.* The sources are always exciting, but they flow formless. . . . How to capture them, how to retain them without *form?* Not being a stenographer, nor a recording machine, my course seems clear: to cast the living thing into an immutable form. . . . In a word, I *invent nothing, I imagine everything.*"

In this humility transfixed by reality as perceived, Henry Miller found a saving grace, a losing the soul to find it, much needed in these days. "I realize in looking at his photos that by looking at things aesthetically, just as much as by looking at things moralistically, or pragmatically, we are destroying their value, their significance. . . . The object and the vision are one. . . . Every man today who is really an artist is trying to kill the artist in himself—and he must, if there is to be an art in the future. We are suffering from a plethora of art. We are art-ridden. Which is to say that instead of a truly personal, truly creative vision of things, we have merely an *aesthetic view.*" And he realized also, what is true of all genuine photographers, that Brassaï "by depersonalizing himself . . . was enabled to discover his personality in everything."

In Brassaï's reporting, you do not find the dominant image that contains the whole, nor the image that exists as a lyric for its own sake. The reality is within; it is felt through his photographs. Nor does Brassaï make photographs beautiful in American eyes; these are routine glossies, blowups from his Rolleiflex or 6 × 9 cm plate negatives, roughhewn, and crudely dodged. "Art-ridden" by the past, few photographers on the Continent today regard a print as anything more than a transition from the seeing to the publication in newspaper, magazine or book. A Brassaï is all here at first look. But what a look! You will never forget that macabre witness for Toulouse and Baudelaire, Bijou, the super-annuated prostitute wreathed in tulle and fake pearls, nor can you wash out of your memory such graffiti as the hanged man gouged into the stone. These are the blink of a Goya or Balzac-like eye.

Brassaï's realities are seen with such mass and volume that with ease he was able to have his photographs of cafés, street corners, Metro corridors enlarged back to the size of the originals to serve as decors for the ballet, *Le rendezvous,* written by Jacques Prévert, with music by Kosma, and for the play, *En passant.* These decors, he insists, must always be lighted as the originals were lighted; the scenes he made for Jean Cocteau's *Phèdre* were ruined by the use of alien light. Photography being light, it offers, as trans-

parency or flat, extraordinary potentials for theatrical illusion, and Brassaï must here be a pioneer in a new field.

The strangeness of the commonplace continues to haunt Brassaï. Into a series of colored folders he keeps putting photographs that are weird or witty metamorphoses of each other; he is assembling a kind of encyclopedia of life "as a stranger from another world might see it." And he goes further; by writing—"the eye ceding its place to the ear, I seek to *sharpen* my thought." Subjects such as Sleep, around which he groups images for his Encyclopedia; *The Story of Marie,* 1949, a char-woman heard through her talk and her thoughts; sketches of the people he has photographed—the concierge of Notre Dame de Paris, whom he bribed to let him go up onto the roof of the cathedral at night; the man-aquarium, who swallows live frogs and fish and then spews them up again still flapping; the old artificial-flower maker and her jealous dove; the ancient news vendor, as much a part of the corner as the lamppost.

Nothing Brassaï might do would surprise his friends; he has too much energy, too wide a horizon to be confined to one or two outlets, even the endlessly multiform mediums of photography and writing. He had been keeping his drawing to himself and a few very close friends. "One day when Picasso came to see me, a little before the war, I brought these drawings out of my boxes. He was seized by them: 'Why have you abandoned drawing, Brassaï? You have a mine of gold and you exploit a mine of salt!' Since then he has never ceased to exhort me to take up drawing again."

During the Nazi occupation, Brassaï succumbed to what he calls "my old demon" of drawing. Exhibited, they won him considerable acclaim; thirty were published in 1946. Dynamic and lusty, they are related to his sculptures, and like those little pebbles that fit into the palm of the hand, like his photographs, too, they have a magnitude far beyond their size. They could grow with ease to dominate a wall, a square or a mountainside.

Naturally Brassaï is now working in film, and the one surprising thing is that he didn't find himself involved in cinematography years ago. His first film, *Tant qu'il y aura des bêtes,* he describes as "entirely musical—musical also in its use of images—a kind of ballet that unrolls itself without a word, even of commentary." Eight hundred people attended its preview in one of the great movie houses on the Champs-Elysées: " . . . and I am very happy. . . . They laughed a great deal, and they were moved to tears." He is now at work on his second film.

It was dark and rainy when we emerged again into the street. A faint drizzle shone on the cobbles and haloed the lights of the fair. A rainy Monday night: the carnival people did not expect much business. Under their canopy of canvas, the little automobiles bumped crazily, incessantly. But the dove and the serpent were immobile. The proprietors of the shooting galleries shouted hoarsely as we approached: "Shoot the heads off the wedding party!—Try your luck with bow and arrow!—Hit the enemy bomber with a machine gun!" Here and there a solitary man picked a chained gun up from the counter. We walked towards the bright comfort of a café, Brassaï, in his flat black hat, holding over us an ineffectual but solicitous umbrella. We were walking through his Paris, through the obsessive images of the night. (pp. 277-81)

Nancy Newhall, "Brassaï: 'I Invent Nothing. I Imagine Everything.', " in Photography: Essays and Images, Illustrated Readings in the History of Photography, *edited by Beaumont Newhall, New York Museum of Modern Art, 1980, pp. 277-81.*

Rosalind Krauss (essay date 1981)

[*In the following excerpt, Krauss explores Surrealist elements in Brassaï's night scenes of Paris.*]

From 1933 we have Brassaï's portrait of the poet Léon-Paul Fargue, a thickset man in fedora and overcoat seated on a park bench, illumined by the gaslight thrown by a lamp we infer but do not see. This, we think, is what Fargue looked like, or, we might add, *really* looked like, schooled as we are in the objectivity of the camera's testimony. In the very framing of the image we find reassurance on this matter of veracity. For unlike the compositional tightness and rigor of painted portraits, there is something happenstance about this image, as though in the effort to capture the sitter *sur le vif* too much of the setting has been included, too wide a visual net has been cast. Fargue sits eccentrically within the frame, and to his left (our right) a seemingly careless expanse of park opens backward into the city's night. The inclusiveness of the setting acts to secure the image's apartness from painting, acts, that is, as a kind of witness to the process of the image's making: internal testimony to the fact that this is indeed a photograph and thus all the testimony we need to the belief that the image is of reality.

That is one way of reading the photograph. But there is another, a second reading triggered perhaps by information external to the image—a historical caption the photograph might but does not bear. Fargue was Brassaï's fellow nightwalker. It was Fargue, a second-order Surrealist poet, who accompanied the photographer through the night streets of Paris, who was his guide on part of the trip that would issue into *Paris de nuit.* Many of the Surrealists were nightwalkers, specialists in an exercise through which they laid their own particular claim to the city, an exercise of particular importance of which Fargue was himself a master—"the self-styled 'Pedestrian of Paris'," Brassaï tells us.

With this knowledge, the seemingly hapless excess at the righthand third of the poet's portrait is no longer a signifier of "nothing but" photography's own claim to candor. On the ground to Fargue's left (our right) the lengthened phantomlike shadow of the poet's body, and most particularly his legs, is cast. In clear opposition to the bulk of the seated figure, the shadow is a form that seems liquid and in motion. Willowy, flattened, this silhouette cast by the legs makes us notice that in recording the actual body of the man a certain doubleness of vision is at work. The top half of Fargue in fedora and overcoat—his square face chiseled by the light, his heavy hands guarding the lap—is the very picture of solidity and stasis. But the lower half, the legs, like the shadow they cast, are of a different order: dissolved in darkness, approaching the condition of the fluid and impalpable. For this reading, then, the image is of a bulky, stolid figure whose legs betray him as, enveloped by night, they portend a kind of weightless glide. This photograph, this portrait, is an image of Far-

gue/Nightwalker and thus Fargue/Surrealist. The shadow is a silent index that points to this reading.

Question: Which is the correct reading of the photograph? The bald one, innocent of its context, yielding a this-is-the-way-it-was realism? Or the one that mediates between the presumed reality and this image a whole set of specific texts—by Aragon (*Paysan de Paris*), by Breton (*L'amour fou*), by Fargue (*Banalité*)—a whole literature, a complete manifesto, an entire *politique* with regard to the very notion of the Real? This is not a wholly rhetorical question, though it does suggest that for any given photograph there may be a number of perspectives of which only one is that of naïve realism.

What follows is an attempt to think about Brassaï in the context of Surrealism, a movement that he served in various ways and that, in turn, served him. Because many of the crucial Surrealist texts—most particularly those by Breton—were photographically illustrated and many of those illustrations were by Brassaï, this investigation entails a consideration of the Surrealist interest in document and the service to which documentary was put. (pp. 33-4)

Brassaï tells us that in 1933 André Breton came to him to commission photographs of the Tour Saint-Jacques, the flower market, and Les Halles at night, to be published in the Surrealist journal *Minotaure* to accompany "La nuit de tournesol," the text that would become the central section of *L'amour fou*. Brassaï did indeed supply these photographs, as he regularly provided many of the images with which *Minotaure* was profusely illustrated. But with regard to these three photographs he tells us that it was unnecessary for him to undertake them at Breton's particular request, because "I had had them for some time, even one of the Tour Saint-Jacques as he had described it, 'beneath its ghostly veil of scaffolding.' " In the early 1930s Brassaï's sensibility and his experience of the city of Paris was, indeed, parallel to that of the Surrealists in many ways. Like Aragon and Breton, he was a nightwalker, and the characters he selected to populate his **Paris de nuit** seem to come straight from the life of the arcades that Aragon had celebrated in the Passage de l'Opéra section of *Paysan de Paris*. And it is not just the characters that are the same—the pimps, the prostitutes, the petty gangsters, the café denizens—but the setting, too, is similar.

Aragon chose the arcades because they were the paradoxical combination of the interior and the street. They offered the seclusion and protection that gave the illusion of privacy, yet were fully public places, open to the anonymous, aggressive flow of pedestrian traffic. Brassaï was also attracted to those places in the city where the barrier between public and private had eroded, where intimacy bloomed in public, where the mirrors of cafés and dance halls could function like the glass of the arcades—could, that is, turn the most secret language of the body's gesture into the flattened, public declaration of the billboard, the poster, the sign.

Photography . . . is itself a species of index. It produces the evidentiary trace of the bodies or objects that have stamped their imprint into the emulsion of the photographic film. In that sense we would think that the photograph's process of reduplication would capture these bodies and objects in their essential unity and coherence. But as Brassaï records these bodies, living out their lives in the semipublic, semiprivate space of the nocturnal city, he displays them as curiously split, or fragmented—he gives them to us, that is, as a concatenation of both themselves and their sign.

The couple embracing in a café in the Place d'Italie is itself embraced by the mirrored corner of the room. The specular action of the mirrors is such that the embrace is replayed on the walls of the café in a representation that seems to signify the opposite of union. Male and female profiles are wrenched apart, each to reappear in near isolation, the image of each figure within its own separate frame. In splitting apart the unity and fusion of the kiss, the action of the mirrors fills the reflected representations of those same actors with another set of signs—whose meanings can be read as narcissism, self-absorption, predatory seduction. The mirrors, which function in this image—as in much of Brassaï—like reduced, miniature photographs contained within the space of the master photograph, imply that any unit of reality can be optically decomposed and then recomposed, or rewritten.

Another of these images presents us with the extraordinarily full-bodied presence of a woman poised behind a snooker table in a café in Montmartre. Her back arched, her chest thrust forward, she fixes the camera with her gaze. Her upper torso claims the center of the image and this very centering seems to declare the indissoluble unity of her physical being. Yet four visual elements pinwheel around this center, creating a relationship that interprets the woman's presence, undermining our sense of her unity and self-containment. Two of the elements are appendages of the woman herself: first, her erect right thumb pressing on the shaft of the pool cue and, second, her left hand splayed in an unconsciously produced representation of parting flesh. The chance arrangement of these hands constitutes an extraordinary sign of sexuality, a sign that is given another level of significance by the two mirrored images in the upper corners of the photograph. On the left, above the erect thumb is the relfected image of a man in profile, the illusion of the photograph suggesting that he is staring at the second mirrored image, which is opposite his gaze. This second image, in which we see the reflected back of the woman's head, is on a vertical axis above her left hand. The relation created in the mirrors implies a coupling between two anonymous beings, the meaning of that coupling made intelligible by the deictic axis along which the image of each partner is joined with an image of its sex. A sign constellates around the woman—a sign that is shifting, fragmented, multileveled, and beautiful—and it reads "hooker."

In a different photograph the mirror placed in the corner of a space—in this case the room of a brothel—functions once again to collect the occupants of that room onto the single visual plane of the photograph, even while it collects them onto a second, unified plane, set within the outer frame of the image. That second plane is the rectilinear, enframing structure of the armoire in front of which a man, dressing, stands looking into the mirror on one of its doors, while his partner's naked body is captured in a virtual image that is enframed by the mirror on the other door. Present only in reflection, the woman is displaced from her position in "real" space and transported to a relation of direct spatial contiguity with her client. In the meeting that is enacted on the picture plane only, the cou-

ple produces a transient, fleeting sign of the meaning of their encounter: its anonymous sex represented by their faceless juxtaposition in the mirrors, by the closure of two bodies back to back in real space.

But there is something else at work in this photograph—as in many others by Brassaï—that is essential to our experience of the constellation of figures opening up a field of signs in which each one becomes a representation of the meaning of the other. That operation to which Brassaï has recourse is technically called *mise en abyme,* the placement within one representation of another representation that reduplicates the first. This technique is obviously at work in a very famous Brassaï photograph of a group of couples seated across from each other at a table in a Montmartre café. In this image the situation that is occurring in "real" space is doubled by reflection in the virtual space of the mirror set inside the photographic field. Placing the subject of the photograph *en abyme,* the mirror image also, quite obviously, places the photographic representation itself *en abyme,* as an interiorized representation of its own process: depicting the fact that photographs themselves are virtual images that only reflect the world of the real. We are forced to acknowledge that the virtuality of the figures seen in reflection is no greater—or less—than the virtuality of the "real" figures seen in the direct representational field of the photograph. Through this deliberate conflation of levels of "reality" Brassaï establishes the surface of the photograph as a representational field capable of representing its own process of representation.

But it is not only to establish photography's own conditions of discourse that Brassaï does this. For the doubling of the "real" situation produced by the mirror records as well another doubling: the four characters on one side of the table being doubled in type, gesture, and feature by the characters facing them. Through the juxtaposition enforced by the field of the photograph and its operations *en abyme* these matching pairs are experienced as representations of one another.

In the photograph of the brothel interior mentioned above this operation of a mirror reflection that places the fact of the photograph as a virtual image *en abyme* is once again at work, so that we get a sense of the photographic field as a nest of concentric rectangles or frames each one containing a reality that is also a representation: the whole frame of the photograph itself containing the image of the corner of the room; the frame of the armoire containing the image of the couple; the frame of the mirror on the left side of the armoire containing the image of the whore. And if we can read this nesting from outside in, we can also read it the other way—from inside out—so that the obvious virtuality of what is present only in the mirrored space spreads outward to include and encompass the imaged world on the other side of that mirror and finally the photograph as a whole. It is because of this process of the transformation of the obduracy and fixity of the "real" into a field of representations that we come to read the very bodies of these actors as signs. (pp. 36-7)

Brassaï was more than just congenial to the Surrealist sensibility, but participated in their work at a deeper, more significant level. It may be objected that there is nothing very surreal-looking about his photographs. Nothing melts or disintegrates, the juxtapositions are not odd or outrageous—though they can be funny or ironic—and

nothing is concerted to produce a simulacrum of the space of dreams. But it is the space of the abyss itself—of man captured in a hall of mirrors, in a constantly bifurcating field of representation—that Brassaï holds in common with men like Aragon and Breton. In *Paysan de Paris* Aragon ends his depiction of the Passage de l'Opéra with a meditation on this experience of the abyss:

> Caught in the maze the mind is dragged toward the dénouement of its destiny, the labyrinth without a Minotaur where, transfigured like the Virgin, radium-fingered Error reappears, my singing mistress, my pathetic shadow. . . . In this whirlpool where the conscious mind feels like a mere level of the abyss, what has become of the wretched certitude which once seemed so important? I am but a moment in some eternal fall. One's footing lost, it can never be regained. The modern world is the only one which answers my mode of being.

When Aragon says "the modern world" he clearly means the city, because it is the city that provided the very grounds of possibility for the kind of conflations in which one thing can suddenly be read as a sign for another, in which the labyrinth of the city of Paris can be mapped onto the labyrinth of Breton's unconscious and a deictic relation that takes the form of a double arrow can show how each one supplies the meaning of the other, each one engulfing the other in its own representational field. The city as a field convulsed and disrupted into a chain of representations, each subsuming the other, the city as a continual process of reference, is what characterizes the Surrealists' conception of it as modern. . . .

Reality understood as the ground for the referential fall *en abyme* is made particularly available through photography. Photography's own status as index assures this. It is in the light of this conception of the Real itself that the presumption of photography's destiny as a realist art must be reassessed. (p. 38)

Rosalind Krauss, "Nightwalkers," in Art Journal, *Vol. 41, No. 1, Spring, 1981, pp. 33-8.*

FURTHER READING

I. Writings by Brassaï

Camera in Paris. Masters of the Camera, edited by A. Kraszna-Krausz. London: The Focal Press, 1949, 95 p.
> Collects sixty-two of Brassaï's best-known camera studies of Paris. The photographs are arranged under seven headings: "The Grand Sights"; "Side Glimpses"; "Famous Shows"; "Nights Out"; "Conversation Pieces"; "Onlookers"; and "The World Goes On."

Picasso and Company. Translated by Francis Price. Garden City, N.Y.: Doubleday, 1966, 289 p.
> Translation of *Conversations avec Picasso* (1964). Documents, in text and photographs, the author's close friendship with Pablo Picasso.

The Secret Paris of the 30's. Translated by Richard Miller. New York: Pantheon Books, 1976, unpaged.

Translation of *Le Paris secret des années 30* (1976). Includes photographs of nighttime Paris taken during the 1930s, with commentary by Brassaï. Sections include: "A Night Walk with the Cesspool Cleaners"; "The Underworld/The Police"; "Lovers"; "Ladies of the Evening"; "Kiki of Montparnasse"; "In the Wings at the Folies-Bergère"; "The Bal des Quat'z Arts"; and "Sodom and Gomorrah."

The Artists of My Life. Translated by Richard Miller. New York: Viking Press, 1982, 224 p.

Photographic record of Brassaï's friends and acquaintances in the Paris art world, with commentary about the artistic milieu of mid-century Paris.

II. Interviews

Berman, Avis. "Guest Speaker: Brassaï. The Three Faces of Paris." *Architectural Digest* 41, No. 7 (July 1984): 26, 30, 32, 34-5.

Contains reminiscences by Brassaï drawn from interviews by Berman in Paris and on the Côte d'Azur. The artist describes the three Parises he knew best as a photographer: "the Paris of 1903, the Paris of 1924, and the Paris of today."

III. Critical Studies and Reviews

"The Language of the Wall." *Arts and Architecture* 74, No. 1 (January 1957): 14-15.

Capsule review of a Museum of Modern Art exhibition of Brassaï's graffiti photographs, with a critical statement by Edward Steichen. According to Steichen, "Brassaï has obviously been impressed with how many of these graffiti begin with two holes in the wall, and he has found and photographed many faces so that the eyes create an extraordinarily dramatic impact."

Ellis, Ainslie. "Artists and Photographers." *The British Journal of Photography* 129, No. 6,378 (29 October 1982): 1158-62.

Reviews a 1982 exhibition of Brassaï's works at the Marlborough Gallery in London. Ellis focuses on Brassaï's relationships with Alberto Giacometti, Pablo Picasso, Henri Matisse, Fernand Léger, and other artists active in Paris during the 1930s.

Krauss, Rosalind. "Corpus Delicti." *October* 33 (Summer 1985): 31-72.

Surveys surrealist photography. Krauss briefly assesses Brassaï's 1933 *Nude,* seeing it as a statement of the collapse of sexual difference in which "the female body and the male organ have become each the sign for the other."

Melville, Robert. "London." *Arts* 33, No. 2 (November 1958): 19, 21.

Reviews an exhibition of Brassaï's work at the Institute of Contemporary Arts, commenting on one "remarkable" graffiti photograph of "what appears to be an almost entirely accidental image." Melville states: "Brassaï didn't tell us anything about it in the catalogue, but it would seem to have been done in the occupation period and to be intended as a Cross of Lorraine. . . . It has taken on the aspect of an aerial configuration, as if it were an announcement from another world, and resembles those presentiments of unknown modes of being which inform the art of Odilon Redon."

Szarkowski, John. "Brassaï." In his *Looking at Photographs: 100 Pictures from the Collection of The Museum of Modern Art,* p. 110. New York: The Museum of Modern Art, 1973.

Brief biography, with critical commentary. Szarkowski states of Brassaï: "Making photographs in the dark bistros and darker streets presented a difficult technical problem. Brassaï's solution was direct, primitive, and perfect. He focused his small plate camera on a tripod, opened the shutter when ready, and fired a flashbulb. If the quality of his light did not match that of the places where he worked, it was, for Brassaï, better: straighter, more merciless, more descriptive of fact, and more in keeping with Brassaï's own vision, which was as straightforward as a hammer."

Salvador Dalí

1904-1989

Spanish painter, sculptor, graphic artist, and graphic designer.

One of the most celebrated and influential figures in twentieth-century avant-garde art, Dalí is best known for his early paintings of the 1930s associated with Surrealism, a seminal post–World War I movement in art and literature initiated by French essayist and poet André Breton and dedicated to exploring irrational, paranormal, and subconscious aspects of the human mind. In his Surrealist paintings, Dalí expressed his childhood fears, obsessions, and dreams in a meticulously realistic style wherein objects from the rational world are set upon vast, dreamlike landscapes and juxtaposed with bizarre images. Although faulted for his commercial inclinations and for his deliberate cultivation of an exhibitionistic public image, Dalí is widely praised for his extravagant imagination and impeccable craftsmanship. James Thrall Soby commented: "With extraordinary invention, he has created a Freudian world which may be partly disentangled by pathological research, but which offers at face value a striking phenomenon in contemporary painting."

Born in Figueras, Spain, Dalí described himself in his biography *La vie secrète de Salvador Dalí* (1942; *The Secret Life of Salvador Dalí*) as a narcissistic and often cruel child given to hysterical fits, exhibitionism, and voyeurism. While attending the Ecole des Beaux Arts in Madrid from 1918 to 1922, he became a talented imitator of such masters as Raphael and Jan Vermeer, but he was expelled from the school for inciting rebellious behavior in his fellow students. In 1928 Dalí visited Paris, where he met Surrealist painters Joan Miró and Pablo Picasso. During this period Dalí also began to develop his celebrated "paranoiac-critical" technique, which requires that the artist attain a genuine state of delusion, as in schizophrenic paranoia, while functioning as an interpretive medium for unconscious images.

Dalí officially joined the Surrealists in 1929. Many of his most famous works from this period, including *The Great Masturbator* (1929), *The Lugubrious Game* (1929), and *The Enigma of Desire* (1929), depict enigmatic figures upon desolate landscapes and feature such icons as the lion, often considered a symbol of the threatening father in Freudian psychology; the locust, associated with sex, onanism, and consumption; and the ant, which most critics regard as indicative of overwhelming sexual desire. Although some reviewers condemned his subject matter as perverse and his symbolism as incomprehensible, Dalí's early paintings were widely praised for their irreverent wit and compared to the works of medieval Dutch artist Hieronymus Bosch and sixteenth-century Italian painter Giuseppe Arcimboldo for their evocative landscapes and organic imagery. Following his first solo exhibition in 1929, Dalí collaborated with director Luis Buñuel on *Un chien andalou*, a short, enigmatic film that is widely regarded as a classic of Surrealism. In 1930, Dalí and Buñuel collaborated on a second Surrealist film, *L'âge d'or*.

Dalí's deliberately provocative works are indicative of his exuberant talent for self-publicity, through which he quickly became one of the most conspicuous exponents of Surrealism in the United States. Dalí's paintings featured in the first American Surrealist exhibition at Julien Levy Gallery in New York City in 1932 were generally greeted with enthusiasm but were criticized by some for their frank biomorphic images. However, Dalí had explained his attitude to such criticisms in his essay "L'âne pourrissant" (1930; "The Stinking Ass"): "It has to be said once [and] for all to art critics, artists, &c., that they need expect nothing from the new surrealist images but disappointment, distaste and repulsion." Dalí's most famous work of this period, *The Persistence of Memory* (1931), features a group of limp watches covered with ants surrounding the closed eye of a misshapen head lying face down on a bleak desert landscape. The image of the face, which recurs in many of Dalí's works, is often interpreted as a self-portrait expressive of shame and impotence. The soft watches, as well as the human figures with huge, distorted protuberances supported by crutches that occur in such paintings such as *The Enigma of William Tell* (1933) and *Average Atmospherocephalic Bureaucrat in the Act of Milking a Cranial Harp* (1933), have also been viewed as symbols of impotence.

In the mid-1930s, Breton began to argue that Surrealism should lend support to the cause of Marxist revolution. Although Dalí had made occasional use of Leftist subject matter in paintings such as *Partial Hallucination: Six Images of Lenin on a Piano* (1931), he refused to become involved in communism. In 1934, Dalí was charged by the Surrealists with glorifying Fascism, in part due to his megalomaniacal obsession with figures of power—particularly Adolf Hitler, a dictator he considered to embody "the perfect image of the great masochist who would unleash a world war solely for the pleasure of losing . . . the gratuitous act par excellence that should indeed have warranted the admiration of the Surrealists." Dalí was acquitted of the charges at a mock trial held in Breton's Paris apartment, yet his political sympathies were again questioned when he declined to choose sides in the Spanish Civil War. A few months prior to the actual conflict, Dalí completed *Soft Construction with Boiled Beans: Premonitions of Civil War* (1936), a work often interpreted as an antiwar statement. William Gaunt observed of this powerful painting of a human figure physically tearing itself to pieces: "As the memento of a cruel century, the painting is comparable with the *Guernica* of Picasso." In addition to his many paintings of this period, Dalí also created sculptures, displays, and many Surrealist art objects, including *Aphrodisiac Jacket* (1936), a blazer adorned with eighty-one small glasses of crème de menthe, and *Lobster Telephone* (1936), a telephone that substitutes a lobster for a receiver. Dalí's deliberate flouting of the Surrealist opposition to formal religion, his ambiguous political position, and his tendency toward exhibitionism and commercialism led to his expulsion from the movement in 1938. During World War II, Dalí devoted himself largely to self-promotion, to designing illustrations for advertisements, and to exploring various genres, including ballet and opera. Commenting upon his post–World War II works, Dalí stated: "The atomic explosion of 6 August, 1945 shook me seismically. . . . Many of the landscapes painted in this period express the great fear inspired in me by the announcement of that explosion. . . . I want to see and understand the forces and hidden laws of things. . . . To penetrate to the heart of things, I know by intuitive genius that I have an exceptional means: mysticism." As a result, Dalí's works of the late 1940s and 1950s often depict the atomic divisibility of matter, as in *Exploding Raphaelesque Head* (1951).

Although receptive to experimental techniques throughout his career, Dalí's religious beliefs and desire to emulate the great paintings of academic masters such as Jan Vermeer and Jean-François Millet finally led him to abandon Surrealist imagery. Dalí's most famous paintings of the early 1950s, *Christ of St. John of the Cross* (1951) and *Crucifixion* (1954), are generally considered sentimental works of mysticism that convey a supernatural dimension to reality through their unusual perspectives. In the late 1950s, Dalí's interest in academicism culminated in gigantic epic compositions, including *Santiago el Grande* (1957) and *The Dream of Christopher Columbus* (1958-9).

In a preface to a catalog to a 1958 exhibition at Carstairs Gallery in New York City, Dalí declared his ambition "to find out how to transport into my works anti-matter." This aspiration is reflected in paintings such as *Sistine Madonna* (1958), in which suspended particles are built up to form the double image of both an ear and a woman. During the 1960s and 1970s, Dalí continued to experiment in a wide variety of genres, as evidenced by *Portrait of My Dead Brother* (1963), in which a granular image similar to a photograph is enlarged in the manner of American Pop artist Roy Lichtenstein. Later, Dalí experimented with stereoscopy and holography, which offered him the technical means to create three-dimensional images from two-dimensional surfaces. *The Chair* (1975), for example, is a stereoscopic painting in which two canvases containing identical images that differ subtly in tone and color are viewed through a stereoscope to create a single, three-dimensional image.

Although his later works were largely eclipsed by the profusion of new art movements that took place during the 1960s and 1970s, Dalí is regarded as one of the most influential role models for various practitioners of those genres. According to A. Reynolds Morse, "With his sheer technical mastery and natural flare for publicity, [Dalí] was able to . . . exercise a profound influence on art as a whole because he had freed himself from the shackles of a minor movement, and stood as a symbol of freedom from the inertia and lassitude which overtook art after the stimulation of surrealism was lessened by use and familiarity and dissensions."

(See also *Contemporary Authors,* Vol. 104.)

ARTIST'S STATEMENTS

Salvador Dalí (essay date 1930)

[*In the following excerpt from his 1930 essay "L'âne pourrissant" ("The Stinking Ass"), Dalí provides a theoretical introduction to the intent and ideas of Surrealism, particularly regarding his concept of the paranoiac mechanism, by which the mind reacts to irrational symbols to create independent images and multiple associations.*]

It is possible for an activity having a moral bent to originate in a violently paranoiac will to systematize confusion.

The very fact of paranoia, and particularly consideration of its mechanism as a force and power, brings us to the possibility of a mental attack which may be of the order of, but in any case is at the opposite pole to, the attack to which we are brought by the fact of hallucination.

I believe the moment is at hand when, by a paranoiac and active advance of the mind, it will be possible (simultaneously with automatism and other passive states) to systematize confusion and thus to help to discredit completely the world of reality.

The new images which paranoiac thought may suddenly release will not merely spring from the unconscious; the force of their paranoiac power will itself be at the service of the unconscious.

These new and menacing images will act skilfully and corrosively, with the clarity of daily physical appearances;

while its particular self-embarrassment will make us yearn for the old metaphysical mechanism having about it something we shall readily confuse with the very essence of nature, which, according to Heraclitus, delights in hiding itself.

Standing altogether apart from the influence of the sensory phenomena with which hallucination may be considered more or less connected, the paranoiac activity always employs materials admitting of control and recognition. It is enough that the delirium of interpretation should have linked together the implications of the images of the different pictures covering a wall for the real existence of this link to be no longer deniable. Paranoia uses the external world in order to assert its dominating idea and has the disturbing characteristic of making others accept this idea's reality. The reality of the external world is used for illustration and proof, and so comes to serve the reality of our mind.

Doctors agree that the mental processes of paranoiacs are often inconceivably swift and subtle, and that, availing themselves of associations and facts so refined as to escape normal people, paranoiacs often reach conclusions which cannot be contradicted or rejected and in any case nearly always defying psychological analysis.

The way in which it has been possible to obtain a double image is clearly paranoiac. By a double image is meant such a representation of an object that it is also, without the slightest physical or anatomical change, the representation of another entirely different object, the second representation being equally devoid of any deformation or abnormality betraying arrangement.

Such a double image is obtained in virtue of the violence of the paranoiac thought which has cunningly and skilfully used the requisite quantity of pretexts, coincidences, &c., and so taken advantage of them as to exhibit the second image, which then replaces the dominant idea.

The double image (an example of which is the image of a horse which is at the same time the image of a woman) may be extended, continuing the paranoiac advance, and then the presence of another dominant idea is enough to make a third image appear (for example, the image of a lion), and so on, until there is a number of images limited only by the mind's degree of paranoiac capacity. (pp. 49-51)

The paranoiac mechanism whereby the multiple image is released is what supplies the understanding with the key to the birth and origin of all images, the intensity of these dominating the aspect which hides the many appearances of the concrete. It is precisely thanks to the intensity and traumatic nature of images, as opposed to reality, and to the complete absence of interpenetration between reality and images, that we are convinced of the (poetic) impossibility of any kind of *comparison*. It would be possible to compare two things only if they admitted of no sort of mutual relation, conscious or unconscious. If such a comparison could be made tangible, it would clearly illustrate our notion of the arbitrary.

It is by their failure to harmonize with reality, and owing also to the arbitrary element in their presence, that images so easily assume the forms of reality and that the latter in turn adapts itself so readily to the violences of images,

which materialist thought idiotically confuses with the violences of reality.

Nothing can prevent me from recognizing the frequent presence of images in the example of the multiple image, even when one of its forms has the appearance of a stinking ass and, more, that ass is actually and horribly putrefied, covered with thousands of flies and ants; and, since in this case no meaning is attachable to the distinct forms of the image apart from the notion of time, nothing can convince me that this foul putrefaction of the ass is other than the hard and blinding flash of new gems.

Nor can we tell if the three great images—excrement, blood and putrefaction—are not precisely concealing the *wished for* "Treasure Island."

Being connoisseurs of images, we have long since learned to recognize the image of desire in images of terror, and even the new dawn of the "Golden Age" in the shameful scatologous images.

In accepting images the appearance of which reality strives painfully to imitate, we are brought to *desire ideal* objects.

Perhaps no image has produced effects to which the word *ideal* can more properly be applied than the tremendous image which is the staggering ornamental architecture called the "Modern Style." No collective effort has produced a dream world so pure and so disturbing as the "Modern Style" buildings, these being, apart from architecture, the true realization in themselves of desires grown solid. Their most violent and cruel automatism pitifully betrays a hatred of reality and a need for seeking refuge in an ideal world, just as happens in infantile neurosis.

This, then, is something we can still like, the imposing mass of these cold and intoxicating buildings scattered over Europe and despised and neglected by anthologies and scholarship. This is enough to confound our swinish contemporary aestheticians, the champions of the execrable "modern art," and enough too to confound the whole history of art.

It has to be said once [and] for all to art critics, artists, &c., that they need expect nothing from the new surrealist images but disappointment, distaste and repulsion. Quite apart from plastic investigation and other buncombe, the new images of surrealism must come more and more to take the forms and colours of demoralization and confusion. The day is not far off when a picture will have the value, and only the value, of a simple moral act, and yet this will be the value of a simple *unmotivated act*.

As a functional form of the mind, the new images will come to follow the free bent of desire at the same time as they are vigorously repressed. The desperate activity of these new images may also contribute, simultaneously with other surrealist activities, to the destruction of reality, and so benefit everything which, through infamous and abominable ideals of all kinds, aesthetic, humanitarian, philosophical, &c., brings us back to the clear springs of masturbation, exhibitionism, crime, and love.

We shall be idealists subscribing to no ideal. The ideal images of surrealism will serve the imminent crisis of consciousness; they will serve Revolution. (pp. 51-4)

Salvador Dalí, "The Stinking Ass," translated
by J. Bronowski, in This Quarter, Vol. V, No.
1, September, 1932, pp. 49-54.

SURVEY OF CRITICISM

ARTnews (essay date 1934)

[*In the following review of Dalí's solo exhibit at the Julien Levy Galleries, the critic praises Dalí as an intriguing humorist but questions whether he should be consid-*

It was Santayana who once said words to the effect that a man had the right to laugh at but not to discuss that which he failed to understand. With due apologies to this revered philosopher, we shall prepare to do both in the case of Salvador Dali. We do not comprehend Dali's dream life because it is utterly impossible to grasp any semblance of truth from the subconscious without personal contact with the man. For the same reason, it is hardly likely that psychoanalysis will ever develop into a correspondence course. If the sibylline words of Gertrude Stein, "A dream is a dream is a dream," were true, Dali would not be so unapproachable, but a dream is a complicated thing. It is a blending of experience, past or present, and symbols which will represent this experience. The symbols may be stirred about in a concoction on our own sphere, then we are privileged to sample them and even to venture an interpretation of the contents, but in the case of Dali's experience we are entirely left in the dark. Perhaps it is just as well that the layman with only a meagre knowledge of psychiatry cannot comprehend, for the only attraction that we can find in this surrealist's painting is the aura of mystery which surrounds it. I think most people will agree that a dream is of paramount interest to the dreamer. Freudian influences are at work to convince him that those occult images of the night before signify some latent individuality or greatness in the dreamer.. . . . Dali's dreams may not result from his world of sleep but he admits they issue from his "subconscious" and from "imagination" and for this reason are "of such stuff as dreams are made of."

Dali does, however, have a distinct function as a humorist. You can enjoy him tremendously at this exhibition, if you are in the right mood. The titles of these pieces of "concrete irrationality" are most intriguing. We can suggest such descriptions as *The Weaning of Furniture-Nutrition* or better still *Skull and Its Lyric Appendage Leaning on a Commode Which Should Have the Temperature of a Cardinal's Nest.* The critical interpretations of Dali also have their amusement value. He has been termed both "exotic" and "neurotic," but we are inclined to agree with neither adjective. His "erotic" tendency is evidenced in the *Spectre of Sex Appeal* and here he seems to be enjoying a good laugh at the expense of Freud and the libido instinct, for this little painting is powerful enough to cause even the most erotic lady to take the veil. As for his "neuroticism," this quality seems to be a superficial thing

acquired, rather than developed, from any disturbance of an emotional nature.

Even if Dali were sincere, and we doubt intensely his integrity, his subject matter does not belong in the plastic world. The psychic should be left to the laboratory or to the psychology journal or, to be a bit more lenient, to the ministrations of James Joyce, Virginia Woolf or Dorothy Richardson. And as long as Dali insists upon this phase of expression, why should we not join his surrealist laughter? Why take him seriously into our art world and, like some of those supposedly learned gentlemen who frequent Julien Levy's sanctuary with the air of being among the first to recognize genius, establish a cult of Dalism? He could be a very witty acquaintance of the moment, but he grows tiresome as a constant companion.

"Salvador Dalí," in ARTnews, Vol. XXXIII, No. 9, December 1, 1934, p. 8.

James Thrall Soby (essay date 1935)

[*A highly influential critic, editor, and champion of modernist painting and sculpture, Soby held several prominent positions at the Museum of Modern Art in New York City and compiled numerous books, articles, and exhibition catalogs on important figures in modern art. In the following excerpt from* After Picasso, *his study of post-World War I trends in art, Soby traces possible influences on Dalí's style and offers a positive assessment of the artist's early achievements.*]

Though many of the Surrealists are older than one might expect them to be, the most promising of them, Salvador Dali, is the youngest, and has done his most brilliant painting since 1930. (p. xii)

Coming to Paris around 1927, [Dali] rapidly assumed a leading position in the Surrealist movement. Not only did his extraordinary paintings and his precise writing contribute a new direction to the movement, but he collaborated with Luis Bunuel on the two most successful Surrealist films to be made thus far. The first, *Un chien andalou,* was a short film without sound, originally made on 35 mm. film and later, rather badly, transferred to 16 mm. The second, *L'âge d'or* was a full-length film with sound, and though inferior technically to *Un chien andalou,* was naturally a more complete document of the newer Surrealism. Both created endless scandal, particularly *L'âge d'or* for its vicious sacrilege.

While all of the older Surrealists have retained traces of the Cubist revolt, Dali has been free to develop the Surrealist art of a younger generation. A devoted admirer of Picasso, he has kept clear of Picasso's influence. Except for minor parallels with the art of Chirico and Tanguy, nothing in his work is reminiscent of modern painters; his painting is, moreover, strongly opposite to the painting of the early Surrealists.

Anxious to stress both an objective expansion and a communication of subconscious imagery, Dali paints the symbols of his obsessions with an incredibly fine talent for the miniature. These symbols are suggested to him by paranoiac processes of thought, and he is careful to say that they are suggested to him in their final and right order. No alteration or revision is made subsequent to the first deliri-

ous dictation of his subconscious mind; frequently he has no idea of what he has painted until delirium has passed. In place of the subjective dislocations of the collage, Dali substitutes the objective mania of paranoiacs. As a result, his symbols are perhaps more widely communicable than the automatism of earlier Surrealists. Scientific evidence is not lacking that the processes of paranoiac reason are not only communicable, but have an awe-inspiring clarity. On the other hand, as Herbert Read pointed out, it is far too early to fix absolute standards for subconscious thought, and the relative accuracy and communicability of Dali's symbols must be determined by a much later science. Meanwhile it will be part of psychology's function to clarify so far as possible the processes of subconscious creation; to act, in other words, as medium between creation and the results of creation. Optimistically, the Surrealists believe that Surrealism itself has made the subconscious clear, and it must be admitted that the meaning of Dali's symbols is frequently apparent to people who have not read either the Surrealists or Freud.

Perhaps the most significant fact about Dali's early development is that he grew up among the astonishing buildings, monuments and decorations of the Catalan architect Antoni Gaudí. Anyone who is familiar with even reproductions of Gaudí's fantastic ornaments and *objects d'art* will recognize that Dali has been influenced from youth by their uncanny and ferocious detail. In both Gaudí and Dali occur definite qualities of the Catalan imagination; its cruelty, its extreme directness, its unlimited capacity for fantasy, qualities which are in opposition to the lyricism of a Miró. In addition to Gaudí, Dali was certainly affected by the *trompe l'oeil* realism of the minor masters in the museums at Barcelona and Madrid. Arriving in France, he was attracted by the nineteenth century realists, Gerome and Meissonier, since the clarity with which they painted historical subject-matter was the clarity necessary for a concrete and literal transcription of the symbols of paranoiac obsessions. It seems possible too that he was influenced by the precise brushwork of Dutch masters like Vermeer, and that the dramatics of his "nightmare" lightning were inherited, through Chirico, from the Baroque masters.

Whatever the sources of his art, there is no precedent in painting for his subject-matter which comes direct from the dreams of Krafft-Ebing's case histories. Apart from the vast number of fetiches which appear in his pictures— slippers, hair, keys and phalli—the processes of paranoia are expressed by the fear of castration and the various phobias of abnormal psychology. (He is obsessed by the emasculated tradition of romanticism springing from Abelard.) The inevitable implements of imagined persecution are here: knives and scissors; the devices of corruption, limp watches and swarming ants. Dali himself has described the three great images of life as being excrement, blood and putrefaction. All three images haunt his painting. With extraordinary invention, he has created a Freudian world which may be partly disentangled by pathological research, but which offers at face value a striking phenomenon in contemporary painting.

Frequently Dali's writings have given clues to his painted symbolism. Thus he once wrote that the insects which swarmed over putrefied flesh were, except for the element of time, capable of appearing as hard and flashing gems.

And in *Persistence of Memory,* Time, symbolized by the watches, has gone limp, and the insects take on the brilliance of jewels.

His paintings, often no larger than postcards, (and usually the smallest ones are the finest) are filled with erotic symbols, of the kind first isolated by Freud, which are scattered against an endless perspective. Technically, he describes them as *photographie à la main* ["photography of the hand"], and his object is to make his images more shocking by heightening their clarity to the point of wonder. He paints rapidly, but with such immaculate detail that his best pictures remain fascinating long after their psychological story has become comparatively familiar. Recently, his color has become increasingly beautiful. Formerly he was so contemptuous of the deliberate search for good taste in painting that he used the most literal realism possible whether it marred the quality of his paintings or not. He availed himself too of the technique, inherited from the *papier collé* and from the collage, of pasting realistic engravings and photographs on his pictures when an exact realism was necessary. The past two years, however, he has progressed to a new skill with both color and painted detail. At the technique of miniature he is without equal among painters today, though like all paintings which demand to be peered at, his pictures are apt to be precious and to lack both the strong emotional appeal of Berard's and the strong intellectual appeal of Picasso's.

Dali's obsessions may be divided, not too strictly, into two classifications: visual and, for want of a better word, philosophical. An important visual obsession has been that of the double image. . . . In Dali's painting, the uncanny mental repercussions aroused by multiple images are an integral part of his symbolism. Thus in a painting like *L'homme invisible* the *trompe l'oeil* of romantic postcards is used along with shrewd technical devices to suggest a variety of images which emerge with disturbing rapidity. Psychologically, the rapid succession of images seems to break down reality altogether, and to hint at counter-appearances which may be more important than reality.

Examples of his philosophical obsessions are to be found in his preoccupation with the legend of William Tell and with the paintings of Millet, especially the *Angelus.* Paranoiac reason has led him to reappraise the legend of William Tell, and to consider it a legend of incest. Haunted for some time by the symbolism of the story, he has made it the central theme of many of his paintings, and has given it a large importance in the film, *L'âge d'or.* In the same way, he has discovered behind Millet's painting a powerful, subconscious force which, Dali claims, proceeds directly from paranoia. The two figures from the *Angelus* are common in his symbolism; he has also used the face of the *Mona Lisa* as a symbol of his obsession with Freud's revelations concerning Leonardo. Both the *Angelus* and the legend of William Tell have served as focal points in his symbolism, and have been central themes around which his remarkable invention has revolved temporarily.

What further expansion of Dali's art will come within the next few years, it is, of course, impossible to say. But he has now arrived at such complete technical mastery, both in painting and drawing, that he must be considered not only the finest of the official Surrealist artists but, along with Berard and Berman, as among the finest young contemporary painters. Even for those who weary of the

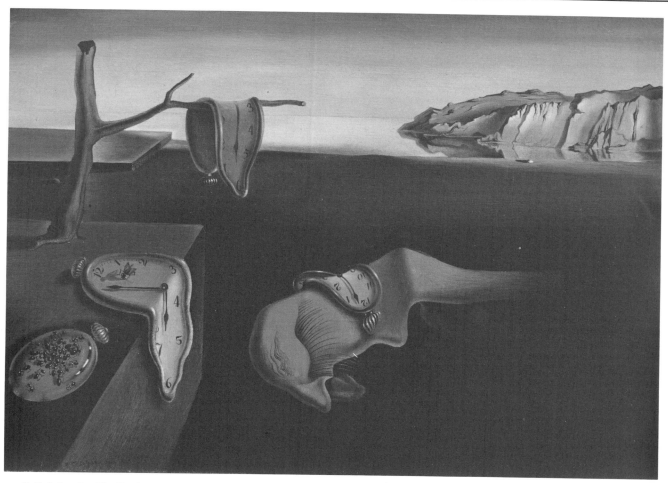

Dalí, Salavador. The Persistence of Memory. *1931. Oil on canvas, 9 ½" x 13". Collection, The Museum of Modern Art, New York. Given anonymously.*

strenuous theory behind his paintings, and who find that the elaborate viciousness of all Surrealists grows mild and stale with time, there are a great many Dali paintings in which the less complicated subject-matter is handled with great skill and charm. The beautiful grays and blues of the **Paranoiac Astral Image,** the carefully measured scaling down of figures and use of perspective, the unbelievably fine painting of the boat and figures, make it a picture which even those who distrust the whole edifice of Surrealism can hardly ignore.

Certainly Dali is the artist who seems likely to lead the Surrealist movement from now on. Somewhere, obscured by the dominance of the Surrealist aestheticians who hold faithful to Arp, Ernst and the other older members of the group, there must be younger painters ready to follow the new objectivity of Dali. And whatever our moral, even psychological, reservations to Surrealism, it must be admitted that the movement has created a new and strangely disturbing romanticism. Not as original as it seems to be, and certainly not as ultimately important as its initiates claim it will be, Surrealism has nevertheless given us a few invaluable works of art. It may be that it has paved the way for a more exact science which will some day tabulate the subconscious beyond confusion. (pp. 106-12)

James Thrall Soby, "Foreword" and "The Art of the Surrealists," in his After Picasso, *Dodd, Mead & Company, 1935, pp. xi-xii, 77-114.*

André Breton (essay date 1936)

[*Breton was a French poet, prose writer, and critic who is best known as the founder of the Surrealist movement. Strongly influenced by the psychoanalytic theories of Sigmund Freud and by the post-World War I movement of Dadaism, Breton regarded reason and logic as repressive functions of the conscious mind and recommended that his fellow Surrealists draw upon the subconscious in the interest of liberating consciousness from societal, moral, and religious constraints. In the following excerpt from his essay "The Dalí 'Case'," originally published in French in 1936, Breton analyzes Freudian aspects of Surrealism as well as Dalí's paranoiac-critical theories.*]

If humour—the denial of reality and the splendid affirmation of the pleasure principle—is in fact the product of a sudden displacement of the psychic accent, which is withdrawn from the *ego* and transferred to the *superego,* and

if the *superego* is in fact the indispensable intermediary through which the apparatus of humour is set in motion, then we can expect the latter to assume a functional and more or less consistent character through a halt in the evolution of personality at the stage of the *superego*. Such states exist: they are the 'paranoiac' states corresponding, according to Kraepelin's definition,

> to the insidious development under the domination of internal causes and following a continuous evolution, of a durable and unmodifiable pattern of delirium which establishes itself with complete retention of clarity and order of thought, will and action.

We also know, thanks to Bleuler, that paranoiac delirium originates in a chronic affective state (based on a complex) that lends itself to the coherent development of certain errors to which the subject shows a passionate attachment. In the final analysis, paranoia supposes a 'powerful circuit impulse' affectivity characterized by stability of reactions and diversion of the logical function from its usual paths. A certain number of these states of mind typical of victims of paranoia are shared by artists, resulting from the latter's fixation at the secondary narcissistic period of development (the reincorporation into the ego of a part of the *libido* and, consequently, of a part of the external world, this part of the libido being already projected upon those objects endowed with symbolic value, that is to say essentially upon parental objects, whence an alleviation of repressive constraints, and adaptation to the *superego*'s autopunitive mechanism). Without any doubt, the extent to which the artist is capable of *reproducing,* of objectifying through painting or any other medium, the external objects from whose constraint he suffers so painfully will determine his relative success in escaping from these objects' tyranny and in avoiding becoming the victim of actual psychosis. The sublimation which comes into operation in such cases appears to be the simultaneous product, consequent upon a traumatic experience, of the need for narcissistic fixation (anal-sadistic in character) and the social instincts (eroticization of fraternal objects) called upon at this period to manifest themselves electively.

Salvador Dali's great originality lies in the fact that he has shown himself strong enough to participate in these events as actor and spectator simultaneously, that he has succeeded in establishing himself both as judge of and party to the action instituted by pleasure against reality. This constitutes the *paranoiac-critical* activity which he himself has defined as follows: 'a spontaneous method of irrational knowledge based upon the critical-interpretive association of delirious phenomena'. He has succeeded in achieving a balance within himself and outside himself between, on the one hand, a lyrical state based upon a pure intuition which insists on proceeding from one enjoyment to another (the concept of artistic pleasure eroticized to the greatest possible degree) and, on the other hand, a speculative state based upon a reflective process which dispenses satisfactions of a more moderate order, but of a sufficiently specialized and subtle nature to provide a further outlet for the pleasure principle. It is perfectly clear that with Dali we are dealing with a case of latent paranoia of the most benign kind, a paranoia on isolated levels of delirium (to use Kraepelin's terminology) the evolution of which is immune from all accidents of a confusional nature. Dali's first-rate intelligence excels at reconnecting these levels to each other immediately after the event, and at gradually

rationalizing the distance travelled. The primary material of his work is furnished by the visionary experiences, the meaningful falsifications of memory, the illicit ultrasubjective interpretations which compose the clinical picture of paranoia, but which to him represent a precious lode to be mined. These characteristics provide the basis for a methodical operation of organization and exploitation which tends gradually to reduce the elements of hostility existing between the different forms of everyday life and to overcome this hostility *on a universal scale.* Dali is, indeed, well aware that the human drama derives chiefly from and is exacerbated by the contradiction which exists between natural necessity and logical necessity; these rival necessities can only succeed in blending together in lightning flashes that reveal dazzlingly for a brief moment, then plunge into darkness again, the landscape of 'objective chance': 'paranoiac-critical activity is an organizing and productive force of objective chance'.

The external object, viewed by Dali in the sense we have already described of arrested development at the *superego* stage and deriving pleasure from this arrested state, becomes endowed with a symbolic life which takes precedence over all other forms of life and tends to make it the concrete vehicle of humour. This object is in fact diverted from its conventional utilitarian or other role and assigned strictly to the *ego,* in relation to which it retains a constituent value. 'You may be sure that the famous soft watches of Salvador Dali are nothing other than the tender, extravagant, solitary paranoiac-critical camembert of time and space.' In New York, Dali has exhibited a telephone painted red, with a live lobster for receiver (here, one can trace as far as its final artistic exorcism the progress from Van Gogh—for example—onwards of the autopunitive mechanism of ear-cropping). His attitude in the presence of what he calls the 'strange bodies' of space provides evidence of his insistence upon an infantile non-differentiation in approach to the knowledge of objects and to that of beings. It is also characteristic of the 'moral aerodynamism' which has allowed him to propose the following extraordinary and spectacular fantasy: 'Hire a well-scrubbed little old woman in the last stages of senile decay and put her on show dressed as a toreador, placing on her head, after shaving the hair off, a savoury omelette which will wobble to and fro because of the little old woman's continuous trembling: one might also place a twenty-franc coin on the omelette.' (pp. 130-35)

André Breton, "Salvador Dalí: The Dalí 'Case',' in his Surrealism and Painting, *translated by Simon Watson Taylor, Harper & Row, Publishers, 1972, pp. 130-35.*

R. H. Wilenski (essay date 1940)

[*Wilenski was an English artist, art historian, and critic of modern painting and sculpture. In the following essay, he assesses Dalí's early works, asserting that Dalí and other Surrealists departed from the movement's idealistic principles of liberation and freedom in their emphasis on sadomasochism and abnormal psychology.*]

After 1929 a new contributor to Neo-Surrealism appeared in the person of the young Catalan Salvador Dali who joined the movement in that year and soon became conspicuous as a Neo-Surrealist propagandist, an inventor of

Dalí on his paranoiac-critical technique:

I am the first to be surprised and often terrified by the extravagant images that I see appear with fatality on my canvas. In truth I am but the automaton which registers, without judgment and with all possible exactitude, the dictates of my subconscious, my dreams, the hypnagogical images and visions, my paranoiac hallucinations, and all those manifestations, concrete and irrational, of that sensational and obscure world discovered by Freud, one of the most important discoveries of our epoch, reaching to the most profound and vital roots of the human spirit.

The fact that I myself at the moment of painting my pictures know nothing of their meaning is not to say that the images in question are without sense. On the contrary, their meaning is so profound, systematic, and complex, that they require an absolutely scientific interpretation . . . The public must draw all its pleasure from the unlimited sources of mystery, enigma, and anguish that such images always offer the spectator's own subconscious, speak exactly the secret and symbolical language of the subconscious, which is to say that surrealist images are perfectly understood by that which is deepest in the spectator and make exactly the immediate poetic affect for which they are destined, even when the spectator consciously protests and believes that he has experienced no emotion whatsoever.

From "Dalí Proclaims Surrealism a Paranoiac Art," in The Art Digest, *Vol. IX, No. 9, February 1, 1935, p. 10.*

Neo-Surrealist films and a painter of Neo-Surrealist pictures. Dali also invented a type of Neo-Surrealist sculpture which he describes as 'objects functioning symbolically'; these Neo-Surrealist 'objects' are either natural objects slightly altered or everyday manufactured objects doctored in some way to create in the spectator a psychological disquiet or a feeling of secret shame; and their ancestors are the anti-aesthetic Dada 'Ready-Mades' by Marcel Duchamp. In my judgment it is an error to regard the concoction of these Neo-Surrealist 'objects'—a teacup lined with fur, a wheelbarrow upholstered in satin, a Louis XV shoe-heel trimmed with cutlet frills—as an art activity of importance; and it can I think be reasonably dismissed as a mildly amusing or mildly bawdy parlour game. Salvador Dali's films and paintings on the other hand are a more serious matter. His admirers' accounts of the film *Un chien andalou* which he devised with Louis Bunuel in 1929, and the Neo-Surrealists' own account of the film *L'âge d'or* which he devised with Bunuel in 1930, make it clear that both films exhibited fertility of imagination, that both contained obscenities, and that *L'âge d'or* was anti-clerical and sadistic. In some of his early pictures—

Les plaisirs illuminés (1929), *La main (Le remords de conscience), Le cheval, La terrasse,* and *Le puits* (1930) for example—Dali did little more than rehash stale abracadabra with technical factors derived from Chirico, Ernst and Mantegna. But from 1930 onwards he transformed the collage procedures of Ernst and the paintings by Pierre Roy, Viollier and Chirico, into a disturbing irrational anecdotic art which he describes as 'paranoiac criticism' meaning thereby the symbolical recording of *soi-disant* obsessions, fetishes and hallucinations. In his pictures of the nineteen-thirties he also gives us, with extreme ingenuity, an image or group of images with double meaning (i.e. a representation of an object or group of objects which can equally well be taken, like a pun, for another object or group of objects) and, as an aid to the rousing of psychological disturbance in the spectator by appealing to his sense of touch, he uses intensely vivid naturalistic (i.e. photographic) representation of the objects selected for emotive juxtaposition.

Technically speaking Dali's pictures have no place in [a] history of the development of modern painting; for thus considered his art is merely a reversion to popular nineteenth-century anecdotic painting executed with daguerreotypic illusionism oleographically coloured. But the character of the subject-matter in some of his pictures cannot be set aside as unimportant or irrelevant. . . . It has been described by Mr. J. T. Soby in *After Picasso* [see excerpt dated 1935] as follows:

> It comes direct from the dreams of Krafft-Ebing's case histories. Apart from the vast number of fetishes which appear in his pictures—slippers, hair, keys and phalli—the processes of paranoia are expressed by . . . the various phobias of abnormal psychology. . . . The inevitable implements of imagined persecution are here: knives and scissors; the devices of corruption, limp watches and swarming ants. . . . Dali himself has described the three great images of life as excrement, blood and putrefaction. All three images haunt his painting.

I find myself entirely out of sympathy with this concept of the art-activity as a kind of amateur psychopathology concerned to illustrate the secrets habitually reserved for confessionals and clinics; and I cannot resist the thought that the sadisms in this art are born of the sadisms which have disfigured life in the totalitarian countries of Europe in the nineteen-thirties, especially when I remember that the nearest parallels to Dali's paintings are certain works by Jerome Bosch expressing the disquiets that made the Reformation and Brueghel's *Triumph of Death* which recorded the burnings, tortures and burials alive of Philip II's sadistic suppression of free thought in the Netherlands. It had been possible to look upon the Neo-Surrealism of 1924 (as defined in Breton's Manifesto) as a flight from the austere discipline of Ozenfant and Le Corbusier's objective Purist-Functionalism to the opposite ideal of subjective romantic freedom, as, in fact, a new romantic individualist movement and a symbolic protest against tyrannies supported by logical ideologies. But no such symbolism will explain the sadistic characters in the later productions of the movement; for these characters, unwittingly may be and against the movements' true principles, are more symbolic of the dominant vices in the international spirit of repression which set out in the nineteen-thirties to undo the Associationism launched by the

international spirit of freedom in the nineteen-twenties. (pp. 282-83)

R. H. Wilenski, in his Modern French Paint-
ers, 1940. Reprint by Harcourt, Brace &
World, Inc., 1963, pp. 267-92.

George Orwell (essay date 1944)

[*An English novelist and essayist best known for his dys-
topian novel* Nineteen-Eighty-Four (1949), *Orwell is
significant for his unwavering commitment, both as a
man and an artist, to personal freedom and social jus-
tice. In the following excerpt from his review of Dalí's
memoirs collected in* The Secret Life of Salvador Dalí
(1942), *Orwell praises Dalí's technical skill as a painter
and acknowledges his right to deal with sordid or un-
pleasant subject matter but asserts that the popularity of
his works is symptomatic of a morally decadent society.*]

Autobiography is only to be trusted when it reveals some-
thing disgraceful. A man who gives a good account of
himself is probably lying, since any life when viewed from
the inside is simply a series of defeats. However, even the
most flagrantly dishonest book . . . can without intending
it give a true picture of its author. Dali's recently pub-
lished [memoir *The Secret Life of Salvador Dalí*] comes
under this heading. Some of the incidents in it are flatly
incredible, others have been rearranged and romanticised,
and not merely the humiliation but the persistent *ordinari-
ness* of everyday life has been cut out. Dali is even by his
own diagnosis narcissistic, and his autobiography is sim-
ply a strip-tease act conducted in pink limelight. But as a
record of fantasy, of the perversion of instinct that has
been made possible by the machine age, it has great value.

Here, then, are some of the episodes in Dali's life, from his
earliest years onward. Which of them are true and which
are imaginary hardly matters: the point is that this is the
kind of thing that Dali would have *liked* to do.

When he is six years old there is some excitement over the
appearance of Halley's comet:

Suddenly one of my father's office clerks appeared
in the drawing-room doorway and announced that
the comet could be seen from the terrace. . . .
While crossing the hall I caught sight of my lit-
tle three-year-old sister crawling unobtrusively
through a doorway. I stopped, hesitated a second,
then gave her a terrible kick in the head as though
it had been a ball, and continued running, carried
away with a "delirious joy" induced by this savage
act. But my father, who was behind me, caught me
and led me down into his office, where I remained
as a punishment till dinner-time.

A year earlier than this Dali had "suddenly, as most of my
ideas occur," flung another little boy off a suspension
bridge. Several other incidents of the same kind are re-
corded, including (this was when he was twenty-nine years
old) knocking down and trampling on a girl "until they
had to tear her, bleeding, out of my reach."

When he is about five he gets hold of a wounded bat which
he puts into a tin pail. Next morning he finds that the bat
is almost dead and is covered with ants which are devour-

ing it. He puts it in his mouth, ants and all, and bites it
almost in half.

When he is adolescent a girl falls desperately in love with
him. He kisses and caresses her so as to excite her as much
as possible, but refuses to go further. He resolves to keep
this up for five years (he calls it his "five-year plan"), en-
joying her humiliation and the sense of power it gives him.
He frequently tells her that at the end of the five years he
will desert her, and when the time comes he does so.

Till well into adult life he keeps up the practice of mastur-
bation, and likes to do this, apparently, in front of a look-
ing-glass. For ordinary purposes he is impotent, it ap-
pears, till the age of thirty or so. When he first meets his
future wife, Gala, he is greatly tempted to push her off a
precipice. He is aware that there is something that she
wants him to do to her, and after their first kiss the confes-
sion is made:

I threw back Gala's head, pulling it by the hair, and
trembling with complete hysteria, I commanded:

"Now tell me what you want me to do with you!
But tell me slowly, looking me in the eye, with the
crudest, the most ferociously erotic words that can
make both of us feel the greatest shame!"

. . . Then Gala, transforming the last glimmer of
her expression of pleasure into the hard light of her
own tyranny, answered:

"I want you to kill me!"

He is somewhat disappointed by this demand, since it is
merely what he wanted to do already. He contemplates
throwing her off the bell-tower of the Cathedral of Toledo,
but refrains from doing so.

During the Spanish Civil War he astutely avoids taking
sides, and makes a trip to Italy. He feels himself more and
more drawn towards the aristocracy, frequents smart sa-
lons, finds himself wealthy patrons, and is photographed
with the plump Vicomte de Noailles, whom he describes
as his "Maecenas." When the European War approaches
he has one preoccupation only: how to find a place which
has good cookery and from which he can make a quick
bolt if danger comes too near. He fixes on Bordeaux, and
duly flees to Spain during the Battle of France. He stays
in Spain long enough to pick up a few anti-red atrocity sto-
ries, then makes for America. The story ends in a blaze of
respectability. Dali, at thirty-seven, has become a devoted
husband, is cured of his aberrations, or some of them, and
is completely reconciled to the Catholic Church. He is
also, one gathers, making a good deal of money.

However, he has by no means ceased to take pride in the
pictures of his Surrealist period, with titles like **The Great
Masturbator, Sodomy of a Skull with a Grand Piano,** etc.
There are reproductions of these all the way through the
book. Many of Dali's drawings are simply representation-
al and have a characteristic to be noted later. But from his
Surrealist paintings and photographs the two things that
stand out are sexual perversity and necrophilia. Sexual ob-
jects and symbols—some of them well known, like our old
friend the high-heeled slipper, others, like the crutch and
the cup of warm milk, patented by Dali himself—recur
over and over again, and there is a fairly well-marked ex-
cretory motif as well. In his painting, *Le jeu lugubre,* he

says, "the drawers bespattered with excrement were paint-ed with such minute and realistic complacency that the whole little Surrealist group was anguished by the ques-tion: Is he coprophagic or not?" Dali adds firmly that he is *not*, and that he regards this aberration as "repulsive," but it seems to be only at that point that his interest in ex-crement stops. Even when he recounts the experience of watching a woman urinate standing up, he has to add the detail that she misses her aim and dirties her shoes. It is not given to any one person to have all the vices, and Dali also boasts that he is not homosexual, but otherwise he seems to have as good an outfit of perversions as anyone could wish for.

However, his most notable characteristic is his necro-philia. He himself freely admits to this, and claims to have been cured of it. Dead faces, skulls, corpses of animals occur fairly frequently in his pictures, and the ants which devoured the dying bat make countless reappearances. One photograph shows an exhumed corpse, far gone in de-composition. Another shows the dead donkeys putrefying on top of grand pianos which formed part of the Surrealist film, *Un chien andalou.* Dali still looks back on these don-keys with great enthusiasm.

> I "made up" the putrefaction of the donkeys with great pots of sticky glue which I poured over them. Also I emptied their eye-sockets and made them larger by hacking them out with scissors. In the same way I furiously cut their mouths open to make the rows of their teeth show to better advan-tage, and I added several jaws to each mouth, so that it would appear that although the donkeys were already rotting they were vomiting up a little more of their own death, above those other rows of teeth formed by the keys of the black pianos.

And finally there is the picture—apparently some kind of faked photograph—of *Mannequin Rotting in a Taxicab.* Over the already somewhat bloated face and breast of the apparently dead girl, huge snails were crawling. In the caption below the picture Dali notes that these are Bur-gundy snails—that is, the edible kind.

Of course, in this long book of 400 quarto pages there is more than I have indicated, but I do not think that I have given an unfair account of his moral atmosphere and men-tal scenery. It is a book that stinks. If it were possible for a book to give a physical stink off its pages, this one would—a thought that might please Dali, who before wooing his future wife for the first time rubbed himself all over with an ointment made of goat's dung boiled up in fish glue. But against this has to be set the fact that Dali is a draughtsman of very exceptional gifts. He is also, to judge by the minuteness and the sureness of his drawings, a very hard worker. He is an exhibitionist and a careerist, but he is not a fraud. He has fifty times more talent than most of the people who would denounce his morals and jeer at his paintings. And these two sets of facts, taken to-gether, raise a question which for lack of any basis of agreement seldom gets a real discussion.

The point is that you have here a direct, unmistakable as-sault on sanity and decency; and even—since some of Dali's pictures would tend to poison the imagination like a pornographic postcard—on life itself. What Dali has done and what he has imagined is debatable, but in his outlook, his character, the bedrock decency of a human

being does not exist. He is as anti-social as a flea. Clearly, such people are undesirable, and a society in which they can flourish has something wrong with it.

Now, if you showed this book, with its illustrations, to Lord Elton, to Mr. Alfred Noyes, to *The Times* leader-writers who exult over the "eclipse of the highbrow"—in fact, to any "sensible" art-hating English person—it is easy to imagine what kind of response you would get. They would flatly refuse to see any merit in Dali whatever. Such people are not only unable to admit that what is mor-ally degraded can be æsthetically right, but their real de-mand of every artist is that he shall pat them on the back and tell them that thought is unnecessary. (pp. 170-76)

But if you talk to the kind of person who *can* see Dali's merits, the response that you get is not as a rule very much better. If you say that Dali, though a brilliant draughts-man, is a dirty little scoundrel, you are looked upon as a savage. If you say that you don't like rotting corpses, and that people who do like rotting corpses are mentally dis-eased, it is assumed that you lack the æsthetic sense. Since *Mannequin Rotting in a Taxicab* is a good composition (as it undoubtedly is), it cannot be a disgusting, degrading pic-ture; whereas Noyes, Elton, etc., would tell you that be-cause it is disgusting it cannot be a good composition. And between these two fallacies there is no middle position; or, rather, there is a middle position, but we seldom hear much about it. On the one side *Kulturbolschewismus;* on the other (though the phrase itself is out of fashion) "Art for Art's sake." Obscenity is a very difficult question to discuss honestly. People are too frightened either of seem-ing to be shocked or of seeming not to be shocked, to be able to define the relationship between art and morals.

It will be seen that what the defenders of Dali are claiming is a kind of *benefit of clergy.* The artist is to be exempt from the moral laws that are binding on ordinary people. Just pronounce the magic word "Art," and everything is O.K. Rotting corpses with snails crawling over them are O.K.; kicking little girls in the head is O.K.; even a film like *L'âge d'or* is O.K. It is also O.K. that Dali should batten on France for years and then scuttle off like a rat as soon as France is in danger. So long as you can paint well enough to pass the test, all shall be forgiven you.

One can see how false this is if one extends it to cover ordi-nary crime. In an age like our own, when the artist is an altogether exceptional person, he must be allowed a cer-tain amount of irresponsibility, just as a pregnant woman is. Still, no one would say that a pregnant woman should be allowed to commit murder, nor would anyone make such a claim for the artist, however gifted. . . . And, after all, the worst crimes are not always the punishable ones. By encouraging necrophilic reveries one probably does quite as much harm as by, say, picking pockets at the races. One ought to be able to hold in one's head simulta-neously the two facts that Dali is a good draughtsman and a disgusting human being. The one does not invalidate or, in a sense, affect the other. The first thing that we demand of a wall is that it shall stand up. If it stands up, it is a good wall, and the question of what purpose it serves is separa-ble from that. And yet even the best wall in the world de-serves to be pulled down if it surrounds a concentration camp. In the same way it should be possible to say, "This is a good book or a good picture, and it ought to be burned by the public hangman." Unless one can say that, at least

in imagination, one is shirking the implications of the fact that an artist is also a citizen and a human being.

Not, of course, that Dali's autobiography, or his pictures, ought to be suppressed. Short of the dirty postcards that used to be sold in Mediterranean seaport towns, it is doubtful policy to suppress anything, and Dali's fantasies probably cast useful light on the decay of capitalist civilisation. But what he clearly needs is diagnosis. The question is not so much *what* he is as *why* he is like that. It ought not to be in doubt that he is a diseased intelligence, probably not much altered by his alleged conversion, since genuine penitents, or people who have returned to sanity, do not flaunt their past vices in that complacent way. He is a symptom of the world's illness. The important thing is not to denounce him as a cad who ought to be horsewhipped, or to defend him as a genius who ought not to be questioned, but to find out *why* he exhibits that particular set of aberrations.

The answer is probably discoverable in his pictures, and those I myself am not competent to examine. But I can point to one clue which perhaps takes one part of the distance. This is the old-fashioned, over-ornate, Edwardian style of drawing to which Dali tends to revert when he is not being Surrealist. Some of Dali's drawings are reminiscent of Dürer. . . . But the most persistent strain is the Edwardian one. When I opened [*The Secret Life of Salvador Dali*] for the first time and looked at its innumerable marginal illustrations, I was haunted by a resemblance which I could not immediately pin down. I fetched up at the ornamental candlestick at the beginning of Part I. What did this remind me of? Finally I tracked it down. It reminded me of a large, vulgar, expensively got-up edition of Anatole France (in translation) which must have been published about 1914. That had ornamental chapter headings and tailpieces after this style. Dali's candlestick displays at one end a curly fish-like creature that looks curiously familiar (it seems to be based on the conventional dolphin), and at the other is the burning candle. This candle, which recurs in one picture after another, is a very old friend. You will find it, with the same picturesque gouts of wax arranged on its sides, in those phoney electric lights done up as candlesticks which are popular in sham-Tudor country hotels. This candle, and the design beneath it, convey at once an intense feeling of sentimentality. As though to counteract this, Dali has spattered a quill-full of ink all over the page, but without avail. The same impression keeps popping up on page after page. . . . Picturesqueness keeps breaking in. Take away the skulls, ants, lobsters, telephones and other paraphernalia, and every now and again you are back in the world of Barrie, Rackham, Dunsany and *Where the Rainbow Ends*.

Curiously enough, some of the naughty-naughty touches in Dali's autobiography tie up with the same period. When I read the passage I quoted at the beginning, about the kicking of the little sister's head, I was aware of another phantom resemblance. What was it? Of course! *Ruthless Rhymes for Heartless Homes,* by Harry Graham. Such rhymes were very popular round about 1912, and one that ran:

> Poor little Willy is crying so sore,
> A sad little boy is he,
> For he's broken his little sister's neck
> And he'll have no jam for tea,

might almost have been founded on Dali's anecdote. Dali, of course, is aware of his Edwardian leanings, and makes capital out of them, more or less in a spirit of pastiche. He professes an especial affection for the year 1900, and claims that every ornamental object of 1900 is full of mystery, poetry, eroticism, madness, perversity, etc. Pastiche, however, usually implies a real affection for the thing parodied. It seems to be, if not the rule, at any rate distinctly common for an intellectual bent to be accompanied by a non-rational, even childish urge in the same direction. A sculptor, for instance, is interested in planes and curves, but he is also a person who enjoys the physical act of mucking about with clay or stone. An engineer is a person who enjoys the feel of tools, the noise of dynamos and the smell of oil. A psychiatrist usually has a leaning towards some sexual aberration himself. Darwin became a biologist partly because he was a country gentleman and fond of animals. It may be, therefore, that Dali's seemingly perverse cult of Edwardian things (for example, his "discovery" of the 1900 subway entrances) is merely the symptom of a much deeper, less conscious affection. The innumerable, beautifully executed copies of textbook illustrations, solemnly labelled *le rossignol* ["the nightingale"], *une montre* ["a watch"] and so on, which he scatters all over his margins, may be meant partly as a joke. . . . But perhaps these things are also there because Dali can't help drawing that kind of thing because it is to that period and that style of drawing that he really belongs.

If so, his aberrations are partly explicable. Perhaps they are a way of assuring himself that he is not commonplace. The two qualities that Dali unquestionably possesses are a gift for drawing and an atrocious egoism. "At seven," he says in the first paragraph of his book, "I wanted to be Napoleon. And my ambition has been growing steadily ever since." This is worded in a deliberately startling way, but no doubt it is substantially true. Such feelings are common enough. "I knew I was a genius," somebody once said to me, "long before I knew what I was going to be a genius *about*." And suppose that you have nothing in you except your egoism and a dexterity that goes no higher than the elbow; suppose that your real gift is for a detailed, academic, representational style of drawing, your real *métier* to be an illustrator of scientific textbooks. How then do you become Napoleon?

There is always one escape: *into wickedness.* Always do the thing that will shock and wound people. At five, throw a little boy off a bridge, strike an old doctor across the face with a whip and break his spectacles—or, at any rate, dream about doing such things. Twenty years later, gouge the eyes out of dead donkeys with a pair of scissors. Along those lines you can always feel yourself original. And after all, it pays! It is much less dangerous than crime. Making all allowance for the probable suppressions in Dali's autobiography, it is clear that he has not had to suffer for his eccentricities as he would have done in an earlier age. He grew up into the corrupt world of the nineteen-twenties, when sophistication was immensely widespread and every European capital swarmed with aristocrats and *rentiers* who had given up sport and politics and taken to patronising the arts. If you threw dead donkeys at people, they threw money back. A phobia for grasshoppers—which a few decades back would merely have provoked a snigger—was now an interesting "complex" which could be profitably exploited. And when that particular world col-

lapsed before the German Army, America was waiting. You could even top it all up with religious conversion, moving at one hop and without a shadow of repentance from the fashionable *salons* of Paris to Abraham's bosom.

That, perhaps, is the essential outline of Dali's history. But why his aberrations should be the particular ones they were, and why it should be so easy to "sell" such horrors as rotting corpses to a sophisticated public—those are questions for the psychologist and the sociological critic. Marxist criticism has a short way with such phenomena as Surrealism. They are "bourgeois decadence" (much play is made with the phrases "corpse poisons" and "decaying *rentier* class"), and that is that. But though this probably states a fact, it does not establish a connection. One would still like to know *why* Dali's leaning was towards necrophilia (and not, say, homosexuality), and *why* the *rentiers* and the aristocrats should buy his pictures instead of hunting and making love like their grandfathers. Mere moral disapproval does not get one any further. But neither ought one to pretend, in the name of "detachment," that such pictures as **Mannequin Rotting in a Taxicab** are morally neutral. They are diseased and disgusting, and any investigation ought to start out from that fact. (pp. 176-84)

> *George Orwell, "Benefit of Clergy: Some Notes on Salvador Dalí," in his* Dickens, Dalí & Others: Studies in Popular Culture, *Reynal & Hitchcock, 1946, pp. 170-84.*

A. Reynolds Morse (essay date 1945)

[*An art collector and critic, Morse is president of Salvador Dalí Foundation, Inc. and operator of the Salvador Dalí Museum in St. Petersburg, Florida. Morse also specializes in studies of Dalí's work; his many critical and biographical appreciations include* Dalí: A Study of His Life and Works *(1958),* Dalí—1910-1965 *(1965), and* Dalí: A Collection and Panorama of His Art *(1973; revised, 1975). In the following excerpt, Morse assesses Dalí's impact as the foremost exponent of Surrealism in America and affirms him as the movement's most significant contributor.*]

To any student of modern trends in art it is readily apparent that Salvador Dali's present position is at best a most ambiguous one. The "experts" and "critics" have consistently refused to assign him any lasting or consecutive place. They still seem to regard his influence as unimportant upon anything except possibly advertising art, and—as has been facetiously said—himself!

And yet it is well known that during the ten years, 1930-1940, Salvador Dali cut a wide and glittering swath across the fields of art in general and surrealism in particular. He came to the United States on the crest of the surrealist wave which did not reach this country till the early 30s, just in time to recompense us for the lost realities of the fat years of the late 20s, in time to offer the American public a world of fantasy far more acceptable than the realities of the depression. Dali had the ability to abstract and refine all the real values of the movement. He was therefore able to present to America the very essence of it, ennobled by the full effect of his intricate personal symbology. But he far eclipsed the surrealists, for he did not fall heir to the

psychopathologies which finally caused the movement to die out in fitful, pathetic sputters in the flesh pots of Europe. With his sheer technical mastery and natural flare for publicity, he was able to make surrealism in America his own, and to exercise a profound influence on art as a whole because he had freed himself from the shackles of a minor movement, and stood as a symbol of freedom from the inertia and lassitude which overtook art after the stimulation of surrealism was lessened by use and familiarity and dissensions. He therefore gradually became synonymous with all that surrealism implies in art both here and abroad, while the original surrealists, one by one, have fallen into all varieties of second class discard. (pp. 111-12)

So Dali emerged from this productive decade having succeeded in almost completely identifying American surrealism with his own symbology, at least in the popular mind. This was an accomplishment of no small scope, and may yet prove to be of tremendous ultimate importance in the artistic history of our time.

But by and large the critics and the inner circles of the art world have remained stonily unimpressed by Dali's concepts and conceits, refusing even to be amused. Only a very few museums have examples of his work, and those examples are about equally divided between gifts and purchases. Many important new books on art decline to give Dali any real recognition, implying he is either beyond the scope of the work, or has become too controversial a subject to merit a place in contemporary appraisals of artistic influences. Now that Dali has virtually forsaken easel painting for a wide variety of projects in the fields of ballet, opera, portraiture, and writing, as well as special promotional assignments, one may look back over the past fifteen years of his career and observe with some perspective what he has accomplished, and wherein he will perhaps be charged with failure.

There has no doubt been some chicanery in his career, artistic and otherwise. The aura of his antics has to no small extent permeated, and perhaps to some esthetes, tainted his works. But withal, his recorded dream world stands like a splendid if somewhat deprecated monument to his genius. His easel paintings of the 30s will eventually come to be regarded as immortal sign posts pointing the way out of a sloppy, hopelessly jumbled, and decadent surrealism, as well as a way out of the general impasse in which all art found itself about this time when there were no great innovators or leaders except Dali, and one or two other geniuses.

Yet Dali has always managed to stand apart from the minor movements in modern art, like a Leonardo of the age, and as such—an individualist—he is still subject to attack by the proponents of a socialized or popularized art. If these regimentalists had their way they would systematize art, claiming such a sterilizing procedure would make it readily teachable. And they would eliminate all eccentricities, irregularities and innovations from it. Since they could not account for Dali they would eliminate him by minimizing his influence and accomplishments in somewhat the following vein.

Dali will undoubtedly be called a casualty of the war, for since he left Spain and his native Catalan background, he has perhaps tended to reminisce rather than to create, has tended toward seeking the lucrative in art, rather than the

verities of it. It might be charged that the novelty of his symbology ceased when he left the old world, and that since he has been in this country he has painted more like a man influenced by Salvador Dali than like Dali himself. It will be said he has merely parodied his own work, and that one by one he has prostituted the sacred symbols of his own distinctly personal surrealism to common commercial ends. It will be said that his symbols are like Frankenstein's Monster, turning against their creator. When he sits down to paint he will be likened to an old maid making Dali samplers. His works will have lost their punch, the age of his dream-whimsey will have died, he will become victimized and ridiculed by his own cosmology. The surrealist symbols he elevated to be art in the popular mind were adapted to various publicity stunts. The telephone which he originally taught was fraught with the timeless significance of Munich will be likened to a night club ad; the ant which he said was the delicate symbol of the jewel-like matter of our own eventual decay will become associated with a gross caricature of itself on a necktie; the dream-like lassitude of the perfect clouds from the fruitful decade will be said to have degenerated to sharp and thinly-painted frou-frou to embellish expensive portraits. He will be pointed out as a man who mimicked his own surprises to the point where they no longer surprised anyone, to the point where no one will ever take his symbology or intentions seriously again.

Some critic is sure to point out before long that everything seen in Dali's most serious works is being seen again in parody form in stocking ads in *Vogue,* or vastly blown up on a ballet curtain, or even taken for a background of a musical show. Such reexpression of his original artistic dream surrealism is undoubtedly remunerative, but it does provide a fine target for the critic who can logically raise the question if Dali ever had anything else in mind but an ultimate commercial exploitation of his art, and if that fact having been perceived by connoisseurs has not militated against his mastership in art. Such a reuse of the established symbols will indubitably be said to be bad for his artistic reputation, for no museum will value a picture—a masterpiece—which has been parodied in a necktie pattern and advertised in *Esquire*—at least not until the necktie has been forgotten for a long time!

And yet such tactics have made Dali and his intimate personal concepts the talk of every shop girl in the land! That art should be for the masses, that the luxury of the little private madnesses and eccentricities is no longer exclusively reserved for the well-to-do, but can now be indulged in by anyone to whom Dali has brought his symbols, is a matter of such fundamental and tremendous importance to the art world that its significance has barely begun to be apparent. Even the bourgeoisie puts up a feeble protest against any novelty in art, especially any novelty which hints at their own neuroticism and fear of change, by calling Dali childish and insane. It will be said in resistance to Dali's exceptional originality that such a broad concept of art as would admit his artistic antics is not really "art," but merely an immediate and shrewd merchandising of it.

Someone may also point out that Dali perhaps defeated his own purpose in his publicity stunts and sensational painting, for while he thereby achieved a momentary fame in *Life* and *Sunday Magazine Supplements*—fame of a rather "notorious" kind because it was among the mass-

es—he at the same time made himself shocking and undesirable to the often ultra-conservative persons who control the purse strings of museums and so in turn the somewhat sanctimonious judgment of the director in his inner office. It is obvious that the tone of many museum collections is all too often determined by the spinsterish tastes of affluent donors behind the scenes, not the progressive student or even reasonably emancipated visitor. Many museums also have a policy of waiting until an artist's work becomes rare and expensive, and make the tacit assumption that these two facts have made him immortal, famous, or both, and hence desirable as a "public" possession. This policy, coupled with the chicanery sometimes attributed to Dali, no doubt accounts for so few of his works being in permanent museum collections. (pp. 112-16)

Before long some one will undertake a survey of Dali's influence upon advertising art. Innovators in this field where novelty is at a premium were quick to seize upon the deep perspective publicized by Dali in such pictures as *The Font* and *Shades of Night Descending.* Almost overnight the tone of the slick paper magazine ad was changed. Yet Dali's activities in this direction, while they had a far-reaching influence on American Art as well, will, however, probably be said to have lowered the value of his serious works. All the nostalgia of one of his masterpieces will be found in a garter ad in the *Saturday Evening Post.* He will be accused of bringing the lofty concepts of his art into a realm where they could not descend without cheapening their ultimate value as museum pieces. Yet on every hand we now accept ads with ridiculous dream-world juxtapositions of extraneous objects selected for their incongruity. A few years ago, before Dali, our sensibilities would have been outraged.

In literature a great many dream worlds exist which are accepted as masterpieces. Yet in the field of painting a curious taint attaches to any picture which is the least bit experimental in its subject matter. Many "art masterpieces" are experimental, even insane, in technique, and yet they are accepted by the very conservative. But where the subject matter is not in accord with even the most drunken preconception of reality, the work is slighted even though the technique is perfection itself.

There remains one chink in Dali's armor. This is not an age of great artistic freedoms. Wherever there are purges, bannings, and bowdlerizings, radical artistic concepts like Dali's will be automatically subject to critical interpretive readings in the search by both sides for alien motives. There is no avenue of neutral gray between the black of one side and the white of the other down which an artist may walk in freedom, for if such paths were left open to the artist they would also be open to the average man whose horror of war is becoming increasingly pronounced, but whose conceptions cannot yet seem to encompass a vast zone of freedoms between various ideologies. It is too bad that an artist and his art cannot exist apart from the conflicting political movements of his times. The fact that Dali has never come out with any clear-cut statement as to his political leanings means that he and his art are both probably suspected by the party in ascendency as well as by the party being submerged. There is also some reaction against him as a result of his being a foreigner, a feeling that he has come to this country merely to cash in on it, not to become part of it. Such senti-

ments are just as jejune as saying that because the titles of his works are often almost facetious or without the brief dignity ordinarily attributed to 'masterpieces,' his works are not finding their way museum-ward. *The Average Atmospherocephalic Bureaucrat in the Act of Milking a Cranial Harp* is a title, which while it might distract a routine mind, nevertheless to a free mind connotes a free artist.

But in spite of all these varied potential counter-arguments, there still seems to be an ultimate destiny of some importance for Dali's works, even though that destiny may be but dimly perceived at present by professional critics who in most cases dismiss Dali as a mere clever artistic mountebank. Dali has always painted with some purpose, a far vaster and more comprehensive purpose than is found in the works of the lesser surrealists and more conventional artists of the period. One sometimes gets the feeling that the average surrealist, whose inspirations on the whole were remarkably limited and one-tracked, disowned Dali out of sheer jealousy of his manifold talent and inclusive concepts which of course enabled him to make a far better living than the small fry of the movement. All too often such fundamental and human motivating factors are overlooked in art criticisms. (pp. 119-20)

From the very beginning of his productive years Dali manifested a tremendous energy and versatility which enabled him to encompass without copying all the major aspects of surrealism as expressed in the works of minor artists of the times. He has always been an exquisite miniaturist. Under a magnifying glass the detail of his works maintains all its precision and perfection. Works so incredibly fine and delicate, like a dream landscape, are reminiscent of reality rather than realistic. It is as though one were focusing on some memory through the wrong end of a telescope. Or again, it is as though one were studying a color negative of an actual scene. Should the topic of a Dali painting ever be presented to you in reality, it would be recognizable immediately from the "color plate" once seen in the painting. Infinite detail beyond the scope of most artists is an essential to such visions. Yet for the obtuse or slightly unimaginative person, the subject matter of a Dali canvas often acts to obscure all the classical perfection of the painting itself. Such an individual should realize that Dali does not produce a mere picture: he far transcends the commonplace reality, and snatches details from his subconscious mind which are often gruesome and fantastic, even though such details stem from classical memories of Vermeer, Leonardo or Raphael (as in *The Madonna of the Birds*). Dali's memories are probably not without conscious direction; and they are sometimes distorted in the mutation to the point where their impact ceases to be surrealist and becomes of a far more comprehensive importance to the field of art in general in perpetuating renovated or revivified twentieth century conceptions of the conventional classics. Everything else in life is being modernized, why not modernize some established conceptions? This type of classical inspiration for Dali's surrealism, however, is not to be confused with his more whimsical inspirations such as *The Ship,* wherein he begins with an ordinary color print and imposes his vision upon the original conception.

Dali has given impetus to several potential or nuclear movements in art, particularly in the field of psychological art, which have not yet begun to be apparent for two reasons. First, we are too preoccupied with war and its implications to demand or require novelty in art; and second, because Dali's colossal conceit in evaluating his own potential influence on art in his Secret Life has acted to inhibit any immediate claimants to such an impertinent influence which could possibly predict its own importance in a field as vagarious as art. Nevertheless Dali himself is adept at expressing in his works all the things in life which ordinarily cannot be made verbally or pictorially explicit. Since these things do not have the familiar and reassuring outlines of sanity and reality which would tend to make them acceptable (perhaps in the guise of experimental art) to the good, stolid citizen, it may be said that Dali is painting years ahead of his time. But the times are fast catching up. Our wars with all their vast contradictions, and our increasing industrial crimes against man's simple nature are generating a vast audience of psychoneurotics to whom Dali will make an increasing amount of sense. (pp. 121-22)

What will the repercussions on art be ten or fifteen years after we have done without the current hypnotic hysterics of war? When there is no more war anymore, there will be no compensating social conditions to produce the environments which succor the relatively harmless madness of surrealism. We only need a super-reality (a Dalinian dream world) when society foists an intolerable reality upon us. Therefore the future may well see a resurgence of some type of surrealism, possibly revolving around certain elements of the Dalinian symbology. By remaking advertising techniques Dali has already laid the ground work for the future acceptance of himself in the popular mind. The need for such an escapist cosmology as Dali's, such an interpretive madness, such an ultimate freedom for the individual mind as Dali propounds in his paintings wherein he most eloquently pleads for the right of every man to his own madness, is engendered because even adults must have some place where they can escape robot bombs, regimentation, and indeed our very sanity which seems to lead us into war. Dali is the one artist who energetically picked art up from the post-surrealism (post war) doldrums and is carrying it over to the next "ism." He is the link between the art of postwar yesterday and the art of postwar tomorrow.

Dali constructs a heaven which is found in a capricious reality imposed however incongruously upon the elements of what for more and more people may yet prove an intolerable one. Dali teaches a super-experience one can enjoy while living, no matter how precariously, and his truths become the more apparent as one grows less able to stand the realities of what the senses actually convey. Dali's paintings will have an increasing amount of appeal to a scientific nation, for the science of humanity lags far behind the science of things; and as we become more highly industrialized we become more maladjusted, more neurotic, more in need of irrational comforts such as Dali provides.

Thus Dali's surrealism, or something stemming from it, actually may yet become one main hope for the survival of a basic artistic freedom from regimentation in the postwar era—a freedom from a cruel, rational reality. Reality may well prove to be insupportable again for sensitive peo-

ple, esthetes, and others. They will have no enthusiasm for anything in art except what does not remind the beholder of the potential postwar chaos, of all the tragic disillusions which follow the cool breath of Victory, of new W. P. A.s in art, of all the floundering disjointed souls who cannot find peace because the narcotics of war are being denied them. They will only be able to find equivalent excitement and release in the intensified experience of their imaginations in which realm Dali has been pioneering with such purpose for so long.

One may still see Dali's imaginative dream world symbology reborn, revitalized, becoming the very symbols of hope for the distraught neurotic masses of the world. By then people will probably finally realize that they have been horribly fooled by a "correct" rational reality. They will be ready to accept the reflowering of a human, an irrational surrealism which can bring all the comfort and stimulating distractions of a magic world to them as cultural neophytes. If this should happen, the high purpose many feel inherent in Dali's darting surrealism will have more than triumphed over the charges made against it, and established the artist in the permanent annals of art. If it does not, then the socialization of art will probably have become complete, and Dali's works will remain as final (and no doubt suppressed) tributes to a dying individualism in a world of regimented and enervated art. (pp. 122-26)

> *A. Reynolds Morse, "The Dream World of Salvador Dalí," in* Art in America, *Vol. 33, No. 3, July, 1945, pp. 110-26.*

Marcel Jean with Arpad Mezei (essay date 1959)

[*Jean was a critic and painter who played an active role in the publications and exhibitions of the Surrealist group from 1933 to 1950. In the following excerpt Jean and his collaborator Mezei provide an analysis of Dalí's early paintings and film collaborations with Luis Buñuel, and discuss Dalí's involvement with the Surrealists.*]

[In 1929, the journal *La révolution surréaliste*] revealed a new painter: Salvador Dali. The review reproduced three of his paintings, *Accommodations of Desire, Illumined Pleasures* and one without a title. Cast shadows, perspectives involving long rows of columns, pictures within the picture, occasionally *collages,* often round, malleable shapes modelled in *trompe-l'œil,* and effects of 'matter' obtained by sweeping the brush lightly through the wet paint: Dali appropriated all these various aspects of the surrealist world of images and proceeded to define them, systematize them and amalgamate them with a view to provoking mythologies which were certainly fantastic and also proved to be somewhat artificial. The lighting in his paintings is more electric than solar, and the colouring tends to assume the forced and dubious tonalities of colour photography: there is always that slight suggestion of gradually decomposing flesh. The shadows, encircled by white haloes, seem to be cut out of black paper. These colour-prints of the imaginary are really pretexts for their author to demonstrate his technical skill and his craftsman's obsession with minutiae, in which respect he easily outclasses his precursor in this field, Pierre Roy. Dali has made extensive use of collage in his compositions, but so cunningly that only the most careful examination of a pic-

ture will reveal the parts added on separately: like those seventeenth century Dutch painters who glued real butterflies' wings to their canvases, with the result that it was the butterflies that seemed painted, surrounded as they were by such superbly imitated flowers!

Dali gave a new emphasis to the importance of the human figure, which he sometimes reproduced literally from photographs (Magritte's concept of 'painted *collage*' becomes transformed into 'pseudo-*collage*'); more often, the sweeps of his brush created roughly approximate limbs and muscles. As for the metaphorical scenario of these images, Dali's method is to juxtapose intriguing anecdotes: cyclists balancing rocks on their heads, a leering face shaped like a jug, and so on. In *Accommodations of Desire,* the same lion's head is contained inside identical soft surrounding shapes, presented successively as a grey silhouette, a white silhouette, realistically, without its muzzle, gnawed by ants, etc. According to the artist, this symbolizes the desires that are 'accommodating themselves'; there may also be an astrological allusion, perhaps, since the artist's ascendant is in the sign of Leo. (pp. 199-200)

[There] are absolutely no signs of any preoccupation with dadaist or surrealist themes in Dali's early artistic experiments, which showed themselves to be influenced by very disparate tendencies: at one moment, Vermeer's inspiration can be seen in *Girl Sewing* and *The Basket of Bread,* then Synthetic Cubism becomes his model, or Ingres in the manner of Picasso, or the *Scuola metafisica*(*Neo-Cubist Academy, Figures on the Sand*). These works achieved a considerable measure of success in Catalonia. . . .

Apparently Dali discovered Surrealism only during the course of 1927, no doubt through reviews or catalogues; *Variétés* must have brought him a wealth of information in 1928. Two paintings dated 1927 show a remarkable change of front in their author's attitude: *Apparatus and Hand* and *Blood is Sweeter than Honey* (notice the literary air of the second title and its sadistic note) are both images with a strongly surrealist tendency and, according to James Thrall Soby, 'must be read as a forecast of what we now know as the Dalinian style'. And the artist's own account, in his *Secret Life,* of his working methods during that period show the degree to which he had been impressed by the theses in the *Surrealist Manifesto;* he attempted, in his turn, to adapt the processes of automatic writing to painting (p. 203)

On a first visit to Paris, Dali went to see Picasso. Then, during a second stay he met his compatriot Joan Miró, who told the surrealists about his strange compositions. . . . In 1929, Dali finished *The Lugubrious Game,* a completely surrealist little painting: it is a mixture of objects, female figures, birds' heads, hands, hats, pebbles, tentacles, all flowing out of an architecture viewed in perspective and rearing up like a monstrous plume in front of a statue garnished with an enormous hand, on the plinth of which is engraved: 'Gramme, centigramme, milligramme'—the motto of Salvador Dali's minutely detailed painting.

Dali collaborated with Luis Buñuel, whom he had known in Madrid in a student circle, in the making of their film *Un chien andalou.* When the film was completed, he joined Buñuel in Paris for its first showing, and duly put in an

appearance at the Café Cyrano, in the Place Blanche, where the surrealist group was meeting at the time. At first he was careful to observe the modest attitude appropriate to a neophyte. His reserve contrasted strongly with his new friends' usual boisterousness, although he was able occasionally to make a definite impression on a gathering most of whose members were either poor or pretended to be so. For instance, he invariably paid for his drinks with a hundred franc note, appearing to consider coins simply as paper-weights, designed to keep the bank-notes from blowing off the café table; and he enquired about the possibilities of living in Paris on only ten thousand francs a month (about £50 or $200 in 1929!). . . .

The word *film* expresses perfectly the nature of an art which has rightly been called 'epidermic', a synthesis and substitute, for better or usually for worse, of the adventure-serial of previous eras and the documentary or suggestive postcard. Buñuel had had the idea (according to Dali in his *Secret Life*) of taking a daily newspaper for the theme of his first film, in which all the images would be animated, from the local news right through to the comic strips: in the end, the newspaper would be swept up and thrown into the garbage-bin. But *Un chien andalou* turned out to be a very different conception; dream-like adventures bound together by a secret necessity, demanding the spectator's participation outside the limits of direct understanding; a thread of irrational consequences which never breaks; the imaginary following inexorably a desperate, irrefutable logic. (p. 204)

Dali played a major part in the writing of the scenario, but it was Buñuel who succeeded in endowing his friend's ideas, and his own, with an extraordinary sense of actuality. Scorning the technical pretensions and failures which characterize so-called avant-garde films, his production was simple and precise, with an infallible sense of *tempo* . . . ; the result was more than an arresting spectacle—it was a stupefying experience. In the opening scene, a razor-blade seen in close-up slices through a young woman's eye with the same precision as the thin wispy cloud passes across the face of the moon in the preceding image. Neither the admirers of beautiful photography nor the lovers of realism had the time to worry about 'how it was done'; already other scenes were introducing the spectator into an increasingly tragic atmosphere. Buñuel was so emotionally involved in the film's realization that he was ill for several days after slicing through the cow's eye which provided the illusion of a human eye on the screen.

Un chien andalou was something so obviously out of the usual cinematic rut that, by sheer force of contrast, it achieved an immediate success—of which the surrealists promptly made full use. Some difficulties had already arisen as a result of the publication of the scenario, which Buñuel had quite innocently offered to the publisher Gallimard for his *Revue du cinéma*. The surrealists indignantly protested to their new friend that this constituted a 'distraint' upon a work which they claimed for themselves, and there was even talk of a punitive expedition to the printing-works to break up the type for the article. Finally, Eluard and Buñuel contented themselves with going to Gallimard to ask for the return of the text, a request which was refused. Thereupon, the scenario was reprinted in *La révolution surréaliste* (No. 12) with this introductory note by Buñuel:

> The publication of this scenario in *La révolution surréaliste* is the *only one authorized by myself.* It expresses, without any reservation whatsoever, my complete adherence to the ideas and activities of Surrealism. *Un chien andalou* would not have existed if Surrealism had not existed.
>
> "*A successful film*" seems to be the opinion of most of the people who have seen it. But what can I do about those who go mad about anything new, even if the novelty in question outrages their deepest convictions? What can I do about a bribed or at least hypocritical press, and this cretinous mob which labelled as *beautiful* or *poetic* what is basically nothing but a desperate, passionate incitement to murder?

Shortly before *Un chien andalou* was first shown, the first exhibition in Paris of Dali's paintings took place at the Galerie Goemans (September, 1929). André Breton wrote the preface:

> . . . These new creatures, whose evil intentions are apparent, have just started moving. We experience a dark pleasure at the realization that nothing on their path exists any more except themselves, and we recognize that their habit of multiplying themselves and *melting away* identifies them as beasts of prey.

The Lugubrious Game was shown, together with *Apparatus and Hand, Accommodations of Desire, Illumined Pleasures* and some other paintings.

The artist made use of his own manual dexterity as a 'means of forcing inspiration' in a few of his earlier pictures which are certainly the most genuinely surrealist paintings of his whole career: *The Font* (1930), *The Profanation of the Host* (1930), *The Dream* (1931). Against a background of coloured waves, swirling currents intermingle and focus themselves finally into figures and objects. They are not so much dream-images as illustrations of a kind for a still unwritten manual of psychoanalysis: even the titles sometimes provide a commentary with Freudian undertones. A predilection for suggestive or even remarkably unsymbolized sexual themes is noticeable in his work (Dali is the author of some extraordinary erotic drawings).

In 1930, the Editions Surréalistes published Salvador Dali's *La femme visible* (followed in 1931 by *L'amour et la mémoire*, under the same imprint). The frontispiece consisted of an engraving by the author, a jumble of strange shapes, blazing chalices and coprophagous androgynes, with the following lines, just above the artist's signature, taken from the chapter entitled 'The Great Masturbator':

> . . . in the cruel ornaments of false gold
> which cover his soft delicate forehead
> imitating
> the shape of an imperial crown
> whose fine leaves of bronzed acanthus
> reach as far
> as his smooth rosy cheeks
> and extend their hard fibres downwards
> until they dissolve
> into the snow-white nape of his neck

This is one of the appearances of the 'Great Masturbator', a favourite theme at that time in Dali's pictures. In his

same role of poet, he describes with equal satisfaction 'the Avenue of Spiritoartistic Sciences' in which can be found

> the usual sculpted couple
> with tender nostalgic faces
> and it is the man who devours
> the immeasurable shit
> which the woman
> craps
> lovingly
> into his mouth

coprophagy, like putrescence, being an important factor for the artist at that period (in his artistic and literary activities, of course).

La femme visible includes a 'theoretical' section under the headings 'The Putrescent Donkey', 'The Sanitary Goat' and 'Love', concerned mainly with the *paranoiac-critical method* which Max Ernst described, later on, as a 'rather pretty term, which will probably have some success because of its paradoxical content.' Dali's definition is equally paradoxical, and all his terms are more or less contradictory: 'Paranoiac-critical activity: spontaneous method of original knowledge based upon the interpretative-critical association of delirious phenomena'.

Critical paranoia might be compared to an image-interpretation test, a test repeated interminably, and invariably producing different results: a given reality suggests two, three or more different ones (depending on the individual's imaginative capacity), each one as acceptable as the original since each variation can be perceived and accepted as real by others. For instance, one can see, or persuade others to see, all sorts of shapes in a cloud: a horse, a human body, a dragon, a face, a palace, and so on. Any sight or object of the physical world can be treated in this manner. From which the proposed conclusion is that it is impossible to concede any value whatsoever to immediate reality, since it may represent or mean anything at all.

Envisaged in this way, critical paranoia is not only a creative method in which we can easily recognize the 'means of forcing inspiration' and the gazing at old walls advocated by Leonardo, but, in addition, an attempt to disorganize the outside world, a sort of paroxysmal impetus towards disorientation. (pp. 206-07)

Dali had much in common with those circus performers who, with an imperturbable seriousness, perform sketches based on themes as banal as climbing a ladder or playing a trumpet solo. He was a dazzlingly intellectual acrobat with a matchless instinct for 'sensitizing' the most worthless themes. The most vulgar clichés were grist to his inventive mill. And soon he began to discover the element of surprise in the familiar, in the terribly familiar: all this with a deliberately cretinizing intention which did not spare his own friends.

In 1933, Dali transformed Millet's *Angelus* into a positive geyser of associative images: he had discovered that the figure on the left was hiding his turgescent sex under his hat, that the woman was pregnant, that the wheelbarrow suggested an erotic attitude, that the pitch-fork was stuck into the 'meat' of the earth, which represented nourishment, etc. According to Dali, it was these hidden meanings which were responsible for the picture's fame, rather than its more apparent aspect as a commonplace religious image. The artist painted a series of pictures in which he achieved a more or less complete metamorphosis of *The Angelus,* including **Meditation Upon the Harp** and **Gala and the Angelus of Millet Immediately Preceding the Arrival of the Conic Anamorphoses,** reproduced in *Le Surréalisme A.S.D.L.R.,* No. 6 (May 15, 1933). Another series of pictures had exploited the theme of William Tell, with the Swiss patriot appearing as the hero of an 'enigma' or of some complex (presumably of frustration). One of the images in this cycle is remarkable for the sheer fantasy of its flying pyramids of obsessional objects, old women with beards, pianos with tails, putrescent donkeys, and so on.

After that, the author of **The Lugubrious Game** made a great commotion about 'anamorphic' images, resembling the vapid reflections of the distorting mirrors of fairground sideshows, which do in fact provide rather Dalinian views of reality: anyone contemplating himself in such mirrors may see all the marks of invincible genius or congenital cretinism, passing through the whole spectrum of the most unlikely morphological accidents. Then came another sideshow, 'anaglyphs'; Dali discovered a curious book on this subject which he recommended to all his friends. He announced that he intended to paint anaglyphic pictures: these would appear to be three-dimensional when looked at through special glasses. But the project was not executed.

Most notorious of all, perhaps, were his dithyrambic eulogies of Meissonier, that finicky calendar illustrator who was one of the best paid painters of his time and is considered today to be one of the most worthless of any age. Dali undertook to rehabilitate this nullity, and lavished the full resources of his fertile imagination on the scheme. When I mentioned the 'chronogram' photographs in the first issue of *Minotaure,* he immediately assured me that Meissonier's picture, *1819,* depicting Napoleon and his general staff on horseback in a landscape of churned-up ruts and mud, was a chronogram of the movements of a horse, 'because the horses in this picture all had their legs in different positions'. (pp. 208-09)

Dali's ceaseless interventions contributed in no small measure to the movement's continued effervescence, and he soon achieved a position of prime importance in Surrealism. (p. 213)

But Breton had been well aware, from the beginning, of the dangers lying in wait for this new recruit. In his introduction to the 1929 exhibition at the Galerie Goemans, he had written: 'Dali is like a man hesitating (his future will show that he did not hesitate) between talent and genius, or, as one would have said in a previous age, between vice and virtue.' Couched in these terms, the prophecy could hardly fail to turn out true in one way or another, but Breton's preface became more explicit in a later paragraph:

> On one side there are the mites which attempt to cling to his clothes and never to leave him even when he goes out into the street; these particular mites say that Spain and even Catalonia is fine, that it is thrilling that a man can paint such small things so well (and that it is even better when he *enlarges*), that one person with his shirt stained with shit, like the one in **The Lugubrious Game,** is worth thirty well-dressed men and even more than a hundred naked men and that it is about time the rabble should be cock of the walk in our beloved country

and its fallow capital. . . . On the other side there is hope; the hope that everything will not crash into ruins after all and that, to start with, the sound of Dali's admirable voice may continue to ring true in his own ears, despite the interest that certain "materialists" have in persuading him to confuse it with the creaking of his patent-leather shoes.

The provocative scatology of some of Dali's themes, his declarations on the virtues of putrefaction in which he praised what he claimed to be its 'terrorizing' effect, might lead one to think that he was too apt to confuse terror and disgust, the latter sentiment being in general unpropitious for opening the path to knowledge. On the other hand, his ultra-finicky technique was very popular with a number of collectors of modern art whose nostalgia for academicism was thus gratified. But despite all this, Surrealism pinned its hopes on this artist who was so anxious to place 'the ideal images of Surrealism' (his own paintings) at the service of 'the imminent crisis of consciousness', at the service of the Revolution; who denounced any activity of a *foreseen* nature in categorical terms: music ('song takes on the thousand atheistic forms of the praises of God'), the cult of classical beauty, of harmony ('this is harmony, this is filth, this is the realm of sheer shame'); . . . who finally drew a picture of the Saviour with a flaming heart and this inscription underneath: 'Sometimes I spit on the portrait of my mother from sheer pleasure!' With their second film, *L'age d'or,* which was shown at the end of 1930 at Studio 28, Luis Buñuel and Salvador Dali achieved far more than a simple demonstration of their continued attachment to Surrealism: they provided new fuel for 'the soul of the group' with their sensationally direct approach and images of violence and revolt pitched to the highest possible degree of intensity. (pp. 213-14)

While this film deliberately refused in advance the kind of success achieved by *Un chien andalou,* it was nevertheless stamped with the same simplicity of expression and technical virtuosity as its predecessor. Its scandalous potentiality was so much the greater, and the years have not weakened its power: it is still impossible to show *L'âge d'or* today except in the small auditoriums of a few cinema clubs. The scenes include 'a blind man being ill-treated, a dog squashed, a son killed almost wantonly by his father, an old lady slapped, an unconsummated love-scene dominated by the violence of frustrated actions,' and symbolic images like that in which the heroine sucks with rapture the big toe of a marble statue of Apollo. As a final shock to the sensibilities, the Comte de Blangis, Sade's protagonist in *Les 120 journées de Sodome,* appears in the guise of Jesus Christ ('this latter episode is accompanied by a *pasodoble*'); the last image in the film is of a crucifix on which several women's scalps are nailed. (p. 214)

From the pictorial point of view, Dali's paranoiac-critical method achieves concrete form in the process of the *double image.* This, basically, is the often engaging game of puzzle pictures: 'I've lost my sheep, where can they be?' asks the shepherdess, and the sheep are revealed in the outlines of the branches of a tree, in the grass or in rocks. From the double image one passes to the multiple image, in which the same picture can represent several different images at the same time. To illustrate this theory, Dali accomplished several genuinely curious *tours de force:* **The Phantom Cart** (1933), **Nostalgic Echo** (1935), **Spain** (1938), **Old Age, Adolescence, Infancy** (1940), etc.

It is questionable whether an absolute freedom of interpretation and creation is really the concern of concrete things. What would total liberty represent, ultimately, except nothingness? Even if it were possible for a person to do exactly what he wanted, his activity would inevitably be devoid of any sense or form. The very concept of the *object,* as we have seen, presupposes the idea of an obstacle. True creation, creative freedom, is a struggle to liberate oneself from a fixed and determined past, but at the same time it is based upon another determination—that of its own future.

What is involved essentially is the reality of symbols. The picture which represents one anecdote can convey another or several others, but with the whole contained within a more general theme. Dali's multiple image is a superimposition of anecdotes, but it is simple in the sense that it expresses a single symbol under various pretexts. The cluster of meanings contained within a single picture is far from being arbitrary. In the Rorschach test, for instance, one subject may interpret an image symbolically which another subject will envisage entirely differently, but the two different visions derive from more general systems which embody yet other types of interpretation.

Dali seems to have foreseen this objection because, in his book *La femme visible,* the symbolic construction appears also as a pyramid of associations culminating in a 'gratuitous point . . . absolutely proof against any psychosensory influence'. In *The Conquest of the Irrational,* the paranoiac-critical method is even reversed and the author declares that 'pictures as different as *La gioconda,* Millet's *Angelus* and Watteau's *The Embarkation for Cythera* signify exactly the same thing'.

It seems, in fact, that the structure of Symbols is much closer to being a genuine *language,* relatively free and creative, certainly, and capable for this very reason of expressing its individual and subjective aspects. The paradox in Dali's case lies in his attempt to uproot symbols in order to ascribe an arbitrary sense to them. But we are never as 'gratuitous' as we would like to be. Take, for instance, one of the artist's most curious inventions, that of the *soft watches* (*montres molles*) which are to be seen for the first time in **The Persistence of Memory,** painted in 1931, as objects in a landscape that resemble watches but have the consistency of limp rags. 'You may be quite sure,' wrote Dali in *Conquest of the Irrational,* 'that the famous soft watches are nothing else than the tender, extravagant, solitary paranoiac-critical camembert of time and space.' Although Dali's commentators have apparently all accepted this version, we may have on the tip of our tongue (appropriately enough!) an entirely different explanation from that of the relativist cheese. If the paranoiac-critical method is anything more than an imposture, it can bring us in this instance an infinitely more coherent interpretation.

The word *montre* (watch) is a word-image with a double meaning: in French, it is the imperative of the verb *montrer* (to show) and the name of the apparatus *montrant* (showing) the time. But there is a very common childhood experience: the doctor asks the sick child to *'montrer sa langue'* ('show his tongue'), which obviously is soft. The child, we may say, *la montre molle* (shows it soft: with the double sense that in French this phrase can also mean 'the soft watch'). The irrational and even anguishing nature of this act for the child, in view of the circumstances, could

certainly constitute an experience capable of leaving profound impressions in the psyche. Here, then, is a most concrete origin for the image of the soft watches, an origin founded in an authentic childhood memory; this seems to be confirmed by the title of the picture, which may not have been premeditated by the artist but remains far from 'gratuitous', as can be seen. The watches in *The Persistence of Memory* resemble tongues more than anything else.

The word-play is untranslatable into Spanish, but the picture was painted in Paris when French had already become Dali's second language. A later picture of his, painted in America, with the rather farcical title *Uranium and Atomica Melancholica Idyll,* depicts among other things a watch ending in a tongue. In English, the phrase: 'Watch your tongue', while not an equivalent of *'montre ta langue',* conveys the same sense of adult supervision of the child's activity.

It would have been most interesting if the artist had indicated clearly the true explanation, but one can easily understand why, consciously or not, he has preferred to conceal it behind the deceptive symbol of Einsteinian camembert. The image of the soft watch is not only double but multiple: the tongue itself is a symbol, that of a soft penis. Dali has always been haunted by ideas of deficiency. The great number of crutches and of figures deformed by soft extensions or substitutions, which he has always enjoyed painting, is revealing. The case of Dali provides a good illustration of Adler's theory that anxiety about insufficiency is balanced by compensatory ideas of power: his paintings often include human figures whose heads are fantastically swollen. (pp. 217-18)

The happenings in the outside world during this period— Hitler's rise to power in Germany, and the political reactions of the left-wing parties to this new menace—gave rise to repeated discussions within the group. But Dali appeared less and less often at these conventicles, and in 1933 refrained from following his friends into the Association of Revolutionary Writers and Artists (the *A.E.A.R.*) which had just been founded. Their previous dealings with the politicians of the extreme left-wing allowed the surrealists no illusions as to the possibility of their achieving effective action in this alliance which came under Communist control from the start; but they did not think fit to refuse *a priori* their participation in the enterprise, having already proposed the same idea themselves: they had, indeed, not long before, attempted to set up an organization of this type which would have grouped writers and artists of revolutionary convictions. The surrealists were, in any case, very quickly excluded from the *A.E.A.R.,* or they resigned, as a result of a whole series of incidents which almost immediately led them into conflict with its Communist leaders. But even if Dali's refusal to embark on this sad adventure can thus be justified in retrospect, a much more disquieting aspect of his political tendencies was the interest he began to show in Nazism and in the personality of Hitler. It was charitably considered to be humour— which it was, no doubt, but of a dubious kind—when themes such as the 'Hitlerian nurse' began appearing in his pictures. Dali's contribution to a pamphlet devoted to Violette Nozières was considered by some of the surrealists to be a joke in extremely bad taste, consisting as it did in a 'paranoiac portrait of Violette Nazières (Nozières)',

a repulsive-looking figure with sagging breasts, and an immense nose supported by a crutch, with the explanation: 'Nazi, Dinazos, Nazière.—Nez' ['Dinazos' is a term used to designate members of a Belgian Hitlerite group].

Another approximation of the same kind was contained in a huge picture which Dali painted shortly afterwards, entitled *The Enigma of William Tell,* in which Lenin appears without his trousers, one of his buttocks fantastically elongated and resting, of course, on a crutch—a very different painting from the kind of mystical vision which the leader of the Russian revolution had previously inspired in him: *Six Apparitions of Lenin on a Piano.*

In January, 1934 it was decided to call Dali to account, and he was summoned to the rue Fontaine where the group was assembled in André Breton's studio. The tone of the discussions, which was calm to start with, very soon became heated, and it must be admitted that the show (there were several performances) was well worth seeing. The number of gags which the painter of *The Lugubrious Game* invented on these occasions would have made the fortune of a variety theatre. Pretending to have flu, he declaimed with a thermometer in his mouth, occasionally interrupting himself to read his temperature. He kept pulling up his socks, and, like the character in Molière's *Précieuses ridicules,* started peeling off layers of extra undergarments, he knelt down at Breton's feet as though he were confronting the Blessed Sacrament, he began reading out a preposterous communication intended to demonstrate the surrealist and Maldoror-like character of his admiration for Hitler. But he had gone too far. At the point in his speech where he reached the phrase 'But, in my view, Hitler has four balls and six foreskins . . . ' Breton interrupted him brutally with: 'Do you intend to bore us much longer with this damn nonsense about Hitler?' Dali was so taken aback that he stopped his peroration, and nobody ever knew what other characteristics he might have ascribed to the Führer's morphology.

Beneath its eccentric mask, his argument was limpidly dogmatic. Basing himself on the original definition of Surrealism as the dictation of thought outside all esthetic or moral considerations, etc, Dali was in effect saying: I transcribe my dreams, therefore I have no right to exercise any conscious control over their contents; is it my fault if I dream of Hitler, or Millet's *Angelus?* Turning to Breton, he shouted, above the laughter of the company: 'Every night I dream that I'm buggering you' (he used a more forcible term) 'so I have the right to paint my dream, and I shall paint it!' Needless to say, he did not.

At this stage of the debate it might have been pointed out to him that Surrealism was not obliged to sponsor any or all of his private obsessions. It might also have been added that the initial theories of Surrealism seemed rather out of date by now; that, in addition, the purely oneiric origin of his pictures was by no means convincingly established; and that, finally, concerning the Hitler-Maldoror 'analogy', the regime of terror instituted by Germany's new masters represented essentially the wrong exit from a patriotic-economic dead-end, which really had absolutely nothing to do with Lautréamont. It must be said in Dali's defence that his opponents in the room were far from having reached a unanimous, or, for some of them, simply a clear opinion on these questions. Also, to his eternal credit, he had succeeded in creating an atmosphere remarkably un-

conducive to any rational and logical argument. Neverthe-less, some of those present, more annoyed than amused by the stratagems of the one-time author of *L'âge d'or,* made no attempt to hide from him their opinion that his Hitleri-an fantasies seemed to indicate to them, in view of the menacing future, a carefully calculated submission in which Surrealism wanted no part and to which it would lend no support. 'But,' replied Dali, this was just 'primary surrealism.' 'And who are these primary surrealists?' thundered Breton: 'name them!' 'It is André Breton at the moment,' retorted Dali.

In fact, Breton was by no means anxious to separate him-self so hastily from such an excellent publicity-agent for Surrealism: he was more concerned with checking Dali's ebullience. And, for their part, Dali and his wife Gala would have been extremely inconvenienced by a condem-nation, which might have had serious effects on the sale of his pictures. During these goings-on, Tzara, Eluard and Crevel were all on the Riviera and had written to oppose any idea of excluding Dali during their absence. However, during the course of one last heated discussion, Dali was indeed excluded, and soon afterwards a few members of the surrealist group, including Breton, agreed in writing to 'fight him by every possible means'.

Finally, the affair petered out. The fascist riots in Paris of February 6, 1934, and the ensuing counter-attack by left-wing groups, engaged the whole of the surrealists' atten-tion and time. Given the alert on February 7 by a group of young intellectuals, the surrealists collaborated in the formulation of a *Call to Action* which brought together a great number of signatures and provided the first step to-wards the formation of the Committee of Vigilance of Anti-fascist Intellectuals.

The Dali case became of secondary importance, while the artist, from then on, ceased attending the regular meetings of the group. But he was still invited to contribute to most of the surrealist exhibitions, and was even able to hang *The Enigma of William Tell,* prominently and without any untoward incident, in the guise of a 'phenomenon of affective cannibalism' among the other paintings in his ex-hibition at the Galerie Jacques Bonjean, from June 20 to July 15, 1934. (pp. 219-23)

> *Marcel Jean with Arpad Mezei, in their* The History of Surrealist Painting, *translated by Simon Watson Taylor, Weidenfeld & Nicol-son, 1960, pp. 177-226.*

Elizabeth C. Baker (essay date 1968)

[*In the following excerpt, Baker discusses* Pax Vo-biscum (1966), *a collaborative work of art by Dalí and New York jeweler Carlos Alemany composed of painting and gemstones.*]

Dali refers to his latest extravaganza in gold and precious stones as a "jewel for contemplation." Actually, it has lit-tle of the expected frivolity of a Dali jewel or *objet de vertu;* in its blazing ostentation and traditional format, it is an icon. Titled **Pax Vobiscum,** the piece was designed by Dali and executed by him and his collaborating jeweler, Carlos Alemany of New York. It has been bought by the Owen Cheatham Foundation, with whose collection of Dali jew-

elry it is currently touring various U.S. museums. . . . (p. 45)

The most prominent feature of this intricately-wrought foot-and-a-half-high showpiece is the central pointed-arch window whose shutter is an enormous topaz, which con-tinually opens and closes, moved almost imperceptibly by a motor. It alternately reveals and conceals a Dali-painted face which is simultaneously a trompe-l'œil landscape, one of those familiar dream-vistas filled with nostalgic, mellow light. An angel casts a long thin shadow and does double duty as the nose, and a branch of coral forms an irregular mouth.

The thickness of the topaz makes it necessary that the painted insert be recessed a considerable distance, and thus an actual remoteness is added to illusory depth. Spiky metal radiations of the halo are diamond-studded. The transparent topaz fragments the face into facets when it is closed. Everything else is different densities of gold, with peridots.

Dali writes, "Through the labyrinths of world tensions, a tabernacle of hope for peace opens. In the sky of the Sav-ior's forehead the cypresses of creation ascend towards final universal unity. The angel and the coral are the sym-bols of cosmic incorruptibility." However, the piece looks more traditional than it is. The face is not exactly Christ; the hands, though represented by red coral which could suggest stigmata, are not specifically this (mainly, they are startling patches of brilliant color). Dali has spoken of his face-apparition as a kind of "guru," adding that the ceme-tery cypresses and Catalonian olive trees embody life, and the topaz, hope—but in any case, it is not dogma as such that is involved, but rather a kind of vague, religio-mystico-spiritual, incantatory communication, housed in a physical splendor which is an end in itself.

Altogether something of a blockbuster, this is an exceed-ingly curious object. On the one hand, it can be seen as ex-pensively corny neo-Catholic flummery, fraught with moribund ideas—a ritualistic re-casting of a religious trea-sure spiked with a touch of Surreal hot sauce. On the other hand, it seems to recapture in somewhat different form and rather unexpectedly, some of what characterized Dali's earlier work at its best. (The fact that most of the piece was not made by Dali himself should hardly be an issue in this age of custom-fabricated art.)

That Dali's temperament and way of seeing, along with his passionate craving for precious substances, would lead to jewels, seems inevitable. Some of his early small paint-ings are not so much painted as they are crafted—his paint is not paint, but a neutral substance which causes objects to appear with hallucinatory precision. They exist as if in atmosphereless, dramatically-lit showcases. Whether rock-insects, watches, putrefying organic excrescences or strange boxes (like ghostly precursors of Minimal sculp-ture), all surfaces are identically gemlike in their clarity. Similarly, some of Dali's recent jewels are hard objects which double for his painted ones; they seem to epitomize a whole area of his work and are, perhaps, what many of the paintings aspired to, in their small concreteness.

Dali's work is rarely subjected to a hard scrutiny, and it is useful to see what this "icon," loaded with extra-visual baggage, consists of on its own. Its various disparate ele-ments work unexpectedly well together. The gold foliage

massed in layers of overlap and undercut, is delicate and fragile in workmanship, but as an aggregate it is harshly physical and insistent as a surface. It contrasts with the deep central hole and the face-landscape with its ethereal spaces. Also contradictory, the coral is painted trompe l'œil but looks more real than the gold and stones, which blur impressionistically through reflection and glitter.

The most striking element of the goldwork, and in fact of the entire piece, is the flat strapwork which cuts repeatedly across the leafage with perverse, almost obliterative insistence. Dali interprets these bands as cosmic lines of force, or crystalline structuring of matter. As in his DNA pictures or his "atomist" ones, he appropriates the aura of far-out science with which he feels inextricably linked. But the major visual effect of the straps is that they give an appearance of toughness and flatness to the Rococo insubstantiality of the leaves, imprisoning them like a rigid cage, and producing visual unity through brute force.

All this physicality bolsters the face-landscape; more important, it turns it into a kind of painted object—partly because its formula is so totally recognizable, partly because it is only a small element in the whole. By self-imitation, Dali has made his own earlier style into a miniaturistic insert, encased in pomposity. The doleful, soulful eyes seem as ironical as the chromo-landscape—the double image super-Surreality of the face is a quotation which is not without Pop overtones. It looks almost as campy as the mustachioed Mona Lisa, or as an old taxi-cab.

The real spirit of Surrealism is absent with a vengeance. So is religiosity. Instead, this is a virtuoso performance which grabs for ideas with Dali's usual voracious eclecticism. There are traces of the Byzantine icon, the Spanish retablo, medieval illumination, a fin-de-siècle decadence gaudier than Gaudi, close to Gustave Moreau (whose disembodied, spikily haloed *Apparition* is recalled). But what is most ironic is that Dali has somehow also been involved in aspects of the '60s with this icon. It is simultaneously Pop (the gold leaves seethe like Rosenquistian spaghetti), kinetic (the motorized door) and an Object. (He is hardly an Oldenburg, but his sympathy for various Pop artists, some of whom he has written on, is relevant.) All of this is no more preposterous than the fact that this should turn out to be one of Dali's more substantial recent works. (pp. 45, 61-3)

> *Elizabeth C. Baker, "Dalí: Making It Surreal," in* ARTnews, *Vol. 67, No. 3, May, 1968, pp. 45, 61-3.*

J. H. Matthews (essay date 1977)

[*A Welsh critic, Matthews is considered one of the foremost scholars specializing in Surrealist literature, music, art, and film. In the following excerpt, he analyzes Dalí's celebrated paranoiac-critical method and assesses his contribution to the development of Surrealism.*]

A surrealist picture by Salvador Dalí possesses, as image, a value quite independent of certain painterly qualities, many of which the critics have deemed reactionary. The distance separating surrealist criteria from those applied by art critics may be estimated if we contrast Sidney Tillim's—as implied in his judgment, "The Surrealists had nightmares because they couldn't paint too [*sic*] well"—

with André Breton's comment on the painting of Max Walter Svanberg, to the effect that the criteria currently presiding over the appreciation of painting done by surrealists appear "ridiculous in the presence of work like this." In the case of some important graphic products of surrealism it is no paradox, and no excuse, either, to say that surrealists deny painterly technique in the interest of the image. Attention is directed primarily to what is shown, made visible. . . . The way visual effects have been obtained is quite definitely of secondary interest here. Eloquent testimony to this underlying feature of surrealist creativity is the outdated meticulousness of photographic realism, as revived by Dalí, or the customary flatness of a Magritte canvas, where perspective receives cursory attention at most. (pp. 26-7)

Inflated as it sounds to those whose ear is not yet attuned to the resonance of certain words recurrently employed by surrealists, the closing lines of Dalí's essay "L'ane pourrissant" [see Artist's Statements above] faithfully reflect the surrealist point of view: "The ideal images of surrealism will serve the imminent crisis of consciousness: they will serve Revolution." Indeed, the special interest offered surrealists during the thirties by Dalí's celebrated paranoiac-critical method lay in its subjection of outer reality to the inner necessity experienced by the artist. For paranoia, as understood by Salvador Dalí, "uses the external world in order to assert its dominating idea and has the disturbing characteristic of making others accept this idea's reality." In this way, the reality of the outer world "is used for illustration and proof, and so comes to serve the reality of our mind." Hence Dalí's much publicized double images were obtained in a manner he termed "clearly paranoiac."

Although his use of the word "paranoia" was typically provocative, Dalí was behaving in conformity with surrealist directives. The paranoiac-critical method stands for something of more lasting significance than Daliesque self-advertisement. (pp. 51-4)

The special contribution made by Dalí to the surrealist concept of the reality of things is this. His paranoiac-critical method vigorously affirmed the polyvalent function of visible forms. "L'ane pourrissant" reduced natural inclination to theory, when it stated that the number of images visible to us is limited only by "the mind's degree of paranoiac capacity."

During the thirties, the very exaggeration of Dalí's claim made the surrealists listen attentively. They were ready to approve the general trend of his theory, even if not quite willing to agree with its systematic application. What really mattered to them, and would continue to do so after Dalí's exclusion from their company, was this. Poetic objects test our sense of what is real, of what makes objective phenomena real to us. It is of no moment that, in the end, treatment of the concrete materialization of dreams may lead somewhere different from the self-serving arguments expounded in "L'ane pourrissant." Dalí, after all, departed in some important respects from the surrealist standpoint. He opposed to objective reality "the intensity and traumatic nature of things," denying "interpenetration between reality and image," and asserting "the (poetic) impossibility of any kind of *comparison*," on the grounds that such a comparison, if it could be made tangible, "would clearly illustrate our notion of the arbitrary." Yet the arbitrary has no meaning in surrealism, except as a false im-

pression that inevitably must give way to a more reward-ing sense in which apparently unrelated elements and conflicting factors become excitingly one. (pp. 182-84)

J. H. Matthews, in his The Imagery of Surrealism, *Syracuse University Press, 1977, 293 p.*

James Bigwood (essay date 1979)

[*In the following article, Bigwood provides an overview of Dalí's contributions to the film medium.*]

"Contrary to popular opinion," wrote Salvador Dali in 1932,

> film is infinitely poorer and more limited for the expression of the actual functioning of thought than writing, painting, sculpture, and architecture. Nothing is beneath it but music, the cognitive value of which, as everyone knows, is practically nil.

Dali is nothing if not absolute. He has been making such pronouncements since the twenties, when he was a struggling member of the universally misunderstood and ridiculed surrealist movement. Over the years, surrealism's shock—and influence—have waned, but Dali, now seventy-five, is still thriving. In May he was admitted to the French Academy of Fine Arts. . . . (p. 62)

Since making his statement on film, though, Dali seems to have tried as hard (and as often) as possible to prove himself wrong. In fact, with the exception of Andy Warhol, Salvador Dali has made more ventures into the alien medium of film than has any other painter.

Dali's first film, *Un chien andalou,* made with Luis Buñuel, premiered in October 1929, and his magnum opus, *The Prodigious Adventure of the Lace-Maker and the Rhinoceros,* is in the process of being edited fifty years later. In the intervening years, numerous other projects have achieved various stages of completion—including collaborations with Alfred Hitchcock, Walt Disney, and even Harpo Marx.

But still the work of Dali the filmmaker remains virtually unknown. This is not as paradoxical as it might seem. Dali has deliberately cultivated a public image that is bizarre, flamboyant, and unpredictable, causing many observers to dismiss his work as superficial. Some film critics even disregard Dali's contribution to *Un chien andalou,* and instead use the film as the cornerstone for a monument to the career of Luis Buñuel.

But the works of Salvador Dali—in all media—are not haphazard frivolities. They follow a very formal structure which Dali has written about in numerous books and articles. He has developed an artistic theory derived initially from Freud and refined over the years into something he calls his "paranoiac-critical method."

The famous melting watches of Dali's best-known canvas, *The Persistence of Memory* (1931), epitomize his obsession with the "softness" of all objects—which his imagination reshapes into the multiple images and visual puns of his work. It is this metamorphic quality (which even Dali can only carry so far with canvas and oils) that dominates his film work. Film, with its numerous effects of fades, dissolves, and superimpositions, provides the ultimate metamorphic tool.

John Hench, who once worked with Dali at the Disney studio, describes Dali's technique:

> When we were doing *Destino,* Dali invented a brand-new motion picture device that had never been used before. Now D. W. Griffith must have covered everything from cross-dissolves to the flashback, but Dali made a dissolve that you weren't aware of. For instance, there was a shot of skiers coming down a hill. You cut to another hillock and the camera panned around. You had no indication that the scene had switched—but no skiers came over the snow. The camera pulled back . . . and it was the belly and hips of a nude. He'd made the switch way back in the scene, but you weren't aware of it. You persisted in thinking it was snow *built* like a woman, until it became absolutely impossible to believe anything except that it was a woman.

This was in 1946, but Dali had already tried the technique in a less sophisticated form in *Un chien andalou.* He turned the arm of a reclining woman into a sea urchin lying on a beach and, in an intensely erotic sequence, faded from the frantic fondling of a woman's breasts to the equally frantic kneading of her buttocks—melting the two sexual symbols into one.

Salvador Dali's first contact with the movies came early. He grew up in Spain, and throughout his childhood, films were screened in his home. Max Linder, Mack Sennett, Harry Langdon, William Powell became his favorites—and, for a while, so did Charlie Chaplin. (pp. 62-3)

But not until the early thirties did Dali discover his true idol—Harpo Marx. With a face Dali has described as that "of persuasive and triumphant madness," Harpo was a kindred spirit. His screen persona perfectly matched Dali's carefully cultivated image. Dali has been known to appear in public with a loaf of bread balanced on his head; Harpo would carry a steaming cup of coffee in his pocket. On one occasion Dali arrived to deliver a lecture dressed in a deep-sea diving suit and leading two Russian wolfhounds; he told the audience he wanted "to show that I was plunging deeply into the human mind." Harpo's clothes were no less unconventional.

Surrealists had long considered the Marx Brothers the leading exponents of screen surrealism, but Dali was the only one to act on the notion. He arrived in Hollywood in 1935 with a harp strung with barbed wire and an idea for a movie. He stayed with Harpo—who had absolutely no idea what surrealism was—and between them they developed a screenplay called *Giraffes on Horseback Salad.*

The film, of course, was never made. All that survives are a dozen of Dali's sketches and some cryptic notes for a scene in which Harpo, dressed as Nero and covered in chains, was to have been put on trial "for using money for mad and immoral ends, compromising public order—Groucho takes his defense." Not ideal material for 1935 Hollywood.

Giraffes was not the only film work Dali undertook in the thirties. In 1932 he published *Babaouo,* a screenplay with more technical detail than is found in any of his other non-collaborative film projects. In 1935 he turned out a synopsis, with sketches, for *The Super-Realist Mysteries of New York.* Neither project was filmed—hardly surprising, con-

sidering some of the scenes. In *Babaouo,* for example, Dali called for a scene with "an enormous bus, five times bigger than life, and inside it, on the water which fills it, a little boat in which three little Japanese legless cripples, their eyes all white, sing with great sensuality the rumba 'The Peanut Vendor.'" Another scene had "a violinist frozen in the passionate attitude of a virtuoso, and balanced on his head, a wardrobe of an average height, its drawers and doors open, showing linen overflowing in tumultuous disorder. This violinist in his fanatical pose will have his whole body resting on one leg, the cuff of the other pant leg carefully rolled up, and the bare foot plunged into a dish of milk."

Fortunately, his next collaborator—Alfred Hitchcock—was looking for exactly that nightmarish quality for the dream sequences in *Spellbound.* Hitchcock was tired of the conventional dream sequences with the swirling smoke made by dry ice and the camera slightly out of focus. He wanted to convey the dreams with visual sharpness and clarity, and Dali's style was exactly the opposite of misty dreams.

"I could have chosen de Chirico, Max Ernst—there are many who follow that pattern," Hitchcock once said in an interview, "but none as imaginative and wild as Dali."

Dali enjoyed working with Hitchcock, whom he described as "one of the rare personages I have met lately who has some mystery." But he was taken aback by the way his sketches were translated into sets. Dali wanted to hang fifteen huge pianos from the ceiling of the ballroom, swinging very low over the heads of the dancers. But the dancers would really be cardboard silhouettes placed in diminishing perspective into infinite darkness. Hitchcock accepted Dali's idea with enthusiasm.

"The idea was then passed along to the experts," Dali wrote in his short-lived *Dali News,* "because in Hollywood there are experts to perfect everything." Later, when Dali went to the studio to film the scene, he was "stupefied at seeing neither the pianos nor the cut silhouettes. Then someone pointed out to me tiny pianos in miniature hanging from the ceiling and about forty live dwarfs who, according to the experts, would give perfectly the effect of perspective that I desired."

"I thought I was dreaming," Dali continued.

> The pianos didn't at all give the impression of real pianos suspended from ropes ready to crack and casting sinister shadows on the ground (for another expert imitated the shadows of the pianos with false shadows projected with a very complicated apparatus). And the dwarfs—one saw, simply, that they were dwarfs. Neither Hitchcock nor I liked the result, and we decided to eliminate this scene.

Apparently, Hitchcock neglected to mention to Dali that the dwarfs were his own idea. He had used the same trick to achieve false perspective as a designer on *The Blackguard* in 1924. Though Dali's contribution to *Spellbound* was drastically cut as the film progressed, the result was impressive. The dream sequence remains a high point in a film which as a whole has not held up particularly well.

For Dali, though, *Spellbound* led to what might have been his most spectacular piece of film work—had it been finished. He was invited by Walt Disney to create a six-minute animated segment for a compilation along the lines of *Make Mine Music.* The segment was called *Destino,* and it became the epitome of his metamorphic style. "It was full of those double-image devices he loves so much," John Hench recalls.

> I remember one of the scenes with a large antique head of Jove. It was really an archway, but at first glance it was Jove, and then, as you approached it, you saw that it was the female protagonist with her round head as a ball, hummingbirds, and shells. Dali was very skillful at this manipulation.

As far as can be determined from the storyboards and the fifteen seconds of footage that were shot, the film segment was to have been in a constant state of metamorphosis. The outline for the opening scene offers a good example: A pyramid, carved in relief with a statue of Cronos holding a large clock face, stands on an endless plane. Perched on top of the pyramid is a round ball. The pyramid dissolves into a road drawn in sharp perspective, occupying the exact same space. Walking toward the camera, on the road, is a woman. The clock face becomes a large watch that sits on the road. The ball becomes the moon, which walks in the background on spider legs. The woman leaves the road, which is now occupied by lighted candles slithering like snakes. She becomes the negative space between the faces of a man and a woman gazing at each other.

The only sequence that was actually shot, Hench says, showed

> two jeweled tortoises which came from each side of the screen with appendages mounted on their shells—drapes and things—on one of Dali's limitless planes. There was a ball on the horizon, far away. The two tortoises came in and stopped, and a girl appeared in the space that was left between the two structures—the ball was the head—and she stepped down. It certainly was startling.

An example of what might have been had *Destino* been completed can be found in a recent television commercial, in which a Datsun was matted into an animated Dali landscape. It demonstrated that Dali's art, as expected, is perfect for animation.

Though the Disney studio could still revive *Destino*—the compilation project was abandoned due to cost—what will no doubt emerge as the ultimate Dali film is still in progress and has been for the past twenty-five years. The film is ***The Prodigious Adventure of the Lace-Maker and the Rhinoceros,*** and it is the only true Dali film to date, although he is again working with a collaborator, his friend Robert Descharnes. But the project, Descharnes says, exists only because Dali wants it to exist and not because somebody else asked him to do it. The film began almost accidentally. Descharnes had shot numerous photographs for Dali and had made several blowups of models for some of Dali's major oils. When Dali went to the Louvre in 1954 to paint a copy of Vermeer's *The Lace-Maker,* he asked Descharnes to film the event, which became a turning point in Dali's philosophy.

It was at this point that Dali discovered a connection between Vermeer's *Lace-Maker* and the horn of a rhinoceros (a connection, granted, that only Dali had observed). He insisted on painting the horns he felt were in Vermeer's

painting, and when he did, several months later at the Vincennes Zoo, that event was also filmed.

Dali and Descharnes then decided that the emerging film should be not mere archival footage, but a document presenting Dali's theories. Between 1954 and 1961, live footage was meticulously planned and shot on location in Cadaques near Dali's house, and since then, photographs, paintings, and documents have also been assembled. Together, they will describe Dali's artistic philosophy, which sees a logical progression from rhinoceros horn to *Lace-Maker* to sunflower to cauliflower to sea urchin to a drop of water to the goose pimples on the skin of a nude—all connected, Dali claims, by a logarithmic spiral scientifically traceable to DNA. But in the film Dali lifts his theories from the abstract by making stunning visual connections between the dissimilar elements.

This is the heart of the film, but by no means all of it. Throwbacks to earlier films (*Un chien andalou* especially: an idyllic pastoral scene by a lake which is suddenly revealed to be the face of Adolf Hitler) all form a part of a document which, when finished, may be not only the ultimate Dali film, but the ultimate comment by Dali on his entire career.

Dali has involved himself in several other film projects since beginning *The Prodigious Adventure,* including *A Soft Self-Portrait of Salvador Dali* in 1968, *Hello, Dali!* for the BBC in 1973, and *Voyage to Upper Mongolia* (which incorporates the Hitler image already described) for West German television in 1974. *A Soft Self-Portrait,* though essentially a documentary, contains two amazing images as important as any Dali has filmed.

One, lifted from *Destino,* shows a man and a woman facing each other. They pull away out of the shot, but the white space between their faces remains. It turns out to be Dali, wrapped in a sheet and wearing a pointed white hat. The second involves the transformation of a little hill planted with cypress trees into the face of a woman made up as Pierrot. But despite these digressions, *The Prodigious Adventure* remains Dali's one true film since it avoids what Dali considers to be the negation of film as an art. (pp. 63, 70-1)

James Bigwood, "Salvador Dalí: Reluctant Filmmaker," in American Film, *Vol. V, No. 2, November, 1979, pp. 62-3, 70-1.*

Edward B. Henning (essay date 1979)

[*A curator at the Cleveland Museum of Art in Ohio, Henning is the author of several full-length works on modern art. In the following excerpt from the catalog to a Surrealist exhibition held at the Cleveland Museum in 1979, he discusses Dalí's relation to the Surrealist movement and examines some features of his early works.*]

The strange career of Salvador Dali is one of the enigmas of the Surrealist movement. Once considered by Breton and other Surrealists to be a brilliant young artist who would carry Surrealism forward into new areas of psychic investigation, he was later denounced by them for his reactionary politics and avaricious actions. (p. 98)

In 1929, the year he painted his first Surrealist pictures,

he was visited by Magritte, Paul and Gala Eluard, and the dealer Camille Goemans. (He had already met Picasso and Miró on his trips to Paris.) At that time he was engaged in painting his first major Surrealist picture, **Le jeu lugubre (The Lugubrious Game),** which he regarded as a personal manifesto.

Almost immediately a close relationship developed between Dali and Gala Eluard; it resulted in her deserting the poet to marry Dali. Her influence on his work has been so great that he has even signed some of his paintings with both their names. It was she who convinced him to put his thoughts down for the composition *La femme visible (The Visible Woman)* in 1930. She then organized these into a statement revealing his creative method that he called "paranoiac-critical." . . . [Dali] accepted the Surrealist emphasis on free association but went beyond it in simulating a state of paranoiac delirium in order to generate the images which served as the basis for his creative act.

Dali was careful to make clear that he was not truly paranoid (paranoia being a mental disorder characterized by delusions and hallucinations), but that he could induce this paranoid-like state at will and thereby use self-induced hallucinations to stimulate his imagination. He also stressed his power of seeing multiple images in fully defined, discrete images by concentrating intensely on the canvas.

Dali made greater use of Freudian symbols (and images derived from his reading of Krafft-Ebing) than any other Surrealist painter; and Freud was more interested in Dali's work than in the other Surrealists' works or theories. The psychoanalyst was visited by Dali in London in 1939 and admitted that he found this strange young Spaniard fascinating. However, Freud—whose own analyses of works of art are somewhat less than profound—suggested to Dali,

> It is not the unconscious that I seek in your pictures but the conscious. While in the pictures of the masters—Leonardo or Ingres—that which interests me, that which seems mysterious and troubling to me, is precisely the search for unconscious ideas, of an enigmatic order, hidden in the picture. Your mystery is manifested outright. The picture is but a mechanism to reveal it.

Dali has been more than a painter and theorizer, however; he has also designed jewelry, furniture, dresses, and store windows, as well as sets and costumes for the ballet. He has made prints, organized carnivals, and collaborated on films. Yet his most striking creation remains himself: the mad dandy, leading an ocelot on a leash down Madison Avenue. Far from being mad, however, he attempts to expose the insanity and stupidity of society by means of his solemn clowning on the one hand, and commands attention and garners rewards for his bizarre and entertaining behavior on the other. He protests against the word clown as applied to himself, however: "I am the *Divine Dali*. . . the word 'harlequin' is synonymous with Hermes, with Mercury as a go-between . . . makes me . . . a harlequin."

Dali has said his ambition is to make of painting handmade photography in color. His idols are Vermeer (above all), Velásquez, Raphael, Bouguereau, Millet, and the late nineteenth-century academician Ernest Meissonier. Dali's technical ability to produce slick, overall surfaces does in-

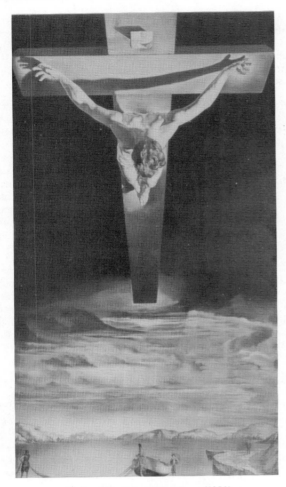

Christ of St. John of the Cross (1951)

more, his method for *controlled* simulation of a paranoiac condition was intended to be applied to all actions and not just the production of paintings. Although Dali's technique is closely related to that of Meissonier, his painting contains elements related to works by Chirico, Ernst, Magritte, and Tanguy (especially the latter's extended spaces and carefully modeled shapes). Dali's results, however, are quite different from works by any of these painters.

His insistent perversity finally caused him to react against the Surrealist program. In the face of Surrealism's dalliance with Communism, Dali accepted the Cross of Isabella the Catholic from Generalisimo Franco and was reconciled with the Catholic Church. He also seemed obsessed by the figure of Adolf Hitler. Confronted with this charge by Breton, he "innocently" replied that as a Surrealist he was committed to recording his dreams without any outside intervention and that it was not his fault if he dreamed about Hitler. Finally, contrary to the Surrealists' anti-bourgeois, anti-capitalist stance, he came to the United States and hired out his talents to outrageously commercial ventures.

In recent years he explained his acceptance of the Falangist decoration by insisting that he has always rebelled against his bourgeois background and has touted the virtues of aristocracy and monarchy at the same time that he was an anarchist:

> . . . both aim at absolute power. I accepted the Cross of Isabella the Catholic from Franco's hands simply because Soviet Russia never offered me the Lenin Prize. I would have accepted it. I'd even consent to a badge of honor from Mao Tse-tung. I've never committed myself. . . . Only people with a servant's mentality commit themselves. I prefer being a nobleman and so I couldn't ask for anything better than being covered with all kinds of medals.

As for his commercial ventures, he explains,

> I am a supreme swine. The symbol of perfection is a pig. . . . The pig makes his way with Jesuit cunning, but he never balks in the middle of the crap in our era. I feed my crap to the Daliists. Everybody's satisfied. . . . I've always been impressed by what August Comte wrote. . . . He felt that we cannot build the world without bankers. I myself decided that for my personal and absolute power, the essential thing was to have lots of money.

Concerning the time that he spends in the United States, he says he lives there simply "because I'm always in the middle of a cascade of checks that keep pouring in like diarrhea." He refers to "Daliists" as parasites and *arrivistes,* at the same time admitting that he himself is a great *arriviste.* "I get more out of them than they get out of me. They give and they give. And I profit immensely." Concerning his return to the Church, he compares his attitude with Voltaire's: "Whenever he passed a monstrance he would doff his hat. One day an astonished friend cried out: 'I thought you were an atheist.' Voltaire rejoined: 'Listen, God and I are not on speaking terms, but we do greet one another on the street.'"

Finally, about his own paintings, he says: "They're badly painted . . . the *Divine Dali* of today would be incapable of doing even a mediocre copy of a canvas by Bouguereau or Meissonier, both of whom could paint a thousand times

deed rival Meissonier's; however, he uses his technique to beguile his audience into accepting the hallucinatory images that he creates. Obsessed with erotic and scatalogical subjects, his iconography deals openly with onanism, putrefaction, excrement, voyeurism, castration, and impotence.

The small, jewel-like paintings that he did during the half-dozen years following 1929 are his most impressive works. These pictures [according to William S. Rubin] "are ideal for an image projected from the imagination, analogous as they are in size to the 'screen' of the mind's eye, which we feel to be located just inside the forehead."

In the second Manifesto of Surrealism published in 1930, Breton recognized that Dali added a new dimension to Surrealism. In this Manifesto Breton deplored the fact that automatism, which he had hailed in the first Manifesto, often led to the creation of works of art rather than the liberation of man through self-knowledge gained by exploration of the unconscious. At the time, the Surrealists did not consider Dali's paintings to be works of art, since they were not concerned with formal values and their subjects were derived from his so-called "paranoiac-critical" method. Their primary significance lay in their role as evidence of the artist's investigations of his unconscious. Further-

better than I can." Earlier he had said: "I have always affirmed that I'm a very mediocre painter. I simply believe that I'm a better painter than my contemporaries. If you prefer, they're much worse than I am."

When is Dali serious? Is he a poseur and opportunist who, according to Breton's accusation, has sold himself for dollars? Or has he taken Jarry's advice and made his life "a poem of incoherence and absurdity" in order to demonstrate his "contempt for the cruelty and stupidity of the universe"? His arrogant attitude, even toward his admirers, tempts one to believe that he is fully aware of the implications of his actions. Perhaps he has made of his life a continuous Surrealist act, so extreme that it mocks the seriousness of Surrealism itself. Many people, and most Surrealists, believe that he is a Surrealist *manqué*—that, like Chirico, he has simply lost his way. He himself has said that he goes through life appearing to make fun of everything, and "that is what most successful dandies do. . . . But whatever happens, my audience mustn't know whether I'm spoofing or being serious; and likewise, I mustn't know either. . . . "

Yet, for more than ten years Dali did produce major works such as *Accommodations of Desire, Illumined Pleasures,* and *Angélus architectonique de Millet.* Rubin has analyzed *Illumined Pleasures* in detail, tracing the symbolic images to their sources. Since many of these motifs play an important role in Dali's early works, a brief summary may serve as a clue to other paintings of this period.

[In *Illumined Pleasures,* three] boxes containing different scenes appear in the foreground of an extended, flat landscape. Various images that play a significant role in Dali's symbolic iconography surround the boxes; many of them can be traced to the influence of other artists (including Chirico, Ernst, Magritte, and Tanguy) and to Dali's early life.

The central and largest box contains Dali's self-portrait which rests face downward with eyes closed (an image which reappears in many of his early works). Rubin points out that this attitude was suggested to Dali by two anthropomorphic rocks at Cape Creus. Irregularly shaped holes cut in the covers of the boxes reveal other images; especially significant is the grasshopper, which Dali sometimes calls a locust or a praying mantis. The multiple associations of this image, also repeated in other paintings, include onanism, the connection of erotic elements of sex and of eating (Dali referred to the luscious, crunchy taste of locusts), and Dali's childhood fear of being eaten. . . . (pp. 98-101)

The left-hand box contains a photographic image of architecture which refers to Ernst's early collages, and a male figure gesturing magically at a cephalic rock. The right-hand box depicts a crowd of Magritte-like men on bicycles with sugared almonds on their heads (according to Dali: "the sugared almonds of the Playa Confitera which tantalize onanism").

The surrounding images include a column of birds clearly referring to Ernst's bird images; a lion's head (Dali's father image) joined with a leering woman's head, which is also a pitcher (an obvious Freudian symbol of the woman as a vessel); an apparently shamed young man on the right side of the central box; the father image holding a woman

attempting to cleanse her bloody hands in a miniature wave, while her hand holding a bloody knife is seen to the left being restrained by another hand. Rubin remarks that any interpretation of this must be speculative since, unlike the other images, it does not appear in any of Dali's other works. One perhaps-too-obvious interpretation is that of the castrating mother; however, there are many other possibilities. In the distance a metal, cephalic, seamed shape . . . is torn open to reveal a toupee, which appears in other paintings by Dali and in several by Chirico. Near this image two male figures embrace in a manner suggesting Chirico's *Return of the Prodigal.* The ominous cast shadow in the foreground is another Chiricoesque device.

The dominant figure in this work is the father, and the major theme is onanism. Dali's startling clarity and technical precision seem to shock and fascinate his many admirers.

Accommodations of Desire reveals many of the same images. The lion-father image is repeated nine times—partially or completely—most often on boulders strewn across the flat landscape. The woman vessel appears on the left and the father embracing the shamed son while biting his fingers appears in the upper right center of the painting. One of the rocks is covered with ants, referring to overwhelming sexual desire.

Hallucination partielle: Six images de Lenine sur un piano (Partial Hallucination: Six Images of Lenin on a Piano) painted in 1933, is one of the very few paintings in which Dali refers to the political concerns of Surrealism. The figure seated with his back to the viewer may be Max Ernst, judging from the shock of light hair and the lean figure. In 1932 Ernst was blacklisted by the Nazis; here he seems to be contemplating the hallucinatory father image of Lenin, but the music sheet above is covered with the ants of sexual desire. The luscious cherries on the chair again suggest the association of sexual and gustatory eroticism, and the great rock formation outside a half-open door culminates in the head of a young woman. The piano top repeats the angle and invites opening of the door. The seemingly obvious implications of the combination of political and erotic images in this painting are surely too simple. The dangers of speculation, however, forbid drawing further inferences.

Jean-Francois Millet's famous painting *The Angelus* has provided the theme for a number of Dali's drawings and paintings. For Dali, the religious sentiment simply concealed its sexual implications. One of the most successful versions is his painting *Angélus architectonique de Millet* done in 1933. The figures of the peasants have been replaced by great looming, anthropomorphic rocks with Gaudiesque architectural overtones. The female image is on the left, head bowed as in Millet's painting; she can be identified by the orifice in the center of her form. The smaller male form penetrates her with an enormous erect member while at the same time he is supported by one of Dali's crutches (perhaps doubling for one of Millet's peasant's pitchforks). Beneath this great sexual act by the "figures of the earth" a father and son walk hand in hand toward a small figure in the distance before low-lying hills and buildings.

Cardinal, Cardinal, painted by Dali in 1935, is signed by Gala as well as Salvador Dali. On the left-hand side, four

mysterious figures barely emerge from the shadows of a dark stone wall. They seem to be made of almost the same material as the wall. On our right, Gala stands, smiling in the bright sunlight, bare to the waist and holding up her removed halter. A strange figure sits between Gala and the darkling figures; he hunches over a low wall pouring the contents of a pitcher behind a cabinet. A rope dangles over the wall in front of him.

The contrast between the brilliantly lit, smiling, half-nude Gala and the mysterious male figures—none of whose features are defined—is startling. Her form is photographic, theirs resemble molten lava. If the pitcher is here interpreted as the female vessel, and the chest with a drawer and cabinet also as a female image, how do we interpret these symbols? The small flock of birds feeding on crumbs in the left foreground are surely not there for compositional reasons.

This appears to be one of Dali's most ambiguous paintings. Are the shadowed figures, so intently scrutinizing the female symbols, impotent? Does the limp rope refer to the same thing? Is Dali contrasting them with the healthy sexuality of Gala? And who is the small Chiricoesque figure in the distance?

Darkness and light; symbol and reality; walls and open ground; photorealism and thick, viscous surfaces—contrasts abound. What was Gala's role in creating this work that she too signed it? Dali's earlier works are more easily deciphered; works done in the mid-thirties, such as **Cardinal, Cardinal,** become more difficult.

Always one ends with the same question: Who is the real Dali? Dali seems to pose that very question to himself. (pp. 101-04)

> *Edward B. Henning, "Surrealism and the Visual Arts," in his* The Spirit of Surrealism, *The Cleveland Museum of Art, 1979; pp. 62-124.*

Carter Ratcliff (essay date 1982)

[*In the following excerpt, Ratcliff analyzes Dali's function as a popular icon in modern culture and assesses his importance in modern art, noting the conflict between his commercial aspirations and complex aesthetics.*]

Yes, one says, flipping through the pages of *Harper's Bazaar Italia* for December 1981, Salvador Dali is incorrigible, a virtuoso offender. The cover of the magazine is a Dali original, especially commissioned for this issue. . . .

[The article on Dali features a] famous double exposure from around 1932: Gala by Dali superimposed on Dali by Gala, an image for which the artist used to claim magical powers. Any double exposure, he said, is the emblem of a destiny. Gala and Dali were indeed inseparable—overlapping, intertwined, and in part indistinguishable for half a century. But this photo promised more, that they would be the hero and heroine of a high-art fairy tale. Instead, Dali's magic turned out to be . . . a marketing knack. Or at least that is how the indictment reads. . . . Dali is a sell-out. . . .

The piece on Dali rehashes and (competition for editorial space being what it is in a fashion magazine) drastically condenses the artist's standard self-promotional spew. The writer, who goes by the name of Janus, homes in on Dali's Theater-Museum at Figueras, Spain—

> center of the universe, situated near the church where Dali was baptized . . . a place of magic encounters with the artist, on the one hand, and on the other his paintings, his Surrealist objects, his entire oeuvre, at the heart of which is his vision, his obsession with femininity, a subject dear to the Surrealists: here is celebrated the mystery of the feminine, that most recent of European mythologies to appear, and here Gala delves the myth to its foundations. . . .

Harper's Bazaar is going to spotlight the wife whenever possible, right? And in fact Dali has always insisted that Gala, ex-*femme fatale* of Surrealism's inner clique, is crucial to his art, indeed, to his sanity. Janus, hovering like a windblown Cupid over the thin line between "*la sessualità*" and "*il misticismo,*" would like to see Gala as Beatrice to Dali's Dante; or, zipping a few centuries down the line, as one of those female "phantoms of European Romanticism" who turn men into Byronic burnouts.

Janus is subject to swoons of adulation, yet is not completely mistaken here. Less impressionable writers have long charged Dali with a cruel and unusual exploitation of Romantic cliché. In self-defense, Dali has gone so far as to claim a drift toward Cartesian rigor. (p. 33)

There were three Salvador Dalis: the artist; his father (who struck the boy as a mixture of Moses, Jupiter, and William Tell); and a brother who died before the youngest Salvador was born. A picture of the dead son hung in the parents' bedroom. They doted on the boy even—or especially—in death. The youngest Salvador grew up convinced that when his father looked at him he saw the absence of his first son, not the presence of his second. This gave the artist-to-be a sense of nonbeing from which, on Dali's repeated testimony, only Gala could rescue him. "Gala," he wrote in 1973, "drove the forces of death out of me . . . first and foremost the obsessive sign of Salvador, my dead elder brother; the Castor whose Pollux I had been, and whose shadow I was becoming." Gala was an alter ego he could live with, the only self other than his own to whom he could make love. In other words, Gala inspired Dali to stop masturbating, or at least to try something else once in a while.

Before he met Gala, Dali's dilemma was standard, save for the images it generated: *The Great Masturbator, The Dismal Sport, The Accommodations of Desires* (all 1929). These early "dream photographs" celebrate the impotence he suffered in all presences, at all hands, save his own. He was harried, asleep and awake, by visions of castration, incontinence, putrefaction. Slim, good-looking, he could drag his death-haunted presence into the open only with a slime of pomade on his hair and the costume necessary to finish off this "Argentine tango-dancer look." His other look included a "silk blouse . . with broad puffed sleeves that I completed with a bracelet, and a low neckline to set off my necklace of fake pearls. I became a bachelor-girl, androgynous . . . At first blush, Gala did not make me out. The mask was misleading." But not for long. Stripping away his mask, Dali saw a bearable vision of himself in her. His Gala-self freed him from the clutches of that masculinity that demands perfection and humiliates any

putative male who doesn't measure up—that is, paternal authority.

The cane, the moustaches (perpetually at "Present arms"), the Wagnerian strut—Dali flaunts these emblems of masculine creativity with an air both sordid and quixotic. Once given to wearing drag, he now impersonates the grand Nietzschean procreator. To be male, he hints, is only to play at mastery. Dali still lives in fear of impotence, of humiliation, of sinking into that passive state he defines as feminine. At the same time, woman's passivity threatens always to turn aggressive, fanged and allengulfing. Dali preserves these sexual stereotypes in order to rearrange them. In a way, he and Gala are the straightest of straight couples. In another way, they are bent into shapes of exquisite oddness.

When Dali reconstructed himself in the mirror of Gala's body he devised a sexuality of engulfment or, in more recent terms, of consumerism. He recognized himself as a licker and swallower, a masticator and ingester. This post-Gala version of maleness is determinedly "female"—and endlessly versatile. Inspired by her, Dali turned the androgyny of his transvestite days from a panicky subterfuge into an esthetic of the mouth, a source of power that has made him one of the century's two or three most famous artists.

His first act under this new regime was to banish signs of self-destructive obsession from his art. As these disappeared, so did the attention of "serious" viewers. Dali counts among Modernism's elite so long as he confesses weakness, a Surrealist answer to Cézanne's doubt, Baudelaire's spleen, the sorrows of young Werther. Such afflictions of the self are as ironic as they are sincere. The sufferer displays wounds as the signs of a superiority to which the rest of humanity is, of course, free to aspire. Thus certain deeply painful symptomatologies must be inverted before reading, for the artist displays them as claims to transcendent strength. Born of privileged vulnerabilities, that strength brings with it a high place in a relentlessly hierarchical structure of culture. The moment Dali threw his esthetic of the mouth into gear, those with a "serious" interest in art cast him into the lower depths—and that is precisely where he wishes to be, for it is in the limitless mud flats of consumerism, with no heaven of high art above, that his image-ingestion and regurgitation brings him the fullest degree of worldly power.

During the 1930s, Dali the right-wing top was less outrageous to Modernism's defenders than Dali the window dresser at Bonwit's. Perhaps Dali offended most deeply by garnishing his commercialism with strong hints that "seriousness" is as often as not a sham, that the artist is not a privileged self but a marketable image. As Dali's claims for his genius grew more strident, he showed himself readier and abler by the season to mire himself in the pretentious crap of haute couture. (Of course, to talk of fashion that way is to deny Dali's prescient vision.) If the history of Modernism were an international spy thriller, we who remain "serious" about art would say that Dali was bought by the agents of consumer culture. Our faith requires us to believe that he has betrayed himself and us, that he is a too-willing collaborator with the other side, a lost cause for whom no exchange ever need be contemplated.

But this would be to misread signals Dali has been sending since the early 1930s. He didn't capitulate to consumerism. On the contrary, he gave the finishing touches to his esthetic of the mouth by adjusting it to the scale of the marketplace, where the images of fashion, advertising, the movies, and, later, television are spewed forth and gobbled up. With comic bravura, Dali inserted himself into those patterns of production and consumption, thereby devising a market from tastes suited to his palate. When he was still close to the Surrealists, he proposed the entire group, himself included, as a cannibalistic banquet for a public whose imagination had been starved by the realism of popular entertainment. In 1934, the year of his expulsion from the Surrealist cadre, *Time* magazine swallowed whole a press handout in which Dali described how he had posed lambchops on Gala's shoulders, arranged her before a sunset, and then, observing the slow shifts of meat-shadows, managed to paint canvases "sufficiently lucid and 'appetizing' for exhibition in New York."

Later, alone with Gala, and now one of mass culture's abiding presences, Dali volunteered himself as the entire meal. "I am the most generous of painters," he said in 1962, "since I am constantly offering myself to be eaten, and thus I succulently nourish our time"—this apropos of his *Soft Self-Portrait with Fried Bacon,* 1941. Toward the end of the psychedelic '60s, he updated his offer: "I have never taken drugs, since I am the drug. I don't talk about my hallucinations, I evoke them. Take me, I am the drug; take me, I am hallucinogenic!"

"The jaws," he says, "are the most philosophic instrument that man possesses." This is a comment on his *Atmospheric Skull Sodomizing a Grand Piano,* 1934. The jaw, mandible as phallus, doesn't look particularly "philosophic" at first glance, yet it is like the rest of the artist's allusions to the body: for all their aggressive twists and ghastly turns, each of them shows a transcendent bent. In 1945 Dali recalled seeing "at the age of five, an insect eaten by ants" who left "only the clean and translucent shell. Through the holes of its anatomy, one could see the sky. Each time I wish to approach purity, I see the sky through the flesh." Ordinary consumption—eating—fuels ordinary lives, whose chief by-product is sewage. The Dalinian eye eats its way through this ordinariness, ingesting it in order to create the pure and the absolute in forms that are in their turn consumable. Dali says he painted the National Gallery's *Sacrament of the Last Supper,* 1955, to prove his suspicion that he is the best-loved of living artists. It's as if he suffered from what was known twenty years ago as nymphomania. Postcard sales, he says, have produced indubitable evidence that he was right.

The Dalinian sacrament initiates a peculiar transsubstantiation. To consume his *Last Supper* is to be consumed by it, utterly, having been first reduced to the sheerest image of an art lover. Dali and his audience are joined in ceremonies of mutual ingestion. Dali's bulimia dominates. He vomits out images faster than his fans have ever been able to swallow them, though volume is not the only factor. Dali's bulimic eye is an organ with the transcendental knack of turning visual fodder into images with the aura of an ultimate reality. His theatrics advance the claim that he and he alone, thanks to the gemlike accuracies of his brush, is able to refine truth from the shit of ordinary life. That, according to Dali, is the material from which post-

war abstractionists built their images. He, by a humble submission to the methods of past masters, is able to engulf all of the visible world, then regurgitate it in images crystalline in their persuasiveness.

Dali's esthetic of the mouth is the public face of the coprophiliac, death-ridden esthetic that won him the uneasy support of André Breton in the late '20s. Dali knows this and knows we know it, signaling his grasp of the facts with the Baroque sleaze of his rhetoric, the grungy elegance of his moustaches, the dreadful shimmer of a coiffure whose sliminess has persisted for more than fifty years. Talking to the earnest, left-wing humanist Alan Bosquet in 1966, Dali admitted with no hesitation that he, no less than the arrivistes and other parasites around him, is a "swine," a snuffler in garbage willing to gobble up anything thrown his way—even one of those Crosses of Isabella the Catholic that Generalissimo Franco used to hand out to sympathetic spirits. "I would have taken two of them," Dali said. Yet even now Dali is despised less for his sordid politics than for his esthetic betrayals.

The main point that any high-art prosecutor would want to make at this late date is that Dalinian shoes and Dalinian women (including Gala) mix and match too nicely with the rest of the women, shoes, luggage, and other consumer goods that fill the world. (And, no, there is nothing unconscious about my listing women among consumer goods.) So why does Dali matter, if all the mystery of his art seems exhausted the moment one recognizes it as his, if he puts his brand-name imagery at the disposal of Bonwit Teller's, Walt Disney, and *Harper's Bazaar,* American as well as Italian? The question is an impatient demand for the all-too-obvious answer that he matters not at all, not in the least. Somewhat less obvious and far more interesting are the premises of the question, which include the belief that there *is* a clear, perhaps uncrossable line between high and low culture, between "serious" imagery and the trivial, throwaway kind. This is a faith that charts an imaginary space we've already entered—heaven above, the mud below. If one is able, somehow, to establish oneself in the upper regions of the chart, one has cultural weight. If not, not. And caring about high art often comes down to the maintenance of this hierarchical cosmography. The "serious" sometimes allow that there could be no definition of the high without the horrible example of the low, yet they permit no or very little communion between extremes.

For Dali, our culture has the oneness of a sprawling, often vacuous web of images and associated sentiments. In 1943, he talked of "the unsuspected poetry of America—from the calm classicism of the Californian landscape to the poignant billboard of the Gilmore Red Lion, suddenly emerging weakly silhouetted in pale neon tubes under the serene sky of a desert, late afternoon." Letting himself be swept away by this pre-Pop, post-Stuart Davis image of a billboard, Dali claimed it for his own. And he sealed his proprietorship with very strong hints that there is no heaven above, only a marketplace of images scattered in every direction across a range of cultural possibility as flat and wide open as any Southwestern desert. In this view high art occupies an ecological niche no more or less important—certainly no more elevated—than any other. In a system of production and consumption, of eating and being eaten in turn, each element is equal once the system strikes an overall balance.

So if we return to the question, we could say Dali matters because he is the only artist with "serious" credentials (long since revoked, of course) possessed of this ecological vision in which high art enjoys a functional intimacy with low. (pp. 33-6)

Dali matters because he has dragged a high-art sensibility through the low-culture mud decade after decade, so long and so visibly that he has martyred himself to the vulgarity of his success, because he is, a saint of consumerism, and if his humiliation has not made him humble—well, how could it? A consumerist saint has to be shameless and grandiose and, above all, aggressive. Rather, he must promote his public presence with all the doggedness of an agency hotshot directing an ad campaign. And he must design the images of his art to support the primary image, that of himself. It is Dali's inauthenticity that matters; or put it this way: Dali matters because he doesn't exist, because he is sheer image, and because he inspires the fear that his condition is universal. (pp. 36-7)

Surrealism revived the Romantic hope that art could demechanize consciousness, and that consciousness thus liberated could liberate the world. As with Shelley or Turner, so with Dali: we judge him authentic to the degree that his revolutionary program strikes us as sincere and promising. Such programs can easily become programmatic, mere formulas, but they originate in genuine possibilities for the recreation of the self. We look for an artist remade by the experience of making art, for paintings and poems that are confessional, for the spectacle of an uncensored self, for that condition in which the defiance of social convention leads to formal invention. From 1929 to 1932, Dali set his inventiveness the messy task of telling all, and rather directly at that. His "serious" paintings are a string of psychoanalytically-tinged anecdotes about an emotional no-man's-land. Then, as if a switch had been thrown, the dreadful light of Dali's confessional delirium went out. An instant later, he replaced it with the "poetic" light of his first trompe l'oeil paintings. There is hardly any other change—not in his touch, not in his manner of disposing images in pictorial space. Nor does his repertoire of images drastically widen or narrow. Yet a fundamental change had taken place. Dali was now declared inauthentic. After the early 1930s, no trace of the talented Surrealist remained, only a simulacrum, the great Salvador, seated at the console of the image machine, shuffling and reshuffling his motifs, tinkering with patterns of association, keeping the image-flicker lively enough to prevent the audience from drifting away.

Authenticity is a notion that generates hard-liners, like the ones at the Museum of Modern Art who dismiss late Giorgio de Chirico out of hand. Those same hard-liners grant the true Dali an even shorter life, yet Dali himself dismisses the paintings of his Surrealist period as minor. Only after he broke with Breton and company did his "imperialistic genius" ascend to its full power, he says. Only then, one might add, was he seated comfortably at the image machine. And Dali does what he can to suggest that he was always seated there, even as a 14-year-old, a precocious assimilator of Neo-Impressionism, Cubism, and the rest of the School of Paris repertoire. To substitute the inauthentic for the authentic Dali was sleight of hand, a flicker of images of the kind that illuminate each niche in the cultural ecology. His image machine is ours—or ev-

eryone's, and thus no one's. Perhaps it possesses us, no less when we manipulate the machine than when we ingest vast, bulimic helpings of its product.

Dali shimmers with the aura of genius rampant, yet the deliberate sleaziness of his self-image suggests that he knows better than any of us that he is the victim of stratagems beyond anyone's control. If this dazzlingly successful manipulator is himself manipulated, who is not? In regions of "seriousness," the answer is still automatic: the authentic are not; authenticity is a shield against image-mongering. I sympathize with that answer and with the Romantic-Modernist premises that dictate it, especially the one that locates the origin of value in the self's struggle for selfhood. As a consequence, I read in Dali's career the lessons offered by a major episode of treason to our century's best possibilities.

There would be no necessity to analyze Dali this way if he had simply lived and worked in bad faith. Instead, he chose a flamboyant martyrdom to our culture's most insidious mechanisms. He made a long career of feeding himself in grandiose and duplicitous fragments to a naive and greedy audience. He flaunted a genius for self-betrayal. This last should be taken as evidence that he had, after all, a self to betray. The "serious" art world has never made that argument, not once in fifty years of Dalinian silliness. It has chosen to quarantine him, as if inauthenticity were easy to spot and simple to confine. The art world's image of Dali's treason is the shallowest possible. This makes it tempting to suggest that many in that world maintain an opposite and equally shallow image of their own good faith in esthetic matters. The further temptation is to suppose that the work of these artists, and of the critics and curators who support them, is just as mechanical as Dali's. Is there a Picturesque of "seriousness"?

Dali's Picturesque works much as a fashion photographer's does. Images appear, their associations mesh, this generates auras dazzling to the eyes of one audience or another (but rarely more than one: markets enlivened by tactics of fragmentation must of necessity be fragmented themselves). For example, the "craftsmanship" of Dali's *Leda Atomica,* 1949, invests the painting with an atmosphere of tradition-hallowed realism. The cluster of images—swan, nude in a high-art manner, mushroom cloud—brings with it a charge of mystery. Even the most sympathetic viewer doesn't look closely at this canvas, but instead reads off its play of the true and the awesome, permitting each to tinge the other with its aura. Likewise, a successful fashion photograph owes its glamorous authority to the way emblems of a rigid iced-over decorum click with emblems of white-hot sexual heat. Such images offer the best of two worlds without inconveniencing us with the experience of either.

We've seen that doubleness elsewhere, in color-field painting, with its strenuously insisted-upon debt to Jackson Pollock and its decorator colors. Look at Jules Olitski, Kenneth Noland, and the rest in this light, and one raises harsh questions about the critics who promoted those painters. They did not, it would seem, say much about the experience of the art in question. Rather, they labored long and with an appropriate pretentiousness to invest the look of that art with marketable associations—Impressionism, Pollock, alloverness, flatness, opticality,

radicality, essences, historical inevitability. Dali's writings perform the same task for his paintings. Or is it that his paintings provide his writings with the associations they need? In any case—in all these cases—a mechanical esthetic is at work grinding out consumable images.

No matter how debased consumerism happens to be, this season or next, we feel compelled—and I would say legitimately—to find it intelligible. Hence art-world professionals often end up, in social situations, talking about the movies. We *must* know what is glamorous, if only to dismiss it, to construct a counter-glamor, some form of "seriousness." Unless we are willing to let our "seriousness" drift hopelessly far out onto the moment's peripheries, we have to let ourselves be drawn now and then by the consumer world's bogus allure. We do this, we hope, in full consciousness. Yet what if there is a Picturesque of "seriousness"? If there is, then we who have turned away from popular culture toward high art must sometimes be reduced to the merest consumers at moments when we imagine our sensibilities to be soaring on esthetic updrafts. Some of the art we call the newest, the most difficult, the most genuinely radical may be, or quickly may become, nothing of the sort, only alight with the auras of those things. (pp. 37-8)

Dali has never been Modernist debasement's representative man. His is the lamp of the hustler, the conformer to popular taste whose grandiose refusal to fit in anywhere gives him the power to make revelations just about everywhere. Dali offers us the spectacle of an authentically confessional artist curing himself, not of the afflictions, the archetypal neuroses he felt driven to confess, but of the confessional urge itself. When Dali transformed his impotence into his esthetic of the mouth, he denied his weakness by denying the standards that defined him as a weakling. Thus he brought down the hierarchy that placed paternal authority and sibling perfection above, and him below. In the larger world, this tumbling of hierarchies brought the heaven of high art down to ground level. Dali's strategy was not only salvation for the great Salvador, it reflected with awesome accuracy a shift in the culture at large.

Dali plays the 19th-century maestro for obvious, avant-garde-baiting reasons. Nonetheless, he is obsessively up-to-date, having hyped his esthetic of the mouth to the point where it is no longer the symptom of a traditional neurosis but a means to enjoying a contemporary replacement for neurotic suffering. His stints at the image machine serve a late-20th-century character disorder—specifically, bulimia. So in all his flagrant oddness Dali has much to teach us about image gorging and regurgitation, not only in the media, in fashion, and in the world of architecture and design, but in the art galleries, museums, and magazines, in artists' studios and on those public sites fated to play host to "serious" sculpture. Dali manipulates the image machine to satisfy his own and his audience's voracious eyes, and the spectacle of him performing with such ghastly brilliance inspires the fear that betrayals like his take place on both sides of the border dividing high and low. (p. 39)

Carter Ratcliff, "Swallowing Dalí," in Artforum, *Vol. XXI, No. 1, September, 1982, pp. 33-9.*

Dawn Ades (essay date 1982)

[*Ades is a noted art critic and the author of several major studies of Surrealist art. In the following essay, she evaluates Dalí's post-World War II contributions to modern art and his integration of contemporary experimental styles.*]

Since 1945, Dalí has both shown a paradoxical openness to experimental techniques and to the innovations of the post-war generations of painters, and has produced what have been described, I think mistakenly, as his first 'historical' pictures. Such works as *The Dream of Christopher Columbus,* huge and epic in scope, in fact run on the theme familiar with Dalí of faith and the strength of tradition. But in being pro-tradition he was by no means anti-modern. Not only did he express his enthusiasm for the American Abstract Expressionists, especially de Kooning, whose influence is visible in Dalí's work in the late fifties, and collaborate with the most prominent exponent of the French version of Abstract Expressionism, Georges Mathieu, but he was particularly in favour of the discoveries of modern science (not least because, in the branch of cryogenics, a way might be found of preserving him alive). Among the problems to be reconciled in this post-war period is the relationship between his desire to emulate the great achievements of the oil paintings of the old masters and his pursuit of visual experiment. The result of Dalí's apparently unending appetite for new ideas and techniques is that once again, in his later years as in his early ones, he paints in a number of different styles simultaneously.

Linking the manifestations of Pop Art, optically illusionistic painting, photographic hyperrealism, Divisionism, Abstract Expressionism, stereoscopy, and holography, all of which make their appearance in his post-war work, is the theme of realism, although this could be subdivided into the pursuit of pictorial and scientific realities. However, such a subdivision does not hold completely, and Dalí is profoundly antagonistic to the separation of scientific from other modes of human knowledge. (p. 173)

The event that influenced Dalí most deeply was the explosion of the atom bomb at Hiroshima at the end of the war:

> The atomic explosion of 6 August, 1945 shook me seismically. Thenceforth, the atom was my favourite food for thought. Many of the landscapes painted in this period express the great fear inspired in me by the announcement of that explosion. I applied my paranoiac-critical method to exploring the world. I want to see and understand the forces and hidden laws of things, obviously so as to master them. To penetrate to the heart of things, I know by intuitive genius that I have an exceptional means: mysticism

The discoveries of the atomic physicists concerning the structure of matter, which had revealed the release of energy involved in breaking up atomic particles, were immediately fastened on by Dalí if only to be applied metaphorically. *Inter-atomic Equilibrium of a Swan's Feather* (1947) suspends disparate objects in space in what appears to be a state of immobility brought about by the forces of mutual attraction and repulsion. It is not, of course, 'inter-atomic' at all, since he is using not atomic particles but particles of objects or even whole objects. Striking here, and in *Nature morte,* is precisely that sense of relative

weight and texture abolished by generalized theories of atomic matter. However, the overall sense of the divisibility of matter—first posited by the Greeks two thousand years ago but only proved with such devastating force in our century, appears again and again in different forms in Dalí's paintings of this period. *Exploding Raphaelesque Head* (1951) and the *Madonna of Port Lligat* (1949) offer interesting contrasts in his treatment of this theme. Each is very closely related to Italian Renaissance painting too; in the first, Dalí has linked a Raphael head of a Madonna with the interior of the Pantheon in Rome, and then shattered them into multiple elements taking the form of rhinoceros horns. . . . 'To the continuous waves of Raphael', Dalí commented on this painting, 'I added discontinuous corpuscles to represent the world of today.' The model for the *Madonna of Port Lligat* is Piero della Francesca's Brera Altarpiece, *Madonna and Child with Angels and Six Saints,* with the Madonna translated as usual into Gala. Although the figures and the architecture are pierced and dismembered, the effect is still one of equilibrium, emphasized by the egg suspended from a shell balanced immediately over the Madonna's head, as it is in Piero's altarpiece (except that Dalí reverses the shell) where it probably stands as a symbol of eternity.

An even more curious merging of the theories of nuclear physics and Dalí's brand of mysticism occurs in the *Anti-Protonic Assumption* (1956). Dalí here is drawing on the combination of the theories of quantum mechanics with relativity, which showed that corresponding to any particle was an anti-particle of the same mass, and that when they met and annihilated each other they let off an enormous amount of kinetic energy. The Assumption of the Virgin takes place, he suggests, not by the power of prayer but by the power of her own anti-protons. She is, in Dalí's opinion, a kind of Nietzschean superwoman, representing the 'paroxysm of the will-to-power of the eternal feminine'. Christian dogma, here, becomes a form of superior science-fiction.

In the Preface to the catalogue of his exhibition at the Carstairs Gallery in New York in 1958-9 Dalí included a 'Manifesto of Anti-matter', in which he wrote:

> I want to find out how to transport into my works anti-matter. It is a question of the application of a new equation formulated by Dr Werner Heisenberg which . . . can give the formula of the unity of matter.

> I love physics. Recently I had to stay for a month and a half in hospital to recover from a delicate appendix operation. I had the leisure to study nuclear physics during this convalescence . . .
> Today the external world—that of physics—has transcended that of psychology.

> Today my father is Dr Heisenberg . . .

(whereas during the Surrealist period his father had been Freud).

Dalí's frequent use of religious subject-matter during this period is part of his overall strategy to reintroduce metaphysics into physics. While he was working on *Corpus Hypercubicus* in the summer of 1953, a group of young nuclear physicists came to visit him, bringing with them coincidental confirmation of Dalí's choice of cubic form for the cross: 'they left again, intoxicated, having promised

to send me the cubic crystallization of salt photographed in space. I should like salt—symbol of incombustibility—to work like me and like J. de Herrera on the question of the ***Corpus Hypercubicus.'*** Herrera, the sixteenth-century Spanish architect of Philip II's palace, the Escorial, wrote a *Discourse on Cubical Form* which had initially inspired Dalí's painting. Herrera was only a generation or so older than Velázquez and Zurbarán, and it was specifically to them, and above all Zurbarán, that Dalí had looked to find a way of painting, as he put it, the 'metaphysical beauty of Christ'. 'I want', he wrote in his 'Mystical Manifesto' (1951), 'my next Christ to be the painting containing the most beauty and joy of anything anyone has painted up to the present day. I want to paint the Christ who will be the absolute antithesis of the materialist and savagely anti-mystical Christ of Grünewald.' So he adopts the same technique that he had used in the two versions of ***The Basket of Bread*** from Zubarán, for his two versions of Christ on the Cross, of 1951 and 1953-4. The dramatic angle of the cross in ***Christ of St John of the Cross*** was in fact inspired by that in the drawing of Christ on the Cross by the Spanish mystic St John of the Cross.

In ***Exploding Raphaelesque Head,*** and in several other pictures of the fifties like ***Corpuscular Madonna,*** Dalí, as already noted, represents the disintegrating particles of matter in horn-like shapes, which he identifies as rhinoceros horns. In 1955 he gave a lecture at the Sorbonne in front of an enthusiastic audience to whom he attempted to prove that Vermeer's *Lacemaker* was morphologically a rhinoceros horn.

> That summer of 1955, I discovered that in the junctions of the spirals that form the sunflower there is obviously the perfect curve of the rhinoceros horn. At present the morphologists are not at all certain that the spirals of the sunflower are truly logarithmic spirals. They are close to being so, but there are growth phenomena which have made it impossible to measure them with rigorously scientific precision, and the morphologists do not agree on whether or not they are logarithmic spirals. However, I was able to assure the audience at the Sorbonne yesterday that there never has been a more perfect example in nature of logarithmic spirals than those of the curve of the rhinoceros horn. Continuing my study of the sunflower and still selecting or following the more or less logarithmic curves, it was easy for me to distinguish the very visible outline of the *Lacemaker.* . . .

(pp. 174-79)

Dalí's thought has taken, here, as so often, a route that is a bewildering mixture of scientific and paranoiac logic. So, for example, his interest in the logarithmic spiral, and hence in the rhinoceros horn, led on to the making of the film ***The Prodigious Adventure of the Lacemaker and the Rhinoceros.***

In the 1955 lecture Dalí also claimed that ***The Persistence of Memory*** was the first occasion on which the form of the rhinoceros horn began to detach itself. This may be, and is clearly hindsight anyway, but it is interesting to compare this famous image of soft watches with the post-war atomic and rhinoceros pictures, because it does have a greater and unforced hold on the imagination, partly because it is less obviously and consciously determined. The soft watches are an unconscious symbol of the relativity

of space and time (Camembert of time and space, Dalí described them), a Surrealist meditation on the collapse of our notions of a fixed cosmic order. . . . (p. 179)

Later in the fifties, Dalí turned increasingly to the Abstract Expressionists for formal inspiration. ***Velázquez Painting the Infanta Margarita with the Lights and Shadows of his Own Glory*** (1958) is obviously influenced by gestural painting. . . . The influence of the free and lyrical abstraction of Mathieu, 'ecstatic', as Dalí called it, is evident in the ink drawings of 1958, or such oil paintings as ***The Servant of the Disciples of Emmaus*** (1960). In 1956 he produced a series of lithographs to illustrate *Don Quixote,* using a variety of more or less improbable methods which produce a curiously abstract Mathieu-esque calligraphy: for one, he dropped an egg filled with ink on to the lithographic stone, for another he fired an arquebus given him by Mathieu on to the stone. At about the same period Dalí arranged for a work to be 'danced' rather than painted, when he brought the Spanish dancer La Chunga to Port Lligat, laid out a stretcher on the terrace with a couple of square metres of canvas on it, and, as she danced to the accompanying guitarist, squeezed paint from tubes round her feet which mixed it and spread it across the canvas.

It was more or less simultaneously with these experiments that Dalí was painting the gigantic epic compositions, ***Santiago el Grande*** and ***The Dream of Christopher Columbus*** (1958-9), 'history paintings' which are oblique, paradoxical and probably ironic affirmations of the continuity of tradition, culture and religion, and above all of mystical experience.

Even in Dalí's continuously productive life, the late fifties were years of exceptional activity and disconcertingly various ideas. He began to experiment with Pop and Op Art, culminating in the stereoscopic paintings and holographs of the seventies.

Dalí first presented his ***Sister Madonna*** . . . at the end of 1958, in the context of his exploration of anti-matter. However, it could be said that it is really doing the opposite of the ***Exploding Raphaelesque Head,*** because, rather than taking an object and shattering it into fragments, he is starting from a regular pattern of, in this case abstract, particles, and from them building up an image. It has obvious connections with the screened dot paintings of a Pop artist like Lichtenstein, but is in fact too early to be placed in the context of Pop Art. He has obviously used a perforated screen. Raphael's Sistine Madonna takes shape out of the dots, and then a second image, of an ear, framing the Madonna and intended to offer a morphological resemblance of the kind Dalí suggested between the rhinoceros horn and *The Lacemaker.* Closer to Lichtenstein, in such works as his screen-print *Cathedral* of 1969, is Dalí's ***Portrait of My Dead Brother*** (1963), which similarly resembles the dotted image of a blown-up newspaper photograph.

Dalí had, of course, been using photography in various ways almost since the beginning of his career. Gala's face in ***Gala with Two Lamb Chops Balanced on Her Shoulder*** (1933), for example, is copied from a photograph of Gala and Dalí taken at Port Lligat that year. In *The Conquest of the Irrational* Dalí had stated that painting was only 'hand-done colour photography', and, as he said in *Un-*

speakable Confessions, he was convinced that Vermeer used an optical mirror to trace the subjects of his paintings. For **Santiago el Grande** (1957) Dalí used a photograph of the vault from a book on Santiago de Compostela that the Vicomtesse de Noailles had shown him: 'I was immediately struck by the shell-shaped architectural vault that is the palm tree of the famous shrine which I decided to reproduce.' He then searched for a photograph of a horse which he copied in the same way. Dalí had had, incidentally, a glass floor built into the studio of his house at Port Lligat, which he could use to get the dramatic foreshortening effects in paintings of this period, by placing the model above or below himself.

Dalí was also using the technique of projecting a photographic image on to the canvas and copying it: certain areas of **Tunny-Fishing** (1966-7), for example, are produced like this.

In holography and stereoscopy, Dalí delighted in finding an area where technology could help create a new means of expression. He is not, of course, the first artist to experiment with stereoscopy to reproduce the spatial dimension lacking from a single two-dimensional image. By using binocular vision, a sensation of three-dimensionality is created. Dalí's most important predecessor was probably Duchamp, . . . who was still interested in binocular vision in his last work *Etant donnés* (1946-66), which has to be viewed through two holes pierced in a wooden door. Dalí, after some experiments in the early sixties with small postcards, turned in about 1975 to full-sized oil paintings: two more or less identical images, some as in **The Chair** (1975) differing in light and tonality, are placed side by side and then viewed through a stereoscope. A special stereoscope using mirrors was adapted by Roger de Montebello to accommodate the monumental scale of **The Chair.**

Dalí's first holograms were shown at the Knoedler Gallery in New York in April 1972. Dr Denis Gabor, the inventor of the hologram, wrote the catalogue, where he explains what it is and how an artist can use it:

> For the artist, the hologram represents the opening towards the third dimension. The first stage, now achieved, is the photography in three dimensions of objects and scenes, which, having been impressed onto a holographic film where they remain invisible, are reconstituted in three dimensions in their original aspect and can be seen from all sides but in only one colour.

The most ambitious of Dalí's holographs or holograms was **Holos! Holos! Velázquez! Gabor!,** shown at the Teatro Museum Dalí in Figueras; it attempted to realize a double image formed of the *Meninas* and a photograph of card players. Dalí had, with the help of a holograph expert, Selwyn Lissack, mounted the two images on sheets of glass disposed in different planes, thus creating the first holographic photomontage. The second and third stages of the holograph forseen by Dr Gabor were the use of natural colours and the combination of natural colours with 'an unlimited restitution of distance. The artist will be able to create in his studio landscapes which will spread to the horizon and need never have existed.' Holographic technology has not yet advanced as far and as fast as Dalí had hoped, and such landscapes so far remain unrealized. With the hologram, as so often with Dalí's work, it was the initial idea which passionately interested him, and it

was not the first time the ambitious scale of Dalí's idea outstripped the capacity of the medium to contain it. (pp. 180-90)

> *Dawn Ades, in her* Dalí and Surrealism, *Harper & Row, Publishers, 1982, 216 p.*

FURTHER READING

I. Writings by Dalí

"The Object as Revealed in Surrealist Experiment." *This Quarter* V, No. 1 (September 1932): 197-207.
 Dalí's analysis of evolving Surrealist aesthetic theories and their application in Surrealist art.

The Secret Life of Salvador Dalí. Translated by Haakon M. Chevalier. New York: Dial Press, 1942, 400 p.
 Autobiography centering on Dalí's childhood, adolescence, and involvement in Surrealism, with an introduction by Robert Melville. This volume also features appendices containing the scenarios of Dalí's film collaborations with Luis Buñuel, *Un chien andalou* and *L'âge d'or,* and two previously published monographs, *Conquest of the Irrational* and *Diary of a Madman.*

Diary of a Genius. Translated by Richard Howard. 1965. Reprint. New York: Prentice Hall: 1986, 229 p.
 Memoirs by Dalí, largely devoted to promoting his eccentric public image but also covering his career from 1952 to 1963.

The Unspeakable Confessions of Salvador Dalí. Edited by André Parinaud. Translated by Harold J. Salemson. New York: Morrow, 1976, 300 p.
 Described on the jacket as a "Dalinian novel," this book consists of transcripts edited from tapes in which Dalí provides personal reminiscences as well as criticism of his own work and that of others.

II. Interviews

Bosquet, Alain. *Conversations with Dalí.* Translated by Joachim Neugroschel. New York: E. P. Dutton, 1969, 123 p.
 Selected interviews featuring Dalí's opinions on art, Surrealism, and contemporary culture.

III. Biographies

Cowles, Fleur. *The Case of Salvador Dalí.* Boston: Little, Brown and Co., 1959, 334 p.
 Focuses on the relationship between Dalí's public persona and his private life.

Descharnes, Robert. *Dalí: The Work, the Man.* Translated by Eleanor R. Morse. New York: Harry N. Abrams, 1984, 455 p.
 Comprehensive study of Dalí's life and art, featuring numerous color reproductions.

Maddox, Conroy. *Dalí.* New York: Crown, 1979, 96 p.
 Short biography of Dalí, containing sixty-one illustrations.

Morse, A. Reynolds. *Dalí: A Study of His Life and Work.*

Greenwich, Connecticut: New York Graphic Society: 1957, 96 p.

> Biographical and critical analysis of Dalí's life and oeuvre.

Secrest, Meryle. *Salvador Dalí.* New York: E. P. Dutton, 1986, 307 p.

> Comprehensive biographical study.

IV. Critical Studies and Reviews

Ades, Dawn. "Unpublished Film Scenario by Salvador Dalí." *Studio International* 195, No. 993-994 (1982): 62-78.

> Facsimile of a film scenario by Dalí with an explanatory introduction by Ades.

Capasso, Nicholas J. "Salvador Dalí and the Barren Plain: A Phenomenological Analysis of a Surrealist Landscape Environment." *Arts Magazine* 60, No. 10 (June 1986): 72-83.

> Examines Dalí's use of space and landscape in his early Surrealist paintings.

Chadwick, Whitney. "Dalí's *Mythe tragique de l'angelus de Millet* and the Paranoiac-Critical Method." In *Myth in Surrealist Painting, 1929-1939*, pp. 61-73. Ann Arbor, Mich.: UMI Research Press, 1980.

> Analysis of Dalí's attempts to create a mythology surrounding Jean-François Millet's painting *Angelus*.

Descharnes, Robert. *The World of Salvador Dalí.* Translated by Albert Field. New York: Harper and Row, 1962, 228 p.

> Critical survey featuring color reproductions of Dalí's works.

Finkelstein, Haim N. " 'A New Dream'—Dalí's Paranoia Criticism." In his *Surrealism and the Crisis of the Object,* pp. 29-43. Ann Arbor, Mich.: UMI Research Press, 1979.

> Analysis of Dalí's paranoiac-critical method and its impact on Surrealist art.

————. "Dalí and 'Un chien andalou': The Nature of a Collaboration." *Dada; Surrealism,* No. 15 (1986): 128-42.

> Examination of the collaborative nature of Dalí's first film with Luis Buñuel in which the author contrasts the relative contributions of each artist.

Gaunt, William. *The Surrealists.* New York: G. P. Putnam's Sons, 1972, 272 p.

> Discussion of Surrealism from its inception in the 1920s to its influence in the early 1970s, featuring individual commentaries on thirteen color reproductions of Dalí's works.

Homage to Dalí: Special Issue of the XXe Siècle Review. Translated by Joan Marie Weiss Davidson. Secaucus, N. J.: Chartwell, 1980, 160 p.

> Collection of nineteen essays—including tributes, psychoanalytical studies, and critical analyses—by various European commentators. Also includes numerous photographs and color reproductions.

Kayser, Stephen S. "Salvador Dalí's Search for Heaven." *The Pacific Art Review* II, Nos. 3-4 (Winter 1942-43): 30-56.

> Analysis of Dalí's complex attitude toward religion and Christianity in which the artist's later metaphysical paintings are viewed as representing a spiritual quest for heaven.

Matthews, J. H. "Salvador Dalí." In his *Eight Painters: The Surrealist Context,* pp. 79-92. Syracuse, New York: Syracuse University Press, 1982.

> Examines Dalí's contribution and achievement within the Surrealist movement during the 1930s.

————, ed. *Salvador Dalí, 1910-1965.* Greenwich, Connecticut: New York Graphic Society, 1965, unpaged.

> Catalog of a retrospective exhibition held at the Gallery of Modern Art in New York City in 1965, with descriptive captions for color illustrations written by Dalí and introductory notes by Theodore Rousseau, F. J. Sanchez Canton, and Carl J. Weinhardt, Jr.

Pressley, William L. "The Praying Mantis in Surrealist Art." *The Art Bulletin* LV, No. 4 (December 1973): 600-15.

> Analysis of the praying mantis as a significant, recurring symbol in the works of Dalí and other Surrealists.

V. Selected Sources of Reproductions

Descharnes, Robert. *Dalí.* Translated by Eleanor R. Morse. New York: Harry N. Abrams, 1985, 127 p.

> Includes an overview of Dalí's career and nearly 200 color and black-and-white illustrations with accompanying explanatory text.

Gérard, Max, ed. *Salvador Dalí.* Translated by Eleanor R. Morse. 1968. Reprint. New York: Abradale Press / Abrams, 1986, 263 p.

> Includes a critical survey of Dalí's career.

Gómez de Liaño, Ignacio. *Dalí.* Translated by Kenneth Lyons. New York: Rizzoli, 1984, 33 p.

> Large-format color reproductions with an introductory essay by Gómez de Liaño.

Larkin, David, ed. *Dalí.* New York: Ballantine Books, 1974, unpaged.

> Forty reproductions of works from Dalí's career, with an introduction by noted science-fiction writer J. G. Ballard.

Longstreet, Stephen, ed. *The Drawings of Dalí.* Los Angeles: Borden Publishing Company, 1964, unpaged.

> Selected drawings featuring an introduction by Longstreet.

Morse, Albert Reynolds. *Salvador Dalí: A Catalog of Prints, Lithographs, Etchings: 1924-1967.* Cleveland, Ohio: Reynolds Morse Foundation, 1967, 16 p.

> A catalog of Dalí's graphic art in the Reynolds Morse collection.

Soby, James Thrall. *Salvador Dalí: Paintings, Drawings, Prints.* New York: Museum of Modern Art, 1941, 87 p.

> A selection of Dalí's characteristic Surrealist works with a catalog by James Thrall Soby.

Alberto Giacometti

1901-1966

Swiss sculptor, painter, and graphic artist.

Regarded as one of the most important figures in modern sculpture, Giacometti was a versatile artist, working with exceptional success in other media as well. Although he is generally known for the hauntingly elongated sculptures of his later, figurative, period, Giacometti also played a significant role in the development of non-figurative art through his association with the Surrealist movement. In fact, according to the American art historian H. H. Arnason, Giacometti was the greatest Surrealist sculptor. Rather than a concession to traditionalism, the artist's return to figurative expression stemmed from a desire to grasp the essence of reality, to see things as they are, and to free the spirit of the misleading mediation of the senses. Giacometti's quest for the absolute drew the attention of philosophers and writers such as Jean-Paul Sartre, Albert Camus, Maurice Merleau-Ponty, and Jean Genet, who interpreted his work as a profound expression of the anguish of human existence.

Giacometti was born in the village of Borgonovo, in the Italian part of Switzerland, into a well-known artistic family. His father, Giovanni, was a distinguished Impressionist painter. Having manifested an extraordinary artistic talent in childhood, Giacometti studied painting in Geneva in 1919-1920. Between 1920 and 1922 he lived in Italy, where he assiduously studied the old masters and also became familiar with modern Italian art. In 1922 he settled permanently in Paris.

Closely associated with the French Surrealist movement in the 1920s and early 1930s, Giacometti produced a series of outstanding Surrealist sculptures. Representative of this period is *The Palace at 4 A.M.* (1933), an open structure resembling an eerie dollhouse, which conjures up an atmosphere of solitude and despair that for many interpreters later became the fundamental characteristic of Giacometti's art. In 1935, however, the artist, feeling that non-figurative art had alienated him from reality, broke with the Surrealist movement and returned to figurative representation. Yet critics have emphasized that Giacometti's new style in many ways implied and incorporated the techniques and artistic philosophies of the major twentieth-century artistic orientations, including Cubism and Surrealism. His goal was to transcend what he perceived as the limitations of abstract art. The limits of artistic expression, Giacometti believed, could be pushed back only by striving to transcend expression itself. The task that Giacometti imposed upon himself was to create art that would reveal the essence of things, and not merely represent them.

Giacometti's search for a new style was an arduous process which included lengthy experimentation with form and perception. Initially succumbing to a desire to decrease his figures to hardly perceptible dimensions, the artist later found that extremely elongated, almost skeletal figures adequately satisfied his need to incorporate optical

distance and emptiness as integral elements into the work of art. Plagued by self-doubt and aware of the fundamental contradiction inherent in his attempt to see things as they are, Giacometti nevertheless received tremendous critical acclaim in the 1950s, emerging as one of the great names of contemporary sculpture. Many of his works, sculptures such as *Chariot* (1950), *Composition with Seven Figures and One Head* (1950), and *Dog* (1951), were immediately recognized as classics of modern art.

The drawings, paintings, and sculptures of Giacometti's final period remain as a testimony to the artist's titanic struggle to understand the nature of perception. By patiently reworking the same figure numerous times, Giacometti sought to transcend mere representation, entering the enigmatic sphere of a person's true being. The numerous portraits of his brother Diego, his wife Annette, and his mother, constitute unfinished series, works in which the artist sought to objectify those whom he knew and understood most intimately. Perceived as an eminently Existential artist because of the essential anthropocentrism of his art, Giacometti drew enthusiastic praise from Jean-Paul Sartre, who admired the artist's heroic insistence on representing the most elusive, essential human qualities. In addition, the European intellectual elite of the 1950s and 1960s embraced Giacometti's work as representative of the anguished spirit of the times, devoting numer-

ous essays to the interpretation of his works. However, critics have stressed that Giacometti's art cannot be interpreted within the historical and spiritual context of a particular period, since the artist strove to penetrate the timeless mystery of human existence. This timeless quality of Giacometti's works comes to the fore in his numerous standing figures, which project the power of archetypes. Giacometti himself, perhaps because of his awesome dedication to art, assumed some of the mysterious aura of his sculptures. The studio in the rue Hippolyte-Maindron, which he occupied from 1927 until the end of his life, was often likened to a laboratory, where Giacometti pursued his solitary nocturnal quest for the artistic key to the human enigma.

In 1955, the Solomon R. Guggenheim Museum in New York organized an important retrospective exhibition of Giacometti's works; the following year, he had exhibitions in London and Bern. Three years later, he started working on a monumental sculpture for the Chase Manhattan Bank in New York, a project which remained unfinished. Toward the end of his life, Giacometti received numerous honors, including the First Prize for Sculpture at the 1962 Venice Biennale and the 1964 Guggenheim International award for painting. The artist died in 1966, revered as one of the crucial figures in the turbulent history of twentieth-century art.

Highly valued for its originality and power, Giacometti's oeuvre, although incomplete according to the exacting standards of its creator, remains fascinating for critics and scholars, who are still investigating his life and work. As an artist attuned to the mysteries of existence, Giacometti addressed universal human concerns, transcending historical periods and styles. According to Jacques Dupin, Giacometti embodied the human yearning for the unknown, going "from known to unknown by stripping down, by progressive asceticism. He flays appearances and digs into reality until he renders visible the essence of their relationship, that is, the presence of something sacred. . . . Giacometti drives it out of hiding and wakens it where it is hidden, in the depths of each new thing and each being."

INTRODUCTORY OVERVIEW

Roy McMullen (essay date 1976)

[*McMullen is an American art critic and journalist whose writings include* Victorian Outsider: A Biography of J. A. M. Whistler *(1973), and* Mona Lisa: The Picture and the Myth *(1975). In the following excerpt, he traces Giacometti's artistic and intellectual development, emphasizing the artist's titanic struggle to attain a kind of pure and absolute perception, freed from the distorting mediation of the senses.*]

Alberto Giacometti's place in art history is secure; indeed, in the decade since his death he has become a modern classic, a standard museum attraction. But defining his importance is not easy. He did not launch any revolutionary "ism." He has had very little influence, except perhaps as

a model of probity. Today he is frequently referred to as an expressionist—fair enough if one thinks only of certain aspects of the work of his last phase. Forty years ago, however, when he was making what he called "objects without pedestals and without value, to be thrown away," he was regarded as the official court sculptor of the Paris surrealists and their dictator, André Breton. At one point he was a first-rate cubist. In some ways he was scarcely modern at all: he complained regularly, for instance, about the difficulty of doing a human nose "after nature," and he was unabashedly interested in returning to the ancient Mediterranean notion that man was the proper subject of art.

During the last phase of his career Giacometti was typecast as an apostle of existentialism, a victim of anxiety, an incarnation of the Outsider—in short, one of our representative modern *misérables*. Today, ten years after his death, he is sometimes still cast in that role, and not without reason. He was often in the company of the existentialist pope Jean Paul Sartre and the counterculture rebel Jean Genêt, and he was something of a real-life version of Roquentin, the character in Sartre's *La nausée* who is transfixed by the sheer "otherness" of things. Moreover, the best-known Giacometti sculptures—the ravaged, desolate figures produced after World War II—imply estrangement in many ways. They stare. They are as thin as matchsticks. They are earnestly futile. The men stride masterfully off toward nowhere; the naked, hysterical women, thighs tightly locked, stand and wait like unemployed caryatids.

Evidence of alienation, or at least of a strange sentiment of loneliness when confronted by the physical world, can also be found in some of the stories Giacometti told about his perceptual adventures. For instance, late one night on his way home to No. 46 rue Hippolyte-Maindron, on the southern edge of Montparnasse, he was wrenched by an extraordinary anguish. "I felt," he said later, "that I was changed into a dog, a dog of my quarter sniffing the ground with his muzzle, a ground I saw in front of me with ghastly clarity."

There was another time, according to his own testimony, when everyone in the Paris subway looked stone dead. And one evening in the Brasserie Lipp, he glanced up from his table and noticed that the waiter's head had popped out of the stream of time, like a frozen shot in a film: he was "leaning over me, mouth open, with no connection at all with the preceding moment, nor with the following moment, mouth open, eyes fixed."

Sometimes the transformations involved objects. One day a portfolio left on a chair in his bedroom abruptly acquired a new mode of existence, a mixture of uncanny solitude, vividness, and negative gravity. "I had the impression," he reported to Genêt, "that I could take away the chair without causing the portfolio to change its place. It had a place of its own, a weight of its own, even a silence of its own."

The oddness of such experiences went with an oddness in the man himself. By middle age he seemed about to be metamorphosed into a dusty plaster cast; his bushy hair was gray, his haggard, mobile face—the face of a sad Italian mime—was gray, even his lips and teeth were gray. In 1938 he had been run down by a drunken motorist, and as a result he walked with a slight hobble, like the god Vulcan. His habits were thoroughly Bohemian. He occupied his small, dark studio in Montparnasse from 1927, when

he was twenty-six, until his death in 1966; and each year the clutter grew deeper. He was indifferent to fame and money; he enjoyed the company of social outcasts, particularly the prostitutes and beggar women of his quarter.

Odd, too, for a successful artist was his talk about the utter hopelessness of his efforts to sculpture, paint, and draw; toward the end of his life he dismissed his career as "thirty-five years of dishonesty." Another day or two of trying, he would say, and then he would be ready to give up forever. Anyway, he would argue, statues and pictures were not nearly as important as a lot of other things in the world; if he ever got caught in a burning house with a Rembrandt and a cat, he would save the cat. People who noticed that he was a reasonably prolific artist thought this despair over his work was a joke. Yet his models—his mother, his wife Annette, trapped friends, and above all his brother Diego—testified to his cycles of depression and his habit of undoing, like Penelope, what he had just done.

Clearly, then, if we define "existentialist" in the loose, mournful terms that caught the popular imagination of the 1950's, Giacometti had what it took to play the role in which he was cast. But he was not just a professional pessimist, and certainly not just a Left Bank period phenomenon. He was a fiercely conscientious man who struggled with problems that have been ignored—or regarded as themes for reactionaries—by most of the major artists of the twentieth century. His achievement is probably best summarized as a long, fitful, painful evolution toward a compassionate yet unsentimental humanism and a unique style of realism.

At Stampa, the village in Italian-speaking Switzerland where he was born and raised, he was surrounded by reproductions and original works of art. His father, Giovanni Giacometti, was a respected impressionist painter; his father's cousin, Augusto, was a pioneer abstractionist, and his godfather, Cuno Amiet, a postimpressionist follower of Gauguin. By the time he was ten Alberto was already accomplished enough to produce his own sketched version of a Dürer engraving, *Knight, Death, and the Devil*; at twelve he painted his first oil, a still life with apples; and at thirteen he did his first sculpture, a bust of Diego. In 1920, at the age of nineteen, he went to Italy for an artistic grand tour. "In Venice first," he wrote, "where I spent my days looking mostly at the Tintorettos. . . . To my great regret, on the day I left Venice, Tintoretto was a little dethroned by the Giottos in Padua, and he in turn some months later by Cimabue at Assisi." He lived in Rome for nine months, painting and sculpturing a little, reading Sophocles and Aeschylus, and mostly visiting museums and churches: "I wanted to see everything. . . ." In 1922 he settled in Paris and for three years was a pupil of the sculptor Antoine Bourdelle, a poetic ex-disciple of Rodin who urged students to become "mathematicians in form and musicians in proportion."

During this formative period Giacometti acquired the habit of making pencil copies of the drawings, paintings, and sculpture of past masters. It was a habit he never abandoned. There were times, in fact, when the habit almost dominated him, when he felt that he was about to penetrate some mighty secret by forcing his hand to follow the movements of long-dead hands. In 1965, a few months before he died, he described his vivid memories of those early years:

> Suddenly I see myself in Rome at the Borghese Gallery copying a Rubens, one of the great discoveries of the day, but at this same moment I see myself in all my past: at Stampa near the window around 1914 concentrating on a copy of a Japanese print, every detail of which I can describe . . . and then a Pintoricchio surges up, and all the frescoes of the Quattrocento painters in the Sistine Chapel; I see myself four years later coming back in the evening to my Paris studio and going through books and copying this or that piece of Egyptian sculpture or a Carolingian miniature.

As well as intimately acquainting himself with the great art of the past, Giacometti absorbed the work of contemporary artists; in Paris he learned much about intellectual clarity, geometric discipline, and the rhythmic possibilities of light and shade from the cubist sculptors Henri Laurens and Jacques Lipchitz. He studied the slender forms of Constantin Brancusi and the rough textures of Rodin, who was almost a contemporary, having died in 1917.

The combination of family influence, study of great works, and proximity to the modernists in France could easily have led to a fairly safe career as either a conventional traditionalist or a conventional modernist. That Giacometti finally became neither was the result of his obsessive preoccupation with visual perception, a preoccupation that, at first, threatened to undo him psychologically.

In Rome in 1921 he began work on two busts. Then suddenly, he later recalled, he found that he could not focus properly: "I was lost, everything escaped me, the head of the model before me became like a cloud, vague and undefined." He demolished the busts. In Paris the next year the trouble began again. In the drawing classes he attended at the Montparnasse Académie de la Grande-Chaumière, he felt that he was too close to the model. When he concentrated on details of the human anatomy, they quickly became monstrous; the tip of a nose, for example, dissolved into "little more than granules moving over a deep black void," and the space across the nostrils loomed at him "like the Sahara, without end."

By 1925 he was convinced he was heading toward a psychological catastrophe, and in the hope of saving himself he decided to abandon live models and work only from memory or imagination. During the next ten years, neglecting his painting and drawing, he produced a miscellaneous collection of avant-garde sculptures. There were semiabstract idols, some reminiscent of primitive African sculpture; there were vaguely symbolic surrealist objects, like **Woman with Her Throat Cut,** and cagelike constructions, notably **The Palace at 4 A.M.,** the result of Giacometti's desire to represent what he termed "a sense of the whole, a structure, also a sharpness I saw, a kind of skeleton in space." Finally there were macabre creations like a **Cubist Head** of 1934-35, which, despite its forceful geometry, recalls an Aztec death's-head.

But he could not remain indifferent to the reality of the human figure, and in 1935 he began to work again from a live model. His idea was to do "one or two studies from nature, just enough to understand the construction of a head," but the outcome was five years of daily struggle and defeat: "Nothing was as I had imagined. A head (I quickly abandoned figures . . .) became for me an object com-

pletely unknown and without dimensions. Twice a year I began two heads, always the same ones, never completing them."

In 1940 he tried again to do without a model, relying this time on his ability to recall his visual perceptions. The result was another disaster: "The sculptures became smaller and smaller, yet their dimensions revolted me, and tirelessly I began again, only to end several months later at the same point."

He spent the last three years of World War II in Switzerland, still struggling unsuccessfully to overcome the small scale of his work. When he returned to Paris in 1945 his entire production for those three years was said to fit into six matchboxes; this may be an exaggeration, but the sculptures were alarmingly tiny. Then, apparently through the discipline of drawing, he got his sense of scale under control. In the late forties he began the creation of the tall, slim, rough bronzes, the pencil or pen sketches, and the paintings, usually portraits, that were to occupy him for the remaining twenty years of his life. And at about the same time, through the sale of his work, he emerged from the financial difficulties that had for a while forced him and his brother Diego, an able artisan in bronze, to earn their living by making lamps, vases, chairs, and other furnishings for a Paris interior decorator.

Despite continual new beginnings and frequent failures, Giacometti produced enough work to have successful one-man shows in Paris and New York. A German critic, Willy Rotzler, wrote of a visit to the artist's studio in the spring of 1950:

> He was in the middle of extremely intensive and fruitful work on his skinny, fantastically elongated standing figures. His ground-floor room was filled with them in all sizes, states, and materials. Giacometti, cigarette never absent from his left hand, walked restlessly up and down, searching like an animal in a cage. Then he carefully unwrapped the damp, clayey cloths from the figure on which he was currently working. Hesitantly at first, then as if an idea had unexpectedly occurred to him, kneading hurriedly, gouging valleys, building up ridges and knolls, his fingers crawled up and down the figure on its wire core.

Among the major pieces of sculpture of this postwar period are *Man Pointing,* a proud but haggard figure made in 1947; *City Square,* a bronze slab across which five lonely figures stride; the *Chariot*; a series of female figures; a series of men walking; a number of portraits, executed between 1954 and 1964, of his wife Annette; and a number of portraits of his brother Diego. To be in a room with some of these objects is to be in a place that is unmistakably inhabited, as if by living people. It is also to be in an atmosphere heavy with anxiety. Yet Giacometti frequently denied, especially during his last years, that his aim was to suggest any particular psychological reality, such as loneliness. He claimed that he was concerned exclusively with visible reality—optical data. But can we accept this assertion?

Certainly we cannot accept it without some commonsense qualifications. To begin with, what he sometimes called his "vision of reality" was plainly affected by his knowledge of the art of the past. His gaunt bronzes, although in no sense replicas, recall Egyptian, Archaic Greek, Cyclad-

ic, and Etruscan sculpture. The usually strict frontality and the hypnotic stare of his painted figures remind one of Sumerian worshipers, Byzantine mosaics, and the large-eyed Egyptian mummy portraits of the Roman era.

We can also assume that his vision was conditioned by his technique. Whereas an Eastern Islander or a Michelangelo carves away waste material from a block until he has the image he wants, Giacometti built up his most characteristic images by adding blobs of clay to an armature. Instead of tools he used his hands, in particular his gouging thumbs. (He took much the same kind of approach in his drawings and paintings, where the images are built up by repetitive strokes, elaborating the basic "armature.")

Certainly his private fantasies and emotional experiences entered into his sculpture. The Giacometti who was changed into a sniffing Montparnasse mongrel, for instance, exists in bronze. Made into sculptures, too, although in a less precise way, were his visions of the zombies of the Paris subway and the waiter at the Brasserie Lipp. The bronze *Chariot,* a slender nude standing on a two-wheeled platform, is partly the metamorphosis of a pharmacy wagon that was wheeled around his room when he was in the hospital after his accident in 1938.

There is much about Giacometti's work, however, that cannot be explained by art-historical or personal factors. He actually was concerned with *seeing* in the ordinary sense of the word, and he did, in fact, have difficulty with perception. Specifically, he seems to have had trouble with the visual constancies, the perceptual processes that lead us to disregard, or to compensate for, the information on our retinas and thus finally to see what we think makes sense.

Size constancy, for instance, as we all have learned and probably forgotten, enables our brains to adjust for the fact that the retinal image of an object halves with each doubling of the distance of the object from the eye. Without such psychological tampering with optical reality, we would see mountains as molehills, molehills as mountains, and a friend across the room as an elf. Precisely this sort of aberration appears to have afflicted Giacometti all his life. The evidence is not only in his Sahara-size noses and Lilliputian nymphs, but also in his paintings of relatively conventional subjects. One of his portraits of his mother in her parlor shows her pathetically dwindled; in another she seems about to disappear altogether. In a desperate attempt to control such effects, he painted red marks on his studio floor to indicate the exact positions of himself and his model.

Our brains also adjust for the angles of view that produce "distortions" of shape in the retinal images. If it were not for this, we would see square tables as diamond-shaped and round glasses as oval, and we would be baffled by the thinness of people seen from an angle. Giacometti insisted that he actually saw people who looked strangely thin, who seemed to have part of their mass eroded by space. Obviously, the attenuated forms of his bronze men and women cannot be explained completely by the failure of shape constancy; in fact, Giacometti once said he wished to convey the lightness of people in motion by making his figures so thin. But his reliance on uninterpreted retinal data may have contributed to their distortion.

Although we can never know exactly what Giacometti

saw, it is clear that through his observations and the discipline of drawing, he developed an unusual capacity that the critic Reinhold Höhl has termed "absolute eye," analogous to absolute pitch in music. As Höhl described it:

> Giacometti's optical memory became so exact with time that, when he resumed work on a canvas he may have begun months earlier, he knew, to the centimeter, whether or not the model was sitting the same distance from him as in the earlier session. This ability brought experience with it, and a very personal way of seeing things: he saw nothing and no one life-size.

Giacometti himself once said: "Life-size does not exist. It is a meaningless concept. Life-size is at the most your own size—but you don't see yourself."

His "trouble" with size and shape constancies, then, was not attributable to some peculiar eye malady; it was the result of his commitment to the problem of reconciling art, reality, and visual perception. He seems to have felt that conventional ways of looking, fostered in part by sculptors and painters, had finally, after centuries of acceptance, become barriers between ourselves and what is not ourselves: "The gap between any work of art and the immediate reality of anything has become too great," he once wrote, "and I have reached a point where nothing except reality interests me." He was ready, therefore, to run the risk of trying to start the whole business of seeing and depicting over again, from scratch. He was often quite explicit about what he was trying to do. In 1957 he expressed his dilemma to Jean Genêt: "You have got to paint exactly what is in front of you. And, in addition, you have got to produce a painting."

He knew that the problem he had set himself was finally insoluble. In 1964, without his usual irony, he admitted that "to render what the eye really sees is impossible." Yet he continued to work productively, remaining a remarkably optimistic *misérable*. A few months before his death he sized himself up in his notebook with characteristically cheerful disenchantment: "I don't know, am I a comedian, a swindler, an idiot, or a very scrupulous fellow? I only know I've got to keep trying to draw a nose after nature." (pp. 86-94)

> *Roy McMullen, "'To Render What the Eye Sees Is Impossible',"* in Horizon, *Alabama, Vol. XVIII, No. 1, Winter, 1976, pp. 86-95.*

SURVEY OF CRITICISM

Jean-Paul Sartre (essay date 1948?)

[*A French philosopher, playwright, critic, novelist, essayist, and political polemicist, Sartre is regarded as one of the seminal figures of twentieth-century culture. Although he made significant contributions to many areas of philosophy, he is primarily known as an apostle of modern Existentialism, a worldview which defines existence as a project ultimately dependent on an individu-al's ability to make choices. Sartre's writings include* L'etre et le néant (1943; Being and Nothingness, 1956), Critique de la raison dialectique (1960; Critique of Dialectical Reason, 1976), La nausée (1938; Nausea, 1949), *a novel,* Les mains sales (1948; Dirty Hands, 1949), *a play, and* Qu'est-ce que la littérature? (1948; What is Literature? 1949), *a polemical examination of the nature of literature. In the following excerpt, Sartre defines Giacometti as a unique phenomenon in the history of sculpture. Before Giacometti, Sartre writes, "men thought that they were sculpturing being, and this absolute dissolved into an infinite number of appearances. He chose to sculpture* situated *appearance and discovered that this was the path to the absolute."*]

A glance at Giacometti's antediluvian face reveals his arrogance and his desire to place himself at the beginning of time. He ridicules Culture and has no faith in Progress—not in the Fine Arts, at least. He considers himself no further "advanced" than his adopted contemporaries, the men of Eyzies and Altamira. . . .

His model: man. Neither a dictator nor a general nor an athlete, primitive man still lacked the dignity and charm that would seduce future sculptors. He was nothing more than a long, indistinct silhouette walking across the horizon. But his movements were perceptibly different from the movements of things; they emanated from him like first beginnings and impregnated the air with signs of an ethereal future. They must be understood in terms of their ends—to pick a berry or push aside a briar—not their origins. They could never be isolated or localized. (p. 82)

His substance: a rock, a lump of space. From mere space Giacometti therefore had to fashion a man, to inscribe movement in total immobility, unity in infinite multiplicity, the absolute in pure relativity, the future in the eternal present, the loquacity of signs in the tenacious silence of things. The gap between substance and model seems unbridgeable, yet exists only because Giacometti has gauged its dimensions. I am not sure whether he is a man bent on imposing a human seal on space or a rock dreaming of human qualities. Or perhaps he is both and mediates between the two. (p. 83)

I know no one else who is as sensitive as he to the magic of faces and gestures. He looks at them with passionate envy, as if they were from another kingdom. At his wit's end he has at times tried to mineralize his equals: to envision crowds advancing blindly toward him, rolling across boulevards like stones in an avalanche. Thus each of his obsessions was a task, an experience, a means of experiencing space.

"He's crazy," people say. "Sculptors have been carving away for three thousand years—and nicely, too—without such rigmaroles. Why doesn't he try to produce impeccable works according to tested techniques instead of pretending to ignore his predecessors?"

The truth is that for three thousand years sculptors have been carving only cadavers. Sometimes they are shown reclining on tombs; sometimes they are seated on curule chairs or perched on horses. But a dead man on a dead horse does not make even half a living creature. He deceives the rigid, wide-eyed people in the Museum. His arms pretend to move but are held fast by iron shanks at each end; his rigid outlines can hardly contain infinite dis-

persion; mystified by a crude resemblance, the spectator allows his imagination to imbue the eternal sinking of matter with movement, heat and light.

It is therefore necessary to start again from zero. After three thousand years the task of Giacometti and of contemporary sculptors is not to glut galleries with new works but to prove that sculpture is possible by carving. To prove that sculpture is possible just by walking Diogenes proved to Parmenides and Zeno the possibility of movement. It is necessary to go the limit and see what can be done. If the undertaking should end in failure, it would be impossible to decide under even the most favorable circumstances whether this meant the failure of the sculptor or of sculpture; others would come along, and they would have to begin anew. Giacometti himself is forever beginning anew. But involved here is more than an infinite progression; there is a fixed boundary to be reached, a unique problem to be resolved: how to make a man out of stone without petrifying him. All or nothing: if the problem is solved, the number of statues is of little consequence.

"If I only knew how to make one," says Giacometti, "I could make them by the thousands. . . ." Until he succeeds, there will be no statues at all but only rough hewings that interest Giacometti only insofar as they bring him closer to his goal. He shatters everything and begins anew. From time to time his friends manage to save from destruction a head, a young woman, an adolescent. He raises no objection and again takes up his task. In fifteen years he has had but one exposition. (pp. 83-4)

What bothers him is that [his] impressive works, always mediating between nothingness and being, always in the process of modification, perfection, destruction and renewal, have begun to exist independently and in earnest, and have made a start, far from him, toward a social career. He prefers simply to forget about them. The remarkable thing about him is his intransigence in his quest for the absolute.

This active, determined worker is displeased by the resistance of stone, which slows down his movements. He has chosen a weightless substance which is also the most ductile, perishable and spiritual of all substances—plaster. He hardly feels it at his fingertips; it is the impalpable reflex of his movements.

One first notices in his studio strange scare-crows made of white daubs that coagulate around long reddish strings. His experiences, his ideas, his desires and his dreams project themselves for a moment on his plaster men, give them a form and pass on, and their form passes on with them. Each of these nebulous creatures undergoing perpetual metamorphosis seems like Giacometti's very life transcribed in another language.

Maillol's statues insolently fling in our eyes their heavy eternity. But the eternity of stone is synonymous with inertia; it is the present forever solidified. Giacometti never speaks of eternity, never thinks of eternity. I was pleased by what he had said to me one day concerning some statues that he had just destroyed: "I was happy with them, but they were made to last only a few hours."

A few hours—like the dawn, like sadness, like ephemera. And his creations, because they were destined to perish on the very night of their birth, are the only ones among all the sculptures that I know to retain the ineffable charm of transiency. Never was substance less eternal, more fragile, more nearly human. Giacometti's substance—this strange flour that slowly settles over his studio and buries it, that seeps under his nails and into the deep wrinkles on his face—is the dust of space.

But space, even if naked, is still superfluity. Giacometti is terrified by the infinite. Not by Pascalian infinity, not by what is infinitely great. The infinity that runs through his fingers is of a more subtle and secretive type. In space, says Giacometti, there is a superfluity. This *superfluity* is the pure and simple coexistence of juxtaposed elements. Most sculptors have allowed themselves to be deceived; they have confused the proliferation of space with generosity, they have put too much into their works, they have been captivated by the plump contour of a marble bosom, they have unfolded, stuffed and distended the human gesture.

Giacometti knows that there is nothing superfluous about a living person because everything is function. He knows that space is a cancer that destroys being, that devours everything. For him, to sculpture is to trim the fat from space, to compress it and wring from it all its exteriority. The attempt may well seem hopeless, and I believe that on two or three occasions Giacometti has reached the verge of despair. If sculpturing entails carving and patching in this incompressible medium, then sculpture is impossible. "And yet," he said, "if I begin my statue, like others, at the tip of the nose, it will not be too great an infinity of time before I reach the nostril." Then it was that he made his discovery.

Consider Ganymede on his pedestal. If you ask me how far away he is, I will tell you that I don't know what you are talking about. By "Ganymede" do you mean the youth carried away by Jupiter's eagle? If so, I will say that there is no *real* distance between us, that no such relation exists because he does not exist. Or are you referring to the block of marble that the sculptor fashioned in the image of the handsome lad? If so, we are dealing with something real, with an existing mineral, and can draw comparisons.

Painters have long understood all that since in pictures the unreality of the third dimension necessarily entails the unreality of the two other dimensions. It follows that the distance between the figures and my eyes is *imaginary*. If I advance, I move nearer to the canvas, not to them. Even if I put my nose on them, I would still see them twenty steps away since for me they exist once and for all at a distance of twenty steps. It follows also that painting is not subject to Zeno's line of reasoning; even if I bisected the space separating the Virgin's foot from St. Joseph's foot, and the resulting halves again and again to infinity, I would simply be dividing a certain length on the canvas, not flagstones supporting the Virgin and her husband.

Sculptors failed to recognize these elementary truths because they were working in a three-dimensional space on a real block of marble and, although the product of their art was an imaginary man, they thought that they were working with real dimensions. The confusion of real and unreal space had curious results. In the first place, instead of reproducing what they *saw*—that is, a model ten steps away—they reproduced in clay what *was*—that is, the model itself. Since they wanted their statue to give to the spectator standing ten steps away the impression that the

model had given them, it seemed logical to make a figure that would be for him what the model had been for them; and that was possible only if the marble was *here* just as the model had been *out there.*

But what exactly is the meaning of being *here* and *out there?* Ten steps away from her, I form a certain image of a nude woman; if I approach and look at her at close range, I no longer recognize her; the craters, crevices, cracks, the rough, black herbs, the greasy streaks, the lunar orography in its entirety simply can not be the smooth, fresh skin I was admiring from a distance. Is that what the sculptor should imitate? There would be no end to his task, and besides, no matter how close he came to her face he could always narrow the gap still further.

It follows that a statue truly resembles neither what the model *is* nor what the sculptor *sees.* It is constructed according to certain contradictory conventions, for the sculptor represents certain details not visible from so far away under the pretext that they exist and neglects certain others that do exist under the pretext that they are unseen. What does this mean other than that he takes the viewpoint of the spectator in order to reconstruct an acceptable figure? But if so, my relation to Ganymede varies with my position; if near, I will discover details which escaped me at a distance. And this brings us to the paradox: I have *real* relations with an illusion; or, if you prefer, my true distance from the block of marble has been confused with my imaginary distance from Ganymede.

The result of all this is that the properties of true space overlay and mask those of imaginary space. Specifically, the real divisibility of marble destroys the indivisibility of the person. Stone and Zeno are the victors. Thus the classical sculptor flirts with dogmatism because he thinks that he can eliminate his own look and imbue something other than man with human nature; but the truth is that he does not know what he is doing since he does not reproduce what he sees. In his search for truth he encounters convention. And since the net result is to shift to the visitor the responsibility for breathing life into his inert images, his quest for the absolute finally makes his work depend on the relativity of the angles from which it is viewed. As for the spectator, he takes the imaginary for the real and the real for the imaginary; he searches for indivisibility and everywhere finds divisibility.

By reversing classicism, Giacometti has restored to statues an imaginary, indivisible space. His unequivocal acceptance of relativity has revealed the absolute. The fact is that he was the first to sculpture man as he is seen—from a distance. He confers *absolute distance* on his images just as the painter confers absolute distance on the inhabitants of his canvas. He creates a figure "ten steps away" or "twenty steps away," and do what you will, it remains there. The result is a leap into the realm of the unreal since its relation to you no longer depends on your relation to the block of plaster—the liberation of Art.

A classical statue must be studied or approached if it is continuously to reveal new details; first, parts are singled out, then parts of parts, etc. with no end in sight. You can't approach one of Giacometti's sculptures. Don't expect a belly to expand as you draw near it; it will not change and you on moving away will have the strange impression of marking time. We have a vague feeling, we

conjecture, we are on the point of seeing nipples on the breasts; one or two steps closer and we are still expectant; one more step and everything vanishes. All that remains are plaits of plaster. His statues can be viewed only from a respectful distance. Still, everything is there: whiteness, roundness, the elastic sagging of a beautiful ripe belly. Everything except matter. From twenty steps we only think we see the wearisome desert of adipose tissue; it is suggested, outlined, indicated, but not given.

Now we know what press Giacometti used to condense space. There could be but one—distance. He placed distance within our reach by showing us a distant woman who keeps her distance even when we touch her with our fingertips. The breasts that we envisioned and anticipated will never be exposed, for they are but expectancy; the bodies that he creates have only enough substance to hold forth a promise.

"That's impossible," someone might say. "The same object can't be viewed from close range and from afar." But we are not speaking of the same object; the block of plaster is near, the imaginary person far away.

"Even so, distance would still have to compress all three dimensions, and here length and depth are affected while height remains intact." True. But it is also true that each man in the eyes of other men possesses absolute dimensions. As a man walks away from me, he does not seem to grow smaller; his qualities seem rather to condense while his "figure" remains intact. As he draws near me, he does not grow larger but his qualities expand.

Admittedly, however, Giacometti's men and women are closer to us in height than in width—as if they are projecting their stature. But Giacometti purposely elongated them. We must understand that his creatures, which are wholly and immediately what they are, can neither be studied nor observed. As soon as I see them, I know them; they flood my field of vision as an idea floods my mind; the idea has the same immediate translucidity and is instantaneously wholly what it is. Thus Giacometti has found a unique solution to the problem of unity within multiplicity by simply suppressing multiplicity.

Plaster and bronze are divisible, but a woman in motion has the indivisibility of an idea or an emotion; she has no parts because she surrenders herself simultaneously. To give perceptible expression to pure presence, to surrender of self, to instantaneous emergence, Giacometti has recourse to elongation.

The original movement of creation—the timeless, indivisible movement so beautifully epitomized by long, gracile legs—shoots through his Greco-like bodies and lifts them toward the heavens. In them even more than in one of Praxiteles' athletes I recognize man, the first cause, the absolute source of movement. Giacometti succeeded in giving to his substance the only truly human unity—unity of action.

Such is the type of Copernican revolution that Giacometti has attempted to introduce into sculpture. Before him men thought that they were sculpturing *being,* and this absolute dissolved into an infinite number of appearances. He chose to sculpture *situated* appearance and discovered that this was the path to the absolute. He exposes to us men and women as *already seen* but not as already seen

by himself alone. His figures are already seen just as a for-eign language that we are trying to learn is already spoken. Each of them reveals to us man as he is seen, as he is for other men, as he emerges in interhuman surroundings—not, as I said earlier for the sake of simplification, ten or twenty steps away, but at a man's distance. Each of them offers proof that man *is* not at first in order to be *seen* after-wards but that he is the being whose essence is in his exis-tence for others. When I perceive the statue of a woman, I find that my congealed look is drawn to it, producing in me a pleasing uneasiness. I feel constrained, yet know nei-ther why nor by whom until I discover that I am con-strained to see and constrained by myself.

Furthermore, Giacometti often takes pleasure in adding to our perplexity—for example by placing a distant head on a nearby body so that we no longer know where to begin or exactly how to behave. But even without such complications his ambiguous images are disconcerting, for they upset our most cherished visual habits. We have long been accustomed to smooth, mute creatures fashioned for the purpose of curing us of the sickness of having a body; these guardian spirits have watched over the games of our childhood and bear witness in our gardens to the notion that the world is without risks, that nothing ever happens to anyone and, consequently, that the only thing that ever happened to them was death at birth.

Against this, something obviously has happened to Giaco-metti's bodies. Are they emerging from a concave mirror, from a fountain of youth or from a deportation camp? We seem at first glance to be confronted by the emaciated mar-tyrs of Buchenwald. But almost immediately we realize our mistake. His thin, gracile creatures rise toward the heavens and we discover a host of Ascensions and As-sumptions; they dance, they *are* dances, made of the same rarefied substance as the glorious bodies promised us. And while we are still contemplating the mystical upsurge, the emaciated bodies blossom and we see only terrestrial flow-ers.

The martyred creature was only a woman but she was *all* woman—glimpsed, furtively desired, retreating in the dis-tance with the comic dignity of fragile, gangling girls walking lazily from bed to bathroom in their high-heeled shoes and with the tragic horror of scarred victims of a holocaust or famine; all woman—exposed, rejected, near, remote; all woman—with traces of hidden leanness show-ing through alluring plumpness and hideous leanness mol-lified by suave plumpness; all woman—in danger here on earth but no longer entirely on earth, living and relating to us the astounding adventure of flesh, *our* adventure. For she chanced to be born, like us.

Nevertheless, Giacometti is dissatisfied. He could win the match promptly simply by deciding that he has won. But he can't make up his mind and keeps putting off his deci-sion from hour to hour, from day to day. Sometimes, dur-ing the course of a night's work, he is ready to acknowl-edge his victory; by morning everything has been shat-tered. Is he afraid of the boredom that lurks beyond his triumph, the boredom that beset Hegel after he had im-prudently stapled together his system? Or perhaps matter seeks revenge. Perhaps the infinite divisibility that he elim-inated from his work keeps cropping up between him and his goal. The end is in sight, but to reach it he must im-prove.

Much has been done but now he must do *a little* better. And then *just a little* better still. The new Achilles will never catch the tortoise; a sculptor must in some way be the chosen victim of space—if not in his work, then in his life. But between him and us, there must always be a dif-ference of position. He knows what he wanted to do and we don't; but we know what he has done and he doesn't. His statues are still largely incorporated in his flesh; he is unable to see them. Almost as soon as they are produced he goes on to dream of women that are thinner, taller, lighter, and it is through his work that he envisions the ideal by virtue of which he judges it imperfect. He will never finish simply because a man always transcends what he does. (pp. 85-92)

Jean-Paul Sartre, "The Quest for the Abso-lute," in his Essays in Aesthetics, *edited and translated by Wade Baskin, Philosophical Li-brary, 1963, pp. 82-92.*

Michel Leiris (essay date 1949)

[*A noted French poet, essayist, and anthropologist, Leiris is known for his belief in the revelatory and ultimately redemptive power of language. In the following excerpt, he asserts that Giacometti's originality lies in his struggle to differentiate between the apparent and real diameters in objects. According to Leiris, the artist "shows that he knows how to make this sort of distinction when he fash-ions figures whose 'natural size' is not dependent on their measurable height."*]

Until now, only astronomers have really troubled about the *apparent* and *real* diameters in the objects of their vi-sion. Giacometti shows that he knows how to make this sort of distinction when he fashions figures whose 'natural size' is not dependent on their measurable height.

People standing, people walking, figures crossing or meet-ing in a place which may be public or private, a single arm, a nose thrusting itself forward as though some enormous face were indiscreetly intervening; these are some of the ways for sculpture to make itself felt according to the dif-ferent protocols of Giacometti's conception. He works in the large atmospheric box which we inhabit, whose space is so different from that of the museums.

What one sees walking along a pavement when things strike one at eye-level. What one only sees at a distance from a window.

Whereas a sculpture is generally an object surrounded by space (as opposed to a cannon or a hole surrounded by bronze) Giacometti is today concerned with creating a space containing one or more objects.

Reasons for thinking that Giacometti has a byzantine sub-tlety: the ceaseless attention he gives to very simple prob-lems (but for this reason more difficult than many to de-fine, even if one only weighs words), problems posed by the way in which people and things are presented to us.

To limit oneself to what is peculiar to man: to stand, to walk by moving one leg after the other.

As a result of an accident which left him with one foot se-riously injured, Giacometti could only walk with the aid of a stick for several years. Then, one day he decided to

get rid of his stick, and no sooner had he taken this decision than he began to move without it. In the same way his sculptures stand up without either sticks or crutches.

After the well-polished solid forms with which he began (steles or water-worn pebbles, all that remains of the perception of a living thing), after the open-work constructions and the playthings which refuse to be blocks in space, have come figurines no bigger than pins and others slightly larger but still very thin, images of the vertical stance, the human form at its material minimum as growths around a plumb-line.

These elongated effigies were once painted, for the most part spattered with rust-coloured blobs, as though the necessity for giving blood to them had called this clayey colour to their surface.

Are they statues which have returned to the natural state as a result of some accident or according to a custom as yet undefined? Or just natural bodies elevated to the rank of statues by means of slight alterations or a period of ripening?

Giacometti's last sculptures have a look of 'found objects'. Inclination to believe, after all, that they are idols or mummies which have emerged from a bed of parched sand or from a volcanic formation. Comparisons: the desert formation called *rose des sables*; certain physical changes caused by erosion; certain utensils deformed by becoming embedded in molten lava or directly eaten into by a consuming vapour.

Extreme reduction of matter following an economic law which seems to determine both the quality and the quantity of the attack thereon. Only a very little, in fact the barest minimum of necessary matter, deprived of its own accord of any lustre, as though to demonstrate that richness is to be found elsewhere.

Cut away down to the bone, to the indestructible. Or, inversely, add space where the apparent desire is to eliminate yet another few grains of matter.

Between the geological and the aerial a party wall-surface.

Something of the ruins of Pompeii and of wall-paintings which have retained their freshness despite winds, storms and ashes. The kind of discoveries made by archaeologists are a point at which thousands of years of antiquity converge with an abrupt interruption of time: the sudden uncovering of a figure in which the whole of a long past is for ever summed up. As for his own discoveries, Giacometti it seems (giving orders to his hands as to a team of excavators) would pull them out of his brain complete in every detail.

Accent on speed, without which creation could not happen. Instead of the patiently elaborated work of art we now have something which rises up suddenly and which is all the more evident for looking as though it had suddenly arrived, without either roots or history: instantaneous and outside time. Given this view it is better to destroy completely than to try and correct. Watching the sort of mass sacrifices in which Giacometti indulges I have sometimes wondered whether sculpture is not for him simply a way of making something which can at once be destroyed.

Problem of the *real presence* posed and resolved by Giacometti whereas it seems to have escaped practically all our other sculptors, who are purely architects or manufacturers of mannequins which are never present despite the fact of being stuffed. (pp. 414-16)

Michel Leiris, "Contemporary Sculptors: VIII—Thoughts Around Alberto Giacometti," translated by Douglas Cooper, in Horizon, *London, Vol. XIX, June, 1949, pp. 411-17.*

Jean-Paul Sartre (essay date 1954)

[*In the following excerpt from an essay originally published in 1954 in the journal* Les temps modernes, *Sartre discusses the philosophical and psychological underpinnings of Giacometti's conception of perception and reality. Comparing Giacometti's art to that of a magician, Sartre observes that the artist "works by guesswork in accordance with what he sees, but above all in accordance with what he thinks we shall see." "His aim," Sartre concludes, "is not to present us with an image, but to produce simulacra, which, while standing for what they actually are, excite in us the feelings and attitudes which ordinarily follow from an encounter with real men."*]

"Several nude women, seen at *Le Sphinx,* and I, seated at the far end of the room. The distance separating us (the shining parquet floor which seemed impassable in spite of my desire to cross it) moved me as much as did the women" (from a letter by Giacometti to Pierre Matisse). The result: four inaccessible figurines balanced on a deep swell, which is really only a vertical parquet floor. He made them as he saw them: distant. Here [in *Four Figures on a Pedestal*] we have four attenuated girls, present to an overwhelming degree, who surge from the ground and, with one movement, threaten to fall upon him like the lid of a trunk. (p. 26)

[Distance for Giacometti] is not voluntary isolation, nor is it recoil: it is requirement, ceremony, an understanding of difficulties. It is the product—as he himself has said—of powers of attraction and forces of repulsion. If he could not cross the few meters of shining parquet separating him from the naked girls, it was because timidity or poverty had nailed him to his chair; but if he felt their inviolability so strongly, he must have wanted to touch their expensive bodies. He rejects promiscuity, good-neighbor relationships, but only because he longs for friendship, love. He does not dare take because he is afraid of being taken. His figurines are solitary; but if you put them together, in no matter what order, their solitude unites them; they instantly form a little magical society. "Looking at the figures which, in clearing the table, I had set on the ground at random, I noted that they formed two groups which seemed to correspond to what I was seeking. I mounted the two groups on bases without changing their order in the least . . . "

An exhibition by Giacometti is a whole people. He has sculptured men crossing a square without seeing one another; they criss-cross irrevocably alone, and yet they are *together*; they are about to lose each other forever, but would not be lost if they had not first sought each other out. Giacometti defined his universe better than I could

The Palace at 4 A.M. (1933)

when he wrote of one of his groups that it recalled to him "a corner of a forest seen over a number of years where the trees, with bare and lashing trunks, . . . always seemed like personages immobilized in their step and conversing."

And just what is that enclosing distance—which only the word can cross—if not the idea of the negative, the void? Ironical, defiant, ceremonious and tender, Giacometti sees the void everywhere. But not everywhere, it will be said. For there are objects which touch one another. But here is the point: Giacometti is not sure of anything, not even that objects really touch. For weeks at a time he is fascinated by the legs of a chair: they do *not* touch the ground. Between things, between men, connections have been cut; emptiness filters through everywhere; each creature secretes his own void. Giacometti became a sculptor because he is obsessed with the void. Of one of his statuettes he wrote, "Me, hurrying down the street in the rain." Sculptors rarely do their own portraits. If they attempt a "portrait of the artist," they look at themselves from the outside, in a mirror; these are the prophets of objectivity. But imagine a lyric sculptor: what he wants to render is his inward feeling, that void which as far as the eye can see encloses him and isolates him from any shelter, his dereliction under the storm. Giacometti is a sculptor because he

bears his void as a snail in its shell, because he wants to explore this void in all its aspects, in all its dimensions. Sometimes he lives in peace with the miniscule exile he carries everywhere—and sometimes it fills him with horror. (pp. 26-7)

But can sculpture suffice? Kneading the plaster, he creates the void *from a starting point of the solid*. Once the figure has left his fingers it is "at ten paces," "at twenty paces," and in spite of everything remains there. It is the statue itself which decides the distance from which it must be seen, just as court etiquette determines the correct distance from which it is permitted to address the king. The real engenders the no-man's land which surrounds it. A figure by Giacometti is Giacometti himself producing his small local nothingness.

But all these delicate absences, which belong to us as do our names and shadows, do not suffice to make a world. There is also the void itself, that universal distance of everything from everything. The street is empty, in the sun; and *in this emptiness* a personage suddenly appears. Sculpture *starting with the solid* created the void; can it show the solid surging from a prior emptiness? Giacometti has tried a hundred times to answer this question. His composition, **The Cage,** corresponds to "the desire to abolish the

base and to have a *limited* space in which to realize a head and a figure." For the whole problem is there: empty space can pre-exist, the beings that fill it can be immemorially before them, if first one encloses it between walls. This "cage" is "a room I saw; I even saw the curtains behind the woman . . ." Another time he makes "a figurine in a box between two boxes which are houses." In short, he frames his figures; they keep an imaginary distance with respect to us, but they live in a closed space which imposes on them its own distances, in a prefabricated void which they do not succeed in filling and which they submit to rather than create.

And what is this filled, framed void if not a painting? Lyrical when he is a sculptor, Giacometti becomes objective when he paints. He tries to catch the features of his wife Annette or of his brother Diego as they appear to him in an empty room, in his barren studio. . . . [He] approaches sculpture like a painter in that he treats a plaster figurine like a character in a painting: he confers on his statuettes an imaginary and fixed distance. Conversely, I can say that he approaches painting like a sculptor, for he would like us to take for a *true* void the imaginary space which the frame limits. He would like us to see the seated woman he has just painted through layers of emptiness; he would like the canvas to be like still water, and his personages to be seen *within* the picture, as Rimbaud saw a salon in a lake, through transparency. Sculping as others paint, painting as others sculp, is he a painter or a sculptor? Neither one nor the other; and both. Painter and sculptor, because his epoch does not allow him to be sculptor and architect: sculping to restore to each individual his enclosing solitude, painting to replace men and things within the world, that is to say, within the great universal void, he reaches the point where he is modeling what he first wished to paint. But at other times he knows that sculpture (or in some cases painting) alone enables him to "realize his impression." In any case, these two activities are inseparable and complementary: they enable him to treat the problem of his relations with others in all its aspects, according to whether their isolation springs from themselves, from him, or from the universe.

How paint the void? Before Giacometti, it seems that nobody tried. For five hundred years, paintings have been full to the bursting point: the whole world was crammed into them. From his canvases, Giacometti begins by expelling the world: [in his 1952 painting **Diego,** Diego is] alone, lost in a shed: that is enough. Again it is necessary to distinguish the personage from what surrounds him. Ordinarily one does this by emphasizing the contours. But a line is formed by the intersection of two surfaces, and the void cannot be represented as a surface, still less as a volume. A line separates the container from the contained, but the void is not a container. Shall one say that Diego stands out "in relief " from this wall behind him? Not the relation of "form-background" exists only for relatively flat surfaces; unless he leans against it, this far-off wall cannot serve as a background for Diego; his only contact with it is that the man and the object are in the same painting, they must bear certain practical relationships to each other (tones, values, proportions) which bring unity to the canvas. But these correspondences are at the same time canceled out by the nothingness which interposes itself between them. No, Diego does not stand out against the grey background of a wall; he is there, and the wall is there,

that is all. Nothing enfolds him, nothing supports him, nothing contains him: he *appears,* isolated in the immense frame of the void. With each one of his pictures, Giacometti leads us back to the moment of creation *ex nihilo,* each one of them poses again the old metaphysical question: why is there something rather than nothing? And still, there is something: there is this stubborn apparition, unjustifiable and superfluous. The painted personage is hallucinatory, for he presents himself in the form of a *questioning apparition.*

But how fix him on the canvas without drawing his outline? Will he not explode in the void like a deep-sea fish dredged to the water's surface? Precisely no, for the drawn line expresses an arrested flight, it represents an equilibrium between the internal and the external; it winds itself about the form taken by an object under pressure of outside forces; it is a symbol of inertia, of passivity. But Giacometti does not regard finiteness as a limitation which has to be borne; the cohesion of the real, its plenitude and its definiteness are the same single result of its internal power of affirmation. The "apparitions" affirm and limit themselves in defining themselves. Like those strange curves which mathematicians study, and which are at once enveloped and enveloping, the object is its own envelope. . . . The line is the beginning of a negation, the passage from being to non-being.

But Giacometti considers the real to be pure assertion: *there is* being, and then suddenly there is not; but there is no conceivable transition from being to nothingness. Note how the many lines he draws are *inside* the form they describe; observe how they represent intimate relations of the being with itself, the fold of a jacket, the crease of a face, the jut of a muscle, the direction of a movement. All these lines are centripetal: their purpose is to tighten, contract; they force the eye to follow them and always lead it back to the center of the figure. We are shown without warning a sudden dematerialization.

Here is a man who crosses one leg over the other; so long as I had eyes only for his face and shoulders, I was convinced that he had feet too, I even thought I saw them. But when I look for them they ravel out, they are gone in a luminous fog, I no longer know where the void begins and where the body ends. And do not make the mistake of thinking that what we have here is one of those disintegrations whereby Masson tried to give objects a kind of ubiquitousness, diffusing them over the whole canvas. If Giacometti has not indicated where the shoe ends, it is not because he deems it limitless, but because he counts on us to limit it. In actual fact, the shoes are there, heavy and dense. In order to see them it is only necessary that I do not quite look at them. To understand this procedure, it is enough to examine the sketches Giacometti sometimes makes of his sculptures. Four women on a base, just that. Let us turn to the drawing: here is the head and the neck fully drawn, then nothing, still nothing, then an open curve around a point: the belly and the navel; here is a stump of a thigh, then nothing, then two vertical lines and below these two more. That is all. A woman, complete.

What have we done? We have relied on our knowledge to re-establish continuity, and we have used our eyes to bind together these *disjecta membra:* we *have seen* arms and shoulders on the white paper; we have seen them because we *recognized* the head and belly. And these parts of the

body were in fact there, although not actually drawn. In the same way we sometimes form lucid and complete thoughts which have not come to us in words. Between the two extremities, the body is a live current. We are in front of pure reality, invisible tension of the white paper. But the void? Is it not also represented by the whiteness of the sheet? Precisely. Giacometti rejects both the inertia of matter and the inertia of pure nothingness; emptiness is fullness relaxed and slackened; fullness is emptiness given direction. The real is a flash of lightning.

Have you noticed how many white lines striate these torsos and faces? This Diego is not solidly stitched together, he is only basted. Or can it be that Giacometti wants to "write luminously on a black background"? It has almost become no longer a question of separating the solid from the empty, but of painting plenitude itself. But this plenitude is both one and many; how to differentiate without dividing it? Black lines are dangerous, they run the risk of scratching the being, of splitting it. In employing them to encircle an eye, to hem in a mouth, we might be led to believe that there are fistulas of emptiness at the heart of reality. These white striae are there to indicate without themselves being seen, they guide the eye, directing its movements and melting under the glance.

But the real danger is elsewhere. We have all heard of Arcimboldo's successes, of his piled up vegetables and heaps of fish. What is it about these tricks which seduces us? Might it not be that the method has long been familiar? And what of our painters? Each after his own fashion, were they all Arcimboldos? It is true that they would scorn to compose a human head of a pumpkin, tomatoes and relishes. But do they not daily compose faces of a pair of eyes, a nose, two ears and thirty-two teeth? What real difference does it make? A head becomes in its turn an archipelago. What should one paint? That which is, or what we see? And what do we see? This chestnut tree under my window is for some a large, uniform and trembling ball; others have painted its leaves one by one with each vein noted.

But Giacometti wants to paint what he sees precisely as he sees it; he wants his figures, at the heart of their original void, to pass and repass unceasingly on his immobile canvas from the continuous to the discontinuous. He wants to isolate the head since it is sovereign; at the same time he wants the body to recapture it, so that it becomes nothing more than a periscope of the belly, in the sense that one says Europe is a peninsula of Asia. Of the eyes, the nose and the mouth he would make leaves in foliage, separate and merged at one and the same time. He succeeds in this, and it is his major success, by refusing to be more precise than perception. It is not a question of painting *vaguely*; on the contrary, he is able to suggest a perfect precision of being under the imprecision of knowing.

In themselves, or for others gifted with better sight, for the angels, these visages rigorously tally with the principle of individuation; they are defined in their slightest details. This we know from the first glance; moreover we instantly recognize Diego [in **Diego**] and Annette [in his 1954 painting **Annette Seated**]. This would be enough to free Giacometti from the reproach of subjectivism if that were necessary, but at the same time we cannot regard the canvas without uneasiness; we want, despite ourselves, to ask for an electric flash, or simply a candle. Is it a fog, the fall of

dusk, or have our eyes grown tired? Is Diego opening or closing his eyelids? Is he dozing? Is he dreaming? Is he spying on us? It is true that one asks these questions in front of portraits so indistinct that all answers are equally possible, none more than the others. But the indetermination of awkwardness has nothing in common with the calculated indeterminateness of Giacometti; should not the latter, by the way, be called over-determination? I turn back to Diego, and from one moment to the next he sleeps, he wakes, he glances at the sky, he fixes his eyes on me. All this is real, evident, but if I incline my head a little, if I change the direction of my glance, the evidence fades away and something else replaces it. If I tire of this and want to stick to one conception, my only way of doing so is to walk away from it as fast as possible. Even so, that conception will remain—fragile and merely probable. Thus when I detect a face in the fire, in an ink-spot, in the arabesques of a curtain, the form, appearing suddenly, sharpens its outlines and imposes itself on me; but, while I cannot see it differently from the way I do, I know that others will see it differently. But the face in the flame has no veracity; in the pictures of Giacometti, what annoys us and at the same time bewitches us is that *there is truth* here, and we are sure of it. It is there at hand, however little I seek it out. But my vision blurs and my eyes tire: I give up. The more so since I begin to understand: Giacometti holds us fast because he has inverted the data of the problem.

These extraordinary figures, so completely immaterial that they often become transparent, so totally and fully real that they affirm themselves like a blow of the fist and are unforgettable, are they appearances or disappearances? Both at once. They seem sometimes so diaphanous that one no longer dreams of asking questions about their expression, one pinches oneself to be sure that they really exist. If one obstinately continues to watch them the whole picture becomes alive, a somber sea rolls over and submerges them, nothing remains but a surface daubed with soot; and then the wave subsides and one sees them again, nude and white, shining beneath the waters. But when they reappear, it is to affirm themselves violently.

They are entirely in action, and sinister, too, because of the void which surrounds them. These creatures of nothingness attain the fullness of existence because they elude and mystify us.

A magician has three hundred helpers every evening: the spectators themselves, and their second natures. He attaches a wooden arm in a fine red sleeve to his shoulders. The public demands two arms in sleeves of the same material; it sees two arms, two sleeves, and is content. And all the time a real arm, wrapped in a black invisible material is at work seeking a rabbit, a playing card, an exploding cigarette. The art of Giacometti is related to that of the magician: we are his dupes and accomplices. Without our avidity, our heedless precipitation, the traditional errors of our senses, and the contradictions of our perceptions, he could not succeed in making his portraits live. He works by guesswork in accordance with what he sees, but above all in accordance with what he thinks we shall see. His aim is not to present us with an image, but to produce simulacra, which, while standing for what they actually are, excite in us the feelings and attitudes which ordinarily follow from an encounter with real men. (pp. 27-8, 63-5)

Jean-Paul Sartre, "Giacometti in Search of Space," translated by Lionel Abel, in ART-news, Vol. 54, No. 5, September, 1955, pp. 26-9, 63-5.

Dore Ashton (essay date 1959)

[*Ashton is an American educator and critic who has written extensively on modern artists and art movements. In the following excerpt, she praises Giacometti as an artist capturing the essence of the human being.*]

[Giacometti's] incantatory power doesn't have to be described. Why do his shafts in space mean more than the many literal representations of the miserable human condition . . . ? I think it is because . . . Giacometti *is* concerned with essence, since essence is irreducible form. Giacometti is creating a large metaphor. He is restoring mythic grandeur. His province is the universe, and though his human figures stand alone and are perhaps threatened by that universe, they do stand immovable with the aura of ineffability that surrounds an Egyptian carving. There may be a reference to Sardinian sentinels, or to pre-historic figures, but it is a reference among many. Giacometti has transformed the figure as no other artist of his generation has done. He is no longer talking about what is outside the figure really. He portrays the human being when he is reduced to his essence. Giacometti does not question the validity of that essence. (pp. 15, 40)

Dore Ashton, "New Images of Man," in Arts & Architecture, *Vol. 76, No. 11, November, 1959, pp. 14-15, 40.*

Alexander Watt (essay date 1960)

[*In the following excerpt from an essay recounting Watt's visit with Giacometti in 1960, the critic and the artist discuss Giacometti's working methods and his artistic vision.*]

Giacometti had met with me for an *Art in America* interview, so we got started: What did he think of the marked revival and interest in modern sculpture both here and in America? To this, he shrugged his shoulders and merely replied that there apparently does exist a new vision, a sort of *tachisme* of wrought-iron sculpture that was making a certain appeal: but which did not appeal to him at all. But when I asked him whom he admired among the sculptors of today, he would voice no opinion whatsoever. His preference for the deceased modern masters goes to Rodin, Despiau, Germaine Richier and Lehmbruck. But of all the periods of sculpture, Giacometti admires most the Egyptian and Chaldean.

Before tackling more complex problems, I felt I had to ask Giacometti what might appear to be banal questions but the answers to which I consider of importance when attempting to ascertain the *modus operandi* of someone like Giacometti; I, and many others, look upon him as an unrivaled genius in his field.

"Do you work with difficulty?" I asked, just to get him started.

"Not necessarily," he replied.

"Do you work at long stretches, or spasmodically?"

"Rarely spasmodically."

"It is said that a true artist is seldom satisfied with his work. Do you agree and do you destroy much?"

"I am occasionally *relatively* pleased with my efforts, despite the fact that I consider a painting or a piece of sculpture to be never finished. Accordingly, I am quite often inclined to abandon the subject without necessarily having to destroy it."

"What is the medium you prefer?"

"Bronze, of course. But I like to start working on a bust in terracotta and on figures and objects from memory in plaster."

"Do you execute sketches or make annotations before working on the subject?"

"No. I find it unnecessary."

"Have you ever taught sculpture, or had pupils?"

"Sculpture for me is a necessity, but it is what I understand the least. Therefore, I would be incapable of teaching as I am not quite aware of what I myself am doing. It would be a case of my being one of the pupils and not the professor."

After this elementary give-and-take, I realized I had to take the plunge, so I asked him how he came to formulate the very thin, elongated figures for which he is now famous. What gave him the idea? What importance did he attach to a feeling for space in the creation of his works?

"I just can't tell you what gave me the idea," he answered. "It came to me involuntarily. Contrary to what one might believe, I 'discovered' the very small (about one-third life size) Egyptian heads in the Louvre *after* I had started to execute my own figurines. Now I have reached the stage when I wish to escape from producing them in this manner; but I am not succeeding in doing so. I find that the more I construct, the more I compress. Up until 1944, I saw people in their natural life size; since then they have been growing smaller and smaller, everyone and everything becoming tinier.

"When I look at you across this table, I don't see you at all. To get a proper vision of you, I have to retreat to a distance. You see, it is the space-atmosphere around a person and, correspondingly, its interpretation in sculpture, that are of major importance. I am incapable of visualizing anyone who may be walking alongside me down the street. In order to be able to see them I must ask them to cross the street and walk down the opposite pavement."

We then proceeded to discuss "reality." Giacometti remarked that the more he has wished to express objective reality, the more difficult it has become for him. He tries to copy as much as possible of what he himself sees without transposing it. It is not merely a matter, he explained, of painting fine pictures and making good sculpture, but rather of trying to convey as nearly as possible one's own vision of reality. It is not the portrait that is the principal thing; it is the subject that counts.

Giacometti was a close friend and admirer of Henri Laurens whose sculpture he describes as being a veritable pro-

jection of himself in space, rather like a three-dimensional shadow:

> One never quite makes contact, so to speak, with his sculpture. There always exists a space of indefinable dimension which separates us from it and which is yet the sculpture itself.

> One must create a vision and not merely something that one knows to exist. When you are engaged on a bust you see the front of the head, and the side or sides, but not the back of the head. Compare, for example, a head in marble by Houdon with one in wood by an African Negro—which is flatter, less three-dimensional. Well, for me, the truer, the more real one is the African carving. Even when working on a familiar subject, as for instance the bust of my brother Diego, I find it increasingly difficult to complete. The more I work on it, the less I feel I am going to achieve. And as I gradually do feel I am completing it, the more I feel I will have to start on it all over again. The fact remains that the unknown is reality, and vice versa.

It is much easier for Giacometti to execute a piece of sculpture from his imagination than it is for him to do a portrait bust. When I asked if he pondered about his subjects, and did inspiration come to him easily, he quoted his *Chien* as an example of something that had long been lurking in his mind, and had suddenly appeared plausible and easy for him to produce. His *Chien* had been on his mind for four years or more; to such an extent that, as he put it, he almost started to become a dog himself. Then, in a flash, he visualized the dog exactly as it should be. He rushed back to his studio and executed his now well-known piece of sculpture in the course of an afternoon— "so as to get rid of the hound once and for all." (pp. 100-02)

Giacometti showed me many drawings and several paintings, one a still life with apples; the other a quite detailed, head-and-shoulders portrait study of his wife, Annette. Both were painted in a harmony of blacks and greys with faint added touches of pale yellow ochre, terre verte and rose madder. But Giacometti confessed that he had lost interest in these two canvases. He said that he had overaccentuated a black line underneath one of the apples and if he removed it everything in the color composition would have to be altered and he would, virtually, have to paint a completely new version of the same subject. As for the portrait, it needed a soupçon of pale ochre but then the whole composition would have to be chromatically rebalanced and he did not intend to tamper with it any more.

One gets the impression that color, for Giacometti, is as much a mystery and a problem as is the question of expressing his own vision of form in sculpture: "Color is an adventure," he said, and then we started discussing the merits of Cézanne (who had obviously influenced him in his still life composition of the apples) whose famous remark about form being color he refuted, to my surprise. Neither was Giacometti in agreement with Braque's statement that "in painting, the thing of most importance is that which cannot be explained."

Said Giacometti: "Braque may well convey a lyrical expression of his thought. But that is not what I am attempting to do. On the contrary, I try to avoid evading issues." (p. 102)

Alexander Watt, "Paris Letter: Conversation with Giacometti," in Art in America, *Vol. 48, No. 4, Winter, 1960, pp. 100-02.*

Max Kozloff (essay date 1965)

[*Kozloff is an American educator, art critic, and photographer whose writings include* Renderings: Critical Essays on a Century of Modern Art (*1969*), Photography and Fascination: Essays (*1979*), *and* The Privileged Eye (*1987*). *In the following excerpt from the first-named work, Kozloff questions the originality of Giacometti's post-Surrealist sculptures—which reflect the artist's theories concerning the perception of space—by maintaining that the extreme distortion of the human figure was related to "the displacement of his various erotic or castration ironies and condensations by a heroically pictorial mode that nevertheless retained their underlying anatomy."*]

The difficulty in viewing any large-scale exhibition of Alberto Giacometti, such as the show now at the Museum of Modern Art, is to accommodate oneself to the problem of the one and the many. Every single piece gains credence and potency—the dessicated, saturnine flitch figures he has done since World War II, as well as his earlier Surrealist creations—from the company of its fellows. The spectator grows convinced that he is in the presence of a *Vision*. At the same time, the single-mindedness of that vision, its poverty of themes, especially as the work comes closer to the present, expunges the uniqueness and individuality of his sculptures. They begin to seem mechanized concretions of some wholly foreordained and self-convinced scheme of three-dimensional life. Can two hundred versions of the same predicament have as much point or maintain as much impact on the consciousness as twenty? Even Giacometti's much-touted sense of the impossibility of art has not prevented him from being one of the most prolific poets of agony and uncertainty. Known far and wide as one of the most intensely self-critical of artists, he has significantly refused to ration or vary to any extent the production he sends into the world. It is left entirely to his viewers to sort out the high points of an almost animal collision between a painful obsession and a facile execution.

There has always been something very unsatisfying to me about certain premises and aspects of Giacometti. The moral example set by the sobriety of his life and by his devotion to his craft has issued in sculptures that are often extraordinarily stylized and mannered. Some of them come close in spirit to the Buffet paintings that so cheaply derive from them. And many of Giacometti's paintings of heads bear a resemblance to such modishly X-rayed cousins as Tchelitchew's. About his very abandonment to the mysteries of individual sensations (e.g., the uncertain distance between the tip and the bridge of a nose) there is a quality of self-consciousness—in his work, if not his attitude. In fact, the external dictates of style have dominated his art—as much in the postwar era when it seems to be testing itself by observing visual phenomena as during its previous shaping of the grand metaphors of experience in Cubism and Surrealism. Perhaps the very minuteness of the distinctions he has been making for the last twenty years in contour, scaling, and surface has compelled his

fixity of stance and predictability of outlook. For all the lavishness of his scrutiny, his bronze figures remain lumpy armatures because, among other things, he has not given himself enough mass to differentiate them. You can diminish your problems so much that you know their solutions ahead of time. Giacometti's precious indecision comes more from his inability to settle for the results of any one sequence among his many operations than it does from the difficulty of implementing the order he desires. The hand is nimble, but the judgment is paralyzed. His linearism, for example, looks either extremely brisk or scribbly—not at all tortured—and in this, his painting and drawings show rather too much relation to the *bijouteries* of Mathieu and Viera da Silva (which, incidentally, disproves the myth about his solitude). But above all, the Expressionist and archaic aura of the Giacomettis since 1945—they look like Byzantine effigies rumpled with mud—is out of keeping, I think, with an essentially intimist talent.

As presented at the Modern . . . , Giacometti's career stands out clearly enough. At his beginning, as a young Swiss doing loose-limbered oil portraits in 1921, and now, as the grand old lion of the Ecole de Paris, he is dominated by the example of Cézanne. The youth follows his master agreeably and academically; the veteran sees in Cézanne not a problem of construction (although this had been a concern of some faceted figure drawings of 1923-24) but a nervousness of contour that might be construed as a device to suggest movement and spatial displacement. Yet it becomes more often a motorized quaver imposing a badly needed energy upon a stick-rigid composition.

Occasionally, in some remarkable drawings (*Vase of Flowers,* 1959) or paintings (*The Artist's Mother,* 1950), one's gaze is delicately stretched and glued at various translucent planes demarcated by a wiry or scratchy tracery. As Palma Bucarelli puts it: "Space is dangerous . . . it is open to all possibilities; one doesn't know what can happen to him who carelessly enters it. It is like a cobweb: who falls into it is immediately enveloped and kept motionless by thousands of adhesive and flexible threads." It is not, perhaps, the most pleasant feeling, this sense of the atmosphere caving in and yet holding on to you at any point of contact. Unlike Cézanne's, works of this kind now seek to confuse the object with a state of mind or, more accurately, a form of agitation. While they can seem garrulous or overly rhythmic, they are more frequently fragmented, unable to spread out to the margins or to keep huge masses within the field of vision from going out of focus. Possibly nothing more comprehensive could be expected from Giacometti, who becomes fascinated by an eye or a cheek rather than by the overall tensions of a picture. Though his impulses are graphic, he equates the graphic with the volumetric (some of the heads in his pictures are actually bas-reliefs built up like balls of twine), and tries to compensate for his pictorial sketchiness by exaggerating it as an expressive vehicle.

As to his specific sculptural contributions, Giacometti by the late Twenties—and hence prophetically early—had embarked into a wholly Surrealist ambience. Other men, notably Arp, were to insinuate animism into abstract, if amoeboid, forms so that they seem to shimmy by themselves rather than be vehicles of a represented motion. Giacometti, for his part, was to miniaturize the totemic or Cubist syntax so radically that it demanded to be read as

a self-contained landscape or urban tableau. When it was a question of inventing a single shape, such as the platter-like *Head* (1928) or a unique figure-object metamorphosis, like the concave bronze *Spoon Woman* (1926), nothing much occurred except a curiously stiff and tight schematism. But on other occasions, reductions of similar images to the status of Lilliputian inhabitants on a plateau charged the space with an imminence of commuting but irrevocably isolated human forces that had not been seen in European art since the de Chiricos, which might, in fact, have obliquely influenced them (*No More Play,* marble, 1933). It was Giacometti's *The Palace at 4 A.M.* (also 1933), that sinister doll's house, which transmuted more vitality into American sculpture than even the Picassos and Gonzalezes of the time and left a deep imprint on Smith, Hare, Lassaw, and Ernst. Not forms or their echoes but a nightmare of immobility articulated the voids of the composition.

This, perhaps, is the greatest paradox of Giacometti: that he articulates the environment by diminishing as much as possible the mass and restricting the orientation of the elements that occupy space. An irrational process of reverie rather than physical manipulation of shapes completes a dimension that would otherwise be lacking. Much has been written (and encouraged by the artist himself) on the sharp break that occurred in his career during the Second World War—as if the succeeding work was a repudiation of the abstract and Surreal in favor of a new humanism. Yet, if we except the tactility of this sculpture as a reversion to the Expressionist side of his teacher, Bourdelle, the change was not so great—especially concerning his literary feeling for space. For one thing, there are outright continuities of subject: *Main prise* (1932) with *The Hand* (1947) and *Pointe a l'oeil* (1931) with *The Nose* (1947). And the two nudes of 1934-35 are elongated premonitions of things to come. It is all a sign language that Giacometti has worked out to show that limbs can be impaled or stretched to an absurd degree—but more in demonstration of a fantasy trap than as a response to outer violence or events. (The 1950-51 cage pieces are an effective display of this spirit—they go back to the Palace—while at the same time they embody a nice sense of the theater.) But what essentially had happened was the displacement of his various erotic or castration ironies and condensations by a heroically pictorial mold that nevertheless retained their underlying anatomy. In one sense, this was a regression to the Rodin tradition; but on another level, it was a sharing of the contemporary urge for that heightened surface activity which had engulfed painting.

It would have been interesting to report that Giacometti had become the Abstract Expressionist sculptor par excellence, for neither his development nor his concentration on the figure were out of phase with that moment. Unfortunately, his attempt to pierce a delusion about the unfamiliarity of all faces and figures *was* out of phase. Given the hypotheses of his art up to then, the naturalism he now wanted to impose upon his vision was indeed impossible. There emerged a war between the conceptual and the sensorial in which the former won, but not before being uprooted from the whole formally nourishing environment of modern art, which Giacometti, among others, had enjoyed prior to 1939 (and which has not given sign of reviving since). Suddenly, everything becomes preposterously difficult for him, and the most trivial verification of a point

or plane in space slips beyond his grasp. It is the material—the clay—that now pays the price by being clawed into shriveled or gummy tatters. Worse still, far from being some newly felt equivalent of optical data, it registers that tiresome anguish, that intimation of death and destruction, which is far more explicit and illustrational than he would ever have permitted in the past. Before this dilemma, his sensitivity softens and washes timidly around what are sometimes striking, but more often vacant, ciphers. And after all his experience, the final retreat back to Cézanne is too late and misconceived. What stand out in the end are some very poignant vignettes in drawing and sculpture of city men and women walking in a square—poignant because their disorientation reflects some of Giacometti's own. (pp. 182-87)

> *Max Kozloff, "Giacometti," in his* Renderings: Critical Essays on a Century of Modern Art, *Simon and Schuster, 1969, pp. 182-87.*

John Berger (essay date 1966)

[*Berger is a distinguished English novelist, poet, translator, and art critic. His writings include* The Success and Failure of Picasso (*1965*), Art and Revolution: Ernest Neizvestny and the Role of the Artist in the U.S.S.R. (*1969*), *and* A Seventh Man: A Book of Images about the Experience of Migrant Workers in Europe (*1975*). *In the following excerpt from a 1966 essay which was later published in his 1969 book* The Moment of Cubism, and Other Essays, *Berger examines Giacometti's artistic legacy, remarking that the artist, although opposed to the idea of a shared reality, remained faithful to the principle of artistic truth and honesty.*]

The week after Giacometti's death *Paris-Match* published a remarkable photograph of him which had been taken nine months earlier. It shows him alone in the rain, crossing the street near his studio in Montparnasse. Although his arms are through the sleeves, his raincoat is hoiked up to cover his head. Invisibly, underneath the raincoat, his shoulders are hunched.

The immediate effect of the photograph, published when it was, depended upon it showing the image of a man curiously casual about his own well-being. A man with crumpled trousers and old shoes, ill-equipped for the rain. A man whose preoccupations took no note of the seasons.

But what makes the photograph remarkable is that it suggests more than that about Giacometti's character. The coat looks as though it has been borrowed. He looks as though underneath the coat he is wearing nothing except his trousers. He has the air of a survivor. But not in the tragic sense. He has become quite used to his position. I am tempted to say 'like a monk', especially since the coat over his head suggests a cowl. But the simile is not accurate enough. He wore his symbolic poverty far more naturally than most monks.

Every artist's work changes when he dies. And finally no one remembers what his work was like when he was alive. Sometimes one can read what his contemporaries had to say about it. The difference of emphasis and interpretation is largely a question of historical development. But the death of the artist is also a dividing line.

It seems to me now that no artist's work could ever have been more changed by his death than Giacometti's. In twenty years no one will understand this change. His work will seem to have reverted to normal—although in fact it will have become something different: it will have become evidence from the past, instead of being, as it has been for the last forty years, a possible preparation for something to come.

The reason Giacometti's death seems to have changed his work so radically is that his work had so much to do with an awareness of death. It is as though his death confirms his work: as though one could now arrange his works in a line leading to his death, which would constitute far more than the interruption or termination of that line—which would, on the contrary, constitute the starting point for reading back along that line, for appreciating his life's work.

You might argue that after all nobody ever believed that Giacometti was immortal. His death could always be deduced. Yet it is the fact which makes the difference. While he was alive, his loneliness, his conviction that everybody was unknowable, was no more than a chosen point of view which implied a comment on the society he was living in. Now by his death he has proved his point. Or—to put it a better way, for he was not a man who was concerned with argument—now his death has proved his point for him.

This may sound extreme, but despite the relative traditionalism of his actual methods, Giacometti was a most extreme artist. The neo-Dadaists and other so-called iconoclasts of today are conventional window-dressers by comparison.

The extreme proposition on which Giacometti based all his mature work was that no reality—and he was concerned with nothing else except the contemplation of reality—could ever be shared. This is why he believed it impossible for a work to be finished. This is why the content of any work is not the nature of the figure or head portrayed but the incomplete history of *his* staring at it. The act of looking was like a form of prayer for him—it became a way of approaching but never being able to grasp an absolute. It was the act of looking which kept him aware of being constantly suspended between being and the truth.

If he had been born in an earlier period, Giacometti would have been a religious artist. As it was, born in a period of profound and widespread alienation, he refused to escape through religion, which would have been an escape into the past. He was obstinately faithful to his own time, which must have seemed to him rather like his own skin: the sack into which he was born. In that sack he simply could not in all honesty overcome his conviction that he had always been and always would be totally alone.

To hold such a view of life requires a certain kind of temperament. (pp. 112-14)

But it is by no means only a question of temperament: it is even more a question of the surrounding social reality. Nothing during Giacometti's lifetime broke through his isolation. Those whom he liked or loved were invited to share it temporarily with him. His basic situation—in the sack into which he was born—remained unchanged. (It is interesting that part of the legend about him tells of how

almost nothing changed or was moved in his studio for the forty years he lived there. And during the last twenty years he continually recommenced the same five or six subjects.) Yet the nature of man as an essentially social being—although it is objectively proved by the very existence of language, science, culture—can only be felt subjectively through the experience of the force of change as a result of common action.

Insofar as Giacometti's view could not have been held during any preceding historical period, one can say that it reflects the social fragmentation and manic individualism of the late bourgeois intelligentsia. He was no longer even the artist in retreat. He was the artist who considered society as irrelevant. If it inherited his works it was by default.

But having said all this, the works remain and are unforgettable. His lucidity and total honesty about the consequences of his situation and outlook were such that he could still save and express a truth. It was an austere truth at the final limit of human interest; but his expressing of it transcends the social despair or cynicism which gave rise to it.

Giacometti's proposition that reality is unshareable is true in death. He was not morbidly concerned with the process of death: but he was exclusively concerned with the process of life as seen by a man whose own mortality supplied the only perspective in which he could trust. None of us is in a position to reject this perspective, even though simultaneously we may try to retain others.

I said that his work had been changed by his death. By dying he has emphasized and even clarified the content of his work. But the change—anyway as it seems to me at this moment—is more precise and specific than that.

Imagine one of the portrait heads confronting you as you stand and look. Or one of the nudes standing there to be inspected, hands at her side, touchable only through the thickness of two sacks—hers and yours—so that the question of nakedness does not arise and all talk of nakedness becomes as trivial as the talk of bourgeois women deciding what clothes to wear for a wedding: nakedness is a detail for an occasion that passes.

Imagine one of the sculptures. Thin, irreducible, still and yet not rigid, impossible to dismiss, possible only to inspect, to stare at. If you stare, the figure stares back. This is also true of the most banal portrait. What is different now is how you become conscious of the track of your stare and hers: the narrow corridor of looking between you: perhaps this is like the track of a prayer if such a thing could be visualized. Either side of the corridor nothing counts. There is only one way to reach her—to stand still and stare. That is why she is so thin. All other possibilities and functions have been stripped away. Her entire reality is reduced to the fact of being seen.

When Giacometti was alive you were standing, as it were, in his place. You put yourself at the beginning of the track of his gaze and the figure reflected this gaze back to you like a mirror. Now that he is dead, or now that you know that he is dead, you take his place rather than put yourself in it. And then it seems that what first moves along the track comes from the figure. It stares, and you intercept

the stare. Yet however far back you move along the narrow path, the gaze passes through you.

It appears now that Giacometti made these figures during his lifetime, for himself, as observers of his future absence, his death, his becoming unknowable. (pp. 114-16)

> *John Berger, "Artists and Their Meaning: Giacometti," in his* The Moment of Cubism and Other Essays, *Pantheon Books, 1969, pp. 112-16.*

Harold Rosenberg (essay date 1974)

[*Rosenberg was an esteemed American art critic and a frequent contributor to such major publications as the* New Yorker, *the* Kenyon Review, *and* Partisan Review. *Although he discussed a wide range of aesthetic issues in his writings, he is best known for his advocacy of Abstract Expressionism throughout his long career. In the following excerpt from his review of the 1974 Giacometti retrospective at the Guggenheim Museum, Rosenberg discusses the evolution of Giacometti's aesthetic aims.*]

As a legend, Giacometti is a match for Duchamp, though of an opposite order: against the celebrated impresario of non-works ("ready-mades"), he represents the absolute worthwhileness of engaging in the processes of creating sculptures and paintings. His elongated thin figures, axe-blade heads, and portraits in oil and pencil have aroused more notions about their meanings than have the works of any other artist of his generation. Giacometti turns the human body and physiognomy into a metaphysical substance. Picasso, who regarded him as his sole competitor in fame, said that he had conceived "a new spirit in sculpture." Breton, Genet, and Sartre—names outside those that usually swell the bibliographies of museum catalogues—have written of him as one who enlarged their points of view. He was close to Beckett, and is said to have realized the theory of perception of Merleau-Ponty, the Sisyphean vision of Camus, and the narrative reductionism of the *nouveau roman.* In the introduction to the catalogue of the large retrospective at the Guggenheim Museum, Reinhold Hohl, also the author of the exhaustive *Alberto Giacometti* [see Further Reading] found himself obliged to deny that the thinness of Giacometti's personages (who include an emaciated cat and dog) has to do with war, famine, or concentration camps, "as has often been proposed." Nor, in Hohl's opinion, does a work such as **The Cage,** in which a bodiless male head on a long, stringy neck confronts an erect, pencil-thin mummy of the same height, stand for "existential solitude." Yet, for all his objections to inflated interpretations, Hohl identified Giacometti's women with "the myth of Life"—a myth that culminated in the monumental group that was planned for the Chase Manhattan Plaza but never executed—and he concluded that "Giacometti belongs among the artists who set a milestone not only for their own century but for a millennium."

Hohl's conception of Giacometti as a thousand-year artist is in line with the overtones of fable of Giacometti's art itself. His sculptures and paintings are overlaid with intimations of antique mysteries: Egyptian tomb deities, sentinels in the desert, darkening caverns. Giacometti's imagination

Chariot (1950)

is anthropological. His giant buried up to the shoulders at the feet of an array of entranced vestals (*Composition with Seven Figures and a Head* [*The Forest*]); his erect nudes with bodies and faces eroded by time (*Large Figure*), and others with tiny heads but features starkly detailed, as in a dream (*Woman of Venice II*); his male heads poised piteously on stakes, like victims of a jungle massacre (*Head of a Man on a Rod*)—all these are evocative less of the art of the past than of its rituals, celebrants, and talismans. Giacometti "museumizes" his subjects; in *The Cage* and *Figure between Two Houses* the figures appear in display cases, and his completer portraits are built into frames drawn on the canvas—often a succession of frames, one inside another, receding into the distance. His sitters, including his brother and his wife, who modelled for him continually, as well as passersby on the street, are taken out of time and transformed into exhibits. Yet the museum into which they have entered is not an art museum but a museum of man, of ways of life alien to Western idealizations.

Extending into fable, Giacometti's theatre without words reaches at the same time into contemporary fact. The rigid, hieratic women, arms pinioned to their sides, suggest temporal remoteness. But they are also women of our day, seen according to certain spatial hypotheses, and the sitters for his portraits, for all their odd staring and removed location, wear sweaters and business suits and pose in the artist's messy studio. Basic to Giacometti's vision is the phenomenon of distance, in actual space and in the psychology of seeing. Observed from afar, a standing figure appears to be fused into a narrow, compact monolith, armless and with legs grown together into a tree trunk, while a walking figure is surprisingly slender and long-

legged, as are Giacometti's reedlike men. In his art, stick figures of the kind incised on the walls of caves become pedestrians in chance combinations on busy street corners. The celebrated wedge-shaped heads of his brother, Diego, with their uncanny likeness, are demonstrations of Giacometti's notion that where the gazes of the right eye and the left intersect, the width of objects diminishes toward zero and a head consists of a wafer of two profiles, a ketchup bottle of a vertical red line. Narrowing and elongation, accompanied by a strange fixity and transparency, occur, too, in faces seen reflected in a bottle or a convex mirror.

With Giacometti, one may also speak of metaphysical distance—the space by which the dead are separated and in which they are enveloped, and the space of apparitions. Throughout his life the artist recalled two decisive experiences when he was about twenty, during a trip to Italy; each resulted in a radical transformation of his apprehension of size and distance. One was the sudden death of a travelling companion, who thought he would be better the next day but of whom Giacometti recalled that "by late afternoon I had the feeling his nose was growing longer." Then his friend was dead, "had turned into an object," and things "started to fall apart." The dead are smaller and less material than the living; they weigh less. Giacometti's sense of the separation and motionlessness of objects, of space as a void in which all physical contact has foundered, was what impressed Sartre. Giacometti himself described in rather melodramatic terms ("I looked at my room in terror," "cold sweat ran down my back") the way he saw the furniture in his studio become weightless and immobile, the legs of the table not resting on the floor but barely touching it. Later, it occurred to him that weightlessness was the explanation of why his sculptured figures were so thin. He also associated this impression with the absence of weight of people who pass one on the street—a way of saying that the flowing crowd is a throng of ghosts, as in Eliot's *The Waste Land*. "All living things," said Giacometti, "were dead, and this vision often recurred, in the Métro, on the street, in restaurants."

The other experience that changed Giacometti's apprehension of things came while he was walking through the streets of Padua, painfully trying to resolve conflicting feelings aroused by the impact of Giotto on his admiration for Tintoretto. "These contradictory feelings shrank to nothing when I saw two or three young girls walking in front of me. They appeared immense to me, all out of proportion to normal size. . . . I stared at them like a madman, fear shot through me. It was like a fissure in reality. . . . The connections between things had changed." For Giacometti, the "two or three" oversized girls (it is notable that he is vague about the number but absolutely positive about the total impression) became the representation of "reality"—a reality that stood against art, even at its highest (Giotto), and nullified it. The vision of the girls and the vision of the companion alive one moment and turned into an object the next had in common the suddenness and unexpectedness of the metamorphosis. Reality became defined for Giacometti as a flash struck from dead space by an ecstatic apprehension of particulars. This dual theme of death as an impassable distance and of reality as a transcendental glimpse recurs in each phase of his career, accompanied by episodes of shock and illumination. One day he leaves a movie house and sees the Boulevard Montparnasse "as I had never seen it

before. . . . Everything appeared different to me and completely new." Twenty years later, James Lord, after numerous sittings for his portrait, observed that "if Giacometti cannot feel that something exists truly for the first time, then it will not really exist for him at all." The identifying mark of the newborn reality, painfully sought in the portraits through repeatedly painting out likenesses, is an evanescent presence; he had hold of it, he told Lord, but "stopped five minutes too late." Giacometti's formal devices consist of his otherworld stagings of his subjects, as in the livewire highlighting of the blackened faces of his portraits and in their backgrounds that sink into nowhere, or the amazed staring of his busts of Annette, as if she had been transported to some non-terrestrial realm, or the truncated and incomplete bodies on which his heads are mounted. In his search for their final image, Giacometti portrays his sisters in the process of being lost, and barely prevented from disappearing like ghosts at cockcrow.

Giacometti's moods, his rhetoric of fear and despair, his symbolism of death and isolation associate him with the Existentialists. In addition, his major style—the elongated sculptured figures—belongs to the period of Existentialist prominence, the years immediately following the last great war, although he had been a well-known Surrealist in the thirties and his **Palace at 4 A.M.** is an outstanding Surrealist masterpiece. In the journalism of art, all new creations of 1945-55 are "Existentialist." (The label has been applied also to the American Abstract Expressionists, and with much less justification.) Actually, however, there is no such thing as Existentialist painting and sculpture. Existentialism, a tendency in philosophy and literature, never developed a style in the plastic arts. "People talk so much . . . about Existential anxiety," Giacometti remarked, "as if it were something new! Everyone at every period in history felt it. You only have to read the Greek and Latin authors!" He broke with Surrealism in 1935, but his practice as an artist owes more to Surrealism than to Sartre, Camus, or Merleau-Ponty. The glorifying of surprise in his seeing and as an aim in his work was basic to Surrealism, too; like his Padua girls, Breton's Nadja identified herself as a super-reality by the suddenness of her presence. Mystery, dissociated images, primitive signs, exaggerated and distorted perspectives, chance meetings, fabulous coincidences belong to the Surrealist prescriptions for circumventing the everyday. "The state of expectation," wrote Breton in 1934, "is wonderful, no matter whether the expected arrives or not. That was the subject of a long chat I had with my friend Alberto Giacometti."

Giacometti parted with the Surrealists on the issue of "reality," but his conception of how to attain that reality drew upon the heritage of Surrealist conjurations. His new style emerged through a species of automatism: "I wanted to make her [the model] about eighty centimetres [thirty-one and a half inches] high. To make a long story short: she got so small that I couldn't put any more details on the figure. It was a mystery to me. All my figures stubbornly shrank to one centimetre high." Later, his figures reversed themselves, and, with the same autonomy, became tall and thin. In his application of Surrealist processes to non-Surrealist ends, Giacometti is a post-Surrealist— or, preferably, since he extended Surrealism by contradicting it, an anti-Surrealist. More important in regard to his work than the ideology of Existentialism is the fact that his art *carries the psychic revolution of Surrealism into new*

regions of experience. The postwar American abstractionists had a parallel relation to Surrealism, but they developed their styles on a narrower theoretical basis.

Surrealist aesthetics presupposes a dual world—that of the ordinary and that of the mythic. For Breton, actuality could be taken for granted: its reproduction had been successfully assumed by the camera. Relieved (or deprived) of his old function of looking, the artist had become a "seer," according to Rimbaud's prophetic vision. Giacometti's defection from Surrealism came with his return to nature, to the study of the model. To Breton, this could mean nothing but abandonment of the imagination and a surrender to the conventional view of things. "A head," he protested, "everybody knows what a head is!" It was precisely the Surrealist notion of a reality exhausted by common knowledge which Giacometti had resolved to challenge. Everybody knows what a head is at first glance—but that glance has grasped only an abstraction. A head looked at for a long time becomes increasingly strange and inaccessible. What is more "arbitrary" than a nose—and the way it is attached to the face? Or that human faces are wrapped in skin, a cat's face in fur? Giacometti had discovered the "fissure in reality," the change in the connections of things, that made ordinary subjects more imaginatively prolific than the dream.

There is a hiatus of seven years in Giacometti's accomplishment after 1935; apparently his break with Surrealism reached very deep. When I met him in Paris in 1951, his new style in sculpture had become famous, yet he was still replying mentally to Breton. Reality, he assured me, had by no means been commandeered by the camera; there was an absolute difference between people on a movie screen and people in the street. His ambition was to paint a café or a taxi just as it was. "*I* can be boring. Reality never!" was his rejoinder to Breton's fear of the banal. His sculptured groups of pedestrians possessed, in his view, a political content distinct from both Surrealism and Marxism: in them the individual appeared neither as the isolated ego of the dreamer nor as the regimented marcher of totalitarian politics but as a participant in the ever-shifting relations of actual existence. This concept is visually confirmed by a sculpture such as **City Square,** whose five figures create the illusion of constantly changing places.

In Surrealist paintings and collages, art images mingle with impressions of daily life, as they do in the Freudian analysis of dreams—for example, Ernst's gentlemen in dinner jackets but with the heads of Egyptian bird deities. For Giacometti, with his goal of "reality," art was the obstacle that stood in the way of truth. "The more I studied the model, the thicker the veil between its reality and me became. At first one sees the person posing, but little by little all the sculptures one can imagine interpose themselves." Thus, in each work the artist begins his task by putting himself in the condition of one totally lacking in the technical means for carrying it out. In his anti-Surrealist mode, Giacometti sought to impose upon himself the limitations of the primitive or naïve artist. Like a self-educated painter, he placed himself at the mercy of his subject. His assumption of naïveté in his day-to-day drama of incapacity and failure is the subject of James Lord's remarkable notes on posing for the artist over a period of almost three weeks [see Further Reading, section III]. Lord

questioned Giacometti about his "technique" for translating his "vision into something which is visible to others." "That's the whole drama," Giacometti replied. "I don't have such a technique." He then said that despite his excellent training he had never been able to paint what he saw. "So I had to start all over again from scratch . . . and things have been going from bad to worse."

The struggle for perceived reality is a struggle against inherited styles—an extreme reversal of values introduced by modern art. (In the past art took its departure from imitation of styles.) The effort to realize images independent of known art forms has long been a feature of American painting, as part of the aim of depicting the New Land; this experience may account for the emergence of American artists after the war as leaders in the final phase of modernism. Giacometti was ideally qualified for the modernist role of divesting himself of his training and talent in order "to see a landscape instead of seeing a Pissarro." An exhibition at the Guggenheim running concurrently with the Giacometti retrospective—*Three Swiss Painters*—of canvases by Giovanni Giacometti, Alberto's father, by Cuno Amiet, his godfather, and by Augusto Giacometti, his father's second cousin, showed the skill, sensitivity, and sophistication of the artists among whom Giacometti was brought up. Augusto in particular stands at the aesthetic peak of his time, with an individual Art Nouveau style and pioneering excursions into abstract art; *Summer Night* is a lyrical anticipation of Hans Hofmann. Giacometti was literally born into an avant-garde academy; he had only to go forward under the influence that surrounded his cradle. Before he was fourteen, he was able to draw so well from nature that he was convinced he could "copy absolutely anything." At sixty, he could only repeat, "It's impossible to reproduce what one sees. . . . I've been wasting my time for thirty years. The root of the nose is more than I can hope to manage."

It is Giacometti's practice of art as ignorance in the Socratic sense that has endeared him to philosophers and poets. He had found the means for attaining to the springtime of direct intuition, the vision of "the first man." Sartre spoke of him as placing himself "at the beginning of the world," a contemporary of the cave painters of Altamira. Painting and sculpting are transformed into a process of knowing and self-knowing; "whether an art work is a failure or a success," Giacometti said, "is, in the end, of secondary importance." The repudiation of aesthetic objectives makes finishing a painting impossible, since reality has no formal goal. The artist is "only working for the sake of the experience that I feel when working," and he could keep busy forever on a single canvas, producing a rubble of feelings, sensations, perceptions, all passé, like those in a stack of rejected photographs or the chaos discovered at the end of Balzac's *The Unknown Masterpiece*. Giacometti brought work on Lord's portrait to a finish when he was given a deadline for shipping it to an exhibition. Basically, the artist paints the struggle between himself and his subject. In the Lord portrait, the struggle is represented in the circling lines, the darkening tones, the background masses, the white neon highlighting. There are intervals in this transaction in which the painting comes to life. The reality of James Lord keeps appearing and slipping away. Yet each act of return is a further separation from the mere appearance of the sitter. Liberating himself from the habits of the eye and the preconceptions

of the hand, the artist attains an automatism that is the opposite of letting go.

An artist who interprets his own creations rarely lacks collaborators. Giacometti's legend focuses on his inability to attain the real, a legend consistent with the literature of Existentialism. With or without Existentialist editorializing, his striving to circumvent existing forms continues the tradition of self-estrangement from nature and society that is inherent in advanced art. That there was nothing in art that he could not do lent significance to his complaints that he could do nothing—for this consummate craftsman to exclaim, "If one could only paint a tree!" was to raise bottomless questions as to what painting a tree means; it calls to mind Magritte's Surrealist painting of a pipe with the legend *This Is Not a Pipe*. Like Duchamp, Giacometti was aware of the impression he was creating, and he kept recounting the chief episodes of his history and revising them. In their sum, they achieve a greater unity and coherence than are possible in autobiography. "Giacometti," writes Hohl, "corrects 'yesterday's facts' with 'today's truths.' " For an artist to whom past art is no longer available as a standard of reference, mythmaking and myth management are essential in order to shape the aesthetic identity that gives meaning to his creations. (pp. 120-30)

> *Harold Rosenberg, "Giacometti: Reality at Cockcrow," in his* Art on the Edge: Creators and Situations, *Macmillan Publishing Co., Inc., 1975, pp. 120-31.*

Michael Gibson (essay date 1978)

[*In the following excerpt, Gibson discusses the humanistic universality of Giacometti's art.*]

It is not surprising that Giacometti should have attracted the interest and friendship of philosophers like Merleau-Ponty and Jean-Paul Sartre (not to mention a writer such as Jean Genet). Although he had drifted through the Surrealist ranks in the prewar years, Giacometti was as stubbornly uncertain in his art as André Breton was dogmatic. Philosophers know too much about the difficulties of knowledge to appreciate simple declarative statements, but Giacometti's groping and doubt were close to their own ripe uncertainty when confronted with the immediacy of experience.

It is on this matter of immediacy, in fact, that Giacometti's experience casts a most interesting light. Even before the war he had stopped producing his sculptures in a Surrealist mode and begun to work once more on the human head.

This heresy drew Breton's thunder. Giacometti was no longer a Surrealist, he said. "A head!" he grumbled. "Everyone knows what *that* is!" But Giacometti's own experience of this period throws doubt on Breton's simple conviction: "I thought these studies would take me a fortnight . . . [in fact] I worked in the presence of a model every day from 1935 to 1940. Nothing was as I imagined. A head turned into something totally unknown and dimensionless."

In the early 1920s he had already encountered difficulties of this sort: "If you started by analyzing a detail, the tip of a nose, for instance, you were lost. Shapes disintegrate,

they are no more than motes hovering over a deep dark void. The distance between one wing of the nose and the other is like the Sahara. . . . "

In the early '40s, his sculptures began to shrink until they were only half an inch high. "And then, one jab of the thumb and—pft!—no more statue." Then, after the war, and still against his will, his sculptures began to take on that elongated wiry form which today is called to mind by the artist's name. He destroyed the first few and began all over again, but with the same results.

This strange adventure of an artist whose work disobeys him with a stubbornness that is beyond mere technical difficulty calls to mind the fearful experiences of Alice in Wonderland. But what are we to make of it today? Giacometti ventured to explain the matter to himself on several occasions. He was striving to render reality—nothing but reality and all of reality. When his statues began to shrink, he said, it was because he was setting his subject at the real distance at which he was seeing it. His model, seen from 15 meters, was in fact only ten centimeters tall. His later works were thin because he was irritated by the huge weight of bronze figures which five men could not lift. "A man walking in the street weighs hardly anything. Much less than the same man dead or in a faint. He stands in balance on his own legs. You don't feel his weight."

Maybe so. But one suspects that Giacometti was still too close to his own effort, too deep in the immediacy of his undefined task to grasp the deeper reasons for all this. And also there would have been something indecent—had it, in any event, been possible—in setting in the neon glare of language what he was then trying to grasp in the blind depths of his art.

It is easier for us today and no longer indecent to suggest, from a distance at which we can more easily focus on that period now revolved, some possible causes for the idiosyncratic behavior of Giacometti's sculpture, which he himself found "terrifying."

It may be merely coincidental that these works finally appeared at the outcome of a war whose most exemplary survivors walked like skeletons out of the death camps. But the coincidence is horrifying and perhaps not meaningless. The stripping down of the idea of man had begun in the preceding centuries, when there were good arguments in favor of such a painful philosophical diet. The experience, however, was traumatic for many, and at one familiar point it was perverted into a bare desire to destroy. Emerging from all that (and already, with intuitive foreboding, in the '30s), Giacometti, who was also a man with broad humanist interests and a strong argumentative bent, appears to have been preoccupied with one central question: What remains of man today?

The question allowed no simple answer, but it demanded an image and that image, in its complexity, was Giacometti's answer. What does remain is a figure without mass or volume—an extraordinary achievement in sculpture, or a figure of multiple outlines in his paintings and drawings. A figure, wasted like a candle but, like the candle, rising on one broad foot, almost nonexistent and yet so powerfully, burningly present by virtue of the accentuation of the single most eloquent symbol of all human dignity—the upright stance.

The value of Giacometti's statement here arises out of the fact that it is both thoughtful and unpremeditated, without any edifying intention, being the expression of a deep, essential need which he could not help feeling as a man.

That, it would seem, is the way his work was received. One may plausibly assume that it is also, in part at least, the way the artist himself approached it. But at the same time he did not allow himself to command his hands into making such and such a statement. This spiritual discipline of his that made his work the product of a whole life is also what allows it to be persuasive.

Hegel, as the father of much of modern thought, saw three steps in the act of knowledge. In the first moment the mind is *an sich,* in the vicinity, the immediacy of itself, too close to grasp either itself or its object clearly. In the next step it is *aussersich,* outside itself, in a position where it can perceive conceptually and understand but is at the same time deprived of itself. The last stage, *an und für sich,* in the immediacy of oneself and in possession of oneself, is a state of fullness of quasi-mystic scope in which both the former states are united.

The artist, when he is authentically *that,* is groping about in the darkness of immediacy, with an intuitive touch that precedes any clear conceptual knowledge. It is, I suspect, this sometimes frightening plunge into immediacy that Giacometti's philosopher friends found so deeply interesting because out of it he returned with an ethical statement, unwilled, unaware. The strange adventure of the dwindling statues also finds its resolution in the intimate choice, made without sentimentality or edifying intent, having weighed man, to see him worthy of existing—worthy not because of any massive weight of bronze but because of the weightless qualities of presence and perseverance and tattered courage which all these works reflect. All of which, again, while essential, is far too simple when set in the presence of the artist's work. And that is why the work is necessary. (pp. 133-34, 138, 141)

Michael Gibson, "What Remains of Man Today?" in ARTnews, *Vol. 77, No. 9, November, 1978, pp. 133-34, 138, 141.*

Michael Brenson (essay date 1979)

[*In the following excerpt, Brenson describes Giacometti as an artist whose work not only "feeds on and is about an acute experience of duality," but embodies the entire archetypal range of opposites.*]

Even more than with most modern artists, Giacometti's work feeds on and is about an acute experience of duality. Romantic and classic, relative and absolute, expression and abstraction, solid and void, man and woman, life and death—the whole archetypal range of opposites is embodied in his work. The language that enabled him to express and build with his experience was the language of Cézanne and Cubism. Giacometti's approach to composition was based on opposition; through the dynamic equilibrium that resulted, he was able to create what was for him a viable and convincing sense of life. In his 1948 ***Three Walking Men,*** each element is both immobile and mobile, both a projection into space and a buttress. The contrary movements are so perfectly equilibrated that the men seem at the same time to be walking and standing still. The ten-

sion fills space, creates weight. The act of walking seems to have become eternal. The same compositional principle is at work in the apparently straightforward 1951 **Cat.** The animal's body consists of two opposing parts: the straight, inflexible head, neck and front legs, and the flexible hind legs and tail. The cat seems to have been stretched taut. The front and back pull against each other as forcefully as the tiny heads and huge feet in Giacometti's standing women. The equilibrium of flexible and inflexible, soft and hard, accessible and inaccessible, both gives the cat its identity and brings that identity to life. (pp. 119-20)

Michael Brenson, "Looking at Giacometti," in Art in America, *Vol. 67, No. 1, January-February, 1979, pp. 118-20.*

W. S. Di Piero (essay date 1987)

[*In the following excerpt, Di Piero traces Giacometti's artistic development, describing his career as a permanent struggle to faithfully express an inner vision.*]

Sailing to New York in 1965 for the opening of the big retrospective show of his work at the Museum of Modern Art, Alberto Giacometti wrote a preface to the collection of drawings later published as *Giacometti: A Sketchbook of Interpretive Drawings.* For many years he had made copies of images originated by others—a Rubens at the Borghese Gallery, a Pintoricchio at the Vatican, a Matisse or Egyptian sculptures in Paris, a Japanese print at his family home in Stampa. During his transatlantic voyage, in his mind's eye he suddenly saw them as an interfused but not undifferentiated community of forms: "How can one describe all that? The entire art of the past, of all periods, of all civilizations rises before my mind, becomes a simultaneous vision, as if time had become space." To his consciousness, any interval of time could be transformed into a concentrate of space: that continuous transformation was the purpose back of his daily work as an artist. Giacometti's painting and sculpture do not represent or dramatize time's passing and the changes it exacts. They translate the feeling of time—of present, past, and what his friend Sartre called the "project" of the future—into spatial relations, the most crucial being the changeful pressure of an empty immensity on the figures that inhabit it. The forms for which Giacometti is best known, the skinny bronzes which seem unconquerably alert to the unhoused distances on which they fix their gaze, are leached of anecdote. Though many of the figures are in some gesture of motion, or stand in an attitude out of which motion might ensue, they have been exiled from narrative time. This could be said about most figurative sculpture. But in Giacometti's things time is converted into the turbulence of matter laboring against the flaying, laving, purgatorial force of space. It is the torment of contingency. Giacometti wanted to cast or fix the action of the pressure ("as if time had become space") that he described in his little preface. But in the course of his life's work he achieved something else of profound importance for the life of forms in our lives. In the dizzying, cavernous oil portraits and the fibrous bronze stalks of men and women standing, walking, pointing, Giacometti made manifest the heroism of the encounter between the visible world and the testimonial eye, an encounter unavoidably inaccurate but driven by a fanatical self-revision and endlessly readjusted de-

cisiveness. That was the empowering torment of his career, the products of which remain, in their startling resoluteness, magisterially unfinished. (p. 15)

An artist's confident feel for his materials can induce a chastening sense of failure, because a feel for materials intensifies one's vision of the perfectibility of the work. Giacomo Leopardi, one of the most diligent students of the failure of aspiration, wrote in his daybooks in 1821: "The more you understand the materials of your work, the more you see them and feel them in your own hands, the easier it becomes to push beyond, farther and farther, and to perfect even that which seems already perfect." This is also a condition of self-nurturing despair: so long as everything is in process of the realization of perfection, perfection is impossible. For Giacometti, perfection was the accurate representation in plastic forms of his retinal vision of reality. His vision, he insisted time and again, was not penetrative, not a seeing into the essence of things. Nor was it illustrative of a view of the human condition. . . . Giacometti's task was not expressionistic. He wanted merely to re-present the look of the object as he viewed it in its space. His vision of things, in his plain and direct terms, was his own kind of idealization.

The oldest description of this desire and frustration is probably Vasari's remark about Leonardo, who "through his comprehension of art, began many things and never finished one of them, since it seemed to him that the hand was not able to attain to the perfection of art in carrying out the things which he imagined." The persuasion of the unfinishable is not therefore an exclusively Romantic or modernist trait. It is the quality of a particular kind of artistic intelligence, one which treats all its products as projects; its intentions are always in process of redefinition or of merely provisional resolution. Giacometti's art is heroic because the struggle with impossibility is emergent and fully articulated in the actual work of his hands, undeflected by ironic elusiveness or righteous declamation. His way of looking at things was so intense that his conception of a possibly perfected representation of a dog or cat, a human head (the "dome," he called it), an arm, leg, nose, wheel, "base," or *place,* was impossible to realize. He was fated by the plasticity of his materials never to succeed at anything. "Everything fails," he said. The only difference is of degree. He complained, perhaps a little impishly, that if only he could find an artisan with the technical virtuosity to represent what his own eye actually saw, *then* he might be able to satisfy himself.

The crisis of representation was complicated by his working methods. In a sense, his methods were the motor that drove the machinery of failure. More than earlier artists like Leonardo, Giacometti was caught up in the changeful life of his materials. The process of plastic emergence—the kneading, the paring, the hacking and gouging with knife and spatula—was an enactment of the stress of distance between his eye and its object of vision. Every figure he made in his later period acknowledges and measures that stress. Many kinds of representationalism follow, in their effects, the program of Browning's protorealist, Fra Lippo Lippi: "We're made so that we love / First when we see them painted, things we have passed / Perhaps a hundred times nor cared to see; / And so they are better, painted— better to us." Art, under this prescription, restores to us the timeliness of visible reality, which is morally improved

in its representations. It is art as visual and moral enhancement which stuns us momentarily out of the dulled wits of habit.

Though we know from his youthful drawings and paintings that Giacometti from the beginning possessed prodigious skills as a realist, he was not so concerned with imaginative enhancement as with the process by which new images are forged. If realists of Lippi's (and Browning's) persuasion are most concerned with resolution of image and moral effect, Giacometti is instead committed to impassioned, inconclusive deliberation. For him, the measure of the image-making process is the squeeze or exhalation of space around the figure, and the continued snags and ravelings of stress within the material itself. From roughly the mid-1940s till his death in 1966, his chief work was to make manifest the strain of pure becoming. Because his paintings and sculptures record for us the quickened movements of his imagination—interrogatory, abrasive, nurturing, corrective—we become second witness to the way the imagination may be lived in and through. When he travelled to Stampa to visit his family, and on the few occasions when he was hospitalized, Giacometti always took along in shoeboxes (or matchboxes) clay figurines wrapped in damp rags, which he would work on whenever possible. He was always working. And it was not a mere busyness or neurotic activity, for "work" was the constant formative exercise of skills on material that might eventually, miraculously, coin the perfect representation of what he ordinarily saw. I do not know of any other artist of our time who, crowded by the exempla of the enormous simultaneous past, so matter-of-factly conducted his art at the margins of what is possible.

The more than two hundred paintings, drawings, and sculptures recently on view at the Gianadda Foundation in Martigny, Switzerland, show the entire crisis-laden stream of Giacometti's career, from the crayon sketches done in his teens, through the tough uncertainties of the Surrealist period, to the wise and solemn busts of Elie Lotar in 1965. The problem of the fated failure of his materials emerged in 1921, when he was trying unsuccessfully to finish a simple female bust. He later described his feeling of doomed ineffectuality as an expulsion from Paradise: "Before that, I believed I saw things very clearly, I had a sort of intimacy with the whole, with the universe. Then suddenly it became alien. You are yourself; and the universe is beyond, which is altogether incomprehensible." He felt himself cast out of the familiar community of representational forms. The loss of clear vision meant the loss of the primordial home where there was an immediacy of relation, almost a simultaneity, between the thing seen and its imitation in paint or clay. Once expelled, he had to bear the curse of work, and his major chore would be the recovery of that now lost oneness. By 1925, in his sculpture Giacometti was already in exile from the figural, though not in his painting, where he managed to sustain sculptural feeling in his way of working the paint. In a self-portrait of 1921, the artist's three-quarter profile twists back toward us over his shoulder, his gaze defiant, void of wishfulness. The quilted coloring, both here and in a larger, more frontal portrait of 1923, is strongly suggestive of Cézanne's, but the action of the paint is muscular, the textures so dense that you feel the image has been modeled out of paint.

In his sculpture, however, Giacometti at that time was feeling more and more estranged from the human figure. Familiar definitions began to melt away. The features on the series of heads that he did of his father in 1927—in marble, granite, and bronze—are nearly re-absorbed into the blank of the material. All suggestion of skeletal and carnal expressiveness is being planed away. The figure retreats more and more furtively into the anonymity of stone slugs. It's astonishing that, feeling himself expelled from his Eden, Giacometti did not collapse into chaos or despair. Instead, he struck his own temporary bargain with vision by resorting to a thesis: sculptural representation is not emergence, it is *arrangement,* of concave and convex surfaces presented as idealized abstractions of natural forms. As a consequence, many of the pieces he produced in the late 1920s and early 1930s are spookily clean, polished, purged of all traces of the artist's exertions. They are a kind of willed (or trumped-up) deliverance.

The Gianadda show displays two versions of **Tête qui regarde** executed between 1927 and 1929. (The English title, **Head,** doesn't suggest the activity of looking which Giacometti intended; several of his early works are entitled simply **Tête.**) These are rectangular broadside slabs of glassy marble or bronze, druidic, anonymous, recondite. On the left side of the slab is an upright lozenge-shaped depression, on the right a concave ovoid. The effort behind these works is, I think, primarily to smother or conceal figural inflections. Their energy is all invested in a tremendous holding back of the will to externalize, to manifest. These are not negligible works, nor are they formal dead ends. Thirty years later, in the busts of Diego and Annette, that slab, ridged and roughened by the swarming return of human features, will turn to face us, like the jagged blade of a ruined axhead. Convinced as he was in the 1920s and 1930s of the failure of his vision ("Before that, I believed I saw things very clearly"), Giacometti coded into those near-blank forms, into **Tête qui regarde,** the disappearance or unfindableness of the human gaze.

The concave impression became a more important, and less mystifying, physiological sign in Giacometti's female figures. In a hermetic, monumental bronze like **Woman** (plaster, 1927-1928; cast in bronze, 1970), the round scoop of the feminine occupies nearly half the sculpture's surface. It's an abstract work insofar as it is abstracted from, not representative of, the image in nature, and like much of his work from this period it is guarded and affectless—it might be a signpost, menhir, or club. The best known and most statuesque in this family of forms is the large bronze **Spoon Woman** of 1926. Her entire torso is a concavity, a cobra hood spread atop a narrow pedestal. The **Spoon Woman** has a strange talismanic effect. You sense sexual force momentarily in check, but with possibly tremendous engulfing power. Formally, it is assertive, exercising the traditional sculptural sovereignty of matter dominating and restructuring its surrounding space. But its stolid forms take the edge off sexual menace. The torso catches available light in its shallow bowl, but there is nothing reactive in that encounter.

The avoidance or difficulty of giving more immediate expression to sexual force led Giacometti finally to the operatic expression of sexual fear in **Woman with Her Throat Cut** (1932), probably the most notorious of his works and the one which, if the spectators at the Gianadda exhibit

are any measure, draws more shocked, titillated attention than any other single work he produced. The sprung rib cage lies in shattered repose, but it is also a sex trap, the sharpened staves triggered to snap shut. The woman's legs, splayed wide as if hooked in delivery-room stirrups, push her pelvis up in a hideously ambiguous attitude of torment *and* availability. The impossibly long chain of neck vertebrae arc forcefully upward like the legs and the inverted ladle of her belly. It's as if the studiously determined concavities of Giacometti's spoon women had been angrily pulled inside out. The almost hysterically expressed sexual dread in this image might be less outrageous if it were not also so programmatic. The horrific sentiment is worked out in contrived, semi-abstract terms, the skeletal contortions, gruesomely pictorial, played off against the featureless abstraction of the upper torso and head. There's a vaguely spiteful glee in the tone—a woman murdered in what seems a moment of self-offering—which is the Surrealist's glee in overdetermined shock effects meant to outrage the norms of bourgeois pictorialism. *Woman with Her Throat Cut* is not a frivolous or wicked piece of work. Giacometti was temperamentally incapable of frivolity and uninterested in moral effects. But this and other things usually listed in the roster of his Surrealist works (*The Palace at 4 A.M., No More Play, Hand Caught by a Finger* [*Main prise*], *Disagreeable Object*) seem to me productions of an artist so stricken by his fall from the Eden of innocent representations that he elects a program of contrived images as a stay against inactivity and as a willed continuance while he tries to find his way back. In any event, Giacometti lacked the snickering bad-boy wit and antic buoyancy of the Surrealist intelligence. His troubles in the late 1920s and 1930s are evident in the impoverished plasticity of his materials. We do not see the clay and plaster toiling in the finished work. This is most conspicuous in the stacked, angular catwalks of *Reclining Woman Who Dreams* (1929) and in the cross-barred penitentiary grid of *Man (Apollo)* (1929), the two most industrial and architectural of his works in bronze, where his subject is not being re-imagined in and through the material. Giacometti's exile from the Garden is truly an Adamic drama in that he lost faith in his ability to model nature in clay. His chore thereafter, and his curse, was to win back that enabling faith. And that in turn required a journey of self-restoration toward a new Eden where he would never, could never, arrive.

Giacometti once told James Lord that all during the Surrealist phase he knew he would sooner or later be obliged to go back to nature: "And that was terrifying, because at the same time I knew that it was impossible." There are signs of that return as early as 1932-1935, the years of the tall tubular *Nude* and *Invisible Object (Hands Holding the Void)*, with its owlish, contrite female visage. Although the spookiness of the Surrealist mood is still on him, and although he even experiments with Cubist volumes in *The Cube* and *Cubist Head* (both executed in 1934), Giacometti is being more attentive to the model. His return was contested at every point, however. The more he looked at the model, he said, "the more the screen between his reality and mine grew thicker. One starts by seeing the person who poses, but little by little all the possible sculptures of him intervene. . . . There were too many sculptures between my model and me." His relation to the natural figure was hopelessly complicated by all the mediating serial possibilities of representation. That kind

of plenitude freezes progress. In the searing magnificence of his later work we can actually read or imagine, in the heft and texture of the final "abandoned" product, the intervening forms that mediated its progress. In light of the crisis he had to work through in the 1930s, it's remarkable that Giacometti did not seek shelter in self-glorifying parody or in the preciosities of an "art of exhaustion." Instead, he absorbed the very threat of dissolution, or dissipation, into his newly developing form-language as a kind of apotropaic act, to make his despair breathe deep within the formal life of the work. Around 1937 he tried to model a complete figure in plaster, a standing woman about eighteen inches tall. The figure grew smaller and smaller beneath the exertions of his knife until the needle of chalk crumbled. That was no self-canceling gesture. It was the as yet unredeemable consequence of an artist's desire to answer to his vision by interrogating his materials. It was form pulverized by the desire for form. In this respect, too, Giacometti is Cézanne's great successor, for both of them made the action of their materials—their *work*—supremely and devastatingly answerable to what their eye saw.

The emergence of the famous late style required a purging of vision. It required revelation. In 1942-1943 Giacometti produces the first *Woman with a Chariot.* (The "chariot" is a nurse's cart he had seen in a hospital.) The figure already suggests the new sculptural form he is working toward: the woman stands upright, legs closed, hands locked to her sides, with little definition of feature except for the rather innocently exposed bulge of sex. In 1945 he produces two figurines . . . , each mounted on an oversized square pedestal; both are about four inches high, including base. The figures are mere slivers, fantastically reduced versions of the human offered up like sacrificial victims on altars, or chopping blocks. In 1946 came the revelation. Watching a newsreel in a moviehouse, Giacometti suddenly realized that the screen image was just a montage of dots on a flat surface, whereas the reality around him, which till that moment he had always viewed photographically, as if the world were a composite of colored figures and swatches of light on flat surfaces, was something altogether different. He experienced what he called "a complete transformation of reality, marvelous, totally strange." Space thickened around bodies, pinching and abrading them. The body's topography roughened into sinewy, cratered exposures. The head seemed at once islanded and enraptured by its aura of emptiness—the stricken skyward cry of *Head of a Man on a Rod* (1947) is one answer to that aura.

Giacometti's new vision, to which he brought the intensity of gaze that he had been sharpening since childhood, was of a preternatural embodiment of the human form in nature. He was witness to, and forger of, a baffling restoration of appearances. The stress of space determines form, but space as a measure is itself changeful, indeterminant. That indeterminacy is caught in the molten, eruptive surfaces of all of Giacometti's later works in bronze, and it is momentarily held in check by the tentative housings—the boxes, birdcage halos, and cloisters—that frame the heads in his oil portraits. The things from the major period seem to have been let go of, released, only moments before we bear secondary witness to their becoming. The blistered erosions of the busts seem still cooling. The isolated gestures—the head on a rod, the outstretched arm with its

bony, panicked hand, the alarmed stillness of a cat, the dirt-hunger of a dog—seem a pause in the stream of pure becoming. If Giacometti's is an art of agony, it is because at its heart is an *agon,* the contest between space and matter and the intelligence which seeks to represent it. The slabs and blanks of the earlier work are gone, replaced now by the armature, the stake, where the work of the agon takes place.

With the emergence of the major style in the 1950s comes a more complex and fine-toned presentation of the female form. Each of the five sculptures from the ***Women of Venice*** series on exhibit at the Gianadda (Giacometti produced ten of them for the 1956 Biennale) bears a different sexual character. One figure's breasts are splayed, another's bulbous and low slung, another's melted nearly flat. In each, though, the breasts are sexual eruptions on an otherwise disinterested heraldic stillness. The ambiguous sense in each is of power restrained *and* a haughty indifference to that power. The measure of sexual availability varies from one to another. One figure's hands are fused to her thighs, the pelvic area recessive, protected, with no hint of sexual availability. In another, the entire torso is brittly concave, punched in, the belly reminiscent of the spoon-woman form; her shape bears a kind of unembarrassed sexual welcome, but her face is twisted into a sneer or grimace. The apparently candid invitation is chilled down by her sardonic, faintly contemptuous reserve. Giacometti's female figures never express the somnolent ecstasies of Brancusi's women, and they don't have the archetypal bombast of many of Henry Moore's queens and mothers. And yet the inflections of sexuality in his work are surprisingly rich. He commands nearly all the registers of the testing or trying out of sexual feeling, sexual mood. And unlike Brancusi's and Moore's representations of women, Giacometti's are not so easily owned by the male eye. Even when a figure seems most welcoming, that is never a pure tone; it is inescapably mixed with suspicion, regret, sullen withdrawal, or clenched aggressiveness. All this becomes painfully obvious by comparison with the most disconcerting and vulgar piece in the Gianadda show, the bust of ***Mlle. Télé*** (1962), where coquettishness is rendered in such conventionally vampish terms—the lifted shoulder, the cocked head, the "fetching" expression—that the figure's sexual charm is utterly trivialized. There is plenty of sexual charm in Giacometti's work, but it is only effective (and true) when blended with the sort of black magic that promises transformations at the edge of a darkness.

Like the free-standing constellation of the ***Women of Venice,*** the ***Four Women on a Base*** (1950) is remarkable for the painstaking differentiation of the figures. One pouts, one grins (rather mischievously), another cringes as if fearstruck. The fourth and tallest is clearly the dominant member of the clan. Each sexual gesture is different, measurable by the half-closed hands flaring from the hips. Their attitude, their stance, is a way not of occupying space but of inhabiting it, as if the air were their culture, shaping them while they shape it. Giacometti painted this, and many other bronzes, often at the last minute just before an opening. Once he made his breakthrough in the late 1940s, he could never leave his work alone: once back in his sight, "finished" paintings and sculptures were sucked back into the vortex of his desire for the impossible perfect representation. Usually, as in ***Four Women on a Base,*** he streaked or daubed the bronze with rouge, cream, or grayish tints. The first effect is to dramatize the topography of the figure, to provoke a reaction from light's impingements on matter. But the effect is particularly odd with female figures, as here, because it makes them at once gaudier and more intensely secretive, their sexual character enfolded more cunningly in disguise. For all their diversity, the four figures share their platform, the elevated rail or ledge that anchors them in space and also binds them in a tribal relation. It locates them, naturalizes them in what we can imagine to have been an unpopulated waste. From the 1940s on, the form that becoming takes in much of Giacometti's work is a risenness; the standing figures seem recently emerged from the ground—they are The First Ones. Before anything else they are expressions of vegetative force. Thus Giacometti gives the title ***The Forest*** to a group of seven standing figures and a small shrubby bust arranged on a shallow concave ground; and ***The Glade*** to a tribal grouping of nine odd-sized reedy figures. In both ensembles the human stalk rises from a warped, seething earth.

The genesis poetry prevails also in city representations. In ***Homme traversant une place*** (1949), the forward lean of the figure across his public space is retarded by the strangely crystallizing elasticity of the ground. He uses his spatular hands like paddles to coax his way free of the earth's pull. The viscous space he moves through drags him back even more. And yet his head and face are gnarled with resolve, beautifully detailed in the knot of muscle at his jaw. Giacometti's walking figures inevitably have a purposefulness which the standing figures lack. If the standing figures suffer the air of contingency, the walking figures lean into it, resisting its sorrows. The movement of ***Walking Man II*** (1960) is the quotidian tilt of curiosity tensed toward some destination; it is the will impelling matter away from the mud-pool. The squared, bigbooted feet of walking and standing figures alike are the gritty, magmatic residue of material creation. The tree that Giacometti and Samuel Beckett collaboratively designed for a production of *Waiting for Godot* seems grown out of ***The Leg,*** which is seven feet high and looks like a young tree shattered by lightning. The two essential facts after the loss of Eden are that nothing is ever finished and that everything in some way fails.

Giacometti's movie-house revelation deepened the sense of estrangement that followed his earlier loss of intimacy with nature, but it also initiated his journey into the mysteries of otherness, toward a recovery of the visible world in the forms of sculpture and painting. In his late work the will to encounter and recover takes the shape of auroral greeting. Not a gesture of hopeful anticipation, and not anything as vulgar as optimism, the greeting is a primeval moment in the strenuous task of becoming in which the figure acknowledges and goes out toward that which is other. The mood of the greeting, especially in the busts Giacometti produced in the mid-Fifties, changes from work to work—stoical, impatient, wondering, fearstruck, quizzical, arrogant, bemused—each expressing some sort of pained attentiveness on the long morning after the fall from Eden's golden unities. In ***Diego au blouson*** (1953), ***Diego au chandail*** (1954), and ***Tête de Diego*** (1955), all the inchoate force of the titan's torso rises up and concentrates in the roughened, charred ridges of the narrow head, which inhabits only a slot in space. And yet we can-

not see past it. Its gaze stops us. Its acute attention is so aggressively outwarding that it traps our attention in its greeting. The tragic energy of these works is plied into the gashed, restless textures of the bronze.

The relation between Giacometti's sculpture and painting is one of the major conversations in modern art. On canvas he could shape and color the action of space around his subject, then translate those relations back into the volume and elasticity of clay. The pressure built up in the sheer bulk of a sculpted torso could not be achieved in the frontal, two-dimensional presentation of portraiture. The auroral greeting in the portraits is therefore fanatically concentrated in the face and eyes. In *Diego* (1958), *Portrait of Annette* (1958), and *Portrait of Yanaihara* (1959), the head unscrolls from a bituminous murk—the greeting is an arduous attempt to see out of an enveloping darkness. We can feel Giacometti trying, unhappily and with his typical sense of fated failure, to hack resemblance out of the resistant mass of undifferentiated colors. In these and later oil portraits, as you look away from the wiry loops and nodes of the darkened face—the eyes are craters, instruments nearly burnt out by overuse—the paint thins out, the scarifying blacks and blue-grays run a feebler smoky white. Portraiture, like sculpture, was for Giacometti expressive of the agony of its making. Just as he painted his bronzes at the last minute, he could not leave his paintings alone, either, so long as they remained in his studio. (James Lord's *A Giacometti Portrait* [see Further Reading, section III] is noble testimony to that.) In three portraits of Diego done in 1964, the image is a history of the passionate self-corrective energy that brought the image into existence. Giacometti made a whole art out of pentimenti. First to finishing stroke, each act of figuration was in some way a pentimento. It was the only way he knew to arrive at a representation of what he called "the simple thing seen."

Around 1964, the emotional tone of the paintings changes. The febrile gaze of the 1950s portraits softens to a more aloof self-containment. The greeting is not so electric with the possibility of surprise or revelation. By this time the sculptures have changed, too. The heads thicken, broadening and filling out into more classically spherical forms, no longer so whittled and crimped by space. The two busts of Diego from 1965 included in this exhibition show at once tormented exertion and withdrawal, the neck craned forward, face buckled and sour, skull and shoulder cavities emaciated, cadaverous. The greeting is sustained only at great physical cost; the human form seems to be collapsing into itself, such is the effort to preserve its attentiveness. In an oil portrait of Diego from 1964, the subject's head is nearly lost to its black ground; out of the little dome shine splinters of light, like bird bones. The following year, however, Giacometti produced three of his finest works, the busts of Elie Lotar. Lotar was a sad familiar figure in Giacometti's circle, a failed photographer, destitute and alcoholic. (Giacometti not only used him as a model but also more or less took him in, letting him run errands and do odd jobs around the studio.) The torsos of the Lotar busts are more combustive than ever, but out of that turbulence rises a solemn, piercingly handsome, imperial head. The calm, alert eyes, welling out of deep pouches, cast the unsurprisable gaze of a being who greets the world by awaiting its manifestations. Desire, expectation, anticipation, all evaporate in the dispassionate regard

of Lotar's gaze. The human figure is not resigned, certainly not self-abandoning, but it is no longer driven or terrified either. The strain of becoming so elaborately inflected in the previous work momentarily resolves here into a fearless *amor fati,* a condition just this side of irrational joy, though the figure expresses no joy at all.

Two of Giacometti's heroes were Giotto and Tintoretto. Early in his career he was overwhelmed by the Scrovegni Chapel frescoes, the figures "dense as basalt, with their precise and accurate gestures, heavy with expression and often infinitely tender." The weighty tenderness of the Lotar busts has its source in that early discovery. Giacometti said that Giotto replaced Tintoretto in his affections, though he had loved the Venetian's work "with an exclusive and fanatic love." And yet I think it is Tintoretto's influence that was most formative, especially for the work of Giacometti's later period. In formal terms, he took over the geometries of passion he found in Tintoretto, the smallish heads yearning from overmuscled, squarish bodies, the human figure—as in *Cain and Abel*—a bundle of volcanic torsions. And it is Tintoretto, not Giotto, who in his paintings for the Scuola di San Rocco gives us the carnal immediacy of mysterious emergences, transformations, and manifestations—image after image of agonized greeting. Giacometti, the least devout of men, possessed that sense of life as a suffering toward recognitions of reality which I think is the essence of heroic religious feeling. He believed not in redemption or arrival but in the fully experienced continuity of existence, in the need and desire to return to our imagined source, to the lost garden of perfect recognitions and representations. (pp. 16-23)

W. S. Di Piero, "Out of Eden: On Alberto Giacometti," in The New Criterion, *Vol. 5, No. 9, May, 1987, pp. 15-23.*

FURTHER READING

I. Writings by Giacometti

"The Automobile Demystified." *Tracks: A Journal of Artists' Writings* 1, No. 2 (Spring 1975): 36-7.
 Giacometti juxtaposes the machine and the work of art, remarking that unlike a mechanical object, which can always be perfected and replaced, the work of art remains unique and irreplaceable.

II. Biographies

Lord, James. *Giacometti: A Biography.* New York: Farrar, Straus & Giroux, 1985, 376 p.
 A detailed, sympathetic biography by one of the most noted commentators on Giacometti's life and work.

III. Critical Studies and Reviews

Breton, André. *Mad Love.* Lincoln: University of Nebraska Press, 1987, 129 p.
 The celebrated French poet and founder of the Surrealist movement offers a personal assessment of Giacometti's art in the third segment of his book. This work is a translation of *L' amour fou,* which was published in 1937.

Forge, Andrew. "On Giacometti." *Artforum* XIII, No. 1 (September 1974): 39-43.

 An analysis of Giacometti's art prompted by the 1974 retrospective exhibition at the Solomon R. Guggenheim Museum in New York. Forge interprets Giacometti's view of art as a philosophical realization that the artist's quest for certainty can never be freed from doubt.

George, LaVerne. "Giacometti and the Lonely World." *Arts Digest* 29, No. 18 (1 July 1955): 6-7.

 Review of a 1955 comprehensive exhibition of Giacometti's work held at the Guggenheim Museum in New York. Commenting on the artist's mastery of various media, the critic asserts that "Giacometti is not a sculptor who merely paints, or vice versa, but a whole artist, almost in the Renaissance sense, whose fund of ideas cannot be realized by a single means."

Gibson, Eric. "Giacometti: A View from the Interior." *Studio International* 198, No. 1011 (December 1985): 4-7.

 Includes a review of the 1985 retrospective exhibition of Giacometti's works at the Sidney Janis Gallery in New York. Gibson also provides an assessment of James Lord's book *Giacometti: A Biography,* cited above, hailing it as the definitive work of its kind.

Hess, Thomas B. "Giacometti: The Uses of Adversity." *ARTnews* 57, No. 3 (May 1958): 34-5, 67.

 Includes fragments from a conversation with Giacometti in which the artist discusses the inescapable technical obstacles to artistic expression.

Hohl, Reinhold. *Alberto Giacometti.* New York: H. N. Abrams, 1972, 328 p.

 Critical interpretation and evaluation of Giacometti's work by a leading German scholar. Includes illustrations and an extensive bibliography.

Juliet, Charles. *Giacometti.* New York: Universe, 1986, 120 p.

 A concise overview of Giacometti's art.

Kirili, Alain. "Giacometti's Plasters." *Art in America* 67, No. 1 (January-February 1979): 121-23.

 Kirili, a French sculptor, discusses the irrational and metaphysical qualities appearing in Giacometti's work following his break with Surrealism.

Kramer, Hilton. "Giacometti." *Arts Magazine* 38, No. 2 (November 1963): 52-9.

 Argues that critics fail to grasp the totality of Giacometti's oeuvre when they insist on dividing his artistic development into distinct phases.

Lake, Carlton. "The Wisdom of Giacometti." *Atlantic* 216, No. 3 (September 1965): 117-26.

 Recounts a visit with Giacometti in 1965.

Lanes, Jerrold. "Alberto Giacometti." *Arts Yearbook* 3 (1959): 152-55.

 Discusses the function of space in Giacometti's sculpture, with particular emphasis on the artist's expression of a sense of emptiness and absence.

Liberman, Alexander. "Giacometti." *Vogue* 125, No. 1 (January 1955): 146-51, 178-79.

 A sympathetic description of the artist at fifty-three; includes a discussion of Giacometti's artistic idealism.

Limbour, Georges. "Giacometti." *Magazine of Art* 41, No. 7 (November 1948): 253-55.

An analysis of Giacometti's explorations of the human figure.

Lord, James. *A Giacometti Portrait.* New York: Museum of Modern Art, 1965, 68 p.

 An account of the author's eighteen sittings for a portrait by Giacometti; includes fragments of conversations between artist and model.

 ———. *Giacometti Drawings.* Greenwich, Conn.: New York Graphic Society, 1971, 252 p.

 Assessment of the artist's accomplishment as a draftsman. Includes color plates and black-and-white illustrations of superior quality.

Matter, Mercedes. "Giacometti: In the Vicinity of the Impossible." *ARTnews* 64, No. 4 (Summer 1965): 26-31, 53-4.

 Discusses Giacometti's awareness of the precarious nature of perception; includes photographs of representative works of art.

Megged, Matti. *Dialogue in the Void: Beckett and Giacometti.* New York: Lumen, 1985, 71 p.

 Comparative analysis in which the author comments on the striking artistic, philosophical, and psychological similarities between Giacometti and the celebrated playwright and novelist Samuel Beckett.

Melville, Robert. "Giacometti & Others." *Architectural Review* CXXXVII, No. 824 (October 1965): 283-85.

 A review of the 1965 retrospective at the Tate Gallery in London.

Neubauer, Peter B. "Alberto Giacometti's Fantasies and Object Representation." In *Fantasy, Myth, and Reality: Essays in Honor of Jacob A. Arlow, M. D.,* edited by Harold P. Blum, et al., pp. 187-96. Madison, Conn.: International Universities Press, 1988.

 Discusses possible psychological reasons for Giacometti's apparent inability to maintain accurate visual images and suggests that his art was an attempt to compensate for this condition.

Silver, Jonathan. "Giacometti, Frontality and Cubism." *ARTnews* 73, No. 6 (Summer 1974): 40-2.

 Argues that Giacometti's figurative works in many ways imply the techniques and aesthetic accomplishments of non-figurative art.

Watt, Alexander. "Alberto Giacometti: Pursuit of the Unapproachable." *Studio* 167, No. 849 (January 1964): 20-7.

 Brief, illustrated account of a visit to Giacometti's studio.

IV. Selected Sources of Reproductions

Fletcher, Valerie J. *Alberto Giacometti.* Washington, D.C.: Smithsonian Institution Press, 1988, 250 p.

 Catalog for the Giacometti exhibit organized by the Hirshhorn Museum and Sculpture Garden. Includes comments on 105 works, emphasizing Giacometti's versatility and creative range.

Giacometti, Alberto. *Alberto Giacometti.* New York: Museum of Modern Art, 1965, 119 p.

 Catalog of the 1965 exhibition organized by the Museum of Modern Art; includes an autobiographical fragment by the artist.

 ———. *Alberto Giacometti: A Retrospective Exhibition.* New York: Solomon R. Guggenheim Museum, 1974, 202 p.

Includes large black-and-white and color reproductions.

Lust, Herbert C. *Giacometti: The Complete Graphics.* New York: Tudor, 1970, 224 p.
Includes reproductions and descriptions of 353 graphics with evaluations by Lust.

Matter, Herbert. *Alberto Giacometti.* New York: Harry N. Abrams, 1987, 223 p.
Large-format photographs of Giacometti and many of his works.

Vincent van Gogh

1853-1890

Dutch painter.

Hailed as one of the early masters of modern art, van Gogh is noted in particular for the dramatically subjective style of his later works. Throughout his brief career, van Gogh continually sought a means of communicating his personal responses to the subjects of his paintings, experimenting with different forms of realism and eventually abandoning objective representation in favor of the simplified forms and brilliant, non-naturalistic colors for which he is best known. Van Gogh's innovations have led to his designation, along with his contemporaries Paul Gauguin and Paul Cézanne, as one of the principal forerunners of modern abstractionism in art, while his concern for the specifically emotive aspect of his work is regarded as a primary inspiration for the German Expressionist movement.

Van Gogh was born in the village of Zundert, in the Dutch province of North Brabant. His family had been involved in the buying and selling of art for several generations, and upon completion of his primary education he was apprenticed to the international art firm of Goupil, in which his uncle was a partner. Van Gogh remained with Goupil for nearly seven years, working in The Hague, London, and Paris; but, following an unhappy love affair in 1874, he experienced a lengthy and severe depression that led to his dismissal from the firm. After working briefly as a teacher in England, he returned to the Netherlands, where he decided to study for the clergy. Church officials, however, were alarmed by van Gogh's extremely literal interpretation of scripture and his excessive asceticism, which extended to the point of self-torture, and they refused to ordain him.

Although van Gogh had been sketching since childhood, it was not until after the failure of his clerical career and his subsequent crisis of faith that he decided to make art his vocation. Transferring much of his fervent religious devotion to this new endeavor, he began to copy the works of artists he admired in order to systematically master the rudiments of drawing. For the next six years, he moved restlessly throughout the Lowlands, supported morally and financially by his younger brother Theo, who was working for Goupil in Paris. Studying with other artists and teachers in Brussels, Antwerp, The Hague, and Amsterdam, van Gogh quickly refined his talents and experimented with watercolors and oils; in The Hague he made great progress under the direction of Anton Mauve, a noted Dutch landscape painter. During this apprenticeship, known as his Dutch period, van Gogh concentrated on portraits of peasants and depictions of peasant life, of which *The Potato Eaters* (1885) is considered a particularly fine example. Although his concern for realistic representation dominates the work of this period, commentators note that subtle exaggerations, intended to convey van Gogh's great sympathy for the poor, and his frequent use of symbols foreshadow the expressionism of his later works.

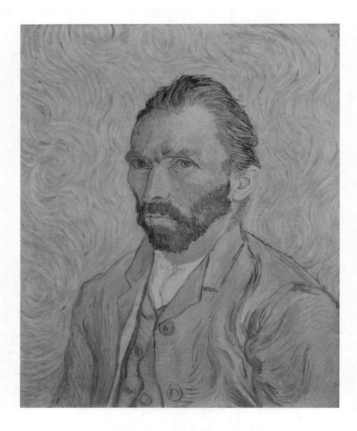

In February of 1886, van Gogh joined Theo in Paris, where a series of artistic revolutions were taking place. Most notably, the Impressionists, inspired by the new theories concerning the mechanics of perception, were creating a heated controversy with their attempts to recreate the subjective effects of light and atmosphere through manipulation of color. Van Gogh was greatly influenced by their techniques, incorporating their use of vivid, broken colors into his many floral still lifes and cityscapes. At the same time, van Gogh's immersion in the Parisian art world led to excessive drinking and a frantic working pace that resulted in ill health, and in 1888 he left Paris for Arles, in the south of France, seeking a more serene and healthy environment.

It was during his stay in Arles, which lasted from February of 1888 to May of 1889, that van Gogh produced many of what are now considered his masterpieces, including the sunflower paintings, the two versions of *The Woman of Arles* (both 1888), *Night Café* (1888), the *Zoave* (1888), *Vincent's House at Arles* (1888), and *Van Gogh's Bedroom at Arles* (1888). Influenced to a great extent by the Japanese prints he had begun collecting in Paris, he now favored large areas of brilliant, pure colors, with yellows predominating, and an ever-increasing simplification of forms. In one of his many letters to Theo he explained:

"Instead of trying to render exactly what I have before my eyes, I make use of color more arbitrarily in order to express myself strongly." Van Gogh cherished hopes of establishing an artists' colony at Arles, and in October of 1888 he persuaded Gauguin to join him there. During the brief time the two artists lived and worked together, Gauguin created his renowned portrait of van Gogh in the act of painting one of his sunflower paintings. However, van Gogh's behavior became increasingly aberrant during this period, and following a psychotic episode in which van Gogh severed part of his ear and delivered it to his favorite prostitute at the local brothel, Gauguin returned to Paris, informing Theo of his brother's deteriorating mental condition. As a result, van Gogh was voluntarily confined to the asylum of St. Paul in Saint-Remy in May of 1889.

Lucid much of the time, van Gogh received permission to paint while confined at St. Paul's, and he executed a number of pictures of the asylum and the surrounding countryside. His style underwent another change, in which the brilliant flat colors of the Arles masterpieces were replaced by subdued, swirling blues and greens and more muted shades of yellow. After one year, during which his condition improved markedly, van Gogh was transferred to the care of the noted physician Dr. Gachet in the town of Auvers, near Paris. An amateur artist and avid collector, Dr. Gachet encouraged his patient to continue painting when his condition permitted, and van Gogh painted portraits of Gachet and his family as well as a number of well-known rural landscapes in which he further refined the textural effects he had begun to use at Saint-Remy. During the summer of 1890 van Gogh became despondent over the lack of recognition for his work, the financial burden his illness had inflicted on his brother, and the possibility of a serious relapse. On 27 July he shot himself in the abdomen, inflicting injuries that claimed his life two days later.

Although van Gogh experienced periods of mental disturbance throughout his adult life, critics now agree that his paintings should not be viewed, as was frequently the case in early estimates of his work, as manifestations of a pathological condition. This more recent view is based primarily on the evidence of van Gogh's many letters, which contain well-reasoned explanations for the artist's changing methods and show that his unwavering goal was to create art that would transcend mere depiction. Explaining van Gogh's aesthetic aims, Herbert Read has noted: "His life was one long quest for a *style,* which Goethe was the first to define correctly as the quality in art which rests on the deepest foundations of cognition, on the inner essence of things. This inner essence of things was Vincent's life-long quest, and his final achievement."

INTRODUCTORY OVERVIEW

W. Scherjon and Jos. de Gruyter (essay date 1937)

[*In the following excerpt, Scherjon and de Gruyter pro-*

vide an overview of van Gogh's career and discuss significant examples of his work.]

Although van Gogh's pictorial development was far from being very regular or gradual, we may nevertheless divide the main body of his paintings into three distinct periods, roughly describing these consecutive stages as the realistic, the impressionistic, and the expressionistic or imaginative. Thus the whole of his life-work broadly sums up the evolution of European art in the second half of the nineteenth century and the early part of the twentieth; a fact assuredly surprising when it is realized that he was, essentially, a self-taught man, and that the tragic circumstances of his living enabled him to pursue his calling for the scope of barely ten years, the time needed by most painters to "find" themselves and fully to master their technique.

But we must not forget that van Gogh embarked upon his artistic career at the relatively advanced age of twenty-seven. His mind then was already matured; his character, his will, his sense of purpose, had been steeled by a series of fruitless attempts to gain a grasp on reality in other realms of human activity. He had successively been a picture dealer with Goupil and Co. in The Hague, London and Paris; then a school-teacher and a kind of curate in the London neighbourhood; then, back again in Holland, a salesman in a bookshop at Dordrecht; then a theological student at Amsterdam, and finally a missionary among the mining population of the Borinage, the Black Country of southern Belgium. And in all these occupations he had proved deficient, either by giving too little or too much of that which the situation demanded. He had had to acknowledge defeat time and again: had suffered, struggled, dreamt, and thought: had travelled, had seen, had read and had experienced vastly more than most men of his age, but only to find himself beaten again and again, only to realize that he had missed the mark or gone beyond it. In a word, he had failed fully to realize his intention or to establish some kind of harmonious relationship with the outer world.

Shortly before he is to become a painter, he tells us that men are often incapacitated from doing anything because they feel themselves prisoners: "prisoners in an I-don't-know-what-for horrible, horrible, utterly horrible cage." And from the same letter to his brother Theo, a long and significant letter, written in French from Cuesmes and dated July 1880: " . . . Then there is the man who is doomed to remain idle, whose heart is eaten out by an anguish for work, but who does nothing because it is impossible for him to do anything, because he is as it were imprisoned in something. Because he hasn't got just that which he needs in order to be creative. Because the fate of circumstances has reduced him to a state of nothingness. Such a man often doesn't know himself what he might do, but he feels instinctively: yet am I good for something, yet am I aware of some reason for existing! I know that I might be a totally different man! How then can I be useful, how can I be of service! Something is alive in me: what can it be!" But there, in the Borinage, this vague something living within him, this something he needs in order to be truly productive, stirs at last, compelling him to take first his pencil and drawing-pen in hand, then, when the most tedious first lessons are learned, his brushes for oils. And the man who until then had only drawn by way of pastime, had only indefinitely experi-

enced his "homesickness for the land of paintings", now knows with adamantine certainty that he has found his ultimate task, and is reconciled with life. The completeness of this illumination may seem surprising, just as the rapidity of growth in following years, already hinted at, may strike with wonderment the adept who is aware of the exacting demands of the technique of painting. But those who take to art in advanced years have, as a rule, something of the nature of meteors: they *are not,* and all of a sudden they too *are.* Such suddeness, however, is in fact fictitious. As a plant gathers strength and forms itself in the nether darkness for a long while, feeling its way and thrusting its roots in many directions, then rises with seeming abruptness above the soil's surface, so too in the psychological field we must needs believe in a hidden development preceding the one manifest to the mind's eye; and often this period of concealed inner growth is of lengthy duration and in every sense decisive. Nor will the attentive reader of van Gogh's early correspondence experience any difficulty in accepting this proposition, though he well may surmise literary possibilities rather than pictorial.

Again, we must bear in mind that modern life, lacking spiritual security for the artist and a final authority to which he can submit himself without the risk of self-violation, places great problems before the great thinker or dreamer of our days. Problems perhaps, which concern his art only indirectly, but with which he is nevertheless compelled to grapple. Society no longer shows, as it once did, that organic unity which enabled the artist to take many vital things for granted, thus allowing him to concentrate the whole of his attention upon his work. Is it not significant that various highly important authors of recent times, such as Multatuli in Holland and Lawrence in England, were scarcely able to accept themselves as "literary men", but rather felt they were continually concerned with issues lying outside the immediate field of artistic vision?

Beyond doubt van Gogh was fully aware of the dilemma here alluded to. "The trouble is," he writes to his friend Bernard, "that Giotto and Cimabue, as well as Holbein and van Eyck, lived in a well-built, obelisk-like community, if you get my meaning, in which everything was arranged with architectural method and in which every individual was a living brick of the total structure, all things holding together and forming a firm social monument. I have little doubt this state of affairs will be established again if only the Socialists are able to construct their edifice with a similar logic. But as yet we are far from that, and meanwhile, you know, we live in the midst of complete *laisser-aller* and anarchy. Loving order and symmetry all we artists can do is to isolate ourselves and to work at introducing a little harmony into some well-defined corner of the world."

Now this exacting task of boldly facing the vital problems of life, of discovering and creating some form of order and authority in the rush and flurry of our desultory age, obviously takes on specific forms in the case of every individual artist or thinker: forms psychologically determined by the inner and outer circumstances of his life. So we return, after these generalisations, to van Gogh and try to conceive in a nutshell the paramount problem which confronted him. Was it not the problem of religion in the wid-

est sense? Was it not, during the early years of gloom and failure and tentative effort, the compelling need to free himself from the religious concepts instilled in him from his childhood onward, and to find out what the heart really wanted, what the spirit could really believe in? And are not his ferocious outbursts of light and colour, the many ringing halleluyas he sang in praise of the sun and the earth, are these not possible *only* to one who first had taken the frigid and forbidding mentality of nineteenth-century provincial Calvinism in desperate earnest, only to be driven at last, in particular during his student days at Amsterdam, into a very frenzy of ascetic self-denial?

Those days spent studying theology had been the most appalling van Gogh endured: "the worst time I ever lived through", as he stated afterwards. The reserved, pondering, proselytising middle-class young man then turned into an unrelenting, abstracted fanatic, persistently chastising himself, eating dry bread and sleeping on a board, burning books that extolled the sensuous mode of life like a second Savonarola. He could not afterwards think of this period without shuddering. "My youth has been sombre and cold and sterile, under the influence of "le rayon noir" (the black ray, to wit Calvinism) However, I don't want to blame anyone but myself for that. All the same the black ray is unspeakably cruel, unspeakably But now I say as brother to brother, as friend to friend: though our sombre youth went against the grain, let us *from now onward* seek the soft light, for which I know no other name than "le rayon blanc" or "la bonté" (the white ray, the goodness of heart)."

So he turned his back on every system of religion and set out to discover the divine in actual life, realising the futility of denying the laws which govern God's own creation, realising that it was more truly devout "to study a single blade of grass", as did the Japanese artist in joyous self-possession. But the search for the "white ray" took him many years, and the revolt against the tyranny of clericalism and academicalism gradually brought about a state of violent opposition to all that is cold and smug and hypocritical in present-day civilisation. Van Gogh inevitably became an individualist and a revolutionary, truculent in appearance and wayward in trend of mind: snapping all conventional cables and trusting only to his own sense of what is beneficial or detrimental: guarding his integrity with a fierce urgency, an ever vigilant passion. So, like Blake and Nietzsche, he came to live in a world "beyond good and evil", where the only valid standards are those discriminating between the sincere and the false, between half living and fullness of life. A world in which his soul found itself naked at last, and its own inviolable master.

The early drawings, and in particular the earliest which were done consecutively at Cuesmes, Brussels, Antwerp and The Hague, show a stubborn desire for assidious study. They are not so much wavering or faulty as awkward and angular in their taut, analytic realism; and their importance has been overrated, we think, by certain Dutch critics and collectors.) Effort is only too visible, though technical shortcomings are frequently atoned for by a dark and strangely Gothic intensity of expression. As yet we are very far removed from the spirited solace of the "white ray": almost the whole of van Gogh's early output appears painfully stern and sombre. Country meadows have at times the barren look of waste land; storm clouds

slowly gather above a group of rustic dwellings, humbly squatting on a boundless heath; a street in a suburb, with a forlorn figure and a row of thin spiky trees, seems bathed in a twilight of nostalgic gloom. Humanity is usually portrayed in the moil and toil of daily occupations, somewhat after the manner of Israëls and Millet, but sadder, more sullen and ponderous. The studies heightened by water-colour are somewhat less insistent, and they frequently possess a peculiar melancholy stillness. In these, a blind reaching out for beauty, almost in the poetic and disinterested sense, replaces up to a certain point the close intentness of laboured draughtmanship. A similar mood of wistful intimacy was occasionally attained in the drawings, notably in that fine study from Etten of a garden corner with a little arbour, so precise, yet free from niggling finish.

But the most impressive things of the early period were undoubtedly the later canvases from Nuenen. As time progresses van Gogh's style becomes broader, more potent and masterful, and the lurid glow of certain dusky landscapes and peasant portraits from this village near the Belgian frontier, where the last two years were spent before leaving for Antwerp and Paris, already preludes the elemental works executed towards the close of his life at St. Rémy and Auvers. (pp. 9-13)

His second, Paris period appears in a sense less intrinsically convincing than the preceding phase in Holland and Belgium; yet the two years spent living with Theo in the French capital undoubtedly brought him a good deal nearer the goal of ultimate self-realisation. It is here he makes the acquaintance of such painters as Gauguin and the young Bernard, Pissarro and Sisley, Lautrec and Seurat; the first two of whom were to play a significant role in his later life. And it is here that he is brought into immediate touch with French impressionism, a more radiant and very different thing from that which is called impressionism in the Low Countries, where the dampness of atmospherical conditions tends to blend and subdue all intense local colouring.) Even a superficial comparison of the canvases from Nuenen and those from Paris reveals at a glance the change that now takes place in van Gogh's art. By leaps and bounds his crepuscular "soft soap" colouring becomes lighter and more vivid under the influence of that irresistible palette, which Delacroix had forestalled, which Monet brought into fashion, and from which Seurat and Signac, the so-called neo-impressionists, were busy distilling their scientific method, thus accentuating a tendency towards the abstract which was, in one sense, inherent in impressionism from the very first. (p. 14)

Even in the Ville lumière ["City of Light"], however, van Gogh retains many qualities essentially Dutch. His splendid self-portrait now at the Stedelijk Museum in Amsterdam, erroneously ascribed to his Arles period but pertaining to the preceding months, shows the sturdy peasant-like thinker from Brabant rather than a denationalized, jaunty *boulevardier*. However powerfully influenced by his surroundings—and in his work, we find not the slightest attempt to disguise such influences—van Gogh had little in common with the déraciné ["deracinated"]. He felt himself swayed and enriched by the easy and orderly, sensuous grace of the Latin mind, but at bottom he remained an obstinate, heavy-handed son of the North. And it was not long before the pendulum swung right back again; before he yearned to escape into the solacing solitudes of the country. Already he felt quite sick of the hectic studio-talks, and craved to get away from the sight "of so many painters who disgust me as men". Paris had "degenerated" him, the Parisians were "as changeable and perfidious as the sea." Moreover, his health was again in danger, as it had been already at The Hague, in Drenthe, at Antwerp; he feared in fact that he was on the verge of a stroke. So he slipped off one February day towards the South, not feeling able to say goodbye to Theo. He was too fond of him for that. Instead he nailed his canvases to the wall, in order that his brother might feel he was still there, left flowers and a cheerful farewell note on the table, and quietly slipped away.

Arles came as a revelation, infinitely reassuring. As if the old world had given him up from the womb and had put him into an unknown paradise, where one could begin all over again. Everything new: everything wonderful: everything clear and simple and bright as glass. In no time it was spring, the trees sprang into blossom, and it seemed "like being in Japan". He felt a second life had come to pass, new strength awoke and a new dawn blazed indomitably within him.

Day after day he entered into the unspeakable brightness, painting the various versions of the ***Pont d' Anglais*** and the impressive series of the orchards. The picturesque and taking canvases of the drawbridge with the little cart and horse going over it, (the replica of which is finer in composition than the study from nature) may be considered as blithe as anything he ever did. The river blue and the sky blue, the banks vivid orange with rich green grasses, a batch of many coloured washerwomen on one side, and the little horse nattily, gallantly crossing the water with all the importance of the world. So vivid this picture, that one almost hears the swishing and thudding of the busy women, and the distant clop-clopping of hoofs on the wooden bridge. The two uprights of a small pear-tree show the same serenely brisk and playful mood, which again recurs in the charming still-life of a majolicapot filled with wild flowers, three lemons and a cup with a pattern in orange and blue. But sterner and more comprehensive subjects are likewise tackled, such as the preceding still-life nakedly spiritual both in line and in colour; or again as that imposing vista ***The Harvest,*** scrupulously honest in vision, solid and satisfying in its detailed yet terse statement. Such a landscape as this seems aglow with the splendour of the Provence, and in it van Gogh reaches the high-water mark of happy *descriptive* power. The directness of his enthusiasm captures us more readily as it is led along well devised and firmly controlled channels. He brings the whole weight of his mind to bear upon his vivacious impressions without robbing them in the least of their bloom, and his spontaneity shows no trace of hit-or-miss frivolity. Even at his gayest, van Gogh did justice to the seriousness of life and art. In this he reminds one of Beethoven, and the paintings mentioned above seem aptly to illustrate the bubbling Scherzo and the quaint Trio of a Beethoven symphony. Unhappily this period was as short-lived as most Scherzos and Trios are. And a thundering Finale, colossal in force and mighty in stride, soon swept the composer himself off his feet.

For the stay at Arles ended in a catastrophe, and the reader will in all probability be acquainted with the further tragic facts of van Gogh's life. . . . Now, the name of

Gauguin is closely linked up with the sad and violent affair at Arles, which marked van Gogh's first attack of insanity; and it is no doubt difficult to do justice in this connection to the painter of the Yellow Christ and the author of Noa-Noa. Let it be borne in mind, however, that no one but the two painters themselves will ever know *precisely* what was said and what was felt in the "terribly electric" atmosphere of those unfortunate days. If Gauguin is to blame, then his fault seems rather to lie at the very outset in his willingness ever to join van Gogh, than in anything that occurred in the little yellow house on the Place Lamartine. He seemed reluctant enough to come and was very slow in responding to his friend's impatient and insistent call. Probably he would have held back altogether, had not Theo had the fortune, or misfortune, of selling two paintings for him. By the time he did arrive, van Gogh was almost on the verge of a break-down as a result of his incessant strenuous work; being "vain" enough, as he tells Theo, "to want to make a certain impression on Gauguin". (pp. 15-17)

[Van Gogh's mental breakdown] inevitably left its impress upon his work. And soon we find him expressing the wish to return to a palette of broken tones, a palette "as in the North." He writes concerning his Quarry entrance, St. Rémy, that it was indeed "a more sober attempt, *restrained and without display in colour*" (the italics are ours). But this reversion to a more subdued colouring, which after all was a very relative matter, is not the main development confronting us in his later work. It must be pointed out on the contrary, that the most essential change to take place had already announced itself in such paintings as the *Sower* and the *Poet,* both of which were executed a good while before Gauguin's arrival and the subsequent first crisis.

The canvases alluded to may be considered more or less failures, as a comparison of the *Sower* with that wonderful study of the *Reaper* will clearly reveal. All the same, they are profoundly significant as indications of the direction in which van Gogh was developing. For they are his first attempts towards a more free and symbolic mode of expression, and almost every word he writes concerning them is worthy of the reader's special attention. We are aware that it is not always easy for those who are not painters themselves, or intimately concerned with art, to follow van Gogh's aims during his last, most vital period of creative activity. The chief thing to bear in mind is his gradual rejection of naturalism, this as a result of his struggle towards a more inwardly complete, more imaginative and elemental utterance. And it is only an apparent contradiction when we observe that van Gogh, being a Dutchman to the core, belonged to the world of solid fact rather than intangible dream. The earth and all things material were dear to him, and he possessed, as is already evinced by the work of his first period, in great measure the gift of vivid reality of conception and unadorned simplicity of treatment. His strong square style seems so compellingly appropriate precisely because one never thinks of style at all. He paints the flowers and grasses in a corner of a sunlit meadow with that naked candour and unspoilt ardour, which comes from his unquestioning acceptance of these things, his whole-hearted identification with them. At Arles, however, he is without doubt influenced to some extent by the decorative, folklore and "symbolist" tendency then manifesting itself in the works of Gauguin,

Bernard and others. And through dint of practice he might have become capable of working from the imagination, had he persisted in this course, as Gauguin advised him to. But it went against the grain of his nature and he deliberately desisted.

"When Gauguin was at Arles", he afterwards writes to Bernard, "I allowed myself to be led to working from the imagination, and at the time the road to the abstract seemed to me a charming track. But it's an enchanted land, my dear friend, and soon one finds oneself up against an insurmountable wall." In a similar strain he writes to Theo . . . that he has told both Bernard and Gauguin that to *think* not to *dream* is a painter's duty. His studies of olives, he tells us, are "a rather hard and coarse reality beside their abstractions", but on that account they will give "the sense of the country, the smell of the soil". Very significant too, in this connection, is the following passage to Theo: " . . . If I but dared to let myself go, dared to risk more, to deviate from reality and to make out of colour a kind of music of tones But then the truth is so dear to me, and likewise *the search after truth* . . .".

There can be no doubt whatever that van Gogh was, and remained to the end, a realist, fundamentally averse to the purely decorative or the purely fantastic: but even so, a realist of the imaginative order. The symbolic aspect of his later period has a sterner meaning, rising as it does from his realisation that "*all* reality is a symbol". We are faced in his case with that pristine, pre-cerebral form of symbolism, which characterises the primitive mind, and does not as yet differentiate between the actual fact and its transcendental significance, between the two interrelated worlds of existence and of being. And it was precisely this more instinctive symbolic awareness of life which led van Gogh rightly to distrust the more conscious, intellectual forms of symbolism so-called. These latter tend as a rule to the "literary" in pictorial art, and allow ideas to be introduced from the outside and then to parade in the Sunday dress of grave allegories, instead of permitting them to spring forth spontaneously from immediate vision. With van Gogh it was the sheer vehemence and completeness of his response to the visible which urged him further and further into the realms of the invisible, compelling him to explore the possibilities of expressionistic "exaggerations", and finally goading him to his almost Apocalyptic registrations of an "unseen world".

Thus we find him hoping some day, as he says [in a letter] from Arles, "to express the love of two lovers by a marriage of two complementary colours, their mingling and their opposition, the mysterious vibrations of kindred tones. To express the thought of a brow by the radiance of a light tone against a sombre background. To express hope by some star, the ardour of a being by a sunset radiance. To be sure, there is nothing of stereoscopic realism in that, *but is it not something that actually exists?*" We render in italics the most characteristic passage of this remarkable excerpt. There is, indeed, in the whole of van Gogh's production nothing "that does not actually exist": it is his limitation and his greatness: nothing thinly spiritual, nothing gossamery or evaporated, nothing subsisting on mere thought or fancy or calculation: and yet all the same this consuming desire to express hope by a star, and the soul's ardour by a radiant sunset. In the seeming contradiction lies, we feel, the soundness of his instincts.

Typical again is what he writes shortly afterwards, after mentioning to Theo his **Sower,** his **Night Café,** his **Old Peasant** and his **Poet:** "It isn't a colour locally true from the point of view of the cherry-to-be-picked-by-the-bird ideal, but a colour suggesting the emotion of an ardent temperament. When Paul Mantz saw at the exhibition which we visited at the Champs Elysées, the violent and ecstatic sketch by Delacroix—the Christ in the boat—he went home and wrote in his article: 'I never knew one could be as terrible as all that with a little blue and a little green.'

> Hokusai wrings the same cry from you, only he does it by his lines, by his drawing—as you say in your letter: 'these waves are claws and the ship is caught in them, you feel it'. Well now, if one makes the colour exact and the drawing exact, one never gives emotions like that.

Henceforth van Gogh becomes more and more engrossed in giving "emotions like that." His admiration for the impressionists remains undiminished, but he realizes there is more to be said yet. Had he not felt all along that Delacroix had grasped for greater truths? Could not Nature be interpreted more profoundly and essentially than ever was possible by the means of analysis and transcription, however vivid, however radiant? Thus in his later works the principle of French luminism is divested of its momentary and accidental traits, it is brought under command of the Teutonic, the "barbaric", the religious spirit, and is raised to a more ultimate plane of expression. The experimental and descriptive attitude must now give way to higher and more vital aims, to a more imaginative sense of direction and purpose. No longer are we charmed by those gracious flirtations with effects of light and shade, of "values" and such like which had, to a fair extent, busied him when at Paris. Rather we find a yearning to make manifest the full mastery and mystery of light: an immediate communion with the source of light itself, the non-human or superhuman fountain of life. And thus he wins back the vision which must have inspired the sun-worshippers of old, expressing it not in calligraphic symbols, but "by means of the vibration of our colourings." The compelling sense of the magnificence of light invades him, intoxicates him, overpowers him and strikes him to the soul, till he tells us that he scarcely knows any longer what he is doing, working "as in a trance". "When I came out of hospital with good old Roulin, I fancied nothing had been the matter with me, but *afterwards* I realized that I had been ill. No help for it, there are moments when I am wrung with enthusiasm or madness or prophecy like a Greek oracle on a tripod."

The sun now no longer moves with domestic familiarity, with the automatic certainty of twice two are four: it is transfigured into a blazing orb, burning its way through day and night, through the vast heavens and the dark underworlds. It is strong and fierce beyond human understanding, self-assertive in its untamed vigour, its splendid overbearingness. As he stands painting in the fields amidst the gently swaying corn or in the full blast of the mistral, he sees it rising in all its felicity, this cosmic sun of the ancients, then gaining the zenith in a swift fury of possession, then crouching on the Western horizon like a spitting raucous yellow cat, ready to pounce upon the mouse-like distant village of red-roofed Arles.

Sorrow (1882)

And so, too, the earth becomes divested of its domestic, opaque greyness. The threadbare veil of passive naturalism is ripped across and flung aside, the good soil and all things upon it are bathed in newness, are thrown into bold relief by a strange, elemental wonderment. He watches in amazement the processes of growth, and he is forcibly reminded that the soil is virgin, and is fecundated by the piercing brilliance of the southern sun. He is thrilled by the germinating power of the seed, ravished by the bursting of buds: a myriad plants and shrubs and trees springing forth from the earth: a myriad fountains of divers greens, blue-greens, yellow-greens, bronze-greens, here, there, everywhere at one and the same moment, a very riot of fertility. And so he plunges into the heart of nature and paints no longer the flower only, but also its sap, suggests no longer the ostensible aspect of a tree, but rather its power of growth.

This vision of soil and sun, of the earth and the heavens, then becomes so loaded at last with a truly symbolic awareness, that the entire visible world is eventually consumed by it, devoured by it, burnt up in a conflagration of vehement desire and assertion. There is no question either of an ascetic or of an intellectual denial of the world of material existence: but only a veritable bon-fire of over-emphatic, over-keen spiritual affirmation. Life resolves into one vast, swaying ocean of resolute surging, wave-tip overlapping wave-tip, rhythm following upon rhythm. Things coloured and tangible sprouting out of an invisible tide of dauntless energy, suddenly flung into being, sud-

denly whirled into power, yet all the time rhythmic, controlled, and not without a certain logic in the sequence of brush-strokes and in the juxtaposition of tones. Until finally little more remains of stereoscopic reality than a dynamic and ornamental script of lines and colours, won in the exulting flash of a moment, yet expressing something of the ultimate and the eternal.

In all this there is nothing, or next to nothing, of the irresponsible rapture of madness. The treatment of a painting, say, as the final study of **The Ravine** is far too well controlled and too resolute ever to be considered the product of a madman's scattered brains. Only in a number of canvases from Auvers, for instance in that much overrated painting of a blasted cornfield beneath a menacing flock of jet-black crows do we find a certain wild desperation, something delirious, something derailed. But on the whole van Gogh's art, however extreme, seems perfectly sane: precise, deliberate, integral. (pp. 19-23)

It is not difficult to realize van Gogh's limitations and shortcomings, if we wish to label as such certain inevitable peculiarities in his mental structure. It is not difficult, indeed, to imagine an art more graceful and disciplined, or more potent in the sensual sense. His paintings very rarely reveal anything approaching the detached mood of the poet, who lives at peace with all the world and contemplates its many beauties with steadfast, intimate, voluptuous delight. This we rather find in the work of Gauguin: this power of intricate yet harmonious composition: this faculty for letting the lines, as it were, produce themselves, for letting the colours issue forth from the canvas itself and sing in unison with slow, measured, deep suavity. Van Gogh was far too tempestuous for any such thing, too much possessed by a fury for deliberate self-expression. At times his naked spirituality jars and almost exasperates by its restless, hurtful, emphatic directness.

These things may be taken for granted, attack and defence of van Gogh in the familiar manner being quite out of date. The lonely tormented recluse has survived a period of exaggerated lionism as certainly as he did the preceding phase of common abuse and high-brow indifference. He has become an historic event, a landmark in the near European past.

Assuredly a conspicuous landmark, taken both as a man and as an artist. But the two are, in this case, altogether inseparable. The key to van Gogh's greatness lies in his tremendous, irresistible sincerity. It seems the simplest thing in all the world, to be sincere, and it is profoundly difficult. The wish alone, however earnest, does not suffice, one must have the power to be sincere. Rarely has an artist shown such complete absence of affectation as did the painter of the sunflowers, the orchards and the cypresses. "One must work", he once wrote, "as though one were making boots, without artistic prepossession." This unassuming, unsophisticated attitude towards life and art, this basic simplicity of mind is the more startling in so far as he was a reckless adventurer: experimental in his technique and daringly dramatic in his utterance: the very antipole to all that is timid or mediocre. Van Gogh has painted both banal and amazing pictures, but every stroke of his brush has an indisputable air of truth. He staked his life with every new subject he tackled and his paintings are in essence, quite as much as his letters, ruthlessly, passionately autobiographical.

Thus it is that his art not only gives a smaller or larger amount of aesthetic satisfaction, but stimulates and inspires the observer, dipping him into some sort of involuntary re-birth. It is not the titillating performance of a man of genius on the modern pictorial stage, but rather a quickening of our total, innermost being. In vain we guard ourselves from being swept away, in vain we try to hold at arm's length such paintings as the various versions of the Woman Cradling or the three last portraits of the Postman, perceiving the blatant insistence in the means employed, pointing out the lack of erudite refinement and concealed mastery, and calling to mind van Gogh's own words, repeated almost *ad nauseam usque* in the letters, concerning the resemblance of his canvases to cheap chromolithographs.

In spite of all—and let it be clearly understood, that such "faults" were in great measure the outcome of deliberate intention—in spite of all these works seem tingling with magnificence, and commensurate with our present-day needs. Subtler, more carefully matured and very much better balanced paintings have been conceived and executed time and again, not only in the great periods of the past, but also to a lesser extent in recent years. Yet not many of these possess a similar crucial significance, a similar eye-opening power; and a fair number appear downright trivial or frigid by the side of van Gogh's unceremonious, savage vitality.

One is bound to accept this man for what he was. A vast, awkward, brooding spirit, whose northern blood was eased and quickened and liberated by the goodly glamour of the South. A brave, unhesitating soul, with a firm grasp of essentials and a keen power to discern between the true and the false: bravely and unhesitatingly combating the life-destructive forces of his own past and of modern civilisation at large: gaining moments of the purest self-control, moments of a wonderful lucidity, an enchanted ringing blitheness: heightening all the while the magical properties of colour to their utmost, and painting the cornfields refulgent with light, the agile boats on the Mediterranean shore, the orchards in a riot of bloom, the glowing vineyards, the fierce bright sunflowers, the soldier and the poet and the postman, the beautiful women of Arles. Until out of this vast sense of splendour comes a first, fatal proclamation of doom. Until he is intermittently caught in the downward dragon-clutch of his mental disorder, loads on the paint with unrestrained ardour, rises to a pitch of ecstatic agony and achieves what are, perhaps, his most expressive, most magnetizing things.

Canvases which seem to rock and swing and shudder with passion; landscapes which make visible the sprouting and urging, the rolling and unfolding of the life of the cosmos; swift, keen, pristine flower pieces such as the roses and the irises, which stab like a flash of lightning, or like the menacing thrust of some delicate weapon; cypresses, rushing up from the earth like huge columns of throbbing darkness, an upward rush of a thousand dark green cypress-serpents; and then that last, heroic self-portrait, the portrait of an ultimate human on the shores of chaos, on the brink of death. (pp. 24-6)

W. Scherjon and Jos. De Gruyter, in their Vincent van Gogh's Great Period: Arles, St. Rémy and Auvers sur Oise, *"De Spieghel" Ltd., 1937, 400 p.*

Van Gogh on his early paintings:

When I call myself a peasant-painter, that is a real fact. . . . I feel at home in the country, and it has not been in vain that I spent so many evenings with the miners, and peat diggers, and weavers, and peasants, musing by the fire—unless I was too hard at work for musing. By witnessing peasant life continually, at all hours of the day, I have become so absorbed in it that I hardly ever think of anything else. In fact I have no other wish than to live deep, deep in the heart of the country, and to paint rural life. I feel that my work lies there, so I shall keep my hand to the plough and cut my furrow steadily.

> *Vincent van Gogh, in an excerpt from* Dear Theo: The Autobiography of Vincent van Gogh, *edited by Irving Stone and Jean Stone, Doubleday & Company, Inc., 1937, p. 338.*

SURVEY OF CRITICISM

Roger Fry (essay date 1923)

[*A member of the Bloomsbury intellectual circle, which also included such noted figures as novelist Virginia Woolf and economist John Maynard Keynes, Fry was one of the most important English art critics of the early twentieth century, serving as director of the Metropolitan Museum of Art in New York City from 1905 to 1910 and as the editor of* Burlington *magazine from 1910 to 1919. He is remembered in particular as a champion of the Post-Impressionists and is credited with introducing their works, as well as those of the Fauvists, to England with his unprecedented "Post-Impressionist" exhibitions held in London in 1910 and 1912. Fry was also a painter and the founder of the Omega workshops, in which he and other artists produced decorative objects designed for everyday use, including textiles, furniture, and pottery. Despite his general approval of van Gogh's work, Fry, like many of his contemporaries, interpreted the painter's later style as a manifestation of his psychological disturbance, and in the following review of the first major solo exhibition of van Gogh's works in England, he praises the works of the Arles period while lamenting the inferior quality of later works.*]

The Exhibition of van Gogh's works at the Leicester Galleries gives us, for the first time in England, the opportunity of seeing something of the extraordinary artistic Odyssey which this strange being accomplished in the incredibly short time between his first devoting himself to painting and his tragic end. It is characteristic of his intensely personal and subjective talent that at each period he managed to convey so much of his beliefs, his passions, and of their effect on his temperament. Perhaps no other artist has illustrated his own soul so fully, and this all the more in that he was always the passive, humble and willing instrument of whatever faith held him for the time being in its grip. What strikes one all through his work, and with a fresh astonishment every time one sees it, is the total self-abandonment of the man. He never seems to be learning his art. From the very first his conviction in what he has to say is intense enough to carry him through all the difficulties, hesitations and doubts which beset the learner. He works, like a child who has not been taught works, with a feverish haste to get the image which obsesses him externalized in paint.

One could see that he must have always worked at high pressure and topmost speed, even if his large output in so few years did not prove it. He has no time and no need for that slow process of gradually perfecting an idea and bringing out of it all its possibilities. He is too much convinced at the moment ever to have doubt, and he is too little concerned with the fate of his work or of himself to mind whether it is complete or not, so long as he has, somehow, by whatever device or method that may come ready to his feverish hand, got the essential stuff of his idea on to the canvas. This is not the way of the greatest masters, of the great classic designers, but no one can doubt that it was the only way for van Gogh. And so the fiery intensity of his conviction gave certainty and rhythm to his untrained hand.

What astonishes one most in this series is not only the rapidity of the work itself but the rapidity of the evolution which he accomplished. The ***Pair of Boots*** is a still-life study in which the influence of his early Dutch training and his enthusiasm for Israels are still apparent. This belongs to the year 1887. The latest work is the ***Cornfield with Rooks*** done at Auvers just before his death in 1890. And the difference of spirit between these two is immense.

In between lies van Gogh's *Annus mirabilis* 1888, the year of his sojourn in Provence, of his comradeship with Gauguin and his first tragic outbreak. And in that year he had not only to sum up, as it were, all his past endeavor, but to accept and digest the influence of so dominating a character as Gauguin's. We see him in the ***Zouave,*** frankly accepting Gauguin's oppositions of flat, strongly coloured, lacquer-like masses, but this is the only obvious evidence of Gauguin's effect on van Gogh's art. ***The Sunflowers*** is one of the triumphant successes of this year. It has supreme exuberance, vitality, and vehemence of attack, but with no sign of that loss of equilibrium which affects some of the later works. It belongs to a moment of fortunate self-confidence, a moment when the feverish intensity of his emotional reaction to nature put no undue strain upon his powers of realization.

Van Gogh had a predilection for harmonies in which positive notes of yellow predominated. In his thirst for colour and light combined, he found in such schemes his keenest satisfaction. Here he has chosen a pale lemon-yellow background to set off the blazing golden glow of the petals of his sunflowers, which tell against it as dusky masses of burnished gold. Here, as so frequently in van Gogh's art of this period and as in most of Gauguin's work, preoccupation with the arrangement of the silhouette is very apparent. And, moreover, the source from which both artists got the idea—the Japanese print—is evidently disclosed.

A lapse from this careful organization of the surface unity on decorative lines is seen, however, in another work, . . . *The Yellow House at Arles.* Here the composition shows perhaps a reminiscence of that momentary period when Seurat and Pissarro were his guiding lights.

There is, by the by, a most interesting landscape here of fruit trees with figures which is carried out almost entirely in the style of Pissarro, modified, of course, as all the many styles van Gogh tried were, by his peculiarly emphatic temperament; though, perhaps, this is less clear here than elsewhere. Certainly one feels that he was bound to abandon so carefully planned, so slowly constructed and so minutely observant a method of painting for some other that would promise a more rapid realization of his idea.

But to return to the Arles picture. Perhaps nowhere else has van Gogh expressed so fully the feeling of ecstatic wonder with which he greeted the radiance of Provençal light and colour. He had shrunk at nothing in order to find a pictorial phrase in which to sing of the violence of the sun's rays upon red-tiled roofs and white stone walls. To do this he has saturated and loaded his sky, making it, not indeed the conventional cobalt which is popularly attributed to Mediterranean climes, but something more intense, more dramatic and almost menacing. How utterly different is van Gogh's reading of Provençal nature from Cézanne's contemplative and reflecting penetration of its luminous structure. Here all is stated with the crudity of first impressions but also with all their importunate intensity—and they are the first impressions of a nature that vibrated instantly and completely to any dramatic appeal in the appearances of nature. In striking contrast to Cézanne, too, is van Gogh's indifference to the plastic structure of his terrain, which is treated here in a cursory and altogether insignificant way. The artist's interest was entirely held by the dramatic conflict of houses and sky, and the rest has been a mere introduction to that theme.

The canvases of the succeeding year, 1889, show another rapidly accomplished evolution. The brushwork becomes more agitated, or rather the rhythm becomes more rapid and more undulating, and all the forms tend to be swept together into a vortex of rapid brush strokes. There are no examples here of the more extreme developments of this period. One *Rocks in a Wood* is quite unusual for this period. It shows, indeed, the new vehement rhythmical treatment of the forms and the agitated handling; but with this goes a singularly well-balanced composition without any strong dramatic effect, and with a peculiarly delicate and tender harmony. It expresses altogether an unfamiliar mood.

The one masterpiece of this period, *The Ravine,* is not here, unfortunately—I believe it is now in America. In this, by some fortunate influence, all the agitated vehemence of handling of this period serves only to give vitality to the structure of the rocks, and here, under the dominance of a more steadily held impression, van Gogh has been able to persist until the loaded paint has become fused into a substance as solid and as precious as some molten ore shining with strange metallic lustres.

It is in the *Cornfield with Rooks* that, as far as this exhibition goes, we get a glimpse of van Gogh's last phase of almost desperate exaltation. Here the dramatic feeling has become so insistent as to outweigh all other consider-

ations. There is no longer any heed given to questions of formal design, and van Gogh ends, as one might have guessed from his temperament that he must end, as an inspired illustrator. (pp. 306-08)

Roger Fry, in an excerpt from The Burlington Magazine for Connoisseurs, *Vol. XLIII, No. CCXLIX, December, 1923, pp. 306-08.*

Meyer Schapiro (essay date 1946)

[*A Russian-born American art historian and critic, Schapiro was also a classical Marxist who believed that cultivation of the arts would best be achieved in a socialist state. In the following excerpt, he discusses van Gogh's reluctance to completely abandon objective representation and views* Crows over the Wheatfield *as the culmination of expressionistic tendencies in van Gogh's mature style.*]

Among van Gogh's paintings the *Crows over the Wheat Field* is for me the deepest avowal. It was painted a few days before his suicide, and in the letter in which he speaks of it we recognize the same mood as in the picture. The canvas is already singular in its proportions, long and narrow, as if destined for two spectators, an image of more than the eye of one can embrace. And this extraordinary format is matched by the vista itself, which is not simply panoramic but a field opening out from the foreground by way of three diverging paths. A disquieting situation for the spectator, who is held in doubt before the great horizon and cannot, moreover, reach it on any of the three roads before him; these end blindly in the wheat field or run out of the picture. The uncertainty of van Gogh is projected here through the uncertainty of movements and orientations. The perspective network of the open field, which he had painted many times before, is now inverted; the lines, like rushing streams, converge towards the foreground from the horizon, as if space had suddenly lost its focus and all things turned agressively upon the beholder.

In other works this field is marked with numerous furrows that lead with an urgent motion to the distance. These lines are the paths of van Gogh's impetuous impulse towards the beloved object. Recall how Cézanne reduced the intensity of perspective, blunting the convergence of parallel lines in depth, setting the solid objects back from the picture plane and bringing distant objects nearer, to create an effect of contemplativeness in which desire has been suspended. Van Gogh, by a contrary process, hastens the convergence, exaggerating the extremities in space, from the emphatic foreground to the immensely enlarged horizon with its infinitesimal detail; he thereby gives to the perspective its quality of compulsion and pathos, as if driven by anxiety to achieve contact with the world. This perspective pattern was of the utmost importance to van Gogh, one of his main preoccupations as an artist. In his early drawings, as a beginner struggling with the rules of perspective and using a mechanical device for tracing the foreshortened lines which bewildered and delighted him, he felt already both the concreteness of this geometrical scheme of representation and its subjective, expressive moment. Linear perspective was in practice no impersonal set of rules, but something as real as the objects themselves, a quality of the landscape that he was sighting. This paradoxical scheme at the same time deformed things and

made them look more real; it fastened the artist's eye more slavishly to appearance, but also brought him more actively into play in the world. While in Renaissance pictures it was a means of constructing an objective space complete in itself and distinct from the beholder, even if organized with respect to his eye, like the space of a stage, in van Gogh's first landscapes the world seems to emanate from his eye in a gigantic discharge with a continuous motion of rapidly converging lines. He wrote of one of his early drawings: "The lines of the roofs and gutters shoot away in the distance like arrows from a bow; they are drawn without hesitation."

In his later work this flight to a goal is rarely unobstructed or fulfilled; there are most often countergoals, diversions. In a drawing of a ploughed field, the furrows carry us to a distant clump of bushes, shapeless and disturbed; on the right is the vast sun with its concentric radiant lines. Here there are two competing centers or centered forms, one, subjective, with the vanishing point, the projection of the artist not only as a focusing eye, but also as a creature of longing and passion within this world; the other, more external, object-like, off to the side, but no less charged with feeling. They belong together, like a powerful desire and its fulfillment; yet they do not and can not coincide. Each has its characteristic mobility, the one self-contained, but expansive, overflowing, radiating its inexhaustible qualities, the other pointed intently to an unavailable goal.

In the *Crows over the Wheat Field* these centers have fallen apart. The converging lines have become diverging paths which make impossible the focused movement toward the horizon, and the great shining sun has broken up into a dark scattered mass without a center, the black crows which advance from the horizon toward the foreground, reversing in their approach the spectator's normal passage to the distance; he is, so to speak, their focus, their vanishing point. In their zigzag lines they approximate with increasing evidence the unstable wavy form of the three roads, uniting in one transverse movement the contrary directions of the human paths and the sinister flock.

If the birds become larger as they come near, the triangular fields, without distortion of perspective, rapidly enlarge as they recede. Thus the crows are beheld in a true visual perspective which coincides with their emotional enlargement as approaching objects of anxiety; and as a moving series they embody the perspective of time, the growing imminence of the next moment. But the stable, familiar earth, interlocked with the paths, seems to resist perspective control. The artist's will is confused, the world moves towards him, he can not move towards the world. It is as if he felt himself completely blocked, but also saw an ominous fate approaching. The painter-spectator has become the object, terrified and divided, of the oncoming crows whose zigzag form, we have seen, recurs in the diverging lines of the three roads.

And here, in this pathetic disarray, we begin to discover a powerful counteraction of the artist, his defense against disintegration. In contrast to the turbulence of the brushwork and the smallest parts, the whole space is of an unparalleled breadth and simplicity, like a cosmos, in its primitive stratified extension. The largest and most stable area is the most distant—the rectangular dark blue sky that reaches across the entire canvas. Blue occurs only here and in fullest saturation. Next in quantity is the yellow of the wheat field, which is formed by two inverted triangles. Then a deep purplish red of the paths—three times. The green of the grass on these roads—four times (or five, if we count the thin streak at the right). Finally, in an innumerable series, the black of the oncoming crows. The colors of the picture in their frequency have been matched inversely to the largeness and stability of the areas. The artist seems to count: one is unity, breadth, the ultimate resolution, the pure sky; two is the complementary yellow of the divided, unstable twin masses of growing corn; three is the red of the diverging roads which lead nowhere; four is the complementary green of the untrodden lanes of these roads; and as the n of the series there is the endless progression of the zigzag crows, the figures of death that come from the far horizon.

Just as a man in neurotic distress counts and enumerates to hold on to things securely and to fight a compulsion, van Gogh in his extremity of anguish discovers an arithmetical order of colors and shapes to resist decomposition.

He makes an intense effort to control, to organize. The most elemental contrasts become the essential appearances; and if in this simple order two fields are apart in space, like the sky and the roads, they are held together by additional echoing touches of color which, without changing the larger forces of the whole, create links between the separated regions. Two green spots in the blue sky are reflections, however dimmed, of the green of the roads; many small red touches on the wheat field along the horizon repeat the red of these paths.

In the letter to which I have referred, Vincent wrote to his brother: "Returning there, I set to work. The brush almost fell from my hands. I knew well what I wanted and I was able to paint three large canvases.

"They are immense stretches of wheat under a troubled sky and I had no difficulty in trying to express sadness and extreme solitude."

But then he goes on to say, what will appear most surprising: "You will see it soon, I hope . . . these canvases will tell you what I can not say in words, what I find healthful and strengthening in the country."

How is it possible that an immense scene of trouble, sadness, and extreme solitude should appear to him finally "healthful and strengthening?"

It is as if he hardly knew what he was doing. Between his different sensations and feelings before the same object there is an extreme span or contradiction. The cypress trees which he compared with an Egyptian obelisk for their beauty of line and proportion become restless, flaming shapes in his pictures. Yet he practiced his art with an extraordinary probing awareness; it was, in his own words, "sheer work and calculation." His letters contain remarkable illuminations on the problems of painting; one could construct a whole aesthetic from scattered statements in the letters. But when he looks at his finished work, he more than once seems to see it in a contradictory way or to interpret the general effect of a scene with an impassioned arbitrariness that confounds us. Sometimes it is a matter of the symbolism or emotional quality of a tone for which he possesses an entirely private code: "a note of intense malachite green, something utterly heartbreaking." In another letter he describes a painting of a wheat

field with the sun and converging lines—a picture like the drawing mentioned above, perhaps of the same theme—as expressing "calmness, a great peace." Yet by his own account it is formed of "rushing series of lines, furrows rising high on the canvas"; it exhibits also the competing centers which create an enormous tension for the eye. To another artist, such lines would mean restlessness, excitement. Similarly, van Gogh speaks of a painting of his bedroom in Arles as an expression of "absolute repose." Yet it is anything but that, with its rapid convergences and dizzying angularities, its intense contrasted colors and the scattered spots in diagonal groups. It is passionate, vehement painting, perhaps restful only relative to a previous state of deeper excitement, or as an image of his place of sleep.

In this contradiction between the painting and the emotional effect of the scene or object upon van Gogh as a spectator, there are two different phenomena. One is the compulsive intensification of the colors and lines of whatever he represents; the elements that in nature appear to him calm, restful, ordered, become in the course of painting unstable and charged with a tempestuous excitement. On the other hand, all this violence of feeling does not seem to exist for him in the finished work, even when he has acknowledged it in the landscape.

The letters show that the paradoxical account of the **Crows over the Wheat Field** is no accidental lapse or confusion. They reveal, in fact, a recurrent pattern of response. When van Gogh paints something exciting or melancholy, a picture of high emotion, he feels relieved. He experiences in the end peace, calmness, health. The painting is a genuine catharsis. The final effect upon him is one of order and serenity after the whirlwind of feeling.

Yes, there is health and strength for van Gogh in his paroxysmal rendering of the wheat field and the sky. The task of painting has for him a conscious restorative function. He believed already some time before that it was only painting that kept him from going mad. "I raced like a locomotive to my painting," he wrote, when he felt that an attack was coming. He spoke of his art as "the lightning conductor for my illness." It is customary to describe van Gogh as an inspired madman whose creativeness was due to his unhappy mental condition, and indeed he admitted this himself. Looking back on the intense yellows in his work of 1888, he said: "To attain the high yellow note that I attained last summer, I really had to be pretty well strung up." But he saw also that he was not insane, although subject to attacks: "As far as I can judge, I am not properly speaking a madman. You will see that the canvases I have done in the intervals are restrained and not inferior to the others." Whatever may be said about the connection between his calling as an artist and his psychic conflicts, it remains true that for van Gogh painting was an act of high intelligence which enabled him to forestall the oncoming collapse. In his own words, he "knew well what he wanted." The psychiatrist and philosopher, Jaspers, in a book on great schizophrenic artists, in which he examines the lives of Hölderlin, Strindberg, and van Gogh, observes as a peculiarity of van Gogh "his sovereign attitude to his illness," his constant self-observation and effort of control. The painter, more than the others, wished to understand his own state. With a rare lucidity he watched his behavior to foresee the attacks and to take precautions against them, until in the end his despair destroyed him.

If van Gogh derived from internal conflicts the energies and interests that animate his work (and perhaps certain original structures of the forms), its qualities depend as much on his resistance to disintegration. Among these qualities one of the most essential was his attachment to the object, his personal realism. I do not mean realism in the repugnant, narrow sense that it has acquired today, and that is too lightly called photographic—photography has also a deeper expressive side in its fascinating revelation of things—but rather the sentiment that external reality is an object of strong desire or need, as a possession and potential means of fulfillment of the striving human being, and is therefore the necessary ground of art. When van Gogh describes his paintings, he names the objects and their local colors as inseparable substances and properties, unlike an Impressionist painter who might be more acutely observant but would be less concerned with the object and would, on the contrary, welcome its dissolution in an atmosphere that carries something of the mood of revery without desire, as if a primordial separateness of man and the neutral things around him had been overcome through their common immersion in a passive state called sensation. For van Gogh the object was the symbol and guarantee of sanity. He speaks somewhere of the "reassuring, familiar look of things"; and in another letter: "Personally, I love things that are real, things that are possible . . . " "I'm terrified of getting away from the possible . . . " The strong dark lines that he draws around trees, houses, and faces, establish their existence and peculiarity with a conviction unknown to previous art. Struggling against the perspective that diminishes an individual object before his eyes, he renders it larger than life. The loading of the pigment is in part a reflex of this attitude, a frantic effort to preserve in the image of things their tangible matter and to create something equally solid and concrete on the canvas. Personality itself is an object, since he is filled with an unquenchable love for the human being as a separate substance and another self; he is able then to paint himself and others as complete, subsistent objects and through such paintings to experience their firmness and sure presence and to possess them. That is why, standing before the ominous sky and wheat field, with the oncoming crows, he is able to paint not only this sadness and solitude, but also the health and strength that reality alone can give him.

Yet can it give these to him? we must ask. Or is this a desperate effort to obtain from the landscape what it no longer possesses? Is van Gogh perhaps the last great painter of reality and the precursor of an anti-objective art because his earnest attempt to integrate himself through the representation of things is hopeless? Is this the crucial personal failure, the tragic artistic success for which he pays with his life? We have seen how his devoted vision of the exterior world is disturbed by emotionally charged forms that subvert the perspective relations, how the convergence towards the horizon through which the whole space normally appears ordered with respect to the fixed gaze of the beholder, is confused by divergences and complexities arising from stresses within the artist which resist this harmony, this preestablished coordinating system in the glance. Nature is now foreign to man, its highest consciousness and reflector. It has ceased to be a model of inner harmony and strength. From this time on external reality will no

longer offer artists "healthful and strengthening" objects of love, only random elements for dreams or aesthetic manipulation.

But dreams are just what van Gogh avoided as the paths to insanity. "To think, not to dream, is our duty," he wrote. To his friend Bernard, who described to him his new religious pictures inspired by medieval Christianity, the former theological student and missionary replied that such an attempt in our age was an impossible evasion: "It's an enchanted territory, old man, and one quickly finds oneself up against a wall"; only the reality of our time could provide the ground of art and human satisfaction. But he himself could not survive on this ground. It implied faith in a social order of which he perceived the injustice and cruelty and growing chaos. At this moment already to artists of insight, "reality" meant for the most part the things that constrain or destroy us. Vincent observed that under modern conditions artists were bound to be somewhat crazy; "perhaps some day everyone will have neurosis." Without irony he opposed to Bernard's painting of the *Garden of Gethsemane* his own picture of the garden of the hospital where he was confined. He would not turn to an inner world of fantasy that might console him, since he knew that for himself that surely meant madness. Towards the end he was drawn at times to religious fancies, but fought them off as unhealthy. The figure of the human Christ still attracted him. If he wrote of God as an artist whose one great creation, the world, was "a study that didn't come off," he revered Christ as the supreme artist, "more of an artist than all the others, disdaining marble and clay and color, working in the living flesh." But the few Christian themes that he painted while in the asylum were, without exception, copied from prints after other artists, and were significantly images of pathos, like the Good Samaritan and the Dead Christ. His sincerity, requiring always faithfulness to direct experience, kept him from inventing religious pictures. When inspired by the vision of the **Starry Night,** he put into his painting of the sky the exaltation of his desire for a mystical union and release, but no theology, no allegories of the divine. He had written to Theo some time before, after describing his plan to do difficult scenes from life: "That does not keep me from having a terrible need of—shall I say the word—of religion. Then I go out at night to paint the stars." There is, however, in the gigantic coiling nebula and in the strangely luminous crescent—an anomalous complex of moon and sun and earth shadow, locked in an eclipse—a possible unconscious reminiscence of the apocalyptic theme of the woman in pain of birth, girded with the sun and moon and crowned with the stars, whose newborn child is threatened by the dragon (Revelations 12, 1 ff.). What submerged feelings and memories underlie this work is hinted also by the church spire in the foreground, Northern in its steepness and acuity, a spire which in the earlier drawing is lost in the profusion of writhing vertical trees—the monotony of uncontrolled emotion—but is disengaged in the final work where a pictorial intelligence, in clarifying the form, strengthens also the expression of feeling.

This painting is the limit of Vincent's attempt to go beyond the overtness of everyday objects, and it is, interestingly enough, an experience of the Provençal night sky, an image of the actual place and moment of religious incitation to his lonely soul. Here, in contradiction of his

avowed principles and in spite of his fear of the vague, the mystical, and the passive surrender to God, he allows a freer rein to fantasy and hitherto repressed trends of feeling. Yet his vision remains anchored to the ground of the given, the common spatial world that he has lived with his own eyes. Thus even in this exceptional work of a spontaneous religious tendency we discern the tenaciousness of his objective spirit.

In the same way his effusive color symbolism—the "heartbreaking" malachite green or the deeper green which represents the "terrible passions of mankind" and the intense blue background which would evoke infinity in the portrait of an artist-friend whom he loves—all this concerns the qualities of particular visible objects and his feelings about them.

But his interest in symbolic coloring is already a shift in attitude. Together with it he resolves to paint less accurately, to forget perspective and to apply color in a more emphatic, emotional way. In this change which is legible in certain pictures and letters of the summer of 1888, I think we shall not be wrong in seeing a suggestion from the Paris milieu which Vincent had come to know the year before and with which he maintained his intimacy by correspondence all through 1888, especially with Gauguin and Bernard, the leaders of the new trend of Symbolism in painting. Vincent was a deeply receptive man, eager always for friendship and collaboration; while in Arles, far from his friends, he constantly stirred in his mind common projects which would reunite him with these Parisian friends. In the letter to Theo expressing his Symbolist ideas about color he attributes them to Delacroix; we can scarcely doubt that they are more recent and represent the viewpoint of the young *avant-garde* in Paris. If, in the following year, he criticizes Bernard severely for his religious paintings, Vincent in that same summer undertakes several himself, not so much to emulate Bernard and Gauguin—we have seen that his religious pictures are copies—but out of sympathy and brotherliness and a desire to share their problems. Yet these impulses toward religious themes are momentary and slight deflections. There is an inner growth in his art, so closely bound to his state of mind and the working out of his interior conflicts, so compulsive in its inventions, that he seems to originate Symbolism and Expressionism entirely from within, apart from all that is going on around him. Most likely he could not have formed his art without the spur of his Parisian experience and the contact with men whose congenial spiritual independence was joined to an attitude of artistic innovation, such as he had not suspected before he met them. He retained, however, to the end the fidelity to the world of objects and human beings that he had sworn at the beginning of his studies. The pictures of his last months, no matter how fantastic certain of their forms may appear, are among the most penetrating in their vision of things, their reality. His self-portrait, with the swirling, flamboyant lines of the background—one of the most advanced works of his time in the approach to an abstract Expressionism—is also a marvel of precise portraiture, with an uncanny liveness of the features. He had given his answer once and for all to Bernard in a letter of 1889, when most tormented by conflicting impulses: "Above all it's really a question of sinking onself anew in reality with no preconceived plan and none of the Parisian prejudices."

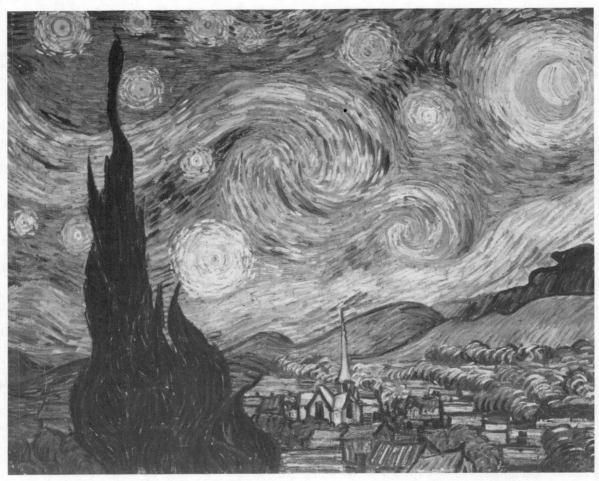

Van Gogh, Vincent. *The Starry Night.* (1889). Oil on Canvas, 29″ x 36¼″. Collection, The Museum of Modern Art, New York. Acquired through the Lillie P. Bliss Bequest.

When the self at the edge of destruction holds on to objects so persistently, its protective reaction permits us to see that the painter's attachment to things is not passive or photographic, nor due simply to his origin in a period of naturalistic art, but is a constructive function with deep emotional roots. When he comes as a foreigner to Arles, a strange town, he paints everything—day and night scenes, people, children, whole families, houses, cafés, streets, his own room, and the surrounding country—as if to enter completely into this new milieu, unlike an Impressionist, who in painting at a resort or country site gives us little sense of material things and people. Even van Gogh's choice of still-life objects, however trivial or incidental they may seem, is hardly indifferent; they constitute for him an intimate and necessary world. He needs objectivity, the most humble and obvious kind, as others need angels and God or pure forms; friendly faces, the unproblematic things he sees about him, the flowers and roads and fields, his shoes, his chair and hat and pipe, the utensils on his table, are his personal objects, which come forward and address him. Extensions of his being, they image the qualities and conditions necessary for his health of mind. We may quote here what he said in another context: "It sounds rather crude, but it is perfectly true: the feeling for the things themselves, for reality, is more important than the feeling for pictures; at least it is more fertile and vital."

We understand then why he called imaginative painting "abstraction," although it was still an imagery of living forms, and why, on the other hand, the *Crows over the Wheat Field* for all its abstractness of composition represents with a tormented veracity an experienced landscape. But it is also a moment of crisis in which contrary impulses away from reality assert themselves with a wild throb of feeling. There is in the picture of the *Crows* something of the mood of the *Starry Night.* In its dark pulsating sky the great motor-storm of brush work and the green round spots over the horizon are like the animated clouds and stars of the night painting. After we have seen in the latter its startling, transfigured sky and have felt the pantheistic rapture stirring the immense bluish space with an overpowering turbid emotion, we are prepared to recognize in the later work the traces of a similar yearning. The endless sky of the *Crows* appears to us then an image of totality, as if responding to an hysterical desire to be swallowed up and to lose the self in a vastness. In the abnormal format there is already a submersion of the will. The prevailing horizontal is a quality of the mood more than of the frame or canvas; it has the distinctness and intensity

of the blue and belongs to the deeper levels of the work. It is not required by a multiplicity of panoramic objects or a succession in breadth. In the common proportioning of pictures, approximating the golden section (0.618:1), the larger dimension has to contend with a strong subordinate, so that the relation of self and world, expressed in the contrast, is an opposition in which both elements are active and distinct. This is classical in spirit and corresponds to the accepted notion of the harmonious and normal in our own society. In van Gogh's spontaneous, unconventional format, the horizontal governs the space as an enormous dominant beside which the perpendicular hardly comes into being and is without an echo in the composition. (A similar one-sidedness, but ruled by the vertical, occurs in the *Cypress Trees* with moon and star, like two suns, an obsessive image of uncontainable excitement.) In his earlier landscapes the convergent lines in depth, intensifying the motion inward, gave a certain energy to the perspective flight; here the endless depth has been transposed into a sheer extension that exceeds the individual's glance and finally absorbs him. (pp. 87-99)

> Meyer Schapiro, "On a Painting of van Gogh," in his Modern Art: 19th & 20th Centuries, 1978. Reprint by George Braziller, 1982, pp. 87-99.

Horace Shipp (essay date 1948)

[*In the following excerpt, Shipp discusses van Gogh's drawings.*]

Any artist's drawings tend to be a thinking aloud as it were, and in the case of van Gogh, the most personal and extrovert of all artists, they add enormously to our knowledge of his aims. Those aims with van Gogh are of two kinds. On the one hand there is a baffling element of mysticism, a search for some reality—dare we call it God?—which would unite man and nature as aspects of one creation. On the other stands the search for a satisfying technical means of expression; a search which led him to the older generation of the Dutch painters of his time, to Millet, to Delacroix, to the Impressionists, to the Japanese, and even to the popular journalistic engravers of the illustrated papers.

Out of this eclecticism, pursued with the wonderful humility of a man willing to learn of any so only that he could find a language in which to deliver his message, came his own highly individual style. It came from his spiritual integrity, from a flame that burned within him so fiercely, so concentratedly, that it fused all elements into one glowing mass, and ultimately destroyed the crucible of his tormented body. One of the world's greatest individualists he was nevertheless unselfconscious and profoundly humble. "To die to oneself," that phrase he culled from Renan which so deeply influenced his life, was an aesthetic as well as a spiritual creed, and in his art as well as in his spirit he had the satisfaction which all mystics know of immensely enriching his life by losing it.

One of the most interesting facts about van Gogh is that he never did what he set out to do. His first impulse in art was towards humanity. "I want to paint humanity, humanity, and again humanity," he cries. He never truly succeeded. If anything he succeeded less and less as he went

on. Trees and flowers, the wonder of growing corn, the sun in the sky, the chair in his room, all these yielded their secrets more and more; humanity receded.

He begins his drawings entirely with people. They are invested with a fierce passion of pity. Van Gogh loved mankind and he took up his pencil and chalk in an attempt to express that love. His early tentative and naïve drawing of miners going to work need only detain us as an indication of the direction he was taking. "I feel the need of studying the drawing of figures from masters like Millet, Breton, Brion or Broughton or others." That was in 1880; but little more than a year afterwards he is drawing the *Peasant with a Sickle* and the growth of his power of draughtsmanship is remarkable. There is the promise of mastery in the way the stresses of the body in action are indicated, the pressure of the feet on the earth, the strain and swing of the arms.

Throughout all this early Dutch period it is this human side which holds him. Everything he draws is invested with that poetry of pity. The old, the sad, the downtrodden, the lonely: these are his subjects. The emotional quality is so great that we are in danger of forgetting his achievement in technique. In those years he made the drawings *At Eternity's Gate:* an old man seated with bowed head, his clenched hands pressed against his hidden eyes. In the last year of his life he made a painting from this eight-year-old drawing, but it remains a picture; there is no conviction save of the beauty of painting. "How beautiful is such an old workman, with his patched fustian clothes and his bald head," he had written when he made the drawings. That passion by the time he is making the ultimate painting has moved to the living phenomenon of cypress trees. "The cypresses are always occupying my thoughts."

So the drawings of that later period are almost all of trees, of plants, of the park, of the hospital, with no figures or figures of such small scale that they are only a part of the design. The life he had once sought in the stance of peasants at their work, of a woman washing her earthenware, of old men and women in the almshouse, or the potato-eaters at their meal, is now found in the surge upwards and outwards of branches and foliage, the radiation of growth. By this later time van Gogh has not only been driven by his own inner urges to take up new subjects but by his search for a method to express them in his own highly individual technique. The black and sepia chalk drawing with the high lights brought out in white chalk has given place to the reed pen. With thousands of short, swift lines the ever-changing directions of the growth are expressed so that the volumes emerge. Sometimes he makes these lines with curves and there are occasions (as in the *Cottage and Cypresses*) when they lose strength and become slightly sentimental. At their best, however, they are worked into a synthesis of form as the broken colour touches of the Impressionists were, and they convey the form and the inward life of the plant with a vibrancy, a sensitive vitality which more solid methods would inevitably lose.

Before he arrived at that ultimate method, however, van Gogh had travelled far. From 1883 until 1885 he still was primarily concerned with the human. These people and the earth are one. As he writes of the *Potato-Eaters:* "These people have dug the earth with those very hands

they put in the dish." His studies for this, his most ambitious work of the whole Dutch period, and his other drawings of the peasantry made at this time are all in black chalk. Bold and strong they are impressive in their feeling of *terre-à-terre,* but in sheer draughtsmanship van Gogh seems never to achieve truth to proportion in the human figure. The element of caricature in the coarse faces, the gnarled hands, the ungainly poses, gave him the quality of reality which he sought, however, a more important thing to him than the orthodox methods of foreshortening and anatomy.

In the third period, in Paris, denied the peasant type which interested him, he turns to buildings, to street impressions, and to flowers. Except the flowers, all this was not for him. His careful studies of the city are surprisingly realistic and, for him, tame. Pen and coloured chalks on slightly tinted paper, bare trees daintily etched against the calm skies: everything confesses the new Japanese influence which ever after is in his work. How often does he throw the single bare branch of a tree right across his drawing in the Japanese manner; how often have recourse to the weeping ash or other such trees beloved by the Japanese.

When van Gogh left Paris and went south nature completely triumphed. True there are portraits of his little circle there, but one feels that his passion for the sun and the trees, the corn and the wide landscape has all his heart. Only the project for *The Sower* reminds us of the old days when he drew "humanity."

Pen or reed pen and Indian ink seem now to be his favourite medium for the drawings, and that method of short vibrating lines, of stipple, and broken crescent shapes to convey both tone and form. In this period he manages to make even the black and white drawings strangely lush. The paintings are sometimes almost too emotional, but the drawings reveal that van Gogh is intellectual as well as inspired. The drawing for *Cornfield and Cypress* shows that in a medium of ink and lead pencil van Gogh could record exactly what he wanted for his ultimate picture. How brilliantly he puts in those growth lines which obsessed him, the differing textures of rock and waving corn, of cloud and hill! In face of such drawings it is difficult to remember that this was accomplished only four years after van Gogh had left Holland.

Let it be granted that in face of the eternal values of great art it should not concern us that the artist practised for so short or so long a time, but that it is the result alone which has significance. Even on that showing we need make no apology for the absolute achievement of van Gogh at his best.

Horace Shipp, "The Drawings of Van Gogh," in Apollo, *Vol. XLVII, January, 1948, p. 4.*

Lionello Venturi (essay date 1950)

[*In the following excerpt, Venturi traces the development of van Gogh's mature style, focusing on his break with Impressionism and his expressionistic use of color.*]

[In September of 1888, van Gogh wrote from Arles], "I am beginning to feel completely different from what I was when I came here; I no longer have doubts, I no longer hesitate to attack a problem, and these feelings may well

increase." His feelings of certainty are a reaction against the world of impressionism and divisionism, which he found too complex: he was seeking a more direct form of expression.

> The fact is simply that I find that what I learned in Paris is disappearing, and that I am returning to my ideas which had come to me in the country, before I met the impressionists. And I should not be at all surprised if before long the impressionists found something to criticize in my way of painting, which has been fertilized by Delacroix's ideas rather than theirs. For instead of trying to render exactly what I have before my eyes, I make use of colour more arbitrarily in order to express myself strongly. Well, let's leave theory alone, but I am going to give you an example of what I mean. I should like to paint the portrait of an artist friend, who dreams great dreams, who works as the nightingale sings, because that is his nature. This man will be blond. I should like to put into the picture my appreciation, the love I have for him. I shall paint him, therefore, just as he is, as faithfully as I can—to begin with. But the picture will not be finished then. To finish it, I shall proceed to be an arbitrary colourist. I shall exaggerate the blondness of his hair, even using orange tones, chromes, pale lemon. Behind his head, instead of painting the banal wall of the shabby room, I shall paint infinity; I shall paint a simple background of the richest, most intense blue that I can possibly mix; and by means of this simple combination, the blond head illuminated against the rich blue background, I will obtain an effect as mysterious as a star in the deep azure of the sky.

The entire program of van Gogh's mature style could not be better expounded: the adherence to reality which was innate in the programs of the impressionists (though not in their works) was abolished, and for it was substituted an ideal that transforms the portrait of a man between four walls into a star in the sky. And this transformation was to be accomplished exclusively by means of the language of colours. Pissarro had opened the way for van Gogh: "What Pissarro says is true: we should exaggerate the effects which colours produce by their harmonies or dissonances." But into this abstract program van Gogh injected a new way of feeling, a new need to become simple and popular: "I am beginning more and more to look for a simple technique, which perhaps is not impressionist. I should like to paint in such a way that, were it necessary, anyone with two eyes could understand."

Revelation of spirit by means of colour: that was van Gogh's dream. He concentrated on

> the study of colour. I am always hoping to find something in that. To express the love of two lovers by a marriage of two complementary colours, their blending and clashing, the mysterious vibrations of combined tones. To express the thoughtfulness of a brow by the radiance of a light tone on a dark background. To express hope by means of a star. The ardour of a human being by means of a ray of the setting sun. This is certainly not a realist *trompe-l'oeil,* but is it not something that really exists? I should like to paint men or women with an indefinable eternal something about them; the halo used to be the symbol of what I mean, and now we seek

it in radiance itself, in the vibrancy of our colouring.

<div align="right">(pp. 184-86)</div>

When [van Gogh] painted *The Flowering Tree,* April, 1888, he was still using an impressionist brush stroke, but already his colours were his own. He has discovered the joy of tender and pure colour; the pink of the peach-blossoms against the blue and white of the sky, the lilac of the earth against the orange of the fence are marvels. It is a tribute to the memory of his master Mauve, which he expressed at the same time in joyful lines:

> Do not think the dead are dead.
> As long as there are living men
> The dead will live, the dead will live.

His gradual separation from impressionism, together with a curious discovery of a Japanese motif in Provence, can be seen in *The Drawbridge,* May, 1888. Broken tones become increasingly rare: the blue of the water is dominant against the yellow and green of the earth, and the dark blue of the cypresses is dominant against the light blue of the sky. These tones are made effective by means of delicate gradations which detract not at all from the splendour of the colours.

Van Gogh's most popular picture is unquestionably the *Sunflowers,* August, 1888. He painted several versions of this to decorate his room at Arles, "with the gusto of a Marseillais eating bouillabaisse." "I am thinking of decorating my studio with half a dozen pictures of Sunflowers, a decoration in which raw or broken chromes will burst out against various backgrounds of blue, from the palest Veronese to royal blue, framed in narrow strips of lath painted in lead orange. Effects like the stained glass windows of Gothic churches." The success of these pictures is due to the relationships of the yellows, which go from lemon to orange, with the blues. And yet anyone can see that they are more than mere plays of colour. A human zeal makes itself felt, not in the sense of sentimental participation but in the artist's compelling drive to make himself objective. To create beauty the Greeks and the Italians of the Renaissance discovered proportions; van Gogh explodes the colours of the August sun of Arles. The way is different, but the goal is the same: creation of an object beautiful in itself, detached from its creator. Van Gogh's concentration in creation, his joy that is too profound to be gay, his vague presentiment that the sun which is beating on these flowers is driving him mad, his faith in this bit of nature, as though it were an idol—all these give the character of art to the beautiful object.

Vincent's House at Arles, September, 1888, is also a beautiful object, thanks to the relationship of the lemon yellows with the dark blue of the sky. But we sense that the time of mental torment is near: something menacing is unleashed by this beauty.

A month later, in October, 1888, he painted *Van Gogh's Bedroom at Arles,* of which he made a replica now in the Art Institute of Chicago. This, too, is one of his most famous pictures, and he speaks of it at length in his letters.

> This time, it is simply my bedroom; but here the colour must do the trick, and in giving a greater style to things by its simplification must be suggestive of rest or sleep in general. In short, the sight of the picture must rest the mind, or rather the imagination. The walls are pale purple. The floor is of red tiles. The bedstead and chairs are fresh butter yellow, the sheet and pillows very light lemon green. The blanket scarlet. The window green. The dressing-table orange, the wash-bowl blue. The doors lilac. And that is all—there is nothing in this room with its closed shutters. The sturdiness of the furniture must once again express complete rest. The portraits on the wall and a mirror and a hand-towel and a few clothes. The frame—since there are no whites in the picture—will be white. This is to take my revenge on the enforced rest which I have been obliged to take. I shall work at it all day tomorrow, but you see how simple the conception is. Shadows and cast shadows are eliminated; it is coloured in flat tints like Japanese prints.

This is a new type of still life—an interior which would be inanimate but for the participation of the artist. He reveals his intent—to express by means of simplified colour a state of calm and repose—and all the other notations serve only to make this intention precise. Unwittingly he lets slip the fact that the picture is indeed a *revenge* on rest: the revenge is more strongly expressed than the rest. Van Gogh was melancholy and discouraged at this time, clinging tenaciously to work as to an anchor of safety. He wished to represent sleep and could not. The tragedy of his mind was approaching, heralded by signs of derangement, and it allowed him neither rest nor sleep. Calm reigns in the abandoned room, but it is a calm without hope and without pity. It is an empty room and is so not by mere chance: it is abandoned forever, because of departure or death. The colours are brilliant and pure, without shadows, but they do not suggest joy—only sadness. It is a rest that is born of despair. The colours reveal the artist's state of mind without his knowing it. He is not aware of what he feels, either in his letter or in his picture, and thus his feeling, his heavy-hearted humility, is expressed spontaneously. And extending even beyond his feeling is his faith in pure colours, which give his expression a mediate, indirect quality, the quality of art.

At Arles van Gogh often complained that he had too few models to be able to satisfy his desire to paint figures. He often speculated concerning the relationship between his areas of pure colour and the formal limits necessary to the human image, and he was convinced that only the human figure could give his art greater profundity.

In August, 1888, he painted *Roulin the Letter Carrier.* The blue of the uniform on the light background and the form, which preserves a certain amount of light and shadow, realize an effect of tone and volume. The vivacious—indeed violent—image impresses the beholder with its reality and monumentality. In his letters van Gogh describes the character of his friend Roulin with verve and perspicacity, but in the picture he renounces any description of the physical or spiritual reality of his model and concerns himself only with the energy and presence of the image.

Roulin the Letter Carrier is a halting-place, perfect in itself, on the road to a style more completely detached from the painting of the past, more purely van Gogh's own.

The masterpiece which personifies this utter individuality is *The Woman of Arles,* November, 1888. The impressionists avoided black, but van Gogh takes the black of the dress and of the hair as his basis, to contrast it with the yellow of the background. A few reds (in a book and in

the chair), a few light or dark greens, a few pink greys accompany the principal motif. But when we say black or yellow we speak of tints; in van Gogh they are colours, not only because of their composition, but especially because of their form. It is indeed the form which acts upon the colours, making them sharper and more expressive. This is almost the first picture in which van Gogh discovers for a human image a form consisting entirely of impetuous strokes and accents, without relief, without gradations, simplified to the extreme. This is the only form that is suited to van Gogh's colour. And just as his colours are at the opposite extreme from impressionist colour, so his form is at the opposite extreme from that of Cézanne. This picture is on the plane of the popular image, but raised by genius to the level of sublime art. Anyone who wishes to be convinced of the "necessity" of this form has only to look at the various pictures of the same woman of Arles which van Gogh painted after a drawing by Gauguin: when the form necessary to his colour is lost, the colour itself fails. And yet he knew himself so little that when two friends admired his first **Woman of Arles** he attributed its merit to the model and not to his own painting.

At Saint-Rémy van Gogh was only intermittently lucid, but when he was able to paint, he did so with particular intensity, continuing to create masterpieces. His style changed from that of the Arles period not because he adopted new theoretical principles, but because his new eagerness for life and his sense of oncoming tragedy called for a new form, and his powerful fancy was equal to the demand made upon it.

If with the **Sunflowers** we compare the **Iris** of May, 1889, or the **White Roses** of May, 1890, we immediately see a new vibrancy in the line and a new reserve in the intensity of the colour. Drawing seems once again to take the upper hand. No longer, as in the **Bedroom,** is the task of expression confided to the colour alone.

In the **Iris** the relationship of the blue and green is magnificent, but it is no longer detached, isolated, imposed, as is the colour relationship in the **Sunflowers.** And the texture of the lines has a value in itself, quite independent of its representational value. If instead of flowers the subject happened to be a slab of rock, the linear texture would be very much the same.

If these lines be taken to represent the artist's torment, in the **White Roses** the torment is overcome, and there appears a certain serenity, even though joyless and pervaded with a tender tremulousness. The representation is more natural and more refined than in the **Sunflowers,** though at the same time less magical. The roses are now white, now pink white, now white with a few touches of red, outlined in blue and blue green on a background of green veined with pink. The nervous outline suggests an accent of light in the colour, and the mass of the motif, despite the white, has a darker tone than the light background.

It was in November, 1889, that Vincent wrote to Théo of his need to adhere to the reality which he saw, to avoid the fanciful quality in the art of Gauguin and Bernard, and he quoted as examples of his patient studies of the truth his paintings of olive groves and cypresses. **The Olive Grove,** which is autumnal, and the summery **Yellow Wheat and Cypresses** are two typical examples of van Gogh's new style.

Rocks (as we shall see) and olive trees are the natural motifs most suited to express van Gogh's tragic passion. With their serpentine lines the olive trees give a sense of the struggle which they have undergone to free themselves from the earth and push their branches toward the sky: they are like roots, penetrating the air with as much effort as they would make to penetrate the earth. There is no better mirror of van Gogh's spirit: he feels his own drama projected not only in the trees, but also in the earth. Everything throbs in an invocation to life, in a struggle against evil. And the style of this struggle is found in the strips of colour following one another like waves tormented by the wind, like accents which alone form entire words.

As soon as van Gogh can face a far-off horizon, he responds quickly to the beauty of nature, and then his tormented lines become calm, as in **Yellow Wheat and Cypresses.** Here the colour once again takes on the splendour of **The Crau,** and the composition is successfully organized, beginning at the cypresses and developing in distance, with the fiery yellow of the fields and the green of the shrubs against the light blue of the mountains and the lilac white of the sky. In the foreground the earth is burning, and the cypresses have the form of flames; in the distance is the desire for space and peace.

As in his olive trees, and to a greater extent than in his cypresses, van Gogh projects his torment in rocks, as in **The Ravine** (**Les Fontettes**), December, 1889, and **At the Edge of Les Alpines,** May, 1890.

Concerning **The Ravine** Vincent wrote to Emile Bernard, "I am working on a large canvas of a ravine . . . two extremely solid bases of rock, between which flows a thin stream of water, a third mountain closing the ravine. These motifs certainly have a beautiful melancholy about them, and besides it is amusing to work in very wild places where you have to bury your easel in the stones so that the wind doesn't blow everything down."

The romantic motif is furnished by the blue mass of the rocks against the green sky, but since the blue contains green touches and the green contains blue touches the effect of contrast is not as clear as in the Arles period. Furthermore the artistic value is in the form, the commalike form, which is not concerned so much with volumes as with vibrancy. The chromatic vibrancy of the impressionists is here fully transformed into a formal vibrancy. The distant rock is for van Gogh majestic and rigid, but the more the rocks are drawn forward to the foreground, the more tormented their life becomes, to the point of being awesome and demoniacal in the arching rock corroded by the torrent. Rarely has the violence of the struggle between the elements of mineral nature been felt with such passion. It is as though in this ravine the artist had had a Dante-esque vision of hell.

Moreover, despite van Gogh's urge to portray reality faithfully, his style acquired an ever clearer autonomy, as is shown in **At the Edge of Les Alpines.** A comparison with any one of Cézanne's paintings of rocky Provençal hills will show more clearly than words the unbridgeable gap between the two painters. Van Gogh does not paint the rocks, but his own torment, which he projects into a legendary upheaval of gigantic rocks as though he were witnessing the chaos that preceded the creation of the world.

In *Starry Night,* June, 1889, his contemplation of the night sky is a vision of the moon, of the stars, of fanciful comets, as though the sky, transmuted by his yellows and blues, were becoming an explosion of lights, bringing panic fear to human beings in touch with the mystery of nature.

Even in a portrait, the *Portrait of Dr. Gachet,* painted in June, 1890, one month before his suicide, he employs the style in undulating strips, which had had its beginning at Saint-Rémy. His interest in the formal motif distracts van Gogh's attention from colour contrast: both the coat and the background are blue green, and only the neutral and orange tones of the face detach themselves from the rest in order to suggest, in the calligraphy of the style, a sudden, magic apparition. Van Gogh himself understood the tragic quality of this image: for him it was the expression of the conditions of his epoch. It is evident that this picture was painted by a sick man. But the sick man achieves such intensity of expression that by any standards his work is art.

It is not easy to evaluate van Gogh's art objectively in the midst of the beautiful French taste of the period, so full of the restraint, the balance, the refinement that he did not possess. Still, no one who looks at *The Crau* or *The Woman of Arles* can deny that the artist has created a colour harmony of a type previously unknown, and that with a power of expression all his own he has found in this harmony a new quality of the image *per se,* the quality of an image to be worshipped. Further, in *The Olive Grove* and in *The Ravine* he has created a new form, filled with commalike shapes, devoid of volume but capable of infusing into the images his aspirations to freedom from tradition and from evil, in order that he may attain a more synthetic and immediate mode of artistic expression.

These are great things, and however his work may shock our habits of feeling and thinking, we cannot but admire it as that of a human conscience burning with desire for goodness, for beauty, for freedom of fancy. Out of his mistakes and his sufferings, out of the sacrifice of his life, van Gogh succeeded in creating a few pictures of absolute perfection, sufficient in themselves to ensure his glory. And we must not forget how seminal his work has been in encouraging other artists to dare everything in the world of colour and in the expressive intensification of synthetic form. Over and above his art, he left a message that was acclaimed by the fauvists and the expressionists, and which sixty years after his death is still alive in the art of the world. (pp. 189-99)

Lionello Venturi, "Vincent van Gogh," in his Impressionists and Symbolists, *translated by Francis Steegmuller, Charles Scribner's Sons, 1950, pp. 177-99.*

Fritz Novotny (essay date 1953)

[*Novotny was a noted Austrian art historian and the author of numerous studies of nineteenth- and twentieth-century art. In the following excerpt, he explains the wide appeal of van Gogh's work.*]

Whether or not the popularity of van Gogh is of a special kind represents a valuable subject of study insofar as it also allows for a better understanding of the art and of the personality of the painter. . . . It is an indisputable fact that the magnitude of the popularity of van Gogh knows no parallel, at least if one uses as a measuring rod the number of reproductions which have been made of his works. From the work of no other master have so many facsimiles been made, especially so many in color. In addition, exhibitions of van Gogh's works in recent years have consistently drawn record numbers of visitors. . . . In short, it is the work of this "modern" painter, one of the founders of modern art, which stands at the forefront of popularity rather than that of some Realist or of a Victorian Romantic, whose folksiness is in need of no explanation.

Does this all point to a genuine enthusiasm, a real understanding of the essential character of the art of van Gogh? In a lecture given over the BBC radio on the occasion of the major London van Gogh exhibition of 1947 (incidentally, bearing the same title as the present article), Mr. E. F. E. Schoen answered this question in the negative. He found "that an extensive and uncritical attraction to the art of van Gogh exists and that sentimental factors, which have nothing to do with the pure aesthetic enjoyment of great art, are mixed in with this attraction." Such sentimental factors derive from a knowledge of the dramatic life story of van Gogh, from a "curiosity about his abnormalities," and from an admiration for the moral qualities which played such an important role in the creation of his art. Certainly, such motives as these exist, although they are as little able to preclude an understanding of genuine artistic merit as they are able, possibly, to deepen such understanding. But are these factors of great importance?

Most questionable, as with all generalities, is [Schoen's] lumping of all the various manners of appreciating the art of van Gogh into one category, and the concept of "popularity" is itself ambiguous enough. Nonetheless, in this case one can exclude at least one kind of popularity, since the role of fashion or educational prejudice surely has been minimal in building the fame of van Gogh. The many prints of the *Sistine Madonna* [by Raphael] in the homes of earlier generations and the many color reproductions of the *Sunflowers* by van Gogh in the homes of today do not belong in the same category. The popularity of the old masters constitutes a pseudopopularity; in general it represents merely the vacant popularity of a name, a result of general education, and only rarely is a true fascination for the actual work of art imbedded therein. This is the false popularity of great art, which is closely related to the true popularity of phony art, the sentimental kitsch of much genre painting. With van Gogh, however, we have a quite extraordinary phenomenon—great art here becomes popular in the true sense.

Should the subject themes, which is to say, the moving quality or significance of the subjects rather than the character of the artistic form and manner of expression, constitute the determining factor in this popularity, then the dark pictures of the Dutch period—the farmers and weavers, scenes like the *Potato Eaters,* and, in addition, the many later paintings after Millet, Rembrandt, Delacroix, and Daumier—would have to be the ones best loved. This, however, is not the case. In general awareness, van Gogh is much more the painter of the sunflowers and the chairs with straw caning, the landscapes of Provence, and the many monumental portraits of everyday people.

Moreover, even the dramatic and gripping life story of van

Gogh plays a less than crucial role in reference to the effect of his work. For, despite many more or less "popularized" accounts, the biographical facts are far from being known to all the people who nonetheless are moved in one way or another by his art. It is to be asked, in reference to the argument of Schoen, whether such knowledge as this would not, in fact, be rather desirable in terms of the understanding of the work, first, because of the variable degrees of truth and value which are contained in such biographical descriptions and, second, for the deeper reason that the problematic relationship between the life and the work might become better appreciated.

In reference to the first question, the very agitated and eventful life of this artist is not easy to describe, if one does not content oneself exclusively with sensationalism. It is also understandable that the life drama of van Gogh, the special character of his tragedy, invariably leads to description in the form of superlatives and psychological exegeses. What is, in fact, this special character? Apparently everything which happened in his life. Thus van Gogh has become for posterity a suffering and heroic figure, comprising a legend in which reality has been transformed earlier in time than is the usual case. Since his life was indeed filled with suffering, this is cause enough to describe as heroic the many forms of demanding exertion with which such a life and such an outpouring of work were sustained. However, it is nevertheless incorrect to view in isolation the sufferings of a solitary individual, who at the time—before he finally became an artist—suffered more on behalf of others than on behalf of himself. This comprises discrimination against the others. In this context one should not abstain from the sobering consideration that ultimately he could view such sufferings as the price which had to be paid for the achievement of something very grand, for his art. For what purpose, however, suffer the nameless? The special character of van Gogh rests much more on what he accomplished than on what he suffered. . . . The ruling principles of this activity, which operated throughout the periods of seeking which preceded his periods as an artist, but which also lasted for a considerable duration into the latter periods as well, were characterized by great simplicity. In van Gogh's spirit and in his humanity there existed a powerful simplicity, of which, of course, much in his art speaks, but which, however, was not embodied in similar measure in his painting. There were limits both for his life and for his art. His sickness and his temperament created such limits, so that in the realm of personality, too, not everything was so simple. Yet, an abnormal power of will was able time and again to bind together in unity all forms of personal obstinacy and disparity. But, in reference to art, simplicity is not a question of will, since such a quality can never be forced. Art does not enjoy this privilege, at least it is not given to a painter in his own time. Clearly, van Gogh wished that his art would embody the greatest possible degree of simplicity; [yet,] this dream of innocence was impossible even for van Gogh to realize in his work. All his strivings on its behalf and the many transformations through which his manner of representation passed make up one of the fundamental themes, one of the most important messages, in his letters.

It is quite another matter when we come to the mysterious powers which were at work during the later phases of his career, beginning with the conclusion of the Paris period.

For van Gogh it was a burning question as to how much of the human side of the farmer and worker representations from the Brabant period could be subsumed in his new sense of form. Could sympathy be expressed in painting, if it were not, as formerly—most profoundly and magnificently, in the conception of the **Potato Eaters**—actually expressed as part of the thematic content?

In fact, recognizable pictorial themes of that type disappear almost completely from his later works, [except rarely as, for example, in] the long series of paintings after works by Millet. . . . Yet, here too, . . . the individual element in the forms of van Gogh is so emphatic that the latter works no longer comprise merely imitations of the model which was used. Whether or not we wish to characterize these new personal forms of van Gogh as more powerful, harder, and less sentimental, it is unquestionable that in such paintings, and, in general, in all his painting following the Paris years, if these are judged retrospectively in terms of the earlier manner of representation, the thematic idea has now become more complicated and filled with greater tension. In the painting of the **Potato Eaters,** for example, the dull, dark colours—the "greenish soap" color of that period—and the hard, "proletarian" character of the drawing detail determined the pictorial language. Since there also is a similar consistency of form and content in the paintings of the mature periods—and that this is so needs no special emphasis—a decisive change consequently must have occurred in the content and in the pictorial language. For, the formal language has been radically altered in one cardinal respect—the color. Among all the characteristics of Vincent's painting, it is the color which has the greatest effect upon the greatest number of people. The streaming, unmixed colors (which were scarcely to be exceeded even by the extremely strident colorism of the following generation) clearly represent the most striking of the formal means which have made his paintings so popular. This fact is not to be wondered at particularly, and it concerns a relatively external effect. In itself, this usage could provoke either fascination or fright (as indeed it did at first). It is true, in any case, that the violent power of his colors, which to such a high degree is foreign to natural appearance, even as are the excessive forms in his drawings, is not consciously noticed to any particular degree by many viewers. These same people would withhold their approval from similarly strong deformations and violence in the drawing and color if found in works by other masters. As great as are the grip and the magnetic power of these formal devices of van Gogh, they nonetheless almost without exception remain means of representing individual objects. The viewer feels himself conducted towards such details, he is constantly beset by a kind of binding power which draws his visual attention and his feeling towards some kind of living center in the separate objects, whether they be living beings or only plain inanimate objects. It is understandable that attempts to describe the magical power of van Gogh's painting so frequently have sought cover in the formula, "he has expressed the heart, the essential character of things." One can give to this rather harmless superlative a more precise meaning, moreover, if one attempts to clarify in what respect van Gogh's manner of representing the "essential nature of things" is to be differentiated from similarly deep characterizations of particularized objects by other artists. The unique concentration upon individual objects in van Gogh's pictorial world draws its power from a tension, an

opposition in his manner of representation to pictorial usages that are directed to mutually antagonistic goals. In the manner of representation used by van Gogh, appearances become an illustration of the "elements," of that which is found in nature, but in which individual objects are brought into a determined order. The streams of movement, which in his paintings encompass all individual, living and dead objects, are, rationally understood, directly opposed to the particularization of appearances, and logically irreconcilable with this principle. However, artistically they signify something which can be looked at in various ways. For example, in terms of historical developments, this pantheistic intoxication with color and movement was the aspect of van Gogh's painting by which he plunged furthest into the new perceptual world of Post-Impressionist art. It is in this aspect that his role in the creation of this new perceptual world most clearly can be seen. In terms of the narrower confines of his personality, the peculiarity of the passionate quality in his temperament constituted a lasting source of agitation. Finally, it appears (to repeat an earlier point) that a primary cause of the frequently shocking and constricting forcefulness with which he depicted individual objects—the human figures, a chair, every tree, and the various objects in a still life representation—resides in the fact that the painter wished to defend his representations against hyper-individual sensations, to the illustration of which he was otherwise susceptible. This aspect remains puzzling and in need of explanation to most viewers, and it is indeed puzzling to the point of seeming demonic. An enchanting and exciting aspect of determinateness which contrasts with the frequently threatening lack of determinateness just discussed is offered to the viewer by the immediacy with which images of particular things are depicted.

To the recognition of such tensions as these in the mature art of van Gogh a knowledge of the facts and the demonstrable traits of his personality makes little contribution. Repeated attempts have been made to discover a relationship between that which remains veiled forever, his life, and that which remains forever on display, his work. Insight into such relationships has not made a very great contribution to the popularity of van Gogh. The factors which do play a decisive role are, in fact, not peripheral, but central to the actual artistic process. What is singular in the popularity of van Gogh and is directly related to what is singular in the art of van Gogh is contained in the following observation: the viewing of works of van Gogh invariably leads one back, and in a very particular way, to the reality of the represented objects. Naturally, this is true in principle for any art which is more or less based upon a conscious realism. Every form of painting which takes as its point of departure the experiencing of reality must afterwards retain a certain measure of this reality. It is, to be sure, this measure of reality which makes a difference here, since it declines progressively as one accommodates oneself to plastic representation in terms of stylized forms. Should one already be very familiar with the characteristic flat countrysides and woodlands in the landscapes of Ruisdael, then one is inclined, while looking at genuine flat country landscapes, whether Dutch or not, and at real forests, to seek and find something "Ruisdael-like." There are art lovers who forbid themselves such habits, because they believe that this leads to blindness towards the specifically artistic element, which is precisely that which distinguishes a painting by Ruisdael from natu-

ral appearance and which is called, as a collective designation, "stylization." The danger of bypassing this essential experience is in fact less, if one experiences a landscape painting by such a painter—and this is valid for the Baroque period as well, despite its realism—only in terms of these characteristic forms, rather than [approaching it] as if one were reexperiencing an actually viewed natural reality. This holds true in even greater degree if one reexperiences, let us say, a landscape by Cézanne in this manner while viewing nature. Such an experience obviously is more appropriate, if one pays attention only to the element of pictorial structure, since paintings like those of Cézanne allow for a better idea of the structure of things than do objects from the real world. In general one can say that a manner of observation which is, above all else, attendant upon an experience of form should not preclude a certain degree of reexperiencing of reality. The painting of van Gogh assumes a special position in this context. One might imagine that the aggressive power of his forms, his colors, and his linear structures, ought also to be experienced essentially as illustrations of structural considerations, as is the case in the painting of Cézanne. In the instance of van Gogh, however, one experiences only the single aspect, that previously mentioned anti-individual tendency in his art. In actuality, it is the separate objects in his paintings which have a stronger fascination for most viewers. And this is, in fact, the appropriate manner of experiencing these paintings. One can say that one has not really experienced the art of van Gogh, if one, upon having, from time to time, experienced in reality a railway underpass, a flat stretch of land, a piece of deserted street, or a factory on the outskirts of the city, and then having seen the same objects in paintings by van Gogh, does not experience the real objects more deeply. That which in all other contexts may be considered peripheral and which does not contribute to the experiencing of "pure art" in the strictest sense, here with van Gogh relates directly to what is most essential in the artistic experience. In this characteristic aspect, a small part of his utopian vision of art for the people in some marvelous way has been fulfilled. Whereas one is normally inclined on the whole towards skepticism in respect to hopes of seeing an extensive appreciation of art, it must nonetheless be recognized that in the case of van Gogh such an extreme unlikelihood has occurred. His art has had a profoundly penetrating effect, and, although by no means containing only easily understood characteristics, it has proven approachable for an astonishingly great number of people. It has led them as has the work of no other single painter, to a deeper experiencing of nature. Often this consists in no more than that one, for example, while viewing the terrace of a café in the evening, is reminded of van Gogh's painting of such a café seen under a starry sky, because suddenly everything which belongs to the essential character of the scene seems to have been expressed in this painting. A further step leads to this reflection: how can it be that so much of the character of the subject can be concentrated in a painting which leaves out so many of the actual details in nature and which simultaneously is so filled with the subjective personality of the painter? How does one explain that the many *staffage* figures in the landscapes of van Gogh (the promenading couples and the other people in the gardens and on the streets), despite the apparent haste with which they were sketched in, nonetheless give the impression of being irreplaceable individuals and, at the same time, help-

less and melancholy members of the masses, just as such strollers sometimes appear at specific moments on a Sunday street? And always there are new and far-reaching questions which occur to one. How can a painting such as this report so much about the reality of objects and yet also represent "pure painting" so clearly? The answer would involve a further description of the particular character of the realism of van Gogh. . . . What is the significance of the fact that not anything of the darker side of the grievous destiny of this painter is reflected in the paintings of his last years, during which time they continually become much more luminous and achieve an almost overpowering brightness?

Such questions and such reflections, which always lead back to the most essential and most purely artistic qualities of the work, are of concern, to be sure, to only a restricted circle of viewers, although even here the number is considerable. How justly has his own, highly confident prophecy been substantiated, now more than one hundred years after his birth: "Yes, here in my head, behind the walls of my brain, great things reside. I shall be able to give something to the world, which perhaps will keep people concerned for a century and which perhaps will require a century to think about." (pp. 114-20)

> Fritz Novotny, "The Popularity of van Gogh," translated by Bogomila Welsh-Ovcharov, in Van Gogh in Perspective, *edited by Bogomila Welsh-Ovcharov, Prentice-Hall, Inc., 1974, pp. 114-20.*

Van Gogh on *The Night Café:*

In my picture of the **Night Café** I have tried to express the idea that the café is a place where one can ruin oneself, run mad, or commit a crime. I have tried to express the terrible passions of humanity by means of red and green. The room is blood-red and dark yellow, with a green billiard table in the middle; there are four lemon-yellow lamps with a glow of orange and green. Everywhere there is a clash and contrast of the most alien reds and greens in the figures of little sleeping hooligans in the empty dreary room, in violet and blue. The white coat of the patron, on vigil in a corner, turns lemon-yellow, or pale luminous green.

So I have tried to express, as it were, the powers of darkness in a low wine-shop, and all this in an atmosphere like a devil's furnace of pale sulphur— all under an appearance of Japanese gaiety. . . .

> Vincent van Gogh, in an excerpt from Dear Theo: The Autobiography of Vincent van Gogh, *edited by Irving Stone and Jean Stone, Doubleday & Company, Inc., 1937, p. 455.*

Herbert Read (essay date 1967)

[*A prominent English novelist, poet, and art historian, Read was best known as an outspoken champion of avant-garde art. Several convictions are central to his aesthetic stance, the foremost being his belief that art is a seminal force in human development and that a perfect society would be one in which work and art are united. Read presented his theories in numerous highly regarded studies, including* The Meaning of Art (*1931*), Education through Art (*1943*), Icon and Idea (*1958*), *and* The Forms of Things Unknown (*1960*). *In the following excerpt, he describes the nature of van Gogh's talents, stressing the relationship between the painter's alienation from society and the expressionistic qualities of his work.*]

[Van Gogh's] genius was the product of two factors—a trained sensibility and a sympathetic imagination. The one factor gave him at great pains the ability to give form to the feelings aroused by the other factor. His life was one long quest for a *style,* which Goethe was the first to define correctly as the quality in art which rests on the deepest foundations of cognition, on the inner essence of things. This inner essence of things was Vincent's life-long quest, and his final achievement.

By birth and tradition Vincent was a Northern artist. He himself was quite clear about his affinities—he was with his countrymen Hals and Rembrandt. Of Hals he said (in a letter to Bernard)—

> He painted portraits, and nothing, nothing else. Portraits of soldiers, gatherings of officers, portraits of magistrates assembled to debate the affairs of the Republic, portraits of matronly old ladies with pink or sallow skins, wearing white caps and dressed in black satin or wool, who discuss the budget of some orphanage or almshouse. He painted the portrait of many a good bourgeois surrounded by his family, husband, wife and children. He painted the drunken toper, the haggish old fish-wife in gay mood, the pretty gypsy tart, babies in their diapers, the dashing, self-indulgent nobleman with his moustache, top-boots and spurs. He painted himself, together with his wife, young, deeply in love, seated on a bench on a lawn after their wedding night. He painted vagabonds and laughing urchins, musicians too and a great fat cook.
>
> He did not know greater things than that, but it is certainly Dante's Paradise, or Michelangelo or Raphael, or even the Greeks. It's as beautiful as Zola, healthier as well as merrier, but as true to life, because his period was healthier and less dismal. . . .
>
> Hammer into your head this master Frans Hals, a painter of all kinds of portraits, the immortalizer of a whole vital and dazzling republic. Then hammer into your head the other no less great and universal master of portraiture from the Dutch Republic— Rembrandt Harmensz van Rijn, a broad-minded and very natural man, as healthy as Hals himself.

Such was van Gogh's own ideal—the depiction of humanity. But in a certain sense humanity failed him, for there was no unity in the civilization into which he had been born. His work therefore lacks the single-mindedness of a Hals or a Rembrandt—the limitation that is often the

condition of the highest genius. He was compelled to turn from the human scene with all its injustice to contemplate 'the too great calmness' of nature. But for this too he had beloved masters from the Dutch Republic—Vermeer and Ruysdael.

'The too great calmness of nature'—that phrase indicates the alienated nature of expressionism, and in this sense Vincent was an expressionist, the greatest of all expressionists. But alienation does not conflict with but rather gives passionate force to the aim of the artist, which is to impose a unity or order on the multiplicity and confusion of his feelings. Always in Vincent's work there is this drive to order, to formal unity, but it must be understood as an order distinct from the natural order. For the order assumed by the artist's perceptions and sensations need not necessarily be the order of nature. With Wilhelm Worringer we must distinguish between Nature and the Laws of Nature. Nature is the whole realm of existence and experience, and from our observation of this realm we may derive various hypotheses about the structure of reality. These hypotheses do not correspond to the total reality, to reality itself, which consists of spirit as well as of matter, and, indeed, of matter still beyond the reach of our knowledge. It is above all the spiritual aspects of reality that seek expression in art. Vincent in his letters was always making this same distinction: for example—'. . . *studies* done in the open air are different from pictures which are destined to come before the public. In my opinion, the latter result from the studies, yet they may, in fact must, differ a great deal from them. For in the picture the painter gives *a personal idea;* and in a study his aim is simply to analyse a bit of nature—either to get his idea or conception more correct, or to find a new idea . . . [my italics].

'I consider making studies like sowing, and making pictures like reaping.'

Or from another letter of this same year 1882:

> *I do not know myself* how I paint (it). I sit down with a white board before the spot that strikes me, I look at what is before my eyes, I say to myself, that white board must become something; I come back dissatisfied—I put it away, and when I have rested a little, I go and look at it with a kind of fear. Then I am still dissatisfied, because I still have that splendid scene too clearly in my mind to be satisfied with what I made of it. But I find in my work an echo of what struck me, after all. I see that nature has told me something, has spoken to me, and that I have put it down in shorthand. In my shorthand there may be words that cannot be deciphered, there may be mistakes or gaps; but there is something of what wood or beach or figure has told me in it, and it is not the tame or conventional language derived from a studied manner or a system rather than nature itself.

Such is the aim of the alienated artist: to reveal the secret of nature, to interpret the spirit of nature, and for this purpose to use a language that corresponds to the experienced reality and not to the conventions of language and scientific method. The result is the style we call expressionism.

Expressionism is not a betrayal of nature, least of all a denial of our human nature. Rather it is an attempt to humanize nature, and those who accuse the modern artist of 'dehumanizing art', or of failing to maintain a human measure or a human standard of values, are themselves denying what is most human in humanity, our capacity to transcend appearances, our ability to assert spiritual values in a world of fact. What is human in an artist is not his ability to depict humanity, nor even his ability to impose human values like restraint or dignity or nobility on the complexity of the visible universe: his duty, his simple duty, is, as Cézanne said, to be humble in the presence of nature, or, as Vincent said, to be fearful in the presence of nature. Then nature will speak through what is most natural in the artist, his sensations and feelings, his 'personal idea'.

From the point of view of an artist like Vincent, the spirit is transcendent: there exists in man a vital force, a transforming energy, that moulds every perception in the shape of a visionary or imaginative reality. Unless we concede to the imagination of the artist this 'shaping power', we can never for a moment understand the place of art in the history of mankind; we can never for a moment comprehend its variety and complexity, or its function in the evolution of human consciousness. (pp. 106-09)

> *Herbert Read, "Vincent van Gogh: A Study in Alienation," in his* Art and Alienation: The Role of the Artist in Society, *Horizon Press, 1967, pp. 94-109.*

Mark Roskill (essay date 1979)

[*Roskill is an English-born American art historian and the author of the study* Van Gogh, Gauguin, and the Impressionist Circle (*1970*), *in which he examines in detail developments in the Parisian art milieu during the last decades of the nineteenth century. In the following excerpt, he discusses the role of personal and universal symbols in the interpretation of van Gogh's work.*]

Vincent van Gogh was interested in communicating through the creation of images that are made suggestive by the associations that they carry and by their mode of visual presentation. In a letter to his brother, he wrote about the uses of color and imaginative elements in figure-paintings, and the moods they could convey:

> I want to paint men and women with that something of the eternal which the halo used to symbolize, and which we seek to convey by the actual radiance and vibration of our coloring. . . . I am always in the hope of being able to express the love of two lovers by a wedding of two complementary colors, their mingling and their opposition, the mysterious vibration of kindred tones. To express the thought of a brow by the radiance of a light tone against a somber background. To express hope by some star, the eagerness of a soul by a sunset radiance.

Van Gogh was also intensely involved with the responses that particular people, sights, and events engendered in him, as they bore on the creative process and its attendant sense of emotional identification. Indeed, he chose subjects to paint because they mirrored his own psychological and spiritual states. As he wrote in a slightly earlier letter concerning two key portraits of this time, those of the painter Eugène Boch ("the poet") and the postman Roulin:

> I should like to paint this portrait of an artist

friend, a man who dreams great dreams, who works as the nightingale sings, because it is his nature. . . . I want to put my appreciation, the love I have for him into the picture. . . . I do not know if I can paint the postman as I feel him.

This implied problem of the different kinds of "meaning" or significance that a work of art can have was one much discussed in Symbolist theory during the last years of van Gogh's life and through the early years of this century. It affected the intentions of contemporary Symbolist artists, such as Edvard Munch, and bequeathed itself as an issue to twentieth century artists in both the late Romantic and the Expressionist traditions. The problem is particularly present in those forms of art where the artist's own quality of feeling and perception are reflected or stamped directly on to the character and emotional timber of the visual images themselves.

In the context of the art of van Gogh this problem can be expressed as one of "public" and "private" meanings, and of the ways in which they may overlap.

"Public" meanings are those which, in the character of the images themselves and/or the way they are structured and presented, are posited as being accessible to the "unprivileged" viewer. "Private" meanings, in contrast, are those which a "privileged" viewer may be in a position to discern—that is, a viewer who has access to the work's meaning which is not normally available to others, or not available without special bases for familiarity or sources of insight.

Van Gogh was capable of spelling out the meaning, or *raison d'etre,* of a particular image in his paintings in a way that appears to rule out, or at least render more speculative, the attribution of other possible "meanings." A good example is provided by a third portrait from the fall of 1888, that of Lieutenant Milliet. The subject, who was a second lieutenant in the Zouave regiment, is shown in a frontal head-and-shoulders view, in military cap and uniform, against an emerald green background; on that background, at top right, are superimposed a yellow crescent moon and a five-pointed star within it. In a postscript to a letter, van Gogh specifies that he has depicted in the background "the arms of Milliet's regiment, the crescent and a five-point star." In other words, moon-and-star represent here identifying military insignia which have been imaginatively transferred from uniform to background; and any further suggestions as to what moon-and-star might denote would either have to seek to supplement or refine that essentially "public" meaning or, in interpreting the choice and placement of images in psychological or metaphysical terms, move into essentially hypothetical territory.

That van Gogh was himself aware of the underlying distinction between "public" and "private" meanings is shown by his response to the Symbolist critic and poet Albert Aurier on the subject of his paintings of *Sunflowers.* In a January 1890 article on van Gogh's art which placed much stress on symbolic and affective reasons for the choice of particular images, Aurier wrote:

> How would one explain. . . . his obsessive passion for the sun's disk. . . . and also for that other sun, that star of the plant world, the sumptuous sunflower, which he repeats without growing tired of

it, with a monomania. . . . how to explain it, if one refuses to admit his persistent concern with some vague and glorious sun-mythical allegory?

Van Gogh responded to the article both in a personal letter to Aurier and in parallel remarks to his brother:

> Suppose that the two pictures of *Sunflowers . . .* have certain qualities of color and that they also express an idea symbolizing "gratitude." Is this different from so many flower pieces, more skillfully painted and which are not yet sufficiently appreciated, such as ones by Father Quost? The magnificent bouquets of peonies which Jeannin produces so abundantly?

Van Gogh discounts in this passage the personal significance that the sunflowers had for him. They might indeed "symbolize gratitude" for him, as he also wrote to his sister—the sunflower had a popular religious connotation of gratitude for God's beneficence over the universe, and had been used iconographically in earlier art to denote both art and friendship—but that did not in itself differentiate them from late Romantic flower paintings, in the tradition to which he saw them belonging.

In putting "personal" symbolism to one side, and by designating, as he did in other passages in the letters, the dominant effects of color and mood that these canvasses were set up to impart, van Gogh wanted his *Sunflowers* to convey in that tradition the life and death of the blooms, their effulgence and withering, against a background of room wall "opened up" by means of color and texture to suggest the outdoors. The bases for a wider kind of response on the viewer's part lay, according to this stand, within the expressive character of the painting itself—in the feeling for the life-cycle of the plants that is dramatically conveyed, and in the suggestion of a transcendence (or supererogation) of mere worldly reality.

Thus the assignment of psychoanalytic implications and intimations to these paintings—as in the varying affirmations that the *Sunflowers* symbolize mother love, or the son taking possession of the maternal breast, or that they are soft and feathery like birds' nests—goes against the grain of van Gogh's own volition in the matter. In order to keep in tune with that volition, one has to designate this as "latent" or "unconscious" symbolism; and though there are proper avenues for the exploration of such "meanings," and though the presence of deep feeling and commitment on an artist's part may lead inevitably to their being hypothesized, this does not fall within the province of what van Gogh *qua* artist wanted to communicate. To use a term that he sometimes favored himself, they are not part of the language that his paintings "speak."

The critical problem that emerges is not a matter of ruling out "private" meanings in favor of "public" ones, but of estimating and interrelating the contributions made by both kinds of meanings.

There are cases in van Gogh's work where "personal meaning" is dominant in the total conception, endowing the work with a range of associations and implications that could hardly be gleaned independently from the painting itself. There are cases where personal meaning has directed the creative process, but has finally subordinated itself to other creative impulses, so that its presence

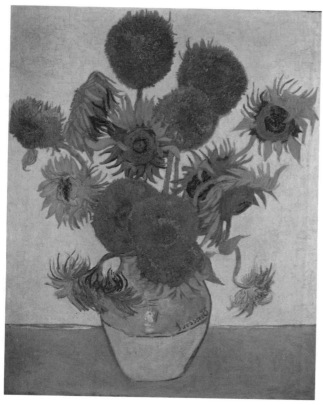

Sunflowers (1888). National Gallery, London.

lies in the background only. And finally there are cases where public and private meanings have completely interfused, so that awareness of the presence of particular personal elements and the associations attached to them only supports and ratifies what can be gained in principle from the visual make-up of the work itself.

An example of the first kind, showing obtrusive personal meaning, is provided by the ***Open Bible*** of October 1885, painted in the last month before van Gogh left Holland permanently. This still life is a commemorative reference to the death of the artist's father, the parson, some seven months earlier. The Bible in the center, a used and familiar object, is associated both with the dead man's ministry and, in this domestic setting, with his role as head of the family. To indicate departure from both of those roles, it is juxtaposed with an extinguished candle, which traditionally and popularly connotes death. Heavy and cold in its coloring—"broken white . . . bound in leather, against a black background," according to van Gogh—it lies with two pieces of dull metal, its clasp and part of its stand, that are again associated with everyday presence and use. Light falls on the Bible and the lettering on the right-hand page, clearly visible close up, shows it to be open at a passage from *Isaiah* (52: 13-15) which is about the "suffering servant" released from bondage. Also on the table below, contrasting in character and lightness with the Bible's bulk, is a yellow novel identifiable as Zola's *The Joy of Living*.

Given these details about the objects and their properties, the inclusion of the contrasting novel then becomes a sym-

bolic "marker" or token of van Gogh's sense of himself and where he stood at this time. In personal terms, it brings to symbolic expression the feelings of release that he had at the death of his father, especially release from the state of open warfare that had developed between him and his family, with whom he had been living at Nuenen. This correlates with the choice of Biblical text, and with the choice of novel title—which Zola had used ironically—as an index of van Gogh's desire for the future to enter into the moral viewpoint and quality of life-experience of the "new times" in which he lived.

The contrast between the two books in size and placement might then be taken as psychologically embodying the feelings of a son with a powerful father figure; and the Bible, by way of a stand-in for that missing father, might be seen as interposing itself, in a kind of clumsy overbearingness, between the stiff, cold candle and the more energized brushwork of the novel below. But neither that contrast, nor the nature of the lighting scheme, as it embraces all the objects brought together symbolically, goes beyond conventional expectations for a domestic still life of this kind. And though strong in the simplification of mass and planes in space, in terms of quality of coloring and attention to surface, the rendering of the Bible does *not* present itself as a painterly transition between candle and novel, or between dark background and light foreground. The visual character of the painting therefore places a clear constraint on interpreting it along lines suggested by van Gogh's personal history.

An example of the second kind, where "personal" meaning becomes of directive rather than of absolute importance as the creative process takes its course, is provided by the paintings and drawings that van Gogh did of his ***Bedroom at Arles.***

On completing the first version of this painting in October 1888, van Gogh wrote both to his brother and to Gauguin of how by dint of simplification, particularly in the coloring, he had aimed at an effect of simplicity that would express "absolute restfulness" and be suggestive of sleep in general.

It is hard to see how an unprivileged viewer could in any concrete sense (other than by a subjective and imaginative reading-in) find restfulness in its visual character, or feel responsively that it had such an effect. At this point in van Gogh's career, to refer to the harmonization of colors and the mood they impart as "restful" can only be (as in the violet-blue-lilac combination of tones here, and the contrasting red of the bedspread) a relative statement. The lines of the floor-tiling arrow themselves outward from the back wall towards the eye and, lower down, seem to rush or veer precipitately towards the bottom of the painting. The objects in the room all seem compressed inwards by the surrounding walls; they hang or tilt in different places and at different angles in relation to one another and to the space overall. Whatever the procedural reasons (some have been suggested) for these aspects of the painting's structure, the movement of the eye from object to object is jumpy rather than smooth.

In doing a little sketch, in his letter to Gauguin, to indicate what the finished painting was like, van Gogh did, however, move towards making the composition appear simpler and more stably organized in its general character. That

this was not simply a result of his use of the pen here, to give a quick indication of the key features in outline form, is shown by comparing this drawing with one he had similarly put into his letter to his brother; it had evidently been done before the painting was completed, since it differs from it in a number of details. Along with the curtailment of the composition at the top and bottom, which eliminates or drastically reduces the sense of outward and downward pull, the patterning of the floor has become much less varied and busy; the objects are shifted subtly in position and angle so that they fit with the room space in a more ordered and anchored fashion (especially the legs of the bed, which seem in the painting like animate legs made to "dig in," in order to hold back the shelving movement of the floor); and further changes of detail, in the positioning of clothes and hat behind the head of the bed, help to create more of a distinct space tied in between bed and back wall.

Almost a year later, in September 1889, after the original had been damaged, van Gogh made a second version of the same size, and also a smaller version for his mother and sister. There again—in what was specifically an act of replication and revision, rather than mere transcription— he made changes in the treatment of the floor and placement of some of the objects, and in the relationships of the furnishings to the space and to one another. These changes need not be described in detail, since their effect is of the same general order as already discussed. The colors are also made somewhat paler overall. But there is still another kind of change made, which is particularly interesting from the standpoint of van Gogh's aim of conveying restfulness. It concerns the paintings shown on the walls of the bedroom.

In the original version the two portraits to the right were those mentioned earlier of Milliet and of Boch ("the poet"), which actually hung in the bedroom at that time and are shown correspondingly in the heavy oak frames that van Gogh had specially ordered. In the later versions, by an imaginative touch associating itself with the motif of the two pillows side by side on the bed—as if for a man and woman together—the portraits become in each case one of van Gogh himself, and one of a woman who appears to be imaginary. The painting hanging behind the bed is, in the original version, most probably one by Emile Bernard sent to van Gogh earlier which showed a "yellow tree," regarded by van Gogh as a markedly "wild" motif. If so, the landscape which is substituted for it in the later versions is a notably more serene one, both in motif and in the rendering of its brushwork.

Here then, in these last transformations, both the personal view of country beds as giving an "appearance of solidity, durability and quiet" and the personal meanings that the portrait images must have had for van Gogh merge into the larger aim of achieving a distinct, apprehensible mood of restfulness, in the rendering as a whole.

From a critical standpoint the most interesting paintings, however, are those where there is no specific statement or pointer from van Gogh as to the meaning of a work.

Interpretation then has to proceed from the suggestive character of the images themselves and their combination together; what can be adduced from material in the letters (having to do, most especially, with early experiences or fundamental feelings of the artist) serves only as possible supporting evidence. Two paintings which qualify here, chosen because of their separation from each other in time, are the *Pair of Boots,* from around mid-point in van Gogh's ten-year career, and the *Road with Cypress and Evening Star,* from close to the end of his life.

The *Pair of Boots,* painted either in 1885 at the very end of his time in Holland or at the beginning of his stay in Paris the following year, is the earliest of four different treatments of paired boots or shoes which continue into 1887. In the absence of reference of any kind to this painting or choice of theme in the *Letters,* it is clear nevertheless that the very decision to paint worn boots in this fashion implies a particular tie of feeling, personal and associative, between the artist and the subject. The imprint upon their appearance, or missing presence, of the person who has worn these boots is implied both in the way in which the boots stand up as a pair on a barely specified surface, to expose differences of shape and protrusion between them, and in the revelation of the light that the artist has shown falling on them. Furthermore, the showing of the boots as worn, unlaced, and empty renders them like the boots of a miner or peasant which, in the traditional lore of such working people, are to be preserved like cult-objects— isolated, as here, from their original use and service—to record and commemorate, after death or cessation of labor, the specific activity and physical demands of the work which had engaged their owner.

Support for the premise that the painting of boots carried overtones in both of these ways is to be found in a story promulgated by Gauguin much later, as to why van Gogh chose to paint old shoes (probably not these, but a later version of the subject done at Arles in 1888 and seen there by Gauguin, in which the shoes are specifically the artist's own). According to the story, heard from van Gogh himself, he preserved his own old shoes, with a reverence that made them a fit subject for painting, beginning with the footwear that he had worn when he went to live and preach among the miners of the Borinage (in November 1878). After a mine explosion in which one of the miners was very badly burned, van Gogh took over his care when it seemed hopeless. When the man did recover and went back to work, what was physically visible as the hallmark of his suffering and endurance became transfigured for van Gogh, taking on (in the image of Christ's marks of suffering) a deeply spiritual import.

Thus the two different things that van Gogh does with the pictorial image of boots work to create an import that is, in principle, open and accessible to the viewer. He personalizes the traditional and spiritually charged act of preserving boots, in record of the working activity of their wearer. And he presents them in a way which gives them a special, physically characterized life of their own, as in the shape and curves of the leather, laces, and eyelets. The "private" associations become contributory factors, which they genetically are, within the "public" meaning that is visually established.

The *Road with Cypress and Evening Star* painted at Saint-Rémy in May 1890 is described in a letter to Gauguin in the second half of June 1890, but only in terms which enumerate the component elements of the imagery, as shown in an accompanying sketch:

a night sky with a moon without radiance, the slender crescent barely emerging from the opaque shadow cast by the earth. . . . one star with an exaggerated brilliance. . . . a road bordered with tall yellow canes, behind these the Basses Alpes, an old inn with yellow lighted windows, and a very tall cypress, very straight, very somber. On the road, a yellow cart with a white horse in harness, and two late wayfarers.

This passage begins by calling the painting a "last attempt [from Provence]," a statement which relates the work back to the "starry night" and cypress tree subjects done at Arles and Saint-Rémy at differing times during the previous two years. The individual images that van Gogh described are all, in fact, to be found in preceding paintings of those years. But this does not mean that their import here is necessarily the same as in their earlier appearances. They had become "basic" images for van Gogh, elements of a language developed to define and evoke the underlying character of Provence; and they are brought together here in a context that is imaginative and poetic in nature—as in the *Starry Night* and *Cypresses* (by themselves) of June 1889—rather than being descriptive of experience. That this is so is recognizable from the play with the shape and rhythm of individual elements (trees and house especially), the particular way in which the images coexist or hang together in a single sector of landscape, and the acid or artificial quality of the coloring.

The cypress was, according to comments bearing on its use as a key image, an emblem of surging upward growth, like the earlier *Sunflowers;* it possessed the imperturbability and serenity that van Gogh associated with Egyptian artists—a connection probably arrived at through the reading of Whitman's *The Lesson of a Tree*—and correspondingly had the beauty of line and proportion seen in an Egyptian obelisk: it memorialized the work of Monticelli in painting the landscape of Provence, in a continuation of that endeavor of which this was the core. To call it "phallic," or more broadly, sexual, therefore seems irresponsive to the multiplicity and richness of van Gogh's associations here; and to designate it as a "funeral flame" is simply to give it a popular symbolic connotation of which van Gogh was well aware. Road, inn, travellers on the road, and sky with a single star in it represent recurring elements in a language of pilgrimage on this earth and divine carefulness for humanity that van Gogh had used as texts and meditations in his earliest letters, drawing especially on Christina Rossetti's poem "Up-hill"; and the inn is like his pictorial renderings of the low-slung cottage-homes of peasants. Crescent moon and evening star, mountains and corn recur equally in other pictorial representations, as linked elements of the natural landscape which affirm in recollective and imaginative experience the presence of an ulterior, spiritual design in the fabric of things. As to the horse and cart, in motion as in other paintings and with a couple in it, this carried one of the deepest associations of all, going back to the childhood in which van Gogh remembered his parents driving off down the road in a similar carriage when they left him at boarding school.

But the painting has elaborations and touches in it that work in a larger metaphorical sense. The cypress, with its tufted edges and increasingly swirling shapes making the transition explicit, serves as a direct link between the realms of earth and sky. Star and moon, light irradiating and light eclipsed, are counterpointed either side of its crest, caught up in a movement that seems to come from beyond their patterning of strokes and through. The travellers, returning from work as implied by their costume and spade over one shoulder, are paired together like the twin trunks of the tree; the road in its rhythms and curves appears like a river in course. An evocation of the flow and passage of life emerges more comprehensively in the appearance of distinct episodes in space and time, grafted together—ones chosen so that they body forth oppositions which include departure and home-coming, expansion and contraction, the plenitude of harvest and the bareness of mountains, flux and stability, excitation and quiet. In this evocational scheme, governing all of the associations, the "private" and the "public" are completely merged.

The separation of "private" and "public" meanings, insofar as it can and needs to be made, is a constraint upon interpretation and critical understanding in any period in the history of art, as well as in the individual cases of particular artists about whom enough is known to make the distinction feasible.

In the modern period, as distinguished from earlier ones, greater prominence and emphasis are given to artistic intentions. A word should therefore be added about intentions—both personal and psychological and also (since these are often brought in) unconscious—as they bear on the attribution of meaning to a particular work of art, seen and taken as a whole.

"Personal" meaning of a symbolic order can be attributed to a work on the basis of what the artist said it meant to him or her, in a particular context of pronouncement or as gathered from other evidential contexts; what part is played psychologically, in creative and personal development; and what kinds of unconscious roles it may be said to have fulfilled. But however revealing or suggestive about the work and its context of creation the finding and amplifications of personal meanings may be, they are limited in their contribution to understanding.

Personal meaning does not elucidate from a structural standpoint the artist's use of particular elements or images in combination and association together. It is precisely here, indeed, that a call may be felt to talking of the intention of the work rather than the intention of the artist. By the same tokens, even when the personal meanings attached to a work are as emotionally and creatively charged with bearing on its character as was true with van Gogh, the distinction of "private" and "public" meanings of the work can still be important for a focused understanding of how visual communication takes place. (pp. 157-69)

Mark Roskill, " 'Public' and 'Private' Meanings: The Paintings of van Gogh," in Journal of Communication, *Vol. 29, No. 4, Autumn, 1979, pp. 157-69.*

Carol Donnell-Kotrozo (essay date 1983)

[*In the following excerpt, Donnell-Kotrozo maintains that commentators have traditionally overemphasized van Gogh's use of distortion to convey his emotional re-*

sponses and that his primary artistic goal was simply to depict reality as he perceived it.]

Emphasis on personality and emotional form has obscured the representational content of van Gogh's art. Most critics erroneously equate his "distortion" of reality with a form of deliberate antinaturalism in the interest of personal cathartic release. They seem cavalierly to assume that his interest was not in representing his visual experience of nature, and that he used motifs from reality merely as a pretext for emotional expression. Although van Gogh's art is certainly not naturalistic, it must be considered representational in that it is based on and presents a direct visual response to nature. In fact, although the conventional usage of the term *realism* is not applicable to his art, van Gogh is a realist in the sense that his art is rooted in visual impressions of everyday reality.

From the first work to the last, his drawing is directed to the rendering of character and expression. His study of modeling is pursued with the vision of the realist who wants his work to give the effect of nature with a maximum of conviction. In a letter to Emile Bernard, from the last months of van Gogh's life, there is a passage by the artist that seems to belie the interpretation that has been advanced by those who would see him a protagonist of pure expression.

> When Gauguin was at Arles, as you know, I let myself turn to abstraction . . . and at that time abstract painting seemed to me to offer a charming path. But it is a land of sorcery . . . and one quickly finds oneself standing before a wall. I do deny that, after a lifetime filled with research, with hand-to-hand battling with nature, one may take a chance at such things; but for my part I don't want to bother my head with them. . . . I am working at present among the olive trees. . . . I seek out the varying effects of a gray sky against a yellow earth, with a note of black-green on the foliage; another time, the earth and the foliage are streaked with violet against a yellow sky; then again the earth will be of red ochre and the sky of a greenish pink. And I tell you that that interests me more than the abstractions mentioned above.

Despite the uniqueness of his personal vision and approach, van Gogh's art is nevertheless an attempt to recreate his experience with real people and real locations as described in his numerous letters to his brother, family, and friends: "I won't say that I don't turn my back on nature ruthlessly in order to turn a study into a picture . . . but in the matter of form I am too afraid of departing from the possible and the true . . . I exaggerate, sometimes I make changes in a motif; but for all that, I do not invent the whole picture; on the contrary, I find it all ready in nature, only it must be disentangled." Considering such a statement, it should not be inconceivable to the critics of van Gogh that his roots were planted in the soil of Dutch realism. He is known to have admired painters such as Rembrandt and Hals who shared the same concern for reality and expressive form. In response to the critics who value van Gogh as the archetype and forerunner of modern expressionism, it must be pointed out that his art is deeply rooted in the past, in the European tradition of realism and representational art. It is this close bond between the artist and reality which distinguishes the post-impressionists from the expressionist painters of the twentieth century.

The innate taste for reality present in van Gogh was so strong that in his early paintings he identified reality with conventional realism. During the Nuenen period, many of his works are "all darkness and gloom." The ***Potato Eaters*** (1885) is perhaps the best example of his preference for contemporary realism of subject matter and style: "I have tried to emphasize that those people, eating their potatoes in the lamplight, have dug the earth . . . so it speaks of manual labor and how they have honestly earned their food. . . . I get better results by painting them in their roughness than by giving them a conventional charm. . . . A peasant is more real in his fustian clothes in the fields. . . . If a peasant picture smells of bacon, smoke, potato steam—all right. . . . If the field has an odor of ripe corn or potatoes or of guano or manure—that's healthy." Van Gogh felt that he had truly captured the reality of his subject, a reality that was familiar and meaningful to him. A work such as the ***Potato Eaters*** expresses a view of life and the world in which the humanistic motif of nature was given the main stress. Vincent considered living beings as tightly bound to nature. "That is why he objected to working from a dream. . . . He much rather started from thought which is much more bound to natural reality." This perhaps best demonstrates the way in which the artist's visual experience of reality and the subjective feelings aroused by it are inseparable. It is also the reason why the artist's medium of expression and his particular style of rendering forms are clearly derived from his impression of the subject rather than from arbitrary distortions. Van Gogh's own concept of realism in art pervades this painting on every level: "Working and seeking and living with nature . . . there is nothing that gives me such a solid base for my theory as that saying which expresses Millet's color and technique so perfectly: 'Son paysan semble peint avec la terre même qu'il ensemence' ['His peasant seems to have been painted with the with the very earth he sows']."

After passing through an impressionist period in Paris, the art of van Gogh underwent a metamorphosis in Arles, suggesting an awakening and a change in attitude toward nature: As he stated it, "I feel that what I learned in Paris is leaving me. . . . Instead of trying to reproduce exactly what I have before my eyes, I use color more arbitrarily so as to express myself vigorously." This remark has been the basis of much error surrounding the criticism of the artist. The change in attitude toward nature is not so radical as many critics maintain. It was more of a return to previous ideas about reality after an unfulfilling impressionist phase than any substantial reversal of attitude. Since the time of his early paintings at Nuenen, van Gogh had developed an extraordinary sense of color; but he never lost his ambition to depict what he believed to be the essential character of his subjects. It can be maintained that his art, like that of any major artist, is personal and expressive, yet, rather than being an expressionist, van Gogh creates images of reality which unite artist and nature, mood and design. He was an artist who could identify himself with the tremors of nature, inevitably employing his imagination in the service of its representation. The expressionist theorists have failed to see that an honest endeavor to represent may be combined with an unusually

strong emotional reaction to one's perceptions, so that one's feelings become a permeating quality.

In view of these facts, the art of van Gogh is not unique simply because it is expressive, as so many critics claim. In the light of the aesthetic theories of Langer, Arnheim, and others, it can be seen that all art must be considered expressive in some degree regardless of the artist's attitude toward the subject depicted. The idea of "self-expression" as a primary goal in art does not appear until the following generation of fauves and German expressionists. On the contrary, with van Gogh, it is still easy to reconcile expressiveness in art with the artist's vision of reality. No art is more immediately personal than van Gogh's. Everything he did turned into a self-portrait—landscape, still life, and figure—into which he injected himself, inventing a new handwriting of line and color to record his intense feelings for nature. What his eye revealed was instantly blended with what he felt about his subject. Increasingly, he tried to reduce the interval between vision and execution, fusing everything into a tense, expressive unity. This, perhaps, is true of all good artists and clarifies the paradox that van Gogh's art is expressive, yet not radically expressionistic.

Van Gogh himself provides the best evidence to invalidate the expressionist fallacy (and particularly the controversy surrounding the *Starry Night*): "At present I absolutely want to paint a starry sky. It often seems to me that the night is still more richly colored than the day, having hues of the most intense violets, blues and greens. If only you pay attention to it you will see that certainly stars are citron-yellow, others have a pink glow or a green, blue and forget-me-not brilliance. . . . Putting little white dots on a blue-black surface is not enough." This quotation demonstrates, first of all, that rather than being a product of violent self-expression, van Gogh's art is, to a certain extent, calculated and controlled. (pp. 66-9)

Van Gogh provides further evidence that the expressiveness conveyed by his subjects is not purely of a personal nature but is often an expression inherent in the subject: "There are vast fields of wheat under troubled skies, and I did not need to go out of my way to express sadness and extreme loneliness." Or: "I rather like the *Entrance to a Quarry*. . . . The somber greens go well with the ochre tones; there is something sad in it which is healthy. . . . Perhaps this is true of *The Mountain* too. They will tell me that mountains are not like that and that there are black outlines of a finger's width. But after all it seemed to me it expressed . . . a desolate country of somber mountains." Unlike the impressionists, van Gogh felt there was more to nature than a transitional state of fleeting glance. Rather, his vision and his emotional response are so united that nature becomes inherently expressive, surging with underlying life. He not only saw a cornfield but felt the stalks swaying with the surrounding air, moving and swirling in rhythm. His experience of synaesthesia was as real and vibrant to him as his feeling of the vibrations of the sun's rays.

It is apparent that Vincent van Gogh saw nature as inherently charged with diverse moods—from the anguish of a twisted cypress to the peaceful calm of *La berceuse.* As one critic aptly expresses it: "A high tensioned animism instantly distinguished his work from that of the impressionists. . . . For their lyricism of light and color he offered images charged with violence and love." The

fact that he was impelled to emphasize the feelings that were evoked in him by his subjects is not reason enough to label him as a doctrinaire expressionist, or is it evidence that he was not interested in representing reality as it appeared to be. He was aware of and shunned naturalistic representation in the interest of a higher truth about the nature of reality; but in this, he resembles many leading artists before the advent of nineteenth-century naturalism. (p. 70)

If van Gogh's paintings express something beyond or beneath conventional visual reality, such as "inner life" or personal meaning, it is not because he intended them to convey purely subjective meaning. Rather, any meaning found in his art was, for him, as for most artists before nineteenth-century naturalism, inextricable from the reality which inspired it. His problem was not so much to remain photographically faithful to his subject, as it was to find an expression that would convey his feelings within the framework of accuracy. "When the thing represented," he asked his brother, "is in point of character, absolutely in agreement with the manner of representing it, isn't it just that which gives a work of art its quality?"

With these statements in mind, it can no longer be assumed, despite the stylistic changes that may have taken place from his work in Holland or Paris, that van Gogh is purely interested in a decorative design modeled after Japanese prints. This was merely a popular idea that arose out of the "distortion" theory of van Gogh's art. No doubt the artist was influenced by these prints (as seen in such paintings as *Blossoming Pear Tree, Japonaiserie: The Bridge, Japonaiserie: The Tree,* and *Japonaiserie: The Actor*), as he also was by the art of Daumier, Millet, and others. However, it must be stated that, as with the art of Gauguin, this influence has become subtly integrated within his own vision—a vision still based on a faithful response to nature, expressed in poetic (aesthetic) form.

It can be concluded from the artist's own statements and from the experience of the paintings that the means by which he renders reality is inextricably tied to his visual perception of it. If van Gogh simplifies form, it is because he wanted to give a "true idea of the simplicity in Arles." If some of his paintings appear to resemble Japanese prints in the flattening of space, it is because, as van Gogh says, "here in Arles the country seems flat . . . and the landscapes in the snow, with the summits white against a sky as luminous as the snow, were just like the winter landscapes that the Japanese have painted." It is unlikely that van Gogh consciously distorted and flattened space or simplified forms for the sake of decorative design alone or through a desire to imitate the Japanese. It was, rather, that the Japanese had taught him to look at reality in a new way, with "an eye more Japanese," as van Gogh liked to state it. (pp. 71-2)

The goal of postimpressionistic art is not to render reality naturalistically, but to render it convincingly. Van Gogh's art expresses his vision of nature in a style he felt was true to reality, as true as any artist's illusion can ever be. When he describes forms in what may seem exaggerated line or color, it is simply because, for him, in Arles "things here have so much line." It is not because of his violent temperament that he emphasizes brushwork. "Is it not intensity of thought that we seek, rather than a calm brush? And in the conditions of spontaneous work, work done on the

scene in the immediate presence of nature, is a calm and well-controlled brush always possible? To me it seems no more possible to be calm at such times than when lunging with a foil." On his brushwork in the South, van Gogh provides another, seldom-considered, interpretation: "I think that the continual wind here must have something to do with the haggard look the painted studies have. Because you see it in Cézanne, too. . . . As half the time I am faced with the same difficulties, I get an idea of why Cézanne's touch is sometimes so sure, whereas at other times it appears awkward. It's his easel that's reeling." In this statement van Gogh is referring to the effects of Mistral, the strong Provençal winds, which he felt had an impact on the formal values of his own work as well as that of Cézanne.

If van Gogh's forms and colors seem exaggerated, it is because he sought "the real character of things," a truer reality than a mechanical description of surface appearances, but one that exists for everyone to see in nature, and one that can be captured through the interpretive medium of art. . . . Certainly the artist was not imagining colors in nature, nor were his colors purely the result of a psychotic mind seeking pure emotional expression. In a letter, van Gogh justifies his colorful perception of reality: "Fromentin and Gérôme see the soil of the South as colorless. . . . My God, yes, if you take some sand in your hand . . . and also water, and also air, they are all colorless looked at in this way. . . . There is no blue without yellow and without orange." In addition, in another letter that responds to an article by Albert Aurier, van Gogh specifically denies that his usage of color is imaginary: "Aurier's article would encourage me, if I dared let myself go, to run greater risks in leaving reality behind, and in creating a kind of tonal music with color, as in certain works by Monticelli. But the truth is so dear to me, and the effort to create what is true! After all, I really believe that I should rather be a shoemaker than a musician in color." It must be assumed, therefore, that van Gogh's palette is the result of the perception of nature by an artist with an acute sensibility for color. What he paints on the canvas is essentially what he sees in reality. Statements by the artist provide the best evidence to contradict the theories of the critics who particularly emphasize his use of arbitrary complementary colors as willful distortions of reality in the interest of psychologically expressive design. Though his colors may appear to be exaggerated in terms of established nineteenth century conventions of depicting reality, we cannot ignore the fact that van Gogh did see violet in the fields or citron yellow reflected by the sun in the sky. He claims that it was the clearness of the air on the Mediterranean coast that distinguished the color in the south from the tones of the north. Whether or not this is verifiable is unimportant. Because nature is ever-changing and presents a new aspect every day, reality has multiple aspects even to scientifically descriptive vision. Moreover, it is unimportant how much Vincent's own moods or sentiments may be responsible for the characteristics he saw in nature, for everyone's perception of reality is unique and reflects his disposition, a product of the union of psyche and environment. The irrelevance of descriptive accuracy in art, as in poetry, becomes clear when one considers the active role of the imagination in vision, a faculty that van Gogh felt should be developed in order to lead the artist toward the creation of "a more exalting and consoling nature than the single brief glance at reality—which in our

sight is everchanging, passing like a flash of lightning—can let us perceive." Critics have become so involved with interpreting van Gogh's art as a reflection of his personality, particularly his emotional states and psychoses, that they have failed to see expressiveness in his work apart from a preoccupation with conceptual symbols. The idea that van Gogh's art is uniquely symbolic is erroneous in that all art is symbolic, including all forms of representation, even naturalism. To be symbolic of emotional states, detached from authentic representation, is to be symbolic in a special, unusual, and unjustifiable sense of the term. (pp. 73-5)

If van Gogh's art is not to be valued in terms of its symbolic communication of psychological states, how is the meaning of his work imparted to the viewer? It must be through the expressive form of the representation. Susanne Langer explains that art is not to be considered either as the sum of its individual parts or as communication by discursive symbols. Any symbols that exist in the work enter into and become inseparable from the expressive form of the whole. This expressive "art symbol" does not need to convey something referentially, for its import lies in its unique form. In van Gogh's representational art, the viewer can and should experience the expressiveness inherent in the representation without reference to circumstances in the artist's life and without presuming a preoccupation with self-expression as conscious goal.

Van Gogh's art is universal and symbolic because it is a way of visualizing reality that is convincing and available to everyone. It need not rely on psychological or conceptual symbols unique to his own life. His expressiveness is the expressiveness inherent in nature. Self-expression for its own sake may be less universal, more idiosyncratic, and often less significant in content. ("His *Night Café* of 1888, explicitly designed to 'express the terrible passions of humanity by means of red and green,' remains, whatever else it may be, a cafe at night.")

It is apparent that the expressiveness in van Gogh's art corresponds to the artist's perception and experience of reality. What is expressed is based on visual experience and is congruent with such experience. Because of the subjective component of all perception, all representations will naturally involve personal feelings and psychic associations. These feelings awakened in the moment of vision, and inextricably tied to it, pervade van Gogh's work.

Critics who value van Gogh's art for its symbolism or its expressive distortions and emotional intensity are forgetting its origin in a strong response to nature. In their persistent attempt to evaluate art in terms of its contrast to scientific naturalism, which is their standard concept of visual reality, they fail to witness the union in art of man, imagination, and reality. Both the "symbolist" critics and the "expressionist" critics suffer from a narrowness of viewpoint, erroneously assuming a dichotomy between meaning and symbol, and between reality and human psychology. With van Gogh, it is not a question of dispensing with nature in favor of expressionism, since his expressiveness is derived from experiences with reality. If representation in art is in itself unimportant and, in fact, impossible in a literal way, his "distortions" for expressiveness can be understood as revealing his true relationship to nature, not as signaling a deliberate deviation from it.

Critics often obscure the true nature of van Gogh's art and the primary means by which it is appreciated. It has become extremely difficult to divorce the appreciation of his art from the great myths obscuring it, particularly his passionate and violent temperament, and his religious and sexual anxieties with which he is presumed to be preoccupied. Art becomes a mere therapeutic activity as novelists inflame his story and as psychiatrists debate the exact etiology of his madness. The artist is in critical danger of disappearing altogether, lost amid the clutter of so many exaggerated popular biographies. (pp. 77-8)

> Carol Donnell-Kotrozo, "Vincent van Gogh: Mysticism, Madness, and Misrepresentation," in her Critical Essays on Postimpressionism, *The Art Alliance Press, 1983, pp. 56-85.*

Jed Perl (essay date 1984)

[*In the following review of the 1984 exhibition "Van Gogh in Arles" at the Metropolitan Museum of Art, Perl comments on aspects of van Gogh's style during the Arles period.*]

For the modern New Yorker, van Gogh's world offers none of the pleasant shock of recognition we know from Manet and Renoir and Seurat. "Van Gogh in Arles," the exhibition currently on view at the Metropolitan Museum of Art, is not a beguiling spectacle; in the South of France, van Gogh does not take the part of the city dweller on vacation in the country. Arriving in the South from Paris—where he had spent the past two years living with his brother Theo—van Gogh, who always felt happier in a rural setting, dives so completely into the place as to make us feel that he is a native. While painting the members of the Roulin family, he writes to Theo that he is a bit like a family doctor, on familiar terms with a whole clan. Though van Gogh's Arles paintings have the perfume of the South, you can spend hours at "Van Gogh in Arles" without being particularly conscious that the artist is at the edge of the Mediterranean, in a world steeped in Roman culture. Van Gogh seems utterly uninterested in the Roman antiquities; he is not a tourist, and when he does write of the place in a detached way he talks of it as a fictional land—the Japan of the woodblock prints.

Van Gogh had taken the great Parisian bath. He spoke, in a letter from Arles, of "living in the full tide of civilization, of Paris, of the arts," and even on the morning of his departure for Arles he had visited a studio—Seurat's. Still, van Gogh's culture—his sense of himself in the world—was not urban, but pre-urban, pre-industrial, grounded in his sense of a man's relation to the earth and his neighbors: an older European idea of human experience. There was some of this as well in Cézanne—in the late portrait of his gardener Vallier—but Cézanne never had van Gogh's old-fashioned reverence for the singular facts of the world. The fascination with an earlier or more primitive human order was part of what van Gogh shared with Emile Bernard and Gauguin. With them, though, sentiment was often separated from sentimentality by nothing but a carefully arranged modern pose. Van Gogh understood that you cannot stylize sentiment and keep it pure. With van Gogh, being a great modern painter never comes between him and the subject. Though as preoccupied with questions of style as any painter who ever lived, van Gogh

often approached his subjects as if he had no preconceptions at all.

At "Van Gogh in Arles" I felt sometimes almost embarrassed by the directness of Van Gogh's approach. Some of the drawings, such as the great panoramic views of fields done from Montmajour in July, 1888, seem like simple declarations of affection: "I love this place." And many of the paintings just tell the truth: "I will now show you what the odd thatched cottages at Saintes-Maries-de-la-Mer look like." Van Gogh never makes fetishes of his objects: **Van Gogh's Bedroom** is the most unaffected of paintings. Standing close to it, you feel not so much its great design as the voice of the artist saying, "In my bedroom there is this and this and this . . . "—a catalogue of things, as if out of an old account book. The two portraits of Armand Roulin, the sixteen-year-old son of the postmaster, are suffused with an empathy that must owe more than a bit to van Gogh's powerful sense of brotherly ties. Here van Gogh begins to break through to a Rembrandtesque vision of portraiture: the adolescent uncertainty of Armand's eyes recalls the eyes of Rembrandt's portraits of his son Titus. Out of the stark, flat-colored backgrounds of the Armand portraits shine forth visages both lovely and tragic, strong in their forms, yet touched with a quality of melancholy.

In the Arles paintings, the complementary colors—blue and yellow, red and green—clang against one another like bells. These hues, painted in great, flat shapes or worked into the modeling of faces, signal the liberation of color from nature—and yet one is always brought back to nature. At the center of the opaque, playing-card-like arrangement of blue, green, and yellow in **L'arlésienne: Madame Ginoux** is a unique, stubborn face. Madame Ginoux seems to be fighting her way out of the picture. The paintings van Gogh did after Arles come more near resolving everything into art; at Arles Van Gogh will not yet equate style—the subjective—with truth. The work is done in a spirit of affirmation of the natural world. Van Gogh's colors, which he often spoke of in terms of "scales," climb toward the golden sun.

There is much that is deeply traditional in the great art of the late nineteenth century. Van Gogh, Seurat, and Cézanne each labored to reinstate an idea that early Impressionism, with its insistence on the direct, unreconstructed experience of nature, had to some extent undone: the classical ideal of the picture as a self-contained, logically consistent analogue of the natural world. Monet and Renoir returned in their later work to a more self-contained idea of the picture, and Renoir became the first modern artist to demonstrate that aesthetic revolution did not prevent an artist of sufficient genius from creating an authentic art out of older pictorial forms. (In this he foreshadows Picasso's Neoclassicism and Matisse in the 1920s.) But for the generation of the 1880s, Impressionism was too fresh to be completely passed over, and the strain of getting through Impressionism to a more traditional sense of composition, form, and meaning necessitated enormous readjustments in the way the artist went about making art and the public went about viewing it.

The generations of Courbet, Manet, and the Impressionists had expressed their expansive sense of the world by painting virtually everything; for van Gogh, Seurat, and Cézanne in the 1880s the gathering crisis in pictorial art

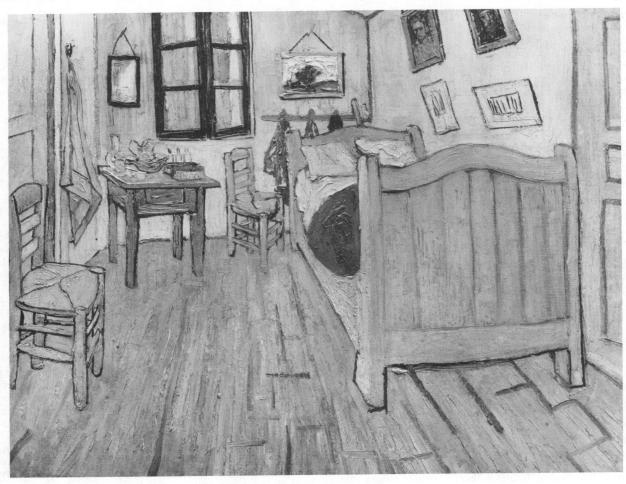

Vincent's Room at Arles (1888)

made the role of subject matter in painting increasingly unclear. Seurat painted the procession of modern life—the circus, the park, the boudoir—with so strong a sense of classical form as to make his images feel somewhat withdrawn, remote. Cézanne, by focusing on but a few subjects, made each of them function at least in part as an extension of the artist's psyche. The stable, monumental aspect that Cézanne and Seurat gave to their everyday motifs functioned as a counterweight to their increasingly fluent, unstable sense of form. The subject, unemphatic in itself, was thrust toward the viewer through the hyperbole of new ways of painting—pointillism, Cézanne's flat strokes; the piquancy of the picture rested in part in the way unexceptional things were revealed in a new light. This was one of the essential lessons Picasso and Braque were to learn from Cézanne: analytical Cubism wrings from nature's most modest façades—pitchers, glasses, guitars, newspapers—a classical order in which jokes, paradoxes, disjunctures are muffled by an overall radiance of beige or silver chiaroscuro.

Cézanne, Seurat, and the Cubists viewed subject matter in somewhat classical terms: the subject should be treated in a way that is not too personal, too specific; it should point toward the universal and the immutable. For van Gogh, any sort of detachment was impossible. At the same mo-

ment he was pressing through to a new pictorial language, he tangled with all the emotional and associative implications of realistic subject matter. At Arles, where the range of van Gogh's subjects is greater than either before or after, the variety that came before his brush must have felt exhilarating. He revitalized the old subject categories, viewing them from new angles. Scenes are caught off-balance, in odd, unexpected perspectives; faces are placed flat out in the centers of paintings with a directness that abolishes dramatic distance. Van Gogh was assaulted by a barrage of images that he felt he must absorb into his art all at once, in much the way generous spirits take in the dizzying heterogeneity of life itself. Leaving the van Gogh show, you may feel that van Gogh's willingness to embrace life is infectious—that your sense of the world is more alive, more resonant than before: an odd shopsign, a tradesman going about his business, or a cozy bit of greenery appears, suddenly, freshly significant.

Van Gogh demonstrates in his art an extraordinary range of feeling; he regards the world in a variety of ways. He has a taste for the exotic, picturesque aspect of the South of France that one feels in the portraits of the Zouave, in the paintings of indigenous architecture, and in the zest with which he attacks the brilliantly colored, folk-art look of the coaches in the *Tarascon diligence.* In such works

van Gogh seems to be savoring the special flavor of the South as one might delight in the piquancy of Southern food. The exoticism of Arles, though, is seen within the context of day-to-day, lived experience. Indeed, at the Metropolitan the brilliantly colored *Tarascon diligence* is hung right next to van Gogh's paintings of the iron *Trinquetaille Bridge* and the *Railroad Bridge,* grim, gray structures that signaled the new, more impersonal form of urban scene. (Industrialization was just reaching Arles in those years.) This social landscape is further enriched in the portraits, which are extraordinarily attentive to the net of conventions that define the individual. The images of postmaster Roulin in his uniform are perhaps more sensitive than any other works of the century to the importance of the profession in the life of the petite bourgeoisie. In the last portrait of Roulin included in "Van Gogh in Arles," the word "POSTES" on Roulin's hat becomes a central element in the composition—as much a sign of the real world as "JOURNAL" in a Braque or Picasso. The settled, resolute character of the portraits of Madame Roulin gives another side of the social picture, as do the sun-scorched face and hands of *Patience Escalier,* which Meyer Schapiro has called "the last realistic portrait of a peasant in the tradition of Western painting. It is perhaps also the only great portrait of a peasant."

Oil painting demands that the viewer enter into a dialectic between paint and what paint signifies—between substance and illusion. Vasari marveled at the way Titian's late paintings, chaotic from close up, fell into a perfect order from a certain distance, and since then it has been part of the viewer's job to find a proper viewing distance—a point from which all the elements of the painting, which you can appreciate separately close up, compose into a single, unified whole. Impressionism altered the terms of representation, but it still resulted in paintings that cohered from a distance where the viewer could take in the whole scene at once. It is really with van Gogh, Seurat, and Cézanne that the viewer begins to be uncertain about where the painting ought to be seen from. Seurat's work must, at least in part, be looked at from close up, from two or three feet away, where you can feel the miracle of his dots and dashes of color converging into palpable forms. But even as you regard a Seurat from close up, you want to move away (to perhaps five or six feet from one of the small landscapes) so as to see how the small elements compose into one of Seurat's grandly plotted designs. With Seurat, there is no single proper vantage point; you experience his ineffableness as you shift closer toward, further away from the picture in search of a completeness that is there but is constantly opposed to the anarchy of a fluid, atomized surface. Cézanne, especially in his last decade, leaves you with similar indecisions about your relation to the painting. There are parts of Cézanne's *Le Château Noir* in the Museum of Modern Art—the château itself, the dense foliage below—that only begin to feel fully dimensional when you get very close to the painting and study the relations of the planes of color one by one; yet the painting must also be taken in from a greater distance, where you lose this dimensionality but gain a sense of the overall design and the large spatial relations that Cézanne's design gives expression to.

The brushstroke had played a central role in van Gogh's art from his first maturity, with *The Potato Eaters,* in 1885. In *The Potato Eaters,* the big, choppy brushstrokes

sculpting the peasants' heads gave the impression that van Gogh was willing his peasants into life. When van Gogh went to Paris his encounter with the lighter, all-over stroke of Impressionism necessitated a temporary change in the quality of his own hand—a weakening in the force of the brush that accounted, in large measure, for the lowered intensity and less personal quality of some of the work of the Paris period. Paris was van Gogh's last apprenticeship, and after the first spring in Arles, when he painted the flowering orchards in a still Impressionist way, he continued in a direction begun in the late Paris phase and reclaimed the large, emphatic brushstroke as a central element in his art. Now the sculptural quality which the brush gave to the forms in *The Potato Eaters* period was opposed to an idea of surface design derived in large measure from the study of Japanese prints: van Gogh wanted to bring the subject close to the viewer in a way both sculptural and planar. (This foreshadows a similar struggle between the sculptural and the planar that preoccupies Matisse and Picasso between 1905 and 1912.)

The importance of the Japanese print for van Gogh at this stage in his development was immense—incalculable, really. Van Gogh was not the first artist to have looked closely at these images, but he does seem to have been the first to take very seriously the later, more brightly colored prints of Hiroshige and his generation. Van Gogh was probably the only painter of the time who actually copies the Japanese prints, and his oil paint copies—one of which, after a print by Kesai Eisen, is included in "Van Gogh in Arles" even though it was done in Paris—are extraordinary. Japanese art seems to have functioned for van Gogh in much the way African art did for Picasso: van Gogh extrapolated from the woodblock prints not the elegant graphism of so much Eastern-inspired art of the time but a vigorous design that electrifies the oil paint surface. Through his examination of the graphic techniques of the Hokusai sketchbooks, where dots, dashes and twirls of line are used to describe all kinds of natural forms, van Gogh found a way to activate the entire surface. At Arles, the Hokusai influence moved van Gogh to fill up the surfaces of his drawings with many short jots of the pen.

Seurat and Cézanne forced the viewer to the actual spot—arm's length from the canvas—where they had painted. They demanded that the viewer understand their reconstructions of the world through a close stroke-by-stroke observation of their painting processes. This is the case with van Gogh as well. When you stand too far away from the Arles paintings their forceful designs become overpowering and tend to swamp the subjects. You may feel, from six or eight feet away, that the central impulse in *L'Arlésienne* or *Street in Saintes-Maries-de-la-Mer* is something totally abstract—that the reality which van Gogh invokes is merely a pretext. This was surely not van Gogh's intent. Only by standing close to the Arles paintings—and with some of the best, such as the portraits of Armand Roulin, the closer the better—do you become alive to the way the individual strokes of color break into the flat design and pull it out into the viewer's space. It is the stroke that makes the large color shapes in a picture like *Tarascon diligence* breathe; it is the stroke that gives the organic logic.

The confluence in van Gogh's art of an extreme unconventionality of style with a deep commitment to the immedi-

ate realities of the world does not seem to have struck him as strange. Van Gogh knew that his style was strong but he felt that it was right to his subject. Especially, though, during the Arles period, when van Gogh had not yet learned to unite subject and style so fully as he did at Saint-Remy, we can often find ourselves somewhat mystified by the confluence of an intense care for faces, expressions, and social ambience with an equally powerful sense of abstract form. I know I am not the only visitor to "Van Gogh in Arles" who has at times found the images strangely inconclusive. Perhaps some of us have come to think, more than we imagine, of abstraction and representation as irreconcilable: we are unsettled by the idea of an artist who so evidently has the idea that he will remain true to what he sees—will, in fact, reveal it—by transforming it into a fabric of brilliantly unnatural color.

We may do well to keep in mind, when looking at those van Gogh paintings that trouble us, the clear, powerful voice of his letters. In the letters, as in the paintings of the Arles period, van Gogh does not begin with an effect or idea in mind so much as with the thought of being true, piece by piece, to what he feels or sees. The way van Gogh's words—rather simple words—form a modest, evenly spaced procession and compose a picture of something he has felt or seen recalls the process by which, in the paintings and drawings, the strokes compose an image. An excerpt from a letter van Gogh sent to Theo from London in 1876, even before he had begun to paint, gives the flavor of his prose.

> The suburbs of London have a peculiar charm, between the houses and gardens are open spots covered with grass and generally with a church or school or workhouse in the middle between the trees and shrubs, and it can be so beautiful there, when the sun is setting red in the thin evening mist.
>
> Yesterday evening it was so, and afterwards I wished you could have seen those London streets when the twilight began to fall and the lamps were lit, and everybody went home; everything showed that it was Saturday night and in all that bustle there was peace, one felt the need of and the excitement at the approaching Sunday. Oh, those Sundays and all that is done and accomplished on those Sundays, it is such a comfort for those poor districts and crowded streets.

Note the extent to which van Gogh keeps himself out of his description: it is about the people and their world.

Van Gogh during his time in Arles was the last great representative of the nineteenth-century realists' dream: the last to believe that art could be grounded in the everyday, social facts—the truths of the common world. He is in the tradition of Courbet, Millet, and the Barbizon painters, yet he seems closer to understanding some essential life principle than any nineteenth-century naturalist. Perhaps van Gogh was less ideological than the naturalists: with van Gogh life itself becomes the source of moral example, and the objects—the flowers, chairs, faces, fields—take on an authority unknown before in art.

Van Gogh's sense of the authority of nature is his most precious legacy to the twentieth century. To understand him as an Expressionist is a mistake, for distortion is not, really, what comes to mind in looking at his work: van Gogh transforms things, but this is simply the way he real-

izes the essence of the object. With van Gogh, the real mystery lies in how he manages so completely to avoid the anecdotal. If the unity of his late work leads away from nature, it is toward a view of nature's coherence that is classical in much the way of late Cézanne. Van Gogh's lesson rests not in ways to transcend nature but in new methods for grabbing hold of nature. It is van Gogh's example that lies behind the insistent presence of the objects in Matisse's *Red Studio*. He is there, everywhere, especially in the 1930s, in Picasso: in the way Picasso brings the emotions of his portrait subjects straight up to the surface. And it is van Gogh's example that moves Braque, at the end of his life, after he has finished his Studio series, to paint fields of golden wheat. I have been reminded, in looking at van Gogh's pictures, of more recent works as well: the dark and exciting urban scenes of the contemporary English artists Frank Auerbach and Leon Kossoff seem to echo, in their brushwork, in their few, anonymous, rushing figures and their handling of space van Gogh's *Trinquetaille Bridge* and *Railroad Bridge.* Artists are still going out to nature with the hope that the contingent, the everyday, will surprise them into new ideas of form. (pp. 30-5)

> *Jed Perl, "Van Gogh at the Met," in* The New Criterion, *Vol. 3, No. 4, December, 1984, pp. 30-5.*

Ronald Pickvance (essay date 1986)

[*In the following excerpt, Pickvance discusses the paintings of van Gogh's St. Remy and Auvers periods.*]

Van Gogh's artistic odyssey lasted ten years. The final fifteen months of his life were spent in a private asylum in Saint-Rémy-de-Provence, in the South of France, and in the small village of Auvers-sur-Oise, some twenty miles northwest of Paris, where he committed suicide in late July 1890. Like Raphael, Caravaggio, Watteau, and Toulouse-Lautrec, he died at the age of thirty-seven.

In van Gogh's case, there was what has been seen as a pre-ordained progression from asylum (with the implied assumption of madness) to suicide, which has fueled the myth of the mad genius. But whatever the illness may have been—and some form of epilepsy seems the most probable, whether exacerbated by absinthe, glaucoma, Digitalis poisoning, or syphilis—the fact is that it did not directly affect his work. His paintings are neither graphs of his so-called madness nor primarily indicators of his mental state. Between his breakdowns at the asylum he had long periods of absolute lucidity, when he was completely master of himself and his art.

That his mind was informed and imaginative, interpretive and highly analytical can be seen in the way he assessed his own work. From Saint-Rémy he sent seven batches of paintings to his brother Theo in Paris. . . . At one level, this periodic chore was undertaken primarily to thank Theo for his unfailing financial and moral support. But it also provided a series of progress reports on recently completed work, demanding selection in the first place and then commentary and exegesis. Van Gogh categorized his paintings with care, referring to individual works as studies or pictures, as paintings from nature or studio repetitions, as part of a series or as independent entities. He

described handling, color, and design in terms that respond far more to internal artistic necessity than to psychological quirks or medical abnormalities; he conceived of process, purpose, and function with a quite deliberate and almost programmatic intent. He provided a degree of multifaceted analysis a small fraction of which would bring Cézanne, Seurat, or Toulouse-Lautrec so much closer to us. (pp. 15-16)

Van Gogh, like many artists and writers in exile, had an intensely heightened sense of place. The longer he stayed in Provence, the more he strove to capture its atmosphere and essence. And the longer he stayed, the more he felt he could achieve this in series paintings devoted to individual motifs. "My God!" he wrote to his friend Émile Bernard, "It is a very bad sort of country here; everything in it is difficult to do with regard to disentangling its inner character and to avoid making it a vaguely apprehended thing instead of the true soil of Provence." And to Theo he expressed the hope that when he eventually left Saint-Rémy, his work would form "at best a sort of whole, 'Impressions of Provence'."

Cypress trees, olive orchards, mountains—these were the three motifs van Gogh wanted most to capture in series. He never completed the cypresses or the mountains to his highly exacting standards, but he did succeed with the olives. He began with three summer paintings whose stylistic and coloristic forebears include Monet, Gauguin, and Bernard. After prolonged observation, he undertook an autumn series that eventually comprised eight large paintings. . . . (p. 16)

Writing from Auvers to the Dutch art critic J. J. Isaäcson, he explained what he was attempting to do:

> The effect of daylight, of the sky, makes it possible to extract an infinity of subjects from the olive trees. Now I, on my part, sought contrasting effects in the foliage, changing with the hues of the sky. At times the whole is a pure all-pervading blue, namely when the tree bears its pale flowers, and big blue flies, emerald rose beetles and cicadas in great numbers are hovering around it. Then, as the bronzed leaves are getting riper in tone, the sky is brilliant and radiant with green and orange, or, more often even, in autumn, when the leaves acquire something of the violet tinges of the ripe fig, the violet effect will manifest itself vividly through the contrasts, with the large sun taking on a white tint within a halo of clear and pale citron yellow. At times, after a shower, I have also seen the whole sky colored pink and bright orange, which gives an exquisite value and coloring to the silvery gray green.

Ironically, however, posterity has tended to ignore the paintings of olive orchards as a series, perhaps because the autumn sequence in particular contradicts so much of what is thought to represent van Gogh's late style. Instead of violently impetuous brushstrokes, thick impasto, and turbulent compositions, they display a remarkably lucid and unified brushstroke system, a consistently harmonious surface, carefully planned compositions, and a pervasive mood of contained serenity.

In Saint-Rémy, van Gogh's color scale was more muted; the "high yellow note" of his dazzling Arles palette was abandoned. He began using ochers again, and contemplated returning to the more somber palette of the North (that

is, of his Dutch period). Elsewhere he wrote: "What I dream of in my best moments is not so much striking color effects as once more the half tones," influenced, he affirmed, by the pictures of Delacroix that he and Gauguin had seen in the Bruyas collection at Montpellier in December 1888. His interest waned in the compositional and coloristic devices he once so admired in Japanese woodblock prints.

Time of day, weather, season, as well as composition, viewpoint, color, and morphology of brushstroke, are modified from canvas to canvas in the four versions of the walled wheat field painted between early September and mid-November 1889. Two of them, the ***Reaper*** and ***Enclosed Field with Peasant,*** were seen as pendants by van Gogh, the one, he felt, too hastily conceived in thick impasto, all in yellow, the other painted calmly, over several days, in the complementary contrast of violet. The two should hang together, he instructed Theo. . . . (p. 17)

Van Gogh painted relatively few still lifes in Saint-Rémy and Auvers. During his last days in the South, however, he made a quartet of flower still lifes. Formalistic color exercises, whose essential unity fuses in a supremely economical treatment that presages the work of Matisse, these too were probably conceived as a group, one in which variations of color are played off one another within the framework of complementary vertical and horizontal formats.

Van Gogh's brand of Post-Impressionism was overtly heterodox, broader in its admirations and admitted influences than Cézanne's, Gauguin's, or Seurat's. He carried a heavy artistic burden that included seventeenth-century Dutch painting and the Barbizon school, Meissonier and Monticelli, European realist illustrations and stylized Japanese woodblock prints; he wanted somehow to combine past and present, North and South, Rembrandt and Delacroix, Europe and the Far East. In his portrait of Trabuc he used only images of the past, wood engravings and etchings in black and white. But when he painted Dr. Gachet, he described at length in a letter to his sister Wil his conception of the "modern portrait," of color, of the future, creating an ideological base as well as a practical exemplar for Fauvist and Expressionist portraiture. Portraits were surprisingly few in Saint-Rémy and Auvers. This was one reason van Gogh chose to make so many painted copies after such artists as Delacroix, Millet, Daumier, Rembrandt, and Gauguin. Even self-portraits number only three; all were executed in fairly close succession during August and September 1889. In his last self-portrait, peasantlike and beardless, he again blended past and present, summoning memories of his boyhood in Brabant, yet creating a "modern" image.

After his Provençal sojourn, van Gogh saw the Northern landscape with a sharpened and heightened vision. In Auvers there was a conscious change in his pictorial language. In his landscapes whites, blues, violets, and soft greens dominate. In his portraits, by contrast, he used the harsher primary colors and was ready to impose his color theories on his sitters. There was, too, a certain unevenness and impetuosity of brushstroke, a simplifying of the composition, and, above all, a change in format to the double-square canvas.

Van Gogh lived in Auvers for only seventy days, during

which time he painted some seventy canvases. Only half are documented in the letters, and a chronological sequence is not easily proposed, especially for the last month of his life, when letters are scarce. While he led a restricted and isolated existence in Saint-Rémy, van Gogh was able in Auvers to wander freely, to choose his own motifs, and to paint whenever he wanted to. His most deliberate artistic decision was to adopt a double-square canvas (19⅝ x 39½ in.). Thirteen such canvases were painted: twelve landscapes and one portrait. A single-square canvas (19⅝ x 19⅝ in.) was used for six others: four portraits, one landscape, and one still life. Van Gogh himself said nothing about why he began using these unusual formats. Begun in mid-June 1890, the paintings were probably envisaged as a series to be hung and exhibited together, a continuation of van Gogh's ideas on decoration that had so obsessed him in the Yellow House in Arles. (pp. 17-18)

> *Ronald Pickvance, in his* Van Gogh in Saint-Rémy and Auvers, *Harry N. Abrams, Inc., Publishers, 1986, 325 p.*

Ross Neher (essay date 1989)

[*In the following excerpt, Neher summarizes van Gogh's aesthetic aims and varying styles, suggesting that many of his works fail because of their unsuccessful synthesis of realistic depiction and abstractionism.*]

The occasional child prodigy notwithstanding, one may assume that playing the piano is not a natural activity but requires specialized training and arduous practice. With work comes a knowledge of the instrument and the repertoire. But effort alone will not insure pianism on a concert level. Beyond work there must be an aptitude, a talent; beyond talent a vision, a unified view of the world the pianist sets out to express as he or she speaks through the composer; and propelling all of these, a driving ambition. Horowitz, Pollini, and Brendel offer different world views, embody different attitudes toward art, but share a mastery of their medium obvious to the sensitized ear.

In a somewhat similar fashion, the acquisition of traditional drawing skills can be an excruciating process, as novices' attempts at figure drawing usually show. Tiny monkey hands, oversized heads, figures that do not "sit" comfortably on the page, disproportionate limbs, and defects in depth perception, are common trademarks of the beginners' efforts, which often resemble *The New Yorker* cartoons of Roz Chast. But whereas the not uncommon phenomenon of the precocious musical talent, such as the young Mozart, amply demonstrates that at least in some cases musical ability comes "naturally," as if by special gift, in the visual arts such youthful virtuosity occurs much more rarely and almost never before puberty. The great draftsmen of the West, such as Michelangelo, Ingres, and Degas, though prodigiously endowed with native talent, struggled to attain their mastery. Classical draftsmanship, which consists of a set of learned conventions that make perfect perceptual sense once assimilated into the artist's motor apparatus, requires a mature critical intelligence as much as it does physical dexterity. The arm is attached to the brain, to paraphrase Michelangelo. Even under optimum conditions, therefore, progress in drawing is often measured in months if not in years. One does not attend drawing class for instant gratification.

Few artists worked harder at drawing than Vincent van Gogh. He spoke often in his letters of the importance of drawing as the basis for painting, and was critical of those who attempted to hide faulty draftsmanship with slick painting technique. The frustration familiar to the beginner was not spared van Gogh, who wrote in despair, "What is drawing? How does one learn it? It is working through an invisible iron wall that seems to stand between what one *feels* and what one *can do*. How is one to get through that wall—since pounding against it is of no use?" The metaphor of an invisible iron wall is, as we shall see, significant.

By all accounts, it would appear that what van Gogh wished for more than anything was a command of drawing equal to the masters. We know, for example, that he worked from an exercise book by Bargues; that he had a perspective frame built to his specifications, which he took with him on location; that he would hire models out of his allowance from Theo; that he sought out his cousin, the established Hague painter Anton Mauve, for advice; that he briefly attended the Academy in Antwerp and later (also briefly) worked in Fernand Cormon's studio in Paris; and that he was an inveterate copier of other artists' work, that of Delacroix and Millet in particular. All of this bespeaks a conventional ambition.

Yet, as we know, van Gogh's career was hardly conventional. Moreover, the pursuit of his craft could not be characterized as a patient overcoming of obstacles encountered by one not blessed with superabundant technical facility, but rather it was marked by frequent outbursts of anger and defiance, often directed at artists with whom he had formed close personal relationships. Thus he smashed the plaster casts Mauve suggested he work from, throwing them into a coalbin and saying that he would "draw from those casts only when they become whole and white again." Soon after his relationship with Mauve was effectively ended, ostensibly because Mauve disapproved of van Gogh's liaison with a prostitute, though it is likely van Gogh's habitual contradiction of any artistic advice contributed to the strain. We know further that van Gogh chided his friend Anthon van Rappard for entering the Academy in Brussels, calling the academicians "despicable," and that he broke off his friendship with Rappard when the latter criticized a lithograph of *The Potato Eaters.* His vehement arguments with his mentors at the Academy in Antwerp, who regarded van Gogh's work as incompetent (by academic standards at any rate), are well documented, as is the famous rupture with Gauguin. We might add that, in all of these episodes, van Gogh tended to confuse personal with artistic issues.

It is, of course, easy to understand van Gogh's intolerance of the academicians' autocratic teaching methods. Early on, van Gogh decided he must find his own way of working, a way that captured the vitality and immediacy of life. He therefore detested drawing from lifeless casts, and he refused to emulate the watered-down marmoreal classicism the academicians extolled. Furthermore, van Gogh did little to disguise his preference of the emphatic gesture to overwrought Beaux Arts perfectionism.

Van Gogh would have us believe that he was recasting the familiar debate between the ancients and the moderns, between les Poussinists and les Rubénistes. A fervent admirer of both Rubens and Delacroix, he was tepid in his en-

thusiasm for Poussin (but respectful of Ingres). However, it should be borne in mind that even when the battle between classical and romantic points of view was at the most intense level, as it was when joined by Ingres and Delacroix, the two antagonists bore a grudging respect for each other that implicitly acknowledged common cultural ground. The debate turned on contrasting views of human nature for which an appropriate pictorial syntax was created. It was about the *use,* not the *nature* of art. Delacroix, we may recall, was as much an official salon artist as was Ingres. He was no self-taught outsider attempting to challenge the nature of art, and his "modernity" consisted in making a contemporary contribution to a venerable tradition of painting that extended back to the Venetians. I do not believe van Gogh participates in that tradition, however much he may have felt an affinity for it. If anything, he was prevented from doing so on psychological grounds. Perhaps sensing this, van Gogh advanced inextricably linked moral, political, and artistic motives.

It is apparent that van Gogh's artistic career was an extension of his failed ministry, and indeed he took as his first principal subjects the peasants who had constituted his congregation in the mining district of the Borinage in southern Belgium. Van Gogh saw life in biblical terms. His sympathies resided with the working poor, with the peasant farmer and miner whose labor brought them in intimate contact with the earth, with nature. (With Cézanne, van Gogh shared a mistrust of the industrialized urban center.) Van Gogh identified with rural laborers to such an extent that he would dress like them, often attending drawing classes at the Academy in Antwerp wearing a "blue smock, such as Flemish cattle-dealers wore." This may be interpreted as a political statement of sorts. It is likely van Gogh drew parallels between the politically oppressed peasant and his own oppression by the academicians. In a letter to Rappard, he called the academicians "Pharisees," and in so doing may have seen himself as a persecuted Christ figure who, in delivering art from the control of hypocritical authority would, at the same time, symbolically liberate the meek souls destined to inherit the earth (as he may have secretly hoped to inherit a prominent place in art history). Van Gogh's inner logic dovetails. The poverty-stricken laborers van Gogh sought as his subjects were at a far remove from the academicians' ideal of beauty. They often displayed the physical deformities symptomatic of poor nutrition and hard working conditions. On a moral level, such deformities, such deviations from the norm, such *distortions,* could be interpreted as outward manifestations of suffering and goodness, while simultaneously signaling political oppression. But here the moral shifts to the aesthetic level, for in van Gogh's scheme, goodness does not so much adhere to beauty as begin to oppose it. Ugliness itself comes to be endowed with moral, political, and artistic attributes.

Yet van Gogh's misshapen faces and hands do not issue from any formal necessity, as they do in Picasso, nor would we mistake them for realistic representations. With Picasso we are rarely in doubt as to his artistic purpose, for the intent is borne out by what we see. Picasso's distortions are determined by the overall conception of the work; his art does not contradict the fundamental law of internal consistency. Van Gogh's appear willful and arbitrary and tend to mar otherwise intelligently constructed compositions. In a van Gogh painting we are often "stopped" by his odd visual decisions and the emphatic physicality of his facture. The *painting* is presented as *fact.* Indeed, van Gogh may well be the first modern artist to have self-consciously viewed the art object as an icon of cultural/historical necessity, and in this sense he may be said to have prefigured the readymade.

Rackstraw Downes, in writing of Henri Rousseau, notes that "the twentieth-century taste for naïve art is a twist in the long story of [the] ancient antithesis of culture and nature. . . . The naïve in naïve art is not there by virtue of what the picture represents, since a naïve action or sentiment could just as well be depicted in a sophisticated painting. Rather, an equation is made between an unknowing technique and a pure heart." Now, Degas's laundresses are no less oppressed, and Gericault's insane men and women are no less deranged, for having been skillfully drawn and painted. With both artists we are given full access to their subjects because the issue of artistry is not in question. Van Gogh consciously cultivates a folksy peasant style, decidedly amateurish in effect. His exaggerated primitivism is meant to establish his sincerity, honesty, and moral kinship with his subjects. It is the artistic equivalent of special pleading. We are meant to feel sorry for his subjects and guilty if we don't.

It is interesting to note that after years of frustrating effort, van Gogh did achieve a level of academic proficiency, judging from extant studies. Thus his stylistic decisions do not issue from simple incompetence, though to be sure a feigned incompetence is much more easily sustained than a competence that requires perpetual vigilance. In any event, it is not for his disdain for the felicities of draftsmanship that van Gogh may be criticized—neither Rembrandt nor Delacroix were considered paragons of drawing in the Florentine sense—but for his unwillingness to explore a fundamental aspect of Western painting for which an understanding of drawing's role is crucial. That aspect is space. However, it is in discussing the subject of space in painting that confusion is most likely to arise.

Given a flat surface, we have three ways of viewing it. The first way is as a neutral zone or "top" that may serve as a repository for any method of literal marking. This could variously include a Shakespearean sonnet, an abstruse mathematical computation, or a child's graffiti-like scrawl. Here the surface acts as a support for signification and simultaneously recedes in consciousness as the information is absorbed. This first option may be termed literal-lateral. It allows for writing, which may be restated as the conceptual transmission of information by means of symbolic line.

The second approach also regards the surface as a "top," but attempts to build out from it physically. Collage, assemblage, constructivist relief sculpture, all utilize the paper, canvas, or wall in this manner. This second approach may be termed topographical. It exists as a function of architecture. Its means are the design and arrangement of discrete, solid, often planar materials, and its effect is theatrical.

Because in both approaches the surface is regarded as an ancillary "glue" binding the elements (be they words or objects), it has no positive psychological or conceptual force itself. Objects and words may be used in any combination deemed necessary. The "structure" of a piece is,

perforce, linguistic. Meaning is dependent upon syntactic arrangement.

We may choose to view the surface a third way: we may choose to see *into* it. Not through it as one would look through a window and out onto a real space, but into it the way one looks into a mirror or reflecting pool. We may choose to regard the paper or canvas as a bounded shape of absolute spatial indeterminacy. This space is pliant and giving; it is not the obdurate "top" upon which writing, symbolic figures, or extraneous materials may be put. An image may reside in the space but simultaneously be coterminous with the surface. When someone says, "Go look at yourself in the mirror," one means go look *at* your flat image seen three-dimensionally *in* the mirror. Likewise the space of the paper and canvas may be looked both at and in. Richard Wollheim calls this phenomenon "seeing-in." It is, he says, "a special kind of perceptual experience . . . *Seeing-in* [is] marked by this strange duality—of seeing the marked surface, and of seeing something in the surface." Seeing-in engenders a related notion that Wollheim calls "twofoldness." Twofoldness is a "distinctive phenomenological feature . . . because, when seeing-in occurs, two things happen: I am visually aware of the surface I look at, and I discern something standing out in front of, or (in certain cases) receding behind, something else." Wollheim further notes that these are not two different experiences, but two aspects of a single experience. It must be emphasized that while the phenomenon of seeing-in is demonstrably real, it is conditional upon attitude and ability. When Clement Greenberg observes how "the first mark made on a surface destroys its virtual flatness," he has opted to see-in. He demonstrates an essential capacity and willingness.

This third manner of viewing a flat plane may be termed spatial-metaphorical. It is the manner in which we view painting. Its means are fluid, plastic materials, and the effect is psychological.

Indeed, the psychological implications of seeing-in should be obvious. Because the space of the paper or canvas is not restricted to its surface area alone but is indeterminate, there are no front-to-back coordinates. One floats free. To anyone desperate to maintain absolute control over every aspect of their lives, this is an altogether horrifying prospect.

Van Gogh refused to see-in, for to do so would have meant the destruction of his "invisible iron wall." This wall, I suggest, is a metaphor for both the picture plane and for some form of internal resistance van Gogh was never able to break through. While he desperately wanted to get beyond it, it was a necessary component of his psychic stability.

Van Gogh's space is, by and large, flat and diagrammatic. The drawings he executed with the aid of his perspective frame are accurate in a schematic way, but the planes appear stitched together—they do not flow back continuously into space, but rather denote space. Van Gogh saw drawing as a form of writing, as a corollary to his interest in literature. The reed drawings in particular are notational and approximate, the calligraphic inventions of a profound letter writer. This notational, structural method served him well as the basis for his painting. Once he had a drawing he liked, he would execute a painting quickly,

almost always respecting the boundaries of the initial design. After he had "filled in" a canvas, as if completing a kind of impastoed number painting, he was loathe to rework it. Van Gogh's painting technique was not so much spontaneous as it was direct and fast. It certainly was not improvisational. Indeed, contrary to the expressionist or romantic impulse, what is most striking about van Gogh's manner of working is his need for control.

Van Gogh's painting method results in some curious effects, especially in the portraits, where the desire is to model a three-dimensional form, Rembrandt being a primary influence. Given the distorted drawing and the flatness of the space, the form has nowhere to go—it by turns swells and collapses, and the results are invariably awkward. Van Gogh fares better with the landscapes where the sky-earth relationship may be rendered in planar terms and where distortion may be subsumed within an overall conception, as in the uniformly baroque (albeit flat) cypress paintings. But his most successful pictures, ones for which he truly deserves his place in the pantheon, are those landscapes, mostly from the Arles period, in which he employs his perspectival schema and augments it with a paint facture that diminishes as it goes back in fictive depth. Here, two methods used to suggest deep space are held in tension by two opposed methods, namely his matter-of-fact paint handling, which directs our attention to the painting's surface, and his rich, gem-like color, which sparkles and glows throughout. A delicate and precious balance is achieved, classical in its repose. It is as if van Gogh's monumental ambition drives him to the solution for which he had been prepared by years of study of isolated areas.

The purpose of learning how to draw conventionally is to develop and enlarge one's capacity to see-in, as well as to achieve a necessary hand/eye coordination; it is not to produce academic realism. It is in this specific sense that drawing is the basis for painting. (We should therefore discount those aging abstractionists who, having already learned to draw, seek to diminish its importance in their work.) But as in any learning process, some kind of human intervention or guidance is necessary. One must be *taught* how to draw, how to see-in, how to view the flat plane spatially. As in learning how to walk, swim, or ride a bicycle, another person must be present to show how it's done. It appears that van Gogh was not entirely unaware of the importance of learning from others, as his painting *First Steps,* derived from a Millet drawing, would indicate. Nevertheless van Gogh appears to have been incapable of accepting such guidance, which for him may have constituted an unmanly submission. That is why his fierce arguments, not only with the academicians, but with peers such as Rappard and Gauguin, seem overdetermined. His appropriations of other artists' stylstic emblems—the pointillism of Seurat, the cloissonnism of Bernard, or the flat, abstract patterning of Gauguin—are notably two-dimensional and can be inserted at will into his schematic world.

The tragedy of van Gogh is that he wanted it both ways; to be part of the tradition of Western romantic painting, as well as to play the role of the heroic revolutionary, freeing art from a burdensome and oppressive past. (pp. 43-6)

Ross Neher, "Van Gogh and the Problem with

Tradition," in Arts Magazine, *Vol. 63, No. 5,*
January, 1989, pp. 43-8.

FURTHER READING

I. Writings by van Gogh

Dear Theo: The Autobiography of Vincent van Gogh. Edited
by Irving Stone. Garden City, New York, 1946, 572 p.
 Selected letters from van Gogh to Theo. Stone explains
 the title of this work in his preface: "There was no idea
 or thought too small, no happening too trivial, no ele-
 ment of his craft too insignificant . . . for Vincent to
 communicate to the only other living person who con-
 sidered his every word and feeling precious. Thus Vin-
 cent wrote the story of his own life."

The Complete Letters of Vincent van Gogh. 3 vols. Green-
wich, Conn.: New York Graphic Society, 1958.
 The complete correspondence with reproductions of the
 many drawings van Gogh included in his letters.

II. Bibliographies

Brooks, Charles Mattoon, Jr. *Vincent van Gogh: A Bibliogra-
phy.* 1942. Reprint. New York: The Museum of Modern Art,
1966, 58 p.
 Comprehensive listing of writings on van Gogh through
 1940. The 1966 reprint also contains a catalog of select-
 ed works by van Gogh compiled by Alfred H. Barr in
 1935.

III. Biographies

Burra, Peter. *Van Gogh.* New York: Macmillan, 1934, 142 p.
 Sympathetic biography.

Dunlop, Ian. *Van Gogh.* Chicago: Follett, 1974, 232 p.
 Written for the general reader.

Hanson, Lawrence, and Hanson, Elizabeth. *Passionate Pil-
grim: The Life of Vincent van Gogh.* New York: Random
House, 1955, 300 p.
 Attempts to dispel the many myths surrounding van
 Gogh's life.

Lubin, Albert J. *Stranger on the Earth: A Psychological Biog-
raphy of Vincent van Gogh.* New York: Holt, Rinehart, and
Winston, 1972, 265 p.
 Views van Gogh's paintings as the products of his aber-
 rant mental states, focusing in particular on his identifi-
 cation with religious martyrs.

Meier-Graefe, Julius. *Vincent van Gogh: A Biographical
Study.* Translated by John Holroyd Reece. New York: Pay-
son & Clarke, 1928, 299 p.
 Considered the definitive critical biography.

Stone, Irving. *Lust for Life.* New York: Longmans, Green,
and Co., 1934, 489 p.
 Fictionalized biography based on van Gogh's letters.

IV. Critical Studies and Reviews

Benson, Gertrude R. "Exploding the van Gogh Myth." *The
American Magazine of Art* 29, No. 1 (January 1936): 6-16.

 Asserts that van Gogh's works prove he was brilliantly
 lucid throughout much of his artistic career, deploring
 the popular fascination with the lurid aspects of his life.

Bury, Adrian. "The Mystery of van Gogh." *Saturday Review*
150, No. 3910 (4 October 1930): 398-99.
 Focuses on the unevenness of van Gogh's output.

Cabanne, Pierre. *Van Gogh.* Translated by Daphne Wood-
ward. London: Thames and Hudson, 1963, 287 p.
 Biographical and critical study that includes numerous
 color reproductions.

Dow, Helen J. "Van Gogh: Both Prometheus and Jupiter."
Journal of Aesthetics and Art Criticism XXII, No. 3 (Spring
1964): 269-88.
 Discusses van Gogh's paintings in relation to his theo-
 logical, aesthetic, and ethical ideas.

Goldwater, Robert. "Suggestion, Mystery, Dream." In his
Symbolism, pp. 115-47. New York: Harper & Row, 1979.
 Discusses van Gogh's works in the context of the devel-
 opment of Symbolism in the late nineteenth century.

Graetz, H. R. *The Symbolic Language of Vincent van Gogh.*
New York: McGraw-Hill, 1963, 315 p.
 Study of the iconography of van Gogh's major paintings
 in relation to the events of his life.

Johnson, Ron. "Vincent van Gogh and the Vernacular: His
Southern Accent." *Arts Magazine* 52, No. 10 (June 1978):
131-35.
 Argues that van Gogh's work of the Arles period is
 "more programmatic, symbolic, literary, and conceptu-
 al" than is generally acknowledged.

Krauss, André. *Vincent van Gogh: Studies in the Social As-
pects of His Work.* Gothenburg: Acta Universitatis Gotho-
burgensis, 1983, 205 p.
 Seeks to define "the social message expressed in van
 Gogh's work during the . . . Dutch period" through an
 analysis of van Gogh's early paintings and drawings.

Loevgren, Sven. "La Nuit Etoilée." In his *The Genesis of
Modernism: Seurat, Gauguin, van Gogh, and French Symbol-
ism in the 1880s,* rev. ed., pp. 159-91. Bloomington: Indiana
University Press, 1971.
 Examines the influence of the major literary, philosophi-
 cal, and critical trends of the late nineteenth century on
 the development of van Gogh's art.

Murray, Ann. " 'Strange and Subtle Perspective . . . ': Van
Gogh, the Hague School and the Dutch Landscape Tradi-
tion." *Art History* 3, No. 4 (December 1980): 410-24.
 Argues that "van Gogh's perspectival distortions,
 whether they deviate in degree or in kind from the pro-
 jections of a Euclidean spatial structure, are present not
 only in his paintings of 1888 onward, but are latent in
 his earlier pre-Paris drawings and relate ultimately to his
 own Dutch artistic heritage."

Myers, Bernard S. "Vincent van Gogh." In his *Modern Art
in the Making,* pp. 235-247. New York: McGraw-Hill, 1959.
 Biographical sketch with discussion of the major paint-
 ings.

Nadelman, Cynthia. "Van Gogh's Light-Year." *ARTNews*
84, No. 1 (January 1985): 62-70.
 Appreciative review of the exhibit "Van Gogh in Arles"
 at the Metropolitan Museum of Art.

Pollock, Griselda. "Stark Encounters: Modern Life and Urban Work in van Gogh's Drawings of the Hague 1881-3." *Art History* 6, No. 3 (September 1983): 330-58.

Examines van Gogh's depictions of The Hague in the eighteen drawings commissioned by his uncle, C. M. van Gogh, in March of 1882.

Rewald, John. "Van Gogh vs. Nature: Did Vincent or the Camera Lie?" *ARTnews* XLI, No. 4 (1-14 April 1942): 8-11, 30.

Assesses the extent and effects of van Gogh's perspectival distortions, comparing his paintings with photographs of the scenes depicted.

————. *Post-Impressionism from van Gogh to Gauguin.* Second ed. New York: The Museum of Modern Art, 1962, 619 p.

Extensive discussion of van Gogh's life, works, and relationship to other Post-Impressionist painters. Includes numerous large-format color reproductions of Post-Impressionist paintings.

Roskill, Mark. *Van Gogh, Gauguin and the Impressionist Circle.* Greenwich, Conn.: New York Graphic Society, 1970, 310 p.

Includes general discussion of van Gogh as a post-Impressionist as well as three chapters devoted specifically to van Gogh's interaction with Emile Bernard and Paul Gauguin and its influence on the work of all three men.

Schapiro, Meyer. *Van Gogh.* New York: Harry N. Abrams, 1951, 130 p.

Discussion of the major periods in van Gogh's career. Schapiro assesses van Gogh's work as "the first example of a truly personal art, art as a deeply lived means of spiritual salvation or transformation of the self."

Stein, Susan Alyson, ed. *Van Gogh: A Retrospective.* New York: Hugh Lauter Levin Associates, 1986, 385 p.

Comprehensive compilation of early commentary, personal reminiscences, and correspondence concerning van Gogh. Includes numerous large-format color reproductions.

V. Selected Sources of Reproductions

Elgar, Frank. *Van Gogh.* London: Eyre Methuen, 1981, unpaged.

Small-format color reproductions with a biographical essay by Elgar.

Faille, J.-B. de la. *Vincent van Gogh.* Translated by Prudence Montagu-Pollock. New York: Hyperion Press, 1938, 812 p.

Complete catalog of van Gogh's paintings with accompanying illustrations, most in black-and-white.

Hulsker, Jan. *The Complete van Gogh.* New York: Harrison House/Harry N. Abrams, 1977, 498 p.

Comprehensive catalog raisonné with large-format color reproductions.

Leymarie, Jean. *Van Gogh.* Translated by James Emmons. New York: Rizzoli International Publications, 1977, 211 p.

Large-format reproductions with accompanying biographical text.

Uitert, Evert van. *Van Gogh Drawings.* London: Thames and Hudson, 1979, 238 p.

Black-and-white and color reproductions of a large number of van Gogh's drawings. Includes a biographical and critical essay.

Wallace, Robert, et al. *The World of van Gogh.* New York: Time-Life Books, 1969, 188 p.

Large-format color reproductions with a biographical essay.

Zurcher, Bernard. *Vincent van Gogh: Art, Life, and Letters.* Translated by Helga Harrison. New York: Rizzoli International Publications, 1985, 325 p.

Large-format color reproductions of many of van Gogh's best-known works with accompanying explanatory text.

Ralph Goings

1928-

American painter.

Goings is considered one of the most notable exponents of Photorealism, a style of painting in which objects are represented in a manner so realistic that the image approaches the verisimilitude of a photograph. Concentrating on such symbols of contemporary American culture as pickup trucks, diners, and fast-food restaurants, Goings produces paintings that celebrate the beauty or simple visual interest of his subjects while subtly conveying their cultural implications. Although the pure objectivity of his style has been dismissed by some as lacking in aesthetic significance, he has nevertheless gained wide recognition for his skill in selecting and reproducing evocative images of American life.

Goings was born in the northern California town of Corning, attending local primary and secondary schools and displaying a talent for drawing at an early age. After serving in the army from 1946 to 1948, he studied at the California College of Arts and Crafts, where, despite the traditionalist orientation of the curriculum, he became interested in Abstract Expressionism, which was at that time the dominant force in avant-garde art. Goings utilized the abstract style in his own paintings throughout the next decade. However, in the early 1960s he experienced a creative crisis, and, unable to complete any of his abstract canvases, he began to copy photographs as a means of recreation. Finding the results particularly satisfying, he quickly refined his realist technique, duplicating images exactly as he had photographed them by working from color slides projected directly onto a canvas.

In his early Photorealist paintings, Goings focused primarily on depictions of pickup trucks, attracted by the visual interest of their smooth, reflective surfaces. Later, he began to paint other icons of the contemporary California landscape, including hamburger stands, supermarkets, and gasoline stations. In these works, he often favored interior perspectives, continuing to exploit the visual complexity of reflective surfaces as well as the shadows and highlights that resulted from indirect sunlight. Since moving to New York state in 1974, he has painted primarily interior views of classic East Coast diners and has included human figures in his compositions for the first time. However, Goings explains that he carefully avoids portraiture in his works, treating human figures simply as part of the visual information contained in the photograph and even deleting them if they appear to dominate the composition.

Commentators frequently stress the implicit irony of Goings's work, maintaining that his depictions of shiny, mass-produced items and franchised building designs illustrate their transience and their aesthetic vapidity. Peter Frank has written, "Goings captures the deadness of the McDonald's universe with vertiginous precision." Nevertheless, Goings frequently asserts that he chooses his subjects primarily for their visual interest and pays little at-

tention to their societal implications. His goal, he insists, is to create a realistic depiction and then "to step back, be completely anonymous, and let the thing stand by itself, and have people say, 'Look at this, I hadn't noticed this before, I hadn't seen reality in this way'."

ARTIST'S STATEMENTS

Ralph Goings with John Arthur (interview date 1983)

[*In the following excerpt, Goings explains his aesthetic aims and discusses the development of his techniques.*]

[Arthur]: *The first of your paintings I can remember seeing were the women standing on boxes. That was in the 1969 Milwaukee exhibit,* Aspects of a New Realism. *But by then I think you'd already started some of the pickup paintings, isn't that right?*

[Goings]: Right.

Also, that was one of the first major exhibits of contemporary Realism. How familiar were you at the time with other Photorealists, such as Richard Estes, Malcolm Morley, and Robert Bechtle?

I didn't know what they were doing. Jack Taylor came out to see me in California when he was putting the Milwaukee show together. He had written to me and explained who he was, but he didn't say anything about the exhibit. When he arrived and we started talking about the Realist show he was putting together, I was really surprised, because I didn't know there were that many people doing Realism. I was aware of Bechtle because he lived in the Bay Area, although, at that time, we didn't see each other at all. I would see his work occasionally in Bay Area group shows, but as for the painters in the East or Midwest who were doing similar things, I wasn't aware of them at all, and I was really surprised that he was able to get enough work to mount a show based on that premise.

Had you seen any of Richard Estes' paintings? His first exhibit was 1968.

No, I had never been to New York until my first show in 1970, so I wasn't aware of what was going on in the galleries.

You were teaching in high school.

Yes, for fifteen years, then about a year and a half at Davis [University of California at Davis].

The pickups and Airstream trailer certainly moved you into the mainstream of Photorealism. How did the change from the paintings of women on boxes to the pickups come about?

This is a story I've told a thousand times.

It actually goes back further than that. Up until 1962, I was trying to be an abstract painter and it wasn't working out. I quit painting for a year. I didn't do anything because I was really at a loss. I couldn't find a direction that fit with abstraction.

Teaching in high school, you use every device and gimmick you can, and I had the kids in some of the beginning classes doing a lot of paste-up things with magazine photographs. So there were always boxes of magazine photographs around which I collected—not with any particular theme, just photographs that interested me for one reason or another. Sometimes I would make collages from them. At any rate, in 1963 I wanted to start painting again but decided I wasn't going to do abstract pictures. It occurred to me that I should go as far to the opposite as I could, which was in part an intellectual process, partly intuitive, and also because of what was at hand.

One day I was looking through the boxes of photographs in the studio and I thought, "What would happen if I were to copy one of these on the canvas, just to see if I could do it and just for something to do." It was something to occupy me because I was really at a loss, really at a low place. I picked out a photograph with a couple of figures in it and sketched them on a little canvas with a piece of charcoal and dug out what few little brushes I had (I'd been painting abstract pictures and had all these big brushes). Then I tried literally to copy the photograph on the canvas, and it was a hell of a lot of fun! I spent about a week painting these two figures, then I rummaged around in my box of photographs and found a photo of an object—and painted that on the same canvas with the figures. After two or three weeks of taking things from different photographs, I filled up the canvas. It was like a collage of photographs, all fitted together, but painted with oils. I was having a great time.

That led to a series of paintings in a somewhat more serious vein, based on magazine photographs—juxtaposed images from unrelated sources. There was no particular intent to make a comment by the juxtapositions. I was simply painting objects that looked like they would be interesting to paint. Maybe some Ritz crackers with a pretty girl from a fashion ad. There was no relationship other than a visual, tactile one.

As I did more, I got a little better and a little better, and finally the magazine ads didn't provide enough. I began to get a notion of the kind of images I wanted and spent days looking through hundreds of magazines trying to find a particular form or image. Finally it occurred to me that I could take my own photographs and wouldn't have to rely on magazines. Oddly enough, I started out with black and white.

The first part of that series of girl pictures you mentioned were done from black-and-white photographs.

You were drawing those on the canvas; you weren't projecting them?

Right. In the beginning they were just blocked in with charcoal or pencil. There was a lot of sloshing around with very thin paint to develop the drawings, but the finished paintings had a photographic look. I didn't show any of these to anyone. Most of the artists I knew in the Sacramento area were really macho abstract painters, and I didn't want them to ridicule me, so I just told them, no, I'm not working anymore. Finally a couple of them saw what I was doing and they made fun of it. I really kind of enjoyed the fact that they thought that what I was doing was so outrageous, that it was really awful to copy a photograph. So I thought, how can I make it even more awful—just as despicable as possible? It occurred to me that projecting and tracing the photograph instead of copying it freehand would be even more shocking.

First, I projected black-and-white negatives, which was pretty funny—trying to trace a negative with everything reversed. That presented a lot of interesting problems that probably could have led into an entirely different direction if I had pursued it, but I decided that if I was going to project the images, I should shoot slides so I would have a positive image. Color slides are so nice anyway. The last three or four pictures of the women were done from projected slides.

I wasn't terribly single-minded about the image. At the time I was doing the women, I was also doing other things. Some were combinations of slides and images from magazine photographs—kind of a mishmash of things. I wasn't so much interested in the image as in the process of painting it. I was learning to make the painting look the way I wanted it to look. I had a notion about how the surface should be and how the colors should look.

The notion that projecting was a despicable thing to do led to expanding on that to being as despicable as possible

about the process. To copy a photograph literally was considered a bad thing to do. It went against all of my art school training and went against what everybody else was doing—at least that I knew. Some people were upset by what I was doing and said, "It's not art. It can't possibly be art." That gave me encouragement in a perverse way, because I was delighted to be doing something that was really upsetting people. It irritated their notions of what art was, and I didn't really care if it was art or not. I was having a hell of a lot of fun learning how to paint images.

That working process has, over the years, become legitimate, at least to most people. But originally it flew in the face of the status quo. All through my career, as an art student and in my association with other artists, there was always this idea that you had to develop a painting in its total—a little bit here, a little bit there. You brought it to completion as a whole, instead of finishing one little part and going on to another. I thought, what the hell, I'll start at the top in the upper left-hand corner, and when I get to the lower right-hand corner I'll be finished. I'll do everything as right as I can get it before I go on to the next little space. It was like reading from the top down and from left to right.

You were painting the pickups at that point?

Yes.

With those paintings of the trucks, Ralph, you were depicting a commonplace subject in a specific locale, which is quite a move from the women on boxes, which were artificial and obviously posed.

Yes. The women were posed.

Those paintings of pickups and trucks really brought you into national prominence as a painter.

Most of the Photorealists have tended to pick a certain subject, and they really don't stray too far from a particular iconography. We identify them more from the subject than from style of content. I'm thinking of John Salt's wrecked cars. John Kacere's asses, and Richard McLean's horses. It's a bit superficial. How do you feel about that aspect?

I've thought about it a lot. I think it happened because we all came on the scene at about the same time. I was painting trucks, Richard McLean was painting horses, Estes was painting street scenes, and we all got tagged. If you look at our paintings side by side, there are obvious technical and stylistic differences. But the eye of the art community was accustomed to such a different kind of painting up to that point that all Realist painters looked alike. I think most people could distinguish one artist from another only by subject matter.

This has been a thorn in my side and also a stimulus, because it occurred to me that this was another one of those things: an expectancy or attitude developed by the people who look at an artist's work, which becomes a sort of tacit agreement that a painter doesn't violate. So I felt compelled to violate it by finding other subjects. At the same time it brought around a new notion about the subject matter of painting and the fact that the subject matter is important.

But I think that is a major distinction, Ralph.

Yes, it is.

Image as opposed to content. Most of the Photorealists put the emphasis on the image and seldom move their subject beyond its inherent banality. There is no subtlety or nuance. I think the big shift in your work—at least, it was the point where I really warmed up to your paintings—was when the subject and content seemed to become the dominant factors.

It's an ongoing process with me. Every opportunity to find a chink, something that was or is a no-no. If you think about it, subject matter in twentieth-century American painting has not been too important for its own sake. Well, I'm getting into trouble here because you are going to throw the Ash Can group at me, and they had a tag on significant subject matter. But most modernist thinking hasn't allowed for the importance of subject matter. The subject is simply a vehicle, a means to an end.

Clive Bell's significant form, et cetera.

Yes. So we again have realistic painting, painting that goes out of its way to "copy" reality. This is one of those knee-jerk words that I really like because the camera makes a "copy," a chemical, mechanical copy. I take the photograph and I make a copy, translating the image the camera made into a painted image that is in many ways much like the photographic image. There's an element of style there that nobody has touched on.

Along with all this, we can talk about painters like Morley who were the precursors. Morley was making a literal copy of a picture postcard or whatever, but he went to great pains to point out that the image represented was not particularly important. It was the process that was important. The subject matter depicted was simply what he happened to use. But why couldn't subject matter be meaningful in a new way?

We have scorned subject matter in the past because it got so cloying in the nineteenth century, especially with the Victorians and all of the sticky, ickyness of their subject matter.

I think the impersonal character of the photograph leads to a rather detached kind of painting in most photo-derived work, which gives us a chance to deal with the subject matter in a rather impersonal way, yet, at the same time, depicts subjects that are significant to our time and our society. It has meaning, but not in a literal or anecdotal sense. I think that Photorealist subject matter is important on one hand because it's an aspect of this particular moment.

But that has been one of the most important elements of Realism from Courbet through contemporary Realism.

Except that there's a problem in this. The element of the picturesque has to be avoided, I think. The "picturesqueness" of a subject can cancel out any potency that the subject has. I think the subject has to be mundane, so ordinary it's almost boring, before it can have any real significance as a painting.

A lot of the best Realism and Photorealism is of subjects that people ignore in a first-hand encounter. No one is really attracted to the actual streets Estes has painted.

No, and you can't see the streets the way he sees them. Even with style and emphasis aside, you can't really see

one of those particular streets as a visual feast until a piece of it is separated and put on a nice white wall. Then you can focus on it. This is the valuable thing that photography allows a painter to do—take a chunk of reality with all of its random disorder and, by putting a frame around it, isolate a little section. So what if a little piece of something goes out the side of the picture? If you were composing on a sketchpad, you'd tidy everything up, keep the prominent forms from jutting out the edges. That's the way we have been taught—not to have awkward juxtapositions. We have been taught to make them overlap or keep them apart so that it's clear what's happening. But we're able to read photographs, so when photographic information is translated into painting, it has meaning now. Before photography, it probably would not have made sense visually.

We grew up on Life, Look, National Geographic, *and the movies. Our generation in particular was tuned in to photography.*

Right. Photographs are as much a part of our environment as air.

I remember reading an account by an anthropologist who showed a primitive tribe with tattooed faces some Polariod photographs of themselves. No one could recognize himself, his wife, or his friends. But when the anthropologist showed them schematic drawings of their tattoos, they could recognize anyone in the village. Interpreting photographic information is an acquired ability that separates us not only from them but from those artists working prior to photography. A painter can move away from or toward its influence, but photography cannot be ignored.

But, to continue, were your paintings, such as the Burger Chefs *and* McDonald's, *done on the West Coast?*

Yes. They actually grew out of the paintings of pickup trucks, which were sometimes in their parking lots. It was just a matter of pulling back or moving over and there they were.

A major shift in your choice of subject matter seems to have coincided with your move to New York State in 1974. You began to include the people in the truck stops and diners. I think the fast food chains were always empty.

They were, and that was conscious.

I would assume that sometimes you were taking them out. There must have been people in your photographs.

I did. At that point I thought the human figure would be visually and intellectually more important than the environment and all the little details. I didn't want to emphasize any one element. I wanted all things equal, as they were in the photograph. The camera isn't selective. It simply records whatever it's aimed at. I wanted that same quality in my paintings, and it seemed that the camera was neutralizing the figures, but the very fact that they were people seemed to make them more important. I came around to the idea that people could work in the paintings if they were treated with as much or as little attention as everything else. They could exist compatibly with the ketchup bottles, counters, windows, et cetera. In some instances they seem to be a necessary part of the environment.

This has nothing to do with technique or style. It has to do with the look of the fast food places in California. They seemed better without the people because the dominant aspect seemed to be the inanimate objects and the light. In the West, all of them have large windows with lots of light coming in. Also, when I first started doing the fast food places, I wanted to show part of the inside, but with a view out the window so that you were aware of the environment outside. There were a number of pictures, such as the ***Kentucky Fried Chicken*** painting, in which the outside was more prominent. And there's another painting of a supermarket interior in a collection in Canada that I like even better. Through the long windows you see the parking lot and, beyond, two or three blocks down the street. That painting was really the epitome of the notion of being on the inside looking out, with the sunshine streaming in making patterns on the floor.

Then I got away from painting the windows to emphasizing an interior view, and the figures seemed to be more compatible with that space.

Another aspect of the fast food chains, such as those you painted on the West Coast, is that the entire building is a trademark. No matter which Kentucky Fried Chicken you stop at, the colors, the lights, booths, and menus are always the same.

Yes. That's why it was important to show something beyond the windows; the environment identified the location.

The big change in the subjects you're now painting is that each diner and truck stop is unique.

Well, that really struck me when I moved here. I was not familiar with the country diner as it exists in the East, especially the stainless steel diner. They aren't on the West Coast at all. The closest thing to the eastern diner in California is the coffee shop or the small cafe. But the small cafe in California aspires to be like a fast food chain. It has to do with the way it deports itself, the kind of counters and stools it has, and so forth. Whereas the diners here in the East, many of them are old buildings. Most of the stainless steel diners were made in New Jersey in the thirties, some in the twenties, so they have an element of architectural interest. They're a unique kind of enclosed space—long, narrow buildings with long counters and shiny surfaces, not very big windows in most of them. That has to do with the location.

But the new paintings, Ralph, the paintings from the past five years, I think could accurately be described as genre.

Yes, they are. I think all Photorealism is genre painting. The photograph makes the subject specific and particular, and it's verifiable. The painting depicts an everyday scene, a real place. Richard McLean's horses are specific horses, horses that are bred to show, and the owners are very proud of them. You can go to any one of the diners I've painted and say, yes, I recognize this place. You might even see the same people in them.

Maybe what I've described is genre painting of contemporary subjects, but to me one of the most important aspects of Photorealist painting is that specificity—the images are verifiable.

Another thing that struck me about Richard Estes' paint-

ings is that he has made us see aspects of the city that we have previously overlooked, which I think is a very valuable aspect. Once, in a cab in New York, I saw Helene's Florist flash past, and, of course, even with all of the street activity, I recognized it immediately, but what struck me was that the painting is silent.

Yes, and it's also static.

Silent, static, frozen, and isolated.

Well, those things focus the image for you.

When I was doing the pickup trucks, people would see the paintings and immediately start telling me about terrific pickup trucks they had seen and end up saying they had never paid that much attention to pickup trucks before. I'd always thought of them as just trucks and wasn't interested in the pickup culture. I was just interested in the way they looked.

I'm interested in the look of diners, and I'm sure Richard McLean is interested in the way horses look. That's what Photorealism is all about. Taking these things and saying, "This is the way this looks. Isn't it fantastic?"

Do you shoot a lot of slides?

Yes, lots—hundreds of them.

And very few eventually end up being painted.

Oh, yes. If I can get one slide that has possibilities out of a whole roll of film, I feel very lucky. Sometimes I get only one out of six rolls of film.

Can you describe how you decide which one you think will make a painting? Is it just the formal qualities?

It's a lot of things, I suppose. The selection is mostly intuitive. I go out for a day or take a two- or three-day trip, and I come back with six or eight rolls of film that I've shot. I send them off to be processed, and when I get the slides back, I spend a day or two projecting them in the studio, just looking at one after another. I eliminate the ones that just don't do anything for me and end up with about a half-dozen. I put those away and take them out again in two or three weeks and look at them again. Then I usually eliminate a couple more. A lot of factors are all meshed together.

One thing I've been curious about, which is a rather mundane technical question—when you're shooting interiors, a lot of the view outside the window is shown in great detail. Do you use tungsten or daylight film?

I always use daylight film—Kodachrome, never Ektachrome, which is too blue and does unpleasant things to artificial light. Kodachrome distorts artificial light—it's not naturalistic color or light—but the distortions are interesting. Ektachrome just goes all green or blue in artificial light.

Are the still lifes always photographed exactly the way you find them in the diner?

Occasionally I will turn a ketchup bottle so that the label is away from me—I've painted so many Heinz labels. But I don't change the setup because each counter arrangement is an example of the sensibility of the person working behind the counter. Each one is a little bit different. Some-

times all the salt and pepper shakers are in front of the napkin holder, sometimes they are divided with one on each side, and sometimes they are both on the right side and the ketchup bottle is opposite.

You'll notice, however, that in each diner all of the arrangements along the counter are the same. If the ketchup bottle is on the right-hand side of the napkin holder, it's on the right-hand side of all the napkin holders. Should you put it on the left, soon whoever is working behind the counter will come by and put the ketchup bottle back over on the other side. They all have worked out a routine, and they stick with it. It's incredible. (pp. 84-91)

Another thing you mentioned briefly was that things go in and out of focus in your paintings.

Yes, in the still lifes, but in the diner pictures I try to sharpen everything up as much as I can. There isn't a hard-and-fast rule for this, but focus is one of the characteristics of photography that I want to translate into painting. In . . . (**Ralph's Diner**) those objects on the counter on the right-hand side are going to be a little out of focus so that, as you move back in the picture, everything sharpens, but I want it to be gradual. I think that focus is one of the visual characteristics of a photograph that can be utilized in a painting as a spatial element.

There are other things in the photograph that I have tried to translate into stylistic painting devices. A lot of times the way the light affects an object in a photograph is contrary to our knowledge of its form in reality. I find myself drawn into accepting the way the photograph has interpreted that form as light falls on it, even if it's contrary to what I know to be visually logical. The painting ends up being a mix of photographic form and logical form, and I don't find that contradictory. It adds the kind of spiciness I like.

In the photograph, that ketchup bottle in front of the menu is even flatter than I'm making it in the painting because it's a bit out of focus, and the way the light hits it is odd. Intellectually, I can understand what is happening in the photograph, but in this case I want that bottle to be a little more substantial, whereas in the case of the two waitresses, they become one form in the photograph. Because of the highlight on the hair of the girl closest to us, and the light part of the skin on the girl facing us, it's hard to tell where one ends and the other begins. It's something that happens in photographs that you don't see in reality, and that delights me. I really like that. (p. 93)

I'm probably opening a big can of worms, but you are very successful and no one would dispute that you are a key figure in Photorealism, and yet there has been very little written about your work, a few short reviews and blurbs in books, nor have you ever had a retrospective or a museum exhibit. That's surprising.

I suppose it is, but it doesn't matter. I have work in good collections, people buy my pictures, and I make a good living. Of course, what really matters to me is making pictures, making them as good as I can. Everything else is an interesting side effect. (p. 97)

Ralph Goings and John Arthur, in an interview in Realists at Work *by John Arthur, Watson-Guptill Publications, 1983, pp. 82-97.*

INTRODUCTORY OVERVIEW

Linda Chase (essay date 1988)

[*In the following excerpt, Chase discusses Goings's work in the context of the Photorealist movement.*]

During the past nineteen years, from his first glossy depictions of Sacramento pickup trucks to his current, more contemplative evocations of rural diners and their habitués, Ralph Goings has laid claim to a quintessentially American subject matter and has created a body of work that ensures his position as one of our foremost twentieth-century realists.

There is always a small shock of wonder and surprise when confronting a Goings canvas. No matter how many we have seen in the past, we are continually struck anew not only by the clarity of his style and the effectiveness of the illusion, but also by that combination of total artistic mastery brought to bear on a commonplace subject matter that infuses these works with their unique energy and appeal. His blatantly straightforward depictions of pickup trucks, fast-food emporiums, diners, and ketchup bottles are remarkable for their exquisite detail and breathtaking verisimilitude, but they are also intrinsically modern in style as well as content. In Goings's paintings we find a perfect marriage of subject and sensibility, which enables him to capture, more than any other artist of his generation, both the physical reality and spiritual essence of America.

In the late 1960s, with such paintings as **Safway Jeep** and **Plumbing Heating Truck,** Goings established himself as one of the leaders among a group of artists, quickly dubbed Photo Realists, who were determined to portray aspects of the American scene normally considered outside the province of art through the intermediary of the photographic source. Since the invention of photography, artists have used photographs as both a tool and an inspiration in their work, but the Photo Realists were the first to unapologetically translate the information from one medium to another, to make paintings that were not simply based on photographs but were paintings *of* photographs. It was a new kind of realism, characterized by a cool, radical objectivity in regard to what was being portrayed, combined with an intensity in relation to the act of painting itself—and to the act of seeing directly, unhampered by preconceived notions about the image or, for that matter, about what art ought to be.

Mavericks who spawned a maverick movement, these artists tended, like Goings, to develop outside New York, away from the mainstream of the art world, and they tended to be unaware of each other's work during the developmental stages. The dominant fact in the artistic lives for this generation of artists was the near total eclipse of realism by abstraction. For these emerging artists the freedom heralded by Abstract Expressionism—with its idealization of innovation and self-expression and rigid interpretations of what constitutes the province of the "real artist"—quickly became a trap. The use of the photograph offered a way out of these bonds for the Photo Realists;

it offered neutrality as opposed to self-conscious self-expression, and a new schema for representation that was in direct contradiction to the concerns of traditional realists, for whom the personal, idiosyncratic translation of the three-dimensional object in the real world to the two-dimensional plane of the canvas is the central concern.

Photo Realism is fundamentally different from traditional forms of realism, and the photograph is central to that difference: it is both symptom and cause. The wholesale and wholehearted acceptance of the photographic source and all that this implies in terms of underlying philosophy, attitudes toward art-world prejudices, and the visual context in which we live, is intrinsic to these artists' intentions and to our understanding and appreciation of their work. With the use of the photograph, which both registers this change and helps to achieve it, the Photo Realists altered the artist's relationship to subject matter.

In its use of photographic material, its incorporation of banal subject matter, and in the return to recognizable imagery itself, Photo Realism owes a debt to Pop Art. But the Pop painters were concerned with capitalizing on the connotations of their imagery, often juxtaposing images to enhance their signification and reveal their subliminal meanings, and they were often satisfied with a rough, almost shorthand approximation of the image. Although both of these movements used imagery to challenge the sway of abstraction, the Pop artists maintained the artist's subjective relationship to subject matter and the denial of true illusionism. The Pop artists were dealing with images as prototypes; the Photo Realist, on the other hand, is interested above all in specificity, in portraying with loving attention to detail the uniqueness of a given moment or situation as captured by the camera.

Photo Realism is an art of many ironies—not the least of which is that the artist seeks a directness in relation to the visually experienced world through the use of secondary source material, and that he achieves a heightened sense of reality by reproducing an illusion of an illusion. With his use of the photograph, the artist actually gains a double immediacy. The mechanical nature of the camera enables him to achieve the impartiality he seeks, while at the same time imparting a compelling sense of the present moment. The medium of photography itself is the apotheosis of the coexistence of two opposing principles, the permanent and the instantaneous.

The decision to embrace a full-blown illusionism based on a photograph was an anti-Modernist, or more precisely, a Post-Modernist impulse: an impulse that responded to Modernist dictums against borrowing from other mediums and the use of imagery, which denies the flatness of the picture plane, with a resounding "Why not?" Coming of age in the Modernist era, these artists were far from aloof from Modernist concerns—and they shared with the Conceptualists and Minimalists a predilection to see art-making as a decision-making process that was, at its core, a paring down of options. It was as if artists of the period were responding through their work to the question raised in the writings of such critics as Joseph Kosuth and James Collins: *how much can we take away and still have art?* Goings talks about his desire to choose and to limit the arena in which personal conscious decisions come into play in his art, and the decision to paint from the photograph was,

Dick's Union General (1971)

at least in part, a decision to eliminate certain kinds of choices.

The selection of a subject matter and of particular scenes to photograph and the decision of which slide to paint, all, of course, involve choices on the part of the artist, but for Goings, these are choices made primarily on the intuitive level, and clearly his instincts have served him well. In his paintings of the early and mid-seventies, he brought to us a world of glass, metal, and Formica that glittered in a bright, intense, yet eerily cool California sunshine. A master at recreating the variations and modulations of sheen, he revealed in his trucks, drive-ins, and fast-food eateries a glamour that was at once both spurious and real: a glamour of harsh reflective surfaces that seemed to be a mirror of our time. **Kentucky Fried Chicken,** a quintessential Goings painting of this period, is a virtual rhapsody to reflective surfaces. The glossy Formica table and booths in the foreground lead our eye through the gleaming plate-glass window of one fast-food place to the panoramic view of yet another. These places are remarkable to look at, his paintings told us—and although our cultural predispositions often made us reluctant to admit it, we had to agree.

Goings has always been unabashedly and unashamedly interested in the surfaces offered to us by the modern world,

and in the kind of visual situations created by the play of light as captured by the camera. As he said in an interview of the early seventies [see Further Reading], he was drawn to his subject matter not because it was beautiful but because it was "terrifically beautiful to paint"—and clearly this commitment to and fascination with the variegations of the visual world is everywhere apparent in his work. Underlying this, however, is an equally evident desire to confront the coexistence of beauty and banality. The Photo-Realist impulse has always encompassed a desire to revalue what we as a culture find easiest to dismiss.

The world of Goings's early work, with all its synthetic purity, was a world essentially without people; this was a necessary aspect of the distance he wanted and needed to create between himself and his imagery in order to see and reveal it with a new and potent objectivity. In seeking subject matter that was as modern as his method of depicting it, Goings, like other Photo Realists, looked to the artifacts of the modern world. The figure was in one way too "hot" a subject matter—and in another way simply not the point.

In the late seventies, with such paintings as *Twin Springs Diner* and *Pee Wee's Diner,* the figure became a major element in Goings's work for the first time. The change came

shortly after he moved from California to New York State and discovered the diners as a fertile area for exploration. For the first time, the people seemed a necessary part of the scene—as natural as the chrome stools they sat on or the salt and pepper shakers on the counter in front of them. The sun is not as bright in these New York scenes, but in its pale shimmer there seems to be more warmth. The introduction of the figure brings to the paintings a new sense of intimacy and raises new issues in terms of both the artist's and the viewer's relationship to the subject matter.

The figure—particularly depicted in a non-studio, "real life" context—carries the potentiality for anecdote and tends to elicit a kind of interest and emotional response in the viewer that is very much outside Going's intentions as an artist. Our innate predisposition toward the human form creates a hierarchy of interest that his dispassionate handling seeks to deny, or at least refuses to abet. The overall evenness in surface, in tonality, and in detail that he has sought since his first Photo-Realist paintings (and which is a characteristic of the photographic source) is even more crucial here.

The people in these paintings tend to be ordinary blue-collar, working-class types: people you might see in any small town. They are caught at casual, unimportant moments—usually at rest or lost in thought. There is nothing dramatic or idealized in the way they are portrayed, nothing significant in their position or stance. On the other hand, they are never allowed to become generalizations; they represent no one but themselves. They may be workers, but there is no sense that they are besieged, downtrodden, or especially admirable. Like everything else within the frame, they simply are. There is none of the sentimentalizing of such genre paintings as Sir Hubert von Herkomer's *Hard Times,* its laborer cutting a noble profile as his weary family rests by the side of the road; or Henry Wallis's *The Stonebreaker,* who lies overcome by his toil. One sees none of the romanticization of the laborer and his labor found in William Bell Scott's *Iron and Coal* or even in Gustave Caillebotte's *The Floor-Scrapers.* Nor is there the sense of lonely desolation so characteristic of Edward Hopper's treatment of similar subject matter. If Goings's work presents a Post-Modernist illusionism, it also confronts us with a post-humanist figuration. There is no hierarchy of objects in these paintings, no meaningful or unmeaningful space.

Yet, in the fine-art context of the paintings, these ordinary people become striking in their ordinariness. The very process of choosing something out of the vastness of experience inevitably gives it a new weight. The balance that must be maintained between focusing his attention on such an essentially charged subject and yet preventing this attention, in spite of the artistry of his portrayal, from appearing to grant an undue emphasis, has presented Goings with a new and provocative challenge—one that has resulted in a broadening and deepening of his achievement. Paintings such as ***Collins Diner, Blue Diner with Figures,*** and ***Diner with Pink Tile*** are masterpieces of painterly and artistic integrity and control. The richness of the visual information; the natural, "found" complexity of the composition; the dynamic interplay between the figure and the other visual elements; and the dispassionate perfection of the execution, enhance each other to create a synergistic balance and surface tension that give these works their tremendous power.

Goings explains how he came to paint his first picture of a pickup truck:

I was invited to participate in an annual group show in one of the galleries in Sacramento, and every year they had a theme. This particular year the theme was "Views of Sacramento." And I thought, you know, *views!* I was well into the concept of working from photographs, and I went out with my camera to try to find a view of Sacramento. At first you think in terms of obvious things, so I was thinking of a cityscape, but I couldn't find anything I wanted to take. At that point in my career I was not invited to participate in a lot of shows, and this was a big thing for me, but it was also problematical because I hadn't really formed a specific direction yet and so it was intruding on me. I went out for two or three hours one day with no results. I was sitting in my car in a parking lot thinking, should I go home and forget all this or should I go down to the levee and take some pictures of the Sacramento River. And I looked over and there was this pickup truck that someone had really overcustomized. It was painted shiny black and chrome and had decals and stripes and outrageous things. It was a piece of sculpture. . . .

I decided to take a couple of pictures of that truck because it was a magnificent job. So I got a couple of shots of it, and then I looked around the parking lot—and half the cars in the lot were pickup trucks. I thought, what the hell, I'll just take some pictures of these trucks—if Ed Ruscha can document all of the apartment buildings on some street in LA, then I can document all the pickup trucks in Sacramento. I wasn't thinking of it as the subject matter of a painting.

When I got the slides processed and looked at them, I thought, I've got something here. I've got to paint one of these. I was so excited about painting this object that I wasn't even thinking of it as something for the show. I finished a week or so before the deadline, and one of the guys from the gallery called and said that he was going to be in my area and if I had something for the show he would pick it up. I showed him the pickup and he said, yeah, I don't see anything wrong with that. Looks like a Sacramento scene, why not? So I put it in the show and got some good responses, and in the meantime I'd already started another truck picture.

Ralph Goings, in an excerpt from Ralph Goings *by Linda Chase, Harry N. Abrams, Inc., 1988, pp. 22-3.*

No matter how factual or unemotional, a painting can never be truly anonymous. The artist may use the photograph to prevent himself from distorting the subject matter with his sensibility, but it will be filtered through that sensibility nevertheless. As E. H. Gombrich observed: "What a painter inquires into is not the nature of the physical world, but the nature of our reactions to it." What comes through in Ralph Goings's work itself, and in all of his comments about it, is a sense of harmony—a oneness of thought and feeling, form and content, intention and execution. He is at peace with the world he chooses to depict—and with the challenges he has set up for himself and for us. But it is a harmony that is, nevertheless, infused with a dynamic tension. . . . Goings has always enjoyed treading on "dangerous" ground artistically, and it has consistently proved fruitful. But if he is a rebel, he is not an embattled one; and though he has chosen the role of dispassionate chronicler, he is far from cold. His is a clear-eyed vision married to a painstaking and loving execution. (pp. 7-15)

> *Linda Chase, in her* Ralph Goings: Essay/Interview, *Harry N. Abrams, Inc., Publishers, 1988, 120 p.*

SURVEY OF CRITICISM

Gerrit Henry (essay date 1970)

[*In the following review of Goings's first solo exhibition, Henry comments on the quality and visual interest of Goings's technique.*]

Painter Ralph Goings had his first one-man show at O. K. Harris downtown this past month. This Sacramento-based photographic realist takes as his subjects various American landscapes as seen by the camera eye; creativity becomes involved in the metaphysical space between photograph and painted canvas. Formally, Goings' work is superb: the colors he applies to his motels and airports and shiny aluminum trailers are not those that would be recorded by the camera, and therefore can be seen as being more than slightly idiosyncratic (to whatever end); the arrangement of "real" elements, advertisements, buildings, reflections on shiny and dull surfaces are classically worked out and, except where a certain "focusing" necessary to photographic "trompe l'œil" gets in the way, are flawlessly complementary. As with Ingres' delicate portraits, this flawlessness was unsettling: although Goings' tones are less electric than those of his photo realism colleagues, the pinks, peaches, tans and slate blues used repeatedly toted up to a kind of anxious blush, as if a Hopper canvas had overheated. Two of the pictures in particular stood out: one, a close-up of a blue truck parked in front of a wall, echoed in its arrangement of Pepsi bottle-top ads and similarly colored, window-reflected signboards the sort of diluted Cubism Times Square at night seems prone to. The other was notable for making a social commentary that arose *from* the formal rigors of painting rather than defeating them; this canvas was a rendering of a flag and flagpole standing next to a roadside McDonald's stand, the red-and-white striped pattern of the flag being carried out compositionally (and *really*) on the exposed side wall of the restaurant. This putting the whole idea of "composition" to question is an achievement the photo realists are, or should be, notorious for: it is absolutely true that McDonald's stands have side walls that are painted like the American flag, yet few of us have probably ever noticed the fact. Any number of conclusions can be arrived at from the exhibition of this perception; the technique of painting from photographs has given the artist the opportunity to remain true to a traditional ideal while exposing it, to unveil the final results (as they are worked on the *natural* landscape by lesser minds) of the artist's admittedly "imperialist" soul. Evidently the space Goings inhabits between the illusion of the photograph and the illusion of the painted surface is a reflective, and therefore a possibly moral one.

> *Gerrit Henry, in a review of "Ralph Goings,"* in Art International, *Vol. XIV, No. 9, November 20, 1970, p. 71.*

William C. Seitz (essay date 1972)

[*An American artist and respected critic, Seitz was the author of numerous studies of modern art. In the following excerpt from his essay on the Photo realists, he praises Goings's technical accomplishments and comments on the statements implicit in his choice of subject matter.*]

Ralph Goings, who in 1968 was painting straightforward studies of students that resemble those of [Wayne] Thiebaud (though they were derived from photographs), soon turned to franchise lunchrooms, gasoline stations, parking lots and, with special success, pickup trucks. Such pictures contain as little overt clue to his attitude toward his subjects as those of [Richard] Estes and, though entirely different in personal style, are painted with an equally disciplined but affectionate craftsmanship that can make ugly or mundane subjects almost lyrical.

Among the primary hallmarks of the best Radical Realism are superbly professional use of the medium, whether oil or acrylic, brush or air gun, and perfection of both mechanical and optical detail (or controlled variation and blurring of photographic focus). In these qualities, as well as in the choice of mechanical subjects, we are seeing an updating of the "Immaculates" of the 1920s. Except that everything in sight in a painting by Goings . . . has been scrupulously swept and dusted, and every detail of his trucks and automobiles (like the steel and glass in Estes' scenes of New York) is factory-new and polished, these environments are those we pass through daily, usually without looking at them. His immaculate images somewhat resemble sterilized automotive advertising, except that happy consumers, mountains and sunsets are absent and the vehicles are presented in a workday, utilitarian situation. But more has been altered—for example, in *The Blue Jeep* (1969)—than sweeping and polishing. Common artifacts and effects have been formalized, most conspicuously in the beautifully formed shadow of the truck, the relation of the verticals of the superstructure of its bed to the posts of the porch, and the opposition of these to the horizontal building lines. The surface of the canvas is so glassily obliterated that, in a reproduction, it is hard to see

it as painted by hand. Yet in viewing the originals, the paint surface evidences a sensuousness, however muted, like that spoken of by Thiebaud. A surrogate nature still exists in the tree at the upper right, but only as a patterned remnant. *Airstream Trailer* (1970) has a strange, surreal presence. Each dent in the aluminum surface provides an occasion for a play of light and dark, for passages of fine, essentially abstract tonal painting. Isolated on a desert lot, this gleaming artifact of the sixties, it seems, is presented for examination as if in it were concentrated the value system of an entire culture. Such a response is subjective. Objective depiction ("no invention at all," to use Chuck Close's phrase) is a razor edge, and interpretation is affected by the viewpoint and background of the spectator, both personal and social. It is also colored by both the objects and situation presented and the group or society which they reflect, as well as by standards of visualization, style and quality. Most of the Radical Realists sidestep questions concerning socially critical intent; but the subjects they choose, and their anti-art manner of presentation itself, belie total neutrality. (pp. 68-9)

> William C. Seitz, "The Real and the Artificial: Painting of the New Environment," in Art in America, *Vol. 60, No. 6, November-December, 1972, pp. 58-72.*

Peter Schjeldahl (essay date 1973)

[*In the following review, Schjeldahl notes the limitations of Photorealism but commends Goings's skillful manipulation of its essential elements.*]

Photo-Realism is making its niche with the relentless drip of water on sandstone. With a regularity exhausting any possible opposition, nearly every month brings the debut of a new opaque-projector prodigy or the latest show by a relatively veteran member of the movement. It is an oddly undramatic process, more like an intensifying gravitational field than an accelerating force. It is also a phenomenon very much in key with the mood of post-Vietnam, mid-Watergate America—disgust with the many excesses of faith and optimism, or apocalyptic pessimism, of the past decade. The no-comment factuality of Photo-Realism has at its back the renascent moral glamor of "the truth," meaning the commonsense facts.

In its "pure" form, Photo-Realism mobilizes the whole available technology of painting—or, as Ralph Goings has modestly and shrewdly said, of "rendering"—to produce a simulacrum of commonsense facts as devoid as possible of sensibility. Certainly no one is more purely a Photo-Realist than Goings, and his recent show of Sacramento roadside scenes, rather fancily called "Apropos of Sacramento," might serve as a touchstone for the style. Apropos or not of Sacramento—as opposed to any of a thousand other gasoline communities—his expert pictures of diners, drive-ins, supermarkets and parking lots are quite piercingly pertinent to a consideration of what is happening to realist painting these days. In these pictures there is a steady expansion of technique and a steady suppression of "interesting" form and feeling.

Even the spectacle and irony that characterize the leanest Pop Art are absent from the work of the pure Photo-Realist. The "emotion" of Goings's pictures is sheerly one of absentminded absorption in the act of looking. Nor is there any of that self-conscious fussing about the look of the photograph or photographic reproduction that smacks of old-fashioned modernist esthetics in the work of many Photo-Realists. Goings has given himself over to his subject matter, and his subject matter is not art. It is a subject matter, moreover, increasingly drained of the kind of sentimental attachment that invites identification. Goings is no longer the poet of the pickup truck.

In the most striking of his recent paintings the view is from the inside of a diner or fast-food emporium, looking out: background sunlit, foreground in shadow. This may sound like a small novelty, but its effect—of locating the viewer in a particular space and distancing him from the most vivid details—seems significantly canny. The result is a greater equalization of emphasis among all the elements of the picture, a sort of built-in confusion factor that makes the painting truer to the experience of seeing than is possible in even the most casually come-upon outside scene. Also significant is a tactful down-playing of such typical Photo-Realist flash effects as multiple reflections (they are there, but faintly).

Goings is less successful in his struggle with what may be the classic problem of Photo-Realists who have eschewed the appearance of the photograph: the handling of atmosphere. Perhaps there is simply no way for a meticulous painter of surfaces to render atmospheric haziness without having it look phony. (I have yet to see a Photo-Realist picture in which the sky color is convincing.) The same may be true of flesh, judging from the tackiness of the few figures Goings has introduced into his previously deserted views. Unsolved problems aside, however, it is clear that Goings's comprehension of the nature of the Photo-Realist enterprise is among the most rigorous and complete so far. He is an artist of finesse and subtle abnegations. (pp. 111-12)

> Peter Schjeldahl, "Ralph Goings at O. K. Harris," in Art in America, *Vol. 1, No. 2, September-October, 1973, pp. 111-12.*

American Artist (essay date 1980)

[*In the following excerpt, the critic discusses Goings's artistic aims and working methods.*]

"My paintings are all about me and the world I live in." And that world, the world that Ralph Goings shows us, is a rich, insightful look at the culture and trappings of middle America. From the early Goings pickup trucks to the fastidiously painted fast-food interiors, his paintings are as solid and vital as the people he depicts. Whether hunched over their coffee cups or conversing with a waitress, his subjects are intimate reminders of an environment we all share.

Ralph Goings is a man who feels a deep dedication and zeal for the entire process of painting. His ideas regarding the photograph and its translation onto canvas were formulated over a fifteen-year period of painting and teaching. During this time he was immersed in the philosophy of modernism, which he eventually viewed with enough skepticism to give up his own abstract imagery and experiment with what would evolve into his present Photo-Realist style.

From his earliest abstract works, Goings had always used photographs for reference and information. But in 1965 he began to photograph pickup trucks—not dusty, dented, farm trucks, but spit-and-polish, chrome-embellished pickups that are a status symbol in Northern California.

Although he admits to not being a "truckaphile," he found the shapes, variation of color, parts, and models intriguing—as well as the idea of painting from a photograph. By translating the photographic image into a painting, Goings creates a tension based on the viewer's ability to read the painting two ways; we see the final image as an arrangement of shapes upon a flat surface and as an illusionary depiction of objects in space.

"I wanted to paint from a flat, two-dimensional surface. There was something there that interested me in the way images looked that were derived from a photograph as opposed to reality."

In his early realist paintings, every detail from the photograph was rendered on canvas. Nothing was left out. The painting appeared almost as a photo-facsimile. "I used to say: 'I put in everything that's there and don't leave anything out or change anything.' But that's not true anymore. My attitudes have changed, the way I work has changed. Everything has changed in the last ten years." . . .

For years Goings felt that the truck imagery held enough interest for him to continue painting it indefinitely. "There was a time when I thought I would paint pickup trucks forever because growth and development in painting can be gotten by using the same image. I believe that there's a big difference between painting the same *image* and painting the same *painting* over and over."

But eventually his view began to include not only trucks but the environment around them. Exteriors of fast-food buildings around which trucks corralled became his focal point. From there his eye moved inside to the gleaming counters, neat rows of plastic covered chrome stools, and the other accoutrements of no-nonsense eateries. But perhaps the biggest change in his subject matter was the eventual inclusion of people in his paintings—people who take their eating seriously but don't waste time doing it. People, as in **Tiled Lunch Counter,** who are caught in situations that are as everyday as the food they eat; and although many of these most recent paintings may not feature trucks, their presence is felt just the same.

As Ralph Goings's subject matter changed so did the way he worked. He began to reassess the photographic image that he once rendered so faithfully from photo to canvas. Now he began to alter, add, delete . . . enriching the image with more of his own personal vision. (p. 64)

[Goings] describes his work as being in two phases—photography and painting. "The camera is an important tool, as important as the paintbrushes or tubes of color." And the taking of the photograph is where the painting begins. "It's like my sketchbook or preliminary drawings. It's the first step, not isolated or separate, just another integral part of the whole process."

Goings maintains that it's important for him to take his own pictures. "Everyone works differently. I go into a place, order a cup of coffee, and shoot a roll in ten minutes.

I have a motor drive on my camera. I just aim, focus generally at segments of the area, and shoot. I take the photo intuitively and often when the slides come back I discover a lot of things I didn't see when I took the photo. A lot of formal structure appears there naturally without moving anything around."

While Ralph Goings looks for subject matter with strong visual appeal showing various aspects of working-class America, he's not interested in making sociological statements. Of greater concern to him is the quality of light. He explains: "I look for situations that have an interesting light potential as I'm more concerned with light than mood. But the light isn't the only factor; I'm concerned with the objects, the people, the whole situation.

"It bothers me that I must be controlled by the weather. I'm always thinking of alternatives, either staged shots, artificially lit, or dealing with imagery on a dark, gloomy day." (pp. 64, 95)

He shoots a tremendous number of slides so the sorting-out process is very time-consuming. A selected image will usually be projected onto any of the four canvas sizes he uses (the canvases range from 4 ft. x 5 ft. down to 24 in. x 32 in.). The slow, meticulous drawing of the image onto the canvas takes him a full day to complete. "I want the drawing onto the canvas to be as impersonal and unartistic as possible. The drawing is only a guide, much like a grid." For this reason Goings includes as much information as possible even though he may later delete areas or change them.

For color reference he uses an 8 x 10 color photograph as well as the slide. "The painting goes beyond the photo but I need it for a starting place." . . .

He enjoys the struggle of manipulating the paint in a variety of ways, working whole days on an area that he may later take out. He knows exactly what he wants, exactly how each passage should look, and doesn't take short cuts to achieve that.

In the end one is struck not by how much time or challenge went into a Ralph Goings painting, but by the richness of his Vermeer-like still lifes of ketchup bottles and saltshakers and how much of ourselves we see in his intricate compositions of diners, half empty but full of powerful light and tension. (p. 96)

"Ralph Goings," in American Artist, *Vol. 44, No. 451, February, 1980, pp. 64-5, 95-6.*

Pepe Karmel (essay date 1980)

[*In the following excerpt, Karmel discusses the evolution of Goings's style, praising the implicit humanism of his later works.*]

Within the circumscribed limits of its usual subject matter and technique, Ralph Goings's work has undergone a slow and subtle transformation. A new luminosity now fills his images, a brilliancy and clarity of color uncharacteristic of paintings that merely attempt to reproduce the effects of photography. Too much is visible, neither in a photograph nor with the naked eye would we perceive so clearly. Thus there is an eerie edge to Goings's pictures:

they seem perfectly normal and yet abnormal all at once. Super Realism here approaches Surrealism.

Transferred to painting, the characteristics of photography change their significance. When fragments of background appear out of focus in still-life photographs, we tend to ignore such areas. But when Goings paints them in a manner that mimics the out-of-focus effect, we are forced to confront the illogic of our tendency to accept that illegibility. In his pictures we can read these areas only as swatches of pure paint; the self-consciousness characteristic of abstractionism thus reappears, as it were, in the margins of Goings's Super Realistic technique. His pictures owe almost nothing to the traditional realistic quest to reveal the structure of the object through its illumination. The "photographic" light defining Goings's objects is only haphazardly related to their essential structure. In a particularly lyrical painting of a coffee-cup and a slice of pie, blue shadows mount diagonally across a white counter toward the picture frame. Nothing we see in the picture accounts for these shadows, though we accept their existence within the composition. Once again, an abstract reading of the picture becomes relevant.

Goings's diner interiors seem like a commentary on Renaissance perspective. His counter-top edges aim straight at an appropriate vanishing point, while the diminishing ellipses of his stools demonstrate a mastery that Leonardo might have envied, even though it is a technical commonplace today. These diners are too clean, too perfectly organized, too luminous, too shiny—in short: too beautiful. The only light-absorbent, imperfect objects in them are the human beings. In Goings's earlier pictures there might be several customers in a diner, and someone behind the counter. In the new pictures there is never more than one person to a diner, the sole inhabitant of a mysteriously deserted world. This isolation heightens the contrast between human imperfection and the effulgent perfection of the chrome stools, coffee machines, and wall paneling. As if to stress their blemishes, Goings's characters are often old or obese. The strongest and most recent picture in the show has a black worker alone at a blue and silver counter. He bears the familiar stigmata of imperfection: a paunch, a too small T-shirt that doesn't reach his pants in back. For an awful moment one is tempted to think that his blackness too is being opposed as a sign of inferiority to the luminousness of the diner. But here the antithesis reverses itself: the man, depicted in the pose of Rodin's *Thinker,* becomes a symbol of strength and life, implicitly condemning the cold brilliance of the metal-clad decor.

The man's dark head is almost lost in the darkness of a doorway opening behind him, as if to suggest that to go on from here we have to abandon superficial brilliance and advance into the darkness of the unknown and the human. (pp. 151-52)

Pepe Karmel, "Ralph Goings at OK Harris," in Art in America, Vol. 68, No. 5, May, 1980, pp. 151-52.

FURTHER READING

I. Interviews

O'Doherty, Brian. "The Photo-Realists: 12 Interviews." *Art in America* 60, No. 6 (November-December 1972): 88-89.
 Includes an interview in which Goings explains his aesthetic aims as well as his relation to other Photorealist artists.

II. Critical Studies and Reviews

Battcock, Gregory. "New York." *Art and Artists* 8, No. 89 (August 1973): 48-9.
 Positive assessment of Goings's paintings.

Karp, Ivan. "Rent Is the Only Reality; or, The Hotel Instead of the Hymn." *Arts Magazine* 46, No. 3 (December 1971-January 1972): 47-51.
 Includes Goings in a discussion of the aims and techniques of various Photorealists.

Marandel, J. Patrice. "The Deductive Image: Notes on Some Figurative Painters." *Art International* XV, No. 7 (20 September 1971): 58-61.
 Compares the techniques of several Photorealist artists.

III. Selected Sources of Reproductions

Chase, Linda. *Ralph Goings: Essay/Interview* New York: Harry N. Abrams, 1988, 120 p.
 Includes numerous color reproductions of Goings's paintings as well as an introductory essay by Chase (excerpted above) and a lengthy interview with Goings.

Alex Katz

1927-

American painter.

Katz has been acclaimed as one of the most significant contemporary American painters. Schooled in an era dominated by abstraction in art, Katz flaunted fashion and instead developed a simplified representational style best exemplified by his large-scale portraits of his family and friends in the New York art world. However, critics note that despite their overt delineation of content, his compositions also reveal a sophisticated awareness of both abstract and Modernist formal concerns, and Richard Marshall has written that "Katz's astonishing achievement is to have reconciled abstraction and realism in post-World War II America."

The son of Russian émigrés, Katz was born and raised in New York City. He began painting watercolors when he was just five years old, encouraged by his parents, both of whom were artistic by nature. Katz later spurned their advice, however, and attended a vocational school instead of high school, motivated by his desire to become a commercial artist. After serving in the navy at the end of World War II, Katz studied at the Cooper Union School of Art in New York, where he gradually shifted his focus to the fine arts. By 1949, when Katz received his certificate from Cooper Union, he was committed both to painting and to a representational style. He further developed his style under the tutelage of Henry Varnum Poore, his instructor at the Skowhegan School of Painting and Sculpture in Maine, where he studied the following two summers.

During the 1950s, Katz experimented with a variety of representational approaches and formats, including collages and cut-outs. His early paintings were typically landscapes and light, airy interiors that bore a resemblance to Impressionist and Post-Impressionist French paintings. In particular, critics cite Henri Matisse as a principal influence on the young Katz, based on their mutual preoccupation with color. Although he never strayed far from figuration, Katz also absorbed many of the ideas of the Abstract Expressionists, especially the all-over patterning of Jackson Pollock, whom the young Katz greatly admired, and Mark Rothko's notion of "color as weight." Katz distilled these disparate influences into a unique, aesthetic vision, creating realistic figurative paintings that are distinctly modernist in their use of flattened space, their lack of painterly detail, and their large, simplified forms. According to Lawrence Alloway, Katz evolved a unique style that drew on European models and his own American perspective: "European painters provided Katz with precedent and information, whereas America provided a sensibility, the set of values through which they had to be filtered."

In the late 1950s and early 1960s, Katz began painting large-scale portraits, a direction many critics describe as a pivotal breakthrough in the artist's career. The wall-sized paintings, commentators argue, allowed Katz to successfully reconcile the conflict between the realist impulse

manifest in his representational approach and his abstractionist concern for form by enlarging his subjects' features to a point where their compositional implications became obvious. According to Irving Sandler, Katz "achieved a new style which was at once an embodiment of his unique artistic personality and an opening toward a fresh and major direction in the art of our time." Katz's paintings of enlarged heads in a simplified, iconic, almost cartoonish style, led many critics to note the influence of Pop art on Katz's work of this period.

Katz is most often remembered for his single and group portraits, including numerous studies of his wife, Ada, and his son, Vincent. For his other subjects Katz chose predominantly his friends from the art world and typically rendered them in social situations. Two of his most famous and highly regarded works are *The Cocktail Party* and *The Lawn Party* (both 1965), large-scale paintings (eight feet wide) that capture the aura of relaxed glamour conveyed by these art-world celebrities. Because of Katz's stylized presentation, such works also maintain an emotional distance, sometimes to the consternation of critics. John Russell wryly comments on Katz's tendency to focus on the beautiful: "If we had to be reincarnated, one of the better ideas would be to come back to life in a painting by

Alex Katz. The weather would always be good, there wouldn't be an ugly or disagreeable person in sight, and every house would be in decent repair." Katz also painted flowers, in the same simplified, enlarged manner that he employed in creating his portraits. In addition, he has been involved in printmaking, set design for theater and dance, and has illustrated several books of poetry.

Since his first individual exhibition in 1954 at New York's Roko Gallery, Katz has become one of the most frequently exhibited contemporary American painters and examples of his work hang in major museums throughout the world. In 1986, the Whitney Museum of American Art in New York presented a thirty-year retrospective of Katz's work. In addition to his painting, Katz has taught at a number of art schools, including the Skowhegan School, Yale University, the Pratt Institute, and the University of Pennsylvania. He has also won numerous awards, including a Guggenheim Painting Grant in 1972.

ARTIST'S STATEMENTS

Alex Katz with Gerrit Henry (interview date 1975)

[*In the following interview, Katz discusses his understanding of modern portrait painting and the impetus that led him to adopt a figurative style in an era marked by abstraction.*]

[Katz]: If you work strictly in the portrait form, the likeness is a factor in how good the picture is, strangely enough—if you don't have a good likeness, you don't have a good picture. That's up to a certain point—past that point, you can squeeze the painting to death on the likeness. You can wreck a painting very easily if you get obsessive about likeness.

When I started doing portraits, it was around 1957—at that point it seemed questionable whether you could make a valid painting that was a portrait—a modern painting, so to speak. I studied at Cooper Union, and I had done a lot of drawing from casts even before I went there. I had done a lot of academic drawing. But the kind of drawing I needed for my painting I had to reinvent. After that I stopped drawing, and I've only taken it up again very recently, after almost 20 years of not drawing. Painting from life—realistically—I had no experience with. It took me a year or two years to figure out how to paint well—to get the expression in the eyes.

In 1957, I was doing still-lifes, interiors and landscapes that ended up extremely spontaneous. I started to think this was a very shallow value, and I wanted a vehicle to get into something else. I remember, in the early '50s, I was in a cafeteria at four in the morning after a party, with a bunch of people on Fourteenth Street—you can imagine how gruesome that looked. There was a guy there, a painter, who was talking about never wanting to show his paintings on brick walls—it was very amusing—he really wanted to show them on velvet, which for that day was pretty unique. And he said that really what he wanted to do was

"get the expression in the eyes right." I thought that was the wildest thing I ever heard. I thought—hold on, well, let's see if I can get the expression in the eyes right. So I started painting from life, and the painting technique I'd had collapsed—it broke the whole way I had been painting, and I had to build up a new technique.

[Henry]: *The minute you say expression, even the expression in the eyes, you're introducing a human—*

A human value, that's precisely it. I wanted to break the painter part so that it wasn't all even strokes. It became so that some strokes were denser, and others were more open; the whole thing became less precious, the painter-surface that you went over and over.

Do you have to have a strong feeling for your sitters? To paint them?

Generally, I do people I know, and people I find interesting enough to want to spend a couple of hours with.

Do you feel you're idealizing or ennobling them?

I guess I've been accused of that. I don't know how to answer that . . .

Well, certainly you're not going after anti-beauty, as it seems some of the Photo-Realists are.

Well, realism that has to do with 19th-century ideas of truth makes life sordid, and I've always found that idea terribly sentimental. So . . . sometimes I might be showing things at their best moments—under the best possible conditions—but that's as real as anything else. And to me, it doesn't make that ghastly error of sentimentality under the guise of "brutal realism."

As anyone knows, appearance is a variable—it's not a constant, whatever it is. You come to it with your philosophical attitudes towards life.

I have a weakness for painting beautiful people. I enjoy painting beautiful people of all kinds. It's a sensual thing—it has something to do with the person, but it's not necessarily falling in love with your sitter. You know, it's possible to fall in love with your sitter for two minutes, or a minute and a half . . .

When you're involved in portrait painting, it's an optical thing, an optical form. And the form is the end, almost—it's a real challenge to paint in that form. Any digression from the form—like painting from a photograph—would be to me an intellectual compromise of that form. The portrait form is where the challenge is. It's much easier to make a "modern" picture outside of the form. You can take photos, make negatives of them and then set them up in series—and you have a modern painting. It meets the requirements of a modern painting. But it's much harder to achieve that taking the form head-on, working optically with perceptual information.

Some of my paintings are in the portrait form, others are less so. If the painting is less in the portrait form, the likeness can be a little less specific even if it's a recognizable person. The thing is, to recognize the fact that the portrait form *is* the point of doing portraits. It's very hard for anyone who was brought up on the good manners of modern art to accept that. It's very easy to say, oh, it isn't the likeness, it's the abstract composition. But if I wanted to make

an abstract composition, I would have made an abstract composition. I wouldn't have made my life so difficult for so many years. You have to recognize portrait painting as a form. (pp. 36-7)

Alex Katz and Gerrit Henry, in an interview in Art in America, *Vol. 63, No. 1, January-February, 1975, pp. 36-7.*

INTRODUCTORY OVERVIEW

Ellen Schwartz (essay date 1979)

[*In the following excerpt, Schwartz provides an overview of Katz's life and career, based on the painter's own comments during a meeting with Schwartz in 1979.*]

When Alex Katz began to evolve his present figurative mode some 15 years ago, he was considered an anomaly. Representation, of course, was enjoying a fashionable comeback under the banner of Pop. But while the tongue-in-cheek witticisms of artists like Warhol and Lichtenstein left no room for doubt about their modernity, Katz was veering dangerously close to painting things the way they actually looked. Not only did he refuse to make signs out of objects, but he chose for his subject matter portraits, a genre that by definition smacked of academicism. Nor did Katz's portraits reveal much about either the models or the artist. There was none of the emotion-laden energy of de Kooning's *Woman* series or of the expressionist angst that had characterized the paintings included in the Museum of Modern Art's 1959 "New Images of Man" show. Katz's figures just stood there submitting to scrutiny, as if saying, "This is how people look in 1964."

Katz's paintings have continued to keep up with the times, but the changes they have undergone have been largely cosmetic. The compositions have grown more open and elegant, the brushstrokes smoother and more refined, the colors more tonal, in keeping with the lower-keyed chic of the '70s. More dramatic has been the way the times have caught up with the paintings. Suddenly Katz has been catapulted to fame as one of America's leading figurative painters. (p. 42)

The belated recognition has brought a good deal of critical analysis focusing on the formal as well as psychological components of Katz's art. Little effort has been made, however, to bring the man out from behind the cool exteriors of his canvases.

Despite the relaxed sociability of his subjects, Katz himself has chosen to remain a nonpresence, an eternal observer. Even when he actually appears in a painting, he is strangely inaccessible—caught from the rear, perhaps, or disguised by a broad hat or reflecting sunglasses. Katz's resemblance, as dispassionate chronicler of his environment, to Baudelaire's contemporary hero, the dandy, has often been noted. "The distinguishing characteristic of the dandy's beauty," wrote the poet/critic in 1860, "consists above all in an air of coldness which comes from an un-

shakeable determination not to be moved." Baudelaire found this quality epitomized in the art of Constantin Guys, and also admired him for so thoroughly identifying with the anonymous "man of the crowd" that he refused either to sign his works or to allow his name to appear in print in reference to them. Katz, too, has chosen not to sign his works since the late '50s, partly to avoid what he considers the unnecessary visual distraction, but largely to remove himself as intermediary between viewer and viewed. But Katz, like Manet, comes closer to Baudelaire's ideal than Guys because his temperament and lifestyle are in perfect alignment with his dandified subject matter and detached style of painting.

Thoughts such as these seem less idle when one meets and talks with Alex Katz. . . . When he greeted me at his SoHo loft recently, he wore a faded T-shirt tucked into clean blue jeans, and his hands bore no traces of the work he had been doing all day. Not surprisingly, the room Katz uses as a studio lacked the familiar chaos of brushes, cans, canvases and drop cloths. Here was an artist neat in the extreme. A large cartoon lay on the floor in one corner, and two paintings were propped up against the wall—one just completed, the other merely drawn in with outlines. (pp. 42-3)

Like the people in his paintings, Katz is willing to show interlopers only his best side—the public side. As soon as we sat down, he made clear that the absence of overt feeling in his work is deliberate. "I'm not trying to tell anyone about what I'm doing, just to paint what I see. If you see clearly, you're going to get all that anyway, just in another sequence. I don't want to tell a story about what I feel for another person. That kind of painting is alien to my temperament." He manages to maintain this aloofness even when painting his wife, Ada, who has been his most frequent model since their marriage in 1958. Indeed, with the exception of commissioned portraits, dance pictures and an occasional landscape, Katz invariably paints people significant to him personally—his son, Vincent, now 19, friends like poet and dance critic Edwin Denby, poets Anne Waldman and Kenneth Koch and photographer/painter/filmmaker Rudy Burckhardt.

To Katz, the question is not why he has limited his sights to intimates and acquaintances, but "Why not? My style has enough generality that I can paint someone close to me and still have it become Man, Boy or Woman. My starting point is an optical experience: I see something and go *Wow!* The image begins with the particular, and then becomes generalized. I make symbols out of the things I see—it's a simple game, really. It isn't just a portrait, it goes off to Person. The picture flips, goes back and forth from one aspect to another." Katz defines the difference between his symbols and Pop signs as a question of relative specificity. "Symbols are real specific," he says. "If I'm interested in painting the light coming through a window and the sky behind it at 4:30 in the afternoon, the Pop artist would concentrate more on the window. Signs are more generalized than symbols." The recognizability of his portraits notwithstanding (assuming you know the subjects in the first place, since few have public identities), Katz is clearly after something more than a likeness. A husband objected to a 1976 picture of his wife, *Karalyn,* because she was portrayed as being far more stylish than she is. "When you see people as symbols," Katz explained, "you cast

them in roles. They become that for you. I can use the same people in many different roles; once I did Vincent as an androgynous youth. He was the right age, and he looked the right way, but some people were shocked that I could do that with my own child. For me it seemed perfectly normal. I've also painted Vincent as a dancer [*The Dancers,* 1978] and as a swimmer [*Swimmer #3,* 1973], where you can hardly tell who the person is at all. On the other hand, some pictures do come strictly from a visual experience, even just from a gesture."

Katz has been criticized on occasion for attempting to combine a very "ordinary" kind of subject matter with a modernist hankering after high style—that is, for aggrandizing triviality through the use of outsize scale and slick painting. "I like the liveliness of contemporary society." Katz protests. "I want part of my painting to be about the way people look now, or the way they looked last year in last year's painting. A lot of it does seem very intimate to me, but I never could understand why it couldn't be done on a grand scale. My *style* isn't small, it's big. And a beautiful woman is really much more suitable for a large scale than King Lear. Why paint tragedy when life can be so nice? My paintings are truer than blood-and-guts realism. A picture of a family can be as monumental a theme as Marat or a Spanish elegy."

Katz's own family was an important factor in his decision by age 14 to become an artist. He remembered these early years vividly and gave a rare look at some of the inchoate forces that come to bear on youthful ambitions. "My father was born in Lida, a small town in Russia. He studied to be a rabbi, but it didn't take. He said his blood was too hot. My father owned a tile factory before he went to Berlin and then came to America in 1922. He spent a lot of his time in Russia playing billiards or pool. He loved to gamble, and would do almost anything on a bet. He told me he had even jumped off bridges on horses, just for the hell of it. He went pretty straight in this country, though, buying coffee from wholesalers and selling it to restaurants. He had strange theories, like about mowing the lawn—he never wanted to retrace his steps, so he mowed in concentric circles. My father was very muscular—looked like Tarzan—but he had a good taste in clothes that I couldn't appreciate until I was older." Isaac Katz was killed in a car accident in 1944, when Alex was 16.

Katz's mother was hardly a less dynamic force in the household, having been an actress on the Yiddish stage in both Russia and New York before her marriage. "She used to say she could have been a great star if she had been able to sing and dance," Katz recalled. "There were a lot of oils in the house of her from when she was a student in Russia. They had a lot of artist friends in the old country, and there were Russian Expressionist paintings all over. I thought it was pretty awful stuff, although later when I got to art school I realized some of it was quite good. Actually, my parents were more bohemian than I am. It was easy to become an artist around them. They were sympathetic and involved with style and taste. When I was just five years old, my father would do watercolors with me. Mine were similar to his, but more childish. Both of them painted rooms and furniture, but my father was more involved in decorating. He painted flowers on a velvet bedspread and put a pattern on the wall of the sun porch. The design was dark red, sort of a triangular design

with broken edges. It was painted very neatly, but I don't think he used masking tape."

Katz attended P. S. 140 in Jamaica, Queens, then overruled both the principal and his parents by insisting on attending a local vocational high school, where he could study art half the day. "I had always liked advertising images, and I wanted to be a commercial artist. I spent a lot of my time during high school making drawings from casts. I wasn't drawing the casts so much as trying to make a drawing that looked like the cast drawings they had around. The teacher thought that was just swell. He used to speak in terms of organizing tones, of keeping the dark harmonies together. Later, those were the same words Carol Harrison would use to teach Cubism at Cooper Union.

"The other students were completely divorced from 'culture,' but they really knew all about popular culture. We used to argue about jazz and jazz musicians, and we all danced. The basic local style was the 'Jamaica Drape,' which was a restrained, reductive type of dance you could do to almost any kind of music. Fast dances were felt to restrict a person's style." Perhaps because Katz was introduced to the arts via dance, he has continued to associate it with high style and modernity over the years. He began painting portraits of dancer/choreographer Paul Taylor as early as 1959 and rapidly moved on to the entire company, caught in arrested motion. Though he doesn't attend performances as often as he used to, he says he is endlessly fascinated with the "visual flash" of brilliantly dressed figures carving up space with their bodies. His most recent project, unexhibited as yet, is a suite of four close-up torso views of dancer Janna Jensen, which fairly fly off the canvases and into the room. Interestingly, dancers have rarely appeared as cutouts, perhaps because their gestures are too broadly three-dimensional to be able to withstand such summary treatment. A canvas is flat, but spatially ambiguous once painted; a Katz cutout is flatter than flat—its real depth can be gauged by just walking around it. At the same time, a cutout is freestanding and thus highly illusionistic, a quality that could compromise the elegance and quick gestalt of the image unless it is kept in close check by simple contours.

After high school, in 1945, Katz joined the navy to avoid the draft. The war ended within a month, so he spent the better part of a year as a first-class seaman aboard the *Hermitage,* a seized Italian luxury-liner turned troopship, and upon his release he applied to Cooper Union at the suggestion of a friend. To his surprise, he was admitted. "This was a turning point in my life," he said. "I was at a tremendous disadvantage and felt awful at having wasted so much time. I thought at least I could draw and letter well, but I had never done any fast drawing from life, only slow, and my lettering was also found wanting. But everything at Cooper Union was very exciting. I still wanted to be a commercial artist. I was very uneducated about fine art, and I thought to be a painter you had to be some kind of genius." Katz gradually began to spend more of his free time painting "because it was just more interesting," and during the summer of 1947 he painted six hours a day, five days a week, "organizing my time as if painting were a job. One of the pictures I spent a lot of time on was a music painting, squares with a piano player. I liked Mondrian's *Broadway Boogie-Woogie,* and I liked real boogie-woogie,

too, so I wanted to do a painting like his but with a figure in it. It was awful. I worked like a donkey and ended up throwing all the paintings out."

Back at school in the fall, he continued his advertising studies, but began to branch out further into both painting and sculpture. "My design teacher was Peter Busa, who was considered really avant-garde at the time. His paintings were like Indian blankets; he used bright, dissonant colors, which I liked. At Cooper Union you were generally encouraged to paint in tasteful, subdued colors, but that got boring very quickly. I wanted to put two colors together that would offend Busa but please me. He also showed me some Miró at the time, and I took out all the books I could find at the libraries on him—a total of two. At night a group of us used to go to hear Dixieland concerts, and I made drawings of the musicians. That summer I painted with the same routine as before, and did a jazz musician without the Mondrian squares. By now I was ready to drop commercial art altogether. I decided I'd give painting a whirl because it was so much fun. I didn't care any more whether I was any good or not."

There was never any question in Katz's mind about doing anything other than figurative art. "I got a real charge out of painting from life. I was lucky to find my subject matter so early in my career, so I just had to find a style to go with it. There were no role models around, since most of the interesting painting on the scene was abstract. I knew there was a good chance I would make third-class paintings for the rest of my life, but it was what I wanted to do." Two summers at Skowhegan on scholarship in 1949 and '50 under the tutelage of Henry Varnum Poore gave still greater impetus to Katz's desire to paint what he saw around him. At about the same time he was taken with Jackson Pollock's momentous drip pictures, which he admired particularly for what he calls their "quick light," a concept easily applicable to his own figurative concerns. "Pollock dominated my vision, but I could see the landscape—subject matter—through his abstract work." Katz explored Pollock's light initially in a series of paintings of bare trees, splaying them across the canvas (or, more frequently at the time, board) in an even screen of lights and darks. He worked quickly to capture a momentary visual effect and allowed the resultant loose brushwork to stand, a necessary evil. When he moved indoors to focus on objects and people at closer range, however, he ran up against the conflict between his rapid all-over working method and the growing inclination to incorporate greater naturalistic detail. Part of this shift was due to his dislike of the "violent macho painting" of the second-generation Abstract Expressionists; part was his awareness of how much he was sacrificing for so little. "I got more specific because I got tired of all-over painting. I found the paintings were free, but there was too much of a point being made of the freedom. I wanted something I could work over. So I realized I had to modify my approach and work more indirectly over a longer period of time. I'm still involved with light—an absolute present-tense light—but it can't be achieved spontaneously. It has to be reconstructed."

As a disciplinary exercise, Katz turned to collage between about 1955 and 1960, some measuring just four or five inches to a side. "The collages were a reflective way of painting, which was new to me. I would make a direct drawing and then do the collage afterwards using pieces of colored paper. I wanted to see if I could get a piece of paper to give me a feeling of the light and weight of each of the objects. It was also interesting to see how far I could go by working in this artificial manner. They looked good, so I built part of my vocabulary out of the experience of doing them."

Katz began to feel more comfortable with portraiture as his experiments gathered momentum. He moved still closer to his subjects and tried to capture oddities of gesture, dress and facial expression in works like ***Ada with White Dress*** of 1958. The first cutouts also emerged during the late '50s, the product of chance rather than intention. In 1959 Katz did a picture of two figures in an interior. He considered it a failure as a painting but liked the figures, so he decided to cut them out of the background, just as he had learned to do with paper collages. Once excised, they constituted what Katz considered a strong image. It was a short hop to mounting this and other cutouts on board and a narrow base, freestanding and audacious.

What began as a stopgap measure has turned into a major outlet for Katz's creative energies ever since. "They're exciting—environmental and terribly illusionistic," Katz admitted. "But the canvas is the real battlefield precisely because it is more traditional." During the '70s the cutouts have also returned to their original collage role as compositional elements that can be moved around during Katz's preparation for a new painting. When executed for this purpose, they are loosely painted and fresh as his earliest studies from nature.

Beginning in 1960, the size of Katz's paintings began to grow in fits and starts. "I gradually stepped up the scale so that I could make something that could stand up visually against anything else being painted at the time. It wasn't a question of making a mark so much, but of seeing things I liked and wanting to use them, to catch that explosive energy." Rothko and Newman were important in this regard, but Katz particularly remembers seeing Rosenquist's painting in 1962 and finding in it confirmation of his belief that figuration could be accommodated to large scale with impressive results. Franz Kline he perceived, like Pollock earlier, in figurative terms, as though his swaths of black on white were actually blown-up, cutoff details of a recognizable object.

In his own work, Katz began to crop his images as a natural outgrowth of an ever-closer viewpoint and in response to television advertising ploys that had caught his eye. The result was what he called "exciting" painting, in which figures and things projected (psychologically as well as physically) far more effectively and yet remained more firmly anchored to the picture surface. The large scale also permitted Katz to explore greater detail using a tighter, more refined brushstroke, because the abstract qualities he wanted to retain (or what he calls "generalized references") were guaranteed by the effects of size and cropping. Perched on the edge of this breakthrough to Katz's signature style are two paintings of the same subject, entitled ***Ives Field #1*** and ***Ives Field #2***, both of 1964. In the former he placed five full figures in a landscape, snapshot style. In the latter he moved three of the figures up to the picture plane, cropped at chest or neck, while the other two stood back in the far distance.

Katz was received reasonably well during the '60s, when he showed at Fischbach, though he was never considered mainstream. "It was as though anyone painting representationally was some kind of toad. People were very patronizing, you know, like 'some of my best friends are figurative painters.' But they didn't take it seriously." When realism took over center stage in the wake of Pop and minimalism, and Katz's work steadily acquired greater assurance and suavity, the tables were turned—to a point. "My paintings are still difficult, I think. Sometimes I wonder how people get to them at all. They're slightly out of the straight modernist line, and they're outside the traditional line. Then they have the additional problem that they're supposed to be the way things look. No wonder they think I'm nuts. There isn't a problem with figuration as such at this point, but the museums really haven't opened Pandora's box at all. Painting that deals optically with the world is still not being taken seriously.

"For me, figurative painting is a whole new ball game. Reality is a variable—what things appear to be is something that changes every 20 years. The most interesting painters are the ones in contact with the world they're living in, and they're making new pictures. That's where the excitement is, and that's where the chances are. You can take most of the books and theories of the old masters and just throw them out the window because they're not applicable. Why can't I just paint what I see? I like the optical reality of things, and you can't get everything right with an optical situation. You concentrate on one thing, you sacrifice another, right? Matisse was an optical artist, Picasso wasn't. Me, I see everything in terms of color weights and composition. There has been very little painting involving composition, per se. It's all been either construction or arrangement."

Katz has always felt somewhat separate from the rest of the art world, representational painters included. "Sure, you should try to be totally conscious of what's going on around you, but my life is fairly isolated by choice. I think the trouble with most 20th-century art history has to do with the Impressionists, and that whole romantic thing of guys working together, which I guess the Abstract Expressionists emulated. Everything has been done on a rat pack basis, you know? Abhorrent sentimentality." Perhaps because of the distance he has cultivated, Katz's success has taken him somewhat by surprise. "Not long ago a man came up to me in the middle of nowhere in Chicago and told me he had seen my work in New York and thought it was fabulous. It came as a shock. I wasn't conscious of things having changed that way. But it's definitely part of what my pictures are about—they're meant to be seen, and I do want to be able to compete with the next guy to see who's got the correct solution to the painting of our times." (pp. 43-6)

Ellen Schwartz, "Alex Katz: 'I See Something and Go Wow!'," in ARTnews, *Vol. 78, No. 6, Summer, 1979, pp. 42-6.*

SURVEY OF CRITICISM

Georgine Oeri (essay date 1964)

[*In the following review of a Katz exhibition at New York's Fischbach Gallery, Oeri responds positively to Katz's large-scale portraits.*]

That big, monochrome color surfaces can be impelled by a strong artistic will into constituting expressive organisms of a powerful pictorial presence is manifested in the paintings, mostly portraits, of Alex Katz. . . . His heads have a monstrous, but not forbidding quality. The risk of magnifying their scale is taken deliberately and is part of the artist's intent. The thundering volumes of his color planes burst forth, yet, are contained and controlled to set up magnetic tensions with their neighbors. Katz accepts and relishes the challenge of the vulgarity of the billboard civilization. He is among the first of the painters to discover, years ago, the imagistic possibilities in the folklore of cartoons and cigar store Indians, and to translate them into art, with the endeavour of a Mondrian. His enjoyment of the topical realities is innocent and shrewd, disarmingly unscrupulous and in a pagan way without guilt or compunction. He succeeds in making his experience pertinent and penetrating because it is coupled with a profound and serious drive to master it in plastic terms of form/space relationships. As he propels the dimensions of the human face into the scale of landscape (and sometimes sets them up in an outdoors environment), he summarizes their elements to abstract shape compositions.

At his best, he endows his portraits with psychological depth and imbues them with a moving commitment to the identity of the sitter. The carefully wrought presence of the image always transcends the portrayal. A contributing factor toward this is the painterly brushwork Katz is able to maintain. While his use of pigment is almost sparse, his stroking is fluent and fresh, uninhibited and deft. He watches his daring performances with the critical self-appraisal which has found its way as a characteristic into his *Self-Portrait* [of 1963]. This is a somber pyramid of stern determination, built of triangular shapes within itself. The face, which is tender and scrutinizing, with a touch of irony, is locked in between the black base and the black top, while the whole is held in suspense within a light grey ground. (pp. 17, 20)

Georgine Oeri, "The Object of Art," in Quadrum, *No. 16, 1964, pp. 4-26.*

Sanford Schwartz (essay date 1973)

[*In the following excerpt, Schwartz discusses the development of Katz's style, finding his mature works an amalgamation of realism, Pop art, and color abstraction. Schwartz also praises the complexity of Katz's ideas and his willingness to take risks.*]

On the WNYC radio show "Views on Art", the moderator Ruth Bowman was talking with Alex Katz about his flower paintings and his portraits—what was he after in making the blossoms and the faces so huge, so disassociated from the space around them? Katz, in his direct and low keyed pedagogical manner, talked about how we react to radically unexpected size and scale, about the impossi-

bility of ever getting life-sizeness, about how we see different images that appear simultaneously, about proximity and how it changes our perceptions. . . . Without being heavy, he gave a convincing sense of how complicated his intentions are, and Bowman remarked on it. Their exchange is significant and worth recording, because it tells us a lot about this artist's temperament. Bowman (starting to knit everything together for the listeners): "So, when you decide, when you're working on a painting, or a series of paintings, you *do have* a lot of conscious things that you are concerned about . . . you have schemes and projected ideas." Katz (bland): "I have a lot of ideas . . . you work with a lot of things." Bowman (pitching in): "All painters don't." Katz (still bland): "Well, I like to complicate . . . my paintings are quite complicated. I like something to keep my mind occupied."

Alex Katz's answer was as deadpan dry as his painting. The line is like his art: it's emotionally flat, but it reverberates in unexpected ways. Like a Buster Keaton performance, the Katz style has a witty economy to it, so that when you laugh at what's there you're also laughing at what's been left out. His response shows an astute self-awareness which, despite its ring of impersonal professionalism, doesn't seem fatuous. It's closer to being ingenuous, and there's a quality of naive seriousness in the painting too. By any standards, this describes a rich, quirky, special sensibility, and it's all there in the painting. . . . Katz gives his viewers a lot to work with too.

Alex Katz's art from the beginning (he started showing in 1953) has been of a non-breakthrough variety, very much like a lot of other art in New York, and yet always standing a little elusively by itself. Katz is a purist in his thinking, but he's not a very doctrinaire one. He has allegiances all over the field—maybe this is what has kept his talents from coming into one clear focus, or what has made many people think of him as shifty, "unserious". You can see where he keeps rubbing shoulders with other New York artists—traditionalist, realist easel painters (of the non-photo-oriented school), Pop artists, particularly those who were attracted to that Pandora's box of visual ambiguities, the comics, and abstract color painters, who are interested, like Katz, in environmental scale and massive simplifications of the image.

Katz conceivably could be included in group shows of all three kinds of painters, but he would look like an interesting side light in each one of them. He's brassier than the easel painters, and, unlike most of them, temperamentally unable to keep on refining painterly "passages". He wants to achieve show-stopping, immediately stunning images—something that's considered gauche by many New York realist painters. He's willing to risk more, even to look coarse if it's necessary. And then he isn't, like the pure color painters, determined to arrive at absolutes and stick with them, making them continually more minimal. He has lots of theories, but he can't help scattering them. He's not a concentrator. Katz is most often aligned with the Pops, but he's less thematically loaded and literary than they are; he doesn't trade on images that have accepted meanings to begin with. When he seems banal it derives from an easygoing, considerate familiarity with the terrain he paints—he never suggests banality in the mock-astonished, kitschy put-down way of the Pop artists.

The Pop movement can be seen to have represented a kind of New Journalism for the visual arts, a way to use the raw data of popular culture. Katz toyed with some of the possibilities, but he never joined up seriously. He stayed a far more traditional kind of fictional interpreter—a chronicler of a distinct social milieu, with its own characters, pets, events, places to go to. Without being a literary painter, without concocting situations that are supposed to be "read", he's given us a stock of people and places and sometimes things (mostly flowers) that suggest the relationships and gestures of a large, complete world. At this point, his style is so sure that there are faces and flowers, even trees, that could exist only in a Katz—just as there are people who we're sure could exist only in Yoknapatawpha County. This is a remarkable thing in current painting, this ability to keep up subject matter on a level of personal, almost novelistic commentary, and not have it interfere with the pursuit of carefully mapped-out formal problems. The mixture is what gives his pictures those levels of complication you don't get from the Pop artists, or the more abstract figurative painters.

In the past few years, Katz . . . has achieved a formal breadth and fullness to his approach that, finally, makes irrelevant his relationship with other, larger movements. He's still off by himself, but not so elusively. He no longer looks like he's circling around what others are doing. His ideas, ranging back now twenty years, have been rethought and, intellectually, enlarged, and the rough seas he went through in the mid-1960s have been cleared entirely. At his December show at Marlborough Gallery there will be large group portraits and multiple portraits of the same person, and as a group they represent the most stunning show he's had. The new pictures put Katz in focus as one of the most exciting and satisfying painters in New York, and they also put in focus a lot about his own past.

What's immediately impressive about the new works is how confidently they carry their grand size—most are in the vicinity of $6' \times 8'$ or $6' \times 12'$. The images fill their heroic, *Raft of the Medusa*-scale dimensions without appearing, as his earlier big pictures often did, artificially spacious or blown-up. As he told Ruth Bowman, they "scale in your head", which means you can be intimate with them almost immediately. They don't look ludicrously out-of-proportion—and that's the effect Katz is after.

The ability to deal so effectively with large scale is only one sign of the growing assurance and complexity of his painting. There's a lucidity in the structure of the group portraits that he hasn't always had in his ambitious pictures. The views are all different: in *Evening* five people are seated or standing around a table; in **The Black Jacket** we see the one model, his wife, Ada, in five stages of close-up and medium faraway. Set in the dark, unexplained space, the five Adas nudge each other like a bunch of balloons bobbing around on separate strings, all held together by a single hand (which we don't see). In **Face of the Poet** we're given one face, in back to back profiles, in extreme close-up; in the **Portrait of the Lloyd Family** the father and mother and two children are pressed up close to the picture plane, all heads and shoulders (limner-style, everyone in this family looks as if he's a different size version of the same person). Each view has its own structural set-up for carrying the eye along—he makes sure never to step twice into the same problem.

Everything here underlines that Katz isn't working so frantically to make us see how abstract a painter he is. The images are more naturalistic—they've lost that jerky cartoonyness. The figures are rhythmically related to each other with an unassuming easiness, so that the rhythms don't hit you on the head. We're no longer made anxious about where we're supposed to be in relation to the painting's space: spatial ambiguity isn't something he feels he has to spell out any longer—it's inherent, not tacked on. Katz's strategies have always been more satisfying when we've been made to sense what they are than when we've had them spelled out for us. It's for this reason that one of his biggest, most ambitious pictures, *Private Domain* (1969), with its tricky ins and outs, looks like brilliantly engineered field logistics, or a mechanical painting. He seems less worried now whether we'll recognize the complexity of his decisions, and the decisions seem more masterful.

Katz achieved this evenness earlier in his career, in the collages and paintings of the late 1950s and early 1960s. His ideas about space and color weren't so bold then but, though less ambitious, they were thought through on all fronts. He was after a style that could account for color, light, space, and what to do with drawing and gesture (two things he was mainly interested in being rid of). The spirit of these pictures is maybe overly modest, but they hold up. They contain wonderful, delicate perceptions about the person or thing before him. The views from studio windows, looking out towards windows across the street, are sober, matter-of-fact studies of indoor and outdoor light, and the many portraits of people walking towards us or sitting on chairs are equally straightforward and commentless. The approach is easygoing, a non-fussy reductivism—no details are included to make us sense the "character" of the model or the "place" of the window views, and yet no matter who or what Katz painted his relationship to the subject is always something private and intimate. His affection is a quality you're made to feel off-handedly; it's there in the homemade-looking touch. Space and color are treated with an awkward, child-like clarity—though his instinct for dealing with empty spaces was from the beginning far from child-like. Color painting of such sweetness of mood and exactness of gesture makes you think of Marquet, or early Vuillard.

The recent painting has that magic balance again, and this time there's the added power of new scale, which gives some of these pictures, particularly *The Black Jacket,* a magisterial weight and solemnity. Scale isn't just a question of canvas size—it's a way of filling the size with expression and handling that has the broadness, the grandeur, even, of the dimensions. Many of the early paintings are nearly as large as the new pictures in literal size, but the expression and handling is never quite equal to the scope. Katz is too perky, too "fine"—he doesn't let go of the oil sketch edge, and this holds him back from achieving real massiveness. The images don't carry as grand images, and it's always surprising, when you look at reproductions of these early pictures, to see how enormous the canvases are. In reproduction they look as if they should be small paintings. The new work holds its large scale no matter what size the image is reduced to.

Katz has been headed towards the blunt purity of his current approach all along. In the past, his need to keep the

faces distant and empty resulted in their having, inadvertantly it seemed, a kind of content: either they looked too "innocent" or too Pop-smiley. The faces in new pictures like *Evening* or *Face of the Poet* aren't so straitjacketed by immobile expressions. He's found more successful, certainly less entangling, ways of keeping them blank. Still, the imperturbable, dream-like moods creep in, the way they do in Rousseau—without, you suspect, the artist's being totally conscious of them. Katz's stiff, reductive manner, with its echoes of the directness of primitive artists, has always transformed the model in unaccountable ways, and it continues to happen. The faces in his paintings, encased in their abstract solutions, are turned into icons—sleek, modern, and, like most icons, a little empty-brained. Katz is making his formal deliberations, and meanwhile the real thing is continually being pushed into the corner; what's left of it comes out muffled, like Poe's cat trapped behind the brick wall. Rousseau trapped cats too, though in his case he couldn't help it.

The hip, no-comment expressions and the slick, glassy finish Katz gets are there to alert viewers not to get too involved with the representation, and generally it works, though he can go overboard with the emotional shinyness. Sometimes his descriptions of milieus and types hang in there too much like illustrations of a certain kind of New York social cool. We read the image as ironic, of course, but the literary attitude expressed makes it hard to look at the painting for anything else. Katz needs the emotional cool, but he doesn't need the chic—that just messes up the meanings. The new *Evening,* a picture of four men standing around and smiling at each other while this elegant, out-of-it girl sits in the middle of them, totally ignored, is a wonderfully acidic group portrait, but its milieuness doesn't swamp it. You don't have to be able to read it, or know the actual stories being told, to appreciate it. *Evening* stays in the mind like a lean, wry version of a Rubens or a Watteau: we're at one of those elegant love parties, though instead of taking place in a garden it's a kitchen. The atmosphere is charged with erotic sensations, and the glances, some sharp, some befuddled, carry the signals. The tones are silvery, luxurious but cool. Like Watteau, Katz suggests the glamorous power of sex—and also its way of making us look clownish.

The content in his painting, ironic or otherwise, is always most satisfying when it's inseparable from the formal things he's after. One of the funniest paintings he's done, one of the funniest paintings in American art, I think, is a portrait of his Skye terrier, *Sunny* (1971), who's seen sticking his hairy head up out of long beach grasses (aside from the hair and the butterfly ears, the only other part of him you can see is his tongue). The image is powerful and silly—the humor derives from the looming nearness of this charmingly ridiculous animal and the magnificent farness of the beach and bay behind him. Space itself seems funny, a little weird. As Katz said in the Bowman interview, it's a sensational image.

More importantly than being warning signals, the startlingly impassive presentation of the image and the gestureless handling give Katz the freedom to make sense out of the perceptual problems that most interest him—the simultaneity of different size images, scale dislocations based on near or far distances, how we visualize distance, how space can be rendered. What he said about the flower

paintings, in the interview, applies equally to the portraits and the landscapes: "When you blow something up that big", he noted, "in a nonmechanical way, the tendency's for it to become gargantuan rather than to retain its . . . scale; you want a real big flower to, after you've looked at it, to relate to you like a small flower would, so the size disappears."

He's worked out a dryly glistening color, which lets him be naturalistic and still show the tricks light plays on the way we perceive and remember specific colors. He's interested in how little the real thing is like it's supposed to be: when we're out in the midday sun, how much of what we actually see in the sky is blue and how much yellow? how distorted are colors made by changes in proximity? how much does the lack of sun alter the colors of things from the way we know they appear—leaves are green—to the way they actually appear—closer to grey?

As Katz told Bowman, he does paint with a lot of things on his mind (especially if you take his ideas on such a literal level, in which case he sounds like a neo-Renaissance theoretician), but his vision isn't so protean that it's nourished by any sort of idea it's fed. His range is not such that, like, say, Matisse, his pictures have a rich complication even when he's misguided or confused. At least so far they don't.

Katz was wise in deciding that his early manner was too soft, too refined, too painterly to handle everything he wanted to say. Neat enough as it was for him at the time, it connoted too many extra attitudes, like touch, to allow his ideas to reach their fullest impact. Anyway, considering what he wanted to do with life-sizeness, he had exhausted the manner. It was when he attempted to move on from the early style, when he wanted to find ways of tightening the handling and enlarging the physical size, that the weather got heavy. Pop art was helpful in the change, but he went haywire with its incentive to play with spatial ambiguities.

For a while, he was stuck on faces shoved up to the picture plane, with small bodies walking around in the background. Treated so obviously, his ideas about shifts in scale didn't seem like very sophisticated concepts to base a painting style on. In their new, jazzed-up incarnations, they looked stagey, superficial. He was not exactly Uccello in the spatial shifts department. His concerns weren't treated so demoniacally, or even methodically, that, like Uccello's, they passed over into being a kind of mad, toy-like visual poetry. They were just bizarre. The big heads, with their mechanical, idiot smiles, the flat-footed handling of near and far space, and the billboardy color gave the impression that Katz had swallowed Pop, or at least the comics, whole—where he was just using the exaggerated manner, and not too securely, as a ladder to something else.

Katz's art is more commanding now that handling big size isn't such an obstacle, but sheer bigness isn't the fulfillment of his approach, and it certainly doesn't change his "content" much. His collages, which he stopped making by 1960, and the metal cutouts, which he still makes, are sometimes 6″ or 10″ high, and smaller, and they're as expressive of his thinking as the 6′ x 12′ paintings. Both are more consistently successful than the big works, though less pressure rides on their success. The cutouts (attached to slender metal poles, which can't be seen at a distance) and the collages are disarmingly small and faraway, even from 2 or 3 feet. They're like looking at something through a keyhole—they suck you into their space. The larger, more life-size cutouts aren't so effective. They're a bit mongrelly: they're paintings with a sculptural presence. The confusion they create isn't bad, but it does sidetrack, for us, Katz's intentions. The small ones create their own strange scale, which makes you want to relate yourself to them so that they don't seem so damn small. The problem with the larger ones is that they don't float in space enough.

Over the past twenty years, Katz has been testing his ideas deliberatively. His commitment is impressive, and it hasn't resulted in pompous or pedantic work. Unlike many other first-rate painters in New York, he hasn't been trapped by his ideas; he doesn't operate as if he were his own academician-in-residence. He works patiently, sometimes studiously, exploring every possibility that's open to him, and yet he's always going somewhere with the exploration. You don't get the feeling that in five years he'll just be refining what he's doing now. He has an intellectual liveliness about his hunches, a restlessness to see where any of them will lead, and it's sensed in the way he goes out on a limb perfecting miniature as well as truly enormous size, or in his trying out different versions of images he likes—close-up, medium long shot, long shot. He's open-ended about his goals, and this makes him refreshingly unpredictable.

Between his work of ten or thirteen years ago and the most recent pictures there have been gains in every direction. He's lost only the youthfully assured handling and the doll-like delicacy of expression, and both of these things were necessary casualties if he was going to go anywhere. He's replaced the easy-to-like atmosphere of the one style with a tough and, ultimately, more admirable one. Between *The Black Dress* (1960) and *The Black Jacket* (1972), which is essentially a reworking of the earlier image, the color sense is richer and subtler, the feeling for abstract space more complicated. When he depicts people now he can communicate a wider range of expressions without having to appear more naturalistic; he no longer has to give every face a baby's mask or a cartoon grin. The landscapes are richer, fuller too. He's brought in more of what Roger Fry, talking about Cézanne's imagery, called "lively reality"—at the same time as he's strengthened the abstract perceptions he paints from. From one painting to the other he's done that rare thing in American art: he's made good on a gifted earlier manner. And there's no reason to think he won't get stronger. So far, he's always known when to move on, and what to take with him. (pp. 28-30, 58)

Sanford Schwartz, "Alex Katz So Far," in Art International, *Vol. XVII, No. 10, December 15, 1973, pp. 28-30, 58.*

Hilton Kramer (essay date 1973)

[*In the following review of a Katz exhibition at the Marlborough Gallery in New York, Kramer commends Katz's synthesis of the modern Pop style and the older decorative and coloristic styles, as well as the comic aspect of his approach.*]

With the paintings of Alex Katz, we are never in any doubt about the kind of world the artist has chosen to portray. It is very explicitly "our" world—the observable world of contemporary manners and styles, very "young" and up-to-date in its easy sophistication, its movie-culture look, and its air of untroubled sociability. It is a world in which the darker shades of feeling are, for the most part, unacknowledged. Friends and family abound, but each participant is given a mask designed to conceal his interior life. Like figures in a dance, we know them by their gestures, their costumes, and their carefully rehearsed expressions. We are not invited to penetrate beyond an amiable and appealing surface.

It is, in a sense, a comic world, not only because it contains much that is amusing (and sometimes actually funny) but, in a larger sense, because it is a world of happy endings. It is a world in which no one gets hurt. It is all a fiction, of course, but no more (or less) so than the choreographic or cinematic fictions it so much reminds us of. What is remarkable is the artist's success in bringing such a fictional world to the realm of painting, where it is given a vivid realization in purely pictorial terms.

In the exhibition of Mr. Katz's new work, now on view at the Marlborough Gallery, . . . the artistic strategies he has devised for this pictorial realization are more clearly stated than ever before. As we enter this big exhibition, the walls to the left and to the right are hung with portrait drawings—large heads, executed in pencil, that combine a classical simplicity of image with an extraordinary sense of intimacy for their subjects. Facing us head-on is an immense double-image painting, measuring more than 17 feet in width, called **Face of a Poet,** which can no longer be said to be a real portrait. In the painting, the inwardness of the drawings is jettisoned in favor of a wide-screen movie close-up image designed for maximum legibility at a great distance. Two giant masks are joined in a mural-size composition, and the increase in visual power is won at the cost, it seems, of a certain emotional vacancy.

The drawings, to be sure, are already halfway to being mask-like reconstructions themselves. They remind me of certain pencil drawings by Juan Gris—drawings of objects in which the iron grip of Cubist form is softened by the delicacy of the modeling. In Mr. Katz's drawings, no matter how schematized the illustrational elements may be, there is a subtlety in the modeling that distills an emotional resonance deliberately absent in the paintings, where we are given instead only those faces prepared—as Eliot says in "Prufrock"—"to meet the faces that you meet."

Perhaps for this reason, the drawings seem not quite to partake of that comic world so ebulliently portrayed in the paintings. Some residue of the subject's private self inhibits the kind of comic generalization necessary to the paintings. The drawings, in other words, are portraits (with everything this implies about the depiction of character) in a way that the paintings—even though they contain certain likenesses of particular people—are not. The paintings tend to be comic tableaux in which the individual figures become types, and the types are made to function pictorially in a way that reduces them to little more than their essential visual and gestural attributes.

As in all light comedy, then, there is a reduction of complexity to something simpler and more generalized, and an amplification of these generalized attributes on another, more immediately visible scale. In Mr. Katz's paintings, the pictorial language is similarly simplified and amplified to make its effects quickly, without any labored transitions or distracting embellishments. In a sense, color too is reduced to "type." Drawing is reduced to the simplicity of a schematized cartoon. Every detail—a shoelace, a raindrop, an eyelash—is instantly and unambiguously readable. The movie screen or billboard scale raises the simplified language to a level of eloquent visibility where the anecdote—for there is usually a strong anecdotal interest in Mr. Katz's best pictures—no longer determines our response to what we see. The anecdote serves the interest of a purely visual comedy.

Two quite different kinds of painting, or ways of thinking about painting, are joined in this remarkable style. From pop art, Mr. Katz has taken the big-scale cartoon drawing of close-up details. From color-field painting as well as from his own earlier use of Matisse and Milton Avery, he has taken that freedom to project immense areas of flat, decorative color and endow them with an interest of their own.

To this personal synthesis he has brought his own humor, a keen sense of gesture and *mise en scene* derived from his immersion in movies and dance, and a sharp eye for the world he lives in. He is highly selective about what he carries over from that world into his painting—he avoids all intensity, all extreme emotions, everything "interior" or ugly or alien or difficult—but what he does select has a wonderful authenticity and wit.

Mr. Katz must surely be counted among our most accomplished artists and the present exhibition is a great pleasure. He is the closest thing we have in painting to the old Broadway musical. Like the latter, his art abounds in "big numbers," bright, light, extrovert emotion and fast moves. And we carry away from the show certain memories that are the visual equivalent of those tunes people were once said to leave the theater humming.

> *Hilton Kramer, "The World of Alex Katz: 'Big Numbers,' Fast Moves," in* The New York Times, *December 16, 1973, p. 25.*

Richard Martin (essay date 1974)

[*In the following review of a Katz exhibition at the Marlborough Gallery in New York, Martin examines the nature of Katz's figurative art, affirming that evident throughout the artist's admirable work is the tension between "the revealed and the secret."*]

The work of Alex Katz has consistently eluded classification. In the course of two decades of representational painting, collage, and cut-outs, Katz has brushed realism and even grazed Pop Art, but has resisted both to refine a representational style stark in its abiding humanism and laconic in its formal presentation. The consequence has been the freedom of the image from the banal and anecdotal origins of the figuration and the opportunity to raise the individual as a commonplace to the icon as a monument.

Katz's figurative art might easily slip to the level of trivial journalism of the New York literary and artistic *haute*

monde were it not for his singular ability to transform the *soigné* into the stable and the momentary into the permanent. Like Manet's work of the 1860s and 1870s, the direct confrontation with contemporary reality is refined by monumental presentation and by the solidification of figures into the immobile piers of a stabilized order. Manet's *Concert in the Tuileries* . . . in its contrived presentation of the contemporary literary and artistic figures in frozen configuration is like Katz's monumental social tableaux which likewise crystallize the prosaic attitudes of the new bourgeoisie in an arresting planar tableau. The more intimate domestic scene of Manet's *The Railroad* is recaptured in Katz's monumentalized portraits of Vincent (the artist's son) and other children caught in the otherwise invisible formalities of play. Moreover, the duality of figures in Manet's *The Railroad* is similar to Katz's propensity to double portraits, the one figure in counterpoint to the other. As in the works of the Impressionist, Katz's art is never primarily about perceived reality, but is rather an inflected transformation in scale and dimensionality of the real into an explicitly conceptualized program.

The constant paradox of Katz's work is between the revealed and the secret. In the intense self-scrutiny of the **Self-Portrait with Sunglasses** (1969) enlarged to cinemascopic size, the apparent revealing of the subject is balanced by the concealment of the dark glasses, denying further examination or penetration. **Summer Game** (1972) is correspondingly a group activity, but each member of the group retains a privacy, as it were, in the secrecy of the cards and in the concealed gaze in opposition to their grouping. The cocktail- and lawn-party figures have a like tendency to be unyieldingly private even as they confront one another. Double portraits achieve a hermetic character through obscured portions: in **Vincent and Sunny** (1967) the dog hides the lower portion of Vincent's face, leaving only a tentative gaze devoid of either confirmation or contradiction in the mouth. Hence, the frequent analogy between Katz's work and billboards is hardly apt, inasmuch as billboard figuration is fully demonstrative and communicative, whereas Katz's figures generally express a restraint or concealment. The intimate enlarged remains intimate and personal in Katz's work.

In Katz's own detached view of his subjects, there is a constant capability for the whimsical or even the sly. The theatrical cut-outs for Kenneth Koch's *George Washington Crossing the Delaware* (1962) as recently seen in the Martha Jackson Gallery retrospective at the Finch College Museum of Art, are ironic in their displacement of traditional imagery, as are the later large-scale canvases of flowers in their *coup-de-grâce* to the genteel tradition of flower painting. As in many of Katz's figurative paintings from the mid 1960s, much of the impact of the flowers comes from his abrupt cropping of the image, adding to the impersonality of the images.

The constant factors of Katz's work, including the close-up (e.g, **Boy with Open Mouth,** 1973), the cut-out (e.g., **Trophy III,** 1973), and the profile full face group portrait (e.g., **Supper,** 1973), have prevailed in the artist's recent work done under a Guggenheim Foundation grant. Frank O'Hara's comment . . . in 1966 that Katz is "one of the most interesting painters in America" remains true. (pp. 56-7)

Richard Martin, in a review of an exhibit at the

Marlborough Gallery in Arts Magazine, *Vol. 48, No. 4, January, 1974, pp. 56-7.*

Carter Ratcliff (essay date 1978)

[*In the following excerpt, Ratcliff addresses the ways in which the presentation of form and content in Katz's work successfully conveys a wealth of meaning.*]

Alex Katz's subject matter is, first of all, the way people look. He records civilized clothes, poses, gestures and expressions. Rather, his lean, public style makes clear his civilized—and tough-minded—response to these things.

Rudy and Yvonne (1977) shows a man and a woman facing each other across an interior space infiltrated by the glow of a rural landscape. They are "summer people", urbanites who have left the city's worst season behind them. With their summery surfaces, they clearly know how to reside in pleasant weather. The moment shows them relaxed, immersed in the steady light. This immersion brings a pictorial benefit, an "allover-ness" that frees line to accelerate and decelerate with grace—to glance off the scene's high-keyed surfaces, tilting them against the picture plane, then slow down as it eddies into shadow. There, it arranges the tones of the woman's face and neck in an elegant manner.

Her elegance is static and iconic—because Katz's line is severe even at its most delicate. The woman's pose has an edginess which could be taken as the sign of an emotional crosscurrent the artist wants to reveal. In other words, you could give the painter's linear reductions, his abrupt flatnesses, an expressionist reading. But that would be a shame. It would require an immediate delving under the surface of the image, most of which would then go unseen. Katz has said he doesn't try to paint "psychological states. That imposes on the sitters, and tells the audience what to think." Instead, he "proceeds from the surface. To deal with things empirically is much more mysterious than dealing with them through some kind of psychological symbolism. As far as people are concerned—the surface is what they show you, and it's absolutely amazing." (p. 26)

For Katz, the surfaces of flesh and of clothes are metaphors for everyone's intention to present the self in a social mode. The surfaces of objects and architecture extend that metaphor beyond the body. So you have to come at the edginess of the woman in **Rudy and Yvonne** in a socially alert condition—the way Katz himself does. When you do, her taut, poised quality reads as a response to the calm liveliness of the situation. She is about to jump into the flow of talk. Katz's image evokes both her tact and the pleasurable impatience that goes so well with the entire work—whether it is viewed anecdotally or as a formal pattern generating a serene pictorial light.

By staying with the amazements of the visible, Katz maintains his own tact. His world is animated by socially-intended surfaces, anticipatory surfaces. His idea of virtue is to respond sufficiently to all the public energy he conjures up when he designates his sitters. The search for objectivity, for visual "truth", is left at the outer threshold and, very fast, vision turns a corner to a realm, complexly-lit, where the slightest cue can generate endless speculation. Katz's paintings, then, are parallel in intention to

Rudy and Yvonne (1977)

novels of manners. They are fields of personal interchange, all the more intense because his sitters tend to be, as he is, not only mannered but well-mannered. (Or perhaps it's more important that all parties concerned are not only well-mannered but—to save their social energies from blandness—mannered, too.) For Katz's subjects to be on their best, most richly-inflected behavior, they have to understand that being asked to sit for him is to be invited to an occasion whose social nature is elaborated as it goes on, efficiently, toward its result—the painting.

As a response to surfaces, visible and metaphorical, Katz's art offers its meanings in a variety of ways. I know his world somewhat. As we've seen, this makes me likely to break all the modernist rules and give his images a literary treatment. Or a sub-literary treatment which mixes minutiae of attitude and expression with minutiae of gossip. It's difficult for me to keep from investing his imagery with a vague or not-so-vague aura of narrative. But that aspect of the surface is especially slippery. Even if you know something really juicy about the people in the painting, your eye goes from the implications of a smile to the implications of a form and a color. Everyone, sooner or later, finds Katz's art moving off to the same distance as, say, Bronzino's. This is the distance at which figurative art reveals all its concerns, from the diaristic to the "formal".

Somewhere between those extremes, Katz maintains his accuracy about fashion. This isn't just a matter of recording the details of what his sitters wear. It's a matter of choosing sitters whose clothes address the moment with stylistic cogency. Of course, the cogent is fluid. In **Nabil's Loft,** one man wears a crew-neck sweater. The other has on a V-neck. The first wears his shirt collar out, while the points of the second's shirt collar are held in by his sweater. This—in 1977, the year of the painting—happens to be right, whereas, two seasons ago, the man with the V-neck would have points of his shirt collar showing. Granting this, what are you to make of the woman in the pink and green shawl? Not only are those particular pinks and greens dangerously close to the day-glo hues of the sixties, but the tie-dyed pattern of the shawl is—no doubt about it—the sixties personified.—Shades of hippie-dom and, ugh, lyrical abstraction!

Is that why her expression is a bit uneasy, while the two men are, at least on the surface, calm? But is that all their surfaces show? And is the woman all that uneasy? That may be a tense upper lip or a tautly-shaped one. In the gulf between expression and physiognomy, it becomes possible to wonder if the shawl's pattern is really tie-dyed. Maybe it's crocheted. Maybe it's a print. Maybe it's just a quality of light that pushes its colors toward day-glo. How, in

what is probably a night scene, are you supposed to judge day-glo's absence or presence? The flurry of questions raised by her clothes makes it likely that the woman is the equal of the men in matters of self-presentation, and this shifts the eye to the relations between the three of them. Who is or is not looking at whom?

Now, I'm aware that these speculations are set off by fashion cues that may be empty, say, in Paris. They may be empty in San Francisco or in some other neighborhood of Manhattan. (Nabil's loft is in Tribeca, that art-zone one step ahead of SoHo in renovator's cachet.) But that, I think, is not a problem. When you look at a Bronzino portrait, do you doubt that the sitter has gotten his clothes, his posture and his look right for the occasion? And when you look at a bespangled earl by the Elizabethan miniaturist, Nicholas Hilliard, do you doubt that the sitter—with the inspiration of a brilliant provincial on what was then the periphery of the Western world—has gotten *his* clothes, posture and look as right as he can possibly get them, all things considered? Do you doubt that that provincial has considered all things? You don't have to be a sixteenth-century Florentine, an Elizabethan or an expert in costume to make sense of such images. What you need is a feel for the geography and the chronology of culture, and for the painter's degree of authority. With how much sureness has he responded to the surfaces of his subject? And what is the nature of that sureness, such as it may be? You answer these questions by seeing the way brushstrokes turn into form, how they set form in space. If they do these things with flair, you believe the sitter himself has the degree of flair he claims by his manner of self-presentation.

To get back to **Nabil's Loft,** it isn't necessary to have kept track of the way sweaters were worn last year in SoHo and Tribeca to sense that the two men are wearing theirs the right way—that their style would have currency uptown, as well. It helps to note the brusque fineness with which the planes of their faces are adjusted to signify degrees of calm just less than complete. Other things go on in their expressions, but the certainty with which Katz has given both male sitters a large share of outward calm convinces you that their clothes, casual as they are, reflect elaborately accurate considerations of time and place. It's a matter of trusting the social, hence subjective, responses of the artist. The ambiguities in the woman's face make it right to wonder about the rightness of what she wears—even if you happen to *love* reminders of the sixties. And you wonder, next, about the nature of her presence. What is she doing between the two men? Here the focus of your looking may shift. Katz makes it likely that she's there for reasons advanced by the painting in its own concern to develop a striking presence—formal rather than social.

A figurative artist needs to mediate between the extremes of his art. Katz does it with his "light", itself a mediation, a balancing of tone and color. Instead of going from faces and fashion notes to the various degrees of calm inhabiting **Nabil's Loft,** you can get to the same place from another direction. . . . [The] dark patch, the short-sleeved V-neck sweater, balances out against the keyed-up grays of the man's shirt sleeve and collar. This is complex, but starkly simple compared to the way the tone of the crewneck sweater to the left connects with the wall-tone and the tones of the other colors, mostly greens, surrounding

that dark patch. The painting is built out from the two nearblacks, the sweaters, each of which comes to its own terms with its immediate setting. As they do, the resulting calm drifts through the scene, and, ever mannerly, permits itself to be modified.

The grand busyness of the woman's shawl impinges on the tonal elegance of the shirt and V-neck sweater to the right. Intricacies of pattern and the fact of pink-and-green make that side of the painting as complex in hue and tone as the left-hand side. Thus the painting's formal calm is inflected in different ways across the surface; there is a metaphorical shift to social surfaces—the sitters' expressions, in particular, and you arrive at the sense that the uneasiness mixed in with their social calm has been shared out unequally.

It's possible to go from formal qualities to the qualities of personal presence in Katz's paintings because his mediating light—his mediation of tone and color—is not dictated to him by perception. It takes off from perception toward the meaning of the occasions that result in his art. Katz's is a public light, a light flavored by social responses—his to the sitters, the sitters' to one another.

If it's the light in each painting that defines the surfaces of his people and places, it's the sweeping efficiency of his line that brings those surfaces forward, that holds them to the actual surface, that rescues its actuality from a brute physical state. Formal immediacies advance, become social immediacies, cultural immediacies, and so on. These metaphoric transformations may seem at times to point inward to thoroughly private qualities in his sitters. You may feel that even in his most public mode Katz undertakes a sort of "psychological probing". He even seems now and then to turn toward self-expression, despite his proclaimed indifference to any such thing. His style emphasizes the latest news about the styles of other people in his world, yet that doesn't account for all his concerns. Katz has a full range of them. His style is able to bear their weight precisely because it insists so self-consciously that it *is* a style—a conveyor of meaning outward to an audience, a social contract proposed to each viewer by every one of his works. All styles are social contracts with whatever audiences accept them. The meanings of Katz's art are especially rich because he is constantly enriching the *contractedness* of his style, making that necessary condition of any style the primary meaning conveyed by his.

The unities produced by Katz's up-to-the-minute iconmaking compress the space of his paintings. When there are more than two sitters, the result is usually one of his re-inventions of the frieze. And yet in several of the new paintings, unities persist even in space that zooms back very fast or opens out to an extraordinary degree. In **David and John** (1976), you can read the image as a flat pattern or you can step back and watch the high-keyed light of the painting carry the far figure into a silvery miniaturization. In **Round Hill** (1977), there is a firm invitation to bring the sky, with its pattern of clouds, into the same plane as the beach, with its evenly-spaced clumps of vegetation and seawrack. Accepting, the eye can arrange the five figures in an elaborate frieze. But perspective and cropping maintain the distances between them. And the light in the sky is different from the light they inhabit. The two regions of the painting have their own sets of hues. Marvellously tenuous tonal plays unite them, finally, but before that hap-

pens the tilt of the foremost figure has launched the eye into spaces deeper, perhaps, than any Katz has ever presented before. The casual, even wearily casual, poses of all five figures are lit, slowly and quietly, by the grandeur in which they are immersed.

By very sharp contrast, Katz has designed a billboard in which the space is more compressed and the pattern more frieze-like than in any of his other works, save his flattest allover flower paintings of the mid-sixties.

The billboard image . . . stretches 240 feet along the top of a three-story building at the northeast corner of Seventh Avenue and 42nd Street. The faces of eleven women, some of them repeated, all of them severely dazzling, are set into the billboard's shallow field of harsh green and stacked against the same color on the three visible sides of the tower that rises 57 feet above the billboard in competition with the office buildings and other gigantic outdoor images that crowd the neighborhood—Times Square. (pp. 26-8, 50)

The billboard is a stunning work. The tight placement of the women's heads helps the image hold up against the immensity of the setting—the openness of the sky, the commercial clutter, the geographical and cultural intensities of Times Square. And Katz has drawn on those immensities to focus his painting. His earliest works threw action painting into a figurative mode. He matured as he guided his art toward the formal clarity of public styles, including those of billboards. Now, in a real billboard, he has achieved his version of the "New York sublime", that imaginative vastness sought by the inventors of action painting, abstract expressionism and all the heroic post-war styles that formed Katz's background when he set out to be a painter twenty-five years ago. In differentiating himself from that background, in achieving his own style, he has reached a scale as heroic as that of his New York School forebears.

I'm not sure that the city, especially that part of the city where the billboard appears, is able to make much sense of what Katz has done. I'm not sure it matters, because it's not certain that "the city" exists in the form of an audience for art. What matters is that "the city" existed for Katz in the form of an opportunity, that he responded in an appropriately gigantic manner, and that the result—like any work of art—is there for the audience ready to step up to its level. (p. 50)

Carter Ratcliff, "Alex Katz: Style As a Social Contract," in Art International, *Vol. XXII, No. 2, February, 1978, pp. 26-9, 50-1.*

Richard Marshall (essay date 1986)

[*In the following excerpt, Marshall, an associate curator at the Whitney Museum of American Art and organizer of the Katz thirty-year retrospective exhibition held there, surveys the range of artistic and cultural influences on the evolution of Katz's painting and assesses his achievement in reconciling "abstraction and realism in post-World War II America."*]

Alex Katz is a complex figure to unravel. His works reveal conflicting and opposing impulses and elicit contrary responses. They are often called slick, stylish, and unrealis-

tic likenesses of their subjects. They are, but not in a pejorative sense. They are technically and assuredly rendered with smooth, confident application of oil paint. They are glossy, bright, optimistic, direct, aggressive, and well composed, as is all of the best American visual art. But Katz's works can be at the same time passive, moody, ambiguous, and awkward. Characteristically, they display a shallow visual space that acknowledges the two-dimensionality of a painting and the tendency toward a reductive attitude in presentation; but they still elicit a deep resonance of psychological innuendo. Although portraiture is Katz's chosen mode of expression, allegiance to authentic physical features and personality evaluation is not his goal. Katz's Adas, Vincents, couples, and bathers are contemporary symbols. Their generalized countenances serve as vehicles for the exploration of the formal aspects of picture-making, while allowing for multiple readings that hint at narrative. Katz's astonishing achievement is to have reconciled abstraction and realism in post-World War II America.

Katz accomplished this feat by choosing from the visual, literary, and social stimuli surrounding him those attitudes and features that best suited his aesthetic stance. Painting representationally was never in question: "I knew I had to go with what I saw, the objective world, and that was what I was going to paint and that was all there was to it." The real question for Katz was how to make a representational painting as modern, sophisticated, and grand as the Abstract Expressionist painting he admired. He wanted to create a painting that would compete with the philosophy and energy of a Kline or a de Kooning. Because Katz was well versed in the history of art, earlier figures also gained new importance for him. He acknowledges Pollock as the artist who opened up these vistas for him: "When I saw Pollock, I realized he had sensation, energy and light, and it seemed much more like the motif I was painting than my paintings. . . . The paradox with Pollock is that as he questioned the 20th-century French painting he made me reconsider other European artists: Tintoretto, Fragonard, Velásquez and Watteau. . . . Pollock made it possible for me to participate. The establishment of sensation painting was something I could relate to my experience. . . . The establishment of a grand impersonal style offered many possibilities for a large number of artists."

Katz's reevaluation of modern European masters also clarified his attraction to what he refers to as "high style" art. He defines this as a type of painting that is ambitious, large-scale, elegant, reflective of a specific time period, yet impersonal and timeless; art that displays "self-indulgence in a big art form, rather than self-indulgence in personal feelings." High-style painting is typified for Katz by Manet, Matisse, Picasso, and Léger, among others, and in the work of each he observed affinities to his own attitudes that provided inspiration and afforded him the freedom to pursue his own approach to realism.

Ada in Blue Housecoat, 1959 is Katz's [version of Edouard Manet's] *Woman with a Parrot.* He saw in Manet a painter of contemporary urban life whose works made reference to earlier art but were very modern in their attention to light and color over subject matter. Manet's non-sentimental portraits, with their large flat planes of color, served as an example to Katz of specific yet general-

ized portraiture. A recent description [Françoise Cachin in *Manet, 1832-1883*] noted that Manet's "work offers the most varied images of contemporary life, with the grandeur of classical painting and the freedom of modern art; and it is in this duality that his individuality lies." This observation is an equally appropriate description of Alex Katz's position in recent art history.

Picasso offered Katz another source of ideas about representation, figuration, and abstraction. *Les Demoiselles d' Avignon* is a monumental composition that crowds five figures into an ambiguous and shallow space. The outlining of figures and the flat planes of color defining a skewed perspective had obvious appeal, but what spoke most forcefully to Katz was the fact that Picasso planned the composition of the painting. For Katz, a painting is conceived through sketches and an outlined cartoon on canvas rather than, as in Abstract Expressionism, "found" in the act of painting. Katz's multiple-portrait paintings, such as the early *The Black Dress,* 1960, suggest a similar type of carefully pondered figure placement. His composition of six Adas required deliberate planning in order to build a powerful and legible grouping of figures. Ada is also seen full face and in profile, a conceit that may represent a parsing of Picasso's device of simultaneous views in a single face. *Place,* 1977, a later multiple portrait of five different people, recalls as well Picasso's rejection of traditional Renaissance space; as Roberta Smith describes *Place* [in *Alex Katz in the Seventies*], it "is one of Katz's most powerfully primitive and abstract images. . . . This forceful, stacked-up, top-heavy composition doesn't bother explaining how all the heads and shoulders physically fit into the shallow space, much less where the rest of their bodies might be."

Katz likes to take those kinds of liberties. He will forsake realism for the compositional success of a picture, a freedom he attributes to the influence of Matisse: "A lot of great representational art is not involved with being realistic at all. . . . Matisse is my hero for realistic painting. People think realism is details. But realism has to do with an over-all light, and having every surface appear distinctive." Matisse's *Dance* was particularly important for Katz's early development. *After Softball,* 1953, and *Two Figures,* 1954, display a Matisse-inspired flatness, implied motion, and broad, flat color areas defining abstracted shapes that become trees, road, or figures. Katz's *Ada in White Dress,* 1958, a later, more confident and powerful work, beautifully employs a Matisse-like color application of vibrant, sharp green around a schematically outlined, lonesome, and unmodulated figure. As Matisse used descriptive color in *Dance,* Katz has laid down a flat, over-all surface that releases the full strength of the color and fuses the image and ground together. Léger also offered Katz a related aspect of figuration—unromantic, mundane, and conventional subject matter, which appealed to Katz because it deemphasized content, allowing attention to be directed to structure, composition, color, and style. [Katz has said:]

> The representational painting in America, post-World War II, developed. . . . mostly out of abstract painting: Willem de Kooning and Hans Hofmann being the main influences. . . . I developed an attitude that a painting could deal with specific information about the external world and that it, in itself, could be the subject matter rather than a so-

cial or philosophic illustration. . . . representational painters in the United States, in the 1950s, kept the social and philosophical content minimized, with the emphasis placed on formal values.

Among Katz's earliest works are a series of landscapes that explore formal attributes of painting. Like *Winter Scene,* 1951-52, they were painted outdoors, following the two summers he spent at the Skowhegan School in Maine, where he came to appreciate painting directly from nature. These paintings were also translations of the quickness of Kline and the light Katz saw in Pollock's drip paintings: "Pollock dominated my vision, but I could see the landscape—subject matter—through his abstract work." *Winter Scene* makes literal the representational suggestion that Pollock later made more apparent in *Blue Poles.* Katz's work is an abstracted representation of the impression of light coming through a stand of trees, executed in quick, fluid brushstrokes that expand beyond the edges of the canvas. His attention to light is evident in his earliest works and it never ceases, even in the portraits that he began soon after these landscapes: "I got more specific because I got tired of all-over painting. . . . I had to modify my approach and work more indirectly over a longer period of time. I'm still involved with light—an absolute present-tense light—but it can't be achieved spontaneously. It has to be reconstructed."

Throughout his career Katz has addressed more fully the issue of specific types of light, and his titles frequently make clear his intention of depicting the light associated with various times of day—*Swamp Maple, 4:30,* 1968, *Twilight,* 1975, *Night,* 1976; and times of year—*October #2,* 1962, *December,* 1979. Other works, although less specifically titled, deal with the impression of bright sun—*Ada with Superb Lily,* 1967, *Vincent with Radio,* 1974, *Roof Garden,* 1975; light reflected off water—*Blue Umbrella #2,* 1972, *Swimmer #3,* 1973, *Eleuthera,* 1984; and artificial interior light—*The Cocktail Party,* 1965, *Thursday Night #2,* 1974.

Katz's rejection of the all-over gestural approach was a result of his perception that Abstract Expressionist art, especially that of his contemporaries among the second-generation New York School painters, had become mannered. Katz had selectively appropriated the philosophical and formal attributes of Abstract Expressionist work, but he was committed to the representational approach and determined to clarify, refine, and define his own attitude about realism. Frank O'Hara observed that at this time in his development,

> Katz was pulling together his enthusiasms and influences into a congruent assemblage. . . . He freed his own painterly feelings and widened their range of possibility precisely at the moment when he was focusing them on a specific intention. . . . Katz has found a liaison between the personal and the general, the intriguing dialogue without which one is left with either formalism or expressionism.

The early portraits—*Track Jacket,* 1956, *Ada in Black Sweater,* 1957, and *Self-Portrait (Cigarette),* 1957—exhibit the rawness of a gestural realist approach but display a tightening up of composition and restriction of color. Here Katz has eliminated any background detail or reference and centered a roughly outlined figure cropped at the waist or knees. These works mark the beginning of

his full concentration on portraiture, and coincide with his marriage to and ongoing fascination with Ada. And it was a kind of portraiture—expressive in gesture, yet generalized in details—with precedents in American figurative works by Gorky and de Kooning, both artists whose works became increasingly abstract while retaining representational allusions.

In 1958-59, Katz produced an important group of pictures that resolved and surpassed issues explored in earlier paintings. These works, such as **Irving and Lucy,** 1958, **Bather,** 1959, and **Paul Taylor,** 1959, present full-length figures placed on an anonymous, monochromatic ground and display a more direct and controlled paint application. The importance of these paintings in Katz's development is their increased scale, both in format and in figures, and the restraint of gestural paint handling. The decrease in personalized gesture serves to abstract and generalize the subject, releasing its formal and typological potential. Katz's lack of attention to details of hands, feet, and clothing confirms his use of the figure as an abstract compositional device to be located on a two-dimensional ground in relation to the top and sides of the canvas, balancing color, weight, and scale. In this sense, the figures operate like the compositional elements of a Barnett Newman painting. In fact, the various Adas in this group—in white dress, in blue housecoat, in bathing suit—can be seen to function like Newman "zips."

The paintings of this period also seem to have benefited from the concepts Katz explored in the small cut-paper collages he began in 1955. These works represent tiny figures or objects cut out of painted paper and glued to a solid colored ground. The physical cutting and manipulation of the figures allowed Katz to test internal scale relationships and study effective figure, ground, and color relationships exclusive of subject matter. The collages also initially suggested to Katz the idea of a figure removed from the surface of a painting and the background, and resulted in the painted wood cutouts begun in 1959. Among these is one of Katz's first double portraits, **Ada Ada,** 1959. Double portraits had been done by Larry Rivers, Katz's contemporary in age and impulse, but without Katz's bland, factual aggression. The dual, repetitive portrait afforded Katz another device to subvert the importance of the subject while enhancing the formal and generic presence of the image. A repeated Ada or Rauschenberg is jarring and illogical, and the redundancy actually tells us less than expected about the subject. The **Double Portrait of Robert Rauschenberg,** 1959, also makes reference to Rauschenberg's *Factum I* and *Factum II,* each of which contains a double portrait of Eisenhower. Rauschenberg's almost identical works proclaim that the apparent spontaneity of gesture, so crucial to Abstract Expressionist tenets, is inauthentic; and they share with Katz's work of this period a partial rejection of loose, personalized expressionism.

In the mid- and late 1950s, Rauschenberg, Johns, and Katz all sought to move away from the ambiguous, subconscious presentation of Abstract Expressionist work toward a more factual, controlled, and predetermined expression. Johns' choice of subjects—flags, targets, maps—are known, recognizable, impersonal images, and are conceptually aligned with Katz's interpretation of the human form. Katz's 1958-59 portraits begin to reduce the visible

drips and the reliance on accident; what drips and gestures remain are intentional—a reminder of his debt to Abstract Expressionism and, at the same time, a way of announcing what is being rejected.

By the early 1960s, Katz had assimilated or rejected various aesthetic devices and concepts of the Abstract Expressionist, Color Field, and proto-Pop artists. His work now began to display more confidence, power, and skill. With paintings such as **Passing,** 1962-63, **Eli,** 1963, and **The Red Smile,** 1963, Katz made a big leap into larger scale, media-inspired horizontal formats and cropping, and an assured, smooth paint surface. His subjects became more impersonal, being executed in a flat, shallow space that further suppressed descriptive and painterly detail. Katz was attuned to the emerging aesthetic of the early 1960s. Along with Stella, Kelly, Warhol, and Judd, he worked at making art that was emotionless—clear, reductive, and unambiguous. But for Katz, that goal was difficult because of the inherent content of portraiture and representational subject matter. To ease the problem, he looked to mass media—television, movies, advertising—for devices that would give his work increased clarity, high impact, compositional directness, and impersonality.

> Visual symbols today are complicated by the movies, T.V., billboards, book reproductions, etc. They exert a continual pressure and in some cases, have taken the place of painting in that they have dominated our vision. . . . The media have also exerted influence on most high style figurative art and have in turn been influenced by fine art.

Katz's statement acknowledges the dominant force of the media, and that advertising, in particular, offered him visual clues to picture making.

One media device that began to influence Katz's work in the early 1960s was a new form of billboard advertising. The 1950s were referred to as the "Golden Age of Paint" in the billboard business. The hand-painted billboard replaced the illustrational and photographic paper paste-ups of earlier billboards to become the primary form of outdoor advertising. The painted billboard offered a larger, bolder image in stronger, more luminous colors. The speed and frequency with which a new generation of consumers traveled on highways necessitated a larger scale for outdoor advertising and, during the 1950s, the size of the billboard increased to 14 by 48 feet. A face or product enlarged to that preposterous size became an arresting, eye-catching image, and the smallest detail grew more important and recognizable. The most often used device was a dramatically cropped face that loomed above the highway. Cropping at the forehead or jawline was visually startling, making this huge face appear even larger, since it implied an unseen continuation. The concept of the image extending beyond the edge was, of course, occurring simultaneously in Abstract Expressionist painting, and was probably the source for advertising designers. But billboard design extended the idea further by attaching cutout plywood extensions to the rectangular form of the billboard. These overscale cutouts of smokers, beer bottles, or automobiles accentuated the surrealistic overtones already used in advertising, and gave the billboard a three-dimensional character by taking the image out of the painted plane and into the reality of the landscape or cityscape. It was this illusionistic and environmental aspect of

advertising cutouts that had prompted Katz in 1959 to make his own cutouts. In his paintings, he adopted other characteristics of this new advertising age—large scale, intense flat color, gigantic cropped faces, and an absence of sentimentality—to achieve a modern representational art, at once fast and expansive, but devoid of the emotionalism of Abstract Expressionism and the overwrought narrative often contained in realist work. The same aggressive visual salesmanship that promotes the staples of American consumerism can be seen in Katz's depictions of *Eli,* 1963, *The Red Smile,* 1963, and *Paul Taylor,* 1964. They represent Katz's unique, Americanized brand of realism.

Katz's use of advertising techniques has been observed since the beginning of his career. In 1964 Irving Sandler noted that "Katz's portraits look singularly contemporary. By making them Gargantuan, he calls to mind enormous billboards. His approach to the human figure is a novel one, for he works on a scale seldom seen in art but familiar enough in our everyday life. . . . He does not simply re-create commercial art, but uses its impersonality as a contrast to the poignant intimacy imparted by his sitters. . . . The tension between Katz's love of tradition and his response to what he sees about him underlies his painting." In a related comment, Edwin Denby found in Katz's work "the optic flash associated with advertising. . . . It upset the picture's weight—the rest of the painting couldn't keep up with its speed. Some Cubist

and abstract pictures had caught the speed, but at the time representationalism could not." But Katz had caught that speed by the early 1960s and harnessed its style and technique to evolve a similarly clean, quick, straightforward approach to painting.

An additional and related source for Katz were movies, which presented images in a grander, more stylish manner. Katz's use of the motion picture's close-up device is the most pronounced characteristic of his compositions. The large heads of *Ada with Bathing Cap,* 1965, *Swimmer #3,* 1973, or the glamorous *Upside-Down Ada,* 1965, are dramatically cropped, and situated on a horizontal field that aggressively pushes the image forward into the viewer's space. The enlarged and strongly lighted contours of the face, hair, and clothing allow Katz broad expanses of flat and smooth color, accentuating the largeness and visual impact of the form, as in *December,* 1979, and *Red Coat,* 1982. Paintings such as these are often reminiscent of movie stills that freeze and isolate an image, and remove it from the narrative of a film. In addition, Katz uses this zoom lens approach to clarify, generalize, and idealize the countenance in order to make the image symbolic: "an art where the image and symbol are one. . . . to make a symbol that is clear as well as multiple; a symbol that can mean different things to different people, rather than a sign that is the same to all people." It is here that Katz diverges radically from the Pop artists with whom he was

The Red Smile (1963)

prematurely and erroneously grouped, although they are related in their use of figurative elements and media-derived imagery. Andy Warhol's Campbell Soup cans or Marilyn Monroes, for instance, are culturally and socially recognizable signs that have shared meaning in the public consciousness. In a similar way, James Rosenquist's direct borrowings of fragments of advertising imagery deliberately thwart any implied narrative because they are arranged in jarring juxtapositions that do not allow for romanticized or symbolic readings of the paintings.

Ada in **Blue Umbrella #2,** 1972, is surprisingly similar both in feeling and composition to a frame in Fellini's *La Dolce Vita* and, like the cinematic figure, is a singular, striking, and clear image that elicits multiple, ambiguous meanings. Ada can be read as a symbol of beauty, sorrow, mystery, coldness, or desire. In terms of physiognomic stylization, Ada also bears a striking resemblance to Elizabeth Taylor in a film still from *The Comedians.* And when Ada appears in a car (**Impala,** 1968, **Ada and Vincent in the Car,** 1972,) her portrait is imbued with the romance of the automobile and of the independent woman. Katz, in fact, has referred to **Impala** as "my Polish Rider," suggesting an analogy to Rembrandt's romantic and symbolic image of adventure and mystery. The possible meanings inherent in a Katz portrait are manifold and the artist's strength lies in his deliberately ambiguous narrative—one without sentimentality and one that emphasizes appearance over meaning. The psychological content of some 1960s movies, such as Antonioni's study of ennui and alienation in *L'Avventura* or Bergman's *Persona,* display the same coolness and distance as a Katz painting, the same supersession of style over content. This type of atmosphere was observed [by Jack Kroll] in a review of an early Katz exhibition that described the image of Ada "scoped and scaled like Antonioni, hardly more a presence than an impact on emptiness."

But Alex Katz's work is, in fact, not empty, but full of formal, social, and psychological references, both historical and current. The resonance of Katz's art lies in its seamless amalgam of sources into his own distinct style. His work adroitly and intelligently synthesizes influences and impulses that emerge from and respond to the contemporary world: "I think of myself as a modern person and I want my painting to look that way. I think of my paintings as different from some others in that they derive a lot from modern paintings as well as from older paintings. . . . They're traditional because all painting belongs to the paintings before them, and they're modernistic because they're responsive to the immediate." (pp. 13-20, 22)

Richard Marshall, in his Alex Katz, *Whitney Museum of American Art, in association with Rizzoli International Publications, Inc., 1986, 157 p.*

Ruth Bass (essay date 1986)

[*In the following review of a thirty-year Katz retrospective at the Whitney Museum of American Art in New York, Bass discusses many aspects of Katz's artistry, including the evolution of his style as reflected in his portraits of his wife, Ada, and the manner in which he creates his paintings.*]

"The ordinary is quite marvelous," says Alex Katz, and one need only see the works in his current retrospective at the Whitney Museum of American Art in New York to concur with this view. He translates the ordinary sights of everyday experience into images that are extraordinary in their own right and that, according to curator Richard Marshall, "have reconciled abstraction and realism in post-World War II America" [see excerpt above]. (p. 107)

One of Katz's most remarkable achievements has been to take images that are quite personal and specific to his own life—his wife, Ada, their son, Vincent, their friends and neighbors, their dog, their yellow house in Maine—and transform them into images that have meaning for everyone. He can also take motifs that are downright ugly and make them into something magnificent. **Moose Horn State Park** (1975), for example, is a great horizontal canvas filled with the cropped image of a brown moose with its rear end jutting out at the viewer. There is not one pretty color in the painting: the moose is a dull brown, the background water a pale gray and the few weeds on the shore a sour yellowish green; and there is not one element that is sentimental or picturesque. The animal is just there, majestic in the fact of its very being, with its horns creating an almost Baroque splendor as they fan out across the horizon.

First and foremost, Katz is concerned with the way things look. He may catch your eye with a brilliant color combination, monumental scale, multiple images of the same figure or a daring composition. He wants the works to "come right off the wall at you." Then, once you're hooked, he says, you can think about the social connotations of the image, about light, paint, space and atmosphere, the relation of painting to art history and to popular icons. "It's all there," Katz says, and he's right. In this way he's very American and very much of his time, taking his cue from billboards, advertising, fashion, movies, giving you something that is spectacular, pleasing and seemingly simple to read.

Katz chooses to paint people at ease: beach and boating scenes, unremarkable moments in family life, friends standing around or sitting and talking or people at parties such as the one implied by the monumental oil-on-metal cutout **One Flight Up** (1968), which contains at least two dozen heads elevated almost six feet from the ground. The closest thing to work depicted is in his marvelous paintings of the Paul Taylor dancers. Violence, domestic strife and emotional anguish are absent, as is the actual strain of painting. "Nothing's supposed to show," Katz says. "It's supposed to be easy. It's a kind of artifice, and it seems to reflect my personality. I couldn't be a let-it-all-hang-out Bohemian type if I tried." Yet he imposes his vision on you by the bigness of the work, by a certain static balance, by what he calls "bland power." The sheer scale of the works, with their disarming subject matter and daringly reductive composition, forms and color, helps create energy without angst, drama without histrionics.

The evolution of Katz's mature style can be seen in the paintings of Ada, whom he married in 1958. In **Ada in White Dress** (1958), she stands clutching her wrist in the center of a green field. The fact that her feet are covered by the rather brushy green paint suggests that it is grass, but the green also functions as the field of a color-field painting, glowing and vibrating on its own even as it com-

presses the space, at once flattening the roughly outlined figure and emphasizing its status as a shape on a painted surface. *Ada Ada* (1959), an oil-on-wood cutout, is Katz's first multiple image (followed by *Double Portrait of Robert Rauschenberg,* an oil on canvas of the same year). *The Black Dress* (1960) is a brilliant use of multiples with six figures of Ada, one sitting and five standing in slightly varied poses. Here the bright red lips and brilliant blacks of the dress, shoes and hair present a striking contrast, playing off against the flat gray wall and brown floor, reiterated in slightly different form by part of a Katz portrait seen on the wall—a male figure clad in black in a brilliant red frame that backs the right outline of the last Ada.

Katz claims that his paintings of Ada are not really likenesses, that the faces are completely different from painting to painting and that she becomes a different sort of symbol each time. By "symbol" he means an open image that may have universal appeal but has different meanings for different people. *The Red Smile* (1963) is one of his first cropped billboard-scale images. The head with its cheerful smile and bright blue headband juxtaposed against a flat red field may be a symbol of glamour, beauty, sexual desirability, social acceptability or masked sadness. Images from the movies, television, magazines and billboards fascinate Katz because they are eye-catching, easy to read, recognizable to almost everyone and exert an enormous influence on our values and visual consciousness. In *Upside-Down Ada* (1965), the exploration of media ideals of beauty is pushed even further as the inverted head fills the 65-by-52-inch canvas diagonally, the hair flowing back in an allusion to fashion photography and perhaps to movie and TV visions of female sensuality as well. The literary content of *Impala* (1968) is particularly important to Katz. This is his version of Rembrandt's *The Polish Rider,* with the car as a symbol of implied faraway places, or mystery, romance and adventure. The work is also a tour de force of painting, with the radical spatial shifts from the profile of Ada in the foreground through the interior of the car in which she sits to the far distance of the landscape seen through the side window.

Katz describes Ada as a person who "has an idea of what she looks like all the time. She's only interested in things that look good on her, and she doesn't care if it's fashionable or not." In a sense this might be a description of his own paintings. He cares about the way they look, and uses or rejects fashion as it suits his purposes. He accepts the world around him with all its banality and vulgarity but picks and chooses the elements he wishes to address. At the same time he is very much aware of art as a vocation and deals with many of the problems that have traditionally been the concern of artists.

Katz . . . was seriously involved with painting by the time he was in high school. "It was easy, somehow. I liked doing it and my parents liked art, so it was just very easy and natural." But however easy it may have seemed, he worked hard at it. "I took courses in cast drawing, and I worked three to four hours every day. By the time I was 16, I could draw from the antique very well, and I got more serious when I went to art school." Art school was Cooper Union, where he studied with Robert Gwathmey, Peter Busa, Morris Kantor and Carol Harrison. After graduation, he spent the summers of 1949 and 1950 at Skowhegan School of Painting and Sculpture in Maine. It was at this time that he found his subject matter. "I knew what my subject matter was real early, right after art school, and it was just a matter of figuring out how to paint it. I just started painting and it was kind of terrific and that's what I wanted to do."

Katz's concern with the quality of light, both indoor and outdoor, may have come from the Skowhegan experience. Many of his works have titles that merely indicate the time of day or the month in which they were painted. *October #2* (1962), for example, is a view through his studio window at part of a tenement wall. In *Cocktail Party* (1965), the guests are clustered together against a backdrop of neon light and darkened buildings seen through the window, their skins made ghastly—the color of the studio walls—by fluorescent lights, with a few figures wearing pink, red or green clothing that adds just enough color to bring the work to life. *Twilight* (1975) is a fascinating indoor scene, a close-up of a young man lighting a woman's cigarette as they stand in front of *Walk* (1970), an outdoor painting of Alex, Ada and Vincent in brilliant morning light. The figures of the guests intertwine ambiguously with the figures in the painting, as do the indoor and outdoor lights, the evening and morning lights.

Swamp Maple, 4:30 (1968) is a stunning painting of a single tree on a hazy August afternoon. The tree itself divides the 144-by-93-inch canvas smack in the middle, a daring compositional device that Richard Marshall likens to "a Barnett Newman zip." The sky is pure golden yellow, and the water is a color that Katz describes as "a yellowish blue that isn't green." When it is suggested that most people wouldn't see the sky as yellow, he replies that "people don't bother looking at the sky. They accept the sky as blue. I don't think that appearance is the same to all people, and I think artists can show you the way things look."

Katz says that the ideas for the paintings "come in different ways. Some things come out of conceptions. They take a long time. Other things come out of, Bam! I see something!" Many of the works are set up at specific times with specific artificial or natural lighting effects in mind. In the case of *Walk,* Katz recalls, "I just saw something that looked great. I was there in the morning and everything looked great so I painted it."

Although Katz seems calm and relaxed, his conversation is punctuated with expressions like "Wow!" "Bam!" "Terrific!" He obviously delights in his work. He has taken the happy, untroubled world of Impressionist painting, with its love of light and the outdoors, of friends and family at ease, and brought it into the 20th century by suppressing the brushwork and enlarging the scale. Yet despite the handsome images, fluid surfaces and distanced quality of his canvases, his consciousness was deeply influenced by the Abstract Expressionist painting of his immediate predecessors, such as Jackson Pollock and Franz Kline. Thus he describes the act of painting as a "real strain," but it is a strain that doesn't reveal itself through process.

He starts with a series of small oil sketches, which may take no more than a half hour each, that establish the basic composition and lighting conditions. After choosing the sketch closest to the concept he wants to convey, he enlarges it and transfers the resulting cartoon to the canvas, sometimes using a studio assistant to help with the transfer process and the mixing of the paint. After all the colors

are premixed, he will usually paint six or eight hours at a stretch, doing the painting all wet, all at one time. He likes to "pull" the paint, using long strokes so that it refracts less light and has a mat look. The risks he takes are not so much in the art of painting, as for a previous generation, but in tackling impossible, reductive compositions such as **Swamp Maple** with its "zip" down the middle, **October #2** with its six flat windows seen through four flat transparent panes, **The Black Dress** with its multiple images and **The Red Smile** with its field of pure red. All these show Katz's knowledge of abstraction and Minimal art, and his willingness to break the rules of traditional realism to get the effect he wants. He also feels a sense of risk in doing the cutouts—works that are both sculpture and painting at the same time and therefore challenge our assumptions about two or three dimensions in art.

The most recent work in the show is the four-panel **Eleuthera** (1984), which is ten feet high and totals 22 feet in width. Each panel features two young women in bathing caps and Norma Kamali bathing suits against a background of vibrant aqua. Although fashion would seem to be a natural subject for Katz, he didn't get involved with it until 1983, when *New York* magazine asked him, along with other well-known artists, to collaborate on a fall fashion issue. In any case, bathers have long been a trademark subject for Katz, **Eleuthera** is only tangentially about fashion, and, as usual, content is submerged in other issues, such as composition, color and painting. The figures pose facing forward in a manner that is almost confrontational, but the gazes are directed slightly away from the viewer, Katz's way of avoiding a "hot spot" right in the middle of the canvas. Striking swimsuits and colorful bathing caps are played off against the blandness of the models, and the canvas is further activated by the simple reductive shapes of cast shadows. Wildest of all are the highlights—square patches of white paint just sitting on shoulder or belly, suit or cap, noses or knuckles, wherever the artist deemed them necessary. This is quintessential Katz: something to knock your eye out and then make you aware of what contemporary painting is all about. (pp. 107-11)

Ruth Bass, "Bland Power," in ARTnews, *Vol. 85, No. 4, April, 1986, pp. 107-11.*

Bill Berkson (essay date 1986)

[*In the following excerpt, Berkson discusses a number of the works displayed at the Katz retrospective exhibition at the Whitney Museum of American Art.*]

Alex Katz has worked at deciding for himself what is most admirable and ripe in traditionally balanced oil painting—a tradition he confronts quite sharply and has gone some lengths to enlarge. Through some of the thornier questions of contemporary style and content, as well as through the curatorial bans on energetic realism, he has managed to cut his own wide, steady swath. His big, clear, largely declarative pictures take their basis in peculiar facts of seeing and how seeing and knowing match up. Their luxury is a wealth of style. Their realism extends from how the world looks to Katz's eye and incidentally from how his models present themselves.

Katz's subjects are from life: New Yorkers mostly, friends and family, observed singly or as groups in ordinary social space—a city loft or vacation house or field in Maine where Katz spends summers. As in conventional portraiture, a sitter's personal expression will be seen to hold sway over the final image. The sitters' poses are natural but the naturalness of their settings is simulated (that is, the situations themselves are posed), and the colors, light and space usually have an extra measure of formality or idealization or both. There are rooms and landscapes with and without people, and window views and animals. There are few objects aside from clothing and other appurtenances: a glass, a cup, cigarettes, a radio, a free-floating canoe. In **Night** (1976), a houseplant tilts in front of a painting, and opposite, there's an empty chair beneath a lamp, rare items that click to the mood.

Asked a few years ago about the gracefulness of his figures in contradistinction to their realism, Katz replied, "I might be showing things at their best moments—under the best conditions—but that's as real as anything else." Katz paints character in the light of the moment. If the moment is casual or bland, he doesn't press it with an anterior sense of importance. His profounder images, which can be counted on the average of about one a year, posit the difference between intending a pathos and observing it if it happens—the former being a privation of the moment's integrity while the latter is an extrusion in the present tense. The human meaning is proffered at face value, self-evident.

Critics stymied by the seeming offhandedness of Katz's non-editorializing approach have no use for the actual surface look of his paintings. Others, those who object to the class appearance of his figures—stylish clothes, civilized miens, and other ambient pleasures of urban art, whether Bohemian or straight—show a strange irritability where their own social markings are concerned. The culturally touchy among iconographers resent finding themselves or their next-door neighbors represented at the level at which they actually live. (As one poet/critic who should know once countered: "If we're not middle-class, what the hell are we?") Katz, for his part, delights in recognizable neighborhood plumage as physical fact. About the declassified cultural openness of Rudy Burckhardt's street documentaries he once wrote: "It's great to have someone show you a thing you have passed thousands of times as something you never saw, and after seeing it you continue to pass it again and again and not see it."

A typical Katz will have an unfussed look as if done on the spot, *alla prima*, even though the most recent ones are more methodically designed. Since the mid-'60s generally, he has gone more for power than charm, and the wit that used to be part of his subject matter now serves formally—to get a composition out of a tight corner, to turn an unwieldy tableau into a ruckus of deflection, no less beguiling for the outsized oddities gathered edge to edge. Instead of romanticizing the blockbuster format, he takes it as a public conveyance for information just wide of the general scope. His pictures have pleasurable sweeps and disconcerting elements. Where an awkward passage in a four-foot portrait can be charming, at twice that size it is grotesque. Many of Katz's bigger pictures are grotesque. Like Guston, to whom he is otherwise antithetical, Katz came to grand-scale painting by discrete stages from an essentially lyric impulse, consolidating and then retrenching for definition and release. In the '50s, Katz showed the influ-

ence of Guston's shimmering touch and softly spreading tonal light. Of course, Guston's imagery was the more subjective. Katz is an objectivist.

If scale is the live aspect of size, character is that quality of energy discriminated as vivid fact. Painting's imaginary light modulates character and scale and introduces a time element. In a broadly conceived tradition of imagemaking intent on maximum visibility (viz., Egyptian murals, Edo prints, quattrocento frescoes and bas-reliefs, Mondrian, Léger) one general approach involves integrating stylized character, light and scale so that the whole of an image can be seen in the instant before the mind entangles itself in lesser details. The outright appearance forestalls bafflement about what's visibly real and hypothetically improbable. A remark on this score made by Edwin Denby in 1965 has become so identified with the light-and-energy quotient of Katz's work as a whole, that its original application to the tiny collages of the '50s is largely forgotten. What Denby said was in the form of a question: "How can everything in a picture appear faster than thought, and disappear slower than thought?"

At the Whitney, the immense space of the central gallery designed for the present show put the public on notice as to the maximizing tenor of Katz's work, as well as its distancings. This "great hall" effect took some getting used to, although right off you could see the benefits of the airy, long-range focus conferred on a 30-foot painting at the far end. Close to the elevators, facing them and away into the room, the freestanding group portrait (some 40 front-and-back, head-and-shoulders cutouts) *One Flight Up* (1968) provided the show's overture. The eye, thus oriented, cast clockwise to five big paintings.

Here are three of them:

In *December* (1979), we see the head and shoulders of a woman (a rather Japanese-looking Ada, the artist's wife) in soft brown hat, coat and muffler, wrapped against the elements, while the snow splotches about her. The look is slightly askance—she's just flashed an attitude—but utterly intense and furled. The entire space is pivotal, on the brink. The weather intensifies the sharpness of feeling, but the character, being projective (she is herself, the month, the climate, a sudden city sight), appears impervious to the weather. She's absorbed in something else, serious and determined. She addresses herself to a second presence, which may well be the viewer, or light. But, on the other hand, the character and *its* light are one.

The weather in *Swamp Maple, 4:30* (1968) is no less intense. The slender titular tree bisects an overcast Maine landscape view. The painting doesn't flatter nature but steps right up, augmenting its sudden composure. The sky's dun chrome descends like a dusty window shade and presses forward, riding a blue ridge. A lake or cove is rimmed by three shores. The dark middle shore, jutting, discloses the source of light as do the tree's darker higher leaves which, in the late-afternoon peace, make a sparrow-like flutter. The real cracking on the maple bark wasn't planned but happened as the paint aged in the artist's New York loft, a neat accident (also unusual: Katz's oil colors otherwise tend to retain their fresh-squeezed look).

Unlike the two other pictures, *Pas de deux* (1983) does without intimation or nature and hinges on a kind of hieratic nonchalance. Five enpaneled couples read right to left

like instantaneous, progressively explosive shifts in a dance line. The performers are just schematized models wearing chic street clothes. The picture takes off on fashion styling and partnering conventions in classical dance. The men in the lineup recede as if in deference to the up-front women, but instead of lifting or supporting, they weigh them down—hands on shoulders, arms around waists. The women look cheerful, the men a little stupefied. Katz has the men gravitate downwards by the device of lowered eyelids. The multiple hand gestures stop short of intimacy; palms in or out, fingers pointing or spread, they jab and flicker laterally across the frieze. The figures are cropped at the thighs, the stagelighting steady and unstopped by the perimeter cuts.

For years, Katz has been attempting large formal dance pictures, always with mixed results, silly and/or mechanical. *Pas de deux* succeeds like a machine painting in the good sense, a showpiece that works. It has a strange abstract zing. The figures are real people acting out an artifice, which is the surface show. Staging such a production number out front let the museum audience in on a secret: that Katz's paintings of people catch perceptible dancelike postures in everyday life, postures that are part of the theatrical forward thrust of character associated with contemporary New York.

If New York is the court of modern high visibility, Katz stands as First Painter to its acculturated peers. His figures are focal points in the neatly partitioned syntax of urban flux, New York's nonpareil spillway of grandeur and duress. Bravely undisheveled and refusing simply to meld, their mutabilities chronicle the floating world of the downtown art scene from its blooms in the '50s and early '60s to its presently still-bright but fungoid state. You can follow the dress codes as indexes of period styles: from, say, Rauschenberg in suntans, open collar, and rolled-up sleeves to David Salle in a shiny black sharkskin suit. The art-world look, as Katz finds it, is oft times modestly dumpy, or conversely too much of the moment; more likely, though, styled for speed and comfort, with snazzy colors and touches of Olympian self-amusement—the allover pattern of little stars on a pleated skirt; a single earring, big and round like a stateroom porthole, an aqua dish.

In New York's sociable purgatory (with heaven always in mind, or at least the Empyrean of Style), the range of human types seems boundless. People, as they are set forth, suggest a native tact about distance: eyes in groups meet or stare away or come straight for you; at close quarters, elbows have a personal edge. (But what's with all these toothpaste grins—signs of a baffled complicity, or a friendly monster showing its teeth?) Portentously swaddled, a planetary character will reveal concentration at the neck, or a beautiful absence will simper, or a loft-dweller's basic tenderness be etched in features grayed-out under fluorescent glare. Surface is the great revealer. As Katz has said, "Vitality being what emanates from the surface, manners and intent have no meaning." Pungently, a single sitter's gaze flattens wide, beyond any set contingency. (A technical mystery twist: the wider the gaze of the figure, the bigger the image's scale—in the realm of appearances, we are truly rounded.)

Delivering a slide talk to art students in San Francisco a couple of years ago, Katz began by anticipating their difficulties. "With slides," he said, "you don't know the size,

the touch, or how they're painted, and the color's wrong—so you don't really have much." That settled, he proceeded to make a number of clear-cut distinctions, some of them professional pointers tuned to the occasion and others specific to his own painting or to painting generally. With each slide, he emphasized the "optic element" and actual dimensions. About dynamic versus implied motion, he remarked, "The more dynamic the action in a painting, the less you're able to take it seriously as painting." He outlined his art-school beginnings: "Painting outdoors was where everything clicked. The paintings didn't look good but the process was dynamite—and I said, 'I'm going to be a painter'. "

He then leveled on basics, a five-point program: (1) "In painting, you have your personality and you have painting, and you have to reconcile the two. Every time period represents a different cultural attitude. My attitude was formed by the war years when people just really wanted to have a good time. I was interested in dancing and playing basketball. . . ." (2) "Everyone has a three-year period when they connect, when they're hip, and that's your period." (3) "A painter has a shorter time than a fashion designer to be on top of styling. After that three-year period, good painters go out and spend the rest of their lives painting masterpieces. Painting seems to me to be an older man's business. You know you're out of it and you just paint masterpieces, and you get better." (4) "In art school, if you don't have developed cultural attitudes, your painting is limited, no matter how good you are technically. You can be hip, but your time period should be three years from now, not now." (5) "To learn good habits, paint six hours a day at least six days a week for at least six years—and then you'll see if you like it." (Q: "Could you explain 'cultural attitude'?" A: "Well, Jung was hip in the '30s and Pollock picked up on Jung.")

Elsewhere, in Rudy Burckhardt's film on his work, Katz says: "I would like to make a painting that's so proficient technically that if you're going to say it's no good it's got to be because the man's character is bad."

Katz's progress reflects his culture as a native New Yorker, his inborn sense of theater, his early training in commercial art, his interests in literature and dance, and his fascination with the relation of style to expression and of both to social manners. The earliest paintings in the show—*Winter Scene* and *Four Children* (both from 1951-52)—have all of his elements and no particular style. You see his enjoyment of the profuse material life a painting can have—a profusion which, handled delicately later in terms of color, widened the prospects of the work. His maturity began in 1956 when he made friendships that stimulated him toward a heightening of style and richer conception of surface. Edwin Denby, Rudy Burckhardt and Frank O'Hara all came into his life at that time; and a year later, so did Ada Del Moro, whom he married. His painter friends in the '50s included Jane Freilicher, Al Held, Philip Pearlstein, Lois Dodd and other members of the Tanager Gallery group, and Fairfield Porter.

The half-length portraits of this period and the full-length ones of a few years later charm as much by their tentative placements as by the lushness of their veneers. (The earliest are oil-on-board; with the change to canvas around 1958 the pictures begin a yearly progression of enlarging by halves, with bigger jumps in 1963 and 1969 when Katz moved to successively roomier lofts.) Where the earliest figures stop shy of the plane, the one in *Track Jacket* (1956) advances stealthily but tucks inward at the sleeve and neck. Trouble in undefined space shows up mostly at the tops and bottoms. The problem of getting a head to sit straight on the shoulders is dealt with by leaving it off-kilter and wobbling, an awkward/lively skew. As Katz remarked, "A lot of these paintings don't have any floor"—so footholds had to be established mostly within the gestures of the figures themselves. *Paul Taylor* (1959) has duck feet. In *Irving and Lucy* (1958), Irving Sandler's brogues flatten and smudge. *Ada in White Dress* (1958) resolves the no-floor enigma by sinking up to the ankles in a green setting that spreads to the top without receding or localizing as a grassy field.

Both the collages begun in 1955 and the cutouts invented four years later figured first as ancillary problem-solving devices for painting. The cutouts have continued as both a form in themselves and adjuncts to the making of big pictures. The collages, intermittent after 1957 (the last is dated 1960), were superseded in function by prints. (The retrospective includes neither drawings nor prints.) In the collages, Katz applied his wit to the incalculability of actual size. Minuscule arrangements of near and far tones fasten on the idea of life size and undermine it, throw it back on itself like a well-staged pun. The tiniest details agglomerate in the middles and cue the images' central weights. The basic four-tone merger of *Dog at the End of Pier* (1960)—two grays, jet black and a buff wash—is the "Whistler's Mother" of the set. The angular profile dog sits center sheet, lifted there by oblique patchwork as if on a pedestal, a truncated pearl. A similar joke of balance and tones lifts the cutout *Rudy and Edwin* (1968) into an adjacent world. Like real New Yorkers, the two old friends are a little bit off the planet, mutually amused in their folding chairs as on a parade float.

After years of watching the early portraits expand in afterthought, one is struck by what trim sizes they really are. One is reminded, too, of how such pictures led the sensibility attack of Gestural Realism out of the parlor into a grittier citywide scale. In *Red Smile* (1963) and *Upside-down Ada* (1965) you see how the developing tonal range takes up the graphic statement, so that colors press at the contours and color and character become coextensive. *Ada in Bathing Cap* (1965) is the first to add a recognizable counterweight of thought (it's a green thought). In *Vincent and Tony* (1969), both thought and size are doubled. Two boys, white and brown, sit shoulder to shoulder at the edge of a lake. A mopey-looking Vincent (the artist's son) looks off, but his more inquisitive friend rivets on the viewer. Their halftone shadings jog the stillness, while the sky behind them stretches a long, thin vanilla skein.

Character, says Katz, "can get to you from a bend in the back." Two of his self-portraits are actually three-quarter back views done partly with mirrors and partly made up. He speaks of "casting" himself in self-portraiture objectively so that, in the hail-fellow-well-met of *Alex* (1968) or the hard-nosed vacationist of *Self-Portrait with Sunglasses* (1969), you get both Katz the actor and Katz the deliberate physiognomist. (Even more typically, as in *Passing*, 1962-63, he'll treat you to an unalloyed Katz scowl.)

There's a sensible distinction between images of lived-with

selves (the self-portraits, the Adas, Vincents, or longtime friends) and those of a less intimate cast. The Vincent pictures now represent the span of a coming-of-age. In *His Behind the Back Pass* (1978), the deep shades of lawn between father and son as they "frisbee" seem to be marking a major turn. The portraits of Ada and their extra-autobiographical grandeurs are better known and have been remarked upon commensurately. . . . Ada reduplicated is also basically Ada in company with her constant self, as well as seen by someone who sees her shift, limitless of aspect, in the varietal spectrum of marriage. The exact hiatus of personal/impersonal in those pictures is complicated even when most clear.

Less intimately seen models lead to the logic of blander, plainer forms. In *Eleuthera* (1984), the huge finale picture of the show, with its rather balloon-headed swimsuit pleasures, the eight female figures exude a generic glossiness solidified only in their shady parts. Even more low-definition images can dissolve into something genuinely evanescent. Of one portrait (a rare commission of the '60s), Katz recalled at the time, "I couldn't see the face so I painted the makeup." What all this argues, I think, is that Katz's cool, his supposedly smooth detachment, has been too conveniently overrated. His passion for exact appearance (if not always for likeness as such) is aligned with a truthfulness about how people appear to one another, how they register in the world. This truth, like that of character, is a social thing. For better or worse (empty or not), an evanescent sleekness is one fact of the way we manage our communal lives.

Katz's pictures of the last ten years or so stand or fall literally according to their lights, which extend to the nature of social events. When the pictures lapse, it is into a clatter of partial caricature—that is, they fall back on a lesser wit, with seams and blanks showing between bravura details. At their best—as in *Round Hill* (1977)—distinct shapes meet the rush of light as if cued by a beat. The confident light drives across the likenesses, probing, adjusting, zooming on. Looking at *Round Hill* in the last gallery of the Whitney show, one observer noted the way the local scale "implicates the viewer and throws the light back on him." Of such powers—and of Katz's attitude generally—the mountainous moose of *Moose Horn State Park* (1975) seems particularly emblematic. A juggernaut of heaving lights and darks, with his rear slammed up against the picture plane, he is guardian, from his marsh end, of one of Katz's most munificent lake views—a soft-focus, silvery stretch with bright stabs of birches along the far shore.

The installation at the Whitney had a pedagogical bearing, a cumulative air of proof that seemed unnecessary (and unwise) like a case of last-minute jitters. What could be proven at this point? That Katz's development, unique and challenging, must be reckoned with in the dilapidated modernist canon? That his virtuosity should somehow be more astonishing than it is? On the whole, I thought, a show calculated to impress rather than please, although, as it turned out, it accomplished both. In the five days I was in town last spring, the exhibition drew crowds pleased to linger over the formal and fanciful imagery and the paintings' puzzles of scale and relations. The audience went for Katz's finesse, and most of the local reviewers did too. (pp. 152-8, 183, 185)

Katz's new popularity—his elevation from specialty act to fast classic (however woozily perceived)—provides a kind of taste test for the wider audience. Will it value his real strengths or dispose of them? His combination of lucid contemporary spectacle with a durable scale, among them, is foremost and unbeatable. Katz is a witness, transforming his views of how we do or might appear into telling, luminous, renewable states. His watchword style turns the key to resonance. (p. 185)

Bill Berkson, "Alex Katz: First Painter of Character," in Art in America, *Vol. 74, No. 11, November, 1986, pp. 152-59, 183, 185.*

Donald B. Kuspit (essay date 1988)

[*In the following review of a Katz exhibition at New York's Marlborough Gallery, Kuspit asserts that Katz's work seeks to capture the moment of tension in which "the world converts itself to art."*]

Alex Katz, who is usually associated with the bright (if edgy) side of things, has given us some extraordinary new works: paintings that are literally black. *Night I* (1987) is a meticulously painted inky field into which four dashingly, though smoothly, painted horizontal windows are set. Two large windows appear at different levels; two more of the same type, but visually smaller, are placed diagonally between the first pair, as though to connect them. The ambiguity of scale and perspective among the four rectangles throws the whole picture off, and throws us into an incalculable distance. It is as if the infinite were brought up close without our losing a sense of its immeasurable extent. This strange effect of being thrown off, beautifully achieved with a minimalist economy of means, unites the works. Here, we are in the realm of solitude first mapped out by Edward Hopper in a realist vein and by Milton Avery abstractly, a realm Katz has now detailed in an excruciatingly perfect way.

The radical simplicity in these paintings makes them a kind of ultimate statement of Katz's intention, forcing a reconsideration of his entire oeuvre. Clearly, *Full Moon Sunset, View, East* (all 1987) and *A Tree in Winter* (1988) show him bridging realism and abstraction and creating a new tension between them. There is always an acutely observed reality underlying Katz's recent shift into nonobjective gear. The differentiation is never complete in Katz's vision, as, in fact, it never is in the most casual looking. This perceptual ambiguity—this "natural abstractness" of which Katz is a master—quickens the psychological drama of his larger body of work. It is a drama which has always been acknowledged but never adequately described.

To characterize Katz's paintings simply as celebratory of a certain kind of sophisticated society, as has been done, is to miss the peculiar tension of the human relationships in his works, a tension evident also in the black paintings with their mixed urban and landscape subject matter. It is this complex tension, evident even in the "bright" Ada works (one of which was exhibited), that gives his works their force, however palpable the stillness of his world.

One of the striking things about the black paintings is that they are "anti-social." They are not figural; even when they are architectural, as in *Wet Evening* (1987) and *Snow* (1988), the suggestion of social reality is minimal. There

is little overt sense of the human condition—and yet in all these works it is clearly there in the unresolved tension between the forms, in the odd muteness of the scene and in the sense of uncompromising aloneness pervading the picture. Dare we speak of this as a new, 20th-century kind of transcendentalism, one with uncertain recourse to nature as a healer of urban wounds? For Katz, nature abstracted into art is more awesome than it is in life—where the first American transcendentalists found it. Art can make a "second nature" out of even such a stark, inhumane environment as the contemporary city.

I think this is the point of the black paintings: to seek out and highlight the moment of tension when the world converts itself to art. This tense moment of abstraction is for Katz one of great solitude and intimacy; there is enormous private passion behind his public restraint. It is this air of the private in the midst of the social that Katz articulates with extraordinary finesse. (pp. 178-79)

> *Donald B. Kuspit, in a review of exhibits at the Marlborough and Massimo Audiello Galleries in* Art in America, *Vol. 76, No. 11, November, 1988, pp. 178-79.*

FURTHER READING

I. Critical Studies and Reviews

Alloway, Lawrence. "Alex Katz's Development." *Artforum* XIV, No. 5 (January 1976): 45-51.
 Analyzes Katz's aesthetic development, particularly in relation to twentieth-century art movements, and identifies several major artists who influenced Katz's style.

———. "The Constant Muse." *Art in America* 69, No. 1 (January 1981): 110-18.
 Examines Katz's development as a painter through a study of the artist's many portraits of his wife, Ada.

Antin, David. "Alex Katz and the Tactics of Representation." *ARTnews* 70, No. 2 (April 1971): 44-7, 75-7.
 Seeks to define Katz's aesthetic sensibility through a study of his works. Antin employs the term "dandyism" to refer to the polymorphous style of Katz's art that embraces several aspects of modern art within a representational mode.

Review of an exhibition at the Marlborough Gallery in London. *Art International* XXV, No. 5-6 (May-June 1982): 51-3.
 Contends that Katz's work appears "unfeeling and remote" and affirms that the large-scale portraits on exhibit accentuate "certain weaknesses" in his painting, including "the fact that Katz is not always a very sure draughtsman."

Bass, Ruth. "Alex Katz." *ARTnews* 87, No. 7 (September 1988): 152-53.
 Praises Katz's later, dark paintings on exhibit at the Marlborough Gallery.

Beattie, Ann. *Alex Katz.* New York: Harry N. Abrams, Inc., Publishers, 1987, 91 p.

Collection of twenty-six color prints with five chapters of commentary by Beattie, an acclaimed contemporary American writer.

Berkson, William. "Alex Katz's Surprise Image." *Arts Magazine* 40, No. 2 (December 1965): 22-6.
 Critical assessment of Katz's early work and survey of the artistic influences that have contributed to his painting.

Calas, Nicolas. "Alex Katz: Faces and Flowers." *Art International* XI, No. 9 (20 November 1967): 25-6.
 Examines several examples of Katz's oversize paintings, asserting that "Katz enriched the expansive style practiced by the younger artists of our day with portraits of faces and flowers taken from life and not from lively magazines and ads."

Denby, Edwin. "Katz: Collage, Cutout, Cut-up." *ARTnews* 63, No. 9 (January 1965): 42-5.
 Discussion of Katz's early work with collages and cutouts by a friend who posed for the artist.

Dilauro, Stephen. "Alex Katz." *American Artist* 50, No. 524 (March 1986): 30-5, 74, 79.
 Provides a concise overview of the life and career of the artist, occasioned by the thirty-year retrospective exhibition of Katz's work at the Whitney Museum of American Art.

Levin, Kim. "Alex Katz." *Arts Magazine* 54, No. 9 (May 1980): 5.
 Contends that Katz's large-scale portraits on display at the Marlborough Gallery "look inept": "The large size exaggerates the lack of scale; the empty faces seem insipid more than placid, shallow rather than flat."

Loring, John. "Alex Katz." *Arts Magazine* 50, No. 7 (March 1976): 13.
 Assesses two of Katz's portrait prints, *Boy with Branch I* and *II,* and comments on his "immediate, nonreflective, and intensely present" portrait style.

Mahoney, Robert. "Alex Katz: From the Early '60s." *Arts Magazine* 62, No. 4 (December 1987): 107-08.
 Commends the examples of Katz's early work on display at the Robert Miller Gallery.

O'Hara, Frank. "Alex Katz." *Art and Literature* 9 (Summer 1966): 91-101.
 Appreciative overview of Katz's work through 1966.

Sandler, Irving. "Alex Katz, 1957-1959." *Arts Magazine* 55, No. 6 (February 1981): 98-9.
 Praises the retrospective exhibition of Katz's early work at the Robert Miller Gallery for capturing the pivotal moment in the artist's development. According to Sandler, this breakthrough consisted of Katz's reconciliation of "the competing demands of representation, which required the accumulation of information, and color, which required the elimination of intricate drawn and modeled details."

Schuyler, James. "Alex Katz Paints a Picture." *ARTnews* 60, No. 10 (February 1962): 38-41, 52.
 Describes in detail the manner in which Katz paints, including photos of Katz at work in his studio.

Tillim, Sidney. "Month in Review." *Arts Magazine* 35, No. 7 (April 1961): 46-9.
 Includes a review of an exhibition at the Stable Gallery.

Tillim asserts that Katz's "paintings are basically uncertain of their pictorial conventions and that the underplaying is a form of chic, converting the romance of Abstract Expressionism into a new image of (simple, middle-class) man."

———. "The Katz Cocktail: Grand and Cozy." *ARTnews* 64, No. 8 (December 1965): 46-9, 67-9.
> Critical assessment of Katz's work. Tillim argues that Katz's effort to reconcile banality and style results in an inevitable compromise, leaving even his best work devoid of "the force of visual concentration."

II. Selected Sources of Reproductions

Marshall, Richard. *Alex Katz.* New York: Whitney Museum of American Art / Rizzoli International Publications, 1986, 157 p.
> Provides ninety-four color plates and includes essays on Katz by Richard Marshall (see excerpt above) and Robert Rosenblum, a list of exhibitions, and a bibliography.

Sandler, Irving. *Alex Katz.* New York: Harry N. Abrams, 1979, 222 p.
> Includes 217 color and black-and-white plates, an essay by Sandler discussing the development of Katz's art, a biographical outline, lists of exhibitions, and a bibliography.

Anselm Kiefer

1945-

German painter and mixed-media artist.

Although he is widely regarded as one of the most important artists of his generation, the provocative subject matter in many of Kiefer's works has elicted harsh criticism, making him the source of much controversy. With heavy layers of dark paint, charred straw, bits of metal and fabric, and scrawled German words, Kiefer attempts to express in his paintings the horror of Adolf Hitler's tyrannic domination of Germany and the tragedy of the Jewish Holocaust. However, some have understood his quest to come to terms with his country's dark past as an expression of Nazi sympathies, while others view his work as a trivialization of one of the most cataclysmic events in human history.

Kiefer was born in Bavaria in March 1945. As a boy growing up in the postwar period, he became increasingly aware that his elders refused to discuss their wartime experiences, and, as he matured, his inability to learn about the Nazi era and the subsequent partitioning of his country led him to feel as though he lacked an important part of his identity. In 1966, he dropped out of law school and journeyed to France to visit a monastery in La Tourette, where he stayed for three weeks as a guest of the Dominican monks. There Kiefer began to conceive of a form of artistic expression for his feelings and ideas about the Holocaust, and upon his return to Germany he enrolled in art school. One of his first works was a series of photographs called *From Summer to Fall of 1969 I Occupied Switzerland, France, and Italy* (1969). These depicted Kiefer dressed in military garb giving the Nazi salute in front of various European monuments, in direct confrontation with the painful shadows of his country's past. In 1970 Kiefer moved to Dusseldorf where he became a student of Joseph Beuys, the eminent German abstract and conceptual artist. Beuys encouraged Kiefer to pursue artistic expression through painting and later introduced him to the renowned German art dealer Michael Werner. Under Werner's patronage, Kiefer's career flourished. He gained world wide recognition with a controversial exhibition at the 1980 Vienna Biennale, where some critics hailed him as a genius while others were shocked by what they viewed as highly nationalistic tendencies in his work. Kiefer is currently one of the best-known and most successful artists in the world, despite his scrupulous avoidance of publicity, and his paintings are among the most valued contemporary works of art.

While Kiefer was initially influenced by Beuys, other artists have also played a role in his artistic development. Kiefer himself expresses an affinity with the American artist Andy Warhol. After Warhol's death in 1987, Kiefer recalled: "Andy Warhol was doing perhaps the same thing as I'm doing, but his medium was the surface. He was so extremely superficial that he was saying there is something behind it. I can see that he was looking into the depths, like me." Many critics observe similarities between Kiefer's works and those of the American Abstract Expressionist painter Jackson Pollock. According to art critic Peter Schjeldahl, "in 40 years no other European artist— not one!—has so thoroughly assimilated and advanced the esthetic lessons of Jackson Pollock, specifically Pollock's doubleness of spatial illusion and material literalness on a scale not just big but exploded, enveloping, discomposed." In addition to these artists, Paul Celan, a Jewish-Rumanian poet, also influenced Kiefer's work. Celan's poem "Todesfuge," or "Fugue of Death," which describes his experiences in a German concentration camp, was the basis for Kiefer's *Margarete and Shulamith* paintings, in which the artist used Aryan and Semitic female archetypes to explore the tragedy of the Holocaust.

While Kiefer's paintings of the past two decades have in many ways contributed to the German people's willingness to confront their role in the Holocaust, he has often been accused by his compatriots of unnecessarily evoking painful and profoundly humiliating memories. When asked at one point if he had fascist leanings, the painter said, "I need to know where I came out of. There was a tension between the immense things that happened and the immense forgetfulness. I think it was my duty to show what is and what isn't . . . In '69, when I began, no one dared talk about these things." Although some critics continue to oppose Kiefer's choice of subject matter, he has earned the respect of many who admire both the emotional power and the skill of his work.

SURVEY OF CRITICISM

Lizbeth Marano (essay date 1983)

[*In the following excerpt, Marano discusses Kiefer's works and their relation to "the complex cultural and spiritual dilemma" of post–World War II Germany.*]

Anselm Kiefer has proved himself to be the most provocative of the new German painters. Juxtaposing such seemingly opposite conventions as landscape and history painting with Abstract Expressionism, arte povera, and other recent forms of Modernism, he injects his paintings with his own mixture of poetic, political, religious, and mythological references. But Kiefer is closely aligned with the German Romantic painters of the early nineteenth century in his symbolic use of landscape and his return to Germany's pre-Christian cultural roots—what art historian William Vaughan describes as the move toward the "indigenous, the emotional, and the irrational." Unlike most of today's Neo-Expressionist German artists, who revive past art movements and ideas intact, instilling them with self-conscious angst and novel strategic twists, Kiefer has

created his own vocabulary to communicate a new and problematic vision of German culture.

His works address such taboo subjects as Nazism and German nationalism, provoking a profound uneasiness in his audience by his refusal to take a specific point of view. On this subject matter laden with significance yet left ambiguous, Kiefer superimposes the notion of the artist and art as a redemptive force. As Rudi Fuchs, director of the Dutch Van Abbemuseum, has said, Kiefer's art "is an amalgam of bizarre suggestions, private opinions, ambiguous references, blurred and fragmentary, often taken out of the context of historical time, combined in artistic freedom. . . . " (p. 102)

Kiefer's first published piece, a photographic Conceptual artwork, appeared in the German art magazine *Interfunktionen* in 1969. The 1981 catalogue for "The New Spirit in Painting" described the piece briefly: "While traveling through Switzerland, France, and Italy in 1969, Kiefer visited various historic sites and had himself photographed, dressed in riding attire and saluting." This tepid account belies the facts—that the "riding attire" mimics an S. S. uniform and the "salute" is the German "Heil Hitler" salute—and the implications of the title, *From Summer Until Fall of 1969 I Occupied Switzerland, France, and Italy.* Two other photographs in the series show the artist, same uniform and salute, standing in water in a bathtub in his studio. The caption, "Walking on Water. Attempt in the bathtub in the studio in my house," seems to link Hitler's role as anti-Christ Savior of the Aryan race with Christ's miracle. Disturbingly ambiguous references to National Socialism surface often in Kiefer's work. The same bathtub, for example, shows up in later photographic books and in paintings, such as *Operation Sea Lion,* 1975, that depict mock naval battles between Germany and England.

Kiefer sketches with a camera. He photographs the woods and plowed fields around his home and arrangements of objects in his studio; these images become the basis for his poetic bookworks and his paintings. But by the late 1970s, Kiefer's Conceptual Art strategies and his use of photography evolved into a more painterly mode. He began to reveal the originality and consistency of his vision in series of paintings devoted to German culture and the redemptive role of art.

Kiefer's . . . allegorical landscapes and architectural interiors continue to develop these themes. However, the enormous theatrical scale, approximately $115 \times 150''$, of the paintings gives them a confrontational impact not possible with smaller easel paintings. Stretched on remarkably thin stretchers, the lightweight canvases sag from the weight of the applied surface. Kiefer is a master of collage and does everything possible to deface the sanctity of the canvas. He pierces and rips it, threads string through it, slaps on medium, cut paper, photographs, sand, straw, and oil paint. For his landscapes, Kiefer incorporates the image and materials from around his home. Two of the paintings, *Ikarus* and *Balders Träume,* or *Baldur's Dreams,* in his November 1982 show at Mary Boone Gallery in New York, were painted over mural-size black and white photographic enlargements of long rows of plowed earth or undulating wheat fields that converge at a very high horizon line. Extending Conceptualism, the artist superimposed the literal object—straw—on a photograph of

the field from which it came. He absorbed the straw into his palette, making it as plastic as the paint itself. In *Balders Träume,* the photograph is entirely obscured; in *Ikarus,* it is visible under the subsequent layers of shellac, sand, straw, and paint.

Ikarus takes its title from the Greek myth, but Kiefer offers his own interpretation, with a winged palette flying over a burning landscape. Kiefer often uses images of the painter's palette, making the role of the artist a major symbol. Here, the ascending or winged palette may also refer to Caspar David Friedrich's pictorial epitaph, *Clumps of Grass and Palette,* circa 1839.

Another of Kiefer's most obsessive symbols is fire, and the results of fire, the scorched earth. For the artist, fire is both destructive and cleansing, catastrophic and regenerative. In a 1974 painting, *Malen = Verbrennen,* or *Painting = Burning,* he specifically identifies fire with art.

One group of . . . paintings takes their inspiration from Wagner's *Die Meistersinger von Nurnberg.* The opera revolves around a song contest of master singers and has been interpreted as a victory of genius over pedantry and conventionalism. The parallel between Wagner and Kiefer is clear; as Wagner makes the creation of song the subject of his opera, Kiefer uses painting as the subject of his art. In *Die Meistersinger* and *Nürnberg,* the lower half of the canvas is impregnated with thick clumps of straw. The illusionistic space created has a literal physicality far more effective than Julian Schnabel's device of broken crockery.

Kiefer's paintings frequently refer to Wagnerian operas, especially *Parsifal* and the Ring series, based on the ancient Germanic myth of the Nibelungen. He seems to be involved not only with the symbolic and literary aspects of Wagner's art but also with its ideology, including the German nationalism that surfaces, with racist overtones, at the end of *Die Meistersinger:*

> Beware! Evil tricks threaten us:
> if the German people and kingdom should
> under a False, foreign rule, one day decay
> soon no prince will understand his people
> anymore,
> and foreign mists with foreign vanities
> they will plant in our German land:
> what is German and true no one would
> know anymore,
> if it did not live in the honour of the German Masters.
> Therefore I say to you:
> honour your German Masters!

In such paintings as *Deutschlands Geisteshelden,* or *Heroes of the German Spirit,* 1973, *Wege der Weltweisheit,* or *Ways of World Wisdom,* 1976-77, and *Wege IV,* or *Paths IV,* 1978, Kiefer seems to be applying this nationalistic maxim to his art. He "honors the German Masters" with portraits of poets, philosophers, and soldiers.

In *Balders Träume,* 1982, Kiefer deals with Teutonic myth, the source of so much Wagnerian imagery. The Norse gods were not immortal; they continually renewed their youth by eating the apples of Idun yet remained prisoners of their fate. They approached their imminent doom—*Ragnarok,* the dusk of the gods, what Wagner called Götterdämmerung—with composure and gloomy horror. Baldur, the god of Spring and of Light, had recur-

ring dreams of disaster. His mother, Frigg, asked all beings and things to pledge themselves not to harm Baldur but forgot to secure the pledge from the mistletoe. Loki, the Norse giant who personified evil, placed a twig of mistletoe in the quiver of Baldur's brother, the blind Hadur, and aimed it at Baldur. This missile fatally wounded Baldur and precipitated *Ragnarok*. In Kiefer's painting, a landscape of cultivated fields textured with straw, string, and paint is punctuated by a large sprig of mistletoe, and the words "Balders Träume" are scrawled across the foreboding sky.

Imminent destruction as reality, not myth, becomes the departure for a series of paintings based on "Death Fugue," written in 1945 by the Jewish-Roumanian poet Paul Celan. Celan, who escaped from a concentration camp, was the only member of his family to survive the Holocaust; he committed suicide by drowning at the age of forty-nine. Kiefer repeatedly borrows imagery and titles from "Death Fugue," Celan's most famous poem.

> Black milk of daybreak we drink it at sundown
> we drink it at noon in the morning we drink it at night
> we drink and we drink it
> we dig a grave in the breezes there one lies unconfined
> A man lives in the house he plays with the serpents he
> writes
> he writes when dusk falls to Germany your golden hair
> Margarete
> he writes it and steps out of doors and the stars are flash-
> ing he whistles he packs out
> he whistles his Jews out in earth has them dig for a grave
> he commands us strike up for the dance
> Black milk of daybreak we drink you at
> night . . .

Two lines of this poem, "your golden hair Margarete" and "your ashen hair Sulamith," are the subject of a cycle of paintings called "Margarete-Sulamith." Flames of straw become Margarete's golden hair, a metaphor for Aryan Germany, while Sulamith, a Jewish archetype, appears as a naked woman with streaming hair and blood, sometimes seated in front of a cityscape. Nicholas Serota of Britain's Whitechapel Art Gallery has interpreted these paintings as allegories of the void created in Germany by the destruction of Jewish culture; they can also be read as the artist's facile attempt to identify himself with the victims of the Holocaust.

Kiefer's subject matter is heavy with contradictions. His work raises literary, intellectual, and cultural questions but evades their difficult implications. By escaping into a mytho-poetic fantasy of the artist as redeemer, and at the same time fleeing from the loneliness of individual creativity into identification with the collective unconscious, Kiefer unwittingly exposes the impotence of the artist in the face of the real political and cultural forces that shape his destiny. He expresses his confused feelings as a post-war German artist through a web of symbols, mythology, and religion that leaves his viewers confused as well.

Kiefer creates a compressed backdrop to stage his revivals of the heroes and antiheroes of German culture. His work reveals an estranged theatricality that runs the gamut from sentimentality to the *Sturm und Drang* tradition revived by Joseph Beuys. It has been said that his strategy is to create a pictorial world "without being rigidly confined by a specific meaning." His subject matter, with the

predictable uneasiness it inspires, serves as the departure point for impressive visual and formal inventions. These, however, remain an illustrational device. Moreover, twentieth-century history has made it difficult to distinguish German nationalism from racism and impossible to employ such loaded topics as "German Masters" and anti-Semitism merely as confrontational, anxiety-producing art strategies.

The contradictions that Kiefer does not resolve—that may, in fact, not be resolvable—are the weakness and the strength of his paintings. The force of their cultural and pictorial collisions demands the viewer's participation— an overwhelming and acutely disturbing experience. Alone among today's German artists, Kiefer has found an original voice to express his country's complex cultural and spiritual dilemma. (pp. 102-05)

> *Lizbeth Marano, "Anselm Kiefer: Culture as Hero," in* Portfolio, *Vol. V, No. 3, May-June, 1983, pp. 102-05.*

Rupert Martin (essay date 1983)

[*In the following essay, Martin examines Kiefer's style, relating his work to German Expressionism and to that of his contemporaries.*]

In his recent series of oil paintings and watercolours on the theme of Margarete and Shulamith, inspired by Paul Celan's poem 'Todesfuge' ('Fugue of Death'), Anselm Kiefer has created a visual elegy which touches our conscience and probes the recent past with ironic detachment. Paintings such as these have been the subject of much criticism, but to condemn Kiefer's preoccupation with taboo themes is to ignore the ironic perspective he employs and the complex iconography which he has evolved. By exposing the consequences of war and confronting the dogma of National Socialism, Kiefer offers a way of coming to terms with the trauma of the past. In this respect he subscribes to the idea advocated by his mentor, Joseph Beuys, of the artist as a healing force within society. But whereas Beuys derives his symbolism from direct experience of the war, Kiefer enacts an imaginative drama which fuses his observation of the landscape with a matrix of symbols culled from history and mythology.

Kiefer's landscapes are characterised by their emptiness and apparent devastation. The level plain of the Mark Brandenburg or the flat arable land which surrounds Kiefer's home town of Hornbach stretch uninterrupted into the distance, and the gloom is lightened only by the flames from the burning stubble which flicker sporadically and leave black scars across the land. More recently Kiefer's paintings have depicted the neo-classical monuments of the Third Reich; gutted and decaying. . . . For Kiefer's landscape is a war zone, a no-man's-land, unpeopled and lifeless. It is a landscape rooted both in observation and in history. The land and the buildings seem to be devoid of hope, a realisation of the 'horror vacui' which he painted in 1979. His painting seems to be gratuitous, nihilistic and crude; a devastating indictment of war and of tyranny, and an ominous portent for the future. The watercolour *Et la terre tremble encore* with the land scarred and cracked as if by an earthquake implies the imminent danger of war, and the land embodies the suffering of its in-

habitants. Kiefer's vision is similar to that described by the English poet Geoffrey Hill in his sequence 'Funeral Music':

> some trampled
> *Acres, parched, sodden or blanched by sleet,*
> *Stuck with strange-postured dead. Recall the wind's*
> *Flurrying, darkness over the human mire.*

The landscape, however, which Kiefer portrays in the series *Malerei der verbrannten Erde* (*Paintings of the Burnt Earth*) 1974, is a landscape as much purged as devasted by fire. As R. H. Fuchs observes [in his 1980 catalogue *Anselm Kiefer*], "Mythical fire, as a pure force of regeneration recurs time and again in Kiefer's work." In the painting *Maikafer Flieg* (*Cockchafer Fly*) the black cloying earth is covered with frost. Scrawled across the hill in the distance are the words of an old German song:

> *Cockchafer fly*
> *Father is in the war*
> *Mother is in Pomerania*
> *Pomerania is all burnt up.*

The landscape is literally inscribed with a sense of abandonment and loss; a loss that is still acutely felt in Germany today. And yet, looking closely at the painting, the impression is not of total desolation; the flames persist even in winter. Another painting made in the same year is called *Malen = Verbrennen,* (*Painting is Burning*); the act of the imagination is equivalent to the transformation wrought by fire. *Mann im Wald* (*Man in the Wood*) shows a man walking through a forest holding a blazing branch in his hand. The fire that exists in these paintings is a fire which burns but does not consume. The man holds the branch carefully like an insignia, a torch, a source of light in the forest.

If fire is both a destructive and a creative force in Kiefer's paintings, the painter's palette is a more positive, less ambiguous symbol. The palette is a key icon in his work, and is frequently used along with other symbols of the imagination. Two paintings in particular show the connotations of this image and reveal the multiple levels of meaning which exist in Kiefer's work. In *Resumptio,* 1974, a winged palette rises from an anonymous grave: the spirit of art triumphing over death, imagination over oppression. *Palette,* 1977, is less exuberant, more fragile and ambiguous. Attached to the palette are two black lines like string, which appear to hold it suspended in space. Flames threaten to burn through the string and plunge the palette into the abyss. This interpretation of the fragility of artistic vision could be supplanted by another in which the twelve tongues of flame, six on either side of the palette, are like pentecostal fire sustaining and giving inspiration to the artist, for whom by a process of metonymy the palette stands. The palette seen in this light appears to rise on wings of flame. Both interpretations are equally valid and the ambiguity is sustained by the simple device of extending the lines to the edge of the picture frame. Such ambiguities inform the paintings of Kiefer, in which the icons of hope alleviate [Hill's] 'stark ground / Of pain'.

Nowhere is this more apparent than in the series which revolves around the poem 'Todesfuge', in which Margarete and Shulamith embody the Aryan and Jewish ideals of beauty and come to represent the tragedy of genocide. Paul Celan was born in 1920, his parents died in a concen-

tration camp and his experience of war and imprisonment was to haunt his poetry and culminate in his suicide in 1970. In this poem, the pain is transmuted into a lyrical beauty. The brutality of 'Death . . . the master from Germany', is counterpointed by the beauty of both the lover and the victim:

> A man in the house he plays with the serpents he writes
> he writes when the night falls to Germany your golden
> hair Margarete
>
> Your ashen hair Shulamith we are digging a grave in the
> sky it is ample to lie there.

In the poem as in the paintings we are all indicted, and the paintings act as a kind of atonement for our collective guilt. Kiefer employs the same allusive, indirect method as Celan, by transforming historical fact and human identity into a symbolic landscape in which the golden hair of Margarete is metamorphosed into the ripe ears of corn or the golden strands of straw, while the dark hair of Shulamith is depicted as the blighted ears of corn or the burnt stubble. The transformation is partly achieved by writing Celan's words on the paintings and partly by incorporating straw in the oil paintings. The words point to the ideas which the paintings embody and are part of Kiefer's conceptual idiom, whilst the straw introduces a sculptural third dimension, and further intensifies the metaphor. We are confronted with the material substance of metaphor in a theatrical manner which draws attention to the process of its making. The land with its seasonal rhythms becomes the theatre in which the painter can re-enact man's recurring inhumanity to man.

In his subsequent series *Dem unbekannten Maler* (*To the Unknown Painter*) Kiefer moves from landscape to architecture. A precedent for this occurs in his earlier series in which he painted the wood panelled halls of Nordic legend, and in the paintings of Shulamith which show her seated in the foreground with her hair falling across her face while in the background stand tall buildings gutted by fire. The imagery of the series *To the Unknown Painter* derives from various Nazi buildings such as Albert Speer's Reichskanzlei, Hitler's Chancellery building in Berlin, demolished at the end of the war, or the unrealised architectural projects such as a Glorium for fallen soldiers. The buildings, with their sinister overtones, appear in the paintings like follies, hollow chambers, theatrical facades, made more two-dimensional by the application of collaged woodcuts. The sham neo-classical style and the vast scale of these projects is derided in the paintings, while Kiefer, through the violent application of paint, shellac and straw makes us tangibly aware of their reality. What were designed to last a thousand years no longer exist except, by a twist of irony, in these paintings. In one of these, entitled *Heliogabal,* flames appear in the windows; in another the shellac is chipped away by the artist; and in another the artist has attacked the canvas, tearing a hole in its surface as if to illustrate the actual destruction of the buildings. Kiefer's purpose in recreating these buildings is to attack the ideology which invented them and to undermine its very fabric. Their apparent grandeur of scale is undercut and the irony sustained by the pointed, almost whimsical, presence of the ubiquitous palette, perched upon a tall stand, mocking the absurdity of the architecture. The tiny size of the palette in no way detracts from its visual or symbolic power and the ironic title of the paintings, *To the*

Unknown Painter, testifies to the way in which painting can appropriate objects, even taboo objects, to celebrate itself.

By representing these subjects Kiefer deprives them of their taboo status and effectively demythologises the war; by depicting in the devastated landscape the consequences of war he offers us a vision of potential peace; and by visualising the fugue of death he celebrates the beauty that has been destroyed.

Kiefer uses history as a medium for his own ideas. His emergence as a conceptual artist in 1970 has its legacy in his development of an art in which ideas are dramatised. His art is an eclectic one, drawing from many sources the raw material of his ideas and fusing them together. Although it is an intensely personal vision, he does not work in a vacuum and his work can be seen in the context both of the early expressionist painters and of his contemporaries.

In 1974 Kiefer visited Norway and the following year painted a watercolour entitled *Kranke Kunst, (Sick Art),* in which a Norwegian landscape is covered with blotches of pink and yellow paint resembling running sores. The landscape recalls the work of Edvard Munch whilst the title *Kranke Kunst,* echoes the title of the Nazi's exhibition in 1937, *Entartete Kunst* (Degenerate Art). Anselm Kiefer belongs to a second generation of expressionist artists whose vision is as much formulated by the spectre of war as the first. They seek to re-establish the continuity of German art which was interrupted by the Nazi interregnum and by a war which deprived Germany of much of its creative genius. Although the historical context of their work differs, theirs is also a visionary art in which the urge to find a personal artistic identity coincides with the need to create a new indigenous art. In his introduction to a catalogue on A. R. Penck, Richard Calvocoressi writes:

> German so-called Neo-Expressionism can be seen on one level as a search for identity, an existential response to the alienating and psychologically humiliating effects of post-war German society. In order to resist the massive injection of predominantly American values—economic, political but above all aesthetic—the artist has been forced to draw strength from a specifically German tradition.

Without coming together as a group, Anselm Kiefer, Jörg Immendorff, Markus Lüpertz and A. R. Penck attempt to re-interpret through painting the recent German past, in order to come to terms with the division of Germany into two countries and the impoverishment of German culture caused by war and anti-semitism. They concern themselves with the possibility of a renewal of German culture, by drawing on history and myth. Kiefer goes further in his efforts to resuscitate German culture and to find a context for his work by returning to the Nordic and Teutonic myths. His preoccupation with myth is, however, prevented from becoming a glorification of teutonic ideals by a distancing irony, an irony that changes the *Nibelungen Lied* (*The Song of the Nibelung*), on which Wagner based his Ring Cycle, to the *Nibelungen Leid* (the *Suffering of the Nibelung*). Markus Lüpertz in his *Black, Gold, Red,* part of the 'dithyrambic' paintings, combines visual motifs drawn from the discarded paraphernalia of war with a reference to the classical myth of Dionysus. The dithyramb

is a wild choric song and implies the ritual of a second birth. Lüpertz' use of this terminology points to the underlying concern in the work of several contemporary German painters who employ a wild, almost savage, expressionistic technique, to embody the idea of regeneration. This both establishes their links with the interrupted course of expressionism and asserts their own identity as painters in a divided country. A. R. Penck's paintings *East* and *West,* made in 1980 at the time of his flight from East to West, illustrate well the predicament of contemporary German artists. While the symbolic contrast between black and white, good and evil, appears clear-cut, there is an ambiguity in the imagery and a similarity between the paintings which makes them difficult to interpret with any clarity. Perhaps the best commentary is provided by Max Beckmann:

> Yes, Black and White are the two elements I have to do with. For good or evil, I cannot see everything in black or everything in white: if I could, it would be simpler and less ambiguous, but it would also be unreal. Many people I know would like to see everything white, that is objectively beautiful, or black, that is negative and ugly; but I can only express myself in both together.

In his use of a personal iconography and in his allusive approach to history Kiefer comes close to Beckmann, and he shares with Beckmann an ironic vision which is capable of representing and transforming the most appalling facts. Kiefer's painting has a ferocious urgency which transcends the conceptual and manifests a primitive energy [as described by Beckmann]:

> Nothing could be more ridiculous or more meaningless than a philosophical conception, painted in purely intellectualistic fashion, without the terrible fury of the senses, reaching out for every visible form of beauty and ugliness.

There is the same inclusive, all-embracing and passionate conviction in Kiefer's paintings. Nothing is outside the scope of his vision and commitment, and his choice of subjects is an almost wilful assertion of the right of the artist to grapple with forbidden themes. [According to Fuchs] "Painting is salvation; it preserves the freedom of thought of which it is the triumphant expression." Kiefer is not afraid to include evil in his scenario: Satan is present in *Quaternity,* and a snake appears at the base of *Resurrexit.* The incorporation of a religious dimension in many of his paintings brings to mind the fervour of Emil Nolde's religious paintings. Of his painting *The Last Supper,* 1909, Nolde wrote: "I followed an irresistible desire for representation of the deepest spirituality, religion and fervour, without much will, knowledge, or deliberation." Although the ironic, systematic approach of Kiefer to painting of necessity includes deliberation, the extravagant almost violent application of material—oil, straw, shellac, collage—is motivated by 'the terrible fury of the senses'. The result is a tension between conception and execution, the idea and the surface appearance, and this accounts for the at once ironic and visionary nature of his work. The repeated words

> Dein Goldenes Haar, Margarete
> Dein Aschenes Haar, Shulamith

which is the counterpoint in the fugue of Celan's poem, form a kind of litany, and possess an incantatory power

in Kiefer's series of paintings, enhancing the visionary nature of the work, and holding the viewer spellbound. Contrasting motifs recur in the paintings: the flame creates a blazing light in the dark landscape, the palette takes flight from the grave, the Phoenix strives to escape. It is this visionary aspiration which characterises Kiefer's painting, and which relates it to the mystical work of Caspar David Friedrich. The spiritual vision which is the essence of Kiefer's painting, (**Malen = Verbrennen**), is as much a personal as a cultural one, and the horror to which he frequently alludes is redeemed by the fire of intellect to achieve a fragile and luminous tranquillity, [Hill's]

> A palace blazing
> With perpetual silence, as with torches.

<div align="right">(pp. 26-30)</div>

Rupert Martin, "Anselm Kiefer," in Art scribe, *No. 43, October, 1983, pp. 26-30.*

Donald B. Kuspit (essay date 1984)

[*In the following excerpt, Kuspit examines Kiefer's art as an attempt to come to terms with his German heritage through the deconstruction of traditional German ideology.*]

One of the attractions of Anselm Kiefer's pictures is that they look old, not new. In general, the new German painters appeal to us because they remind us of the past; they project no future. Even Jorg Immendorff, of all of them the painter who most explicitly depicts present history, offers no "future solution"—whether utopian or apocalyptic. This throws what he depicts back in time, makes it seem instantly archaic, age-old. This evocation of a seemingly timeless, primordial past makes the German painters seem like "old masters," for one of the things it means to be an "old master" is to paint the world as if it has already happened—as if it has long been the case, and is even more inwardly familiar to one than one is to oneself. It does not have to be achieved, the way one's sense of self does. This is why the old masters clothed the world they knew in idealizing mythological costume; such treatment made it seem "traditional," old and real before one attended to it.

Several of the German painters have said they want to restore the tradition of "great paintings." Rudi Fuchs observes that Kiefer wants "to reinstate painting as an art of High Seriousness (which does not exclude irony) and to bring it back into the realm of Grand Rhetoric; to liberate it from self-reflective esthetic exercise." This can also be said of Immendorff, as well as Markus Lüpertz, George Baselitz, and A. R. Penck. But what differentiates Kiefer from them is that he uses the abstract, idealizing methods by which a sense of inescapable signigicance is generated—the sense of the fundamental associated with "tradition"—in order to dissolve or "de-signify" a very particular historical tradition: the tradition of being-German. Kiefer continues the tradition of German preoccupation with what it means to be German but in an unexpected way. Usually, . . . German depth is contrasted with Italian superficiality, German strength with Mediterranean weakness, German hardness with Mediterranean softness. Just those traits which since antiquity have led Mediterranean cultures to describe Germany as uncivilized or barbaric, and regard it as an outcast or outsider—

"borderline"—society, are idealized. . . . But Kiefer shows us that in today's world there is really very little depth of meaning to being-German. He demonstrates that the "eternal German" is absurd, a pathetic joke that makes itself manifest in isolated historical moments in which the Germanic was not as unequivocally triumphant as was later supposed. He shows us that German power—be it military or intellectual power—was not so absolute as was later thought. By articulating German megalomania in profoundly abstract fantasies, he reduces it to the symbolic fiction it always was. The "episode" character of his works reflects the historical episodes that constitute the fiction, in effect dismembering it, denying its cohesiveness. With that loss of unity, the "German" evaporates into a series of discontinuous dream sequences, a narrative "tale told by an idiot."

Kiefer suggests that the German myth has come to the end of its history, for it exists only in vague, "vain" abstract form—in a series of tragicomic representations which add up to little more than a pathetic delusion of grandeur. Kiefer also suggests, by his comic sense of the modes of representation available to him—by the freedom with which he utilizes all the stylistic possibilities of the modern tradition—that modern art has also come to the end of its history. It is now a warehouse of mythical styles that can be used to a mythical end: the depiction of the bankruptcy of a myth. Kiefer mocks the heroic pretensions and sense of uniqueness of both German identity and modern artistic identity. He is as irreverent toward the Germanic as he is toward the artistic, using a number of hybrid forms—each of his "works" is a potentially infinitely extended or open-ended "confederation" of such forms—to dissect both. Thus he offers a stylistically incoherent structure of theatrical performances, photographic performances, "abstract" performances with such traditionally artistic materials as paint, as well as book performances, which correspond, in their disjunctiveness, to his conceptual "performance" of his subject matter. Indeed, Kiefer can best be understood as a conceptual performance artist deconstructing the concept of the German, a performance which was "sold out" by its creators. But such artistic "demonstrations" show us that art can be useful. Kiefer, in my opinion, is desperate to give art a socially useful character, liberating it from aesthetic delusions of grandeur. Kiefer shows us that art is a useful way of staging the world, abstractly bracketing it so that its meaning structures can become evident.

Kiefer, then, engages mythical tradition—in modern art as well as German history—only to deconstruct it, to show how questionable and fragmentary it is today. In part this is done by giving us both art and history as an incomplete mosaic, never adding up to a whole. It must be emphasized that Kiefer deconstructs German tradition and modern artistic tradition simultaneously, showing that for all their momentousness there is something hollow in both, since neither affords the perspective necessary to create a total world-picture. German tradition is inadequate because it excludes European tradition, or rather has a negative, antagonistic relationship to it. And modern art is inadequate because it is obsessed with novelty to the point of ignoring the rhetorical possibilities of art—because it dismisses the rhetorical as beside the aesthetic point and so trivial, giving it the same status as the decorative. Kiefer restores the literary with a vengeance, suggest-

ing that the visual arts are incomplete—even inept—without it. Similarly, he reminds the German of the European by showing the German as having its specifically German—aggressive—qualities only in relation to the European. The German refusal to assimilate into Europe makes it the aggressive shadow—the violent abstraction—Kiefer depicts it as. Kiefer deconstructs the mythically German and the mythically modern in order to reconstruct—complete—our self-understanding.

What is "difficult" about Kiefer is not his post-modern use of cultural content and art—his sense that there are no surprises to be expected from them, no novelty left in them—but his implicit attempt to reconstruct a sense of autonomous self, master of its cultural and creative history. The idea of autonomous self is modern, but the postmodern sense of autonomous self frees it from the bourgeois sense of its inevitability—the bourgeois belief that one has a right to an autonomous self, as a sign that one is "destined." Kiefer suggests that this traditional sense of autonomous self is a bankrupt mythologization of it. It must be worked at, created on the basis of a universal sense of being-human—as a demonstration of the universal experience of being human. A recent cycle of works, "Margarete-Sulamith," based on the poem "Todesfuge" ("Fugue of Death") by Paul Celan (1945), makes this clear. The poem deals with the inseparability of the blonde German Margarete and the dark Jewish Sulamith—with the light and the dark sides of the self. The destruction of the Jewish, leading to the self's loss of unity, is the destruction of its humanity. The German, in Kiefer's art, constantly shows itself as the arrogantly incomplete human—the destructively inhuman. Kiefer wants to destroy the German tradition that allows this arrogant definition of the human as the inhuman, that is satisfied with a partial sense of self. Fuchs writes that Kiefer "recedes from tradition, leaving it behind like scorched earth, in order to start anew: a flame rising from the ashes." But the "German themes: burning out, turning into wood, sinking, silting up" Kiefer deals with—in a kind of reactive, hyperbolic, regressive destructiveness—exist to create a new order of human self free from the partial German self based only on destructive power. Kiefer uses barbaric German methods—destroying civilization, ironically "returning to nature"—against the idea of the German. Kiefer turns destructive German power inside out, using it against German one-dimensionality. This purge of the Germanic in flames restores the possibility—if not clearly the actuality—of being-human to the German. The phoenix that rises from the flames of Kiefer's destructive German art is not a revitalized arrogant German self, but a newly human self.

The reference to "transmuting externalization" in my title—a reference to what I understand to be Kiefer's artistic method—utilizes Heinz Kohut's concept of "transmuting internalization," which he uses to describe structure formation in the psyche. I think Kiefer reverses this process, de-structing—returning to dreadful amorphousness—the German psyche. Kiefer eliminates its arrogant structures by decomposing them, turning them against themselves, so that a fresh start can be made toward the creation of a new human self. Kohut argues that when the psyche has matured to the point where it is ready to become autonomous, it withdraws its feelings from "those aspects of the object imago that are being internalized,"

then introjects these now depersonalized aspects as the foundation of its sense of itself—the structural basis of its selfhood. This process of self-formation involves, among other things, the creation of a self able to monitor and control impulses, whether erotic or aggressive (constructive or destructive), arising from within the larger life of the psyche. Implicitly, for Kiefer, reviewing German history and the mythical sense of self it implies, the German self was ill-formed. Kiefer thus wants to reverse the process by which the German self came into being—a process which created a self that had no control on its aggressive impulses, and which idealized its erotic impulses to the point of uselessness. Aggression became an all too concrete part of the German character, and love became an all too abstract part of it. It became split grotesquely into a brutally materialistic part that made war, and into a sublimely spiritual part that made music and philosophy.

Sometimes deliberately violating the spiritual part of this German self—as in his fantasy project for flooding the traditional university town of Heidelberg (1970)—and sometimes ruthlessly extending the aggressive part—as in his literally burning the earth in Buchen, the name of the old district in which he lives (1974)—Kiefer means to undo the traditional German self. By both reenacting its history on an artistic stage, and acting against it in imagination—literally creating images of destruction of spiritual symbols—Kiefer clears the ground of the German psyche so that a new sense of self can grow in native soil. This process of transmuting externalization of the traditional German self—sharply split into aggressive and spiritual parts—makes way for an untraditional (in German society) sense of self, that is, of a self that seems whole because it is in control of all its parts. But Kiefer does not show us the new German self in formation; only history can give the German a new human self. Kiefer, reviving the shamanistic function of art, only purges the old German inhuman self, at once too violent and too sublime—both too low and too high for human good. Kiefer's idealization of art (see his many "palette" pictures) depends entirely on his expectation that it can "de-realize" the traditional German image.

One of Kiefer's very first projects, in which he made the Nazi salute in various European towns, shows his need to reenact aggressive episodes in the German past—above all, shows his need to engage and reconstitute German arrogance. Everything falls into place from that theatrical moment, that moment of high performance. Kiefer, born in 1945, the year in which World War II ended, seems to have a compulsion to reconstitute the collective German identity which was given to him by history—a national identity that is involuntarily his, and that he does not so much want to make his own as destroy, so that he can find his human identity. He must work his way back through German history to the original "object imago" of being-German from which the German tradition began. To me, he reaches this point in *Wege der Weltweisheit—die Hermanns-schlacht* (1978), in which he deals with the legendary German chieftain Arminius (later called Hermann by German historians) who in 9 A.D. destroyed three Roman legions under the command of Quinctilius Varus in the dark Teutoburger Forest. This "moment of destiny" aroused the imagination of generations of German artists, poets, historians, politicians, and even generals. In the 19th century, when the dream of German unification grew

powerful, Hermann became a symbol of national liberation. Kiefer depicts the primordial German forest where the battle took place with images of the figures who idolized him and the power he represented—writers such as Fichte, Klopstock, Grabbe, von Kleist, Mörike; generals such as Count Schlieffen, Blücher, von Moltke; and moralists and philosophers such as Heidegger and Langbehn. Kiefer gives us a textbook illustration of the genuinely German—in a sense literally, since "Wege der Weltweisheit" is a high school textbook title.

This work brings together the two sides of the "German ideology" for Kiefer—the land and the people. He deals with either genuine German land or genuine German people, and often both. He is in hot pursuit of the "German type" through an examination of its "tokens." Thus, in *Maikäfer Flieg* (1974), referring to an old song about war and the destruction of Pomerania, he shows, in a kind of abstract panorama/map, a land that became Russian after World War II. In *Märkische Heide* (1978), he gives another example of "genuine German" land, the Mark Brandenburg, a county east of Berlin, a Protestant area which eventually became part of the Prussian state, the leader of the new German Empire. The Mark Brandenburg, along with the rest of Prussia, has also been lost to Germany. Is it still genuine German? Is it part of eternal Germany?

As his enterprising use of the Hitler salute showed, Kiefer is not afraid of tackling the most inhuman aspects of the German ideology. Thus, in *Das deutsche Volksgericht* (*Kohle für 2000 Jahre*) (1974), Kiefer ironically deals with German racism—Germany's belief in the superiority of the German (Aryan) type over all other types. (This is also implicitly at stake in the *Wege der Weltweisheit* series.) The German face that grows out of the German forest (the grain of wood)—that is so rooted in "Being"—shows itself to be rather ordinary, indeed, all too typical. German superiority and authenticity, based on a claim of greater closeness to or intimacy with Being (in the form of Nature)—symbolized by the intimately depicted wood grain—shows itself to be rather grotesquely banal. German stupidity is signified in the *Unternehmen Seelöwe* series (1975), Hitler's codename for the invasion of England that never materialized. The plans for it were confused and infantile — altogether inexperienced — as Kiefer shows, with his bathtub full of toy boats.

Again and again, Kiefer deals with the German ideology, ruthlessly anatomizing it, until on the table of his art there is only its corpse, never to be put together again even by a Dr. Frankenstein. Curators and critics have described Kiefer's art as poetic and beautiful, but it is really beyond beauty and ugliness. Kiefer is attempting nothing less than a Nietzschean transvaluation of German values, hopefully not in the name of a new will to political power. Instead, he shows what the German will to artistic power has always, at its best, arisen from: an encounter with the concept of the genuinely German, as reified in the German landscape, the German people, and German history—in German insularity. Kiefer is concerned to determine what the genuinely, "purely" German is, in the most austere ontological sense possible. We think of the best German art as "expressionistic" because of this claustrophobic urgency about the German being. The traumatic effect of dealing with the hermetic German being as if it were the essence of Being itself leads to disruptive expressionistic ef-

fects. The sense of the expressionistic—of the displacement of expression—always results from the attempt to take one limited kind of being, define it as the only authentic kind, and regard it as the privileged means of access to Being.

But the expressionistic has a double, self-contradictory meaning. Not only is it the method of articulating ontological absolutism, but of resisting it violently in the name of a new immediacy of experience. In Kiefer's case, this doubleness shows in an ironical attitude toward being-German: he shows us the purely German, but he shows it to us in terms of the fiction of artistic immediacy. Kiefer offers us an expressionistic stream of artistic consciousness of being-German, a barely controlled free-associational "system" obsessively revolving around the theme of being-German. But that it is an artistic consciousness shows that it transcends its theme. Kiefer is, in the true psychoanalytic sense, "working through" the nightmare of being-German toward the daylight of being-human. He is working through what was given to him by birth, but which he does not experience as innate to his person—the basis of true selfhood. (It is worth noting, in this context, that he is the direct protagonist in his early works and the indirect protagonist in later performances, that is, the "stage manager" or impresario responsible for the manipulation of the artifacts and actors used, at once playwrite and puppeteer. The *Meistersinger* series is perhaps the clearest articulation of this.)

But there is a problem with this expressionistic irony. For insofar as Kiefer retains expressionistic method and sensibility, even in abstract form, he keeps alive the deepest part of the German ideology, and shows himself to be German by personal choice, not just by social history. For the deepest part of the German ideology is the confused belief that the expression of power is at once the authentic sign of being-German and the way of reaching beyond the German to others. The German believes that power is the direct manifestation of pure Being but also the way of denying the uniqueness of one's own (German) being, since power is understood as a sign of universal humanity. Kiefer is profoundly confused: his art is an exhibitionistic demonstration of artistic power in the name of universal humanity, and of German power in the name of unique German being. His art, indeed, is finally very German, just because it is ambivalent about being-German. As Heine, Goethe, and Nietzsche suggest, the most German of all the Germans are those who, with all their beings, despise being-German. It is no doubt unfortunate that the world reads even German self-disgust as an expression of the German will to power—as a less than sublime but still incisive display of being-German. (pp. 84-6)

Donald B. Kuspit, "Transmuting Externalization in Anselm Kiefer," in Arts Magazine, *Vol. 59, No. 2, October, 1984, pp. 84-6.*

Hilton Kramer (essay date 1988)

[*Former longtime art-news editor for the* New York Times, *Kramer edits the monthly journal of art and literature the* New Criterion, *which he founded in 1982. In the following excerpt, Kramer assesses the effectiveness of Kiefer's art, maintaining that while his symbolic landscapes are compelling, the artist ultimately fails in*

Ways: March Sand (1980)

his quest to incorporate and redefine German history in his work.]

It may be premature to speak of his "greatness," and victories of the moral imagination are not, I think, to be . . . quickly proclaimed, but [Anselm] Kiefer is undoubtedly an artist of extraordinary gifts. The critical questions to be answered are: What exactly are those gifts, and what has the artist accomplished with them? That he is undaunted by the challenge of very large subjects—whole areas of German history, mythology, and culture, and the peculiar modalities of German social pathology, all of which remain, as far as their art is concerned, a closed book to the majority of contemporary artists—does not necessarily mean that Kiefer has been consistently successful in finding a way to deal with such subjects as a painter.

The secret of Kiefer's immense appeal just now—if, indeed, it can be described as a secret—lies, I believe, precisely in his willingness, or, if you will, his compulsion to place these subjects at the center of his art. To the degree that we sense in this compulsion something authentic and involuntary—an impulse that goes beyond anything we have lately come to associate with the tasks of art—it speaks to our own appetite for an art that transcends the aesthetic, and it is natural that we should be exhilarated by our initial encounters with it. As I share in that appe-

tite, at least some of the time, I have a certain sympathy for artists who are driven to minister to its needs, and Kiefer is clearly one of them. (He may even, in this sense, be "the best" in his generation—but where, alas, is the competition?) Yet as I am also aware of how easily such an appetite for the extra-aesthetic is nowadays satisfied—and how short-lived such satisfactions so often turn out to be—I tend to be wary of the kind of art that makes its appeal in the name of something other than art.

But is this, in fact, what is actually going on in Kiefer's art? Or is his status as a visionary with something important to tell us about history and the human condition a phenomenon that has been imposed upon a body of work that cannot finally support the heroic role that is now being assigned to it? I count myself among Kiefer's admirers, but what I admire in his art does not seem to have much to do with what so many others see in it, or claim to see. For in my view Kiefer is an artist who demonstrates over and over again what, in the last years of the twentieth century, the *limits* of art—particularly the limits of the art of painting—now are when it comes to dealing with the great moral and historical issues of the modern era.

That Kiefer has made a determined and sometimes inspired effort to test and transcend these limits is, it seems to me, undeniable. That he brings immense reserves of energy, imagination, and invention to bear on his quest for

a meaning "beyond" art is certainly to be accounted a significant part of his artistic enterprise. But the quest itself has an essentially Sisyphean character; it is its destiny to be repeatedly defeated. It is this pattern of Sisyphean defeat that gives to Kiefer's art its special poignancy—a poignancy, it must be said, that is not always clearly distinguishable from a certain mode of German sentimentality. The spiritual yearning in Kiefer's work is something that we are all made to feel. There is no way to miss it, if only because it is given such elaborate, operatic trappings. But in neither art nor life are yearnings to be mistaken for realizations. And in art at least, it is only realization that counts. Everything else—even the most exalted yearnings—belongs to the realm of failed dreams.

Kiefer paints—or perhaps one should say constructs, for he uses all sorts of materials—three types of pictures: landscapes, images of architecture, and what might be called didactic diagrams or charts. Many are of immense size, most conform to a bleak and mournful palette of blacks, grays, and earth colors, some—quite a few—have words inelegantly painted onto their surfaces, and all are weighted with symbols drawn from history, mythology, literature, folklore, or the artist's own biography.

The best of these paintings are the more recent symbolic landscapes: *Nuremberg* (1982), *The Mastersingers* (1981-82), *Midgard* (1980-85), *The Book* (1979-85), *The Order of the Angels* (1983-84), *Emanation* (1984-86), and *Jerusalem* (1986). The least successful are certain of the didactic-chart paintings—*Ways of Worldly Wisdom* (1976-77), for example, which is said to commemorate, with appropriate irony, the victory of the ancient Germans over Roman invaders at the Battle of the Teutoburg Forest in the Year A.D. 9. I must confess to having no interest in the subject, and the ponderous ineptitude with which the painting is executed, even if intended as a mockery of the theme (but how can one tell?), does not offer much in the way of aesthetic compensation. Kiefer's gift is the characteristic German gift for graphic images, but wherever his subject calls for the representation of faces or figures—*Ways of Worldly Wisdom* is almost all faces—he shows himself to be a very inadequate draftsman. His drawing is always at its best—which is to say, most powerful and moving—where it serves, as it does in the symbolic landscapes, to provide his paintings with a simplified, overscale format. It is drawing that takes little interest in the subtleties of pictorial space—as we can see at a glance in the macabre architectural paintings. If not for their references to the architecture that Albert Speer created for the Nazi regime or their other historical allusions, the architectural paintings would have to be considered eccentric variations on familiar academic themes. Even with their highly charged "content," I am not sure they escape a descent into pictorial cliché. It is, in any case, on the basis of the symbolic landscapes—and on certain works on paper that are related to them—that Kiefer is likely to survive and develop as a significant artist. The architectural paintings are a dead end, and the didactic charts and diagrams have already been abandoned.

It is in the contemplation of nature that Kiefer's pictorial imagination seems to attain an expressive freedom it does not enjoy in relation to his other subjects. For the German imagination, nature is not always a realm entirely distinguishable from culture. In Kiefer's painting, certainly, na-

ture is by no means free of the darkness of history that is his abiding obsession. It is deeply implicated in the myths of a culture that has conferred so many spiritual or symbolic meanings on natural phenomena that the life of the earth seems at times to have been stripped of its independent existence. Which is to say that for Kiefer, as for so many German artists, nature is an allegory—a world of spirit as well as a realm of organic materiality—and it is in the effort to encompass its double nature, so to speak, that his landscape paintings achieve their special distinction.

There is much about these landscape paintings that identifies them as belonging to the Neo-Expressionist school—not only their oversize, "heroic" scale, but their curious mix of materials: straw, lead, sand, crockery, etc. In Kiefer's case, however, we are always made to feel that something akin to a systematic iconography is what governs this use of materials even if we cannot instantly identify the exact iconographic use to which they are being put. More often than not, there is in these landscapes an overload of materials attached to their surfaces that makes the paintings look heavy, ponderous, and overworked in the Neo-Expressionist manner. Yet in Kiefer's case, these excesses appear, paradoxically, to be in the firm control of a very particular vision—a vision that is mystical in the German style, turning every material perception into a metaphysical conundrum.

About this whole aspect of Kiefer's work, the wonderfully detailed catalogue that Mark Rosenthal has written to accompany the exhibition is an indispensable guide. James N. Wood and Anne d'Harnoncourt, in their Foreword to the catalogue, speak of Mr. Rosenthal's lengthy text as "an essential tool for our understanding of the quotations and iconography that are central to [Kiefer's] work, much as a skillfully annotated edition of *Ulysses* aids the reader of Joyce," and they are right to do so. On everything from the kind of use Kiefer has made of Caspar David Friedrich and Jackson Pollock to his relation to Joseph Beuys to more specifically iconographic research—which buildings are referred to, what historical events or literary symbols or private experiences are invoked—Mr. Rosenthal can usually be relied upon to give us the requisite information. In this respect, his catalogue is a triumph of art-historical scholarship. But, as is even the case with *Ulysses,* such aids to understanding esoteric allusions are not to be taken as a substitute for our experience of the work itself. Even when we find ourselves properly informed about the Battle of the Teutoburg Forest, there is still the problem of what to make of *Ways of Worldly Wisdom* as a painting.

The landscape paintings are less problematic, to be sure, because they are so much more accomplished—so immediately compelling—as paintings. They have a power, at once pictorial and poetic, that is not dependent on our perfect understanding of their symbolism. Kiefer is an artist who imparts to every picture a characteristic emotion—an emotion that is relentlessly dour and obsessed with death—and you can't mistake it for anything else. Every painting sounds the requiem note, and the landscape paintings sound that note more effectively than any others.

Indeed, I think it is only in the landscape paintings that Kiefer has to some extent freed his painting from its dependence on hermetic symbolism and achieved the kind of archetypal expression he is searching for. The landscape

paintings are wasteland paintings. They are scorched-earth images—images of an earth and a world that is rotting and returning to the primordial mud. They are images of a sublime that has "fallen" into decay. Their real subject is death, and the death that haunts them is as much the death of art as it is the death of the earth. All of this can be vividly—and indeed, insistently—seen in the so-called "books" that Kiefer has produced in such profusion, for what are these large sketchbooks or scrapbooks of images and non-images if not an avowal of the death of art in the face of the enormities of modern history?

In speaking of Kiefer's relation to Joseph Beuys, Mr. Rosenthal writes that Kiefer "undoubtedly gained from [Beuys] an enormous sense of mission and ambition, that is, the wish to grasp great regions of human history within the boundaries of his art." It is this sense of a great mission that has conferred on Kiefer's enterprise its enormous prestige. Yet in the celebration that is now being lavished on this gifted and unusual artist, we ought not to overlook the central place that the death motif occupies in the oeuvre that is celebrated. For myself, though my admiration for Kiefer is undiminished, I cannot say that I have been persuaded that he *has* succeeded in bringing "great regions of human history within the boundaries of his art." On the contrary, what this retrospective makes clear to this observer, at least, is that the object of Kiefer's Sisyphean quest continues to elude him. (pp. 2-4)

> *Hilton Kramer, "The Anselm Kiefer Retrospective," in* The New Criterion, *Vol. 6, No. 6, February, 1988, pp. 1-4.*

Peter Schjeldahl (essay date 1988)

[*In the excerpt below, Schjeldahl offers a comprehensive analysis of why Kiefer's paintings have enjoyed such widespread popularity in the United States.*]

"Wouldn't it be amazing if he turned out to be *really* great?" someone blurted at me recently apropos of Anselm Kiefer. I understood the speaker's mixed emotions, which I share: joy in being the contemporary of an extraordinary artist—it's a lucky feeling, a sort of vicarious redemption—shadowed by suspicions of eventual disappointment. Thus the note of wistfulness. (The speaker, like me, had been drinking.) Hedged awe is the generous variant of a mental distress—call it Anselm Angst—widespread in art circles this winter, as Kiefer's long-awaited American retrospective begins, in Chicago, what promises to be a triumphal march through these States. The mean variant is the somewhat comical grumpiness of purists and hipsters betrayed by fascination with the German's work into unaccustomed agreement with a middle-brow, market-and-publicity-driven majority. They would be only too happy if Kiefer proved not to be "*really* great," especially if they were the first to target his Achilles heel. Lacking that bull's-eye, they may be expected to level shotguns at the excesses of Kiefer's following, with its sententious journalists and salivating millionaire collectors.

Why is Kiefer so popular in the United States? The often-asked question would be more interesting were Kiefer not popular in a lot of places. His shows have drawn crowds and praise throughout Western Europe and in Israel. Even some of the English and the French—testy and disdainful,

respectively, toward most contemporary art—have permitted themselves to melt a little. Young painters everywhere flatter him with imitation. Only in his own land, at least until recently, has the prophet lacked honor. I've heard Germans denounce him with a vehemence I don't entirely understand, though it seems to entail bitterness at being represented, internationally, by an artist somehow inauthentically German, unlike their beloved, *echt-Deutsch* Georg Baselitz. Bizarre suggestions, once rife there, that Kiefer is some kind of neo-Nazi seem to have abated, however; and an issue of *Der Spiegel* last year reported a tidal shift of German opinion in Kiefer's favor, maybe because he's become a world-beating export right up there with the BMW. (His new paintings sell in the high six figures.) Still, there is a particular flavor, as well as an eerie unanimity, to Kiefer's welcome in the U. S. It may owe to the mixture of esthetic, historical and emotional susceptibilities that I find in, making a specimen of one American, myself—with the consequent misgivings that symptomize full-blown Anselm Angst.

I think Kiefer hits the spot with us in four main ways, none readily separable from his talent but each giving its appeal a peculiar spin. In no special order: 1) he roils our very complicated feelings about World War II, an event that apotheosized American power, pride and delusions of moral grandeur; 2) he reawakens the glamour of European pastness, a half-forgotten American ache for lost roots; 3) he is a public individualist of a sort, pledging unallegiance to both custom and fashion, we may still idealize but seem increasingly helpless to produce; and 4) he is an "American-type" painter. In saying the last, I am aware that Kiefer's sensibility has been a sort of Rorschach test for national narcissisms: some French see a reviver of 19th-century French Romanticism (Victor Hugo laced with Baudelaire), some Scandinavians an heir of Munch and Strindberg (citing the latter's little-known, quite apposite paintings), and some English a Turner avatar (an affinity anyone with eyes must note). All foreign claims will have to wait, however, this is an American essay. Simply, in 40 years no other European artist—not one!—has so thoroughly assimilated and advanced the esthetic lessons of Jackson Pollock, specifically Pollock's doubleness of spatial illusion and material literalness on a scale not just big but exploded, enveloping, dis-composed.

Contrary to an inexplicably persistent critical shibboleth, Pollock's esthetic has nothing to do with emphasizing the picture plane. Rather, it renders "surface" unlocatable, replacing it simultaneously with optical depth and tactile fact—infinity and *stuff*—defying us to know what, exactly, we are looking at. Omnipresence of this tension throughout the (big) picture makes the scale. Pollock's own uniformity of marking is not required, but only an overall, energetic pressure of frontal/recessive contradiction, evoking at once a wall and a veil. Is this practically an academic convention in painting by now? It is (and is treated as such, to sardonic effect, by Kiefer's older countrymen, Gerhard Richter and Sigmar Polke), but Kiefer cranks up its tension to a fantastic, unprecedented pitch with receding architectural and landscape images that amplify illusion, and encrustations that maximize literalness. He resensitizes us to the convention, making it new somewhat the way the young Manet renewed past Spanish masters. For Americans, the resulting formal idiom is as clear as

a Midwestern newscaster, as big as all outdoors, and straightforwardly stunning.

What's unclear is why so many of us experience Kiefer's works—even in the first split second of a first encounter (I saw an acquaintance, catching her initial glimpse of one, almost fall down)—as so much more than gratifying esthetic presences. His big paintings instill a feeling of conviction bordering on religious faith, an intuition of knowledge which proves remarkably inarticulate when you try to debrief people about it. It can't be a function of Kiefer's narrative and poetic themes, of which many American Kiefer fans remain complacently ignorant. . . . The feeling is mysterious even to the intellectually prideful who, finding it regressive, might love to analyze it away—the problem being that to analyze it you have to feel it, and doing that puts your analytical faculties in traction. Listening to word of mouth and reading reviews of the Chicago show, I get the sense that American emotional responses to Kiefer, matched against what I think is actually there in the art, are largely distorted and probably irresistible, a reflux of collective psychic material that says more about us than it does about him—while saying much *for* him, as an artist on the nerve of his world and time.

The immediately recognizable master metaphor of Kiefer's art is the Wasteland, the modernist trope par excellence for this century's characteristic experiences of fragmentation and chaos. An Englishman (Charles Harrison, in *Artscribe,* Nov.-Dec. '86) observed: "The 'wasteland' space functions in [Kiefer's] pictures much as the pastoral landscape functioned in the art of the seventeenth century: as an historical terrain upon which diverse material may be assembled into allegorical form, and thus absorbed. . . ." That seems correct, but it doesn't begin to account for the impact of an image which, even as a kind of meta-cliché, has nothing neutral about it. The Wasteland idea has taken on a lot of contradictory freight since a distraught young expatriate from St. Louis, T. S. Eliot, gave it supreme literary expression nearly 70 years ago. For Americans, I think it retains the special aura it had for Eliot, one not apt to be shared by a German born in 1945: an emanation of deep, unkillable yearnings toward the "heap of broken images" that remains of a lost European heritage. Eliot surely couldn't have disagreed more with his colleague James Joyce's sentiment, palpably seconded by Kiefer: "History is a nightmare from which I am trying to awake." For many of us, on the contrary, history is a dream we'd be thrilled to sink into if only the racket of modernization, blasted at us through media that have already forgotten what happened last week, would shut up for a second.

I think the quasi-religious feeling triggered by Kiefer's Pollockian machines—with their heart-grabbing yellows, blacks and browns that affect like tastes, sounds and smells, and their incorporation of photographs that drench the mind in tones of memory—this feeling is a delicious, melancholy, slightly masochistic sense of abasement before sheer ancientness. Such seems the gist of an eloquent, extremely American take on Kiefer by Sanford Schwartz (*The New Criterion,* Mar. '83):

> Enthralling and bleak at the same time, [Kiefer's paintings] are like a visit to a great cathedral on a winter's afternoon, when the light is sunless and white, snow is in the air, and you have the place to yourself. As you go away, you may believe that you have taken the sacred and sad drama into yourself, and that it has ennobled and elevated you; later, though, you may be left with a feeling that your experience can't be made part of the rest of your life, and that it sucks out of you more than it gives.

For "a great cathedral" read "Europe" or "the idea of Europe," or whatever signifies for you a civilized spiritual nourishment you crave and, if you were unfortunate enough to get it, couldn't possibly digest. The trouble with this response to Kiefer's art is that it may well be the opposite of what he intends. It is humorless, for one thing. Kiefer is usually funny.

Broaching Kiefer's humor can stop a conversation, I've found. People blink, and I start thinking I must be wrong. Only patient looking, staring down "the sacred and sad drama" for which I, too, am a pushover, convinces me that it's true: even the most plangent or anguished of Kiefer's works, when he is obviously fired with sincerity or gripped by some unresolved hysteria, display joke-structures—antic stuff with palettes and angels, slaphappy incongruities of scale like **Operation Sea Lion** battleships in bathtubs in plowed fields, "books" in which absolutely nothing happens (except that at a certain point, as the pages turn, your hair may suddenly stand on end), and in case we didn't get it—Kiefer may wonder at times if anyone in the land of industrialized comedy has a funny-bone—cast-iron skis attached to an 18-foot-long picture called **Jerusalem,** violating the delicately haunting associations of the layered, punished surface with the suggestion of a Middle Eastern Aspen. The provocation is so blatant that one might want to make excuses for it, as in retrieving a friend's social gaffe; but Kiefer is incorrigible. He affixes a lead propeller to another grand painting (**The Order of the Angels . . .**) to hammer home an awful, bookish pun on the name of an early Christian theologian, Dionysius the Areopagite—"Aeropagite," maybe because Dionysius's obsession with angels suggested flyboy proclivities. With such things, Kiefer makes rude noises amidst his own painstakingly induced reveries, and if viewers persist in genuflecting, they're on their own.

The art student who began his career two decades ago by having himself photographed giving the Nazi salute in various European locales was a sort of prankster, though a serious as well as a staggeringly audacious one—getting at something that needed to be gotten at, the repressed emotions of the Third Reich, as a means to the end of a comprehensive, untrammeled art. "How could it happen?" he was asking, partly as a young German disgusted with the evasiveness of his elders but most pointedly as an ambitious, rebellious artist, defiantly asserting, right from the start, an absolute license for his imagination. Faustian pride may underlie the defiance, but its operative mode is Mephistophelean irony: self-satirizing in the Nazi-salute images . . . and in such subsequent things as drawings of **The Artist's Studio** as a fiery aerie or sullen bunker and a hilarious lead sculpture of a winged palette as bird of prey. Kiefer's recent preoccupation with alchemy is likewise double-edged, I believe, evoking at once a mystic metaphor of creativity and the folly of mumbling crackpots who, in stinking laboratories, tried to make matter imitate an idea. Kiefer quite directly mocks most of his thematic material, historical and mythic, theatricalizing it into absurdity. In the process, some very serious, barely

sane, perhaps poisonous meanings are released as an intoxicating poetic vapor.

I know a woman who when excited or moved, in ways that would make me exclaim or get a lump in my throat, invariably laughs—"because it's *wonderful,*" she says. I think Kiefer is like that. Even his darkest work has a warmth, if not of humor then of the eroticism that probably underlies the polymorphous, "wonderful" type of laughter. I'm thinking of his "Margarete/Shulamite" series of works about the Holocaust, which do the supposedly impossible—make successful art of the ultimate horror—by elaborating Paul Celan's tragic erotic projections, the "golden-haired" Aryan and the "ashen-haired" Jew. No humor there, but an emotional nexus of desire and loss, love and death, that may be related physiologically to the release of laughter (the sudden restoration of subjectivity that has been threatened). The feeling-saturated terrain of this and other themes from Kiefer's Wasteland—a realm of stories with which he keeps himself engaged and interested, scared and entertained—has nothing in common with the American way of revering things historical, thereby to fantasize ourselves into a past we never had. Oppressed by history, Kiefer uses fantasy to spring the locks on one dungeon of pastness after another. When he succeeds, there is a buoyancy, a glee. I think we may sense this even as we cling to the projection of our own nostalgias. No wonder Kiefer confuses us.

The single most beclouding element in American responses to Kiefer is our complex of feelings about World War II, Nazism and the Holocaust, subjects really addressed only in some of his work and never so directly as imputations of "mourning," "catharsis" and "exorcism" (the obligatory terms in Kiefer criticism) would suggest. Even indirect reference more or less ended five years ago, when the masterpiece **Shulamite** (menorahlike flames in a war-hero memorial) climaxed both the "Margarete/Shulamite" series and another protracted series based on motifs of Nazi architecture. Kiefer has since been off into regions ahistorically mythical, theological, alchemical and otherwise self-referential, making art largely about the mental and physical processes of making art. Kiefer's involvement with Third Reich themes needs to be confronted—it remains the most riveting aspect of his career—but with reference to pertinent works rather than to everything from the artist's hand. The ingenuity of a Jack Kroll (*Newsweek,* Jan. 18, '88) shows what Kiefer is up against in his efforts to change the subject: "[*Jerusalem*] is a touchingly surreal image of transcendence, as if Germany, crazy with remorse, were saying to Israel: 'Here, take our skis. They take us through our mountains. Maybe they'll take you through yours.' "

Crazy is right, though Kroll's heuristic high jump is so terrific I'm half-convinced. (My own initial association to those skis, I recall, was to the scene in the movie *The Young Lions* where soon-to-be-Nazi-soldier Marlon Brando is a ski instructor romancing an American girl in the Alps; the memory popped into my head and wouldn't budge. I offer it as worth exactly nothing, except in affirmation of Kiefer's conduciveness to delirium.) Where Kroll's conceit fails the test of Kiefer's established artistic temperament is in having "Germany" talk to Israel, or to anybody. Kiefer may cultivate imaginative territory cleared by Joseph Beuys, but he is no Beuys-like holy fool

or shaman, ritualizing collective hopes, guilts and fears. He has always operated strictly on his own, a lone artist bent on becoming ever more alone, and free, through acting out, then having done with, the determining myth and history of "a German." As an artist, he speaks neither for nor to Germany, nor even for himself as a German citizen—a subtle point, given his massive use of highly charged stuff from his German heritage, but the crux of his meaning. An Israeli critic, Meir Ronnen (in *The Jerusalem Post Magazine,* July 27, '84), got it succinctly: "While Kiefer the German acknowledges his past in a way that suggests exorcism as well as a search for cathartic understanding, Kiefer the painter rejects it." That is, what he feels as a citizen belongs to the material, not the motivation, of his art. The motive is an aggrandizement of art's critical as well as esthetic powers.

The major critical project pursued by Kiefer from his first Nazi salutes to the 1983 **Shulamite** seems precisely a reclamation of certain esthetic modes (Neo-Classical, Wagnerian, nature-romantic) from the death grip of their political uses in the Third Reich: comprehension of the real beauty of an Albert Speer interior, say, simultaneous with comprehension of its sinister historic significance. The procedure might be compared to a vaccine which, mimicking the action of a virus to produce antibodies, forestalls the virus. Of course, vaccines can be contaminated, and Kiefer's—his absolutist conception of the artist—is scarcely hygienic. Kiefer's heroizing of the artist (never exactly himself, never exactly not himself) is subject to a risky volatility apparent in the adventures of his signature symbol, the palette: associated to the megalomania of a Nero (**Nero Paints**) or a Hitler (**Operation Barbarossa**), imposed on scenes of nature like an angry cancellation mark or identified with a missing, mysterious "Unknown Painter," tropes that bespeak the vicissitudes—arrogance, hysteria, depression—of piloting an archetype. The palette is straightforwardly ironic in its archaism (as a post-easel painter, Kiefer doesn't use that item of professional equipment), but he leaves himself and us no choice except to regard it as a serious declaration of his willfulness. It is the badge he flashes to go wherever his imagination tends, most particularly to places marked "Off Limits." In Germany, that would seem to be anywhere it is possible to experience emotions even remotely associated with Nazism.

Embarrassment is a frequent theme of German journalistic attacks on Kiefer (translated for me by writer Ulrike Henn): "Painfully embarrassing nationalist motifs," complained a 1982 issue of *Der Spiegel,* and a Frankfurt critic in 1984 saw a German past "dark, whispering, embarrassingly remembered ('How grand we were!')." Petra Kipphoff (*Die Zeit,* Apr. '84) specifically ruled out "the freedom of art" as an excuse for a painting titled **Poland Is Not Yet Lost,** because "this song title [that of a Polish anthem], misused by German aggressors, cannot be used lightly by any German." Taking another tack, a critic of the *Kölner Stadtanzeiger* (Feb. '81) decried Kiefer's wholesale implication of Germanic history and culture in the Nazi disaster (as in his **Ways of Worldly Wisdom** roundups of the good, the bad and the ugly from two millennia of German artistic, military and political worthies): "It is not only failed but dangerous historic consciousness to link wars to demonic powers of fate." The common thread in all these journalistic scoldings is an implied demand for civic rectitude, obedient to the compunctions of postwar German

political culture. Such crudely censorious German reactions, to an artist who happens to have vastly enhanced the prestige of contemporary German art in American eyes, gives rise to a sense of cognitive dissonance between our countries that makes the head swim.

Americans will have to get used to such things. The Kiefer phenomenon only contributes to a virtual reprovincialization of the U. S. as regards renascent cultural energies in Europe. How the mighty have fallen. "Think of it!" yet another wistful friend said to me the other day, with reference to art and tennis. "Germany has Kiefer and Boris Becker. We've got Schnabel and John McEnroe." He might have added Fassbinder versus Spielberg and Peter Handke (okay, an Austrian) versus Raymond Carver—it's a game you can play. At any rate, we are put in the unaccustomed position of spectators trying to figure out such dramas, on distant stages, as the one apparently being enacted between Kiefer and his country's cultivated, happy-face image as a hardworking, social-democratic, loyal international good guy with a sideline in smoky, sexy, *Cabaret* wildness. (Might Kiefer propitiate his country by engaging in a little spectacular self-destruction à la Fassbinder?) This particular spectacle may appeal strongly to our individualist mythos, casting Kiefer as a foe of repression. The nature of the repression—German war neurosis, say, which is not our problem—matters less than the way it activates values of our own, with which we may have lost touch. Anselm Kiefer is not Ralph Waldo Emerson, and he is not Davy Crockett. But he is self-reliant, and he's got guts. Attending to him, we may seem to remember something pretty good about ourselves.

I propose, finally, to set all such projections aside: the sick excitement of historical associations, the afternoon-in-a-cathedral afflatus, the flattery of recycled American esthetics and the appeal of Kiefer as a good old Black Forest country boy. What's left? I think it is the figure of an artist in a studio, tinkering interestingly with interesting ideas and materials. He is exemplary. His work conveys the texture, the feel of making something substantial out of nothing much. He is the maker, deciding what he'd like to do and doing it. Each thing retains the rough evidence of his decisions about it. It has no style other than the manner of its making, which looks simple and self-evident, like something anyone could do. I've had such thoughts and feelings about Marcel Duchamp, Jasper Johns, Bruce Nauman, Ed Ruscha and other artists, not very many. (People are surprised to hear that Ruscha is a favorite of Kiefer's, but they shouldn't be: the books, the uses of language and photography, the odd materials, the playfulness with scale, the putting of words in landscapes and an individualism expressed in geographical isolation all make the affinity a natural one.) Like those artists, and also like Beuys and Andy Warhol, Kiefer rattles the received wisdom about what an artist is and does, letting us know that the world has changed even as art has found a new way to go on. (pp. 116-25)

Peter Schjeldahl, "Our Kiefer," in Art in America, *Vol. 76, No. 3, March, 1988, pp. 116-26.*

James Yood (essay date 1988)

[*In the following excerpt, Yood explores the influence on*

Kiefer's artistic development of the refusal of postwar Germany to acknowledge the atrocities of the Nazi period.]

It is part of the peculiar history of the Second World War that it ended with both a bang and a whimper. The bang—or, more accurately, the two bangs—that closed it in Japan still resound in our minds, with a chastening portent for our future. The whimper—a world's shock and revulsion at the depth of Nazi atrocity—seems more the stuff of history, a horrible memory too often suppressed, an unbelievable descent into our heart of darkness.

Its awful mystery still haunts us: how could a Western nation in the middle of this century descend so far; how could this stain on our collective history occur? Was it a horrible aberration, or is our awe at it linked to our knowledge that its potential still lies within us?

Anselm Kiefer witnessed nothing of what we know today to have comprised the Nazi crimes against humanity. His birth in Donaueschingen in March 1945, a few months before the end of World War II, put him, rather, in the position of being an heir to a bitter patrimony. It is a position that by inclination and temperament Kiefer has been willing to accept; like some latter-day Prince Hamlet he has continually and often magnificently probed the implications of his inheritance and, again like Prince Hamlet, he never seems to tire of examining and re-examining his situation, almost to the point of catharsis by repetition.

In a way, Kiefer is always painting that which he really never paints directly—the Holocaust, and the legacy of recent German history. His concern with evil, with understanding the savagery that can all too often be found in our collective activity, has made him seek for its causes in and around himself, in his conception of his own Germanness, and in the patterns and inclinations that have formed his nation. His insistent examinations and recollections of earlier German culture and mythology act finally as a kind of cultural and societal psychoanalytical inquiry, as if, in taking an almost Freudian approach, he locates the roots of modern aberrations deep in the past, in the hope that understanding—if not expiation—will accompany their uncovering.

One of Anselm Kiefer's most firmly held beliefs, and one alluded to in canvas after canvas, is that artists possess a spiritual and redemptive power that can counter and surmount the vagaries of existence. In this belief he is not alone; one of the most insistent myths of collective Modernism—and one that Postmodern art and culture often attempts to undercut—rests in this identification of the artist as seer, as the voice of conscience, as an arbiter of civilization. In Kiefer's case, the implication of his subject matter exudes such a heavy load of guilt and horror that to many he is more than seer, conscience, or arbiter; he has become shaman.

Kiefer's conception of the artist's role is visually manifested by the touchingly/cloyingly heart-shaped palette that often appears in his works, sometimes flying above the scorched and soiled earth, sometimes enshrined into a canny monument to art, but also sometimes as a belief at risk, in images in which the palette is afire, about to be consumed by the forces around it. Indeed, that his art exists at all seems an effort at affirmation, surviving a rather savage gestation. Matted straw, bits of metal, molten lead,

sand, tar, pieces of cardboard, photographs, smashed por-celain, twigs and leaves and more are selected and com-bined with aggressively painted and scumbled surfaces. These issue forth from the crucible of his vision in a new kind of alchemy, with art its end result.

Kiefer's sincerity, his focus, and his skill in its explication made the crowds that walked through [his 1988] exhibi-tion look like pilgrims on a journey through the Stations of the Cross. But what makes Kiefer particularly interest-ing is that at the end of the journey was no end—not the offer of redemption one might have expected but, rather, a sense of return and reimmersion, a going back to the be-ginning, as if this was all a wheel and not a continuum.

This sense of perpetually resituating oneself, of always preparing a context that is unlikely ever to move forward, gives Kiefer's vision an odd sense of both self-love and self-abnegation. In 1980 Kiefer stated, "I do not identify with Nero or Hitler, but I have to reenact what they did just a little bit in order to understand the madness. That is why I make these attempts to become a fascist." It is this quali-ty of history-appropriation, a continual artistic clearing of the throat, that in the final analysis makes Kiefer a mag-nificent retrograde, the last (and best?) gasp of a positivist Modernism.

The manner that Kiefer employs to investigate fascism has proved problematic for some in his audience, particularly those in his own homeland. The specificity of his inquiry, often re-evoking images and symbols of the Third Reich, has led many to fear that his art may re-empower what it attempts to examine. Like Hamlet's feigned madness, Kie-fer's feigned fascism can work on many levels, not the least of which can be to evoke nascent fascist urges in his audi-ence.

Anselm Kiefer walked this precarious line even in his ear-liest works. In the late '60s, then working in a conceptual-ist/performance mode, Kiefer had himself photographed as he gestured the Nazi salute at various sites in Europe. This need to confront his own history and, through the mediating aspect of art-making, to speak the unspeakable has been of concern to him ever since. His critical recep-tion at home and abroad has read this in two desparate ways: some see him as a petulant child, relishing the act of pronouncing forbidden curse words; others regard him as an artist of reflective sensitivity, willing to face the de-mons within us all.

On these issues, and on almost everything else concerning the public reception of his work, Kiefer himself is largely silent, willing to let the work alone speak. Like a magician hesitant to show too much of his wares, he no longer per-mits photographs to be taken of himself, is for the most part unavailable for interviews, and works in relative se-clusion in a rural area in southern Germany.

From there he remembers—or better yet, he recon-structs—as well as he can within the context of his culture. While it would be interesting to learn more about his par-ents, one of whom was an art educator, Kiefer and his chroniclers are either vague or silent on this question. Somehow, in the midst of a Germany determined to for-get, deny, cover-up, circumvent, obfuscate, and erase—a German culture today well symbolized by Kurt Wald-heim, the anti-Kiefer—he grew up obsessed with the sins

of his fathers, grew up vowing not to forget or to avenge but to accuse, both them and himself.

It is difficult to pinpoint exactly how this might have oc-curred, but one could argue that the spectacle of Albert Speer was of interest to Kiefer, an interest he would mani-fest by many references to Speer's architecture in his works. Speer personifies much of what fascinates Kiefer. An artist who succumbed to the lure of power and fas-cism, Speer was a witness to history; to some degree and at some level he was a participant in savagery and abomi-nation—in all, he was everything Kiefer probably fears he himself might have been had he been born 40 years earlier. Beyond that, one notes Speer's 1970s "rehabilitation"—his life after Spandau Prison as an urbane, highly literate, and extraordinarily personable raconteur, a media dar-ling, this seemingly harmless Nazi; not an image in a grainy photograph but present in flesh and blood, Speer both reopened and assuaged old fears. To Kiefer's hair-trigger sensitivity on this issue Speer must have seemed a specter from Hell. To understand Hitler fully, Kiefer had to become Speer and to purge Speer, to remake his build-ings, to tear them down and to reshape their form in an ultimate de-Nazification, thereby transforming them into monuments to art and to loss.

The intensely personal journey that Kiefer has undergone has almost been in spite of his experience of Joseph Beuys, whom Kiefer deeply respected and still cites as his teacher. The two artists were in close contact in the early 1970s and, in an odd way, they share and shared many of the same goals: to activate and stimulate our lives, to make us richer and deeper and more aware. Even so, marked dif-ferences in character, vision, and artistic necessity have re-sulted in two divergent bodies of work. Where Kiefer is historical and revelatory in nature an artist of memory creating objects that are the scrupulous end results of his inquiry, Beuys was forward-looking and social in vision, a conceptual seer whose resultant art objects are but sign-posts, shards of life—not self-contained, aesthetic state-ments. Beuys's personality and commitment to many of the issues facing modern Germany led him to a highly public profile, with almost an attendant career as a social activist. Beuys was willing to play out his concerns on the largest stage possible, something that Kiefer—by nature and inclination rather reclusive—could never do. Kiefer's urge for solitude, for reflection, inevitably led him to rumi-nate backward over history, rather than to press forward to social change.

At a moment when the look of paint is highly desired, and when the tactile and didactic art object seems to hold a special fascination, Anselm Kiefer possesses one of the era's most profound voices. All in all it is a cunning and bracing voice, impressive in its intellectual focus, in its ability in work after work to ring out its message clearly. It speaks of our legacy and our limitations, and it speaks of our struggle to understand what we as a civilization have done and can do, and of what we may have to bear along the way. But no small part of its magic lies in what Kiefer seems to believe: that Armageddon does not await us in some distant future—that the fantasy of a final purg-ing, a final cleansing of the slate, must be laid aside. Rath-er, Kiefer seems to believe something yet more telling, yet more awful: it may indeed be that Armageddon has al-

ready occurred, and that we are but the hollow shades who grope and gyrate in its wake. (pp. 25-7)

James Yood, *"The Specter of Armageddon: The Anselm Kiefer Retrospective,"* in New Art Examiner, *Vol. 15, No. 7, April, 1988, pp. 25-7.*

Jed Perl (essay date 1988)

[*In the following excerpt, Perl strongly objects to Kiefer's work, disagreeing in particular with his use of the Holocaust as a central theme. "I would argue that Kiefer's troubles begin right there," Perl asserts, "because to treat the Holocaust as a symbol is to belittle it, to make it bearable."*]

Half a century after *Kristallnacht,* the Holocaust is a treasure trove of super-strength imagery that artists are inclined to adapt with little apparent hesitation. In some cases, there's an honest if dangerous effort to bring the unimaginable into line with the needs of the contemporary imagination; elsewhere images are presented in such a way that their precise relation to Hitler's Final Solution is veiled, even obfuscated. The Anselm Kiefer retrospective . . . is a phenomenon that has brought an aestheticized fascination with Nazi Germany to the attention of an enormous public. Kiefer's mammoth images of charred tracks of earth are if nothing else a tabula rasa upon which many critics have inscribed their own overheated associations. And these associations have been abetted by curator Mark Rosenthal's text for the catalogue, which marshals the forces of art-historical scholarship to lend Kiefer's jazzy reputation as a contemporary tragic hero some weight, some dignity, some mythic resonance. Meanwhile, for those of us who are disinclined to take our Zeitgeist readings from the media or the Museum of Modern Art, the appearance of the Holocaust as a motif in half a dozen shows by contemporary Americans suggests that Kiefer is hardly alone as he stirs the once irreducible facts of annihilation into a modern artist's metaphorical stew.

Despite all the attention that's been focused on Anselm Kiefer, people seem uncertain about how to react to his use of modern German—and modern Jewish—history. Because he's creating Art, people assume they have to suspend all (or at least most) reservations. Jews seem to feel almost guilty about their discomfort, as if they would expose a lack of cultural refinement by concluding that the obliteration of their not-too-distant ancestors was a dubious occasion for exercises in the Beautiful or the Sublime. Moreover, art critics, unlike literary critics, have rarely tackled the many aesthetic and extra-aesthetic questions that bear on the Holocaust. (p. 14)

Perhaps the best place to look for some insight into the contemporary fascination with fascist ideology is Saul Friedländer's extraordinary book *Reflections of Nazism: An Essay on Kitsch and Death.* Friedländer is a Jew who spent his childhood hidden in Nazi-occupied France (this part of his life is related in a widely acclaimed book of reminiscences, *When Memory Comes*); he has also published a number of scholarly works on the Holocaust. In *Reflections of Nazism* he brings to a very difficult subject an impassioned yet somehow cool intelligence. The book is rather unusual in the literature of artistic responses to the

Final Solution in that, unlike most studies, which deal with works created by survivors, it focuses on the image of the Holocaust in literature and movies since the Sixties. Though Kiefer isn't mentioned, many of Friedländer's observations throw light on Kiefer's art and reputation.

"Attention," Friedländer writes,

has gradually shifted from the reevocation of Nazism as such, from the horror and the pain—even if muted by time and transformed into subdued grief and endless meditation—to voluptuous anguish and ravishing images, images one would like to see going on forever. . . . In the midst of meditation rises a suspicion of complacency. Some kind of limit has been overstepped and uneasiness appears: It is a sign of the new discourse.

Reflections of Nazism is difficult to summarize, probably because much of the beauty of this brief book rests in the elusive, circuitous manner of Friedländer's reasoning, his unwillingness to simplify or to tie together ends better left loose. It's the very porousness of his effects that enables him to suggest some of the strange ways in which "the endless stream of words and images becomes an ever more effective screen hiding the past." Through quotations from Joachim Fest's biography of Hitler and the memoirs of Nazi architect Albert Speer, Friedländer demonstrates how Hitler succeeded in projecting himself as a German hero and his cause as a German cause by swathing Nazi ideals in a kitsch imagery that had a strong hold on the middle-class imagination. Kitsch—which Friedländer, quoting Abraham Moles, calls that "pinnacle of good taste in the absence of taste, of art in ugliness"—still appeals; and Friedländer's central insight is that the contemporary avant-garde's fascination with Nazi images echoes the original appeal of the Nazi mystique. The contemporary artist's response to the symbolic power of Nazism may not be so different from the response of the German of fifty years ago. About this mirroring of the past in the present Friedländer is obviously ambivalent: it's dangerous, but at the same time certain contemporary works may help us to understand something about the overwhelming attraction of a hideous ideology. "In effect," Friedländer writes, "by granting a certain freedom to what is imagined, by accentuating the selection that is exercised by memory, a contemporary re-elaboration presents the reality of the past in a way that sometimes reveals previously unsuspected aspects."

Over and over again Friedländer emphasizes how ambiguous a role Hitler has in contemporary art. Hans-Jürgen Syberberg's movie *Hitler, A Film from Germany* is perhaps the central piece of evidence—a movie that intermingles fascist kitsch, as in the sentimental memoirs of Hitler's valet, with the avant-garde infatuation with kitsch. Of Syberberg's effort, Friedländer writes, "It may result in a masterpiece, but a masterpiece that, one may feel, is tuned to the wrong key." "In facing this past today," Friedländer says later on, "we have come back to words," to images, to phantasms. They billow in serried waves, sometimes covering the black rock that one sees from all sides off the shores of our common history." Aestheticism, he says, is a defense against reality. This, it seems to me, is a perfect description of the appeal of Anselm Kiefer. In Kiefer's work, as in many of the works Friedländer discusses, the Nazi past has become a potent but also elusive presence—a sort of texture, made up of the burnt grays

and blacks that evoke charred bodies, a sensuous texture, a texture that seduces more than it illuminates. And this seduction serves to divert our attention from the hard facts.

Mark Rosenthal, the curator at the Philadelphia Museum of Art who wrote the catalogue for the Kiefer retrospective, isn't unaware of some of the problems that Saul Friedländer raises. Rosenthal's essay, however, grows out of a desire to operate in sync with Kiefer, and this ultimately amounts to something like collusion. The Holocaust is barely mentioned; and so the central fact of modern German history, the fact that makes it qualitatively distinct from all other histories, is a mist.

Kiefer's **March Heath** (1974) depicts the wide-open perspectives and dappled birch trees of an area southeast of Berlin that's long been admired by Germans for its natural beauty. Rosenthal tells us that "the area is happily recalled for many Germans in Theodor Fontane's *Walking-Tours through the Brandenburg March,* written in the nineteenth century"; but this wistful, rather literary nostalgia is hardly the point when, as Rosenthal explains, the March Heath that Kiefer presents is layered with metaphoric importance. According to Rosenthal, this is an area "which in this century was lost first to Russia and later to East Germany." And "adding to the multiple associations of the painting is [the fact] that 'Märkischer Heide, märkischer Sand,' an old patriotic tune of the region, becomes a marching song for Hitler's army." To say, as Rosenthal does, that the territory depicted in **March Heath** "has become a sad memento mori of the Nazi experience and the separation of Germany" is both to aggrandize the meaning of a fairly ordinary landscape and to engage in Holocaust control. "Sad memento mori" softens the past, pretties it up; and the equation of "the Nazi experience" with "the separation of Germany" suggests a capitulation to the idea that the Holocaust is merely one calamity among others. Elsewhere, Rosenthal speaks of "the more difficult aspects of [Kiefer's] German heritage"—again, a euphemism. And of how Kiefer "drifted further back in German history"—again, calamity as an atmosphere one floats through.

Also disturbing are some comparisons that Rosenthal makes between Kiefer and other modern or contemporary artists. These art-historical sallies have the effect of deflecting attention from the uniqueness of Kiefer's situation. "In *Cockchafer Fly,*" Rosenthal observes, "Kiefer became a kind of war poet, and the blackened, scorched earth his central motif, his Mont Sainte Victoire, as it were, showing the province of the landscape to be human suffering, not the glory of nature." "A kind of war poet" is again a case of prettying things up. The comparison to Cézanne casts Kiefer in a cleansed, elevated, modern-masterish context. To say that Kiefer makes the landscape "the province of . . . human suffering" only points up the way he sanitizes suffering. After all, how much easier it is to imagine a landscape "suffering" than to imagine a person suffering.

Another comparison, this one to Warhol. Speaking of Kiefer's **Ways of Worldly Wisdom**—a painting that includes portraits of figures out of German history "taken from either dictionaries or books about the Third Reich"—Rosenthal says, "Kiefer's depictions recall Gerhard Richter's '48 Portraits' series of 1971-72 and Andy Warhol's

many celebrity portraits from the 1960s onward. Like the American artist, Kiefer looks at the heroes of his country in a deadpan way. . . ." No, no. To associate the tongue-in-cheek glamour of Warhol's high-society gang with Kiefer's origins-of-totalitarianism motifs is to make a muddle, and finally to reassure viewers that all subject matter is equal. Here aestheticism is a leveler. And so, a couple of pages later, we're informed that "Kiefer offers art as a theoretical antidote for the terror of human history and the failure of mythic figures." Art as a theoretical antidote to the Holocaust?

In the past few years, Kiefer has visited Israel and begun to take some of his subjects from Old Testament history—he seems to have a particular fondness for Moses and the story of the crossing of the Red Sea. Perhaps some will see in this new twist of Kiefer's career a desire to escape the chronology of modern European history. But his tendency to mythologize everything (and Mark Rosenthal's tendency to use art-historical references to further muddy the waters) denies us exactly what we need when we confront Hitler—which is absolute, total clarity. The Kiefer who now memorializes ancient Jewish history was, twenty years ago, going around Europe taking photographs of himself dressed up in Nazi-style gear while giving the Nazi salute. These photographs were put together in a suite called **Occupations,** which was published in the magazine *Interfunktionen* in Cologne in 1969—it's the nadir of neo-Nazi campiness. "I do not identify with Nero or Hitler," Kiefer is quoted by Rosenthal as saying, "but I have to re-enact what they did just a little bit in order to understand the madness. That is why I make these attempts to become a fascist." Rosenthal underlines this. "He assumed the identity of the conquering National Socialist. . . . [I]n the flamboyance [!] of the Nazi *Sieg heil* he spares neither the viewer nor himself since he serves as the model for the saluting figure." And: "Kiefer tries on the pose of inhuman cruelty, plunging into a state of spiritual darkness in which he can coolly and almost dispassionately ponder one of the most . . . " It's amazing that this museum catalogue has been greeted with such mildness, with such appreciation.

I very much doubt that Kiefer's early conceptual "Sieg heil" works would have earned him a show at the Modern; voices might have been raised. And yet it's exactly the same love-hate relation to the German past that's earned him his retrospective; only now the same attitudes are packaged in the trappings of high modernist art. As Rosenthal puts it, by 1980 "Kiefer had, in effect, integrated his ongoing thematic concerns with the outsize proportions of Abstract Expressionism and the modernist insistence on the literal qualities of the object." The secret of Kiefer's fame is that a sensational and even I would say pornographic obsession with Nazi atrocities is welded to a mainstream modernist aesthetic. No wonder William Rubin, former Director of Painting and Sculpture at the Modern, said in a *Times Magazine* piece on Kiefer: "I don't think that any of the contemporary American or European painters is as good as Kiefer. He is my bet." Kiefer is a postmodernist that a modernist really can love—or at least a modernist like Rubin who desperately wants to make his peace with the new artistic order.

Kiefer's paint is said to evoke rock and earth, the soil of

Germany; and Kiefer tries to heighten our sense of earthiness through the inclusion of handfuls of straw, or the thickening of the paint with sand. This surface is the alpha and omega of Kiefer's art, and yet it's hardly the metaphoric miracle it's been claimed to be. Kiefer treats the canvas as if it were an upended track of land; he wants to imbue the flatness of the support with the lyric physicality of a nature poem. But his strong formalist leanings—and his infatuation with Abstract Expressionism—are in collision with what may or may not be a genuine gift for lyric evocation. Rosenthal has compared Kiefer to Pollock—he sees echoes of Pollock's *Blue Poles* in **The Mastersinger** and **Margarete.** This is Pollock with metaphysical and metaphorical trimmings, and the trimmings seem to come unglued as easily as Kiefer's hunks of straw. Strip away the fancy titles and the little representational doodles and you find paintings that look uncannily like post-Pollock formalist abstraction—especially the recent sensuous yet austere work of Jules Olitski and Lawrence Poons, both of whom, like Kiefer, paint with acrylic and like to build up the surface until it projects fairly far off the wall. In Kiefer's **The Book,** the surface is thickened with acrylic; and the translucent acrylic, after it has dried, is dusted with a dark tone. The effect is Olitski-ish—a kind of optical shimmer. Precisely what the painting lacks is the tactile gravity that we would expect in a painting that invokes earth—the weight that we know from some of the great modern expressionist landscapes, from certain Soutines and de Staëls, the late landscapes of Georges Braque, and the canvases of the English contemporary Leon Kossoff.

Kiefer is easy for current taste to assimilate because his sensibility is, at heart, a postwar American sensibility. His sizes are Ab Ex sizes; and, like an Abstract Expressionist, he articulates the surface only insofar as articulation reinforces homogeneity. The perfunctory lines of perspective which Kiefer inscribes here and there do little to create dynamism, or variety, or surprise. There's really next to nothing in these vast paintings. (Some of the smaller ones are more nearly credible.) This is metaphysical formalism, and I don't think the artist I went to the opening with was far from the truth when she commented that "six million Jews had to die so all these people could wear black tie." To claim for a reductive pictorial structure all the meanings that have been claimed for the Kiefers is to conflate the old formalism and the new taste for narrative in the most extreme and disastrous manner. It's fifty years ago that Clement Greenberg declared the absolute separation of high and low taste in his essay "Avant-garde and Kitsch." Now, with Kiefer, the sort of optically alluring surface that characterizes what has been called Greenbergian abstraction is joined to a voyeuristic sentimentalizing of Jewish history we'd normally expect to encounter in a TV miniseries or a trashy novel. The end result of Greenbergian taste—the heavily impastoed acrylic surfaces of Olitski and Poons—has been joined to a romantic infatuation for Nazi kitsch.

Just after I saw the Kiefer retrospective, I read *The Drowned and the Saved,* the book Primo Levi completed before his suicide in 1987. It's quite different in tone from Levi's earlier memoirs in that he has now left behind the narrative made up of anecdotes and portraits-in-miniature in favor of a severe essay style. Gone for the most part is the comfortable, consoling effect of painted scenes; here there are only a few hard facts, presented without half-

tones. It's a purified, skeletal book; and after I'd started it, I couldn't put it down, and found myself staying up late, both hands clutching the pages very tight, until I'd gotten to the end. In the closing chapter, "Letters from Germans," Levi describes some of the correspondence he received after *Survival in Auschwitz* was published in Germany. In particular, he details a long exchange of letters with a woman, Mrs. Hety S. of Wiesbaden, who came from a family of leftists, had kept clear of the Nazis, and was, as he says, of all his correspondents "the only German 'with clean credentials' and therefore not entangled with guilt feelings." In one of the letters that Levi quotes, Mrs. S. writes, "For many among us words like 'Germany' and 'Fatherland' have forever lost the meaning they once had: the concept of the 'Fatherland' has been obliterated for us." It's exactly this concept that Kiefer is trying to reinstate.

But if Kiefer's staggering success tells us something about Germany today, it may tell us even more about how desperately people in the art world want to believe that art has content, always more content, and how willing they are to believe that content exists not so much within the work as in a drama that's grafted onto the work. It's an overpowering sense that the Holocaust is the ultimate *event* of modern history that attracts artists now. (pp. 14-19)

As for Anselm Kiefer, we can say for sure that no artist has gambled more on the appeal of the Holocaust as a symbol. I would argue that Kiefer's troubles begin right there, because to treat the Holocaust as a symbol is to belittle it, to make it bearable. Maybe that's what people really like about his work. The advertisements that the Museum of Modern Art is running for the Kiefer show present him as a special case, an *interesting* case. "Something big," the headline informs us, "is happening at the Museum of Modern Art." Kiefer, we're told, "paints public memories mixed with private dreams—as he shuns the comfort of custom and fashion. Only 43 years old, he has already challenged the traditional ideas of what an artist is and does. . . . Kiefer's work demonstrates that boundaries of time and place need not be barriers to creativity." I'm not exactly clear on what this all means, except that the Modern knows it has a-hit-that's-much-more-than-an-art-show on its hands and feels no compunction about milking it for all it's worth. One thing is for sure: new-style content has never had so sweet a revenge on old-style formalism as right now, when they're hyping the Holocaust at, of all places, the Museum of Modern Art. (p. 20)

Jed Perl, "A Dissent on Kiefer," in The New Criterion, *Vol. 7, No. 4, December, 1988, pp. 14-20.*

FURTHER READING

I. Critical Studies and Reviews

Ammann, Jean-Christophe. "A Talk: Joseph Beuys, Jannis

Kounellis, Anselm Kiefer, and Enzo Cucchi." *Flash Art,* No. 128 (May/June 1986): 36-9.

Excerpt from a discussion with the artists entitled "The Cultural-Historical Tragedy of the European Continent."

Bell, Jane. "What Is German about The New German Art?" *ARTnews* 83, No. 3 (March 1984): 96-101.

Includes a brief discussion of Kiefer in the context of contemporary German art. Bell associates Kiefer's "supersensuous" artistic style with the German Romantic movement of the nineteenth century.

Fisher, Jean. "A Tale of The German and The Jew." *Artforum* XXIV, No. 1 (September 1985): 106-10.

Analyzes Kiefer's representation of both Jewish and German subjects in some paintings.

Gilmour, John C. "Original Representation and Anselm Kiefer's Postmodernism." *The Journal of Aesthetics and Art Criticism* XLVI, No. 3 (Spring 1988): 341-50.

Traces central themes in some of Kiefer's works, comparing and contrasting the artist's manner of representation with the theories of such postmodern philosophers as Jacques Derrida, Jean Baudrillard, and Frederick Jameson.

Harrison, Charles. "Importance: Kiefer and Serra at the Saatchi Collection." *Artscribe International,* No. 60 (November-December 1986): 50-5.

Review of a joint exhibition of the works of Kiefer and Richard Serra at the Saatchi Museum. Harrison suggests that Kiefer's works fail to support the narrative weight typically attached to them, while maintaining that one of the artist's most compelling and most overlooked achievements is his humor.

Januszczak, Waldemar. "Is Anselm Kiefer the New Genius of Painting? Not Quite!" *Connoisseur* 218 (May 1988): 130-35.

Evaluates Kiefer's artistic maturation, concluding that the artist's style hides more than it reveals.

Jones, Ronald. "Anselm Kiefer." *Flash Art,* 136 (October 1987): 94.

Remarks on Kiefer's *Brennstäbe,* one of two paintings in his *Isis and Osiris* series, as a reflection of "the ominous myth of our future technology."

Koether, Jutta. "Under the Influence." *Flash Art,* No. 133 (April 1987): 46-50.

Briefly describes Kiefer's work as "a monument to the German spirit, a broken one, but nevertheless a German spirit."

Kroll, Jack. "An Epic Artist of Desolation." *Newsweek* CXI, No. 3 (18 January 1988): 77.

Explores Kiefer's work, maintaining that it represents "an investigation, an indictment, an exorcism" of his German heritage.

Liss, Andrea. "Whispering Pines and Cutting Jaws: The Kiefer Symposium." *Artweek* 19, No. 30 (17 September 1988): 10.

Describes a symposium on Kiefer's works and the varied responses to his work presented by Peter Schjeldahl, Benjamin Buchloh, John Neff, and Wibke Von Bonin.

Madoff, Steven Henry. "Anselm Kiefer: A Call to Memory." *ARTnews* 86, No. 8 (October 1987): 125-30.

Records Kiefer's thoughts on many of the issues surrounding his controversial works, culled during a visit to the artist's studio.

McCloud, Mac. "The Triumph of Anselm Kiefer." *Artweek* 19, No. 27 (6 August 1988): 1, 3.

Praises Kiefer as one of his generation's leading artists, applauding in particular the moral intensity of his work.

"Anselm Kiefer Retrospective." *Museum News* 66, No. 4 (March/April 1988): 60.

Brief biographical and critical account of Kiefer's career.

Robins, Corrine. "Your Golden Hair, Margarete." *Arts Magazine* 65, No. 5 (January 1989): 73-7.

Explores Kiefer's artistic expression of his German heritage.

Schwartz, Sanford. "Anselm Kiefer, Joseph Beuys, and the Ghosts of the Fatherland." *The New Criterion* 1, No. 7 (March 1983): 1-9.

Discusses Kiefer's art and relates it to that of Kiefer's mentor and teacher Joseph Beuys.

Sherlock, Maureen. "Romancing the Apocalypse: A Futile Diversion?" *New Art Examiner* 15, No. 10 (June 1988): 24-8.

Examines the influence of Kiefer's German heritage on his artistic style, concluding that his "reappraisal of history is offered as an overcoming of the forgetfulness of the present and the restoration of a more remote but authentic past."

Taylor, Paul. "Painter of the Apocalypse." *The New York Times Magazine* (16 October 1988): 48-51, 80, 102-03.

A comprehensive analysis of key figures and events that have influenced Kiefer's artistic development.

II. Selected Sources of Reproductions

Kiefer, Anselm. *Anselm Kiefer: The High Priestess.* London: Thames and Hudson/Anthony d'Offay Gallery, 1989, 227 p.

Reproduction of Kiefer's work *The High Priestess,* which consists of approximately 200 books made of lead in two steel bookcases. Includes critical commentary by Armin Zweite.

Kiefer, Anselm. *A Book by Anselm Kiefer.* Boston: The Museum of Fine Arts/George Braziller, 1988, 96 p.

Reproduction of Kiefer's art book *Transition from Cool to Warm,* with a critical introduction by Theodore E. Stebbens, Jr. and Susan Cragg Ricci.

Rosenthal, Mark. *Anselm Kiefer.* Chicago and Philadelphia: The Art Institute of Chicago and Philadelphia Museum of Art, 1987, 172 p.

A comprehensive catalogue of Kiefer's works, accompanied by Rosenthal's critical commentary.

Sischy, Ingrid. "A Project by Anselm Kiefer." *Artforum* XIX, No. 10 (Summer 1981): 67-73.

Presents a picture construction by Kiefer which relates the epic of *Gilgamesh* through a series of photographs enhanced with paint.

Oskar Kokoschka

1886-1980

Austrian painter and graphic artist.

Kokoschka is regarded as one of the most important painters of the twentieth century. While early in his career he aligned himself for a brief period with the German Expressionist movement, he otherwise eschewed both traditional and Modernist aesthetics, seeking to express through art his own visionary concepts. Like many Expressionist painters, Kokoschka sought to produce images that transcended the purely superficial appearance of his subjects by using linear distortion and bold coloration, an approach considered particularly effective in his early portraits. At the same time, he insisted that his style remained firmly rooted in objective representation, and his vehement rejection of abstract art is viewed as a reflection of his intensely humanist ideals.

Kokoschka was born in the town of Pöchlarn, Austria, but spent most of his youth in Vienna, where his parents moved when he was three years old. After completing his primary education, he attended the Vienna School of Arts and Crafts, studying such subjects as drawing, bookbinding, lithography, and ceramics. From the beginning, Kokoschka objected to the purely decorative geometric and botanical designs emphasized in his curriculum and preferred depictions of the human figure to all other subjects. Between 1907 and 1910, Kokoschka worked as an instructor at the School of Arts and Crafts and designed postcards, fans, bookplates, and bindings for the Vienna Crafts Studio, which also published a collection of his lithographs and poems, *The Dreaming Boys,* in 1908. That same year, Kokoschka was invited to participate in the first Vienna *Kunstschau* ("art show"). The most significant of his several entries, a huge painting entitled *The Dream Bearers,* shocked the judges of the show but attracted the attention of the noted architect Adolf Loos, who also opposed the prevailing ornamental style. Loos befriended the young artist, arranging for his first portrait commissions and introducing him to prominent members of the European intelligentsia, first in Vienna and later in Switzerland and Berlin. It was in Berlin that Kokoschka came into contact with members of the German Expressionist movement, whose quest to improve the world by exposing its cruelties in their art appealed to Kokoschka. For their part, the Expressionists were greatly impressed by Kokoschka's visionary aesthetics, and his portrait style is believed to have exerted a great influence on the development of German Expressionist painting.

Returning to Vienna in 1911, Kokoschka resumed his teaching career and subsequently became involved in an affair with Alma Mahler, the widow of composer Gustav Mahler. Their brief, tumultuous relationship inspired several of Kokoschka's most renowned works, including *The Tempest* (1914), in which Mahler and the artist are depicted reclining and intertwined, adrift without a vessel on a churning sea. The affair ended shortly before the outbreak of the First World War in 1914, and soon afterward Kokoschka volunteered for military service. In September of

1915 he was severely wounded—shot in the head and bayoneted in the chest—and he spent the next several years recuperating from his injuries. Although his behavior became somewhat bizarre following this episode, earning him the nickname "The Mad Kokoschka," he nevertheless continued to produce works of a high quality, and many commentators rank his early landscapes, which were painted during this period, among his finest works.

Kokoschka spent most of the 1920s and part of the 1930s traveling throughout Europe and North Africa, painting landscapes commissioned by the German art dealer Paul Cassirer. After settling in Czechoslovakia in 1934, he continued to concentrate on landscapes, but he also painted one of his most renowned portraits, that of Czech president Tomas G. Masaryk. However, due to increasing political tensions in Central Europe, Kokoschka fled to England in 1938. In the ensuing war years, he painted landscapes of the English countryside and aided various humanitarian causes, sometimes selling his works to raise money for victims on both sides of the combat. Although his paintings had always carried a subtle didacticism, the abominations of the war led Kokoschka to view his art more than ever as a vehicle for social criticism, a convic-

tion explicitly realized in the bitterly repellent imagery of *What We Are Fighting For* (1943).

Following the war, Kokoschka moved to Switzerland, considering its neutral wartime stance the mark of an advanced and humane culture. He once again returned to teaching, establishing what he called the "School of Seeing" during the early 1950s in order to encourage young artists to reject academicism and to paint using "a direct, spontaneous approach to the world." During the final decades of his life, Kokoschka also began to paint monumental canvases based on classical themes, inspired in part by his many trips to Greece, and he continued to work energetically until his death in 1980.

Although Kokoschka's boldly expressive style has gained wide acceptance, some aspects of his work are nevertheless regarded as problematic. His early portraits are universally praised for their penetrating and skillfully realized insights into the attitudes and circumstances of their subjects, yet many critics believe that in later portraits his use of distortion became a merely formal convention, exemplifying a lack of development in his style. In addition, while his early symbolic compositions and landscapes are frequently included among his finest works, praised in particular for their exhuberant brushstrokes and vibrant colors, many critics consider this same technique ineffective in his later monumental canvases. Nevertheless, Kokoschka's successes are regarded as major landmarks in the development of twentieth-century art, and he remains one of the most widely revered of modern artists.

ARTIST'S STATEMENTS

Oskar Kokoschka with Wolfgang Fischer (interview date 1966)

[*In the following interview, Kokoschka discusses his early artistic aims and influences.*]

[Fischer]: *I should be interested if you could tell me something about the way you used colour in [your] early period. In the Wiener Werkstätte postcards, the colour lithographs for the **Dreaming Youths** and the early posters—the one you did for the 1908 Kunstschau, for example—you composed entirely in terms of flat, well-defined areas of colour. Did the Japanese woodcut or Toulouse-Lautrec have anything to do with this?*

[Kokoschka]: I can't remember being influenced by Toulouse-Lautrec, but I certainly knew Japanese woodcuts. The Vienna Crafts Museum has a splendid Asiatic section, and we art students could get to know Japanese woodcuts from the books in the large Museum Library. It's not only the sense of colour that distinguishes them, but also the economy of line and the lightning speed with which a scene is grasped and comprehended. It was perhaps because of them that when I was allowed to teach at the Art School I used groups of playing children as models instead of the sad and stiff old man who used to sit motionless in front of the students leaning on his stick. Also in

my 'School of Seeing' in Salzburg I tried to get my students to capture and retain the fleeting moment.

The colour red which I used in the **Dreaming Youths** is inextricably bound up with an experience I had in my youth. Red for me is a colour with powerful associations. At that time one of the art students was a Swedish girl who for one reason or another had taken a liking to me. She used to come to see me frequently and was sitting in the corner one day while I was drawing the dreaming youths. I found the girl very exciting. Swedish, she was blonde with blue eyes and wore a very red coat. I had never seen a red like that before. You just didn't see that sort of colour in Vienna—it wasn't a synthetic dye, but was made from plants. The Scandinavians of course have got this great tradition of dyeing and weaving. At any rate this was one of the most remarkable reds I have ever seen—this colour sent me into ecstasies—like a melody—like Mozart. The girl didn't need to do anything. Mostly she wore a thin scarf over her head so that I saw almost nothing of her face—just this apparition, this lovely apparition in the red dress. I used to dream about that red. I was so much in love with the girl that I wanted to write her a letter, but was far too shy to talk to her about it. The letter had to be illustrated of course. She drew so beautifully herself and was always giving me drawings, sweet, lovely drawings. I started on the book and showed it to the staff at the Wiener Werkstätte so that they could publish it, the lithographs with the text. My love-letter is called **The Dreaming Youths.** But then I'm afraid a painter friend of mine told me some terrible things about this girl. They were quite untrue—slander—but when you're in love you'll believe anything, and the news astounded me, worried me and made me feel quite desperate.

Does red have any other associations for you?

No. That was my first experience of colour, and perhaps it was that which brought my entire colour-sense into being. Before that I'd only made drawings. (p. 4)

The front page of the Sturm *for 14 July 1910 reproduces an illustration to your drama* Murder, The Hope of Women. *The two foreground figures look as if they're tattooed, and the three heads in the background combine front and profile views, a device which was very important for Picasso, too, and which appears in your posters of 1912 and 1923. Was there a particular source for these things?*

The tattooing, the way you describe the drawing within the contours of the figures, is easy to explain. At the première of the play—in the Vienna Kunstschau Theatre—the actors wore skin-tight, flesh-coloured costumes, and I painted nerves and veins on them in vivid colours. I wanted, in fact, to turn the figures inside out, to make the inner man visible, and did exactly the same thing in the illustrations to the play.

I am very proud of the combination of profile and full face in the three heads which you noticed on the *Sturm* front page. This juxtaposition is not a stylistic affectation, but an important contribution to the development of seeing in our century.

And about thirty years later this same device can be seen on a monumental scale in Picasso's Guernica!

Yes, you're right. But I didn't conceive this device intellec-

tually. I really saw those heads like that. Perhaps it has something to do with my gift of second sight. As you know, in my youth and long before I was wounded in the First World War, I saw myself in a kind of hallucination, stretched out and wounded, trembling in the air. Perhaps the juxtaposition in the heads has something to do with this ability—or sickness, if you want to call it that.

There is a space of five years between the illustrations for Murder, The Hope of Women (*1908*) *and the lithographs you did for* Columbus Bound *in 1913. The hard, sharp, cutting line in the earlier series gives way to a softer and more painterly technique. How did this change come about, and does the title* Columbus Bound *have a symbolic significance?*

The difference in style comes from the technique I adopted in each series. I made preparatory drawings with a very fine pen for the *Murder, The Hope of Women* illustrations, and the result was a sharp, incisive line. The contours of the figures consequently stand out against the white of the paper. In the later series I used lithographic chalks which permit a more painterly treatment of the theme. With this technique more depends on the contrasts between black and white and on the various intermediate tones which you can achieve when you work in chalk. It is possible to get the various tones between black and white even without using colour. These 'colour values' are enormously important for me, of course, for they are vital to my conception of space: the advancing and becoming clearer, the gradual disappearance, turning to yellow, turning to white. . . .

And you can achieve this without colour, precisely with black and white contrasts.

Yes exactly. It was for this reason that I took up lithography, because it permitted me to draw colourfully what *I* felt, without using colour—just with black and tonal values.

Columbus Bound is me again of course, and in this sense the title is symbolic—bound by a woman, whose features I have depicted on the title-page. My Columbus ventures out not to discover America but to recognize a woman who binds him in chains. At the end she appears to him as a love-ghost, moon woman. . . .

In 1963, in London, you told me that Busoni's pupil Leo Kestenberg had played you the Bach cantata, 'O Eternity, thou fearful word', on the piano, and that this had inspired this cycle of lithographs. The playing was the immediate stimulus, but the general significance was the battle between hope and fear, or also perhaps between male and female principle. Had you made up your mind about the theme before you heard Kestenberg play?

Not at all. The theme developed while I was working. I don't draw and paint according to a predetermined logical pattern. The very act of drawing and painting is at the same time the meaning of my work. Everything else is interpretation after the event. It was the text rather than the score of the Bach cantata which gave me my starting-point. The text suggested a certain train of thought which I then pursued quite subjectively and independently and expressed in pictures. Certainly it's hope and fear that I'm depicting, but this wasn't thought out and laid down beforehand.

Were your war experiences the inspiration for the religious lithographs of 1916, The Passion, *which later appeared in the almanack,* Der Bildermann?

No, not in the exact sense of the word, but I was horrified by that aspect of the human personality which made it possible for hundreds and thousands of men to stick bayonets into each other's bodies. I simply couldn't understand it, and this shock, this profound depression, this agony brought on by my fellow human-beings was the experience which formed the background to the *Passion*. In this deeper sense then, you can say that the various themes, the crowning with thorns, Christ on the Mount of Olives and so on, are connected with the profound shock I experienced in the First World War. (p. 5)

Wolfgang Fischer and Oskar Kokoschka, in an interview in Studio International, *Vol. 181, No. 929, January, 1971, pp. 4-5.*

Oskar Kokoschka (essay date 1983)

[*In the following essay, Kokoschka explains his approach to art.*]

I'm now fifty years old. Twenty years it took me to grow up, and I have spent thirty years trying to stay outside the very society I have observed and painted. Due to my profession, which has taught me to rely on my eyes and what they see, I have also developed the instinct to sense that exact moment when a painter might be dragged over to his subject's side. My constant subject: society.

My birthplace is Pöchlarn on the Danube, the Bechelaren of the Nibelungs, who guarded the golden treasure of the Rhine. When I was born, however, there were only depreciated bank notes in the vault. This taught me from very early on to be independent and to work for my own support.

But in the latter I was soon interrupted. I was involved in an important undertaking: together with a police prohibition against my play *Murder, Hope of Women,* I was called up for military duty during World War One. However, I didn't have the courage to shoot down a supposed enemy unknown to me. Instead, I saved the lives of some Russians by taking them as prisoners of war, and for this I was decorated. I myself received a bullet in the head and a wounded lung. Yet, I didn't feel that I had done enough for culture and so I decided to return to my previous occupation: painting.

But in my own country my painting was forbidden before the war. One gallery that had dared to exhibit my work was converted into a vegetable stand as punishment after an official inspection by the archduke. The title "bugaboo of the bourgeoisie" was gratuitously bestowed upon me.

I then relocated to Germany. Following an unexpected success, I had to go to Venice as an official representative of the new generation of German painters at the Biennale. My work was shown in the main hall. In a certain sense I was the accredited ambassador of German art. The *Berliner Tageblatt* regretted the fact that a "foreigner from Austria" should be the officially designated representative of German culture in Venice.

In 1933 my works were removed from German museums.

A certain Mr. Hinkel won his place in the history of art by referring to me as a "bolshevik of culture."

Why am I still the "bugaboo of the bourgeoisie" at the age of fifty? Was I badly brought up? Before I could read I owned the book *Orbis Sensualium Pictus* by Comenius. At an early age, therefore, I began to base my judgement on what my eyes saw instead of straining my ears and believing the platitudes of my elders. My childhood love for Comenius taught me later on to admire his life, those forty years of exile from his fatherland, during which the emperor, the pope, and the parliament continually denied him what he asked for and what he considered to be the only road to peace between nations: the establishment of a primary educational system as a protection against tyranny; the education of the people to reason based on the use of their five senses. This educational system was to be under international supervision which would take the schooling of the young out of politics because youth is not yet mature enough for it. A league of primary education of all states!

Today I propagandize the ideas of Comenius: the securing of peace through an international primary educational system. But despite this three-hundred-years-old demand, no country is willing to support these ideas, ideas that I believe have the power to protect children against the sins of their fathers. Universal peace means the unconditional implementation in school of the commandment "Thou shalt not kill."

Big industry has never given me a million-dollar check so that I could spread the pacific ideas of Comenius although the future of this industry as well as the economic prosperity in general depend on the preservation of the human race. Instead, the English journal *New Statesman* refused to publish my Geneva proposal for reform titled *International League of Primary Education.* I was disconcerted to find my proposal for reform of the traditional international education methods rejected by a reviewer who was certainly cognizant of Spencer's *Essays on Education* and who was nurtured in a nation that had introduced "common sense" into philosophy as a new unknown.

It is well known that artists are eccentrics and chase after illusions; nevertheless they preserve the faith that an idea can be stronger and more just and valuable than the material power of money. The monetary support that I have never received may curtail the propagation of my ideas, but it cannot devalue them.

Indeed, an artist has a freelance profession, and I was hungry often. It is said, however, that future generations will compensate the artist for his privations. Probably it did not depress a Rembrandt that he did not know at the beginning of the week how he was going to make it through the seven days to come. But if he were alive today, he would certainly be appalled by a society that not only demands that an artist be dead first, but also prefers a fake Rembrandt to a genuine one.

Therefore I am not ambitious that my name should be preserved by a mankind so constituted that it has to falsify ideas to make them viable. Today, in my opinion, every rational human being can quietly shut the book of history. Historians have always preferred to tell of dynasties, their battles, heroic deeds and reigns, instead of narrating cultural events; and today it is generally known that the history of our own time is subject to the laws of the stock exchange. Economics has wrapped its tentacles around the world, and some little Armenian profiteer can set the press and the state in motion in order to satisfy that great magical formula: "In time of war, business is good; in time of peace, it declines!"

While I was painting his portrait, the biologist Auguste Forel explained to me that the same irrational and relentless war of extermination found in the human community also prevails in the insect world. Forel made me almost skeptical about the human intellect: when will man, so young when compared with the oldest inhabitants of the earth, the insects, ever learn to stop hating his fellow man just because he comes from a different nation, speaks a different language, and belongs to another race?

Which contemporary artist do I prefer? Max Liebermann, the German painter who certainly did not die of old age.

How do I define art? A work of art is not an object of monetary value; it is a timid attempt by man to recreate the miracle of which every young woman is capable: to produce life from nothing. Hence, only women and artists have respect for life, and the segment of the so-called "society" that denies women the right to vote and therefore to participate, and denies artists the right to exist, does not really care for life. It oppresses humanity, and it has, directly or indirectly, a vested interest in wars. (pp. 13-15)

> *Oskar Kokoschka, "As I See Myself," in* Oskar Kokoschka, Drawings and Watercolors: The Early Years, 1906 to 1924 *by Serge Sabarsky, translated by John Van de Grift and Christa E. Hartmann, Rizzoli, 1986, pp. 13-15.*

INTRODUCTORY OVERVIEW

Richard Calvocoressi (essay date 1986)

[*In the following excerpt, Calvocoressi traces the development of Kokoschka's art.*]

The early Kokoschka, that is to say up to 1908, is best seen in the context of *Jugendstil,* a florid late-symbolist style similar to *art nouveau* which made a strong impact on the applied arts and which in painting is associated with the artists of the Vienna Secession. Like so many German and Austrian painters who were to develop in an expressionist direction, Kokoschka's background was in the applied arts. He studied at the School of Applied Arts and in 1907, while still a student, became an associate of the Wiener Werkstätte, the geometrizing design workshops run by the architect Josef Hoffmann. **The Dreaming Youths,** Kokoschka's proto-expressionist illustrated 'fairy-tale', which he dedicated to Klimt, was published by the Werkstätte in 1908. He also designed posters and postcards, and decorated fans for them. But by the summer of 1909, when he graduated from the School, his style and preoccupations had begun to shift fundamentally. Encouraged by the architect Adolf Loos, who took a paternal in-

terest in him, the twenty-three-year-old Kokoschka severed his connection with the Werkstätte and exchanged a moderately secure job in commercial art for the financially uncertain world of the portrait painter. Although his subjects were some of the leading Viennese intellectuals of the day, especially the small circle of writers and musicians around Loos and Kraus, temperamentally he had left 'Vienna 1900' far behind; and within a year he had gone to seek his fortune in the more receptive, less provincial climate of Berlin.

The *fin-de-siècle* cult of decadence scarcely affected Kokoschka, although a powerful sense of physical and mental decline is evident in a number of his early portraits. But the morbid self-consciousness and concern with adolescent eroticism typical of the more mannered art of Egon Schiele are conspicuously absent. Kokoschka let violence and sexuality emerge in his poems and plays, notably *Murderer Hope of Women,* but in the final analysis they must count as *juvenilia.* In his paintings he concentrated less on giving a literal record of his sitters than on portraying their psychological traits. Factual likeness, though not to be ignored, was subservient to capturing the emotional mood or feel of his subject. In this respect Kokoschka differs substantially from his German Expressionist contemporaries—for instance Kirchner and the artists of *die Brücke*—in whose work the portrait plays a relatively minor role. The *Brücke* insistence on pure saturated colour and spontaneous brushstroke as signifying the primitive or elemental qualities they cultivated has no parallel in Kokoschka's work of this period. Colour is severely muted in the earliest portraits, which give the curious impression of being barely painted at all. As we might expect from someone who began his career as a graphic artist, line is used to great expressive effect.

Much has been written of Kokoschka's 'X-ray eyes', his ability to penetrate the minds and even the souls of his models. Kokoschka himself once used the memorable phrase 'a psychological tin-opener' to describe his method of encouraging the sitter to move, talk, read or become absorbed in his or her thoughts, unconscious of the artist's presence, before he would start work. Most of the early portraits are half-lengths, usually stopping just below the hands, on which the artist places heavy emphasis. Fingers are shown clenched or clasped, as in the portraits of Loos and Harta; unnaturally bent or distorted; or long and sensitive as in the majority of female portraits. Sometimes the hands are outlined or stained in red, an idea developed in portraits from 1911 onwards in subtle passages of flesh and earth tones which evoke the colour and texture of putrefying meat. In the paintings of consumptives done in Switzerland in early 1910 this blood red is allowed to impregnate the face, giving ominous spots of high colour to an otherwise deathly pale complexion. Facial features may also be delineated in red, suggesting veins or blood vessels. The spectator's attention is frequently drawn to the eyes, which are often asymmetrical, with one larger than the other. Their owners occasionally look directly at the spectator but more usually gaze distractedly elsewhere, as if obsessed with their own inner selves.

Whereas Schiele's figures communicate through an exaggerated body language, Kokoschka's portraits rely on minute inflexions of face and hands for their smouldering psychological charge. Bodies are seldom contorted but remain comparatively inert. In the portrait of Lotte Franzos, for example, her body is indicated perfunctorily by a bluish aura drawn around it, while her clothes are almost completely unpainted, leaving visible large areas of ground. Such an insubstantial appearance lends a visionary quality to the image; this is intensified by the blank, anonymous background which isolates the subject even further. By contrast with their bodies, the sitters' faces and hands seem to twitch and pulsate with life. This can partly be explained by the peculiar manner in which they are painted. Kokoschka would often scratch the wet paint with the sharp end of the brush or possibly with a fingernail, producing lines of varying degrees of thinness which form a complex network of graphic signs at certain crucial points. Sometimes these lines animate the space around the figure, as in the portrait of Joseph de Montesquiou, where they perform a decorative function perfectly suited to the doll-like, effeminate appearance of the sickly aristocrat. In Kokoschka's portrait drawings of 1910, such as **Karl Kraus, Herwarth Walden** and **Paul Scheerbart,** every muscular and nervous tic is exposed on the surface of the skin, joining scars, warts, wrinkles and other external blemishes in a vibrant pattern of marks and dots made with the pen, the equivalent of the brush handle or fingernail.

The paint texture of several early oils is thin and dry, with a rubbed or scraped quality that implies the use of the hands or a cloth. The effect of this flatness and lack of modelling is to convey an eerie sense of immediacy, as if a photographic negative or X-ray of the model had been imprinted on the canvas. A handful of pictures, such as the brightly coloured **Still-Life with Pineapple** 1909, and the portraits of Loos, Harta and **Father Hirsch,** employ thicker, oilier conglomerations of paint and a more energetic brushstroke, suggesting the influence of van Gogh, whose work Kokoschka first saw at the international *Kunstschau* in Vienna in the early summer of 1909. Kokoschka's portraits share with van Gogh's certain obvious characteristics, including a preference for half- or three-quarter-lengths seated against stark backgrounds and depicted full-face or half-turned; and a prominence given to the hands, which are shown either tense and gesticulating, resting on a table or the back of a chair, folded together, or holding an object such as a book. But above all it is the humanity and nervous intensity of van Gogh's images which Kokoschka transposes into his own, idiosyncratic idiom. Whether he also knew van Gogh's ink drawings, with their hatchings, loops, whorls and other rapid calligraphic strokes, is not recorded; but it seems likely in view of the foregoing. (pp. 9-10)

It has been remarked that 'the artist is always tempted to invest his models with his own psycho-physical qualities.' Kokoschka was no exception; in later years especially he would project his long upper lip and pugnacious chin on to the faces of his sitters, male or female, so that in extreme cases the finished result is closer to self-portraiture. The notion of empathy is crucial to an understanding of Kokoschka's sensibility: 'I cannot paint everybody. It is only people who are on my antennae . . . certain people whom I discovered an affinity with—with one facet of my own being.' This may explain why, in the early portraits, we are rarely given any clues as to the social status, profession or interests of the person depicted. . . .

During 1911 a change gradually came over Kokoschka's painting, probably as a result of his recent contacts with the more cosmopolitan art world in Berlin, where he had lived for much of the previous year, helping Herwarth Walden on his Expressionist periodical *Der Sturm.* The change is noticeable in works of different types. In portraiture, the subject is rendered with greater plasticity, almost equal attention being paid to the body as to the face and hands. Gone are the etiolated, semi-transparent forms of 1909-10, to be replaced by emphatically modelled volumes and a more mature sense of the possibilities of colour and brushwork. New structural concerns are evident in the series of paintings on biblical themes, in which the figures are integrated with their environment by a dense all-over faceting. This softening of outline, which can likewise be seen in the portrait of Egon Wellesz, is a striking departure from Kokoschka's earlier employment of a sharp contour to define physical mass. It recalls Cubism, as, too, does the general opacity of the 1911 pictures. In 1912, however, Kokoschka broke through to a sparkling translucency in paintings such as **Two Nudes; Alpine Landscape, Mürren** and the portrait of Alma Mahler. The pastel colours, particularly pink, blue, green and yellow, and the fragmented, crystalline structure of these works suggest the influence of a Cubist offshoot such as Robert Delaunay. In **Two Nudes,** an odd transitional picture in which the figures are not very satisfactorily opened up into surrounding space, Kokoschka seems to be attempting to express movement of a kind. (p. 11)

The great symbolic compositions of 1913-14, in which Kokoschka either celebrates his love for Alma Mahler, reflects on its problems, or foretells the end of the relationship, demonstrate a freer technique and an awareness of light as a means of enlivening surface and denoting depth. Paint is generally creamier and applied in broad, fluid strokes. Colour, though often restricted to a sombre range of blue and green or brown and grey tones, is rich and sensuous, while forms are highlighted with bold touches of white, sometimes flecked with red, causing the image to quiver before our eyes. The predominant effect is one of restless, dynamic movement. Furthermore, **Still-Life with Putto and Rabbit** and **Knight Errant,** despite their iconographic complexity, are self-allegories of haunting power: not until the Second World War would Kokoschka be roused to produce works of equal emotional intensity.

In January 1915, five months after the outbreak of war, Kokoschka volunteered for a cavalry regiment in the Austro-Hungarian army. Eight months later he was badly injured in the head and the lung during a skirmish with Russians on the eastern front. At the end of October he was brought back to Vienna, where he remained in hospital until February 1916 and where he convalesced for a further three months. The portrait of Heinrich von Neumann, the doctor treating him, dates from this time. In July Kokoschka was posted south to the Italian front to serve as an officer responsible for looking after war artists and journalists. In late August he developed shell-shock and was transferred once again to a military hospital in Vienna. A week later he was released and given extended sick leave by the army.

By the end of the year, after a brief stay in Berlin, Kokoschka had been admitted to a sanatorium in the rural Weisser Hirsch district of Dresden. Here, at a nearby inn,

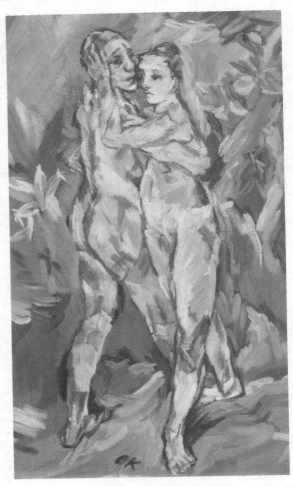

Two Nudes (The Lovers) (1913)

he met a handful of pacifists, most of them Expressionist actors, playwrights or poets, who became his companions and whom he used as models in two symbolic group portraits, **The Exiles** 1916-17 and **The Friends** 1917-18. Other paintings of this period, such as **Lovers with Cat** and **Portrait of the Artist's Mother** 1917, demonstrate a feverishness in execution which may reflect the artist's precarious state of health. Scarred both physically and psychologically by his wartime experiences, Kokoschka was further depressed by the break-up of his affair with Alma Mahler. The trend towards greater naturalism discernible in the portraits of 1911-14 is now reversed. Paint is worked into a thick impasto by means of writhing, organic brushstrokes, so that at certain points the forms appear to loosen and even dissolve altogether. (p. 12)

If the paintings of 1917 present a degree of formal incoherence, those of 1918-19 onwards, beginning with **The Power of Music,** seem by comparison more compact and resolved. In terms of colour they relate to German Expressionism, for instance Nolde and some of the artists of the *Brücke,* whose work Kokoschka knew from his association with Herwarth Walden in Berlin before the war. The composition is now disposed in irregularly shaped smears and patches of pure unmixed colour—usually green and the primaries, especially red—which are not divided by

contour lines but which abut one another directly. The effect is of a dazzling radiance akin to stained glass. Kokoschka himself was the first to recognize the monumental possibilities of his new language of colour. He had in fact been commissioned by the architect Max Berg to paint frescoes for a crematorium at Breslau shortly before the First World War; and, although the project was never realized, he remained interested in the problems of creating a cycle of large-scale images intended to be seen from a distance.

The Power of Music; Mother and Child and *The Slave Girl* are double-figure compositions with both sensual and violent overtones, suggesting that pathos and brooding introspection were still important elements in Kokoschka's work. The series of Dresden townscapes, however, strikes a lighter, more optimistic note. In the summer of 1919 Kokoschka was appointed to a professorship at the Dresden Academy, a job he had coveted ever since arriving in the city over two years previously. He moved into his studio in the academy, which overlooked the Elbe, in the autumn, and from its balcony painted the first of several views across the wide river with its elegant bridges. The baroque houses and spires huddled together on the opposite bank are translated by Kokoschka into a jostling patchwork of small planes and strips of colour. In one picture of the series, *Dresden, the Elbe Bridges (with figure from behind)* 1923, the silhouette of his own head and shoulders dominates the foreground, turned away from the spectator in contemplation of the scene, while a yellow tram crosses the nearest bridge beneath which a barge floats silently by. Such details look forward to those atmospheric panoramas in which he would brilliantly convey the very essence of London, Prague and other centres of European culture and history which meant so much to him. (p. 13)

A summary of Kokoschka's movements between August 1923, when he left Dresden, and September 1930, when he came to roost in Paris, gives some idea of his astonishing energy and intense curiosity for new sights. During those seven years—that is, between the ages of thirty-seven and forty-four—he visited eleven different European countries (including Ireland and Scotland) and explored much of North Africa and the Middle East. His travels began in earnest in February 1925, when his agent, the famous Berlin art dealer Paul Cassirer, agreed to subsidize his trips on a generous scale in exchange for a regular supply of landscapes. . . .

The dating of the so-called 'travel pictures' has been made easier by the survival of a succession of illustrated post-cards which Kokoschka sent to his family in Vienna and to other friends, sometimes at the rate of two or three a week. On the back of these cards he would invariably give a brief account of his progress, noting the start or completion of a painting, the state of the weather, his future plans and so on. In the case of the three Scottish landscapes of summer 1929 (*Scotland, Dulsie Bridge; Scotland, Plodda Falls* and *Junction of the Divie and Findhorn Rivers*), he sent back picture post-cards showing the actual motif of each: whether the purchase of a particularly striking or attractive photograph inspired him to go and search out the original must remain a matter for conjecture. (p. 14)

Whenever he could, Kokoschka preferred to look down on his motif from a high viewpoint, climbing to the top of a hill or the tenth floor of a building in order to achieve maximum breadth and distance. He also adopted the unusual technique of painting the same picture from two different standpoints, so that, as he later recalled, 'I doubled the width of my visual field'. This double perspective accounts for the slightly spherical composition of many of his townscapes, similar to a wide-angle photograph, as well as the sense of a spinning motion that inhibits the eye from fixing on a single focal point and which gives equal significance to what happens at the periphery of vision. In short, they are at their best paintings which capture the very feel of life itself; even Kokoschka's buildings, it has been said, seem to 'grow, move and breathe'.

In these paintings of the twenties Kokoschka fully lived up to the promise he had already shown as a landscape artist in *Les Dents du Midi* of 1910, which so convincingly reproduces the invigorating sight of an ethereal alpine landscape under snow. In that work the sun is shown breaking through mist or cloud, a typically baroque effect which Kokoschka repeated in the twenties and which he continued to use up until the last landscapes of the 1960s, though his manner of suggesting light became more summary, almost ideographic. But the similarities with the earlier picture end there. To suit his new habit of painting in the open air or from hotel balconies, Kokoschka evolved a style radically different even from the works of the immediately preceding Dresden phase. In the latter, the spectator is made conscious of paint as *material,* as if it were a substance like clay which the artist has worried and moulded into thick slabs; colour breaks free from its descriptive function and assumes an autonomous role. If we compare this approach with a painting such as *London, Tower Bridge* 1925, or *The Coast at Dover,* we notice both a stronger degree of objectivity in response to the subject matter and a corresponding relaxation in pictorial terms. (pp. 14-15)

Despite his preoccupation with landscape in the twenties, Kokoschka did not neglect portraiture, but continued to produce good work. While staying with his family in Vienna he took the opportunity to paint his old friends Arnold Schoenberg, in 1924, and Karl Kraus in 1925. Nothing is allowed to detract in either portrait from the image of the sensitive artist concentrating on his particular task—Schoenberg playing the cello, Kraus fingering a book with one hand and gesturing with the other, as if reciting. Fine examples of expressionist portraiture though they undoubtedly are, they nevertheless typify the same systematic, less intuitive approach to subject matter that characterizes Kokoschka's townscapes and landscapes. This becomes more evident later in the decade, with the portraits of Elza Temary, the Marabout of Temacine and Marczell von Nemeš, in each of which the figure is drawn in greater volume and depth than hitherto and occupies more of the canvas. If the degree of paraphrase is minimal in comparison with the 'psychological' portraits of 1909-11, it is made up for by the massiveness of the subject, whose physical presence seems all the more palpably real. As if to balance this naturalistic treatment of the human figure, Kokoschka introduces a narrative element, for example in the portrait of Adèle Astaire, where background objects or symbols allude to the interests and profession, and by implication the personality, of the sitter. Over the next twenty years Kokoschka would increasingly resort to this tra-

ditional device, sometimes including a complete scene in the background. (p. 16)

For the first nine months of 1931 Kokoschka lived in Paris, a city whose reputation as the European capital of fine art he regarded with suspicion, if not disdain. Years later at Salzburg he would warn his students of the corrupting influence of the 'beauty industry', as he dubbed the School of Paris. In March 1931, however, Paris did Kokoschka the peculiar honour of a one-man exhibition at the Galeries Georges Petit, which was actually a reduced version of his retrospective held at Mannheim earlier in the year. It was surprisingly well received, and for a while it must have looked to Kokoschka that he was poised on the brink of international acclaim. Simultaneously with the exhibition at Petit's, the Museum of Modern Art in New York organized a large survey of *German Painting and Sculpture,* in which Kokoschka was represented by four oils, including **Woman with a Parrot** 1916 and **Girl with Doll.**

In Paris Kokoschka rented a studio above Augustus John, who later did much to help Austrian and German artists find refuge from the Nazis in England. In the summer Kokoschka took over the house and studio of his friend the painter Jules Pascin, who had committed suicide. He also met and was photographed by Brassaï. But in September 1931, his contract with Cassirer's having collapsed some months previously, he was forced for financial reasons to return once more to Vienna. He spent a further year in Paris, from March 1932 to May 1933, during which time he painted **Self-Portrait with Cap** and a number of other works. It was in Vienna, however, that his art discovered a new sense of purpose, which grew stronger as the decade progressed inexorably towards its dreadful conclusion.

In 1920 Kokoschka had managed to buy his parents a villa in the Liebhartstal, a pleasant district on the western outskirts of Vienna consisting of mainly wooden houses, surrounded by gardens, orchards and avenues of chestnut trees. It was to this peaceful environment that Kokoschka repaired in the autumn of 1931, in time for his mother's seventieth birthday (his father had died in 1923). Refreshed and stimulated by his surroundings, he made friends with a fifteen-year-old girl, the daughter of a neighbour, who agreed to pose for him. In all, some twenty drawings and half dozen paintings of Trudl exist, showing her in a variety of roles and moods. In their heavy, rounded forms and air of classical repose, these pictures are the direct antithesis of the portraits of highly strung individuals whose psyches he had probed, with an astonishing indifference to matters of technical skill, over twenty years earlier. If nothing else, a work such as **Trudl with Head of Athena** 1931, with its range of sensuous reds, is a splendidly bravura piece of painting.

Chance played its part in turning Kokoschka's attention again to questions of content. Shortly after his arrival he was commissioned by the socialist council of 'Red Vienna' to paint a picture for a prominent place in the Town Hall. For a suitable theme he looked no further than his immediate neighbourhood. The Liebhartstal lies between two hills, the Galitzinberg and the Wilhelminenberg. Five minutes walk uphill from the Kokoschkas' house stood Schloss Wilhelminenberg, a former imperial palace which had been expropriated by the authorities and converted into an orphanage. Kokoschka was moved and encour-

aged by this development and, as he could hear and see the children from his second-floor studio window playing in the palace grounds, he decided to paint them.

Vienna, View from the Wilhelminenberg is a townscape with a difference. Although the background affords a panoramic view of the whole city, in which distant landmarks such as the spire of the nineteenth-century gothic Town Hall are clearly visible, the focus of the composition rests in the foreground activity. In the park beneath the palace little knots and clusters of children are shown playing specific games. Kokoschka based this idea on a famous painting by Brueghel in the Kunsthistoriches Museum. Somehow he must have connected it in his mind with his hero [seventeenth-century theologian and pedagogue Jan Amos] Comenius and the latter's ideal (as Kokoschka himself later put it) of 'the education of people to reason on the basis of using their five senses', since each of the children's games in the picture—blind man's buff, ring-a-ring-a-roses and so on—involves the use of a different sense. Kokoschka argued that received opinion, second-hand knowledge, hearsay, or whatever we like to call it, was largely responsible for society's ills. To support his case he quoted St Thomas Aquinas: 'The senses are a kind of reason. Taste, touch and smell, hearing and seeing, are not merely a means to sensation, enjoyable or otherwise, but they are also a means to knowledge—and are, indeed, your only actual means to knowledge . . .' This may explain why, after the war, he called his course at Salzburg the School of Seeing.

Wilhelminenberg, then, is a symbolical painting. Given the high value Kokoschka attached to a supra-national constructive education, as opposed to military or nationalistic indoctrination, it is not difficult to understand why he later referred to it as his 'first picture with a political meaning'.

Kokoschka's mother died in July 1934. Two months later, finding the political developments in Austria intolerable and disappointed by the lack of portrait commissions, Kokoschka departed for Prague. (pp. 17-18)

It was in Prague that Kokoschka met Olda Palkovská, a young law student who was soon sharing his eccentric life and who later proved indispensable in helping the artist leave Czechoslovakia.

The two masterpieces of Kokoschka's Prague period, the first of which can be read as a political testimony, are the portrait of Thomas G. Masaryk and the ironically titled **Portrait of a 'Degenerate Artist'** 1937. The permission to paint the first President of the Czechoslovak Republic may have arrived before Kokoschka left Vienna. He instinctively warmed to this eighty-five-year-old democrat; their conversations ranged widely but tended to concentrate on Masaryk's humane educational policies, which coincided with and reinforced Kokoschka's own half-formulated ideas. Their mutual admiration for Comenius was a frequent topic of discussion. In the portrait, Kokoschka explicitly links Masaryk with Comenius, who is shown by the President's side holding up a tract, his *Via Lucis,* on which are illustrated the five sensory organs. Three months after starting work on the portrait Kokoschka said in an interview:

. . . According to Comenius it is easier to teach by means of pictures than by means of words; and so

a modern, symbolic portrait like this should serve to be instructive . . . Neither cape nor crown, neither sceptre nor sword, denote this President's status . . . I want to make it a historical picture; a picture that can be shown in schools, to teach the children that patriotic tasks, as well as personal duties are united in humanism.

The ***Portrait of a 'Degenerate Artist',*** even more than the portrait of Masaryk, concludes the switch to a monumental plastic style first intimated in Kokoschka's paintings of the mid-twenties but not fully evolved until the *Trudl* series. Not the least remarkable aspect of this searching self-portrait is Kokoschka's brushwork, the superficial untidiness and spontaneity of which conceals a deft, assured touch which unites all the disparate elements of form, colour and tone into a resonant whole. (p. 18)

In October 1938, less than three weeks after the Munich agreement which sealed the fate of that 'far-away country' Czechoslovakia, Kokoschka and Olda Palkovská managed to fly to London. Kokoschka entered the country on a Czech passport, Masaryk having helped him apply for Czech citizenship in 1935—a step which was later to prove beneficial to the artist. In the panic of summer 1940, after the fall of France, thousands of German and Austrian refugees were classified by Parliament as 'enemy aliens' and interned. Czechs, on the other hand, were deemed to be 'friendly aliens', with a government in exile in London headed by Edvard Beneš; and although their movements about Britain were restricted, they were otherwise more or less left in peace. (p. 19)

A few weeks before the outbreak of war Kokoschka and Olda Palkovská left London, which was becoming too expensive for them, and went to live in the picturesque fishing village of Polperro on the southern coast of Cornwall, where the sculptor Uli Nimptsch and his family had settled. In a letter to the painter Hilde Goldschmidt Kokoschka described Polperro as a 'beautiful, healthy place . . . much lovelier than a cosy little Italian port because so much more real' (*viel echter*). His opinion was evidently not shared by the writer Rayner Heppenstall, who recounts a visit to Kokoschka in his autobiographical novel *Saturnine* (1943), the dustjacket of which Kokoschka illustrated.

Never had I seen a place so female, so closely shut in as this inhabited cleft between two plump hills, opening out at the front into a harbour over which one felt that hands were crossed in modesty. As a place to inhabit in the ordinary way, it was horrible.

I bore left along the crease between the right buttock and thigh, a little above the level at which this mighty, inverted limb plunges into the water.

However ironical, the author succeeds in this extract in catching the intrinsically dramatic quality of the Polperro landscape, which alters with every step, revealing a succession of new shapes and vistas, both natural and man-made but all worn by centuries of fierce storms. Some of Kokoschka's finest wartime landscapes are in fact views of small fishing ports on the Atlantic coast of Britain. In addition to the series of Polperro oils and watercolours, which were painted from the terrace of his cottage, he made coloured pencil sketches of Nevin in North Wales, Port William in south-west Scotland, and the less enclosed

harbour of Ullapool on the north-west Scottish coast, where he also painted the oil ***Ullapool.*** Heppenstall's landscape-body analogy is not inappropriate to Kokoschka's work. While his cityscapes have been likened to living human profiles marked by time, so his landscapes occasionally seem to suggest an anthropomorphic element. Kokoschka himself wrote in his autobiography that 'All landscapes are given their shape by man; without a human vision no one can know what the world really is'.

By the summer of 1940 it was no longer permitted to foreigners, friendly or otherwise, to remain in coastal areas, especially if they were close to important naval bases (Polperro is near Plymouth). Regulations had already come into force about photographing, sketching or painting sites designated as 'restricted', for which a written permit had to be obtained from the highest authority. In retrospect we may be grateful for these restrictions, since they forced Kokoschka to turn his mind to a medium, watercolour, which he had hardly touched since the 1920s. Back in London in September 1940, with the Blitz just beginning, he produced the first of many fresh and delicate still-lifes of cut flowers, thereby maintaining a symbolic link with nature until he was able once again to go out into the real landscape. (pp. 19-20)

In London, much of Kokoschka's time was taken up with political activity, making speeches, writing articles for anti-Nazi refugee newspapers, and helping to raise funds. His abhorrence of nationalism, coupled with his own unique personal history—born an Austrian, regarded by many as a major German artist, but holding Czech citizenship—made him the ideal figure to bestride the various refugee political organizations, who tended to keep to themselves when they did not openly squabble. . . . In 1946 he was still trying to raise money for humanitarian causes—in this case 'for the Viennese children who are starving'. In an open letter to the critic Alfred Neumayer published in the American *Magazine of Art,* he declared his intention to find £1,000 in the U.S.A.

for a political painting I did in 1943, with the title: ***What We Are Fighting For.*** It is a large and striking work. If you know somebody or some institution interested in it I would like to send you a photograph of it . . .

What We Are Fighting For was actually the last, and certainly the most sardonic, in a series of five pictures attacking the war and the conduct of both axis and allied powers, which Kokoschka painted between 1940 and 1943. The experience of meeting and painting Masaryk in Prague had deepened and enriched Kokoschka's art to a degree that became explicit only now, when he felt an even stronger urge to clarify his intellectual and moral position. He resorted once again to a kind of baroque allegory, but he also drew on a specifically English tradition, that of political caricature, with its crowded figure compositions, discrepancies of scale, violent and grotesque imagery, animal and food symbolism, use of inscriptions and so on. Robert Radford has suggested that Kokoschka may have based ***The Red Egg*** on Gillray's satire *The Plumb-Pudding in Danger* 1805, which shows Pitt and Napoleon greedily carving up the globe. (pp. 20-1)

The sarcastic political allegories represent a brief but intense phase in which Kokoschka perceived his art as having a didactic function. At one point in 1941 he was anx-

ious to produce **The Red Egg** in poster form, as emerges from a letter to Michael Croft.

> Some friends of mine help together so that I can now print my Mussolini-Hitler caricature 'Appeasement' in colours and original size . . . And I will be the first one to have started a Red-cross help for it [the Red Army] in selling my print for the benefit of the fighters.

How effective **The Red Egg** would have looked translated into the flatter medium of lithography is open to doubt. Kokoschka's agitated brushwork, which vitalizes the image and conveys the artist's strength of emotion, would certainly have suffered; and the clashing, high-key colours, so finely judged in the original, might have seemed cheap and vulgar. But Kokoschka clearly wanted to reach a wider public. His chance came in 1945, when he found the money to print his drawing of a baroque Christ, based on a statue on the Charles Bridge by Matthias Braun, leaning down from the cross to comfort a group of children. Along the crossbeam are inscribed the words 'IN MEMORY of the CHILDREN of EUROPE WHO HAVE to DIE OF COLD and HUNGER this XMAS.' Over a thousand (some say as many as 5,000) copies of this simple, moving image were put up in the London Underground and on the buses in December 1945. At an earlier stage Kokoschka seems to have been under the impression that it would be 'posted everywhere in England by the Church'. For the artist, the significance of the poster lay in the fact that, as he wrote to Emil Korner, 'there is no organization, nor Party, nor collect mentioned'. His art never descended to the level of ideological propaganda.

The loose, nervous handling of the political paintings is also apparent in the few portraits Kokoschka painted at this time, among which those of the young Michael Croft, his sister Rosemary and Lady Drogheda are outstanding. In the two Croft pictures Kokoschka paints skin almost as if it were raw flesh, anticipating his own searing self-portrait of 1948 and the even more livid complexions of some later subjects. (p. 21)

Although the Kokoschkas did not finally settle at Villeneuve, on the eastern shore of Lake Geneva, until September 1953, from the spring of 1947, when Oskar's first post-war retrospective opened at Basel, they were almost continually on the move throughout continental Europe. In 1949 Kokoschka flew to the U.S.A. for the first time, to see the big travelling exhibition of his work there and also to teach at the Tanglewood Summer School near Boston, which in retrospect can be seen as the prototype of his School of Seeing at Salzburg.

As the war neared its end, Kokoschka's mood, instead of growing more optimistic, had darkened. He and Olda were concerned about the fate of their relations in Vienna and Prague, of whom there was no news. When word finally arrived, it was not promising: 'Prague is very bare of all food and clothing'; 'Vienna . . . seems to be worse off than any other part of the continent, no food at all and no contact possible'. Their energies were devoted to writing, making enquiries and sending parcels of food, medicine and clothing by circuitous routes. (p. 22)

However, the exhibition at Basel in 1947 marked a turning-point. Its huge success gave Kokoschka back his 'joie de vivre, faith in humanity, and hope for the future',

as he told his sister. Kokoschka was now sixty-one and had just become a British subject. Over the remaining twenty-five years or so of his creative life he emerged as a public figure—to some a prophet—who spoke out against the dehumanizing effect of mass society wherever he detected it, in art as much as politics. Social engineering, belief in technological progress and, not least, standardized patterns of thought were evils which would lead to the 'suicide of society'. At Salzburg where he taught every summer from 1953 to 1963 he was at last able to put his anti-rationalist philosophy of learning through seeing—his language of the eye—to the test. Confronted by the rising tide of what he pointedly referred to as 'non-objective' art, he alone reiterated the importance of content and of the dynamic representation of space and light in painting. Respect for tradition, for the inheritance of Greece and Rome, became an integral part of his credo. In the great monumental works of the early 1950s, **The Prometheus Saga** and **Thermopylae** triptychs, he understood his mission as one of defending the artistic tradition of Europe.

Kokoschka continued to paint portraits. Beginning in 1949 with Theodor Körner, Mayor of Vienna and later President of Austria, his subjects included many of the architects of post-war European reconstruction. His townscapes became ever more atmospheric and broken in style, the best of them, such as **Berlin, 13 August 1966** and **New York,** evoking a cosmic or apocalyptic dimension. As its relationship to ecstatic baroque rhythms grew more explicit, the visionary power of Kokoschka's painting intensified. In December 1953, shortly before starting work on the **Thermopylae** triptych, he advised [his pupil] Philip Moysey to copy Rubens's *The Judgement of Paris* in the National Gallery, London.

> You ought to learn about the different ways of his wonderful brush, how he paints light, skin, complexion, the grey half-tones beneath the overlaying lustre and last touches. Sometimes he started with a tempera-white design, always used a reddish flesh-tone background, different layers, which you only can see, adore and get drunken with . . . when you are trying to copy it.

In their robustness and vitality, the pictures on classical and mythological themes, such as **Herodotus** or the massive **Theseus and Antiope,** rank with the grandest and most ambitious of Kokoschka's earlier works. The bright, powdery colours (especially scarlet and yellow), the vigorous and direct paint handling, and, after he had passed his eightieth birthday, the poignant, self-mocking images of the artist as an old man—all the hallmarks of a distinctive late style are present, comparable to Picasso's in its freedom and reckless disregard of academic norms.

Interviewing Kokoschka at the time of his Tate Gallery retrospective in 1962, Andrew Forge put it to the artist that 'the total sum of your work is like a painting of the whole world, as though you had tried to embrace the whole world, its cities, its people, its condition'. The key to Kokoschka's *Weltanschauung* is best provided by those who sat to him or were taught by him. Gitta Wallerstein recalled that 'While he was working he was a lover towards his subject—both men and women . . .' Philip Moysey and Ishbel McWhirter both remember him as an intuitive teacher who recommended them to ignore irrele-

vant prosaic detail and concentrate on the essentials of a person or scene. 'You have eyes, use them, love what you see', he told Moysey. The word 'love' also occurs in Kokoschka's letters to McWhirter.

> My advice is to portray as sincerely and well [as] you can do it—again and again! It will ease the tension and make you more human as an artist because love is the best teacher.

It may sound trite or sentimental to talk about an artist's compassion, but there is no doubt that emotion, and not intellectual theory, was the basis of Kokoschka's teaching as it was of his art. His interest in children was informed by precisely similar feelings. As a student at the School of Applied Arts in Vienna he had fallen under the spell of the remarkable Franz Cizek, the pioneer of children's art education, who encouraged his classes to draw freely from their imagination as opposed to making sterile academic copies. Cizek was one of the first to take child art seriously; a room of his pupils' work was included in the 1908 *Kunstschau,* at which Kokoschka exhibited his illustrated 'fairy-tale' **The Dreaming Youths.** When Kokoschka was employed as a drawing master at Eugenie Schwarzwald's progressive school in 1911-12, he adopted Cizek's methods. His reading of Comenius, as we have seen, convinced him of the necessity of allowing a child to develop naturally through first-hand experience of the world, helped by pictures, demonstrations, games and other visual and practical aids. In London during the war Kokoschka opened two exhibitions of children's art, at which he outlined the educational ideas of both Cizek and Comenius. The second of these, *The War as Seen by Children,* was organized by the Refugee Children's Evacuation Fund, of which the educationalist A. S. Neill was a patron. Drawings by Neill's pupils at Summerhill were exhibited at the Arcade Gallery in London in 1944; and in April 1945 Kokoschka spent three weeks at another famous progressive school, Dartington Hall in Devon.

The School of Seeing, in other words, was the culmination of a lifelong concern with the true purpose and value of education. In 1941 Kokoschka wrote that 'The main task of democracy is to realize the universal debt of the old men to the youth of the world'. At the School of Seeing he discharged that debt and inspired a whole generation. (pp. 22-3)

Richard Calvocoressi, in an introduction to Oskar Kokoschka: 1886-1980, *The Solomon R. Guggenheim Foundation, 1986, pp. 9-23.*

SURVEY OF CRITICISM

Herbert Read (essay date 1947)

[*A prominent English novelist, poet, and art historian, Read was best known as an outspoken champion of avant-garde art. Several convictions are central to his aesthetic stance, the foremost being his belief that art is a seminal force in human development and that a per-fect society would be one in which work and art are united. Read presented his theories in numerous highly regarded studies, including* The Meaning of Art *(1931),* Education through Art *(1943),* Icon and Idea *(1958), and* The Forms of Things Unknown *(1960). In the following excerpt, he praises the transcendent vision of reality presented in Kokoschka's works.*]

Though he is undoubtedly one of the major artists of our time, the work of Oskar Kokoschka is not so well known in the United Kingdom and America as it should be. It is true that the Museum of Modern Art in New York has two superb paintings in its permanent collection, and most of the important art galleries in the U.S.A. possess one or more examples of his work. In England, the Tate Gallery has a portrait and a landscape, and there is a single example of his work in the National Gallery of Scotland. But in all these places considerably more space is given to artists of considerably less stature.

In a world of competing interests, of conflicting nationalisms, of the increasing commercialisation of art, the fame of any one particular artist is a counter, thrown into the game of wits. A poet is good if he sings the praises of the dominant party leader; a painter is good if he depicts the inevitable progress of the working-classes or flatters the vanity of the rich; and poet and painter sink or swim with the political fortunes of the country where they happen to be domiciled. If the country is a stable one, it may still be a question of the relative value of its exchange rate: for art is an export of potential value. The dealer plays a part, the press plays a part. What seldom gets a chance, in this sordid trafficking, is the unprejudiced sensibility of the people—of those people who can respond to the appeal of a work of art without the stimulus of fashion or fortune.

But even supposing we were back in a state of such innocency, and art was to be enjoyed for itself alone, it is idle to pretend that the work of Kokoschka would everywhere have an immediate appeal for the unsophisticated. That work does undoubtedly meet with uninstigated resistance in some quarters, and particularly in England. We feel abashed by such relentless realism. Even if we are not sentimentalists, we shrink from the exposure of nerves—our own nerves no less than the twitching nerves of the painter's victim. It is for this reason that a critic so typically English as Roger Fry could not wholly accept Rembrandt—or Picasso. It is a Quakerish restraint in us. But then, we are not consistent. We accept El Greco, in spite of the quivering limbs, the distorted features, the fingers pointed with agony. We accept El Greco partly because we have been told to accept him by the critics, partly because his mysticism and masochism are expressed in Christian symbols. But there is no artist of the present time so near to El Greco as Kokoschka. I am not saying that the styles are related—stylistic comparisons are not part of my present purpose. It is the ideals that are related. Once we have discounted the symbols, which are useful conventions to which an artist may be driven by the circumstances of his time—then it is the essential humanism of the two artists which brings them together: they are both artists of love, of suffering, and of redemption.

Love is, of course, a soiled word. In Kokoschka it is instinctive identity; identity with the colour of the flower, the iridescences of fish scales and shells, the fluctuation of light over hills, or its splendour as it strikes the massed

roofs of some city. It is the plastic artist's peculiar power of translating his sensations into living forms, and that power is effective in the degree that the love of the objects which arouse the sensations is pure and intense. There is no pride in such love, no judgement. The flayed carcass belongs to the same order of existence as the flower. But beyond love is suffering, and it is that perception which makes Kokoschka an exceptional artist in our age. His portraits reveal the mute suffering of the individual, of the person crucified on the codes of false social values. A few larger symbolic paintings resort to symbolism, not Greco's symbolism, but rather Goya's, to depict the suffering of oppressed peoples, the tortures of war.

And then beyond is the note of redemption. In this case it is not the divine redemption of the Christian religion, but a human redemption which Kokoschka takes over from his master and countryman, Comenius—redemption by education, by creative activity, by art. This theme is not, of course, explicit in Kokoschka's paintings. But it is the practical aspect of his humanism. It is implied in the love of man and in the belief that man can participate, through art, through creative activity, in the world of objective beauty—can become a part of that universal harmony which the great artist sees so clearly revealed in the world of objective fact. (pp. 7-8)

> *Herbert Read, in a foreword to* Kokoschka: Life and Work *by Edith Hoffman, Faber & Faber Limited, 1947, pp. 7-8.*

J. P. Hodin (essay date 1958)

[*Hodin is a Czech-born critic and the author of numerous studies of modern art, including a biography of Kokoschka and several studies of his work. In the following excerpt, Hodin offers an appreciative overview of Kokoschka's works.*]

The Vienna of the early years of this century was a very conservative city. It regarded even the rhetorical and decorative painting of Klimt with greatest disfavour. Hating Klimt and his 'Secessionist' followers, it had nothing but hostility for the youthful mural designs (*The Dreamborne*) of the young unknown Kokoschka of 1907. His was an experience similar to that of the young Cézanne when the latter exhibited with the Impressionists. He was howled down as a Communard. Kokoschka on this occasion lost his position as teacher of drawing at the School of Arts and Crafts, at which he himself had been a student, and soon afterwards he went to Berlin where a more friendly reception awaited his art. But his love-hatred for Vienna dates from the time of that exile.

Two years earlier, i.e. in 1908 Kokoschka had exhibited at the Kunstschau, among other things, a brightly coloured clay bust, pastels and drawings, decorative panels done on packing paper, and—postcards; and on that occasion Adolf Loos, the pioneer of modern architecture in Middle Europe, recognized in the young artist an exceptional talent, for whose development another and better way should be devised than that offered by membership of the 'Wiener Werkstätten', at that time becoming known for its well designed utility products. It was because of his recognition of Kokoschka's outstanding talent, and also because of his contempt for petit bourgeois concern with

the arts and crafts (a contempt which he shared with Le Corbusier) that Loos actively furthered Kokoschka's breaking away from this group.

From the moment of that severance began the development of an artist who will undoubtedly go down in the history of art as the conscience and the synthesis of a whole age: Kokoschka the portraitist who painted the inner countenance of his generation, in the sense of Dürer's 'Interior figure', the creator of pictures which possess the suggestive force of a Mathias Grünewald. Besides being the most important portrait painter of the present day, Kokoschka, when he turned his attention from his sitters to the earth they inhabit, portrayed her in many landscapes. In Panoramas and images of cities he expressed his love for Being. Besides the means at the disposal of the plastic artist, Kokoschka made use also of the word, in the first place the spoken word of the stage in which to communicate the tragic pessimism, the doubt and bewilderment of contemporary youth in revolt. And just as his development as an artist led from the draughtsman's line to the painter's colour, so his growth as a thinker led him from the darkness of youthful pessimism up to the light of a new humanism affirmative of life. In poetry, drama and in graphic series he wrestled with those metaphysical problems which face every succeeding generation anew whatever the century. His preoccupation with those forces which are forever active behind the visible reality of life gave him the constant renewal of power and courage which he needed to complete the image of his time.

Let us pass in review the series of portraits, witnesses to that generation to which their intuitive creator belonged with every fibre of his being—a generation which prepared the way to the catastrophe of the first World War. To his artist's gaze the spiritual landscape of a face unmasked itself like the face of the surrounding landscape. His was a look that penetrated the surface of things, one that could not allow itself to be deceived by the outward appearance, the mask, one that pierced with X-ray force to the core of reality. It laid bare thoughts and tensions, destinies and unconscious tendencies, exposing the nerves, the highways of human decisions. Kokoschka's 'faces' are inscribed with mysterious signs, tattooed by reality. When in 1908 he painted the *Trance Player* his power of intuition at once revealed itself irrespective of the outward experience which to the twenty-year-old introverted artist must have been unknown. This picture was the beginning of that series of psychological portraits which established his fame: those of Adolf Loos, Bessie Loos, Else Kupfer, Karl Kraus, Peter Altenberg, Arnold Schönberg, August Forel and many others. No less a writer than Thomas Mann said of this powerful art of characterization that it was 'civilized magic'. In it not only conscious knowledge is at work but a primary spiritual power. For Thomas Mann, Kokoschka was a 'cunning dreamer, a master of precise phantasy, in whose magical work spirit becomes nature and reality becomes transparent for spirit'. His portraits are painted psychoanalysis. After the faces it is the hands that impress us both as living entities in their own right and as mirrors of his model's personality. Those of the *Trance Player* in their mollusc-like fleshiness are the embodiment of all that is equivocal; or the interlocked fingers of the architect Adolf Loos telling of a nervous creative energy. The hands of the research worker in the field of sex, August Forel, form an ornament symbolic of the

delicate mechanisms at the service of the seeking mind. And how much is told us by the hands of the parents bearing the new-born child into life! In such power we feel intensely the inheritance of Dürer and Grünewald. In these early pictures the highest importance is given to characterising draughtsmanship. Colour still plays the subordinate part of support to the emotional content of the picture. And this emotional content is by no means of a pastoral or melancholy nature, nor is it religious. It exudes even a certain air of cruelty and coldness. Such portraits were exhibited in Vienna as early as 1911.

The first World War came. The self-portraits of the post-war period and paintings such as *Friends,* 1918 pointed in an entirely new direction. Kokoschka, who had discovered colour in the years 1911-1914 had begun to model with it. The tones were strong and dark, even sensual and material. *The Power of Music,* 1919, is one of the most important of the compositions of this period. Against a background of polyphonic blue and lilac a woman is playing on a yellow trumpet whilst a bright red figure of a boy is about to spring out of the right-hand corner of the picture. Kokoschka achieved a powerful dynamism in his paintings through the tension set up between a wide, narrative foreground and a distance dissolved in light. With reference to his later landscapes, but more particularly to the pictures painted in Prague in the years 1934-37 one might even speak of a transcendental fourth dimension.

Pictures such as *Portrait of a Woman* and *Double Portrait* from the year 1913, occupy a special place. In their mysterious Leonardo-like sweetness they seem to tell of what was perhaps the only happy event of the pre-war years, a tale of the new land of passion the artist had discovered; they remind us how much ardent desire and devotion lay hidden behind his youthful mask of Baudelairean bitterness. *The Dreaming Youths,* an early narrative poem, and one which he also illustrated, is a record of a first experience of love. The passion of desire between man and woman which lashes the feelings as the storm the sea (*The Tempest,* 1914) soon proved to be a curse. Both sexes seemed to embody forces of nature at enmity with each other. In the drama called *Orpheus and Euridice* Kokoschka says: 'Monotonous song of Earth / what we strive after, eternal happiness is other / is it hate, this love? / This yearning . . . /' Even darker problems presented themselves. 'And the beast ate the man and spewed him up.' With pencil and with word Kokoschka tried to represent the conflict between the opposing forces of creation in the series of lithographs *Passion* and *O Ewigkeit, Du Donnerwort,* the latter based on the experience of Bach's cantata of that name. Later it was neither personal destiny nor the workings of cosmic law that supplied the motive, but rather the tragedy of a civilization which threatened human culture and the meaning of creative work with annihilation through war. It was mankind itself that, like a destructive force of nature, had begun to tear down all that the ages had built up in order to complete the biological tragedy.

Kokoschka painted himself as the *Knight Errant,* 1915, lying among clods of earth on the battlefield, with a deadly wound in his breast, face and gestures asking the question: What is the object of life? The clods of earth, the human form, features and hands are all painted in the same convulsive manner and with the same chaotic material. Ev-

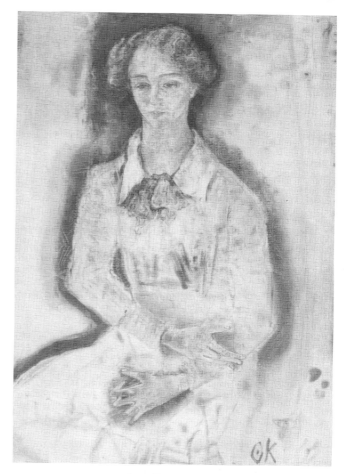

Lotte Franzos (1909)

erything seems to be made of the same stuff—the earth and the human body; everything writhes in the same violence, whilst an ineffable melody seeks to bring reconciliation and the angel of death glides slowly down to earth. The colour of *The Exiles,* 1917, is also heavy and massive. Painted with dramatic light and shade effects of a Rembrandt are three human figures in flight from the terrifying reality, homeless, driven away from their peaceful existences. In a composition *Knight, Death and the Devil* of the year 1910 Kokoschka had already expressed those powers to which life had been given over. He painted other allegories of which the *Still Life with the Dead Sheep,* 1909, bears the most strange witness to the mysterious light and darkness in which he saw the world immersed. The allegories painted in London during the second World War are of a more politically satirical character.

At first not even nature brought consolation. Kokoschka saw her as being neither idyllic nor kindly. It was elemental nature that he saw. Looking upon the natural scene he felt himself to be a witness to the creative act where mountains are piled the one on the other, narrow valleys are formed with roaring torrents, whilst the sun, immeasurably distant, glides out of a cold sky. Only later, after the oppression of the 1914-18 war had been lifted, the yearning to travel seized him, the desire to paint the picture of the world, Orbis Pictus. (pp. 33-6)

The handwriting of Kokoschka is a faithful copy of his state of mind at any given time. The Apollonian and the Dionysian types in psychology have their corresponding types in the art of painting, the classic and the romantic, the idealistic and the dynamic. Kokoschka belongs to the latter type. Even in those pictures which do not represent figures in movement the colour, the composition, the folds in the clothes, the features, the broken planes and the violence of the lines betray his inner excitement. His landscapes seethe with vitality. They are visions rather than descriptions of reality. They carry the stigmata of their time, being the products of a feverish, destructive, 'Expressionist' epoch. To get away from the restlessness of his own nature Kokoschka yearned to paint 'beautiful' pictures. To paint beautifully, was that not to look back at something lost—to a Paradise of harmony?

After a short stay in London and Paris we find Kokoschka 1933 in Vienna where, in order to keep him in the city, the post of Director of the School of Arts and Crafts was offered him. After the war of 1914-18 he had been for a while Professor at the Academy of Fine Arts in Dresden. This time, however, the artist made stipulations with reference to the teaching of the young. In his opinion the elementary and secondary schools should become an 'officina humanitatis', serving the cause of culture generally and of good will among the peoples of the world.

Kokoschka's proposals were turned down. He went from Vienna to Prague where he lived from 1934 to 1938. He painted more pictures of Prague than of any other city; and in no other city did his genius shine more brightly. His pictures of Prague are symphonic compositions dedicated to the beauty of the work of human hands harmonized with the beauty of nature. And whilst he was painting these hymns to the earth he was fortifying himself in his convictions as to the sole way toward human salvation. He studied the works of the Bohemian educationalist and philosopher Jan Amos Comenius and developed them. A unitary universal preparatory school for the young should be founded, a unified teaching manual written and adopted. Anything leading to intolerance and war should be expunged from it. He would have liked to establish in Geneva an international censorship of school books.

Perhaps it was the presence there of President Thomas G. Masaryk that kept Kokoschka so long in Prague. He found in Masaryk another student and admirer of Comenius. He painted a portrait of the President with Comenius as his genius on the background of Prague; a synthesis of Kokoschka's humanism, of his art as portraitist and landscape painter. The picture was bought by the Carnegie Institute in Pittsburgh.

The time in which Kokoschka lives and works is not one notable for its finer feelings. Between him and an Edvard Munch lies a generation of trial and of bitter disappointment. The second World War and the preparations for it hindered Kokoschka from approaching that noblest of all tasks that the art of painting has to offer: mural decoration. In his earliest youth he brought to this a first (and a rejected) offering, and this was later, at the beginning of the first World War, to be joined by a design for the wall decoration of a crematorium to be built according to his own plans. During his exile in London at the end of the second World War, he at last began to realize his earlier ambitions. He painted the triptych **The Prometheus Saga,** a ceiling painting representing the primal forces of life and the cultural background of Europe, and this he followed with the triptych **Thermopylae,** a wall painting depicting the battle in which Western freedom won its victory over Eastern despotism, planned and accomplished in Villeneuve between 1954-56, his new domicile in Switzerland, near Montreux. Myth and History are both represented in this painting. It is a warning to our cultural conscience, and a witness to human grandeur in a time of crisis. (pp. 37, 61)

J. P. Hodin, "Oskar Kokoschka: Painter and Humanist," in The Studio, *Vol. 156, No. 785, August, 1958, pp. 33-7, 61.*

Kokoschka on representational art:

I freely confess that in [**The Prometheus Saga**] . . . I have intentionally disregarded all the taboos of the international art world today. This painting was meant to reveal content and space, as every European living in the stream of history has a right to expect. I have preferred a concept of space to which I have consciously added a fourth dimension of movement, discovered in the Baroque period, and this to a certain point allows the onlooker to follow the events portrayed in the painting in temporal sequence. I am well aware that this will be blasphemy to abstract painters because the *Fauves* decreed, as a first principle, that pictorial imagination must be reduced to a two-dimensional plane, and this is undeniable so long as it is only a question of solving a problem of wall-decoration. However, if two-dimensional vision expresses the philosophy of the long-haired bearded youths who gather in the cities of the world to discuss modern problems of existence, and who prefer to discard their clothes along with their European traditions to be ready, in the guise of *sans culottes,* for the coming revolution that is supposed to outstrip even the 'Back to Nature' philosophy of Rousseau, then at my age I suppose I must be patient, for, so far, every generation has proved that the must in the barrel turns to clear wine in the end.

Oskar Kokoschka, in an excerpt from Oskar Kokoschka: The Artist and His Time *by J. P. Hodin, New York Graphic Society, 1966, p. 190.*

Alfred Werner (essay date 1959)

[*In the following excerpt, Werner discusses Kokoschka's relation to the Baroque tradition in art.*]

Of all the Austrian artists of our time grown to manhood before the overthrow of the Hapsburg regime, [Kokoschka] more than anyone else represents the *"oesterreichische*

Mensch" ["Austrian man"], the *"oesterreichische Idee"* ["Austrian idea"], that Austrianship which might be compressed in the term *"Barockgeist"* ["Baroque spirit"]. Austria's Baroque (later than its Italian equivalent) is a phenomenon *sui generis.* Although it originated at a time and place which saw the firmest alliance between Catholicism and Absolutism, its general philosophy is broad enough to shelter a Socialist iconoclast like Kokoschka. It is, basically, nothing but a surprising victory over tendencies that would seem to cancel out each other as well as their victim—these tendencies being fear of death and appetite for life. The synthesis was found in a creed that, without concealing the realization of life's transitory character, makes it possible to carry the burden by transforming life into a play, by transfiguring matter into timeless music: pageant, drama, opera, and, the receptacle of all, architecture.

Kokoschka's art is humanist art for man's sake, and this is also what the Benedictine monks desired when they called upon the best available architect (Prandtauer) and the most representative artists to build and embellish, high above the Danube village of Melk, what was to become the noblest and largest monastery in all German lands (Sacheverell Sitwell calls it "one of the wonders of the eighteenth century"). I mention the monastery because Kokoschka must have been impressed by it—his own, inconspicuous town of Poechlarn being only a few miles upstream. "Victory over terror," this huge, sprawling, yellowish building with majestic squat towers might be called, and this is also what Kokoschka's work appears to be: the triumph of vigor, imagination and spiritual fervor over the bourgeois mediocrity that ruled supreme in Austria prior to the catastrophe of 1914.

For Baroque is more than flowing scrolls, florid decoration, mechanized puppet shows and formal gardens, and to Kokoschka at least it meant revolutionary fight rather than the lassitude of repose. The charges of "irregularity" and "capriciousness," of "illogicality" and "lack of structure," that were leveled against Baroque were heard again when Kokoschka's work was reviewed. In his essay on Bohemian Baroque churches, published in *The Burlington Magazine* of November, 1942, the artist, then a refugee in England, noted with grim satisfaction that the term "degenerate" applied to him by the Nazis had also, at one time, been used in arguments against the Baroque.

Kokoschka is frequently included in volumes on German modern art. But it might be more appropriate to see in him the termination of the Baroque spirit rather than to link him—as has often been done in recent years—with the pagan uncouthness of the heavy-handed Heckel or the Nordic Gothicism of the always somber and severe Nolde. Not Napoleon, not Bismarck, not even Hitler was ever able to put a total end to the Baroque tradition in Austria, if it is understood as a grappling, through visual media, with metaphysical bliss and distress. Curiously, indeed, in the great eighteenth-century church decorators (Gran, Troger, Maulpertsch) one can see aesthetic precursors of Kokoschka: there is the same fullness of dramatic, expressive pathos; the immoderateness and even violence of gesture; the passionate disorder; the dissolution of linear form; and the adaptation (by means of nervous, restless brushwork) of sensuous color, applied in monumental grandeur.

This should not be astonishing. These men who covered the ceilings of Austrian cupolas with weightless figures, gesticulating amidst whirlpools of clouds, lived in a world of tension and exertion not too different from the *fin de siècle* in which Kokoschka came of age. Both worlds were experiencing a breakup of inherited values and forms, of time-honored concepts in religion, science and politics, the difference being only in the speed with which the process of disintegration took place. Unfortunately, among nineteenth-century Austrian artists there was no clairvoyant or prophet like van Gogh, one who knew that a catastrophe of world-wide magnitude was in the making. For van Gogh did write in 1886 (the year Kokoschka was born):

> One feels instinctively that many things are changing and that everything will change. We are living in the last quarter of a century which will end again in an enormous revolution . . . We shall certainly not live to see the better times of pure air and the refreshing of the old society after those big storms . . . We are still in the closeness, but the following generations will be able to breathe freely.

Twenty years later, however, a nervous and introverted young man like Kokoschka could not "breathe freely" in the Vienna of apocalyptic frivolity and startling psychoanalytic discovery. If disaster could not be averted, he wondered, could it not be enacted on the stage and thus deprived of its most painful sting—incomprehensibility? In this respect he was not untypical. Perhaps the playgoing mania of the Viennese can be explained, in part, by the need for catharsis in a city as exposed to pestilence and invasion, to the influx of new people and new ideas, as was aged and conservative Vienna. Hofmannsthal was another representative Austrian, but, unlike Kokoschka, he was not a rebel. In one of his celebrated verse-plays he made his audiences tolerate the world, as it identified with King, Beauty, Wisdom, Richman, Peasant and Beggar, all of whom, after doubt and rebellion, eventually become ready to accept and act the roles assigned by the Lord.

Kokoschka's counterattack was two-pronged. In a half-dozen plays, loosely composed in a poetic staccato prose, he did rebel, Job-like, assailing a world which pitted man against woman, driving people together and then apart, and offering to the good and noble only pain and despair. Simultaneously, there were the painted portraits and self-portraits, in which tortured color cries out against the maladjustment of man, enmeshed in a mechanized, materialistic civilization. While his plastic gifts are infinitely greater than his literary ones, the "formlessness" that prevails in these early days haunts the painter's work too, not only the unbridled visions of the neophyte that caused nearly every exhibition (like every theater performance) to break up in a riot, but also the creations of the older man, whom one might have expected to become more quiet, less arbitrary, better "adjusted."

He was not an Austrian Fauve, however. What he produced was not the primitive force of a Nolde, nor did it ever come near the self-propelling color birth and burst of Abstract Expressionism. If in Kokoschka's work there is much gesturing of frighteningly expressive hands, wild staring of eyes, the picture remains within the frame, the function is never lost, and "Art" plays its role as laid down by the heavenly Régisseur. Kokoschka's is a theatrical art

in the best sense of the term. Indeed, he should long ago have been given all the stages of the major art centers for his forceful brush—alas, the decorations for the Salzburg Festival's *The Magic Flute* did not come until he was seventy. As a portraitist, Kokoschka is the painter of "actors"; each one of the sitters (his "victims," as he calls them), who include scientists, scholars, writers, musicians and statesmen, is playing a part—grimacing, gesticulating, or just simply "being" in an unforgettably dramatic way.

Never is there anything static about his work; he is clearly related to the creators of great "machines," from Tintoretto to Tiepolo, whose disciples were the gifted decorators of the Danube lands. No proof is needed so far as the huge triptychs on the Prometheus and Thermopylae themes are concerned (the first was painted for a ceiling in a house in London, the second for a public building in Hamburg). But even the townscapes and landscapes seem to have been painted as though to serve as backdrops for theatrical performances.

Here, then, we have a man both modern and antiquated. Modern he may very well be in his unstudied, ferocious application of paint, and in the breadth of his subject matter, but one need only look at any of his pictures, chosen at random, to recognize in him the special case of a Baroque sensibility transplanted into our time. . . . [One] almost gets the notion of a desperado singlehandedly battling the forces of the Classical past (the Austrian brand): opposing to the Classical order (solid objects symmetrically arranged) the frenzy of dynamic eruptions as uncontrollable as the ecstasies of Counter Reformation preachers; dissolving static form and confined space by means of a rhythmical movement, leading, with a tempestuous whirl, into a whole imaginary space that tolerates no boundaries. The opalescent colors are of a Baroque richness: reds, deep blues, greens and oranges, and red-golden twilight skies. Baroque is his love of wide spaces (whenever he painted a townscape he took lodgings at the top of a high building so that his eye could sweep over a broad vista). And Baroque, finally, is the close affinity of this dissolving space to the fluidity of music (Bach's oratorios, Handel's operas, Mahler's symphonies, and, among moderns, possibly, Krenek and Hindemith).

Had he spent his formative years in Paris rather than Vienna, Kokoschka might have had an easier life, for he would not have been alone in his crusade against the forces of reaction. Austria, in the nineteenth century, had had several very gifted painters, but they worked in isolation, often unappreciated, and nearly always without communication with the rebels of Paris. I might mention here Waldmueller, who dared to paint in the open air, in full sunlight, and, for the unorthodoxy of his opinions, was ousted from his teaching position by the Academy. There was Rudolf von Alt, who anticipated Pointillism and, as an octogenarian, headed the Sezession group's revolt against the dry and stilted academic art. There was, in particular, Stephan Romako, who committed suicide a year before van Gogh; his glowing color was admired by the young Kokoschka, whose excellent biographer, Edith Hoffmann, characterized Romako's quasi-Baroque compositions in terms that might also be applied to [Kokoschka]: "His [Romako's] compositions were dramatic in con-

ception, crowded with figures that swept over the surface like a tempest."

But Romako was soon forgotten, and the one important master to stand, chronologically, between him and Kokoschka, Gustav Klimt, was also too revolutionary for the Viennese: three large paintings of his, symbolizing the faculties, and intended for the University's aula, were withdrawn at the petition of seventy professors (more powerful than the protests of his few supporters who were clamoring, "Let our period have its own art—let art be free!"). Next there came Kokoschka, whose trail-blazing activities, his breakthrough to Expressionism by means of Baroque fervor (rather than Oceanian and African sculpture or Gothic influences), enabled those who came shortly after him, especially Egon Schiele and the now sixty-five-year-old Herbert Boeckl, to pursue their aims with greater plastic freedom.

Significantly, Kokoschka, who was never popular in Austria—despite the support given him, for political rather than aesthetic reasons, we assume, by the Socialist administration of Vienna—is not much appreciated by the generation that has come up since 1945. They did go to his retrospective in the Künstlerhaus last year, but they came out with the realization that with Kokoschka an epoch had come to an end. Baroque, to them, is a philosophy that was moribund by 1918, bankrupt by 1938. It is seething inner chaos, repressed until at last it bursts open and destroys its creatures. It is precious wisdom coupled with inability to formulate a plan of practical action. It is an ominous phthisis, a hectic love of a life already colored by death. It is waltzing into disaster.

Hence the new generation—those born in the twenties, such as Johann Fruhmann, Josef Mikl, Fritz Riedl and Herbert Tasquil, to name just a few—have moved straight into the front trenches of nonobjective art, with an earnestness and a determination that may make Austria, at long last, one of the countries in the vanguard of new plastic expression, completely un-Baroque, severe and austere. In their total repudiation of Kokoschka and all he stands for they are not entirely fair to one born at a time when not even the Realism of a Courbet or the Impressionism of a Monet had penetrated to the capital of the Hapsburgs. They reject his large allegories as though there were no difference between his performances and the huge canvases the grandiloquent Makart once filled with luscious nudes and festive throngs.

But whereas Makart was a schemer (though an immensely gifted one), Kokoschka is truly obsessed by his visions, in his best as he is in his worst. Americans, free of the historical associations afflicting the young Austrians, are more apt to appreciate without bias what they can view in American public collections—the double portrait of the late art-historian couple Tietze, for instance, the vistas of Dresden, Hamburg, Prague, London and Florence, the portraits of vanished European personalities. When, about a decade ago, he informally taught here at several colleges, his students were overawed by this large, clumsy, not particularly articulate man who somehow managed to formulate his credo, one that is applicable to the work of his fathers, Maulpertsch and Romako, no less than to that of the earnest young men and women who have gone much further than he in the exploration of the painterly universe: "Just be conscious of your heart beat. Each painting

is part of your life. It is jealous, it needs all your intensities, all your time, all of you. You must only paint when there is a necessity. We should be on our knees, for it is the soul that handles the brush." (pp. 43-7)

Alfred Werner, "Kokoschka's Baroque Expressionism," in Arts, Vol. 33, No. 10, September, 1959, pp. 42-7.

Remigius Netzer (essay date 1974)

[In the following excerpt, Netzer discusses the expressionistic nature of Kokoschka's paintings and comments on his use of color.]

Everything Kokoschka creates is the product of experience: fire, which has excited him since childhood; fear and awe of Woman, whose influence has often overwhelmed him; wonder at the suddenly intensified reality of the Other—that moment, anxiously awaited in the course of painting a portrait, when the sitter will show his true face, the characteristic expression on which the artist pounces at once.

Even as a student at the Kunstgewerbeschule in Vienna, where he pioneered the use of life models in motion, Kokoschka established that the draughtsman's true objective is to capture and record the moment in all its purity. Later, he stationed himself close to the bars of the tigon's cage in order to experience the shock of its spring; what he painted was not the animal's exotic colourfulness but its wildness and fierceness.

Kokoschka is not an Impressionist, assembling the chromatic sensations of the hour into a pictorial combination; he is not one who pursues the course of a shadow in order to make a composition of it. The structure of his paintings is formed by the visions which sights and events have provoked in his mind. He cannot turn his back on reality. He paints, almost always, from nature. But he must encounter reality anew, within himself: it must touch him, fascinate him, move him.

His portraits are not photographs but encounters with the human individual; his landscapes are not meteorological bulletins but combinations of different views and diagonally ranged horizons, producing a global unity. His figure paintings are not classical structures but statements about what is seen and what is lived. *The Bride of the Wind* is the resolution of the drama of his relationship with Alma Mahler; *The Knight Errant* expresses premonitions of war and wounding; *The Woman in Blue* transposes into art the state of spleen in which he once commissioned a needle-woman to make him a lifelike doll.

The 'Fortuna' of the title print of the lithograph series *O Ewigkeit—du Donnerwort (Bach Cantata)* also formed the subject of a painting, in 1915; almost three decades later he painted 'Liberty', fleeing with her chains broken after the burning of Athens by the barbarians, and holding out her hand to the spectator. Kokoschka does not fear allegory in its wider sense: it is part of a tradition to which he holds fast, and on which he lays emphasis. Allegory—felt, not reasoned—is very much a part of his artistic personality.

Kokoschka declares that he never starts out with a plan or a recipe for a picture: he waits for the moment of true feeling, the stimulus, the sensation of living reality. This is the emblem of his lasting Expressionism, in the true sense of that word. He has, of course, often and rightly rejected attempts to include his art within the ambit of the stylistic term 'Expressionism'. Expressionism as a style means the use of large surfaces tending towards decorative painting, thickness of contour and to the point of destruction of painterly quality, stylization of natural forms to the point of rigidity, emotional turmoil to the point of ecstasy. All this has absolutely nothing in common with Kokoschka's feelings or with his ideas, which are directed towards a continuation of the great expressive art of the past. (pp. 215-16)

The 'painterly' painters of tone-values, and their myriad virtuoso variations of shimmering light, have never interested Kokoschka. The Impressionists' colour never appealed to him, because it serves only as a means to the exact description of lighting, of the choicest moments in the experience of nature. He rejected the colour of the Pointillists or Divisionists, because the scientific method used to reproduce them held no promise, for him, of artistic effect or of life. Kokoschka values Seurat for the strength of his compositions, and for his ability to bring a subject to life through the use of light—especially in the *Baignade*—but not for the discovery of the analysis of colour into pure tones.

Colour, for Kokoschka, has always meant intensification; its function is to give depth to the spaces within the picture, to give dynamism to the composition, and to embody the artist's vision.

Colour has always been important to him: it is a source of life. With coloured crayons he has copied ancient sculptures and reliefs in order to enhance his own visual awareness of them. Colours are the element of movement in Kokoschka's pictures.

Over the decades, Kokoschka's colours have become brighter, and—without loss of intensity—more differentiated. The incomprehension which often greets the works of Kokoschka's late period springs from a failure to see.

His capacity for sensation—metamorphosed into the psychic structure of his compositions of colours and spaces—has become more refined. A mood of euphoria, revelling in the fact of being older and wiser, gives rise to a certain summariness, a delight in the sureness of the initial stroke; and sometimes the artist takes pleasure in the game of making an image brighter by overpainting with lighter and lighter colours. The colour-combinations in Kokoschka's late works give off a sweetness which can appear in such perfection only in the works of maturity.

It is understandable that Kokoschka, who was once attracted by the powerful twisting movement of Titian's *Assumption* in the church of the Frari in Venice, now, in all humility, attributes ultimate perfection to Titian's last and probably unfinished, work, the *Pietà,* in the Accademia. In the apparent dissolution of form in that painting lie painterly strength, sublimity and wisdom. The fruits of a lifetime's journey.

In the course of Kokoschka's continuing process of self-liberation, his constant pursuit of new goals—ever since Loos, his Vergil, led him to knowledge of the ancient

world—he has made the powerful narrative of the Odyssey so much his own that he has succeeded in retelling it in graphic terms, and has thereby given a new confirmation of his ability to record the world through the eyes of the spirit. (pp. 227-28)

> *Remigius Netzer, in a postscript from* My Life *by Oskar Kokoschka, translated by David Britt, Thames & Hudson, 1974, pp. 215-31.*

Benjamin Forgey (essay date 1979)

[*In the following review of a 1979 exhibition of Kokoschka's graphic art, Forgey discusses the characteristic themes and techniques displayed in those works.*]

Drawing and printmaking have been integral parts of Oskar Kokoschka's art throughout a career spanning more than seven decades of our century. This fact is celebrated in an exhibition of some 100 Kokoschka prints, recently shown at the Phillips Collection in Washington and now circulating in the United States under the aegis of the Washington-based International Exhibitions Foundation.

As a printmaker, Kokoschka was not a craftsman deeply involved in the interchange between technique and expression. For Kokoschka, from the very beginning, the idea of personal expression was paramount. For this reason, in addition to the particular nature of his gifts and style, Kokoschka's favored medium in the graphic arts has been lithography. The prints themselves tell this story. Kokoschka's characteristic mature style of draftsmanship consists of building an image with a weaving, flexible, swiftly executed, subtly weighted network of lines and shadings. The spontaneity of drawing with a litho crayon directly on the stone corresponded precisely with his needs.

Although Kokoschka is known to have used preliminary "idea sketches" for some of his late narrative lithographs, the final images were always executed freshly on the stones. As publisher Bernhard Baer comments in his catalogue statement concerning the methodology of Kokoschka's late lithographs, "Quite literally Kokoschka has no time for graphic processes which require step by step development. . . . It is unthinkable for Kokoschka to square up a drawing for transfer into another size or another medium. The conception is meditated upon, the setting down is intuitive." This also explains the rarity of multicolored prints in Kokoschka's graphic oeuvre. The artist himself protested to Baer, who had suggested the use of a second color, that to add another color he (Kokoschka) "would have to design on two sheets or stones at the same time. Each stroke on one of the drawings would have to be woven into the corresponding one of the other as in a tapestry. It would hamper my imagination and my spontaneity."

The earliest works in the show, a set of 18 tiny postcards the young Kokoschka did as a student at the Vienna School of Applied Art (the famous Wiener Werkstätte, which published more than 900 such postcards between 1906 and 1914), are more remarkable for imagination than for spontaneity. However, they may be the last of Kokoschka's works in which these two fundamental qualities are split. They are tightly composed color lithographs done in a choppy, angular, linear style more appropriate to the woodcuts.

After 1907, when he left the Vienna school at the age of 21, Kokoschka visited the artistically more lively city of Berlin, where he became associated with the early German Expressionists and the avant-garde magazine *Der Sturm* (The Storm). The affiliation with *Der Sturm* was particularly important in stimulating Kokoschka's graphic production, as the magazine commissioned and reproduced his first important series of portrait drawings. These appeared periodically under the title **Human Heads (Menschenköpfe)** and included well-known figures in the avant-garde circles of the day, such as the aging singer Yvette Guilbert, architect Adolf Loos, the writer Karl Kraus and Herwarth Walden, publisher of *Der Sturm.* Later, during the World War I period (Kokoschka was injured at the Russian front in 1916 and spent the remaining war years in Berlin and Vienna), he began to receive the important patronage of Paul Cassirer, who published many editions of his lithographs, including the series of five prints, **The Concert,** in 1921.

A comparison between these two sets of works clearly illustrates the dramatic transformation of Kokoschka's graphic style in the decade between 1910 and 1920. The **Human Heads** are characterized by busy, sharp, angular lines and a sort of nervous tension between mark and white space that carries over into the expressive message of the portraits. This is also emphasized by exaggerated contortions of posture and gesture. Even as a young artist, Kokoschka was difficult to categorize in any schematic fashion, but these works clearly show his early affinity with the German Expressionists. The **Concert** prints, by contrast, are developed with the rapid tapestry of fluid strokes that was to become a hallmark of Kokoschka's mature style as a draftsman. In both, however, we can see Kokoschka's concentration upon human personality and character.

Kokoschka has been an extraordinary, empathetic interpreter of human beings, especially in his graphic production; his acute sensitivity to subtle shifts in mood is perfectly demonstrated in the **Concert** prints, which are in fact studies of the same woman as she listens to the music of Beethoven. (The lithographs were based upon a series of more than 20 drawings made by Kokoschka of Camilla Swoboda, wife of the Viennese art historian Karl Maria Swoboda.) As E. H. Gombrich points out in his introduction to the catalogue, there is an element of self-portraiture in all of Kokoschka's studies of human beings, due to "the way Kokoschka attunes his own body to resonate to his model, re-enacting the expressive movements of his fellow humans so as to understand them more fully."

Kokoschka himself was aware of and fully exploited this tendency towards simultaneous revelation of the self and the other. He referred to it many times, as when he identified himself with the aged King Saul in his lithographic series on the theme of Saul and David: "Saul is as furious at being 80 as I am. He cannot grasp the fact that he is now 80, as yesterday he was only 18—like David, who is standing behind him. It seems only yesterday that I was 18."

Predictably Kokoschka was a superb self-portraitist throughout his life. There is no more moving image in the show than his lithographic self-portrait made in 1966, at age 79—a massive, stolid figure whose eyes, alive behind heavily drooping lids, seem suspicious of the knowing interloper who regards the mirror so intensely. It is interest-

ing to compare this portrayal with that of **David in His Old Age** from the **Saul and David** series made three years later. For the similarities in physiognomy and mood are self-evident and striking.

Narrative themes from the Bible, from Shakespeare and from Greek mythology are the triumphs of his later graphic works, although here, too, there are clearly parallels in his early works (such as the series of illustrations for his own plays). Indeed it is not too much to say that Kokoschka is one of the supreme dramatic illustrators of the century, so persuasive is his ability to occupy the world of the story and to make it vividly meaningful in visual and emotional terms. This is not "mere illustration" in the Berensonian sense. Kokoschka does not illustrate in a literal way. He penetrates to the human and ethical core of a story or an event. To cite just one example, there is the baleful image of Cassandra from Euripides' *Trojan Women,* economically portrayed as she is being tugged away, a prisoner, to Agamemnon's ship, casting a last look over her shoulder at the ruins she had prophesied.

Kokoschka has indeed been an individualistic, independent artist, but as his graphics impressively reveal, there is a profound inner consistency to his lifework. (pp. 76-7, 79, 81)

Benjamin Forgey, "Oskar Kokoschka: Empathetic Interpreter of Human Feelings," in ARTnews, Vol. 78, No. 3, March, 1979, pp. 76-7, 79, 81.

Achille Bonito Oliva (essay date 1983)

[*In the following excerpt, Oliva explores the nature of Kokoschka's artistic vision.*]

> My vanity, which is not interested in my body, would gladly acknowledge itself in a monster, if it recognized the spirit of the artist there too; I exult in the testimony of a Kokoschka because the truth of a genius that distorts is higher than the truth of anatomy, and because in the presence of art reality is merely an optical illusion. (Karl Kraus, *Die Fackel*)

Oskar Kokoschka utilizes painting as a kind of anamorphic mirror capable of altering the symmetrical distance between the model and the painting, capable of obliterating the straightforward vision of common man who uses his eyes as an organ of simple optical reproduction and in its place establishing a new dimension of visual sensibility. An ineluctable penetrating force suffuses all of his work. This force plays with the data of external reality, with men and material things, with landscapes and still lifes. The picture therefore becomes an organ with a double polarity that functions through the elements of introversion and extroversion.

Introversion results from the necessity of grinding the perception of external reality within the field of its own internal deformations. The expressionism of O. K. is charged with a will for power and an *impulse for destruction and reconstruction.* This impulse breaks down the apparent integrity of external phenomena into finite parts and then reassembles them according to an equilibrium of precarious nature. In any case, art here strives to disarticulate and scar the illusionary opulence of the world in order to es-

tablish a different kind of visual opulence that is galvanized by a dimension beyond physical reality.

O. K. himself spoke about the difference between vision and a picture. While vision records the three common dimensions of external reality, a picture captures a fourth dimension, that of the psyche and the interior. Hence a picture has a creative capacity that belongs solely to the artist who is equipped with a particular sensibility and an extremely fragile psychic alarm system. The sheer intensity of the picture outstrips the temporal nature of things understood as an unaltered perception of the present, and enters into a broader, prophetic temporality. Wolf-Dieter Dube recounted the story about Kokoschka's portrait of Forel, which was rejected by the scientist's family because they didn't think it was a good likeness. After suffering an apoplectic fit, Forel increasingly resembled the portrait painted by O. K.

Art, therefore, possesses a kind of circular temporality that understands the future, the past, and the present. This probe into the future can penetrate the psyche and explore the hallucinatory interior of the subject. The artist thus expands the perspective field and establishes the new image that emerges from a profound perception of the subject and the artist's own impulses projected on it.

The truth expressed in a picture by O. K. is thus problematic. This truth is a monstrous visual epiphany transcending all levels of simple social respectability; it literally becomes the clinical picture of an epoch that has lost all sense of proportion and symmetry. The resulting artistic creation presupposes the existence of another order beyond the one we know through reason.

Even more significant are the compulsions that overcome all inhibitions and defenses, that replace the image of man as a social animal with another image outside the codes of decency and early twentieth-century bourgeois edification. These codes are skeptical toward the *discovery* of the unconscious achieved by Freud. During a performance of O. K.'s drama *Murder, Hope of Women* there was a disturbance provoked by a Bosnian regiment of soldiers who, at the height of trauma, also wanted their "murder." Art is not always in accord with edificatory impulses: it possesses a voracious amorality and seeks scandalous solutions. Hence it transgresses the hierarchy of social and moral values by means of a forceful, striking image that cuts through all types of conventions, including visual ones. This image created by the artist displays a hallucinated and hallucinatory dimension that reveals the blemishes and wounds, scars and irregularities that gradually undermine inhibition.

Thus a primary impulse of art is to act as the *murderer* of linguistic, moral, political, and social conventions. Beyond this, the artistic process concerned with constructing a new image results from the destruction of convention.

O. K. is the artist who produces this reasoned, ferocious, and even cheerful assassin and who penetrates his pictorial creation beyond the threshold of privacy without ever withdrawing from the inexpressible and indecent apparitions of hidden truth.

Consequently, O. K. becomes the *murderer, hope of art* in the sense that he wields his brush like a knife that rips open resistance and the social mask of the subject. He does

this in order to restore an identity, dictated by the image, that honors no respectful sentiments or decent people: "There once was a time when I knew how to evoke the essence of a character—as we say, the 'daimon'—in such an elementary way that the main lines made one forget about the accidental elements which were omitted . . . Sometimes we succeeded and the result was an image of the kind of person we see when we think of our friends. But this image was more vivid than what we can see with our eyes because it is concentrated on a focal point and therefore unattainable through ordinary perceptual means."

Kokoschka's works passed through a phase of graphic scarification that obliterated detail. Relying on a sensibility consonant with Japanese art, all was reduced to a linear essence. This led to a concentration of the image to a "focal point" that revealed a hidden and inaccessible identity.

This focal point had great potential in the sense that it produced an image with radiant, expansive energy that transfigured the subject placed against an internalized plane. At the same time, Kokoschka's graphic scarification was further realized through a densely layered pictorial materiality reminiscent of Titian, Tintoretto, and Veronese. We see a double passage from appearance to substance, from the sketch to the richness of a new flesh.

Kokoschka's art is both a murder and a resurrection, a rending apart and sewing together, a disrobing and a dressing again, a reduction and restitution of materiality:

> Now I construct composites of human faces (models such as the people who have opposed me for so long, people who know me and are known to me so well that they persecute me as if I were an incubus) and in these compositions one person is in conflict with another, in stark contrast like love and hate; and in each painting I seek the dramatic "accident" that will unite the individual spirits and thus raise them to a higher order.

Love and hate, death and resurrection, murder and hope intertwine in an ambivalent, complex image. Two currents, one gothic, the other baroque, intersect in the work of O. K. The gothic current tends toward scarification and the restitution of an eternally mournful image, while the baroque current redeems these impulses and overturns them with a vital, positive application.

The material and the spiritual confront and pass by each other in an ambivalent manner, revealing a truth not adhering to any formulaic solutions. In this sense the art of O. K. results from an enrichment of common sense, a shift from what is purely seen to a vision of such complexity that it is separate from the realm of our simplified existence. Therefore Nazism, with its regressive economy that sought a mythic order of rural civilization, could never accept the explosive obscenity of such ambivalence, nor could it refrain from condemning the spectral order of Kokoschka's murderous art. (pp. 17-22)

Achille Bonito Oliva, "Murder, Hope of Art," in Oskar Kokoschka, Drawings and Watercolors: The Early Years, 1906 to 1924 *by Serge Sabarsky, translated by Jon Van de Grift and Christa E. Hartmann, Rizzoli, 1986, pp. 17-22.*

Eric Gibson (essay date 1987)

[*In the following review of Kokoschka's 1986 retrospective exhibition, Gibson praises Kokoschka's early portraits but suggests that they represent the artist's only successful works.*]

There are in a sense two Oskar Kokoschkas in the public mind, the early-twentieth-century portraitist, and the post-war cosmopolitan crusading for peace. For the former, art was a mirror held up to the frailties of society and the psyche—his own and his sitters'. For the cosmopolitan, art was still a mirror, but this time one to be aggressively held up to a world seemingly bent on self-destruction out of the hope that it would reform before it was too late. It was the sad task of the Guggenheim exhibition, a revised version of the Tate Gallery's 1985-6 exhibition, to show us that these two personas were fundamentally at odds. Kokoschka's career as a creative force in the art of his time essentially stopped in 1917, less than ten years after it began.

There can be hardly anyone who questions the importance, the sheer originality and force of the portraits Kokoschka painted in Vienna at the outset of his career. Even the notorious effects of the Guggenheim's [sloping] exhibition ramp and the unfortunate necessity of hanging so many works side by side barely diminished their force. Kokoschka used to describe himself as a 'psychological tin-opener', and it is true he was able to plumb his sitters' inner depths, revealing their interior stresses and disturbances in a way few others could. At the same time, of course, he projected himself onto his sitters to such an extent that we feel the agitated presence of the artist himself always with us. In portraits like *Felix Albrecht Harta, Peter Altenberg* and *Hans Tietze and Erica Tietze-Conrat,* as well as his own 1913 self-portrait, we feel the eerie vibration of the artist's own sensibility conditioning our view of his sitters. Kokoschka's are among the most forceful portraits in modern art: taut, febrile, their harsh, scraped surfaces somehow speak of a like condition of the contemporary psyche. Aside from Beckmann, it isn't until Bacon that modern portraiture reaches this sort of pitch.

What the exhibition made clear was that this kind of driven, corrosive sensibility sustained him only until World War One. Perhaps he needed *fin-de-siècle* Vienna's sulphurous atmosphere to sustain him. At any rate, from psychological probing he soon retreats into a variety of manners: society portraitist; jilted lover; painter of ponderous allegorical machines; propagandist for peace; cosmopolitan painter of landscape vistas. At the centre of it all is the rapid academicisation of a style into mere illustration. There are some exceptions, of course, such as his second portrait of Karl Kraus (1925), which retains some of the old-style unease. More indicative, however, are the portraits of Nancy Cunard and Arnold Schoenberg of the year before. In these, Kokoschka is content to record exterior appearance only, rather than use it as the conduit to the inner self. Paint matter and surface texture are used not as a species of psychological index, but as so much compositional filler. If purgatory for an artist is the time between the expiration of his talent and death, then Kokoschka, who lived to be ninety-four, endured the longest one of all. (pp. 26-7)

Eric Gibson, "Klee and Kokoschka," in Studio

International, *Vol. 200, No. 1017, August, 1987, pp. 26-9.*

———

FURTHER READING

I. Writings by Kokoschka

My Life. Translated by David Brett. New York: Macmillan, 1974, 240 p.
 Kokoschka's autobiography. Includes, as a postscript, the essay by Remigius Netzer excerpted above.

II. Biographies

Hodin, J. P. *Oskar Kokoschka.* Greenwich, Conn.: New York Graphic Society, 1966, 251 p.
 Biography based to a large extent on the author's conversations with Kokoschka.

Hoffmann, Edith. *Kokoschka: Life and Work.* London: Faber and Faber, 1947, 367 p.
 Comprehensive critical biography.

Whitford, Frank. *Kokoschka: A Life.* London: Weidenfeld and Nicolson, 1986, 221 p.
 Biography written for the nonspecialist.

III. Critical Studies and Reviews

Bass, Ruth. "A New View of Kokoschka." *ARTnews* 86, No. 2 (February 1987): 106-11.
 Review of the 1986 retrospective exhibition at the Guggenheim Museum. Bass argues that the show demonstrates the power of Kokoschka's later works, which are often considered inferior to his early portraits.

Calvocoressi, Richard. "Kokoschka's Highland Journey." *Burlington Magazine* CXXIX, No. 1009 (April 1987): 220-25.
 Discusses Kokoschka's 1929 trip to Scotland and examines the three paintings he executed during his stay.

Gaunt, William. "London: Oskar Kokoschka on Seeing." *Art Digest* 28, No. 17 (1 June 1954): 12, 24.
 Brief discussion of Kokoschka's approach to art composed largely of quotes from Kokoschka himself.

Gombrich, E. H. *Kokoschka in His Time: Lecture Given at the Tate Gallery on 2 July 1986.* London: Tate Gallery, 1986, 32 p.
 Discusses Kokoschka's art in the context of literary, political, and artistic developments in Germany and Austria during the early twentieth century.

Hodin, J. P. "The Graphic Work of Oskar Kokoschka." *Studio International* 171, No. 875 (March 1966): 94-7.
 Discusses the evolution of Kokoschka's graphic style.

Leshko, Jaroslaw. "Oskar Kokoschka's *The Tempest.*" *Arts Magazine* 52, No. 5 (January 1978): 95-105.
 Analysis of the iconography of *The Tempest* (1914), which symbolically depicts Kokoschka's tempestuous affair with Alma Mahler. Leshko views *The Tempest* as the second painting in a trilogy concerning Kokoschka's

breakup with Mahler that also includes *Knight Errant* (1915) and *Still Life with Cat, Rabbit, and Child* (1914).

———. "Oskar Kokoschka's *Still Life with Cat, Rabbit, and Child.*" *Arts Magazine* 54, No. 5 (January 1980): 84-8.
 Analysis of *Still Life with Cat, Rabbit, and Child,* which Leshko considers "the most mysterious and hermetic" of the 1914-15 Mahler paintings.

———. "Oskar Kokoschka's *Knight Errant.*" *Arts Magazine* 56, No. 5 (January 1982): 126-33.
 Analysis of Kokoschka's painting *Knight Errant.*

Levy, Alan. "Oskar Kokoschka: Reality Is But an Optical Illusion." *ARTnews* 73, No. 2 (February 1974): 28-35.
 Account of the author's visit with Kokoschka at the latter's home in Switzerland. Includes some discussion of Kokoschka's life and career.

Neumeyer, Alfred. "Oskar Kokoschka." *Magazine of Art* 38, No. 7 (November 1945): 261-65, 279.
 Overview of Kokoschka's early works.

Neve, Christopher. "View from the Top: Oskar Kokoschka, 1886-1980." *Country Life* CLXX, No. 4377 (9 July 1981): 112-13.
 Review of a memorial exhibition held at the Marlborough Gallery, in London. Neve praises Kokoschka's unique style but notes: "His international reputation never seems to get Kokoschka quite right."

Ratcliff, Carter. "New York Letter." *Art International* XXV, No. 2 (January 1982): 114-20.
 Includes a review of an exhibit at the Marlborough Gallery. Ratcliff comments: "Kokoschka's struggle in the latter half of his career was to keep his confidence from overpowering those uncertainties which drive an expressionist style. . . . [He] succeeded more often than not."

Schmalenbach, Fritz. *Oskar Kokoschka.* Translated by Violet M. MacDonald. Greenwich, Conn.: New York Graphic Society, 1967, 80 p.
 Analysis of the development of Kokoschka's style. Includes numerous color reproductions.

Schorske, Carl E. "Artist of Angst." *New York Review of Books* XXXIII, Nos. 21 & 22 (15 January 1987): 20-2.
 Biographical summary.

Werner, Alfred. "OK at Ninety." *Art and Artists* 10, No. 11 (February 1976): 18-21.
 Appreciative overview of Kokoschka's works.

Whitford, Frank. "London, Tate Gallery: Oskar Kokoschka, 1886-1980." *Burlington Magazine* CXXVIII, No. 1001 (August 1986): 622-24.
 Positive assessment of the retrospective exhibition held at the Tate Gallery in 1986.

IV. Selected Sources of Reproductions

Bultmann, Bernhard. *Oskar Kokoschka.* Translated by Michael Bullock. New York: Harry N. Abrams, 1961, 132 p.
 Includes large-format color reproductions with explanatory text and a biographical essay by Bultmann.

Goldscheider, Ludwig. *Kokoschka.* Greenwich, Conn.: Phaidon, 1963, 78 p.
 Includes color reproductions and an interview with Kokoschka.

Kokoschka, Oskar. *Orbis Pictus: The Prints of Oskar Ko-*

koschka, 1906-1976. Santa Barbara, Calif.: Santa Barbara Museum of Art, 1987, 104 p.

> Catalog to an exhibition of Kokoschka's prints held at the Santa Barbara Museum of Art. Includes an appreciation by E. H. Gombrich and a detailed discussion of Kokoschka's graphic works.

Plaut, James S. *Oskar Kokoschka: A Retrospective Exhibition.* New York: Chanticleer, 1948, 88 p.

> Includes color reproductions, a biographical essay by Plaut, a bibliography, and a letter from Kokoschka.

Rathenau, Ernest. *Oskar Kokoschka Drawings, 1906-1965.* Coral Gables, Fla.: University of Miami Press, 1970, 285 p.

> Black-and-white reproductions of Kokoschka's drawings with a brief foreword by the artist.

Sabarsky, Serge. *Oskar Kokoschka: Drawings and Watercolors, The Early Years—1906 to 1924.* New York: Rizzoli, 1986, 132 p.

> Color reproductions with a brief introduction by Sabarsky. Also includes the essays by Kokoschka and Achille Bonito Oliva excerpted above.

Solomon R. Guggenheim Museum. *Oskar Kokoschka, 1886-1980.* New York: Solomon R. Guggenheim Museum, 1986, 246 p.

> Catalog to the retrospective exhibition held at the Guggenheim in 1986. Includes numerous color reproductions and the comprehensive biographical essay by Richard Calvocoressi excerpted above.

Wingler, Hans Maria. *Oskar Kokoschka: The Work of the Painter.* Translated by Frank S. C. Budgen et al. Salzburg: Galerie Welz, 1958, 401 p.

> The definitive catalog of Kokoschka's works to 1958. Includes an introduction by Wingler.

Dorothea Lange

1895-1965

American photographer.

Lange is best known for her photographs that record the human suffering of the economically depressed 1930s. Among her hundreds of photographs, *White Angel Breadline* (1933) and *Migrant Mother* (1936), in particular, captured the plight of out-of-work, starving men and women and helped speed the administering of relief efforts to the unemployed during the worst years of the Great Depression. In addition, Lange movingly captured on film the disenfranchisement and concentration of Japanese-Americans in American detention camps during World War II. These pictures, among many others, have led critics to consider Lange one of the foremost American documentary photographers, and Edward Steichen has called her "one of the truly great photographers of all time."

Born Dorothea Margaretta Nutzhorn in Hoboken, New Jersey, she was the daughter of middle-class German immigrant parents who separated when she was a child. Living with her mother until adulthood, Dorothea adopted her mother's maiden name, Lange, as her own. During her late teens she studied to enter the teaching profession, but then abruptly embraced photography as her chief interest. Lange studied photography at Columbia University under Clarence White, later working for a time under noted portrait photographer Arnold Genthe. In 1910, she embarked on a round-the-world journey, hoping to support herself by taking and selling photographs along the way. This ambitious plan ended in San Francisco, where Lange lost all her money. She obtained work in a camera store in San Francisco, later opening her own portrait studio in 1916. This proved a successful venture as Lange took occasional portraits in a markedly genteel atmosphere for middle- and upper-class clients. She married the painter Maynard Dixon in 1920 and accompanied him on journeys to the Southwest during the 1920s.

A few years after the Stock Market Crash of 1929, during the worst years of the Great Depression, Lange ventured into the San Francisco streets one day to photograph a crowd of out-of-work men standing in a breadline operated by a wealthy woman nicknamed "the White Angel." Of the several photographs she took that day, one in particular launched her career as a documentary photographer; this was *White Angel Breadline,* which shows a grizzled old man wearing shabby clothes standing with his back to the breadline while holding an empty tin cup: a portrait, at once tragic and pathetic, of spiritual resignation and defeat. This picture and others Lange took soon afterward caught the attention of photographer Willard Van Dyke, who wrote an enthusiastic article about Lange in *Camera Craft* and exhibited her work at his gallery in Oakland. There her work was noticed by Paul Taylor, a professor at the University of California and a researcher interested in the use of photography as an instrument of social change—and the man who married Lange after her marriage to Dixon had ended. In 1935 Taylor was hired by the State of California to report on the conditions of

migrant laborers, and with the state's permission to use photographic evidence, he hired Lange as his assistant. The resulting report, complete with Lange's photographs, was instrumental in leading the state government to build shelters for the migrants. Speaking on the dispossessed and her aim in photographing them, Lange later said, "Their roots were all torn out. The only background they had was a background of utter poverty. It's very hard to photograph a proud man against a background like that. . . . I had to get my camera to register the things about these people that were more important than how poor they were—their pride, their strength, their spirit."

Later in 1935, having recognized the accomplishment of the California model of relief administration, the federal government set up a photographic division of the Rural Resettlement Administration (later called the Farm Security Administration). Director Roy Stryker hired Lange, along with Walker Evans and other distinguished photographers, to roam the country recording the effects of the depressed economy and the worn-out land upon people in rural America. Lange's photographs of the unemployed and underemployed proved crucial in stirring support for relief programs. Lange's most acclaimed and widely reproduced photograph, *Migrant Mother,* was

taken and published during her years with the FSA. One of a series of photographs taken within ten minutes on a cold day in 1936 at a migrant camp in California, *Migrant Mother* captures the worry-lined face of a thirty-two-year-old mother of seven as she holds a sleeping baby in one arm while holding her free hand to her face in a gesture of indecision. "This picture, like a few others of a few other photographers, leads a life of its own," wrote George Elliot, years later. "That is, it is widely accepted as a work of art with its own message rather than its maker's; far more people know the picture than know who made it." In 1939, Lange and Taylor published an illustrated chronicle of the Depression's effects on rural Americans, *An American Exodus: A Record of Human Erosion.*

Two years later, Lange received a Guggenheim Fellowship which she resigned during World War II in order to work on photographic projects for the federal government. Following the issuance of Roosevelt's Executive Order 9066, which gave the American military an essentially free hand to execute national security procedures as it deemed best, Lange photographed the internment of Japanese-Americans in civilian detention camps. (Although sponsored by the government in this assignment, Lange's photographs were not published for thirty years.) She accompanied photographer Ansel Adams on several domestic assignments during the war, and in 1945 she recorded the San Francisco Conference, which established the United Nations. Shortly afterward, her health collapsed and she was unable to work for several years. When she resumed work in the mid-1950s, she joined the staff of *Life* magazine, working with Ansel Adams in photographing scenes from Mormon life and traveling to Ireland to record images of rural life. From 1958 until the end of her life, Lange worked in a free-lance capacity, taking time to photograph her grandchildren and the land around her longtime home in Berkeley, California, as well. She died of cancer in 1965, shortly before a major retrospective of her work opened at the Museum of Modern Art in New York. In her last interviews, she spoke at length of the need for a federally sponsored project, similar to her work with the FSA, to photograph people throughout America every fifteen years and establish a national archive of these photographs.

Interviewed in 1952 by her son, Daniel Dixon, Lange explained that her approach as a documentary photographer was based upon three considerations: "First—hands off! Whatever I photograph I do not molest or tamper with or arrange. Second—a sense of place. Whatever I photograph, I try to picture as part of its surroundings, as having roots. Third—a sense of time. Whatever I photograph, I try to show as having its position in the past or in the present. But beyond these three things, the only thing I keep in mind is that—well, there it is, that quotation, pinned up on my darkroom door." Here Lange referred to a quotation by Francis Bacon which she took as her professional credo: "The contemplation of things as they are, without error or confusion, without substitution or imposture, is in itself a nobler thing than a whole harvest of invention."

ARTIST'S STATEMENTS

Dorthea Lange (essay date 1960)

[In the following excerpt, Lange reminisces about how she came to take her most famous photograph, Migrant Mother *(1936).]*

When I began thinking of my most memorable assignments, instantly there flashed to mind the experience surrounding ***Migrant Mother,*** an experience so vivid and well-remembered that I will attempt to pass it on to you.

As you look at the photograph of the migrant mother, you may well say to yourself: "How many times have I seen this one?" It is used and published over and over, all around the world, year after year, somewhat to my embarrassment for I am not a "one-picture photographer."

Once when I was complaining of the continual use and re-use of this photograph to the neglect of others I have produced in the course of a long career, an astute friend reproved me. "Time is the greatest of editors," he said, "and the most reliable. When a photograph stands this test, recognize and celebrate it."

Here then is that same picture, once again, and this time with the story. I have never captioned it other than with date and place. The circumstances surrounding it are not spectacular, but important to me in a different way.

Migrant Mother was made 23 years ago, in March, 1936, when I was on the team of Farm Security Administration photographers (called "Resettlement Administration" in the early days). Their duties and the scope of their work is a story well known to students of contemporary photography. We had a unique job, and the results of our travels over the U.S.A. have proved of real value. . . .

To repeat, it was 23 years ago at the end of a cold, miserable winter. I had been traveling in the field alone for a month, photographing the migratory farm labor of California—the ways of life and the conditions of these people who serve and produce our great crops. My work was done, time was up, and I was worked out.

It was raining, the camera bags were packed, and I had on the seat beside me in the car the results of my long trip, the box containing all those rolls and packs of exposed film ready to mail back to Washington. It was a time of relief. Sixty-five miles an hour for seven hours would get me home to my family that night, and my eyes were glued to the wet and gleaming highway that stretched out ahead. I felt freed, for I could lift my mind off my job and think of home.

I was on my way and barely saw a crude sign with pointing arrow which flashed by at the side of the road, saying PEA-PICKERS CAMP. But out of the corner of my eye I *did* see it.

I didn't want to stop, and didn't. (p. 42)

Having well convinced myself for 20 miles that I could continue on, I did the opposite. Almost without realizing what I was doing, I made a U-turn on the empty highway. I went back those 20 miles and turned off the highway at that sign, PEA-PICKERS CAMP.

I was following instinct, not reason: I drove into that wet and soggy camp and parked my car like a homing pigeon.

I saw and approached the hungry and desperate mother, as if drawn by a magnet. I do not remember how I explained my presence or my camera to her, but I do remember she asked me no questions. I made five exposures, working closer and closer from the same direction. I did not ask her name or her history. She told me her age, that she was 32. She said that they had been living on frozen vegetables from the surrounding fields, and birds that the children killed. She had just sold the tires from her car to buy food. There she sat in that lean-to tent with her children huddled around her, and seemed to know that my pictures might help her, and so she helped me. There was a sort of equality about it.

The pea crop at Nipomo had frozen and there was no work for anybody. But I did not approach the tents and shelters of other stranded pea-pickers. It was not necessary; I knew I had recorded the essence of my assignment.

This, then, is the *Migrant Mother* photograph with which you are so familiar. It has, in a sense, lived a life of its own through these years: it goes on and on. The negative now belongs to the Library of Congress, which controls its use and prints it. Whenever I see this photograph reproduced, I give it a salute as to an old friend. I did not create it, but I was behind that big, old Graflex, using it as an instrument for recording something of importance. The woman in this picture has become a symbol to many people: until now it is her picture, not mine.

What I am trying to tell other photographers is that had

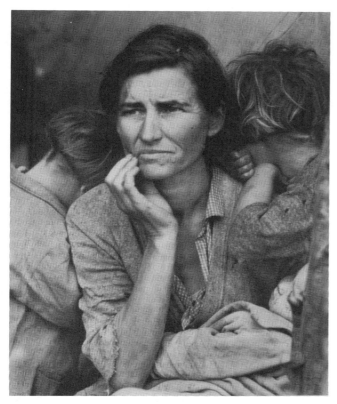

Migrant Mother (1936)

I not been deeply involved in my undertaking on that field trip, I would not have *had* to turn back. What I am trying to say is that I believe this inner compulsion to be the vital ingredient in our work; that if our work is to carry force and meaning to our views, we must be willing to go "all-out."

Migrant Mother always reminds me of this, although I was in that camp for only ten minutes. Then I closed my camera, and *did* go straight home. (pp. 42, 126)

Dorothea Lange, "The Assignment I'll Never Forget: Migrant Mother," in Popular Photography, *Vol. 46, February, 1960, pp. 42, 126.*

SURVEY OF CRITICISM

Willard Van Dyke (essay date 1934)

[*In the following excerpt, Van Dyke praises Lange's documentary approach to photography, comparing her work to that of noted Civil War–era photographer Mathew Brady.*]

Dorothea Lange has turned to the people of the American Scene with the intention of making an adequate photographic record of them. These people are in the midst of great changes—contemporary problems are reflected on their faces, a tremendous drama is unfolding before them, and Dorothea Lange is photographing it through them.

She sees the final criticism of her work in the reaction to it of some person who might view it fifty years from now. It is her hope that such a person would see in her work a record of the people of her time, a record valid of the day and place wherein made, although necessarily incomplete in the sense of the entire contemporary movement.

One of the factors making for this incompleteness is the camera itself. It must make its record out of context, taking the individuals or incidents photographed as climaxes rather than as continuity. In approaching the subject or situation immediately before her she makes no attempt at a personal interpretation of the individual or situation. Neither does she encompass her work within the bounds of a political or economic thesis. She believes and depends more on a certain quality of awareness in her self. This awareness although perhaps inarticulate through herself (in words) is apparent in her adherence and approach to certain subject material. She is not preoccupied with the philosophy behind the present conflict, she is making a record of it through the faces of the individuals most sensitive to it or most concerned in it. Her treatment of this type of human subject shows her in turn sensitive and sympathetic to the uncertainty and unrest apparent at the present time.

Naturally the range of human emotions which Dorothea Lange now photographs are not those which a sitter expects in a studio portrait. Sixteen years as a portrait photographer have shown her that the subject of a commission rarely sees himself as the camera does, even at its best,

and is unlikely to be convinced of the objective truthfulness of the camera. Sitters mistake the lens for a mirror wherein they are wont to see themselves colored by the glamour of their romantic ideas. Of course, in order to please patrons, one must make concessions and this limitation led Dorothea Lange to photographing people with or without their knowledge, outside of the studio.

Most photographers under similar circumstances would have turned to photographing other subject material, or away from photography entirely, but Miss Lange's real interest is in human beings and her urge to photograph is aroused only when human values are concerned. (pp. 461-62)

Miss Lange's work is motivated by no preconceived photographic aesthetic. Her attitude bears a significant analogy to the sensitized plate of the camera itself. For her, making a shot is an adventure that begins with no planned itinerary. She feels that setting out with a preconceived idea of what she wants to photograph actually minimizes her chance for success. Her method is to eradicate from her mind before she starts, all ideas which she might hold regarding the situation—her mind like an unexposed film.

In an old Ford she drives to a place most likely to yield subjects consistent with her general sympathies. Unlike the newspaper reporter, she has no news or editorial policies to direct her movements; it is only her deeply personal sympathies for the unfortunates, the downtrodden, the misfits, among her contemporaries that provide the impetus for her expedition. She may park her car at the waterfront during a strike, perhaps at a meeting of unemployed, by sleepers in the city square, at transient shelters,—breadlines, parades, or demonstrations. Here she waits with her camera open and unconcealed, her mind ready.

What is she seeking,—what is the essence of the human situation and through what elements or items does it reveal itself? The scene is a panorama, constantly shifting and rearranging. For her it is transformed into a pageant of humanity across the ground glass—the drama moves, the individuals stir and mill about, by what motivation she cares little. It may be hours before a climax arrives worthy of that decisive click of the shutter. Suddenly out of the chaos of disorganized movement, the ground glass becomes alive, not in the human sense alone, but in the sense that only a photographer can recognize—a scene, a negative, finally a print that is itself alive. And here is where the photographer becomes the creator, feeling all the thrills and all the responsibilities of the creative artist. A dozen questions of possible technical failure flash simultaneously thru the mind and resolve themselves into: "Has the touch upon the shutter release killed something that was palpitating and real a moment ago, or has it preserved it for others to share and enjoy?"

Perhaps the impulse that causes any photographer to open his shutter finally to the object before his lens, is the conviction that the demands of the basic photographic values which give life to a plate have been satisfied, whether the objects which he is photographing be living or inanimate. For Miss Lange, the final clicking of the shutter has the added thrill that she has recorded another climax in the turbulent drama of human relations. Her individual shots cannot tell the whole story, nor has she any plan of sequence—it is only in the broad scope of her life's work, the

constant reiteration of the climaxes, that her commentary upon humanity is to be found.

There is no attempt made to conceal her apparatus. Miss Lange merely appears to take as little interest in the proceedings around her as is possible. She looks at no individual directly, and soon she becomes one of the familiar elements of her surroundings. Her subjects become unaware of her presence. Her method, as she describes it, is to act as if she possessed the power to become invisible to those around her. This mental attitude enables her to completely ignore those who might resent her presence.

Perhaps we can arrive at a better evaluation of her record in terms of a future observer than as contemporary critics. We ourselves are too poignantly involved in the turmoil of present life. Much of it is stupid, confused, violent, some little of it is significant, all of it is of the most immediate concern to everyone living today—we have no time for the records, ourselves living and dying in the recording.

We can assume the role of that future critic by looking back to the work of Mathew Brady, who in the dawn of photography made a heroic record of another crisis in American life. Brady and Lange have both made significant use of their common medium—they differ mainly in terms of the technical advancement of the medium itself. Lange can photograph the split-seconds of the dynamic surges of the scene about her—Brady, carrying a complete darkroom about with him through the northern battlefields of the Civil War, sensitizing his own plates before each shot, making twenty minute exposures, had to wait for the ample lulls between engagements. The implications of his record are retrospective, the scene after the battle, the dead that were once living, the ruins that were once forts, faces still and relaxed. Both Lange and Brady share the passionate desire to show posterity the mixture of futility and hope, of heroism and stupidity, greatness and banality that are the concomitants of man's struggle forward. (pp. 464-67)

Willard Van Dyke, "The Photographs of Dorothea Lange—A Critical Analysis," in Camera Craft, *Vol. XLI, No. 10, October, 1934, pp. 461-67.*

U. S. Camera (essay date 1940)

[*In the following assessment of Lange's achievement, the critic provides an overview of the work Lange accomplished while with the Farm Security Administration, offering insight into her intent and technique.*]

As photographer for the Farm Security Administration for the past four years, Dorothea Lange has held down one of the biggest and the toughest photographic assignments ever handed to a woman. Her task has been to document the lives, the attitudes and the struggles of rural Americans caught in the web of an overwhelming social and economic problem. "Photograph the face of rural America" was the assignment given out in 1935 when the work first started under the Historical Section of Resettlement Administration (subsequently become FSA), and she has since been filling this comprehensive order over a vast chunk of American territory that has included all the areas of severe agricultural upheaval—the Old South, the Southeast, the Southwest, the Pacific Coast and Pacific

Northwest. She has traveled almost constantly, her assignments skipping her as far as from Oklahoma to Oregon, depending on where the critical scene of drought, dust storm, tractor placement or migrant congestion may be located at the moment. In one summer alone, her car's meter rolled up 17,000 miles.

To this decidedly man-sized job she brought not only the courage to tackle such a staggering task of social documentation, but a thorough background of photographic experience. She learned photography at 16 from an itinerant photographer who set up a darkroom in her mother's chicken house in the back yard of their home in Englewood, New Jersey. Later she did spotting and retouching and darkroom work for commercial studios in New York while still in school. She got her start on the west coast doing photo finishing for a Market Street store in San Francisco.

In 1920 she opened her own portrait studio in San Francisco which she maintained until 1934. Despite the commercial nature of this venture, her work's keen delineation of character and uncompromising honesty of technique won her an acknowledged reputation as one of the west coast's leading creative photographers.

But this wasn't enough. She had become dissatisfied with the narrowness of the portrait field. As she puts it, "I felt the limitations of working only for those who were able to pay me. I asked myself: If I really am interested in photographing human beings, how is it that I find myself photographing only those who come to me?"

And so in 1932-33 during the darkest years of economic dislocation she cut loose and shifted the whole emphasis of her work. "Just on a hunch, I took my camera out of the studio into the street."

She photographed breadlines, soup kitchens, employment agency crowds, street meetings, labor parades, jungle camps, Hoovervilles—the story of those Americans whom unemployment had washed up along the San Francisco Embarcadero or into the Third and Howard Streets district of employment agencies known as the "Slave Market."

It was a tough photographic stint, done without encouragement or hope of remuneration. Directed only by a personal conviction that the crisis of those years was a turning point in American history, she worked alone in an attempt to capture the scene of human wreckage that followed economic disaster. In doing it she at last hit her true stride as a photographer—the ability to document social crisis in terms of human experience.

This is her special gift. This, specifically, is the ability she has brought to her government work which gives it such impact. (pp. 63, 71)

Into the background of government documentary photography goes much exhaustive research. Choice of subject matter is predicated upon the photographer's possession of a thorough knowledge of a given social problem. Neither subject nor photographic condition can be chosen at will. This imposes many restrictions upon the photographer as an artist and requires technical skill if the result is to function either as documentation or as photography.

Dorothea Lange sums up quite simply her own approach to the problems which confront a documentary photographer in the field: "One is a photographer second," she says. This statement is important, and does much to explain her methods of work. She has shed the studio viewpoint in more ways than that of simply taking her camera out into the wide world. What she has accomplished is subordination of "photography's ideals" to the specialized problem of recording the contemporary social scene in terms which contribute to its understanding.

But as "a photographer second" there is little doubt that Dorothea Lange stands in the first ranks of her chosen field. Pare Lorentz of the U.S. Film Service has called her "the best documentary photographer in the land." To one of the biggest and most exacting problems ever meted out to a photographer she has brought a solution based on technical knowledge, social understanding, artistic integrity, the capacity to pour human energy into a job and a firm belief in its social function. (p. 71)

> *"An American Exodus: A Record of Human Erosion," in* U. S. Camera, *Vol. 1, No. 9, May, 1940, pp. 62-3, 71.*

Daniel Dixon (essay date 1952)

[*Dixon is the son of Lange and her first husband, Maynard Dixon. In the following excerpt, he attempts to define the quality of Lange's accomplishment and technique.*]

Among that company of photographers called documentary, probably none is more celebrated than Dorothea Lange. Many people believe her best photographs to be works of art, and enlisted in this belief are some of the most esteemed and gifted persons in the photographic world. Ansel Adams is one, Pare Lorentz another; Edward Steichen has said she is "without doubt our greatest documentary photographer" and, beyond that, "one of the truly great photographers of all time." Poets have discovered in her photographs the images of poetry; the makers of motion pictures have relied upon them as upon counsel; painters have used them as models and material for their work. Printed and reprinted in magazines and newspapers across the country, her photographs of migrant labor aroused a public which had never been aroused before; and it is no exaggeration to say that measures were taken to aid these stricken people which without her work might never have been taken at all.

No less might be expected of the talent pronounced to be "our greatest documentary photographer"—but what kind of a photographer, exactly, is that? The photographer herself jumps into this perplexing question: "For me documentary photography is less a matter of *subject* and more a matter of *approach*. The important thing is not *what's* photographed, but *how*." Asked to define this approach, Miss Lange declines, saying that the method changes with the subject, and that because the documentary photographer has before him what amounts to a universe of material, it is futile to reduce his freedom to a single practice. "I will say, though," she goes on, "that my own approach is based upon three considerations. First—hands off! Whatever I photograph, I do not molest or tamper with or arrange. Second—a sense of place. Whatever I photograph, I try to picture as part of its surroundings, as having roots.

Third—a sense of time. Whatever I photograph, I try to show as having its position in the past or in the present. But beyond these three things, the only thing I keep in mind is that—well, there it is, that quotation, pinned up on my darkroom door." It is a passage from Francis Bacon, and it reads: "The contemplation of things as they are, without error or confusion, without substitution or imposture, is in itself a nobler thing than a whole harvest of invention."

Some mulish minds, however, will not be led away from their obstinate conviction that the documentary photographer is, pure and simple, a photographer of unpleasantness. As an example, they point to Miss Lange, whose photographs show the breadline and dustbowl, hunger and dispossession, catastrophe and despair. Why doesn't she photograph something else?

The answer, say her defenders, is that she *does* photograph something else, but that because she is so well known for another kind of work, hardly anybody seems to know about it. And in the final analysis, are ugliness and horror really the subjects of her photographs? No, the subjects of her photographs are the people to whom ugliness and horror have happened. Her attention is not given to misery but to the miserable. Her concern is not with affliction but with the afflicted. (pp. 68-70)

It's not true of her as it's true of others that in her pictures the photographer behind the camera is as clearly exposed as the subject in front. In no way are her photographs interpretations, or statements, or impressions of herself, though they are a form of self-expression. But before she seeks self-expression—or maybe *as* she seeks it—she seeks also to let her subjects express themselves. They, not she, are the focus of her attention. (p. 70)

> *Daniel Dixon, "Dorothea Lange," in* Modern Photography, *Vol. 16, No. 12, December, 1952, pp. 68-77, 138-41.*

Margaret R. Weiss (essay date 1966)

[*Weiss is an American educator, editor, and essayist on photography and photographers. For many years she was the photography editor at* Saturday Review. *In the following excerpt from an essay written shortly after Lange's death, Weiss surveys Lange's career and salutes her accomplishment as a purveyor of "art for life's sake."*]

Critics who separate "art that involves" from "art that detaches" would find it difficult to classify Dorothea Lange's photography. For its creative insigne—and no small part of its strength and durability—has been the immediacy with which it invites both emotional involvement and reflective detachment.

In essence, this defines the character of Dorothea Lange the woman as well as Lange the photographer. Her intuitive responses to the human condition were insights filtered through the prism of intelligence; her way of knowing was also her art of seeing.

Somewhere in her unpublished notes she had written, "A photographer's files are, in a sense, his autobiography." And the gallery walls of the Museum of Modern Art,

where her first major retrospective has been installed, echo the truth of that observation.

For Lange, people existed in a rhythmic flow of relationships; man lived in symbiosis with his physical and social environment. It was to reveal this organic reality that she used her camera, producing what her friend George P. Elliott has termed "art for life's sake." Not concerned with abstract symbols, she sought out, scrutinized, and really saw individuals. Her subjects became prototypes—even archetypes in some instances—but not stereotypes. There was a fine distinction made between the meaningful detail and the merely incidental.

It was these qualities in her early self-assigned coverage of the San Francisco scene that brought her photography its first exhibition at Willard Van Dyke's studio in 1934, and in turn the attention of Paul S. Taylor, a University of California economics professor whose coworker and wife she became a year later. Serving as visual reporter for their collaborative social-research projects, she grew increasingly aware of how powerful an instrument of communication and persuasion the camera could be.

In the decade that followed, many readers were to sense that power as they looked at her incisive documentation of migratory workers, of Japanese-American relocation camps, of the United Nations Conference. Later, too, there were longer, more leisurely nongovernment assignments—photo essays on **"The New California,"** on Mormon communities, on Ireland, and on the peoples of Asia, Egypt, and South America—and the continuing pictorial chronicling of her own family and home.

"Whether Dorothea's camera focused on stoop labor in the lettuce fields, delegates around the conference table, villagers in the Nile Valley, or patients in a Venezuelan government hospital." Professor Taylor remarked during a recent visit to New York, "her special 'seeing' was seeing *relationships*. That's what mattered most to her: the relationships of people to people, people to place—to season—to home and garden, photo to photo, subject to subject, tonality to tonality." (p. 50)

> *Margaret R. Weiss, "Recording Life-in-Process," in* Saturday Review, *Vol. XLIX, No. 10, March 5, 1966, pp. 50-1.*

Margery Mann (essay date 1970)

[*Mann is an American educator, essayist, art dealer, and photographer. She is also the author of a 1974 biography of photographer Imogen Cunningham. In the following excerpt, Mann surveys the more outstanding photographs of Lange's career.*]

A retrospective survey of Dorothea Lange's work, a collection of over 200 prints, was shown first at the Museum of Modern Art between January 24-April 10, 1966. It has since been shown at the Worcester Art Museum and the Los Angeles County Museum of Art, and it now hangs in the Oakland Museum. (p. 84)

The prints may be roughly divided into three groups: photographs of America, rural and urban: photographs of her home: and photographs she made on the trips she took with Paul Taylor during her last few years.

Dorothea's philosophy of work is set forth in an article published in *Aperture*. (Dorothea Lange and Daniel Dixon, "Photographing the familiar," *Aperture,* 1 (2): 4-15, 1952). The article suggests that one of the problems of the photographer is the struggle to be different:

> . . . the spectacular is cherished above the meaningful, the frenzied above the quiet, the unique above the potent. The familiar is made strange, the unfamiliar grotesque. The amateur forces his Sundays into a series of unnatural poses: the world is forced by the professional into unnatural shapes.

She deplores the distrust of the familiar: ". . . to be good, photographs have to be full of the world." (p. 100)

Many of the people in her most characteristic photographs gaze directly at the camera, and the photographs are strong because the relationship between photographer and subject was strong. The people are not so much aware of the camera as they are of the intense woman behind it. *Migrant Mother, Nipomo, California,* 1936, has turned from the camera for just a moment to pursue private thoughts of her own.

Damaged child, Shacktown, Elm Grove, Oklahoma, 1936—I don't know her story, but I'm sure Dorothea did—is a universal symbol of the destruction of a human being by forces beyond her control. She could be a Vietnamese child. She could live next door in almost any town.

Six Tenant Farmers without Farms, Hardman County, Texas, 1938, stand in a row and look solemnly at the photographer. In the companion print, *A Half-Hour Later, Hardman County, Texas,* 1938, the five remaining farmers sit or squat in the same place. The photographer no longer particularly interests them. They made their effort for her half an hour before. Now they have returned to their own sorrow and defeat.

She also told powerful stories about people without showing their faces. The backs of two men, one with his arms folded loosely behind him at his waist, 1935, and one with his hands clasped behind his head pushing his hat forward, 1938, are equally eloquent descriptions of the people and their state of mind.

The *Migratory Cotton Picker, Eloy, Arizona,* 1940, combines hands and face. Only his eyes and nose are visible. His mouth is masked by his left hand displayed palm outward while his right hand clasps a fence rail. He hasn't much money, but his hands will make his living, and he has his strength and dignity.

In the early 40s, Dorothea's eyes began to see the ironies of her world—an abrupt about-face from the earlier complete identification with the people she was photographing. Irony, I think, demands the detachment of an outsider—an onlooker who relates what he sees in front of him to a larger reality that essentially negates the immediate.

In *One Nation Indivisible, San Francisco,* 1942, a Japanese girl pledges allegiance to the flag of a country that is sending her and her family into exile. Two workers in the Richmond Calif., shipyards in 1942, a man and his wife still in their work clothes, wearing hard hats, have shopped for their Easter dinner. The man carries a big bag of groceries and the woman a bag with a potted Easter lily. Few photographs more explicitly point out how the sym-

bolism of a religion has been absorbed into a culture, while its basic precepts have been ignored.

In 1956, *U.S. Highway No. 40, California,* she saw the irony of affluence. Cars and trucks have been discarded in a field beside the highway while on the road above them, a truck and trailer carries new cars and trucks to the consumers.

Most of her later photographs, however, were again devoted to the familiar. In *Spring in Berkeley,* 1951, which she made when she began to photograph again after a long illness, she showed a middle-aged woman spraddled on her walk on a piece of folded awning. The woman wears an old hat and curlers in her hair, and she grubs weeds from her flower bed and jams them into a big egg carton.

In 1956, she photographed the bottom half of a man carrying a paper sack, *Man Stepping from Curb,* a fresh and imaginative view of a completely everyday occurrence. Some of the photographs published in *The American Country Woman,* perfectly ordinary women whom Dorothea photographed with the things that surround them while they talked about their lives, were made in the 50s.

All except one of the photographs in the *Home* section of the exhibit were also made in the 50s—a charming photograph of her son John's arm and hand offering a bunch of daisies was made in 1931. She photographed the big oak trees she could see from the window of her house, and she photographed her husband and children and grandchildren. (pp. 100-01)

Dorothea was an American photographer, and, according to the people I know who worked with her, her conversations with the people she photographed and her understanding of their way of life were as much a part of the print she achieved as the camera or the film.

The Irish photographs are not as perceptive as the American ones, although there is obvious give and take between photographer and people, and I find the Egyptian and Asian prints use the people primarily as elements in a design. But they point up what a splendid designer she was— and I looked at the American prints again to study how she had organized space rather than how she had responded to the world.

These Egyptian and Asian prints also lead us to specific motifs that recur throughout her work. Since we are less emotionally involved in them, we are more aware of form than content. We are aware of the mechanics.

The closely cropped face of the *Korean Child,* 1958, follows *The Public Defender, Alameda County Courthouse, California,* c. 1955-57; the *Crown of Gregor's Head,* 1953; *J. R. Butler, President of the Southern Tenant Farmers Union, Memphis, Tennessee,* 1938; *Hopi Indian, New Mexico,* c. 1923; and an undated portrait of Dorothea's mother.

The concentration on the feet of her subjects in Indonesia, Burma, and Vietnam in 1958 follows the isolation of the feet of the *Man Stepping from Curb,* 1956, and the many feet and long shadows in *End of Shift, Richmond, California,* 1942.

Hand, Indonesian Dancer, Java, 1958, is a beautiful design, but it is not as meaningful as the hands mentioned

earlier, or the hand protecting the face in *Bad Trouble over the Week-End,* 1964, or the outstretched hand of the woman in *Berryessa Valley, Napa County, California,* 1957, or *Paul's Hands,* 1957, or the helpless hands of the *Woman of the High Texas Panhandle,* 1938.

In Egypt, she saw processions—*Procession Bearing Food to the Dead, Upper Egypt,* 1963, and people and bullocks in *Nile Valley,* 1963. But she had earlier seen people in rows—*The Church Is Full, Near Inagh, County Clare,* 1954, and pea pickers from *Near Westley, California,* 1938.

Her repetition of motifs is not a gimmick. She may not have been conscious of it as she made thousands of negatives, and may even have been unaware of it as she edited her prints for the last time.

But it is what gives her work its unique style that sets it apart from the work of other photographers. Her work shows hands as expressive as faces, and faces made more expressive by being combined with hands.

Few photographers have continued Dorothea's work. Many have photographed extraordinary events. There is currently at the Phoenix Gallery in Berkeley a big, sprawling exhibit with prints by many photographers that bursts with the intense spirit of last summer's People's Park confrontation. But few have photographed the familiar—the meaningful, the quiet, the potent—to give new insight into a world where the extraordinary has become commonplace. (p. 101)

> *Margery Mann, "Dorothea Lange," in* Popular Photography, *Vol. 66, No. 3, March, 1970, pp. 84, 99-101.*

Hilton Kramer (essay date 1972)

[*Former longtime art-news editor for the* New York Times, *Kramer edits the monthly journal of art and literature, the* New Criterion, *which he founded in 1982. In the following excerpt from a review written for the* New York Times, *he praises "Executive Order 9066," an exhibition of photographs on wartime Japanese-American internment, giving particular attention to Lange's contributions to the exhibit.*]

Thirty years ago a wartime President who was also a liberal hero—Franklin D. Roosevelt—signed an order condemning 110,000 Japanese-Americans, native-born citizens and aliens alike, to military internment in what have often been described as the first American concentration camps. Now an extraordinary exhibition of documentary photographs recalling this grim episode in public hysteria and the abrogation of Constitutional rights has come to the Whitney Museum of American Art.

Organized by Maisie and Richard Conrat for the California Historical Society, the exhibition is called "Executive Order 9066," and consists of 65 photographs, with explanatory captions. It opened at the Whitney yesterday. Nearly half of the pictures are the work of the late Dorothea Lange, one of the legendary figures in the history of American photojournalism. The result is an exhibition harrowing in its vivid glimpses of Americans suddenly made refugees and prisoners in their own country. It is also an exhibition that reminds one of how powerful the photographic medium has been in recording the political horrors of the modern age. . . .

Although there are some excellent pictures here by Francis Stewart, Clem Albers and others, Miss Lange's work dominates the exhibition. Her pictures of the Japanese internment are, in a sense, a further extension of her work of the thirties in which the victims of a catastrophic social fate are so graphically particularized that we can only with difficulty ever again regard them as belonging to an abstract historical event.

There is nothing either sentimental or ideological in these pictures of children and grandparents tagged for shipment like so many pieces of baggage; of mothers proudly displaying, in their camp quarters, the flags indicating their sons are serving in the armed forces; of the billboard in Richmond, Calif., bearing the message, beside a "for sale" sign, "It takes 8 tons of freight to k.o. 1 Jap." There is only an extraordinary truth.

The documentary function is not the only interest that the art of photography can claim, but it is certainly one of its great functions and Miss Lange was clearly one of the great practitioners of the documentary medium. In the photographs that have been brought together in "Executive Order 9066," she and her colleagues have left us a moving and permanent record of a human and political catastrophe—something that no other medium could have done in quite this way, with quite this effect.

> *Hilton Kramer, " 'Executive Order 9066' of 1942: Whitney Photos Recall Internment of Nisei," in* The New York Times, *September 16, 1972, p. 25.*

Van Deren Coke (essay date 1973)

[*Coke is a respected American photography teacher and writer. In the following excerpt, he illuminates four of Lange's Depression-era photographs and assesses Lange's accomplishment.*]

It is now 40 years since Dorothea Lange made the earliest of her documentary photographs. An entire generation has no recollection of the period she recorded. But through her photographs the symptoms of the Depression are clearly set forth and through them we can better understand the tragic events of those times. She made intimate contact with the victims and therefore was able to catch the deadening effects of the disaster that depopulated parts of mid-America, as well as the South and Southwest. (p. 90)

[*White Angel Breadline, San Francisco,* 1933] demonstrates her ability to give evidence while creating pictures that have remarkable power as artistic statements as well.

During the early years of the Depression there were many breadlines. Lange was making her living at the time as a portrait photographer. As she looked out of her studio window she saw unemployed men walking the streets hunting for jobs or a place to get something to eat. She felt deeply the plight of those men and decided to take her camera into the street to record the feeling of destitution and bitterness she sensed. With economy sympathy, can-

dor, and an eye for a single moment that could sum up a situation, she recorded the alienation effect on men who have to stand in line to be given a bit of food or cup of coffee. She was concerned with the overall social consequences of this means of bare existence but she also created in this case a symbol of an individual's reactions to being forgotten in the jungle of a society that had lost its way.

Three years later she photographed *Migrant Mother, Nipomo, California.* This powerful picture lays bare in straightforward language, the hurts to the spirit suffered by those who were dispossessed. The mother's face is a telling index of the bitterness felt by many women who with children were forced to wander from field to field to get subsistence-level work picking peas or cutting lettuce so as to survive. Lange wrote in her notebook that this particular picture was taken "in a squatters camp at the edge of a pea field. The crop froze that year and the family is destitute. On this morning they had sold the tires from their car to pay for food. She is thirty years old."

In 1938 Lange photographed *Funeral Cortege, End of an Era in a Small Valley Town, California.* This is a quiet image caught by a keen observer. The woman's eye looking out at you through the oval opening somehow stirs universal and deep-rooted sentiments. She seems close and at the same time far away. We sympathize with her after we read the caption and understand what we are seeing, but the intensity of her gaze is somehow disquieting. Her gnarled hand, held uncertainly to her mouth, speaks of the accretions of time. This is as sobering as the shadow cast by the spectre of death.

Lange's *Migratory Cotton Picker, Eloy, Arizona,* 1940, is a stark and dramatic picture. Stamped on the man's hands and face are the effects of working long hours in the bright sun until one's palms and neck become stained and tough as leather. It is notable that in each of these four photographs the individual's hands convey as poignant a message as do their faces and here, as in the other pictures, there is evoked a sense of the thought, running through the mind of her subject. Lange's sensitivity to the moods of the people she photographed explains why she was so successful in catching in truly human terms the feelings of so many men and women without resorting to dramatic devices that would have dissipated the sense of credibility that so characterizes her work.

In addition to the revealing and informative quality in her work, there is another ingredient of utmost importance. This is the unforced interplay of the formal elements she incorporates in her pictures: the foil of black and white passages, the use of a low or high camera position to sim-

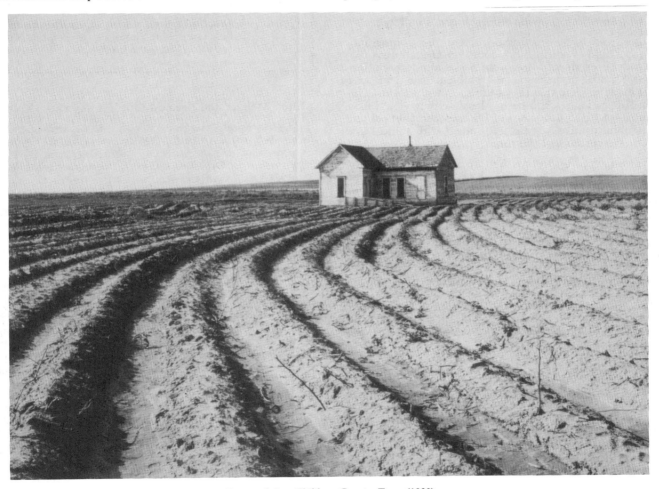

Tractored Out, Childress County, Texas (1938)

plify her compositions or to give emphasis to an element of importance to the meaning of a photograph. Lange was first married to the artist Maynard Dixon and with him traveled extensively through the Southwest where he painted landscapes and the Indians. Probably as the result of this experience she developed an eye for strong compositions. She consistently found ways to isolate the things she wanted us to see on first glance. She also gave thought to the placement of elements of secondary importance that would cause a viewer to return for a second and more searching look.

It was her usual practice when photographing a person to place the individual's head in the center of the picture and to subordinate details on the edges either by selecting an uncluttered background or by slightly burning in elements that would be distracting. In this regard it should be noted that Lange was not a master printer and did not concern herself with achieving rich tonal relationships. She thought in terms of photographs to be reproduced in books, newspapers, magazines, and reports. (pp. 90-5)

Where does Dorothea Lange's work stand in relation to that of other documentary photographers? She stands with the best—Lewis Hine and Robert Frank. Her pictures are as disturbing as those of Lewis Hine's and show as much insight as Robert Frank's. Lange's pictures made during the Depression were meant as an indictment of society just as were Hine's, made in the early years of the century and Frank's made a decade and a half ago.

In addition to being objective documents, her photographs offered a kind of polemical discourse on the failures of society and even though they were personal interpretations and a form of propaganda, the problems she dealt with were made so plain that they were accepted without question. If her pictures had been otherwise they would have been suspect, for her views of life and her political and philosophical ideas were closely allied with radical and subversive currents of the time.

Always marked by feeling, her work before, during the FSA period, and at the beginning of World War II when she resigned a Guggenheim Fellowship to document the harsh removal of all people of Japanese ancestry from the West Coast to inland concentration camps, reflects her genuine concern—concern for people who have suffered one or another kind of discrimination or privation. Because her pictures were always convincing, she succeeded in her aim to sharpen her fellow man's awareness of the sense of dislocation and humiliation suffered by those who stood in bread lines or rode out of the Southwest into California in rickety old cars to labor in the rich fields there, having been forced from thousands of small farms by drought and the low yields of overworked land.

She also caught a feeling of toughness and pride in the face of poverty and backbreaking labor for little reward. Beaumont Newhall noted this in *Dorothea Lange Looks At The American Country Woman.* He wrote, "She found dignity, strength of character, and fortitude in the midst of suffering, and her remarkable ability to capture the human spirit so ennobled her photographs that many of them, though rooted in time and place, are timeless." It is this timelessness that more and more has become apparent with the perspective of over a third of a century behind us.

Lange's pictures of the thirties have endured as important referential documents which help to define a dark period in our history but they are much much much more than a collection of facts of social import. They are symbols of the erosion of a peoples' spirit in a time when nature turned its back on those who tilled the soil. They are also readily accessible metaphors that speak of man's suffering and man's perseverence when faced by a society that no longer has a respected place for a segment of that society.

The somber moods Dorothea Lange caught so graphically on film confirm that photography is a medium of great power not only for the making of vivid documents, but at the same time, is a medium for creating works of enduring aesthetic value. (p. 95)

> *Van Deren Coke, "Dorothea Lange: Compassionate Recorder," in* Modern Photography, *Vol. 37, No. 5, May, 1973, pp. 90-5.*

Lange on photography:

One should really use the camera as though tomorrow he would be stricken blind. Then the camera becomes a beautiful instrument for the purpose of saying to the world in general: "This is the way it is. Look at it! Look at it!"

> *Dorothea Lange, in a quotation from an article in* Popular Photography, *Vol. 58, No. 5, May, 1966, pp. 58, 60.*

Milton Meltzer and Bernard Cole (essay date 1974)

[*Meltzer is an American historian who has written extensively on the African-American experience, the Great Depression, and the history of Jewish Americans. He is the author of* Dorothea Lange: A Photographer's Life *(1978). Cole is an American photography instructor and photographer. He has traveled extensively throughout the Americas documenting stories in the social-medical field for several medical magazines and such organizations as UNICEF and International Planned Parenthood. In the following excerpt, Meltzer and Cole survey much of Lange's career, emphasizing her role in raising the nation's social conscience.*]

In her FSA service Lange learned not to rely on past performances, not to linger in comfortable ruts, not to shy away from strange depths. She had to work in painful heat and cold, in storms of sand and wind. "What am I doing here?" she sometimes asked herself. "What drives me to do this hard thing?" The end of a working day was always a great relief. But at the moment when she was doing her job, when she thought, "Maybe that was all right, maybe that will be it," she knew the greatest satisfaction. What she was doing, wrote author and critic George P. Elliott, "was picturing some of the disgracefully invisible people of our society, making them visible to all with humane eyes to see."

Her pictures, like those of others on the FSA team who would become legends in their own time, *persuaded.* They were seen everywhere—in newspapers, magazines, exhibi-

tions. They made Americans know how unbalanced, how unfair, how wrong, how unjust, their society had become. Edward Steichen, one of the master photographers of the century, called the FSA photographs "the most remarkable human documents ever rendered in pictures." They were photographs, another critic said, that "altered America." As the depression decade came to an end, Pare Lorentz noted in *U. S. Camera 1941* that "if there are transient camps, and better working conditions, and a permanent agency seeking to help migratory workers, Lange . . . and Steinbeck . . . have done more for these tragic nomads than all the politicians of the country."

Perhaps Lange put it best herself. What she was trying to do, she said, was "to say something about the despised, the defeated, the alienated . . . about the crippled, the helpless, the rootless . . . about duress and trouble . . . about the last ditch."

American photojournalism was born in these years of the thirties. *Life* magazine appeared late in 1936, and soon was joined by *Look, Photo, Friday, Picture, Click,* and many others. (pp. 78-9)

But documentary photography, as Dorothea Lange viewed it, developed slowly. Good examples were scarce, she said. "Mostly it's something people love to *talk* about and very few *do*." Why? Because it's hard to do, and it usually pays poorly. People don't demand it. Photojournalism, on the other hand, is quicker and easier to do. It can be superb, she said, but it's not the same as documentary, that kind of picture taking "where you go in over your head, not just up to your neck."

To her the documentary photograph was not simply a factual photograph. Rather it was a picture that carried "the full meaning of the episode or the circumstance or the situation . . . that can only be revealed by a quality the artist responds to." The documentary photographer and the artist—to Dorothea Lange there was no warfare between them. They were one.

She did not define the "quality" she spoke of. Perhaps Roy Stryker came near to what she meant when he wrote:

> Documentary is an approach, not a technic; an affirmation, not a negation. . . . The documentary attitude is not a denial of the plastic elements which must remain essential criteria in any work. It merely gives these elements limitation and direction. Thus composition becomes emphasis, and line sharpness, focus, filtering, mood—all those components included in the dreamy vagueness 'quality'— are made to serve an end: to speak, as eloquently as possible, of the thing to be said in the language of pictures. . . . The question is not what to picture nor what camera to use. Every phase of our time and our surroundings has vital significance and any camera in good repair is an adequate instrument. The job is to know enough about the subject matter to find its significance in itself, and in relation to its surroundings, its time, and its function.

In the winter of 1938-39 Dorothea Lange and Paul Taylor worked on a book called *An American Exodus: A Record of Human Erosion,* which became a classic example of how the documentary image can be wedded to the printed word. Its form emerged from their team effort to make people understand "easily, clearly, and vividly" the exodus from the soil of millions of Americans during the depression decade. They set their theme upon a tripod of photographs, captions, and text. Printed with the pictures were excerpts from talk heard when the photographs were being taken. The reader knows what the people in the photos think, not what the authors guessed might be their unspoken thoughts. The book was published at the end of 1939.

During the next few years Lange took occasional assignments from government agencies other than the FSA. When war with Japan came in December, 1941, over one hundred thousand Japanese-Americans living on the Pacific Coast were forced into internment camps, deprived of their constitutional rights as well as their property. The effect of that collapse in national conscience was photographed by Dorothea Lange on assignment from the War Relocation Authority. Her pictures are documents of the survival of human dignity under the crushing weight of a brutal system. It is ironic that the very authority that carried out the racist policy commissioned the photographs that will never let us forget this national sin. (pp. 79-81)

"Truly great art such as Dorothea Lange's," wrote the critic Allan Temko, "belongs so completely to its own time that it transcends time, and belongs to all civilization to come. The underlying principle of classic art of course is not simply permanence, for many worthless things are relatively longlasting. Its main principle is intrinsic excellence. And such excellence rests not on technique, although every great artist is necessarily a great technician—and Dorothea was one of the finest. Such excellence is the resultant of spiritual and intellectual insight which leads the artists to discover—where others do not seek even to find—new truths in the cause of man." (p. 81)

> *Milton Meltzer and Bernard Cole, "Dorothea Lange," in their* The Eye of Conscience: Photographers and Social Change, *Follett Publishing Company, 1974, pp. 68-91.*

Hank O'Neal (essay date 1976)

[*In the following excerpt, O'Neal offers a favorable assessment of Lange's achievement.*]

Dorothea Lange was the supreme humanist in the FSA program. Other photographers on the staff, notably [Ben] Shahn, had the ability to produce photographs that revealed the character of people and made moving visual statements about the human condition, but no one did it with such regularity and compassion as Lange. Her ability to sense a situation, work with her subjects and produce striking visual images was a talent that very few photographers ever possess and she may very well have been at the height of her powers during the years 1935-40. She appears to have been a person whose talents were asserted in their finest fashion when genuinely moved by conditions of human need and suffering; when she felt her talents might in some way relieve the despair she observed in others. Lange saw these conditions around her in the decade prior to World War II and in that period she produced some of the most moving photographs of that or any other time. (p. 77)

> *Hank O'Neal, "Dorothea Lange," in his* A Vi-

sion Shared: A Classic Portrait of America and Its People, 1935-1943, *St. Martin's Press, 1976, pp. 75-114.*

Robert Coles (essay date 1982)

[*Coles is recognized as one of the leading authorities on the issues of poverty and racial discrimination in the United States. He has devoted much of his life to studying the effects of poverty on young children and has spent many years observing the psychiatric aspects of school desegregation in the South. Coles is best known for his five-volume study of children in various stressful situations,* Children of Crisis *(1967-78). In the following excerpt, he assesses the quality and importance of Lange's work.*]

Dorothea Lange is one of those rare but recurrent figures in a particular American tradition—the artist drawn to the lives of people otherwise unknown, to places seldom visited, to experiences many would prefer left neglected. Such artists have characteristics uniquely their own, not the least of which is a kind of hobo spirit, a companionable feeling for the down and out. Such artists produce texts or pictures that pulse with moral passion, awakening our own connection to the individuals who are their subjects. Such artists go exactly to the moment, exactly to the situation; they create images or works which acquire a measure of universality. The transcendent power of that work, of course, has to do with the observer's artistic gifts.

Lange was an exceptional photographer before—and often a brilliant one after—the great Depression. Those chaotic years, the vastness of the event, called forth something more in her. Today her images retain their emotional vitality, their faithfulness to the experience, long after the subjects, the circumstance, and the photographer herself have passed from the scene. There are few who possess the intuitive sense necessary for accurate social observation—the identification of the remark, the image, the situation that tells the greater story. There are very few indeed who combine with this capacity the personal vision and developed gifts of the artist. Among Lange's colleagues on the now legendary photography staff of the Farm Security Administration (FSA), there were such artists: Walker Evans and Russell Lee. That fearsome decade of the thirties also kindled the genius waiting in writers such as John Steinbeck, John Dos Passos, and Clifford Odets. They belong to a lineage that stretches back to Mathew Brady and Walt Whitman and forward to Robert Frank and Jack Kerouac, chroniclers of American manners and mores in the fifties. They are more precious than we might imagine, these artist-observers, in the unfolding experience of our society. (p. 8)

Looking back, the Farm Security Administration (FSA) photography seems like an unlikely, utterly fortunate accident. It emerged in the heady shuffle and reshuffle of government agencies as Franklin D. Roosevelt's New Deal plunged into the task of reviving a shattered economy. Organized under Roy E. Stryker, who also was a relatively unlikely yet happy choice, the FSA Historical Section, as it was formally known, managed to amass more than 250,000 negatives in seven years—an unparalleled chronicle of national change. (p. 18)

[Lange's *Migrant Mother*] became the best-known photo-graph made by Stryker's group, one of the most widely reproduced and exhibited images in history. Many years later, writing the introductory essay for the Lange retrospective in The Museum of Modern Art, George P. Elliott grasped, as few have, the magic of such a photograph:

> *Migrant Mother* is famous because key people, editors and so on, themselves finding it inexhaustibly rich, have urged the rest of the world to look at it. This picture, like a few others of a few other photographers, leads a life of its own. That is, it is widely accepted as a work of art with its own message rather than its maker's; far more people know the picture than know who made it. There is a sense in which a photographer's apotheosis is to become as anonymous as his camera. For an artist like Dorothea Lange who does not primarily aim to make photographs that are ends in themselves, the making of a great, perfect, anonymous photograph is a trick of grace, about which she can do little beyond making herself available for that gift of grace.
>
> (p. 20)

Dorothea Lange's accomplishments during those five short years with the FSA are so evident today, so much a part of our national consciousness of the era, that we may well lose sight of how original her contribution was. Her photographs marshaled public sympathy for a necessary relief program. Her photographs persuaded a reluctant Congressional committee to vote funds for that program. Those photographs were part of what is called the documentary tradition. Lange did not need such terms, though; she simply wanted to see and hear, to render and evoke, to transmit, arouse, and record. (p. 25)

The call of sympathy, empathy—yes, to political activism—was a reasonable one fifty years ago, and still is today. A photographer has every right to heed a particular expedition's imperatives: show the hurt and sorrow; show the waste of human resources; show the plain scandal of people treated unjustly, meanly by other people.

The issue is not one of accuracy as against distortion—at least of the deliberate, mischievous variety. The black people who figure in *An American Exodus* are extremely hard-pressed men and women, and their misery is no fictive matter, no mirage conjured by a camera at the beck and call of a Washington, D.C., bureaucrat, anxious to stay on the federal payroll. The same goes for the Oklahoma and Texas farm and small-town people whom Lange caught (I believe) in all their complex relationship to the Midwestern land, never a completely reliable provider, due to the unpredictability of the weather. In the best of her pictures, individuals appear harrassed, yet determined; humbled, yet proud; uncertain, yet quite clear about what series of misfortunes have happened, what (hope against hope) must happen, if complete disaster is to be avoided. In other words, life's contradictions and inconsistencies, so acutely perceived by the black Mississippi sharecropper, have a way of demanding their due, no matter the particular, honorable intent of an observer who was quite properly horrified at the sight of human loss, at the sight of a community's "erosion"; and who was anxious to portray such a development so that others would know and be inclined to act. (pp. 28-9)

Lange deftly solved the problem of intellectual predisposition and prejudice. She knew the literature of her subject matter—the government investigations, the political

speeches, the regional histories, the economic and social surveys. Her habit was always to research after the fact, after the photographic expedition. She dismissed the practice lightly, saying her reading was simply "to see if my instincts were right." They were instincts of considerable sophistication. She spoke often of the need for blankness, the value of the receptive eye in photography. First came the image, then the research that interlocked the intricate features of the history she was recording. Obviously this is the closest anyone can approach to objectivity. Less obvious is the rarity of such practice, the passion for comprehensive understanding, particularly among photographers who often sacrifice breadth and profundity, in the name of visual purity. (p. 31)

For the best of reasons, the FSA wanted Lange's help in educating a nation—teaching its citizen voters what was wrong, sorely wrong, with an economy, by showing them how much wretchedness had suddenly come upon an advanced industrial nation. Yet her American people, her American land, her barns and stores and road scenes attest to a vitality, a perseverance, a willfulness; one can even find "beauty" in all that injury and perplexity— strong, handsome faces, vigorous bodies, attractive buildings, a grace and grandeur to the countryside, even its ailing parts. An artist has asserted herself, it can be said—no matter a strong interest in polemical statement, in argumentative portrayal. In her later, international work the same tension persists: Lange as the pained observer, herself reasonably well off, yet terribly cognizant of, responsive to the difficult situation of so many others; yet, Lange as the visual observer, the person whose sensibilities are extremely broad, and whose representational faculties are awake, energetic, stubborn, and refined. In Ireland, in Nepal, in Egypt, in Korea she saw extreme poverty. She also saw objects to admire; scenes to record in all their striking charm or symmetry; faces of men, women, and children whose dignity, whose inviting loveliness simply could not be denied or overlooked. (p. 36)

It is fitting in connection with Lange's work to reflect on William Carlos Williams and Walt Whitman, even on those decidedly aristocratic, wonderfully astute observers of America, Alexis de Tocqueville and Henry James. The last of these may have summarized it all—what any of us who try to do "documentary studies" can only hope to do with a small quota of his brilliantly penetrating success: "The manners, the manners," his terse mandate of what must be seen, what must be set down for others to see. Whitman was more celebratory, less dispassionate. Williams was a fiery enthusiast, a mordant critic, if not vigorous combatant. The French visitor de Tocqueville was less literary than James, more systematic in his elegant, nineteenth-century prophesy not only of America's coming history, but a new division of intellectual activity—the so-called social sciences. Lange reveals elements of all those observers in her work. In the Jamesian tradition, she can concentrate on the distinctive appearance of a woman's neck, on the complementary splendor of two shoes, on the extended power of a particular barn's sloping roof. She can roam America, follow its various roads, large and small, marvel at the variety and robustness of our people—in the tradition of Whitman: a gentle and loving, but also a tough, willful, and resourceful traveler, determined to return home with productive, inspiring memories. She can shake her fists—as Williams used to do—at the stupid-

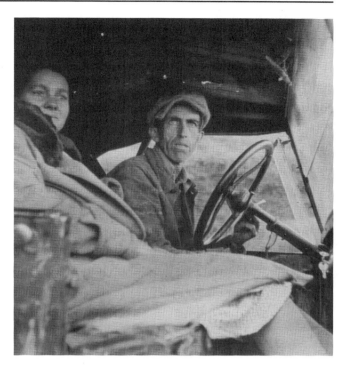

Ditched, Stalled, and Stranded, San Joaquin Valley, California (1935)

ity of so many, the needless injuries to people who deserve better; and like him, she can summon a redemptive, celebratory music in response to what she has seen others experience, and through them, herself experienced. She can even be the careful analytic student de Tocqueville was— those hands she gives us, those tools, those clothes, those signs; in sum, those physical aspects of existence that reveal so much about a given people's aspirations and difficulties.

Dorothea Lange was finally another restless visionary artist, using film to make the point novelists and poets and painters and photographers and sculptors all keep trying to make: I am here; I hear and see; I will take what my senses offer my brain and with all my might offer others something they can see or hear, and doing so, be informed, be startled, be moved to awe and wonder, be entertained, be rescued from the banality, the dreary silliness this world, inevitably, presses upon us. She failed at times; failed personally, as she herself acknowledged, when she discussed the many leaves of absence from her home, her young children; failed artistically, when she lapsed into the photographer's version of coyness, rhetorical overstatement, repetitive posturing. But she succeeded repeatedly—gave us our rock-bottom selves a clear and trenchant portrait of any number of this earth's twentieth-century people. (p. 43)

> *Robert Coles, in an essay in* Photographs of a Lifetime *by Dorothea Lange, Aperture, Inc., 1982, pp. 8-43.*

James C. Curtis (essay date 1986)

[*Curtis is an American historian. In the following ex-*

cerpt, he describes the composition of Lange's Migrant Mother *series, focusing on Lange's artistic manipulation of her subjects in order to portray their plight most powerfully.*]

On a cold, rainy afternoon in March 1936 a government photographer named Dorothea Lange made a brief visit to a camp of migrant pea pickers near Nipomo, California. She took a series of pictures of a thirty-two-year-old woman seated under a makeshift tent with her children. One of these images soon became known as **Migrant Mother** and has been called the most famous documentary photograph of the 1930s. (p. 1)

Lost in the appreciation of **Migrant Mother** as a timeless work of art is its personal and cultural genesis. Like many documentary photographers, Lange thought of herself as a clinical observer committed to a direct, unmanipulated recording of contemporary events. On the door of her darkroom, she displayed the following quotation from Francis Bacon:

> The contemplation of things as they are
> Without substitution or imposture
> Without error or confusion
> Is in itself a nobler thing
> Than a whole harvest of invention.

Lange believed that to stray from this credo was to record only one's preconceptions; to her this was "false" and limiting. Yet the power of Lange's work came directly from her own personal values and from her heartfelt need to communicate with her contemporaries in terms that they would understand. While not inventions, the exposures Lange took on that chilly and damp March afternoon reveal more about the photographer and her audience than about the life of Migrant Mother.

This is not to argue that Lange broke faith with the documentary tradition, but only that our understanding of that tradition is somewhat limited. Recent definitions of documentary photography have concentrated on the act of taking pictures and the bearing a photographer's motives had on that decisive moment: honesty, directness, a lack of manipulation—these qualities distinguish the work of documentarians who are often regarded as sociologists with cameras. However insightful and persuasive this line of argument is, it obscures the artistic ambitions of influential figures like Lange and Walker Evans. They knew from experience that nobility of purpose and commitment to human betterment were not guarantees of success. They had to produce images of technical distinction and aesthetic merit in order to communicate effectively with their audience. (pp. 1-2)

In addition to being a timeless work of art, **Migrant Mother** is a vital reflection of the times. Examined in its original context, the series reveals powerful cultural forces of the 1930s: the impact of the increasing centralization and bureaucratization of American life; the anxiety about the status and solidarity of the family in an era of urbanization and modernization; a need to atone for the guilt induced by the destruction of cherished ideals, and a craving for reassurance that democratic traditions would stand the test of modern times. (p. 2)

"I saw and approached the hungry and desperate mother, as if drawn by a magnet," the photographer would later say of her most famous assignment. "I do not remember how I explained my presence or my camera" but moved "closer and closer from the same direction." In her approach to the tent, Lange took a series of pictures, the last of which is a closeup of Migrant Mother and three of her children. Lange did not arrive at this final composition by accident, but by patient experimentation with various poses. The images in the series comment on each other and represent a logical progression and development of subject matter. Internal evidence in each provides important information on Lange's choice of symbolism and the values she sought to communicate. As a group, the images provide a revealing commentary on middle-class attitudes toward the family.

Lange, her biographers, and scholars of documentary photography have described the **Migrant Mother** series as consisting of the five photographs that she submitted to Stryker and that are now located in the FSA collection in the Library of Congress. Lange took an additional picture that she withheld from the government most probably for aesthetic reasons. This long shot appears to be the first in the series, probably taken as soon as Lange had unloaded her camera equipment from her car. By comparison with the five known exposures, it is a rather chaotic image, lacking control and a central focus. The teenage girl, seated in a rocking chair inside the tent, is turned away from the camera. One of her younger siblings stands nearby, looking at Lange but crying and making a motion with her hand that blurs the image. Migrant Mother is close to being crowded out of the frame; she, too, is looking away from the camera, and her posture all but obscures the fourth child. It would appear that Lange took this as a trial picture, to introduce her subjects to the photographic process and to ease them into the posing and arrangement that a portrait session required.

The trial succeeded, for in the next image the family has rearranged itself and now fits more comfortably into Lange's viewfinder. Migrant Mother looks toward the camera, as do her younger daughters, who stand, somewhat stiffly, to her right. The teenage girl poses in a stylized fashion in the rocking chair, which has been moved from inside the tent and now occupies the foreground of the picture. While better composed and more neatly arranged than her first picture, this second photograph contains confusing elements. In her caption for this photograph, Lange says that this was a "Migrant agricultural worker's family. Seven hungry children and their mother aged 32. The father is a native Californian." Although Lange conversed enough with her subject to learn that Migrant Mother's husband was a "native Californian" and thus even more deserving of relief funds than a newly arrived "Okie," she probed no further into the reasons for his absence or that of the other three children. Perhaps it was a press for time, perhaps a reluctance to learn more than she cared to know. What if the father had abandoned the family?

The father's conspicuous absence served several useful purposes. Viewers could easily presume that he was working or at least looking for work. Either interpretation highlighted the consequential cost to the remainder of the family unit. (pp. 4-5)

In the **Migrant Mother** series, the father is missing from all the pictures; indeed, Lange's shots do not even include

all the children. Three of the seven are missing. Where they were that cold March day is impossible to say. Even if they were nearby, it is quite possible that Lange chose not to include them in her photographs. Five figures posed enough of an obstacle to intimacy; one of the youngsters in the tent was smiling, thereby negating the aura of desperation the family's plight evoked. (p. 5)

Although focusing on the family and shaping it to manageable size, the two long shots contained unwanted elements. Technically the teenage daughter was almost old enough to be self-sufficient. Her presence in the photographs presented awkward questions as to when Migrant Mother began bearing children. Was she a teenager herself when she gave birth to her first child? Having already produced more children than she and her husband could support, would she enlarge her family yet again? While middle-class viewers were sympathetically disposed to the needs of impoverished children, teenagers posed thorny questions of personal responsibility. . . .

Lange's third photograph eliminated the teenager. For this, Lange moved closer to the tent, focusing on the powerful bond between the mother and her infant. Apparently she asked the two small children to step aside so that she could feature the act of breast-feeding. Since neither of the first two photographs shows Migrant Mother nursing her child, it is possible that the photographer arranged this candid scene. With the decision to make an explicit record of this intimate nurturance, Lange related her composition to a cherished icon of Western art: the Virgin Mary in humble surroundings. Indeed, ***Migrant Mother*** is often called *Migrant Madonna*. (p. 9)

Experience, not modesty, pushed Lange to search for more subtle variations of the Madonna theme. Even as her shutter released, she sensed a flaw in her composition. She had captured an intimate moment in Migrant Mother's life, one rich with symbolic potential, yet the woman's facial expression, the key ingredient in a revealing portrait, was all wrong. Migrant Mother looked downward, as if wishing to shield herself from the scrutiny of the camera. Lange knew this defense mechanism, having used it herself as a teenager in the streets of New York: "If I don't want anybody to see me," she later claimed, "I can make the kind of face so eyes go off me." (p. 11)

Had Lange been able to elicit a more expressive facial gesture, one indicative of sorrow or anxiety, her portrait of the nursing mother would have succeeded. Instead, Lange had triggered what she would call that "self-protective thing." Because she sensed that she was invading her subject's privacy and was causing discomfort, Lange used her fourth shot to regain cooperation and recruited the children to help to overcome their mother's reserve.

She incorporated children into the close-up with some misgivings. Although preteenagers had long been used by documentarians to symbolize the sufferings of the dispossessed, Lange had limited experience making children's portraits. If she spent time taking pictures of her two sons, she chose not to exhibit these images in her own lifetime, and only a few have appeared in the several biographies published since her death in 1965. Her previous photographs of California's migrants concentrated on adults and their problems.

Despite her lack of experience with children as models,

Lange managed in the next few minutes to elicit the complete cooperation of her young subjects. Moving slightly closer, she asked one of the young daughters to return to the tent and to stand resting her chin on her mother's shoulder. While awkward, this posture immobilized the girl's head, thereby reducing the chance that any sudden motion might spoil the picture. The young girl removed her hat so as not to obscure her facial features. The fading afternoon light fell on her tousled hair. Where she had been smiling at the photographer in the second picture, she now looked down and away from the camera.

The facial expressions of both mother and daughter were now acceptable, but Lange decided she could do better. She repeated the composition with critical modifications. Lange moved slightly to her left and switched from a horizontal to a vertical format. This allowed her to center her subjects in the frame, give them ample headroom, and present them against the backdrop of the tent canvas. The tent post no longer obscured part of the infant's head. This new perspective also enabled Lange to eliminate the piles of dirty clothes so visible in her third composition. Given the option, she preferred to excise such details and the suggestions they intruded. The public might be less sympathetic to migrants who could not even pick up their personal belongings. But if set against a spare backdrop, a migrant family could become a stirring symbol of deprivation and discipline and lay great claim to public support. Lange certainly did not go so far as her colleague Evans to avoid including dirt and disorder, yet she shared with him a determination to present her subjects as dignified human beings, struggling to surmount the consequences of society's neglect.

The vertical format also permitted Lange to feature the trunk and the empty pie tin, each a powerful symbol of the migrant condition. The well-worn trunk which runs at an angle into the frame provided clear evidence that this was a family on the move, forced by circumstances to leave home and to take to the road. (pp. 11-13)

More alarming than such signs of uprooting were those of starvation in a country renowned for the self-sufficiency of its agrarian populace and the plenty of its land. The bare pie tin on the corner of the trunk called attention to Migrant Mother's plight more forcefully than did the phrase "Seven hungry children without food" that Lange later used in the caption for the fifth image in the series. Lange's artistry made verbal descriptions superfluous. In this composition, she turned the portrait tradition on its head. Where affluent sitters posed amid artifacts attesting to their status and economic achievements, Migrant Mother was surrounded by objects mutely testifying to her poverty. The stained tent canvas, the kerosene lamp, the battered trunk, the empty plate—each suggested yet another dimension of poverty.

Lange's positioning of her subjects was no less accomplished than her focus on surrounding detail. She sensed the enormous power that lay in the contrast between the dignity of this family and the deprivation of its circumstances. To achieve this, she crafted a formal pose, a striking departure from the candid effect associated with most documentary photographs. She directed the daughter to shift position slightly; to rest her head on her mother's shoulder, not to peer awkwardly over it; to reach out and grasp the tent post so that her delicate hand came into full

view of the camera; and then to look wistfully into the distance.

The arrangement succeeded brilliantly, combining and enriching the religious and familial themes that Lange had pursued from the outset of the series. Her composition could easily fit into a long-standing tradition in Western art where the Madonna and Christ child were surrounded by young angelic figures whose innocence and devotion to Mary bespoke divine grace. (p. 14)

In her fifth composition, Lange employs a pose that suggests the affectionate bonding that sociologists considered characteristic of the modern urban family. The daughter displays a familiarity and a fondness by resting both her head and her hand on her mother's shoulder. These loving gestures, at once dependent and supportive, contrast markedly with the presentation of the rural family in literature and art of the Great Depression. Erskine Caldwell's *Tobacco Road* (1932) shocked readers with its lurid account of the Lesters who were a family in name only. The oppressions of southern tenantry had destroyed familial feeling as surely as they had ravaged the soil. (p. 16)

Rich in symbolism and brilliantly composed, Lange's fifth image did not quite measure up to her most expressive studio work. Migrant Mother's reserve continued to be the main obstacle to intimacy. Throughout the brief photographic session, she had held the same posture, her body rigid, her face impassive as if recoiling from the camera's lens. In all these pictures her hands are clasped to support and keep her infant son near the soothing sounds of her heartbeat. Lange was reluctant to alter this arrangement for fear that the child might awaken and spoil her composition. Yet she knew that the mother's facial expression was the key to a powerful photograph. Lange moved closer, hoping that her subject would cooperate in one final picture. A beautiful metamorphosis occurred in the next few moments. Migrant Mother surrendered herself to Lange's expert direction, striking a pose that would burn itself into the memory of American culture.

Lange worked swiftly with a confidence bolstered by her successful incorporation of the young child in the two previous frames. She balanced her composition by summoning the other small child to stand to Migrant Mother's right. Lange had the youngsters place their heads on their mother's shoulders but turn their backs to the camera. In this way Lange avoided any problem of competing countenances and any exchanged glances that might produce unwanted effects. She was free to concentrate exclusively on her main subject. Again Migrant Mother looks away from the camera, but this time she is directed by Lange to bring her right hand to her face. This simple gesture unlocked all the potential that Lange had sensed when she first approached the tent.

In the studio and in the field, Lange had developed a keen sensitivity to the expressive potential of body language, especially the importance of hand placement. Two previous and highly acclaimed documentary images feature details similar to the gesture that Lange was incorporating in the final frame of the series. *White Angel Breadline* (1933) shows an unemployed male, in the midst of a relief crowd, leaning on a wooden railing, his arms encircling an empty tin cup. The man's hands are clasped so that he resembles a communicant at the altar rail. Lange's message was ob-

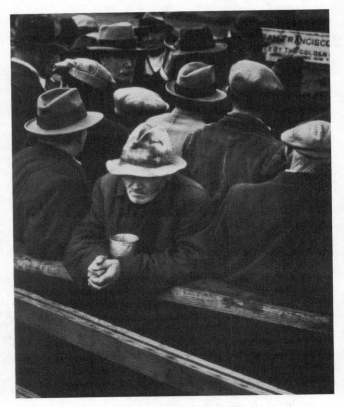

White Angel Breadline (1933)

vious, as it was the following year in her portrait of a San Francisco policeman standing in front of a crowd of strikers. The power of the constabulary is evident from the repose of the folded hands against the man's uniform with its gleaming buttons and badge. What makes this presumption of authority so powerful is the position of the policeman: his back is turned to the protestors. In both these pictures Lange had taken swift advantage of chance encounters with her subjects. "You know there are moments such as these when time stands still," she was moved to remark in looking back at *White Angel Breadline* thirty years later, "and all you do is hold your breath and hope it will wait for you."

The exposure of the final frame in the **Migrant Mother** series was not such a moment. Instead Lange had seized control of the situation in an effort to create the type of portrait her sensibility perceived. The hand framing the face, calling attention to Migrant Mother's feelings, breaking down her reserve, was the critical element lacking in the previous exposures. (p. 17)

Ironically, Lange's control over her subject is confirmed by another gesture—an unwanted element that escaped the photographer's attention in the field but that later in the darkroom would emerge as a "glaring defect." In bringing her right hand to her face, Migrant Mother apparently feared that she would lose support for her sleeping infant, and so she reached out with her left hand to grasp the tent post. Her thumb intruded into the foreground of the image.

Caught up in the excitement of what she knew was an ex-

traordinary photographic session, Lange failed to notice this intrusion. Within days of her return to San Francisco, she rushed several prints from the series to the *News* where they illustrated a wire-service story of hunger in the frost-destroyed pea fields. . . . By 1941 the picture had become a recognized documentary masterpiece and was enshrined in the Museum of Modern Art. While preparing her print for permanent exhibit, Lange was haunted by the disembodied thumb in the foreground of the negative. Over objections from Roy Stryker, Lange directed a darkroom assistant to retouch the negative and eliminate this aesthetic flaw. Having worked so hard to overcome her subject's defensiveness, having converted her to a willing and expressive model, Lange did not want a small detail to mar the accomplishment.

This alteration removed Migrant Mother further from the realm of reality toward that of universal symbolism. This transformation had begun with the required suppression of the subject's individuality so that she could become an archetypal representative of the values shared by Lange's middle-class audience. Lange never recorded Migrant Mother's name, eliminated her older daughter from all but the first posed photograph in the series, moved the young children in and out of the scene, and directed her subject's every gesture. Then in the darkroom she removed the last traces of the one instinctual motion that Migrant Mother made. Aesthetic liability though it proved to be, this gesture gave clear evidence that Migrant Mother's highest priority remained the support of her family and that posing for a government photographer was a secondary concern. (pp. 17-20)

James C. Curtis, "Dorothea Lange, Migrant Mother, and the Culture of the Great Depression," in Winterthur Portfolio, *Vol. 21, No. 1, Spring, 1986, pp. 1-20.*

FURTHER READING

I. Interviews

Deschin, Jacob. " 'This Is the Way It Is—Look at It! Look at It!'—Dorothea Lange, 1895-1965" *Popular Photography* 58, No. 5 (May 1966): 58, 60.
 Interview with Lange in which she speaks at length on the need for government-sponsored photographic surveys of the United States every 15 years.

II. Bibliographies

Dixon, Penelope. "Dorothea Lange." In her *Photographers of the Farm Security Administration: An Annotated Bibliography, 1930-1980,* pp. 53-71. New York & London: Garland Publishing, 1983.
 An extensive catalogue of books and articles by and about Lange, as well as films about and interviews with her. The bibliography is prefaced by a short biographical sketch.

III. Biographies

Meltzer, Milton. *Dorothea Lange: A Photographer's Life.* New York: Farrar Straus Giroux, 1978, 399 p.
 Comprehensive biography based in part on Lange's own letters and journals.

IV. Critical Studies and Reviews

Deschin, Jacob. "Lange and Conrat—A Relationship of Conflict but Great Productivity." *Popular Photography* 70, No. 6 (June 1972): 32, 38.
 Interview with Richard Conrat, Lange's darkroom assistant from 1963 to 1965. Conrat details the at-times prickly working relationship with Lange and assesses her accomplishment.

Smith, W. Eugene. "One Whom I Admire, Dorothea Lange (1895-1965)." *Popular Photography* 58, No. 2 (February 1966): 86-8.
 Enthusiastic panegyric of Lange's life and example.

Szarkowski, John. "Dorothea Lange: American, 1895-1965." In his *Looking at Photographs: 100 Pictures from the Collection of the Museum of Modern Art,* pp. 130-31. New York: Museum of Modern Art, 1973.
 Commentary upon Lange's use of natural light and gesture to add power to her photographs, with special reference to the 1938 photograph, *Back.*

Taylor, Paul. "Migrant Mother: 1936." *The American West* VII, No. 3 (May 1970): 41-5.
 Background of Lange's initial involvement with the Resettlement Administration. Taylor, Lange's husband, also describes the effect of Lange's work—especially *Migrant Mother*—upon the Administration's decision to provide relief to California's migrant workers.

Tucker, Anne. "Dorothea Lange: 1895-1965." In *The Woman's Eye,* edited by Anne Tucker, pp. 61-75. New York: Alfred A. Knopf, 1973.
 Biographical essay accompanied by a selection of eight photographs.

V. Selected Sources of Reproductions

Aperture. *Dorothea Lange.* Millerton, N.Y.: Aperture, 1981, 93 p.
 Includes a concise biographical essay by Christopher Cox, with some criticism of Lange's early studio work as well as *Migrant Mother.*

Lange, Dorothea. *Dorothea Lange.* New York: Museum of Modern Art, 1966, 112 p.
 Full-page reproductions of the 91 photographs exhibited at the Museum of Modern Art in 1966. The collection includes an introduction by George P. Elliott.

———. *Dorothea Lange Looks at the American Country Woman.* Fort Worth: Amon Carter Museum; Los Angeles: Ward Ritchie Press, 1967, 72 p.
 Posthumously published collection of 28 photographs taken between the mid-1930s and the mid-1950s. These illustrations of American women include captions by Lange and commentary by Beaumont Newhall.

Lange, Dorothea, and Mitchell, Margaretta K. *To a Cabin.* New York: Grossman Publishers, 1973, 128 p.
 Selected photographs from Lange's last years, depicting the artist's cabin, its surroundings, and her grandchildren. These 43 photographs are accompanied by Lange's own notes on her subjects and text by Mitchell.

Lange, Dorothea, and Taylor, Paul Schuster. *An American Exodus: A Record of Human Erosion.* New York: Reynal & Hitchcock, 1939, 158 p.

Pictorial record of the mass uprooting and emigration of Americans from the South and Midwest to California from 1937 through 1939. Interspersed with commentary by Taylor, this collection includes ninety-three photographs by Lange.

René Magritte

1898-1967

Belgian painter.

Magritte is considered one of the most important representatives of Surrealism in the visual arts. Conceived immediately after World War I, Surrealism was a seminal movement in art and literature initiated by French essayist and poet André Breton and dedicated to exploring irrational, paranormal, and subconscious aspects of the human mind. Magritte's art reflected the basic premises of Surrealism in its disavowal of traditional representation for a new pictorial vision based on the synthesis of conscious and unconscious reality. With regard to the sophistication of his art, Magritte is often compared unfavorably to other Surrealists, such as Yves Tanguy and Salvador Dalí. However, the intellectual rigor and imaginative depth of his paintings earned him the esteem of the leading authors and painters of the international Surrealist movement.

Magritte was born in 1898 in the Belgian town of Lessines in the province of Hainault. His father, Léopold, was apparently involved in buying and selling real estate, while his mother, Adeline Bertichamps, had been a milliner. During Magritte's youth, the family travelled frequently, moving to Gilly in 1902 and then to Châtelet. During this time, Magritte spent his holidays in Soignies with his grandmother and his aunt. It was in Soignies that his interest in painting was sparked while playing in the old cemetery, where an artist at work struck Magritte as "performing magic." Magritte enrolled in his first painting course in Châtelet in 1910. His carefree childhood abruptly ended on 12 March 1912, however, when his mother, who suffered from a recurring mental illness, committed suicide by throwing herself in the Sambre river. The following year, Magritte's father moved the family to Charleroi, where Magritte spent three years studying the humanities. His real interest, however, remained art, and from 1916 to 1918 he studied painting at the Académie des Beaux-Arts in Brussels. Magritte soon rebelled against the academicism of his instructors, and in 1918 he began associating with the nascent artistic and intellectual avantgarde in Brussels and Paris, who introduced him to the Cubist, Futurist, and Surrealist styles. Magritte's work from this period (1918-1922), such as *Three Women* (1922), was derivative of the Cubo-Futurist tradition. In 1922, Magritte married Georgette Berger, whom he had originally met in 1913 at a fair in Charleroi. Following his marriage, he took a job designing wallpaper for the firm of Peeters-Lacroix in Haren and later became a painter of commercial posters. However, he continued his involvement in the Surrealist movement in Belgium, becoming friendly with, among others, the noted poet and composer E. L. T. Mesens. Magritte's stylistic breakthrough occurred around 1923, when he was shown a reproduction of a painting by Giorgio de Chirico, *The Song of Love* (1914), in which such disparate objects as a classical bust and a rubber glove are juxtaposed in a formal, oneiric setting, and painted in false perspective. Magritte quickly assimilated de Chirico's poetic, metaphysical approach to

the composition of pictorial space, asserting that this painter "was the first to dream of *what must be painted* and not *how to paint.*" In 1925, Magritte completed *The Lost Jockey,* which he considered his first "surrealist" painting. However, *The Threatened Assassin* (1926), a more complex narrative composition, is usually cited as his first truly individual work.

Magritte moved to Perreux-sur-Marne, a suburb of Paris, in 1927, and there he became acquainted with Breton, Paul Eluard, Joan Miró, and Salvador Dalí. He stayed in Perreux for three years, completing a series of paintings that evidenced a sharper thematic focus than his previous work. In the *False Mirror* (1928), for instance, Magritte depicted a greatly magnified eye, the iris of which mirrors a cloud-flecked sky; the image of the painting suggests the ambiguous relationship between the perceiving subject and the object of perception. *Discovery* (1927) and *Gigantic Day* (1928), on the other hand, connote through bizarre metamorphosis of the female figure a brutal, Freudian sexuality, while *The Lovers* (1928), depicting the heads of a couple shrouded in sheets, is thought to refer to the grim circumstances of Magritte's mother's death. Finally, in *The Use of Words I* (1928-29), an apparently straightforward rendering of a pipe captioned with the ironic state-

ment "ceci n'est pas une pipe" ("this is not a pipe"), Magritte questioned the semiotic relation between pictorial and linguistic representation, a concern he addressed throughout his career.

In 1930, Magritte quarrelled with Breton and other members of the Parisian Surrealists and returned to Brussels, where he renewed contact with the Belgian Surrealists. Except for occasional visits to France, Holland, England, and the United States, Magritte remained in his native country for the rest of his life. Throughout the 1930s, Magritte continued to work in the Surrealist idiom. In *The Key of Dreams* (1930), for example, compartmentalized objects designated by inappropriate names brought up once again the problem of language and "significance." *The Human Condition I* (1934), in which a painting on an easel represents precisely that part of the landscape obscured by the canvas, reiterated Magritte's fascination with the confrontation between real space and pictorial illusion. Other works from the period display the persistent Surrealist obsession with the oneiric and the irrational, such as *The Red Model* (1935), which depicts a pair of boots metamorphosing into feet, and *Collective Invention* (1935), in which a reclining female figure terminates in the head of a fish, a witty inversion of the myth of the mermaid. Also of note are *The Therapeutist* (1937), one of Magritte's most iconographically complex paintings, and *Time Transfixed* (1939), which portrays a scaled-down locomotive emerging from a staid bourgeois mantelpiece.

Following the German occupation of Belgium in May 1940, Magritte inexplicably abandoned his now established style for Impressionism, painting mainly nudes and still lifes in the manner of Renoir as an ironic commentary on the miseries of the war. In 1947, he also worked in the Fauvist style of Matisse, though only for two weeks. After these relatively brief experiments, Magritte returned to his characteristic style, often referred to as "Magic Realism" for its extremely literal rendering of everyday objects. His imagery, if less original or provocative than his earlier work, retained its characteristic wit and incisiveness. In his parody of Jacques-Louis David's *Madame Récamier* (1949) and Edouard Manet's *Le balcon* (1951), for instance, he replaced the human figures with coffins. Critics generally assert, however, that his finest work of this period was *The Empire of Light* series, in which elements of day and night were observed simultaneously, challenging conventional perceptions of time. By the 1950s, Magritte's reputation in his own country was such that he was commissioned to design eight murals for the grand salon of the Casino of Knokke-le-Zoute. He also designed murals for the Palais des Beaux-Arts in Charleroi in 1957 and for the Palais des Congrès in Brussels four years later. Magritte's painting continued to evolve in the 1960s. In paintings such as *Infinite Gratitude* (1963) and *The Great War* (1964), he elaborated on the figure of the "bowler-hatted man," who was frequently projected onto a surreal landscape or dematerialized in the guise of absurdist, Dada-like collages. Critics frequently compared his work in this vein to Pop Art, an analogy he fervently rejected. Magritte continued painting until his death in August 1967, by which time he had achieved international recognition.

While art historians frequently acknowledge Magritte's limitations as a painter, citing in particular his lack of stylistic development and repetitive iconography, other commentators point out that the conceptual and philosophical emphasis of his work requires a different set of critical values. As his American biographer Suzi Gablik explains: "The meaning of [Magritte's] paintings does not reside in any literary explanation or interpretation which can be offered. They are the evidence, however, of a philosophical temperament which was continually investigating and analyzing the structure of our common-sense beliefs and struggling to reconcile the paradoxes of existence."

ARTIST'S STATEMENTS

René Magritte (letter date 1959)

[*In the following letter to a friend, Magritte explains the psychological process that led to his discovery of the "image" represented in* La durée poignardée (Time Transfixed).]

The question you ask concerning the conception of the painting **La durée poignardée** (**Time Transfixed** doesn't seem to be a very accurate translation) can be given an exact answer insofar as *what I was thinking of*. As for trying to explain *why* I thought of painting the image of a locomotive and *why* I was convinced this painting should be executed, I cannot know nor do I wish to know. Even the most ingenious psychological explanations would have validity only with regard to a "possible" interest in an understanding of an intellectual activity that posits relationships between what is thought and what has nothing to do with thought. Thus, I decided to paint the image of a locomotive. Starting from that possibility, the problem presented itself as follows: how to paint this image so that it would evoke mystery—that is, the mystery to which we are forbidden to give a meaning, lest we utter naïve or scientific absurdities; mystery *that has no meaning* but that must not be confused with the "non-sense" that madmen who are trying hard to be funny find so gratifying.

The image of a locomotive is *immediately* familiar; its mystery is not perceived.

In order for its mystery to be evoked, another *immediately* familiar image without mystery—the image of a dining room fireplace—was joined with the image of the locomotive (thus I did not join a familiar image with a so-called mysterious image such as a Martian, an angel, a dragon, or some other creature erroneously thought of as "mysterious." In fact, there are neither *mysterious* nor unmysterious creatures. The power of thought is demonstrated by unveiling or evoking the mystery in creatures that seem familiar to us [out of error or habit]).

I thought of joining the locomotive image with the image of a dining room fireplace in a moment of "presence of mind." By that I mean the moment of lucidity *that no method can bring forth*. Only the power of thought manifests itself at this time. We can be proud of this power, feel proud or excited that it exists. Nonetheless, we do not count for anything, but are limited to witnessing the manifestation of thought. When I say "I thought of joining,

etc., . . . " exactitude demands that I say "presence of mind exerted itself and showed me how the image of a locomotive should be shown so that this presence of mind would be apparent." Archimedes' "Eureka!" is an example of the mind's unpredictable presence.

The word *idea* is not the most *precise* designation for what I thought when I united a locomotive and a fireplace. *I didn't have an idea; I only thought of an image.*

The power of thought or "presence of mind" manifests itself in different ways:

—For the painter, thought becomes manifest in *images* (for the exacting painter, and not the painter who has "ideas" or who "expresses" his "sublime" emotions).

—For Bergson, thought manifests itself in *ideas.*

—For Proust, it manifests itself in *words.*

I am very exacting, and in conceiving a painting I avoid "ideas" or "expressing emotions." Only an image can satisfy these demands.

La durée poignardée is only an image. Because of that it testifies to the power of thought—to a certain extent. While looking at this painting, you think of Bergson and Proust. That does me honor and demonstrates that an image *limited strictly to its character as an image* proves the power of thought just as much as Bergson's *ideas* or Proust's *words. After* the image has been painted, we can think of the relation it may bear to ideas or words. This is not improper, since images, ideas, and words are *different* interpretations of the *same* thing: thought.

However, in order to state what is *truly necessary* about an image, one must refer exclusively to that image. . . . (pp. 81-2)

P.S.—The title *La durée poignardée* is itself an image (in words) joined to a painted image.

The word *durée* was chosen for its poetic truth—a truth gained from the union of this word with the painted image—and not for a generalized philosophical sense or a Bergsonian sense in particular. (p. 82)

> *René Magritte, in a letter to Hornick on May 8, 1959, in* Magritte: Ideas and Images *by Harry Torczyner, translated by Richard Miller, Harry N. Abrams, Inc., Publishers, 1977, pp. 81-2.*

René Magritte (essay date 1960)

[*In the following statement originally published in the exhibition catalogue* René Magritte in America *(1960), Magritte explains his conception of "resemblance" and its relation to the art of painting, including his own work.*]

Resemblance—as the word is used in everyday language—is attributed to things that have or do not have qualities in common. People say "they resemble each other like two drops of water," and they say just as easily that the imitation resembles the original. This so-called resemblance consists of relationships of similarity and is distinguished by the mind, which examines, evaluates, and compares. Such mental processes are carried out without being aware of anything other than possible similarities. To this awareness things reveal only their similar qualities.

Resemblance is part of the essential mental process: that of resembling. Thought "resembles" by becoming what the world presents to it, and by restoring what it has been offered to the mystery without which there would be no possibility of either world or thought. Inspiration is the result of the emergence of resemblance.

The art of painting—when not construed as a relatively harmless hoax—can neither expound ideas nor express emotions. The image of a weeping face does not express sorrow, nor does it articulate the idea of sorrow: ideas and emotions have no visible form.

I particularly like this idea that my paintings *say nothing.* (Neither, by the way, do other paintings.)

There is a mistaken idea about painting that is very widespread—namely, that painting has the power to express emotion, something of which it is certainly incapable. Emotions do not have any concrete form that could be reproduced in paint.

It is possible that one may be moved while looking at a painting, but to deduce by this that the picture "expresses" that emotion is like saying that, for example, a cake "expresses" the ideas and emotions of those of us who see it or eat it, or again, that the cake "expresses" the thoughts of the chef while baking a good cake. (To the man who asked me, "Which is the picture that 'expresses' joy?" I could only answer "The one that gives you joy to see.")

The art of painting—which actually should be called the art of resemblance—enables us to describe in painting a thought that has the potential of becoming visible. This thought includes only those images the world offers: people, curtains, weapons, stars, solids, inscriptions, etc. Resemblance spontaneously unites these figures in an order that immediately evokes mystery.

The description of such a thought need not be original. Originality or fantasy would only add weakness and poverty. The precision and charm of an image of resemblance depend on the resemblance, and not on some imaginative manner of describing it.

"How to paint" the description of the resemblance must be strictly confined to spreading colors on a surface in such a way that their effective aspect recedes and allows the image of resemblance to emerge.

An image of resemblance shows all that there is, *namely, a group of figures that implies nothing.* To try to interpret—in order to exercise some supposed freedom—is to misunderstand an inspired image and to substitute for it a gratuitous interpretation, which, in turn, can become the subject of an endless series of superfluous interpretations.

An image is not to be confused with any aspect of the world or with anything tangible. The image of bread and jam is obviously not edible, and by the same token taking a piece of bread and jam and showing it in an exhibition of paintings in no way alters its effective aspect. It would be absurd to believe [this appearance] capable of giving rise to the description of any thought whatsoever. The same may be said in passing to be true of paint spread

about or thrown on a canvas, whether for pleasure or for some private purpose.

An image of resemblance never results from the illustration of a "subject," whether banal or extraordinary, nor from the expression of an idea or an emotion. *Inspiration gives the painter what must be painted:* that resemblance that is a thought capable of becoming visible through painting—for example, an idea the component terms of which are a piece of bread and jam and the inscription, "This is not bread and jam"; or further, an idea composed of a nocturnal landscape beneath a sunlit sky. De jure such images suggest mystery, whereas de facto the mystery would be suggested only by the slice of bread and jam or the nocturnal scene under a starry sky.

However, all images that contradict "commonsense" do not necessarily evoke mystery de jure. Contradiction can only arise from a manner of thought whose vitality depends on the possibility of contradiction. Inspiration has nothing to do with either bad or good will. Resemblance is an inspired thought that cares neither about naïveté nor sophistication. Reason and absurdity are necessarily its opposites.

It is with words that titles are given to images. But these words cease being familiar or strange once they have aptly named the images of resemblance. Inspiration is necessary to say them or hear them. (pp. 132-33)

> *René Magritte, in an excerpt from* Magritte: The True Art of Painting *by Harry Torczyner, with the collaboration of Bella Bessard, translated by Richard Miller, Thames and Hudson, 1979, pp. 132-33.*

René Magritte with Paul Waldo Schwartz (interview date 1967)

[*In the following interview, Magritte discusses his theory of painting, focusing on the relationship between image—"the description of an inspired thought"—and reality.*]

In June of 1967, René Magritte told me that the invisible is a dimension inconsistent with painting, by nature the art of the visible. Two months later, the Paris daily *France-Soir* proclaimed, 'René Magritte is dead; he was the master of the invisible'.

On which side of the mirror did Magritte function? His words, in this regard, resisted penetration. . . .

The rue des Acacias, where [Magritte] lived and worked in Brussels, came as a curious shock; a long bourgeois façade of trim brick and careful chintz. It was a human labyrinth reduced to the immobility of still-life. Immobility describes unreality, and here was the world of Magritte's *Golconda,* even without paradox, dissonance or surreal innuendo.

Magritte's house intensified this feeling. The cut-glass vases and sofas and knick-knacks were doubtless repeated in succession the length of the street. An insistent order pressed to the point of irritation. Magritte chain-smoked but the ashtrays seemed to remain empty. His silver cravat matched his silver hair; dressed in a black suit he moved about with the diffidence of a banker. The studio upstairs

was scarcely a studio in the usual sense but the den of the same banker who paints on Sunday. One corner of the neat little room, the part near its only window, contained an easel—with a blank canvas—and a palette encrusted with the blues and whites and silvers of Magritte's spectral skies.

Downstairs, Magritte sat beneath his paintings. He sat dead in the middle of the sofa, which only added to a surfeit of symmetry, and said that 'There are so many kinds of painting that when someone says the word painting I hardly know what he means.'

But you've spoken of a kind of painting that surpasses the idea of a physical surface.

'Yes, well, I'll tell you first of all what I understand painting to be. Painting is the art of juxtaposing colours in space in such a way that the effective aspect of the colour disappears to allow for the description of an inspired thought. This description is an image that one can see. Thus, a description of the thought is poetry, and poetry means the creation of something—the image that one paints. . . . That is what I take painting to be.'

But in general painters detest the word description, even the description of an idea.

'Yes, but I don't describe an idea. I describe a thought which contains only visible figurations, and that can be described. If the thought contained ideas I would not be able to paint them.'

The phrase *la pensée inspirée* was repeated incessantly in Magritte's conversation as obliquely and hermetically as the most tantalizing of his images. 'It is fundamental,' he said, 'that according to my conception, only the visible can be shown in a painting.'

But it can also suggest?

'Yes, it can suggest, but then there is no precision. What can a mountain suggest? Weight? Height? Well, I don't know.'

The spectre of a bird, perhaps?

'No!' Magritte became adamant. 'It does not suggest a bird. One sees! It doesn't suggest, it's there, it's precise. One sees a bird in the form of a mountain. It's precise. In the end, the images that I paint are explicit, they hide nothing, because an image is intangible. Visible things always hide other visible things, but an intangible image can hide nothing.'

And yet, there are symbols concealed in the image?

'There are *no* symbols in my painting. What is a symbol? It's a conventional figuration which is sensed, represented, an idea. But poetry and reality surpass the symbol.'

Still, there are certain themes in your work which repeat in an obsessional pattern.

'But there are no themes at all. I can't say because I always see the sky, the birds, houses, that these are themes. These are realities, not themes. A theme is a subject that one treats in a certain way, but I have no subjects in my paintings. I have to discover the subject, and the things which permit me to discover a subject are the figurations of the visible. That's very different and, as for me, I have no artis-

tic aptitude. I am not a painter in the sense one generally means, one for whom painting consists just in putting beautiful colours on a canvas to make something beautiful for the eyes.'

But these visible figurations, juxtaposed, describe a personal universe.

'Not juxtaposed—united. It's the colours that are juxtaposed. But the forms are united by the poetic thought. I don't believe that a universe can be personal; one would go mad. But what I think is in question in my painting is the universal. It's the real world, that of reality, and not myself, that comes into question. It's not myself because I am not interesting. I don't have interesting ideas to communicate with people, nor extraordinary sentiments. I am a man who is altogether—if the word means something—normal, ordinary. I only see the things everybody sees, the sky, the trees, the mountain. I don't see invisible things like people who have had visions.'

But the unity of visible forms produces a mystery that questions the real.

'Ah now, the mystery is there because a poetic image has a reality. Because 'the inspired thought' imagines an order that unites the figures of the visible, the poetic image has the same genre of reality as that of the universe. Why? Because it ought to respond to an interest we naturally have in the unknown. When one thinks "universe" it's the unknown one thinks of—its reality is unknown. Which is why, when one sees a poetic image, one poses questions. Thus, I make—with known things—the unknown.'

Throughout, the terms *la pensée poétique* and *la pensée inspirée* resisted explanation. The conversation switched to books, and Magritte's answers were surprising. Surely Magritte would feel some affinity to the work of his fellow-Belgian Michel de Ghelderode, author of *The Chronicles of Hell,* who wrote, 'Have you ever come across your image already present in an old mirror?' Or, again, 'One has seen objects seeking to do one ill . . . and Hieronymus Bosch has depicted very well for us the inscrutable, redoubtable world of things.' Or, even, 'I discovered the world of shapes before discovering the world of ideas.'

'I don't know about Ghelderode,' Magritte said. 'I've seen his plays and they bored me.' Yet Ghelderode dealt with the appearance of the invisible in the visible, the shadow of the invisible.

'It's obvious that the invisible surrounds us. For example, we are surrounded by what they call Matter. And this Matter is invisible. I have never seen Matter. One sees objects which have appearance and they are said to be made of Matter. This table is made of wood. I see wood. . . .'

But not the archetype?

'Ah, that's something else. That belongs to a theory of knowledge, Plato's. But I don't go along there. I think as though no one had thought before me. I am not a philosopher, not a metaphysician. I paint images that are not indifferent. They are not indifferent because they are poetic. I harness myself to that and it seems quite a sufficient programme for me. I don't know how to do anything else. . . . Realism is something vulgar, ordinary, but for me reality is not easily attained. And that's why I say sur-

realist to mean this reality we perceive at certain privileged moments when we have presence of mind.' (p. 74)

Paul Waldo Schwartz and René Magritte, in an interview in Studio International, *Vol. 177, No. 908, February, 1969, pp. 74-5.*

INTRODUCTORY OVERVIEW

William S. Rubin (essay date 1968)

[*Rubin is a distinguished American art historian and the writer of a series of well-regarded studies on modern art. His works on Surrealism include* Dada, Surrealism, and Their Heritage *and* Dada and Surrealist Art, *both published in 1968. In the following excerpt from the latter work, Rubin appraises Magritte's overall achievement as an artist, identifying the principal motifs of his paintings as well as their primary philosophical and aesthetic intentions.*]

In 1922 Magritte and [his friend E. L. T.] Mesens were shown a reproduction of de Chirico's *The Song of Love* in *Les cahiers libres.* The picture so moved them that they sought out copies of *Valori Plastici,* in which they were able to see many more of de Chirico's paintings. This experience, and that of Ernst's proto-Surrealist imagery of 1922, not only subsequently changed the course of Magritte's art, it also led Mesens to abandon music for painting. It is of special interest that *The Song of Love,* the first de Chirico these Belgian artists saw, was particularly distinguished by the simplicity of its juxtapositions, which created an image [that has] . . . the force of Lautréamont's evocation of the sewing machine and umbrella on a dissection table. Magritte would later allude to this de Chirico in a picture titled **Memory,** which in a like manner isolates the head of an antique sculpture in an architectural setting. In the Magritte, the white-marble head bears a bleeding wound, possibly a reference to Lautréamont's famous *"tache de sangue intellectuel"* ["intellectual bloodstain"].

Paintings in this new Chiricoesque style were exhibited in 1927 in Magritte's first one-man show, at the Galerie Le Centaur in Brussels. Neither the public nor the critics took much notice, but the show did serve to bring Magritte close to a small Surrealist group that had already been formed in Belgium under the leadership of Paul Nougé and Camille Goemans (later the founder of a Surrealist-oriented gallery). That August, Magritte moved to Perreux-sur-Marne just outside Paris and came in touch with Eluard and Breton. During the three years he lived in France, his work was exhibited by the Surrealists, and "from that time on," Breton observed, "he was a main prop of Surrealism."

From the earliest of his de Chirico-influenced pictures, executed during the winter of 1925-26, through the paintings of 1928, Magritte's mood, expressed in dominants of gray, brown, and black, is more somber than in his later work. *The Conqueror* (1925) incipiently establishes the perspective space and modeled forms out of which his illusionism

is to be created, along with the use of *trompe-l'oeil* collage. Here we confront the upper torso of a man in evening dress, whose head has been replaced by a wood panel; behind this figure is a landscape of dunes above which floats an uprooted tree trunk.

This "levitation" of objects, one of Magritte's most familiar themes, is also present in *The Great Voyages* (1926), where the torso of a woman floats above a mountainous landscape. Inside the outlines of her legs, as though on a screen, appears the precise image of a factory town. To this "transparency," destined to remain another recurrent Magritte theme, *The Great Voyages* added a third motif (purged from his art by 1928): the biomorphic, or free, form. The arm of the floating woman in *The Great Voyages* ceases to be associated with human anatomy and becomes ambiguous and indeterminate, changing at its extremity into a tree. Such "fusion" of images will also be seen later in Magritte, but as in *The Red Model* (1935), where boots fuse into feet, and *The Explanation* (1952), which witnesses a Freudian fusion of a carrot and a bottle, the later mergings take place without the agency of ambiguous, abstract, or invented shapes.

Another characteristic Magritte motif, the picture-within-a-picture, is already established in 1926 in *Wife of the Phantom.* This device (which would influence Dali) derives from de Chirico, not from the motif as we see it in *Grand Metaphysical Interior* but rather from *The Double Dream of Spring,* where the illusion of the picture within the picture is shown ambiguously as being continuous with the illusion of the painting's space as a whole. Magritte's *Wife of the Phantom* shows an easel supporting a picture frame (whose biomorphic "bone style" is a mark of its early date), but we cannot be sure whether or not the frame contains a separate picture, since the landscape vista inside it is continuous with the whole landscape background of the painting. This same kind of ambiguity is sharpened in such later pictures as *The Beautiful Captive* (1931) and *The Human Condition, I* (1934).

Another device of enigmatic description anticipated by Redon, de Chirico, and Ernst is the unexpected disparity of scale by which the horse and rider of *The Lost Jockey* (1937) shrink to minuscule size, while the toilet articles of *Personal Values* (1952) expand to gargantuan proportions. . . . (pp. 199-205)

Using the ambiguous picture-within-a-picture, Magritte drew attention to his definition of painting as something other than the objective reality it represents. A realistically descriptive style like his runs the risk of having the painted image understood merely as a substitute for the object itself. Magritte rightly insisted, however, that his art goes beyond the creation of illusions of objects in combinations that might in principle exist on the same plane of reality as combined Readymades (like Duchamp's *Why Not Sneeze?*). For Magritte the art of painting consisted in representing images. But though the image is made up of illusions of objects (or even of a single object), the conversion of these *objects* into the state of *images* transforms their meaning. "An object," Magritte asserted, "never serves the same function as its image—or its name." The painted image of a hat releases signals of far different meaning than the hat itself or the word *hat;* "there is little relation between an object and that which it represents."

The transformation results from representing the object on a flat, delimited surface—that is, *as an image;* and this must be entirely independent, Magritte insisted, from the enhancements of color, impasto, or other painterly devices. Indeed, all displays of pure painting can only harm the purity of the image, "the precision and charm of which depends upon the resemblance—and not on the imaginative manner of depicting it. . . . 'How to Paint' depends solely on spreading the colors over the surface in such a way that their actual aspect recedes and lets the 'image of resemblance' emerge." Magritte's picture-within-a-picture reminds us that we are looking not at reality but at painting, and it does so by equating the two pictures. Were we really to see the landscape image in *The Human Condition, I* against its real "life" source, there would be no confusion.

Nowhere has Magritte made the enigma of the image clearer than in his famous *The Wind and the Song* (1928-29), which is a straightforward image of a smoker's pipe under which is written (in French): "This is not a pipe." The first thing understood here is that this is not a real pipe, because it is an image of a pipe; the next is that this is not a *pipe,* because that word has a nature foreign to the image of a pipe. But if the image of a pipe is not to be associated with the word *pipe,* it may, nevertheless, give off signals leading to other words. Therefore, in *Key of Dreams* the isolated objects have written titles below them which bear no rational relation to the image: a drinking glass is "the storm," a hammer "the desert," a man's hat "the snow." For Magritte these names go with the images in the sense that they respond to the image signals. In *Key of Dreams,* which is consciously arranged to suggest the illustrations of a grade-school primer, we are made to feel that our accepted and cherished sense of the relation between words and images has been undermined.

Like the written legends of *Key of Dreams,* which constitute titles for the imaged objects, the titles for the pictures as a whole were arrived at through association after the finishing of the painting, usually by Magritte himself but not infrequently, according to Paul Nougé, by friends in sympathy with his art. "The titles of my paintings accompany them," said Magritte, "in the same way that names correspond to objects, without illustrating or explaining them."

What distinguishes Magritte's painting from "literature" is the essential estrangement of his images from the language that would ordinarily be used to identify the objects that are images; *what his pictures present cannot be verbalized.* His painting is not "literature"; what it is, Magritte assures us, is a form of poetry, his images being metaphors, not constituents of narration. But while their processes are analogous to poetry, Magritte's images are not translations of verbal configurations. On the contrary, Magritte insisted that to understand "poetry-in-painting" is to perceive that an inspired image is "an idea capable of becoming visible only through painting" and is in its nature as inseparable from a visual image as the idea of a poem is from a verbal one. The art of painting thus becomes "the art of describing thought that lends itself to being made visible, thus to evoke the mystery of the experience."

Magritte conceived of the affective image as "inspired visual thought." Sometimes such images present themselves

to the artist complete in all their parts and relationships. But often he has to explore and experiment before all the elements fall into satisfactory relations with one another to form the *image juste*. This exploration may occur in the mind, but more frequently it takes place in a series of sketches, a kind of free-associational iconographic improvisation in which objects absent from the original conception may force their way into the image. An interesting insight into this aspect of Magritte's procedure is revealed in a letter he wrote to a friend, the young American art writer Suzi Gablik, describing the origins of his recent painting ***Hegel's Holiday*** [see excerpt dated 1970]. This picture began with speculation on a glass of water: how to show it in a revelatory manner "with genius." "I began by drawing many glasses of water," Magritte wrote, "always with a linear mark on the glass." After a great many drawings, "this mark widened out and finally took the form of an umbrella. The umbrella was then placed inside the glass and, finally, underneath it. Which is the exact solution to the initial question: how to paint a glass of water with genius. I then thought that Hegel (another genius) would be very sensitive to this object. . . . He would have been delighted, I think, or amused (as on vacation) and I called the painting ***Hegel's Holiday.***"

Critics of Magritte's art, following the painter's own lead, have been content to locate his genius solely in the power of his images, without reference to his compositional structures or his style. But I believe this does him some injustice. For, more than most other "precisionist" styles, Magritte's maintains a considerable *standard of abstraction,* and the degree to which this obtains is easily measured by comparing Magritte's manner with that of Dali, the abundance of whose closely modeled detail reveals a style like that of the fussiest Pre-Raphaelite. A good deal of Magritte's appeal lies, therefore, in the area of the purely esthetic: the compositional breadth, the massive contrasts of solids and voids, the economy of means. Even his most poetically compelling images would be considerably less satisfactory pictorially if treated in Dali's much tighter style. This is implicitly recognized by that sector of art opinion devoted to abstract art insofar as it accords Magritte a tolerance not shown to Dali, or even to Tanguy. Moreover, the effect of compositional—as distinguished from iconographic—factors on the quality of Magritte's art can be gauged by comparing different versions he has made of the same iconographic idea. I refer here to his variants, not his replicas. In these variants, despite little or no change in iconography, we find a considerable range in the impact of the pictures resulting from purely compositional differences. The various versions of ***Memory*** and ***Delusion of Grandeur*** are cases in point.

Magritte's stay in Paris coincided with the end of what I have called the "heroic period" of Surrealist painting. . . . By 1930, when he left France for England (in 1931, he returned to Brussels, remaining until his death in 1967), Magritte had witnessed the redefinition of Surrealism in Breton's second manifesto and the apotheosis of the young Dali as the paragon of Surrealist artists. Except for the years of World War II during which he executed his personal imagery in bright colors and with Impressionistic brushwork—he soon renounced this—his painting did not alter stylistically, though he constantly enlarged the range of his iconography, usually within the framework of the conventions developed in the paintings of the late twenties and thirties described above. (pp. 205-09)

William S. Rubin, "The Resurgence of Illusionism: Tanguy and Magritte," in his Dada and Surrealist Art, *Harry N. Abrams, Inc., Publishers, 1968, pp. 194-209.*

SURVEY OF CRITICISM

André Breton (essay date 1964)

[*Breton was a French poet, prose writer, and critic who is best known as the founder of Surrealism. One of the most influential artistic schools of the twentieth century, the Surrealist movement began in 1924 with Breton's* Manifeste du surréalisme. *Strongly influenced by the psychoanalytic theories of Sigmund Freud, the poetry of Arthur Rimbaud, and the post-World War I movement of Dada, Breton proposed radical changes in both the theory and methods of literature. He considered reason and logic to be repressive functions of the conscious mind and sought to draw upon the subconscious through the use of automatic writing, a literary technique closely related to the psychoanalytic technique of free association. Breton's theories, however, reached far beyond the realm of literature; he considered Surrealist art a means of liberating one's consciousness from societal, moral, and religious constraints, thereby enriching and intensifying the experience of life. In the following essay, originally published in 1964, Breton affirms Magritte's capacity for conflating the realms of conscious and subconscious reality in his paintings.*]

For centuries now mankind has contented itself with distinguishing two modes of cognition (or faculties of thought), namely cognition of *relative reality* through sensory perception and cognition of *absolute reality* by means of abstract thought serving the purposes of philosophy, art and love. We are indebted to the philosopher Constantin Brunner for having at last, in our times, established the inadequacy of this method of approach which takes little account of a third faculty, of fundamental importance and necessity, that he christens ANALOGON. Brunner shows that this analogon, or *fictionalism,* which he defines as 'superstitious thought' in the sense that it takes as object 'relativity converted into the absolute, in other words the fictitious absolute' (governing religion, metaphysics and ethics), may compound, as the third faculty of thought, with either of the two others but never with both at the same time. Brunner's elevation of this third element to a dominant status in the general mental structure of human beings coincides remarkably with contemporary predispositions and demands.

An extremely penetrating and important restatement of this question, in the field of art rather than of philosophy, by Dore Ashton, must be considered equally cogent in relation to contemporary anxiety and the very definite gains which this prevailing uneasiness can achieve. She writes: 'The artist who believes that he can maintain the "original

status" of an object deludes himself. The character of the human imagination is expansive and allegorical. You cannot "think" an object for more than an instant without the mind's shifting. . . . Not an overcoat, not a bottle dryer, not a Coca-Cola bottle can resist the onslaught of the imagination. Metaphor is as natural to the imagination as saliva is to the tongue.'

A fairly extensive interference fringe unites these two fields of speculation, and it is this fringe which René Magritte has set himself the task of exploring during the past forty years; the only one to do so with absolute strictness—a task which rewards us all (and him as well) with ever-increasing pleasure. His half-open half-closed eyes, endowed with perfect visual acuity, have been uniquely capable of tracking down and then being guided by the precise moment when the oneiric image topples over in the waking state and when, too, the waking image collapses at the doors of sleep. Are we not foolish to alienate ourselves from familiar, everyday objects by confining them strictly to their utilitarian functions? Yet if we consider a different category of reference there is no doubt at all that it is such objects which in most cases go to make up the symbolic structure constituting the dream's framework, as psychoanalysis has demonstrated fairly conclusively. Magritte's supreme originality has been to bring his investigations and his intervention to bear at the level of these, in a sense, primary objects, and of their sites (rural, wooded, cloudy, maritime or mountainous) which loom large and with such immense power behind the simple image conjured up by our first 'object-lessons' (indeed, whenever I think about Magritte it is always these last two words that spring to my mind). But it is precisely at this level, too, that Magritte, while caressing with his hand those elements deriving intensely from *relative reality,* able also to liberate with 'a single wave of his magic wand' (in the literal sense of the phrase, before it becomes vulgarized as we grow up) the latent energies smouldering within them. In fact he has, of course, occasionally permitted himself the luxury of performing his magical act, with an appropriate hint of humour, in front of our eyes, as in his celebrated paintings **The Red Model** (1936) and **The Explanation** (1951). Everywhere else the visually meticulous and carefully delineated material elements jettison their weight as they declare their independence of the humble tasks we expect of them. They act as *decoy-birds* and their whole function is to lure from cover what Magritte calls the 'visible poetic images'. Their point of egress is none other than that canvas resting on an easel, besides which he occasionally depicts himself standing, a canvas with clearly outlined borders but whose surface has been reduced by the intensity of its inner flame to total transparency (one cannot fail to think of Mallarmé's 'virgin paper'). Magritte has given to several versions of this painting the title **The Beautiful Captive (La belle captive),** a marvellously apt description, for no 'captive' could be more desirable than she who strips naked in full mystery, fulfilling a process which in its final stage is as hidden from the watching eye as is the moment of the chrysalis's mutation. Magritte is the first artist to have reckoned his *vanishing point* in relation to the humblest of objects (in agreement with Dore Ashton's precepts) and to have wanted to embrace everything to be found on the other side. He has thus placed himself in an ideal position to put into play *as a shuttle* Constantin Brunner's analogon between the 'relative reality' furnished by the senses and the 'absolute reality' sought

by the mind's imagination. These two alternating movements, designed to control and balance each other, seem to me to signalize *La condition humaine* (*Man's fate*) in the most essential meaning of those words. Magritte has himself used this title for one of his paintings, and so reaffirmed their significance by the very fact of his choice.

René Magritte's work and thought could not fail to emerge at the very antipodes of that zone of easy alternatives—and refusal of responsibility—which we recognize under the name of 'chiaroscuro'. The task inevitably fell to him of separating the 'tenuous' from the 'dense', without which operation no transmutation is possible. He must have had to call upon all his reserves of audaciousness to tackle the twin problems of extracting the essential light from the shadow and, at the same time, the essential shadow from the light (as in **The Empire of Lights,** 1952). The overthrow of accepted ideas and conventions is so complete, the moment we feel the heavenly bodies within our reach, that, as René Magritte has assured me, most of those who pass by quickly believe that they have seen the stars in the day-sky.

Magritte's whole approach culminates in what Apollinaire has called 'genuine common sense, meaning the sense common to the greatest poets'. (pp. 72-3)

André Breton, "Magritte's Breadth of Vision," translated by Simon Watson Taylor, in Studio International, *Vol. 177, No. 908, February, 1969, pp. 68-73.*

The Empire of Lights (1952)

Max Kozloff (essay date 1966)

[*Kozloff is a highly esteemed art critic and author and the winner of a Pulitzer Prize for his art criticism published in the* Nation *magazine. His book-length studies include, among others,* Photography and Fascination *(1979) and* The Privileged Eye *(1987). In the following excerpt, first published in the* Nation *January 10, 1966, Kozloff praises the conceptual and aesthetic innovations of Magritte's work, arguing that it stands apart from orthodox Surrealism.*]

As recently as five years ago I had resigned myself to a mere fondness for the art of René Magritte. His deadpan pranks in paint, such as the choo-choo steaming out from beneath the mantle, tickled a genuine, if self-indulgent, wonder. But it was not the regressiveness of my taste for seeing impossible things that held back respect. Rather, it was the absence of any striving for the impossible in his *way* of seeing them—which is to say that the transparent means by which he visualized his images were academic, or at least appeared to be academic.

And now, after Johns and Pop art, after the *chosisme* of Robbe-Grillet and the illusionist theories of Ernst Gombrich, there seems something not only more cagey and owlish in Magritte but more profound and liberating as well. The enigmas he set out "to picture" have backfired into the substance and meaning of that "picturing"—that is, the representational process itself. . . . (pp. 114-15)

Practically everything within Magritte's extremely diversified output can be summarized by the word "contradiction." If one does not understand that objects or conditions are deliberately opposed to each other, one understands nothing. The village sleeps in deadest night and the sky unpretentiously glows with the day in *The Empire of Light.* These are hard, unalterable facts. Of course, there are different values of contradiction and of understanding. Conversely, there are also different aspects of intention and overall significance. What so frequently happens in Magritte is that a self-evident idea-puzzle conceals a subtle epistemological jolt. Understanding has here to be a little tactless, a little analytical.

Perhaps the least arresting of his procedures is initially the most shocking: metamorphosis. Nothing by now could be more banal than fish-headed humans, shoe feet, and burning tubas. Such mutations or miracles, long a stock in trade of fantastic art, are arch when they are not romantic. And Magritte, with his factual style and suburban outlook, tends not to be a romantic.

But the discrepancy between metamorphosis and *displacement* gratifies the curiosity in a more demanding way. Perhaps the most celebrated of his canvases is *The False Mirror* (1928), an enormous eye whose iris has been replaced by the sky and whose pupil becomes a black sun. Instead of rapidly adjusting to slick plastic surgery—the sort of thing so tasteless in Dali—the spectator here oscillates between the sensation of looking through, and of being observed by, an aperture; or of being simultaneously inside and outside an interior. Spatially it is a clever enough *double-entendre,* but intellectually it succinctly illuminates Magritte's diabolical open-endedness. The mind and the eye are false mirrors of reality, echoing nothingness between themselves. And yet, they are the only organs of perception we have. Although he rightly disclaims using

symbols, here is symbolism of a kind—and the real chimera of his vision.

From *The False Mirror* to *The Human Condition I* (1934), the most archetypal of his ideas, one takes only a short step. A view of a landscape from a window is almost blocked out by a canvas on an easel depicting that same landscape. Yet, with huge coincidence, "painted" and "real" nature turn out to be identical. The contradiction here consists in *not* showing the difference one expects. There is a tradition in modern art of painting pictures within pictures. Whether the contained is in the same style as the container is relatively unimportant if the overall style—that is, the particular subjugation of the outer world—is established. But Magritte's transparency, his apparent *stylelessness* gives this scene a disturbing plausibility. By showing that there is no difference between "fact" and "representation," he undermines both. *The Human Condition* is an epiphany of artifice. No matter how objective, the artist is doomed to paint only what pre-exists in his mind. Yet, if sensory data happen to concur with mental prejudice—and in Magritte nothing is accidental—then the idea of the imagination itself is a figment. It goes a long way to explain the still-point, or perhaps the still-life, aspect of Magritte's art, that everything one knows is at the same time self-canceling and affirming. Painting, considered simply as a process of "making" images and "matching" them with observed "reality"—in Gombrich's terms—becomes an infinitely mysterious business.

As if to ward off those who would insist on making distinctions of quality within that mystery, Magritte reiterates that he is not interested in painting. This is his ultimate contradiction. The real heresy to an artist of his persuasion would be the sniffishness of a spectator who would deflate enchantment into a sequence of handsome or indifferent objects. Often enough, in his works, one finds no correlation between extraordinary conceptions, such as those just mentioned, and beautiful handling. Under no circumstances will Magritte tolerate any aesthetic distance from the bewilderment he hopes to elicit. But this is a heresy the viewer in turn transcends, if he recognizes at all the differences between art and life. Any distractedness, any merely prosaic limning of the Magrittean world, in fact, tends to prevent him from entering with the desired credulity. These delirious coincidences have to "exist" after all, and only the power of painting—luminous, tactile and chromatic—can bring about that existence.

The most remarkable aspect of Magritte's pictorial vocabulary is its uncanny equilibrium between the general and the specific. Rather flat and dry, with a firm tonal control, his execution is well suited to a descriptive chore it never quite completes. Part of its appeal is that it can obviously tell so much more than it is willing to tell. Solidity is just a trifle too bald, and atmospheric distance a bit overschematized, to root one down or gear in space with perfect comfort. The light, too, in his paintings is tangible without being particular. Unlike de Chirico, who in other respects greatly influenced him, Magritte de-emphasizes shadow. Given these strictures, it requires the most exquisite discrimination, the most diffident bravura, to cube a fluffy clouded sky or paper it onto the walls of a room. And to anyone interested in the vicissitudes of lines that lose themselves in leafy shapes or blur into mountain creases

or ocean foam (they exhibit a surprising similarity), Magritte's drawing can be a very subtle spectacle. Throughout, there is a whiff of stage-set painting here, done up, however, with a great deal more good faith, high definition, and optical brilliance than the "real" thing.

Or rather, one should say, there is a portrayal of stage-set situations, for if one can accept, one cannot quite locate, the environment of his various tableaux. Psychologically it is absolutely necessary that this be so, for to personalize a dilemma is also in some fashion to be able to escape from it. Magritte's settings, while obviously Northern European, are denatured enough to press deeply into everyone's consciousness of the familiar. Yet there is nothing very nostalgic or very immediate about his quotidian. A homeless naturalism informs his parks and caves and hotel rooms, and a geographical vagueness lurks under every physical clarity. Exempt from time, the bourgeois context, with its imaginatively wrought *déjà vu,* distills a reluctant poetry.

But it is more in a kind of inverted logic that Magritte, diverging rapidly from orthodox Surrealism, excels. Rain may fall on *top* of a lowly cloud, a tree may take the shape of one of its leaves, or a house will appear within the room revealed through an opened window. In *The Wind and the Song* (1928-29), a pipe is subtitled *Ceci n'est pas une pipe*—startlingly but rationally, since one can't smoke it. Representations, words, and the objects they label are demonstrated not to be the same things, which makes a great deal of sense, but not to customary usage. Magritte was also among the first to make primers of discontinuity, so that a man reading a paper is present in only one of four portrayals of his living room, or the body of a nude is segmented rather agonizingly in five small panels. These irrevocable absences, cuts from a witless cinema, are highly disconcerting. Milder, but I think more beautiful, are the analogies, sometimes incidental, sometimes prominent, that the artist makes between disparate phenomena. The striations in a giant tortoiseshell comb and those in cloud patterns have something to do with each other. And the conical turret juxtaposed with a receding boulevard the same height and shape on a canvas within the canvas (*The Promenades of Euclid*) almost foils examination. These are not visual quips so much as isolations and magnifications of neglected confusions. Compared to such extremely simple, intimate analogies of totally unlike presences, techniques of scale change and levitation, spelled out elsewhere, do not reveal Magritte at his best. For they require him to "picture" an exotic vista, instead of far more sympathetically camouflaging, and hence abstracting, the ordinary.

By means of this camouflage, Magritte raises the most fruitful doubts about the conventions of painting—doubts that are now seen to have pointed toward the future. (pp. 114-19)

> *Max Kozloff, "Magritte," in his* Renderings: Critical Essays on a Century of Modern Art, *Simon and Schuster, 1968, pp. 114-19.*

Philippe Roberts-Jones (essay date 1969)

[*In the following excerpt from his study of Belgian painting from 1850 to the mid–twentieth century, Rob-*erts-Jones *gives a positive assessment of Magritte's contribution to the Surrealist movement, outlining recurrent motifs and images in his paintings that indicate a conceptual unity in his work.*]

"To represent visible poetic images", this was . . . René Magritte's declared aim. If he was scorned at the outset [of his career], held with "disgust" by some at the time of his 1927 exhibition at the *Centaure,* and if when he had arrived, he was acclaimed as one of the great masters of contemporary sensitivity as his retrospectives travelled round the world from New York (1965) to Rotterdam (1967), his life as a man and a creator was that of rectitude and loyalty to himself. But for this artist to fulfil himself an atmosphere was needed, as for all human beings; his was the circumstance of the surrealist adventure that André Breton let loose, . . . in 1924, by his *Manifesto* in which he legalised the right of way of the unconscious free of control by reason, aesthetics or morality. Dreams and obscure desires were masters of the city. Would not Sigmund Freud, who compared man's psyche to an iceberg where the visible, conscious part is minimal compared with the immersed and essential mass, have found in Magritte's picture **The Art of Conversation** an inverted but equally eloquent illustration of his thoughts? Here, a pile of enormous stones, a perforated edifice, a temple of an apparently fulfilled civilization, not precolumbian but preconscious, and whose portal reveals the cult by the inscription of the world "dream", dominates with its gigantic proportions two human ants practising the daily art of conversation.

Although Magritte adhered definitively and from the very outset to surrealism, he nonetheless was not to indulge in the method of fortuitous associations or of searching far and wide for accidental coincidences. The creator acted as a liaison and instigated common understanding. Moreover Breton spoke of his "steps which were not automatic but on the contrary fully deliberated". If we had to define further, we should be tempted to say that in Magritte the unexpected did not spring from a strange atmosphere, the fruit of the subconscious, but from the conscious juxtaposition or superimposition of elements drawn from reality and diverted from their usual function. The elements which were selected for this did not lose any of their fundamental and individual reality, but through their unexpected encounters, created a fresh reality, wilfully composed by the artist. Thus Magritte's contribution to surrealism was so original and important that we could never emphasise it sufficiently. His work was in no way gratuitous because of this. On the contrary it was the difficult, slowly emerging product of a profound dialogue between the artist and reality; a dialogue which was to give birth to an image which, in its turn, established a new dialogue between reality and the latter's representation in the image, between the chosen object and its projection into the new imaginary world. This coming and going between reality animated by the artist and that of the daily world creates in the suitably predisposed spectator an object of poetry. Magritte thus, through a modification of day-to-day reality, deeply corroded habit by putting in question the world which surrounds us, and modified not only the traditional relationship between objects, but also fundamentally shook our association mechanism.

Magritte used a vocabulary, or recurring themes, which

he investigated thoroughly, distilled, modified and conjugated. To wish to decipher a symbolic language in this would contravene the artist's consciously asserted wishes, and to refuse to read its signals would be contrary to every man's freedom since each work of art is, according to Odilon Redon's happy formula, "the ferment of an emotion proposed by the artist". Without wishing to give a restrictive definition to Magritte's universe, some constants do merge: the perpetual struggle between reality, appearances and their representation, which went from *False Mirror* which was the eye and from the pipe faithfully painted *which was not a pipe,* to **The Human Condition** where the picture was within the picture itself representing the reality of this fact and its ambiguity; the wilful confusion between the external and internal idea—present in this work—was even more complex in **The Midnight Marriage** or **In Praise of Dialectic** which used the procedure dear to Magritte of inversion in the sequence of admitted notions; the duality between the unstable and the rigid which both defied the laws of mass and fossilised moments on earth or in the sky; the opposition between what is and what is missing as in the absence of a face making the presence of "man become object" more agonising . . . The cult of the object turned off its usual path, that of certain privileged objects, banisters, little bells or leaves, the cult of the object for its own sake, disturbing in the course of its metamorphoses, as in the famous **Red Model,** or in its omnipresence when an apple filled a whole **Listening Room,** that sense of the object which found its source in the realist tradition and went back to the apples of a Van Eyck, smaller but just as necessarily present in the Frankfurt *Virgin and Child,* all this took on a new resonance in Magritte. In, for example, **Personal Values** the scale of certain elements such as a comb, a shaving brush, a cake of soap or a glass gave a fullness, an unaccustomed "value" to routine objects and made of Magritte, among others, a precursor of neo-realism.

Eroticism also played a powerful role in Magritte's work, although it was intellectual in essence and principally based on the ambiguity of the picture, of materials and associations of objects or ideas. Although a comparison is not always proof, it is interesting to parallel the picture that Frits van den Berghe offered of the *Rape,* which released a physical frenzy, with that evoked in Magritte by the same act, which provoked a mental aggression; the same as in **The Ready-Made Bouquet,** where Botticelli's Spring dwelt in the person's back, the idea in the back of the Magritte's mind being loaded with cultural resonance, whilst the weight of the partner bent the back of a *Perpetual Presence* in Frits van den Berghe. Expressionism's material reality found a perfect echo in another work by Magritte, contemporary this time, **The Day-Dreams of the Solitary Stroller,** but this work showed clearly the great gap separating the two universes of the experienced and the imagined.

We have passed over many aspects of his work, images often disturbingly representing forms and materials, objects which found another name, written words which replaced an image—for, according to Magritte "in a picture words are of the same substance as images". Everything combined in a fundamental drive towards poetic creation and, moreover, Magritte surrounded himself with friends whose medium was the word, Marcel Lecomte, Pierre Bourgeois, Paul Nougé, Louis Scutenaire, Paul Colinet,

Marcel Mariën, Achille Chavée and others, without forgetting E. L. T. Mesens, a major figure in surrealism in writing, collage and personal involvement. This circle earned him the epithet "literary" and his technique was dubbed "academic" in the pejorative sense of the words. Nothing could have been less true. Magritte was neither banal nor an innovator and did not consider painting as an end in itself but as a language, a means of communication. A means on the visible plane, for his pictures are not to be explained; this time there is no key to decipher secrets. His work, multiple in its riches, full of entreaties in its diversity, achieved numerous summits where fullness and equilibrium indefinitely prolonged the state of the waking dream and of the poetic life, from **Summer's Steps** to **The Empire of Lights** following the curve of the **Traveller,** a kind of pearl of the dream and concrete mass of reality that peopled a space. In bringing indelible pictures to the imaginary gallery we carry inside ourselves, René Magritte will henceforth travel with us on every journey of daily life. Does it not often happen that, at particular or privileged moments, we say: "That's a Magritte", as we meet with a certain clarity or observe the unexpected meeting of two objects? His contribution to the great international surrealist movement was unique and fundamental. (pp. 143-49)

> *Philippe Roberts-Jones, in an excerpt from his* From Realism to Surrealism: Paintings in Belgium from Joseph Stevens to Paul Delvaux, *translated by C. H. Mogford, Laconti, 1972, pp. 143-49.*

Suzi Gablik (essay date 1970)

[*In the following excerpt from her authoritative study of Magritte's life and work, Gablik distinguishes Magritte's rational, dialectical juxtaposition of objects in his paintings from the Surrealists' conception of the 'found' object.*]

[The] 'coming of age' of the object, weaned from its source and left to seek out relations other than familiar ones, was a major achievement of Surrealism. Breton had raised the problem of the Surrealist object as early as 1924. At that time he defined the ambition of Surrealism as the rehabilitation of the object: alienating it from its habitual context so that its purpose would become unknown, or would at least be altered. This would serve to awaken the latent life in objects. It would also serve to enlarge our experience of them, which otherwise tends to be bound by utility and guarded by common sense. For the Surrealists, the object was considered a concrete reality which must somehow be recreated rather than represented. By juxtaposing unrelated objects—in the manner of Lautréamont's sewing machine and umbrella—they revealed unexpected affinities between different objects. Moreover, the process relates to Baudelaire's concept of imagination (as distinct from fancy): 'an almost divine faculty which perceives at once, quite without resort to philosophic methods, the intimate and secret connections between things, correspondences and analogies'. The Surrealists devised numerous methods for provoking these chance revelations. They also invented the 'found' object, which represented the material expression of benevolent chance between the object and its 'creator'. However, according to Magritte, 'as removed as

one may be from an object, one is never entirely separated from it'.

Magritte made a very particular contribution to this complex group of Surrealist ideas. In this view, every object is linked, even in ordinary experience, to another object with which it has rational, if unacknowledged, connections that need to be discovered: the cage and the egg, the tree and the leaf, the aperture and the door. This discovery led him to think of pictures as problems. It involved him in a systematic search for the particular psychological or morphological evidence, obscurely attached to an object, which would yield up the unilateral and irreversible poetic meaning of that object. Thus, in what may be considered his second period, Magritte no longer juxtaposed *dissimilar* objects in what had become the classic Surrealist manner; he now explored the hidden *affinities* between objects—the relation of shoes to feet, or of the landscape to the picture, or of the female face to the female body. It was at this point that Magritte developed a methodology that was entirely his own. The element of shock or surprise became more rigorous, more conscious and controlled than it had ever been in De Chirico's work. The notion of bewildering disorientation (*dépaysement*) no longer seemed applicable. '*Nous sommes là chez nous*', Magritte has said: 'here is where we really belong.'

Thus Magritte evolved his own complex mental operation for calling objects into question. It was more premeditated and deliberate than the automatic and chance methods used by the other Surrealists. His method was essentially that of trying out assumptions in a series of speculative drawings until an answer was found to each familiar object. The underlying principle for nearly all the work that followed was based on a kind of Hegelian dialectic of contradictions, in which a union of opposites operated as the mainspring of reality. He pursued these investigations until just before his death. . . . For Magritte's work did not evolve, in the usual stylistic sense. Except for those deviations in style during the 1940s . . . , Magritte spent his time refining and elaborating the same philosophical method.

He had actually been doing 'problem' pictures, like the door in **The Unexpected Answer** and the window in **The Human Condition,** for quite some time before he was fully conscious of what he was doing. The turning-point, when he became aware of his own method, came in 1936, when he painted a picture called **Elective Affinities** (the title is that of a novel by Goethe).

> One night in 1936, I awoke in a room in which a cage and the bird sleeping in it had been placed. A magnificent error caused me to see an egg in the cage instead of the bird. I then grasped a new and astonishing poetic secret, because the shock I experienced had been provoked precisely by the affinity of two objects, the cage and the egg, *whereas previously I used to provoke this shock by causing the encounter of unrelated objects.* Ever since that revelation I have sought to discover if objects other than the cage could not likewise manifest—by bringing to light some element peculiar to them and rigorously predetermined—the same evident poetry that the egg and the cage were able to produce by their meeting.
>
> This element to be discovered, this thing among all others obscurely attached to each object, suddenly

> came to me in the course of my investigations, and I realized that I had always known it beforehand, but that the knowledge of it was as if lost in the recesses of my mind. Since this research could yield only one single exact response for each object, my investigations resembled the pursuit of *the solution to a problem for which I had three data: the object, the thing attached to it in the shadow of my consciousness, and the light wherein that thing would become apparent.*

Thus, an image for Magritte would often be the result of complex investigations—an authentic revelation after a long period of calculated reflection. For certain paintings the solution was already tacitly comprised in the problem but remained to be found; for example, in trying to find a way to paint a bicycle, the solution which finally presented itself was the rapprochement of a bicycle and a cigar. Preliminary thoughts which had suggested themselves were a bicycle on top of a banana, or a valise, or astride two masked apples (an image used in other paintings), or a chair riding on the seat of the bicycle.

But none of these 'solutions' proved correct until the cigar suggested itself, thus creating **State of Grace.** (It can happen that a bicycle passes over a cigar thrown into the street. Any circumstance, Proust has written, consists of one-tenth chance and nine-tenths the disposition to fall in with it.) It is false, according to Breton, to pretend that it is the mind which seizes the rapport between two realities. To begin with, nothing has been seized consciously. It is out of the juxtaposition of the two terms, in a way which is in some manner felicitous, that a light is kindled: the light of the image. In that light the idea makes its visible appearance.

> Painting has no thickness: thus my painting with the cigar, for example, has no perceptible material thickness. *The thickness of the cigar is in the mind.* This is not lacking in importance if a preoccupation with the truth has any importance. In fact, a painting conceived and painted with this preoccupation must have the unequivocal character *of an image.* It is not a cigar which one sees, but *the image of a cigar.*

In just the same way, the image of a pipe is not the same thing as a real pipe. Hence Magritte's inscription 'this is not a pipe'.

What one sees in an object, then, according to Magritte's calculations, is another object hidden. In the case of the violin, for example, what was needed was a white tie and starched collar: **A Little of the Bandits' Soul.** The idea of a knot had been clairvoyantly implicit throughout. At intermediate stages in the development of the final idea, the violin appeared knotted into a girl's hair-bow, and intertwined with a snake, until finally the knot resolved itself as part of the bow tie on the starched collar of the violinist.

Magritte's intention was to create, from the flux of existence, autonomous and fixed images whose existence would no longer depend on any knowledge we might have and would be independent of our ideas about objects. In this way, forms of the visible world would bypass their contingent functions and be restored to their absolute identity. To use Hegel's term, they would become 'concrete universals'.

The problem of 'rain' produced a view of a rainy landscape

with an enormous stormcloud on the ground (*The Song of the Storm*). The problem of 'woman' yielded *The Rape*. In it, the features of a woman's face are composed of various parts of her body: the eyes have been replaced by breasts, the nose by the navel, and the mouth by the sexual organ, as if in some erotic metamorphosis of consciousness.

Sometimes, an image was born in a single vision, in a kind of rapid hallucination—although these occasions were rare. For example, the automobile surmounted by a jockey on his horse, in *The Wrath of the Gods,* appeared to Magritte as a sudden and complete image, without the usual long period of reflective examination. *The Wrath of the Gods,* therefore, was not exactly an answer to the 'problem of the automobile', in that both elements in the combination were given spontaneously, by inspiration. (The problem of the automobile, if it had been posed, would no doubt have yielded up something quite different after long research.) Another example of an image born from a sudden vision is *Time Transfixed . . . ,* where a miniature locomotive thrusts itself through a fireplace.

Magritte never dealt with single, static identities. His images incorporate a dialectical process, based on paradox, which corresponds to the unstable, and therefore indefinable, nature of the universe. Thesis and antithesis are selected in such a way as to produce a synthesis which involves a contradiction and actively suggests the paradoxical matrix from which all experience springs. The fundamental dynamism of Magritte's images depends on an exploitation of the free field of possibilities, or potentialities, which lies outside the range of what are usually considered 'normal' situations. The fact that a possibility is not a reality means only that the circumstances which are affecting it at a given moment prevent it from being so. If, however, the possibility is freed from its bonds and allowed to develop, a utopian idea is likely to emerge. In Magritte, the synthesis through paradox which brings conflicting possibilities into a unified focus is intended to suggest the ambivalent nature of reality itself. For example, he puts forward the 'possibility' that one thing can also be two things. In *The Seducer* the sea takes the form of a ship. In *Plagiarism,* a bouquet on a table has been replaced by the landscape outside. In this painting the antithetical concepts 'inside' and 'outside' (or 'here' and 'there') have been synthesized in a single image, but they are also still understood as two images by the mind.

But a single conceptual image will not express the synthesis of two or more conceptual images unless it occurs at the intersection of a paradox. That is, in order that something become two things, an 'active compound' must be created within the interpenetrating images. It is also possible to reduce the images to binary structures, as with the tower and the street which both become cones in *Euclidean Walks.* This results in a different double-reading, based upon a hidden calculus of relations. The bipolar nature of reality is also expressed in the juxtaposition of night and day within the same picture: in *The Empire of Lights,* a street at night appears under a daylight sky. In *Hegel's Holiday,* Magritte has evoked a hidden correspondence between two seemingly unrelated objects: a glass of water and an umbrella.

> My latest painting began with the question: how to show a glass of water in a painting in such a way that it would not be indifferent? Or whimsical, or arbitrary, or weak—but, allow us to use the word, with genius? (Without false modesty.) I began by drawing many glasses of water, always with a linear mark on the glass. This line, after the 100th or 150th drawing, widened out and finally took the form of an umbrella. The umbrella was then put into the glass, and to conclude, underneath the glass. Which is the exact solution to the initial question: how to paint a glass of water with genius. I then thought that Hegel (another genius) would have been very sensitive to this object which has two opposing functions: at the same time not to admit any water (repelling it) and to admit it (containing it). He would have been delighted, I think, or amused (as on a vacation) and I call the painting *Hegel's Holiday.*

In his old age Hegel found the spectacle of a starlit sky dull—'which is precisely so', according to Magritte. But the image of a starlit sky need no longer be dull if that image were to evoke mystery. The mystery would result from the lucidity of a painter who was able to paint the commonplace image of a starlit sky in such a way that it might have evocative power. Hegel saw only a 'constant' image without the intervention of the mind. Since he probably valued only the manifestation of the mind through ideas, he might have been agreeably distracted (as a sort of holiday relaxation) by looking at images.

Magritte's paintings are a systematic attempt to disrupt any dogmatic view of the physical world. By means of the interference of conceptual paradox, he causes ordinary phenomena to inherit extraordinary and improbable conclusions. (It is only when we once pass through this baptism, the Zen philosopher D. T. Suzuki has written, that a single hair of the tortoise begins to weigh seven pounds and an event of one thousand years ago becomes a living experience of this very moment.) What happens in Magritte's paintings is, roughly speaking, the opposite of what the trained mind is accustomed to expect. His pictures disturb the elaborate compromise that exists between the mind and life. In Magritte's paintings, the world's haphazard state of consciousness is transformed into a single will.

For example, qualities normally associated with rocks are heaviness and immobility. In Magritte's paintings the law of gravity is defied through levitation—the paradoxical antithesis of gravity—so that rocks can suddenly float in the air like clouds, as in *The Battle of the Argonne.* They also lose their quality of seeming to have a fixed or final location; we can never be completely sure whether they are floating upwards or falling downwards or merely suspended in space. Just as with the ambiguity of 'inside' and 'outside', Magritte avoids any absolute finality of placement by playing on the bipolarity of 'here' and 'there'. As in *The Empire of Lights,* where he has used two apparently irreconcilable events (night and day) observed from a single point of view to disrupt our sense of time, in paintings like *The Battle of the Argonne* Magritte has similarly disrupted our sense of space.

This plural significance of experience, in which spatio-temporal measurement is seen as the relation between observer and phenomena, corresponds to Einstein's theory of relativity in physics, which abolished the 'absolute' space and time of Newtonian theory. Relativity represent-

ed the demise of any view of the universe as static and predictable. It represented the shift from a timeless, Euclidean world in which all is precise, determinate and invariable, to a dynamic universe where everything is relative, changing and in process. Magritte's paradoxical combination of precision and indefiniteness is perfectly adjusted to the crisis of modern physics, in which the necessity of causal relations has had to be abandoned in favour of probability statistics. Although his style and temperament were attuned to exactitude, it could be said that apart from and beyond this quality everything was indefinite.

Rocks are inanimate. Magritte used this fact to reverse the natural properties of the living world in a series of paintings in which absolutely everything has turned to stone: *Remembrance of a Journey.* As if by an invisible catastrophe, the nicely arranged world of merely objective nature has reverted to a mineral state, where even the stones are sexual and seem to see and hear, just as people believed they did in the Middle Ages. In one version the man dressed in an overcoat and carrying a book was Magritte's friend, the poet Marcel Lecomte.

It is living and not living, according to Breton, which are the imaginary solutions; existence is elsewhere. However, these improbable events reflect the unrealized potentialities of nature, in which analogous visual deceptions do exist and serve mostly as a means of escaping detection. Processes of adaptation, which operate between the animal and plant kingdoms for the benefit of each, often entail changes in structure, behaviour or coloration to secure an effective resemblance. Various forms of mimicry and protective colouring that serve as deterrent and camouflaging techniques in plants and animals recall the stone fish in *The Lost Steps* and the leaf-bird in *The Flavour of Tears* and *The Natural Graces.* In the deserts of South Africa, for example, there are succulent plants known as 'living rocks'; they have fleshy leaves whose shape and surface markings resemble the stones among which they grow, and by this means they escape the notice of desert animals which would otherwise eat them for their water content. A South American nightjar, which nests on top of a tree stump, escapes detection by brooding throughout the day without moving, its head pointing upwards so that it looks like a continuation of the stump. By means of adaptive mimicry, certain grasshoppers imitate decaying leaves; insects and caterpillars often look like twigs; certain spiders behave like ants. In the Amazon, a leaf-fish gets within striking distance of its prey by looking like a dead leaf drifting along the current. There is an Australian seahorse which is protected from attack by the fact that it resembles marine vegetation and sprouts imitations of three different kinds of seaweed from various parts of its body. Thus we can see that many of Magritte's utopian ideas are less improbable than they seem, for in the same way that nature produces its own orderly miracles, Magritte presents images of mystery which are as removed from the hypotheses of science as from the approximations of poetry; but they resemble those presented to us by nature every day.

Large birds, states a Surrealist proverb, make little Venetian blinds; and several children, wrote Eluard, make an old man. In *The Red Model,* the image starts by being a foot, and ends up, through a process of hybridization, with the properties of a boot. 'The problem of shoes', Magritte has written, 'demonstrates how the most barbaric things pass as acceptable through the force of habit. One feels, thanks to *The Red Model,* that the union of a human foot and a leather shoe arises in reality from a monstrous custom.' In this case, the container (boot) and the thing contained (foot) merge to create a new object. In *The Explanation,* a carrot and a bottle are combined to produce a bewildering new object. In *Collective Invention,* a fish and a woman combine to produce the opposite of a mermaid—a fish with human legs instead of a woman with a fish's tail.

For Magritte, painting was not an end in itself; it was the means of formulating an awaited response so that objects could exist with maximum impact. A crisis of the object could be brought about in any of the following ways: (1) Isolation. An object, once situated outside the field of its own power and removed to a paradoxically energetic field, will be freed of its expected role. (2) Modification. Some aspect of the object is altered. A property not normally associated with a particular object is introduced (human flesh turned to wood or stone); or, conversely, a property normally associated with an object is withdrawn (gravity from a rock). (3) Hybridization. Two familiar objects are combined to produce a third, 'bewildering' one. (4) A change in scale, position or substance creates an incongruity (an enormous champagne glass in a mountain landscape or an apple which fills the room). (5) The provocation of accidental encounters (a rock and a cloud meet in the sky). (6) The double image as a form of visual pun (a mountain in the form of a bird or the sea in the form of a ship). (7) Paradox. The use of intellectual antitheses as in the delicately balanced contradictions of the glass and the umbrella. (8) Conceptual bipolarity. The use of interpenetrating images where two situations (a landscape outside and a bowl of flowers inside) are observed from a single viewpoint, modifying spatio-temporal experience. (pp. 102-25)

Suzi Gablik, in her Magritte, *Thames and Hudson Ltd., 1970, 208 p.*

Uwe M. Schneede (essay date 1973)

[*In the following excerpt from his book-length study of Magritte's life and work originally published in German as* René Magritte, Leben und Werk *in 1973, Schneede examines the style, content, and theoretical basis of Magritte's "language pictures."*]

Toward the end of the 1920s, a clarification of approach became evident in the work of the thirty-year-old Magritte. Disparate pictorial experiments and concepts began to disappear. Each work concerned itself with a specific problem of pictorial representation, and a surveyable number of such problems shaped the remainder of Magritte's production until his death in 1967. As a consequence, there are series of pictures in which each deals with and modifies a certain idea. . . . (p. 35)

Among the first of the "language pictures" is a painting which, because it is simple in concept and easy to identify, is one of Magritte's best-known works. This painting, *The Use of Language* or, as it is sometimes called, *The Betrayal of the Images* (1928/29), illustrates the exclusively intellectual basis that Magritte worked from and that distinguished him from his Surrealist comrades.

Magritte explains his theory of painting:

In the images I paint, there is no question of either dream, escape, or symbols. My images are not substitutes for either sleeping or waking dreams. They do not give us the illusion of escaping from reality. They do not replace the habit of degrading what we see into conventional symbols, old or new.

I conceive painting as the art of juxtaposing colors in such a way that their effective aspect disappears and allows a poetic image to become visible. This image is the total description of a thought that unites—in a poetic order—familiar figures of the visible: skies, people, trees, mountains, furniture, stars, solids, inscriptions, etc. The poetic order evokes mystery, it responds to our natural interest in the unknown.

Poetic images are visible, but they are as intangible as the universe. These poetic images *hide nothing:* they show nothing but the figures of the visible.

Painting is totally unfitted for representing the invisible, that is, what cannot be illuminated by the light: pleasure, sorrow, knowledge and ignorance, speech and silence, etc.

After having attempted to understand nontraditional painting, we admit that it cannot be understood. In any case, we are not assuming any serious responsibility: we do not have to know or to learn anything. Imaginary irrationality is futile and boring. However, we can understand poetic thought by making it a part of ourselves and by taking care not to remove from the known the unknown elements it contains.

René Magritte, in an excerpt from Magritte: Ideas and Images *by Harry Torczyner, translated by Richard Miller, Harry N. Abrams, Inc., Publishers, 1977, p. 224.*

A first glance at the pipe with its caption "This is not a pipe" might lead one to believe that Magritte intended the picture as a dadaistic gag. Why else should the picture be contradicted by the text? A second view shows that Magritte is working with a problem that is not usually treated within art works themselves—namely, the aesthetic problem of the relationship between reality and the work of art, between that which is being depicted and its depiction.

On the level of the painting itself, Magritte brings together a pictorial and a linguistic statement that seem to contradict each other. By means of language, he suggests that the medium he works in—i.e., the painted picture—is limited in the amount of reality and, therefore, truth it can convey: this is not a pipe but the representation of a pipe. Magritte is demonstrating that the picture operates on a different level of reality than does the item depicted; namely, a real pipe. In this sense, ***The Use of Language*** is a reflective picture that clarifies the relationship between art and reality. It not only represents something but incorporates into the picture the process of transformation that artistic representation brings about.

This type of experiment is based on specific ideas about the representation of reality through linguistic and pictorial signs, ideas that have been systematically developed by Ludwig Wittgenstein and his followers. In the process of depiction, a sign for the depicted object is created which loses its reality-content. The depiction is not identical with the real object, but it represents this object by means of signs which are, in turn, subject to the laws and techniques of their medium: in this case, of painting, of visual imagery, of two-dimensionality. "Everything points to the fact," Magritte wrote in 1929 in his pictorial essay "Words and Images," "that hardly any relationship at all exists between an object and that which represents it." The sign *signifies* reality; it functions as its representation. The sign or representation is therefore a means of evoking the concept of an object without being identical with this object.

As a rule, it is the viewer of a work of art or the reader of a text who must undertake the theoretical task of distinguishing between these levels of reality, for the producer of the work concerns himself mainly with the manner, the techniques, and the content of the depiction. By means of the apparent contradiction between image and text, Magritte includes both levels of reality in his picture and thus leads us toward the idea imminent within the work itself. When the viewer begins to think about the painting, he/she does not have to waste any time in abstracting. The painting has already done this. The viewer is prompted and challenged to reconstruct the reflection begun in the picture and to expand on that reflection.

For this reason, Magritte's "language pictures" as well as his "pictures of pictures" can be characterized as reflective artworks. Other Surrealists and the Dadaists in particular engaged in similar experiments during the 1920s. In 1921, Picabia glued a photograph of himself onto a piece of cardboard and wrote "Photograph" under it; he then made a drawing of this photograph on the same piece of cardboard and wrote "Drawing" under it (*La veuve joyeuse*). The point of this was not to do a self-portrait, but to demonstrate how different the same motif will look when presented in two different media (photography and drawing). Around 1930, Max Ernst did a series of pictures and a number of collages and *frottages* that all contained an artificial figure named "Loplop"; these combined the features of a bird, an easel, and a human being. By displaying, as at an exhibition, elements from the artist's own stock of motifs, this figure showed how pictures could be placed within pictures.

Thus, Magritte's theoretical approach only appeared to be at odds with the Surrealists' intentions, which it would be unjust to label as purely irrational. Ultimately, the Surrealists were concerned with the development and expansion of consciousness and, of course, of the subconscious.

In 1929 Breton wrote in his second manifesto, published in the journal *La révolution surréaliste:* "Regardless of the diverse projects that all those who have been or still are affiliated with Surrealism have engaged in, they will all have to admit in the end that what Surrealism wanted to do above all else was to initiate—in the intellectual and

moral realm—a *crisis of consciousness* of the most widespread and serious nature possible; and they will have to admit further that its historical success or failure will depend solely upon whether it achieves the goal or does not achieve it." And as Max Ernst put it in his foreword to the Zurich Surrealism Catalog in 1934: "By revolutionizing the relationships between 'realities,' it [the Surrealistic movement] could not but help to accelerate the general crisis of conscience and consciousness in our time." The strengthening of consciousness by unsettling it was the Surrealists' goal.

In this context, as well as in relation to the "language pictures," a statement of Magritte's is particularly revealing: "For me painting is simply a tool; it allows me to describe an idea shaped solely by that which is visible in the world. This idea is not that of a specialist; it strives only to see the world—or better, to become the world, just as it is." Again, Magritte's main concern was the intellectual aspect of painting.

Although Magritte's reflections on painting became ingredients in his pictures, he did not paint his subjective thoughts but made objective facts visible: this is, in fact, not a pipe; it is, in fact, the representation of a pipe.

In Magritte's works the intention determines the tools, and the tools in turn are oriented neither toward the compulsion for originality nor toward individual expressiveness. The aim of "describing an idea" requires the clear representation of those objects which serve to exemplify something. It requires the tool of realism: "The description of an idea that resembles the world . . . tolerates neither fantasy nor originality. The precision and the charm of a likeness will be lost if the painter develops that mediocre skill of painting with 'originality'."

Magritte did not want his painting techniques—which are purely descriptive and assertive in *The Use of Language*—to lead an independent existence, to betray the presence of a particular hand, or to reveal emotions. They had the subordinate function of creating a sign that could be identified as standing for an object, and the object was to illustrate an idea in turn. "The likeness," Magritte explained, "must limit itself to a dispersal of paints over a surface in such a way that its actual appearance diminishes in importance while at the same time it allows the image of the idea to manifest itself."

Magritte often modified a single idea in the course of several paintings. Two versions of *This Is Not an Apple* (1928/29 and 1964) make two approaches to the problem of depiction, using an apple instead of a pipe. *The Two Mysteries* (1966) has an additional complication: an easel displays a picture similar to *The Use of Language,* above which hovers a pipe. The number of levels of reality has increased here. The pipe of the picture within the picture has proved to be a representation. The floating pipe in the painting should therefore be its counterpart in reality. But that is not the case because this pipe, too, is a representation. What we have, then, is an object that the picture within the picture maintains is a representation; we also have an object, identical in form, that the *viewer* recognizes as a representation even though its realistic character is being simulated; and finally, there is the actual object, which is to be conceived of as the model. The viewer who has been educated by Magritte (specifically by *The*

Use of Language) will be able to separate the levels of reality Magritte has piled one upon another here.

When Magritte shows smoke rising out of a pipe and has the pipe cast a shadow in *The Air and the Song* (1964), thus identifying the pipe as real—despite the fact that the now familiar and paradoxical caption, together with the painted picture frame, annuls this claim to reality—then it is clear that these works of Magritte's want not only to stimulate reflection, but also to surprise or confound the viewer. Or to put it even more accurately, they use surprise to stimulate reflection.

Guillaume Apollinaire, who was so highly respected by the Surrealists, wrote in 1917 in *L'Esprit nouveau:* "Surprise is the [Surrealists'] most important new tool, and what distinguishes Surrealism from all other artistic and literary movements is this very element of surprise and the significance that the new spirit of this movement accords to it." The Surrealists regarded all things surprising, unfamiliar, and ambiguous as enriching stimuli to be valued for their inspirational character.

In a series of pictures entitled *The Key of Dreams,* most of which were painted between 1927 and 1930, Magritte drew the logical conclusion from the knowledge that a pipe depicted in a painting is not a pipe. He divided the painting into several parts, each of which shows a single object. The captions bear no relation to the objects: the egg is labeled "acacia," the shoe "moon," the bowler "snow," the candle "ceiling," the water glass "storm," and the

The Key of Dreams (1930)

hammer "desert." Meaningful or formal relationships between image and name do not exist. . . . (pp. 35-41)

The divergence of images and names in this picture demonstrates that neither are identical with the real objects, that names and images exist within their own independent systems, i.e., within language and depiction. The connection between name and object and image and object is based on a convention that Magritte calls into question. "No object is so inextricably linked to its name that one could not give it another name that would suit it better," Magritte wrote in 1929 in the journal *La révolution surréaliste*. He also maintained that "an object never functions in the same way as its name or its image." Neither language nor depiction are likenesses themselves; they are instrumental systems or media with the aid of which and under the assumptions of which reality is represented on the level of appearance.

Magritte drew a different conclusion in the painting **Man Walking toward the Horizon** of 1928/29. Within the suggested landscape are two kinds of motifs: an identifiable motif (the man) and five unidentifiable motifs (the abstract shapes). The latter bear the inscriptions "rifle," "cloud," "horizon," "armchair," and "horse." The verbal designations give content to the indefinite shapes. Magritte wrote in "Words and Images" (1929): "Sometimes the name of an object takes the place of its image," but he also adds in this same essay: "In reality a word can take the place of an object." In almost pedagogical fashion, Magritte shows that the articulation of the word "cloud" is, in the realm of conventional and direct (oral) communication, a succession of sounds which, like their fixation in writing, take the place of the object. It is precisely this process, the details of which we are not at all conscious of, that Magritte reproduces in **Man Walking toward the Horizon** when he replaces the pictorial sign with the linguistic sign.

In the aforementioned picture essay, Magritte touched on the way perception is conditioned by different media: "One perceives images and words differently in a painting." The **Phantom Landscape** of 1928/29 illustrates this proposition: the word "mountain" is lettered across the representation of a woman's head. Magritte was not concerned here with the problems involved in naming objects or with the missing inner link between name, image, and object; his focus is on the problems of perception. To read the writing, to recognize the name as a concept, to identify the concept with the object in mind—these processes, because language is more abstract than painting, require a different kind of perception from the viewer than does the process of identifying a picture that resembles a certain real object with the object depicted.

In these "language pictures" and their variants, Magritte concentrated primarily on semantic problems. The visualization of such problems reveals a didactic intention, and the paintings need not be appreciated as "art" but rather as informative charts. For Magritte himself, they probably served as a kind of alphabet, a systematic foundation for his later work, an attempt to clarify for himself the relationship between object and depiction, all to the end of discovering the possibilities of the depiction process.

Combining images and words for the purpose of mutual clarification (and, in the process, using the talking balloon to illustrate spoken language), Magritte summarized his

thinking on the semantics of pictorial and linguistic signs in the essay "Words and Images," which I have cited frequently here. This pictorial essay attests to the systematic nature of Magritte's endeavors. No matter how much he may have disagreed with specific points of Breton's Surrealist doctrines, he and Breton shared the basic insight that art had to develop "beyond any esthetic or ethical considerations" (Breton, *Surrealist Manifesto*, 1924). Yet Magritte, unlike the Paris Surrealist, was not an anti-bourgeois Bohemian who violated as many tabus as possible. He was, instead, a simple, unobtrusive middleclass citizen who explicitly rejected the designation of "artist" for himself. But here lies another point of contact with the Paris Surrealists. Max Ernst wrote in 1934 in the Zurich Surrealism Catalog, "In Western culture, the fable of the artist's creativity has remained as an undispelled superstition, as an unhappy remnant of the myth of creation. One of Surrealism's first revolutionary accomplishments was to have attacked this myth objectively and in the sharpest manner possible and—let us hope—to have destroyed it forever." The fact that Magritte's motivations in this regard were fundamentally different from Max Ernst's reflects the divergencies of opinion that existed within the Surrealist movement, a movement in which the rejection of harmony and homogeneity and a predilection for contradiction were adhered to as guiding principles. (pp. 41-6)

Uwe M. Schneede, in his René Magritte: Life and Work, *translated by W. Walter Jaffe, Barron's Educational Series, Inc., 1982, 144 p.*

J. H. Matthews (essay date 1977)

[*Matthews is a Welsh critic who has written numerous studies of Surrealism and Surrealist authors and who is considered one of the foremost scholars of that movement. In the following excerpt from his study of the nature of Surrealist imagery, he examines the close relationship between Surrealist poetry and Magritte's manner of representing familiar objects in "new associations" in his paintings.*]

On some occasions more directly than on others, surrealists have justified the creation and circulation of objects, at the same time defining the role intended for them, by reference to the work of poets they esteem highly. The implication is clear. The value of the surrealist object is to be gauged by standards set in verbal poetry. Very significantly, in theoretical discussion of the contribution to be demanded of objects and comments upon the practical application of these theories through objects inspired by them, surrealists have borrowed some of the terminology usually thought to be more appropriate to the art of writing—metaphor, anagram, and analogy, notably. As they use these terms to explain how and why they and their friends have experimented with creating objects, they confirm the fundamental unity of surrealist imaginative exploration, highlighting therefore the essential role of image-making in surrealist creative activity.

The image-making process from which surrealist objects result accords perfectly with the one to which we owe certain verbal surrealist images. So there is no need to marshall numerous examples of the latter in order to demonstrate how the poet with words provides object lessons comparable with the concrete objects offered by certain

artists. All the same, to demonstrate that agreement between surrealist writers and creators of objects is not confined to the level of theory and speculation, a sampling may be taken from surrealist poetic texts as a reminder that surrealist writing contributes its share of bewildering objects.

In the short poems of André Pieyre de Mandiargues's *Les incongruités monumentales* (1948) abound disconcerting objects inexplicable to reason. A Spanish general's tear and a Portuguese general's both tremble in an urn shaped like nasal mucus that will be hung from the skeleton of a cow in future deserts. A traveler back from India reports that rajahs wash their feet in pieces of furniture shaped like Queen Victoria. Fuegian honor, we are told, demands a billiard table of seaweed, in which three lobsters roll about in glass balls. Mandiargues brings before us, also, a tongue of green porphyry, two yards thick; the corset worn by the model who posed for the Statue of Liberty, now used as a lampshade on the Speaker's rostrum in the French Senate; a hat, "unbuttoned like a closet," full of crushed brains, serving as a hive for bluebottles; a lighthouse modeled on the leg of a king's mistress; a tongue piano that feeds on diplomat semen and is led about on a leash by Meret Oppenheim.

The poems of Benjamin Péret, Jehan Mayoux, and Maurice Henry yield a comparably rich crop of objects. Some of these, in fact, point to an imaginative freedom that does not have to take into account practical considerations of three-dimensional representation. It is fitting, all the same, to give more attention to tangible surrealist objects than to their two-dimensional images in words. For the real significance with which these objects are invested in surrealism lies in their function. They materialize dreams, aspirations, needs, and compulsions. It is in this sense that we must understand the statement by René Magritte cited in Breton's *Le surréalisme et la peinture:* "My pictures are images. The valid description of an image cannot be made without the orientation of thought toward liberty."

To give Magritte's words their full weight, we have to note that he does not mean description to serve as an explanation. His *Manifestes et autres écrits* states categorically: *"One explains nothing, by the way, in any domain."* As Magritte sees it, what customarily passes for an explanation always comes down in the end to "a necessary deforming translation" of the very thing being explained. We are close indeed to Breton, dismissing *explication de texte*—the method of literary analysis fed as a staple diet to French high school children—as irrelevant to the true appreciation of poetry. Moreover, René Magritte takes us farther than we could go without him. Recurrently and consistently, his work shows him rejecting the view that two-dimensional representation of a familiar object is to be interpreted simply as a translation of the same object, perceived three-dimensionally in the day-to-day world. It is through *décalage,* the *shift* made possible by pictorial representation (ironically realistic in appearance), that he appropriates everyday objects to surrealist purpose.

In a letter written to Nougé during the twenties, Magritte confided:

> I'm realizing more and more that the objects appearing in my painting have no cause (there is more to the effect than to the cause) but the effect is not obtained if it is due to a simply ingenious arrangement. The operation must be carried out by a feeling that knows no hesitation or enthusiasm. A sort of advance, there's no doubt about it, toward what is unknown, the departure alone being known. The whole difficulty for me lies in having that feeling.

Contrivance must be eschewed, Magritte believed. Otherwise, the effect produced by the pictorial image will be diminished. In one of his canvases, a rock looks like a sculptured garment—even as we note this impression we find ourselves paying tribute to an order of precedence established by common sense: the latter tells us we are looking at a rock represented as a garment, because it cannot accept substitution of a garment for a rock, where, from the standpoint of reason, it would be more appropriate to find the latter. During a lecture delivered under the title "La ligne de ma vie" at the Musée des Beaux-Arts in Antwerp, on November 20, 1938, Magritte commented:

> I painted pictures in which objects represented with the appearance they have in reality, in a style objective enough to ensure their bewildering effect—which they would reveal themselves capable of provoking thanks to certain means utilized—would be experienced in the real world from which the objects had been borrowed. This by a perfectly natural transposition.
>
> In my pictures I showed objects situated where we never find them. *They represented realization of the real of unconscious desire existing in most people.*

Beyond any question, the poetic function of the pictorial image, as Magritte understood it, is to resist the assimilative process that allows the human eye, when trained by reason, to classify and locate objects, while often the image appears to invite such classification through exact reproduction of objective forms borrowed from life. This is the nature of the "figurative bias" for which Breton praises him in *Le surréalisme et la peinture:*

> It is a matter, certainly, first, starting out from the objects, sites and people that make up our everyday world, of giving us back appearances with complete fidelity, but much farther still—and it is here that Magritte's totally original and capital intervention lies—of awakening us to their latent life by appeal to fluctuation in the relationships they bear one another. To strain, if necessary to the point of violating them, these relationships of size, position, lighting, alternation, substance, mutual tolerance, development, this means taking us to the heart of a second figuration that transcends the first by all the means rhetoric enumerates as "figures of speech" and "figures of thought." If the concrete figuration, in the descriptive sense claimed by Magritte, were not so scrupulous, this would be the end of the great *semantic* bridge permitting passage from the proper sense to the *figurative* sense and of combining both these senses in one glance with a view to a "perfect thought," this is to say one that has reached its complete emancipation.

On the level of technique, Magritte's work presents no great complexity and certainly no subtlety. It is not even original. Add to the example set by Ernst in his collages the influence of Giorgio de Chirico's metaphysical painting, and there is little excuse for trying to present Magritte in the guise of a technical innovator. What impresses, though, is the simplicity, at once disarming and unsettling,

with which he applies borrowed methods. Magritte offers object lessons in which things, taken in eminently recognizable form from the world about him, are arranged in a manner that undermines generally accepted notions regarding objective reality.

At the same time, objects are represented with scrupulous care. Magritte's method is so far removed from the painterly sophistication characteristic of much twentieth-century art that he comes closer, it seems, to the naiveté of the self-taught Sunday painters—Douanier Rousseau, notably—than to the expertise usually considered a prerequisite for greatness or even for respectability among the painters of our time.

Shadows are rarely given close attention, except where they serve to dramatize a scene, just as in the early paintings of de Chirico. Normally, Magritte's work betrays little or no concern to present people and things in the round. It is not their presence that matters but their potential—brought out by their unwonted proximity—for triggering new associations. These associations do violence to the ordered universe familiar to us all, where, so we thought, everything has its designated place and prescribed role. An enumeration of typical elements in Magritte's pictorial universe introduces Nougé's statement in "Les images défendues," "L'expérience va commencer." What is about to begin is at once an experience and an experiment (both rendered by *expérience* in French). In "Ligne de vie" Magritte furnishes a specific example:

> One night in 1936, I awakened in a room where a cage and the bird sleeping in it had been placed. A magnificent visual aberration caused me to see an egg, instead of a bird, in the cage. . . . From the moment of that revelation I sought to find out whether other objects beside the cage might not likewise show—by bringing to light some element that was characteristic and to which they had been rigorously predestined—the same evident poetry as the egg and the cage had produced by their coming together.

Magritte speaks of evident poetry. Eluard writes an important theoretical article under the title "L'evidence poétique," and Breton explains in *La clé des champs* how the only evidence that counts for him is governed by relationships insolently established in defiance of common sense. Surrealist poetry renders evident things that reason can neither project nor encompass, and may well not be able to tolerate. Péret proclaims, "J'appelle tabac ce qui est oreille" ("I call tobacco that which is ear"), while Magritte paints a picture, **La clé des songes (The Key to Dreams),** divided into six panels, each occupied by a titled object: an egg (called acacia), a woman's shoe (the moon), a bowler hat (snow), a lighted candle (the ceiling), an empty glass (the storm), and a hammer (the desert). In a statement quoted by Marcel Brion, he explains, "The art of painting, as I conceive it, permits representation of visible poetic images."

Upon the apparently innocuous premise that painting is the art of representation, Magritte found he could build in such a way as to disturb the spectator's confidence in the art of imitation. Waldberg reports this axiom: "One can create new relationships between words and objects and render precise a few characteristics of language and objects, of which people are generally ignorant in daily

life." In the special number of *L'art belge* devoted to his work Magritte goes into greater detail: "The art of painting—which really deserves to be called the art of resemblance—makes it possible to describe, through painting, a thought capable of becoming apparent. This thought comprises exclusively the shapes [*figures*] that the apparent world offers us: persons, trees, pieces of furniture, weapons, solids, inscriptions, etc. Resemblance spontaneously brings these shapes together in an order directly evocative of mystery."

Here is the key to the figurative system operative in Magritte's painting. Meaning comes from redistribution of familiar forms for which there is no counterpart or precedent in daily experience. Thus forms are valuable less for the associative memories they bring up than as testimony to a new order. Magritte goes on to point out, *"Inspiration gives the painter what he must paint."* In other words, the first obligation imposed upon any spectator is to transcend banal associations that do not serve the poetic purposes of painting.

Magritte's pictures take issue with the conventional modes of perception and interpretation by which we customarily measure resemblance. In this respect, they stand for **La trahison des images**—the betrayal of images—to avail ourselves of the significant title of one of his canvases. But the process of poetic expression is not purely negative in function. Appreciation of the work of René Magritte requires us to be able to go beyond appearances in order to grasp meanings perceptible only when we have come to understand resemblance as Magritte himself did:

> . . . resemblance which is a thought capable of becoming visible through painting: for example, the thought in which the terms are a pipe and the inscription "This is not a pipe" or again the thought constituted by a nocturnal landscape under a sunny sky. . . . Resemblance does not trouble itself to accord with or defy "common sense." It spontaneously brings together shapes from the apparent world in an order furnished by inspiration.

The precision, the care for exact rendition of shapes taken from everyday reality, with which Magritte paints forms he has no intention of using in their familiar connotation—like the smoker's pipe that is not what it appears to be—seems so paradoxical that his work is a source of perpetual confusion to the reasoning mind. A 1960 statement cited by José Pierre in *Le surréalisme* insists:

> The art of painting really deserves to be called the art of resemblance when it consists in painting the image of a thought that resembles the world: to resemble being a spontaneous act of thinking and not a relationship of reasonable or delirious similitude.

> Resemblance—capable of becoming visible through painting—comprises only shapes as they appear in the world: persons, curtains, weapons, stars, solids, inscriptions, etc., brought together spontaneously in an order in which the familiar and the strange are turned over again to mystery.

Clarification of this concept of resemblance comes most easily, perhaps, when we turn to Paul Nougé's *Pour illustrer Magritte.* Noting that a familiar object normally indifferent to us can move us, when seen out of its normal environment [*dépaysé*], Nougé asks himself why this should be so. He adduces two reasons. The first is that, in

a new world, this object "gratifies our secret desire to over-turn [*bouleverser*] the universe that is given us." Seen again in habitual circumstances, it retains a more or less pronounced *"vertu de provocation."* The second reason follows from the first. Nougé remarks that in daily life most objects are "practically invisible." The rest we perceive only as *"signs."* A chair serves merely to signal that we may sit down. "But place that chair on a sea of cloud, and relocation [*dépaysement*] no longer permits us to be content with recognition of a few significant traits at the expense of the multiple qualities obscured by that recognition."

Resemblance, for Magritte, comes from realizing, as Nougé puts it, that "The object exists *qua* object and moves us by its up to now misunderstood virtues."

Three aphorisms by Magritte, published in the twelfth number of *Rhétorique* (August 1964), sum up what he has told us so far:

> Nothing is confused, except the mind.

> What is invisible cannot be hidden from our eyes.

> There is moonlight and the locomotives are returning from the sea.

The last two, especially, illuminate Magritte's approach to painting. In the same magazine he comments on his conception of the painter's art, which can be explained "if some kind of superiority is not granted the invisible over the visible." This is to say that the work of Magritte is most comprehensible in terms appropriate to explaining the existence of surrealist objects. These objects and the Magritte canvases stand for faith in an art of concrete presences which cannot be ignored as irrelevant to human experience. Magritte made his special contribution by persistently employing only forms borrowed from day-to-day reality, in accordance with his conviction that "what the world offers by way of the visible is rich enough to constitute a poetic language evocative of the mystery without which no world and no thought would be possible."

On two occasions we have heard René Magritte refer to "thought." At no time in some forty years of creative endeavor, though, did he confuse thought with didacticism, with implementation of a theory for which the picture would provide suitable illustration. So consistent was his attitude that reason's inability to interpret the thought sustaining his work has left many with no alternative to believing—all too conveniently perhaps—thought to be altogether absent from his work, that therefore Magritte was a painter of mediocre talent and no defensible sense of purpose. Such people are incapable of appreciating what he had to say in the last issue of *La révolution surréaliste:* "an object never serves the same function as its name or its image." Responding fruitfully to the work of René Magritte means benefiting from a process of reeducation of vision and of the deductive faculties by which recognizable forms are to be interpreted in their interrelationship.

Published in *Rhétorique* in October 1962, a text of Magritte's called "Leçon de choses" ("Object Lesson") indicates that "An unknown image of the shadows is called forth by the known image of the light." Two close friends of the painter help elucidate this statement. Louis Scutenaire

does so when looking back to the pictures Magritte painted during the years 1926-1936—"the result of a systematic search for a bewildering effect that, obtained by bringing objects on stage, would give the real world, from which these objects were borrowed, a poetic sense, thanks to a perfectly natural exchange":

> The means employed were firstly the relocation [*dépaysement*] of objects, for example: the Louis-Philippe bust on the ice floe. It was fitting that the choice of objects to be relocated should fall on very familiar objects so as to give relocation maximum efficiency. A child on fire will move us, in fact, more than a planet being consumed. . . .

> The creation of new objects; transformation of known objects; the change of materials in some objects; a wooden sky, for example; use of words associated with images; false designation of an object; implementing in a work ideas furnished by friends; representation of certain visions seen when half-asleep, were in general the means of obliging objects to become sensational at last and of establishing a profound contact between consciousness and the outer world.

Paul Nougé's contribution, in "Les images défendues," leads us beyond the forms represented to speculate upon their function within the picture:

> We notice now that if Magritte paints an action in process of accomplishment, he will never fail to render its mental development impossible by a few almost always identifiable methods, the most important of which have to do with the *strangeness* he confers on that action, its particular absurdity.

> This strangeness once guaranteed, all the other elements of the picture will be treated according to the viewpoint of habit, which guarantees everything, by a sort of familiarity of access, the maximum of bewildering effect.

One picture, typical of so many, exemplifying the characteristics singled out by Scutenaire and Nougé, shows a circus strongman holding just above shoulder level a weight-lifter's bar that he evidently is strong enough to raise one-handed to the full extent of his arm. However, the weight at one end of the bar is the performer's own head: he cannot raise the bar without lifting his head from his shoulders.

Magritte's form of visual poetry is especially impressive to one poet with words, Gui Rosey: "Poetry leaps at my eyes more often than it invades the mind secretly. It looms on the far reaches of an ideal region, just this side of the unknown. Image and thought are one, where painting [*peindre*] and depicting [*dépeindre*] are two contrary forces." Rosey has heeded the warning voiced by Magritte in a private letter: "A symbol is never identified with what it symbolizes . . . things are significant in themselves." We too must heed this warning, if we are to give the attention they deserve not only to Magritte's pictures but also to the three-dimensional objects of surrealism. (pp. 211-24)

J. H. Matthews, "Object Lessons," in his The Imagery of Surrealism, *Syracuse University Press, 1977, pp. 165-224.*

Whitney Chadwick (essay date 1979)

[*Chadwick explores different levels of semiotic meaning in Magritte's* The Liberator, *arguing that the painting's principal motifs may all be traced to other, earlier works by the artist.*]

Like Beckett, the Belgian Surrealist René Magritte has long perplexed audiences with his baffling array of recombinant images, objects and words. His insistent denial of any symbolic or ideational content in his work continues to challenge traditional art historical methods of analysis and evaluation. *The Liberator,* painted in 1947, depicts a single figure seated on a low stone wall. Dressed in baggy trousers and heavy shoes he holds a sturdy cane in one hand and with the other grasps a jewelled monstrance containing a woman's eyes and mouth. The figure is as rigidly frontal and hieratically posed as any noble sitter in the history of portraiture; nothing in the posture suggests the casual air of a traveller resting on his journey through this bleak landscape. Next to his out-turned foot a small worn suitcase repeats the oblique recession of the rocks on the right. A straw hat and a red cloth draped as a cloak and drawn back to reveal a paper or cloth sheet, slightly torn at the bottom, replace the figure's head and torso. The silhouettes of a bird, a pipe, a key and a wineglass are cut out of this screen. Behind the figure a river meanders through the landscape and disappears into one of several blue cubic arches stacked up on the horizon. Fluffy white clouds float through the arches and drift between the flat black edges of the background.

Rejecting the conventions of symbolism Magritte has emphatically stated that, "In my opinion, nothing other than

The Liberator (1947)

images should be represented in painting. I have no desire, therefore, to express ideas or sentiments through painting even if they seem to me extraordinary . . . " Systematic attempts to explicate these paintings risk denying them their power as pure visual images and their complexity as non-verbal statements; at the same time simple description tends to render them flat and somewhat prosaic. But the absence of symbolic meaning does not *per se* exclude the presence of significant content and a search for such content, following the methods laid down by the painter himself, may reveal more fully the internal logic of Magritte's imagery and the particular quality of his imagination. Deeply committed to the evocation of mystery through painting, he relied on the juxtaposition of images having no apparent logical connection as the means to this end. Unlike Dali and other illusionistic Surrealists who sought to portray with startling precision and clarity the landscapes of an interior world, Magritte's painted images derive their power from their reflection of a recognizable, though idiosyncratic, external reality and, more important, from the richly individualistic mental process that determines their selection and sequencing.

As Suzi Gablik records in her study of the painter, Magritte preferred to reject the designation of artist for himself saying, "that he was a man who *thought,* and who communicated his thought by means of painting, as others communicated it by writing music or words." Accepting Surrealism's commitment to the figurative nature of thought he evolved a visual language through which the complex relationship between interior and exterior realities might be constantly reevaluated. As others have noted, the model that most readily suggests itself for eliciting the significance of these paintings is a linguistic one, but one which rejects the metaphysical implications of language in favour of a more concrete use of the image. Like Wittgenstein, who was dictating *The Blue and Brown Books* to his students in Cambridge at the time Magritte was completing *The Human Condition* (1934) and other seminal works, the painter confronted the problem of how language and thought are related to reality. His basic hypothesis concerned the nature of the picturing process and led to a series of works which remained remarkably consistent in style and iconography over some forty years. The hypothesis that Magritte depended on a specific "vocabulary" of images seems to be confirmed by the series of panels at Knokke-le-Zoute entitled *The Enchanted Domain* and executed in 1952 after oil studies by the painter. Here familiar images are combined in ways which recall but do not reproduce earlier works. In a text accompanying the series, poet Paul Colinet briefly describes each panel and lists other pictorial sources for the images. Any discussion of *The Liberator*'s meaning must, then, also begin from this point: the examination of recurrent images concentrating on the context in which these occur and the manner in which they are transformed to reveal the structure of Magritte's painted world.

Magritte himself defined the basic tenets of such an approach, suggesting that the paintings executed between 1926 and 1936 all resulted from the search for an unsettling effect produced by a series of substitutions. New objects are synthesized from familiar objects, known objects are transformed. The transformation is continued verbally by falsely designating objects. By these means objects be-

come sensational and a new and vibrant relationship between consciousness and the external world is established.

The process through which objects are transformed into images is also the process by which their meaning is established in a pictorial context. Magritte rejects symbol and ideation as products of the conscious mind, substituting for them a poetic structure based on the free flow of associative thought. Examining a series of works reveals the formal structure of this thought as it progresses from the interrogation of a known external reality to its replacement with an interior model drawn from visual and verbal association. For example, in *The False Mirror* of 1928 the sky appears in the cornea of an eye viewed from outside. Whether the clouds and sky are reflected in the eye or revealed beyond, inside the head, remains ambiguous and suggests that logical distinctions between inside and outside are untenable for Magritte. The painting playfully attacks a series of visual conventions that lead us to equate, at least metaphorically, eye and mirror. Here the pupil, the true receiver of visual data, is a black void and the cornea which, in fact, has no visual function "sees." Magritte's eye is a false mirror because the wrong part of the organ receives the image; the human eye is an equally false mirror for it merely receives inverted impressions of the external world—images which are then converted by the brain to correspond with our conventional philosophical conception of reality.

Magritte suggests, then, that it is possible for the painter to separate the visual statement from its traditional associations with a conceptualized logic. Though an identical mechanism of perception belongs to both the object and the visual image (that is, we see both with the eye) they are not the same.

Magritte returns to the problem of the relationship between nature perceived and nature conceptualized in *The Liberator,* arbitrarily cutting apart the flat blue sky and reconstructing it as an illusory architectural construction—a profusion of arches. Retaining the arch's metaphoric reference to the dome of heaven, he makes it clear at the same time that the blue sky which we see around us is as much an illusion as the painter's blue constructions. Specific atmospheric conditions create an illusion of blue sky; the sky is in fact a black void as we see here at the painting's edges.

As others have noted, the relationship between the seeing eye and the seeing mind is of fundamental importance for Magritte. About his painting *The Human Condition* (1934) the painter has said, "The problem of the window"—in many ways analogous to the eye as a defining perceptual framework—"led to *The Human Condition.* In front of a window, seen from the interior of a room, I placed a picture that represents precisely the portion of landscape blotted out by the canvas. The tree, for example, replaces in the painting the tree situated behind it, outside the room. For the spectator, it is simultaneously inside the room, in the picture, and outside, in the real landscape, which is how we see the world, namely outside of us." In the same breath, however, Magritte points out that the physiological act of perception is consummated only within the brain; that is, internally. In *The Human Condition* the painted landscape is framed, limited by drawn curtains just as the picture within it is framed by the edge of the canvas. Like Pirandello's plays within plays, Magritte's

paintings function as images within images. But the confusion between image and reality, between the painting of a landscape and the landscape outside the window, between the two- and three-dimensional worlds, is in the mind of the spectator, for the artist has clearly defined the physical boundaries which exist between each.

Essential to the content of Magritte's painting is temporal dislocation; things happen concurrently and we engage with interior and exterior reality simultaneously. The condensation may be historical as, for example, when an image from Botticelli's *Primavera* appears superimposed on the back of a bowler-hatted male figure in *The Ready-Made Bouquet* of 1957. In this way images may have more than one meaning; their meaning deriving both from their original source and their new context. The jewelled monstrance held by the Liberator (identifiable here by its form, the base on which it rests, and the manner in which it is held) recurs in a work entitled *Sheherazade* (1950) where its simplified form and lack of a base suggest its transformation into a jewelled mask for costume balls. Although Magritte slightly alters the form he retains the eyes and mouth which, instead of the Eucharist, are contained within the pearled frame. The companion relationship between painting and title—the one accompanying but not explaining the other—is particularly striking. Sheherazade, *The Arabian Nights* heroine who saved her life by relating stories to the king each night, is an image of personal salvation. The monstrance as the repository for the Eucharist carries the means of Christian salvation. Moreover, the image of a jewelled mask, of a type that might be worn to make a woman more alluring, evokes Surrealism's commitment to the idea of love as salvation and its concomitant, the salvationary heroine of numerous Surrealist paintings and poems.

It is in this way that Magritte's images accrue meanings which confirm each other without recourse to traditional methods of symbolic allusion. Bypassing the conventional obligation upon the spectator to interpret they nevertheless demand that he enter into Magritte's world, understand its laws and accept its paradoxes. We accept the appearance of image/object and image/word combinations of no apparently logical relationship in Magritte's painting. The painter himself has said, "Sometimes the name of an object takes the place of an image . . . a word can take the place of an object in reality . . . everything tends to make one think that there is little relation between an object and that which represents it . . . any shape whatever may replace the image of an object . . . an object never performs the same function as its name or its image." The process of substitutions and accrued meaning can only be understood by unravelling the images' multiple realities within the context of a specific painting and its related works. If, in fact, Magritte's paintings depend on a vocabulary of images then, like words, these images will retain a consistent referent but derive the greater part of their communicative power from their relationship with other images (as words derive part of their meaning from their relationships within a sentence). William Rubin has noted the similarity of this method to that of certain Dada Readymades Assisted, like Duchamp's *Why Not Sneeze, Rrose Selavy?*, in which the artist, instead of creating painted illusions, drew upon an existing repertory of actual objects, recombining them in ways which would transform their meaning. Deriving his painted images from the

objects of the natural world Magritte continues this transformation on a pictorial level.

The major forms contained in **The Liberator** all appear in other works. A seated figure, cloaked and with the torso replaced by a bird cage, makes its first appearance in 1937 in a work entitled **The Therapeutist.** The work recalls a Surrealist poem by Jacques Prévert, *"Pour faire le portrait d'un oiseau,"* in which the poet uses words to paint a cage into which will fly a "real" bird. Like Magritte, he intentionally confuses the distinctions between real, painted and written, concluding that:

> Si l'oiseau ne chante pas
> C'est mauvais signe
> Signe que le tableau est mauvais
> Mais s'il chante c'est bon signe
> Signe que vous pouvez signe
> Alors vous arrachez tout doucement
> Une des plumes de l'oiseau
> Et vous ecrivez votre nom dans un coin de tableau.

Magritte's Therapeutist evokes, without necessarily consciously signifying, the role of the therapeutist in ancient and modern history: from those ancient "physicians of the soul" the *therapeutae* whose monastic order devoted to the study of the meaning of the scriptures is recorded in Philo's *De Vita Contemplativa* to Magritte's contemporaries, the Therapeutic Positivists, who undertook to remedy the ambiguities and paradoxes of traditional metaphysical problems by using logical analysis to disclose the linguistic confusions that give rise to them. The Therapeutist is an essential figure in Magritte's attempt to purify the language of painting, curing the spectator of visual preconceptions not through logic, which denies paradoxes such as a man with a birdcage torso, but through the painted metaphor. Substituting birdcage for ribcage, dove (love bird) for heart (love), hat for head, the painter invents a new language to talk about his subject (the world), our understanding of which has previously been limited by the structure of our language (i.e. words) and our perceptions (our conventional notions of reality).

With his cane clutched in one hand, Magritte's Liberator is not so much a weary traveller as an old photographer posed and ready to freeze—with his art—the transient phenomena of the natural world. The suitcase at his feet remains closed, its contents undisclosed. Hat, cane, suitcase and cloak are the attributes of our journey-man artist, proferring salvation with his right hand. But the core of the painting, as in **The Human Condition,** is the picture within the picture, the Liberator's "coat of arms." The cut out forms which appear on the chest covering, all of them derived from common and recurrent images in Magritte's work, are no longer representational images, but signs, signifiers of the objects of the world on a level more abstract than the naturalism of the painted image. They recall the system of equations established by Magritte in earlier works such as the well-known **Treachery of Images** (1928) in which a painted pipe appears accompanied by a written statement, "ceci n'est pas une pipe." As Michel Foucault has pointed out [see Further Reading], we are confronted here with a statement that is both painted and written, an image of a pipe and an image of a word. The painting illustrates one model for the relationship between object, image and the word used as image (as well as conveying a titular warning as to the inadvisability of confusing any

of those modes of representation—the treachery of images is that they are often confused with objects by the unsuspecting). Two analogies are suggested here: word is to object as image is to object; and word is to image as image is to object. But the written word and the sign are also interchangeable, with each other and with images and objects.

The signs that appear on the Liberator's torso also occur in several other paintings of these years. In one, a work of 1937 entitled **Spontaneous Generation** they are incised into the surface of a slab-like human head. Beyond the head a flock of seagulls hovers beneath a stormy sky and a forest of underwater mines rest upon a flat scape. Both the mind and the mines contain explosive charges, psychic and physical energy respectively. In English, the relevant colloquial expression is, of course, the "blown mind." Within this head exist the signs or images that are generated without conscious thought, but that acquire their power through the structures of emotional association and cathexis. Here the profusion of mines indicates another kind of spontaneous procreation; their fecundity suggests another parallel with the fecundity of creativity, the "spontaneous (i.e. extra-rational) generation" of the images that form the basis of Magritte's art.

David Sylvester has noted the hieroglyphic character of these low relief emblems. Whether the forms are read specifically as hieroglyphs, or as alchemical notations, seems less important than that they be recognized as adhering to the principles of ancient methods of pictographic notation, signs which "stand for" essential terms in Magritte's visual vocabulary. They reappear in a painting entitled **The Alphabet of Revelations** (1935) which depicts a blackboard divided into two equal sections and framed by a narrow painted wooden molding. One section is completely black and on it appears a piece of wire or cord twisted into a design that "puzzles" because it cannot be visually unravelled and reduced to recognizable form. It is, however, depicted volumetrically and naturalistically, suggesting that we *should* understand its form and significance. The other half is covered with a sheet of white paper, or perhaps canvas. On it the silhouetted forms of a pipe, a key, a leaf and a wineglass appear. Whether the forms are cut through the paper to reveal the black background or stencilled onto its surface is debatable. At the bottom, a jagged tear runs diagonally across the paper and a torn flap falls over the wooden frame. The blackboard is a common communicative medium. Used didactically, it normally and ephemerally conveys words, equations or any other verbal or visual message. The wire maze on Magritte's blackboard cannot be visually unravelled; it puzzles because even in its formal clarity it is unrecognizable. Ultimately, the signs which seem completely straightforward are as much a riddle as the puzzle: they mystify just as the image of the pipe perplexes the spectator who confuses it with its corresponding object. Seen together the two sections of the blackboard suggest the visual ambiguity between perceptual and conceptual knowledge and between illusionism and signification. The tear in the paper implies destructibility, the transitoriness of any painted world—a message briefly revealed but soon to be obscured.

Evidence for viewing **The Liberator** as a powerful affirmative statement continues to mount as references to therapy and revelation combine with visual images of triumph and

salvation in this enigmatic work. From object to image to sign the painter moves along a path that frees the image from its connections with the external world so that it may reappear as the core of a more compelling mental reality. The world that Magritte paints *looks like* the world that we see outside ourselves. It isn't, though the two share the same figurative language.

When the Liberator reappears in the series of panels at Knokke-le-Zoute he does so as a composite figure (combining elements of both *The Therapeutist* and *The Liberator*) accompanied by a rose-garlanded lion. The attribute is that of a Saint Jerome with his faithful beast but the pose and gesture suggest (whether consciously or not is impossible to determine) an identification with the figure of *Jeronimus Doctor,* not in his study or tending to the lion's wounded paw, but posed triumphantly and presenting to the world the results of his life's work—his translation of the Old Testament from the Hebrew—as in the fourteenth century St. Jerome in the Strozzi Chapel at Santa Maria Novella in Florence.

No mere translator, Jerome was also responsible for treatises and commentaries like the *Questiones hebraicae Genesim,* a philological inquiry concerning the original text. It is not surprising that Magritte, with his interest in pictorial language and the function of the image, turned to this particular church father for his own Liberator. Saint Jerome, enthroned under the dome of heaven, dressed in ecclesiastical vestments and holding a copy of the Book, is a familiar image in the history of both northern European and Italian painting; Magritte must have known the so-called "Sforza Triptych" in the Royal Museum in Brussels with its grisaille Saint Jerome attributed to Hans Memling on one of the outside wings. A closer source may have been one of the many woodblock illustrations from Jacobus da Varagine's *The Golden Legend* which contains a description of this saint's life and works and which served as the title for a well known Magritte painting of 1958. Saint Jerome offered the world the words of the Old Testament translated into the language of the New; Magritte's Liberator offers us alternative ways of seeing. In reality and in painting we see only illusions. Magritte made of this fact the fundamental *raison d'être* of his life's work. (pp. 11-16, 36)

> *Whitney Chadwick, "René Magritte and the Liberation of the Image," in* Art International, *Vol. XXIII, No. 1, April, 1979, pp. 11-17, 36.*

Pere Gimferrer (essay date 1986)

[*In the following excerpt, Gimferrer assesses Magritte's stature as an artist, focusing especially on the importance of poetic or literary techniques in* The Empire of Lights, The Collective Invention, *and other paintings.*]

"It's Magritte weather today": Max Ernst's celebrated phrase seems, with all the precision of poetic definition, to delimit the terms of the problem definitively and, for that very reason to cancel it out in some way. Apart from those of a biographical nature, the approaches that have hitherto been made to the world of René Magritte have, in fact, been mostly poetical. In this field Magritte himself is at once insuperable and indescribable. It is impossible to really put into words what his works express in purely plastic terms; nor can one imagine that any poem could achieve anything like the works' immediacy of revelation, imbued with irrefutable force. It is true, of course, that a work by Magritte acts in exactly the same way as a poem would; but there is no poem that acts like a work by Magritte. In this sense Ernst's phrase, however evanescent it may seem at first glance, attains a maximum of precision: Magritte is, in fact, a sort of "weather," and even a whole climate—a propensity of thought, perhaps what some might call a state of mind—a world or an atmosphere. It is in this that his specific excellence is to be found.

Magritte is certainly not the only artist of this century who has painted things that do not exist and are in fact inconceivable within normal perceptions of phenomena. His *confrères* in this approach include Ernst himself, Chirico, Tanguy, Dalí, and Delvaux—to mention only some of the best known artists who never (except for Ernst, in certain areas of his work) abandoned what is usually known as "figurative" painting. This of course leaves out painters like Joan Miró or André Masson, who did depart considerably from the usual system of representation. And yet in no way can any of the painters who, like Magritte, depicted "impossible things" be confused with him (in passing I may say that it would be pretty difficult to confuse any of them with any of the others, although that is not a question that concerns us at the moment). Given Magritte's artistic premises, no matter how exceptional his individual talent may have been, what he actually achieved was, in theory, well within the reach of any of his contemporaries. It is no disgrace for an artist to create a "school," or for his style to coincide with those of others. Nevertheless, although Magritte has had posthumous imitators (some of whom, admittedly, have merely popularized or trivialized his art) and has exerted a lasting, latent influence on the sensibilities of our time, if we go to the heart of the matter there is no painter remotely approaching his stature who can be either compared to or confused with him. In this respect, too, Magritte is irreducibly unique.

Those with the closest affinities to the artist—Max Ernst, for instance, or Louis Scutenaire or Patrick Waldberg—produced a poetical atmosphere analogous, though not identical, to that of his canvases. At what might at first sight seem to be the opposite extreme, an essay by Michel Foucault [see Further Reading] proved to be the most important contribution to the study of Magritte. In an apparently paradoxical procedure, Foucault applied to the artist's works the very premises that his paintings either avoid or openly reject, examining Magritte's output as a painter according to the usual laws of representation and the data that form part of the usual viewer's phenomenological experience. Foucault then proceeded to a description that was quite deliberately intended to appear tautological, in a purely Socratic exercise.

What Foucault did was to take to its ultimate consequences (consequences irrational precisely because of their extreme concern for scrupulous rationality) the instinctive response elicited by Magritte's canvases—or, to be more exact, by what exists in them—the response called forth not, that is to say, by their hypothetical (and, when all is said and done, utopian) reference to reality, but by their effective plastic reality. It is a fact that a work by Magritte provokes a particular reaction, which conforms to

certain laws of internal logic that govern plastic works in general, but not specifically those of Magritte. Out of the simple examination of this fact—which in itself is so well known as to be useless in any critical interpretation—Foucault succeeds in extracting the highest degree of empathy for Magritte that is attainable in an essay. His extreme rationalization of what is pure evidence constitutes a subversive exercise as penetrating and lucid—and, at bottom, as poetic—as the synthetic formula invented by Max Ernst.

Up to now I have referred only to those who, from a position of friendship or affinity, and occasionally from both at once, were advocates of Magritte's work. It is impossible to go further than Ernst or Foucault along the path they chose to follow; possibly it was only by being Ernst or Foucault that either of them went so far. But perhaps there may be another, more oblique, way of approaching Magritte, one that has the additional, incidental advantage of meeting an objection that was sometimes made to the artist's work even during his lifetime. It must be admitted, indeed, that poetic approaches such as those of Ernst or Scutenaire are to some extent acritical by definition, while Foucault's study, important though it may be in many respects, cannot be regarded as belonging to the field of art criticism in the strictest sense. Art critics in different countries have from time to time expressed reservations about Magritte—not, in fact, about his early, still rather tentative paintings, nor yet about those atypical works of his *période vache,* but rather the very works that have been the basis of his fame, that constitute the real nucleus of his total *œuvre.* Some of those critics have talked of literary painting; others have hinted, or openly asserted, that the painter's values were exclusively, or at least principally, literary. The most severe of these objections could serve to confirm that Foucault's analysis demonstrates the excellence and conceptual singularity of Magritte's art, but neither proves nor can prove anything about its pictorial nature.

Here we may find ourselves exploring barren ground. There is no sense in comparing Magritte with artists such as Braque, Mondrian, or Pollock, whose raw material is pure pictorialism. Only purely pictorial excellence can be expected from them, just as only the most refined verbal excellence can be expected from Rimbaud or Mallarmé. Does not the greatness of Mallarmé invalidate to some extent that of Lautréamont or of Germaine Laye, who were far from operating, like Rimbaud or Mallarmé, through the sheer semantic, sonorous expansion of words? In comparison with Rimbaud or Mallarmé, admittedly, we do find in both Nouveau and Lautréamont a certain margin of verbal "imperfection," as of something "unfinished"; but no poet can be asked to write poems other than his own. It is as difficult to imagine Lautréamont producing the *Sonnet en ix* as it is to think of Mallarmé composing *Les chants de Maldoror.* Particularly from the viewpoint of Surrealism—and that is the only one from which Magritte's activities can be fairly judged—in the evolution of the artist's painting may be seen a continuing subversive attitude that parallels the trenchant condemnation of "retina painting" implicit in the work of Duchamp.

It is true that Magritte's principal source of income for many years was publicity drawing or industrial design (wallpapers, advertisements, and publicity for couture houses). It is likewise true that, unlike other painters who have engaged in this sort of work (Antoni Clavé, for instance, who in his younger days did many posters for cinemas), Magritte's works—especially his most highly appreciated and characteristic works—always reveal something of the working methods used by artists who engage in publicity work. And finally it is true that, whatever judgment we may be inclined to pronounce on them, it is not the works of his "Renoir period" nor yet those of the *période vache* that have been responsible for Magritte's great fame and influence but rather those that describe, in meticulously realistic technique, associations that are impossible in real life. This technique—and even, we must perforce admit, some of these associations—belong to some extent to the same order of things as his paintings for advertising campaigns. (Indeed, although I mention the fact only as a curiosity, in 1986 an important publicity campaign promoting computer software used a strictly Surrealist oil painting by Magritte as its graphic motif.)

There is no need to stress contemporary recognition of the artistic merits of graphic publicity—as seen in the famous posters of Toulouse-Lautrec, for instance—or to make any mention of the vast increase in the awareness of design that has taken place over the last few decades. It is sufficient, I think, to point out that the chief characteristic of Magritte's works (particularly when one sees them "in the flesh," so to speak, since photographic reproduction always modifies, be it ever so slightly, this phenomenon) is that they are authentic "dream advertisements." The logic that prevails in them is, undeniably, the logic of the world of publicity—in which, as in magical thought, according to Frazer, the workings of contiguity or analogy take the place of those of causality. Moreover, the orientation of Magritte's works vis-à-vis traditional painting in oils is not so very different from that of advertising art in relation to "serious" art.

In both publicity and Magritte's Surrealist paintings, we are presented with something that is at once a simulation and a substitute: the appearance, at first glance, of a traditional oil painting, but only the appearance; in exactly the same way as we are presented with the appearance—again, only the appearance—of a traditional realistic representation. In this respect Magritte is as lucidly critical as Duchamp of what the latter called "retina painting," but Magritte chooses to display his criticism in another way; one that is more oblique and yet at bottom more homologous, which he chooses in order to make explicit his radical disagreement with the ordinary perception of everyday reality.

Magritte's capacity for combination seems inexhaustible—and since nobody but he could exercise it, his physical disappearance admits no palliatives. Magritte can be imitated, albeit in a sterile fashion, but he cannot be replaced. We often find that his true successors are those who seem the least likely, for his attitudes towards art and life can be inherited, but not the iconographical repertoire that is his alone. And yet it is really rather remarkable that an artist whose imagination was so indefatigably varied should have been so firmly convinced of the need to rework some of his most important paintings over and over again. True, there is a long tradition of artistic revision in the history of art; any well-educated person will recall the two versions of Watteau's *Embarquement pour Cythère.*

But Magritte did not work with previously existing themes, which by their nature admit different variations or concurrent treatments; nor did he work on commission, as did such painters as Bellini, Canaletto, and Fortuny, who had to cater for a clientele that demanded new formulations of one subject. Magritte's returns to certain themes belong rather to another tradition in art history. Like Joan Miró—an artist from whom he differs in a great many aspects, but with whom he is morally at one in his radical adoption, to its ultimate consequences, of the Surrealist attitude—Magritte returned again and again to certain obsessive motifs, which on first encounter afforded him an initial shocking revelation. These motifs were imbued with a poetic potential akin to that of the *objet trouvé,* one that in Magritte's case came into play exclusively thanks to the operation of art.

What is probably Magritte's most celebrated work, *The Empire of Lights,* provides us with one of the most characteristic examples of the painter's way of reacting to the obsessive nuclei of his imagination. Magritte painted no fewer than ten versions of this work, the last of which, significantly enough, remained unfinished owing to the artist's death, so that we may say that this image accompanied him over the two final decades of his life, until his very last moment. Any viewer who is in the least familiar with Magritte's work or is even minimally interested in contemporary painting is acquainted with the subject of *The Empire of Lights,* which does not vary substantially in the course of its different versions. It is a painting in which there is no sign of any human or animal figure: in short, no living beings at all. And yet the scene is not static or lacking in movement, for motion is evoked by the ethereal cotton-wool clouds floating across the upper part of the painting. It is not this part, however, that principally attracts the viewer's gaze, which is inevitably drawn first to the lights that give the picture its title: light from one or more lampposts and one or more windows in a building apparently uninhabited and totally devoid of all human activity. This is the only element in the work that is absolutely fixed and unalterable. The number and arrangement of lights and windows, the inclusion of both (as is most common) or of only one—occasionally the lamppost is omitted, a circumstance all the more surprising inasmuch as the feature of *The Empire of Lights* most immediately recalled by the vast majority of viewers is in fact that very lamppost, or lamppost—are factors that vary from one version of the work to another. This is true (even more so) of the possible presence, in the lower part of the picture, of the still waters of a river, pond, or canal in which the light from the lamppost can be reflected.

From this it can be seen, of course, that the area in *The Empire of Lights* that most immediately attracts and retains the viewer's interest is a nocturnal scene. Absolutely of the day, however, is the clear blue sky dotted with floating white clouds that occupies the upper part of the scene. A sky like the one depicted naturally rules out any illumination like that shown in the lower part, and especially the penumbra dispersed by such illumination. There can be no doubt that the work would not be nearly so disquieting without this contradiction. But unlike other pictures by Magritte, in which one can immediately see the impossibility (in accordance with the most elementary laws of physics) in real life of what is represented on the canvas, in my opinion what most impresses the viewer about *The*

Empire of Lights is not the fact that such physical laws should have been transgressed, but rather the special quality that is gained—and indeed, heightened—through this transgression. The truth is that the vast majority of viewers do not quite realize that the scene represented is not realistically presented.

Undoubtedly the house or houses with the lighted windows, and the light from the lamppost, when there is one, are given so much plastic emphasis that they force one to accept the scene fully and without reservations. More or less consciously, the viewer tends to believe, for instance, that what he sees is simply an anomalous twilight in which darkness has come on much more quickly, possibly owing to the shadows in the dense foliage of the trees, in the area of the house than in the vault of heaven above; or else it is taken for granted that the house lights—since nobody seems to be home—have either been left on outside of normal hours or have been switched on prematurely. None of these explanations is acceptable, of course, since the darkness enveloping both the house and lamppost cannot be taken for anything but true nocturnal darkness. The poetical impact of this work on the viewer derives not from any transgression of the laws of meteorological verisimilitude but from the visual authority with which the lights of the house and the lamppost are presented. What is essential in this work, and more generally in all of Magritte's poetical imagination, is not so much the violation of verisimilitude, and the terms in which that violation is carried out, as the new plastic entity to which it gives rise.

On the subject of *The Empire of Lights,* Magritte himself wrote: "For me the conception of a picture is an idea of one or several things that can be made visible through my painting . . . The conception of a picture—that is to say the idea—is not visible in the picture itself; an idea cannot be seen with the eye. What is represented in the picture is what is visible through the eyes, the thing or things of which I have found it necessary to give an idea. Thus, the things represented in the picture *The Empire of Lights* are the things of which I have had the idea: is to say, exactly, a nocturnal landscape and a sky such as we see in broad daylight." These words of Magritte's are extremely revealing in their apparent simplicity; on reading them one cannot help recalling Leonardo da Vinci's celebrated description of painting as *cosa mentale;* or calling to mind, in an order of things which is literally closer still, a certain moral tale by Ramon Llull: "There was once a painter who painted the image of a man on the wall. While that painter was painting that image, many men who were close to the painter praised the painter for the great mastery he showed in painting that image. And it happened that the painter asked one of those men who were praising him whether he was more deserving of praise because of the imagination he had within himself in imagining the image he was painting, or whether he deserved praise rather for the image that he was creating." Undoubtedly, it was not by chance that Ramon Llull was one of the writers whose works were recommended reading for the Surrealists; the terms in which Llull describes the operation of painting, at all events, are approximately equivalent to the words of Magritte on the subject of *The Empire of Lights.*

Any approach to the previous idea will explain the foundations of Magritte's fascination; but the fascination in itself does not depend on the idea but rather on the object—

that is to say, on the work. Thus in the case of *The Empire of Lights,* for instance, it is not the mere coexistence of day and night—the previous idea—but the visible object engendered by it (a plastic sublimation of the artificial light that could not occur in any other way) that speaks to the imagination of the viewer. The viewer, accepting the scene as it is presented to him, accepts its contradictions as the necessary pictorial artifices that sometimes transgress the laws of verisimilitude, after the fashion of those strained perspectives, foreshortenings, or anatomical excesses to be found in Mannerist painting, or of the unreal arrangement of real objects that we sometimes see in such eighteenth-century forms as the *capriccio* or the *veduta fantastica.*

The idea is more visible in another celebrated picture by Magritte, *Dangerous Relationships.* The transgressions of verisimilitude contained in this work have been related in detail by Foucault in a most productive critical work. Most viewers, however, will merely feel a vague uneasiness without being able to specify the exact scope (which is really explicable only through a thorough analysis) of the deviations from verisimilitude that appear in this picture. They will see, of course, that the looking glass, instead of reflecting, is transparent, and that the position of the woman's torso is inverted in relation to the part of her body not framed by the glass; but will probably not perceive other discontinuities and peculiarities such as the proportional size of each part of the body, the position of the hands or the shadow on the wall. Grasping the idea behind the work will help the viewer to reconstruct Magritte's creative mechanism, but the idea will not replace—though it may explain—the work's imperious plastic effectiveness.

Quite frequently, Magritte's pictorial operation can be summarized in comparatively simple and explicit terms: the terms proper to poetical language. For example, in his works the oppositions between the natural world and the artificial world on the one hand, and between open space and closed space on the other, converge in a single plastic theme that appears in at least three important reworkings: *The Listening Room* (which might perhaps be equally well translated as *The Listening-in*), *The Anniversary,* and *The Tomb of the Wrestlers.* In all three, inside a space that is at once *closed* and *artificial*—a room, absolutely new and clean, but without any furnishing except for a curtain at the window, and in *The Listening Room* a room without even a curtain—there is an element of the *natural world*—a rose, an apple, a mineral. This element, because of its nature and because of the immense size or scale with which it is presented, we associate immediately with the notion of *open space.* More complex but equally clear-cut is the operation carried out in the case of *The Golden Legend,* in which we witness one of the actions that constitute the very foundation of poetical language: the transition from simile to metaphor.

It is true, indeed, that it can be said of the great white clouds that appear in the different versions of *The Empire of Lights* that they look like loaves of bread. It can be said, but in fact it is not said, because this would really be what is called a "descendent image," insofar as it compares an object with another of a less lofty nature, thus inverting the magnifying objective of imaginistic transfiguration. The poetics of the avant-garde movements, however, do occasionally make use of the descendent image (especially,

for instance, among the works of the Russian Futurists), since for them the sublime is not necessarily associated with the lofty but rather with the unusual. Since the clouds look like loaves of bread, then, Magritte's procedure is quite consistent: in *The Golden Legend* the clouds do not *look like* but *are* loaves of bread in the serene blue sky. Here we may observe the thaumaturgical power of the image. A simile merely relates two elements through an analogy that is sometimes tangential or fortuitous; a metaphor constructs, on the basis of that analogical relationship, a new reality that exists only in the poetical word. The loaf-clouds in *The Golden Legend* are, precisely, a visual metaphor—or, still more precisely, the visualization of a metaphor, transformed into a new order of reality that exists only in the picture.

The relationship of what is represented in one of Magritte's works to the title of that work, and the fixed, variable, or combinatory value acquired by each element from one work to another, can guide us to the central nucleus of the painter's plastic operation. As everybody knows, it frequently happens that the titles of avant-garde paintings derive their subversive force from a precise and submissive attempt at description. For instance, nobody will dispute, after closely examining them, that paintings such as Picabia's *Very Strange Painting on the Earth,* Duchamp's *Sad Young Man in a Train,* Ernst's *The Robing of the Bride,* or Miró's *Dutch Interior* (four pieces that at least have in common that they belong to the Peggy Guggenheim Collection in Venice) bear titles perfectly suited to their plastic reality. Yet it would be difficult to imagine anybody deciding, without previous knowledge, to assign such titles to them; not difficult because to do so one would have to be thoroughly acquainted with a certain field of knowledge (as, for instance, Renaissance and Baroque painters were with the themes of classical mythology), but difficult in the sense that the things one needs to know in this case are not part of a repertory available to everyone but belong exclusively to the artist. Magritte's titles, however, function in another way, as an additional factor, a new element of criticism and disturbance.

Let us examine one of the more moderate cases—by which I do not mean a work in which it is quite obvious that the painter is aiming at a maximum of tension between title and picture and a maximum of the illogical in the former (as in *Time Transfixed,* a title in itself entirely irrational unless it is taken as a criticism of Bergson's philosophical terminology, for designating the image of a smoking steam locomotive embedded in the fireplace of a bourgeois dining room). Let us take, rather, a case in which it is comparatively easy to reduce the possible genesis of the manner to rational criteria, even though it be purely by way of conjecture. Let us take, then, a canvas such as *The Beautiful Relations* as our starting-point. Like *Time Transfixed*—and, I should add, like the great majority of Magritte's works—this canvas is based on the effect of strangeness derived from the juxtaposition in one and the same space of several elements, none of which by itself would cause any surprise, since they all belong to everyday reality. Let us for the moment forget about the great sky with white clouds on a background ranging from blue to pink, and the tiny village with lights showing in its apparently Lilliputian windows that can be seen at the bottom of the canvas. These elements (which contain hints of *The Empire of Lights*) support what constitutes the real subject of the

composition, which cannot be defined as other than a human face. This face is not only of cosmic proportions (as though it were the unimaginable face of the sky, or the world, nature personified) but is also quite devoid of features, being only partially constituted of human elements. It is an allusion to a face, a face that is uniquely elided.

Nevertheless, it seems somehow typical of Magritte that the theme of the cosmic face, and at the same time of the non-face, the face that exists only by allusion and is not even entirely anthropomorphic (a theme extremely characteristic of contemporary art, and more often than not, as in the work of Ernst, quite frightening) should here strike us as being perhaps a little irritating, but by no means tragic or terrifying; in fact hardly more than vaguely threatening. This is so not only because of Magritte's temperamental penchant for "everyday unusualness" and avoidance of tragic pathos (insofar as it would mean favoring the exceptional, and thus impairing that continuity of the unusual which his art postulates), but also because the elements that go to make up this face are, to some extent, cosmic elements. Only the eye on the left-hand side—the one human eye—escapes this connotation. We may, perhaps, be taken aback by its hypnotic fixity, the absolute whiteness of the cornea contrasting with the tremendously intense blue of the pupil, or by the pink borders of eyelids, totally innocent of lashes; but even in such an emblematic role this eye is in itself neutral, by which I mean perfectly serious. The same can hardly be said of the other elements forming this face. The lips are intensely red, as heavily painted as a lipstick advertisement, and quite unmistakably feminine (whereas the severity of the eye suggests rather a masculine personality); the nose is an exaggerated pink conk like a clown's (always supposing that it is a real rather than a false nose, since we cannot see the nostrils); the balloon, finally, not only offers the burlesque contrast between its almost spherical shape and the transversal narrowness of the eye on the left but, for today's viewer, makes by its very presence an allusion to a past age invented by Jules Verne, at once chimerical and anachronistic. This is everydayness, yes, but it is the everydayness of a superseded yesterday. And yet, from the convergence of these very doubtful elements—a single eye, an exaggerated nose, a pair of vamp's lips, a hot-air balloon—a face emerges that gazes out at us and occupies the whole sky. There can be no doubt about it; what binds these elements together is what the French call *des belles relations;* not in the sense of harmonious coexistence but in the typical bourgeois sense of "being well connected," i.e., having friends who are both influential and socially impeccable. Magritte's title in this case is perfectly descriptive, although it may indulge, in passing and on the rebound, in ironical commentary on another aspect of everydayness—a cliché from the horrid, priggish repertoire of the petite bourgeoisie. (pp. 5-13)

Although it may occasionally be through a voluntary and very successful *reductio ad absurdum,* some of Magritte's works display a fairly rational combination of elements, explained by an equally rational title. This is the case, for instance, with *The Collective Invention.* Now, a mermaid, like any other mythological creature, may indeed be fairly regarded as a collective invention; and since a chief characteristic of several mythological beings—the mermaid and the centaur being the best-known—is that they are half human and half animal, there does seem to be a cer-

tain logic in the idea of a mermaid who has the torso and head of a fish but is a woman from the waist down. To be sure, the operation is rather disturbing in several senses, beginning, perhaps, with its effect on the viewer's eroticism. The pubic hair and guessed-at female sexual organs, as well as the soft curve of the thighs, are (unlike the images in the works of such a painter as Paul Delvaux, from whom Magritte declared himself to be very different) totally lacking any tinge of sexuality, their erotic possibilities cancelled out by the obtuse, distressing eye of the fish. The principal visual interest of this picture, in fact, lies in the nucleus formed by the head of the fish in the foreground, its rearing fin behind, and the sea in the background with its ripples visibly in harmony with the outline of that fin. We quite clearly perceive not only that the eroticism of the traditional mermaid is of a psychological nature and based on the face but also that, however disjunctive the erotic obsession may prove, an erogenous zone—in this case the pubis—can be neutralized simply by dissociating it from the rest of the body; i.e., by taking the fetishistic disjunctivism to its last and strictest consequences. Thus, the ultimate theme of *The Collective Invention* is really the plastic dissolution of the erotic myth of the mermaid, in what Magritte himself calls "the answer to the problem of the sea." This ocean background—as majestic and lyrical as one of Vernet's seascapes—finds its natural correlation in the disquieting fish's head, and dilutes or dissipates the plastic entity of the female pubis.

Apart from this, the central combinatorial motif in *The Collective Invention* is, after all, simply a new manifestation of what was Magritte's fundamental obsession: the coexistence, in the plastic space of the canvas, of all that is different, opposed, and irreconcilable in the space of our experience of phenomena. In a way that is quite as eloquent and vivid as that of El Greco in *The Burial of Count Orgaz, The Empire of Lights* expresses this experience, which is really a rending that leads to a different reality, an opening into the preternatural. In other works we have seen the contagion between open space and closed space, and between the natural world and the artificial world. In *The Collective Invention* this sort of contagion, mutual transfer, or secret intercommunication presents us with a further variation: the transition between the animal world and the human world, which will be echoed or paralleled in other such transitions or permutational exchanges among the classic kingdoms of nature (mineral, vegetable, and animal, particularly) and, in frequent combination or correlation with them, between the animate and the inanimate. Thus a veritable constellation of variables is established: natural-artificial, open-closed, human-animal, animal-vegetable, vegetable-mineral, animate-inanimate, to mention only the most obvious combinations. Naturally, it is not only Magritte's poetical imagination that rests on the rotation of this repertoire of signs, but, in general, all that is imaginary in fantasy and myth, and most particularly the imagery of Surrealism. Even the theme of the masking or elision of identity by means of the non-face— extreme examples of which can be found in the cloth-wrapped heads of *The Lovers,* the total absence of any face at all in *The Healer* or *The Liberator,* or the replacement of the head by an apple in *The Idea*—is in line with this same fundamental dynamic. At the same time, the appearance on one hand of a lunar face in a sphere very similar to the apple in *The Art of Living,* and the representation on the other in *The Postcard* of the character seen from

behind or apparently absorbed in the contemplation of an apple suspended in the sky in front of him, represent two other phases of the same basic idea of decapitation by fruit or moon-dwelling animism.

All of these transactions I have been describing, although they do make us realize the conceptual subtlety of the dream mechanisms in Magritte, do not exhaust or even really explain the intrinsic fascination of his works, which are first and foremost plastic presences. In the mind of the viewer they leave equally the impression of a subtle, subversive displacement of the elements of the visible world, and the memory of a notable clarity of form and an obsessive sense of color. Magritte would be conceptually great (and that is, at least, one way of being great) if he were no more than the medium or the place of certain exchanges and transactions of appearances; but he is also the creator of a plastic world, which is something different from the mere conceptual decomposition of the elements of which it is composed. In other words, Magritte's greatness does not consist solely in having carried out a series of permutations that violate or call into question conventional perception but in having created through these works a disquietingly autonomous plastic world.

This is perhaps particularly noticeable in Magritte's works that deal not so much with the combinatorial interchange of objects as with the fusion or disappearance of limits between them. By this I mean the works in which Magritte must not aspire above all (in his own words) to "an objective representation of objects," for the sake of which he establishes as a basic premise what he calls (defiantly preempting, in the Surrealist fashion, a reproach often visited upon him by the traditional critics) a certain "absence of plastic qualities." In other words, these works exemplify a certain refusal on Magritte's part to paint in any way other than that most readily identifiable with the stereotype of the viewer's experience, which he intends to violate. Magritte's own comments in this regard could hardly be more lucid. In a letter written to Paul Nougé in November 1927 he says: "I believe I've made an altogether startling discovery in painting: up to now I used composite objects, or perhaps the position of an object was enough to make it mysterious. But . . . I have found a new possibility things may have: that of *gradually* becoming something else—an object *melting* into an object other than itself. For instance, at certain spots sky allows wood to appear. I think that this is something totally different from a composite object, since there is no break between the two materials, no boundary. In this way I obtain pictures in which the eye 'must think' in a way entirely different from the usual . . . "

An unequivocal example of the foregoing is **Discovery,** a picture Magritte painted around this time and to which he himself refers in the letter above when he says, almost by way of example, that "a nude woman has parts that also become a different material." It is worth noting that Magritte's description here differs from those he gave on other occasions, in that here he does not go a step beyond the ordinary perception of the viewer, with whom in this sense he equates himself. When we examine **Discovery,** our first impression is that the picture before us is the portrait of a nude woman whose body is covered with tattooing. Very quickly, however, we realize that her skin is not tattooed, nor even covered with, for instance, paint or ink.

There is nothing drawn or engraved on it, but in some parts the skin itself appears to become something else: at some points we seem to see a succession of streaks like the stripes of a tiger, and elsewhere the skin tends rather to suggest the varying roughness of tree bark. Nevertheless, no matter how disquieting this polyvalence may be, in **Discovery** the two materialities that alternately occupy the viewer's visual perception still have in common their allegiance to the realm of things solid and animate, whether it be the human and the animal worlds or even possibly the vegetable kingdom. But it was not long before Magritte's art provided an abundance of still more complex possibilities, confronting the solid with the liquid and the gaseous, and presenting them, moreover, in conjunction with other combinatorial themes already mentioned.

Thus, for instance, in **Decalcomania** we find interwined the theme of the *double*—the split identity—or of *repetition* (i.e., at once the reflection or shadow and the iconic duplicate) and that of the communicating vessels between open environment and closed environment, which is here further reinforced with that of the transition between the solid and the gaseous and between man and the ether. The character on the left of the picture is, in effect, standing in the open air facing the vast sky with its great floating white clouds. On the right of the picture, however, the shadow or reflection or double of this character, situated in a closed environment and facing the curtain of an interior, is turned into a mere outline that contains, at exactly the same height as on the left of the picture, sky and clouds from the part corresponding to the character's bowler down to approximately the middle of his torso, and in the lower part of the shadow torso the expanse of sea of which in the left-hand half we can only see the beginning. The same communication between the human identity and the cloud-peopled sky appears in a fairly early and technically atypical work, **Napoleon's Mask,** a painted plaster cast in which the funeral impassiveness and the blind eyes are subtly transmuted in the dissipation of the Magritte sky, with its scattered group of clouds setting off the cheekbones, the brow, the skull, the cheeks, or the neck of the Emperor, so that something essentially immobile—a mask at once monumental and funerary in its hieratic quality— is placed in constant transition towards all that is more mobile and changing.

The same central motif presides over **The Large Family,** in which, over a choppy sea, we see the flying silhouette of a bird of gigantic proportions yet not at all frightening in appearance. Rather, it is imbued with a sort of serene majesty, the interior of its outline occupied by the everlasting sky with white clouds sailing across it. Air in the air, in this bird the animal and gaseous worlds converge. Fair enough, but it is also impossible to avoid the impression that what we are shown here is the negative, the duplicate, the shadow or projection of the bird rather than the bird itself; its iconographical essence, if you like, rather than its tangible existence. Another, later version of the same theme, **The Large Family,** done fifteen years later in 1963 . . . , presents exactly the same plastic composition, the only difference being in the coloring of the sea and the sky in the background (i.e., the part not included inside the silhouette of the bird). These tend to concentrate light blue or related tones in the lower part of the canvas, so that the continuity established between the sea and the sky in the earlier version now also comprises the

part of the sky contained within the outline of the bird—at its start, at least. In the bird's crop and above all in the wings we certainly still find the impression of volatility (a double impression, given both by the opening and spreading of the wings themselves and by the internal movement suggested by the clouds. This volatility opposes, even by virtue of its simple, radiant clarity, the static character of the firmament, which gradually grows more ominously somber as our gaze moves up the canvas, to a clearly threatening storm in the upper area.

This coexistence of elements, although pleasant enough in the examples I have given up to now, can become a most disturbing confrontation. The cosmic combat of giants show in **The Battle of the Argonne** is such a confrontation, in the empty sky over a little village, between a rock and a huge storm cloud—two of the four classic elements, inanimate in themselves but silently animated by their position as jousters in a tourney umpired, and at the same time visually counterpoised, by the thin line of the new moon. Equally inanimate, the objects in **Personal Values** derive their subversive potential, as Magritte himself pointed out in a letter, from the simple fact that, thanks to their dimensions, they are deprived of whatever practical utility they may possess in everyday life; really, however, the whole composition would not amount to more than a variant of the conception of **The Listening Room** (objects of unusual dimensions, and artificial ones in this case, within a closed space), were it not that here the sky performs the functions of a wall and so presents another confrontation, not only between the manufactured or artificial and the natural but, once again, between the solid and the gaseous. Thus it traces a new front line of challenge parallel to that established by the hypertrophy and bizarre arrangement in the room of the comb, the wineglass, the match, and the shaving brush. Nobody but Magritte could have painted this scene; anybody who questions the specific aesthetic entity of his work must lay down such arguments as he may have in the face of this image, which is only conceivable in pictorial terms, only exists because painting exists: *ut pictura poesis* ["poetry is like a painting"]. The weather in this room invaded by the clouds and the blue belongs to no place in particular. We are living, for good by now, in Magritte weather. (pp. 14-18)

Pere Gimferrer, in his Magritte, *translated by Kenneth Lyons, Rizzoli International Publications, Inc., 1987, 128 p.*

FURTHER READING

I. Writings by Magritte

Torczyner, Harry, ed. *Magritte: The True Art of Painting.* Translated by Richard Miller. London: Thames and Hudson, 1979, 144 p.
 Compilation of writings by Magritte on art, philosophy, and related subjects with accompanying illustrations.

II. Critical Studies and Reviews

Berger, John. "Magritte and the Impossible." In his *About Looking,* pp. 155-61. New York: Pantheon Books, 1980.
 Analyzes Magritte's language of painting in light of his particular artistic intentions.

Calas, Elena. "Magritte: Variations on the Theme of the Bell." *Arts Magazine* 41, No. 7 (May 1967): 23-4.
 Investigates Magritte's use of the bell motif in a series of paintings.

———. "Magritte's Inaccessible Woman." *Artforum* XVII, No. 7 (March 1979): 24-7.
 Assesses the effect of Magritte's mother's early death on his depiction of women in his paintings.

Calas, Nicolas. "Pearls of Magritte." *Arts Magazine* 46, No. 6 (April 1972): 46-9.
 Studies the use of symbols in Magritte's paintings.

Clurman, Irene. *Surrealism and the Painting of Matta and Magritte.* Stanford, Calif.: Humanities Honors Program, 1970, 46 p.
 Substantial paper that aims to "compare and contrast the work of René Magritte and Roberto Matta Echaurren within the context of Surrealism."

Foucault, Michel. *This Is Not a Pipe.* Translated and edited by James Harkness. Berkeley: University of California Press, 1983, 66 p.
 A well-known philosophical analysis of the complex semiotic levels of Magritte's language pictures.

Gedo, Mary Mathews. "Meditations on Madness: The Art of René Magritte." In *In the Mind's Eye: Dada and Surrealism,* edited by Terry Ann R. Neff, pp. 62-89. New York: Abbeville Press, 1985.
 Attempts to "demonstrate how the artist's unique relationship to his mad mother formed and fueled his creativity, setting his brand of Surrealism apart from that of such contemporaries as Max Ernst."

Hurrell, Barbara. "The Menace of the Commonplace: Pinter and Magritte." *The Centennial Review* XXVII, No. 2 (Spring 1983): 75-95.
 Compares and contrasts the illogical worlds of the playwright Harold Pinter and Magritte.

Levy, Silvano. "René Magritte and Window Display." *Artscribe,* No. 28 (March 31, 1981): 24-8.
 Discusses the influence of window display techniques of the 1920s on Magritte's approach to painterly composition.

Masheck, Joseph. "The Imagism of Magritte." *Artforum* XII, No. 9 (May 1974): 54-8.
 Places Magritte's interpretation of the role and function of the image in the context of early Modernism.

Matthews, J. H. "René Magritte." In his *Eight Painters: The Surrealist Context,* pp. 51-63. Syracuse, N.Y.: Syracuse University Press, 1982.
 Outline of Magritte's life and work, focusing on the relation of his art to that of the other Surrealists.

Mesens, E. L. T. "The World of René Magritte." *The Saturday Book* 19 (1959): 273-76.
 Succinct resume of Magritte's life and work by a friend and prominent spokesman of the Belgian Surrealists.

Morstein, Petra von. "Magritte: Artistic and Conceptual

Representation." *The Journal of Aesthetics and Art Criticism* XLI, No. 4 (Summer 1983) 369-74.

> Analyzes the relationship between artistic, referential, and conceptual representation in *The Use of Words I* and other paintings by Magritte.

Noël, Bernard. *Magritte.* Translated by Jeffrey Arsham. New York: Crown Publishers, 1977, 94 p.

> Discusses the aesthetic and philosophical implications of Magritte's use of images. Also contains numerous illustrations, many in color.

Roque, Georges. "The Advertising of Magritte/The Magritte in Advertising." *Print* XXXIX, No. 2 (March-April 1985): 67-73.

> Investigates Magritte's advertising work in the period between the wars, asserting that it had a considerable impact on advertising design in the post-war era.

Shattuck, Roger. "René Magritte Meets the (Irish) Bull." In his *The Innocent Eye: On Modern Literature and the Arts,* pp. 277-87. New York: Farrar Straus Giroux, 1984.

> Discusses the conceptual and literary basis of Magritte's art.

Siegel, Jeanne. "The Image of the Eye in Surrealist Art and Its Psychoanalytic Sources, Part II: René Magritte." *Arts Magazine* 56, No. 7 (March 1982) 116-19.

> Considers the psychoanalytical dimension of the imagery of the eye in Magritte's paintings.

Soby, James Thrall. *René Magritte.* New York: Museum of Modern Art, 1965, 80 p.

> Comprehensive critical overview of Magritte's *oeuvre,* addressing both stylistic and thematic issues.

III. Selected Sources of Reproductions

Gimferrer, Pere. *Magritte.* New York: Rizzoli, 1987, 128 p.

> Comprehensive selection of plates, mostly color.

Hammacher, A. M. *René Magritte.* Translated by James Brockway. New York: Harry N. Abrams, 1974, 167 p.

> Extensive selection of large-format color plates with accompanying critical précis. Includes an historical and critical introduction to Magritte's work.

Passeron, René. *René Magritte.* Translated by Elizabeth Abbot. Chicago: Philip O'Hara, 1970, 93 p.

> Large- and small-format color reproductions. Includes a critical introduction and an interview with Magritte's wife, Georgette.

Torczyner, Harry. *Magritte: Ideas and Images.* Translated by Richard Miller. New York: Harry N. Abrams, 1977, 277 p.

> Includes extensive critical commentary by Magritte on his own work and related subjects, as well as letters and a broad selection of illustrations, in color and black and white, of his paintings and drawings.

Matta

1911-

(Full name Roberto Sebastián Matta Echaurren) Chilean-born French painter.

Considered one of the most important late Surrealist painters, Matta developed an idiosyncratic style utilizing the automatic technique of the Surrealists while rejecting their use of veritistic imagery. Matta's works comprise immediate reflections of his inner feelings, and many of his early paintings are characterized by improvised biomorphic forms rendered against shifting backgrounds of vivid color. His subjective, spontaneous approach influenced such American painters as William Baziotes, Robert Motherwell, and Jackson Pollock, who ultimately rejected the Surrealist emphasis on content over form and founded the Abstract Expressionist movement. After World War II Matta turned from presenting his own feelings to representing various conditions of contemporary society, and he drew images and subjects from modern political, social, and scientific issues.

Of Spanish and French descent, Matta was born in Santiago, Chile. As a student he excelled in the study of architecture, and his achievements were recognized in 1934 when he was accepted as an apprentice to the renowned French architect Le Corbusier. During a tour of Spain in 1936, Matta became acquainted with the Surrealist painter Salvador Dalí. Upon viewing a collection of Matta's drawings, Dalí was impressed with the young artist's talent and presented him to the leader of the Surrealist movement, André Breton. Breton recognized Matta as an artist with great potential and admitted him to the Surrealist circle in 1937. With the encouragement of Breton and the other artists of the group, Matta began painting in 1938. Although he held such leading Surrealists as Dalí and René Magritte in high esteem, Matta always considered his canvases to be the product of an artistic style which was not entirely surrealistic. Whereas the works of the Surrealists realistically represented dreamlike illusions or visions from other worlds, Matta depicted scenes from an intangible universe, reflected in vibrant swaths of color against vaporous panoramas. Because of the violent explosions of color in Matta's early canvases, some critics have dubbed this his "volcanic" period.

Critic James Thrall Soby has noted Matta's belief that a school of art based on contemporary physics could develop in much the same manner as Surrealism had evolved from modern psychological studies, and Matta called his early artistic expression a state of "psychic morphology," defining his art in terms of the science of morphology—the study of form. Matta attempted to utilize a process analogous to that by which a seed develops into a tree, but giving physical form instead to his ideas and psychological states. Combining his understanding of morphology with the automatic technique practiced by Surrealists, Matta held that the picture created should reflect his unconscious state of feeling at that precise moment. Matta experimented with his theory of psychic morphology throughout his volcanic period, culminating in his 1944

masterpiece, *Le vertige d'Eros* (*The Vertigo of Eros*), which, according to William Rubin, suggests that "the life spirit, Eros, constantly challenged by the death instinct, Thanatos, produces a state of vertigo, and the problem is one of remaining erect in this situation, of achieving physical and psychological equilibrium." Here, Matta communicates the importance of equilibrium in achieving union with one's inner consciousness, where "vertigo" becomes the moment of revelation.

In 1939 Matta was among the ranks of European artists who emigrated to New York in fear of persecution by the advancing German army. The arrival of the artists in New York effectively transformed that city into the world's most prominent cultural center throughout the war years. Hoping to take advantage of this new-found availability of many of Europe's leading artists, American painters from all over the country journeyed to New York, giving the city's art culture even greater dimension. Matta attracted a small group of painters, including Baziotes, Motherwell, Pollock, and oftentimes Arshile Gorky. The group's intent, according to Barbara Cavaliere and Robert C. Hobbs, was "to take the germinal idea of [Surrealism], psychic automatism, and use it to create a truer Surrealism that was both more painterly abstract and subjective

than the mimetic psycho-poetic melanges that were often termed Surrealist." Although the American artists were particularly interested in Matta's unique approach to Surrealism, they became increasingly reluctant to admit concerns about content to have any bearing on the forms presented in their works, believing in art as a self-referential entity. As a result, they developed a philosophy of nonrepresentational art—the basis of the Abstract Expressionist movement. Matta found the group's rejection of content unacceptable, and subsequently reaffirmed his affiliation with the Surrealists.

Matta's realization of the devastation of World War II inspired a drastic change in his artistic style after 1943, and critics have described this new phase of expression as his "totemic" period. The paintings in this interval reflect Matta's attempt to apply his psychic morphology to the bellicose, paranoid atmosphere of postwar society. In such works as *Being With, The Heart Players,* and *Splitting the Ergo,* he presented dark images of aerial battles and anthropomorphic beings in menacing atomic worlds of the future. Critics have described the paintings of this period as sinister, and many of Matta's machinelike "totemic" forms are thought to reflect both the influence of his training as an architectural draftsman and his fascination with primitive art forms, an interest he shared with the Surrealists.

In recent decades Matta has continued to paint, concentrating for the most part on enormous mural canvases that express his concern with political and social issues. In 1962 he was presented with the Marzotto Prize, Italy's most prestigious international award, for his *La question Djamila.* Based on a true incident and compared by some critics to Pablo Picasso's *Guernica* for its expression of brutality and terror, the painting depicts the torture of an Algerian girl during that country's struggle for independence. In the 1980s Matta pursued a new artistic direction, integrating myths of antiquity into his expansive canvases. However, he remains best known for his early association with the European Surrealist movement and his influence on the development of American Abstract Expressionism.

ARTIST'S STATEMENTS

Matta with Max Kozloff (interview date 1965)

[*In the following interview, Matta discusses his highly successful and influential years in New York from 1939 to 1948.*]

[Kozloff]: *When did you first arrive in New York?*

[Matta]: October or November, 1939.

Where had you been before that?

Paris.

You were working professionally in Paris?

Yes, you know, I came from architecture. I never paint-ed—I made some drawings—but when I started painting, it was through necessity, of trying to find an expression which I call a morphology, of the functioning of one's thinking, or one's feeling. I used the expression for that kind of work, which was, somehow, for the first time, of psychic morphology. This question of expressing directly on the canvas my state of feeling was symptomatic of control. It was very much in line, according to Breton, with what he thought could be a Surrealist painting. But I had no idea myself that I was being a Surrealist. It was just expressing—when I made some of these pictures—the psychic morphology of desire, of contempt.

You were immersed in the Surrealist ambience, without being . . .

Yes, but how shall I say, it was a different thought from that of the time. To a certain extent one could say that Miró had done things like that. With a great preoccupation with esthetics, while this was trying to be as free, as close to the real feeling as possible, with a minimum of control. No time to compose.

Automatism?

Yes, but automatism had a dose of control . . . pretended to be a language. I felt different when the morphology was of something desperate, of something longing for, you know. Do you understand me?

I understand that you were taking away certain inhibitions.

No, you see, I don't know if you are familiar with morphology, the science of morphology. That is, to follow a form through a certain evolution. For instance, from a seed to a tree, the form is constantly changing under certain pressures, until it arrives at the final form, and then disintegrates. Now, the growth in the change of a form, which concerns any organism, or even mineral, or—how should I say—a stone which is exposed to accidents. . . . This notion of morphology relates to how one's feelings were formed, transformed, through life.

They were natural and biomorphic in their orientation, weren't they? What forms were chosen were not mechanical.

They were my forms. They were whatever I had in storage in my memory. I was trying to use forms that were less known . . . I was trying to go into forms that had been revealed by microscope. Instead of the bones of man, I would use the articulation of the wing of the fly.

How did the situation appear to you when you got to New York?

I never thought of myself as a professional painter; I looked at things mainly as: how a man, with the means he more or less invents, tries to convey how difficult it is to be. To be a man, to be an artist. And I found them experimenting with plastic things. But, as far as form goes, there were such things as—Bob Motherwell who was painting something like Chirico's horses; Pollock was painting more in the Picasso world, you know; and Gorky was painting in some kind of heavy Miró way; Baziotes was painting like Picasso, too.

Did this interest you?

What interested me was to see if everybody could apply

the system that to me was fascinating at the time, to use morphology about my psychic responses to life. And everyone would invent their own morphology, and express this question. I tried to infect them with this idea, as something very good, something in which they could find wealth in their own terms.

You were so convinced that you talked, and discussed these things with them?

Very much, saying that we didn't have to make images in terms of Picasso; that's old fashioned. I was very young, and in those days, very brutal. And very, how you say, strict, severe, against.

How did they react?

Well, we used to meet, in my studio on Ninth Street—Pollock, Motherwell, Gorky—and I used to say, we had to find new images of man. There was a certain amount of scepticism, and it didn't last very long. But people agreed that maybe something could be done differently. And I must say that one of the first that started doing something in that sense, was Pollock. He started using many different images of man, and in serial fashion. I took Peggy Guggenheim to him—this was over a period of a year and a half. And then Peggy gave him a contract, and when people would ask me, I thought that he was interesting in that sense. But he was very inarticulate; whereas someone like Bob Motherwell was more interested in the theory of all this, somehow.

Well, you see, at that period, when they sort of started on this question, I had some kind of trauma when I realized what the war was, and the concentration camps, and I went one step further in my understanding. I tried to use, not my personal psychic morphology, but a social morphology. Using the totemic images involved in a situation which was more historical: the torture chambers, and so on. I tried to pass from the intimate imagery, forms of vertebrae, and unknown animals, very little known flowers to cultural expressions, totemic things, civilizations, you know what I mean? I was still being under the laws of morphology, but this time not so much of the forming, let's say, of an organism, which was symbolic of myself, this time it was the formation of cultures confronting each other. Battlegrounds of feelings and ideas, fighting to see if something would come out of these clashes. I would use what I had in hand; I would use perspective. To them, that sounded backward. This question has never been clear. I claim that I am still doing the same things, that I am consistent, while they thought for a while, that I had gone back, so to speak, to Surrealism. They ceased differentiating the different elements that were important, and it ended in a whirlpool—very pathetic, very dramatic. A whirlpool in which the "I" and the world were just clashing, so to speak, almost cosmically. Involving violence in the use of paint. The development should have gone more towards differentiating more what clashes—do you understand me?

Yes, this is very interesting. The question is, you talk about the violence of paint, but your own work was not violent in its handling?

Yes, but I thought at one point that the introspection transformed itself into world introspection. I should try to use this vision to try to get into what's going on in the world of which I was part. And not only what the world was doing to me. I had all sorts of propositions, for example. I had propositions of—the morphology of meeting—the man meeting with another man in which the effect of the meeting changed the form of the one met, etc. Even today, I'm working in that direction.

But, they saw your paintings fairly recently after that?

I think I was a little bit excluded; no, one of the last things that Gorky said to me was that he wanted very much to get into this kind of creature, this kind of character, this kind of differentiation. He realized that in this kind of cosmic, pulsing matter, that it was important to differentiate and explain a place for man in it. Not being anthropomorphic, necessarily, just some kind of a difference between the whole and the one, the container and the contained, so that one could start a language.

Did you begin to notice during the forties changes in the painting done by these Americans, and if so, what kinds of changes?

Well, in the case of Pollock, who came from what we call "magazine painting"—painting from reproductions, from Masson and Picasso, you know, he started to make something very personal, and his characters became at first "personages," and this precipitated and accelerated until it became a whirlpool, a one-world. But I would say that he too felt the necessity at one point to differentiate again. This whirlpool started again—saying what is "one," what is non-one, and what happens to this one in a world where everything is together, or where things start separating again, or that have identity. But then, in my understanding—well, this is very subtle to say—he went back again to an image, of the nude, if you like, as an image. But this brings us back to Expressionism again, and what we want is something else: the place of man in all these ideas we have of making a society. Man as the target of life and nature.

And did you think that these painters were responding to these ideas?

Well, everyone developed it in his own direction in art. But I think it was a very definite need at the time.

It answered a need?

In my case, it came from nowhere. Only a need. But maybe I was riper before then, because I was in Europe, where it was easier for an artist to get information. This imminence of tragedy and war, etc. These things were like rain catching up with a man who is running.

During these years, what were the social relations between you and these other painters?

Very good. I saw Motherwell very much. Pollock was more . . . fermé. A closed man. Gorky I saw a great deal. Baziotes was a dear friend. There were others as well.

How about the Europeans? Masson was there too?

Yes, Masson lived in Connecticut. I personally didn't see very much of him. I always saw Marcel Duchamp.

What does the term Abstract Expressionism mean to you? Does it seem appropriate?

I authentically believe that modern art aims at giving an

image of what happens. Let's say that the Renaissance managed to give an image of how we see what happens. And perspective was one of the devices to give—how it looked. Surrealism's function was to give an image of the real functioning of thinking, without esthetic or moral prejudice. And that picture of Marcel Duchamp in which he implied that he could picture change, that painting which was called, *Le passage de la vierge a la mariée,* started in me the notion that one can picture change, what happened between A and B in a situation. One had to develop a morphology which would be independent of retinal morphology.

Yes, but how does this apply to Abstract Expressionism?

That's what I'm driving at. The abstract is the sense that algebra is abstract—the development of a family of signs which are an abstraction of phenomena. And Expressionism, in my understanding, tries to express what happens. I believe that we could—for this is not something one can do alone—develop a non-Euclidian space, by which we could refer to the number of constants and variables which are in an event. We could arrive at giving an image of where we lived. To me, that is the objective of modern art. To make visible, to give a vision of, the structure of events. And naturally this would be a completely different art, of which Abstract Expressionism would be the first step.

But did this term have any application to the painting as you knew it?

No. I think the point there is that one wants to grasp the abstract expression of events in a certain sense. You see, if one day, not only artists, but everyone has a picture of, for instance what's going on here: I'm talking and you're listening, but that is not what is going on. Rather, some "bulbs" in your understanding of what we are saying are opening. And I am throwing energy waves in your direction. Certain engineering or structuring of feelings or situations, and understanding those situations: to me, that is the object of abstract art. Except that this isn't clear in the minds of artists. It will take generations for this thing to begin. In that period, some of Gorky, some of de Kooning, represented a beginning.

What about the other painters, such as Newman and Gottlieb or Rothko. Did you have anything to do with them, or did you know of their work?

We are all living in the same century, and the same complex, the same continuum. All of this is going to become the material for the next generation. To use a symbolic morphology or symbolic logic. I picture, this non-Euclidian space, which might be compared to the space of temperatures in a room, of meteorological space, as a container developing the event in a way similar to wave lengths and heatpaths. We need to visualize history.

Well, all right. But now, let me ask you something very specific. During the forties, the color of your paintings was very distinct, very individual. Did it seem to have any effect upon color in New York painting? The gaseous, phosphorescent tonalities you were using.

I think, to some of the painters, it was clear that I wasn't referring anymore to outside experience. That I was abstracting the experience. They themselves started dealing with something that wasn't outside the experience. These

colors, that funny pink, had no reference to everyday life. (Except perhaps insects and certain flowers.) I was getting out of 57th Street, into some kind of social milieu, where there weren't any windows or doors.

What was the impact of such a key canvas of yours as the **Vertigo of Eros?** *Was there any discussion about that?*

When I did things, they tended to say "science fiction," although this was too easy, comfortable an explanation. The reference I was making once again, was to a non-Euclidian space, where all the ordinates and co-ordinates are moving in themselves, because the references to the "wall," shall we say, of the space, are constantly changing. They are not parallel to a Euclidian cube, to which most previous painting has referred. Do you understand?

I'm very confused. To whom does this apply? To Rothko? To de Kooning?

No. I think it applies to Pollock, to a certain extent, and to Gorky. I think de Kooning is involved inside, but is not aware of this need. He's conscious that one can't reproduce anymore what happens in a Euclidian cube, so he bombards a nude under the pressures and actions which come to surround it . . . But Pollock tried to give a picture of the world as a series of waves and shocks, actions and repulsions. Some of my pictures might be thought of as details that could be placed in a square inch of his pictures.

But of course, New York painting took another direction. After all, there was Guston, Kline.

Ah, that's "pure" painting. I'm not interested in that. That's called "painting" it. What interests me is the "picturing." To me, painting is a technique at the service of a certain consciousness. The awakening of a consciousness. That can be painted more or less amusingly. Now, they got tremendously involved in such questions as, "Does the picture exist?", "Is the canvas a reality?", "Is red really red, or is white more white than red is red?" They entered into some funny scepticism about what things are. And they went very far: there are pictures which are all red, or all black. Or pictures such as Rothko's, where the four sides curiously create the space. All this, was to me, speculations about what is a picture. What is a painting. To be sure, this is interesting, but it is not an expressive abstraction of what really goes on in man's experience.

What finally happened in your relation with the painters of New York? How long did you stay, and when did you leave?

I left in 1948, when the thing was getting too "painting" for me. I was more and more involved in giving a material picture of history, of events. And all of that sounded, to them, literary. To me, it wasn't literary at all, it was, how shall I say, it was the object. I mean, art always has been a reflection of the need to re-present reality. Since 1948, although based in Europe, I've returned several times to the United States. (pp. 23-6)

Matta and Max Kozloff, in an interview in Artforum, *Vol. IV, No. 1, September, 1965, pp. 23-6.*

SURVEY OF CRITICISM

Rosamund Frost (essay date 1944)

[*In the following excerpt from an exhibition review, Frost discusses Matta's artistic philosophy and technique.*]

In the same way that modern philosophy is primarily based on physics, so the modern artist, if he is a serious artist, is pledged to interpret scientific facts—called phenomena—which are the true realities of life. So thinks and so paints Matta Echaurren, a Chilean extraordinary, who, since he first showed here in 1940 has carved for himself a new niche among the abstractionists while at the same time meditating on the need for a Third Surrealist Manifesto.

The artist, who for painting purposes has retained only his first name, was born in Santiago de Chile as late as 1912 but lived almost exclusively in Paris. France's spirit of inquiry, its poetic revolutionary fervor, and its admirable professional discipline are triply compounded in his make-up. Architecture was his first study, entailing three years of engineering, ending in the enlightened milieu of Le Corbusier. It was only during the Spanish War that he took up painting, plunging into and mastering its technique in a wave of creative energy which he terms "pure automatism." "Where artists once tried to tell you what it feels like to be a tree, I express what modern life feels like," says Matta. "Painting should interpret facts such as the abstract spaces or imponderable numbers with which any scientist is familiar but which the layman would have to learn a mathematical language to grasp."

Whatever it is, the pinch-of-dynamite quality of Matta's work gets across to people as unversed in "isms" as they are innocent in the realms of pure reason. Moreover, although Matta feels that the artist should denounce or accuse rather than decorate or entertain, there is a great deal of visual enjoyment simply in the way he handles his medium. The waves of color are silky smooth. Glowing, palpitating like flames, they appear to pass through each other without mingling.

Matta's new show at Pierre Matisse—his third in [New York]—brings fresh developments. The extremely high-keyed, near-neon color of two years ago has been largely reduced. More structural lines begin to appear and the interposition of solid geometric areas. In *The Redness of Lead* triptych Matta was fascinated by the idea of the fiery coat of paint protecting the iron hulls of ships which is extinguished in turn by a dull outer covering. When flecks of the latter fall away the fierce metallic tone burns through, seen here in startling red areas. *La vertue noire* is another concept that attracts Matta—a dark yet crystalline one which makes the subject of another painting in the show. *The Bachelors Twenty Years After* takes up where Duchamp left off in 1914.

Altogether it is clear to see why Matta has never been classified. He holds himself nearest the Surrealists but would like to rebuild their ideas into a school of his own. Whether he would have followers is questionable, for few painters indeed are so geared, either technically or imaginatively. More probably he will remain an isolated phenomenon, result of the mingling of the Iberian race, French intellectualism, the American continent, and the modern age.

> Rosamund Frost, "Matta's Third Surrealist Manifesto," in ARTnews, Vol. XLIII, No. 1, February 15-29, 1944, p. 18.

André Breton (essay date 1945)

[*Breton was a French poet, prose writer, and critic who is best known as the founder of Surrealism. The Surrealist movement began in 1924 with Breton's* Manifeste du surréalisme *and became one of the most influential artistic schools of the twentieth century. Based on principles set forth by Breton, the school interpreted art as a means of liberating one's consciousness from societal, moral, and religious constraints, thereby enriching and intensifying the experience of life. In the following essay translated from Breton's* Le surréalisme et la peinture *(1945), he praises Matta as a major contributor to the Surrealist movement.*]

The pearl is marred, in my eyes, by its commercial value. Those who dive for pearls for a living, in art as well as life, begin to look increasingly sickly in the light of day and are quickly ravaged by a dry cough (I am thinking of Valéry's extraordinarily subtle yet at the same time niggardly attitude to life, capped by his nihilistic little laugh). Here, at Perce on the coast of the Gaspé peninsula, the beach is crowded from morning till evening with the young and the old, the rich and the poor, all searching for the raw agates washed in by the tide. These are small stones whose generally dull appearance is fully compensated for by the flashes of light they cast, sometimes only fleetingly, when viewed from a particular angle. But who knows what special ingredient carried within these flashes of light immediately catches *everyone's* eye and so sets in motion the eager quest and the pleasure experienced anew each time a glance is intercepted? This fever is quite different from that for gold or oil, since in the case of the agate the found object is no longer a means but an end (the seekers' passion is unsullied by any afterthought of profit: a few of them, it is true, talk of mounting a stone in a piece of jewellery, but in the majority of cases even this limited ambition is absent). This leads me to think that we are present here at the source of one of the commonest and most urgent of human desires, which is, indeed, nothing less than the desire to expand its consciousness through art, even though the result of such expansion may seem indistinguishable from the commonplace. Surrealism's first gesture was to confront the creeping fog of thought-out and 'constructed' works of art with images and verbal structures absolutely comparable to these agates. How patiently, how impatiently, we sought for them ourselves, and when one appeared—for they did appear from time to time—how we turned it over and over in our hands, and how insatiable we were, always expecting more from the next one than the last. And we knew, too, that there was no chance of the mental, any more than the physical, agate presenting itself to us alone, since it loves and *needs* the company of more humble stones. We gave it the widest possible field of action. The essential thing, surely, was to grasp, learn to handle and then keep available and on display, these moments when the human speech suddenly becomes charged with light and absorbs far more numerous and

more ambitious solutions than the kind which conventional thought processes hold to be within their province. And even in terms of the humble agates of Perce, what human skill or genius can succeed in showing me anything to match what passes between those rounded rhomboids agitated by an inner trembling that is segmented by the superposed curtains of their rainbow windows? The process contains both fusion and germination, balances and departure, it incorporates an understanding between cloud and star, we can see all the way back and all the way down, as man has always dreamed of doing. This may be a mere drop in the ocean, but nevertheless it leads directly to the hermetic concept of living fire, the philosopher's fire. The secret of its attraction and its lasting quality surely lies in the fact that, under a great weight of shadow, the image of 'universal sperm' circulates through it, enhanced by its very multiplicity.

Matta is he who has *plunged into the agate*—and here I am no longer designating by this term a particular variety of mineral but including all stones that secrete this 'exalted water', this 'soul of the water' which, according to the occultists, dissolves the elements and 'gives the true sulphur or the true fire'. It is quite clear that the catchment of this water, to the extent to which it operates as the supreme solvent, leaves no visually apparent trace of conventional appearances. But since, in the person of Matta, the medium is at the same time the liveliest, youngest and gayest being I know, in his case everything which is seen at first sight and no longer with second sight tends to be formulated on the principle of total *animism*. This animism, tracing its path through Lautréamont and Rimbaud, has continued to mature since romanticism, where it may be observed at its infantile stage. Certainly, it is no longer a question today of asking oneself whether the rock thinks or the flower suffers, and even less of envisaging the material world as a crossroads of imprisoned souls, one lot being dragged down towards perdition and the other lot wafted up towards salvation: animism, at the present time, is too thoroughly thawed out to leave any place for the ice-cold mud-bath of sin. What remains, what endures is the conviction that nothing is in vain, that everything that can be contemplated speaks a meaningful language which can be understood when human emotion acts as interpreter. In this respect, Matta's work makes so-called 'paranoiac-critical' activity appear timid and, even, rather retrograde; apart from the fact that the latter concept only permits one to seize, in bare outline, anecdotal aspects which wholly fail to transcend the immediate world, it has, in any case, degenerated, with Dali, into an obsession with visual conundrums. Matta carries the disintegration of external aspects much farther, and in an entirely different direction. For anyone who has eyes to see, all these aspects are *open,* not just open to the light like Cézanne's apple but open to everything else as well, *including the other opaque bodies;* they are constantly ready to blend together, and *only* from this fusion can be forged the key which is the *only* master-key to life. This is why he succeeds in making us touch, as he puts it, 'the opaque shoulders of the smoking trees', and this is why he can choose to guide us through a coralline vegetation representing the nervous system of the kinkajou, not inanimate in the way that dissection would reveal it but living, and doubtless sympathetic to the nervous system of man in terms of the possible relationships that man may have with this little animal. This, equally, is why he invites us ceaselessly to enter

a *new space* which has deliberately broken away from the old conception of space because the latter is meaningful only to the extent that it is distributive of elementary, closed bodies. It is of little importance that this new way of seeing and showing things has, at one time or another, sought support in the scientific insights of psychological morphology, Gestalt psychology, astrophysics, histology and nuclear physics. The need to call upon the support of the most modern resources simply expresses the aspiration to extend the field of vision, and also, it is true, to meet the necessity, if possible, of confounding those who are ready to disqualify as 'abstract' any form which is not at present perceptible to the eye (a century ago, the curve of an electric light bulb's filament would have seemed extravagantly abstract). Beyond these bridges designed to maintain communication between inspiration and experimentation there lies a confidence which is testing itself out and gathering strength, a boundless confidence in the perfectibility of man's faculties, in his capacity for invention, understanding and wonderment which would be limitless if not diverted from its true purpose.

The value of such natural aptitudes must depend entirely, of course, on what the person who shows them has to offer since, after all, one can only give what one possesses. Matta's richness consists in the fact that, from his earliest works onwards, he has been master of an entirely new range of colours: perhaps the only new one, and certainly the most fascinating one, offered to us since Matisse. This range, the gradation of which is based upon a by now famous quick-changing purple rose which Matta seems to have discovered ('surprise', I have heard him say, 'will burst forth like a fluorite ruby in ultra-violet light'), is arranged according to a complex prismatic pattern. Matta's prism, which is in fact composed of the prism of decomposition of solar light in free air combined with that of its decomposition through each of its cells, even goes so far as to correct itself by means of the scale of variations introduced by black light. Above all, he has revolutionized the symbolic interpretation of colours, alone or in relation to each other (blue representing shadow, and so on), through the constant interference between the visual and the visionary) a process which started with Seurat, in whose work, though, the visual is strongly predominant), a phenomenon which finds expression only in the spirit of the primitives, on the one hand, and, on the other hand, in certain esoteric pronouncements of primary significance, such as that by Hermes Trismegistos: 'The raven's head disappears with the night; in the day, the bird flies without wings, it vomits the rainbow, its body becomes red, and pure water floats on the surface of its back'.

Even at the present stage of his evolution, Matta still remains extremely exacting towards himself, never remaining contented with the extraordinary gifts with which nature has endowed him. No one has remained more questioning, no one has shown himself more assiduous in garnering the living substance of works, such as those of Alfred Jarry and Marcel Duchamp, that bristle with difficulties but project their beams of light farther and more probingly than the others; no one's eye has been more piercing than his in discovering around him the living seed of beauty, a truth or a new freedom. 'The greedy sea, as you say,' he wrote to me, 'the forest is poor too, only the scream is full of matter.' Let us recall the genesis attributed to 'astral light', the medium of creation: 'The sun is its father, the



moon is its mother, the *wind* has carried it in its belly.' The earth is only its nurse.

It is Matta who holds the star most steadily above the present abyss which has swallowed all the features of life that might make it priceless, an abyss that spares nothing now but human love, and it is probably Matta who is on the surest path to the attainment of the supreme secret: fire's dominion. (pp. 29-35)

André Breton, "The Pearl Is Marred, in My Eyes . . . ," in Roberto Matta: Paintings & Drawing, *1971-1979, Tasende Gallery, 1980(?), pp. 29-35.*

James Thrall Soby (essay date 1947)

[*In the following essay, Soby offers a comprehensive analysis of Matta's artistic development to 1946.*]

An event of decided interest in the recent New York art scene has been the emergence of Roberto Sebastian Antonio Matta Echaurren as the latest, perhaps for a time the last, important painter of the surrealist movement. Matta was born in Santiago, Chile, in 1911, of Spanish lineage. He once related an anecdote to explain what a Spanish heritage could mean to an artist. A thief in Barcelona, he said, dressed in his finest clothes and went along the quays stealing lemons. When he had gathered as many as he could carry, he walked to the river, threw the lemons in, and watched them float away. Apprehended and brought to court, he explained: "I have never seen the river so black or such bright yellow lemons." Thereupon the judge escorted him to the door and freedom, a carriage of justice not likely to have occurred elsewhere than in Catalan Spain, as Matta pointed out.

Matta's own yellows often float in black pools of pigment, but though he prefers to think of himself as Spanish, his first paintings were notable for a Latin-American exuberance of color—tropical yellows, blues, reds, and greens running over the canvas like thin lava. He came to this country in 1939 from Paris, where he had studied architecture in Le Corbusier's office, his family having insisted that he become an architect rather than a painter. He was enrolled in Le Corbusier's office for three years, but apparently worked there only a few months out of the year, and spent the remainder of his time traveling or conversing with the Parisian surrealists whose group he joined officially in 1937.

During his apprenticeship as an architect, Matta stayed for some time in England. Did he admire there the late paintings of Turner, in which form dissolves in a spreading flame of color? He speaks casually of Turner's art, with no marked respect, yet among paintings of modern times Turner's are perhaps nearest in spirit to Matta's own early works, with two important exceptions—Kandinsky's free improvisations of 1911-18 and Miró's untypical but altogether impressive painting of 1937, *Still Life with Old Shoe.* As to Matta's connection with earlier sources, his veiled hills, jets of fire, and rolling fogs are related, however distantly, to the sixteenth century nocturnal mysticism exemplified by such separate works as Grünewald's *Temptation of St. Anthony* panel at Colmar and Beccafumi's *Victory of St. Michael* at Siena. Significantly, his tissues of flaming color have often assumed El Greco's mannerist forms, notably in a 1942 canvas, *The Disasters of Mysticism.*

Whatever Matta's affinity to previous artists, he has reinvented in personal terms the use of fluidity as a vehicle for semi-automatic expression. His painting has changed drastically over the past few years, as will appear, but we may wonder whether he was once in some degree a prophet as well as an artist. At least his pictures of 1939-44 are strangely attuned to the subsequent atomic era in that they reduce matter to blown vapor. And it is an interesting fact that in 1943 Matta declared his only quarrel with the surrealists was that they disregarded the phenomena of the physical sciences. He felt that a new school of painters could evolve from contemporary physics, as surrealism had evolved from modern psychology.

Surrealism, however, was the main formative influence on Matta's early career, and by 1938 he had so far absorbed its tenets that he had reacted completely away from the concrete, angular order exemplified by Le Corbusier's *machines à habiter.* In that year he published in the surrealist magazine *Minotaure,* an article, *"Mathématique sensible—Architecture du temps,"* in which the intangible reckonings of psychiatry and time-space replace geometry's solid logic. "Let us," he wrote, "overturn all the historical show-pieces, with their styles and elegant ornamentation, in order that there may escape the rays of dust out of which pyrotechnics can create space. . . . We need walls like damp cloths which assume odd shapes and complement our psychological fears." The theory owes much to Dali's interest in a malleable architecture, based on Freudian suitability to human needs, but it is nonetheless an interesting forecast of the direction Matta's painting would take.

This direction was soon apparent. By the end of 1938 Matta had painted a number of canvases in which space is created out of gauzes of color and molten forms, like the filmy images cast on a screen by Thomas Wilfred's Clavilux, a light-machine which Matta saw in operation several years later and admired enormously. Matta was not alone, however, in his predilection for a soft, flowing, and ambiguous space, since Wolfgang Paalen was then working in a roughly comparable direction, while Yves Tanguy had long since proved himself the ultimate master of what is referred to in film production as the "lap dissolve"—the fading of one image into another, as when Tanguy's earth melts into the sky, leaving no line of demarcation and creating a double infinity of distance. From the rigid squares and cones of cubism, abstract form had moved toward the biomorphism of Arp, Miró and the former cubists themselves. Now, seemingly, it was to abandon living contour for an amorphous projection of inner states of mind and spirit, substituting for Kandinsky's musical analogy a reference to psychotic disturbance and release.

Matta was already, in 1938, an independent and original colorist, and thenceforth he developed rapidly. His first one-man exhibition was held in New York in 1940, and in a foreword to the exhibition catalogue Nicolas Calas included an extremely apt quotation from Shelley's "Prometheus Unbound":

Ten thousand orbs involving and involved,
Purple and azure, white, and green, and golden,

Sphere within sphere; and every space between
Peopled with unimaginable shapes.

The color in Matta's oils of 1938-40 was extremely bright, washed thinly over the canvas, but sometimes congealing into quick jewels of gaudy and variable hue. His forms were frequently erotic in connotation, though they were never specific or precise. His bold, Latin-American reds, blues, greens, and yellows floated with subconscious freedom; they swirled around dead pockets; piled up in hard clusters, like dyes spilled on a stream; moved on again in paling color, not only across but into the picture space. Matta was at this time the absolute opposite of those surrealist artists who painted as realistically as possible in order to give public credence to the unbelievable. His technique was spontaneous to the point of being careless. In some of his paintings of this and a later period, for example, he allowed the pigment to spill and run in certain sections, creating its own accidental patterns.

A certain contempt for medium was a fundamental of Matta's esthetic from the beginning, and was encouraged by his association with the surrealists. Moreover, he has always insisted on a preference for "experienced" as opposed to "theoretical" art, assigning most of cubism and all purely abstract painting to the latter category, his own to the former, and deriving the distinction between the two from a devoted reading of the philosophies of William James and John Dewey. As his own "experience" has become more cohesive and mature, he has worked with new authority. By 1941, the uneven brilliance of his earlier canvases had gathered into one impressive whole.

Perhaps a trip to Mexico in 1941 hastened his development. Late in 1940 he had begun to vary the candy-stick tonality of his previous paintings by sometimes using a dark, over-all ground, green or blue or red, in which bloomed sudden vivid crocuses of color. He returned from Mexico with renewed interest in the pyrotechnics which his *Minotaure* article had declared could "create space." The heavens in his pictures now exploded in a shower of volcanic sparks and spiraling lava. At the same time, the landscape of Mexico seems to have taught him a more rhythmic relationship between earth and sky, as in the Museum of Modern Art's fine canvas, *Listen to Life.* His burning stones plunged deeper and deeper into an ethereal maze, and he extended space by a labyrinth of diaphanous screens, tissue behind tissue, the light reflecting back and forth, through and between. But he was apparently dissatisfied with this remarkable spatial manipulation, and toward the end of 1941 there occurred a decided break in his style.

He now began to combine his coloristic and amorphous suggestion of space with a use of linear perspective. The experiment was suggested by surrealism's chief, André Breton, and was given form by Giorgio de Chirico's proto-surrealist paintings of 1910-17, in which strong, architectural lines converge abruptly to suggest a remote distance. In a number of canvases painted in 1941 and 1942, Matta pierced his thin sprays of color with triangular or rectangular corridors, white, solid and heavily lined, leading past walls of flame, or cutting through banked mists of rose, yellow and blue. His dual perspective of color and line was on the whole rather unsuccessful, since the geometric areas broke up his compositions to a degree which no virtuosity of surrounding tonal invention could repair. But

1942 was in any case a year of restless experiment for Matta. He was determined to abandon the beguiling, tropical palette of his vaporish landscapes, and was becoming suspicious of his own moderate popularity. For the most part he now held himself in conscious check, though during the year he completed the large and brilliant *The Earth Is a Man,* now in the collection of Henry Clifford at Radnor, Pennsylvania. The picture is the climax of his early manner, a summary of everything he intended to leave behind in an eventual search for sterner architectonic order and more specific psychological content.

At this time Matta remarked: "Painting always has one foot in architecture, one foot in the dream." By the fall of 1942 he began temporarily to shift his own weight as a painter toward the dream, though he retained a greater respect for the conventional plastic virtues than he had shown in youth. His rigid Chiricoesque platforms gradually disappeared, and he commenced to cover his smoking colors with a meandering surface calligraphy which had appeared only fitfully in previous works. Two dark pictures painted at the end of the year, a red one entitled *Omega of a Lost Word,* and a blue one called *Aquasapphire,* announced the new direction. Both were inscribed with white lines which floated like threads on the swimming space beneath, sometimes following the movement of the color, but more often running free, like automatic writing. It would be interesting to know whether this new style was partially inspired by the installation designed by Marcel Duchamp for the Surrealist Exhibition which opened at 451 Madison Avenue, New York, on October 14, 1942. Duchamp had strung the huge main gallery of the exhibition with white twine, forming an intricate web around pictures and walls, so that everything was seen through an illusory and changeable third dimension. The installation cannot have failed to impress Matta, who was actively connected with the exhibition. The theory of its effect on his painting is the more plausible in that Duchamp's influence on him has been strong, as we shall see. In any case, Matta's surface calligraphy grew more pervasive in pictures like *Absolute Unity.* Presently he began to vary its loose scribble with precise loop-like forms, and black lines often replaced white.

The lines themselves, whether "free" or planned, were of marked distinction, and perhaps this is the place to speak of Matta's drawing as an independent medium. Long before he attained maturity as a painter, he was producing an astonishing series of drawings in which he evoked from the crayons of children a brilliance of tone usually reserved for pastel. In general spirit, these drawings belonged to the violently sadistic vein of surrealism already explored by André Masson, and through them Matta developed a number of the iconographical motifs which were to appear in his paintings in more generalized or amorphous form. Gradually, however, his drawings became virtually paintings, so rich was their use of color; and their subject matter often followed a more or less separate track toward the creation of a fantastic bestiary. In 1942 he began to use occasionally the comic-strip technique of presenting images in succession on a single sheet. Picasso, once reported by Gertrude Stein as greatly admiring American comics in his youth, had previously used the technique in his magnificent drawings for *The Dreams and Lies of General Franco.* There can be no doubt that Matta followed his example, particularly since his own drawings

were often of a comparable scatologic intensity. Yet Matta's comic-strips and his other drawings are extremely original in style, and have already exerted a considerable influence of their own on American artists of his and an older generation.

In 1943 Matta completed the second of his large-scale canvases, *The Convict of Light.* The picture reflects the special alarm of that year of war; it portrays a chaotic firmament, filled with colliding planes, fire rising and falling, drifting fogs and zodiacal signs. Late in the same year, he attempted another solution of the perspective problem, turning away from de Chirico's linear system toward the mechano-morphology of Marcel Duchamp's huge glass, *The Bride Stripped Bare by Her Bachelors* (1915-23). One of Matta's earlier canvases, *Fire* (1941), had included a structure of crossbars reminiscent of the watermill section in the lower half of Duchamp's glass; his *Years of Fear* (1942), had utilized a weathervane form which recalls the upper panel of Duchamp's composition. Now, in the late fall of 1943, he painted *The Bachelors Twenty Years Later* in open tribute to Duchamp.

Thenceforth Matta was to draw at intervals on both the morphological and the mechanical spatial techniques of Duchamp. *The Bride Stripped Bare by Her Bachelors* has remained a central force in the formation of his recent esthetic, and may have inspired the interest in multiple-panel compositions which led him at this period to create a number of triptychs in varying sizes. Duchamp and Matta have been close and devoted friends. The older painter has several times remarked that for him Matta is the only very young painter of great talent visible anywhere. And Matta's reverence for Duchamp is understandable: what other twentieth century work of art combines "architecture and the dream" more distinctly than the latter's *The Bride*?

At this point in his career, Matta appears to have felt the need for re-exploring the great trends of the late nineteenth and early twentieth centuries, and one of his 1944 paintings was entitled *Cézanne's Apples,* while another unexpectedly resumed the problems of cubism's structure. But then, through one of those revulsions of spirit which are inevitable in a man of Matta's restless and energetic temperament, he came abruptly to an end of disciplinary retrospection. During the early spring of 1944 he painted one of the outstanding and most personal works of his career—the large *Vertige d'Eros* in the Museum of Modern Art Collection. The picture is extraordinary in its evocation of an inexplicable mythology of forms, emerging and receding in deepest space. The canvas engulfs the spectator to a curious degree, arousing a sensation of dream projection quite unlike the usual esthetic response. Within the composition illusion leads to illusion, as in a superb water carnival where the darkness flares with mysterious activity, far off or near, veiled in haunting ambiguity. What are the objects shown? Matta himself has prepared iconographical charts of several of his large-scale works, but these, though they elucidate his philosophical sources, contribute little to tangible recognition beyond what we ourselves can supply—floating stones, a fire of twigs, a phallus, a bomb burst, an equivocal over-all sky writing. Until clinical evidence in such matters is far more detailed than at present, perhaps we can do no more than

describe Matta as an impressionist of the subconscious mind's eerie light and shadows and forms.

During this same spring of 1944 Matta completed a folio of eleven etchings which announced a further departure in his art. He had previously spoken of his interest in exploring climactic stages of emotion, and had conceived the unlikely project of persuading the military authorities to fly him over battle areas so that he might record his paroxysms of fear. He turned in his etchings to orgiastic scenes, portraying figures which were of a frightening obscenity, but powerful, obsessive and convinced. He often mentioned at this time his admiration for Grünewald's "turning forms," and from the intertwined fingers of the Virgin and saints in the German master's Isenheim altarpiece, he probably drew a good part of his inspiration for the laced figures in his etchings. The influence applies not only to his prints, but to the paintings in related vein which he produced late in 1944 and early in 1945; it may be traced at its most specific in the *Man Trembling.*

The paintings in the 1944-45 series abandon the romantic auras of his early canvases for a vigorous, primarily linear depiction of psychological states and monstrous action. The theme of many is erotic, though less so than in the etchings. But unlike Miró's sexual preoccupation, which Matta once described as "popular eroticism," Matta's imagery is presented in terms of a psychotic symbology, unrelenting in its ferocity and complication. It is worth noting, however, that Matta himself has occasionally made use of "popular" sources. The prickled, hairy arms of certain recent figures are akin to those of Pop-Eye the Sailor Man, while Matta's suggestion of motion by the use of vibrating, hatched lines is perhaps directly evolved from a familiar comic-strip technique.

During the spring of 1946 Matta exhibited in New York the paintings he had completed early that year and late in 1945. In them the erotic tumult of the previous year has relaxed somewhat, and at the same time they show greater technical assurance and care. Two of these works, *Anxiety in Trompe l'Oeil* and *Being With,* reveal in relatively pure and abstract form the continuing influence of Duchamp's big glass. Yet Matta has created a new ambiance for Duchamp's crystalline handling of mechanical perspective. He has evolved a sultry, mustard-colored nether world, furnished with a sort of imaginary modern office equipment, as though his memories of Le Corbusier's office had returned to him in nightmare guise. And in the most impressive paintings of the new series, he retains the large-scale demonic image in quasi-human form to which he had first turned in a painting of 1944-45, entitled *A Poet.* In *Grave Situation, The Argumouth, Chambole-les amoureuses,* and the huge panel, *The Splitting of the Ergo,* Matta peoples his world of glass tables and labyrinthine gadgets with monstrous figures, screaming, hurtling through space, their hands convulsed and knotted, exhibiting a crisis of nerves in a surrounding of fantastic antisepsis. These are figures of almost Germanic violence, not unrelated to Max Ernst's chimerical beings; their torment is inexplicable but agonizingly real. They have emerged from the bedroom which was their milieu in 1944-45 to face grave upheavals in the outer world.

What direction will Matta's art take now? Nothing can be predicted, for it has been his courageous habit to abandon ruthlessly styles which he feels he has exhausted. His ener-

gy and pictorial imagination seem boundless, and for so young a man he has already produced a remarkable body of work. From the tinted quicksilver of his early landscapes to the horrendous demonology of his recent paintings, is a long and drastic journey of the imagination. We may well ask what other artist of his generation has come so far and so boldly on the road which the surrealists rediscovered twenty-odd years ago. (pp. 102-06)

James Thrall Soby, "Matta Echaurren," in Magazine of Art, *Vol. 40, No. 3, March, 1947, pp. 102-06.*

Pierre Mabille (essay date 1949)

[*In the essay below, Mabille praises Matta as the most innovative interpreter of modern reality.*]

Matta should be considered as a realist painter; his paintings are very precise and accurate objective renderings of contemporary reality. Such a statement, obvious enough to myself and a few others, needs some qualifying remarks not to appear a paradoxical joke. I am not thinking of the general public which is always fifty years behind the times and is only now becoming familiar with impressionism. I am appealing to those restless, inquisitive, and observant minds who read the art magazines, go to exhibitions and wish to understand, but who find it very difficult, confused by opposing theories, to distinguish between the contradictory tendencies of contemporary painting and are unable, in the present chaos, to discriminate between the imitators, the talented artisans, and the real innovators.

The discussion about social realism, embittered by political tactics and personal feuds, and the quarrels between 'figuratives' and 'non-figuratives', have particularly helped to obscure a situation which was already confused in the so-called period between the two wars.

The repetition of basic truths is always a matter for some scruple, but reading critical articles invariably brings one back to it.

It is obvious enough that painters are artisans who create forms. They make objects satisfying the aesthetic sense through the style of a line, the fluidity of a tone, the unusualness of a colour relationship, or the balance of a composition. The talent for making pictures lies in the possibility of graphically expressing an emotion, and it communicates itself by the establishment of a technique and personal style. From this point of view, the subject of a painting is of no importance, it is only the pretext for successful or unsuccessful juxtaposition of lines or colours.

In all periods, remarkable individual temperaments have been satisfied to create pleasing, moving, or beautiful images without anguish or metaphysical anxiety, but since the end of the last century, we no longer demand a painter to be a gifted artisan, but to be a restless artist, a poet who reconstructs the universe for us, a seer who makes use of his expressive gift to present us with the unrevealed aspects of reality. We want him to make himself, if not a poet, at least clairvoyant, to render objective those forms which we have difficulty in seeing, or those of which we only catch an occasional glimpse; in other words, that he should help us to establish a new conception of the world.

It is surely true that what we insist on with such impatience today, because we are painfully aware of the inadequacy of our traditional representation of reality, has always been the function of the genuine artist. Art is indissolubly linked to discovery. Technical research is itself not so independent as is generally believed from the desire to explore the unknown.

Permanent exterior reality does of course exist. It is the philosopher's concern to discuss and define it in the abstract. What is important to man is the image he makes of this reality. By experiment, modern psychology has proved that we only see what we are accustomed to see and what suits our ideas and beliefs . . . We build our representation of things on a system which itself reflects our emotional state, our opinions, interests, and social necessities. Experimental science fully confirms the sayings of the Buddhist philosophers who, for more than twenty-five centuries, have repeated that reality is only the habit we have made of reality.

The fifteenth-century peasant, on his way home from tilling the fields, used to see angels and devils whose appearance had been established for him by the cathedral sculptures, chapel paintings, and the descriptions of his priests. At the crossroads, the animistic negro still meets the earth, wind, and forest spirits, as invoked for him by his religion. He is not dreaming, he is seeing them . . . just as eighteenth-century man suddenly saw landscapes and waterfalls because the poets had sung of them to him . . . and as our parents, fifty years ago, used to see cathedrals in the mist, the reflection of the sun on water, the decomposition of light on the leaves or on a woman's cheek, because the impressionist painters had revealed these things to them.

Throughout history, parallel lines have appeared to meet in infinity towards that well-known vanishing-point which we project ahead of us when we observe the horizon and yet we have only become conscious of perspective since Uccello established it as a law for painters. Moreover, for this idea of perspective to interpret the social hierarchy and the new form of a centralized society, liberated from feudal pluralism, as historical materialism would have us believe, there is the possibility that the painter's representation of it has nevertheless been essential for it to become perceptible to the masses.

The crisis in modern painting interprets the profound revolution which is operating within humanity. The different tendencies in the ascendant correspond to the multiple currents which are already in opposition to each other or already established. The work of Picasso, ceaselessly oscillating between the nostalgia for traditional forms (Greek period) and the determination to destroy the accepted appearance of objects so as to present them under all their aspects, in order to render visual their most complete reality, is conclusive enough. Elsewhere I have shown how Picasso, the most gifted of the western painters, had predicted, from the negro period onwards, the failure of the western world and the impossibility of its survival without extensive borrowings from the so-called primitive coloured peoples.

No one can seriously dispute the fact that there is a new reality today even if this reality exists only by virtue of the exploration of hitherto unknown spheres. I am referring

to submarine landscapes, clouds flown over, the close acquaintance with tissues observed under the microscope and spectrographic images revealing the constitution of matter. In our time, the accepted appearance of objects only expresses an average vision, a small section of an extended spectrum, one dimension amongst many others which are just as moving, just as real, certainly more moving because of their novelty and more real because better adapted to the effective forces.

There is a curious coincidence here. During that period when these undisclosed aspects of exterior reality were being discovered by means of powerful instruments, surrealism, exploring the unconscious interior reality and freeing the painter's hand from all technical and aesthetic constraints which up to that time had enslaved him, gave rise to very similar images.

Landscapes are not the only things to be transformed; the intellectual system and social relationships have experienced a profound revolution; our vision must therefore be modified. But what are the aspects of this modern life? I ask what are they and not what would we like them to be, for the great majority of people, when considering this question, think of what is no longer in existence or of what they desire without concerning themselves with what really does exist. The contemporary world has become a compact thing. The halo which used to isolate the man of the last century, giving a unity to his personality, has disappeared. The rooms we live in, the specialization of the social functions, the promiscuity of urban existence, and the incessant intrusion of collective life into the very centre of our personal retreats, turn us into bodily organs linked together within the tangle of collective organizations. At first, on the affective level, we have experienced these collective organizations as agencies of pain but now, becoming more familiar with them, we are able to distinguish some of their aspects. Naturally there is no possibility of examining from the outside these entities in which we ourselves are included; our fragmentary impressions are similar to those which our cell-tissues might have of the architecture of our whole body.

In this new world, there is no possibility of defining the limits of the human being or of the object. Not because these limits are vague and drowned in an impressionist mist; on the contrary, the surfaces are clear, the design is sharp, but the facets are so numerous, so intricate and so mobile that no boundaries can be assigned with any certainty. Human beings and objects resemble the wheels of an infinitely complex machine, turning at a crazy speed. Even an approximately true representation of them must evoke the simultaneity of contrary or synchronous movements, occurring everywhere at the same time. Thus the outlines and divisions become semi-transparent partitions, artificial separations traversed by an infinity of gears and conductor wires.

Marcel Duchamps in *La mariée mise à nu par ses célibataires eux-mêmes* gave us the first valid image, precise yet impalpable, of this complexity, an image dominated by strict mathematical discipline as well as by complete fantasy. Whereas Picasso has served as a model for hundreds of copyists who are obstructing painting today, Duchamps's discovery, doubtless on account of its extreme difficulty, has only been a revelation to a very small number of our contemporaries amongst whom are G. Onslow Ford, Esteban Frances and, more obviously, Matta.

In proportion as the new world becomes more compact, as its contours lose their former solidity, as the unities collapse and become confused, as the suns are replaced by the reflection from spectra and by the glow from nuclear fires, the human being feels himself more solitary, more unable to communicate and more shut in by the private vision of his own frenzied adventure. The strangeness of a cloud-bank, transfixed only by a mountain-peak streaming with lightning-flashes, viewed from the cabin of an aeroplane, means absolutely nothing to the clerk entirely absorbed in the mysterious handing-on of business papers through the ant-hill of his office.

The adventure of modern life has all the characteristics of a schizophrenic progression during which the ties are broken between the human being and the exterior world. Nostalgia-ridden conservatives complain of the inhumanity of the present and long for everything to be reduced once more to the scale of our desires and understanding. Who would not join them in their wish? In spite of sighs and regrets, the adventure continues at quite a different rhythm to that of our hearts, with the aid of infinitely powerful instruments which have evaded human control and act like autonomous monsters, enslaving their creators.

During his first period of research, Matta was fascinated by cosmic chaos, by the consideration of space to the nth dimension, illuminated by explosions and the glowing colours of jewels. Later, he established a more direct contact with the new reality, now his chosen sphere of evolution. All our friends have been preoccupied by the need to surpass the traditional three dimensions but they have run into the difficulty of integrating a coordinated fourth dimension. Matta discovered a neat solution for this by reducing space to a moment in time; space is no longer an expanse but a richness of potential energy.

Classical determinism made a thorough study of the action of the more easily calculable and ascertainable forces. Matta opposes this conception with the convulsive determinism of sudden crystallizations, earthquakes, storms, and turns of fortune. Even if the whole of reality cannot be apprehended in its complexity by the method of controlled surrealist automatism, it is possible to draw the horoscope of the moment. Matta makes use of the brief glow of a lightning-flash in order to pierce the opacity of the divisions between things and to see through and across the void or the solid which are doubtless of the same nature. The entities which he incorporates in his constantly changing personal mythology make their appearance during these flashes. In all his paintings, we have both the sensation of being at the centre of a world and of dominating it from a very high altitude. It is not the sight of the sun which provides the illumination but the fluorescence of blood turned red by the exigency of desire. This desire of which man is the instrument is no less cosmic than the traditional sun; it is a replica of it, the black star with its own speed of rotation in the arterial conduits, in the depths of mines, in the wake of fires; it has its own geometry which is no less strict than that of Newton, a geometry which psycho-analysis allows him to evolve.

For Matta the moment of inspiration results from the shock of two words which combine together and produce

an explosion. Finding the landmarks which allow him to pursue his lightning way in this 'catastrophe' of the interior sky in which words are the constellations, Matta follows, in this respect, the strict tradition of poetic delirium. His powerful vitality, unbelievable optimism and astonishing resurgences of youth are essential to him for such an escapade to be possible without leading to a sacrificial and painful renunciation. (pp. 184-90)

Pierre Mabille, "Matta and the New Reality," translated by Peter Watson, in Horizon, London, Vol. XX, No. 117, September, 1949, pp. 184-90.

Robert M. Coates (essay date 1955)

[*In the following excerpt from an exhibition review, Coates comments on philosophical viewpoint and visual perspective in Matta's works.*]

The only link I can find between the shows under discussion this week is a certain feeling for fantasy. Even that bond is tenuous, for in other respects the works are as different as can be, ranging from the highly specialized symbolic abstractions of Matta, at the Janis Gallery, through the dream-castle stylizations of Bernard Perlin, at the Viviano, to the tight little sermons in Surrealism by Jules Kirschenbaum, at the Salpeter. Of the three, Matta's fantasy is the most ebullient, as his philosophy is the most fully developed. To be sure, it's an extraordinarily pessimistic point of view he offers us, and the playfulness with which he surrounds it—the punning titles, the wryly humorous passages in the pictures, and so on—cannot disguise (in fact, they accentuate) its essential melancholy. Yet he has made a complete world for himself, and though one may recognize some of the influences that have gone into its creation—traces of Picasso, for one, and of Matisse, together with a much larger and more obvious indebtedness to Oceanian tribal art—there's no questioning its consistency and coherence.

Matta, too, is one of the few painters I know of who can use perspective to defeat its usual end (that is, to define a more or less closed, three-dimensional scene) and instead create the feeling of a floating, illimitable scene. He does this, as far as I can make out, by a variation of the so-called "universal" perspective, constructing the picture not from one fixed viewing point but from a number of shifting ones, and what ensues is a wild phantasmagoria, in which the eye is constantly being led toward and then away from actually conflicting vanishing points; there is no set horizon, and the figures and objects, thin as scarecrows, distorted to emphasize their symbolism, and no more than vaguely related spatially, seem to float in an atmosphere that is truly dimensionless and limitless. It's a difficult trick to pull off, and when it fails—as it does in *The Bud Sucker* (with its diffuse design), the cloudy *The Tender Loin,* and the awkwardly patterned *Secret Heat,* all of them in the current show—the results can be spectacularly confusing. When it works, as it does more often than not, the very vagueness of the spatial relationships and the darting complexities of the perspective give the paintings an air of held-in, trembling-on-the-verge-of-explosion activity that is extremely effective. In a way, it's as if the forms making up the design had been whirled together by chance, and one expects, even as one looks, to see them fly apart.

The Thanks Giver, with its wormlike supplicants crouching before a totemic idol or priest and flanked by rows of dark, half-defined savage watchers, is, I'd say, the most ambitious painting in the exhibit, and in point of view of pure design it is probably the most successful. But in this, as in some of the others—*The Dawn Donor,* for instance—that pessimistic streak of Matta's leads him on to accent the grotesqueries of his figures too strongly, and the effect is marred in consequence. I felt better about *New Dew,* darker, denser in pattern, and shot through here and there with little areas of glowing color that recall the paintings of his "jewelled" period of the thirties and that also suggest the misty brilliance of the early-morning scene that is the painting's subject. I'd cite, too, the smaller *Morning Beckon*—on the same theme—as well as *The Kissproof World,* which portrays a mad, outer-space laboratory, and the gray, diagonally patterned, and dryly ironic *The Propheteer.* It's a distinguished show indeed. (pp. 82-3)

Robert M. Coates, "Three Painters, Three Moods," in The New Yorker, Vol. XXX, No. 48, January 15, 1955, pp. 82-4.

Edouard Roditi (essay date 1962)

[*Roditi was a French poet, prose writer, translator, and critic. In the following excerpt, he focuses on* La question Djamila *in a discussion of the implications of the amoral viewpoint in Surrealist art.*]

When textile industrialist Paolo Marzotto's European Economic Community Prize, Italy's most important annual international art-award, was granted a few weeks ago to the Chilean painter Matta, a former Surrealist who resides mainly in Paris, such official recognition of a general revival of interest in certain styles of figurative art came as a surprise to most of those dictatorial souls who have insisted that abstract art, like sex or Hitler's Thousand-Year Reich, was here to stay. The Marzotto Prize had indeed been, until now, one of the new awards that seemed destined to encourage and perpetuate only a kind of non-figurative or nonformal art which, in recent years, claimed to have definitely superseded all the figurative art of the past. Matta's painting selected for the prize had moreover been conceived two years ago, inspired in its theme and title by the tortures inflicted in Algiers, in the secret chambers of French "forces of order," on an Algerian girl, Djamila Boupacha, who remains a symbol of her people's desperate but now successful fight for independence. In a way, such a painting is as *engagé* as Picasso's *Guernica.* Two years ago, the choice of such a theme and title for a major work, however imaginative, unrealistic or even abstract, still required some political courage on the part of a foreign resident of France, where freedom of opinion is often felt to be a privilege only of French nationals.

Matta's work is too well-known to most readers of *Arts* to need, on this occasion, a detailed descriptive analysis. Though he often borrows his iconography from modern science or from a popular pseudo-scientific mythology that also inspires much science fiction, Matta has never claimed, as some abstract artists do, to be a true scientist, experimenting in his art with newly discovered laws or

Locus Solus (1941)

properties of space or matter or discovering new universes or what-have-you. On the contrary, Matta's use of scientific subject-matter has often been frankly fantastic, even caricatural or scurrilous. The relationships between some of his pictures and the realities of atomic warfare, cybernetics or space travel thus remain similar to those between a Goya *Capricho* and the real horrors of Napoleon's Spanish campaign. Matta is still, in this respect, a rare Romantic Humanist among modern painters, more concerned with the human values, if any, of our science or pseudoscience, in fact with what they may mean to us in terms of age-old human hopes and fears, intimations or dreams, than with their subject matter as facts in themselves that may exist independently of any human evaluation. In his spacescapes, for instance, Matta offers us oneiric or visionary transpositions of certain aspects of modern astronautics. He does not present himself to us as a kind of theoretical cosmonaut, but as a dreamer or fantastic satirist, a macaronic Cyrano de Bergerac, Dean Swift or Jules Verne. If he suggests the possible existence of flying saucers, Matta develops no theory about their origins or their nature, never claiming to be exploring reality in itself. He indeed refers, in his works, to a possible reality, but he presents it to us in the form of allegories and dreams, in human terms, without ever insisting on its probability.

However political the reality of the subject of the painting for which Matta has now been awarded the Marzotto Prize, his treatment of its dangerous theme remains similarly free from all immediate or direct political implications such as one finds, for instance, in Picasso's *Guernica,* which was deliberately conceived and painted as a work of propaganda, a real political action in the artist's life as a citizen. A political critic or moralist might thus sense, in Matta's painting, a somewhat disconcertingly ambivalent sympathy for the sadism of Djamila Boupacha's torturers: whereas Picasso, a Communist and a moralist, immediately sided with the victims and condemned his opponents, Matta urges us, as Homer did, to weep both for Greeks and Trojans and to understand and pity the sufferings and aberrations of both the tortured and the torturers.

In Berlin's Galerie Diogenes and Hamburg's Galerie Brockstedt, Paul Wunderlich, a young German artist who lives in Paris, has likewise shocked, in the last couple of months, some more naïve German critics by exhibiting a series of lithographs inspired by the tortures inflicted on the participants in the 1944 attempt on Hitler's life. These fantasies, some of which will soon be exhibited at the Locke Gallery in San Francisco, were felt to be obscene; but so had also been the tortures inflicted on Hitler's vic-

tims, however much the "squares" of Western Germany may now wish to forget such aberrations in their annual speeches to commemorate their only spectacular example of German resistance to Nazi terror. Wunderlich has expressed here his ambivalent emotions as a German artist who realizes, in spite of all official celebrations and speeches, just how intimate was the particular relationship that once bound the victims to their torturers in a world of violence where Germans found themselves committed to one side or the other almost without knowing why. Because we no longer have, as did Homer and his listeners or readers, an all-embracing conception of fate and of human destiny, in fact a belief in gods who are not human, whose reasons we cannot understand and to whom human beings may be but playthings, Wunderlich's or Matta's transpositions of twentieth-century political realities may appear more scurrilous or caricatural than reverent, more sadistic or masochistic than indignant.

In its frank rejection of ultimate moral or religious values, much of the best of Surrealist art and literature thus proposes a kind of residual religious experience to those who have ceased to believe in any dogma but remain afflicted with the basic human hopes and fears on which all religions were once founded. Such an art can no longer be interpreted, like Dante's *Divine Comedy* or a medieval altarpiece, in terms of a system of extraneous beliefs shared by the artist and his public, both equally versed in Scholastic philosophy and Catholic theology or eschatology. At best, we can but psychoanalyze one of Matta's paintings in terms of whatever accidental extraneous events, mere items of news or of personal biography, may have served as the occasion of the artist's "choice of a neurosis" as it is now revealed to us in the work of art. Because, as Freud has pointed out, no two neurotics will choose exactly the same neurosis in exactly the same circumstances and for exactly the same reasons, there remains, in all works of art that can be interpreted only as a private apocalypse, a personal dream or a neurosis, a kind of take-it-or-leave-it quality. Such works may appear absurd, irreverent or scurrilous to those who are not prepared to accept them and communicate with the artist in his individual vision. Dali has now evaded this whole issue by turning his back on Surrealism as a doctrine of Socratic doubt in order to revert to the unequivocal certainties of Catholic dogma; his allegories have become those of a manneristic Pre-Raphaelite rather than a real Surrealist. Other former Surrealists have likewise adopted, for their allegories, rigid systems of symbolical representation, borrowed from Freud or from medieval alchemy or magic, in fact from anything conventionally mysterious, rather than continue to face the ambiguities of their own personal vision. Because such symbols are at least traditional or familiar, we then agree briefly to suspend our disbelief.

Abstract art never poses such problems—which explains much of its popularity: you need only look at an abstraction, without trying to understand it or to share the artist's often ambiguous point of view. It thus remains as amoral as nature itself, requiring no more comment, in human terms, than a flower, a rock or a cloud. But Matta's work, like that of other major Surrealists, makes on us almost impossible demands of moral participation in the artist's emotions or beliefs, in an age of individualistic experience that lacks catholicity. Deprived of the dogma of a Church, we have all become heretics, each one of us seeming ab-

surd, scurrilous or irreverent in terms of what another may consider sacred. Our wars of religion, if any, should be a free-for-all—battle of all against all, each one of us a heretic in the eyes of all others, absurd or foolish as all heretics will seem to a truly humane Catholic, but scurrilous or blasphemous too as all heretics appear to a bigot. Because we can no longer agree on what should be considered sacred, moral or sublime, we are perhaps condemned to commune only in our awareness of the absurd, of the scurrilous, the ridiculous. (pp. 28-30)

Edouard Roditi, "In Praise of Macaronics," in Arts Magazine, *Vol. 37, No. 2, November, 1962, pp. 28-32.*

William S. Rubin (essay date 1968)

[*In the following excerpt, Rubin explores significant subjects, themes, and techniques in Matta's art.*]

Roberto Sebastian Matta Echaurren did not begin painting until 1938. He was born in 1912 in Santiago, Chile, of mixed Spanish and French parentage. In 1934, he went to Paris, where he became an apprentice in Le Corbusier's office at the insistence of his parents, to whom the study of architecture seemed more practical than that of painting. But architecture did not give adequate scope to Matta's restless imagination, and, as the years passed, he spent less and less time in Le Corbusier's office and more and more in the company of Surrealist friends, whose group he joined officially in 1937. That same year, he did a series of colored drawings, some of which, in their morphology and illusionist perspective, came close to Dali, who admired them and encouraged him.

Later, in the following year, Matta began working in oil, and promptly gave up the deep perspective and the tight handling of his first colored drawings. In paintings like **The Morphology of Desire** the shapes are irregular and frequently vague in contour; part of the surface is brushed in, but the thinner veils of paint that dominate the work were spread on with rags. The amorphic forms are engulfed in endless metamorphoses, passing through what appears to be a succession of vaporous, liquid, and crystalline states. Here thicker jewels of pigment cluster to form a highlight; there they eddy away and melt into open spaces as the painter "discovers" his vision improvisationally amongst the blots and spots.

This metaphor, as it were, of the genesis of the cosmos dominated Matta's art in the next five years. It comes into clearer focus in **Inscape** (1939). There the tenuous horizon line clearly suggests a fantastic landscape—a kind of soft-focus Tanguy—which, as the title implies, is discovered within the self. As a projection into pictorial form of impulses, feelings, and fantasies, it constitutes what Matta called a "psychological morphology"—that is a shape-language for psychological experience. The shapes of **Inscape,** though still quite unliteral, are more defined than in the pictures of 1938. Now, in Matta's mind, they would begin to "stand for" trees, birds, hills, and other components of a primordial world.

The vaporous washes of **Inscape** create the illusion of membranous "walls" dissolving into receding space, while the highlights of the pigment clusters suggest, as a form of modeling, projection forward. Yet the spatial defini-

tions of this and the other pictures of 1939-41 remain indeterminate. In the shallow space the forms press forward over most of the surface toward the picture plane, interrupted only occasionally by pockets of depth.

Matta began these pictures by spilling washes of color on his canvas, then spreading them with rags into the broader constituents of his landscape image, after which he used the brush to detail smaller forms. The process was inductive and improvisational; accidents of spilling provoked some of the larger contours, which in turn suggested the smaller and more elaborate biomorphic shapes. Frequently, as in *Prescience,* which Matta painted in New York late in 1939, the accidental dripping and running of the first spillings were left visible in a manner anticipating the more automatic Gorkys of 1944. *Prescience* also contains passages of fragile linear webbing as well as a few more sculpturally modeled biomorphs reminiscent of Tanguy. While Matta was to retain the linear webbing and, in fact, develop it later into complex perspective systems, the few highly modeled forms of *Prescience* had subsequently to be rejected as inconsistent with the illusion of continual metamorphosis that constituted what Meyer Schapiro characterized as Matta's "futurism of the organic." They would return only in the later forties.

In 1941, Matta traveled to Mexico, where he was impressed by the volcanic landscape, burning sunlight, and bright colors. Subsequently, his "Inscapes" became charged with flaming paroxysmal yellows, oranges, and greens. This is the color scheme of *The Earth Is a Man,* which is his first large picture and a brilliant synthesis of all his early imagery. The execution of this picture is tighter and the shading more smoothly graduated than before; as a result, the image seems more sharply focused, the forms more crisp. All this had to do no doubt with the very large size of *The Earth Is a Man,* which required that its layout be less improvised and more carefully planned in advance than had been Matta's habit previously; and it had also to do with the fact that the planning of the picture comprehended a more detailed and highly elaborated iconography than heretofore. The sun, partly eclipsed by a disintegrating red planet, illuminates a primordial landscape of apocalyptic splendor. It is the beginning of the universe; it is also the end. The high horizon line tilts the terrain toward the picture plane—flattening the space and allowing the entire composition to fuse more easily on the surface—and gives us a diving perspective on a landscape of amorphous hills and exploding volcanoes against whose melting surfaces are silhouetted exotic and frequently highly inventive shapes that denote, in Matta's iconography, primeval birds and flowers. The title, *The Earth Is a Man,* draws our attention to the poetic metaphor of the landscape as a projection of the psyche. The rationalist Greeks had used the image of man (the microcosm) to represent the *finite* order and mechanical perfection they attributed to the universe (the macrocosm), but Matta conjures up a galactic vision of the earth to insist upon the infinity and mystery *within* man.

The year 1942 was important for him. In addition to *The Earth Is a Man,* he painted *Here Sir Fire, Eat* and *The Disasters of Mysticism,* a brooding and particularly violent work distinguished by his richest handling of impasto in those years. The first picture is especially inventive and has a highly consistent spatial definition made possible by the elimination of the horizon line. The problem for the landscape painter is always how to articulate the sky as interestingly as the ground and, above all, how to make deep space unfold in continuity with the foreground (the latter was less of a problem for the old masters, who presumptively accepted the illusion of infinitely receding space). Despite the fantastic character of Matta's metaphoric landscape, he had to cope with these same difficulties. In pictures like *The Earth Is a Man* the interesting articulation of the "sky" was not a paramount problem, since the nature of Matta's galactic fantasy admitted a great variety of forms, which gave his "sky" the same compositional density as the lower part of the picture. The diving perspective did not, however, adequately solve the spatial problem engendered by the horizon line; and the remaining ambiguities disappeared only in *Here Sir Fire, Eat,* where Matta simply eliminated the horizon line and thus the implication of landscape space. As a result, the picture, though retaining shallow illusionistic space, has an approximately even depth throughout.

Matta's 1943 pictures explore a number of directions, but their general sense is equivocal. Not until the following year did the last vestiges of the "Inscapes"—the colorful mountains, volcanic explosions, and congealed lava flows—give place to an "a priori" continuum of dimly lit space, in which float a galaxy of smaller and very tenuously linked forms. The eye is now suspended in interstellar space, with its smaller galactic elements all more distant, more silent, more unchanging, and in their morphology more enigmatic than in the inscapes. As in *The Vertigo of Eros,* the only large picture and certainly the crucial one of this phase, the stability previously given by the horizon line is renounced in favor of an effect of suspension. Matta, paraphrasing Freud, declares that the life spirit, Eros, constantly challenged by the death instinct. Thanatos, produces a state of vertigo, and the problem is one of remaining erect in this situation, of achieving physical and psychological equilibrium. Equilibrium in Matta's art, like equilibrium in life, is a continuing dramatic factor. It is constantly being lost and must be regained. Each picture—simply as a plastic problem—repeats the challenge. The delicately equilibrated composition of *The Vertigo of Eros* is a solution bound to the alignment of psychic forces in the moment of the creation of the painting; it would not be viable for the next picture.

The central metaphor of *The Vertigo of Eros* is that of infinite space which suggests simultaneously the cosmos and the recesses of the mind. Afloat in a mystical world of half-light that seems to emerge from unfathomable depths, a nameless morphology of shapes suggesting liquid, fire, roots, and sexual organs stimulates the awareness of our inner consciousness as it is when we trap it in reverie and dreams. Unlike Dali and Magritte, whose imagery accepts the prosaic and realistic appearance of objects seen in dreams, Matta invents new symbolic shapes. These constitute a morphology that reaches back beyond dream activity to the more latent sources of psychic life: an iconography of consciousness as it exists before being hatched into the recognizable coordinates of everyday experience.

The Vertigo of Eros breaks with Matta's work of the previous years by adhering uncompromisingly to a very deep—in fact, infinite—illusion of space that is in some ways like that of the old masters. De Chirico's illusionist

space was achieved by linear perspective, which still allowed his planes to be flat and his pictures to look therefore relatively abstract. Matta's space is constructed primarily by atmospheric or aerial perspective, which precludes this flatness. He achieved this perspective by first laying down a ground of large alternating areas of wine and yellow; over this, when dry, he applied a black wash, which he then partly rubbed away with rags to allow color to emerge from the ground. The more black he rubbed away, the lighter became the final color (as in the lower right corner) and the more gradations were left by the rag to create the shaded passages which give the illusion of atmospheric space. Since the black was never entirely removed (this would have destroyed the tonal unity of the picture), the color is never pure but always "modeled." Within this atmospheric illusion of deep space, many lines—superimposed after the black had dried—crisscross or revolve to form a web of linear perspective that particularizes the co-ordinates of the more vague atmospheric perspective.

That Matta availed himself here of the two fundamental techniques of old-master illusionism—perspective space, and modeling in the round (which he used for the astral-genital eggs and other solid forms floating in his spatial continuum)—gives *The Vertigo of Eros* an old-fashioned look. It stands apart from the main tendency of modern painting, which has been toward greater flatness (that is, anti-illusionism) regardless of the degree of figuration. (Matisse is the epitome of the non-illusionist yet representational painter.) However, the test of any artistic convention is not its place in an historical development but its meaningfulness and viability in terms of feeling. Matta succeeds in moving us with his space because it conveys the mysterious and contradictory nature of consciousness in a revelatory way. Though he had to go back to illusionism for the plastic underpinning of his metaphor, his poetry still has an unexpected quality, and the shapes that carry it link exquisitely in the composition. His exteriorization of interior "space" reveals a new way of using the materials of illusionism; it constitutes the only spatial system of importance since de Chirico's.

Whereas the perspective system of old-master space is ordered by a single unified, governing idea (the perfect convergence of orthogonals in systematic focus perspective), Matta—taking a cue from de Chirico—articulates his deep space not with a single vanishing point but with multiple and frequently conflicting focuses. Like thought, which slips into unexpected byways, drops into maelstroms, and is suddenly frustrated by blockages, Matta's concentric circles suck the eye here and there into whirlpools of space, while at other points opaque planes suddenly materialize to obstruct its passage.

Toward the end of 1944, the deep space of *The Vertigo of Eros, To Escape the Absolute,* and other pictures of Matta's "dark" series gives way to a shallower and more consistently measured spatial illusion that tends to be based on linear rather than atmospheric techniques. The taut and intricately wired *Onyx of Electra* represents the culmination of this tendency. Here gray, white, and lemon prevail over a surface brushed in with comparative contempt for the medium. Gemlike clusters of pigment appear only as sparse accents articulating the perspective system and acting as nodes or terminals for the nervelike

linear circuits (which is the reverse of what they do in the inscapes). The linear webs, which had multiplied in complexity after their tentative reintroduction in the works of 1942, reflected the continued influence of Tanguy and the influence too of the patterns of the mathematical objects Matta had seen at the Poincaré Institute and in the 1936 exhibition in Paris of Surrealist objects; some of the webs, resembling the concentric patterns in contour maps, recall the pictures of Onslow-Ford. James Thrall Soby has pointed out, moreover, their affinity with Duchamp's fantastic network of white cord in the main gallery—which was organized around *The Palace of Windowed Rocks,* Tanguy's largest painting—of the 1942 Surrealist exhibition in New York.

Metaphorically *Onyx of Electra* seems to deal not so much with the deep recesses of the psyche as with a more intimate area, closer to the surface of the self, in which the life force is transformed into mental and nervous energy. In this "electrical" system of the mind all the tensions, ambiguities, contradictions, and frustrations of reality are felt. The space is fraught with pitfalls and sudden obstructions; perspective convergences pull us in opposite directions through planes whose surfaces bend under our impact and past pairs of icons suspended in sympathetic vibration. "It is the *space* created by contradictions," said Matta, "which interests me as the best picture of our real condition. The fault with most pictures today is that they show an a priori freedom from which they have eliminated all contradiction, all resemblance to reality."

There had been vaguely anthropomorphic suggestions in a number of Matta's paintings before 1944, but in that year these began to be more frequent and more legible. For the most part, they suggested only fragments of anatomies, as in *The Vertigo of Eros. To Escape the Absolute,* however, contains an abstract, hard—almost bony—structure which, as it materializes in space, seems almost to imply a total anatomy. The following year, these adumbrations led to Matta's fantastic "portrait" of Breton, titled *A Poet,* the first of the "creatures," or "personages" that have populated his painting ever since. Breton had always looked to Matta like "a sort of lion with horns on his head . . . fixed in a position to carry a mirror," and the gun in Breton's hand, which is also his navel in the shape of a keyhole ("through which we unlock his enigma"), refers to the passage in the second Surrealist manifesto that recommends shooting at random into a crowd as the ideal Surrealist act.

Anthropomorphic personages had always been common in Matta's drawings, but like much else in his early iconography, they had not before found their way onto canvas. Unlike the paintings, the drawings had been frequently novelistic. The "adventures of a pair of biomorphs" which Matta drew in Chinese scroll form for his twin sons is three inches high and fourteen and a half feet long (divided into twelve panels). That Breton should have occasioned the first personage in Matta's actual painting reflects the importance, in this transitional phase of his art, of the "beings" that Breton had called *Les Grands Transparents* (the Great Invisible Ones) in his "Prolegomena to a Third Surrealist Manifesto or Else," which had been published in 1942, illustrated with drawings by Matta. Breton wrote:

> Man is perhaps not the center, the focus of the uni-

verse. One may go so far as to believe that there exist above him . . . beings whose behavior is alien to him . . . completely escaping his sensory frame of reference. . . . This idea surely affords a wide field for speculation, though it tends to reduce man as an interpreter of the universe to a condition as humble as the child conceives the ant's to be when he overturns the anthill with his foot. Considering perturbations like the cyclone—or like war—on the subject of which notoriously inadequate views have been advanced, it would not be impossible . . . even to succeed in making plausible the complexion and structure of such hypothetical beings, which obscurely manifest themselves to us in fear and the feelings of chance.

The two personages in *The Heart Players* seem incarnations of these Great Invisible Ones. They manipulate the universe as they play a game of three-dimensional chess in which the pieces are the astral eggs and planes of the previous year's cosmic iconography. These syntactical constituents of Matta's language of the psyche are thus suddenly discovered to be pawns in the hands of previously invisible crystallizations of causality.

As Matta developed a variety of new and increasingly monstrous personages, he became more interested in Duchamp—to whom he now paid homage with an article and a painting. From Duchamp's cinematic effects he derived the spun, splayed, and shuffled planes of *Splitting the Ergo,* which were soon synchronized, as a kind of fantastic environment in motion, with one of the personages in *A Grave Situation.* All this—the personages (now so varied and so monstrous as to constitute a private bestiary), the Duchampesque passages, in fact everything new in Matta's art after *The Vertigo of Eros*—was summarized in 1946 in an outsize (fifteen feet wide) canvas titled *Being With.* In this and related pictures Matta's handling becomes particularly broad; with their summarily modeled monsters and opaque planes they lack entirely the airy, delicately graduated atmospheric effects and intricate brushwork of his earlier pictures. Since very large canvases would be as frequent as previously they had been rare, this more summary manner became inevitable. Matta was the first painter in New York to make such big pictures standard for himself; it was not until a few years later that Pollock, Mark Rothko, and Clyfford Still were to do so. But when they did, it was in different ways, in ways more related to that of the late Monet than to Matta's; his illusionist scale, whatever the size of his canvas, is always determined by the presence of anthropomorphic figures that act more or less as modules, and to that extent the prototype of his wall-size pictures is the *Guernica.*

In *Being With,* the tendency toward literary specificity that had increasingly characterized Matta's iconography reached a peak from which it has never since then appreciably receded. The monsters are all in easily decipherable "anecdotal" situations; with their semaphoric gestures, their half-insect, half-machine forms, they are intended as cybernetic embodiments of "the hidden forces that seek to control our lives." The specific anthropomorphic character of these creatures . . . was influenced by Giacometti's *The Invisible Object,* by Duchamp's anthropomorphic machines, as well as by certain drawings of Masson (1940-43), and the monsters of Ernst. The characters alter with the experience the creatures undergo, and the space around them bends sympathetically in response to their action.

The solidly modeled figures and hard, opaque surrounding surfaces in the pictures of 1946 continue until the end of the decade, just before which their morphologies become increasingly spike-like and thorny, endowing them with an Expressionist violence not unrelated in spirit to certain developments in American painting at that time. Matta's evolution as an inventor of forms has now slowed down; the novelty of these years is largely literary: the invention of new situations for the personages. Having moved from a pictorial, or (in a Wölfflinian sense) painterly, style to a more sculptural one, Matta may well have considered turning those personages into sculpture in the round (as Ernst had earlier done with his). But though the personages might have become more effective as works of art, they could not then have been so easily arranged in the narrative situations in which resided, as far as Matta was concerned, their main meaning. Matta did turn to sculpture much later, but by then he had reverted to a more loosely brushed, antisculptural style of painting.

By 1950, when Matta's work underwent a new inflection, the last major Surrealist group show had taken place in Paris (1947), and the sense of Surrealism's having run its course was widespread, even among those who held no brief for the emergent new American painting or its European counterparts. In 1948 Matta had been forcibly separated from the Surrealist group because of personal matters. Most of the Surrealists had gone back to France in 1946 and 1947, and even though Ernst remained in America (he would return to France temporarily in 1949, permanently in 1953), and Tanguy stayed behind, there was for Matta little sense of a congenial milieu in New York after 1947. To be sure, the situation in Paris was not much better, for Surrealism had not been able, particularly after the 1947 exhibition, to reimpose itself or restore what in the thirties had been its virtual cultural hegemony. Too many new things were going on, too many new personalities who had gone through the critical years of their development during the absence of the Surrealists were making themselves felt, for Breton's role to be central.

Surrealism nevertheless persisted in many ways as a state of mind, and Matta, committed to the ideal of *peinture-poésie,* now suffered from a feeling of rootlessness. Responding with the courage of his cosmopolitanism, he began to roam: first to England, then to Italy, but finally he returned to France, where he still lives. Matta's art in the fifties—particularly late in the decade—reflected the breakup of Surrealism. With its frequent thinness and in its relative failure to evolve, to create new forms and images, it constitutes a marked contrast to what it was in its early years.

If sculptural illusionism dominated Matta's painting in the late forties, the two revisions of style notable in his subsequent work were both in the direction of the painterly. Beginning in 1949, there was a loosening of the handling; surfaces were increasingly accented by staccato strokes that by 1952 proliferated into effects akin to those in early Futurist Boccionis. *The Spherical Roof around Our Tribe* of that year is like an electromagnetic field in which the charged activity of the white strokes counterpoints the vibrations of a composite creature and a swarm of buzzing insectile heads.

An increasing concern with the more fantastic possibilities of science—versions of the universe as it might be seen through the "poet's" microscope or telescope—produced a number of pictures in the fifties that led to Matta's being criticized somewhat unjustly as a "painter of science fiction." This interest in science led him, at the end of 1952, to the theme of biological growth, the poetry of germination as conceived in terms of a botanical fantasy the germ of which goes back to Redon. The burgeoning forms of *To Cover the Earth with a New Dew* (1953) suggest a sun rising behind a landscape in which a flurry of activity animates the flora: roots spread and pistils discharge clouds of seeds; on the left, huge blossoms of color joyously burst forth. It is as if one speck of soil in the vast cosmic landscape of *The Earth Is a Man* (1942) had been isolated under an enlarging lens. These botanical landscapes have continued to alternate since 1952 with the "novelistic" pictures of personages. The further loosening of the paint handling that they show reflects the feelings of relaxation and *détente* inherent in the theme itself. Airily and thinly painted as they are, these pictures recapture certain aspects of Matta's earliest work and are more universal in their poetry than the novelistic pictures whose iconographies have become excessively journalistic, centering on politics more than on Eros (which had dominated his art in the forties). (pp. 346-62)

William S. Rubin, "Matta," in his Dada and Surrealist Art, *Harry N. Abrams, Inc., Publishers, 1968, pp. 344-62.*

Nicolas Calas (essay date 1974)

[*In the following excerpt, Calas examines Matta's artistic evolution from his "volcanic" period to his "totemic" period.*]

He who reads the future in the past is a visionary and, like Ernst and Tanguy, feasts our eyes with revelatory versions of petrified forests and neolithic landscapes; he who projects his present bewilderment and anxieties into the future, as Chirico and Duchamp have done with their manikins, is a seer. Matta would not have become today the most eloquent witness of eros and terror unless he had learnt from both how to fuse alienation with utopia. (p. 3)

Among his early works most notable are a series of Masson-like drawings enlivened by a very personal version of color automatism. Matta with great skill exploited a new type of polychrome pencil that changed color as one drew. Yet titles such as *The Sun's Anxiety after the Passage of Two Personages* suggest that Matta must have been ill at ease in the world of the labyrinthine mutations of Masson. Paintings such as *Psychological Morphology of Expectation* (1938), producing a rather odd combination of architectural designs and biomorphic shapes, as contrasted to the fusion of the biomorphic with manufactured objects that had become a trademark of Dali. The principal characteristic of Matta's series called *Psychology of Morphology* consists in the brilliant and often fluid chromatic combinations complementing areas of atmospheric hues in which semi-formed bright minerals emerge from chaos, as in *Inscape (Psychological Morphology 104)* (1939). About these paintings of Matta, Breton wrote in *Minotaure*: "In his work nothing is directed. There is not anything which does not result from the will to develop the faculty of divi-

Matta's concept of the artist's role in society (as paraphrased by J. M. Tasende):

I feel the role of the artist is to storm Art, to hit deep at the roots, like an art-quake and not art-kissing.

I have been assassinated several times for several reasons or interests. An artist is a good target since his role is to open eyes and the conventional mind does not like change or growth but prefers to remain childish, in a child dish of delight.

People do not want anything to disturb the order of the current system. The artist and poet are not obligated to cooperate in this respect, their function is exactly the opposite. It is to put the finger on the contradiction and enlarge the conflict. To exist is more than surviving. It is not enough to make the actions that guarantee life and preserve space. The artist and poet want to give sense to the life, beings, and facts around him. A spot on the wall can equilibrate the visual order of the individual but it does not help him to confront or deal with the gradual conflicts that present themselves, nor does it help him to understand his society.

The artist doesn't pretend to offer a solution for everyone's problems. He expresses his way of confronting problems with society and he invites others to confront and resolve their own always with optimism but more important with a sense of humor. The artist must have more of this than anyone else.

J. M. Tasende, "Improvised Colloquy," in Roberto Matta: Paintings & Drawings, 1971-1979 *by J. M. Tasende and others, Tasende Gallery, 1980(?), pp. 11-12.*

nation by means of color, a faculty which he possesses to an exceptional degree."

Destiny willed that Matta's first show was to be held in New York where he established himself on the eve of World War II. In my introduction to the exhibition held at the Julien Levy Gallery in the spring of 1940, I took my cue from the following lines of Shelley's *Prometheus Unbound*:

Ten thousand involving and involved
Purple and azure, white, green and golden
Sphere within sphere; and every space between
Peopled with unimaginable shapes.

and said:

Each artist has his totem: without it how could he fight successfully? Matta has a bird-like vulture; it floats in the air of this room, no more strange than the vulture of Prometheus, no less cruel either . . . Look at Leonardo, how his vulture tore him to

pieces when it lived and when it fell to the ground. Is it strange that the best description of Matta's pictures should be found and foreseen by a man who belonged to the clan of the vulture? . . . In Matta's pictures what came first: space, color or form? Does it matter? . . . The poetic elements in Matta are elementary, but they have the strength and necessity of the elemental. The opposite of fire is, I believe, the crystal, whose laws of birth and life are opposed to the laws of fire. A crystal is the purest part of rock and the hardest. It is there where I see Prometheus bound. A picture is something that is and at the same time is not Prometheus or fire. That it is close to both we can understand perfectly well whenever we look at Matta's pictures: The earth is still of sulphur, the green of his unnatural foliage is as dark as the emerald green of deep waters that lie between lands more familiar to nights of long months than to warm days. The sky has not changed, and Matta's blues are full of air. If the extravagant magenta pinks break the ferocious harmony of the convulsion, it is because joy can live in horror. Perhaps Prometheus laughs. In a world where geometry is still supreme because it is a world still ruled by crystallizations, one shape is not yet formed. How then is it possible to differentiate all passions and recognize them by their inherent but unrevealed structure? It is *a strange silent world*, as Matta himself says in a title of one of his drawings. . . . Voices break the silence but they are and have to be voices of the unconscious. The conscious world has come to the appalling contradiction of understanding only imposed silence. To the consciousness of silence and its burning darkness, we oppose the violent cry of the unconscious, the tempest of cold and heat that create new forms. Where does Matta come from? From a chaotic world! Where is he going, where are we all going? Let us hope, hope, struggle and hope again.

I had no way of knowing at the time that Matta's volcanic period was to be followed by a "totemic" period, nor that the devouring vulture would in the sixties assume the form of a terrifying spaceship. In this light the work of Matta appears as a unique poetic and moral testimony of outrage and hope. Among the Surrealists, only Matta proved to have been equipped to assume such a task. Only Matta was bold enough to reorganize the pictorial structure of the fantastic, but this attempt would have been worthless if it had not been carried out in the name of a new iconic prototype. The poetic incentive came from Alfred Jarry's famous work, *The Acts and Opinions of Dr. Faustroll, Pataphysician* (1911).

In his catalogue of his 1942 exhibition held at the Pierre Matisse Gallery, Matta included Jarry's following witty definition of Pataphysics: "The science of imaginary solutions which bring into symbolic agreement the outlines and the properties of objects as described by their virtuality." To demonstrate the point Matta included six illustrations of properties of objects as described by their virtuality, that when combined could produce a pataphysical painting. One illustration comes from a book of gestalt psychology, another from a book of physics depicting the Hertzian oscillation with its strange humanoid appearance, another is the diagram showing the origin of the aurora, yet another the map of the North Pole. Their illustrations are accompanied by humorous captions.

The pictorial incentive to Matta's new image derives from

another great pataphysician, Marcel Duchamp. In a study of *The Bride Stripped Bare by Her Bachelors, Even,* (written in collaboration with Katherine Dreier), Matta explains that it is a work in which painting, glass and mirror "are three substances in dynamic interrelation to the final image of the glass . . . While we gaze upon the *Bride* there appears through the glass the image of the room wherein we stand and in the radiation of the mirror design lives the image of our own body." This questionable statement heralded Matta's intention to solve Duchamp's dilemma: the contradiction between Duchamp's Cubist paintings and his work on glass by means of what might be called transparent cubism is overcome.

Matta's transparent cubism owes a debt to the *Dymaxion Sky Ocean World Map* of Buckminster Fuller, presented in the form of a pattern. As is well known by now, this basically two-dimensional representation of the world can be folded in such a way as to form a polyhedron version of our sphere. With this shape in mind an artist can construct vitreous or mat geometric planes opening or folding angles on spaces within spaces. In *Vertigo of Eros* (1944), punning with *vert tige d'eros*—an allusion to Freud's *Ego and Eros,* Matta reinterpreted in a dreamlike world, the glass world and the erotic subject matter of Duchamp's *Glass.* The following year with *The Revolt of the Opposites* (1944) Matta overcame the sentimental evocation of dreams of *Vertigo d'Eros* by "anchoring" dark angular planes to the vitreous looking picture plane—a technique that was later to be taken up in abstract art by Hans Hoffman.

Matta publicly acknowledged his indebtedness to Duchamp both in *The Bachelors Twenty Years After* (1943) and in *Les grands transparents (The Great Transparent Ones)* (1944). It is true that this title is a direct reference to Andre Breton's lecture at Yale in which the poet spoke of supernatural beings whom he called *The Great Transparent Ones,* but indirectly it serves to link Jerome Cardan's (1501-1576) dream about transparent beings moving swiftly through space to Duchamp's *King and Queen Surrounded by Swift Nudes* in conjunction with the transparent figures of *The Bride.*

In later years Matta came to view his volcanic early paintings as an expression of a struggle between chaos and cosmos, adding that gradually with his "totems" he began to feel this struggle as taking place within his own self until finally he wanted to express simultaneously the change of the being and the change of the world. In an article written in 1947 Breton attributed Matta's break from his so-called non-figurative period to a personal crisis that compelled him to substitute man for anxiety. Breton sees in Matta's development an example of a psychological process in which no artist can express the torments of the world without having known what it is to be torn asunder himself. Matta's manikins are direct descendants of both the *Surmale* (supermale) of Jarry and of Duchamp's *Bachelors.* No one before Matta, as Breton pointed out, ever illustrated the dramatic and anxiety ridden conflict between eros, the death wish and the super-ego in such poignant terms. Thus, as Breton explained, Matta was able to recapture that horror of the terrible life of concentration camps so poignantly described in works such as David Rousset's *Les jours de notre mort (The Days of Our Death).* Breton was here referring to paintings such as *Le vitreur (The*

Glazer) (1944), **L'octrui** (a neologism derived from *octroi,* grant, and *autrui,* other) as well as **Crucifixhim.** The first is a reinterpretation in totemic terms of the *Large Glass,* but all four seem to fuse the horror of the concentration camps with a "futuristic" view of Golgotha.

To those who are unfamiliar with Matta's frame of reference, the vitreous totemic paintings could be mistaken for illustrations of science fiction. But as Matta said to Lawrence Alloway: "Either science fiction is science or I am." Side-stepping the issue, Alloway explained that, for Matta, "technology had created a paranoid environment, an invasion of privacy, a predicament, a torture." The term paranoid as used here is debatable for, unlike Dali, Matta equates phenomenology with scientific facts. During a symposium held at Bologna on the occasion of an exhibition of his works, Matta explained that while man had previously seen himself as the center of the world, in a revolutionary art the world becomes the center of man. This center, he added, should not be appraised in Copernican terms but in phenomenological ones. According to Matta, the basic questions that the artist has to ask himself are "Where?" and "Where am I?" Matta says: "I can be in this table, not actually bodily but probably in something that can be fused into one." From an empirical standpoint there is no doubt that science fiction often makes more sense than does this phenomenology. For those, however, who from Jarry to Marcuse consider scientific inventions as instruments of oppression, Matta's message is of the utmost importance. According to Matta, the correlations of the need to change one's life with the wish to transform the world is best expressed in a spatiotemporal totality that is four-dimensional, one dimension curved to conjoin in space totems with astronauts and open armed lovers with crucified victims.

These are grandiose metaphors and Matta's totemic paintings "are either poetry or are not." Matta has used and abused phenomenology the way Masson used and abused Greek mythology, the way Ernst violated images and Dali distorted facts. All systems of iconic mutations are valid, surrealistically speaking, provided they engender wonderment and perturbation, perturbation and wonderment.

Matta has identified himself with a catalyst of perturbations by drawing attention to the pun, Matta-Mato, the latter meaning in Italian both madman and the Tarot joker. Reference to this pun is obvious in a painting of totemic cardplayers, **Enlevons les cartes** (1957). Matta should have explained that Jarry is to alienation what Jules Verne is to science fiction. For Jarry science is *la grande scie,* literally *a saw,* but figuratively *a bore.* Matta condemns the robot by fusing him through a historical short circuit with the Eskimo's mask, and this mask with Hell's Angels on a motorcycle, or with the *cyclotrhomme* (literally circling man) an allusion to astronauts orbiting beyond time. *Esquimau* puns with *exquis mot* (exquisite word), recalling the *cadavres exquis* as the Surrealist called their collectively made drawings.

Matta's giant Eskimos personify the villains of Jarry's *Supermale* (1902) a book in which the author predicts that by 1920 masked riders strapped with aluminum tubes would ride a zoomorphic train which, when air-borne, flies at incredible speed. Jarry ended this proto-dadaist work by announcing that the time would come when a machine could be made to fall in love with a human being.

Matta's expression of the antithesis between Eros and Thanatos takes sometimes the form of the opposition between lyrical phantasy, glorious vistas of an organic world shimmering in dazzling colors and nightmarish visions of demons as in **To Cover the World with Due** (1953), **Les Rosembelles** (1953) (dedicated to the Rosenbergs viewed as martyrs), and **The Interrogation** (1958), (inspired by H. Alleg's sensational revelations of torture of the heroic Algerian rebels.) Through the transparency of time Matta invokes the ultimate dimension of history that will not tolerate mock trials. Unlike Goya who gave us images of horror and fear, unlike Picasso who, in *Guernica,* reduces horror to pain, to a common denominator between man and beast; Matta identifies the enemy with the Devil. Again, in contradistinction to those Medieval painters who, through their illustrations of Hell, remind the viewer of the coming Day of Judgment, Matta offers us an inner meaning of contemporary events. Although polemical, such paintings stimulate thought more than they horrify. What is at stake is the eventuality of substituting terror for Freedom. We are now seeing the metamorphosis of warriors into robots with managerial efficiency raining death by remote control. Efficiency is painless and one-dimensional. Pain, love and memory are the elements of the three-dimensional world of poetry Matta's newest astronauts carried into outer space by whirling graffiti reverberating The Large Glass; supersonic counterpoints of color echo Laocoon's immortal Horatian cry: *ut pittura poesis.* (pp. 3-6)

Nicolas Calas, in an introduction to Matta: A Totemic World *by Roberto Matta, Andrew Crispo Gallery, 1975, pp. 3-6.*

Lionel Abel (essay date 1981)

[*Abel is an American playwright and critic. In the following excerpt, he recalls a party given by Matta in 1942 to exhibit and publicly name his painting* The Earth Is a Man.]

Some weeks after our first meeting [in 1942], Matta invited me to a party at which he was to exhibit a new painting of his, and publicly name it. It was to be something like a baptism but not too much like one. Among those present were the painters Chagall, Masson, Tanguy, Seligman, Motherwell, the composer John Cage, the dealer Pierre Matisse, and of course André Breton. At one point in the evening Matta produced his painting and gave it a name, which was, **The Earth Is a Man.**

It might have had any number of names, and I remember asking Breton: "Is there a definite Surrealist theory about how a picture should be named?" "Oh yes," he said. "We have such a theory." What was it? I can't remember the words he used exactly, but the purport was that the name given to a Surrealist painting would have to be such that the picture would remain forever nameless. "Well," I asked him, "take Matta's painting, **The Earth Is a Man.** Is it nameless, now that he's named it?" "Yes," said Breton. "It is now nameless, because the title, **The Earth Is a Man,** is completely independent of that painting." (It most certainly was.) "You can think about it without looking at the picture at all. You could type out that title, **The Earth Is a Man,** and hang the typed letters up by themselves on the wall and they would have some effect

on you." "And I suppose," I replied, "you could hang the painting up without the title." "That's just what I meant," said Breton. "But couldn't that have been done before he invited us here to give the painting a title and called it ***The Earth Is a Man?***" "That would have been more difficult," said Breton, unsmiling—he was always grave. "Because, had he shown it to us without having named it, we would have thought it lacked a title."

As for Matta, he was quite happy with his title. In fact I've never in my life seen anyone so excited as he was that night. And he made a little speech about painting and his notions about painting. He said, "There will never be a recognizable object in a picture of mine. Never. Not one object, not the shadow of an object. No object is good enough to be in a picture of mine. No woman is beautiful enough. Let her hair be green, purple, or pink. No fruit, no bottle, no table, no tree. I will not put them on canvas. Never. I swear it."

I remember asking Breton, "Is that the Surrealist theory of a painting?" "No," Breton answered. "That's his own idea. But as you see, he has charm, and his charm is Surrealist."

What were Matta's paintings like during the years of the war? [Meyer] Schapiro used to say that what Matta painted were *éclats*—bursts—not necessarily of color, though he painted these *éclats* in color, and not in his line drawings of that period, in which there were generally organic forms, often very comical. Now Matta had said that he didn't paint anything, that he would not represent anything in his pictures. On the other hand he would not say that he was painting nothing. He did not claim, as Ad Reinhardt did years later, that he put everything into his paintings by leaving everything out. I think what Matta must have meant was that the "bursts," or explosions, which took place on his canvases, were set off in the act of painting itself, and not calculated in advance. He was an automatic painter from the outset, with all the advantages and disadvantages that implies. (p. 49)

> Lionel Abel, "The Surrealists in New York," in Commentary, Vol. 72, No. 4, October, 1981, pp. 44-54.

J. H. Matthews (essay date 1982)

[*Matthews is a Welsh critic and educator who has written extensively on the Surrealists. In the excerpt below, he traces Matta's association with the Surrealists, discussing the ways in which Matta's intentions and techniques reflect Surrealist principles.*]

On the last page of André Breton's 1941 essay "Genèse et perspective artistiques du surréalisme," figure the names of a number of recruits to surrealism, new and not so new. Their participation draws comment, evidently, because it confirms automatism's continued vitality in keeping "the great physico-mental traffic" going in surrealism.

Seventeen years after he first emphasized in his *Manifeste du surréalisme* that automatism is central to surrealist activity, Breton points to it again, this time as the common element linking the work of a varied group of artists: Oscar Dominguez, Max Ernst (specifically, in recent work done in 1940 and 1941), Kay Sage, S. W. Hayter, Jacques

Hérold, and three young artists. The last he identifies as embarked on the conquest of "a new morphology exhausting in the most concrete language the whole process of repercussion of the psychic on the physical." Of the three—Matta, Esteban Frances, and Gordon Onslow Ford—the first, apparently, is the one whom Breton regards at this stage as having the greatest promise. The final sentence of "Genèse et perspective artistiques" runs, "As for Matta, it is already clear to many people that he has *all* the spells at his disposal."

Born in Chile (1911) of Spanish and French parents, Roberto Sebastian Antonio Matta Echaurren traveled to Paris in 1933 to study architecture under Le Corbusier. Before the end of 1937, however, he had started to paint and had been admitted to membership in the surrealist circle in France. At the outbreak of war in 1939 he and Onslow Ford were among the first in the group to seek refuge in the United States. A decade later, Matta returned to Europe, temporarily estranged from the surrealists.

Matta attracted attention immediately on the surrealist scene, finding virtually all the elements from which he was able to project a pictorial universe without parallel. Initially, he may have come under the influence of Yves Tanguy's painting. Very soon, though, he had discovered that suppression of the horizon line (which never quite disappears from the majority of Tanguy's canvases) could give him access to a world where no one had preceded him and which he was able to devote some of his most productive years to exploring.

Here, Sir Fire, Eat (1942) is among the first paintings in which a major consequence of the horizon's absence may be discerned. The spectator has the impression of looking through receding shifting planes that yield to one another as the eye penetrates the picture. The painting releases in us a feeling of giddiness that prepares us for the title and content of another work, ***The Vertigo of Eros,*** completed two years later. The subject matter of the 1944 canvas is not readily described. A process of elimination leaves us with the rationally defensible impression of looking, perhaps, at a dark pool. Here float a variety of forms, including two eggs. However, the thought that we are gazing at a pool arrives only by analogy. There is no convincing proof that Matta actually intended to paint one. Moreover, we face an insurmountable difficulty when trying to locate the pool. Inconsistent perspective intrudes upon the scene, with the introduction of roughly geometrical shapes which look as though they have been superimposed on the painted surface.

It may not dispose of our difficulty in approaching a painting like this one to know that Matta was engaged in what he termed *"conscienture,"* the painting of consciousness. Even so, his neologism illustrates the purpose behind his canvases. Noting Matta's opposition to "retinal painting," derided earlier by Marcel Duchamp, Sarane Alexandrian reports, "At this time, Matta said to me, in a private conversation, 'I want to make pictures which leap to the eye.' And with his hands raised like a tiger's claws, he made as if to seize an invisible spectator."

Before we can plumb the vertiginous depths of the erotic in ***The Vertigo of Eros,*** we have to let the picture lead us down into the painter's consciousness, where erotic motifs have liberated themselves from attachment to external re-

ality. Matta's universe remains closed to us, until we have allowed his practice as a painter to rearrange our priorities, to show that the inner world can be more real than the outer, more exciting by far to explore through an iconography largely independent of elements borrowed from the everyday world.

In the spring of 1938 Matta contributed to *Minotaure* an article entitled "Mathématique sensible, architecture du temps." It was his aim in this text to do more than reveal something about his professional training in architecture. "We need," he wrote, "walls like damp sheets which warp and correspond to our psychological fears." With the idea of creating buckling walls and bending furniture he started to project the "psychological morphology" he would investigate, soon, in his painting. The following year, Breton was already full of praise in "Des tendances les plus récentes de la peinture surréaliste": "Each of the pictures painted by Matta during the past year is a festivity in which every chance is taken, a pearl that becomes a snowball drawing to itself every gleam, the physical and mental ones at the same time." And he was signaling with enthusiasm one outstanding feature of Matta's work: "The need for a representation suggestive of the four-dimensional universe is affirmed very particularly in Matta (landscapes with several horizons). . . ." The four-dimensional universe of Matta images states of mind more faithfully than it resembles the external world. The latter is "warped" beyond immediate recognition, used in fact to bring us face to face with the reality of psychological tension and alarm.

Time after time the same effect recurs, although with variations that rule out any danger of monotony. Our eye drawn down into the picture, we have the distressing feeling (akin to a physical impression, it is so strong) of losing footing, of being precipitated into a new environment. The latter is either vertiginously turning like a maelstrom or mysteriously still, but of infinite depth. Here perspective is frequently self-contradictory, as it is, for example, in **The Onyx of Electra** (1944). Perspective ceases to be a reassuring phenomenon by which, according to the canons of traditional painting, we find our bearings and learn to know where we stand in relation to what is represented. There are no longer any unquestionable signs testifying to stability and permanence. Typifying more than the dislocation of familiar reality, their suppression intimates that Matta may well have announced his main purpose when naming one of his 1944 pictures **To Escape the Absolute.** Like abandonment of the horizon line, the confusion of perspective is, for him, a means of casting us adrift on an ocean where we miss the lodestar by which we are accustomed to take bearings.

In a July 1947 essay, reproduced in *Le surréalisme et la peinture,* Matta is singled out as having undertaken to "revolutionize perspective," which Breton condemns as having the grave defect of satisfying the eye only. Matta's revolutionary gesture surely has consequences on the technical plane, but it has an even more significant effect also. Matta, Breton argues justifiably, brings other senses into play—"from the coenesthesic sense to the (more or less lost) sense of divination." He is concerned with "representing inner man and the odds he faces." Breton implies here that conventional perspective has no useful role in the work of an artist who immerses man in an element other

than "physically breathable air." That element is chance, "a sort of geometrical plane of resolution of his conflicts."

Roberto Matta may not resolve, every time, the conflicts his pictures represent. Even so, one does not have to be willing to follow André Breton blindly each step of the way before agreeing on one basic point. Disruption of familiar perspective in Matta's work is not a device used for aesthetic reasons. It is a method employed to communicate a response to life, experienced at a level other than that of commonplace exchange between individual consciousness and external reality.

Having stressed that surrealism is "essentially a revolutionary step," Matta once affirmed in an interview granted F–C. Toussaint for *Les lettres françaises* (June 16, 1966) that, for the surrealists and himself, all activity is revolutionary and therefore precludes "contemplative aesthetics." He could not own to an aesthetic position, he said, for "when one makes a revolutionary gesture, it is possible that it is very ugly in its immediate appearance." Even when eventually it can be perceived as beauty, he suggested, the creative gesture and whatever follows upon it really have nothing to do with "the aesthetics that interest many painters." Seen this way, the artist's actions must be weighed against the aims set for him by surrealism: "the complete emancipation of man." For Matta, the significance of emancipation is poetic in the sense that "the function of poetry is to enlarge consciousness of the world."

So far as Matta can be said to show us our own world, it is a world blown apart, caught either in the process of disintegration or engaged in reintegration. "The power to create hallucinations," he once wrote, "is the power to exalt existence." In other words, Matta's own hallucinatory painting is a comment on living. "The artist is the man who has survived the labyrinth"—even though he may still paint for us a labyrinthine world. Hallucination, now, is affirmation, setting its stamp on life, not recoiling from it. The purpose in view? *"To use hallucinations creatively, not to be enslaved by other men's hallucinations, as usually happens."*

There is some danger that we may read too much into these remarks. After all, they express Matta's response to the painting of Max Ernst and were not offered as a statement outlining their author's own position. Nevertheless we can recognize in Matta's words a sensitivity that helps open our eyes to the nature of his own experiments, situated, like Ernst's, "beyond painting" in that zone where the pictorial artist may make a vital contribution to surrealism. At the same time, the evidence furnished by Matta's pictorial investigations indicates that, even though he felt something in common with Ernst, he was not disposed to explore imagery in exactly the same manner as Ernst did when first approaching surrealism.

Matta's painting displays a characteristic that deserves attention at once. His "means of forcing inspiration"—to borrow Ernst's well-known phrase—do not owe much to implementation of mechanical techniques such as Dominguez developed in his "decalcomania without preconceived object" and Paalen discovered in his "fumage." Dominguez and Paalen followed where Ernst had led, seeking imaginative stimulation from methods expressly designed to bring chance into play. Matta's way of arriving at pictorial imagery appears closer to Joan Miró's use

of the accidents of the chosen medium and the revelations produced through accumulation of successive layers of color, overlapping and sometimes bleeding into one another. Matta would apply successive washed layers of paint, utilizing rags as well as brushes to lay them on. He also would wipe away through the accumulated layers, discovering shades of coloration and unforeseen forms as he went.

The method was nonmechanical, but the results obtained were still discoveries facilitated by the intervention of chance, eventually to be embraced in the final multidimensional image. Oddly, though, when giving Yves Tanguy credit for setting Matta an example he was eager to follow, Breton did not mention André Masson. Yet the Chilean painter's technique seems to have more than a little in common with Masson's use of superimposed pictorial planes.

Examined without reference to his work as a painter, Matta's allusions to experiencing hallucinations can sound very ominous and therefore quite misleading. One has to look at his canvases, reflecting on the titles he gave them, in order to appreciate that Matta's was an endeavor sometimes touched by a humor not thoroughly sardonic. Why give a title to what you have painted, Matta seems to ask, unless it be with the purpose of increasing the alarm your picture is more than likely to generate in many a viewer? When he selects an elementary verb form (first person singular, indicative mood), *je marche,* and modifies it to read perplexingly, **Je m'arche,** he manufactures a title that is now a reflexive verb for which the dictionary can offer no definition. As a verb form, *marche* derives from *marcher* ("to walk"). But the French *archer*—the hypothetical infinitive of the verb from which *arche* presumably has come—is exclusively a substantive, having the sense of "bowman" or "archer." This is to say that when calling his picture **Je m'arche** Roberto Matta proposes an entirely original verbal construct, where the first person pronoun is attached to a previously nonexistent reflexive verb that will defy confident translation. All one can say for sure is that the French noun *arche* means both "ark" and "arch." Thus, as he looks at the title **Je m'arche,** the rational-minded spectator is going to conclude he must have a defective copy of the gallery catalog in his hands. But those to whose imaginative powers Matta appeals will find this title suggestive of meanings where the French language has established none with certainty. These are the people who will be ready and able to look with profit at **Je m'honte** (a corruption, supposedly of *Je monte*) being capable of following Matta when he announces, "I am going to make a tour of the I, from the South to the Rmis [*sic*].

The title of Matta's 1946 picture **Splitting the Ergo** is representative of a creative procedure in which semantic play goes appropriately with rearrangement of the physical world by way of a unique pictorial language to which, as Matta took care to indicate, the essential key is morphology.

A necessary step in progress toward appreciation of Matta's work is the realization that titling has nothing more to do with facile cleverness than with triteness. We take this step as we notice that the image is more than the pictorial counterpart of a merely witty play on words. **Splitting the Ergo** offers a puzzling confrontation with shapes tangibly present yet disturbingly free of allusive-ness to familiar objects, bewilderingly assembled in disregard of unifying perspective. Thus it is impossible to say that, finding one motif, *therefore* we find the next, and the next, and so on. Instead, the effect is such that the spectator has the impression of seeing space all jumbled. Strangely dismembered, it is still at the same time uncannily consistent with itself. Here, indeed, lies one of the most remarkable characteristics of Matta's art: its ability to achieve inner cohesion in pictures appearing on first contact to exist as affirmations of cohesion's collapse.

In 1938 Matta executed **The Morphology of Desire,** a painting with a title that brings to mind the term "psychological morphology" by which he was to define his early production. The following year he finished both **Prescience** and **Inscape,** so, as it were, completing a program at which he arrived early and within which he was to conduct his pictorial inquiry henceforth. Landscape painting—in which the artist turns toward the outside—was to attract Matta far less than the kind of picture-making for which he coined the useful term "inscape": the painter looks within for the panorama that becomes the subject of his art. Meanwhile, review of knowledge already gained was to count far less, to Matta, than intimations of the as yet unknown, mirrored in prescient pictorial imagery welling up from the depths captured in the canvas. One can see how the point of departure might have been the strange inviolable universe depicted by Tanguy, but one can appreciate just as readily that attempting to imitate the Frenchman would not have served Matta's purpose by any manner of means.

In 1966 F.–C. Toussaint asked Matta what surrealism represented for him, at that time in his life. In his reply the artist insisted it meant "looking for more reality," in other words, realization of the "social and economic emancipation of the world, and also that of the mind." It was in relation to this last ambition that painting took on relevance for Matta. Gladly paraphrasing Breton's definition in the first *Manifeste,* he continued, "The goal is to find the true functioning of thought, without prejudice or moral or aesthetic regulation, to grasp and understand at the same time human beings and the world." Now the world, he argued, is grasped in its "gestures": "Everything is a gesture," even if it be an inanimate product of nature such as an apple or a flower. "And so all these gestures provoke in me emotions, desires that are themselves also gestures. The confrontation of these two gestures was for me my first language, in what I called 'morphologies.' "

In Matta's work, morphology, the science of form, is present not as a motif but as a structural constant, assuming both its biological meaning and its philological one too. The subject matter of his painting may be explained more easily if considered in relation to Matta's interest in structures, homologies, and metamorphoses that govern or influence animal and plant form. At the same time, he is curious about the branch of grammar concerned with inflection and word formation. He displays curiosity about biological morphology only so far as it provides a metaphor for psychological investigation.

Facing his painting we find ourselves dealing with iconographic discoveries of a kind for which morphological change is a permissible analogy and an enlightening one. Attention to the outside world yields, now, to preoccupation with self-exploration for which, by way of philologi-

cal morphology, the term "inscape" seems to be perfectly acceptable.

Pleasure at seeing how the meanings of words can be bent, fractured, reconstituted, and subjected to modification so as to bring out new insights beyond our anticipation goes with fascination at the spectacle of strange pictorial forms. Before they can hold our attention, the latter do not have to rely on surface resemblance to objects familiar to everyone in their customary context. They exist autonomously, as products of an imagination stimulated by revelatory chance. So, with his painting, Matta leads us to the heart of the surrealist creative process as a cognitive act. The latter is unpredictable because unprecedented. It is inexplicable because creative gestures are accomplished in accordance with no recognized criteria by which artist and public can agree that its viability may be established objectively. Hence knowledge is not verified by the pictorial evidence presented, but is enlarged and deepened by it. As we look, awareness that we are deprived of customary points of reference becomes sharp enough to release a feeling of vertigo, indicative of the disorientation we experience in contact with what we are seeing.

Alluding to the excitement of the hunt and to the unpredictability of its outcome, early in his 1944 preface to a Matta exhibition, Breton referred to searching for rough agates on the Gaspé Peninsula (which he had just visited on his honeymoon). He wished to draw the following parallel: "To the increasing grayness of thought-out and 'constructed' works it was surrealism's first gesture to oppose images, verbal structures altogether similar to those agates." Taken not in its literal meaning but as the stone of which the occultists spoke, the agate contains the "exalted water," the "soul of water." Hence the connection between the verbal image mentioned by Breton and the graphic ones for which Matta is responsible. Fascinated by the esoteric tradition, Breton could not have shown greater regard for Roberto Matta's achievement than to place him among the alchemists.

In the paintings of a number of prominent artists who joined surrealism before Matta (it is ironic that one of these, Salvador Dalí, was instrumental in introducing him to André Breton), the mind is challenged to find enlightenment through adventurous rearrangement of pictorial motifs directly allusive to the everyday world. The work of these painters invites the spectator to make an imaginative leap by which, in an illuminating image, he can embrace a variety of elements that experience and education have taught him to view as incompatible. Thus the means by which we are encouraged to advance into the unknown patently belong to the known. The mystery of the revelatory act of painting can be traced to no other source than the artist's ability to displace, relocate, and rearrange in an order that, while incorporating familiar motifs, mocks the familiar, requiring us to take a step outside the reality recognizable to one and all. Hence in the mind of the museum-goer the classic surrealist approach to painting has bred a cliché (that of the dream-painting) in which it is impossible to accommodate the canvases of Roberto Matta with their "cosmic lyricism," admired by José Pierre. With Matta, progression from reality to surreality, considered to be a fundamental necessity, does not come through use of a method that takes from the known so as to encompass the unknown. As a result, for many viewers the sub-

ject matter of his work is difficult to interpret, the way it should be, as sharing common ground with that of artists whose figurative preferences Matta does not enjoy. "Surprise," he once forecast, "will explode as does a fluorite ruby in ultraviolet light."

In strictly formal terms, Matta's painting is radically innovative and unrestrained by tradition—evidence, then, of self-absorption. One has no trouble appreciating how fascinating André Breton found his pictures during the late 1930s. At that time Breton was becoming more than disenchanted with critical paranoia as Salvador Dalí spoke of it. Later, in his preface to the 1944 Matta show reprinted in *Le surréalisme et la peinture,* Breton would announce—with undisguised pleasure, and with more than a trace of relief, no doubt—that Matta's painting made paranoiac critical activity seem a retrograde step after all. By comparison, Dalinian painting—so impressive when it made its first impact in surrealist circles—could be seen as promoting only "anecdotal aspects," caught "in silhouette," that is to say, "not transcending the immediate world in any way at all." By now thoroughly disappointed with Dalí's indisputable degeneration into "obsession with riddles," Breton was ready and eager to salute Matta for taking "the disintegration of exterior aspects" in a very different direction, so permitting the spectator, in Matta's own words, to "touch the opaque shoulders of the steaming trees."

The confidence Matta inspired helped measurably in laying to rest misgivings about nonfigurative painting, previously viewed by the surrealists as an inauspicious invitation to abstractionism, some aesthetes' field of action. On the plane of surrealist inquiry, it hastened a reconciliation between abstractionism and the figurative mode that had predominated for a decade and more. Therefore it facilitated acceptance of a number of painters—the Montreal *automatiste* Jean-Paul Riopelle, for instance, Rufino Tamayo, Endre Rozsda, and Yves Laloy, to say nothing of Arshile Gorky—who all had a welcome contribution to make. As a result, by 1945 André Breton was stressing, apropos of the work of Jean Degottex, how "things" disappear so that "the *spirit* of things" can be unveiled.

The ambience evoked in Matta's work is not populated by "things." For all that, their spirit is mysteriously pervasive, usually threatening man and severely constricting his activity, when not ousting him altogether from the scene. As practiced by Matta, nonfigurative painting had nothing to do with disposing abstract forms on a canvas in deference to aesthetic principles by which certain artists outside surrealism are pleased to have their achievement judged. Where we may find ourselves speaking, for convenience, of abstractionism, we have to admit, in the end, that its manifestation is quite incidental to Matta's presentation of his special viewpoint on modern life. Hence balances attained in some pictures—sometimes very precarious ones indeed, we notice—have much more to do with the tense anxieties of modern living than with considerations of formal symmetry.

In the mid-forties, a major change of focus led to the appearance of humanoid forms in Matta's canvases. He now directed attention to these in titles like ***The Heart Players*** (1945), ***Starving Woman*** (1945), ***Octrui*** (1947), ***The Pilgrim of Doubt*** (1947), and ***Who's Who*** (1955). Tortured figures sometimes, figures of extreme cruelty at other mo-

ments, they lend themselves to interpretation as personifications of the terrors and threats besetting mid-century Western man. Although their presence does not bring with it a return to concrete reality such as furnishes the background in Dalí's surrealist painting, for some spectators it reduces the charge of mystery from which earlier Matta pictures derived their capacity to rivet attention and induce shock. Looking at these canvases, the surrealist viewer is sure to sympathize with José Pierre's judgment that, here, the human element brings about "a relative diversion of lyrical energy." It is surely true that the referential character of paintings in which that element may be detected compromises free expression of automatism from which Matta's previous work drew its ability to disorient the mind and alarm the sensibility.

This is not to say that, henceforth, the figurative will predominate in Matta's painting. When he begins to introduce human figures into his pictures, where they have been poignantly absent before, it is to show them agonizingly taut, subject to the brutal push and pull of a hostile environment. Rendering the latter entails communication of feelings released by the pressures under which human beings are obliged to function, not painstaking reproduction of identifiable significant phenomena isolated in the world we know. Meanwhile, distortion of the human form—hands and facial features, notably, that often present an animal aspect—goes far beyond stylized commentary on human suffering. Matta's *écorchés* display the grim, irresistable effect of forces rending man as they bend him into conformity with a world committed to severe strain that Matta devotes himself to evoking.

From the outset, Matta brought to his task special gifts which no surrealist has ever had cause to deny. The first time Breton prefaced a show of his paintings, he spoke of Matta's scale of colors as constituting the richness of his work. To Breton's mind, Matta's distinction was a palette unrivaled in its innovation since that of Matisse. Although with the passage of time the overlay of black, through which these colors emerge in the early pictures, disappears, they continue to be just as distinctive in the later canvases, often more brightly lit than their predecessors. If José Pierre has some reservations at this stage, they are provoked by signs that Roberto Matta has chosen with some degree of deliberation the colors to be introduced into pictures where representatives of mankind have a place. Pierre's objections center on the reduction of the role of automatism in the creative gesture, once Matta begins to be preoccupied with man's predicament in a world from which he is alienated and yet by which he is held prisoner.

One can understand that a certain idea of surrealist purity underlies and gives seriousness to Pierre's criticism. But meeting the standards such a concept must lay down could scarcely be demanded in a situation permitting automatism to survive only where spontaneity remains. The spontaneity of automatism is granted a catalytic role. Matta would have been able to ignore the latter's effect only at the price of infidelity to himself. Proceeding no further than automatic experimentation would have been inconsistent with acknowledgment of automatism as a mode of surrealist inquiry. It would have meant failing to follow where discovery led. In Matta's case, meeting that obligation required closer scrutiny of the fate reserved for man

by life in the world of today. Furthermore, the clash between destructive and disruptive forces on the one hand and erotic vitality on the other is so fundamental a feature of Matta's art that it must inevitably bring man on the scene. It explains, for example, the arrival of the figure of the glazier, present in both a 1944 painting, *The Glazier,* and in a 1947 drawing, *Success to the Glazier.* The allusion is patently to Marcel Duchamp, creator of the large glass, *La mariée mise à nu par ses célibataires, même* (*The Bride Stripped Bare by her Bachelors, Even* [1915-23]), which is, incidentally, the subject of an essay written by Matta in 1941.

Man's presence does not indicate that Matta—judged by Duchamp to be "the most profound painter of his generation"—hopes or expects to solve through his painting any of the problems of living. It brings to our attention confrontations as with the *Pilgrim of Doubt,* entrapped in the coils of an indifferent universe. And now the strength to push forward often comes from the erotic drive, as is the case in *Elle Hegramme to the Surprise of Everyone* (1969). The semantic shift from the familiar (*telegramme*) to the inexplicable (*elle hegramme*) is rationally indefensible. Its effect, though, is to bring the human element—*elle* ("she")—into the communicative process.

Matta the surrealist does not paint with the aim of projecting harmony by way of pictorial imagery designed to show the world's imperfections fortunately corrected. Nor does he take up the brush in the hope that its use will bring to light harmony of a kind that, in the world to which we belong, seems always so elusive. It would be impossible for him to work in either fashion, because he looks upon the harmonious in painting as evidence that the truth of existence has been falsified by aesthetic predispositions in the artist. We understand Matta's antiaesthetic position better when we bear in mind that he once spoke of "the *space* created by contradictions" as best imaging man's estate. He dismisses all art from which contradiction has been pruned, on the grounds that art betrays reality once contradictions in the real have disappeared under pressure from aesthetic values, unacceptable as much to him as to other surrealists. What is more, his use of perspective exhibits flagrant contradictions that assume a dramatizing role in his work and could never find resolution without betraying the reality of the mind which his painting is meant to communicate.

With Matta, refusal to heed aestheticism's demands could never be taken for ostentatious posturing. Nor, for that matter, could it be confused with a chronic incapacity to meet aesthetic norms. A radical departure from aesthetically oriented art is imposed by his firm conviction that the clash of contradictions is at the core of human experience with which art must attempt to deal. Why paint, if not to testify to contradiction and to the anguish that reflects appreciation of its central role in our lives?

Matta's working principle is a simple one: "Create in order to see." As the creative act is essentially investigative and not demonstrative in surrealism, Matta does not create in order to show. This is why the results of his "gesture" are to be examined—first by the artist himself, and afterward by his public—as visible proof of creativity. If the bridge between creating and seeing were to sink its foundations in the supposedly solid rock of the predictable, then it would lead to no place worth exploring, al-

lowing us to see nothing substantiating the artist's bold claim to have functioned creatively. Creativity, in fact, turns away from what is commonly termed resemblance, Matta believes.

How then is visible proof to be attained? Matta's answer establishes yet another distinction between surrealism and fantasy, that other surrealists too have found it necessary to emphasize: "Not flight into the fantastic but constitution of the inner *maquis,* the *guerillero* and the inner provo in place of self-criticism." Reference to a variety of revolutionary types indicates that there can be nothing merely narcissistic about the creative gesture, which for Matta is exploratory in character and descriptive in essence. Preparing notes on Infra-Realism for presentation during the Havana Cultural Conference opening at the end of 1967, Matta advised forthrightly, "Respond to cultural revolution with a revelation, the awakening force in the conduct of our infrared life." Commenting on these words, Jean Schuster was to observe, "Supposing an organization of the eye that would permit discernment of infrared and ultraviolet, apprehension of objects simultaneously from different angles, penetration of the glance through the opacity of bodies, the part of imagination would be reduced." But as this in fact is not the case, it falls to the imagination to complete physical perception, the way it does in Matta's work. Schuster's advice is that imagined reality be approached from the working hypothesis that "it does not depend on perceived reality."

Schuster's recommendation brings us to Matta's pointed reference to "a poetic thought that can make the man in us the blind swimmer [the allusion to two canvases by Ernst (1934 and 1948), both bearing the same title, *Blind Swimmer,* is too clear to be missed] or the man shipwrecked within." The idea of an inner shipwreck must not be equated with failure, any more than that of swimming blind is to be regarded as a pointless and potentially dangerous expenditure of effort. Physical blindness need not preclude illumination, by any means. A wreck can mark a release from confinement, actually holding out the prospect of new discoveries: "The inner image, for the real under inspection, corresponds to the woman one loves before meeting her. The whole stress of poetic action is grounded on this divination." Years after André Breton mentioned divination in connection with Matta's work, the artist himself speaks of it also. For Matta, image-making is divination, the discovery of something hidden and now brought to the light of day by the magical means the painter has acquired for himself. The important thing, here, is that discoveries emanate from within, as the artist practices magic upon himself. "I am only interested in the unknown and I work for my own astonishment," Matta once explained. "This astonishment, in front of my pictures, comes from the fact that structures in appearance far removed from anthropomorphy [sic] are capable of communicating the nature of man and his condition with more 'resemblance' than anthropomorphy does."

Like René Magritte, Roberto Matta teaches us to beware of resemblance. More precisely, both these painters demand that we face up to the preconceptions bolstering our habitual idea of resemblance. Both show how these may be prejudicial in the extreme, sapping the vitality of the pictorial image. Matta, though, undertakes to discredit resemblance, as commonly understood, in a manner very different from Magritte's. The Belgian artist sets about encouraging wariness concerning the identity of painted objects which happen to look like things we know, meanwhile urging us to be responsive to a form of resemblance quite independent of surface similarity. Matta, too, gives resemblance a new meaning, but by liberating painting from the role of pursuing resemblance through accurate reproduction of the familiar or the recognizable.

Some spectators find it difficult to penetrate the distracting surface realism which Magritte's canvases require us to transcend, if we are to become sensitive to the poetic virtues of the surreal. Others—and this is a matter of individual conditioning, surely—find it harder to see how Matta attains resemblance while for the most part bypassing similarity, so lending weight to the axiom recorded in Paul Eluard's *Donner à voir:* "There is no model for someone looking for what he has never seen." Working without a model, in search of surprise, Roberto Matta achieves the only kind of resemblance to which he ascribes value. It is for this reason that, during the years when he was estranged from the surrealists—reconciliation with Breton came in 1959 . . . —Matta never ceased to paint in a way that fully qualified him for their approval. (pp. 107-20)

> *J. H. Matthews, "Roberto Sebastian Antonio Matta Echaurren," in his* Eight Painters: The Surrealist Context, *Syracuse University Press, 1982, pp. 107-20.*

Paul Brach (essay date 1985)

[*Brach is an American artist and critic. In the following excerpt from an exhibition review, he considers Matta's paintings of the early 1980s.*]

My own involvement with Matta's work goes back to 1946 or '47 when I was an art student at the State University of Iowa. Every year our chairman would visit the New York galleries to select the paintings for our summer exhibition. The Matta in that year's show was a particularly good one, ***Wound Interrogation,*** in which one of his mantislike humanoids holds up a luminous fleshy form, while a series of tilted planes falls off to a void below. I was struck by this painting. I had been using horses, bulls and other Guernica-derived symbols to express my experiences in the war that I had survived. Matta, as a new inspiration, pointed to a way beyond my mannered derivations of Picasso. As the director of a student-run foreign-film program, I was expected to contribute our profits to a purchase fund. We bought the Matta for the university collection.

In the late '50s Leo Castelli introduced me to Matta. We had a brief friendship and I found his capricious intelligence enormously stimulating. He dismissed the prevailing Abstract Expressionism of that time as "merely retinal" and urged me to convert to figuration, but I held fast to abstract painting. The figurative turn that my work took 20 years later was not, I'm sure, what he had in mind.

Matta had been one of the carriers of ideas about automatism and the use of the unconscious to Gorky and other American painters in the years of World War II. He was sort of a "Typhoid Mary" of Surrealism. This influence was partially acknowledged at the time but soon after it was mostly ignored. Philip Pavia, the guiding spirit of the

"Artists' Club," would have a fit at the mere mention of Matta's name. There was a blackout on talk about his seminal presence on the New York scene in the '40s, and his name never came up in talk at the Cedar Bar. Perhaps all of this was social as well as esthetic. Matta must have seemed too sleek, urbane, international and upper class for the American painters just a decade from the W.P.A. artists project. Maybe the chauvinism implicit in the hype around the "New American Painting" required the de-emphasis of European sources. Later, what really pushed Matta out to the edges of our awareness was the direction his work took in the '60s and '70s. It seemed that his repetition of a "Star Wars" eroticism, his endless variations of the vertiginous tipped planes, insectlike personages and lurid neon color wore pretty thin over the last 20 years.

All of this was the intellectual and emotional baggage that I brought with me when I came down from a ranch in the hills north of Tucson to see a recent exhibition of Matta's new work at the Yares Gallery in Scottsdale, Ariz.

I expected yet another round of easy, accomplished variations on Matta's familiar themes—and indeed, there were a number of paintings that gave me no new messages. *Ecran de la memoire,* 1984, sums up all of those Mattas in which I'd lost interest. The painting consists of a murky, thinly washed gray ground, in which float a series of planar barriers, sort of a deconstructed space station of levitated force fields. This device goes way back in Matta's pictorial evolution to early drawings from the late '30s and '40s that he made while still an apprentice in Le Corbusier's studio.

Ricocheting off, hiding behind or streaking between the planar force fields are calligraphic entities and their lurid tracers. This painting has a jazzy sense of emergency, but most of the credit should go to the special effects rather than to the scenario. There were half a dozen other similar works in the show. In each Matta comes up with enough residual power to attract my attention, but not enough sustained pressure to hold it. But what stopped me and made me look again was a whole new body of work.

The new works were made in the same time span as the others (1981-1984). They are bold, frontal and earthbound. Their cast of characters comes from pan-Mediterranean ancient art. The images derive from Etruscan, Archaic Greek and Sumerian sources, as if the spirits of the old gods had been dormant only to spring up with lusty vigor to celebrate the triumph of eros.

Jeune chaosmos (typical Matta word play—chaos + cosmos) is a large work, almost 7 by 12 feet. Against a blue stained sky-space three large characters dominate the action. A running male figure approaches a hydra-headed female, while a bearded centaur watches from the side. They are accompanied by retinues of smaller creatures. Some enter running, some fly. Some are people, some sheep, some goats, but all are sprightly and highly energized. The figures are incisively drawn. Matta's skills as a draftsman serve him well. There is little attempt to flesh out or give sculptural weight to the figures. Line alone carries the action. Color simply sets the scene with blue above, flecks of red in the central zone and yellow below. (One more example of *Who's Afraid of Red, Yellow and Blue*?) For all of the frantic scurrying about there is an arcadian calm that holds and gentles the action.

Another of these new mythological paintings is *Las scillibas de Scylla* (the syllabification or syllabus of Scylla—one of the two perils of the Straits of Messina). Here there is more chiaroscuro. The figures slide from their pre-Classical origins into Matta's familiar mutant humanoids. Calm and order are retained by tough drawing and the restraint (blue and white) of the color. The few other mythology paintings, although they show debts to Picasso and perhaps to Wifredo Lam, seem equally down-to-earth. Matta's usual multiple-perspective, expanding cosmos has been collapsed back to a single-perspective box of space. This presses the graphic information up to the surface rather than letting it dissipate out into space.

For me it is ironic that this artist, whose influence rescued me from the clutches of Picasso, has entered Picasso's territory. The myths of antiquity had long been one of Picasso's ways of connecting with the art of the past and with the personal mythology of his unconscious. Matta is now in his 70s with a long life in art. At a time when the thrust of his space journey is waning, he has returned to the earth and the old gods that still inhabit it. This new work tells me not to write off my old heroes. (pp. 140-43)

Paul Brach, "Back to Arcady," in Art in America, *Vol. 73, No. 5, May, 1985, pp. 140-43.*

Paul Overy (essay date 1985)

[*In the following excerpt, Overy explores postmodern aspects of Matta's eclectic approach to art.*]

Matta is better known in France and Italy, where he now mainly works and lives, than in Britain or the USA. He spent the war years in New York where his work was a seminal influence on the Abstract Expressionists, but his radical political stance ensured that he was ostracised by the art and dealing establishment during the Cold War and he returned to Europe in 1948. He then lived in Italy and France, spending part of every year in London during the 1970s, although his presence in England went virtually unnoticed. Now Matta divides his time between Paris and Tuscany where he paints his epic-scale canvases in a former convent.

The retrospective at the Pompidou Centre this autumn accords Matta the major status his work demands. As a young artist in the late 1930s he was one of the last painters to be recruited into the Surrealist fold by André Breton. (He was expelled from the Surrealists at the same time as his work was rejected in America.) Yet Matta as a major artist is a product of the post-war world, although his work draws strength from a variety of influences from the formative years of modernism—Kandinsky's abstraction and Duchamp's early painting as much as Surrealism itself. His vision is essentially a post-modern one, to employ the term more seriously than is usually the case, and he locates the post-modern period within a post-war world dominated by nuclear energy, space exploration and information technology.

Matta's enormous canvases depict an extraordinary, complex and compulsive space. The scale of his largest works is comparable to that of a 19th century panorama or a modern cinemascope screen. Matta constructs his illusion of deep space on the canvas by a combination of different

representational systems: traditional perspective, axonometric projection as used in architectural and engineering drawing and atmospheric perspective. In the largest of his huge canvases he uses a kind of anamorphic effect, of a space that curves away from the centre towards the periphery of the painting.

It is this mastery of complex space-creation that enables Matta to construct a world of extraordinary and phenomenal dimensions which corresponds to a new awareness of space and time and their interactions. This relates closely to the 'simultaneity' which the avant garde of the 1910s attempted to represent, the effect of multiple awareness produced by the electrical and mechanical technology of the early 20th century: the wireless, the cinema, the telephone. Matta's aim is to represent the newer but related awareness that is the result of post-Second World War electronic and nuclear technology.

Matta has drawn parallels between modern space exploration and the 'voyages of discovery' of the European adventurers of the Renaissance and post-Renaissance eras. 'The earth is caged in a fantastic technology. One can see now that what happened on the seas of the earth in the 16th and 17th centuries is going on now in space. Beyond the traffic of all the futuristic paraphernalia in orbit—in these "floors of heaven"—with its aquaculture of weapons, who is going to control the police station of space?'

The sci-fi imagery and phenomenal conception of space in Matta's paintings are reminiscent of the world created by William Burroughs in his novels, but whereas Burroughs' cataclysmic vision is amoral and homosadistic, Matta's is apocalyptic and polyerotic. For Matta, Eros is the great counter to the violence and inhumanity of modern life, the resurrective force which enables what has been violated and destroyed to be made whole, created anew. Sex in Matta's vision is not tender or loving. It is a violent force, but it is a *positive* violence which can counteract the violent and destructive forces of evil that have seized the means of communication and coercion.

In Matta's recent works, such as the series of large drawings very freely based on Shakespeare's *Tempest,* there is less stress on the extremes of space and of technological imagery. These drawings are peopled with strange beings, more animal than human, but animals with strong human connotations, like comic-book creations. Matta sees the *Tempest* as an allegory of the oppression of the Third World by the First and Second Worlds (Europe and the USA) and of the Third World's struggle to free itself and make a new world for itself. This, Matta is saying, is the promise of the new technology, if it can be liberated from the hands of the multinationals and the dominant nations who use it to impose their will on the rest of the world. (p. 29)

Paul Overy, "Matta's Multiple Awareness," in Studio International, *Vol. 198, No. 1010, 1985, pp. 28-9.*

FURTHER READING

I. Writings by Matta

"Hellucinations." In *Max Ernst: Beyond Painting* by Max Ernst, et al., pp. 193-94. New York: Wittenborn, Schultz, 1948.
> Describes the function of hallucination and myth for the artist, relating his discussion to Max Ernst's works.

II. Interviews

Simon, Sidney. "Concerning the Beginning of the New York School: 1939-1943." *Art International* XI, No. 6 (Summer 1967): 17-20.
> Discusses the origin of the New York School with Matta and Peter Busa.

III. Critical Studies and Reviews

Ashton, Dore. *The New York School.* 1972. Reprint. New York: Viking Press, 1973, 246 p.
> Briefly describes Matta's influence among the artists in New York in the early 1940s.

Boswell, Helen. "Fifty-Seventh Street in Review." *The Art Digest* 16, No. 14 (15 April 1942): 30.
> Briefly reviews Matta's exhibition at the Matisse Gallery, describing the artist's works as "intensly fired productions."

Bumpus, Judith. "Matta." *Art & Artists,* No. 183 (December 1981): 26.
> Comments on three of Matta's paintings as reflections of the artist's humanist philosophy.

Cavaliere, Barbara, and Hobbs, Robert C. "Against a Newer Laocoon." *Arts Magazine* 51, No. 8 (April 1977): 110-17.
> Comprehensive study of the development of the New York School, examining Matta's role in the cultivation of promising American artists.

Frost, Rosamund. "Matta, Furious Scientist." *Art News* XLI, No. 5 (15-30 April 1942): 27.
> Praises the exuberance of Matta's paintings, noting, however, that there remains "a breath of something cold and impersonal" in the artist's style.

Goddard, Donald. "Matta: A Totemic World." *Artnews* 74, No. 3 (March 1975): 105-06.
> Comments on pictorial structure and imagery in Matta's paintings.

Rubinfien, Leo. Review of an exhibition at the Jackson Iolas Gallery. *Artforum* XVII, No. 7 (March 1979): 67-8.
> Discusses Matta's art in the context of Surrealism, focusing on the presentation of violence and cartoonlike imagery in his works.

Sandler, Irving. "Dada, Surrealism, and Their Heritage, 2: The Surrealist Emigres in New York." *Artforum* VI, No. 9 (May 1968): 24-31.
> Examines the influence of Matta and other European emigres on the artistic development of American artists in the 1940s.

Sawin, Martica. "Prolegomena to a Study of Matta." *Arts Magazine* 60, No. 4 (December 1985): 32-6.
> Explores various key figures and events behind Matta's artistic maturation.

———. "'The Third Man,' or Automatism American Style." *Art Journal* 47, No. 3 (Fall 1988): 181-86.
 Discusses the New York School's aborted attempt to redefine Surrealism in the early 1940s.

Schneider, Pierre. "Art News from Paris." *Art News* 56, No. 4 (Summer 1957): 60; 82-3.
 Includes a brief review of Matta's retrospective exhibition of drawings at the Galerie du Dragon in Paris.

Sims, Lowery Stokes. "Wifredo Lam and Roberto Matta: Surrealism in the New World." In *In the Mind's Eye: Dada and Surrealism,* edited by Terry Ann R. Neff, pp. 91-103. Chicago: Museum of Contemporary Art; New York: Abbeville Press, 1985.
 Assesses Matta's "primitivistic" paintings as an example of the influence of primitive cultures on Surrealism.

Sweeney, James Johnson. "Five American Painters." *Harper's Bazaar* 78, No. 2788 (April 1944): 76-7, 122, 124, 126.
 Includes a synopsis of Matta's artistic style.

"Mysteries of the Morning." *Time* LXI, No. 18 (4 May 1953): 78-80.
 Presents biographical and critical information on Matta.

Tyler, Parker. "Two Americans in Rome." *Art Digest* 28, No. 18 (1 July 1954): 12-13.
 Evaluates the Italian influence on the painting of Matta and Pavel Tchelitchew, who have both lived in Rome.

IV. Selected Sources of Reproductions

Laureati, Luisa. *Matta: Opere dal 1939 al 1975.* Rome: Galleria dell'Oca, 1976(?), 153 p.
 Catalog of selected paintings by Matta, with an introduction by Laureati.

Paula Modersohn-Becker

1876-1907

German painter and graphic artist.

Modersohn-Becker is viewed as a pivotal figure in the development of Modernism in German art and as a significant precursor of German Expressionism, a movement in early twentieth-century art and literature whose adherents deliberately rejected realism in favor of the direct rendering of emotion through the expressive use of line, form and color. One of the first German artists to have assimilated and successfully utilized the ideas of such French Post-Impressionists as Paul Cézanne and Vincent van Gogh, Modersohn-Becker combined the simplified forms, bold colorations, and two-dimensional patterning of the Post-Impressionists with the emotive and mystical qualities of German Romantic art, developing a highly expressive, monumental style that is best exemplified in her many figure paintings.

Modersohn-Becker (neé Paula Becker) was born to a liberal, moderately wealthy family in Dresden. Upon moving with her family at the age of twelve to the city of Bremen, Modersohn-Becker began attending drawing classes and subsequently undertook serious academic training, first in London and later at the Society of Berlin Women Artists. Although her first exhibition at the Bremen Kunsthalle in 1899 aroused negative critical reactions and resulted in her parents' insistence that she abandon painting to become a governess, Modersohn-Becker persuaded them to allow her to study at Worpswede, an artist's colony modeled on the French school of Barbizon painters. The Worpswede motto "Back to nature" reflected a rejection of urban subjects and a concern with the portrayal of natural scenes. Although Modersohn-Becker's early Worpswede paintings reflect such concerns, she soon grew to resist the Worpswede devotion to nature: "I believe one should not think about nature when painting, at least not during the conception of the picture. . . . [Personal] sensation is the main thing. When I have brought that into the picture, lucid in form and color, then I must bring enough of nature into it to make my picture look natural. . . . "

Frustrated by the limitations of the Worpswede style, Modersohn-Becker traveled to Paris in 1900. There she visited her friend Clara Westhoff, a promising artist who was studying with French sculptor Auguste Rodin, and attended anatomy courses at the Ecole des Beaux-Arts. Visiting the Louvre, she became familiar with the work of various French masters as well as that of lesser-known Modernists. The Modernist influence is apparent in the paintings she completed after returning to Germany. Attempting "to become great through simplicity," Modersohn-Becker modified the naturalistic emphasis of the Worpswede painters, producing evocative self-portraits and unsentimental paintings of German peasants and their children that convey earthiness and fertility through simple, large forms and rich colors. In 1901, Modersohn-Becker married Otto Modersohn, one of the more prominent painters of the Worpswede circle. Although Moder-

sohn was supportive of his wife's need for artistic isolation, her domestic duties, which included caring for Otto's daughter from a previous marriage, began to wear on Modersohn-Becker, and in 1903 she returned to Paris. There she encountered the newly-integrated artistic influences of the East in the works of Paul Gauguin. Such paintings as *Bathing Boys by Canal* (1901) and *Old Peasant Woman* (1904), while exhibiting a coarse brushwork reminiscent of van Gogh, also incorporate the flat, monumental forms of Gauguin.

Modersohn-Becker's *Portrait of Rilke* (1904), one of her first works to make use of severely simplified figures, depicts with solemn dignity the German poet Rainer Maria Rilke, who had visited Worpswede in 1900. A later, unfinished portrait of Rilke, dated 1906, was described by Hans Egon Holthusen as "a masterpiece of expressionist painting and the only painting of the poet which is equal to its subject." Despite her artistic progress, Modersohn-Becker failed to achieve critical or popular success in Worpswede and was virtually ignored by her fellow artists. Returning to the more congenial environment of Paris in 1905 and again in 1906, she decided to leave Modersohn but continued to be financially dependent upon him. Following a reunion with her husband in Paris, Modersohn-Becker be-

came pregnant and returned to Worpswede in 1907. During this later portion of her career, Modersohn-Becker produced the nude self-portraits for which she is best known: *Self Portrait* (1906), a highly symbolic painting that reflects the influence of Fauvism in its intense colors and intentional lack of depth, portraying the artist as she holds a flower between her breasts and stands before a leafy hedge of expanding flower buds; *Self-Portrait on Fifth Wedding Anniversary* (1906), in which she portrays herself in an advanced stage of pregnancy; and *Self-Portrait* (1907), in which she holds a large, fully-developed flower, often viewed as a symbol of her artistic fruition. Another famous work of this period is *Self-Portrait with Camelia Branch* (1907), a painting that reflects the influence of Oriental and Egyptian art in its calm evocation of the artist's mysterious and searching expression. Modersohn-Becker died from a pulmonary embolism two weeks after giving birth to her daughter in November of 1907.

Although she remained relatively unknown prior to the posthumous publication of *Briefe und Tagebuchblätter* (1917; translated as *Paula Modersohn-Becker: The Letters and Journals*), a collection of autobiographical writings that shed light upon her artistic and domestic difficulties, Modersohn-Becker is today esteemed as one of the most talented German painters of her generation. Although she is often viewed as a tragic figure due to the curtailment of her career at a time when she had just begun to realize her full artistic potential, Modersohn-Becker expressed unbridled optimism when she prophetically stated: "I know I shall not live very long. But why should this be sad? Is a feast more beautiful for lasting longer? For my life is a feast. My sensual perception grows sharper, as though I were supposed to take in everything within the few years that will be offered me. . . . [And] if I shall have painted three good pictures, I shall leave willingly, with flowers in my hands and in my hair."

INTRODUCTORY OVERVIEW

Peter Selz (essay date 1957)

[*In the following excerpt, Selz provides a general overview of Modersohn-Becker's life and career.*]

Paula Modersohn-Becker first came to Worpswede in 1897 after taking drawing lessons in Bremen and London and serious academic training with various teachers in Berlin. She had studied portraiture, landscapes, nudes in water color, oil, pastel, and charcoal, in the prevalent academic manner. More important, perhaps, were her frequent visits to the museum of Berlin. Her letters told of her great admiration for Rembrandt's painting and Botticelli's drawing and the strong feeling she had for old German masters, such as Dürer, Cranach, and Holbein.

In 1897 she visited Worpswede and was immediately attracted to the land and its people. Her letters and diaries show her admiration for Worpswede's painters, especially Mackensen, Vogeler, and Modersohn.

She decided to study with [Fritz] Mackensen, who, unlike the others, had chosen the human figure as his chief motif. Although her diaries and letters spoke of her love for the breadth and stillness of the wide plains, the open spaces and great distances, the soft blue of the sky, the moor and the heath, she emphasized again and again that man was to be her principal motif. Her early paintings in Worpswede were very similar to Mackensen's work (for example, his *Infant*), but she soon gained a much more immediate understanding of the peasant than her teacher had. In her principal subject matter—mother and child—there was a minimum of portraiture. She saw first a simplicity and largeness of form and color in the motif of mother suckling child; the object became increasingly depersonalized in her work, so that it began to go beyond the representative toward the ideal or symbolic.

When Paula Modersohn-Becker held her first exhibit in Bremen in 1899, the public was very conscious of her difference from the other Worpswede artists, who had been accepted barely four years earlier. Her work was severely criticized. In all her painting there was a tendency toward simplification and basic forms, which was accomplished by increasing emphasis on line, removing her further and further from Worpswede tone painting. Recognizing the importance of the contour, she sought her own structural form and monumentality.

Finally, feeling that Worpswede could not offer enough stimulation, she went to Paris in 1900 for the first time. The entire city and its life excited her. This was especially true of the Louvre, where she made new discoveries to write about in every letter. There were other interests: Clara Westhoff, her friend and companion, studied with Rodin, whom Paula considered the greatest living artist. In addition to the German "romantic classicists" Max Klinger and Arnold Böcklin, whom she greatly admired, she devoted much attention to Miller and, among the Breton symbolists, Charles Cottet and Lucien Simon. It is surprising that in all her Paris sojourns, she wrote about Cottet with more appreciation than for all other living painters; she may have found in his work the same intimacy and directness of expression for which she was striving.

The most important influences seem to have occurred without her conscious knowledge. She did not write about them, but worked them out visually. Cézanne was mentioned only much later (1907) in a letter to Clara Rilke, in which she recalled discovering Cézanne for herself at Vollard in 1900: "I think and thought . . . much about Cézanne, and how he was one of the three or four painters who has acted upon me like a thunderstorm and a great adventure. Do you remember in 1900 at Vollard?" And in the last letter to her mother: "I wanted very much to go to Paris for a week. There are fifty-six Cézannes exhibited there." In Cézanne she doubtless admired the tight structural composition and the penetration beyond surface appearance—both of which were part of her own aim.

When she returned to Worpswede and married Otto Modersohn in 1901, her style had changed. Much in the manner of Bonnard and Vuillard, she filled her canvas completely, leaving no part of the picture plane empty and giving everything an equal value. This highly decorative style changed again after her second trip to Paris in 1903. Perhaps it was van Gogh's influence, perhaps a development of her own style that bent toward a vibrating, curled

and crimped line, especially obvious in the drawings of this period.

The drawing **Infant Nursing** (1904) illustrates her preoccupation with the mother and child motif. Instead of the sentimental attitude with which Mackensen had treated the subject, Paula Modersohn-Becker's drawing indicates a clear and sober observation of nature. At the same time the line has become the immediate carrier of expression. With only a fragment of the mother's head, and with relatively few lines, she has, largely by implication, expressed her feeling of tenderness.

Her painting of the same period was not yet as advanced as her drawing. The **Old Peasant Woman,** also of 1904, was still painted in the dark potato color of the late nineteenth century. Yet she endowed the woman with great dignity by the simplicity and clarity of the painting: a clearly structured, flat pattern of light and dark areas. It is understandable why Cézanne acted upon her "like a thunderstorm and a great adventure," and it is also clear in which direction his influence had pointed.

In 1904 she painted her friend Rainer Maria Rilke, who always referred to her as the "blonde painter." For a long time she had felt that the imitation of nature was not the painter's task. As early as 1902 she wrote in her diary:

> I believe one should not think about nature when painting, at least not during the conception of the picture. One should do one's color sketch exactly as one has perceived something in nature. But personal sensation is the main thing. When I have brought that into the picture, lucid in form and color, then I must bring enough of nature into it to make my picture look natural, so that the layman will only think that I had painted it from nature.

The portrait of Rilke was actually one of the first paintings in which she simplified form severely. The use of light and dark, the large, black eyes, the simplified outline—all add to her incisive interpretation of the poet who later wrote about her: "She was the artist who exposed herself to the Paris of van Gogh, Gauguin, and Cézanne, to the presence of Maillol, and probably even Matisse and Henri Rousseau, and who at times went beyond the German successors of these artists." Indeed, the Rilke portrait, in its intuitive interpretation, is remarkably similar to paintings that Nolde did about a decade later. When she met Nolde (whose name was still Hansen) in Paris in 1900, she noted in a letter to her family merely that he had done postcards of the Swiss mountains and was just turning with great earnestness to serious painting.

Increasingly she felt the confinement of Worpswede, and twice more she returned to Paris, which she called the "world," in 1905 and in 1906-1907. Mackensen, whom she had admired so much before, now seemed petty, and his peasant paintings too much like genre pictures. She felt restricted even by the art of her husband, and knew that she must go her own way—so different from the Worpswede style.

The **Self-Portrait** of 1906 has become highly symbolic. She painted herself, nude with a flower between her breasts, standing in front of a leafy screen budding with flowers. Depth is screened off, as in pre-Renaissance painting. Intense color has been applied in strong, planar brush strokes. Color, as well as line, forms the rather geometric

shapes; this feeling for the structural is especially strong in the almost lapidary planes of the face.

Often, like Gauguin, Paula Modersohn-Becker has been called a primitive painter, but—also like Gauguin—she was not a true primitive. She adapted or developed a strong elementary quality, and deliberately worked toward simplification of form for the sake of more immediate expression.

Her final paintings, done during the last year of her life, were indeed under the influence of Gauguin, whose memorial exhibition she saw in Paris in 1906, yet at the same time show the most consistent development of her own style. Her symbolic tendencies were carried further in her **Self-Portrait** of 1907. The flower has become a full-grown plant, perhaps because she was then approaching her long-desired motherhood. The background is no longer screened off—there is no more need for an excuse for two-dimensionality. She has emphasized her own figure by the long, narrow frame. The shape of the picture, the plant, the necklace—all lead the observer's eye to the point of focus of the picture: the large, wide-open eyes of the figure. Shadows are no longer used for realistic modeling but, like the whole treatment of light and dark elements and of color, are decorative elements in the static, frontal composition.

In these last paintings Paula Modersohn-Becker was considerably in advance, chronologically speaking, of the incipient expressionism in her native city of Dresden. She was unaware of developments there, and the Brücke painters knew nothing about her for a very long time. Her own development seems to have been in the direction of a highly personal symbolism. Her steady simplification of form and search for the essence of matter created a style close to that of expressionism. Often she is considered one of the significant precursors of the expressionist movement. The Brücke painters owe much of their form to van Gogh and Munch; Paula Modersohn-Becker, who began with preimpressionist Worpswede, was the first German painter to evolve a new, vital style under the inspiration of Cézanne and Gauguin. (pp. 43-6)

Peter Selz, "Regionalism, Worpswede, and Paula Modersohn-Becker," in his German Expressionist Painting, *University of California Press, 1957, pp. 39-47.*

SURVEY OF CRITICISM

Bernard S. Myers (essay date 1963)

[*In the following excerpt, Myers discusses Modersohn-Becker's role in the development of German art and notes the influence of various artists on her work.*]

The artistic revolution of the early twentieth century was part of a revolt against encroaching materialism and the ever-growing tendency to subordinate the individual to its strictures. Each country took its own path in that revolt,

influenced by native aesthetic traditions and other historical attitudes. Non-naturalistic art of many types covered the walls of young Europe's exhibitions.

In Germany "*Los von der Natur!*" ("Away from Nature!") had already become the slogan. The Pan-European Sonderbund exhibition at Cologne in 1912, like its predecessors at the Paris Independents and its celebrated American successor, the 1913 Armory Show in New York, indicated quite clearly the force of this antinaturalistic reaction.

But these exhibitions were high-water marks of the movement away from naturalism and were possible only because there had already been powerful efforts along that direction within the various countries. . . .

Between Paula Modersohn-Becker in northern Germany and Oskar Kokoschka in Vienna we find Christian Rohlfs, Ernst Barlach, and other independent Expressionist emanations of the time. Modersohn-Becker's Romanticism and mysticism (especially nature mysticism) made her as truly Germanic as Expressionist; her attempts to achieve a unity between man and nature on a symbolic level pioneered in a direction that was to be followed by many later painters and sculptors.

Like the *Brücke* and Blue Rider artists, she was another example of the blend of French aesthetic elements and native emotional qualities which characterizes Expressionist creation. Coming as early as she did, she was unaware of what others were doing in her own country; she arrived alone at her goal, yet typified the entire movement. (p. 44)

The aesthetic importance of Modersohn-Becker is twofold. On one hand, she represents the reaction against naturalism of the last decade of the nineteenth century, the tendency to stylize nature whose most obvious form is found in the *Jugendstil.* Many of the stylized plant forms and her symbolic drawing may be related to this movement. Her other important quality lies in her fusion of the various non-naturalistic post-Impressionist elements with her personal variant of the Germanic emotional quality.

Worpswede art, from which she started, treated its material externally, either as decorative form or as sentimentally superficial anecdote that ultimately degenerated into the "blood and soil" narrowness and nationalism of Vinnen in 1911 with his violent objections to post-Impressionist French influence. Modersohn-Becker's reaction to the peasant material was empathic in that she was filled with an earnest feeling and sympathy for "poor little humanity." To her these peasants and their plain lives symbolized closeness to nature, of which they seemed to be so much a part; in her work they emerge in a rough and primitive manner, with a certain honest simplicity and unsophistication. Her peasants are as simple as the beasts of the field and as patient in their symbolic suffering; the coarse yet monumental nude women holding children represent, in powerfully poetic terms, a deep earthiness and fertility.

Although her first trip to Paris in 1900 had meant little to her development, contact with the great art of the past dissolved some of the gaucheries of Worpswede. The 1903 trip brought her the newly popularized art of Asia and the Near East, the sculpture of India as revealed in the paintings of Gauguin, and the Persian miniatures which were soon to affect the art of Matisse. Above all, this trip exposed her to the art of Gauguin, van Gogh, and Cézanne. The first two were emotionally congenial to her, the former for decorative and symbolic reasons, the latter because of his portrayals of suffering and his sympathy for humanity. Both these men, like Cézanne, turned her to still-life painting, one of the most important aspects of her work from then on. Modersohn-Becker's art in her last few years shows a curious but altogether understandable mingling of the influence of these three post-Impressionist masters. Together with the linear swing of Gauguin and some actual tonalities such as his purple, the inward meaning and pathos as well as the color contrasts of van Gogh, we find the form building and organic unity of composition that Cézanne taught the entire generation of the early nineteen-hundreds, the German Expressionists as well as the Fauves and Cubists.

On her last Parisian visit Modersohn-Becker was overwhelmed by the great Gauguin show at the Salon d'Automne and regretted missing the Cézanne Memorial Exhibition which took place after she had gone back home. During this last stay in Paris her friendship with the sculptor Bernhard Hoetger offered a powerful confirmation of the monumentalized form-feeling she was already developing. A cultivated and sensitive man, Hoetger had been moving in this direction for some time under the influence of Oriental and Egyptian sculpture. His hieratic and monumental figures are reflected in some of Modersohn-Becker's last pictures. Admitting the powerful influence of the various French masters and of Hoetger, nevertheless her poetic fancy, imagination, and tenderness, her sense of color and starkness of feeling, remain entirely personal. Like most German Expressionists or proto-Expressionists, Modersohn-Becker takes the useful and important aids proffered by modern French painting and utilizes them in the typical Romantic and emotional fashion of German tradition.

We may discern borrowed elements in her *Old Peasant Woman,* 1906-1907, or *Old Almshouse Woman,* but they are personal interpretations and more directly emotional or mystical than post-Impressionist art generally. The *Old Peasant Woman* possesses a Gauguinesque linear quality and large color areas for the white cap, blue dress, yellow hands and face, and bright-green flowered arbor background; and its deliberate coarseness of features, hands, and skin recalls van Gogh. In spite of this, it has an unusual symbolic quality and tension unlike either of those artists. An ordinary person has been turned into a creature from another world.

We may look upon the charming and individual nude self-portraits in the same way. Their magical quiet of suspended animation, their tender and poetic color harmonies, often suggest Gauguin; but they emphasize gentleness and sweetness rather than the resonant passages preferred by the Frenchman. There is a fine 1906 example in the Basel Museum in which a violet-toned figure is set up half-length against a flowered blue background, darker violet blossoms in her hair and in her hands, a yellow necklace offering a decorative point of contrast. With this archaized representation and its pervasively poetic mood the artist has taken us into a special private sphere far removed from the everyday world of reality. Somewhat different in quality but equally strong in effect is a slightly later *Self-Portrait,* 1906, a typical wide-eyed, staring, half-length

figure in tones of Gauguin pink against a light blue-green background, holding a flat green twig in her primitivistically simplified yellowish hand, matching the beads around her throat.

Her poetic feeling for people is illustrated in the portrait of **Rainer Maria Rilke,** 1904, a strangely primitive and intuitive interpretation of Germany's great symbolist poet. Like most of her single figures seen at very close range, this face with its staring eyes emerges from the light-gray background with almost frightening intensity.

Modersohn-Becker's strange poetry reminds us of Marées whom she admired very much, but even more of Böcklin whose influence is so strong on the young Germans of the early nineteen-hundreds. Her young girls with crowns of flowers in their hair are shown looking at the spectator from some faraway place, reminiscent of the never-never land of Böcklin's pictures. The **Girl with a Cat,** c. 1906, and the **Boy with a Cat,** 1905, the muted browns and blacks of the latter relieved only by the white spots on the cat and pinkish tones for the child's hands and face, may be contrasted with the later **Seated Girl** 1907, its yellow skin and floral wreath seen against a strong blue background and dark-green foreground. These pictures differ not only in the change from the quiet colored and brownish early works to the bolder tonalities of the post-Impressionist phase, but spiritually as well. The boy is pure poetry in the Böcklin sense, far removed from anything mundane; the girl is primitivistic and exotic—the escape taking a different direction.

Reminiscences of Marées may be found in the monumental mother nudes suckling their children; there are a good many of these. Naturally, their formalistic qualities are brought up to date technically through the modeling of Cézanne, the contours of Gauguin, and the color expressiveness of van Gogh. The **Mother and Child,** 1906-1907, . . . with its strong outlines and brightly spotted violet background behind a sculpturesque light-brown form, illustrates this almost typical blending. At the same time it brings to mind forcibly the emotional interests of the painter and her poetic manner of expressing them.

In a number of pictures during her last year or two, one suspects the effect of Fauve painting which had just begun to appear. Her **Good Samaritan,** with its heavy stained-glass dividing lines, simplified forms, and rough broad color areas, has qualities that suggest the early work of Kandinsky, Münter, Jawlensky, and others in the Munich area also working from Parisian sources. The **Nude Child with Gold Fish Bowl** . . . , like the **Seated Girl,** shows a breadth of handling and almost barbaric simplicity that recall the real Fauve period in Paris before the school became primarily decorative. Here again, though, whatever influences may have been at work, the young German artist retained her basic emotional approach.

As early as 1906-1907 we are able to distinguish between the respective directions taken by French and German art. In spite of her post-Impressionist background, Modersohn-Becker responded to the symbolic needs of her own temperament and background, strengthening what she took from Gauguin and poeticizing what she found in van Gogh. Her figures were hardly ever studies; they were vehicles for the expression of tenderness, of mystery, of fruit-fulness, or of longing—they became symbols of human emotions and needs. (pp. 45-8)

Bernard S. Myers, "Paula Modersohn-Becker," in his The German Expressionists: A Generation in Revolt, *revised edition,* McGraw-Hill Book Company, Inc., 1963, pp. 44-8.

Alfred Werner (essay date 1973)

[*In the following excerpt, Werner addresses Modersohn-Becker's relationship to other Worpswede artists and offers a favorable overview of stylistic development and representative themes in her work.*]

Travel Books often fail to mention the German town of Worpswede, about 12 miles northeast of the busy port city of Bremen. The town is not only attractive, it is also of cultural importance. Around 1890 Worpswede was one of Central Europe's major artist' colonies, with the motto, "Back to nature." Similarly, few of the histories of art published in English pay more than scant notice to the one painter who was greater than any other of the town's numerous practitioners of art: Paula Modersohn-Becker. At times she is even missed in the literature on women artists, though she ranks with Angelika Kauffmann, Gabriele Münter, Kaethe Kollwitz, and Renée Sintenis, to name only some of her colleagues in Germany. . . .

This most famous Worpsweder was actually a native of Dresden. Her father was a high official in the German railroad administration, and her mother descended from an aristocratic family. When Paula was 12, the Beckers moved to Bremen. The parents were sufficiently open-minded to allow Paula to take art lessons, first in Bremen, and then in London, where the teenager lived for a while with relatives. But they also insisted that she attend the teachers' seminary. Surprisingly, they put no obstacles in her path when, after graduation, she declared that she wanted to be an artist, and they even allowed her to go to Worpswede and to live there alone, unchaperoned, in a studio apartment. She was able to take journeys abroad.

By 1899 she had created enough works to have a solo exhibition at the Bremen Kunsthalle (the city's museum). Yet when her show failed to arouse any enthusiasm by the public or press, she was urged by her family to forget about her art, and to accept a position as a governess. There was one way out, and she took it—by marriage. She became the wife of the Worpswede painter Otto Modersohn, a widower, well-meaning but mediocre in his talents.

Modersohn appears to have been a patient, tolerant man, who understood his wife's need for frequent and lengthy separations whenever she felt she could work satisfactorily only when relieved from the burdens of domesticity. His own unpretentious and unobstrusive pictures pay tribute to the stark beauty of the Nordic landscape around Worpswede: the vast stretches of flat country, broken by the lazily moving waters in rivers and canals; the moors; the birch and pine trees; the sturdy farm houses with their thatched roofs; and above all, the endless skies, usually veiled by fantastically shaped clouds. Subdued in color, and rather traditional in technique and outlook, these paintings lag far behind the bold and daring ones done by his wife, especially those she did in the last three or four years of her short career. For him, Paula's nonnaturalistic

pictures were too much "like posters," as he put it, as they are characterized by large, broad, flat color areas bounded by clear outlines. But he knew that she was greater than he, that she was, as he put it, "a genuine artist such as there are few in the world." He even predicted that one day she would be appreciated everywhere. Surviving his wife by 36 years, he was able to note that his forecast had come true. (p. 16)

[Modersohn-Becker], during four sojourns in France, assimilated all that the Salon d'Automne and Vollard's shop could offer her eyes—especially the work of Cézanne, and, one assumes, also the paintings of Gauguin and van Gogh (though she does not refer to them in her letters or diaries, where she mentions Manet, Redon, Vuillard, and Denis, among others). Even before her first Parisian trip, in 1900, she had begun to rebel against her teacher in Worpswede, Fritz Mackensen: "The manner in which Mackensen paints is not big enough for me; there is too much 'genre' about it. To be brought off, it should be writ large, in runic characters."

Although Paula Modersohn-Becker often shared the subject matter of her colleagues at Worpswede, she was opposed to their prosaic approach. A decade or more before the term was to be coined, she had become a "Post-Impressionist," that is to say, a painter no longer clinging to the classical notion that the salvation lay in the contemplation and imitation of nature. As early as 1902 she wrote in her diary, "I believe one should not think about nature when painting, at least not during the conception of the picture." Unwittingly she thereby echoed Gauguin's declarations, "It is better to paint from memory," and, "I shut my eyes in order to see."

In her mature work, she does not imitate given forms, but finds artistic equivalents for life, as it were. Instead of concerning herself with the surface, as most Worpsweders did, she was as eager as her idol, Cézanne, to grasp the secret organization of things, the structure beneath the appearance, the "bones of nature." She came to realize that it was the painter's task to represent, not to reproduce nature. Gradually she lost interest in light and shade as well as atmospheric perspective as means to produce the semblance of three-dimensionality. She taught herself to use color arbitrarily, to distort or exaggerate ordinary forms of nature to achieve emotional or aesthetic effects, and at times she came close to the aims of a later group of artists, known as Expressionists.

It was her manner rather than her choice of subject matter that distinguished her work from what was done in Central European studios between 1897 and 1907. She wanted to "give figurative expression" to her "unconscious feeling"; she had a "burning desire to become great through simplicity." For her, the main thing was what she called "the personal sensation." Only after having achieved this in her picture would she bring—for the layman's sake— "enough of nature into it to make my picture look natural." Yet apparently this was not sufficient for the viewer who preferred the academic accuracy and smooth technique she lacked.

[Her friend Rainer Maria] Rilke, who belatedly came to recognize her greatness, suggested that she must have seen works by Matisse. "There is an inherent truth which must be disengaged from the outward appearance of the ob-

Paula Modersohn-Becker. German, 1876-1907. Old Peasant Woman, *c.1905. Oil on canvas, 29 ¾" x 22 ¾" (53.385).*

ject," Matisse once wrote: "This is the only truth that matters . . . Exactitude is not truth." Although Paula was quite attractive—she was blond, slim, and wore her long hair in a chignon at the nape of her neck—her numerous self-portraits render, not her prettiness, but her anxiety, her tension, her questioning attitude towards the world, as she appears with a slightly open mouth, and with large eyes that look beseechingly at us. (Repeatedly, she painted herself nude, with a flower between her breasts, and even with the enormous belly of advanced pregnancy.)

Her landscapes and her still lifes lack what is often called feminine tenderness and softness. But they have strength. So do her pictures of men, women, and children of what in the Kaiser's Germany was called the "lower classes," while to her they represented "poor little mankind." They are different from the facile and pretty renderings of rural humanity that were eagerly collected around 1900. Paula's approach was entirely unromantic, unsentimental. Melancholy, suffering or, at best, resignation is written into the raw-boned "ugly" square faces of her stolid and brooding blue-eyed Lower Saxony types. Their large, uncouth hands attest to years of unceasing toil. Nor did her brush omit the aged and the sick.

In the beginning, dark colors prevailed. Gradually the browns gave way to more reds, blues, and greens. The colors within the somewhat stylized, artificial forms remain heavy; the brushstrokes are never concealed; they are always visible. One is often reminded, by their quality, of the

encaustic panels of antiquity. In their brutal directness Modersohn-Becker's pictures are especially reminiscent of the so-called Fayoum portraits of Egypt, mummy portraits with a disproportional emphasis on the eyes as the "mirrors of the soul," and including the most unflattering details.

It is easy to note that the eternal theme, "Mother and Child," takes a dominant position in her work. This motif plays, of course, a very great role in Christian art. While in secular art the subject is not confined to female practitioners, it comes as no surprise that it was favored by Mary Cassatt and Kaethe Kollwitz, along with Modersohn-Becker. . . . Paula Modersohn-Becker regarded her models with sympathy, but without undue sentimentality. The faces of the children often look like potatoes, with little holes for eyes. Yet these awkward creatures, shown in their simple dignity, inspire warm feelings. Van Gogh would have loved what she created. In Modersohn-Becker one is often reminded of him, as she shared his compassion for humanity, and she might have written his lines, "I want to paint men and women with that something of the eternal that the halo used to symbolize, and which we seek to give by the actual radiance and vibration of our colorings . . ."

Van Goghs can be seen here in many a museum. Yet not a single of the approximately 400 oils Modersohn-Becker produced has landed in an American public collection. To see some of these small oils, as well as her drawings and etchings, one must go to Bremen, whose Kunsthalle is one of the finest art museums in Northern Germany. There is even a Paula Modersohn-Becker Haus—entirely devoted to her memory—in the heart of the Old City.

Unquestionably, she died too soon for her talent to come to full fruition. For she had all the gifts to become one of the greatest artists of this century. Somehow, she had a premonition that she would die young. United with her husband again after a long separation, she became pregnant. On November 2, 1907, she gave birth to a healthy baby daughter. But on the 20th of the same month, she succumbed to a heart attack. (She was only 31.) Her final words were simply, "What a pity!" On her grave in the Worpswede cemetery, there is a sculptured group by her friend, Bernhard Hoetger, presenting a dying mother with a child on her lap.

Hoetger had, for a long time, been the only person to encourage her. She had written to him, full of gratitude, "You have given me the most wonderful thing in the world: faith in myself." Her two exhibitions hardly contributed to this sort of faith, for the public's reaction was indignant. Altogether, she sold only two pictures (one more than had van Gogh during his lifetime). When she donated a work of her own to a charity raffle at Worpswede, the winner returned the picture and chose something else instead.

But exactly a decade after her premature death her name suddenly spread through the publication of *Briefe and Tagebuchblaetter*, including the letters and diaries from which I have quoted above. Two years later, in 1919, the first scholarly monograph about her appeared. From then on, her reputation continued to rise (though there was a setback during the period of the Third Reich; the Nazis confiscated as "degenerate" no fewer than 70 of her works from German public collections).

The paintings of Paula Modersohn-Becker are sheer music, fraught with mysticism, with passion. Her work revitalizes her, as she was, in every facet of her being: unconventional, sensitive, warm, but endowed with a tremendous stubbornness and a persevering strong will. Her philosophy of living permeated all she produced, in keeping with her credo that "art must penetrate the whole man, each phase of our existence." (pp. 18-23, 68-70)

Alfred Werner, "Paula Modersohn-Becker: A Short, Creative Life," in American Artist, *Vol. 37, No. 371, June, 1973, pp. 16-23, 68-70.*

Ellen C. Oppler (essay date 1976)

[*The essay excerpted below was occasioned by the centennial of Modersohn-Becker's birth, which was celebrated in Germany with widely attended retrospective exhibitions. Oppler offers a biographical overview of the painter's life attempting to dispel some common critical misconceptions.*]

[Paula Modersohn-Becker] is little known and even less understood outside a few German art centers—often more famous as a legendary artist who died at 31 than valued as an innovator of modern painting. A few obvious reasons for the neglect of her art quickly come to mind. Her greatest work is concentrated in Bremen and Wuppertal, hardly the main stops along the international tourist trail, although a few very fine examples are in other European cities. By contrast, only one significant painting is on view in a major American museum: the *Peasant Woman Praying,* in the Detroit Institute of Arts.

The facts of her poignant biography have become almost too familiar through her enormously popular letters and diaries published in Germany. Her valiant struggles to reconcile the demands of art and of married life, and her premature death after childbirth, just as she was achieving an artistic breakthrough, make her an obvious subject for feminist studies. It has been tempting to claim that she was ignored during her lifetime and little recognized ever since, although the facts indicate otherwise. In Germany, she has been studied in *oeuvre* catalogues, several monographs, and innumerable exhibitions, while in America there have been no museum retrospectives and no monographs. In the pertinent general literature in English, she is discussed briefly though with serious attention—usually as a precursor of Expressionism, or linked with such North-German individualists as Emil Nolde and Christian Rohlfs. Yet even a cursory study of her work reveals that she is neither a typical Expressionist, nor specifically German, since she owed as much to Paris as to her native origins.

Here may be the crucial reason why she has been omitted from our standard lectures on modern art: she cannot be forced into our neat art-historical pigeonholes. Her work requires open-minded, attentive study, and it must be seen in the original; reproductions cannot convey the range of her subtle colors and textures, the tangible impasto with which she molded the two-dimensional image into equivalents of solid reality. One must go to Bremen where the "Paula Modersohn-Becker Haus" in the picturesque Bött-

cherstrasse permanently displays some 30 paintings. In the main art museum, the Kunsthalle, one can also see her paintings, those of related provincial artists, and an extensive collection of drawings. And one must go to nearby Worpswede, the artists' colony where she painted. Though now a thriving tourist resort with craft shops and many art galleries (several with her works), Worpswede has preserved the thatched farmhouses, ancient peat-bog canals, and flat plains beneath changing skies that first attracted artists to this isolated spot.

The Worpswede landscape and especially its peasants, children, and old women from the poorhouse, were her first subjects; still-lifes, self-portraits, and images of mother and child predominate later. In barely ten years, Modersohn-Becker produced some 1,000 drawings and well over 400 paintings—oils and tempera studies and finished canvases of high quality. Fortunately, selected masterpieces will be brought to the American public during the next two years, overcoming a main obstacle to the proper evaluation of her work. Some of the other reasons for misconceptions, distortions, popular myths and legends, are the subject of this essay.

References to the "devastating" criticism of Paula Becker's first exhibit have become a standard element of the legend. The hysterical attack by Arthur Fitger (1840-1909, conventional mural painter turned critic) was primarily intended, however, for Gustav Pauli, the new director who dared to place "studies" by three unknown young women on hallowed museum walls. Precisely what *were* Fitger's objections to the work of Paula Becker, Clara Westhoff (her friend, Rodin student, and future wife of Rainer Maria Rilke), and the now-forgotten Maria Bock? We are never told; it was what we would term a "non-review." Fitger simply considered them "things that the primitive beginner, blushing modestly, might show her teacher or advisor," but surely unworthy of public display.

Further words fit to print fail him, though he talks of nausea and seasickness. Was Paula crushed by this review? Hardly. Her journal contains a laconic entry: "in December 1899, the first exhibition of my pictures in the Kunsthalle Bremen." Otto Modersohn recalled that when she visited his studio with her mother, she was "in good spirits but angry about Fitger." By the end of the month she was on her way to Paris for the first time.

Nor was she ignored or rejected when she exhibited for the second time in the Kunsthalle Bremen, as part of a Worpswede group show in late 1906. Mindful of the critical fiasco of 1899, Pauli himself wrote the newspaper review, observing with satisfaction that the Worpsweders now had asserted themselves even in Bremen. He noted that Otto Modersohn's art had remained pretty much the same, spoke briefly about the others, then focused on "this highly gifted woman artist." Since "even now, her serious and strong talent will not win over many friends among the public at large," he considered it his duty to point out the high quality of her art: her cultivated color sense and strong feeling for decorative tendencies in painting we would now speak of formal or even abstract tendencies). This time, Paula commented to her sister:

> The critical review gave me satisfaction rather than pleasure. The joys, the overwhelmingly beautiful hours take place in one's art without other people

noticing it. The same is true of the sad ones. That's why one mostly is quite alone with one's art. But the review is useful for my debut in Bremen and may perhaps throw a different light on my leaving Worpswede.

Modersohn-Becker's letters and diaries, her *Briefe und Tagebuchblätter,* clearly provide factual information and insight into her emotional experiences as well. First excerpted in an art-and-culture periodical in 1913, they were expanded somewhat into a first edition of 1917 (entitled *Eine Künstlerin*) with primary emphasis on the earliest years from 1896, and Paula's enthusiastic response to her studies at the Berlin school for women artists, ending with the beautiful letter to her mother as she was about to leave for Paris in 1906:

> For I am going to amount to something! How big or how small, I can't say myself, but it will be something complete in itself. This continuous rushing towards one's goal, that's the most beautiful thing in life. . . . I place my head in your lap from whence I came and thank you for my life.

Even in the greatly expanded and definitive edition of 1920 (including now also 16 illustrations), the editor Dorothea Gallwitz retained her emphasis on the early years and the emotional growth of the young woman artist; it was this veritable *Entwicklungsroman* ["novel of development"] that endeared the young Paula to the widest reading public which was unfamiliar with her work and the more demanding aspects of her art. Of 240 pages, only 37 deal with the essential years of her artistic maturity, from 1905 to 1907. The diary entries for these years are particularly scarce: barely six lines for 1905, a page for 1906, nothing for 1907.

The letters also vary greatly in tone and content according to the recipient, hence references to traditional or modern artists familiar to her particular reader predominate: Holbein, Rembrandt, but also Egyptian art, Tanagra figures, Gothic sculpture, and Millet, Segantini, Böcklin, Manet, and Degas. Cézanne, whose paintings she had discovered for herself at Vollard's gallery, she discussed in a letter to Clara Rilke as:

> one of the three or four artistic forces which struck me like a thunderstorm and a great experience. Do you still remember, 1900 at Vollard's?

(pp. 364-65)

A careful reading of her letters and diaries reveals that she was not just the dutiful daughter or wife and friend, but a tough-minded young woman who knew exactly what she wanted, especially when it concerned her work—despite discouraging parental doubts about her artistic future. She had gone to Worpswede because it was the closest artistic center of what appeared to be some new directions in painting. After studying with Fritz Mackensen, however, she soon decided that "the way Mackensen portrays people is not broad enough, too genre-like for me. If one could, one should delineate them in runic script," and she thought of Mantegna, Medieval grave sculptures in the Louvre, and some old women portrayed by von Kalckreuth.

When she saw contemporary work she admired, she promptly visited the artist in his studio, something that,

in the early 1900s, was surely audacious for a young woman still in her twenties:

> I want to look up Vuillard and Denis, for one really gets the strongest impression in the studio. Bonnard right now is in Berlin. . . .

Already in 1900, she had looked up Charles Cottet, whose triptych, *Au pays de la mer,* had impressed her greatly at the Exposition universelle. This practice gained for her the fruitful and encouraging friendship of the sculptor Bernhard Hoetger after she had searched him out in 1906; the following year she wrote this important letter:

> I want to produce the roaring, full, exciting aspect of color, that powerful quality. . . . I wanted to overcome Impressionism by trying to forget it. That's how I was vanquished. We must work with an Impressionism that has been assimilated, worked through.

The preceding year, 1906, had been filled with joyful creativity, and we do Modersohn-Becker a terrible injustice by transforming her into a tragic, romantic heroine who died young and unfulfilled. Her delight in her work and newly achieved personal freedom animated her letters home, especially to her favorite sister Milly:

> I'm going to *be* something—I am experiencing the most intense, happiest time of my life. Pray for me. Send me 60 francs to pay for models. Thanks. Don't ever lose faith in me.

The physical discomfort of her pregnancy which kept her from painting much of 1907 was balanced by the promise of motherhood and of experiencing that very aspect of woman's life which had preoccupied her for years. It had provided her with imagery for some of her best work. These ranged from brutal realism to formal symbolism: the exhausted peasant woman nursing her baby without joy, a naked mother sheltering her offspring on the ground as naturally as a protective animal, a secular madonna with her child enthroned on her lap or arm, and a final, extraordinary icon—a primitive, archetypal life force.

Modersohn-Becker's last great self-portraits have a similar timeless quality. But already the modest self-portrait of 1903 conveyed the ancient runic script she intended, with its surface curiously scratched by her paintbrush handle to give it the rough, vibrating texture she had noticed in Rembrandt portraits and in weathered old sandstone carvings. The superb *Self-Portrait with Camellia Branch* of 1907 stares at us with relentless frontality, its mysterious face brought out with exotic deep color harmonies, recalling the Coptic mummy-portraits of Fayum which she admired. Finally, the daring half-length nude of late 1906, with flowers in her hands and hair, steadily confronts her mirror image (and us) like a visual reply to the famous diary entry of 1900:

> I know I shall not live very long. But why should this be sad? Is a festival more beautiful for lasting longer? For my life is a festival. My sensuous perceptions grow sharper as though I were supposed to take in everything within the few years that will be offered me. . . . And if now love also will blossom for me, before I leave, and if I shall have painted three good pictures, then I shall leave willingly, with flowers in my hand and in my hair.

This late 1906 self-portrait followed another version of

May 1906, again half-nude, and picturing herself as if pregnant, even though she was not. Alone in Paris, she had faced an existential crisis, and portrayed herself in the very role she had rejected—whether temporarily or for good, she could not yet tell—and inscribed the canvas: "I painted this at age 30 on my 6. wedding day. P. B." This work, in turn, evolved into a last *Figure Composition* which further inspired Hoetger's initial design for Paula's grave monument. The three little graces, carved with a child-like, archaic classicism, were considered improper, however, and Hoetger replaced them with a mannered, sentimentalized dying mother and her newborn child. It is the dying mother, not the energetic woman artist, who is commemorated with a carved wooden plaque at the house where she died in Worpswede and by this elaborate tomb. She had wished for an unpretentious burial place surrounded by flowers. Her studio in Brünjes farmhouse where she was happiest in her work, is difficult to find.

The late *Figure Composition* shows the artist's right hand (it had been empty around her waist in the self-portrait as if pregnant) solemnly raised and presenting a bowl with fruit, as for a sacred, even sacrificial rite. Perhaps with this image in mind, Rilke wrote the famous *Requiem* and immortalized his friend as an almost mythical woman artist:

> For that was what you understood: full fruits.
> You used to set them out in bowls before you
> and counterpoise their heaviness with colors.
> And women too appeared to you as fruits,
> and children too, both of them from within
> impelled into the forms of their existence.
> And finally you saw yourself as fruit,
> lifted yourself out of your clothes and carried
> that self before the mirror, let it in
> up to your gaze; which remained, large, in front,
> and did not say: that's me; no, but: this is.

Rilke finally had recognized Modersohn-Becker's greatness; earlier, he had so typified conventional male attitudes that nobody can resist citing the evidence. Although she had spent many animated hours in her studio in September 1900, when he wrote his monograph about the Worpswede artists in 1902, he mentioned neither Paula nor his wife Clara, the sculptor and Rodin student. And his introductory note to Rodin identified Paula as the wife of the very distinguished German painter (which she reported dryly in her next letter to Otto).

Nevertheless, Rilke discovered Paula's achievements in late 1905 and wrote a most perceptive evaluation to Karl von der Heydt, his new patron who also became an important collector of her work. He found that "Worpswede was still the same" except that "Modersohn's wife" was ruthlessly going her own way,

> painting things that are very Worpswede-like, yet which nobody has yet been able to see and paint, and in this quite individual way, strangely approaching van Gogh and his tendency.

After having walked and lunched with Paula some months later, he reported to Clara that "P. B." was "ascending in a good direction, alone as she is and without any help. . . ."

Rilke's final recognition of Paula's artistic significance was one reason why he refused the Becker family's request to edit the letters and diaries. As he explained to his own

publisher, an overemphasis on the early years and such initial influences as Cottet had given a distorted picture of the woman and artist:

> who had let the Paris of van Gogh, Gauguin, Cézanne, the presence of Maillol, perhaps also of Matisse and Henri Rousseau affect her—creating ever bolder works that at times surpassed even the German successors of these artists.

Rilke was not exaggerating: he correctly recognized post-Impressionist influences, and personally knew of Paula's meetings with Maillol and Rousseau. As for Matisse, the generalized body contours and the bright, distinct color patches in the face of the 1906 self-portrait, for instance, suggest that Paula had indeed taken advantage of several Paris exhibitions to study the master of Fauvism.

In the letter to his publisher, Rilke writes, "um *die* Malerin, um *den* Künstler" (about this woman painter, about this artist), changing from the feminine to the grammatically correct masculine article, followed by masculine pronouns. He repeated, indeed emphasized, this point when he wrote the following month about a major retrospective in Hanover: "*diese* Künstlerin, nein *dieser* grosser Künstler" (this woman artist, no this great [masculine] artist). The great poet was very much a man of his times.

Critics and art historians invariably have taken some position on this "woman artist question," whether in the condescending phrases of the young Richard Hamann: "der gemalte Schrei nach dem Kinde" (barely translatable: the painted scream, longing for a child), or Ludwig Justi's curious appreciation of Modersohn-Becker's

> special empathy for living creatures, something womanly-motherly, which otherwise does not occur in art history; women who paint mostly differ from men who paint in the degree of their talent.
>
> (pp. 365-68)

In his introductory essay for the current exhibition catalogue, however, Dr. Günter Busch refuses to continue this discussion and simply uses the words *Künstlerin, Malerin,* with their feminine pronouns, without their traditionally problematic connotations: hopeful signs that during this anniversary year we may be restoring to Paula Modersohn-Becker her full humanity, recognizing her special qualities as a human being and as a painter of rare talent and achievement. And with the prospects of a major retrospective in this country, and publication of her annotated writings in English translation, we also will learn to honor her art without dehumanizing her, finally seeing her as a woman, person, artist. (p. 368)

Ellen C. Oppler, "Paula Modersohn-Becker: Some Facts and Legends," in Art Journal, Vol. XXXV, No. 4, Summer, 1976, pp. 364-69.

Günter Busch (essay date 1983)

[*Busch is widely regarded as one of the foremost authorities on Modersohn-Becker. Together with Liselotte von Reinken, Busch edited a broad selection of Modersohn-Becker's letters and journals in 1979 as* Paula Modersohn-Becker in Briefen und Tagebüchern *(1979:* Paula Modersohn-Becker: The Letters and Journals). *In the following excerpt from his introduction to that work,*

Busch emphasizes the influence of Paul Cézanne on Modersohn-Becker's work and assesses her stylistic development.]

Paula Modersohn-Becker was allotted only ten years for her life's work; three of them were years of study. But in the seven years of artistic production she worked on no fewer than 560 paintings and completed more than 700 drawings and 13 etchings. During her lifetime she sold no more than three or possibly four pictures, two of them to her friends the Rilkes and Vogelers. Much of her work in oil consists essentially of studies, not finished paintings. This applies in particular to the landscapes of her early period and her years together with Otto Modersohn. She was perfectly aware of this herself and saw in certain of her figurative pictures little more than experimental exercises toward larger, more important work.

The image of the child plays a very special role as a theme in her art. For her it was the image of the unspoiled human being, and among the peasant children of Worpswede she found ideal models for her concept of the natural, spontaneous, and unaffected. The same is also true for her representations of the peasant men and women themselves, in which the women are frequently painted as mothers with their children. However, it is essential to point out that these works represent the opposite of any folkloristic, native regional art such as we occasionally see from the hand of other painters of the Worpswede colony. The hallmark of her portraiture is a powerful disregard of all conventional notions of beauty. These paintings are documents of human truth. During the Nazi period this led to Paula Modersohn-Becker's being branded as "degenerate." All her paintings in German museums were confiscated by the so-called Säuberungs-Kommissionen, commissions for the "purification" of what was deemed to be the proper representation of *das deutsche Volk* ["the German people"]. It was claimed that Modersohn-Becker had painted "only stupid, degenerate children" whose "bad racial makeup was the result of deplorable incest" in the moor village of Worpswede. In fact, her representations of human beings in Worpswede are scarcely to be taken as portraits of individuals; their intention was always the rendering of the fundamental and common qualities of the human being per se. In this sense, Paula Modersohn-Becker painted really very few portraits as the word is commonly understood. And when she did, they were inevitably portraits of people close to her: her husband, Otto Modersohn's daughter Elsbeth, Clara Rilke-Westhoff, Rainer Maria Rilke, Lee Hoetger the sculptor's wife, or Werner Sombart, to name the outstanding examples. By contrast, there is a relatively large number of self-portraits and they run the entire gamut of her artistic life. But here, too, the personal element, indeed the entire personal mood or atmosphere, is suppressed in favor of an attempt to evoke and conjure the general human essence. This depersonalizing tendency grew with the years. In this connection we must bear in mind the enduring and powerful impression that the late antique and Egyptian mummy portraits had made upon her. All her striving as an artist was aimed at putting aside the external, the incidental, the specific, and getting to the fundamental, primitive qualities of the human vis-à-vis. It was thus a perfectly natural development in her art that she began early to emphasize the nude, the life study. Originally nothing more than academic exercises, these eventuated ultimately in the great nude compositions of

mother and child and the wonderful nude self-portraits, including those of herself as a pregnant woman. The human being as subject and object of creation was her theme.

Along with her figurative paintings the still life is of particular importance in her work. She painted approximately seventy of them, and in contrast to many of her landscapes and portraits they were almost all "completed" in the popular sense of the word; that is, few of them contain the sketchily painted areas frequently encountered in her other work. It is clear that her experience of the art of Cézanne gave her the impetus for painting these still lifes. Obvious similarities to his method of composition can be detected without difficulty in her pictures. But in contrast to the weightless, sometimes even airborne modulation of his oils, Paula Modersohn-Becker strives to do more than merely penetrate in a formalistic way the depths of the things she is representing. In her fruits, her earthenware crockery, her flowers, and woven materials, the things with which she populates her simple compositions, she tries to make the common components of creation visible—and she does this in an equally weighted, heavy, and earthy coloration fundamentally opposite to that of Cézanne and the Impressionists before him. Finally, in the canvases done toward the end of her life we may recognize the influence of van Gogh. But here, too, it is less a matter of literal borrowings than of creation from a related aesthetic impulse.

Art critics by and large have put particular emphasis on Gauguin as a model for Modersohn-Becker, especially in connection with the late nude compositions. For certain individual motifs and one or two direct borrowings this is accurate, but in a very limited sense. Even here it would be more accurate to emphasize the inspiration of Cézanne who had an equal influence both on Gauguin and on Paula Modersohn-Becker. Nevertheless, we must be careful to detect something fundamentally absent in the work of the German painter and manifestly central to the style of the French artist: there is an almost total lack of the decorative element and preciosity in her work, those things that lend the exotic canvases of Gauguin their particular magic and charm.

Paula Modersohn-Becker was a painter of a rare and individual sort. Her work as a graphic artist is of almost equal significance. At first her drawings are completely within the traditional framework of the old masters and their mode and manner of working. That is to say, in the very act of drawing and in her studies and compositions, she directed her inner vision toward the finished picture, never toward pleasing the viewer. Despite this she created drawings that have the artistic power of great pictures. Both in her drawing and painting she sought the truth, the inner rightness of things, and not any lovely pretense or illusion. Almost every artistic product of her hand (that is, of her eye and her heart) is saturated with a feeling of totality in a very special sense. It is the direct expression of her rare ability to distill something complete from reality and from its fragments. In contrast to the art of many of her contemporaries and of the later Expressionists *sans phrase* this happens without sentimentality or the uncontrolled overflowing of emotion. The language of her canvases is simple, sober, strict, astringent, almost tight-fisted—but it is great in its form and in its demands on the observer.

And yet in every one of her works there is also, even in a hidden way, a human warmth, a heartfelt quality, and love. This is art that a woman created. However, this description of it must not be misunderstood, especially today, for hers is certainly no "feminist art." Everything programmatic or ideological was antipathetic to her personality and creativity. (pp. 7-9)

> *Günter Busch, in an introduction to* Paula Modersohn-Becker: The Letters and Journals, *edited by Günter Busch and others, translated by Arthur S. Wensinger and Carole Clew Hoey, Taplinger Publishing Company, 1983, pp. 1-10.*

Robert G. Edelman (essay date 1984)

[*In the following excerpt, Edelman favorably reviews a retrospective exhibition of Modersohn-Becker's works at the Galerie St. Etienne.*]

[It] is natural to speculate about what Paula Modersohn-Becker might have accomplished had she lived longer. Despite the brevity of her career as an artist . . . , Modersohn-Becker's work is considered to be an important (missing?) link between French modernism and German Expressionism. Beyond any historical significance, however, is the undeniable strength and maturity of her figurative work, most often depicting women, children or herself. When portraying people Modersohn-Becker overcame her self-conscious timidity and a debt to the founding fathers of modern art (all too apparent at times), to give these works a timeless, mysterious presence.

Although much of the production of her formative years can be considered studies or student exercises, there are several pieces that convincingly display Modersohn-Becker's uncommon gift for portraiture and the figure. *Peasant Woman in Profile, Facing Right,* 1898, is a carefully constructed tonal study of sculptural almost geometric forms. But in this drawing there is also a harsh and uncompromising honesty putting Modersohn-Becker in line with the German realist tradition. Modersohn-Becker did not possess the graphic power or social conscience of her fellow country woman, Käthe Kollwitz, but she did evince a far greater empathy for the individual.

With the exception of her portraits, one could suppose that Modersohn-Becker just did not have the time to achieve a mature style. Her landscapes, though appealingly straightforward, are beholden to the painters of Worpswede, an artist's colony which she attended, devoted to the esthetics of peasant life in northern Germany; and there is influence, too, from the work of her future husband, Otto Modersohn, whose sentimental and anecdotal paintings Modersohn-Becker later found pompous and conventional. As for the still lifes, Modersohn-Becker pays homage to the Post-Impressionist paintings in that genre that she had seen during her frequent visits to Paris. *Still Life with Pitcher, Peonies and Orange* and *Still Life with Yellow Bowl,* both 1906, are attempts to reconcile van Gogh's color and texture and Gauguin's pattern with her own almost primitive treatment of objects. These paintings are awkward, stiff and heavy-handed, as though the artist wanted to prove herself capable of dealing with the rigors of composition and color harmony.

On the other hand, the portrait and figure paintings are outstanding for their insight and veracity. *Bathing Boys by Canal,* 1901, which depicts three sallow, skinny youths with sway-backs, distended stomachs and spindly legs, is well observed and full of good-natured amusement. *Girl in Landscape,* also 1901, shows a girl with straw-colored hair staring straight ahead, dark eyes somewhat unfocused, lips slightly parted in a childish manner and two large front teeth barely visible, a detail that lends character to the whole face. Her expression seems to hover between curiosity and fear; she belongs in the gray, rural setting, but also appears isolated from it. The painting is executed with confidence and vitality, yet it is as unpretentious and innocent of guile as the girl.

[Three self-portraits] serve as the best gauge of Modersohn-Becker's progress as a painter over a six-year period. *Self-Portrait in Front of Paris Buildings,* 1900, shows a young woman with pronounced cheekbones, wide-set eyes and a slender neck. She stands in shadow, surrounded by the sun-filled streets of Paris, her collar and tie neatly arranged—the dutiful student. The portrait is reserved and unobtrusive, but also exposes the artist with brutal—because unflattering—truthfulness.

In *Self-Portrait with Necklace,* 1903, the artist gazes directly at the viewer. The previously angular head has been reduced to an oval shape, the features are no longer severe and there is a serenity in the eyes. The softening French influence is immediately apparent, but the artist uses the brush handle to agitate the surface of the painting, an experimental technique perhaps intended to counteract the passivity of the image.

Finally, there is the late (1906) *Self-Portrait with Lemon.* The woman is far more sophisticated and worldly than before. Modersohn-Becker had now come to terms with her German heritage and the influence of (in Otto's words) "modern notions." The color is fresh and bold, the composition well organized, the image provocative. There is a confidence in the way she holds a lemon in a gesture that is like an offering. A slight smile seems to signal a new independence. (pp. 158-59)

> *Robert G. Edelman, "Paula Modersohn-Becker at Galerie St. Etienne," in* Art in America, *Vol. 72, No. 3, March, 1984, pp. 158-59.*

Helen Goodman (essay date 1984)

[*In the following excerpt from a review of an exhibition at the Galerie St. Etienne, Goodman offers a positive assessment of Modersohn-Becker's paintings and comments on her writings.*]

Premature death always seems an affront to nature, but Modersohn-Becker's death in youth takes on especially tragic proportions because it aborted an artistic talent which was not only already well and firmly rooted and flourishing, but which promised even greater power and originality, had it been allowed the time to fully emerge. This is not to suggest that her surviving work is in any respect incomplete or fragmentary: indeed, an evolution of remarkable consistency can be traced in it because very early on she discovered her subject—people—which mainly included herself (she left a striking series of self-

portraits) and the faces and figures of women and children (generally of peasant stock). Recently, over 100 paintings, drawings, and prints by the artist were assembled for exhibition at the Galerie St. Etienne, the largest of its kind ever mounted in the United States. This exhibition confirmed the widely held view that Paula Modersohn-Becker was one of the most significant female painters of early 20th-century Germany.

While the artist painted many handsome still lifes (primarily Cézanne-inspired), some of them dazzling in their vibrant juxtaposition of color, simplified outlined form, and bold brush work, it was people who really captured her interest and who are at the heart of her oeuvre. She favored portraits in which the sitter was seen either in profile or staring unflinchingly out at the viewer. She sometimes used a three-quarter-length format, such as in *Nursing Mother* (1905), *Two Little Girls in Front of Tree Trunks* of c. 1905 (the child on the right is strongly reminiscent of Picasso's *Child Holding a Dove* of 1901), or the startling *Self-Portrait with Lemon* (1906-07); sometimes she cropped her portraits so that no extraneous form could distract from the directness of the sitter's gaze.

The paintings on exhibition were consistently fine; *Blond-Haired Girl in White Shirt* (c. 1905) was especially haunting. A pale blond child painted in strict profile is seen silhouetted against a muddy blue-green background. One is immediately reminded of an elegant Pisanello aristocrat; at the same time, however, the child's small eyes, undistinguished nose, protruding mouth, sloping jaw, and large ears are the roughly molded features of a peasant, and decidedly not aristocratic. The contradictions inherent in this seemingly placid study of a child heighten the expressive essence of this psychologically subtle and beautifully painted work. . . .

Apart from her art, Modersohn-Becker left an additional legacy, her poignant letters and journals. In fact her fame and reputation until the last two decades rested primarily on these important documents. First published in 1917, ten years after her death (and reprinted many times over the next twenty years), her writings reveal the personal life and struggles of a sensitive, talented woman at the turn of the century, and the conflicts she confronted—indeed, which all women of talent confront—as she tried to balance the imperatives of her art with the demands of her marriage and her deep yearnings for a child. . . .

One theme recurs again and again in her letters and journals: she wanted to "be somebody," to "become somebody." While she never explains precisely what she meant by this, it is clear that she felt impelled to follow her artistic course; in so doing, she hoped to produce a body of work in which she alone, at least, could take pride. Paula Modersohn-Becker achieved her goal: she did indeed "become somebody."

> *Helen Goodman, "Paula Modersohn-Becker," in* Arts Magazine, *Vol. 58, No. 8, April, 1984, p. 19.*

Ruth Bass (essay date 1984)

[*In the following excerpt from an essay occasioned by the publication of* Paula Modersohn-Becker: The Let-

ters and Journals, *Bass uses excerpts from the artist's writing to illuminate her works.*]

Straddling two eras, the German painter Paula Modersohn-Becker (1876-1907) was able to synthesize some of the most powerful elements of 19th-century realism and 20th-century expressionism into an intensely personal style. Her portraits of peasants, especially old people, children and nursing mothers, are directly felt and unsentimental, while her self-portraits radiate the inner power that was to earn her a place as one of the precursors of German Expressionism. Indeed, the power of the paintings in the recent one-person show at Galerie St. Etienne in New York give an indication of why the Nazi government saw fit in 1939 to auction off many of her works along with those of other "degenerate" artists such as Gauguin, van Gogh, Matisse, Kirchner, Nolde and Kokoschka. (p. 101)

Many will identify deeply with the inner struggles of this young woman determined to become a great artist in a society unaccustomed to female independence. "You think I am extremely egotistic," she wrote to her aunt at the age of 17.

> I have so often puzzled over that and tried so hard to locate this terrible egotism of mine. I cannot find it. What I have discovered is that I very much want to be in control and that I have gotten used to directing my own life.

For the most part Modersohn-Becker's parents, Carl Woldemar and Mathilde Becker, were extremely supportive. In 1896 they managed to send her to the Drawing and Painting School of the Society of Berlin Women Artists and to pay for additional lessons by taking in a boarder. She spent the summer of 1897 in the countryside near their Bremen home, at Worpswede, a rural colony of artists with back-to-nature goals and ideals similar to those of the French Barbizon group.

Delighted with the natural beauty of the countryside, she wrote in her journal:

> Worpswede, Worpswede, Worpswede! . . . Birches, birches, pine trees, and old willows. Beautiful brown moors—exquisite brown! The canals with their black reflections, black as asphalt. The [River] Hamme, with its dark sails—a wonderland, a land of the gods. I pity this beautiful part of the earth—the people who live here don't seem to know how beautiful it is.

But a few days later she wrote her parents:

> Today I painted my first plein air portrait at the clay pit, a little blond and blue-eyed girl. The way the little thing stood in the yellow sand was simply beautiful—a bright and shimmering thing to see. It made my heart leap. Painting people is indeed more beautiful than painting a landscape.

It is impossible to identify the specific painting referred to in her letter, but her description evokes a motif that became central to later works such as *Girl with Yellow Wreath and Daisy* (ca. 1902), in which the child gazes straight out at the viewer, her haunted eyes ringed by pale brown circles that are echoed by the round yellow wreath encircling her thin blondish hair.

Despite Modersohn-Becker's infatuation with the natural

beauty of the area, her major subjects were peasants, painted without sentimentality or condescension. In *Bathing Boys by Canal* of 1901, for instance, three naked boys stare out at the viewer, defiant and hostile. The thickly painted, acid-green grass serves as an armature to hold the figures in place. The land is not pretty, and the children seem to look at life without hope and without illusions.

Although Modersohn-Becker never completely shared the goals of the other Worpswede painters, she would return often; and it was there that she met Otto Modersohn, a well-known painter eleven years her senior, who was later to become her husband. "And then there is Modersohn," she wrote during her first visit.

> I've seen him only once and then just for a short time—and I did not get a real sense of him. All I remember is something tall, in a brown suit, and with a reddish beard. There is something soft and sympathetic in his eyes. His landscapes, the ones I saw exhibited there, have a deep, deep mood about them—a hot, brooding autumn sun—or a mysterious, sweet evening light. I should like to get to know him, this Modersohn.

In 1898 a legacy from a grandaunt and a generous stipend from other relatives allowed her to complete her studies in Berlin and return to Worpswede, where she continued to draw residents of the poorhouse, old peasants, children and nursing mothers:

> My blonde was here again today. This time with her little boy at her breast. I had to draw her as a mother, had to. That is her single true purpose. Marvelous, these gleaming white breasts in her fiery red blouse. The whole thing is so grand in its shape and color.

In *Nursing Mother* of 1905, this sense of awe remains. The coarse-featured young woman holds her baby in a clumsy embrace. The seemingly old-fashioned earth-color palette is counteracted by the modernist close-up pressing of the profile against the picture plane by a background of birch trees. Despite the drabness of the setting and the roughness of the paint, there is a spark of tenderness that allows the sitter to transcend the harsh reality of her life.

By 1899 Modersohn-Becker was beginning to sense her true gifts as an artist and the limitations of her life at Worpswede. To her sister Milly she wrote:

> I'm going through a strange period now. Maybe the most serious of all my short life. I can see that my goals are becoming more and more remote from those of the family, and that you and they will be less and less inclined to approve of them. And in spite of it all, I must pursue them. I feel that everybody is going to be shocked by me. And still I must go on. I must not retreat. I struggle forward, just as all of you do, but I'm doing it within my own mind, my own skin, and in the way I think is right.

On New Year's Eve, 1899, she left for Paris for the first of four extended stays, timing her arrival symbolically for January 1, 1900. Here she struggled with the rigors of academic training. "We paint using almost no color at all," she wrote to Modersohn and his wife, Helene.

> The alpha and omega here are the *valeurs* [tonal values]. Everything else is incidental. I have been frightfully scolded about mine. I thought that

valeurs were my strong point. Now I notice how much I still have to learn. . . . For two weeks I have been working at a half life-size nude (that is, I have been adding and subtracting highlights and shadow in the proper *valeurs*. One really mustn't call that painting). But I believe that my feeling for form is being refined in the process. Short and sweet: I will endure. On the whole, I think more of the independent individuals who consciously reject conventionality.

At the same time she eagerly absorbed the best influences of the French avant-garde: "You know, the few great French painters here are totally without convention. They dare to see things naively. There is no end to what one can learn from them." That year she discovered paintings by Cézanne at Ambroise Vollard's gallery, visited the Exposition Universelle in Paris and became secretly engaged to Otto Modersohn after the death of his ailing wife.

Throughout her engagement and marriage, Modersohn-Becker's letters to Otto Modersohn were filled with terms of endearment and expressions of deep affection (although, according to one of her letters, he complained that she wrote more about painting than about love). Still, their marriage proved to be rocky. She maintained a separate studio and continued to paint, but the role of housewife seems to have taken its toll. A year after her marriage she wrote:

> My experience tells me that marriage does not make one happier. It takes away the illusion that had sustained a deep belief in the possibility of a kindred soul. In marriage one feels doubly misunderstood. For one's whole life up to one's marriage has been devoted to finding another understanding being. And is it perhaps not better without this illusion, better to be eye to eye with one great and lonely truth. I am writing this in my housekeeping book on Easter Sunday, 1902, sitting in my kitchen, cooking a roast of veal.

For his part, Modersohn seems to have swung between rhapsody and despair, first intoxicated by his wife's talent, then sickened by her ambition and consequent neglect of his needs. He wrote in his journal:

> It is really splendid to work and strive alongside my dear Paula. By evening the new studies are leaning against the plant stand on the veranda. Last evening P. really surprised me by a sketch from the poorhouse with old Three-Legs, goat, chickens—simply wonderful in its color, very remarkable in its composition, and with its surface worked over with the end of her brush, made all swirly. Remarkable how great these things are, everything seen as a true painter.

Yet scarcely two weeks later he wrote:

> Unfortunately, Paula is also very much infected by these modern notions. She is also quite accomplished in the realm of egotism. Whoever is not deep enough or fine enough in her estimation is pushed aside gruffly and ruthlessly. If this goes on much longer we will soon be alone. Another triumph. I, too, have already and frequently been the object of this gruff egotism. I wonder whether all gifted women are like that?

In 1903 she returned to Paris to study and paint on her own. There she became fascinated by the haunting, realis-

tic Egyptian mummy portraits in the Louvre, met Rodin and visited a collection of Japanese art with the Rilkes. "Today I saw an exhibition of old Japanese paintings and sculpture," she noted in her journal.

> I was seized by the great strangeness of these things. It makes our own art seem all the more conventional to me. Our art is very meager in expressing the emotions we have inside. Old Japanese art seems to have a better solution for that. The expression of nocturnal things, of horrors, of sweetness, of the feminine, of coquetry, all these things seem to be solved in a more childlike and concise way than we would do it.

She had herself begun to achieve this expression of inner feeling, not only by simplifying form but through her bold manipulation of texture, building it up or cutting into the thickened paint with the back of her brush or with a palette knife—as in her *Self-Portrait with Necklace* (ca. 1903). Her favorite medium was Wurm's Oil Tempera, a material no longer available today. In her journal she wrote:

> I must learn how to express the gentle vibration of things, their roughened textures, their intricacies. I have to find an expression for that in my drawing, too, in the way I sketch my nudes here in Paris, only more original, more subtly observed. The strange quality of expectation that hovers over muted things (skin, Otto's forehead, fabrics, flowers); I must try to get hold of the great and simple beauty of all that. In general, I must strive for the utmost simplicity united with the most intimate power of observation. That's where greatness lies.

Indeed, the textures of her tender, introspective self-portraits, of her harsh and powerful portrayals of peasants, of her sensuous female nudes and luminous, volumetric still lifes are varied—not simply in order to describe the surface of the forms but so as to best evoke their ineffable inner meaning.

Modersohn-Becker's 30th birthday brought her sense of dissatisfaction to a head. On February 23, 1906, she left for Paris with the intention of never returning to her husband, although, ironically, she was still dependent on him for financial support. She wrote to a friend of theirs.

> I know that I'm doing the right thing, even though I naturally have sad feelings about Otto Modersohn and Elsbeth [her stepdaughter] and my own family. They are now going through the suffering I went through earlier; only they are not getting anything out of it, whereas I have been having some wonderful experiences up to now. You shall see. Now that I'm free, I am going to make something of myself; I almost think before this year is over. . . . I love to fall asleep among my paintings and wake up with them in the morning. With faith in God and myself, I'm painting life-size nudes and still lifes.

In Paris her palette grew lighter and brighter, and her output was enormous. "New work simply pours from her hand," her sister Herma wrote. "This very afternoon I have to go over and pose for her for a few hours. She won't even rest on Sunday. It's nothing but paint, paint, paint—something will come of this." Yet Modersohn-Becker had never learned to earn her own living. She found herself constantly begging her husband for money and increasingly unable to carry on by herself. Eventually, after a num-

ber of attempts at reconciliation, she returned with Modersohn (who had followed her to Paris) to Worpswede, pregnant with their daughter Mathilde, who would be born on November 2, 1907.

In accordance with the medical practice of the day, she was kept in bed for almost three weeks after giving birth. When she was finally allowed to get up, on November 20, her movement—after such prolonged inactivity—apparently caused a blood clot in her leg to dislodge, and she died suddenly of a cardiac embolism.

In one of her last self-portraits (ca. 1906-07) the artist, wearing a string of amber beads, holds a lemon—perhaps a bittersweet emblem of her own fertility as well as a foil for the shimmering yellow background. Her face is a high crimson edged in blue and is supported by a columnar neck of barely modulated gray. Her expression is at once questioning, hopeful, happy and apprehensive. "The feeling I have inside me," she had once written, "is like a gentle weaving, a vibrating, a beating of wings, quivering in repose, holding of breath. When I am really able to paint, I shall paint that." (pp. 101-04)

> *Ruth Bass, "Self-Portrait with Bitter Lemon,"
> in* ARTnews, *Vol. 83, No. 5, May, 1984, pp. 101-04.*

FURTHER READING

I. Writings by Modersohn-Becker

The Letters and Journals of Paula Modersohn-Becker. Translated and annotated by J. Diane Radycki. Metuchen, N. J.: The Scarecrow Press, 1980, 344 p.
 Translation of Modersohn-Becker's correspondence and journal entries originally published in German in 1920 by Kurt Wolff as *Briefe und Tagebuchblätter.* Includes an introduction by Alessandra Comini and a translation of Rainer Maria Rilke's "Requiem, An eine Freundin."

Paula Modersohn-Becker: The Letters and Journals. Edited by Günter Busch and Liselotte von Reinken; edited and translated by Arthur S. Wensinger and Carole Clew Hoey. New York: Taplinger Publishing Company, 1983, 576 p.
 Combines Modersohn-Becker's correspondence and journals originally published in *Briefe und Tagebuchblätter* with a biographical outline, a list of exhibitions, and a bibliography of works on the artist.

II. Critical Studies and Reviews

Payne, E. H. "*An Old Peasant Woman Praying* by Paula Modersohn-Becker." *Bulletin of the Detroit Institute of Arts* 39, No. 1 (1959): 20-21.
 Brief treatment of one of Modersohn-Becker's most famous paintings.

Petersen, Karen, and Wilson, J. J. " 'New Forms and Stranger': 1890-1920." In their *Women Artists: Recognition and Reappraisal from the Early Middle Ages to the Twentieth Century,* pp. 98-119. New York: Harper and Row, 1976.
 Includes a brief biographical overview of Modersohn-Becker's career.

Radycki, J. Diane. "The Life of Lady Art Students: Changing Art Education at the Turn of the Century." *Art Journal* 42, No. 1 (Spring 1982): 9-13.
 Analyzes Modersohn-Becker's struggle to gain an art education despite institutional and social biases against women artists.

Tufts, Eleanor. "Paula Modersohn-Becker: 1876-1907." In her *Our Hidden Heritage: Five Centuries of Women Artists,* pp. 189-97. New York: Paddington Press, 1974.
 Biographical overview of Modersohn-Becker's career tracing the evolution of her style. Includes a translation of Rilke's *Requiem,* five reproductions, and a brief bibliography.

Urban, Martin. "The North Germans: Paula Modersohn-Becker, Christian Rohlfs, Emil Nolde." In *Expressionism, A German Intuition,* edited by J. Greenspun, pp. 29-37, 309-15. New York: The Solomon R. Guggenheim Foundation, 1980.
 Catalog for an exhibition of the same name held in New York and San Francisco between 1980 and 1981. Urban addresses the influence of Paul Cézanne on Modersohn-Becker's work as well as allegorical associations arising from her use of pure and simple forms.

Van Wagner, Judy Collischan. "Paula Modersohn-Becker—Overlooked Modernist." *Drawing* IX, No. 5 (January-February 1988): 105.
 Analysis of Modersohn-Becker's charcoal sketch *Standing Female Nude (Self-Portrait)* (1906) as a contribution to early Modernism.

Werner, Alfred. "Paula Modersohn-Becker." *Art and Artists* 10, No. 12 (March 1976): 18-21.
 Asserts that Modersohn-Becker successfully pursued domestic concerns while creating "indisputable masterpieces." Also addresses the influence of Paul Cézanne and the importance of the theme of mother and child in her work.

III. Selected Sources of Reproductions

Harris, Ann Sutherland, and Nochlin, Linda. "Paula Modersohn-Becker." In their *Women Artists: 1550-1950,* pp. 273-78. New York: Alfred A. Knopf, 1976.
 Catalog to an exhibition held at the Los Angeles County Museum and Brooklyn Museum containing analyses of individual works by Modersohn-Becker and five illustrations from her work.

Perry, Gillian. *Paula Modersohn-Becker: Her Life and Work.* London: The Women's Press, 1979, 149 p.
 Monograph containing twenty-five color plates and ninety-six illustrations.

Henry Moore

1898-1986

English sculptor and graphic artist.

Considered one of the most important English artists of the twentieth century, Moore is best remembered for sculptures executed in stone, wood, and bronze, depicting such classic images as the Reclining Figure and the archetypal Mother and Child. Moore's chief artistic concern was the exploration of the three-dimensionality of sculpture, and his works incorporate forms derived from his observation of nature, reflecting such qualities of organic composition as holes and cavities, asymmetrical construction, structural strength, and upward movement. Praised for evoking the unity of humankind and nature while communicating the dignity of his subjects, Moore's abstract presentations of the human form secured acceptance for Modernist sculpture in England and are now among the most highly prized works of twentieth-century art.

Moore was born in Castleford, a coal-mining village in Yorkshire, and attended local schools. At an early age he decided on a career as a sculptor, but he completed a teaching certificate at the insistence of his father and taught in a grammar school before enlisting in the army during World War I. Following his demobilization in 1919, Moore began classes at Leeds College of Art, and later won a scholarship to the Royal College of Art in London, where he divided his time between the academic discipline of drawing from life and the informal study of African and pre-Columbian art collections in the British Museum. Critics consider this period—as well as his subsequent travels to France in 1923 and Italy in 1925—of great importance in Moore's artistic development because exposure to the works of other artists enabled Moore to more clearly define his own principles of sculpture. He favored carving as a method of sculpture, considering it a more direct method of creation than modeling. At the same time he promoted the idea of "truth to material," by which he meant that the artist should allow the distinct qualities of the material to help define the artistic idea being developed. According to Moore, "Stone, for example, is hard and concentrated and should not be falsified to look like soft flesh—it should not be forced beyond its constructive build to a point of weakness. It should keep its hard tense stoniness."

Beginning in 1923 Moore taught at the Royal College of Art and subsequently founded the sculpture program at the Chelsea School of Art, where he remained until 1939. During this period he exhibited works in London galleries and came to the attention of leading English sculptor Jacob Epstein, who recommended Moore for a project at the headquarters of the London Underground Railway. Moore's first public commission, the relief *North Wind,* was completed in 1929, the same year he married Irina Radetzky, a student at the Royal College of Art. In the 1930s Moore and his wife occupied a studio in Hampstead near the residences of sculptor Barbara Hepworth and painter Ben Nicholson, and Herbert Read, the leading critic of avant-garde art in England. In 1933 Paul Nash,

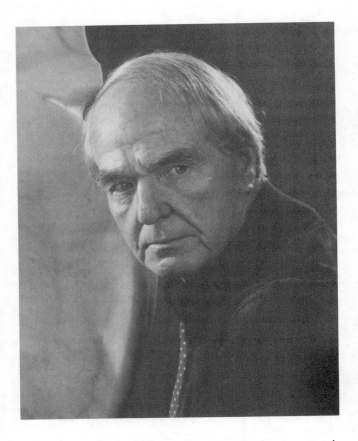

a prominent English painter, founded Unit One, an association of Modernist artists in Britain that included Hepworth, Nicholson, Moore, and several others. The group organized a touring exhibition, and Read edited a book detailing their artistic principles. While Moore's earliest sculptures had reflected the influence of his interest in primitive art in their massive, yet naturalistic forms, his works of this period are distinctly abstract. As Moore's fame grew he became acquainted with many of the leading modern artists in Europe, including Jean Arp, Alberto Giacometti, Joan Miró, and Pablo Picasso, and exhibited in several shows of Surrealist art, but remained independent of the major art movements of the era. At this time Moore's chief artistic aim was to understand the possibilities of three-dimensional form, and he began exploring the creation of space within his works through the use of concavities. The holes Moore carved in such figures as *Reclining Figure* (*1939, elm*) radicalized modern sculpture and became one of the most recognized trademarks in twentieth-century art.

After his studio was badly damaged in a bomb attack on London in 1940, Moore and his wife moved to rural Much Hadham, Hertfordshire, where they lived thereafter. Critics credit Moore's country residence with significantly in-

fluencing his artistic evolution because it allowed him closer contact with nature. He studied such objects as pebbles and animal bones and incorporated qualities of organic form into his works. Early in the Second World War, when wood and stone for sculpture were unavailable, Moore was commissioned to execute a series of drawings recording the experiences of those who sought protection from nighttime bombing raids in the tunnels and stations of London's underground rail system, or "tube." Considered a highly poignant series, the Shelter drawings gained a wide audience for Moore, and he was assigned by the War Artists' Advisory Committee to produce a similar series depicting coal miners at work near his boyhood home in Castleford. These two series of drawings comprise Moore's most important drawings not intended as studies for sculpture, and his rendering of sleeping shelterers wrapped in blankets provided Moore with a motif that he subsequently utilized in various sculptures depicting draped figures. When sculpture materials became available again, Moore was commissioned to create a *Madonna and Child* for St. Matthew's Church, Northampton. Carved in Hornton stone, the *Northampton Madonna* (1944) is more naturalistic than the works he had produced before the war and is considered one of Moore's most emotionally complex and fulfilling pieces. At the time Moore wrote: "The *Madonna and Child* should have an austerity and a nobility, and some touch of grandeur (even hieratic aloofness) which is missing in the everyday *Mother and Child* idea. Of the sketches and models I have done, the one chosen has, I think, a quiet dignity and gentleness. I have tried to give a sense of complete easiness and repose, as though the Madonna could stay in that position for ever (as, being in stone, she will have to do)."

Following the war, solo exhibitions of Moore's works were arranged in the United States and Australia, and Moore gradually gained world-wide recognition. He was awarded the sculpture prize at the Venice Biennale in 1948 and was later elected to honorary positions in academies and art associations in England, Belgium, Sweden, and the United States. Moore completed his first large bronze sculpture in 1949, when the Barclay School of Art in Stevenage, England, commissioned *Family Group*. He continued to cast works in bronze throughout his career, including such important pieces of the 1950s and 1960s as *Reclining Figure* for the 1951 Festival of Britain, *King and Queen* (1953), *Upright Motive No. 1: Glenkiln Cross* (1956), *Locking Piece* (1964), and *Reclining Figure* (1965) for the reflecting pool at the Lincoln Center for the Performing Arts in New York City.

A tendency toward abstraction reemerged in Moore's works of the 1960s and 1970s, and during this time he developed a series of two- and three-piece sculptures, many of which were based on his study of bone structure. Prominent sculptures of this phase of his career include *Three Piece Reclining Figure No. 2: Bridge Prop* (1963), *Knife-Edge: Two Piece* (1962-65), which was placed outside the Houses of Parliament in London, and *Sheep Piece* (1972), a work that remains on Moore's property in Much Hadham. Although sculpting grew more arduous for Moore as his health declined, he continued to work until the early 1980s, reexamining the subjects and themes that had fascinated him throughout his career. At the time of his death in 1986, he was one of the most beloved and esteemed artists of the twentieth century. Concluding his biography of

Moore, Roger Berthoud wrote: "Henry Moore was a man of vaulting ambition, determined to be the world's greatest living sculptor. In his own day he was widely recognized as such. If there is a life hereafter, he will be following the judgements of posterity closely. But he can surely be confident that his best work will have an enduring place in the history of Western civilization. Long may they both last."

ARTIST'S STATEMENTS

Henry Moore (essay date 1934)

[*In the following essay, Moore relates his principles of sculpture.*]

Each sculptor through his past experience, through observation of natural laws, through criticism of his own work and other sculpture, through his character and psychological make-up, and according to his stage of development, finds that certain qualities in sculpture become of fundamental importance to him. For me these qualities are:

Truth to material. Every material has its own individual qualities. It is only when the sculptor works direct, when there is an active relationship with his material, that the material can take its part in the shaping of an idea. Stone, for example, is hard and concentrated and should not be falsified to look like soft flesh—it should not be forced beyond its constructive build to a point of weakness. It should keep its hard tense stoniness.

Full three-dimensional realisation. Complete sculptural expression is form in its full spatial reality.

Only to make relief shapes on the surface of the block is to forego the full power of expression of sculpture. When the sculptor understands his material, has a knowledge of its possibilities and its constructive build, it is possible to keep within its limitations and yet turn an inert block into a composition which has a full form-existence, with masses of varied size and section conceived in their air-surrounded entirety, stressing and straining, thrusting and opposing each other in spatial relationship,—being static, in the sense that the centre of gravity lies within the base (and does not seem to be falling over or moving off its base)—and yet having an alert dynamic tension between its parts.

Sculpture fully in the round has no two points of view alike. The desire for form completely realised is connected with asymmetry. For a symmetrical mass being the same from both sides cannot have more than half the number of different points of view possessed by a non-symmetrical mass.

Asymmetry is connected also with the desire for the organic (which I have) rather than the geometric.

Organic forms though they may be symmetrical in their main disposition, in their reaction to environment, growth and gravity, lose their perfect symmetry.

Observation of Natural Objects. The observation of nature

is part of an artist's life, it enlarges his form-knowledge, keeps him fresh and from working only by formula, and feeds inspiration.

The human figure is what interests me most deeply, but I have found principles of form and rhythm from the study of natural objects such as pebbles, rocks, bones, trees, plants etc.

Pebbles and rocks show Nature's way of working stone. Smooth, sea-worn pebbles show the wearing away, rubbed treatment of stone and principles of asymmetry.

Rocks show the hacked, hewn treatment of stone, and have a jagged nervous block rhythm.

Bones have marvellous structural strength and hard tenseness of form, subtle transition of one shape into the next and great variety in section.

Trees (tree trunks) show principles of growth and strength of joints, with easy passing of one section into the next. They give the ideal for wood sculpture, upward twisting movement.

Shells show Nature's hard but hollow form (metal sculpture) and have a wonderful completeness of single shape.

There is in Nature a limitless variety of shapes and rhythms (and the telescope and microscope have enlarged the field) from which the sculptor can enlarge his form-knowledge experience.

But besides formal qualities there are qualities of vision and expression:

Vision and expression. My aim in work is to combine as intensely as possible the abstract principles of sculpture along with the realisation of my idea.

All art is an abstraction to some degree: (in sculpture the material alone forces one away from pure representation and towards abstraction).

Abstract qualities of design are essential to the value of a work, but to me of equal importance is the psychological, human element. If both abstract and human elements are welded together in a work, it must have a fuller, deeper meaning.

Vitality and Power of expression. For me a work must first have a vitality of its own. I do not mean a reflection of the vitality of life, of movement, physical action, frisking, dancing figures and so on, but that a work can have in it a pent-up energy, an intense life of its own, independent of the object it may represent. When a work has this powerful vitality we do not connect the word Beauty with it.

Beauty, in the later Greek or Renaissance sense, is not the aim in my sculpture.

Between beauty of expression and power of expression there is a difference of function. The first aims at pleasing the senses, the second has a spiritual vitality which for me is more moving and goes deeper than the senses.

Because a work does not aim at reproducing natural appearances it is not, therefore, an escape from life—but may be a penetration into reality, not a sedative or drug, not just the exercise of good taste, the provision of pleasant shapes and colours in a pleasing combination, not a deco-

ration to life, but an expression of the significance of life, a stimulation to greater effort in living. (pp. 29-30)

> *Henry Moore, in an excerpt from* Unit 1: The Modern Movement in English Architecture, Painting, and Sculpture, *edited by Herbert Read, Cassell and Company Ltd., 1934, pp. 29-30.*

SURVEY OF CRITICISM

Geoffrey Grigson (essay date 1943)

[*An English poet, critic, and editor who wrote widely on literature and art, Grigson was also the founder of the influential poetry magazine* New Verse, *which published early works by W. H. Auden, Louis MacNeice, Dylan Thomas, and others in the 1930s. In the following excerpt, he defines Moore's artistic vision and discusses its manifestation in his sculpture and drawings.*]

[Besides Masaccio, whose frescoes in the chapel of Santa Maria del Carmine he studied while in Florence in the early 1920s, many] other artists have influenced Henry Moore—Giotto, Blake, Turner, Picasso. He has seen many other things, such as the palæolithic cave paintings in Spain, but he has most of all been moved by these Masaccio paintings (which he keeps still in his mind), and by the hard solemnity of Mexican sculpture. Masaccio's figures and Mexican carvings are in many ways not unlike. In both, detail gives way to monumentality and strength. In both, features are made simple and subordinate. Both are grand without dictatorial swagger. Both combine deliberation with a held-in immensity of life. That life, that held-in, immense life, is Moore's interest. He is interested in the rounded, solid shapes into which life builds itself. And when he came back from Italy, Moore became a pilgrim . . . to the Natural History Museum. In the British Museum he had seen the carved symbols of life, in the other he now saw life in its natural forms and framework, from the cells to the skeleton. Saying "life" we often mean, especially when discussing writing and art, only human life—not human form and movement in opposition to the form and movement of a dog or a fish, but human beings thinking, feeling, desiring, arranging, and so on. This is not the life of Moore's sculpture. His beings are not springing and leaping, or else brooding in conscious expression of some ideal. His interest is not for heroes, or harmonious perfection, or gods. In some of his tube-shelter drawings, for instance, his women are tortoise-headed, or pin-headed. They have not the heads of Madonnas, or angels, or a governess by Chardin. Moore has never been attracted by the fag-end of the old ideal values of Renaissance Europe. In art, these values have decayed into a set form. In sculpture, the Renaissance Christ has been smoothed into the plaster Christ of the Catholic church-furnisher (in the Church of England sculptural passion has become taste controlled by diocesan advisory committees), and the old ideas of nobility and sacrifice have become a howitzer squatting at Hyde Park Corner

like a petrified toad, and the hero has become a Cabinet Minister on a pedestal, in bronze boots. What sculpture needed in this country was to be thought out again, or re-explored by feeling. So back to life, or the simple, rounded forms of life. Back to seeing everything. Back to the Natural History Museum, as well as to Mexican sculpture and Masaccio.

Henry Moore has made several statements about his own carvings in their relation to bones, shells, pebbles, and so on, and also in their relation to the religious carving of the Mexicans, the Sumerians, the Egyptians, and the negroes.

> Primitive art . . . makes a straight-forward statement, its primary concern is with the elemental, and its simplicity comes from direct and strong feeling.

> The most striking quality common to all primitive art is its intense vitality. It is something made by people with a direct and immediate response to life.

> Sumerian sculpture shows a richness of feeling for life and its wonder and mystery.

But remember, when you look at the shapes cut and smoothed by Henry Moore, that these early peoples, in whose carvings the sense of living form was so strong, had an actual pictorial knowledge of life much less detailed and extensive than our own. They saw life in the form of large organisms, brute or man. We see it also in the plates and diagrams of a biological text-book. Rounded shapes by Moore may be related to a breast, or a pear, or a bone, or a hill, or a pebble shaped among other pebbles on a shingle bar. But they might also relate to the curves of a human embryo, to an ovary, a sac, or to a single-celled primitive organism. Revealed by anatomy or seen with a microscope, such things are included now in our visual knowledge. Art, or the forms of art, change with such knowledge. In the eighteenth century Stubbs painted an exquisite bunch of flowers held in a woman's hand up to the nostrils of one of his anatomically correct horses. Botanical classification and research and interest in gardening helped to make flowers an especial object under eighteenth-century eyes. An eighteenth-century physiologist investigated the way in which a sunflower follows the sun, so Blake and other writers used images about the sunflower. Humphry Davy gave lectures on science; Coleridge went to them to "increase his stock of metaphor". In our age the discovery and study of single-celled organisms has been followed by a search after the units, the source, the primitive form of expression; and no artist can live by himself, or live altogether in, or by, the impressions once vivid in the eyes of a dead generation. So when some critics (critics are very often stuck fast in the record of old impressions) talk persistently of the distorted vision and the disordered mind of contemporary art, they are simply showing the restriction of their own experience. Academic critics will not be familiar with the cells and organs and elements of life, if they read only Plato and Jane Austen, look only at a lion by Rubens and a lady by Gainsborough. Biology must also be acknowledged; and some of the dislike of what painters and sculptors do at the present time certainly does come from this restriction, does come from a narrow, negative sixth-form and university education in the half inhuman humanities. To be interested in life, as Moore is, rather below the conscious level, is not to be subhuman. The rounded limbs of a human fœtus, a fertilized

egg, or the heart of a water flea, or even the pneumococcus that chokes and ruins lungs with pneumonia, would not, when realized with the bigness of life, be less worthy than a lounge suit in white marble or an Alsatian dog a million times smoothly reproduced in coloured china.

All the same it is not so easy to value Moore's big sense of the wonder and mystery of universal life. When I look at his carvings I sometimes have to reflect that so much of our visual experience of the anatomical details and microscopical forms of life comes to us, not direct, but through the biologist. Microscopical forms are as "big" as any other forms, but the "intense vitality" of primitive art was given to carvings because the carvers had a direct knowledge of animals as vehicles of life, alert, walking, leaping and at rest. I do not say that Moore's pantheism is a motive as exalted as the vision of human life in Raphael's *School of Athens* or Michelangelo's two sonnets—

> Heaven-born, the soul a heavenward course must hold;
> Beyond the visible world she soars to seek,
> (For what delights the sense is false and weak)
> Ideal Form, the universal mould,

and so on. Moore's pantheism is not Goethe's or Wordsworth's. Moore does not play up Nature as a beauty. His carvings by no means always reach the grandeur of life. Big without being pompous, the life he carves, you might say, has only the virtue sometimes of not being dead. But that is one virtue up on a lip-service to humanism coupled with a sly and silent support of the robber principles of modern society. Life as life is simply a beginning, an honest beginning. And this life is not by any means the whole of Henry Moore's art. The only vision in art, or feeling in art, is an embodied feeling. Let us see how Moore's vision is bodied out in his sculpture and, particularly, in his drawings.

In Gloucester Cathedral, screens and arches of stone, thrown across the interior, create depth, create ordered images of eternity and infinity. At one place thin stone ribs leap up with superb skill to meet, at a sharp, tense point of spiritual contact, a strut thrusting down from the roof. Here is the builders' intellect brilliantly interpreting the mysteries of religion. In the limestone cliffs of the Gower peninsula, a huge wall, cut through with windows and a door, closes in a narrow, tall cleft, inside which the rock twists into fantastic forms. The rock swirls, and a hollow communicates with another hollow through a deep hole. In the Cathedral, a religious mystery; in the cleft, or cave, a natural mystery, emphasized by man. Come down in scale. Outside the cave there is a beach of pebbles, some of grey, some of pink limestone, ground into different rounded shapes, cut into with hollows, or pierced with holes. The pebble is a cave in the round, and the pebble and the cleft are types of the art of Henry Moore. Analogies are at once obvious: the darkness of the womb, and shapes swelling and thrusting from it; the bony structure of ribs, the round socket of eyes. Eyes in bone, the heart in bone, the embryo in a nook among bones. Or think of another series, the phallus, the tree, the erect posture of human beings, the standing stones of Avebury, the stone images more precisely carved on the slopes of Easter Island, the tapering of the spire of Salisbury Cathedral, or of an obelisk, or of a peak in the Julian Alps. Anything solid that can show the "wonder and mystery" of life appeals to Henry Moore. But his interest is somewhere above

the type, in between the cave (or tube tunnel) and the cathedral, the pebble and the perfect ball, the megalith at Avebury, roughly shaped by the people who put it up, and the cathedral spire. Something still and ordered in the fecundity and muddle of life. His tendency is to humanize rock or wood or bone or geological shape, or biological specimen. That compromise produces some of the most monumental, but also at times some of the least moving of Moore's work. His stony reclining landscape women need to be nearer women, very often, or else further from them; more natural or else more abstract. But his love of the cave and hollow and deep carving gives him room for all kinds of subtlety. His objects of life may be still—a kidney cannot throw a discobolus or hold tables of law—his objects may sprawl, but his scale is always big and he arranges with moving intricacy mass against hollow, hollow against line, and height and breadth. That, after all, is one element by which painting and sculpture have satisfied and delighted human beings all through history and all through changes of style and subject. Compare a tube shelter drawing, for example, the **Four Grey Sleepers,** with Raphael's *Three Graces.* However the two visions differ, the means are exactly the same. In Raphael's three standing figures, the dance of the arms, the heads, the legs, the breasts; in Moore's four sleepers, the solemn, monumental rhythm of the blanket shapes, each stretching outwards from the head, lying like stones on the ground, the rhythm of head against head differently turned, arm against arm, dark depth against depth. Moore has written of the sculptor's need to "think of, and use form in its full spatial completeness", to think of the solid shape "whatever its size, as if he were holding it completely enclosed in the hollow of his hand". And it is necessary, he says, "to feel shape simply as shape, not as description or reminiscence". But he also admits that forms have their meaning: "rounded forms convey an idea of fruitfulness, maturity". So, like the great inventors, Moore balances his road in between the theorem and the heart. Why else does an early painter set up a crucifix in an agony of rocks and skulls, or a painter of the eighteen-hundreds square up a lime-kiln in a wild valley, or extend the arc of a rainbow across the fertile medley of a landscape? Why else the circle and rectograms of Stonehenge in the desolate spread of Salisbury Plain?

In the mess and muddle and fecundity of life which he finds wonderful and mysterious, Moore puts together shapes by which all that life is both ordered and symbolized.

Sculpture is a severe drill for an artist. No man can jot down the sudden illumination, the harmonious, momentary blend of experiences, by the immediate hacking out of a piece of stone. He cannot carve very well from nature. He can do these things in oil paint, easier still in ink or pencil or chalk, or in water-colour. (That surely is a reason for the Romantic development of water-colour in an age of originality and spontaneity and truth to nature, when it was held that "a thought conceived in the first warmth, an effect with which we are struck at the first view, is never so well expressed as by the strokes that are drawn at that instant". The answer was water-colour, and the later manipulation of water-colour for intricate detail across a large area was decidedly the cleverness of perversion.) A sculptor can pinch his flash of experience into wax or into clay, but he will not be inclined to do that, if he believes

that he must feel in the material he uses, wood or stone. It is better to draw.

"At one time, whenever I made drawings for sculpture, I tried to give them as much the illusion of real sculpture as I could—that is, I drew by the method of illusion, of light falling on a solid object." This stoniness or woodenness of drawing was less alien to the slow carving of the final object than the pinching and dabbing of such an opposite, soft material as clay. Later Moore found it dangerous to make his drawings too much a "substitute for sculpture". The sculpture was "likely to become only a dead realization of the drawing", so he put down his three-dimensional vision on paper without all the three-dimensional illusions. He draws, all the same, "mainly as a help towards making sculpture", tapping himself, in his own words, for the first idea, sorting out ideas, developing them, realizing ideas he hasn't time to realize more solidly, and recording from Nature. But he also admits drawing for the enjoyment of drawing. A sign of the artist with great ability is that he can translate the first recorded flash into the more considered, better ordered perfection of the final painting or the final carving, with the flash undiminished and a strength added to it. Sickert once said, unromantically and truly, that "the sketches of a sketcher are separated by a gulf from those of the painter of pictures". But the ability to draw, to make a powerful and appealing use of line, always will be a major indication of an artist's rank and vision. Moore is one of the few living artists I know of who can scarcely put down a line without giving it life and interest, and a reason for this is that Nature is attractive to him: that he can see into natural objects. Light, for most of us, is the most effective of all black-outs. It reveals so many familiar aspects to us that we cease to notice the rest of the outside world. Moore reminds me of a deep-sea fish found off one of the Dutch spice islands. These fish have head-lamps of luminous bacilli near their eyes, and the light can be shut on and off at will. Moore doesn't just see: he sees in his own light. He sees everything, the scratch on the bone, the curvature of hills, the graining of bark; he sees into qualities and relation of objects, roundness, depth, darkness, surface, colour, solidity, everything, by means of his own light. He can shut his own light off, or, rather, he can turn it inwards, and ponder within himself over the things it has revealed. An artist so thoroughly possessed by vision records something of it simply by making any considered mark on a piece of paper. In the corners and unemphatic parts of the drawings and paintings of such men, when working at their best, there are no strokes or spots, without rhythm, meaning, life, and interest. In many drawings . . . this masterly quality is evident. No dullness, nothing emptily and carelessly unrealized. Compare the zig-zagging lines of the floor (any section of it as full as most abstract paintings of our time) and the veining of the right-hand pillars in Raphael's *Fire in the Borgo.*

All this is true of Moore's drawings for sculpture as well as his drawings for drawing, or the enjoyment of drawing. Drawing as an end has been somewhat forced upon him, I think, by the war. For one thing, stone cannot be so easily transported, either to his studio, or from his studio to exhibitions. The drawings have gained from this. In his earlier, more elaborate drawings in which figures of life establish themselves out of uncertainty and darkness, he had been able to record a whole, more intricate and extensive

in scale than can very well be contained in isolated objects of stone. In these drawings the stones have been erect in their setting of landscape and emotion. But they have been drawings in between idea and hard carving. To war-time drawings, such as the **Four Grey Sleepers** again, he has given back some of the stoniness and depth that he had guarded against in drawings meant for sculpture. Here we can thrust the arms of our sight in among forms in an almost "full spatial completeness". Here in these shelter drawings . . . , most of the sculptor and all of the draughtsman have been at work; and the deep figures in their setting are not just figures of life: they are figures of life (at least, in the tube series), the wonder of which is terrifically threatened. The figures still belong to the mass of life; they are below the edge of will. Rather than life vertebrate, active and thinking, they are life to which things (terrible things) are being done. Moore has also been forced by the subject of the tube shelter and coal-mining drawings nearer to the natural proportions of men and women. This is a gain, just as, under other circumstances, a move away from his stony human compromise towards completer abstraction has also been a gain. In fact, in [his] latest drawings . . . , Moore is moving back towards sculpture and asserting once more that he is not bound to any original. The way Moore develops and changes, moving on from one position to another like this, also proves his curiosity and power. He has been influenced by one thing and another, Masaccio and Mexican sculpture, Picasso and cathedral carvings, the effect of natural forces upon stone, English mediæval pottery, etc., but he has always kept and developed his own idiom. He has never got stuck in one phase, or made a habit of repeating himself until style has become a manner. He is always on the move. (pp. 7-14)

Geoffrey Grigson, in his Henry Moore, *Penguin Books, 1943, 16 p.*

Herbert Read (essay date 1944)

[*A prominent English novelist, poet, and art historian, Read was best known as an outspoken champion of avant-garde art. Several convictions are central to his aesthetic stance, the foremost being his belief that a perfect society would be one in which work and art are united. Read presented his theories in numerous highly regarded studies, including* The Meaning of Art *(1931),* Education through Art *(1943),* Icon and Idea *(1958), and* The Forms of Things Unknown *(1960). In the following excerpt, he examines Moore's artistic development.*]

Henry Moore's sculpture, like that of his great predecessors, is based primarily on the close observation and study of the human form. As a student he drew and modelled from life for many years, and he still periodically returns to life drawing. It is so important to stress this fact, that I would like to quote his own words to me:

Every few months I stop carving for two or three weeks and do life drawing. At one time I used to mix the two, perhaps carving during the day and drawing from a model during the evening. But I found this unsatisfactory—the two activities interfered with each other, for the mental approach to each is different, one being objective and the other

subjective. Stone as a medium is so different from flesh and blood that one cannot carve directly from life without almost the certainty of ill-treating the material. Drawing and carving are so different that a shape or size or conception which ought to be satisfying in a drawing will be totally wrong realized as stone. Nevertheless there is a connection between my drawings and my sculpture. Drawing keeps one fit, like physical exercises—perhaps acts like water to a plant—and it lessens the danger of repeating oneself and getting into a formula. It enlarges one's form repertoire, one's form experience. But in my sculpture I do not draw directly upon the memory or observations of a particular object, but rather use whatever comes up from my general fund of knowledge of natural forms.

That is to say, the artist makes himself so familiar with the ways of nature—particularly the ways of growth—that he can out of the depth and sureness of that knowledge create ideal forms which have all the vital rhythm and structure of natural forms. He can escape from what is incidental in nature and create what is spiritually necessary and eternal.

But there is just this difficulty; most of the forms of natural growth are evolved in labile materials—flesh and blood, tender wood and sap—and these cannot be translated directly into hard and brittle materials like stone and metal. Henry Moore has therefore sought among the forms of nature for harder and slower types of growth, realizing that in these he would find the forms *natural* to his carving materials. He has gone beneath the flesh to the hard structure of bone; he has studied pebbles and rock formations. Pebbles and rocks show nature's way of treating stone—smooth sea-worn pebbles reveal the contours inherent in stones, contours determined by variations in the structural cohesion of stone. Stone is not an even mass, and symmetry is foreign to its nature; worn pebbles show the principles of its asymmetrical structure. Rocks show stone torn and hacked by cataclysmic forces, or eroded and polished by wind and rain. They show the jagged rhythms into which a laminated structure breaks; the outlines of hills and mountains are the nervous calligraphy of nature. More significant still are the forms built up out of hard materials, the actual growth in nature of crystals, shells and bones. Crystals are a key to geometrical proportions assumed naturally by minerals, whilst shells are nature's way of evolving hard hollow forms, and are exact epitomes of harmony and proportion. Bones combine great structural strength with extreme lightness; the result is a natural tenseness of form. In their joints they exhibit the perfect transition of rigid structures from one variety of direction to another. They show the ideal torsions which a rigid structure undergoes in such transitional movements.

Having made these studies of natural form (and always continuing to make them) the sculptor's problem is then to apply them in the interpretation of his mental conceptions. He wishes to express in stone his emotional apprehension of, say, the human figure. To reproduce such a figure directly in stone seems to him a monstrous perversion of stone, and in any case a misrepresentation of the qualities of flesh and blood. Representational figure sculpture can never be anything but a travesty of one material in another—and actually, in most periods, sculptors have tried to disguise the stony nature of their representations by painting, or otherwise colouring their statues. It is only in

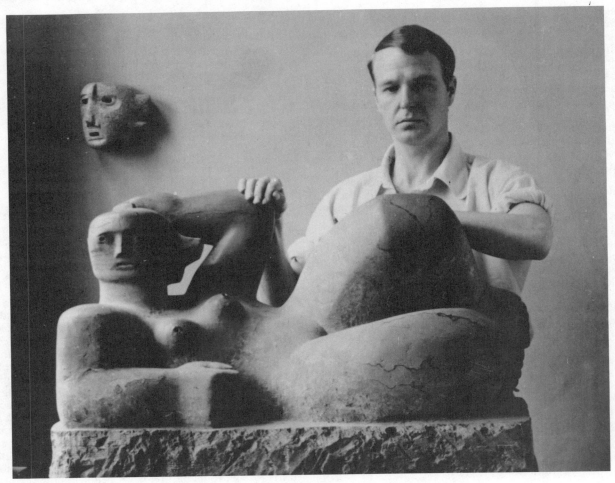

Moore with Reclining Figure *(1929; Brown Horton Stone).*

decadent periods that the aim has persisted of trying to represent flesh in naked stone. *The aim of a sculptor like Henry Moore is to represent his conceptions in the forms natural to the material he is working in.* I have explained how by intensive research he discovers the forms natural to his materials. His whole art consists in effecting a credible compromise between these forms and the concepts of his imagination. A similar aim has characterized all the great periods of art; a confusion arises when we seek to identify this aim with a particular ideal of beauty. Henry Moore has dared to say that beauty, in the usually accepted sense of the term, is not the aim of his sculpture. [He] . . . substitutes the word *vitality*. The distinction is so important for an understanding of his work, and, indeed, for an understanding of many phases of modern art that his words should be carefully pondered:

> For me a work must first have a vitality of its own. I do not mean a reflection of the vitality of life, of movement, physical action, frisking, dancing figures and so on, but that a work can have in it a pent-up energy, an intense life of its own, independent of the object it may represent. When work has this powerful vitality we do not connect the word beauty with it.

Beauty, in the later Greek or Renaissance sense, is not the aim in my sculpture.

Between beauty of expression and power of expression there is a difference of function. The first aims at pleasing the senses, the second has a spiritual vitality which for me is more moving and goes deeper than the senses.

Because a work does not aim at reproducing natural appearances it is not, therefore, an escape from life—but may be a penetration into reality, not a sedative or drug, not just the exercise of good taste, the provision of pleasant shapes and colours in a pleasing combination, not a decoration to life, but an expression of the significance of life, a stimulation to greater effort of living. [see Artist's Statements above]

These are the words of an artist—an artist who has had no truck with metaphysics or æsthetics, an artist who speaks directly out of experience. But they point with precision to the crux of a great debate which extends far beyond our immediate subject, and which we cannot therefore introduce here. The terms of the debate need careful definition, but obviously the whole scope of art is altered if you make it, instead of the more or less sensuous symbolization of intellectual ideals, the direct expression of an

organic vitalism. No doubt intellectual elements will enter into the choice and elaboration of the images which the intellect selects to represent its ideals; but the difference is about as wide as is humanly possible. Nothing is more false than the old adage: *Ars una, species mille.* The truth is rather that the arts are as numerous as the species, and at their extremes are irreconcilable.

This is as far as I can carry a general explanation of the aims of Henry Moore. I would now like to make a short analysis of the artist's evolution which will show how he has gradually realized these ideals. (pp. xvii-xxx)

Moore began with life-studies of a normal type, though even here we can already distinguish his special quality. The early (1928-30) *Drawings from Life* . . . are traditional, but they already have something of the power of a Masaccio for suggesting not merely the tridimensionality but even the solid mass and weight of the subject. But it would be a mistake to give the impression that the artist began with a relatively academic style, acquired in the schools, which he then progressively modified. Earlier than these drawings, and the sculpture contemporary with them, are certain figures and masks in stone, terracotta or concrete and wood which show the wide range of influences—Mexican, African and Egyptian—which he assimilated in his years of apprenticeship. It is as if, after exhausting the formal lessons of these exotic works of art, he returned to the European tradition before venturing to express himself in a wholly personal idiom. In 1928 the architect, Dr. Charles Holden, had the courage to commission the then comparatively unknown artist to execute one of the decorative panels for the exterior of the new Headquarters of the Underground Railway at St. James's. This figure of the *North Wind* though it is a relief and therefore in the artist's own words "foregoes the full power of expression in sculpture" which is only given in the round, is nevertheless his first fully mature work. Onwards from this point his mastery of his material is assured, and the work never falters as a realization of a sculptor's formal conception. The period of ten years between the small *Reclining Figure* in alabaster and the *Recumbent Figure* in Green Hornton Stone of 1938 is full of experimental variation, but there is a recognizable stylistic affinity between these two extremes, and a sustained continuity throughout all the intermediate stages. The variations are stretched between a near-naturalism and an almost non-representational cubism; and between the forms appropriate to stone, terracotta, wood and metal. The forms given to the figures in an extensible material like lead are inconceivable in figures carved in a brittle crystalline material like marble. A Bernini will take pride and pleasure in making his marble resemble any texture or material. Only a narrow mind (more strictly speaking, a blinkered sensibility) will condemn such virtuosity; but between the limited objective of such technical skill and the plunge into the psychic depths of the organic process represented by the discoveries of Henry Moore there is all the difference that lies between an act and a myth, between a symbol and the living truth.

It is important to realize that Moore's figures are never, strictly speaking, symbolic. Therefore he never gives his sculptures literary titles; they are always "figures", "compositions", or simply particular and individual existences—a mother and child, never Maternity. The nearest

he has come to a symbolic content is in his most recent work—the *Madonna and Child,* commissioned for the church of S. Matthew, Northampton. But in a leaflet which was issued to celebrate the Jubilee Festival of this church in September, 1943, there is a quotation from a letter of the sculptor's which shows how cautiously he approaches the task of giving an ideological significance to his work:

> When I was first asked to carve a "Madonna and Child" for S. Matthew's, although I was very interested I wasn't sure whether I could do it, or whether I even wanted to do it. One knows that Religion has been the inspiration of most of Europe's greatest painting and sculpture, and that the Church in the past has encouraged and employed the greatest artists; but the great tradition of religious art seems to have got lost completely in the present day, and the general level of church art has fallen very low (as anyone can see from the affected and sentimental prettinesses sold for church decoration in church art shops). Therefore I felt it was not a commission straightaway and light heartedly to agree to undertake, and I could only promise to make note-book drawings from which I would do small clay models, and only then should I be able to say whether I could produce something which would be satisfactory as sculpture and also satisfy my idea of the "Madonna and Child" theme as well.
>
> There are two particular motives or subjects which I have constantly used in my sculpture in the last twenty years; they are the "Reclining Figure" idea and the "Mother and Child" idea. (Perhaps of the two the "Mother and Child" has been the more fundamental obsession.) I began thinking of the "Madonna and Child" for S. Matthew's considering in what ways a "Madonna and Child" differs from a carving of just a "Mother and Child"—that is, by considering how in my opinion religious art differs from secular art.
>
> It's not easy to describe in words what this difference is, except by saying in general terms that the "Madonna and Child" should have an austerity and a nobility, and some touch of grandeur (even hieratic aloofness) which is missing in the everyday "Mother and Child" idea. Of the sketches and models I have done, the one chosen has I think a quiet dignity and gentleness. I have tried to give a sense of complete easiness and repose, as though the Madonna could stay in that position for ever (as, being in stone, she will have to do).

The qualities which the sculptor suggests as desirable in such a work, destined for a specifically Christian function (qualities such as "austerity", "grandeur", "quiet dignity and gentleness", "complete easiness and repose") are all qualities which can be immediately related to formal values; to angles and geometrical proportions. In other words every intellectual virtue or emotional tone must be given an æsthetic justification. There are some types of religious art for which this has always been a normal consideration for the artist; in a Giotto or a Piero della Francesca, for example. Sentimentality or decadence sets in once the balance of these values is lost. The function of art in religion is precisely to give a formal structure to vague emotions; it is, in an almost literal sense, a process of crystallization.

In this sense, the work of an artist of Henry Moore's seriousness is always religious: though it is not necessarily

Christian or sectarian, but rather mystical (the theological word *numinous* would be more exact). Moore himself has confessed that he is "very much aware that associational, psychological factors play a large part in sculpture. The meaning and significance of form itself probably depends on the countless associations of man's history. For example, rounded forms convey an idea of fruitfulness, maturity, probably because the earth, women's breasts, and most fruits are rounded, and these shapes are important because they have this background in our habits of perception." This, of course, is near to the symbolic conception of art, but the concepts involved (fruitfulness, etc.) are really too generic, in a sense too naturalistic, to be comparable to the dogmatic beliefs and ideological sentiments which are the usual basis of symbolic art. It is really the difference between the conscious ideas of human intellect and the deeper intuitions of what psychologists have called the collective unconscious. "There are universal shapes," Moore has noted, "to which everybody is subconsciously conditioned and to which they can respond if their conscious control does not shut them off". It might be more exact to say that there are universal ideas or archetypal images for which the artist finds the appropriate plastic representation. It is in this sense that Moore's "shapes" are as archetypal as the "idols" which primitive men carved to represent their notion of the unseen powers of the universe. (pp. xxxii-xxxv)

> *Herbert Read, in an introduction to* Henry Moore: Sculpture and Drawings *by Henry Moore, Curt Valentin, 1944, pp. xvii-xliv.*

N. Pevsner (essay date 1945)

[*In the following excerpt, Pevsner offers an appreciative overview of Moore's work to the* Northampton Madonna and Child *(1943-44).*]

There can be little doubt that [Moore] is the greatest British sculptor now alive—serious, intense, highly susceptible to shape in nature, yet never swayed by nature from his own purposes—an untiring searcher, but also an achiever. As to his achievement I take what some critics will regard as a conservative view. To me the acme of his work up-to-date is the **Northampton Madonna**. . . . Looking back from the summit of the Northampton image at the course of Henry Moore's development, one can see it clear and distinct, though with manifold windings and manifold reactions to varying circumstances. His work ranges from the human figure as easily recognisable as in the **North Wind** from the Underground Building to the string composition which has no other tie with the appearance of individual objects around us than its title **Bird Basket.** The range of his media goes from many kinds of stone and many kinds of timbers to lead, terra-cotta, concrete, water colour and chalks. But he has not the break-neck versatility of, for instance, [Jacob] Epstein. His personal idiom is ever perceptible, and it is one and the same however sensitively he may react to circumstances. The **Mask** of 1924 . . . has it already, and it is essentially still the same in the recent clay sketches . . .—an elusive and ever fascinating idiom of bulging and receding matter, surging up in firm parabolic forms or in forms reminiscent of fleshy tentacles, and flowing back into caves deeply scooped out if not tunnelled right through. It is an idiom wholly of na-

Moore on sculpture:

I am a sculptor because the shape of things matters even more to me than the colour of them. It may be that a painter is excited as much by colour as by form. Some painters have been like this, though others have been as interested by form as sculptors are. For me, it is the three-dimensional reality and shape which one wants to understand, to grasp and to experience. This is, I think, what makes me a sculptor—I need these three dimensions, as a musician needs sound and notes of music, and a writer must be interested in words. The different arts call for a different sense—sight, touch, hearing, taste. The actual three dimensions of a form are what I like and need. I want to produce the complete thing, rather than a sketch or an illusion of it.

To understand real three dimensions is to train your mind to know when you see one view what it is like on the other side, to envelop it inside your head, as it were. This is not something that you are born with—a child has to learn how far away a toy is, hung up in its pram, by touching and feeling. We learn distances originally by walking them. We understand space through understanding form.

> *Henry Moore, in an excerpt from* With Henry Moore: The Artist at Work *by Gemma Levine, Times Books, 1978, p. 45.*

ture but hardly anywhere fully of human nature, rarely beautiful but always significant. It is every inch sculptural and every inch sincere, the result evidently of concentrated feeling and of long and tenacious solitary thought.

But it is a solitary art, which bewilders the public, not only because "the public are not worthy of the sculpture," but also because no "spontaneous give-and-take of inspiration and appreciation" can at any time exist between any public and a sculptor who concerns himself so exclusively with "demented existence" (to use Henri Focillon's term). There can be no resounding echo to the statements of an artist apparently so little in sympathy with the individual man, woman and child.

But are we entitled to deny Henry Moore such sympathy? May it not be that it is there, but that he refuses it that direct access to his art which we are used to finding in the works of sculptors of the past? And may he not be right in this? Herbert Read for one thinks so. "Sculpture," we read [in his introduction to *Henry Moore: Sculpture and Drawings,* excerpted above] "is the creation of solid forms which give aesthetic pleasure. . . . They arise and are proliferated by laws which are formal and not representational . . . Nothing, in the history of art, is so fatal as the representational fallacy."

Herbert Read condemns the sculpture of the last centuries, the sculpture between the Renaissance and Rodin, for

this reason. But he should go further. He should include Rheims and Chartres, and Autun and Moissac, and a good deal of what he himself illustrates. Nobody denies that in the admiration of art in the past much has been associational. Eighteenth century philosophers discovered that, and it has not been forgotten since. The importance of associational values may have been overrated in Ruskin's time. But Ruskin was to my mind not much further off the mark than those critics who now insist on an exclusively aesthetic consideration of art. Admittedly a strong dose of aestheticism was, and perhaps still is, needed in Britain to neutralise Ruskin. But an antidote is not necessarily the healthiest of nourishments. The truth, I submit, is that while the specific values of a piece of good sculpture are formal, i.e. measurable only by aesthetic criteria, a piece of good sculpture should have others besides its aesthetic values as well. If it has not, it will be pure, but it may easily be poor. . . . The congruity between natural appearance and form is precisely what has made the work of great sculptors of the past great. This applies to Bernini no more than to the carver of the Chichester reliefs. If, as it happens in so much academic and fashionable sculpture of the nineteenth century, that congruity is not accomplished, if the nude is admired *qua* nude exclusively, and not *qua* form as well, then of course the sculptor has failed.

Now Henry Moore knows that. Herbert Read indeed appears at first sight *plus royaliste que le roi.* Henry Moore says of his **Northampton Madonna** that he intended to endow the figure with "austerity, nobility, and some touch of grandeur (even hieratic aloofness) and with a quiet dignity and gentleness . . . a sense of complete easiness and repose." Herbert Read quotes this statement and qualifies it like this: " . . . all qualities which can be immediately related to formal values." His summing-up is: "Every intellectual virtue or emotional tone must be given an aesthetic justification." But what remains of his indictment of the "fatal representational fallacy," once he is ready to accept associational values, wherever they are "immediately related to formal values"? That is, it seems to me, exactly what the sculptor of the St. Theodore of Chartres did, and what Michelangelo did, while Henry Moore in the majority of his figures refuses to do it.

For what he wrote as his Credo ten years ago [see Artist's Statements above] sounds different from what he has now said about the **Northampton Madonna.** He maintained then that sculpture ought to depend entirely on "vitality of its own, not reflection of the vitality of life, of physical action, frisking, dancing figures . . . " Here, I think, Henry Moore unduly restricts the range of legitimate effects in a work of sculpture. The vitality of the Delphi *Charioteer* is sculptural, i.e. formal, vitality, but the fact that it is just this and no other formal vitality is due to a process in the artist's imagination which was set to work by a charioteer's and not by a ballet dancer's vitality, and which can only be reproduced in the onlooker's imagination with any degree of precision, if the appearance of the *Charioteer's* form offers a clue. Not only will it help the common man's understanding, if he has the visible peculiarities of the *Charioteer* to guide him, but the associational and the aesthetic qualities will indeed enhance each other so that the final result is a fuller and more intense emotional pleasure than that attainable by aesthetic (or associational) values alone.

Thus I contend that Henry Moore has limited the response to his work for reasons of an arbitrary aesthetic purism. What he has achieved in spite of these self-imposed limitations is all the more worthy of admiration. In a piece such as the **Reclining Figure** at the Buffalo Museum (1936) a block of elm wood is hollowed out and pierced in such a way that an immensely suggestive interplay of solids and voids takes place. The grain of the timber underlines forward and backward movements and at the same time the unity of the entire mass. The movements feel convincingly like those of a live body with weight where our sense of stability demands it and perforation where no inert matter must stand. Head, breasts and limbs are indicated just sufficiently to keep our associational faculties at play.

The title **Reclining Figure** alone would of course have done that, and it is noteworthy that Henry Moore nearly always chooses titles for his sculptures more specific than *Composition* and the like. For Henry Moore has at no time ever been an abstract artist, although he has done abstract work. The particular emotional qualities of his work are determined by nothing more decisively than by his refusal to sacrifice natural appearance entirely. On the other hand natural appearance is nearly everywhere reduced to conveying a vitality, *lower* than that of the human (or the animal) body.

Nearly all Henry Moore's figures and groups have this in common that the forms of higher life are converted into something overwhelmingly suggestive of lower life, of the blind growth of roots, of vertebrae or even cartilage, or of the passive suffering of the pebble gradually eroded by the slow action of water and sand. Now Michelangelo had also a deep feeling for nature in her inarticulate growth, for rock as rock; and in carving his figures he often left it unhewn or hardly hewn around them. But in his *Aurora* that rock has a second function besides: the function of expressing the travail of Day, that is full consciousness, arising. In Henry Moore's figures there is powerful existence, but never action. Michelangelo has action—hemmed in by crushing resistance, but action all the same. Man in Michelangelo has the freedom to act. Man in Moore is not fit to act. Limbs often are tapered like stumps, heads often excessively small. The affinity with primeval animal stages, with dinosaurs, the diplodocus in particular, is not accidental. It is a groping towards the elementary, the pre-conscious. And there can be no doubt that this preference for pre-human vitality—in so far as it indicates an outlook on life behind the forms once more severely cuts down Henry Moore's potential public.

Now this is all that I would have had to say, if it were not for Henry Moore's work during the last three years or so. In the **Northampton Madonna** and the watercolours of **Shelterers** and **Miners** the jobs themselves, once the artist had accepted them, forced him into a reconsideration of his theories of 1934. The result in theory has been quoted above. For the result in practice we have to thank Canon J. Rowden Hussey on the one hand, and the War Artists' Committee on the other. The commissions of the War Artists' Committee have been a great gain to British art. They have shown up mediocrity, but they have also opened to a number of genuine artists avenues which, without the stimulus of very specific commissions they might never have explored. This applies to John Piper, to

Kenneth Rowntree, and it applies, in my opinion, very much to Henry Moore. (pp. 47-9)

N. Pevsner, "Thoughts on Henry Moore," in The Burlington Magazine for Connoisseurs, Vol. LXXXVI, February, 1945, pp. 47-9.

A. D. B. Sylvester (essay date 1948)

[*In the following excerpt, Sylvester presents a detailed examination of the evolution of Moore's sculptural style.*]

The creative process is like the Wimshurst machine. The artist's mind corresponds to the power that turns the wheel, the work of art to the spark flashing across the space between the two electrodes, the electrodes to the two poles in the physical world from which art springs— nature and the unshaped artistic material.

The artist's education consists in preparing those electrodes for work, that is to say, in finding out about appearances and in discovering the possibilities and limitations of his medium. Henry Moore separated these two domains of study. He learnt about his material without making any considerable effort to come to grips with nature, basing his early stone-carving on Precolumbian, and his early wood-carving on African, sculpture seen in the British Museum. Meanwhile he studied nature independently of the complications of carving by drawing and modelling the human figure from life, in an idiom influenced by the frescoes of Santa Maria del Carmine—which he visited in 1925 at the age of twenty-seven—that adhered to natural proportions, somewhat thickened out to emphasise mass and eschew Praxitelean prettiness. (The separation was not, of course, complete, because while he was learning about nature he was also learning how to use clay and how to express the knowledge of three-dimensional form on a two-dimensional plane.)

Moore's use, at this stage, of two widely divergent approaches was clearly not the consequence of vacillation, of casting around for a style, because the variation of style always corresponded to the variation of medium, except in the case of one or two stone-carvings in a manner usually associated with his modelling. Nothing, indeed, could have indicated a greater decision and self-awareness. He had decided what artistic traditions of the past had most fully realised the potentialities of wood and stone and, in seeking what he has called 'truth to material', was using their methods and discoveries in order to assimilate the methods and re-make the discoveries for himself. As to nature, it had to be approached with less stylistic prejudice, and was most directly approachable through such highly flexible media as modelling and drawing. The rapidity with which they are executed permits working directly from the model, whereas carving does not. Modelling, moreover, could help him to grasp the tactile as well as the visual plasticity of forms because he could reconstruct them within his hands and thus attain a profounder sense of their volume.

Nevertheless, behind Moore's use of two different approaches there lay something more than recognition of the need for a dichotomous education. Common to all the naturalistic works was a mood of gentle contemplation, while more passionate feelings invariably found expression in the anti-naturalistic carvings. Even in his mature work, Moore tends to adhere more closely to nature when the content of a sculpture is tranquil than when it is more highly charged with drama. Never, indeed, has the duality been more apparent than in the two big reclining figures carved concurrently in 1945-6—the elm *Reclining Figure* and the stone *Dartington Memorial Figure.* Explanation of this will be possible at a later stage in this essay.

Moore's first effort to synthesise his naturalistic and Precolumbian styles was made in the relief *North Wind,* of 1928, on the Underground Building, St James's, a somewhat unhappy work which does not seem to have been conceived as a relief. The movement and solidity to which it tries to give conjoint expression are both present, but side by side, as it were. The attempt at a synthesis fails because the resultant style is neither Mexican nor naturalistic, but a rather commonplace Shell-Mexican geometrified realism. In spite of these shortcomings, it is alone among the Underground Building reliefs in exhibiting real sculptural power.

The sculptor can fulfil the three-dimensionality of a block of stone in two ways: either by emphasising its weight by means of broad masses, or by emphasising its depth by hollowing it or boring holes clean through it, and so letting in light. The latter method was first used to any extent by Moore in the *Reclining Figure* in alabaster of 1929. While a mercurial rhythm moulds the masses into repeated motifs, so that bent knee and upstanding shoulder echo each other to become mountains while the head and each breast assume the shape of a pear, between torso and akimbo arms is hollowed a space into which the breasts project to establish *internal* relations of mass.

In the dynamism of its linear rhythm and in its method of expressing three-dimensionality, this *Reclining Figure* is not typical of the 1929 carvings. A work that is typical is the *Figure with Clasped Hands* in Travertine marble. Here the shapes are more box-like and Mexican, and it is from this box-ness that its three-dimensionality is derived. Every view expresses a different feeling, ranging from the stolid to the quick. The deeply moving plasticity of the head is tense to breaking point as the protruding stylisation of gathered hair at the back struggles to wrench round and touch the face. In *Figure in Concrete,* fully three-dimensional form is achieved by emphasis on both weight (in the breasts and the head and hands built up in planes) and depth (in the carved-out belly). The realisation of both weight and depth reaches a monumental level in *Reclining Figure* in brown Hornton stone, the most ambitious carving of this fertile year and prototype of many later reclining figures. A quietly disturbing massiveness is the effect of its construction in a minimum of surfaces, of the squat dignity of the pose and, above all, of the narrow but deep, mysterious space between the huge, slightly parted, thighs.

It was in 1930 that the separate existence of two styles made way for a synthesis between the Precolumbian idiom and the less angular forms derived directly from nature. One imagines that Moore, now confident of his capacity to give solidity to form, no longer felt obliged to confine himself in carvings to those squat and squarish ones which attain this solidity by the easiest possible means. Modelling ceased and the carving absorbed the residue of its content, becoming more refined, more Italianate, more hu-

manist—capable of achieving both the classical purity of the *Figure* in Armenian marble and the baroque vitality of the *Reclining Woman* in carved reinforced concrete. Humanism took him to the expression of character—a unique accomplishment among modern sculptors of comparable formal astringency. The reticence of expression which follows from that astringency is all the more telling than the over-emphasis of a Rodin: it implies passion never melodramatic, tenderness never cloying, sexuality never lascivious.

In all, Moore's second period (1930-2) can be epitomised as 'humanist'. Although the treatment is by no means as naturalistic as in the early terra-cotta and concrete sculptures, the human head and figure are simplified and modified rather than distorted. The feelings expressed, though not their expression, are essentially commonplace: the mother tenderly suckling her child or fearfully protecting it from a menacing external world, or holding it up as an offering to the sun; or, again, the freshness and virginal simplicity of a series of sculptures called *Girl.*

Overtones of pantheistic mystery and an underlying rhythm of primeval power, present in the first period but absent from the second, later became the predominant feeling-tone of the third. The last works of the second period formed a *cul-de-sac* at the end of a road from which the origin of the next line of development had already branched off in sculptures, untypical at the time, which departed radically from the proportions of nature. As early as 1930, Moore had made such a departure in the Cumberland alabaster *Figure* and Corsehill stone *Reclining Figure.* But in these cases it was perhaps primarily with the intention of exploring new formal relations prior to incorporating them into humanist sculptures, namely the *Mother and Child* in Cumberland alabaster (1931) and *Reclining Woman* in green Hornton stone (1930). (The practice of exploring a sculptural idea first in the abstract and subsequently in a more human form has been recurrent throughout Moore's evolution.) On the other hand, a *Reclining Figure* of 1930 in Ancaster stone, in the same style as the *Figure* and *Reclining Figure* just mentioned, did not proceed, as they did, back to the human figure, but to a still more radical departure from it in the octopoid *Composition* in Cumberland alabaster (1931), with which a single contemporaneous work, the lead *Reclining Figure,* bears stylistic affinities. These two sculptures were the most crucial turning-point in Moore's development, and both were seeds of much that was later evolved: *Composition* of all his third period, *Reclining Figure* of the lead sculptures of 1938-40 and the stringed figures of 1937-40. 1931, then, was the point at which the new road branched away, although for another year Moore carried the old one to its conclusion. Finally, towards the end of 1932, he turned entirely to his new preoccupations and, for some years, never sculpted the human figure as such, except in the carved reinforced concrete *Reclining Figure* of 1933, whose stylistic kinship, however, is with the lead *Reclining Figure* of 1931, in which year the well-known study for it was drawn.

The works of the third period are fantasias composed of forms each of which represents or evokes various species of objects in some respect similar in shape. These objects are bones, shells, pebbles, rocks and caves, birds and fishes, and, above all, isolated organs or fragments of the human body. A number of different kinds of object are evoked by each shape in these fantasias because the sculptural shape is the highest common factor of the shapes of the objects it evokes. Hence, the sculptural forms are, so to speak, elemental, because they are common to objects of widely varied materials and sizes—raised knee and mountain; breast and fruit; vagina and cave—or else the analogy is merely between two or more different parts of the body: navel, nipple and eye. The elemental shapes are combined in the whole sculpture as if the human body had been dismantled and reassembled with the fragments in a new configuration capable of expressing a specific feeling or *conatus* better than it could be expressed by the mere modification of nature's configuration. At the same time, the constituent forms representing the rearranged fragments also evoke extra-human objects. Since they are *multi-evocative* in their reference to nature, these forms carry a rich variety of association, brought from the entire range of the species they evoke, and their emotive value is therefore complex, because of this richness, and mysterious, because they reveal analogies of structure between objects which superficially do not resemble one another, and also because their configuration in the whole fantasia shows how shapes unconnected in nature can be grafted together. Finally, an especial value appertains to those forms which evoke an object in stone and a part of the body because, when nature forms in the material used by the sculptor a shape that already resembles a part of the human body, such a shape is clearly the perfect model for the sculptor who wants to form that part of the body with a respect for the potentialities of his material.

The potentialities of his material, the fact that he was a sculptor and not a poet, were never forgotten by Moore, in whose abstract surrealism the surrealism never became literary, and the abstraction never empty. The juxtapositions of forms unconnected in nature, which arose in the fantastic configuration of the constituent parts, were never visually arbitrary because their *raison d'être* was always primarily plastic, not symbolic. Every new configuration was justified plastically by its capacity to give sculptural coherence to a block of stone.

Seldom has Moore created an image so mysterious and so rich in association as the Corsehill stone *Figure* of 1933. The sinister orifice is the entrance to a cave, a navel, a sexual image, all-seeing eye and all-devouring mouth. The curved back is uterus and egg, symbols of fertility and eternity. The protrusions at the front are breasts and wings. The sum of the parts is not human at all, but a boulder washed by the sea, a dinosaurian creature and a monstrous inhabitant of the moon. Inverted, however, it becomes a female torso, with unambiguous abdomen and breasts.

In a similar work carved the same year, the Travertine marble *Figure,* Moore carried to its logical conclusion the method of asserting the third dimension through the emphasis of depth by carving clean through the block. 'Sculpture in air is possible, where the stone contains only the hole, which is the intended and considered form.' Simultaneously almost, he found in the multiple-figure composition another means of introducing space into the sculpture. The following year he began to subject the surface of the carving to a graphic treatment. This reached its cli-

437

max in the green Hornton *Square Form* of 1936 and thereafter diminished.

We need not labour to expound the value of such graphism when its function is purely abstract. But, where Moore has used it to indicate facial features, the effect is often disconcerting, for it tends less to give the head a greater expressiveness than to detract from its nobility by oversimplifying what is better wholly omitted. How much more expressive, how much richer in its evocation of facial forms, is the mere inflexion of a plane in the face of the left-hand figure of the *Three Standing Figures*—an inflexion which implies the jutting-out of both nose and chin. Again, the features are suggested in certain other works by a hole or a slot—so evocatively that a specific feeling is thereby communicated in spite of the rigid economy of means. We are led to infer that even the simplest plastic treatment of the facial features produces, with Moore, a more powerful expression of them than does a graphic treatment, although the latter is usually more representational.

Between 1934 and 1937, the fragments of the human figure became gradually less conspicuous in Moore's vocabulary of forms, which remained, nevertheless, far more dependent on nature than on geometry. The main sources of his sculpture in stone became—with exquisite logic—rocks, pebbles, shells and bones. At the time of the Corsehill *Figure* of 1933, the primary evocations had been human and the secondary ones inhuman. These roles were gradually reversed, the change reaching its consummation in the 1937 Hopton-Wood stone *Sculpture* and bird's eye marble *Sculpture,* but even here the latent presence of human forms is indicated by the natural growth of the latter work into the *Recumbent Figure* of 1938 in green Hornton stone, and by the creation, in 1936, of two elm sculptures which fully anticipated this *Recumbent Figure.* Moreover, the astonishing *Reclining Figure* of 1937 in Hopton-Wood stone evokes not only a reclining human figure whose face stares at the sun, but—of all things!—a reclining human profile and a shoe. Apart from these considerations, even the works most dehumanised in form—*e.g., Two Forms* and the two *Square Forms* of 1936 and the two *Sculptures* of 1937—were not dehumanised in content. Shapes drawn from the inanimate world served to express human emotions by means of plastic analogies with psychological processes and constellations. In 1937, Moore wrote: 'My sculpture is becoming less representational, less an outward visual copy, and so what some people would call more abstract; but only because I believe that in this way I can present the human psychological content of my work with the greatest directness and intensity.' The diminishing evidence of human shapes was neither intended to make, nor succeeded in making, his work any less a communication of human emotions. There *was* a fundamental change taking place at this time, however, namely, in the precise method of communication, whether the shapes were human or inanimate. The multi-evocative method of communication, with its dependence on the recognition of associations, while by no means eliminated, ceased to be predominant. It became an adjunct to a more direct method, only secondarily dependent upon the interpretation of signs, *i.e.,* evocation of objects, and not at all dependent upon symbolism, *i.e.,* designation, in accordance with some convention, by an object or an idea. With the later works of the third period and their successors, the

spectator's apprehension of the content derives mainly from his intuitive apprehension of an analogy between a shape and a mental event, the efficacy of which analogy depends on unconscious and preconscious awareness of past associations, but not on a conscious (verbal) remembering and recognition of them. Thus he is immediately aware, for example, in regarding a form most of whose weight is near the top, that the form has an upward action and expresses the emotional implications of such an action because the connection between such a form and such an action and such an emotion is firmly established in the memory (in this case preconscious rather than unconscious), since that connection has long been a habitual perception.

The close inter-relation of human, monstrous and inanimate forms in the third period gives rise to a pantheism in which a single life force is imposed on all the divers contents of the physical world. From its connection with the inanimate, the human form acquires endurance and eternity. From its connection with the human, the inanimate form acquires the animistic vitality of the totem. A sense of mystery follows from the supposition of unity between unlike things, from the protean character of a sculpture that can appear, at one moment, to be a fragment of the human form, and, at the next, a fragment of inanimate nature. The protean, metamorphic, forms, with their multiple evocations, here placate us by revealing that functionally similar objects are also physically similar—*e.g.,* breast and fruit—there, startle us by revealing that functionally different objects are physically similar, *e.g.,* nipple and eye. We are led back to a primeval world in which the differences between classes of objects, highly evolved into particularity, are reduced into the primal substance of stone. This primeval world consists of forms which might have existed on some vast seashore before the coming of man. (There is some affinity with Tanguy, whose paintings, however, seem rather to be a *recollection* of such a world, whereas Moore creates that world in its reality—in his drawings no less than in his sculpture, so that this difference from Tanguy is not the product merely of difference of medium.) Some of these primordial forms are huge boulders. Others—though carved at an earlier date—have been evolved from those boulders into living things, dinosaurian monsters. But man is everywhere implied, and it was now Moore's task to evolve man from these primeval entities.

The process of evolution from the primeval to the human was rendered visible in a lead *Reclining Figure* of 1938 in which the upper half of the body grows from the form of a bone. The forearm is stretched and tapered to press upon the earth, while its inner edge forms one side of a nearly semicircular arch, twice hinting at angularity, which springs tensely upwards with the stress of Gothic vaulting.

In the humanist sculptures of the second period, Moore's representation of the human figure had not departed radically from the proportions and external contours of the body. The *proportions* characteristic of the fourth period reverted to those of the human figure—away from the freely invented proportions of the third period—but the *constituent forms* were evolved less from those of the body than from the bone and pebble forms of the later third period. Moore was now more than ever preoccupied with the hole and with concave shapes in general. Since the exter-

nal contours of the human figure are predominantly convex, emphasis on the concave implied seeking inspiration elsewhere: in the shapes of bones—often concave in one dimension, convex in another—such as the knuckle and the femur, in the internal shapes of shells, and in such architectural forms as the arch.

A convex surface encloses the sculptural mass, which withholds its energy from the space surrounding it, so that a sculpture composed mainly of convexes has a quality of repose. A concave surface lets space into the mass. Where the concave is a hollow between convex bulges, the space appears to push against the bulges so that they acquire an explosive vitality. Where the concave is the internal wall of a hole piercing a convex mass, the space within the hole seems to push the pierced mass centrifugally outwards. A combination of convex and concave—whether the concave is hollow or hole—produces a conflict at the surface of the convexes between the force pushing outwards and the contour essaying to confine it. This tension between explosion and repose, producing an effect of held-in energy—'an immense, pent-up energy', to quote Moore—is one of the factors that contribute to monumentality, because monumentality is not merely massiveness but an impression that the form contains tremendous energy, yet is strong enough and big enough to withhold that energy and prevent its escape. Hence, while monumentality can appertain to sculptures primarily dynamic or primarily static, it is necessarily excluded from a work which is the extreme expression of either quality.

Where convexes predominate, sculpture tends to be tranquil; where concaves predominate, to be vital. It is now clear why Moore's more tranquil representations of the human figure adhere more closely to its natural appearance than do his more vital representations, for, as I have just pointed out, most of the external contours of the human figure are convex, so that a statically-inclined representation of the human figure need only modify nature, whereas a dynamically-inclined representation, which has to emphasise the concave to become dynamic, must depart more radically from the human figure, not only hollowing out the mass, but carving large holes right through it, as in the big stone *Recumbent Figure* of 1938 and elm *Reclining Figure* of 1939, so that space can circulate more freely.

Thus the beginning of the fourth period saw not only the evolution of man from the primeval forms of the fantasias, but the start of an extensive use of concave shapes, in Moore's phrase, 'opening-out the forms'. Between the advent of this period in the wood-sculpture and in the stone-sculpture, there was a gap of two years. In wood, it began as early as 1936, with the elm *Reclining Figure* and *Figure*; in stone, with the green Hornton *Recumbent Figure* of 1938 which, though akin in dimensions to the elm *Reclining Figure* of 1939, is closer in shape to the *Figure* of 1936. Moore had long since ceased to sculpt in concrete, but 1938 saw his return to the use of lead—in a style related to that of the stone *Recumbent Figure.* Thus, it can be said that the fourth period got under way in 1938, for the two elm carvings of 1936 were his only antecedent works in the style of the fourth period, since his stone-carvings right up to the end of 1937 retained that of the third. The reason for this time-lag was stated in a recent letter from Moore: 'The explanation why the 1936 elm figures are un-

like any of the stonework of the same date lies, I think, in their material. I have always known and mentioned how much easier it is to open out wood forms than stone forms, so it was quite natural that the spatial opening-out idea of the reclining figure theme first appeared in wood, and it wasn't until two years later that my freedom with stone had got far enough to open it out to that extent without the stone losing its structural strength.' The stone sculpture of the third period had, indeed, evolved towards this opening-out, by means of a gradually increasing use of concave contours and holes. This was certainly one of the factors conducive to its dehumanisation, since natural precedent for the concave and the hole had to be sought elsewhere than in the human body.

That Moore did not hasten prematurely to open out stone forms indicates the respect he pays to the properties of the medium. Even when he did open them out, he did so less emphatically than in his treatment of wood and metal, and it is certain that his partiality to the concave will never be so fully expressed in stone as in these other materials. For stone in itself appears cold, strong and unyielding, and invites carving in those big convex masses which express repose. In contrast, wood of itself appears warmer and more flexible, and these qualities are best realised by carving holes, hollows and other concave shapes which give vitality to the mass. Again, lead has a mechanistic sleekness, and Moore has exploited this in sculptures possessing so much open space, and so little solid mass, that they are skeletons rather than bodies, scaffoldings rather than buildings. Hence, the eye pursues at speed their rhythms and their hard contrasts of light and shadow. Such a treatment makes the best, moreover, of their necessarily small scale, since the extremely dynamic character it gives them preserves them from a monumentality which would make them seem bigger than their dimensions, and cause them to seek the open air, like the stone and wood work, instead of resting at ease indoors. Bronze—in which the most recent metal sculptures have been cast—has not the same sleekness as lead, because of its patina. A surface green and matt, and not black and shining, is respected by a style which tends no less than that of the lead sculptures to perforate the mass with holes, but goes less far towards the condition of scaffolding by leaving unscathed somewhat broader areas of metal.

The opening-out of the mass is the constant factor in all the sculpture of the fourth period. The return to the human figure is not, because humanity was not the only species evolved from the forms of the third period. The second species was the stringed figure, whose seven manifestations in lead and wire, and six in wood and string, were constructed in the years 1937-40. Their initial stimuli were presumably the parallel struts spanning a space in the lead *Reclining Figure* of 1931, the carved reinforced concrete *Reclining Figure* of 1933, and a non-extant stone *Carving* of 1934. The struts recurred after the invention of the stringed figure in a lead *Reclining Figure* of 1939, as well as in various drawings of projects for sculpture which were never realised.

In the stringed figures, the struts are thinned out into lengths of string or wire, and multiplied into sets of numerous parallel or radiating lengths. These lengths traverse the hollow contained by a concave form; sometimes two sets traverse the same hollow in such a way that one

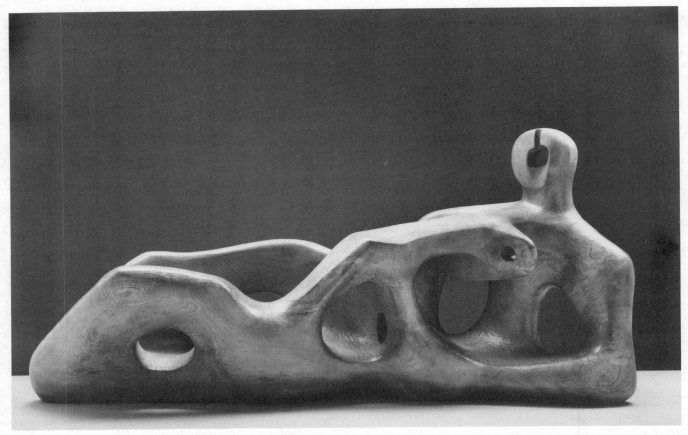

Henry Moore. English, 1898-1986. Reclining Figure 1939. *Elmwood, L: 6' x 7', H: 37", W; 30" 65.108)*

set is seen through the other. The tautness of the string is opposed to the rounded contour of the mass. The fact that space is contained within the hollow is emphasised by the presence of the string within that space. The tenseness of the string inevitably causes the eye to move along its length, so that direction is given to the space it traverses. When one set of bars is seen through another, the conflict of directions makes the space within the hollow circulate. 'Sculpture in air' becomes a reality because the hollow is no longer open and limitless, but is given shape on its open side: the space remains visible but its limits are now defined on all sides; it is a form in air.

A further means of opening out the form was discovered in the combination of internal and external forms. Moore explored the possibilities of the idea only once at this period—in the lead *Helmet* of 1940. (pp. 158-64)

Among the many works of 1938-40, two stand out as the finest produced by Moore before the war: the ***Recumbent Figure*** of 1938 in green Hornton stone, and the ***Reclining Figure*** of 1939 in elm wood. The vibrant elm carving, like its predecessors of 1936, has an essentially feminine character. The trunk, tunnelled all its length along, and corkscrewed within like the barrel of a gun, is no mere sexual *symbol*—for any such tunnel, though shaped with none of the subtlety and power of this, could be thus interpreted—but in every nuance a *rhythmic expression* of female sexuality. It is, moreover, cathedral and cave-like in its mysterious depth and yet again more than this, for we need im-

pose no arbitrary associational limit on the life embraced by its mercurial sensual rhythms, its stress of mass against mass, its grandeur and weight, its play of light that now illumines, now gives way to shadow, now reappears, as the holes in the flanks and the dense masses between them serve as windows and wall. Beside its slender neck and supple grace, the powerful neck and shoulders and aloof head of its complement in stone, the green Hornton ***Recumbent Figure,*** are distinctly male. But here sexuality is a minor factor, irrelevant and, so to speak, unremembered by the figure itself, a figure that has transcended the dynamic to settle into an eternal stillness and silence. It would not be absurd to call it 'older than the rocks'. (p. 164)

The interruption in 1940 of Henry Moore's sculptural activity prevented the realisation in solid form of many fascinating projects displayed in the drawings of 1938-40, the most inventive, the most tense, and the most exciting of Moore's drawings. But circumstance decreed that the shelter-drawings which followed them should have an immediate influence on the sculpture. The ***Northampton Madonna*** (1943-4) and ***Dartington Memorial Figure*** (1945-6) were so much the outcome of the shelter-drawings that they seem to constitute a monument to shelter life, an Apotheosis of the Shelterer seen in the light of Moore's perennial obsessions, the ***Mother and Child*** and the ***Reclining Figure.*** This influence provides one reason for the extreme departure of these carvings from Moore's habitual sculptural style, for in 1943 Moore wrote of the shelter

subject: 'I think I could have found purely sculptural motives only, if I'd tried to, but I wanted to accept and interpret a more "outward" attitude', and this 'outward' attitude was transmitted to the first two large-scale sculptures completed after the shelter-drawings, in spite of his belief, expressed in the same letter, that these drawings would not much influence his carving, 'except for instance, in the future, I may do sculpture which uses drapery, or perhaps do groups of two or three figures instead of only one figure'—which is precisely the way they influenced the recent *Three Standing Figures.* The commissioning of the *Northampton Madonna* made him give the lie to his expectation. It was not so much that a compromise was demanded as that the subject—and, later, the memorial function of the Dartington carving—required something gentle and restrained in mood. This, for reasons explained earlier, involved using a more naturalistic style than that of the concave-ridden works of the period immediately antecedent to the war. A further factor conducive to naturalism was the need to express simple, accessible, finely-shaded, perhaps, but specifiable feelings, as against the complex, mysterious, metamorphic feelings of those works I have termed 'multi-evocative'. In the same way, the naturalistic member of the *Three Standing Figures* expresses a simple, though subtle, womanly emotion, whereas the two other figures, whose style is anti-naturalistic and multi-evocative, are hermaphroditic in form and in content a mysterious, ambiguous, complex of conflicting emotions.

The naturalism of the *Northampton Madonna* was, then, a perfectly adequate means of communicating the feelings which Moore associated with the 'Madonna and Child' theme: . . . the *Madonna and Child* should have an austerity and nobility and some touch of grandeur (even hieratic aloofness) which is missing in the everyday "Mother and Child" idea'. But this is hardly enough. While the need to express the sense of universal motherhood is here recognised, what of the sense of *virgin* motherhood? What of the foreboding of Calvary? Of course, we should never accept at its face value the statement of an artist; of course, any artist—any good artist—never *says* all he means. But in this case the sculpture expresses precisely what the sculptor has said it ought to express—and scarcely more. It fails to go further, towards the saintly, brooding character of the Masaccio *Madonna* in the National Gallery; of the French Gothic wood-carving of a *Madonna* in Moore's home. It is an incomplete conception of its subject. (pp. 189-90)

To explain the insufficiency of the *Northampton Madonna* we must look further than to the personality of the artist. Even assuming that a renascence of ecclesiastical art were possible, the Madonna and Child would be a subject to avoid. Though millions still assent to the Mystery of the Virgin Birth, it is certain that few believe in it with the overwhelming conviction required to give it artistic expression. Without that conviction, it is possible to create only what is virtually another 'Mother and Child'. Now Moore gives not so much as a tepid assent to that belief, and, though being a creator of Christian art does not imply being a Christian, the non-believer can create *as if* he believed only when he belongs to a society of believers whose faith so suffuses the *Zeitgeist* that he can achieve not merely a suspension of disbelief but a positive identification with the feelings of those who do believe. (History seems to contend, indeed, that the non-believer living in an age of Faith produces art more expressive of that Faith than does a believer living among pagans.) In short, there must be some deep emotional sympathy with Christian dogmas—and not just the historical Jesus—in an artist concerned to produce art for the Church. That Moore is not an adherent of Christianity is irrelevant, since this would not preclude his feeling such a sympathy. But all that his sculpture stands for, while far from exclusive of everything that is Christian, has no connection with the more specifically Christian emotions as distinct from the more universal religious emotions: especially does it imply denial of the idea of Virgin Birth. Moore has shown himself at different times as a pantheist and as a humanist. It was not in him fully to identify himself with a third creed.

As to the formal idiom of the work, while it is not, as one writer would have us believe, 'defiantly modern', Moore is not deluded in maintaining that his habitual style and the naturalism of the *Northampton Madonna* and *Dartington Memorial* are based on the same fundamental principles. Hence, it is not on *a priori* grounds that I do not consider them to be among his best sculptures. It is simply that the principles are less well exercised than elsewhere. The head and neck of the Virgin are both lyrical and noble, and these qualities appertain also to the peaceful, contented pose of the Child, the placing of whose legs has an impressive ease and inevitability. His head, on the other hand, is too conventionally bonny. A high level of formal invention is not sustained throughout the Virgin: parts of the figure are monotonous in form while the folds in the skirt disturb by their irresolution of a difficult problem, especially when their rather arid formalism is seen in relation to the insufficiently formalised Child above them. The *Dartington Memorial* is better sustained in conception, but is massive without being expansive. We feel that the head could profitably have been accorded a greater intensity. The treatment of the drapery has lost the mawkishness which marked it in the *Madonna,* but at the cost of skirting dangerously close on arabesque. The mountainous right leg is the crest of the biggest wave in the wave-rhythm of the work, but, instead of appearing to rise up from the body, it seems to be suspended on invisible wires which its dead weight is trying to drag down.

Style is a function of the experience expressed by means of it. Moore did not adopt arbitrarily the naturalistic style of these works: the content he wished them to express could not have been expressed in any other style, and use of the style imposed by their content involved no contravention of the fundamental principles of his work. But the formal excellence of a work is proportionate to the conviction and profundity with which the artist has felt that which is expressed in it. It is, then, not the style which is at fault in the *Northampton Madonna* and the *Dartington Memorial,* but that their emotional content has not been felt at a level as profound as that of the experience expressed in Moore's finest works. That is to say, the place of these carvings in Moore's *œuvre* corresponds not to the place of the naturalistic drawings and pseudo-classical compositions in the work of Picasso, but to the place of the portraits in the work of Gris, in that they represent not a transition to a naturalistic style whose use attains the same level as the artist's use of his customary style, but a lowering of intensity and quality. We are concerned not with evaluating one style as against another but with eval-

uating every work within its own frame of reference. So it is that the naturalistic member of the *Three Standing Figures* is a masterpiece, because it is profound in feeling and consummate in form. Content has determined style, and here the content is profound enough to have procured the successful use of that style.

Moore has always made maquettes for his larger sculptures, but it was not until he cast about half-a-dozen of the ten or so clay studies for the *Northampton Madonna* that he began to make bronzes of them. Later he cast the two *Dartington Memorial* maquettes and two of the three for the 1945-6 elm *Reclining Figure.* The conception of the *Dartington Memorial* seems, indeed, to be more happily realised in this smaller form than in the big stone figure. Of the two bronzes, the one after the rejected maquette has more lyricism and gentle humanity than the one from which the *Memorial* was derived. (The principal difference between them is in the legs, which in the rejected study are parallel—as in the elm *Reclining Figure* of 1945-46—whereas in the definitive study the upper leg—like that of the brown Hornton *Reclining Figure* of 1929—rises like a wave.)

The expression of monumental feeling in a physically tiny form is manifest in the maquette (1945) for the *Three Standing Figures* carved (1947-8) in Darley Dale stone. This has been cast, most suitably, not in metal but in plaster. Dramatically, it is not a whit less impressive than the stone group. What the carving's greater precision, variety, and subtlety of form add are an infinitely greater purely visual interest and, in terms of content, a certain ambiguity, hence richness, of meaning, a broader, more widely implicatory, range of feeling. But the immediate emotional impact of these miniature totems which are the maquette is, if anything, more powerful than that of the carved group. If it is the case that Moore's past work has been elegiac rather than tragic, we are here confronted by an indubitably tragic premonition of conflict and doom, recalling an Æschylean *agon,* whether the ominous choric opening of the *Agamemnon* or the dispute in the *Choephorœ* preceding the murder of Clytemnestra: the latter, perhaps, is more to the point, for these figures are protagonists not spectators.

In extensiveness and variety, the most important series of maquettes is that for a *Family Group* commissioned in 1944 by Impington Village College, Cambridgeshire, but ultimately never executed. The series consists of seven models for a sculpture in stone, one for a sculpture in terra-cotta, and six for a sculpture in bronze. Several of these clay studies have been cast in bronze. (pp. 190-93)

Three of the *Family Group* maquettes were subsequently modelled on a larger scale and cast in bronze. The last and best of these groups showing twin children suspended in the hollow formed between the parents as they face each other is virtually an essay in the combination of internal and external forms which made its first appearance in the lead *Helmet* of 1940. The first and smallest of the three is notable for the conviction of the movement with which the child is passed from one parent to the other and for the successful rendering of a sense of both volume and lightness in the child. In spite of a relatively naturalistic style, the disposition of forms harks back to the lead *Reclining Figures* of 1938-9, in that concaves are extensive. In view of this relation to the lead sculptures, it is not sur-

prising that the most impressive casts in this edition are those in black bronze. These two *Family Groups* were both derived from maquettes actually conceived as studies for a sculpture in bronze. The origin of the other was a study for a sculpture in terra-cotta. There is a painful inconsistency—I do not wish to imply that stylistic inconsistency is necessarily painful—between the style of the stirrup-like torso of the father and hollow gourd-like torso of the mother, on the one hand, and the overgeneralised naturalism with which the children are represented, on the other. Here, indeed, we are brought embarrassingly close to the conflict between naturalism and Moore's established style which has been waged in his work since the time of the shelter-drawings. In 1930-32, he had been able to accept an unequivocal dichotomy of style, pursuing a parallel development of a comparatively naturalistic style already grown to maturity and of the multi-evocative style, then in embryonic state. But in the present phase the inter-relation of the two styles has been more complex, so that its manifestations can be classed in four categories. The first group, including the *Northampton Madonna,* shows a thorough-going naturalism. The second, which includes the 1945-6 *Reclining Figure* in elm and other works to be mentioned below, is what we know as 'Moorish'. The third combines in a single sculpture forms distinctly in one style with forms in the other: of this unhappy compromise the failure among the three larger *Family Group* bronzes is the outstanding example. The fourth comprises works in which the artist has sought an intermediate style, which he has found particularly in the other two larger *Family Groups.* But the conflict seems to have been resolved in a work which does not fit into any of these categories. The *Three Standing Figures* is related to the third group in that one of the figures is Moore's only great essay in naturalism while the other two are more akin to the 'Moorish' style. But the attempt succeeds precisely because the other two figures belong not to the second group but to the fourth, so that the contrast is evident enough to strike us but not so emphatic as to disturb us. Here we feel the presence of an inner logic to justify the contrast, an emotional *raison d'être* absent from the *Family Group* we have deprecated.

It seems most unlikely that many of Moore's future works will be required by their content to posit such a contrast. What is probable, however, is that the two anaturalistic megaliths of the *Three Standing Figures* may become archetypes of the future form of the 'Moorish' style. In taking this style a step further towards naturalism than it has gone before, they are extending a process of evolution which began with the elm *Figure* and *Reclining Figure* of 1936 and got under way with the green Hornton and numerous lead *Reclining Figures* of 1938. For we have already had occasion to remark of these works of the fourth period that, while their constituent forms had their origin in the bone and pebble forms of the third period, their proportions were akin to those of the human figure, in contrast with the freely invented proportions of the third period. In the two right-hand megaliths of the *Three Standing Figures,* not only are the proportions still closer to those of the human figure but the constituent forms approximate more than in the fourth period to the shapes of the parts of the body which they represent. Nevertheless, that they have not disowned their ancestry—the repertory of forms established in the third period—is apparent when we compare the shoulder of the foremost megalith with

the boulder-like abstract *Sculpture* in bird's eye marble of 1937.

We have divided Moore's pre-war work into four periods. It would be unwise to attempt a similar treatment of his later work, since we are too close to it and cannot predict its direction with accuracy. It may be that works such as the *Northampton Madonna* constitute a fifth period and that the *Three Standing Figures* initiates a sixth. But periods overlap and the fourth period has been extended in the works classed just above as the second group of Moore's present phase. The principal work of this group is the elm *Reclining Figure* of 1945-6. One other carving can be included: the brown Hornton stone *Reclining Figure* of 1947. The modelled works, five in number, are also *Reclining Figures.* Two of these are bronzes between 15 in and 18 in. long, dated 1945; two are terra-cottas, one 5 in. long, dated 1945, which is really a maquette, and the other, 17 in. long, derived from a maquette made contemporaneously with the first, dated 1946; the last is a bronze, 7 in. long, dated 1946. Of this last, there exist patined casts, polished casts, and casts left in their 'natural' state: the polished version shows it at its best. My own opinion is that both the small bronze and the small terra-cotta are superior to the larger figures.

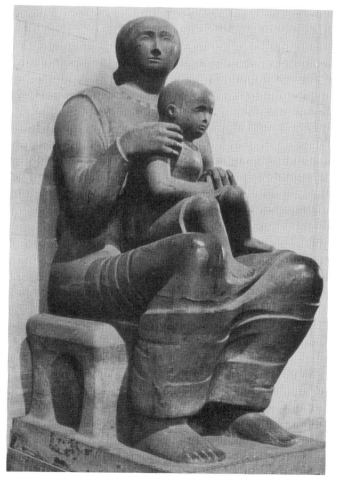

Madonna and Child (1944; *often referred to as the* Northampton Madonna)

If my guess is right that the *Three Standing Figures* are the precedent for a new formulation of Moore's style, then it may be that the brown Hornton *Reclining Figure* of 1947 is the culminating reclining figure of the fourth period. The maquette (1946) for and the present state of a Hornton stone *Reclining Figure* now in progress suggest that this is so, for it is the first carved *Reclining Figure* since 1937, with the exception of the naturalistic *Dartington Memorial,* whose central preoccupation has not been the 'opening-out of the form' which has characterised all the work of the fourth period. Certainly it is difficult to conceive, when confronted by the recent *Reclining Figures* in elm and in brown Hornton stone, how the erosion of mass could, without prejudice to sculptural coherence, be carried further, except by the development, which we have already anticipated, of the idea of combining internal and external forms, as in the lead *Helmet* of 1940. That the source—conscious or unconscious—of this form-idea is the image of the foetus within the womb is almost too evident. What taxes our imagination more severely is finding the source of the opened-out, eaten-away reclining figure.

> Subconscious imagery has the concentrated power to express many emotions at once, and often quite contrary ones, as we shall see. The chest, or breast, is the feeding ground of the child, and it is only natural from the child's point of view that it should be eaten away. Of Moore's two 'obsessions' the *Mother and Child* and the *Reclining Figure,* the latter is the more eroded, since the sculptor has not provided the woman with a child image, a part of which he reserves for himself.
>
> Through the procession of the reclining figures we see the results of this internal festival; but when we come to our 1945-6 *Reclining Figure* we surprise a palpable image of some enormous slug (at once foetus, child, and lover) burrowing with a teredo-like preoccupation; while the woman's head, with no other feature than a slotted mouth, yet manages an expression of satiety. This inward feeding image is even more implicit in the preliminary indications carved on the flank of the elm wood block. [Frederick S. Wight in "Henry Moore: 'The Reclining Figure'," *Journal of Aesthetics and Art Criticism,* Vol. VI, No. 2.]

What the author of this passage from the profoundest study of Moore that has been published did not know, and what so emphatically confirms his analysis—an analysis which shows the two 'obsessions' to be, at root, identical—was a remark which Moore made to me when he was carving the work in question: 'When I carve into the chest, I feel as if I were carving into my own'. This suggests that while, in the sculpture, the eaten-away mother is identified with the devouring and satiated child, the sculptor identifies himself with her and feels as if his chest were being eaten away. (Doubts that inferences drawn from a casual statement might be wildly speculative are allayed by the information that this feeling was experienced uniquely in association with this carving.)

It is to be hoped that the writer we have quoted may attempt to define precisely the unconscious significance of the *Three Standing Figures.* The maternal, protective, sympathetic character of the naturalistic figure is clear, but the hermaphroditic figures seem 'to express many emotions at once, and often quite contrary ones'. The Cy-

clops-eyed figure is tensed like 'a startled rabbit', to use the artist's own phrase, but is also itself startling, an ominous totem. So long as this figure seems frightening, the one behind it appears detached, even benevolent. But, as soon as the former assumes a frightened look, the latter becomes a stern and dominating, just and revenging idol. That the group comprises a trinity at once suggests a father-mother-child relationship: the Family Group is still with us, transformed into this apparently new theme as the Mother and Child melts into the Reclining Figure. If this is indeed a Family Group, the mother clearly presents herself in the figure on the left, the father becomes the partly concealed figure in the rear, turning his head away from the internal relationships of the group towards distant horizons, present both as a beneficent yet aloof power and as the commanding super-ego image, the agent of moral law, while the child is seen in the one-eyed figure, the most dynamic of the three, at once frightened by the authority of the father and itself aggressive and dangerous. But if its air is beyond doubt that of a figure transfixed and trying to escape, we are left in doubt whether it is anxious to break away from the group or whether it is seeking refuge within the family from an outside terror.

What we have been discussing here is, of course, the latent content, the involuntary content, of these works. It is of considerable significance relative to our understanding of the artist's creative process that content we might suppose to be manifest is often in fact latent, so far as he is concerned. Thus, not only the obviously unconscious symbolism of an 'internal festival' but even the relatively manifest double-image in the same work where calves and feet are metamorphosed into thighs and pelvis were not only produced unintentionally but escaped the artist's subsequent notice. In the same way, although the artist was aware of making the forms of the third period sculptures multi-evocative, many of the evocations which startle us long before we venture on any psycho-analytic interpretation did not occur to the sculptor when he was creating the work.

As to ourselves, the analysis of latent content has nothing to do with our æsthetic response to a work; the effect of latent content has everything to do with it. Beyond making this obvious point, it is worth mentioning again that Moore's work since about 1936 communicates its manifest emotional content without relying to the same degree as that which preceded it upon our recognition of the various objects suggested by the multi-evocative forms. The analyses just made of two recent works show their forms to have a multiple significance, but more on the plane of latent than of manifest content, so that it would be stretching a point to call them multi-evocative because evocation is a conscious process and the objects alluded to here—mostly involuntarily—do not have to be recognised consciously before the feeling-tone of the work is communicated to us. Our experience is enriched by such evocations as 'slug . . . fœtus, child, and lover . . . teredo', but it is vouchsafed to us in the first place through our capacity to respond to content expressible in the play of light on and about solid form, in the interplay of one mass against another, in volume and proportion, movement and rhythm.

The *Reclining Figure,* like the sacrificed and resurrected god of a fertility-rite, is at once skeletal and alive, prone in burial and flowering into new life, dug into the earth to be explored like the caves in a cliff or the hollows in a fall-en tree and bursting with energy in every deflection of a rhythm, reinforced by the grain, moving perpetually along the length of the figure and into and around its depth. The chest, a heart twice eroded where slotted by wide apertures, is made by this rupture of convex by concave to inhale and exhale the light. Sexuality is imaged in the huge thighs, the tense, thrusting crotch between them, and the holes at the back which admit light to push the thighs apart. The shape of the crotch is repeated again and again, lengthways and depthways—even in the space between the feet, for the calves, bent back at right-angles to the thighs, are themselves thighs, and the feet a pelvis.

The troubled yet noble attitudes of the *Three Standing Figures* and, above all, the spatial relations between them are dramatic below a surface whose calmness all but conceals the sense of tragic foreboding which yet does not exclude an ultimate apotheosis. Man is both the frightened savage and the tribal god, both off-spring and ancestor of the earth. (pp. 193-95)

A. D. B. Sylvester, "The Evolution of Henry Moore's Sculpture: I & II," in The Burlington Magazine, *Vol. XC, Nos. 543 and 544, June and July, 1948, pp. 158-65; 189-95.*

Rudolf Arnheim (essay date 1948)

[*A German-born scholar and aesthetic theoretician, Arnheim is noted in particular for his highly-regarded studies of the interrelationship of human psychology and art. In the following excerpt, Arnheim focuses on the function of concavity in Moore's sculpture.*]

In the works of Henry Moore's recent style, the trunk of the figure is often pierced and subdivided in such a way that instead of a compact volume one sees a configuration of slimmer units. For instance, the chest may be given as a large hole, which is roofed by the shoulders and flanked by the upper arms. What is the artistic purpose of this peculiar procedure?

The human figure has always presented the sculptor with a compositional problem. The body consists of a heavy trunk and the much slighter appendices of the arms, the legs, and the head. Since the artist's task is not to copy what he sees but to create a whole pattern of unified form, he must find a way of imposing unity on so heterogeneous an object. How can he organize the trunk and the limbs in one integrated composition?

A valuable monograph could be written on the various ways in which different styles of sculpture have coped with the problem. Some fused trunk and limbs into one volume. Others reduced the trunk to stick-like slimness, thus assimilating it to the limbs. Again, limbs could be made short and plump to match the trunk. Intermediate volumes also can be introduced to bridge over the difference between the bulky and the slim. When the artists came to handle the human body more freely they sometimes eliminated the problem by cutting off the limbs and the head. Henry Moore's solution is of a similarly radical nature. By transforming the heaviest volume, the trunk, into a configuration of narrower shapes, a common denominator has been found for the whole figure. The beam-like or ribbon-shaped units which represent arms and legs differ little from those which are found in the area of the trunk; and

the holes that pierce the body resemble those between the legs or between the arms and the torso. In some of the reclining figures, a surprising symmetry is produced by the correspondence between the frame of the pierced chest and a similar frame formed by the two legs. Ingeniously balanced, the figure reposes on its horizontal base.

Uniformity of the parts is one method among others to accomplish unity. Without ever getting repetitious, Moore stresses uniformity, not only in the roughly equal size and proportion of the units, but also in their shape. More and more has he come to eliminate the distinctive formation and detail of faces, hands, feet in favor of some over-all shape characteristics. Wherever we look we notice strongly dynamic form: the tranquillity of the cylinder, cube, or sphere is avoided in favor of conic or pyramidal shapes, which grow smaller or bigger, and egg-shapes, which drive in a definite direction. Moore enhances uniformity and vigorous mobility also by avoiding clear delimitation of parts. Even though precisely articulated, the units flow into each other. Even the dead-ends of the hands and feet are eliminated. They merge with each other or stream back into the body of the figure, thus permitting the circulation of energy to continue unchecked.

This stress of the interdependence of things, their mutual influence, the indivisible unity of the whole is likely to reflect the artist's conception of the world. But the structural pattern which conveys this meaning is possible only at a high level of formal development. True, no work of art lacks an intimate interdependence of parts, but it is well known that at early levels of conception, for instance in the drawings of young children, the complex patterns of a human figure or an animal are built of geometrically simple units, which are kept apart through explicit outlines. Gradually, these subdivisions disappear and the whole is conceived as one complex unit. Only at a late state of this process of growth, which has a parallel in the developmental laws of human thinking, can the complexity of dynamic interchange be grasped through scientific or artistic patterns. One can express this also by saying that stylistic structures like the one created by Henry Moore approach the representation of the irrational. [The critic adds in a footnote: "Rational is everything which can be referred to definable concepts. These concepts may be intellectual, as for instance when we recognize an object of known nature and function: This is a hand! Or they are perceptual, as for instance when the thing we see is relatable to well defined shapes, colors, directions, etc. Both kinds of attribution are made difficult by Moore's style of form."] This is a romantic tendency, which shies away from the defined and congealed. Moore's romanticism cherishes the mysterious intangibility of what grows, changes, and interacts. Herbert Read has aptly analyzed his romantic attempt to derive an image of man from the organic and inorganic formations of nature.

The equalization of the parts, obtained by the breaking-up of the trunk, tends to minimize the biological difference between the limbs as executors of voluntary action and the trunk, which is more directly connected with the vegetative, instinctive functions. A uniform overall-principle of life seems to govern the whole figure in all its parts. This playing down of the late cerebral developments of homo sapiens in favor of more universal forces of nature is again a romantic trait of Henry Moore's art. One notes in this connection that the horizontal position, which he uses so frequently, devaluates the importance of the head and stresses the abdomen as the compositional center. The heads are small. That is, the role of the brain carrier is reduced. These faceless heads do no thinking or feeling of their own; at most, they occasionally turn around to gaze with the simple steadiness of grazing cattle. Similarly, the tentacles of the hands and feet are planed down, fused, tied together. One has only to think of the alert faces and telling gestures of the terracotta figures which rest on Etruscan coffins in almost the same position to realize the difference. The grace and intelligence of Moore's work is all in the form pattern which characterizes the whole figure with no distinction of any specific part.

Another glance at the holes leads us to notice that they are not merely dead and empty intervals between the material parts of the figure but peculiarly substantial, as though they were filled with denser air. Among the factors that make for this effect, one stands out in particular. The surfaces which delimit the openings are frequently not convex but are concave, forming hollow containers of space. Striking examples are the spherical holes which pierce the chests of some of the female figures to indicate the breasts; or the circular holes in ring-shaped heads; or the dells formed by bent arms. Wherever such concavities dent or perforate the sculptural body, a puddle of air seems to fill them almost tangibly. (pp. 29-31)

In any drawing or painting, figure-ground relationships help create the pictorial space. This is true not only where human bodies, houses, etc. are shown in front of a background, but wherever objects or parts of objects overlap. Generally, a number of figure-ground factors are used simultaneously and for the most part antagonistically. That is, a tree may be made to appear in front of a wall, as figure on ground, while at the same time other factors will check the effect by stressing the figure-character of the wall. The reason for this is that the painter has always to cope with the double task of creating space and "keeping the plane." Even where a human figure is shown in front of a homogeneous background, as in the portraits of Holbein or the Quattrocentisti, the unity of the picture-plane can be preserved, for instance, by the amount of space and the color and brightness given to the background.

Thus far, psychologists have studied the phenomenon of figure and ground only in plane patterns, but their results can be applied to the third dimension. True, there are important differences. Whereas in a twodimensional drawing the contour which divides two areas can be observed, the common boundary surface remains hidden when two opaque volumes meet in three dimensional space. You can see the line which separates Olympia's body from the divan on which it rests, but not the surface which the body and the divan share three-dimensionally. An exception occurs when one of the two volumes is transparent, as in the case of air enveloping an object. In this case, however, the transparent volume is non-existent for our eyes to such an extent that one hesitates to speak of a figure-ground relationship at all. It seems more proper to say that a piece of sculpture is surrounded by empty space than that it is seen on a positive "ground."

Within the frame of a painting every spot is positively present, first as a material part of the paint-covered canvas and secondly as a substantial element of the pictorial con-

struction. In a completed painting, the units of the composition vary as to their apparent density and also as to their spatial position within the figure-ground hierarchy, but none of them may give us the impression of an empty gap, a hole torn in the pictorial tissue. This is different in sculpture, where we are used to find all spatial relationships limited to the figure itself. These relations often reach across a void—and the length of the leap counts compositionally—but they generally do not include these intervals the way they would in a painting.

It seems necessary to state this principle of sculpture so positively even though it does not hold completely. The deviation from it which can be observed in Henry Moore's work has historical antecedents. For our purpose it suffices to point out the changed attitude to space in the most extreme but at the same time artistically valid example that is available so far.

Mainly through the use of concave forms, many a figure of Henry Moore's captures portions of space and makes them a part of itself. Much less solid than the wood, stone, or metal with which they unite, these air-bodies nevertheless condense into a transparent substance, which mediates between the tangible material of the statue and the surrounding empty space. Psychologically speaking, these statues do not reserve all the "figure"-factors for themselves. They do have all the "inner articulation" and are enclosed by the surrounding volume of air. But on the other hand they do not consist entirely of bulging convexities, which would invade space aggressively, but reserve an important role to dells and caves and pocket-shaped holes. Whenever convexity is handed over to space, partial "figure"-character is assumed by the enclosed air-bodies, which consequently appear semi-substantial. A fine recent work of Henry Moore's (**Family Group**) shows a man and a woman sitting next to each other and holding an infant. In most traditional works of sculpture the space enclosed by the seated body is essentially delimited by bulging convexities of the chest, the belly, the thighs. Thus it remains an empty interval. In Moore's family group, hollow abdomens make the two seated figures into one large lap or pocket. In this shadowed cavity, space appears tangible, stagnant, warmed by body heat. In its center, the suspended infant lies safely as though contained in a womb softly padded with half-solid air.

Since the holes are often shaped according to the same principle, it will be seen that they pierce the body of the statue in a material but not necessarily in a perceptual and artistic sense. In many cases they do not interrupt the substance of the figure but merely seem to rarify it into a state of transparency. This new function of space offers compositional opportunities. Sometimes, Moore establishes a contrapuntal correspondence between, say, a protruding head and a hollow of similar spherical shape. These instances prove that almost equal rights are conceded to hollows and solids.

Incidentally, this interpretation also seems to throw light on another disturbing feature of Moore's style, namely his use of strings and wires. The strings form surfaces which bound transparent bodies consisting of empty space. They too add volumes of rarified substance to the more solid principal material of the statue. At the same time, the directions of the strings interpret the shape of the volumes they enclose very much like the lines of the grain which

Moore uses so deliberately in his wooden and stone figures. Curiously enough he thus applies the theoretical recipe of another English artist, William Hogarth, who in his "Analysis of Beauty" recommended the interpretation of volumes through similar systems of lines.

The essentially negative role which the surrounding airspace has played in sculpture so far is not due simply to its invisibility, but also to the predominance of convex volumes in the figures themselves. Henri Focillon, in his stimulating book, *Vie des formes,* has distinguished two ways of using space in sculpture, namely *l'espace-limite* and *l'espace-milieu.*

> In the first case, space more or less weighs upon form and rigorously confines its expansion, at the same time that form presses against space as the palm of the hand does upon a table or against a sheet of glass. In the second case, space yields freely to the expansion of volumes, which it does not already contain: these move out into space, and there spread forth even as do the forms of life.

It seems to me that in the interpretation of *l'espace-limite,* too active a part is granted to the surrounding space. An archaic Greek figure, for instance, does not give me the impression that an inner urge to expand is checked from the outside. The discipline of such a style is all "internal." It is dictated by the law of development which limits formal complexity at the early stages. There is little capacity or desire to expand beyond the basic block. The function of the surrounding space is almost exclusively negative. The same holds true for *l'espace-milieu.* From the center of the figure bulging volumes push forward into empty space. Once this principle is stated, a more detailed analysis will trace here at the same time admixtures of a third procedure, which one might term *l'espace-partner.* In the later Greek, the medieval, and particularly the baroque sculpture the use of concavities indicates the possibility of making space an active partner of the figure. In Bernini's horsebackriding Louis XIV the sweeping locks and folds collect the air in hollow pockets. But even here the concavities are subordinated to the convexity of the whole to such an extent that they contribute no more than a minor enrichment. Among the great sculptors, Henry Moore is the first in whose work the surrounding space is not simply pushed out of the way by the aggressive protrusions of the wood, stone, or metal, but in turn thrusts into the figure from the outside, carving depressions into the yielding matter and adding to its substance. The proper balance and integration of the two antagonistic tendencies is a delicate task for the sculptor, in that the totality of the internal and external pushes must create one consistent unified surface. There are instances in Henry Moore's work where space, as if with a ramming thumb, interrupts the rhythm of the figure with a foreign imprint.

The foregoing examples will have shown that the figure-ground relationship is not simply a static distribution of spatial values but a highly dynamic interplay of forces. This is even true for twodimensional patterns. The "figure" is distinguished not only by appearing in front of the ground and by its greater density but also by a tendency to expand, to spread over the territory of the ground. In Henry Moore's sculpture the two-way relationship in which both the statue and the surrounding space assume figure as well as ground functions makes for a dramatic

interchange of forces between the two partners. The sculptural body ceases to be a self-contained, neatly circumscribed universe. Its boundary has become permeable. It has been inserted into a larger context. The masculine activity of its pushing convexities no longer operates in the void but is countered by positive thrusts from the outside, which force the additional role of feminine passivity on the sculpture. In other words, the tendency to avoid isolation and delimitation, to unite parts in an exchange of forces rules not only within the figure but is applied also to the relation of figure and environment. This is a daring extension of the sculptural universe, made possible perhaps by an era in which flying has taught us through vivid kinesthetic experience that air is a material substance like earth or wood or stone, a medium which not only carries heavy bodies but pushes them hard and can be bumped into like a rock.

How valid is this sculptural style artistically? How far can it lead and where? Undoubtedly it involves problems. Since we are all accustomed to thinking that definite boundaries are needed to determine the structure of a work of art, we notice with apprehension that the inclusion of space removes clearly defined delimitation. Those puddles of condensed air which fill holes and depressions have definite contours only where they border upon the body of the figure. For the rest, they seem to dissolve into empty space, thus leaving the work peculiarly open. True, the cubist painters, such as Feininger, have dispensed substantial air in crystalline form, but they had the picture-frame to keep all volumes within the bounds of a rectangle. Henry Moore's figures are frequently enveloped by a field of energetic matter, which weakens in power and density with increasing distance from the figure and finally evaporates. Incidentally, a similar infinity, in the opposite direction, is provided by deep hollows, whose internal end is hidden in the dark. The artistic implications of this style will need to be explored further.

Where will the principle of concavity lead? Its complete realization is known to us only from architectural interiors. But is there any aesthetic law to prevent the sculptor from creating hollow interiors, works one would have to walk into in order to see? I hesitate to call up the experience of climbing the staircase inside the Statue of Liberty. Even so, the principle deserves a trial. The two settings which have attracted Henry Moore as a draftsman are the hollow tube shelters and the interior of coal mines. His **Helmet** would offer to a mouse-sized visitor the most radical experience so far available of the use of surrounding concavity in sculpture.

What prospects are opened by Moore's attempt to decompose large volumes into configurations of slimmer units freely separated by interstices? Undoubtedly, such a style offers to the spectator a more complete survey of spatial relations. No more than three side-faces of a solid cube can ever be seen from one viewpoint. Looking at an open box, we visualize all six of its planes, some from the inside, some from the outside. The skeleton of a cube built of twelve sticks offers even more complete orientation. This principle applies also to the more complex bodies of sculpture. On the other hand, decomposition of volumes carries a greater risk of disintegration. I notice a lack of unity in some of Moore's smaller metal compositions. The reclining figures of the deck-chair type are not easily pulled to-

gether by the glance. This, however, is merely a matter of artistic accomplishment. There is no reason why even Moore's radical attempt to compose a figure of several entirely separate pieces could not be successful. Perceptual unity does not require physical continuity. Extended beyond the single figure, this principle leads to group compositions, which are indeed a major interest of Moore's. It can readily be seen that this sculptor, by his positive use of intervening space, might be more successful in the combination of separate units than Western sculpture has been traditionally. This may also lead to an extension of subject matter. So far, sculpture has fed almost exclusively on the compact bodies of humans and animals. Some playful experiments in modern sculpture, for instance those by Calder, make me wonder whether some day a group of twisted tree-trunks, which would delimit and internally organize a volume of essentially empty space, could not become a legitimate subject. Finally, a more dramatic interrelationship of sculpture and architecture could be envisaged, in which the building would be more than an enclosing box, the statue more than an enrichment of walls. Architectural and sculptural forms could unite in the kind of dynamic interplay which we observe in Henry Moore's arrangements of separate non-objective shapes. (pp. 32-8)

Rudolf Arnheim, "The Holes of Henry Moore: On the Function of Space in Sculpture," in The Journal of Aesthetics and Art Criticism, *Vol. VII, No. 1, September, 1948, pp. 29-38.*

Sir Kenneth Clark (essay date 1951)

[*Clark is an English scholar, lecturer, museum director, poet, and one of the foremost contemporary art and cultural historians. He has produced a wide variety of both scholarly and popular works noted for their erudition, breadth of knowledge, and precise prose. In the following essay, Clark assesses Moore's metal sculpture from the period 1931 to 1950.*]

The chief development in Henry Moore's work during the last five years is his greatly increased use of metal as his medium of expression. His last works on a large scale— the **Family Group,** the **Striding Man** and the **Reclining Figure** for the Festival of Britain—were all designed to be executed in bronze. This shows a radical change in his outlook. In his earlier work he had believed in carving almost as a faith. Even although he did not altogether agree with his own apologists that material should dictate design, he wished to follow what he called "nature's way of working stone," and the almost Wordsworthian pantheism which this phrase implies was a precious element in his art. His stone figures, which he wanted to "look right and inspiring if placed almost at random in field, orchard or garden," no doubt gained some of their quality from a feeling of kinship with the dolmens and menhirs of an ancient countryside; his wooden figures, from their resemblance to the roots of trees. In giving up these materials in favor of metal, Moore was sacrificing a group of early associations which added a particular sentiment to his work. It is therefore of some interest to see how and why he came to do so.

His earliest metal sculpture of any significance is the reclining figure in the Zimmermann collection, New York, dated 1931. It is exceptional in many respects. For one

thing, it is almost the only reclining figure in which an underlying sense of the physical norm has been abandoned. Compared to the reclining lead figure of 1938 in the Museum of Modern Art, the early figure makes more descriptive references to parts of the human body, but the general effect is far less human: is in fact more like some terrifying insect. This piece originated in a drawing of 1931, which is described as being for metal or reinforced concrete, and no doubt the latter material gave Moore the idea of the struts in the creature's stomach. But we may also notice that this and many other drawings of the time presuppose a freedom in space which would have been impossible to the stone-imprisoned reclining woman of the same date.

This monstrous insect woman remained unique in her metal medium until 1938. In that year, Moore made a number of small figures in lead, which were the real beginning of his metal sculpture. I may add that they were lead not because he had any particular preference for this material, but simply because it was cheap and could be cast in the home. At that date, Moore could not afford to have a figure cast in bronze in the very faint hope that someone would buy it. The lead figures of 1938 were melted in Mrs. Moore's saucepan on a Primus stove and cast in the garden, where I remember one or two Cellinesque mishaps taking place.

The origin of this sudden crop of metal sculpture is to be found in the preliminary sketches that Moore did for the wooden reclining figure now in the Onslow Ford collection. In this figure, Moore was determined to satisfy his desire for "sculpture in the air"—in other words, he wanted to make as many holes as he liked. The result is a wonderful growth of roots and branches, but perhaps it would have been impossible to carry the idea any further in wood. At all events the clay models done at this time seemed to demand a completely malleable medium, a material which made no structural demands, and he therefore decided to carry them out in metal. It is, however, fair to say that most of these pieces were conceived as metal sculpture and contain many of his metallic ideas. For example, the reclining figure has already the sharp, hollowed-out abdomen of the father in the *Family Group,* while the figure reproduced as Fig. 104*a* in Herbert Read's *Henry Moore* (third edition, 1949) has the arrangement of rods or shafts joining a disc that was used in the new *Striding Man.* But it is also true that from this date onwards, Moore cast a number of figures which were not originally intended for metal. Sculpture in stone or wood is a slow process, and Moore is extremely inventive. Small clay models multiplied and stood in rows in his studio, clamoring for perpetuation; and his admirers clamored equally for something durable from his hand. The resulting bronzes have given pleasure to a large number of collectors and have done more than anything to extend his fame. But the practice involves two dangers. In the first place, sculpture demands such intense concentration of form that even the most fertile inventor needs periods of execution when the hand is occupied creatively, but the drain on the image-making faculty is relaxed. And secondly, when idea and material are not united at birth, something vital goes out of Moore's sculpture.

No doubt he himself was aware of this. And in his latest metal sculpture the character of the material has been clear from the start. In certain minor works, the rocking

chairs and the new basketwork heads, it has even been extended. In the former he has seen how metallic objects such as handles, sextants, stirrups and weathercocks are designed to be moved and gain character from our knowledge of this fact, especially when we perceive them to be at a point of balance. In the latter, the *cire perdu* process, as used in certain pieces from Benin, has suggested to him a new variation on that inside-outside relationship which was already the chief motive of the lead helmets. Moreover the strips of metal have an interesting surface quality in themselves. Moore is too serious an artist to make texture a prime consideration, but the fact that each strip of wax has retained the touch of his fingers gives these heads the direct, nervous quality of his drawings. But these, as I have said, are minor works, or by-products, compared to the *Family Group* and the *Striding Man,* which are two of Moore's finest and most complex creations in space. And both of these would have been unthinkable in any other material but bronze.

The *Family Group* starts with the concept of hollowed, wedge-like forms which appeared in the lead reclining figure of 1938: within these hollows is placed a solid—at last explicitly a child—and the figures are united by the movement which transfers it from one shelter to the other. The building up of such a composition was only possible to him as a result of his drawings from life made in subways during the war, which taught him how to combine figures into groups, and how to use drapery, without which the female figure could not have achieved her identity. The father also derives from Moore's war drawings, his studies of miners at the coal face, which first showed him how to assimilate the male body to his own form-system. Moore made many drawings and models for the *Family Group,* in some of which a stone-carving idea is evident; but in the end he returned to one of the first, and carried it through without alteration, except for the father's head. Partly from the nature of the commission and partly because of the increased scale, he has substituted a solid head with quasi-naturalistic features for the double protuberance of the sketch. The result is a considerable loss, not only from the point of view of design, but also from that of human vitality. It is a curious and revealing fact that when Moore attempts to treat a head naturalistically, he loses that look of intense alertness and startled animation which he is able to impart to his most abstract pieces. The head is always a problem in ideal art. If it has too much character, it draws away from the effect of the whole; if it has too little, it seems insipid. Looking back over three centuries of ideal art it is surprising how seldom, since Raphael, the problem has been solved. For Henry Moore the difficulty is not that he is an abstract artist, but that he is such a powerfully dramatic one. Since he can give to lumps of stone such vivid expressions of panic or purposefulness, it is difficult for him to animate a real head without over-emphasis; and in his effort to tone it down he often annihilates it. The beatific expression of the *Northampton Madonna,* for example, although not exactly insipid, is clearly the result of conscious effort, and comes from the top layer of his mind.

In his *Family Group,* the effort to make smooth, solid faces was even less convincing because in the first metal sculpture of 1938 he had hit on a way of treating the head which exactly suited the character of the material. How or why he thought of this double protuberance, neither the sculptor nor his apologists can say, but we feel instinctive-

ly that it is right, that the absence of a domed skull is in keeping with the absence of solid stomach or thorax, and that the open, pincer-like form harmonizes with the metallic rhythms of the arms and legs. The double head occurs in all the early metal sculpture and associated drawings; it is once or twice abandoned in the studies for the *Family Group,* but it reappears in the last *Reclining Figure,* with an added force of expression; and it receives its freest treatment in the *Striding Man.* This last piece was conceived shortly after the father in the *Family Group* had been given his respectable cranium, and we may feel that there was an element of compensation in the two alert and almost independent protuberances with which the new metal man surveys the world. (pp. 171-73)

Moore's work has grown more human. It is true that the *Striding Man,* if analyzed in detail, may seem as far from the human norm as the goblins or Martians of 1937. But the general effect is of a quasi-human personality and more than human energy. Unlike the apprehensive ladies of Battersea, he strides along, curious and conquering, his head thrust forward almost aggressively over the fierce little shields which have taken the place of his breast. These shields are a completely metallic form. They may also be quoted as an example of the confluence of associations which makes Moore's work so rich. Triangles are the cruelest of all abstractions, used by Blake in his engravings as symbols of the measuring mind at its most ruthless. And here Moore has put them in place of the most human and reassuring of all forms, the breast. In doing so he has emphasized the ferocious energy of the creature's torso. But as we look at them in this context, these shields change their character and become like vestigial wings, having the same concentration of a lost function as Moore's vestigial heads. As so often in Moore's work, we feel that this creature comes from some early epoch of evolution, as yet undescribed by the palaeontologists but demonstrating a necessary phase in the development of the organism.

While the metal man looks forward to fresh discoveries, the *Reclining Figure* for the Festival of Britain closes an episode: Not that Moore will ever cease to derive formal ideas from the motive of a reclining woman, but that this piece seems to be the ultimate development of the particular ideas which first took shape in the metal sculpture of 1938. After twelve years they have been condensed and refined upon, so that they can be carried out on the large scale demanded by the occasion. Both the similar lead figures of 1938 have a centrifugal movement which would have been disturbing in a life-size work. The new piece gains its static strength not only from the inward-bearing support of its arms, but from the turn of the head and the way in which the struts leading to the legs grow out of a sort of cylinder.

In Henry Moore's development, works of consolidation overlap with new inventions. It is part of his character, and part of our confidence in him, that everything has to take its time. Such is the process by which he has gradually come to adopt metal as his chief material and gained thereby that freedom in space and fantasy towards which we find him striving in his earliest drawings. (p. 174)

Sir Kenneth Clark, "Henry Moore's Metal Sculpture," in Magazine of Art, *Vol. 44, No. 5, May, 1951, pp. 171-74.*

Erich Neumann (essay date 1959)

[*In the following essay, Neumann traces the development of the female archetype in Moore's early sculpture.*]

When we approach the work of Henry Moore . . . , and try to understand the connection between artistic creation and archetypal reality, we shall see at once that Moore is one of those creative individuals whose work revolves round the centrality of a definite content. We shall also have to understand the significance of the fact that, although we are still living in a patriarchal culture largely governed by the masculine spirit, the "Primordial Feminine" stands at the center of his work with such exclusive emphasis.

"There are two particular motives or subjects which I have constantly used in my sculpture in the last twenty years: they are the 'Reclining Figure' idea and the 'Mother and Child' idea. (Perhaps of the two the 'Mother and Child' idea has been the more fundamental obsession.)" In this sentence Moore says something decisive about himself and his work. Not only does he indicate its central content, but, in speaking of these two motifs as "ideas" and of himself as a man with an "obsession," he illuminates the whole inner landscape of his art as with a flash of lightning. One would go very much astray, however, if one supposed from this statement that the peculiarity of Moore's work consisted in the visionary shaping of an inner archetypal image, in the manner, say, of the Surrealists, who bring forth inner images for our contemplation. Although he is, in the true sense, the "seer" of an inner archetypal figure that we could call, for short, the "Primordial Feminine" or the "Great Mother," it is clear, as perhaps nowhere else in the history of art, that for Moore this archetypal image or "idea" is neither inside nor outside, but has its true seat on a plane beyond both.

If the essence of Moore's work lies in its concentration on the archetype of the feminine, then its radical advance from the naturalistic and representational to the "abstract"—though this, as we shall see, would be something of a misnomer in his case—is not to be understood as a formal process having its analogy in the trend of modern art as a whole. The unique feature in the development of Moore's art is that this apparently formal process goes hand in hand with an ever-changing revelation of its archetypal content, in which this content achieves ever greater authenticity and clarity. That this unfolding of the archetypal core of the feminine, together with its spiritual symbolism, should be able to depict itself in the concrete reality of the sculptor's material, and never abandon this concreteness despite all its so-called "abstract" and "conceptual" qualities, is in our view one of the most astonishing paradoxes of Moore's art.

Two essential features characterize Moore's work. The first is his "obsession" with the feminine—in Moore's extensive repertoire there is scarcely one sculpture whose subject is not feminine—and the second is the development of the formal principle from a more or less naturalistic representation of objects to a semi-abstract or at any rate non-naturalistic type of art. The two trends appear to be independent of one another, but it is our thesis that the change of form is in reality an inner unfolding of the archetype and idea of the feminine, of what the "feminine

as such" means. So far as can be gathered from his utterances on the art of sculpture, however, this spontaneous unfolding of the "real" theme of his work seems to have reached Moore's consciousness only sporadically. He himself, so far as he theorizes at all, seeks a new conception of sculpture that in many respects seems to run parallel with the general trend of modern art, but he is not conscious of the extent to which the specific content of his work, the feminine as such, determines his conception of sculpture.

The main difficulty before us is that we cannot begin our exposition by defining what the "archetype of the feminine" is, in order to exemplify its meaning in Moore's work. No such starting point is possible, because the archetypal can only be laid hold of in its transpersonal manifestations, in myths, fairy tales, dreams, etc., but can never be grasped with the help of purely abstract conceptions. For this reason we must try to trace the development of Moore's conscious and unconscious intentions and at the same time discover the meaning of the archetype of the feminine without separating the two interrelated principles of form and content.

As we follow Moore's development we shall see that it is always the two great themes of mother and child and the reclining figure round which his art unfolds. All other objects are only peripheral; they prepare, illustrate, and elucidate what is going on in this central zone of the feminine.

Even his earliest sculptures, groups from the years 1922-25, are configurations of the mother-child problem. In them the so-called naturalistic elements still predominate, but already in their form and content the ground motif of Moore's art is struck: the apprehension of the feminine archetype. Art criticism today generally sees in the sculptures of this period—and rightly so—the influence of primitive art, whether Sumerian, pre-Columbian, or African. If we compare the "reclining figure" from Mexico [*Chac Mool, The Rain Spirit* at Chichén Itzá], the inspiring "prototype" of all similar figures in Moore, with the large **Reclining Figure** [brown Hornton stone] from the year 1929, and take this group of sculptures as the first unit in Moore's development, then the "primitive influence" seems not only self-evident but also sufficient as an "explanation."

For a depth-psychological analysis, however, the real problem only begins here. Moore himself says of Mexican art:

> Mexican sculpture, as soon as I found it, seemed to me true and right, perhaps because I at once hit on similarities in it with some eleventh-century carvings I had seen as a boy on Yorkshire churches. Its "stoniness," by which I mean its truth to material, its tremendous power without loss of sensitiveness, its astonishing variety and fertility of form-invention and its approach to a full three-dimensional conception of form, makes it unsurpassed in my opinion by any other period of stone sculpture.

We shall be concerned with two aspects of this quotation. The first is what Moore, in keeping with the art theories of our time, says about form; the second is that curious "personal" association of Mexican art with Moore's childhood memories—an apparently psychoanalytical train of thought. With regard to the importance of the formal

principle, it should be noted first of all that the Mexican prototype of the reclining figure represents a masculine deity, whereas Moore's figures are exclusively of the feminine goddess who stands namelessly at the center of his art. So already in this first group the trend is from the personal to the transpersonal, from a merely personalistic portrayal to the creation of a suprapersonal and eternal content or relationship.

Whether the child seems to burst forth underneath, as though being born from the stony immobility of the mother, or, drinking at her breast, forms a unity with this huge mountain, or rises above her triumphantly, with almost somber intensity, always the mother-child motif is conceived as something archetypal, perennially human, the ground theme of life. And it suddenly becomes clear that all formal considerations are not peripheral but completely fused with Moore's innermost intention, of which perhaps even he himself is unconscious. He seeks to create an archetypal and essentially sacral art in a secularized age whose canon of highest values contains no deity, and the true purpose of his art is the incarnation of this deity in the world of today.

This principle of incarnation lies at the root of all Moore's views on form, which he has expressed in his remarks on his work as a sculptor. Implicit in the mother-child motif is the whole of man's relation to the world, to nature, and to life itself. In the course of Moore's development the female reclining figure becomes more and more clearly the archetype of the earth goddess, nature goddess, and life goddess. This is not to say that he "knows" about these things, or that he sets out to create "symbolic" figures as ordinarily understood. Only when the unwearying revolution about the feminine center becomes transparently clear in his work as a whole, and one sees how this center continually unfolds in the stadial development of his art, can one understand the essentially symbolic and archetypal nature of the deity to whose incarnation Moore's work is dedicated—one could even say "consecrated."

Whereas the **Reclining Figure** from the year 1929 might still represent an earth goddess in the sense that the Mexican figure represented a god, with the figure from the year 1930 a new principle of representation begins to operate: the transformation of the earth goddess into the earth itself. It is justly remarked of this figure [in *Sculpture and Drawings by Henry Moore,* by A. D. B. Sylvester, 1951] that "it draws an analogy between a reclining woman and a range of mountains which announces the treatment of the female body as a landscape that characterizes most of Moore's later reclining figures." If—to anticipate—we compare it with the **Reclining Figure** [carved reinforced concrete] from the year 1933, this transformation into the transpersonal earth can be seen very clearly. These sculptures do not "express" or "describe" anything, they are not allegorical or symbolical representations of the earth after the manner, say, of a Roman Abundantia or a figure by Maillol; they *are* earth, are a direct incarnation of what the earth archetype is.

This "being the thing itself," this "quiddity," is expressed in Moore's broad specification of what sculpture ought to be: "The sculpture which moves me most is full-blooded and self-supporting, fully in the round; . . . it is static and it is strong and vital, giving out something of the energy

and power of great mountains. It has a life of its own, independent of the object it represents."

In the creative act the artist identifies himself with the thing created, as though giving out a part of himself, like a mother with her child. "He gets the solid shape, as it were, inside his head, he thinks of it, whatever its size, as if he were holding it completely enclosed in the hollow of his hand. He mentally visualizes a complex form from all round itself; he knows while he looks at one side what the other side is like; he identifies himself with its center of gravity, its mass, its weight; he realizes its volume as the space that the shape displaces in the air." The "embracing" quality of the mental creative process is conceived here, characteristically, as an act of envelopment, and "head," "hand," "space" appear as maternal symbols by which the created thing is enclosed. At the same time, the created thing is left free in its multidimensional independence and "self-centeredness."

This description of the creative act is informed throughout by the "Maternal Feminine" principle, and is an extremely concrete expression of what we have termed elsewhere the "matriarchal consciousness." The essence of this creative process is that it springs from, and mostly takes place in, the unconscious. It is a process of pregnancy and inner maturation in which the ego consciousness participates only in the auxiliary role of a midwife. The essential thing here is the form pre-existing in the material itself; by obeying the material, the artist perceives this form and brings it to birth. When Moore says, "The sculpture . . . is full-blooded and self-supporting, fully in the round. . . . It has a life of its own, independent of the object it represents," he means that the reality of the sculptural object subsists "in itself" and is only discovered and externalized by the artist. Nevertheless, the process that makes this kind of creation possible is described by Moore as an essentially "enveloping" one. The exact opposite of this is the more "active" type of sculpture, which hacks out of the "passive" and formless stone something that corresponds to the artist's interior image. In this case it is simply a question of transferring or "projecting" the inside thing to the outside by a deliberate act of the will. The relation of creative mind to created matter is then more like the conscious confrontation of subject and object; it is less a creative than a procreative process, whose most modern form is the making of a machine, which—*contra naturam* and *extra naturam*—is nothing but a product of man's consciousness.

The relation between the creative process and the created form is completely different in Moore. From the perpetual relationship of identity between the thing to be formed and its former a work is born, and in this birth no part does violence to any other; for the formless fertilizes the former just as much as the former delivers and gives birth to the form. In this process Nature herself becomes creative in the creative individual, expressing herself in him and through him in her role of natural sculptor of created things.

This maternal Nature who creates the world of forms is the true object of Moore's work. The basic phenomenon that all life is dependent on the Primordial Feminine, the giver and nourisher, is to be seen most clearly in the eternal dependence of the child on the mother. And it is precisely because the creative individual, being dependent on the nourishing power of the maternal creative principle, always experiences himself as the "child" that the mother-child relationship occupies such a central place in Moore's work.

For this maternal Nature the child is something enclosed and attached, always overshadowed by the great curve of the mother. And whether the child lies snugly ensconced in the mother's breast, as in the figure [*Mother and Child,* Verde di Prato] from the year 1929, or is inserted into her like an embryo, as in the figure from the year before [*Mother and Child,* Styrian jade], the supremacy of the mother is felt with the same intensity as in primitive sculpture, for instance, the sculptured jars of Peru.

In developing the theme of the Feminine as the Great Opposite, whose natural corollary is the childishly small, Moore advanced beyond the realm of envelopment and containment, protection and shelter, to one in which the Feminine appears as something rounded and curved like a fruit, whose epitome is the woman's breasts. This motif can be seen most clearly in the ***Suckling Child*** [alabaster] from the year 1930, where the woman is reduced to nothing more than the globed fruits of her breasts. In the ***Mother and Child*** [Verde di Prato] from the year 1931 the curve becomes the formal principle itself, represented not only by the mother's breasts but by her head, the child's knees, and the globe of its head. The woman and her child are shown—still in concretely representational style—as a living cluster of fruit, creative Nature made manifest as the Maternal Feminine. Moore is attracted to these living forms because, as he rightly says, "Asymmetry is connected also with the desire for the organic (which I have) rather than the geometric." But his understanding of himself goes even deeper, and in his "Notes on Sculpture" he formulates the essential elements of the feminine archetype's form and content in exactly the way that depth psychology and especially analytical psychology conceive them:

> I am very much aware that associational, psychological factors play a large part in sculpture. The meaning and significance of form itself probably depends on the countless associations of man's history. For example, rounded forms convey an idea of fruitfulness, maturity, probably because the earth, women's breasts, and most fruits are rounded, and these shapes are important because they have this background in our habits of perception. I think the humanist organic element will always be for me of fundamental importance in sculpture, giving sculpture its vitality.

(pp. 12-22)

Erich Neumann, in his The Archetypal World of Henry Moore, *translated by R. F. C. Hull, Bollingen Series LXVIII, Pantheon Books, 1959, 138 p.*

G. S. Whittet (essay date 1968)

[*A Scottish critic and poet, Whittet was the editor of* Studio Magazine *from 1946 to 1964. His criticism examines "the human rather than the academic aspect of art. . . . the revelation of the artist's personality and history and through him his society's peculiarities." In the following essay, Whittet focuses on the relationship*

between humanity and nature presented in Moore's works of the 1950s and 1960s.]

Henry Moore at 70 happily persists in the ideal that, as remarked by the late Sir Herbert Read, inspired both Rodin and Medardo Rosso in the year of Moore's birth to make the break with the prevailing classical restraint in sculpture. This phase was called Vitalism by Read and it has long been a tenet of Moore's faith that his work should reflect this spiritual vitality, this power of expressing in plastic terms the significance of life.

In the retrospective exhibition at the Tate Gallery celebrating the sculptor's 70th birthday, the opportunity was offered and splendidly taken of putting on view the largest collection of his sculptures and drawings since his last exhibition there in 1951. . . . Though the sculptures covered Moore's output since 1922, nearly half of the pieces catalogued were dated since the previous Tate show. Thus it was possible to view in time perspective the recurring consistency of the persistent ideal.

Time in fact has come to provide for Moore the possibility of supplying the perfect setting for his sculpture: space and with space the capacity of the spectator to move around the sculpture, another of Moore's conditions for the greatest potential in enjoyment. Yet, paradoxically it is the intrusion of the human scale that has on occasion dwarfed his cosmomorphic imagery. For example, his **King and Queen** even on a Scottish hillside retains some of the mawkish 'quaintness' one associates with those earthenware pixies offered for sale in Cornish seaside resorts. In potent contrast the three **Upright Motives** of 1955-56 magnificently coalesce the elements of the human form and its arbitrary resemblances in a rock pillar with the totemic figuration of the high columns.

It is continually apparent that reference to the human body in Moore's sculpture is most effective when it is paraphrased from the miniature, as in pebble and bone structures, or from the massive, as in geological formations like mountains. About 1957 Moore was working on almost life-size bronzes, more naturalistic in their definition of the human body. These statues of which **Falling Warrior** is a good example forcibly demonstrate the need for a decision to move closer to the abstract and almost untouched metaphors for human personality that are to be found in landscape masses. In the detail of the figures, the diminution of the head, the seat of the intellect and source of conscious motivation, is deliberately contrived so that it becomes an almost shapeless knob with the features economised and eyes reduced to pinholes in direct antithesis to the notion of primitive African carvers who made the head of a statue always larger in relation to the body and, in hierarchic proportion, the chieftain's head larger than any other's.

That man and the primal world are one is always apparent in Moore's work, though it is worth noting that he has never given to primitive tribal art the major place that it possessed in suggestion for Picasso to whom Moore nevertheless was drawn for some of the Spaniard's more grotesque and powerful form-ideas. Since the 1930s, when by force of economic circumstance he was producing relatively small-scale works, it was the archaic Greek carvings and the key Mexican archetype Chacmool, adducing the reclining figure in its four-square aspect, that had been dominant for Moore. His first life-size bronze figures were not completed until 1948 although by this time he had carved various large reclining figures in stone and wood.

Undoubtedly it was living and working in the open countryside—Moore has lived in his present home in Hertfordshire since 1940—that allowed him to work freely without external scale values. Intimate self-related proportions have their own resolved scale which are not brought to adjust with the human module. Thus many of his sculptures, especially in two or three pieces, have the shock and surprise of size relationships rarely encountered in life. In a corner of the Sculpture Hall at the Tate there was a revealing selection of sketch models and of found objects from the artist's studio. Here was the 'button bag' that inspired the initial points of departure for some of the large works seen inside the main gallery rooms and outside on a board-fenced section of the lawn.

To relate significantly shaped pebbles and to vary their proportions and surfaces in the enlarged versions implies a gift for inventing a unified artifact from parts that seem basically disparate. The addition of multiple elements is to all intents and purposes a new departure in sculpture. Carving and the cutting away of extraneous matter has generally left the sculptor at the mercy of the idiosyncracies of his materials. Henry Moore, by the additive process, has travelled a long way from his acknowledged sources of Brancusi's *The Princess* of 1916 and Arp's *Human Concretion* of 1933. Juxtaposition of found objects such as pebbles and bones have eventually suggested an ultimate conversion into large sculptural compositions when the excitement generated by their grouping, magnified and transfigured, passes from artist to spectator.

Rocks in natural or reduced size are evident in some of the more jagged block rhythms of works such as the **Three-Piece Reclining Figure** of 1961-62 with its biomorphic analogy in the knob-headed torso. These adopt strange and oddly compelling silhouettes if seen end-on, as when the unseen spaces in a mountain range are only assumed so that a continuing ridge is often imagined when it does not in fact exist. Through all these pieces runs the necessity to find the ideal viewpoint which, as Moore advises, should be against the sky. Sculpture in fact makes its maximum impact for Moore as the three-dimensional frieze on the invisible wall of the horizon.

Stones, pebbles and bones are adapted in their forming and placing. Sometimes their juxtaposition borders on the surreal without overstepping; because the alignment with the real is achieved by imaginative means never by direct representation. It is safe to say that Moore would never have chosen a toy motor car to cast the shape of a baboon's head as Picasso did though he might carve a form that would 'translate' as both of those objects. Through will and choice, natural forms construct the corporate anatomy so that the **Three-Piece Reclining Figure No. 2: Bridge Prop** of 1963 assumes one of its most effective readings when the pieces are seen to overlap; other viewpoints stimulate the intelligence almost as provocatively.

As Moore has said "The real basis of life is human relationships". These relationships in all their degrees of intimacy and apartness are developed by him with unrepetitive fulness of analogy in the groups and separated pieces. In contrast to the three-piece figures yet connected by its

logic of relations is the **Locking Piece** of 1963-64 in which the curved and grooved extrusions and recesses carry their unmistakable sexual symbolism of people cleft in each other without possibility of separation.

The ambiguity and the visual parables common to all vital art are present in Moore's work constantly, even though some recent images seem to mark a state of independence. The suspension of the mass of a sculpture is acutely judged in the delicate balance of **Three-Way Piece: Points** of 1964 that it is not without an underlying hint of an animal outline. One remarkable bronze of 1966 brings an apparently new source of reference into play; it is the **Pipe.** While it is clear how the sculptor's interest came to be stimulated by the object, the resultant work contains also the double meaning we are accustomed to look for. While the similarities to bones and knuckle joints of their components is obvious, there is also the suggestion of a piston and its connecting rods. Yet, somehow in the context of Moore's oeuvre as we know it, this seems unlikely. Man and nature in their simplest organic entities have sufficed to present his vision of the world, a vision comprising the cell and the honeycomb, the molecule and the mountain.

Three Rings of 1966-67 in glowing red Soroya marble is one of the recent purified dependent separations, notable as much for its chromatic warmth as for its grouping.

Here we are in the presence of an analogy not merely to rock erosion as in an underwater grotto but also to organic matter in an animism of the hard material. More intensely allusive is another work of last year in the same marble: **Mother and Child** with its moving inclination of the parts towards each other, projecting the urge for contact. Even closer in their integrated relationship are the three pieces of **Vertebrae** 1968 seen more essentially in the small sketch model. Here the interlinking of parts, their contrasts of shape and their mutual emphasis of rhythm and mass are totally given in a style that may well precede the triumphant climax of a life devoted to the personal iconography of Man in the Universe.

In the omniscience of the present we can see Moore as the greatest sculptor of the century unconcerned with the fashionable but forgettable exploitation of new materials in the syntax of contemporary prototypes but totally committed to construction from eternal visual motives those slowly absorbing artifacts to which our subconscious universal memory attributes a magic and atavistic significance. Symptomatic of our civilization without religious belief we search unceasingly for an icon. Henry Moore creates it. Pared to the bone, it is humanity itself in the image of the earth. (pp. 25-9)

G. S. Whittet, "Henry Moore, World Master

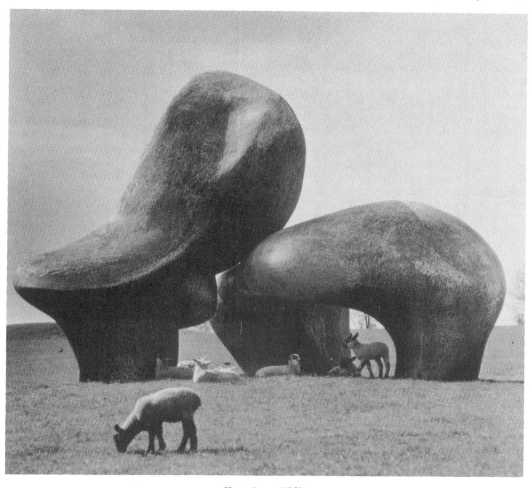

Sheep Piece (1972)

Sculptor," in Sculpture International, *Vol. 2, No. 3, October, 1968, pp. 24-9.*

Stephen Spender (essay date 1978)

[*Spender is an English man of letters who rose to prominence during the 1930s as a Marxist lyric poet and as an associate of W. H. Auden, Christopher Isherwood, C. Day Lewis, and Louis MacNeice. Like many other artists and intellectuals, Spender became disillusioned with communism after World War II, and although he occasionally treats political and social issues in his work, he is more often concerned with aspects of self-knowledge and depth of personal feeling. While his poetic reputation declined in the postwar years, his stature as a prolific and perceptive critic has grown. Spender believes that art contains "a real conflict of life, a real breaking up and melting down of intractable material, feelings and sensations which seem incapable of expression until they have been thus transformed. A work of art doesn't say 'I am life, I offer you the opportunity of becoming me.' On the contrary, it says: 'This is what life is like. It is even realer, less to be evaded, than you thought. But I offer you an example of acceptance and understanding. Now, go back and live!' " In the following excerpt, Spender examines sources, subjects, and settings of Moore's art.*]

The first occasion on which I ever saw a sculpture by Henry Moore was, I think, in the late twenties, when I was shown one by Michael Sadler, the Master of University College, where I was an undergraduate. I forget what it was, but I was struck by the form, the chiselled quality and the stoniness. After this I went to galleries looking for work by Henry Moore. His name acquired for me something of the aura of the artist identified with his vocation which I felt about those of poets like Rainer Marie Rilke and T. S. Eliot.

In coming years I often heard Henry Moore's work discussed among my friends, Geoffrey Grigson and Herbert Read in particular. People seemed sharply divided into those for whom Moore's work had some quality of integrity which seemed absolute to them and unlike anything else being done in sculpture in England, and those to whom it consisted of the famous holes he chiselled through stone or wood surfaces. (p.11)

[In the 1930s] Henry's close neighbours in Parkhill Road were Ben Nicholson, the painter, Barbara Hepworth, the sculptor, to whom Ben was then married, and Herbert Read, the poet and critic. Ben Nicholson was painting circles and rectangles on boards on which he sometimes cut out these forms in bas relief. Barbara Hepworth was doing abstractions also. Ben and Barbara and Herbert used to meet in Henry's studio when I was there sometimes, and show each other recent work. How did Ben's rectangles and circles look in different lights? Did the slightly scooped-out circles sometimes seem to have movement, to rotate even?

Henry at this period seemed to feel that, partly out of loyalty to his friends and partly for reasons to do with his own developments, he ought to produce abstract sculpture. But, as he told me years afterwards, he was never able to make a work which, in his own judgement, seemed completely abstract. His pieces always ended up by looking like something, often like a reclining figure.

It is worth recording that about five years ago, I asked Moore whether during his 'abstract' period he ever regretted his academic art school training which obliged him to draw from the nude: since it was the human figure which kept on intruding itself into his forms when he tried to make abstract sculpture. He answered, no, he had never regretted a training based on drawing from the model, and he felt a bit apprehensive today about the future development of young artists whose art training may have started off at the point of abstract art reached by artists who themselves had started off by drawing from the nude. He felt that this might trap them in non-representational art and limit the possibilities of their further development.

In his indebtedness to a tradition of art training centered on the study of the nude, Henry belongs to the generation of the great modernists of the early part of this century, Picasso, Matisse, Braque, Leger. One of the things that gives such tension to the work of these masters is that it seems to be moving in time in two directions at once, towards the remote—even prehistoric—past and towards the future: and, in geographical space, it shows an immense eclecticism of influence present in the work, André Malraux's *Musée Imaginaire*. At the same time in the greatest work of these masters, a unity which is entirely new is achieved from such variety in time and place. These artists are the last geniuses of the Renaissance tradition. Their academic training—study of the human figure—was the meeting point between past and future which enabled them to travel backwards and forward in their own personal development as artists: sometimes appearing futuristic, sometimes as almost devout traditionalists making replicas of the past. (pp. 11-12)

When my friends and I discussed Moore's work in the early thirties, what struck us above all was the purism of a lover's fidelity to the material employed. Moore chiselled stone and carved wood and brought out the intrinsic texture of stone and wood. It was this reverence for the material as distinct from the subject matter which perhaps first drew Moore (and goes on drawing him intermittently) to abstraction. The subject of a work can be misleading in drawing attention to what the sculpture represents and away from the material used and realised. This was a period when it seemed very important to insist on the actual stuff of paint, or stone, or words, or sounds, of which an art object is made. At the same time as Moore was abandoning for a time the figurative subject in his work, the young poet Auden was writing poems to which he avoided giving titles, because the naming of the subject of a poem detracts from the verbal texture which makes the poetry.

However abstraction is itself a kind of representation—of a pattern or of some very unidentifiable shape called 'significant form', let us say. If you think 'this is an abstract piece of sculpture' you do not necessarily pay more attention to the material than if you think 'this is a mother and child'. You may see the material itself as abstraction.

Another reason why abstraction attracted Moore—or, rather, another two reasons—is that in a sculptor like Brancusi (and perhaps also in the work of Arp) the abstract artist was taking a stand [in Moore's words] 'for shape for its own sake, reducing a thing to just a simple

egg', and because simply to do this the sculptor must employ his utmost skill in mastering the material. 'You begin with a block and have to find the sculpture that's inside it. You have to overcome the resistance of the material by sheer determination and hard work.' Here 'overcoming the material' does not mean what Moore elsewhere refers to as 'being cruel to it'. The sculpture inside a Brancusi is surely the quintessence or epitome or ideal form of the material released.

The sculptor whom Henry Moore always admired as the greatest master of all, and with the greatest sense of vocation, Michelangelo, did not always avoid being cruel to his material. In fact, he sometimes makes it represent skin and drapery in a way which makes one forget that it is marble. Moore disliked what he called the 'leathery' texture of the skin in the figure of Night in the Medici Chapel, in Florence. Moore has had a life-long admiration—adoration even—of Michelangelo. Yet one suspects that sometimes in doing so he has felt himself struggling with a demon-angel. (p. 14)

The paradox of Moore is that he is one of the last great individualist artists, inheritor of a tradition of art based on drawing from the nude, which goes back to the Renaissance; while at the same time he shows a strong penchant towards the anonymous, impersonal and towards pre-Renaissance art and towards the Gothic. His sculpture expresses more of a moving sense of humanity than of the egoistical-sublime of the self-assertive individualist genius. When he expresses a liking for the work of the octogenarian Michelangelo who reverts to a style which is Gothic, he is admiring the Michelangelo who sheds his name and invents an objective symbol for an almost universal human tenderness.

Although a 'Henry Moore' is one of the most immediately recognizable of inventions, if one didn't happen to know his name, one might be content to recognize the style of a great anonymous master, identified perhaps merely as 'the master of Much Hadham'. His works also are sometimes provided with titles so perfunctory (**Locking Piece, Upright Motive**)—or at other times so obvious (**Falling Warrior, Mother and Child**) that they seem to disclaim having any title at all. At any rate, one readily decides for oneself that the title very often is no indication of the real subject. Considering the eclecticism of so much of the work—with African, Mexican, Greek-cycladic, Egyptian and many other influences—and the insistence on the integrity of the material, one might conclude that these sculptures have no subject except, in each case, what the work itself reveals—a material, an influence, brought within the unity of a consummate style by a great master.

However, there are many indications that Moore does have a subject matter, deeply buried in early experiences and his subconscious, which is unique to him. That this is so is demonstrable even in those works in which he seems most concerned with simply inventing a form which realises the intrinsic qualities of the material. Moore himself provides evidence for at least one striking example of this.

He recalls an early experience which he thinks one of several influencing him to become a sculptor. When he was ten or eleven years old, his father took him to see a rock formation near Leeds called Adel Rock—a haunt of tourists. The shape of the leg end of one his earliest two piece 'Reclining Figures' recalls the shape of this rock. But it does more than this. It also recalls that of Seurat's painting of rocks that stand out from the coast, near Etretat, which was once in the collection of Moore's close friend, and patron, Kenneth Clark. Moore, in a cassette tape recorded interview which he has sent me recently, comments: 'So perhaps you look at something and the shape registers and you probably use it; or if that shape comes up again, you like it because it has an emotional meaning for you, even though the memory may not consciously make the connection'.

So there is a memory of a past impression released by a present impression analogous to it. One might add that, to the memory of an emotion about rock which is a fusion of the feelings about Adel Rock and the Seurat, there is the emotion which the sculptor has about the material with which he is actually working and which he shapes not by imitating either Adel Rock or the Seurat, but by creating a third thing, the artefact, by a process of co-operating with the material which he can only describe as instinctive. The basic subject of Moore's greatest works is past memories of shapes seen evoked by present experiences which bear an unaccountable similarity to them. The process is very much that which Proust describes in *Time Regained*.

One of Moore's earliest experiences of sculpture was that of going to Stonehenge when he was a student and of seeing it first by moonlight, and then by day for several days. He has gone back there many times subsequently, for, as he tells me: 'Stonehenge is as much sculpture as it is architecture, being man-made big blocks of stone which have been shaped roughly, with an axe probably'.

Stonehenge also taught him early on the significance of size in sculpture placed outdoors. The great mysterious circles of stones suggested sculpture which you could go inside, which Moore was to make nearly half a century later: **The Arch,** reclining figures of three or four pieces which surround you, and the project for a maze of stone forms which you can enter and of which the sky, changing every hour of the day, and, at night encrusted with stars, and with perhaps the moon, would be the roof. In India, as Henry Moore probably knows, Indians will take you to see temples in the middle of the night. Also in Greece, I have visited Delphi by moonlight and had the mysterious sensation that temples and statues belong as much to a map of the stars, as to their positioning on the earth.

Moore has then a rich and varied subject matter whose sources go back to an almost Wordsworthian contact with his natural surroundings when he was a child. For Wordsworth, of course, his earliest experiences were of untrammelled nature—an Edenic setting which separated him from the industrial landscape—and of the image of the mother which he identified so completely with nature that in *The Prelude* the child seated on his mother's lap—very much, one supposes, in the attitude of a Moore Mother and Child—feels himself one with a mountainous river-flowing landscape. Wordsworth was never able to reconcile the industrial scene in the England of his time with that of untouched nature. One might suggest that Henry Moore, who in his sculpture is so often preoccupied with splitting form and then making a fusion of the two parts, divided by a fissure, within a whole which is the unity of

the sculpture, found in his own childhood the double experience of both nature and industrial landscape which enabled him in his art to solve the Wordsworthian dilemma of the separation of nature from industrial society.

Moore passed his childhood not in the untouched countryside of Wordsworth's Lake District but in a small industrial town—Castleford—in the mining country of Yorkshire. (pp. 19-21)

Like the neighbourhood of D. H. Lawrence's Nottingham, Moore's Castleford is not far from some of the most beautiful country in England. Moore experienced in his childhood the backstreets of the industrial town and the beautiful countryside, and, since he loved both, both are fused within his work. Other noted sculptors, artists and writers have come from this section of Northern England. Moore himself notes four other sculptors—Barbara Hepworth, Kenneth Armitage, Ralph Brown and L. Thornton—who have come from Yorkshire. Perhaps the most sensitive and deeply felt book about Moore is that by Herbert Read, who also came from here. (p. 21)

Read describes the games which Henry played with other children in 'a maze-like labyrinth' of lanes close to the little house, one of a terrace, in Castleford. There was a game called 'tip-cat' played with sticks called 'piggies' which had to be pointed by whittling with a pen-knife. Herbert Read suggests that carving 'piggies' may have been Henry's earliest sculptural experience. One which Moore himself notes, and which is less fanciful, is that he used to rub his mother's back when she had pain from rheumatism in it. 'Not just her shoulder,' he tells me, 'but her whole back down from the shoulder blades with the skin close to the bone, to the fleshy lower parts. I had a strong sense of contrast between bone and flesh. I was seven or eight at the time.' More than half a century later, working on the figure of a pregnant woman, he found himself all the time thinking of rubbing his mother's back. In their front parlour, his mother also scrubbed the back of his father, very much in the manner described by D. H. Lawrence in *Sons and Lovers* of the wife scrubbing her miner-husband's back.

The backs of figures in Henry Moore's sculpture have often something tender and moving about them—a sacred homeliness. They are much worked on, scratched and lined and scarred, like the surface of a much scrubbed kitchen table. They can be gently and beautifully curved, suggesting both dignity and tenderness, as in the back of the King, in the *King and Queen.* One of Moore's objections to sculpture in architecture is that so often it conceals the back of the sculpture. The only sculpture of which there is no trace of influence in his work is the Baroque. This may be because Baroque sculpture is so much made to be looked at from the front—gesticulating figures with actors' or singers' gestures and faces—or screens set against walls, and having no backs to them.

Henry Moore's subjects arise from memories, often unconscious. These connect sometimes with material that is atavistic. Moore has told me that about twenty yards from his home, just along the street, there was a butcher's shop, behind which there was a large room or shed, with door open onto the street, in which the butcher slaughtered cattle once every week. 'We small boys, of the ages of four, five, six and seven, would stand there watching a bull led

in by a rope attached to a ring through its nose, by two men who ran the end of this rope through another ring which was fixed in the wall. Using this as a pulley, they pulled the bull up against the wall. One of the men then struck the bull a severe blow with a stick at the end of which there was a long spike, so that this made a hole in the bull's skull. He then thrust another stick through the hole and stirred up the bull's brains.' The boys stood watching. A man who killed bulls with despatch acquired a local reputation for doing so.

Clearly this experience of the slaughterings had a great influence—sometimes obscure sometimes self-evident—on Moore's work. Cleaving a skull, human or animal (and it is interesting that Moore in describing the scene to me linked it up with people viewing the public hangings which took place at Aldgate in the early 19th Century) is a sculptural act—perhaps the most primitive sculpture of all. The connection of this with several animal heads and animal forms (notably the *Animal Head* of 1956) is obvious, but one feels it imminent in many other pieces.

I have mentioned a Nottinghamshire miner's son—D. H. Lawrence—as being a great modern artist emerging from a background very similar to Moore's. To press the comparison a little throws further light on Moore's work. Both Lawrence and Moore had 'mother-fixations', but whereas Moore's mother seems to have been eminently self-controlled, Lawrence's had a passionate almost hysterical fixation on this, her youngest son, and projected into his consciousness all her frustrated ambitions. Lawrence's father, unlike Moore's, was much less educated than his mother, and became the object of a hatred perhaps not so much Oedipal as transferred onto Lawrence by the will of his mother (but Lawrence was also capable of sharing his father's resentment for his mother). Lawrence and Moore were both conscious of their working class origins, though these produced in Lawrence intense class consciousness and an inability to fit into any social class, whereas Moore never seems to have shown any social embarrassment, hatred or resentment, and to have fitted into every society simply as a member of the human race, with his added aura of being a great artist. (pp. 22-3)

Lawrence is the literary artist of the released unconscious. Beyond the pursuit of sexual union by characters in his novels is that of immersion in dark forces of unconsciousness, a loss of identity and individuality in a beyondness of life forces. Lawrence goes from light down into the darkness of the unconscious, Moore comes up from the unconscious into the light. The difference between the two corresponds almost exactly to Nietzsche's distinction, made in *The Birth of Tragedy,* between the Dionysian and the Apollonian. The characteristic of the Dionysian is to enter into a state of ecstasy in which 'the subjective vanishes into complete self-forgetfulness'. This is the aim of characters in Lawrence's novels and they achieve this condition through sex. The characteristic of the Apollonian Nietzsche calls 'the cheerful acquiescence in the dream-like experience':—

> that measured limitation, that freedom from the wilder emotions, that philosophical calmness of the sculptor-god. His eye must be 'sun-like', according to his origin; even when it is angry and looks displeased, the sacredness of his beauteous appearance is still there.

The Apollonian does not repudiate or reject the phenomenon of the Dionysian 'drunkenness'. He shapes them, illuminates them, brings them up into the light of consciousness. He is aware when he sees the Bacchanalian rites that all this is true: 'that, like unto a veil, his Apollonian consciousness only hid this from view'.

In *The Documents of 20th Century Art,* an interviewer asks Henry Moore the question, what is his reaction to the erotic side in Rodin's work ('he can revel in sensuality in a quite uninhibited way') Henry Moore's answer is worth quoting in full:

> It is certainly very important for Rodin, though it doesn't excite or interest me very much, perhaps because one knows the human figure so well. But for Rodin I think that this erotic excitement was part of his rapport with the human figure. And he was unlike Cézanne, who had his erotic side but who repressed it. This doesn't make Cézanne less of a physical artist, and I don't think you ever need this obvious erotic element for a person to understand the human figure. You don't get it in Rembrandt, and I would say that Rembrandt understands the human figure and the human character and the whole of its dignity and everything else.

That, surely, is a reply from the mouth of the Apollonian artist.

The Apollonian artist brings the shapes of the unconscious up from darkness into the light, encloses them within a surface which is like a shining veil. Certain sculpture of Moore—*The Archer*—for example seem in contact with the light-bearing side of Greek art in exactly this manner. (pp. 23-4)

Since the war Moore has grown increasingly interested in displaying sculpture outdoors. The stimulus for this may have been provided by Tony Keswick's placing of some of his greatest sculptures (*Standing Figure, King and Queen, Two Piece Reclining Figure* and *Upright Motive 1 Glenkiln Cross*) on his estate in Dumfriesshire, Scotland. My wife and I have been to see these, though on a day of pouring rain, and I can well understand how even to the sculptor himself, they must have seemed a revelation. Henry Moore says on the tape he sent me: 'How important to me that Tony Keswick bought that *Standing Figure* and placed it there without telling me until he invited me to see it. The setting is marvellous and so is that of the *King and Queen* and the *Cross.* All are placed perfectly. Seeing them has convinced me that sculpture—at any rate, my sculpture—is seen best in this way and not in a museum'. He was specially impressed by seeing his sculpture placed upon, and among, hills. He comments that if Stonehenge had been in a hollow people would not have approached it seeing the statues against the skyline. (p. 26)

Moore is as excited about sculpture in landscape as he is discouraged by it in an architectural setting. He says that he is never very pleased at the prospect of doing something in an architectural setting. Architecture is horizontal and vertical. It is geometric, and this creates problems for the sculptor, if he puts sculpture in front of it. The problem is to find a blank enough space so that the insistent vertical and horizontal lines of architecture do not insist on their own rhythm counter to that of the sculpture, which has to be related to the architecture. He recollected that when he was commissioned to make a sculpture for the Unesco building in Paris, he spent six months trying to produce a piece which had its own background which would prevent it being interrupted by the architecture. But to do this—in which he was not successful—would have cut out the back of the sculpture. Sculpture has to be seen from a hundred points of view—bird's eye, worm's eye. That's one thing sculpture does that painting doesn't do, Moore says. A painting can only be looked at from the front (unless it's that skull in the Holbein painting of two ambassadors, which can only be seen to be a skull if looked at sideways. But that's just a stunt).

> All the sculptures I've done that had to do with architecture have been a problem. Unless there are so many buildings there already that it doesn't matter—nothing can be done about it. . . . Whereas nature has none of these disadvantages. Nature is asymmetrical and its scale is a human one, even when there are mountains. But architecture can be so brutally big that the humanity drops out of it.

I am quoting from the remarks that Henry Moore sent to me on tape, in the course of a conversation in which I did not participate. If I had been there, it would have been to the point to tell him that his arguments about sculpture and modern architecture confirm the thesis of a famous German novel, *The Sleepwalkers,* by Hermann Broch, which was published just after the first world war. The narrative of this novel which describes the mysterious and chaotic lives of characters in post-war Germany, is interrupted by a thesis argued at considerable length which is that the fragmentation of modern civilization is evidenced by the fact that it is impossible to place sculpture in the setting of modern architecture. The reason why this is so, is because modern architecture itself projects the totally inorganic state of modern society, it being of all the arts the one that represents the contemporary human condition at any given historic time. Medieval architecture reflected man's belief in his religion, which was the core of that society, and therefore the cathedral was organic, the relationship of sculpture to it that of the flower to the plant, the human to the divine.

It might seem that Moore's experiences in trying to relate sculpture to modern architecture are tests which prove Hermann Broch's thesis. He discovers that the geometry of horizontal and vertical box-like and criss-crossed modern buildings threatens any sculpture put in front of it. 'If it's a figure you'll find its head cut off, or that the body is split down the middle. It's no good putting an upright figure against a skyscraper. Sculpture is like a human being. Architecture is inhuman.' 'A sculpture should be good anywhere, provided it isn't put in a situation which impedes it, like a person who may look very well at a cocktail party—but very badly at home.'

Sculpture always looks good against 'the jumble of nature'. 'But the really fool-proof background is the sky. In the city of Edinburgh the statues along the unbuilt-up side of Princess Street always look well—although they are by no means good statues—because they are seen against the sky. And then there is Nelson's column! And Trajan's column!'

'And out of doors the light is always changing, with the hour of the day and with the seasons, and at night. Moonlight magnifies.'

Moore remembers his first visit to Genoa at night and walking through the streets, admiring the buildings by moonlight. But next day, of course, many of them looked terrible. Some were slums. A lot of things admired by moonlight, sunlight shows to be awful.

'Think of bronzes in rain, and of trees themselves sculpture which sheds leaves and reveals the bare skeletons of trunk and branches. But never so geometric as to compete with sculpture, only providing contrasts to it.'

Moore likes the idea of sculpture standing in water, and this he has achieved with the great **Reclining Figure** at the Lincoln Center in New York.

He is glad that he was responsible for arranging the exhibition of sculpture at Battersea Park. 'Being responsible for it, of course I gave my sculpture the best place.'

In his mind's eye, Moore sees, I think, his sculpture as driven out of the cities through being unnoticeable to the inhabitants and scrawled out by the architecture—and add to this, the traffic—and retreating to take up positions in the countryside. The museums are right for what I call his smaller 'domesticated' pieces but too small for the monumental ones. These claim landscapes, and the effort of seeing them should be slightly athletic, a ten minute walk between piece and piece, not that peculiar fatigue called 'museum feet'.

Moore is staking out a claim not only for bits of countryside but for the future. One wonders how these statues will look in fifty or a hundred years time, on hills, on plains, in woodlands, among vegetation, against the fool-proof sky, in rain, against the sea, in the changing light, changing in appearance every minute. If they are not vandalized by the orgiastic Dionysians of our time—the age of terrorists and druggists—or destroyed in nuclear war—they may seem survivals from a great age of art at once individualist and of the liberated unconscious of the beginning of the twentieth century. Some may become popular symbols accepted almost as stereotypes, as has happened with the sunflowers of van Gogh. At any rate they have the look of survival. One notes here the strange abstracted faces of Henry Moore figures—looking into the future. They are not so much abstract as abstracted; or using the term 'abstract' in a Shakespearean way, 'brief abstract and chronicle of the time'.

The faces of the mother in the groups of Mother and Child are abstracts of sacred motherhood. The face of the **Draped Seated Woman** drained or purified of expression, yet seems proudly gazing into the future. Other faces seem abstracts of the modern human condition, for instance that of the **Seated Warrior,** with a hole, or holes drilled through eye-sockets which are seen in profile and between which there is a deep cleft which an axe might have made through the skull. One cannot look at the **Seated Warrior**'s head without thinking that one might thread a string through the head, eyes and this is reminiscent of the bull with a ring in its nose through which a rope is threaded, brought by two men to the slaughter house. Moore always sees affinity between the animal in man and in beasts.

The abstractness of the heads of the seated **King and Queen** is that of gods of the Underworld—D. H. Lawrence might have seen them like that. The twin heads of the armatured, skeletal, **Standing Figure** on Tony Keswick's estate are like antennae, giving the whole figure the look of a standing alerted insect, an erect Praying Mantis, or perhaps of a spanner stood upright. Then there are heads which combine strangely the animal and human, faces from dreams, the unconscious, like those dream symbols which Auden describes Freud (another Apollonian) of bringing up from darkness into 'the bright circle of his recognition'.

Herbert Read looking at a Henry Moore bronze we have at home called enigmatically **Three-Quarter Figure** said to me, 'Henry Moore is the one real surrealist'. By this he meant not that Moore had a leading position—or any position at all—in the surrealist confraternity, but that Moore is the one artist of our time who has unquestioningly and unhesitatingly always drawn on unconscious sources of memory for his inspiration. This is true, I think. He has done so without fuss, and without psychoanalysis. He has always rejected invitations to look too deeply into himself and the processes of his own imagination. Of a book that he was sent by a Jungian psychoanalyst writer called (he thinks) *The Archetypal World of Henry Moore* [see excerpt dated 1959], he commented: 'He sent me a copy which he asked me to read, but after the first chapter I thought I'd better stop because it explained too much about what my motives were and what things were about. I thought it might stop me from ticking over if I went on and knew it all . . . If I was psychoanalysed I might stop being a sculptor'.

These are the observations of a man who does not think of his subconscious as a repository of repressions and inhibitions either to be cured or even sublimated. On the contrary, it is like a well at the bottom of the garden which, in his case, happens to connect with a particularly fecund, ever-renewing spring. Nothing would surprise him less than to be told by Jungians that this well connects with waters underlying all dreams, that there is a collective unconscious, and that his images are among its archetypes. One feels that Henry Moore has always realised this. I have never heard him say anything to suggest that he had given any serious thought to the proposition that other people might find the symbols in his sculpture 'peculiar'. On the contrary, I think that because they constitute an act of recognition on his part of unconscious memories within him, he thinks everyone should recognize them.

From this one might deduce that Henry Moore should be in the best sense of that term—a popular artist. In giving immensely vaulable collections of his work to the nation, he himself perhaps feels that he is an artist of the people. And if the people were educated in recognizing the infinitely rich resources of the imagination accessible to them in their own lives, this would doubtless be the case. The French surrealists once wrote an open letter to Stalin declaring that they were the true communists because the life of the subconscious was the real proletarian element common to the whole society. Coming from André Breton and his friends, this did not mean very much, but it pointed to a truth of which the work of Moore should be an example. But a characteristic of the working class is that they do not think they have a subconscious. A London policeman rebuked the photographer David Finn for wishing to photograph the **Knife-Edge: Two Piece** near the House of Lords in London with the words: 'You have to admit it's just a pile of junk'. Yet one should not be too discouraged

by such a reaction. It is at least positive. It is not one of utter indifference to the whole phenomenon of 'modern art' which one finds among buyers at shopping centres in America. But in all such cases one has to remember the parable of the sower: some seed falls on stony ground, but some on good soil and takes root. (pp. 30-6)

Stephen Spender, in his Henry Moore: Sculptures in Landscape *by Henry Moore, Clarkson N. Potter, Inc., 1978, 129 p.*

FURTHER READING

I. Writings by Moore

"Primitive Art." *The Listener* XXV, No. 641 (24 April 1941): 5.

> Discusses qualities of primitive art which he particularly admires. Of Mexican art, Moore says, "Its 'stoniness,' by which I mean its truth to material, its tremendous power without loss of sensitiveness, its astonishing variety and fertility of form-invention and its approach to a full three-dimensional conception of form, make it unsurpassed in my opinion by any other period of stone sculpture."

Henry Moore on Sculpture: A Collection of the Sculptor's Writings and Spoken Words. Edited by Philip James. London: MacDonald, 1966, 293 p.

> Includes Moore's comments on his life and sculpture, as well as his views on other artists and periods of art.

II. Interviews

Duthy, Robin. "More Intensity: Henry Moore Talks about His Sculpture." *Connoisseur* 213, No. 855 (May 1983): 111-14.

> Discusses carving, materials, siting, architecture, and art criticism.

Moore, Henry, and Hedgecoe, John. *Henry Moore: My Ideas, Inspiration, and Life as an Artist.* Edited by Suzanne Webber. San Fransisco: Chronicle Books, 1986, 208 p.

> Moore's reminiscences about his life and art with photographs by Hedgecoe.

Steingräber, Erich. "Interview." *Pantheon* 36, No. 3 (July-September 1978): 256-60.

> Discussion of the use of maquettes and drawings in developing ideas for sculpture, followed by excerpts from Moore's writings. An accompanying critical examination of Moore's methods by Steingräber is cited below.

III. Bibliographies

Teague, Edward H. *Henry Moore: Bibliography and Reproductions Index.* Jefferson, N.C.: McFarland & Co., 1981, 176 p.

> Offers a chronological list of Moore exhibitions, and provides comprehensive indexes of books, essays, exhibition catalogs, reviews, audiovisual materials, and reproductions of drawings, paintings, watercolors, prints, and sculpture.

IV. Biographies

Berthoud, Roger. *The Life of Henry Moore.* London: Faber and Faber, 1987, 465 p.

> Appreciative, authorized account of Moore's life.

Read, John. *Portrait of an Artist: Henry Moore.* London: Whizzard Press, 1979, 141 p.

> Chronological discussion of Moore's life and career.

V. Critical Studies and Reviews

"Two Sculpture Shows: Sculpture and Drawings by Henry Moore at the Leicester Galleries and Eric Gill and Companions." *Apollo* 24 (December 1936): 372-73.

> Praises Moore's craftsmanship while questioning the significance of his works.

Collis, Louise. "Henry Moore's Summer." *Arts and Artists* 13, No. 5 (September 1978): 22-5.

> Overview of Moore's works occasioned by the abundance of exhibitions in London in 1978 celebrating Moore's eightieth birthday.

De Angelus, Michele. "Henry Moore: Reclining Figure." *The Toledo Museum of Art* 17, No. 3 (1974): 5-7.

> Discusses Moore's various representations of reclining figures, focusing in particular on *Reclining Figure (External Form)*, 1953-54, a bronze sculpture in the collection of the Toledo Museum of Art.

Digby, George Wingfield. "Henry Moore." In his *Meaning and Symbol in Three Modern Artists: Edvard Munch, Henry Moore, Paul Nash,* pp. 61-108. London: Faber and Faber, 1955.

> Detailed examination of Moore's work discussing such topics as themes, materials, processes, symbolism, and significance.

Harrison, Charles. *English Art and Modernism, 1900-1939.* London and Bloomington: Allen Lane/Indiana University Press, 1981, 210 ff.

> Discusses Moore's role in the development of modernism in English art of the first four decades of the twentieth century.

Harrod, Tanya. "Henry Moore at Eighty-Five." *Art International* XXVI, No. 5 (November-December 1983): 14-17.

> Reviews exhibitions at the Tate and Marlborough Fine Art galleries. According to Harrod, "Gallery based shows like these immediately remind us of the pleasures of seeing Moore's large sculptures in an open air setting. The realisation is slowly dawning that Moore is one of the few entirely satisfactory creators of public sculpture in our time."

Hodin, J. P. *Moore.* New York: Universe Books, 1959, 18 p. + 32 plates.

> Assesses the influence of modern science on the forms of Moore's sculpture and presents a psychoanalytic interpretation of the major themes in Moore's works.

Langsner, Jules. "Henry Moore, Sculptor in the English Tradition." *Arts & Architecture* 75, No. 8 (August 1958): 10-11, 28.

> Identifies Moore's sculpture with the English Romantic tradition of sympathy with nature.

Lichtenstern, Christa. "Henry Moore and Surrealism." *The Burlington Magazine* CXXIII, No. 944 (November 1981): 645-58.

Compares Moore's works and ideas with those of French Surrealist artists with whom he exhibited. According to Lichtenstern, "Although Moore never became wholly absorbed in the surrealist experiment, it would nonetheless be mistaken to fail to appreciate its fundamental significance for his most inventive decade from 1930 to 1940."

Lieberman, William S. *Henry Moore: Sixty Years of His Art.* New York: Thames and Hudson, 1983, 128 p.
　　Summarizes Moore's career in an essay occasioned by an exhibition at the Metropolitan Museum of Art in New York celebrating sixty years of Moore's work. The volume also includes reproductions of works exhibited, a checklist of the exhibition, and a bibliography.

Pearson, Ralph M. "Moore: Positive and Negative." *Art Digest* 21, No. 12 (15 March 1947): 29.
　　Considers some of Moore's pieces unbalanced in their development of the positive and negative qualities of form—overplaying "the hollow, thereby weakening the form and the impact on the observer."

Read, Herbert. *Henry Moore: Sculptor.* London: A. Zwemmer, 1934, 16 p. + 36 plates.
　　Important early appreciation of Moore's work.

Richards, J. M. "Henry Moore, Sculptor." *Architectural Review* LXXVI (September 1934): 90-1.
　　Favorable review of *Henry Moore: Sculptor* by Herbert Read, cited above. According to Richards, Moore is "an artist who is first-rate. His importance is due, I think, to his absolute integrity. His work is direct and alive, as it were, with its own and not with extraneous vitality. Above all, he is completely free from the congenital dilettantism which is the chronic obstacle to English artistic achievement."

Richter, Gigi. "Introduction to Henry Moore." *Art in America* XXXV, No. 1 (January 1947): 4-18.
　　Appreciative overview of Moore's life and works.

Robertson, Bryan. "Notes on Henry Moore." *The Museums Journal* 60, No. 11 (February 1961): 272-75.
　　Discusses the development of sensuality in Moore's sculpture of the 1950s—a period when, in general, Moore was modeling and casting in bronze rather than carving stone.

Seldis, Henry J. "Henry Moore." *Art in America* 51, No. 5 (October 1963): 56-9.
　　Informal profile of Moore by the art editor of the *Los Angeles Times.*

Smith, Bernard. "Henry Moore." In his *The Antipodean Manifesto: Essays in Art and History,* pp. 16-24. Melbourne: Oxford University Press, 1976.
　　Discusses Moore's theory of sculpture as presented in *Unit One* (see Artist's Statements above) and reviews the British Council's exhibition of Moore's work that toured Australia in 1948. Smith's essay was originally published in *Hermes: Magazine of the University of Sydney* in 1948.

Steingräber, Erich. "Henry Moore's Maquettes: Observations on the Methodical Evolution in His Work." *Pantheon* 36, No. 3 (July-September 1978): 261-65.
　　Examines Moore's methods of studying and developing ideas for sculpture through drawings and plaster maquettes.

Strachan, W. J. "Henry Moore: The Man and His Work." *Blackwood's Magazine* 324, No. 1,953 (July 1978): 3-10.
　　Informal memoir occasioned by Moore's eightieth birthday.

Sweeney, James Johnson. *Henry Moore.* New York: Museum of Modern Art, 1946, 95 p.
　　Surveys Moore's art and ideas. Sweeney calls Moore "the one important figure in contemporary English sculpture. . . . For as an artist Moore has the courage, the craftsmanship and talent that match his personal sympathy, humility and integrity. And in spite of the maturity and individuality of his early production, Moore has grown in stature as a creative artist with every completed major work, and continues to grow."

Wight, Frederick S. "Henry Moore: The Reclining Figure." *The Journal of Aesthetics & Art Criticism* VI, No. 2 (December 1947): 95-105.
　　Discusses psychological motives behind Moore's explorations of his two most prominent subjects: the Reclining Figure and the Mother and Child.

Wilenski, R. H. "Ruminations on Sculpture and the Work of Henry Moore." *Apollo* XII, No. 72 (December 1930): 409-13.
　　Discusses intention and technique in modern sculpture, focusing on Moore as an example of an original, independent artist whose work demonstrates a modern outlook, modern methods, and modern symbolic content—which Wilenski considers advancements in art since the aesthetics of John Ruskin gained prominence in England in the nineteenth century.

VI. Selected Sources of Reproductions

Bowness, Alan, ed. *Henry Moore: Sculpture and Drawings.* 6 vols. London: Lund Humphries/Zwemmer, 1944.
　　Comprehensive catalog of Moore's works. Each volume contains an introduction, bibliography, and numerous plates.

Clark, Kenneth. *Henry Moore Drawings.* New York: Harper & Row, 1974, 326 p.
　　Includes more than 300 illustrations, forty of them in color, and an accompanying text by Clark on such topics as Moore's life drawings, first drawings for sculpture, drawings of shelterers and miners, reclining figures, and family life.

Finn, David. *Henry Moore: Sculpture and Environment.* New York: Harry N. Abrams, 1976, 493 p.
　　Features black-and-white and color photographs with text by Finn, a foreword by Kenneth Clark considering sculpture placement, and commentary by Moore in an examination of Moore's sculptures in outdoor sites around the world.

Grohmann, Will. *The Art of Henry Moore.* New York: Harry N. Abrams, 1960, 279 p.
　　Includes critical text discussing the works reproduced in black-and-white photographs and color plates.

Melville, Robert. *Henry Moore: Sculpture and Drawings, 1921-1969.* New York: Harry N. Abrams, 1970, 368 p.
　　Includes the introductory essay "Object and Effigy in the Art of Henry Moore" and commentary on numerous black-and-white and color plates.

Moore, Henry. *Henry Moore: Sculpture.* Edited by David Mitchinson. New York: Rizzoli, 1981, 316 p.

Includes accompanying text by Moore and an introductory biographical and critical sketch by Franco Russoli.

Sylvester, David. *Henry Moore.* New York: Frederick A. Praeger, 1968, 168 p.

Thematically arranged photographic reproductions of Moore sculptures and drawings with an accompanying text by Sylvester. With few exceptions, the photographs of sculptures were taken by Moore.

Edward Moses

1926-

American painter, mixed-media artist, and graphic artist.

Moses is an enigmatic figure in contemporary art, highly esteemed by artists and critics for his innovative, abstract works—examples of which hang in museums throughout the United States—yet little known to the public. His relative obscurity is in part a reflection of his adversarial stance toward both the contemporary art world and current aesthetics, an approach that led his friend and colleague Billy Al Bengston to call him "the artists' underground hero of the perverse."

Born in Long Beach, California, Moses attended the University of California, where he took courses in architecture and medicine before graduating with a Master of Arts degree in 1958. In the late 1950s, he began creating geometric paintings which reflected the influence of Abstract Expressionism in their concern for purely formal relations. The solid geometric forms of his early works gradually gave way to diagonal grid compositions during the 1960s, and while many were drawn or painted, Moses also experimented with materials such as tissue paper, fabric, yarns, and various coating substances. In a 1970 show at the Mizuno Gallery in Los Angeles, he drew upon his architectural skills to create an environment piece, in which he cut a hole in the roof of the gallery to allow sunlight to create a pattern on the floor. During the late 1970s, Moses painted severely minimalistic monochrome canvases. He has recently returned to the use of grids, introducing neon colors and some organic forms, most notably spiders, into his compostions.

During a 1987 conversation with Barnaby Conrad III, Moses explained his style as follows: "No arrangements, no geometry, no pictorial illusionism—no nothin'. Just put the . . . paint on." Critics note that despite this seemingly simplistic approach, Moses's paintings consistently display both intelligence and craftsmanship, and Merle Schipper has noted: "a dialogue between structure and spontaneity, and between medium and maker, his oeuvre records the progress of a career in which intuition, always open to provocation but never submitting to fashion, has been an unfailing guide."

SURVEY OF CRITICISM

Peter Plagens (essay date 1972)

[*In the following essay, Plagens discusses Moses's work in the context of California art of recent decades.*]

Los Angeles art bears a peculiar, ambivalent, and unfortunate relation to New York ever since, in the late '50s and early '60s, this city was promoted, inside and outside, as a peer or at least a *strong* second to the Big Apple. (The broader, weirder problem of the mystic critical necessity for diverse artists across this whole bountiful land to sort the same soot as vanguard Gotham *Kunstmeisters* is perhaps the overriding issue; I'm dealing only with one aspect of it.) Until the '50s, Los Angeles was a thinly spread bantamweight—no history, no culture, just a string of defense plants and movie studios—with isolated practitioners of comatose styles (Lebrun, Surrealist Lundeberg, Merrill Gage, et al) copping the "new" market. Abstract Expressionist's overall freedom prompted the area to suppose it could manifest something of its own; since then quality modernists have traveled one of two routes—practicing a New York-based, theoretically "correct" art mode just as heavily as the Manhattanites (Francis, Woelffer, Chamberlain, etc.), or making something glamorously "regional" (without the rural connotations of the word). The latter has amounted mostly to extra spit and polish on Pop and Minimal art, plus space-age materials (Valentine, Bell, Cooper, Irwin, Ruscha, Goode, Price, etc.), and it has oft been described as the "L.A. Look" or the "California finish fetish," or other, less polite, things.

Recently, after five years of pervasive casting, sanding,

polishing, spraying, lighting, and coating, two artists have made it big (critically, in New York) through the neglected first option. Bruce Nauman, a peripatetic only a few years settled in the Basin, investigates the contextual/epistemological problem sired by Duchamp and nursed through Rauschenberg, Johns, Cage, Warhol, and parts of Oldenburg, and together with the mainstream of downtown New York theory, is shepherding it through a healthy adolescence (some say, already, old age). Ron Davis . . . dug himself firmly into the no-nonsense Serious Painting groove (Cubism-Hofmann-Stella) and continues to outpaint guys like Ruda, Avedisian, and Dzubas (no slouches), although of late he's contracted the recent-Poons, recent-Noland Baroque Structure virus. The point is, Nauman and Davis are doing it the hard way, with art which must pass through New York, physically or otherwise. Maybe the choice is between flying to London to do prints or hitchhiking to New York to have articles written about you.

For 15 years, Ed Moses has been plowing a furrow of his own (uncovering an occasional boulder belonging to somebody else), slightly to the right of Nauman, considerably to the left of Ed Ruscha; he's attracted to the regional *rôle* (the portion of it eschewing forced "mainstream" avant-garde art "issues," the artist standing on his own soil saying, "this is where I am and this is where the crop's planted"), but formally convinced by hardcore, serious painting, the kind you see a hundred times more *there* than here. Thus, Moses has been split, neither expansive, sizable enough for New York, nor effete-craftsman enough for Los Angeles.

Moses' was one of the first shows at the seminal Ferus Gallery . . . , because he was the oldest (46 now) of the original stable: Bengston, Ken Price, Ed Keinholz, Robert Irwin. "I didn't make it in L.A. right off because I didn't 'fit'. When everybody else was doing these fetish objects, and the L.A. thing was starting to boom, here I was doing those goddamned valentines." (The "valentines" are small, cutout, pop-up images derived from some shapes on a Swedish greeting card.) A few years later, his show at Riko Mizuno involved, together with canvas tacked to the walls, half-unrolled on the floor, on platforms, and a general smell of in-process carpentry, half-ripping the roof off the gallery, resulting in slanting bands of sunlight floating down from the opened slits in the ceiling; it was quite beautiful, and superficially related to the venetian blind works of Jim Turrell.

> "Ripping up Riko's roof was the most interesting thing I've ever been involved in. Originally, I wanted to take off the whole roof, and make a piece out of the sky. Do you know how the sky looks up through a hole in the roof? There's absolutely no distance, that blue is as deep or as far away as you want it, and it changes with the day. But her landlord threatened to revoke the lease and evict her, so I let it go at that. The piece still worked."

That exhibition exuded Moses' base feelings of anti-hard-edge, anti-art-and-technology, anti-polish—visceral intuitions rather than set policy. "I've always had the feeling relative to the supposed 'finish fetish' of L.A. art, that my asshole is just as much a part of me as my mouth, only, for some reason, we're supposed to keep that *part* covered up. I don't want to, in my art. The mistakes and erasures and additions and changes are part of it."

Typically, a lovely, inclusive exhibition of works ranging over 20 years was not on La Cienega, or in the County or Pasadena museums, but 50 miles eastward in Claremont, an idyllic grove of academe pocketed in the pall of ozone the prevailing winds have unjustly washed to the pastures of Pomona. . . . Here, Moses employs the largest gallery to display several "soft" (unstretched) paintings; in the middle room hang transparent overlay lithographs, one big current painting, one current wrong turn (see below), and a jewel of a poignant, quaint late (1958) Abstract Expressionist straight oil owing not a little to Altoon and Hassel Smith. Off to the left are more drawings mounted with push pins, or simply leaning against the wall. As an entity, the exhibition is more than a simple solo, flexing as it does with Moses hauling semifinished paintings back and forth between Pomona College and Venice; it's a manner of condensed, codified retrospective without the restrictive pomp.

There is a danger of seduction by the good looks of the stuff (Moses has never been *that* far from Los Angeles) and its unexpected "consistency": from the early, student drawings of the Venice boardwalk and the Glady McBean kiln, charged with intense, ruler perspective and compulsive overworking of the surface, to the snap-line, romantic, resined paintings of the last two years, Moses lays down an insistent, reiterated horizontal strata. In a 1968 pencil drawing, like the ground behind a Jasper Johns' coat hanger, that horizontal is an understructure for recorded time clock hours of laborious pencil-patching; in the recent lithographs the lines form wispy color fields interacting with others on separate layers of translucent paper; and in the current, unstretched, resin-backed canvases, the bleeding lines function as both calibrated color areas set against the matte cream canvas and the gloss, maple sugar resin, and as subtly architectonic composition devices preventing the paintings from dissolving into Process clichés. But, throughout most of the work, these lines measure dispersed, compulsive, psychological energy which is, to Moses, the most important part of his art. I asked him if, for instance, it would be wrong to see the painting as simply visually pretty in its balance of elements (which it is). "Yes," he said. "The painting should be done blindfolded, or close up. If I step back, it's lost, and I'm a decorator."

For all the autobiographical paraphernalia of the installation (Moses' attempt to reconstruct the private-public transference of the art), the best work and clearest statements are the big recent paintings. They are mainstream (New York, if you will) in their austerity: canvas, coating, lines. They are unequivocally *painting,* and partake of all the formalist issues of the times. Is the surface flat? *Yes.* Do the materials connote other than themselves? *No.* Is there an ambivalence between the painting as object and what is painted on it? *Yes.* But they also evidence an ethereal romanticism peculiar to recent Los Angeles art, in the bleeding stripes, holes, and seepings in the resin backing, and the urine-colored halation (resin at the edges) extending beyond the canvas perimeter (a device which "sinks" the canvas into the wall, although it is clearly part of a wrinkly object *on top of it*). This subjectivism, attention to sensation (Los Angeles, if you will), weaves itself around a gently architectonic arrangement of lines and voids, color groupings, margin and resin frame, and lifts Moses' paintings a cut above the dead academic formalist paint-

ing which produces pictorial addenda to Greenbergian criticism. Moses' problems arise when he gets too theoretically "correct," as with a new work, a "loom" which is redundant of Eva Hesse and imitative of the au courant soft, shamanist art object. Moses admits, "In every show there's a bummer, a worst work, something embarrassing, something you want to walk around to avoid," and he concedes the "loom" is it.

What Moses' cumulative labor amounts to, however, is not simply a moderately underground (or in-between) career upturning with the surfacing of suitably stylish objects, although the resined paintings are as "together" as anything around. Rather, it is the acting out of the paradox of the works themselves: on the one hand private, personal, fabricated one-to-one in the privileged sanctuary of the studio, and, on the other, coming to cold, clear presence in public, entering its being-in-the-world. If Moses' paintings were merely good-looking, they would simply illustrate that; they are significant because they embody, in elegant existential tension, the standoff between the visual and the visceral. (pp. 83, 85)

> Peter Plagens, "Ed Moses: The Problem of Regionalism," in Artforum, *Vol. X, No. 7, March, 1972, pp. 83-5.*

Bruce Boice (essay date 1973)

[*In the following review of an exhibition at the Ronald Feldman Fine Arts gallery in New York, Boice offers a positive assessment of the works displayed.*]

Ed Moses' four new paintings at Ronald Feldman Fine Arts are different from his resin, canvas, and powdered pigments paintings of the last few years, but they are like the earlier works in certain basic respects. The new works are also paintings that are tacked directly to the wall without supports. They are generally rectangular with rough, erratic edges and, like the earlier works, consist of sets of colored parallel lines.

The new works are made of Japanese tissue paper and acrylic, with the paper playing an active role in the formation of the works. The works are formed by sets of parallel bands of paper on a generally horizontal diagonal. The sets alternate sloping toward right and left and overlap. Of the three works in which the sets of bands are alternating diagonals (the sets of bands in a fourth work are all horizontal), one work is painted in extremely light, faint, pastel colors, except for the top band on each diagonal set, which is painted red. The situation of the sets of bands is essentially the same in two other works, but in one, the individual bands are of alternating pink and gray blue color, and the other was painted both with and against the direction of the sets of bands, producing a woven illusion, and making the identity of the bands nearly indistinguishable.

For me, the work with the red top bands, and that with alternating pink and blue gray bands were the most interesting by presenting an ambiguous illusion of depth and flatness. In both cases, the overlapping sets of diagonal bands are almost like a kind of oriental isometric perspective. One set of colored tissue bands literally overlaps and is in front of another set, with the lowermost set being theoretically also the most forward. The other sets of bands are literally and illusionistically behind this lowest set and

subsequent sets moving up the painting. However, the widths of all the bands and sets of bands are constant, thwarting the illusion of receding in space, and if anything, tend to reverse the expected reading. Within the context of illusionist perspective, the lower sets of bands can appear less forward than the upper sets. The mechanism is like that of looking at an isometric drawing of a cube: because the back side does not appear smaller than the front, as we expect, the back appears larger than the front even though they are the same size. This is essentially the kind of illusionist tension built into Moses' very fragile works. The overlapping is literal as well as illusionistic, and at the same time, the sets of bands literally and illusionistically exist on the same plane. (pp. 84-5)

> Bruce Boice, in a review of an exhibit at the Ronald Feldman Fine Arts Gallery in Artforum, *Vol. XI, No. 10, June, 1973, pp. 84-5.*

Jeremy Gilbert-Rolfe (essay date 1974)

[*In the following excerpt, Gilbert-Rolfe compares Moses's tissue-paper compositions of the mid 1970s to the works of avant-garde painters Frank Stella and Morris Louis.*]

Ed Moses is now painting diagonal stripes on laminated tissue paper in a way that equates the surface—pigment and rhoplex—with its support; the paper is about as thick as the painted skin it bears. Fragility, one of the most immediately apparent properties of such a work as **Coyote,** 1973-74, is as much a physical condition of the piece as it's a feature attributed to it by color or line.

The physical fragility of these works seems important because of, not despite, their involvement with the terminology of '60s modernism. Specifically, they refer to Morris Louis and to the recent work of Frank Stella. Like Louis, who identified the canvas—the literal support—with the picture plane, through stained color that uses the weave of the canvas to impose a planar simultaneity that acts against the intensive bias—toward recession and progression—of individual colors, Moses uses rhoplex to locate color *within* the surface of the painting. Like the recent work of Stella, these pieces of Moses suggest a physical commonality and interaction between surface and support. Like Stella, Moses has developed a strategy that depends on equating the shallow space of modernism with a physical interpretation of the idea. Hence the equality of the thickness of the paper and the paint in these works, an equality which provides a kind of internal model for the reflexiveness between the space of the painting and that of its viewer. This is reinforced by Moses' reliance on diagonal striation, which communicates a sense of movement that complements the fragility—compared to canvas, the impermanence—of the support. Louis had to stretch his canvases in order that the surface might be set in tension with the picture plane, which, seen as a product of the perimeter, is thereby also seen as the product of an equation of drawing with physical specification. Moses locates the drawing within the work—the striation—in order to abandon the stretcher and locate the support, not at the edge, but as an underlying presence throughout the work. Moses seems most like Stella in that he seems to be a painter who's been able to revise the vocabulary of a certain sort of '60s painting in response to an increased awareness of

the importance of literal signification to painting and the other arts.

And it's literal signification that links this new work of Moses to the work he made in the past. His use of paper is of critical importance in that it refers to the notion of drawing as a resource which has a wider range of object reference than painting. Moses' employment of drawing's conventional support suggests that he's looking to it now to provide the means for a transition from the interest in surface that characterized that work to an employment of surface which might . . . involve a more complicated comment on pictorialism per se. To some degree, Moses retains the funky look of West Coast art while adopting an Atlantic, analytic involvement with pictorial morphology.

Jeremy Gilbert-Rolfe, in an exhibition review in Artforum, *Vol. XII, No. 9, May, 1974, p. 69.*

Elizabeth Claridge (essay date 1975)

[*In the following review of a London exhibition of Moses's works, Claridge responds positively to the artist's evocative use of titles in his* Egypt-Trac *series.*]

The material of Ed Moses's new paintings at the Felicity Samuel Gallery was an idiosyncratic composite of tissue, nylon and Rhoplex which is delicately and seductively tactile. Moses home-brewed it as a substitute for the resin on canvas of his previous works, such as those shown in his first London one-man show at the same gallery two years ago, after finding the resin process too threateningly toxic. The new material shares with the resin the quality of seeming tenuous while being substantial. Otherwise it is opaque and impervious whereas resin is translucent and ingestive, and the greater formalization of Moses's new work can be seen as arising from this difference. In the resin works the pigment is suspended within the material. In the new paintings the character of the material precludes any such possibility. Instead the paint is regulated across the surface of the material and an elusive physical presence is replaced by a more concrete one. At the same time the new works are more assertively paintings than the previous ones.

The six paintings at Felicity Samuel's were from two main series titled generically *Egypt-Trac* and *Double Trac.* They demonstrate Moses's continuing predilection for discreet, hesitant effects, for a complexity of quiet incidents.

The *Egypt-Trac* paintings, *A-1, A-2* and *A-3,* are structured on a fine diagonal grid with the paint tracking, as the titles suggest, primarily in one direction. A thin mesh of colour is laid over a ground that is either left free of paint, its desiccated texture exposed, or painted out in a pale colour. The *Egypt* of the title, if not descriptive, is at least evocative and presumably intended to be. Since titles both trigger and regulate the associations made to a work of art, and the more abstract the work the greater their influence, it is surprising that greater critical attention hasn't been paid to their role as part of a work.

Double Trac is a more literal title and indicates how the paintings it refers to are to be received. The paintings *A-1* and *B-2* are comparatively dense in structure

with heavier, more continuous tracks of paint travelling along both diagonals. It is tempting to describe the structure as double woven but in fact one set of tracks more or less overlays, as opposed to weaves into, another. The visual effect is of an open layer of colour revealing another layer beneath and even another beneath that, while adjustments in the colour and dextrous execution keep the activity close to the picture surface. The *Double Trac* paintings are less elusive and less allusive than the *Egypt-Trac* paintings, and perhaps because of this they are less intriguing, however ingenious their distribution of colour and whatever the virtues of their self-containment.

Formalist criticism has made it fashionable to assume that art which tries to suggest nothing outside itself is innately superior. As human beings have an apparently unquenchable instinct to tabulate their perceptions by metaphors, this is a tendentious assumption. It has been responsible amongst other things for the convention that New York of recent years has *per se* been better, because more stringently autonomous, than West Coast painting. This generalization, a sort of racial prejudice, if nothing else has conditioned how West Coast painting has been looked at. Moses's cultivation of seductive material and subtle effects can be considered typical of a West Coast sensibility, and none the worse for that.

Elizabeth Claridge, in a review of an exhibit at the Felicity Samuel Gallery in Studio International, *Vol. 189, No. 973, January-February, 1975, p. 15.*

Joseph Masheck (essay date 1975)

[*In the following excerpt, Masheck discusses Moses's use of Native-American motifs.*]

By "Western Art" in an absolute sense we generally mean Occidental art—the art of Europe and of European colonial extensions in the Western hemisphere. Already a problem of regionalism arises with regard to the art of the West Coast. For at least since the incorporation of the original Northwest Territories (now in the Midwest), the concept "Western" has also had a different, relative meaning in America, implying a steady westward drift eventually to be stopped only by the distant loom across the Pacific of the eastern edge of the Orient. Consequently, many Americans would suppose that what they meant by "Western art" was better represented by *Custer's Last Stand* (recently revived and revised by Peter Saul) or even Puccini's *La fanciulla del West* than by, say, the tradition of the classical nude.

The two senses of Western, or rather of "non-Western," overlap with some irony in the case of so-called Native American or American Indian culture and art. From the Atlantic viewpoint, such art is non-Western in the sense of its being absolutely discontinuous with the tradition of the Athens-Rome-Paris axis. On the other hand, reasonable claims are sometimes advanced that the work of contemporary artists in California or the Pacific Northwest might relate sympathetically to the high cultures of the Orient, as a sort of counterpart to the cultural pull of Europe across the Atlantic. However, the surviving Orientalism in American Indian art—which is itself approached as ahistorical, if not prehistorical—is so indirect or extrud-

ed that it has nothing to do with the more "sophisticated" Orientalism of American West Coast art that relates, for instance, to Zen.

Consider two works of art that raise the issue of admitting aboriginal art to anything but a miscellaneous category within the comprehensive schemata of art history (even Oriental-inclusive art history). One is a great masterpiece of Western painting, the vase representing *Dionysus in a Boat* (ca. 540 B.C.) by Exekias, in Munich. The other is a Pawnee painted drumhead in the Field Museum of Natural History, Chicago. Note first how many questions we must already beg in order to proceed: that the datable "Western-world" object, whose author is known as an individual, simply precedes in a sequential (however discontinuous) way the "wild-Western" work harvested (in 1902) from a traditional culture at the point of its fatal encounter with expanding European civilization. And so on. Not to mention the convention of considering the second object as belonging to the realm of "nature" rather than to a living human cultural patrimony. Or consider in logical terms that the concentration on formal properties encouraged by the alien, if not irretrievable, mythic content of at least one of the examples might or might not be critically advantageous.

We are used to at least two approaches to the appreciation of primitive art in the service of modernism. One approach values mutely "universal" beauty of form, even to the point of capitalizing on the inaccessibility of iconography (which might seem pagan once we did discover it). A more expressionistic approach admires the generalized presence or power of mythic content—the sheer forcefulness and conviction that seem to motivate artistic form—even, once again, when the mythic details are either unavailable, hypothetical, or muddled by a cruder-than-thou affection for primitive *grit*.

In the case at hand, knowing the identity of Dionysus may or may not give the vase painting an edge, depending not only on whether one might actually prefer not to know stories (in order not to be distracted from artistic form) but also on whether one felt that Dionysus was mythic in the sense of legendary, or mythic in the sense of continually pertinent—even to later spiritual outlooks. In a sense, the classical kinship which greets us in the vase, and not in the drum—no matter how admiringly we may look at it, as a tribal object, from without—has to do with the difference between the dominance of a giant bird, separating day from night, versus the perhaps comfortable inhabitation of nature in the other case by a reassuringly cultural *human* form. Not that the giant bird is necessarily crude: indeed, it might comprise a vividly poetic metaphor for nightfall.

Nevertheless, the similarities between these two works are most provocative. So much so that the distinction between a non-literate and a literate mythological art is eclipsed, if not reversed, when we consider the Indian painting as possibly more direct and accessible in its essential "poetic" feature (if not subtleties), whereas the literary feature of the Greek painting seems to depend more upon visually extraneous knowledge. Then, one may wonder, which is really ultimately *classical*—in the sense of appealing to the timeless and universal in human nature? From another angle, the Indian painting is perhaps "more gentile" (more racially and mythologically remote from the Holy Land),

while the Greek painting is "more pagan" (in its representation of a known false god). In any case, I mean to indicate that even in their handling of mytho-poetic content the two paintings are so closely analogous that we can be sure that their stunning formal parallels do not depend on the accidental or willful overlooking of meaning or content.

Certainly both are close to one another in their purely formal configurations. In both a central field is divided into an upper and lower half, with an underplayed orb-like subdivision of the upper half by the dominant, and centered, main motif. And in both an essentially flat and highly rhythmic pattern of animal motifs spreads decoratively across the surface. (Considered somewhat differently, by counting both dolphins and grape clusters in the vase, both have *twelve similar small forms* arrayed more or less equidistantly in the field.) Yet, even apart from the familiarity of information about Dionysus or the giant bird, a continuum connects the vivid formal parallels with similarities that seem more and more deeply involved with content—even content in the isolable sense of the literary "tenor." Thus, in the one case, animal forms adorn a represented sky on an animal skin which is part of a musical instrument used by holding it aloft from handles in the air. And in the other, dolphins and grape clusters adorn the inside of a wine vessel, no doubt still visible there through that very substance—fruit and fluid—to which they allude when the vessel is full and in use, held from *its* handles.

I draw this parallel between a Western painting in the sense of "Western culture" and a Western painting in the sense of "out West," partly in order to demonstrate how much more complex the question of such comparisons is than early partisans of modernism, who often enough were Protestants with a puritan distaste even for much traditional European iconography, made it out to be. But mainly, I want to turn from this to a consideration of the work of the contemporary California painter Ed Moses. His art shares in the less lofty problems of regionalism and provincialism, with respect to a New York considered to be the heir of Paris as the metropolis of art.

The closeness of some of Ed Moses' earlier work to American Indian art, especially to Navajo blankets, makes the positive relevance of "non-Western art" at least as fundamental to his work as the negative question of the ultimate geographic petering out of European cultural hegemony along the Pacific Coast. It's not as though Moses had used Indian art as a mere inspiration, where somebody else might use *kustom kar* painting or vernacular architecture or design, as idiosyncratically as if it just happened to be his "thing." On the contrary, Moses' Indianism meaningfully reflects the West Coast dilemma while, I think, transcending the limitations of regionalism as few nonmetropolitan American artists have managed to do. That, in turn, may prepare us for the decidedly metropolitan issues raised in a group of formidable paintings from the past year.

Note that the art of the Navajo is certainly not alien to California artists, least of all to Moses. Mary Hunt Kahlenberg and Anthony Berlant's beautiful catalogue for the exhibition *The Navajo Blanket,* originating at the Los Angeles County Museum of Art in 1972, shows many fine blankets in the collection of Berlant, the Santa Monica artist, alone. Otherwise, I have already pointed out in a review

[see Further Reading], February 1972), Moses himself is conversant enough with Navajo culture to have derived the titles of such paintings as ***III.166 Hegemann*** (1971) from Elizabeth Hegemann's *Navajo Trading Days* (Albuquerque, 1963).

Waft (1972) is a fine Moses lithograph on two translucent sheets of tissue, one overlaying the other. . . . The sheets are of concrete but negligible thickness; consequently, the design seems as concretely flat as in textiles. The impressions on the two leaves mesh in a design as texturally substantial as it is thin and flat. With another layered lithograph from the next year, ***2nd P*** (1973), ***Waft*** compares surprisingly closely with one particular variety of Navajo blanket. This ***2nd P*** is a hand-colored print with one translucent tissue over one opaque paper sheet. It emphasizes a luridly flavorful pink where the bundled-together lines of ***Waft*** suggest the rubier red of red ink. Both prints, however, relate very closely to one another in design, and equally to Navajo blankets belonging to the second phase of what is called the "chief's" type.

In both works by Moses and in the chief's blanket . . . , a horizontal rectangular field divides into six pairs of alternating dark and light bands, with three pairs on either side of a wider cluster of bands running from end to end at the center. The uppermost and lowermost bands in all three works subdivide into alternating short and long stripes, as do those clustered at the middle. The long stripes extend the whole length of the piece, with the short ones broken into two lengths equidistant from the transverse axis and from the extreme ends of the field. Even the fractured bands and stray lines of the prints resemble broken threads and fibrously tattered edges in the blanket. . . . Again, the resemblance indicates neither a casual inspiration nor a design gimmick, but on the contrary a serious analogy with a native, regional prototype that is itself committed to flat linear design as embedded in the built-in colors of dyed wool and the tight, palpable flatness of a woven facture. This approach reflects on East Coast theories of orthodox abstraction with its own much simpler, homegrown directness.

Dispositions of this kind had appeared earlier in Moses' paintings. In loosely hanging unstretched paintings of 1971 we find that taut, twinelike line which, packed into densely cabled bundles, builds up balanced, banded surface designs. Such lines seem to have the elastic tautness and the tightly twisted consistency of the snapped string lines of colored chalk used by masons and carpenters, which also made in the early 1970s for a nice opposition between the soft, slack hang of a painting as if it were unwilling to assume the formal posture of a stretched canvas, and the flexed, intrinsically colored line that avoided in its own way the arty fetish of "touch." To prints like ***Waft*** and ***2nd P*** the same observations extend, since the unassumingly flimsy fineness of the support is there essential to the translucent overlapping effect. Also, the leaves of paper seem substantially important as woven *stuffs*, much more so than is true in the normal relation of prints to paintings. That materiality is aptly corroborated by the distinct threadlikeness of the lines, just as the very title ***Waft*** plays on the concrete facture of weaving (the weft).

It is worth remarking that Navajo culture does not call for any kind of noble-savage idealization. In fact, one of the most interesting features of its appeal is that its own rela-

tive lack of antiquity cannot show up the novelty of European culture in California. According to A. L. Kroeber's *A Roster of Civilizations and Culture* (1962), the Navajo display an unsophisticated level of development even in purely anthropological terms. Originally a branch of the Apache, they migrated to the Southwest probably soon before the Spanish came. Essential elements of their way of life—including cloth weaving—are borrowed from their Pueblo neighbors, and such borrowings often enough involve obvious vulgarization. Furthermore, as the handbooks point out, the Navajo blanket-weaving industry was already geared mainly to the white man's taste before the end of the nineteenth century. In other words, even when we are dealing with the purest material, we are hardly in touch with anything that could claim racial or patriarchal antiquity, even though we often assume that all primitive art is venerable in a more or less prehistoric sense. On the contrary, the classic Navajo period is hardly a generation earlier than the white man's Texas buildings that Lady Bird Johnson, leading a busload of European journalists, once described with awe as "nearly one hundred years old."

Navajo blankets have, nevertheless, been practically emblematic of literal, Post-Impressionistic flatness for about as long as there has been modern painting in America. Theodore Roosevelt turned easily to them as a paradigm for the definitive flatness of modern painting (even if he did confuse Cubist with Post-Impressionist ideas) in his review of the Armory Show for *The Outlook* of March 9, 1913. "There is in my bathroom," he wrote of Duchamp's *Nude Descending a Staircase* (perhaps intending to be sassy, with Duchamp's urinal *Fountain* in mind?), "a really good Navajo rug which, on any proper interpretation of the Cubist theory, is a far more satisfactory decorative picture." Ten years before, Roosevelt had called the great Boston Orientalist Ernest Fenollosa to the White House for a command performance lecture, when Fenollosa was strongly influenced by Arthur Wesley Dow's notions of flat, decorative design. Now in 1913, Roosevelt claimed, "from the standpoint of decorative value, of sincerity, and of artistic merit, the Navajo rug is infinitely ahead of the picture."

It could be argued that Moses has made *merely* decorative use of the Navajo patterns and compositional types, overlooking or capitalizing on our Gringo insulation from literary, symbolic, or ritual meanings. Yet what is ultimately lost if we comprehend the most forthright features of design and color in a Navajo blanket, ignorant in this case of the Navajo "Spider Woman" who is believed to have taught man to weave, who personifies the textile arts, and who requires textiles as offerings? What is the difference between not knowing about Spider Woman and not knowing that Velazquez' *Las hilanderas* represents the legend of Pallas and Arachne (*Metamorphoses, VI*), a weaving contest, the loss of which caused the mortal Arachne to be shrunken into a spider? The explication of Velazquez' picture as a representation of the Arachne legend was only proposed in 1940: before that even the main-line, "Western," Velazquez half of our comparison could well have been left iconographically dangling.

We can turn to ***Rain-Wedge*** and others of Moses' similar, unstretched paintings of 1973. ***Rain-Wedge*** relates to the format of the prints and the drawings like them, but is

more ambitious in size and construction. Like the graphics, it consists of layers of tissue, here used with rhoplex and pigment and laminated together. Its large-scale zigzag design, with continuous diagonals crossing the width of a vertical format, resembles another Navajo blanket type, although one perhaps less classic than the chief type—the "wedge-weave" or "pulled-warp-weave" blanket. The difference of type is significant: in the wedge-weave type, the diagonal weave builds up gradually, augmenting the angle of the diagonal by progressive increments, which produces a wavering, gently scalloped edge in place of a firm rectilinear boundary. Of course, **Rain-Wedge** is itself built up not from single large (7 by 6 foot) congruent rectangular sheets—in the manner of Moses' graphics—but by long narrow diagonal strips. The result is all the more like the raking weave of the wedge-weave blankets in both its zigzagging facture and its consequently irregular outside edge.

Moses' unstretched rhoplex paintings have a delicacy of pigmental deposit that, in conjunction with the preference for tissue rather than for canvas, suggests the tentative, even moody, responsiveness and translucency of watercolor rather than the plastic opacity of conventional oil painting. (How much acrylic relates to watercolor on this score, particularly respecting the more "lyrical" capabilities of the medium, is an interesting subject for speculation.) Compared, for example, with differences of scale and opacity in the watercolors and paintings on canvas of Sam Francis, Moses' transposition of the watercolor mode to a larger, loosened up, less dense scale is better managed. Another engaging feature of the same transposition is the blotted way, in **Culver Tract A Sec. 2** (1973-74) for instance, that Moses' painted bands get pressed down palpably flat, even overriding other colors occupying the same channel. Even shifts of density locate entirely in these flat, tape-like bands of paint.

Last Spring Moses exhibited in New York some new unstretched, unmounted paintings of laminated tissue with rhoplex and pigment. Now the field was covered with closely and evenly (although not mechanically) spaced stripes of color. Thus in **Dax** (1974), a 6-by-7-foot horizontal painting, there was an even yet still essentially manually painted grille of parallel diagonals, spaced closer together than their width. It seemed important to the manual aspect here that the resultant pattern of bands of several colors—some overlaying one another in several different tints, some starting and stopping as they cross the field—

ran in the direction of cross-hatching as made by right-handed artists, which extended to the broad bands on these large, softly hanging sheets something of the proportion of twine-sized drawing mark to drawing scale.

Dax consists all of diagonal bands, yet a counterpoint of sorts builds up. Emphatic patches array themselves against the grain, not by supplying equal and opposite diagonals to the overall system (which some works hint at with a much lighter, understated, pencilled-in, opposing grid), but instead by stressing within it denser sections in parallel adjacent bands. In its implication of a possible equal and opposite diagonal system, this disposition anticipates the criss-crossing biaxial grids of Moses' works in 1975.

The crisscrossing grids of these new Moses paintings—each of which is identified as **NY. Trac.** plus a Roman numeral—suggests expanded density rather than old-time illusionistic space, as though the notion of the textile weave has, like the watercolor approach in works of a year or two earlier, intelligently accommodated itself to a larger format. There is a New York stridency in the pushy, noisy, unpretty crashing together of the intersecting systems of lines in the plane. That is true of lurching discontinuities in the grid as well, not to mention the understated drips and splatters that here and there punctuate this crowded network. If before we found a calm, stable, repetitious inflection of the surface—as when a housepainter glides in long, skilled but relaxed bands—now we find a strident, jazzy crisscrossing that readily evokes Mondrian's image of New York. (pp. 56-61)

The tapelike banding in Moses' works of 1974 now makes for a biaxial grid that also reads as an orthogonal system rotated 45 degrees from an upright position. A complex dazzle of overlapping and fusing bands provokes only the most tentative or ironic spatial illusion. And these features, combined with a high-key emphasis on black, red, and yellow bands, together point toward Mondrian, especially the Mondrian of the late *Boggie-Woogies.*

For their banded, regular patterning and for their literal involvement with the format, Moses' work has been related to the work of Frank Stella (as by Jeremy Gilbert-Rolfe in a review in *Artforum,* May 1974) [see excerpt above]. Now, in the case of the recent **NY. Trac.** pictures, particularly in the correspondence between a regular banding of fairly even width and a stretcher similarly thick, the issue takes on vital importance. This devious relation to the es-

Wall-Layuca #1 (1989)

tablished tradition of New York grand-manner modernism must also account in the new works for an ironic formality—utterly white-tie by comparison with the unstretched Moses—an orthodoxy deriving from wit and personal *style* rather than from belated dogmatism.

Actually, it is possible that the same procedure, still identifiable with Stella's classic evenly banded phase, can be traced back historically at least as far as Picasso's *The Studio* (1927-28), in the Museum of Modern Art. There a firm right-angular form, like a carpenter's square, appears where the hang of a red tablecloth over the edge and thickness of a tabletop flattens against the picture plane (recalling the equation of the same motif with the parson's-table-like equal widths of a table's legs and table rail in Picasso's *Studio with Plaster Head,* from 1925, also in the Modern). This rigid L-shaped band relates to all the other banded elements of *The Studio:* framed pictures on the wall behind (which function as relationally as the internal picture frames of Degas, Whistler, and Seurat); a large yellow vertical rectangle at the left—banded on three sides with orange—which is either a door behind the artist or else the very canvas on which the artist works (and by inference the canvas before us); to what may be a screen in the upper right; and finally to the inner band that brackets the entire composition in a depicted frame fused to the literal edge of the field and analogous in width to the (real) stretcher.

These various considerations may now begin to resolve themselves before Moses' New York paintings of 1975. Turning away the Navajo format, which conformed only in a qualified, regionalistic way with modernist ideals, Moses revises the significance of the Mondrian/Stella problem. Now the roots of a dogmatic issue in New York art can be traced (What can the enigmatic word "trac." in the titles stand for?) back even further, into the mainstream of the School of Paris. The whole tactical value of Moses' American-Indianism depended, we recall, on its relation to conventions independent of New York claims to the Athens-Rome-Paris legacy of *Western* tradition. For Moses to revert to the conventional format of painting now may thus refer even the Mondrian/Stella device back to a more metropolitan, European, source. That lends his latest paintings a dialectical turn that is wholly unaccountable in terms of "Wild West" art. (p. 61)

> *Joseph Masheck, "Ed Moses and the Problem of 'Western' Tradition," in* Arts Magazine, *Vol. 50, No. 4, December, 1975, pp. 56-61.*

Nancy Marmer (essay date 1976)

[*In the following review of two Moses exhibitions in Los Angeles, Marmer examines the artist's adoption of a severely Minimalist style.*]

In a move that seems, if not perversely belated, at least conspicuously burdened with prominent ancestors, Ed Moses has recently changed his strategy and adopted a renunciatory, rigidly formalist mode of painting. The results—a two-part group of six obdurate, intensely red canvases—were on exhibit this past summer in the Contemporary Galleries of the Los Angeles County Museum of Art. Bolstered by theory, ethics and the single-mindedness of monochrome, Moses' new paintings have the fierce look of position papers. They also have the clarity of signposts

in a career that has not always been limpid in its intentions. The LACMA show coincided with another Moses exhibition, a large and impressive retrospective of drawings sponsored by the Fellows of Contemporary Art, guest-curated by Joseph Masheck, and installed in UCLA's Wight Gallery. The UCLA show surveyed 18 years of variously styled, diversely influenced, but always idiosyncratically personal work. Extending from Moses' Gorkyesque Abstract-Expressionist beginnings in 1958 to a group of very recent pieces, the exhibition included drawings that initially adumbrate and then elucidate the reductivist intentions of the latest paintings. The variety of the UCLA retrospective notwithstanding, the combined effect of the two shows is to present an unusually lean and fastidious image of Moses' talent, a revelation of the Puritan that has always lurked under even his better-known (not exhibited) resin works.

Moses, now 50 years old, first established a name for himself as an Abstract-Expressionist painter closely identified with the Ferus Gallery; he showed regularly between 1958 and '63, but then, during the heyday of "fetish finish," dropped out of public sight for a number of years. When he began appearing again at the end of the '60s, he was often referred to as an "underground" and/or "underrated" artist. By then Moses had begun working on his so-called "resin paintings"—unstretched, casually wall-draped canvases backed with a coating of resin, softened by signs of process and gravity's tug, and in striking contrast to the slick finish of the prevailing L.A. look. These "soft" canvases were influential in Los Angeles, where they were interpreted as anti-materialist and understood to be tinged with scruples; in New York (where the paintings were more frequently shown), attention was directed to their formalist structure and striate imagery. By the early '70s, Moses, along with a number of other Southern California artists, had rejected the toxic resin process; his alternate technique consisted of acrylic paint applied to palimpsest-like layers of laminated tissue, and it is with that fragile, mixed-medium style and a zig-zag or diagonally striped image that he has been associated in the recent past.

Moses' work of the last year, therefore, has been a dramatic volte-face, a change that the artist himself describes as a "return to the mainstream of painting." The new manner—that is, acrylic paint on stretched, conventionally rectangular canvas and a severely reductive image—seems to have moral overtones for the artist as well as esthetic implications. . . . [Moses] indicates his current pleasure in eschewing "synthetics" and "artificial situations": "I realized," he says, "that when I was outside the development of painting that that was a difficult ethical position for me. . . . There are a lot of artists, but for me the only serious endeavor is being a painter." For Moses, returning to the "mainstream" is a rigorous task requiring a doctrinaire acceptance and an exiguous reading of the modernist goal of flatness. He also feels that he must suppress all symptoms of subjectivity, and seems to believe that he can enlist the injunctions of modernism as weapons against his own instinctive, and obviously distrusted, inclination to make a "beautiful, seductive painting."

Three of the paintings on exhibit at LACMA—the subgroup called "cubist-abstractions" by the artist—are nevertheless seductive and reasonably "beautiful" canvases.

Fields of tightly-knit, closely-hued red-on-red plaid, their compressed space and complexly interwoven surfaces appeal directly to that modernist-invented, Reinhardt-nourished appetite for perceiving the almost imperceptible in color juxtapositions. These paintings also exploit the visual appeal of a subtle interplay between gloss and matte bands, and, above all, of the slow seepage of light—the occasional dull gleam that Moses permits himself at the intersection of his diagonals, as if somewhere behind the prison of these densely crossed bars there is still a sun-dazzled Californian at work.

In the second group of paintings—"abstract" is the artist's rubric for these three—the surface is hermetically sealed and the extremist note is sounded. The same size (6½ by 5½ feet) as the "cubist-abstract" works and apparently painted in the same color, the "abstract" paintings are completely uninflected fields of glossy red; they are perfectly executed, homogeneous, seamless, monochrome and monotone. Unlike the "cubist-abstractions," these latest paintings are exclusive, impervious and, since the intense red with its acrylic sheen returns the museum's lights with an irritating glare, they are slightly painful to contemplate. Preceded in their monochromaticism by, among others, Malevich, Rodchenko, Reinhardt, Yves Klein, Rauschenberg, Ellsworth Kelly and Brice Marden, and conterminous last season with Doug Ohlson's red paintings, Moses' canvases, despite their absolutism, can scarcely rank as primal gestures in the modernist canon. One must therefore seek their meaning elsewhere—perhaps as personal tropes, private moves with a traceable lineage within Moses' own often out-of-step (but usually intriguing) oeuvre.

The retrospective at UCLA is full of hints and premonitions. In comparison with the LACMA paintings, the drawing show is anything but doctrinaire in its total impact: there is the relative abandon of the earliest biomorphic drawings; there are works such as a four-paneled screen in which the artist freely indulges his fanciful decorative proclivities; there are mixed-medium, multi-level pieces in which formal structure is made subservient to signs of process. Yet even in Moses' pre-Minimalist work of the early '60s—for example, in a splendid group of 1961-63 drawings based on an allover floral pattern (inspired, according to Masheck, by "a cheap Mexican oil-cloth")—one notes overwhelming evidence of a finical sensibility at work, a control of pencil technique so scrupulous in its treatment of shape and edge, that only minor transgressions from regularity are required for the artist to suggest the press of emotion. The most exquisite of this group is an untitled drawing in silver paint and graphite from 1961, a large work in which the ragged contours and pale pastel colors of an underlying repeated rose pattern are hushed and muffled by a tender overlay of Johns-like tight argentine strokes; here and there a flicker of light barely rims a floral edge, and discreet licks of pale green or wan yellow emerge evanescently from the sober field, but the overriding effect is of a punctilious artistic reticence.

An elegant group of drawings from the mid-'60s is the first indication of the Minimalist geometrizing that will be central to Moses' later style. One is simply a tenantless linear grid. Others are dense allover fields, crowded with variations on the compulsive stroking that also filled earlier flo-

ral compositions. Sometimes the pencil marks are textured enough to mimic a length of serge; elsewhere the underlying grid dominates, and Moses' expressively nuanced hatching only partially occupies the demarcated squares. Between these precise works and the more subtractive style of the very recent drawings, there was an important intervening period in which Moses learned a new iconography from the abstract patterning of Navajo blankets, and experimented with multiple layers of translucent, often puckered, paper. This lyric style, ornamented by poetic transparencies and pallid colors, is also marked by a general loosening of technique and by tracks of the artist's process: rips and wrinkles rumple the surface, guidelines remain visible, edges are violated with casual freedom, and bits of tape are used both as decoration and to establish limits to the composition.

When Moses moves on in the drawings of 1974 to the overt Minimalism of his most recent period, he does not return to the tight precision of the mid-'60s, but instead retains the free handling of the Navajo-patterned works. Now the basic forms, squares and rectangles, are reduced enough to evoke Malevich's suprematist units. Filled by roughly marked diagonals or crossed bands, some of these drawings are flecked or streaked by light; others, however, are as sooty as Serra.

In the context of the 1974-76 drawings, it is particularly interesting to note that the artist's stated intention for his latest canvases at LACMA was "to create a painting that has nothing to do with me or with the three-dimensional world . . . nothing to do with my feelings, my sense, my emotion, or with time. . . ." This desire for a pure state of objectivity, the dream of an art unsullied by the smudge of emotion, is of course a periodically recurrent and familiar note in the history of modernist art—although that desire itself (as Leo Steinberg has pointed out) may be a way of feeling, an "ascetic passion." Ironically, the ease with which Moses is able to extract emotion from bare minimal forms may explain the necessity he now feels, when the objective mood is on him, to remove all manner of inflection from the picture plane. T. S. Eliot once observed that "only those who have personality and emotions know what it means to want to escape from these things." For certain individuals, the absolute gesture, no matter how privative, is the only one that will do. (pp. 94-5)

Nancy Marmer, "Ed Moses' Absolutist Abstractions," in Art in America, *Vol. 64, No. 6, November-December, 1976, pp. 94-5.*

David S. Rubin (essay date 1978)

[*In the following essay, Rubin offers a positive assessment of Moses's series* Cubist Drawings (1976-1977).]

Were Theo Van Doesburg alive today, he probably would be ecstatic upon seeing the recent drawings of Ed Moses. Moses has realized what Van Doesburg dreamed of, but never fully accomplished. The Dutch spokesman for *De Stijl* and, later, Elementarism understood the potential dynamism of diagonal lines. In his "counter-compositions" of the late '20s he sought to express, through restriction of his formal vocabulary to the diagonal, " . . . a new life-form which is adequate to the functioning of modern life."

Van Doesburg's art was rooted in the tradition of Mondri-

an and other *De Stijl* artists, which stressed reduction of form. Diagonal lines in his paintings were few; their force was limited because they were broad and fairly uniform in size, and tightly locked into a composition by large color rectangles. Space was reduced and flatness emphasized. The feeling of expansion beyond the frame was minimal and interaction of lines kept to a few points of intersection. In essence, the "counter-compositions" achieved the effects of a Mondrian, tilted to a 45-degree angle.

Moses' drawings, however, use diagonal lines to their fullest advantage, at least in the direction that Van Doesburg might have gone. The drawings of 1976-77, called *Cubist Drawings* because they use Cubist space, consist of complex networks of intersecting and overlapping diagonal lines on square or rectangular fields. Except for an occasional touch of red, color is restricted to black, white, and gray. The drawings vary in structure from an open space, where the range from light to dark is vast, to the tighter, flatter compositions of black on black.

The open compositions, such as *Cubist Drawing G2* (1977), are the most energetic in temperament, and are the type that would have appealed to Van Doesburg. One's eye is led around the composition in a rapid centrifugal movement. Strong diagonals seem to replicate layer upon layer around a slightly more open spatial core at lower left. There is much to activate the surface: strong contrasts between the white of the paper and the jet black brush-applied ink, variance of length and breadth of each line, occasional breaks or rifts in a single line, and a few Abstract-Expressionist splotches of raw ink. In contrast to the comparatively bland diagonals of Van Doesburg, Moses' are extremely forceful. Moses attains fully the power of the diagonal because of the embellishments, accents, variances, and interruptions described above.

Although it was Van Doesburg who proselytized for the use of the diagonal, there were other artists who preceded Moses in successfully exploiting its dynamic potential. Intersecting crosshatched lines enlivened the etchings of Rembrandt and Villon, and energized the paintings of the Futurists Balla and Boccioni and the vanguard Russians Larionov and Gontcharova. Moses seems also to have learned a lesson from Pollock, evidenced in the use of the controlled drip and in understanding the impact of layering diagonals so that they run into each other and direct the viewer's eye in continual movement.

There is another aspect of Moses' drawings, however, which reveals a polarity in the artist's work. The black on black drawings are *not* characterized by dynamism. Instead, we find a temperament that seems more influenced by the purist traditions of Malevich and Reinhardt. The great amount of variance which was present in the open compositions does not occur. In *Cubist Drawing B2* (1976), for example, the only real contrast is between two shades and textures of black: charcoal drawn lines are flat and opaque, while inked lines are rich and glossy. Another black on black, *Cubist Drawing G4* (1977), is somewhat paradoxical. The interlocking web of diagonals of the open compositions has fused with a black ground. The effect is an austere clam, as if the energy of the diagonals has been quelled suddenly by someone turning off the lights. This and other black on black drawings may therefore leave the viewer a bit uneasy. That is not to say that they are unsuccessful. On the contrary, they are perplexing and enigmat-

ic and that is something of value in itself. They force the viewer to stop to reevaluate his sense of aesthetics. They present a new kind of visual image and thus pose a fresh and vital challenge to the history of art. Although Moses uses a color vocabulary here that derives from Reinhardt, there is now greater contrast between shades of black. Reinhardt's paintings were very classical in that the compositional configurations were in total harmony with the frame: the shape of the canvas was echoed in that of the image Moses' drawings achieve a quiet disharmony in that the configurations run counter to the axis of the field.

Moses considers the art of drawing to be basically an exercise, a sort of "trial run" for a painting. He feels that a drawing in itself is not really an abstraction, but rather a diagram, a charting out for a future project. The problem being investigated in the drawings is that of how to build a single plane by using the constructive method of stroking, layer upon layer. In this sense, the black on black compositions are the most developed—they present a shallower space. Within Moses oeuvre, the configuration of overlapping diagonals derives from earlier paintings which were polychromatic. It should be interesting to see the results if Moses applies the latest monochromatic studies to the larger scale of the painted medium.

David S. Rubin, "Ed Moses," in Arts Magazine, *Vol. 52, No. 5, January, 1978, p. 12.*

Richard Armstrong (essay date 1980)

[*In the following review of a Los Angeles exhibition of Moses's works, Armstrong applauds the artist's development of a completely self-referential style.*]

Ed Moses' natural affinity to Minimalist orthodoxy has rarely been more evident than in the ten new paintings shown [at the James Corcoran Gallery]. Nor have the results of his devotion to reductive painting ever been better. Moses' pursuit of an irreducibly abstract image has been awkwardly out of sync with the wider development of abstract painting during the last ten years. Until now I thought he was beating a dead horse. But it seems that the single-mindedness behind his work allowed for a degree of ahistorical insouciance. His work is distinguished as much by its ascetic rigor (by California standards), as by its tenacity.

All of the paintings on canvas share a format: four independently stretched surfaces hung contiguously. Within each horizontal painting, each of the units (with two exceptions) is a square, variously 2 by 2 feet, 3 by 3 feet or 4 by 4 feet. The Minimalist penchant for aggregate units no doubt motivated this decision, but the separateness of the panels also allows for independent color, opacity, and set of painting marks for each; here, the notions of surface and process become apparent: the panels, mostly matte, reveal their temperaments—brushed, rolled, sanded, painted, scraped. The space each fosters is resolutely literal: one color over another, paint over the entire surface,—or paint thinned and sharing the picture plane with the canvas. All are flat, impeccably modernist. Moses has succeeded in his ambition, which he stated a few years ago as wanting to "create a painting that has nothing to do with me or with the three-dimensional world."

When he juxtaposes an uninflected black panel to a

scraped-down, day-glo-orange one, a green-on-a-day-glo to a thinly brushed black over random red, the inescapable impression is that of a compendium of processes. It is a curious kind of art-for-art's sake, or, better perhaps, art-for-art-making's sake. But its denial and restraint make it interesting. We have not been subjected to yet another expressionist reprise.

The palette Moses has turned to, mostly blacks, fluorescent reds and oranges and a peculiar green (previously seen only in Mangold's paintings), supplies an animating contradiction. All of this pared-down structure supports the loudest, most strident color imaginable. In one painting, close-hued and optically impossible, opaque red and thinned red panels bracket day-glo orange and brillant cerise panels. These combinations blare off the walls like so many flashing sirens. It was Stella who first proposed a repertoire entirely outside "natural" color, but he has since chosen a wildly exuberant way of making pictures, dependent as much on gesture as on hue. Similarly, Al Held, in his new work, suffuses elegantly accommodating, enveloping spaces with a rainbow of oddly appropriate color. Both are after subtleties that are foreign to Moses. It may be Moses' fate to sustain what was once known with approbation as "self-referential painting." His diligence and ease with Minimal ingredients should in turn sustain him.

> *Richard Armstrong, in a review of an exhibit at the James Corcoran Gallery in* Artforum, *Vol. XVII, No. 7, March, 1980, p. 81.*

Melinda Wortz (essay date 1980)

[*In the following exhibition review, Wortz finds Moses's works visually and psychologically abrasive.*]

Ed Moses' work has alternated between periods of controlled expressionism and purist polemics. The former characterizes his chalk and resin paintings of the late '60s and the latter his recent monochromatic presentations of the picture plane itself, with its nonreferential, art-as-art philosophical stance. The new paintings at James Corcoran are constructed of several abutting rectangular canvases, each a self-contained picture plane. Each division between shape and color is a literal one. Most pieces have four sections; some are modular, some have panels of varied widths, but all are the same height. While these parameters are obviously purist and reductive, there is a dramatic change in Moses' new work—an abrasiveness that was completely lacking in his earlier work, notable for its subtlety and elegance.

Abrasiveness informs the new paintings in two ways. They are psychologically abrasive because Moses has replaced pure primaries with strident Day-Glo colors—orange and pink—and the surfaces of many panels have been physically abraded or gesturally stroked. The jarring colors spark aggressive illusions of the panels separating spatially from one another. Optical afterimages compete with the dense black panels to which the brighter colors are juxtaposed. Offbeat, indeterminate colors like gray-green are also introduced between psychedelic reds and deep blacks. The perceptual anxieties induced by Moses' optical assault preclude detached viewing. We cannot ignore the presence

of these works, nor their irritating invasion of our perceptual responses staged in the guise of formalism.

> *Melinda Wortz, "Autobiographical Erasers," in* ARTnews, *Vol. 79, No. 4, April, 1980, pp. 171-73.*

Frances Colpitt (essay date 1985)

[*In the following review of an exhibition at the L. A. Louver Gallery in Venice, California, Colpitt praises Moses's later works.*]

Ed Moses first showed at the old Ferus Gallery in Los Angeles in the late 1950s. Since that time, he has been a regular, vital contributor to the art of Southern California. Although Moses's work eludes strict stylistic classification, his paintings are abstract, immediate and direct—he tends to avoid arcane symbolizing and narcissistic psychologizing. After an energetic, but somewhat disjointed showing at last year's Newport Biennial (at the Newport Harbor Art Museum), Moses's recent work seemed particularly cohesive. The 15 paintings on view exhibited a consistent sense of spontaneity; and, in fact, they were painted outdoors, laid flat on the deck of Moses's new house, over a period of just two months.

The 11 large works on canvas were the most powerful. Moses's familiar diagonal grid forms the substructure in black, hot red and metallic gold acrylic and oil. Great swaths of turquoise, gold, yellow, orange and pink are built up and mopped across the surface, the water- and oil-base paints at places repelling each other so that the colors coagulate and puddle. Here and there the grid is worked in, tightening the image and imposing some control on the many layers of stains, splashes and swipes which seem to argue that denser is better. Unexpected in Moses's abstract space, however, was a new figurative element: stenciled black spiders, a hand's breadth wide.

Moses's work has always been characterized by an elegant draftsmanship which records the process of its making, but never before has the influence of Pollock been so evident. In these paintings color is both gestural and structural: it furnishes the building blocks of the grid that ultimately restrains the gesture. The tension generated by potential conflict between these two functions accounts for the paintings' sense of vitality—some of them even seem to breathe and glow. Moses has learned to abandon himself in order to create paintings which are self-expressive without being self-indulgent.

But the spiders drive people crazy. What are they doing there, and what do they mean? Responding to my own query when I first saw the spiders last year, Moses alluded to the mystery of a dark cave. Entangled in a geometric web, the spiders are indeed mysterious, but in my view their schematic quality renders them completely innocuous. The broader context of the work does not support a symbolic reading. Not conducive to interpretive speculation, Moses's work speaks more purely in the language of paint and gesture.

> *Frances Colpitt, "Ed Moses at L. A. Louver," in* Art in America, *Vol. 73, No. 12, December, 1985, p. 134.*

FURTHER READING

Ashton, Dore. "Art." *Arts and Architecture* 76, No. 4 (April 1959): 9-10, 33.
Includes notice of Moses's premiere showing in New York.

Bell, Jane. "Ed Moses." *Arts Magazine* 49, No. 10 (June 1975): 25.
Exhibition review in which Bell comments on the development of Moses's style.

Crichton, Fenella. "London Letter: January." *Art International* XIX, No. 1 (20 January 1975): 36-44.
Positive review of Moses's 1975 exhibition at the Felicity Samuel Gallery in London.

Dertner, Phyllis. "New York Letter." *Art International* XVIII, No. 4 (20 April 1974): 50-1, 73-4.
Exhibition review in which Dertner views Moses's style as derivative.

————. "New York." *Art International* XIX, No. 6 (15 June 1975): 66-72.
Positive assessment of Moses's diagonal compositions.

Garver, Thomas. Review of an exhibition at the Mizuno Gallery in Los Angeles. *Artforum* VII, No. 10 (Summer 1969): 67.
Favorable evaluation of Moses's lithographs.

Loring, John. "Print as Surface." *Arts Magazine* 48, No. 1 (September-October 1973): 48-9.
Contrasts Moses's treatment of the picture plane with that of abstract artist Gene Davis, who, like Moses, creates ambiguous dimensionality through the use of overlapping lines.

Masheck, Joseph. Review of an exhibition at the Ronald Feldman Fine Arts Gallery in New York. *Artforum* X, No. 6 (February 1972): 84-6.
Discusses Moses's Navajo-inspired drawings.

Perrone, Jeff. Review of an exhibition at the Sidney Janis Gallert. *Artforum* XVII, No. 10 (Summer 1979): 69.
Strongly objects to Moses's most severely Minimalist works.

Plagens, Peter. Review of an exhibition at the Mizuno Gallery in Los Angeles. *Artforum* IX, No. 1 (September 1970): 82-3.
Describes Moses's 1970 installation at the Mizuno Gallery, where he constructed and decorated an entire room.

————. Review of an exhibition at the Mizuno Gallery in Los Angeles. *Artforum* IX, No. 6 (February 1971): 90-1.
Applauds Moses's irreverent approach to art and art exhibition.

Ratcliff, Carter. "Mostly Monochrome." *Art in America* 69, No. 4 (April 1981): 111-31.
Includes a brief discussion of the theory behind Moses's monochrome paintings.

Stitelman, Paul. "New York Galleries." *Arts Magazine* 47, No. 7 (May-June 1973): 55-9.
Includes a review of Moses's work at the Ronald Feldman Fine Arts Gallery. Stitelman comments on the sense of alienation he finds in Moses's style.

Terbell, Melinda. "California: Los Angeles." *Arts Magazine* 45, No. 2 (November 1970): 53.
Positive assessment of Moses's resin-coated paintings.

Wortz, Melinda. "Field Flowers, Plexiglass Horizons." *ARTnews* 75, No. 8 (October 1976): 94-5.
Discusses the development of Moses's style.

Georgia O'Keeffe

1887-1986

American painter.

One of the most renowned American painters of the twentieth century, O'Keeffe is noted for her highly personalized Modernist style, in which the distinction between representation and abstraction is frequently blurred. Taking natural scenes and organic forms as her primary subject matter, O'Keeffe simplified shapes and deemphasized detail to create compositions that convey a clear impression of the objects depicted while exploring their purely formal implications in the manner of abstract art. Although O'Keeffe's style has been linked with a number of divergent artistic philosophies, including Cubism, Surrealism, and Precisionism, she steadfastly insisted throughout her long career that her only aesthetic aim was to capture and convey a sense of beauty.

Born to a prosperous farming family in Sun Prairie, Wisconsin, O'Keeffe decided early in life to become an artist. Immediately after high school, she enrolled in classes at the Art Institute of Chicago, and two years later she attended the Art Students' League in New York City, studying with the noted American Impressionist William Merritt Chase. O'Keeffe was, however, repelled by the rigid academicism of her art instruction, and in 1909 she abandoned her studies to work as a commercial artist in Chicago.O'Keeffe's enthusiasm for painting was reawakened in the summer of 1912, when she was introduced to the aesthetic theories of Columbia University professor Arthur Wesley Dow while attending art classes taught by one of his disciples, Alon Bement. An admirer of Oriental art and a student of Post-Impressionism, Dow had enthusiastically accepted the idea of purely decorative art. O'Keeffe later noted that his only concern was "to fill a space in a beautiful way." Dow's teachings convinced O'Keeffe that there were modes of expression more satisfying than academic realism, and after moving to Texas later in 1912 to accept a position as an art teacher, she began to create abstract compositions. O'Keeffe's early drawings and watercolors featured simple, well-defined curvilinear and geometric forms, which were often arranged in such a way as to suggest a subject, as in her highly regarded series *Light Coming on the Plains* (1917).

In 1916, O'Keeffe sent several of her drawings to a friend, Anita Pollitzer, who was then living in New York. Considering them too good to go unnoticed, Pollitzer showed the drawings to Alfred Stieglitz, a well-known photographer and the operator of an avant-garde gallery. Stieglitz agreed with Pollitzer's estimation of O'Keeffe's work—reportedly exclaiming the now-famous phrase, "Finally, a woman on paper!"—and displayed the drawings in his gallery. Soon afterward, Stieglitz offered O'Keeffe his patronage, beginning a relationship that led to their marriage in 1924. Throughout the 1920s, O'Keeffe and Stieglitz lived and worked primarily in New York, where, due to regular showings, O'Keeffe's work rapidly gained attention. From the beginning, response to her style was posi-

The Metropolitan Museum of Art, Gift of David A. Schulte, 1928. (28.127.1)

tive, with critics noting in particular the evocative power of her bold shapes and luminous colors. O'Keeffe, however, frequently disagreed with critics, even when they offered positive estimations of her style, and she contested in particular any interpretations of symbolism in her paintings.

In the mid 1920s, O'Keeffe painted the first of her renowned flower paintings, capturing the subtle beauty of her subjects' contours and colors in sensuously modeled forms and highly magnified views. The flower paintings began a trend toward a more representational style in O'Keeffe's art, although she continued to create some purely abstract works throughout her life. During the early 1930s, she also painted several series of barn paintings in her classic, simplified style. However, from her first acquaintance with the American Southwest, it was the severe beauty of that region that most interested O'Keeffe as a subject for her art, and beginning in 1929 she spent her summers painting in New Mexico. During this period, she discovered the visual interest of the bleached animal bones often found in the desert and began using them as subjects for paintings, leading some to suggest that her

work had become morbid. O'Keeffe countered that she used the bones just as she had used flowers, for the visual qualities of their curving planes and multiple openings.

After Stieglitz's death in 1946, O'Keeffe moved permanently to New Mexico, continuing to focus in her art on the organic forms and landscape of the desert. In 1958, she traveled around the world by airplane and was inspired to create a series of canvases based on aerial views of the ground. Beginning in 1963, she also executed a series of monumental canvases depicting the sky and clouds as seen from the air, culminating in her largest work, *Sky above Clouds IV* (1965). During the final decades of her life, O'Keeffe's eyesight began to fail, but she completed several canvases in the 1970s and continued to paint up to the time of her death in 1986.

Although O'Keeffe remains one of the most popular American artists, known for her widely publicized images and for her colorful, eccentric life, critical assessments of her achievements differ. She is regarded by many as an artistic innovator whose rejection of nineteenth-century academicism helped to bring Modernism to the United States. Others, however, dismiss her simplified style as an attempt to create accessible, saleable images. Synthesizing both points of view, Edward Abrahams has suggested that while O'Keeffe's early abstract compositions do represent a true innovation and show great promise, her adoption of a more representational style in later works resulted in a betrayal of that promise. Nevertheless, few dispute the wide appeal of O'Keeffe's skillfully executed canvases, and Alfred H. Barr has written that she had "the gift of isolating and intensifying the thing seen, or destroying its scale, until it loses its identity in an ambiguous but always precise beauty."

ARTIST'S STATEMENTS

Georgia O'Keeffe with Katharine Kuh (interview date 1960)

[*In the following interview, O'Keeffe discusses her artistic influences, aims, and techniques.*]

[Kuh]: *What do you feel has been the strongest influence on your work?*

[O'Keeffe]: Some people say nature—but the way you see nature depends on whatever has influenced your way of seeing. I think it was Arthur Dow who affected my start, who helped me to find something of my own. I also studied with [William Merritt] Chase and loved using the rich pigment he admired so much, but I began to wonder whether this method would ever work for me. You know, Chase believed in Meissonier; he bought many, and was convinced this artist would make a comeback. Now we have photographs so I guess we don't need Meissoniers, though of course there's a great sound of battle in them. They were painted in masterly fashion—if that's what you want. Imagine—Chase came to his class in a tall silk hat and light spats and gloves! He was most elegant. I was only

twenty, so when somebody dressed up like Mr. Chase told me that this was *it,* I was naturally apt to believe it. I was given the prize in his class for a painting of a dead rabbit with a copper pot. But I began to realize that a lot of people had done this same kind of painting before I came along. It had been done and I didn't think I could do it any better. It would have been just futile for me, so I stopped painting for quite a while.

Later at the University of Virginia I was impressed when I heard a follower of Dow's talking about art. It was Alan Bement. After that I worked with him that summer and supervised art in Amarillo, Texas, during the winter for two years. I couldn't believe Texas was real. When I arrived out there, there wasn't a blade of green grass or a leaf to be seen, but I was absolutely crazy about it. There wasn't a tree six inches in diameter at that time. For me Texas is the same big wonderful thing that oceans and the highest mountains are. Bement taught Dow's ideas, but if I'd followed Bement's advice you would never have heard of me. He was a very timid man, yet he was an important note in my life. Eventually I came back to New York (as Bement had constantly urged) to study with Dow. This man had one dominating idea: to fill a space in a beautiful way—and that interested me. After all, everyone has to do just this—make choices—in his daily life, even when only buying a cup and saucer. By this time I had a technique for handling oil and watercolor easily; Dow gave me something to do with it.

Why have you always been so interested in simplifying and eliminating detail?

I can't live my life any other way. My house in Abiquiu is pretty empty; only what I need is in it. I like walls empty. I've only left up two Arthur Doves, some African sculpture and a little of my own stuff. I bought the place because it had that door in the patio, the one I've painted so often. I had no peace until I bought the house. They didn't want to sell—it was given to the church and I was ten years getting it. Those little squares in the door paintings are tiles in front of the door; they're really there, so you see the painting is not abstract. It's quite realistic. I'm always trying to paint that door—I never quite get it. It's a curse—the way I feel I must continually go on with that door. Once I had the idea of making the door larger and the picture smaller, but then the wall, the whole surface of that wonderful wall, would have been lost.

Why do you suppose the door interests you so much?

I wish I knew. It fascinates me. The patio is quite wonderful in itself. You're in a square box; you see the sky over you, the ground beneath. In the patio there's a plot of sage, and the only other thing in the patio is a well with a large round top. It's wonderful at night—with the stars framed by the walls.

Has your use of isolated, blown-up details been influenced by photography?

I'll tell you how I happened to make the blown-up flowers. In the twenties, huge buildings sometimes seemed to be going up overnight in New York. At that time I saw a painting by Fantin-Latour, a still-life with flowers I found very beautiful, but I realized that were I to paint the same flowers so small, no one would look at them because I was unknown. So I thought I'll make them big like the huge

buildings going up. People will be startled; they'll *have* to look at them—and they did. I don't think photography had a thing to do with it. At about the same time, I saw a sky shape near the Chatham Hotel where buildings were going up. It was the buildings that made this fine shape, so I sketched it and then painted it. This was in the early twenties and was my first New York painting. The next year I painted more New York scenes. At that time people said, "You can't paint New York; you're well launched on the flowers." For years I lived high up on the thirtieth floor of the Shelton Hotel and painted from the window. This was an endless source of interest for me.

People say you have been influenced by Oriental art. Is this true?

I enjoy Oriental art very much and prefer traveling in the East than in Europe. But tell me, can you find anything in my work that shows an Oriental influence? I had an important experience once. I put up everything I had done over a long period and as I looked around at my work I realized that each painting had been affected by someone else. I wondered why I hadn't put down things of my own from my own head. And then I realized that I hadn't done this because I'd never seen anything like the things in my own head.

Why do you paint in series so often?

I have a single-track mind. I work on an idea for a long time. It's like getting acquainted with a person, and I don't get acquainted easily. Take that ladder painting [**Ladder to the Moon**]; I still think I'm going to paint more ladders. I don't know what interrupted me. In Abiquiu we need ladders to get up on the roof of the house. Ladders are wonderful things—very important in the world. They were the way man first got into his house. I'm also fascinated by the shadows a ladder can make against a wall I've never been able to get anyone to build me exactly the kind of ladder I want—two very tall poles with flat steps that reach above the roof.

Has the idea of symbolism been tacked onto your work by others?

Certainly. I've often wondered where they got the idea and what they were talking about. The wife of a senator from Colorado (I can't remember her name) once said to me years ago, "With all this talk that's going around and with all the things people are saying about you, I can't see that your sex is bothering you very much."

What about the pelvis bones? I read something you wrote about them in 1944 when you were showing the series at An American Place.

I still agree entirely with what I said then. You can quote it if you want.

> When I started painting the pelvis bones I was most interested in the holes in the bones—what I saw through them—particularly the blue from holding them up in the sun against the sky as one is apt to do when one seems to have more sky than earth in one's world—
>
> They were most wonderful against the Blue—that Blue that will always be there as it is now, after all man's destruction is finished.

You see, I knew for a long time I was going to paint those bones. I had a whole pile of them in the patio waiting to be painted, and then one day I just happened to hold one up—and there was the sky through the hole. That was enough to start me. At first these paintings were all blue and white—finally I tried red and yellow. I probably did between fifteen and twenty of them. They made a pretty exhibition. I'm one of the few artists, maybe the only one today, who is willing to talk about my work as pretty. I don't mind it being pretty. I think it's a shame to discard this word; maybe if we work on it hard enough we can make it fashionable again.

Does the accidental have any place in your work?

Once in a while there's a good accident. However, I rarely start anything that isn't pretty clear to me before I start. I know what I'm going to do before I begin, and if there's nothing in my head, I do nothing. Work brings work for me. (pp. 189-94)

Do you make preliminary sketches?

I make little drawings that have no meaning for anyone but me. They usually get lost when I don't need them any more. If you saw them, you'd wonder what those few little marks meant, but they do mean something to me. I don't think it matters what something comes from; it's what you do with it that counts. That's when it becomes yours. For instance those paintings in my present show—they are all rivers seen from the air. I've been flying a lot lately—I went around the world—and I noticed a surprising number of deserts and wonderful rivers. The rivers actually seem to come up and hit you in the eye. There's nothing abstract about those pictures; they are what I saw—and very realistic to me. I must say I changed the color to suit myself, but after all you can see any color you want when you look out the window.

Why have you avoided the human figure?

I've had to pose for too many people myself. It's a hard business and I haven't what it takes to ask someone else to do this for me. (pp. 199-200)

Do you always paint what you see? What about changing light?

You paint *from* your subject, not what you see, so you can't be bothered with changes in light. I rarely paint anything I don't know very well.

What artists do you most admire?

The Chinese. Also, by the time I was through worrying about getting rid of the Stieglitz collection, I think it was probably the Rodin watercolors I enjoyed the most and could have stayed with the longest. In the beginning I wouldn't have thought so—they're slight and of another time. It would never have occurred to me that these drawings could have stood up so well. (p. 200)

Do you consider yourself a "precisionist," as a recent exhibition labeled you?

I think that was an absurd idea. What can you do if people who own your pictures are willing to lend them to any exhibition? I was in the surrealist show when I'd never heard of surrealism. I'm not a joiner and I'm not a precisionist or anything else. (p. 202)

Katharine Kuh with Georgia O'Keeffe, in an interview from The Artist's Voice: Talks with Seventeen Artists *by Katharine Kuh, Harper & Row, Publishers, 1962, pp. 189-203.*

INTRODUCTORY OVERVIEW

Jack Cowart (essay date 1987)

[*In the following excerpt from the catalog to a 1987 retrospective exhibition held at the National Gallery of Art in Washington, D.C., Cowart offers an appreciative overview of O'Keeffe's art and its distinctive characteristics.*]

O'Keeffe, together with her art, helped establish a relationship between the American modern movement and the pioneering European vanguard of the early twentieth century. She was a member, emotionally and professionally, of the group surrounding Alfred Stieglitz and his progressive New York galleries: 291, The Intimate Gallery, and An American Place. Other artists who were part of the Stieglitz circle (Charles Demuth, Arthur Dove, John Marin, Marsden Hartley), as well as their predecessors and successors, helped bridge the gap between American and European art. O'Keeffe drew inspiration from the *avant-garde* on both sides of the Atlantic but at the same time fed influence and especially the energy of her particular imagery back into the art of her time. . . .

It was neither O'Keeffe's art, boxed as it has always been into a limited critical category, nor O'Keeffe the artist, but rather her personality that received the most attention over the years. We are reminded that the cumulative effect of sixty years of art criticism and exhibitions of O'Keeffe's work has resulted in an idea of the person that is larger than life. O'Keeffe herself is at least partially responsible for this situation. As she grew older especially, O'Keeffe knew she filled a void in American art, that her images were becoming icons, and that her deportment was legendary. Events conspired to produce for the public not an informed awareness but a stark cliché, a stereotype. (p. 1)

O'Keeffe's art refers to determinants, to those things or events that have caused her, provoked her, to create. These necessities obliged her to make art, as she tried to portray sensations, ideas, and situations that for her could be expressed no other way. She wrote to William M. Milliken in 1930, "I see no reason for painting anything that can be put into any other form as well—." To her aesthetic world she was compelled to bring her life and actual experiences, expressed through her direct phenomenological point of view. She leaves us the record of all this in her art. Rarely a strict narrative, her art allows us to remember things she had seen, experienced, or sensed, images grounded in authenticity. She consciously nurtured her memories of events, giving them new life as art.

A phrase O'Keeffe used in a letter to Anita Pollitzer, "Tonight I walked into the sunset . . . ," is like all of her best art: immediate, concrete, all-encompassing, with a surprising syntax. Sunset is the time when the world appears least structured, when forms tend to dissolve and are replaced by new colors and sensations. O'Keeffe acted to suspend time, producing art that would capture the transient. For example, O'Keeffe made of a flower, with all its fragility, a permanent image without season, wilt, or decay. Enlarged and reconstructed in oil on canvas or pastel on paper, it is a vehicle for pure expression rather than an example of botanical illustration. In her art, fleeting effects of natural phenomena or personal emotion become symbols, permanent points of reference.

O'Keeffe preferred to distance herself from critics, biographers, art historians, or others who probed. Each work represented an intense and above all, personal investment. With her closest friends, however, she was more open. In the letter to Anita Pollitzer, she described an event, but with an extension to the fantastic. O'Keeffe's imagery is concrete, but the consequence of her concise recounting shocks us to a new awareness. We quickly see her entering the vividly colored sky, becoming one with its greater forces. She does not write of the dust of the trail, the rocks on the road, the length or toil of the walk, but of an effortless, transcendent event. The same happens in her best art—as she suspends the mundane laws of reality and reason. Then she reveals new edges of vision, new attitudes of direct experience, put down in rich color with energetic line in carefully ordered brushstrokes or markings. Each work is self-sufficient, a miniature world with its own rules, bending to her own will. Contrasts of the near and far, both in time and space, distinguish O'Keeffe's art. She has no aerial perspective, but treats everything in focus, ignoring impressionistic values, the actual envelope of the air, or the limits of human (and even mechanical) vision. O'Keeffe gives us a new world made sharp in all of its large and small parts. The strong ordering, a result of her clear optical and mental vision, can intimidate as well as inspire and challenge.

Although O'Keeffe has been an influential figure in American art history for the past seven decades, she has also been a target for criticism by outrageous, outraged critics and writers over the years. She had superior internal resolve to withstand Clement Greenberg's words, " . . . the greatest part of her work adds up to little more than tinted photography. The lapidarian patience she has expended in trimming, breathing upon, and polishing these bits of opaque cellophane betrays a concern that has less to do with art than with private worship and the embellishment of private fetishes with secret and arbitrary meanings" [see excerpt dated 1946 in Survey of Criticism]. She endured a lifetime of sycophants' and novelists' fascination with her personal life, her relationships, her status as role model, her every deep or shallow breath.

Even now the critics are divided in their views on O'Keeffe's art. Some admire her abstractions, others esteem her figurative works. The former group presents the artist as a progressive. The latter places her within the honored, conservative tradition. The two groups challenge each other for critical control, and there is a struggle within O'Keeffe's work as well. She herself alternated, blending abstraction and representation, to arrive at a mature, dynamic synthesis, calling it "that memory or dream thing I do that for me comes nearer reality than my objective kind of work." In late February 1924 she wrote to Sherwood Anderson, "My work this year is very much on the

ground—There will be only two abstract things—or three at the most—all the rest is objective—as objective as I can make it—. . . I suppose the reason I got down to an effort to be objective is that I didn't like the interpretations of my other things—." She felt the abstractions allowed too much room for misinterpretation, as the critics wrote their own fixations or autobiographies into hers. She felt "invaded," unable to accept the point of view that art can also be a resonating membrane for the viewer, who holds the lasting right to its reflections.

O'Keeffe's art experienced a distinctly New World freedom, largely in response to the open spaces of rural America. After the claustrophobic beauty of Lake George, she would freely occupy and explore wide-open stretches of the Southwest. This was at a time when the roads of New Mexico were treacherous, if they existed at all, and electricity, telephones, or other utility services were years away. She would test her physical and psychological independence by living beyond the fringe of civilization. This almost biblical exile was her fundamental path to sustained revelation. It was as if she were laying claim to the "faraway" regions, taking hold of their remarkable presences, seeking discoveries for her art. In the Southwest she was free to pursue the fantastic effects of nature, the forces of the elements, and the geological history so dramatically evident in its canyons and stratified hills. She could travel for miles without human contact or traces of development, accepting the risks posed by weather and wild animals. She could also experience the contradictory overlapping of the rituals of the native Americans and those of the colonial Spanish. In this exotic, foreign atmosphere, the artist was, simultaneously, daredevil, participant, and *voyeur*.

Her art is memorable. A clear, indelible core image of each work is retained in our mind's eye after even the briefest glimpse. This is not to say, however, that we remember the profusion of her nuanced details or artful manipulations. O'Keeffe often obscured the hard work and intense thinking that preceded the finished object. These were subordinated to the direct hard punch of the form, the astonishing key of her color, and the unprecedented juxtapositions. It is not enough to quote Alon Bement or Arthur Dow whose teachings and writings influenced the young artist and who held that the highest goal of art was to fill space in a beautiful way. Neither can one credit everything to the emergence of modern photographic vision, despite the notable contributions of Imogen Cunningham, Edward Steichen, Paul Strand, or the turn-of-the-century German Karl Blossfeldt. Despite O'Keeffe's deep pleasure in Chinese and Japanese art and, indeed, much of the history of art, one still lacks an explanation why her work remains so memorable. Perhaps it is because it is ecstatic, as ecstatic as her relationship to the very real, very visible world around her. To this she adds a distinctive, urgent, and disciplined personal vision. This inner eye of the artist controlled, tightened, made taut the best of her works. O'Keeffe was mad for work. She was adventurous and she had the egotistic notion that she could, in fact, capture an unknown and make it known. Whether O'Keeffe's work was the result of naive folly or inspired genius, her art bears dramatic witness to her wonder in life and the world.

In its visual scale relative to literal size, O'Keeffe's art deceives us. She brilliantly monumentalized her subjects, whether she treated them in a 48×40-inch or a 5×7-inch canvas. Her small works, though, are among her best and most striking ones. . . . In each we find emphatic color, composition, clear conception, and visible signs of execution—the trace of her brush, the delicate ridges of pigment. These elements are then put down without compromise or contrivance.

Her art also speaks about color and its effects. Even the early black-and-white charcoals have a full range, from the highlit whites to the velvety blacks. We supply our own polychromy as we plunge into these charcoals, alluding to her self-described mental visions. The forms are like flickering flames or jewels held aloft by waterspouts. They become animated by our imagination, stimulated by O'Keeffe's curious effects. The academic tradition of monochrome drawing before the use of color is followed, but a quick shift to expressive color comes in the early 1917 paintings, the so-called "Specials." These works are abstract swirls, fantasy renderings, strong forces with multiple associations to states of being, dream influences, and the birth of abstraction in early twentieth-century art. O'Keeffe used her color both to seduce and repel. There are paintings, pastels, and watercolors of overwhelming beauty, where delicate hues delight our eye and a luxurious feeling permeates. But in an equal number of works she created harsh collisions of saturated colors whose initial garish appearances deny our appreciation. (pp. 2-4)

O'Keeffe admitted carrying shapes around in her mind for a very long time until she could find the proper colors for them. When found, those colors would release an image from her mental catalogue and allow it to become a painting. O'Keeffe used color as emotion. Through color she would transfer the power and effects of music to canvas. In her abstractions, O'Keeffe wrapped color around the ethereal. Whether her images are abstract or figurative, O'Keeffe gives the viewer a profound lesson in emotional and intellectual coloring. No reproduction will ever do justice to the intensity, the solidity, or the high pitch of these colors, for the notion of local or topical color in her work is only relative, just the beginning point. Indeed, as we return to reality after looking at O'Keeffe's depictions of landscapes, sunsets, rocks, shells, flowers, any of these natural determinants, we are disappointed. We have come to appreciate and think about those things around us under the spell of her work, but the truth becomes less impressive, milder.

The artist was finely attuned to the sounds of the natural world. In her letters she describes the wild, blowing wind, the deep stillness, the animal sounds, the rustling of trees. All these seem to penetrate the senses of the artist and find expression in her work. These formed for O'Keeffe a kind of natural music, made up of the life and rhythms of the earth. She made art that alludes to sounds, with references to the audible world, from the din of Manhattan to the pure songs of the prairie. She accomplished this through the form and dynamics of her composition and the pitch of her colors.

O'Keeffe's earliest mature works, after c. 1915, are abstractions, dreams and visions made concrete. She would enter periods of mad, crazy work, periods when she knew she had "something to say and feel[ing] as if the whole side of the wall wouldn't be big enough to say it on and then sit[ting] down on the floor and try[ing] to get it on a sheet of charcoal paper." As she followed a compulsive need to

get something down in paint, watercolor, or charcoal, she questioned her art and formulated long, rhetorical letters, devaluing, revaluing, looking for the point of personal balance, wondering whether she was to be master or slave.

The open-ended, exhausting, but exciting works of her period of artistic self-discovery found a point of focus by the early 1920s. Now her observations of landscapes, flowers, or other natural shapes were made inventively ambivalent. They became both abstract and figurative, with elements merged so that colored streaks played across the plains, water rose in a siphon contrail, botanical details suggested human anatomy. O'Keeffe, standing firmly behind her work, found the balance that would inform, fuel speculation, and inspire. The strength of these marriages of forms remains evident in all the best work, regardless of date.

By 1929 O'Keeffe confirmed that her truest, most consistent visual sources were in the American Southwest. These sources refreshed her physically, mentally, artistically. The sky, the vastness, the sounds, the danger of the plains, Badlands, canyons, rocks, and bleached bones of the desert, struck her as authentic and essential to her life as well as to her art. She wrote to Henry McBride from Taos in 1929, "You know I never feel at home in the East like I do out here—and finally feeling in the right place again—I feel like myself—and I like it— . . . Out the very large window to rich green alfalfa fields—then the sage brush and beyond—a most perfect mountain—it makes me feel like flying—and I don't care what becomes of art." In the Southwest she found primal mystery, foreign even to this daughter of Sun Prairie, Wisconsin. And it was from the Southwest that O'Keeffe would so forcefully try to capture the wild, unusual essences in her art as it turned more figurative. In search of the marvelous, she advised Russell Vernon Hunter, "Try to paint your world as though you are the first man looking at it—The wind and the heat—and the cold—The dust—and the vast starlit night . . . When the spring comes I think I must go back to [the Southwest] I sometimes wish I had never seen it—The pull is so strong—so give my greetings to the sky." Her letters mention Taos, Abiquiu, the Chama River, the Pedernal, "Black Place," "Red Hills," "Gray Hill," "Lawrence Tree," all particular sites, points of personal experience that O'Keeffe wove into her art. She wanted to show her wonder. Indeed, it is her wonder, her razor-sharp vision, and her response to that vision that continue to astonish us.

No artist has seen and painted like O'Keeffe, whose spiritual communion with her subject was of a special quality, unparallelled, and irreducible. In the 1930s and 1940s, her ceaseless searching out and intelligent use of the materials of the Southwest enlivened the potentials of her art. The best of her works cross over to abstraction ("that dream thing," as O'Keeffe called it), and then loop back to the figurative, engaging the viewer's full imagination regardless of one's regional bias. In the 1950s and 1960s O'Keeffe's sources would become her immediate world of the Abiquiu patio door, the Ghost Ranch post ends, the courtyard flagstones, and her airplane flights above the clouds. She increased her scale to make a number of six-foot-wide paintings and the striking twenty-four-foot wide mural *Sky above Clouds IV.* The artist was responding to the younger generation of post-World War II artists as they, too, expanded their works to an environmental pro-

portion. Through the late 1960s and 1970s O'Keeffe's large sky and river paintings, and smaller still-life images of rocks or other natural forms, plus her colorful and broadly brushed watercolors, document her still-vital creative energy. (pp. 4-6)

[O'Keeffe] is indeed a proper candidate for wider discovery by the world's public, since the artist is all but unknown outside the United States. In the context of personal idealism and the exemplary breakthrough to artistic freedom achieved by Gauguin and van Gogh, for example, O'Keeffe provides a distinctly twentieth-century American point of reference. Her art reflects not only her time but aspects of our contemporary art environment, and seems to prefigure qualities fundamental to the future of art. (p. 6)

Jack Cowart, "Georgia O'Keeffe: Art and Artist," in Georgia O'Keeffe: Art and Letters *by Jack Cowart and Juan Hamilton, edited by Sarah Greenough, Little, Brown and Company, 1987, pp. 1-6.*

SURVEY OF CRITICISM

Paul Rosenfeld (essay date 1924)

[*An American critic who wrote widely on art, music, and literature, Rosenfeld was also an admirer of Stieglitz and his Modernist circle. In the following excerpt, Rosenfeld compares O'Keeffe's paintings with Modernist music and praises the powerful sense of womanhood that he perceives in her style and images.*]

Known in the body of a woman, the largeness of life greets us in color. A white intensity drives the painting of Georgia O'Keeffe. Hers is not the mind capable of feeling one principle merely. She is not conscious of a single principle without becoming simultaneously aware of that contrary which gives it life. The greatest extremes lie close in her burning vision one upon the other; far upon near, hot upon cold, bitter upon sweet; two halves of truth. Subtleties of statement are fused with greatest boldnesses of feeling; tenderest, rose-petal gradations with widest, most robustious oppositions of color. Complexly varied contraries of tone she juxtaposes with a breath-taking freshness. Her art is a swift sounding of the abysses of the spectrum, and an immediate relation of every color to every other one. She has the might of creating deft, subtle, intricate chords and of concentrating two such complexes with all the oppositional power of two simple complementary voices; of making them abut their flames directly upon each other and fill with delicate and forceful thrust and counterthrust the spaces of her canvases. Her work exhibits passage upon passage comparable to the powerfully resistant planes of intricate harmony characteristic of some modern musics. Through this American, the polyharmonies of Stravinsky and Ornstein have begotten sisters in the sister medium of painting. And the modern music is no more removed from both the linear polyphony of the madrigalists and the preponderantly homophonic effects of the roman-

tic composers, than this art from both the ruggedly but simply interplaying areas of the Renaissance, and the close, gentle, melting harmonies of the impressionists.

Painters have perceived the relativity of all color: have felt that every hue implies the presence in some form or other of its complement, its ideal opponent that gives it force; and have expressed those complements in their works. But few have dared place a sharp triad based on red in as close juxtaposition to one equally sharp based on green as Georgia O'Keeffe has done. She lays them close upon each other, point against point, flame upon flame. For her, the complementariness of these two sets of colors is natural as the green of foliage. Other painters have recognized the relation of all colors to pure white since pure white contains them all; few have had it in them to dare lay hardest piercing white between baking scarlets and the green of age-old glaciers, and make ecstatically lyrical the combination. Others have felt the gamut from intensest cold to intensest heat within the limits of a single color, and have registered it in their gradations; few, it seems, have been able to race the entire scale with such breathless rapidity, to proceed in one small area of green from the luxuriant Amazonian heat of green mottled with dusty yellow to the bitter antarctic cold of green-blue. But it is with subtlety that these tremendous oppositions are given. They are more implied than baldly stated. It may be a chord of burning green that is felt against one of incandescent red, a chord of intensest blue against ripe orange. But most often the greens and the blues will be represented by unusual, subtle shades. They will be implied rather more than definitely stressed; the green felt through a kindred shade of blue, the blue through a kindred green. Besides, O'Keeffe does not play obvious complements of hot and cold against each other. It is more often the two warm tones in the two triads that will be found opposed in her compositions, and the two cold. Oblique, close, tart harmonies occur, flavoring much of her work with keen, pleasant, ammoniac pungency. The latitude between proximate tones, between shades of the same color, is stressed. Dazzling white is set directly against tones of pearl. Violet abuts upon fruity tomato. It is as though O'Keeffe felt as great a width between minor seconds as Leo Ornstein does. And, although she manages to run the full gamut between the heat and coolth of a tone within a diminutive area, her scale makes no sacrifice of subtleties. The most delicious gradations remain distinct and pure. Hence, tiny forms possess the distinct rotundity which many other painters manage to obtain only through bulkier masses.

A combination of immense Picasso-like power and crisp daintiness exists not alone in the color of O'Keeffe. It exists likewise in the textures of her paintings and in the shapes born in her mind with her color-schemes, and expressed through them. Precisely as the widest plunges and the tenderest gradations point against each other in her harmonies and fuse marvelously, so in her surfaces do heavily varnished passages combine with blotting-paper textures, and severe, harsh forms with strangest, sensitive flower-like shapes. In the volumes there lives a similar subtlety in bold strokes, a similar profundity of dainty ones. Rigid, hard-edged forms traverse her canvases like swords through cringing flesh. Great rectangular menhirs plow through veil-like textures; lie stone-like in the midst of diaphanous color. Sharp lines, hard as though they had been ruled, divide swimming hue from hue. Rounds are de-

Blue Lines No. 10 (1916). The Metropolitan Museum of Art, The Alfred Stieglitz Collection, 1949.

scribed as by the scratching point of a compass. But, intertwined with these naked spires thrusting upward like Alp-pinnacles, there lie strangest, unfurling, blossom-delicate forms. Shapes as tender and sensitive as trembling lips make slowly, ecstatically to unfold before the eye. Lines as sinuous and softly breathed as Lydian tunes for the chromatic flute climb tendril-like. It is as though one had been given to see the mysterious parting movement of petals under the rays of sudden fierce heat; or the scarcely perceptible twist of a leaf in a breath of air; or the tremulous throbbing of a diminutive bird-breast.

And in the definition of these flower-movements, these tremblingly unfurling corollas, what precision, what jewel-like firmness! The color of O'Keeffe has an edge that is like a line's. Here, for almost the first time one seems to see pigment used with the exquisite definiteness, the sharp presence, of linear markings. Much of her work has the precision of the most finely machine-cut products. No painting is purer. Contours and surfaces sing like instruments exquisitely sounded. There are certain of these streaks of pigment which appear licked on, so lyrical and vibrant are they. The painter appears able to move with the utmost composure and awareness amid sensations so intense they are well-nigh insupportable, and so rare and evanescent the mind faints in seeking to hold them; and here, in the regions of the spirit where the light is low on the horizon and the very flames darkling, to see clearly as in fullest noon, and to sever with the delicacy and swiftness of the great surgeon.

The sense of vasty distances imparted by even the smaller of these paintings flows directly from the rapidly and unfalteringly executed decisions of the artist. The intense oppositions felt between near-lying colors, the delicate differences perceived between graded shades of a single hue and the extreme crispness and unflagging sureness with which they are registered, carry one down into profound abysses and out through cloud-spaces and to interstellar lands that appear to have scarce any rapport with the little rectangles of canvas through which they are glimpsed. One falls from a single blue to another down gulfs of empyrean. The small intense volumes take on the bulk of cosmical protagonists. Gnarled apples; smooth, naked tree trunks; abstract forms that are like the shapes of sails and curtains and cloaks billowed by sea-winds are each in magical fashion informed by the elemental forces that toss the earth like a baseball in their play. There are canvases of O'Keeffe's that make one to feel life in the dim regions where human, animal and plant are one, undistinguishable, and where the state of existence is blind pressure and dumb unfolding. There are spots in this work wherein the artist seems to bring before one the outline of a whole universe, a full course of life: mysterious cycles of birth and reproduction and death expressed through the terms of a woman's body.

It leads us, this painting, further and ever further into the verity of woman's life. We have scarcely a witness more articulate than that borne by it. There are sonnets of Elizabeth Barrett in this sworling, undulant color; this modern woman, too, has been overtaken unawares by an irradiation of brimming rose, and found her spirit standing up erect and strong in a translucent world. But no inherited rhetoric interposes between her feeling and her form of expression. Her concepts are not half in man's tradition. To a degree they come out of general American life; not out of analyses of Cézanne and Picasso. They come out of the need of personal expression of one who has never had the advantage of the art treasures of Europe and has lived life without the help of the city of Paris; out of the necessity of one who shows no traces of intellectualization and has a mind born of profoundest feeling. An austerity, a fibrousness which is most closely kin to the Amerinds' pervades this paint. But, more directly even than from the plains and the cornlands and the general conditions of life in the new continent does it stem from the nature of woman, from an American girl's implicit trust in her senses, from an American girl's utter belief, not in masculinity nor in unsexedness, but in womanhood. O'Keeffe gives her perceptions utterly immediate, quivering, warm. She gives the world as it is known to woman. No man could feel as Georgia O'Keeffe and utter himself in precisely such curves and colors; for in those curves and spots and prismatic color there is the woman referring the universe to her own frame, her own balance; and rendering in her picture of things her body's subconscious knowledge of itself. The feeling of shapes in this painting is certainly one pushed from within. What men have always wanted to know, and women to hide, this girl sets forth. Essence of womanhood impregnates color and mass, giving proof of the truthfulness of a life. Whether it is the blue lines of mountains reflecting themselves in the morning stillnesses of lake-water, or the polyphony of severe imagined shapes she has represented; whether deep-toned, lustrous, gaping tulips or wicked, regardful alligator pears; it is always as though the quality of the forms of a

woman's body, the essence of the grand white surfaces, had been approached to the eye, and the elusive scent of unbound hair to the nostril. Yet, it is female, this art, only as is the person of a woman when dense, quivering, endless life exists in her body; when long tresses exhale the aromatic warmth of unknown primeval submarine forests, and dawn and the planets glimmer in the spaces between cheeks and brows. It speaks to one ever as do those high moments when the very stuff of external nature in mountainsides and full-breasted clouds, in blue expanse of roving water and rolling treetops, seems enveloped in the brooding principle of woman's being; and never, not ever, as speak profaner others.

For the paintings of Georgia O'Keeffe are made out of the pangs and glories of earth lived largely. Shapes and lines, broad single fields of tone, offer pieces of mountains to the heart, thrust windows open on the great airs and lands. The painter has reds and greens and whites red and green and white with all of passionate feeling of color it seems the hollows of the heart can hold. She has greens flameful and fiery as hottest scarlet. She has reds serene and pure as smoothest white. Marie Laurencin may give us the Watteau grace and delicacy of the Trianon in modern idiom. O'Keeffe brings a spaciousness of feeling, sweep, tumult, and calm like the spaciousness of the ocean and the Texan plains she loves. It may be the most literal representation or the most ethereal abstraction that is rendered; and the artist moves freely from one category to another; for her, the two categories are single—she paints them as one. But, whatever the subject-matter, the expression releases us with the white flames which cast fears out. It is heart-bursting joy that sings, or gaunt sorrow; it is aches and blisses scooped from the depths of the being and offered to the light; it is the hours of great morning when the spirit lifts high its hands in rapture; it is white night when the firmament is a single throbbing presence and quicksilver cuts sharp rims in black and digs a golden hollow in the lake under the mountain-wall. Darkly, purely painted flower and fruit pieces have not a little sorrow; contours silently weep. Pain treads upon the recumbent figure. Pain rends the womb to shreds with knives. Pain studs the universe with shark's teeth. Other times moods play like teasing children at tag. A prim and foolish little house winks its windows, while a flagstaff leans crazy, and mauve evening clouds tumble clownishly. An innocent orange flower is out walking of a nice Sunday morning through sweet green with a new feather stuck in its bonnet. A cow in apple time curls forth its purple watering tongue of flannel and rolls the comic muteness of its impenetrable bovine eye. Then, veils of ineffable purity steam like morning mists off tranquil lakewater. The span of heaven is an arch of bloom. Pearly shapes chant ecstatically against somber backgrounds. Life seems to rise on wing, in the dumbness of utter bestowal, into a climax of seraphic hues.

Fortune appears to have endowed Georgia O'Keeffe with two gifts which are perhaps a single one. It seems to have given her capacity of fiery passion; it has also shod her adamantine with safeguarding purity of edge. Hers is a spirit like steel-construction; all skeleton nudity and savage thrust. Burningness of life can breathe up and breathe free in her. For it rises flame-sharp of rim. Volcanic surge of feeling can find its way clean into the world. For folded in its substance there lies the whiteness of the spot where

the race begins. She goes through the world upholding in her thin sensitive hands above the brushing crowd a bubble of a bowl. The world is rich for this woman because of the unfaltering swift selections of her deep unconscious principle. And it is from the white integrity with which her being is bound that the tremendous decisions which constitute the art of Georgia O'Keeffe proceed. What she herself within herself is, where she is woman most, becomes apparent to her, because of her artist's vision, in external objects. There is no manner of deepened intercourse for the artist which does not become for him a correspondingly approfondized sense of his material. There is no piercing of the rind of nature at any point that is not a simultaneous piercing at many points. There is nothing really experienced which does not become esthetics for him. And, since O'Keeffe knows life as it comes to the passionately living; knows by the side of attraction, repulsion; by the side of life-giving, death-dealing; by the side of birth, decay, she sees scattered over the face of the world, in autumn landscapes, in baskets of fruit, in flower-cups and mountainsides the symbols of extremely concentrated feeling. She sees shapes and hues in the powerful oppositions born of intense passion. As few have seen them, she sees the refractions of light on solids, the relativity of color. She sees clashing principles lying close upon each other, speaking the subtle, wondrous high thing she knows; great forces brought close in upon each other, their virtue increased through the intensity of their mutual resistances under approximation. And, in the arrowlike tongue of her pigment she registers them with unfaltering faithfulness, and gives the personal inner truth of her opalescent sphere.

The American failure has been primarily a failure in men and women. Of the two masterpieces *manqué* the greater failure has been the woman, for the reason that it is she who is the object of labors, the work upon which the care of the artist has most generously been bestowed. It is the woman who has been given the position of honor in American society, been freed not only of conventional restraints, but made the arbiter of education and of life. The great privileges of leisure have gone to the girls. And though the new world has made of the woman a marvelously shining edifice, flowing of line and rich in material, it has also made of her a dwelling uninhabited, gray and chill like the houses where the furniture stands year-long in twilight under its shrouds. For, in keeping the male undeveloped and infantile, American culture has attributed the masculine principle to the female, and divided the female against her proper intuitions. The country has men who are boys and rest sixteen at seventy; and women who are Parian glories outside and little stunted men inside. Of life based upon the whole and developed personality there is scarcely any. But the art of Georgia O'Keeffe is no art of a poor little man. With this young artist, the splendid forsaken mansion flushes suddenly with the radiance of many chandeliers, the long-speechless windows glitter with active life. She is the little girl and the sybil, the wild, mysterious, longhaired one and the great calm rooted tree. The freshness of vesture given the sex by the American adventure is not lost in her. It has merely been made glorious and swift by the woman-psyche accepted, respected, cherished. A woman soul is on the road, going toward the fulfillment of a destiny. The effulgent art, like a seraphic visitor, comes with the force of life. In blaze of revelation it demonstrates woman to the world and to woman. It sum-

mons a psychic capacity toward new limits. It veers nature once again to its great way. (pp. 199-210)

Paul Rosenfeld, "Georgia O'Keeffe," in his Port of New York: Essays on Fourteen American Moderns, *Harcourt Brace Jovanovich, 1924, pp. 199-210.*]

Lewis Mumford (essay date 1927)

[*An American sociologist, historian, philosopher, and author, Mumford's primary interest was the relationship between the modern individual and his or her environment. Influenced by the work of Patrick Geddes, a Scottish sociologist and pioneer in the field of city planning, he worked extensively in the area of urban and regional planning and wrote several important studies, including* The Culture of Cities (*1938*), City Development (*1945*), *and* The City in History (*1961*). *Mumford also wrote much highly esteemed art and literary criticism, and in the following excerpt from a review of a 1927 exhibition of O'Keeffe's works, he asserts that her paintings express powerful emotions through a unique language of symbols.*]

Miss O'Keeffe is perhaps the most original painter in America today. The present show of her recent work leaves one wondering as to what new aspects of life she will make her own. I do not wish to dwell on her paintings as separate canvases, although in *The Wave,* and the sun blazing behind *The Shelton,* and in what is nominally one of her flower-interiors, as well as in several more abstract designs, she has produced pictures upon whose excellence one might well linger for a while. The point is that all these paintings come from a central stem; and it is because the stem is so well grounded in the earth and the plant itself so lusty, that it keeps on producing new shoots and efflorescences, now through the medium of apples, pears, eggplants, now through leaves and stalks, now in high buildings and sky-scapes, all intensified by abstraction into symbols of quite different significance.

Miss O'Keeffe has not discovered a new truth of optics, like Monet, nor invented a new method of aesthetic organization, like the Cubists; and while she paints with a formal skill which combines both objective representation and abstraction, it is not by this nor by her brilliant variations in color that her work is original. What distinguishes Miss O'Keeffe is the fact that she has discovered a beautiful language, with unsuspected melodies and rhythms, and has created in this language a new set of symbols; by these means she has opened up a whole area of human consciousness which has never, so far as I am aware, been so completely revealed in either literature or in graphic art. Unlike the painters who have taken refuge in abstract art to hide their inner barrenness, Miss O'Keeffe has something to communicate; and the human significance of her pictures is enriched rather than contracted by the symbols and the formal figures she employs. (pp. 41-2)

Miss O'Keeffe has found her symbols without the aid of literary accessories; hers is a direct expression upon the plane of painting, and not an illustration by means of painting of ideas that have been verbally formulated. Indeed, Miss O'Keeffe's world cannot be verbally formulated; for it touches primarily on the experiences of love and

passion. Whitman said that the best was that which must be left unsaid, and anyone who has reflected upon his passionate experiences is always a little appalled at the fact that they become so inarticulate in actual life, or so evasive, so skittishly evasive, when they seize hold of the poet.

The premonitions of love, its pre-nuptial state as it were, are the constant themes of poetry; but in literature love and passion retain something of the desire of the moth for the star; when we become conscious of them in other terms, we are faced either by the empty swaggering of a Swinburne or a Wilde, whose personal history gives one reason to doubt if they had anything more than a literary background for their emotions, or by the all too literal allusions of a Rochester. The fact is that words strike love stone-cold; what it is, is something much too deep in the blood for words to ejaculate; and when driven to such an indirect medium, the result is not the original quality of passion or sexual intimacy at all, but obscenity—which is but the ashes from an extinguished fire.

What is true of love holds for other emotions and feelings: if their warm impalpability is to be extracted from consciousness, they must be transformed by painting into their own special symbols, and not first done into a verbal medium; a blasted tree may convey more human anguish than the most scarified and tear-stained face, labeled Antigone. Perceiving this fact, and creating images that are as palpable as flesh and as austere as a geometric figure, Miss O'Keeffe has created a noble instrument of expression, which speaks clearly to all who have undergone the same experiences or been affected by the same perceptions. She has beautified the sense of what it is to be a woman; she has revealed the intimacies of love's juncture with the purity and the absence of shame that lovers feel in their meeting; she has brought what was inarticulate and troubled and confused into the realm of conscious beauty, where it may be recalled and enjoyed with a new intensity; she has, in sum, found a language for experiences that are otherwise too intimate to be shared. To do this steadily, in fresh forms, and to express by new expedients in design—as in the filling of a large canvas with the corolla of a flower—her moods and meanings: these are the signs of a high æsthetic gift. A minor painter might achieve this once; and would perhaps carve a prosperous career by doing it over and over again; Miss O'Keeffe, on the contrary, has apparently inexhaustible depths to draw upon, and each new exhibition adds richness and variety to her central themes. Her place is secure. (p. 42)

> *Lewis Mumford, "O'Keeffe and Matisse," in* The New Republic, *Vol. L, No. 638, March 2, 1927, pp. 41-2.*

Marsden Hartley (essay date 1936)

[*An American painter, poet, and art critic, Hartley was closely affiliated with the Stieglitz circle. The laudatory essay on O'Keeffe excerpted below was written at Stieglitz's request for the catalog to O'Keeffe's 1935 exhibition at An American Place. Here, Hartley characterizes O'Keeffe as a visionary who is able to glorify the beauty of the world through her art.*]

The following episode long since familiar to some—

perhaps more in the inner circle than outside it—will for the purposes at hand, bear repeating.

During the season of nineteen-fifteen—a little lively woman appeared at [the] two-ninety-one room which has long since established certain values in American art, with a roll of charcoal drawings that had been sent her, with the express condition that they were not to be shown to anyone.

The little lively woman's argument was—that having looked at the drawings, deriving singular sensations and experiences from them, and felt that despite their author's admonitions these drawings should be shown to someone closer to these ideas than she could lay claim to be—that is to say—she felt they must have consideration from someone more actually related to esthetic interests, and so she brought them to that unusual little room—two-ninety-one.

That room was full of curious and lively action those days—for it was making known to this country a number of artists now too familiar to speak of—except to say that these artists were Matisse—Rodin—Picasso—Rousseau—Manolo—John Marin—Max Weber—A. Walkowitz—Gertrude Stein—myself, and others. (pp. 102-03)

Did these drawings that were brought by the lively little woman have esthetic value—or did they, strictly speaking, have any value at all?

It was the custom at that period for certain artists to gather daily in that special room—and as in the case of all other products brought there—the drawings were considered and discussed.

Most of them found that the drawings had merit—they were sure that a very definite personality had produced them—sure, first of all that a woman had done them—and those of a psycho-analytical turn of mind said things that mattered very much to them—but of not much consequence to anyone else—for artists are not usually concerned with subterranean reasons.

All that mattered was that the drawings had merit—it was a woman who rose up out of the drawings of a singularly violent integrity—and the woman is she who is now known as Georgia O'Keeffe.

In the two decades that have passed since then we have seen the drama unfold with such uncompromising earnestness and sincerity, of a personality disrobing itself so to speak to the gaze of the world much in the manner of that peculiar translucent literary work known as Amiel's *Journal,* never once considering, for any trivial reason, its relation to any other entity than itself, never once swerving from its documentary persistence, not for any common egotistic reasons—but solely for the sake of getting down in esthetic form, all the involved or simple states of being of a separate and intensified relationship. (pp. 103-04)

From the first the element of mystical sensation appears [in O'Keeffe's work]—and it is not difficult to think of O'Keeffe as a mystic of her own sort—passionately seeking direct relation to what is unquestionably, to her, the true force of nature from which source and this alone—she is to draw forth her specific deliverance.

There are paintings in the stacks of an earlier period that would provoke devotees of arcane research into proving that O'Keeffe had come almost if not completely to the border-line between finity and infinity—there are flames that scorch—there are forms that freeze—there are vapours that rise like the hissing steam of ardent admissions seeking to escape from their own density—then the passionate struggle subsides for a spell, and nature in her simplest appearance is consorted with—and we find numbers of canvases and drawings that seek only to inscribe the arc of concrete sensation and experience—and I am thinking of course of the many smaller essays in flowers and fine shapes from the intricate vegetable world.

There are mysteries from the garden—there are austerities from the forest—there are conversations with shell-curves—and other seeming trivia of the visible world. The vision expands and there are floral figures of enormous size, so huge that they shut out the sky above them—shut out even the morning that opens them—shut out all consciousness of a common world that wearies of its own realities—they become like gates almost that are to close behind a spirit seeking the higher relation known and spoken so freely of by the earlier spiritual romantics, the Christian mystics, they become like corridors of fire and silence through which the spirit must pass to attain its own special and lasting peace—in order to escape imprisonment in a world of defined limitations.

There is the sense also that eternal judgment is not far off in some of these essays, there are blacks that are so black that the peril of annihilation becomes immanent—there are whites so acutely adjusted to their own speechlessness that they seem almost to talk in a prescribed monotone known only to themselves.

There are the flame tones—almost savage reds to verify the flesh—greys of whatever hue that seek to modify them of too much animal assertion—there are disconsolate hues of ash-like resignation, all of which typify the surging passion of a nature seeking by expression first of all to satisfy herself—and in the end perhaps to satisfy those agencies of sensation and emotion that pursue and demand deliverance. (pp. 104-05)

Many times I have had the feeling that in some of O'Keeffe's pictures, that by virtue of their subconscious intensity they reach almost over a disastrous horizon, a Blake-like reaching into other spaces, the difference being that Blake by virtue of his ecstatic religious extravagance through Swedenborgian verifications, seeks to establish a clear view of what to him is undeniably heaven—when in a person like O'Keeffe the struggle is always toward a glorification of the visible essences and semblances of earth, or, to employ a fine phrase of Cocteau's "Enfants terribles"—"the privileges of beauty are enormous—it affects even those who have no experience of it."

There are always a certain number of persons who see grandeur in everything—and are not quite able to state what this grandeur is.

O'Keeffe lays no claim to intellectualism. She frets herself in no way with philosophical or esthetic theories—it is hardly likely she knows one premise from another. She is satisfied that appearance tells everything and that the eye is a better vehicle of truth for picture purposes than the mind can ever be.

O'Keeffe is a highly developed intuitive and she would heartily agree with those pundits who believe that instinct and intuition are all there is to be considered she—to turn, the Cocteau phrase a little—is satisfied to think of the enormity of the sense of beauty and achieve dignified consideration of it. Artists and religionists are never very far apart, they go to the sources of revelation for what they choose to experience and what they report is the degree of their experiences. Intellect wishes to arrange—intuition wishes to accept.

Take the new ram-skull picture [**Ram's Head, White Hollyhock, Hills**] in the present exhibition—it is—or so it seems to me—a transfiguration—as if the bone, divested of its physical usages—had suddenly learned of its own esoteric significance, had discovered the meaning of its own integration through the processes of disintegration, ascending to the sphere of its own reality, in the presence of skies that are not troubled, being accustomed to superior spectacles—and of hills that are ready to receive.

There is, they say, an amazingly moving phenomenon takes place—I do not know if always—in the period of cremation of the human body—when at a given pitch of heat the body is seen actually to rise in the air above its bier before dissolving into ashes. Something of this sort seems to appear to me in the apotheosis of this animal skull attended by a single flower as if to perform the final sealing approval of the august function.

There is nothing forbidding or gruesome in this new essay of this transmigration of bone—and it has, I think a much calmer sense of the same idea that was expressed in the several other ox- and horse-skull pictures where the spirit of death is always present, and the swerve of last earthly rites is being depicted. This brings me to consider the newest phase of O'Keeffe's development, and like all other pictures these new ones also portray the journey of her own inner states of being.

O'Keeffe has known the meaning of death of late and having returned with valiance to the meaning of life—there comes to the surface a confidence that comforts, first of all herself—secondly those who are interested in her as person and artist, greater confidence in the sun and the earth, these new pictures give the feeling that personalisms have vanished—self has been denied—there is the new image living its own life irrespective almost of the person who performed it.

No struggle now, and pictures without ego assertion are always inclined to be satisfying.

You may think of O'Keeffe's pictures as but a further attempt at psychic calligraphy—you may call them image without body—spirit without encumbrance. You may like the new small arrangement of horse-shoe and turkey feather. They may have no meaning at all to you—O'Keeffe like many another significant artist has run the gamut of unqualified praise and qualified condemnation—but she remains the same as always—just what she is, a woman, having a woman's interests, a woman's ardours in pursuit of the sense of beauty—a woman's need of getting at her own notion of truths—she is never struggling for man-power or man equality—she has no need of such irrelevant ambitions—she has never made a cult of her own intensified intuitions—she is even free from the lau-

dations that have been lavishly heaped upon her—she is a woman, utterly free. (pp. 106-08)

Marsden Hartley, "Georgia O'Keeffe: A Second Outline in Portraiture," in his On Art, *edited by Gail R. Scott, Horizon Press, 1982, pp. 102-08.*

Daniel Catton Rich (essay date 1944)

[In the following exhibition review, Rich applauds what he considers O'Keeffe's return to a more reductive style in her paintings of the early 1940s.]

Last year in studying the work of Georgia O'Keeffe I found a descriptive exactness in her later paintings of New Mexico. The discovery was not wholly reassuring. Had the artist become so spellbound by the abstract forms of this fabulous landscape that she was content to *render* New Mexico rather than *express* it? Was the passionate emotion which had so long distinguished her art being sublimated in a new realism towards mesa and mountain? There was still plenty of O'Keeffe left—her clear vision, decorative resources and sensitive painting. But where was the artist of the **Black Cross** and the **Cow's Skull with Calico Roses?**

The answer to all these questions may be read in nineteen new canvases Georgia O'Keeffe has been exhibiting at An American Place. They are last summer's crop and the painter admits that she "had a good year." Among them are familiar themes of enlarged flowers and views from her "front" and "back yards." Here she has refined rather than added anything new. But in one landscape, **The Black Place**—she has so simplified her vision and heightened her feeling that nowhere in her entire work do you find as clear a statement of what New Mexico means to her.

The new note is forcibly struck in a series of seven paintings of desert bones. This is not the first time that O'Keeffe has used these cleansed and whitened fragments. In the past a cow's skull and a thread of black have been employed to suggest the blankness of death. Deer's horns have been floated above a New Mexican vista to symbolize resurrection. But in these recent paintings a fresh emotion is at work. No longer concerned with death or after-death, O'Keeffe holds up an elegantly turned pelvis bone and paints the blue of the sky through its hollow sockets. Bone and sky and mountain are welded into a luminous affirmation. These things, the artist seems to be saying, are eternal and will remain "after all man's destruction is finished."

Technically, this new statement gains by reduction to essentials. The chord of white against blue is struck over and over, but infinitely varied. The sweep of line is balanced by shapes, which, ornamental in themselves, do not impress you as mere ornament. O'Keeffe loves hard materials—stones, shells and bones. But they are never petrified into still life. The close-up (so frequent a device in her art) takes you straight into the object and it is this intimate view, playing against distance that often gives these canvases their peculiar tension. Only occasionally as in the large and over-ambitious **Pelvis with Shadows and the Moon** does the effect fail to come off.

In another picture, **Dead Cottonwood Tree,** the painter uses the white, stiffened trunk as she uses bones, but her eye is already taken by the early green of living trees beyond. This green becomes the theme of another canvas where she manages to convey the sensation of soft leaves blowing in spring. Not since her series of the **Maple at Lake George** (1923-1924) has O'Keeffe expressed quite the same lyricism in treating this motif.

What lies behind this successful new painting? Several things. Last year she spent more time in New Mexico than usual. The "good year" is partly the result of longer residence in the place she loves. Partly it comes, I believe, from her exhibition in Chicago, where for the first time in many seasons she saw a number of her best paintings together. To an honest painter like O'Keeffe it was a help to study the unfolding of her career. It is significant that soon afterward she became interested once more in Oriental art and is now eagerly looking at Chinese scrolls and Japanese prints. Today she is even more determined to make something which in cleanness of line and simplicity of vision is totally American, but never in any narrow sense.

In her introduction to the catalogue of the present exhibition she wrote: "I have used these things to say what is to me the wideness and wonder of the world as I live in it." This is the true O'Keeffe speaking. It means that once again transformation has triumphed over observation. That is all to the good. American art will always have enough observers. (pp. 110-11)

Daniel Catton Rich, "The New O'Keeffes," in Magazine of Art, *Vol. 37, No. 3, March, 1944, pp. 110-11.*

Clement Greenberg (essay date 1946)

[Greenberg is considered one of the most important American art critics of the twentieth century and is renowned in particular for his eloquent arguments in favor of abstract art. In the following excerpt, he asserts that O'Keeffe's paintings are mere technical exercises that illuminate only private, arbitrary meanings.]

Georgia O'Keeffe's retrospective show at the Museum of Modern Art confirms an impression left by the "Pioneers of Modern Art in America" exhibition at the Whitney Museum last month—namely, that the first American practitioners of modern art showed an almost constant disposition to deflect the influences received from twentieth-century Paris painting in the direction of German expressionism. This tendency was more obvious and general in the period that saw Miss O'Keeffe's debut (1915) than it has been since, but it survives even today.

The first American modernists mistook cubism for an applied style; or, like many German artists, they saw the entire point of post-impressionist painting in *fauve* color—or else they addressed themselves directly to German expressionist art as a version of the modern which they found more sympathetic and understandable than that of the School of Paris. In any case they read a certain amount of esotericism into the new art. Picasso's and Matisse's break with nature, the outcome of an absorption in the "physical" aspect of painting and, underneath everything, a reflection of the profoundest essence of contemporary society, seemed to them, rightly or wrongly, the signal for

From O'Keeffe's autobiography:

It was in the fall of 1915 that I first had the idea that what I had been taught was of little value to me except for the use of my materials as a language—charcoal, pencil, pen and ink, watercolor, pastel, and oil. I had become fluent with them when I was so young that they were simply another language that I handled easily. But what to say with them? I had been taught to work like others and after careful thinking I decided that I wasn't going to spend my life doing what had already been done.

I hung on the wall the work I had been doing for several months. Then I sat down and looked at it. I could see how each painting or drawing had been done according to one teacher or another, and I said to myself, "I have things in my head that are not like what anyone has taught me—shapes and ideas so near to me—so natural to my way of being and thinking that it hasn't occurred to me to put them down." I decided to start anew—to strip away what I had been taught—to accept as true my own thinking. This was one of the best times of my life. There was no one around to look at what I was doing—no one interested—no one to say anything about it one way or another. I was alone and singularly free, working into my own, unknown—no one to satisfy but myself.

Georgia O'Keeffe, in her Georgia O'Keeffe, *The Viking Press, 1976, 200 p.*

a new kind of hermetic literature with mystical overtones and a message—pantheism and pan-love and the repudiation of technics and rationalism, which were identified with the philistine economic world against which the early American avant-garde was so much in revolt. Alfred Stieglitz—who became Miss O'Keeffe's husband—incarnated, and still incarnates, the messianism which in the America of that time was identified with ultra-modern art.

It was this misconception of non-naturalist art as a vehicle for an esoteric message that encouraged Miss O'Keeffe, along with Arthur Dove, Marsden Hartley, and others, to proceed to abstract art so immediately upon her first acquaintance with the "modern." (It should not be forgotten, however, that the period in question was one that in general hastened to draw radical conclusions even when it did not understand them.) Conscious or unconscious esotericism also accounts largely for the resemblances between much of these artists' work and that of Kandinsky in his first phase; this being less a matter of direct influence than of an a priori community of spirit and cultural bias.

Later on, in the twenties, almost all these painters, including Miss O'Keeffe, renounced abstract painting and returned to representation, as if acknowledging that they had been premature and had skipped essential intermedi-

ate stages. It turned out that there was more to the new art than the mere abandonment of fidelity to nature; even more important was the fact that Matisse and the cubists had evolved a new treatment of the picture plane, a new "perspective" that could not be exploited without a stricter and more "physical" discipline than these pioneers had originally bargained for. A period of assimilation of French painting then set in that has led American artists to a more integral understanding of what is involved in modern art. But the cost has been a certain loss of originality and independence. Today the more hopeful members of the latest generation of American artists again show "Germanizing" or expressionist tendencies; and these, whether they stem from Klee, surrealism, or anything else, seem to remain indispensable to the originality of our art, even though they offer a serious handicap to the formation of a solid, painterly tradition.

The importance of Georgia O'Keeffe's pseudo-modern art is almost entirely historical and symptomatic. The errors it exhibits are significant because of the time and place and context in which they were made. Otherwise her art has very little inherent value. The deftness and precision of her brush and the neatness with which she places a picture inside its frame exert a certain inevitable charm which may explain her popularity; and some of her architectural subjects may have even more than charm—but the greatest part of her work adds up to little more than tinted photography. The lapidarian patience she has expended in trimming, breathing upon, and polishing these bits of opaque cellophane betrays a concern that has less to do with art than with private worship and the embellishment of private fetishes with secret and arbitrary meanings.

That an institution as influential as the Museum of Modern Art should dignify this arty manifestation with a large-scale exhibition is a bad sign. I know that many experts—some of them on the museum's own staff—identify the opposed extremes of hygiene and scatology with modern art, but the particular experts at the museum should have had at least enough sophistication to keep them apart. (pp. 727-28)

Clement Greenberg, in a review of an exhibition at the Museum of Modern Art, in The Nation, *New York, Vol. 162, No. 24, June 15, 1946, pp. 727-28.*

James Thrall Soby (essay date 1946)

[*Soby was an influential critic, editor, curator, and champion of Modernist art. He is noted in particular for his long association with the Museum of Modern Art in New York City and for his numerous highly regarded critical studies. In the following excerpt, Soby praises the evocative power of O'Keeffe's work.*]

Georgia O'Keeffe, perhaps the greatest of living women painters, is now having a retrospective exhibition at the Museum of Modern Art in New York. I must admit that looking at her pictures year after year at Stieglitz's gallery, I did not know consistently whether I liked them or not. A few weeks ago, after seeing so much of her life work at the Museum, my doubts vanished. I think Miss O'Keeffe creates a world. It is a world of surprising variety. Sometimes her painting seems an art of psychic confession, an

inner recital of symbolic language, like the murmur of aco- lytes. Then again it becomes more objective and she paints the mountains of New Mexico as though they answered when she spoke. Throughout her work there is a dual con- ception of nature: a nature as the painter herself; and na- ture as an unfailing companion with whom she converses in terms of wonderful precision, intimacy, and shades of meaning. In subject matter she turns her back on humani- ty, but there is love in her work, courage, strength, devo- tion.

Her imagery is singularly compelling. Indeed, I can re- member few large exhibition openings like hers recently at which the pictures came out to get you and did not let you go, despite the distraction of people and manners. Hers is a world of exceptional intensity: bones and flowers, hills and the city, sometimes abstract and vigorous, some- times warm and fugitive. She created this world; it was not there before; and there is nothing like it anywhere. (pp. 14- 15)

> *James Thrall Soby, "To the Ladies," in* The Saturday Review of Literature, *Vol. XXIX, No. 27, July 6, 1946, pp. 14-15.*

Edmund Wilson (essay date 1958)

[*Considered America's foremost man of letters in the twentieth century, Wilson wrote widely on cultural, his- torical, and literary topics. In the following review of a 1925 group exhibition at the Anderson Gallery, he ex- amines O'Keeffe's skillful juxtaposition of dissonant ele- ments, likening her work to that of Modernist compos- ers.*]

In Miss Georgia O'Keeffe America seems definitely to have produced a woman painter comparable to her best women novelists and poets. Her new paintings in the Stieglitz exhibition at the Anderson Galleries are astonish- ing even to those who two years ago were astonished by her first exhibition; and they seem to represent a more con- siderable development for the period of the past year than last spring's exhibition did for that of the year before. For one thing, she has gone in for larger canvases; she has passed from close-rolled white lilies to enormous yellow lilies and wide-open purple petunias. Yet although she has allowed her art to expand in this decorative gorgeousness, she has at the same time lost nothing in intensity—that pe- culiarly feminine intensity which has galvanized all her work and which, as a rule, seems to manifest itself in such a different way from the masculine. Male artists, in com- municating this quality, seem usually not merely to impart it to the representation of external objects but also, in the work of art, to produce an external object—that is, some- thing detachable from themselves; whereas women imbue the objects they represent with so immediate a personal emotion that they absorb the subject into themselves. Where the masculine mind may have freer range and the works it produces lead a life of their own, women artists have a way of appearing to wear their most brilliant pro- ductions—however objective in form—like those other ar- tistic expressions, their clothes. So the razor-like scroll- edges of Miss O'Keeffe's autumn leaves make themselves directly felt as the sharpness of a personality; and the dark green stalks of one of her corn paintings have become so charged with her personal current and fused by her per-

sonal heat that they seem to us not a picture at all but a kind of dynamo of feeling, along which the fierce white line strikes like an electric spark. This last picture, in its force and solidity, seems to me one of her most successful.

One finds also among these new paintings remarkable ef- fects of fluidity and vagueness: her white birches are misti- er than last year, and she has found a new subject in the shifting of water over the pebbly bottom of a lake. She combines in other canvases the blurred with the sharp in such a way as to produce violent dissonances; and disso- nance is one of the features of the work of this exhibition. Miss O'Keeffe seems to be bent on bringing together ele- ments of which one would say that they could not coexist in one picture—not only vagueness and edge, but mutual- ly repellent colors. In some pictures, which seem less suc- cessful, this gives the impression of a fault of taste. Thus she will paint a red leaf against a green background in such a way as to give a harmony in bronze, but on the green leaf a neutral brownish leaf which jars with the other col- ors and seems irreconcilable with them. Again, in **Red to Black,** one of her most elaborate pictures, there appears above a rich foundation of flesh-like folds—occupying half the canvas and in her vividest vein of red—a stratum of black, not intense, as the eye expects after the intense red, but discomfitingly washy and dim, and above this a light superstructure of sketchily outlined hills, whose pinks and lavenders seem quite out of key with the deep reds and purples below; the effect is of an overweighted and inartis- tically feathered shuttlecock too heavily dragged to earth. Yet it seems plain from other pictures that these anomalies are deliberate and significant, and we recognize them as analogous to the dissonances of modern music and poetry. A sunken tree trunk is seen in the water, blurred brown under turbid green—but there floats above it a single leaf of blue-silver as livid and bright as the mercury tubes in photographers' windows and so distinctly outlined that it almost seems impossible for the eye, without changing focus, to take in both leaf and log. Again, from a prelimi- nary study of a plain white house with an open door, set in greenery and lilac bushes, she develops an abstract pic- ture (**The Flag Pole**) in which the actual outlines of the house have all but melted away in the exquisite green and lavender mist, while the rectangle of the doorway, dark before, has intensified itself to a black opacity and a strict geometrical exactitude, which cause it to seem projected from the plane of the picture itself and to hang in the air before it. One finds oneself fascinated by these discords at the same time that one is shocked by them: one stares at them, trying to eliminate or to soften the repulsion be- tween opposites—the harsh rectangle and the aura of springtime, the dim lake and the incandescent leaf. (pp. 98-100)

> *Edmund Wilson, "The Stieglitz Exhibition," in his* The American Earthquake: A Docu- mentary of the Twenties and Thirties, *Double- day & Company, Inc., 1958, pp. 98-103.*

Sam Hunter (essay date 1963)

[*In the following excerpt, Hunter discusses O'Keeffe's relation to the central trends of Modernist art.*]

Once the collective nature of our early modernism is es- tablished, and its character as a movement has been ac-

cepted, one can pick out more readily the threads of identifiable originality that separates American and European expressions. The evidence of originality in the continuing dialogue with European authority interestingly provides a link between the modernism of the Armory Show period and contemporary abstraction. The schismatic character of our art is less apparent among artists working in cubist idioms, since there seemed to be less room in those styles for original elaboration. The tradition of biomorphic abstraction, on the other hand, was given a very individual inflection by Dove and O'Keeffe. O'Keeffe in particular seemed able to invest abstract painting with new content, and significant new forms. In such paintings as **Light Coming on the Plains No. 3** and **Pond in the Woods**, there is a daring reduction of pictorial means to a simple scheme of symmetrically opposed color stains, or a serpentine spiral of graduated rings of smudged pastel. The imagistic and symbolist overtones of these simple configurations are all the more surprising since the means are so unpromisingly tenuous and non-aggressive. In these and other paintings she plays with ideas of distinctness and indistinctness, concentration and diffusion until they take on the character of statements about the essential ambiguities of experience itself. In terms of the conspicuous patterning even of the art of Kandinsky, from whom her own painting derives, this seems a sharp departure; O'Keeffe subverts rational ego in favor of a more informal and 'open' kind of painting, as Mark Rothko and, in a different fashion, Kenneth Noland have more recently done. By her sublimation of matter, in her feeling for limitless boundaries and self-renewing images, O'Keeffe treats abstraction not merely as an occasion for formal exposition, but as a mode of experience.

That places her in a somewhat equivocal relationship to European abstract tradition, for she accepts European formality and taste but subtracts something of its explicitness in favor of an unbounded, and more raw and permissive experience. Her art seems characteristically American in standing aloof from final solutions. What must have once seemed a curious lack of commitment to formal exposition, or at best a weak and muffled echo of it, has today become a prevailing way of art in which we see reflected the ambiguity and indeterminacy of our own experience of reality. Despite their essential modesty of scale and ambition, and without being an actual influence, the paintings of O'Keeffe and Dove prefigure attitudes and an imagery that belong to contemporary abstraction; they are part of an intelligible continuity of taste and change. Firmly rooted in European precedent and innovation, they nevertheless contribute significantly to the emerging definition of a new American abstraction. (pp. 22-3)

> *Sam Hunter, in an excerpt in* Georgia O'Keeffe: An Exhibition of the Work of the Artist from 1915 to 1966, *edited by Mitchell A. Wilder, Amon Carter Museum of Western Art, 1966, pp. 22-3.*

Peter Plagens (essay date 1966)

[*In the following excerpt from an exhibition review, Plagens traces the development of O'Keeffe's style.*]

That Georgia O'Keeffe will eventually be assimilated into the vast, slowly receding limbo enigmatically known as contemporary art history is beyond doubt; the timeless beauty or instruction offered by any work or body of works cannot entirely disassociate it from the stylistic and physical chronology of its creator, which becomes the nominal property of those who, with all the clarity of hindsight, chart childhood environment, places of study, occupational history, artistic development, influences taken and given and the momentum generated by the artist. Georgia O'Keeffe, in the current retrospective of 96 works given her at the Amon Carter Museum of Western Art in Fort Worth, Texas, stands precisely on the boundary between our time, now, and history in our time.

There are three general characteristics which lend to Miss O'Keeffe the aura of quiet, monumental sagacity which, in part at least, enjoins the historical: she has visited, fought and won battles of another period which are somewhat forgotten but still indispensable to painting today; she rises out of an American spirit which could be called Romanesque—when our clean, broad vista of waving wheat and cities and radio was coupled with a social drama capable of maturing, enlightening and uplifting a generation, in short, the '30s; and she practices (emphatic present tense) an approach to painting which is subdued, if not rejected, by our current stratum of American painters.

There is, in the formalism of Georgia O'Keeffe, a feeling about painting pictures which is alien to painters of the 1960s. (Miss O'Keeffe herself excepted.) Her paintings, belying the cohesiveness of the exhibited group of works, are singular objects-in-themselves; they are not mere bright ideas proselytizing logistics. They have little militant force in steering modes of art one way or another, and it is doubtful whether this assembling of a large number of her paintings in this one place will revive any latent martial value; Miss O'Keeffe's works, for all the sweep and scale, are essentially of an old-fashioned stripe: objects of quiet delight and contemplation. The paintings also speak of arbitration and planning, conception and execution, which, save for an almost vicious "cool" and cynical removal inhabiting certain current sub-styles, are not of this year, this month, this week. The deer horns are placed on the rectangle with severe aplomb; the mountains are molded carefully to a geological density yet remain flexible, pliable flesh, and the irises are engineered to a lovely, lyric ambiguity of size. Miss O'Keeffe does this with a directness, a thickness of paint, a feeling and respect for the canvas (in sizes that range, with one exception, from art-supply store regularity to slightly odd proportions), and a deliberate, but less than hard, brushwork that has fallen from the possession of a few masterful painters to the almost exclusive province of the student.

The scale is balanced on the opposite side with genuine virtuoso formalism, durability, continuum within the oeuvre and, indeed, a personal image which would defy anything else but **now.** Georgia O'Keeffe's paintings are riddled with recurring problems and solutions that indicate that these hypotheses are never categorically done away with, that they must be attacked and overcome in thousands of pictures, in thousands of ways, from now until there is no painting. Her pictures remain separate, individual manifestations; they make space around themselves; they can breathe and, consequently, they can live relatively long lives. (p. 27)

The earliest work in the exhibition is dated 1915; in those paintings and drawings executed before 1920, one perceives an attempt, conscious or not (judging from Miss O'Keeffe's rather unadorned, straightforward comments about her own work, it would be the former) at limiting the means of picture-making as a discipline, in order to strip away the dead weight of second-hand ideas and to inject an absolute honesty into the process. *Light Coming on the Plains, No. II,* 1917, is a magnificent simplistic watercolor which conveys, in varying blues on a small piece of paper, the grandeur of interacting, omnipresent natural elements: sky and earth. It may be, in relation to both the work of other painters and the rest of Georgia O'Keeffe, the most independent painting of the lot. An oil, *59th Street Studio,* 1919, is a prototype of the New Mexico paintings. Seen alone, it is a rather sensitive, well constructed basic abstraction of building, window, and the grey of city living, while in context it is a demonstration of the woman's remarkable will: the esthetic had nested in the person, and the person proceeded to find a home for both in the land.

The paintings of the '20s display an expansion of pictorial devices revolving around the issue of representation and abstraction (Miss O'Keeffe never made a political commitment to either; she managed, over another twenty years of painting, to invert the matter and make it seem as though the question of illusionistic form was irrelevant as long as she produced works). In this period we encounter the element of ambiguity as a formal tool as basic and utilitarian as line, tone, pattern or color. At first it was size: how large or small *are* those flowers? The paintings have an imperative connoting that just knowing the pictures are big representations of actually small flowers is a cheap, erroneous answer. Later, it grew to include position in space, material and color. And none of it is expedient: the strange feeling that a hill (*Red Hills and Blue Sky,* 1945) might also be a portion of a female nude is not the insinuation of an irrelevant, quasi-surreal facility artificially heightening the impact; it gives to the landscape a corporeal life which, in turn, renders it a more painterly subject. During the '20s, certain periodical criticism inferred vaginal allusions in several of her paintings, though it was never outrightly laid on the line; her work was described as containing "pernicious suggestions that allude to emotional life" and as being "almost unbearably intimate." (All reporting was not so thankless, however, and an occasional insight was recorded: in a group exhibition with Charles Sheeler, among others—with whom she was to be named, out of superficies and coincidence more than anything else, a "Precisionist"—the observation was made that "Miss O'Keeffe's pictures are the clean-cut result of an intensely passionate apprehension of things, Mr. Sheeler's the clean-cut result of an apprehension that is extremely intellectual.") Whether or not there are sexual parts lurking in the pictorial configurations may never get certification one way or another, but in the light of the whole of her work, the idea is painfully trivial. The culmination of the '20s is embodied in *Black Hollyhocks and Blue Larkspur,* 1929, a fantasy of exotic color (something that Miss O'Keeffe, carving a path through taste, antitaste and the stigma of being so obviously pretty, could force to work plastically) and form, although the most impressive single tour de force is *Shelton with Sun Spots,* 1926, an optical illusion which owes its entire representational force to the fact that it is an abstract reconstruction

of, not the scene, but a visual phenomenon. From 1930 through 1939, there is a sorting out of methods; the abstractions (e.g. *Black and White,* 1930, which is relatively unsuccessful) are neglected in favor of simplified and restrengthened means. *Dark Mesa and Pink Sky,* 1930, is notable for both its pictorial clarity through limited size and strangely unglamorous color, and the painting of the pink sky out onto the form (a device which is a performer's trick, for it gives the small painting an enlarged sense of space otherwise unavailable). One of the Canadian barn pictures is a triumph of less-is-more in color; the grey (and, sadly, cracking) roof in that building is probably the most lush, convincing non-chroma that one could see in a lifetime.

The ten years between 1940 and 1950 see a perfection of the ambiguity begun two decades earlier; it has now been expanded and fulfilled (*Red Hills and Sky,* 1945) and extended to include a kind of soaring scale of architecture and emptiness, as in *Pelvis with the Moon,* 1944. And she is able to wring a fantastic depth out of a blue-white painting entitled *Pelvis IV (Oval with Moon),* 1944. After 1950, Georgia O'Keeffe's work undergoes a split: the *Patio Door* series is begun, representing a thread retrieved from the "Studio" painting of 1919. This series of paintings is to result in two wonderful pictures in the '50s—*Green Patio Door* and *Black Patio Door,* both of 1955—and then progress to a more absolute geometry of color-on-white in 1960, *White Patio with Red Door.* But there also occurs,

Cow's Skull, Red, White and Blue (1931). The Metropolitan Museum of Art, The Alfred Stieglitz Collection, 1949. (52.203)

unfortunately, a weaker kind of painting, **Mesa and Road to the East,** 1952, and **Winter Cottonwoods Soft,** 1954, wherein Miss O'Keeffe falls back on an open brushwork, a desert-realist sort of composition, sandy color, and a nostalgia about the landscape, which has been intruded upon by this "road to the east." The half-dozen paintings dating from 1960 are as vital as any of their predecessors: the last **Patio Door,** is an irreducible brown winter road on a white plane, and a huge exception to size. (pp. 27-9)

The Texas plains where Georgia O'Keeffe taught art and first contracted the germ of that pristine, yet tactile and graceful, landscape space with which her paintings are inundated, and the wondrous New Mexico that held her entranced for forty years are now being corroded by other forces in American life and thought. (The Taos and Santa Fe areas were first the subject of romantic illustrator-academicians who sent back pictures of the cliffs, sunsets, broken wagons, and Indians in much the same spirit as "Harper's" published drawings of the Civil War; now, though many of us have never experienced the raw majesty of that country, in spite of Miss O'Keeffe's penetrations, space like that is no longer "out there"; we have pierced it with roads and cars and we are prepared to bridge, circumvent, invade and gouge it with the same Promethean technology that sends payloads to the moon, breeds megalopoli and engages in cybernetic debates over lethal and non-lethal gas.)

Any account of Miss O'Keeffe and this show must mention the gigantic painting, **Above the Clouds,** 1966, fully eight by twenty-four feet. Can it be, one wonders, that the scents of innovation of the last seven or eight years have drifted to New Mexico? Does that vast, mechanical recession of clouds (or, as many at the show seemed to think even after reading the title card, icebergs) contain, daresay it, a schematic banality related to billboards? Or is this the retarded metamorphosis of scale into physical reality, openness into actual surface, light into enormous quantities of white and color into primaries? That Georgia O'Keeffe, after all she has done, can do this, is tribute enough, history notwithstanding. (p. 30)

> Peter Plagens, "A Georgia O'Keeffe Retrospective in Texas," in Artforum, Vol. IV, No. 9, May, 1966, pp. 27-31.

Barbara Rose (essay date 1970)

[*In the following excerpt from an article inspired by a 1970 retrospective exhibition at the Whitney Museum of American Art, Rose focuses on the paintings O'Keeffe completed in the 1960s, discussing their relation to the abstract art of that decade and to O'Keeffe's earlier works.*]

These days it is fashionable to believe that we already have an accurate picture of the quality art of the sixties. The idea that any important work is unknown to us seems out of the question. Yet there exists a body of work done during the decade of the sixties, almost unknown to the general art public, which I believe will endure when the media favorites of today have long faded. I am speaking of the recent paintings of Georgia O'Keeffe which rounded out her recent Whitney Museum retrospective.

The works in question were painted in virtual isolation in O'Keeffe's barn at the remote Ghost Ranch, her adobe home high on a plateau in the New Mexico hills. Yet they share certain characteristics that link them to the most sophisticated abstract painting of the sixties. Large in size and simple in format, the recent works are single-image field paintings rather than multi-focus compositions. They are organized through broad spatial divisions rather than through the balancing out of analogous forms against one another. Like the work of post-war New York School painters, most of O'Keeffe's recent paintings emphasize the relationship of the whole image to the frame rather than the internal relationships of part to part. In their bold imagery, deliberate simplicity and muralesque flatness and monumentality, they also identify themselves clearly as American paintings of the sixties. (p. 42)

In certain respects [O'Keeffe's] recent paintings appear merely to elaborate her traditional themes: the grandeur and vastness of the American landscape, the simple geometry of the patio, the enigma of a single isolated object like a stone, a flower, or a bone examined at close hand. In other respects, however, her recent work is quite different. Instead of the patio door recessed into a wall that is explicitly the side of a building of the forties and fifties we have, in a recent painting of her celebrated Abiquiu courtyard, an open abstract field punctuated by rectangular dashlike markings. Whereas the patio is depicted in past versions of the theme as bounded by a finite architectural context, the 1960 **Patio with Red Door** is distinguished by its lack of confining boundaries. It is quite evidently a fragment of a larger field—an endless blank whiteness infinitely extendible beyond the framing edge. Into this ambiguous ground—ambiguous in the sense that it suggests both the flatness of a wall as well as the incalculable space within a dazzling white cloud—is seen the familiar rectangle of the patio door. But the use of aerial perspective, in the fading of the red to pink from bottom to top, suggests that behind the door there is a view into an infinite distance.

The **Patio with Red Door** is thus a poetic reformulation of the concrete theme of the courtyard with undeniably metaphysical overtones. The rectangular door opens now not to a domestic interior but to the distant vista suggestive of a pure and limitless beyond. The insistent concreteness of O'Keeffe's earlier paintings of skyscrapers, barns, and domestic buildings has been exchanged for a glimpse into the mysteries of a world beyond the one we know so well. The patio now is no longer anchored firmly to the ground, but floats, like the saints ascending to heaven in religious altarpieces, above the horizon. Within an abstract context, O'Keeffe is able to evoke the strange otherworldliness of a mystical experience. Yet even were her content not so deep, **Patio with Red Door** would be a significant painting sheerly on the grounds of its formal brilliance. Further refining and paring down an already highly selective vocabulary of form, O'Keeffe relieves the ascetic symmetry of this composition by value gradations. Thus the gradual reddening of the landscape strip at the bottom of the picture is picked up in reverse contrapunto in the graded red to pink of the patio door and the various roseate tints of the stitchlike row of irregular rectangles that carry the eye across the top of the canvas.

In earlier paintings, too, O'Keeffe's profoundly mystical content was equally manifest. For example, in the highly original **Shelton with Sun Spots,** one of the skyscraper

paintings of her New York period, she painted the hotel where she and Stieglitz lived illuminated by an unnatural brilliance reminiscent of the efflorescence of light surrounding traditional interpretations of the theme of the Transfiguration. But in *Patio with Red Door,* O'Keeffe introduces the theme of the infinite which will be dominant in her paintings of the sixties.

In addition to new themes in her recent paintings, we may remark several other novel elements in O'Keeffe's work of the past decade such as *Red Past View,* the several versions of *Sky above White Clouds I, Above Clouds Again* and the series of cloud paintings culminating in the extraordinary 1965 cloud mural. They include the following: the lack of external referents to orient the viewer geographically, and the use of a paler, whiter, more translucent palette, giving the impression that light is suffused from within rather than focused on forms from a source outside the painting. The absence of cast shadows in these works, together with the close-valued luminous white tints that predominate, contribute to the sense of an incandescent luminosity, of a radiance from within. Their generally pastel range, however, suggests a fragility that softens the forcefulness of their simple, bold design. Edges too are softened through O'Keeffe's avoidance of sharp angles or hard linear contours.

Because we confront an unbounded field lacking the conventional visual cues for bodily orientation, we do not picture ourselves in relation to these paintings as looking at something; rather we are forced to project ourselves imaginatively rather than intellectually, as in the case of carefully constructed Renaissance perspective view into the painting space. Thus, in a curious way, and as always in her own way, O'Keeffe, in her recent works, has joined an important direction in the evolution of modern painting. In the past she has painted birds in flight, picturing their motion as they sweep across the sky. Now she gives us views of the clouds and sky that are in fact what the bird sees when she is flying, so that the floating sensation and the motion become transferred to the viewer's own body. (pp. 43-4)

Perhaps the most original of these views is that depicted in the poetic series *Sky Above Clouds II,* which culminates in O'Keeffe's largest work, the immense 8 by 24-foot mural executed in 1965. Here a double image is unexpectedly insinuated through the introduction of a horizon line above the clouds, suggesting that the blue sky might be the blue sea flowing away toward a distant horizon. The rhythmic movement of the oblong cloud forms fading from view also suggests the rocking motion of the sea and supports the metaphor. The use of exaggerated and rapid diminution of scale pulls our eye rapidly toward a distant horizon, creating the impression that the patch of air or water we see lies at an angle to our vision. Yet the fact that the cloud patches themselves are parallel to the picture plane reasserts the flatness of the plane. (p. 44)

In O'Keeffe's work, the relationships between foreground and background have always been somewhat peculiar and unconventional because she characteristically excludes the middle ground. Because of her use of close-up views together with rapid reduction in the size of cloud units, she creates the feeling that the eye zooms in quickly from foreground to background. Yet the spatial sense created is not that of Old Master paintings—partially because of

the strange absence of middle ground, and partially because of the frontality of the cloud shapes. In addition, the toughness of the paint surface establishes a resistance to visual penetration, almost as strong as that created by painters who deliberately build up painterly crusts to establish a surface plane.

In her earlier paintings, O'Keeffe usually clearly established the background plane. In the paintings of the sixties, however, this is not the case. On the contrary, the "sensation of fading away" is carried to an extreme, the better to convey the impression of a view into infinity. O'Keeffe's images have always had a resolutely stable quality; but in her most recent paintings, the predominance of the horizontal axis establishes a mood of tranquil serenity that projects an even greater resolution than even the architectonic severity of the earlier works.

In the past, O'Keeffe has frequently reworked a theme to refine it. But the cloud paintings represent a particularly significant group of works because they constitute a closed series. The progress from the first, relatively naturalistic and freely painted version to the final severe, hieratic mural not only documents a gradual process of refinement, but gives us important clues to O'Keeffe's current preoccupations.

In the intermediate second and third phases of the cloud series, overlapping in the foreground and reduction in scale of elements meant to be perceived as more distant, give the impression that what we view is gradually receding from us. There is, moreover, a strange sensation of movement attached to this perception, for the smaller clouds in the distance seem to be fading from view at a constant rate. This sensation of movement is achieved by the rhythmic quality imposed on the diminution of intervals in the size of the clouds. That is, the reduction in size of cloud forms from foreground to background is not haphazard.

In the final cloud mural, we can no longer think of ourselves as occupying a point in front of the painting from which we view clouds receding. The flattened clouds are nearly equal in shape and size; and we could only perceive them this way if we walked out of an airplane into the infinite blue sky she paints.

Movement in O'Keeffe's work throughout her career is rhythmic. One of those modernists inspired by analogies between music and abstract painting, O'Keeffe has been extremely successful in creating a sense of rhythmic flow and movement. She also relies on other musical elements, such as repetition and interval. Earlier I spoke of the gentle sense of motion in the cloud paintings. In paintings like the 1932 *Landscape Nature Forms,* which was painted in the Gaspe, O'Keeffe creates this sense of a rolling or swelling motion through the use of rhythmic swirling and spiral patterns. In recent works like *Red Patio,* this sense of movement may be felt as the rapid speed of the highway, whose markings are recalled by the staccato row of rectangular patches which carry the eye rapidly across the canvas in that painting.

During her student days with Arthur Dow, O'Keeffe had learned the importance of interval that is, the space between forms. Even before she came to Dow, however, she had a highly developed interest in Japanese art, with its

emphasis on economy of means, simple forms, bold patterning, and appreciation of negative areas around forms.

Indeed this inborn affinity for both the forms and spirit of Japanese art defined O'Keeffe immediately as a natural modernist. Her earliest drawings and watercolors are amazingly contemporary, as various authors have noted. They are so not from any determined effort on O'Keeffe's part to be up-to-date, but because they are an expression of a spirit that simply appears to have been born modern. For this reason, there is a consistency and a unity throughout O'Keeffe's career that is rare in the art of a painter who has continued to grow and evolve as much as she has. Compare, for example, the sophisticated reductiveness of the celebrated 1916 drawing of blue lines (shown in O'Keeffe's first show at 291) with the 1959 charcoal *Drawing No. 10,* which was the point of departure for the series of paintings based on aerial views of roads and rivers. A comparison of the two images is instructive in terms of comparing the frontality of the former with the oblique tilt of the image in the latter. There are many differences, of course, some of which I have mentioned in the discussion of new elements in the recent works, but there is the same sure control together with the originality and freshness of an artist unafraid to transcribe her experience simply—albeit with a maximum sophistication—and directly. Similarly the early watercolor *Starlight Night* is morphologically related to the recent cloud paintings.

There is no question of the authenticity or singularity of O'Keeffe's vision. To those qualities she adds in the paintings of the sixties an authority which results from the complete mastery of her own idiom, and the extension of her expressive range to include both the most universal and the most contemporary experiences. These paintings, in the strength of their imagery and the character that this strength implies, are the work of an artist who has managed to achieve a rare balance between the extremes of the American temperament. Avoiding the literalist excesses of a photographic realism and the banality of sentimental genre, she nevertheless ties her work concretely to a world of perceived reality. Moderating between the subjective and the objective, the abstract and the concrete, the humble and the epic, the real and the ideal, O'Keeffe is perhaps America's only true classicist. For in her work there is no extreme or excess, no violence and no brutal impact. The mood of her work is contemplative; its intention is to provide a spiritual discipline, not only for the viewer, but for the painter who conceives her art in this way, creating a firm order through will and expressing a moral integrity through craft.

Not much has been said of the intrinsically mystical content of O'Keeffe's work, yet to ignore it would, I believe, miss the essential center of her work. Writing of O'Keeffe in 1936 [see excerpt dated 1936], Marsden Hartley spoke of her approaching "the borderline between finity and infinity" and of her quest "to inscribe the arc of concrete sensation and experience." He saw her as a mystic, correctly locating her within the context of a mysticism firmly grounded in the direct experience of the here and now, a mysticism which insists on the sanctity and importance of the commonest flower or stone. One thinks of certain analogies with such mystics as Meister Eckhart and Saint Teresa as well as the Zen masters who valued the humble and insisted on the holiness of the commonplace. Because

of this content, O'Keeffe's paintings have far more in common with the still lifes of Sanchez-Cotán or Zurbarán than they do with the paintings of the Precisionists who were her contemporaries.

For too many American artists, the finiteness of appearances has been the totality of experience. This is not so for O'Keeffe, who transforms what she sees into something finer, more poetic and perfect than reality, thereby escaping the literalist materialism that has seemed the limit of the American imagination.

O'Keeffe's transformations, her ability to transcend appearance through the medium of intuition, connect her I believe with the American nature religion of Transcendentalism. Describing what Emersonian transcendental idealism had in common with Buddhism, William James wrote, "Not a deity *in concreto,* not a superhuman person, but the immanent divinity in things, the essentially spiritual structure of the universe, is the object of the transcendentalist cult." He could have been describing O'Keeffe's subjects as well.

It is almost too easy to see O'Keeffe as the prototype for the struggles of today's women for a spiritual freedom. Yet it is inspiring to trace the evolution of her imagery from violence and conflagration to the images of floods and deluge in the works of the early thirties through the struggle with mortality that the *memento mori* themes of the late thirties and forties suggest, to these beautiful new works which convey a profound spiritual resolution in a 1923 review by Henry McBride, I was amused to find the following description of O'Keeffe: he called her "a sort of modern Margaret Fuller, sneered at by Nathaniel Hawthorne for too great a tolerance of sin and finally prayed to by all the super-respectable women of the country for receipts that would keep them from the madhouse." In the context of the seventies, the modernity of O'Keeffe's spirit is perhaps even more evident, and the lessons of her discipline even more to be appreciated. (pp. 44-6)

> Barbara Rose, "Georgia O'Keeffe: The Paintings of the Sixties," in Artforum, Vol. IX, No. 3, November, 1970, pp. 42-6.

Sanford Schwartz (essay date 1978)

[*In the following excerpt from a review of O'Keeffe's autobiography, Schwartz briefly analyzes the wide appeal of her art.*]

[O'Keeffe's paintings] are souvenirs of a way of life that is based on the idea that all experience can be seen aesthetically. Yet these souvenirs don't travel very well. Like Shaker furniture, they demand their own setting. In the open competition of the museum, her pictures can seem awkward, raw, precious; you can see that she is serious, but the paintings leave a residue of something garish and untextured. They're sparklingly bright in the wrong way, like Old Master paintings that have been cleaned excessively and turn out to look naked. . . . She is one of the most ambitious artists of her generation, but she has never been fazed by the great desire of her contemporaries, and of subsequent generations: the desire for one's painting to hold its own next to Cézanne, Manet, or any of the modern heroes of the museum. Her art does something else. If O'Keeffe's are often the paintings that we are attracted

to when we begin our careers as museumgoers, it may be because, especially when we come to them in our adolescence, they are among the first paintings that give us an inkling of what style is—of the way every nuance in a work of art can come back to one conception, and the way you can hold that conception in your head, as if it were a real thing. Hemingway does something similar when we first read him. He takes the anonymity out of language, and shows how personal and three-dimensional the use of words can be, how a sentence can have a profile and be as contoured as a carving. O'Keeffe enlarges and animates the formal elements in art and keeps each one distinct: the sharp, clean line and the gauzy lack of line; the heightened bright colors and the glistening blacks; the voluptuous neverending curves and the abrupt, pinpoint conclusions; the creamy surface and the dry, brushy surface. Feeling our way through the parts of a painting of hers is for many of us one of our earliest experiences of the physical act of painting. In retrospect, the experience can seem too simplified; you may want art that gives you all these elements without any of the distinctions among them. Yet, at the time, seeing the elements so distinctly is what is so powerful.

If O'Keeffe expresses the glamour of style for many Americans, it may be because her audience (rightly) intuits in her a disinterest in the sociable, urbane side of style. She represents style without the overtone of stylishness, fashionableness, artificiality. O'Keeffe's aesthetic is closest to Art Nouveau, but she doesn't have the conscious sense of style or the witty-and-romantic double awareness that we expect from figures of the fin de siècle. (Born in 1887, she just missed being part of that era, though she did grow up in its shadow.) Beneath the Art Nouveau surface of her art there is a more deliberative, even obdurate layer, and it expresses itself in a way that almost makes her seem like a primitive—though not in the untaught sense. She resembles a primitive in that she is devoted to reproducing the real world as it appears before her and carries in her mind a very firm idea of how things should look—and the two don't quite match. There is a distorted overlap, and, as is often the case with primitive artists, you don't know how much of this distortion she is aware of. Very little of it, you suspect. The paintings hint at this out-of-sync clarity: it is there in her visionary, looming sense of scale, and in the difficulty of knowing, from painting to painting, whether she wants to be photographically precise or abstract. (pp. 89-90)

Sanford Schwartz, "Georgia O'Keeffe Writes a Book," in The New Yorker, *Vol. LIV, No. 28, August 28, 1978, pp. 87-90, 93.*

Edward Abrahams (essay date 1989)

[*In the following excerpt, Abrahams discusses O'Keeffe's art and her public image, suggesting that the abandonment of her early abstract style resulted in her failure to fulfill the promise shown in her early works.*]

[By] 1986, the year she died at the age of 98, [O'Keeffe] had controlled almost every element of her public image, and of our understanding of her place in the history of American art.

According to the myth she helped create, O'Keeffe cared little for society or material wealth, never compromised her integrity, owed nothing to anyone. She preferred to live in the primitive and pure desert mountains of New Mexico, a great artist, alone, at work. Like other pioneers before her, she sought to discover her identity in the "wonderful emptiness" of the American West. Not for her was the rarefied hothouse of New York City, where intellectuals debated endlessly and futilely about the meaning of art and the nature of the American experience. As she wrote in her autobiography, "Where I was born and where and how I lived is unimportant. It is what I have done with where I have been that should be of interest." She was, she implied, a woman of action, uninfluenced by other people or ideas.

No artist, of course, lives in a vacuum, in no context, beyond influence. O'Keeffe's myth of her own life may have helped to sustain her, but it may also have inhibited her painting. What is really astonishing about it, though, is the extent to which, even after her death, the myth remains unexamined, and continues to serve as a basis for the discussion of O'Keeffe and her work in the scholarly and curatorial world and, not coincidentally, for the public's understanding of the artist as well.

The current retrospective of O'Keeffe's work, on view at the Metropolitan Museum of Art in New York City . . . , seeks to become, with a minor revision, the crowning fulfillment of the myth O'Keeffe orchestrated and found so useful. Unfortunately, the exhibition, heralded by the trumpets of a corporate sponsor and the hoopla of the 100th anniversary of O'Keeffe's birth, does not establish that O'Keeffe was, in the words of the show's curators, one of America's "most inventive artists." Instead, it suggests that after a promising beginning—in the late 1910s O'Keeffe executed some delicate, abstract, now little-known watercolors on paper—she developed into a popular chronicler of the hackneyed images for which she is today widely admired, and rather appropriately exploited by the makers of calendars, posters, and other paraphenalia of commercial culture. (pp. 41-2)

Georgia O'Keeffe has certainly come a long way from [Alfred Stieglitz's gallery] 291, where, unheralded, because Stieglitz did not believe in advertising, her work was first exhibited in 1916. Surely it is her early work, made when she was still influenced by the principles that imbued 291, by its insistence on independence, its commitment to personal expression, and its faith in its revolutionary promise, that is today the most strikingly provocative and original in the show. These are the abstract watercolors and charcoals, which, unlike most of O'Keeffe's better known art, still retain their expressive power. They are the works about which Stieglitz wrote in 1916 that " '291' had never before seen woman express herself so frankly on paper."

O'Keeffe herself sensed that her early work was her best. In 1969, after reviewing some of her lyrical drawings and watercolors of the 1910s to prepare for her retrospective at the Whitney, O'Keeffe turned to her assistant, Doris Bry, and confided privately, "We don't really need to have the show; I never did any better." (pp. 44-5)

Blue Lines X (1916), *Blue No. III* (1916), and *Light Coming on the Plains II* (1917) . . . are far more evocative than the oil paintings of natural objects that later drew O'Keeffe's attention. Flat, realistic renderings like *Cow's*

Skull with Calico Roses (1931) and *White Shell with Red* (1938) look too much as though they had been designed as posters for a folklore exhibit to support the claim that O'Keeffe redefined America's vision. Indeed, many of O'Keeffe's paintings work too well as posters—her tame *Red Poppy* (1927), for instance, plastered all over Washington, D.C., buses as well as the back covers of popular magazines to promote the show. Unlike O'Keeffe's earlier abstract work, however, the flowers, bones, and shells are stylized images. Their meaning remains either nonexistent or idiosyncratic. After the first impact of seeing a gigantic painting of a flower or a dried skull in the desert wears off, as it did long ago, little remains to excite.

When O'Keeffe discarded, with many of her contemporaries, the modern principles she had employed to gain the attention first of Stieglitz and then of the world—when she discarded, in particular, the notion that through abstraction an artist could portray, as Stieglitz's colleague Marius de Zayas put it in 1916, "the subjective truths that give us the reality of ourselves"—she offered no explanation, only a passing reference in a letter to Sherwood Anderson in 1924 that open-ended interpretations of her more abstract pieces bothered her. It was preferable and far easier, she implied, to govern the reception of her work if it was based on easily recognized and "objective" images.

Though O'Keeffe was hardly alone in rejecting abstract expression in the 1920s, the decision was momentous. It meant that although she became extraordinarily popular, she also ceased to fulfill the promise of her early years, when she stood briefly on the threshold of modern painting. (p. 45)

> *Edward Abrahams, "The Image Maker," in* The New Republic, *Vol. 200, No. 5, January 30, 1989, pp. 41-5.*

FURTHER READING

I. Writings by O'Keeffe

Some Memories of Drawings. Albuquerque: Atlantis/ University of New Mexico Press, 1974, 107 p.
> Reproductions of selected drawings with commentary by O'Keefe.

Georgia O'Keeffe. New York: Viking, 1976, unpaged.
> O'Keeffe's autobiography. Accompanied by large-format reproductions of selected works.

II. Biographies

Lisle, Laurie. *Portrait of an Artist: A Biography of Georgia O'Keeffe.* Albuquerque: University of New Mexico, 1986, 408 p.
> Noncritical biography.

Pollitzer, Anita. *A Woman on Paper: Georgia O'Keeffe, The Letters and Memoir of a Legendary Friendship.* New York: Touchstone, 1988, 290 p.
> Memoir written by a close, lifelong friend. Includes numerous letters written by O'Keeffe.

Robinson, Roxana. *Georgia O'Keeffe: A Life.* New York: Harper and Row, 1989, 639 p.
> Sympathetic biography written by an art historian.

III. Critical Studies and Reviews

Coates, Robert M. "Profiles: Abstraction-Flowers." *New Yorker* V, No. 20 (6 July 1929): 21-4.
> Biographical essay in which Coates characterizes O'Keeffe's art as intuitive rather than intellectual.

Davidson, Abraham A. "Precisionism." In his *Early American Modernist Painting, 1910-1935,* pp. 182-228. New York: Harper and Row, 1981.
> Identifies O'Keeffe as a Precisionist painter, comparing her detailed, close-up canvases with the work of photographers Paul Strand and Edward Weston.

Geldzahler, Henry. "The Hard Edge: Industrial and Abstract." In his *American Painting in the Twentieth Century,* pp. 128-52. New York: Metropolitan Museum of Art, 1965.
> Includes a brief, appreciative survey of O'Keeffe's life and career, emphasizing her individuality.

Hoffman, Katherine. *An Enduring Spirit: The Art of Georgia O'Keeffe.* Metuchen, N.J.: Scarecrow Press, 1984, 185 p.
> Critical study of O'Keeffe's work. Includes sections on the milieu in which O'Keeffe worked and the varied critical response to her style.

Homer, William Innes. "Life and Work of the Artists of the Stieglitz Circle, 1913-1917." In his *Alfred Stieglitz and the American Avant-Garde,* pp. 201-56. New York: New York Graphic Society, 1977.
> Includes a discussion of O'Keeffe's life and work up to the time of her entrance into the Stieglitz circle in 1918.

Jewell, Edward Alden. "New O'Keeffe Pictures: A Sharp Monumental Vigor Characterizes the Work of This Brilliantly Original Artist." *New York Times* (9 February 1930): 12viii.
> Laudatory review of O'Keeffe's 1930 exhibit at Stieglitz's gallery, An American Place.

Kotz, Mary Lynn. "Georgia O'Keeffe at 90: 'Filling a Space in a Beautiful Way. That's What Art Means to Me'." *ARTnews* 76, No. 10 (December 1977): 36-45.
> Recounts the author's visit to O'Keeffe's home, incorporating many comments by O'Keeffe on her life and work.

Kuh, Katharine. "Georgia O'Keeffe by Georgia O'Keeffe." *Saturday Review* 4, No. 8 (22 January 1977): 44-6.
> Appreciative review of O'Keeffe's 1976 autobiography, cited above.

McBride, Henry. *The Flow of Art: Essays and Criticisms of Henry McBride.* New York: Athenaeum, 1975, 462 p.
> Contains reviews of four O'Keeffe exhibitions.

Mumford, Lewis. "Images—Sacred and Profane." In his *The Brown Decade: A Study of the Arts in America, 1865-1895,* pp. 183-246. New York: Harcourt, Brace, 1931.
> Includes a brief assessment of O'Keeffe's work. Mumford maintains, "Miss O'Keeffe has done more than paint: she has invented a language, and has conveyed directly and chastely in paint experiences for which language conveys only obscenities."

————. "The Art Galleries: Autobiographies in Paint." *New Yorker* XI, No. 49 (18 January 1936): 48.

Positive review of O'Keeffe's 1936 exhibit at An American Place. Mumford notes the autobiographical nature of O'Keeffe's work and applauds her abandonment of the "conventional symbolism" present in some of her earlier works.

Rose, Barbara. "O'Keeffe's Trail." *New York Review of Books* XXIV, No. 4 (31 March 1977): 29-33.
 Review of O'Keeffe's autobiography. Rose discusses O'Keeffe's artistic influences, including American Transcendentalism and Oriental art.

Rosenfeld, Paul. "Art: After the O'Keeffe Show." *Nation* 132, No. 3431 (8 April 1931): 388-89.
 Praises O'Keeffe's 1931 exhibit at An American Place and pleads for wider recognition of the Stieglitz circle.

Simms, Patterson. *Georgia O'Keeffe: A Concentration of Works from the Permanent Collection of the Whitney Museum of American Art.* New York: Whitney Museum of American Art, 1981, 29 p.
 Commentary on several of O'Keeffe's best-known works.

Strand, Paul. "Georgia O'Keeffe." *Playboy: A Portfolio of Art and Satire* 9 (July 1924): 16, 19-20.
 Critical appreciation by a well-known photographer and associate of the Stieglitz circle.

Tomkins, Calvin. "The Rose in the Eye Looked Pretty Fine." *New Yorker* L, No. 2 (4 March 1974): 40ff.
 Profile of O'Keeffe at age eighty-six, including statements by the artist illuminating her work.

Walker Art Center. *The Precisionist View in American Art.* Minneapolis: Walker Art Center, 1960, 62 p.
 Includes discussion of Precisionist elements in O'Keeffe's art, including photographic realism and Surrealist juxtapositions.

IV. Selected Sources of Reproductions

Callaway, Nicholas. *Georgia O'Keeffe: One Hundred Flowers.* New York: Callaway Editions/Knopf, 1987, 159 p.
 Collects one hundred of O'Keeffe's flower paintings from various phases of her career. The book also offers an appreciative afterword by Callaway.

Castro, Jan Garden. *The Art and Life of Georgia O'Keeffe.* New York: Crown, 1985, 192 p.
 Includes a biographical and critical survey.

Cowart, Jack; Hamilton, Juan; and Greenough, Sarah. *Georgia O'Keeffe: Art and Letters.* New York: Little, Brown, 1987, 306 p.
 Reproductions of the 120 works contained in the retrospective exhibition mounted at the National Gallery of Art in Washington, D.C. Also contains the biographical and critical essay excerpted above and a selection of O'Keeffe's letters.

Goodrich, Lloyd, and Bry, Doris. *Georgia O'Keeffe.* New York: Whitney Museum of American Art, 1970, 195 p.
 Contains a retrospective essay by Goodrich.

Haskell, Barbara. *Georgia O'Keeffe: Works on Paper.* Santa Fe: Museum of New Mexico, 1979, 102 p.
 Reproductions of drawings and watercolors with critical commentary by Haskell.

Rich, Daniel Catton. *Georgia O'Keeffe.* Chicago: Art Institute of Chicago, 1943, 45 p.
 Catalog to O'Keeffe's 1943 exhibition with an essay by Rich.

————. *Georgia O'Keeffe: Forty Years of Her Art.* Worcester, Mass.: Worcester Art Museum, 1960, 47 p.
 Catalog to a 1960 retrospective exhibition with commentary by Rich.

Robert Rauschenberg

(1925-)

American painter, mixed-media and performance artist.

Rauschenberg is considered one of the key figures in Pop Art, a movement that reacted against the seriousness and self-consciousness of Abstract Expressionism, advocating a more relaxed, less intellectualized kind of art. His best known works, which he calls "combines," incorporate elements of collage, painting, and sculpture, using found materials such as newspaper, fabric, industrial junk, and stuffed animals. Praised for his inventiveness and enthusiastic pursuit of new ideas, he has earned both popular and critical esteem, and his works have exerted a marked influence on the development of contemporary art.

Born in Port Arthur, Texas, into a middle class family of both German and Cherokee descent, Rauschenberg studied pharmacology for one semester at the University of Texas. He was drafted into the Navy in 1942 and sent for further training at the Navy Hospital Corps in San Diego. It was while he worked as a neuropsychiatric technician in various naval hospitals in California between 1943 and 1946 that Rauschenberg started visiting galleries and developed an interest in art. Upon his release from the Navy, he enrolled at the Kansas City Art Institute, but soon saved enough money to travel to Paris. After a year at the Académie Julian, during which he fell in love with fellow art student Sue Weil, Rauschenberg decided to go to Black Mountain College in North Carolina, hoping to study with Joseph Albers, one of the most highly regarded and rigorous art teachers in the country at that time. Black Mountain College provided Rauschenberg with a particularly rich learning environment, and he not only developed discipline under Albers, but also met composer John Cage and dancer Merce Cunningham, with whom he was to form lasting friendships and later collaborate.

Despite this satisfying creative network, Rauschenberg began to feel isolated from the larger art world while living in North Carolina, and he moved to New York in 1949. He married Weil the following year and worked at assorted odd jobs, continuing to paint and study at the Art Students League. With his wife, Rauschenberg then turned to experimental photography, using sunlight to produce body images on blueprint paper. The technique brought him limited recognition and some of these early photographs were published in *Life* magazine. More importantly, in 1951 Rauschenberg had his first solo exhibit at the Betty Parsons Gallery in New York, consisting mostly of oil paintings done in white paint with numbers scratched into the surface for texture. Critical reaction was neutral, yet the show provided necessary exposure for the young artist. Only a few of Rauschenberg's early works survive, however, since almost all were destroyed by fire in 1951.

The next several years were somewhat restless ones for Rauschenberg. With his marriage breaking up in 1952, he returned to Black Mountain College, where he worked on a series of all-white and all-black paintings done with housepaint on wood and newspaper, and participated in

multimedia "happenings" staged by Cage and Cunningham. Very much under the influence of Cage's oriental, minimalist philosophy, Rauschenberg said that in the white and black paintings he was striving to create a kind of art that was not driven either by personal taste or the need for self-expression. Divorced by the end of the year, he travelled with a friend to Italy, and later continued alone to North Africa. He had an exhibit in Florence and, at the suggestion of a critic who disliked his work, threw all of his work into the Arno River before returning to the United States. Back in New York in 1953, Rauschenberg participated in a notorious exhibit of avant-garde art at the Stable Gallery—an important landmark in his career because his "living art" compositions (which included growing grass and plants) proved a sensation among critics and branded Rauschenberg as the *enfant terrible* of the New York art world.

Rauschenberg eventually turned to painting with color, first using only red—as in *Charlene* (1954)—and then expanding his palette. In 1955, he met Jasper Johns, then a very promising beginner and later a central figure in the Pop Art movement, and the two lived together until 1962. This period was one of great productivity as well as official recognition for Rauschenberg. He perfected his combine

technique and completed his best known works: *Bed* (1955), which is comprised of an actual quilt and pillow, *Monogram* (1958), his trademark painting incorporating a stuffed goat with a tire around its middle, and *Odalisk* (1958), a painted box with a stuffed chicken on top, poised on a small pillow. Of his unusual choice of materials, Henry Geldzahler has written, "His use of disparate elements within a composition stuns us not because everything is unquestionably where it belongs, which is so, but because each element retains exactly its uniqueness and qualities as object and yet combines to form a painting." Rauschenberg also branched out to graphics, finishing thirty-four illustrations for Dante's *Inferno*. By the time his works were included in the "Sixteen Americans" exhibit at the Museum of Modern Art in New York in 1959, he was regarded as one of the most important artists in America.

Always interested in developing new techniques, in the 1960s Rauschenberg turned to utilizing silkscreens and a new method he had invented for transferring magazine pictures onto canvas. He also traveled all over the world, mounting exhibitions of his work and learning from native artisans techniques that he would apply in his own work. After embarking on a world tour as a stage and costume designer with Cunningham's dance troupe, Rauschenberg wrote his own dance piece, *Pelican,* which premiered in 1967. As a result of his fondness for experimental and collaborative projects, he helped to found EAT (Experiments in Art and Technology), an organization devoted to fostering imaginative joint ventures involving art and technology. His wide-ranging activities and continuing artistic output kept Rauschenberg in the public eye, and by the time he received the grand prize for painting at the Venice Biennale in 1967, he was something of a media figure.

Though he has continued his multiple pursuits in succeeding years, critics consider Rauschenberg's later works inferior to his paintings and combines of the late 1950s and early 1960s. Some see his recent work—for example, the *Hoarfrost* combines (1974-77) and *Quarter Mile Piece* (1984), a painting literally a quarter of a mile wide—as complacent and repetitive. Even his socially committed activities, including the establishment of the Rauschenberg Overseas Cultural Exchange, have been interpreted by some critics as mere gestures. However, other commentators continue to extol his protean imagination, seemingly boundless energy, and ability to embrace many different aspects of life, and few deny the importance of his early radical experiments in art. Critic Max Kozloff has written, "Other than Rauschenberg, no artist I know . . . takes such a polyvalent and imaginative inventory of modern life. It is this fullness of response that gains respect and is deeply moving."

ARTIST'S STATEMENTS

Robert Rauschenberg with Richard Kostelanetz (interview date 1968)

[*In the following interview, Rauschenberg discusses such topics as his attitude toward art history, the origins of some of his works, and his mixed-media theater pieces.*]

[Kostelanetz]: *In high school you had a reputation as a person who could draw or at least do certain kinds of drawings.*

[Rauschenberg]: I never thought of it as much of an ability. I thought everybody could do it a little bit. Some people could draw a little better than other people, but I never took drawing or painting any more seriously than that.

Later, [Josef] Albers told me I couldn't draw—that my whole childhood was wasted. I had an awful time pleasing him. I was too messy for collage, and I was too heavy-handed in my drawings.

He would like open spaces and thin lines.

The Matisse kind of thing.

He would teach a course in form, which he gives year after year, refining it more and more, and a course in the performances of color—a really clinical method. We worked in drawing from the same model week after week. Once a week or once every two weeks, someone in the class at Black Mountain would pose for us. Then, he would talk about the valleys and the mountains and things like that about the figure. Other than that, it was an aluminum pitcher—a shiny volume without a straight line and you couldn't do any shading. It is really the outside and inside that you got to say. You do it with one line, and you can't do any erasing. You feel that there is air on this side of the line and on the other side of the line is the form. In watercolor, we had it again—one model we used month after month; and it was a terra-cotta flowerpot.

I figured out, at least in the watercoloring classes, that what he really had in mind was something like Cézanne. I found Albers so intimidating that after six months of this, during the first year, my whole focus was simply to try to do something that would please him. I didn't care what I got out of class. All I wanted to do was one day walk in there and show him something and hear him say, "That's pretty good."

I have noticed that you wish to avoid historical interpretations of yourself. In general would you prefer not to say that someone influenced you?

No, I've been influenced by painting, very much; but if I have avoided saying that, it was because of the general inclination, until very recently, to believe that art exists in art. At every opportunity, I've tried to correct that idea, suggesting that art is only a part—one of the elements that we live with. I think that a person like Leonardo da Vinci had not a technique or a style in common with other artists but a kind of curiosity about life that enabled him to change his medium so easily and so successfully. I really think he was concerned with the human body when he did his anatomical work. His personal curiosity, apart from any art idea, led him to investigate how a horse's leg works so that he could do a sculpture of it.

497

Being a painter, I probably take painting more seriously than someone who drives a truck or something. Being a painter, I probably also take his truck more seriously.

In what sense?

In the senses of looking at it and listening to it and comparing it to other trucks and having a sense of its relationship to the road and the sidewalk and the things around it and the driver himself. Observation and measure are my business.

I think historians have tended to draw too heavily upon the idea that in art there is development. I think you can see similarities in anything and anything by generalities and warp.

They are concerned with identifying influence and, thereby, continuities.

There's another thing. Now we have so much information. A painter a hundred or two hundred years ago knew very little about what was going on in painting in any other place except with his immediate friends or some outstanding event. It wasn't natural for him also to take into consideration cave painting and fold it into his own sense of the present.

I think, if you want to make a generalization, there are probably two kinds of artists. One kind works independently, following his own drives and instincts; the work becomes a product, or the witness, or the evidence of his own personal involvement and curiosity. It's almost as if art, in painting and music and stuff, is the leftover of some activity. The activity is the thing that I'm most interested in. Nearly everything that I've done was to see what would happen if I did this instead of that.

You would believe then that art is not a temple to which you apprentice yourself for future success.

It's like outside focus and inside focus. A lot of painters use a studio to isolate themselves; I prefer to free and expose myself. If I painted in this room—the stove is here and all those dishes are there—my sensitivity would always take into consideration that the woodwork is brown, that the dishes are this size, that the stove is here. I've tended always to have a studio that was either too big to be influenced by detail or neutral enough so that there wasn't an overwhelming specific influence, because I work very hard to be acted on by as many things as I can. That's what I call being awake.

People are enormously impressed by the variety of your work. How do you look upon your past work as a painter— as an evolution, or merely a succession of islands upon which you've put your foot?

Looking back, I can see certain things growing, as well as a slackening of interest in another area because I am familiar enough with it. So far, I've been lucky enough always to discover that there's always been a new curiosity that is also feeding and building while I'm doing something else. I can figure out some logical reasons when I look back far enough, but I never do when I'm making the work.

Let me take a particular example that interests me—say, the White Paintings [1952]. Here you have created what,

if you believe in linear notions of art history, is a dead end. Did you look upon it as a gesture toward a dead end?

No. It just seemed like something interesting to do. I was aware of the fact that it was an extreme position; but I really wanted to see for myself whether there would be anything to look at. I did not do it as an extreme logical gesture.

But wasn't there an idea there—not a notion derived from art history but of a simple experiment, which was to see if a painting could incorporate transient images from outside itself? Therefore, once you discovered the result of that idea, then you could go on to another.

You could speculate whether it would be interesting or not; but you could waste years arguing. All I had to do was make one and ask, "Do I like that?" "Is there anything to say there?" "Does that thing have any presence?" "Does it really matter that it looks bluer now, because it is late afternoon? Earlier this morning it looked quite white." "Is that an interesting experience to have?" To me, the answer was yes. No one has ever bought one; but those paintings are still very full to me. I think of them as anything but a way-out gesture. A gesture implies the denial of the existence of the actual object. If it had been that, I wouldn't have had to have done them. Otherwise it would only be an idea.

Claes Oldenburg said that he has a dream that someday he would call all his things back, that they had not really gone away.

I have another funny feeling that in working with a canvas, say, and with something you picked up off the street and you work on it for three or four days or maybe a couple of weeks and then, all of a sudden, it is in another situation. Much later, you go to see somebody in California, and there it is. You know that you know everything about that painting, so much more than anybody else in that room. You know where you ran out of nails.

You can look at it then as a kind of personal history.

It's not like publishing, for each one is an extremely unique piece, even if it is in a series. I like to look at an old work and discover that is where I first did a certain thing, which may be something I may just happen to be doing now. At the time I did that earlier piece, I didn't know it was the lower right-hand corner that had the new element—that that part would grow and that other parts would relate more to the past.

Have you ever started something that you couldn't finish?

Yes, but I really try hard not to. I work very hard to finish everything. One of the most problematic pictures I ever made was something I was doing for a painters' picture series in a magazine. I had started the radio sculpture thing, which became *Oracle* [1965]. My mind was more in sculpture or objects free of the wall. I found I was uncomfortable from the new difficulties metal afforded, because I really didn't know what to do with it. So I figured that if I was to be scrutinized, I'd do a painting instead. I said I'd do it, and I try to do what I say I will do. That painting went through so many awkward changes, unnecessarily. It was large, it was free-standing. Then I put it against the wall, then I finally sawed it in half and made two paintings out of it. I wrecked one of them.

I didn't know what to do when Rudy Burckhardt came up and said, "How far did you get today? Can I take the picture tomorrow? Why did you do that? What do you have on your mind?" It just didn't work out. I knew I was compromising at the time; and when the article went in, I insisted that they photograph what I was not doing too. If those things are going to mean anything, they somehow ought to be the truth. In those days, it seemed like that would be your only chance for the next twenty years to get your picture reproduced in color. Now I have this lousy painting.

In looking at your career, critics customarily tote up all the forms you have used: blueprint paper, white painting, black painting, collage, assemblage . . .

I call those things "combines," because it was before the museum show of assemblages. Earlier I had this problem with the paintings that would be free-standing—not against the wall. I didn't think of them as sculpture. I actually made them as a realistic objection; it was unnatural for these to be hung on a wall. So when the sculptural or collage elements got so three-dimensional, then the most natural thing in the world was to put wheels on it and put it out into the middle of the room. That gave two more sets of surfaces to work on. It was an economical thing. I think I've been very practical. Sometimes the underneath surface is also a painting surface, because that would be viewed. In . . . one there is a mirror on the side so that you can see what is underneath there without bending down, or you're invited to.

I thought of them as paintings, but what to call them—painting or sculpture—got for some people to be a very interesting point, which I did not find interesting at all. Almost as a joke I thought I'd call them something, as Calder was supposed to have done with "mobiles," and it worked beautifully. Once I called them "combines," people were confronted with the work itself, not what it wasn't. Sometimes you can choke on these things; people have called my drawings "combine drawings." The word does really have a use—it's a freestanding picture.

Just in passing, let me say there is one work of yours I can't deduce. That is the set **Factum I** *and* **II** *[1957].*

There I was interested in the role that accident played in my work; so I did two paintings as much alike as they could be alike, using identical materials—as much as they could be alike without getting scientific about it. Although I was imitating on one painting what I had on the other, neither one of these paintings was an imitation of the other, because I would work as long as I could on one painting and then, not knowing what to do next, move over to the other. I wanted to see how different, and in what way, would be two paintings that looked that much alike.

How, then, did some critics consider this a comment on action painting?

I think Tom Hess said that. Again, you see, if you do anything where an idea shows up, particularly in those years when an act of painting was considered pure self-expression, then it was assumed that the painting was a personal expressionistic extension of the man. The climate isn't like that now. We've had a history of painting here now, and I think it's unfortunately getting to be a lot like

Europe. We have enough reserve work so that it is very easy for a tradition to exist here which also includes any new ideas, which are immediately tacked onto where we were yesterday.

A painting is pushed into historical perspective before it has become history, as well as critically classified before it is perceived.

I would like to see a lot more stuff that I didn't know what to do with.

In several earlier statements, you said that your paintings were not the result of ideas. What you've said now, however, suggests that they stem from a certain kind of idea.

I think the ideas are based upon very obvious physical facts—notions that are also simpleminded, such as, in the White Paintings, wanting to know if that was a thing to do or not, or in **Factum**, wondering about what the role of accident is. Those aren't really very involved ideas.

That is different from the idea, say, of doing a painting about war, or the idea of realizing a premeditated form.

They are more physical than aesthetic.

Rather than posing a thesis, you are asking a question and then doing some artistic experiment to answer it or to contribute to an answer.

But I do it selfishly. I want to know.

What kind of idea, if you can remember, was present in, say, **Monogram** *[1959], which contains a stuffed Angora goat?*

I have always worked with stuffed animals, and before that, stuffed baseballs—and other objects. But a goat was special in the way that a stuffed goat is special, and I wanted to see if I could integrate an animal or an object as exotic as that. I've always been more attracted to familiar or ordinary things, because I find them a lot more mysterious. The exotic has a tendency to be immediately strange. With common or familiar objects, you are a lot freer; they take my thoughts a lot further. Not only for content was the goat a difficult object to work with, but also because Angora goats are beautiful animals anyway. I did three versions of that painting. For the first one, it was still on the wall; I got him up there safely attached to the flat surface. To make him appear light—and this is the way my mind tends to work—I put light-bulbs under him, which erased the shadow of the enormous shelf that supported him. When I finished it, I was happy with it for about four days; but it kept bothering me that the goat's other side was not exposed; that it was wasted. I was abusing the material. So, I did a piece where he was free-standing on a narrow seven-foot canvas that was attached to the base that he was on. I couldn't have him facing the canvas, because it looked like some kind of still life, like oranges in the bowl. So I had him turned around, which gave me another image which didn't occur to me until, this time, only two days after I had finished it—a kind of beast and vehicle. It looked as though he had some responsibility for supporting the upright canvas or that pulling a canvas or cart was his job. So, the last solution stuck, which was simply to put him right in the middle—to make an environment with him simply being present in it.

How dominant is he?

He is dominant but I wouldn't worry about that as much as how dependent is everything else on him. I think that the painted surface and the other objects were equally interesting, once you see what the goat is doing there.

But doesn't this presume that you forget about the goat to a certain extent?

You forget about how arbitrary a goat is in the picture; that was never the point. It was one of many challenges, but it wasn't a function of the work to exhibit an exotic animal interestingly. Also, the tire around the goat brings him back into the canvas and keeps him from being an object in himself. You don't say, "What is that goat doing in that painting?" but "Why the tire around the goat?" And you're already involved.

This, like so much of your other work, reflects a decided interest in working with unusual and challenging materials. What was your painting **Pantomime** *[1961] about?*

I thought of it as making a surface which would invite one to move in closer; and when you move in closer, you discover it has two electric fans which then join you. I thought of it as kind of an air relief. Any physical situation is an influence on not only how you see and if you look but also what you think when you see it. I just knew that if you were standing in a strong breeze, which was part of the painting, that something different would happen. If I did make a point, it is that even the air around you is an influence.

It's a way of saying to the spectator that the Metropolitan Museum right now, with all the pollen in the air, is a lot different from midwinter.

Also, looking at pictures from one place to another, and also from one season to another, makes them different. That's why, then, the business about masterpieces and standards is all archaic.

The notion of masterpieces presumes that if someone puts the Mona Lisa *in a stuffy New York museum and you have to push your way through a large obnoxious crowd to see it, you should still be greatly impressed.*

Put it in the Greenwich Village outdoor show and see what happens. Put it in the Louvre and send it in with an armed guard, and people will see it. I like the idea of that kind of dramatic carrying-on, for that's part of our time too.

Now that you have become so involved with theater, have you given up painting?

No. That was a mistaken rumor. Giving up painting is all part of that historical thing.

Will you be able to work on a painting while you are doing theater work?

Absolutely, I always did that. You see, it sounds interesting for the painter to give up painting.

It's the myth of Duchamp. Actually, I was thinking more of Claes Oldenburg's statement that when he did a theater piece he temporarily gave up painting.

The last year before I went away with Merce [Cunningham] when I was doing a lot of theater [1963-64], I did more painting than I ever had before. If you're working

on something, it seems to me that the more you work the more you see, the more you think; it just builds up.

You would prefer, then, a more varied regime than a single setup.

Absolutely. I find that when I'm working on paintings, I can do drawings I like very much, although I am forced to adjust to flat surface and a different scale.

How did you become involved with theater?

I've always been interested, even back in high school. I like the liveness of it—that awful feeling of being on the spot. I must assume the responsibility for that moment, for those actions that happen at that particular time.

I don't find theater that different from painting, and it's not that I think of painting as theater or vice versa. I tend to think of working as a kind of involvement with materials, as well as a rather focused interest which changes.

How did you become the author of your own theater pieces?

That skating piece, **Pelican** [1963], was my first piece. The more I was around Merce's group and that kind of activity, I realized that painting didn't put me on the spot as much, or not in the same way, so at a certain point I had to do it.

In some places, like London where [in 1964] the group was held over for six to eight weeks, and we did the piece of Merce's called *Story* three or four times a week, well then it was very difficult to do a completely different thing every night. A couple of times we were in such sterile situations that Alex Hay, my assistant, and I would actually have to be part of the set. The first time it happened was in Dartington, that school in Devon. The place was inhabited by a very familiar look—that Black Mountain beatnik kind of look about everybody; but they occupied the most fantastic and beautiful old English building, all of whose shrubs were trimmed. There was nothing rural or rustic or unfinished about it. For the first time, there was absolutely nothing to use; you can't make it every time. There was a track at the very back of the stage that had lights in it; so the dancers couldn't use that space. About an hour before the performance, I asked Alex whether he had any shirts that needed ironing, which is a nice question to ask Alex because he always did and he always ironed his own shirts. So, we got two ironing boards, and we put them up over these blue lights that were back there. When the curtain opened, there were the dancers and these two people ironing shirts. It must have looked quite beautiful, but we can't be sure absolutely. But from what I could feel about the way it looked and the lights coming up through the shirts, it was like a live passive set, like live decor.

Would you do it again?

I won't do that. You see, there is little difference between the action of paint and the action of people, except that paint is a nuisance because it keeps drying and setting.

The most frequently heard criticism of **Map Room Two** *[1965] is that it was too slow.*

I don't mind that. I don't mind something being boring, because there are certain activities that can be interesting if they are done only so much. Take that business with the tires in *Map Room,* which I found interesting if it is done

for about five minutes. But something else happens if it goes on for ten more minutes. It's a little like La Monte Young's thing, [*The Tortoise, His Dreams and Journeys*]. At some point, you admit that it isn't interesting any more, but you're still confronted by it. So what are you going to make out of it?

However, there is a difference between intentional boredom and inadvertent boredom.

I'd like it if even at the risk of boring someone, there is an area of uninteresting activity where the spectator may behave uniquely. You see, I'm against the prepared consistent entertainment. Theater does not have to be entertaining, just like pictures don't have to be beautiful.

Must theater be interesting?

Involving. Now boredom is restlessness; your audience is not a familiar thing. It is made up of individual people who have all led different lives.

I've been with people who have speech problems. At first it made me quite nervous, later I found myself listening to it and being quite interested in just the physical contact; it can be a very dramatic thing. I've never deliberately thought about boring anyone; but I'm also interested in that kind of theater activity that provides a minimum of guarantees. I have often been more interested in works I have found very boring than in other works that seem to be brilliantly done.

What was it that made them more memorable to you?

It may be that that kind of pacing is more unique to theater-going. The role of the audience, traditionally, I don't find very interesting. I don't like the idea that they shouldn't assume as much responsibility as the entertainer does for making the evening interesting. I'm really quite unfriendly and unrealistic about the artist having to assume the total responsibility for the function of the evening. I would like people to come home from work, wash up, and go to the theater as an evening of taking their chances. I think it is more interesting for them.

I'm bothered about this juxtaposition of interesting and boring. What you're doing, I think, is setting up an opposition to entertainment.

I think that's it. I used the word bored to refer to someone who might look at a Barnett Newman and say there ought to be more image there than a single vertical or two single verticals. If someone said that that was a boring picture, he was using the word in relation to a preconceived idea of what interesting might be. What I am saying is I suspect that right now in theater there is a lot of work described as boring, which is simply the awkward reorientation of the function of theater and even the purpose of the audience. Just in the last few years we have made some extremely drastic changes. Continuity in the works that I am talking about has been completely eliminated. It is usually different from performance to performance. There is no dramatic continuity; the interaction tends to be a coincidence or an innovation for that particular moment.

What else do you think is characteristic of mixed-means theater?

An absence of hierarchy. The fact is that in a single piece of Yvonne Rainer you can hear both Rachmaninoff and sticks being pitched from the balcony without those two things making a comment on each other. In my pieces, for instance, there is nothing that everything is subservient to. I am trusting each element to sustain itself in time.

What do these changes imply?

All those ideas tend to point up the thought that it would be better for theater that, if you went a second night, you found a different work there, even though it might be in the same place and have the same performers and deal with the same material. I think all this is creating an extraordinary situation that is very new in theater; so both the audience and the artist are still quite self-conscious about the state of things.

You would agree with John Cage, then, that one of the purposes of the new movement is to make us more omniattentive.

I think we do it when we are relaxed; all these things happen naturally. But there's a prejudice that has been built up around the ideas of seriousness and specializing. That's why I'm no more interested in giving up painting than continuing painting or vice versa. I don't find these things in competition with each other. If we are to get the most out of any given time, it is because we have applied ourselves as broadly as possible, I think, not because we have applied ourselves as singlemindedly as possible.

Do you have then a moral objection to those dimensions of life that force us to be more specialized than we should be?

Probably. If we can observe the way things happen in nature, we see that nearly nothing in my life turned out the way that, if it were up to me to plan it, it should. There is always the business, for instance, if you're going on a picnic, it is just as apt to rain as not. Or the weather might turn cold when you want to go swimming.

So then you find a direct formal equation between your theater and your life?

I hope so, between working and living, because those are our media.

You would believe, then, that if we became accustomed to this chancier kind of theater, we would become accustomed, then, to the chancier nature of our own life.

I think we are most accustomed to it in life. Why should art be the exception to this? You asked if I had a moral objection. I do, because I think we do have this capacity I'm talking about. You find that an extremely squeamish person can perform fantastic deeds because it is an emergency. If the laws have a positive function, if they could have, it might be just that—to force someone to behave in a way he has not behaved before, using the facilities he was actually born with. Growing up in a world where multiple distractions are the only constant, he would be able to cope with new situations. But, what I found happening to people in the Navy was that, once they were out of service and out of these extraordinary situations, they reverted to the same kind of thinking as before. I think it is an exceptional person who utilizes that experience. That's because in most cases the service is not a chosen environment; it is somebody else's life that they're functioning in, instead of recognizing the fact that it is still just them and the things they are surrounded by.

So you would object to anyone who finds the Navy an unnatural life.

It is a continuation of extraordinary situations. We begin by not having any say over who our parents are; our parents have no control over the particular peculiar mixture of the genes.

Looking back over your involvement with theater, do you see any kind of development, aside from the obvious development that you have now become the author of your own theater pieces, rather than a contributor to somebody else's? Also, do you see any development in your company of more or less regular performers?

Well, that last is mostly a social thing of people with a common interest, and we have tended to make ourselves available as material to each other. It is in no way an organized company, and it changes from time to time—people move in and out. However, where a play could be cast with different actors and you would still get the same play, if I was not in constant touch with these people, I could not do those pieces. The whole concept would have to be changed, if I had new performers—if I let Doris Day take Mary Martin's part in a musical or used the Cincinnati Philharmonic rather than the New York Philharmonic.

You write for these performers, and they have learned to respond to the particular language of your instructions.

It goes beyond interpretation of following directions. From the outset, their responsibility, in a sense of collaboration, is part of the actual form and content and appearance of the piece. It makes them stockholders in the event itself, rather than simply performers.

In **Map Room Two,** a couple of the people involved said that they had now gotten some kind of feeling about what I was after. Because this is my fourth or fifth piece and these people, if they weren't in them, had seen them all, then I think there is a body of work. If someone is working with an unfamiliar kind of image and if you see only one, it looks like a lot of things that it isn't and a lot of things that it is; but you don't really understand the direction. In five of those new things you're more apt to see what they are doing. It's like signposts; you need a few to know that you are really on the right road.

Do you feel stronger and more confident now in approaching a theater piece?

Confidence is something that I don't feel very often, because I tend to eliminate the things I was sure about. I cannot help but wonder what would happen if you didn't do that and if you did this. You recognize the weaknesses in **Map Room Two,** for instance, that weakness of the neon thing coming last. **Linoleum** is probably one of the most tedious works I've ever done, the most unclimactic. If you're in the audience, you simply move into it with your attention and live through this thing. At a certain point it's over.

How did you conceive **Oracle** *[1965], your environmental sculpture?*

I finished it after I got back from Europe, after touring with Merce Cunningham. Technically, it had to be completely rebuilt, because ideas which had been impossible when I started in 1962, later became possible.

In the technological sense?

Yes. It is a single work with five pieces of sculpture. Each piece has its own voice. The controls are a console unit which is embedded in one of the pieces; and all five have a sound source. Each piece can be played independently, because the console has five volume controls, one for each piece. A scanning mechanism goes across the radio dials and provides a constant movement, so that what you control is the speed of scanning. All this gives you the maximum possibilities of varied sound, from music to purely abstract noise and any degree in between. Each piece can be adjusted accordingly. One of the ideas was to make it so simple that you would not have to be educated to do it—so that the thing would just respond to touch.

When this sculpture is displayed, is someone working the dials or are they merely present?

Anyone around it can change it; and it can also be set up so that the sound is constantly changing, independently of anyone's control.

One of the pieces, a cement-mixing tub, is also a fountain, because I wanted another source of sound too in running water. I didn't want to imply that these sounds all had to be electronic.

Do you consider this an "environment" or a "combine"?

Sound is part of the piece; it is not a decoration. It is a part of the climate that piece insists on. You really do get a sense of moving from one place to another, as you shift from the proximity of one piece to another piece.

Because the field of sound is constantly changing. Several questions come to mind: Why the field of sound? How does the sound relate to the visual elements?

The sound relates to the pieces physically by the material interaction—the particular kind of distortion the sound of a voice has as it is shaped by its context. "Why sound?" because hearing is a sense that we use while looking anyway.

One of the myths of modern culture—I associate it particularly with Lewis Mumford's Art and Technics *[1952]—is that art and technology are eternally opposed to each other and that one succeeds only at the decline of the other.*

I think that's a dated concept. We now are living in a culture that won't operate and grow that way. Science and art—these things do clearly exist at the same time, and both are very valuable. We are just realizing that we have lost a lot of energy in always insisting on the conflict—in posing one of these things against the other.

In contrast to nearly all contemporary artists, you did not need to find your own style by first painting through several established styles—by taking them as your transient models. From the start, you were, as we say, an original.

I always had enormous respect for other people's work, but I deliberately avoided using other people's styles, even though I know that no one owns any particular technique or attitude. It seemed to me that it was more valuable to think that the world was big enough so that everyone doesn't have to be on each other's feet. When you go to make something, nothing should be clearer than the fact that not only do you not have to make it but that it could

look like anything, and then it starts getting interesting and then you get involved with your own limitations.

As an artist, do you feel in any sense alienated from America today or do you feel that you are part of a whole world in which you are living?

I feel a conscious attempt to be more and more related to society. That's what's important to me as a person. I'm not going to let other people make all the changes; and if you do that, you can't cut yourself off.

This very quickly gets to sound patriotic and pompous and pious; but I really mean it very personally. I'm only against the most obvious things, like wars and stuff like that. I don't have any particular concept about a utopian way things should be. If I have a prejudice or a bias, it is that there shouldn't be any particular way. Being a complex human organ, we are capable of a variety; we can do so much. The big fear is that we don't do enough with our senses, with our activities, with our areas of consideration; and these have got to get bigger year after year.

Could that be what the new theater is about? Is there a kind of educational purpose now—to make us more responsive to our environment?

I can only speak for myself. Today there may be eleven artists; yesterday there were ten; two days ago there were nine. Everybody has his own reason for being involved in it, but I must say that this is one of the things that interests me the most. I think that one of my chief struggles now is to make something that can be as changeable and varied and alive as the audience. I don't want to do works where one has to impose liveliness or plastic flexibility or change but a work where change would be dealt with literally. It's very possible that my interest in theater, which now is so consuming, may be the most primitive way of accomplishing this, and I may just be working already with what I would like to make.

How will our lives—our ideas and our responses—be different after continued exposure to the new theater?

What's exciting is that we don't know. There is no anticipated result; but we will be changed. (pp. 92-106)

> *Robert Rauschenberg and Richard Kostelanetz, in an interview in* Partisan Review, *Vol. XXXV, No. 1, Winter, 1968, pp. 92-106.*

SURVEY OF CRITICISM

Dore Ashton (essay date 1953)

[*In the following excerpt, the reviewer praises Rauschenberg's early, minimalist works, but suggests that they need to be more rooted "in time and space."*]

Sick unto death of "good painting," Rauschenberg has decided that paintings have lives of their own. They come dressed as they are. One comes as seven pure white panels of sized canvas, symmetrical and identical, blank-faced, untouched by any instrument. Others come as black beasts, with amber overtones and black enameled paper fluttering on their battered surfaces.

Rauschenberg has decided to find and speak of his own experience. (Think of the many before him. Malevich: "I have invented nothing. . . . I have only felt the night." Rauschenberg, too, has invented nothing.) He speaks of the nature of nature: cloaked mystery and deterioration. Beauty is purity, he says, but decay is implicit. Appliquéd newspaper is his disdain of perpetuity. Life is cheap.

Yes, these black and white canvases excite, incite, make vacuums in walls. And they stir up vaguely primordial sensations, and anxiety. But that is all.

Not so Rauschenberg's impromptu sculptures—smooth rocks bound together with frayed rope, boxes with nails and the clatter of stones trapped among them, "readymades" with wit, play, grace.

But isn't Rauschenberg's experience, his unique experience, like a small thorn in the hide of an elephant? Doesn't art require a hint of the banal, a hint of the social role of man to locate it in time and history? (pp. 21, 25)

> *Dore Ashton, "57th Street," in* The Art Digest, *Vol. XXVII, No. 20, September 15, 1953, pp. 21, 25.*

Peter Yates (essay date 1953)

[*In the following review of an exhibition at the Stable Gallery, Yates writes that in presenting his white canvases as art, "Rauschenberg has committed a gratuitously destructive act."*]

Rauschenberg, like a great many other abstract expressionists, [seems] to feel that today not only painting—its appearance, its shapes and surfaces—but art, and the creative process itself must mean something they never meant before.

With the discovery that feelings could be transferred directly to a canvas as line and color, many artists began to paint landscapes of the mind, or rather, the heart. A landscape painting in which trees, rivers and mountains are replaced by joy, desire and fear—shapes, is subject to the same general formal criteria as any other landscape painting. Abstract expressionism is an introverted attitude in art, and where it obeys no principle of intellectual order, it is really a kind of inverted naturalism, the naturalism of the solipsist.

Abstract expressionism deals with hyperaesthetic experience—experience, that is, in which feelings and sensations are seen. Such experience is by no means rare, or limited to artists, and the material an artist acquires in this way must be organized and transformed. It must be edited, too, for an unedited transcript of the affective scene—stream of consciousness painting, one might call it—is no more interesting, as art, than an unedited record of nature. Above all, the artist's experience must be realized as image, and no amount of hard work, of struggling with the medium and making corrections can ensure this where the formative impulse is weak. (pp. 33-4)

Rauschenberg, . . . working instinctively and with little

structural sense, has produced a city-dump mural out of handmade debris.

Handmade debris also describes Rauschenberg's sculpture: a stone suspended at the end of a length of heavy string—like a caveman's noggin knocker; three large pebbles tied at intervals along a string; a wooden block with a rusty tenpenny nail driven into it; a glass covered wooden box, containing pebbles in a maze of spikes. No doubt the author of these contraptions could explain them, but whatever their metaphysical implications, how dull they seem 25 years after Dada, how much less amusing than Duchamp's *objets trouves* and Man Ray's *objets inutiles*.

The low point of Rauschenberg's exhibition, however, was provided by a number of "white paintings," blank canvases on stretcher frames, hung like the collages, edge to edge. As I understand it, one must relate oneself to these directly. They have to be experienced directly because there is nothing in them to remember. But if there is nothing in them to remember, is there anything to experience? I think there is less than meets the eye. Of course, a blank white canvas might be an aid to contemplation, but the four white walls the landlord provides will do as well.

The reader may wonder why I have devoted so much space to something that I consider worthless. It is because it seems to me that in hanging these blank white canvases as works of art, Rauschenberg has committed a gratuitously destructive act—all the more culpable if unintended. It is not a curatively destructive act like those of the dadaists: it does not point to a new conception of art, or decoration. It is materially destructive because the function of a canvas, its destiny if I may call it that, is aborted when it is misused in this way. And it is a self-destructive act for Rauschenberg has backed himself into a corner where there is nothing for him to do but make wall coverings. (p. 34)

Peter Yates, in a review of an exhibition at the Stable Gallery in Arts & Architecture, *Vol. 70, No. 10, October, 1953, pp. 33-4.*

John Ashbery (essay date 1958)

[*Ashbery is an American poet and critic whose works are noted for their radical experimentalism and rejection of conventional syntax, traditional poetic structure, and easily definable meaning. While some critics have found that this approach results in fragmented and often elegant nonsense, Ashbery's works are more often included among the most important and challenging in contemporary poetry. In the following review of an exhibition at the Leo Castelli Gallery in New York, he expresses his regard for Rauschenberg's works and notes that the artist has begun to acquire a following.*]

The junk that collects on New York City streets is used by Robert Rauschenberg to compose large canvases that sometimes look like walls in a house inhabited by very bad children. One painting in his latest show, . . . *The Bed,* is a real bed whose quilt and pillow are caked with flung enamel, scribbled over with a pencil. *Rebus* is an enormous composition using a horizontal row of magazine photographs underlined by paint samples. It does not have the "Step along, please" feeling of a Schwitters collage; it is perfectly all right if you want to look at and chuckle

over the tabloid elements: that is entirely up to you. You also have the artist's permission to get nothing out of looking at his paintings other than the marginal pleasure of being alive. But it is nevertheless impossible not to enjoy them and respond to them. Rauschenberg has what might be termed a "terrific talent"; he could be a sort of avant-garde Cocteau. Recent developments show that he is unwittingly or unwillingly forming a school of disciples. His latest paintings indicate that he is keeping well ahead of them in vast compositions which achieve a difficult serenity through the use of large square forms that are often just sheets of paper, smudged or almost pristine. It is this sense of plastic beauty that distinguishes him. In his small drawings he creates a mood of unbearable quiet with a pencil tracing of a smile or a glass of Coca-Cola, a piece of torn nylon, a stain. But he has not given up his early fireworks, as *Interview* and *Satellite* prove. The former is a shallow wooden closet lined with old photographs and such objects as a baseball, a paint-clotted fork, a brick suspended in front of somebody else's "genuine oil painting" of palm trees; the latter is a scary mass of old bedding, doilies, funny papers and a stuffed pheasant clobbered with paint. (pp. 40, 56-7)

John Ashbery, in a review of an exhibition at the Leo Castelli Gallery, in ARTnews, *Vol. 57, No. 1, March, 1958, pp. 40, 56-7.*

David Myers (essay date 1959)

[*In the following discussion of Rauschenberg's combines, Myers commends the artist for depicting images of America "more clearly and realistically than anyone else."*]

Rauschenberg's recent work includes portraits of Merce Cunningham, Gloria Vanderbilt Stowkowski Lumet, and President Eisenhower. In real life, Mr. Cunningham, the distinguished hoofer, might bump into Miss Vanderbilt, the actress, at a theater party some night; and Miss Vanderbilt, the distinguished daughter, may have already, for all I know, bumped into the President while waltzing at the Inaugural Ball. But that all three should meet, on equal terms, anywhere but in Rauschenberg's mind strikes me as highly unlikely.

Thanks to Rauschenberg's graciousness, however, they do meet quite frequently these days in my own mind too. And though they surely couldn't care less, I care quite a bit. For somehow, seeing them standing there side by side in my head—Miss Vanderbilt in the middle, inexplicably a shade taller than the men, her left hand held by Mr. Cunningham, her right by Mr. Eisenhower, their eyes forward, their shoulders back—I suddenly see America.

This image of our country in our time is, of course, my own contrivance, having little or nothing to do with Rauschenberg, who made his portraits separately and surely for a better purpose. Yet hopefully it may be a flitting, if inadequate, shadow of that purpose, which is, I believe, to give us back the lost world of reality.

In an age which has lost touch with reality, it is logical, I suppose, that the man who is painting that age more clearly and realistically than anyone else should be thought of by the unwashed as difficult and by the overly-bathed as decadent. Neither of these views is, of course,

without its germ of truth. Like life itself, a Rauschenberg painting may be filled with juxtapositions of materials and ideas that are hard to understand and even harder to love; and certainly Rauschenberg's world, like the real one, is not without corpses. But partial truths obscure more than they illuminate. For while there is difficulty and death in Rauschenberg, there is also clarity and newness, wit, cruelty, sentiment, recklessness, control, table cloths, kitchen utensils, light bulbs, animals, baseballs, reproductions of Old Masters, hats, packing crates, aluminum, comic strips, love stories, Coca-Cola, and in one particular canvas (which I am sad to say is no longer with us) fresh green growing grass. In short, there is everything.

Everything, of course, is precisely what the truly great artist always shows us. Like Noah, he somehow manages to gather up the total life of his time in the ark he has been commanded to build against the flood of indifference. No one in Ark History has undertaken a larger task than Rauschenberg, for the world has never before been so crowded. Already bulging at the seams, Rauschenberg's ark is, for me, a brave and beautiful sight. Most any day you can find him hard at work on it, with hammer, saw, paintbrush, and glue-pot, in an isolated loft down at the foot of Manhattan Island—a stone's throw from the old harbor . . . (pp. 54-9)

> *David Myers, "Robert Rauschenberg," in* School of New York: Some Younger Artists, *edited by B. H. Friedman, Grove Press, Inc. 1959, pp. 54-9.*

John Cage (essay date 1961)

[*An influential American composer, author, and printmaker, Cage has long been a major figure in American music. In his controversial work as an avant-garde composer, he has pioneered the use of the percussion orchestra, experimented with noise and silence, originated the concept of multimedia "happenings," and championed electronic and taped music. For Cage's encouragement of exploration in music, critics consider him the father of avant-garde composition in America. In the following excerpt, Cage offers an impressionistic commentary on Rauschenberg's individual works and his philosophy of art. Italicized passages are statements by Rauschenberg.*]

Conversation was difficult and correspondence virtually ceased. (Not because of the mails, which continued.) People spoke of messages, perhaps because they'd not heard from one another for a long time. Art flourished.

The goat. No weeds. Virtuosity with ease. Does his head have a bed in it? Beauty. His hands and his feet, fingers and toes long-jointed, are astonishing. They certify his work. And the signature is nowhere to be seen. The paintings were thrown into the river after the exhibition. What is the nature of Art when it reaches the Sea?

Beauty is now underfoot wherever we take the trouble to look. (This is an American discovery.) Is when Rauschenberg looks an idea? Rather it is an entertainment in which to celebrate unfixity. Why did he make black paintings, then white ones (coming up out of the South), red, gold ones (the gold ones were Christmas presents), ones of many colors, ones with objects attached? Why did he make sculptures with rocks suspended? Talented?

I know he put the paint on the tires. And he unrolled the paper on the city street. But which one of us drove the car?

As the paintings changed the printed material became as much of a subject as the paint (I began using newsprint in my work) causing changes of focus: A third palette. There is no poor subject (Any incentive to paint is as good as any other.). Dante is an incentive, providing multiplicity, as useful as a chicken or an old shirt. The atmosphere is such that everything is seen clearly, even in the dark night or when thumbing through an out-of-date newspaper or poem. This subject is unavoidable (A canvas is never empty.); it fills an empty canvas. And if, to continue history, newspapers are pasted onto the canvas and on one another and black paints are applied, the subject looms up in several different places at once like magic to produce the painting. If you don't see it, you probably need a pair of glasses. But there is a vast difference between one oculist and another, and when it is a question of losing eyesight the best thing to do is to go to the best oculist (i.e., the best painter: he'll fix you up). Ideas are not necessary. It is more useful to avoid having one, certainly avoid having several (leads to inactivity). Is Gloria V. a subject or an idea? Then, tell us: How many times was she married and what do you do when she divorces you?

There are three panels taller than they are wide fixed together to make a single rectangle wider than it is tall. Across the whole thing is a series of colored photos, some wider than tall, some taller than wide, fragments of posters, some of them obscured by paint. Underneath these, cutting the total in half, is a series of rectangular color swatches, all taller than wide. Above, bridging two of the panels, is a dark blue rectangle. Below and slightly out of line with the blue one, since it is on one panel only, is a gray rectangle with a drawing on it about halfway up. There are other things, but mostly attached to these two "roads" which cross: off to the left and below the swatches is a drawing on a rectangle on a rectangle on a rectangle (its situation is that of a farm on the outskirts of a main-street town). This is not a composition. It is a place where things are, as on a table or on a town seen from the air: any one of them could be removed and another come into its place through circumstances analogous to birth and death, travel, housecleaning, or cluttering. He is not saying; he is painting. (What is Rauschenberg saying?) The message is conveyed by dirt which, mixed with an adhesive, sticks to itself and to the canvas upon which he places it. Crumbling and responding to changes in weather, the dirt unceasingly does my thinking. He regrets we do not see the paint while it's dripping.

Rauschenberg is continually being offered scraps of this and that, odds and ends his friends run across, since it strikes them: This is something he could use in a painting. Nine times out of ten it turns out he has no use for it. Say it's something close to something he once found useful, and so could be recognized as his. Well, then, as a matter of course, his poetry has moved without one's knowing where it's gone to. He changes what goes on, on a canvas,

but he does not change how canvas is used for paintings—that is, stretched flat to make rectangular surfaces which may be hung on a wall. These he uses singly, joined together, or placed in a symmetry so obvious as not to attract interest (nothing special). We know two ways to unfocus attention: symmetry is one of them; the other is the overall where each small part is a sample of what you find elsewhere. In either case, there is at least the possibility of looking anywhere, not just where someone arranged you should. You are then free to deal with your freedom just as the artist dealt with his, not in the same way but, nevertheless, originally. This thing, he says, *duplication of images,* that is symmetry. All it means is that, looking closely, we see as it was everything is in chaos still.

To change the subject: "Art is the imitation of nature in her manner of operation." Or a net.

So somebody has talent? So what? Dime a dozen. And we're overpopulated. Actually we have more food than we have people and more art. We've gotten to the point of burning food. When will we begin to burn our art? The door is never locked. Rauschenberg walks in. No one home. He paints a new painting over the old one. Is there a talent then to keep the two, the one above, the one below? What a plight (it's no more serious than that) we're in! It's a joy in fact to begin over again. In preparation he erases the DeKooning.

Is the door locked? No, it's open as usual. Certainly Rauschenberg has techniques. But the ones he has he disuses, using those he hasn't. I must say he never forces a situation. He is like that butcher whose knife never became dull simply because he cut with it in such a way that it never encountered an obstacle. Modern art has no need for technique. (We are in the glory of not knowing what we're doing.) So technique, not having to do with the painting, has to do with who's looking and who painted. People. Technique is: how are the people? Not how well did they do it, but, as they were saying, frailty. (He says—and is he speaking of technique?—"What do you want, a declaration of love? I take responsibility for competence and hope to have made something hazardous with which we may try ourselves.") It is a question, then, of seeing in the dark, not slipping over things visually. Now that Rauschenberg has made a painting with radios in it, does that mean that even without radios, I must go on listening even while I'm looking, everything at once, in order not to be run over?

Would we have preferred a pig with an apple in its mouth? That too, on occasion, is a message and requires a blessing. These are the feelings Rauschenberg gives us: love, wonder, laughter, heroism (I accept), fear, sorrow, anger, disgust, tranquillity.

There is no more subject in a *combine* than there is in a page from a newspaper. Each thing that is there is a subject. It is a situation involving multiplicity. (It is no reflection on the weather that such-and-such a government sent a note to another.) (And the three radios of the radio combine, turned on, which provides the subject?) Say there was a message. How would it be received? And what if it wasn't? Over and over again I've found it impossible to memorize Rauschenberg's paintings. I keep asking, "Have you changed it?" And then noticing while I'm looking it

changes. I look out the window and see the icicles. There, dripping water is frozen into object. The icicles all go down. Winter more than the others is the season of quiescence. There is no dripping when the paint is squeezed from a tube. But there is the same acceptance of what happens and no tendency towards gesture or arrangement. This changes the notion of what is beautiful. By fixing papers to canvas and then painting with black paint, black became infinite and previously unnoticed.

Hallelujah! The blind can see again. Blind to what he has seen so that seeing this time is as though first seeing. How is it that one experiences this, for example, with the two Eisenhower pictures which for all intents and purposes are the same? (A duplication containing duplications.) Everything is so much the same, one becomes acutely aware of the differences, and quickly. And where, as here, the intention is unchanging, it is clear that the differences are unintentional, as unintended as they were in the white paintings where nothing was done. Out of seeing, do I move into poetry? And is this a poetry in which Eisenhower could have disappeared and the Mona Lisa taken his place? I think so but I do not see so. There is no doubt about which way is up. In any case our feet are on the ground. Painting's place is on the wall—painting's place, that is, in process. When I showed him a photograph of one of Rauschenberg's paintings, he said, "If I had a painting, I'd want to be sure it would stay the way it is; this one is a collage and would change." But Rauschenberg is practical. He goes along with things just as they are. Just as he knows it goes on a wall and not any which way, but right side up, so he knows, as he is, it is changing (which one more quickly? and the pyramids change). When possible, and by various means, he gives it a push: holes through which one sees behind the canvas the wall to which it is committed; the reflective surfaces changing what is seen by means of what is happening; lights going on and off; and the radios. The white paintings were airports for the lights, shadows, and particles. Now in a metal box attached by a rope, the history kept by means of drawings of what was taken away and put in its place, of a painting constantly changing.

There is in Rauschenberg, between him and what he picks up to use, the quality of encounter. For the first time. If, as happens, there is a series of paintings containing such and such a material, it is as though the encounter was extended into a visit on the part of the stranger (who is divine). (In this way societies uninformed by artists coagulate their experiences into modes of communication in order to make mistakes.) Shortly the stranger leaves, leaving the door open.

Having made the empty canvases (*A canvas is never empty.*), Rauschenberg became the giver of gifts. Gifts, unexpected and unnecessary, are ways of saying Yes to how it is, a holiday. The gifts he gives are not picked up in distant lands but are things we already have (with exceptions, of course: I needed a goat and the other stuffed birds, since I don't have any, and I needed an attic in order to go through the family things [since we moved away, the relatives write to say: Do you still want them?]), and so we are converted to the enjoyment of our possessions. Converted

Monogram (1958)

from what? From wanting what we don't have, art as pained struggle. Setting out one day for a birthday party, I noticed the streets were full of presents. Were he saying something in particular, he would have to focus the painting; as it is he simply focuses himself, and everything, *a pair of socks,* is appropriate, appropriate to poetry, a poetry of *infinite possibilities.* It did not occur to me to ask him why he chose Dante as a project for illustration. Perhaps it is because we've had it around so long so close to us without bothering to put it to use, which becomes its meaning. It involved a stay in Florida and at night, looking for help, a walk through land infested with rattlesnakes. Also slipping on a pier, gashing his shin, hanging, his foot caught, not calling for help. The technique consists in having a *plan: Lay out stretcher on floor match markings and join.* Three stretchers with the canvas on them no doubt already stretched. Fulfilling this plan put the canvas in direct contact with the floor, the ground thereby activated. This is pure conjecture on my part but would work. More important is to know exactly the size of the door and techniques for getting a canvas out of the studio. (*Combines* don't roll up.) Anything beyond that size must be suitably segmented.

I remember the show of the black paintings in North Carolina. Quickly! They have become masterpieces.

Is it true that anything can be changed, seen in any light, and is not destroyed by the action of shadows? Then you won't mind when I interrupt you while you're working?

The message changes in the *combine-drawings,* made with pencil, water color, and photographic transfer: (a) the work is done on a table, not on a wall; (b) there is no oil paint; (c) because of a + b, no dripping holds the surface in one plane; (d) there is not always the joining of rectangles since when there is, it acts as reminiscence of stretchers; (e) the outlines appear vague as in water or air (our feet are off the ground); (f) I imagine being upside down; (g) the pencil lines scan the images transferred from photographs; (h) it seems like many television sets working simultaneously all tuned differently. How to respond to this message? (And I remember the one in *Dante* with the outline of the toes of his foot above, the changed position and another message, the paper absorbing the color and spreading it through its wet tissues.) He has removed the why of asking why and you can read it at home or in a library. (These others are poems too.) Perhaps because of the change in gravity (***Monument*** 1958)the project arose of illustrating a book. (A book can be read at a table; did it fall on the floor?) As for me, I'm not so inclined to read

poetry as I am one way or another to get myself a television set, sitting up nights looking.

Perhaps after all there is no message. In that case one is saved the trouble of having to reply. As the lady said, "Well, if it isn't art, then I like it." Some (a) were made to hang on a wall, others (b) to be in a room, still others (a + b).

By now we must have gotten the message. It couldn't have been more explicit. Do you understand this idea?: *Painting relates to both art and life. Neither can be made. (I try to act in that gap between the two.)* The nothingness in between is where for no reason at all every practical thing that one actually takes the time to do so stirs up the dregs that they're no longer sitting as we thought on the bottom. All you need do is stretch canvas, make markings, and join. You have then turned on the switch that distinguishes man, his ability to change his mind: *If you do not change your mind about something when you confront a picture you have not seen before, you are either a stubborn fool or the painting is not very good.* Is there any need before we go to bed to recite the history of the changes and will we in that bed be murdered? And how will our dreams, if we manage to go to sleep, suggest the next practical step? Which would you say it was: wild, or elegant, and why? Now as I come to the end of my rope, I noticed the color is incredibly beautiful. And that embossed box.

I am trying to check my habits of seeing, to counter them for the sake of greater freshness. I am trying to be unfamiliar with what I'm doing.

(I cannot remember the name of the device made of glass which has inside it a delicately balanced mechanism which revolves in response to infrared rays.) Rauschenberg made a painting combining in it two of these devices. The painting was excited when anybody came near it. Belonging to friends in the country, it was destroyed by a cat. If he takes a subject, what does he take? And what does he combine with it, once he's put it in place? It's like looking out a window. (But our windows have become electronic: everything moves through the point where our vision is focused; wait long enough and you'll get the Asiatic panoply.) Poetry is free-wheeling. You get its impact by thumbing through any of the mass media. The last time I saw him, Rauschenberg showed me a *combine-drawing,* and while I was looking he was speaking and instead of hearing (I was looking) I just got the general idea that this was an autobiographical drawing. A self-portrait with multiplicity and the largest unobstructed area given to the white painting, the one made of four stretchers, two above, two below, all four of equal size. Into this, structure and all, anything goes. The structure was not the point. But it was practical: you could actually see that everything was happening without anything's being done. Before such emptiness, you just wait to see what you will see. Is Rauschenberg's mind then empty, the way the white canvases are? Does that mean whatever enters it has room? (In, of course, the gap between art and life.) And since his eyes are connected to his mind, he can see what he looks at because his head is clear, uncluttered? That must be the case,

for only in a mind (twentieth) that had room for it could Dante (thirteenth-fourteenth) have come in and gone out. What next? The one with the box changed by the people who look at it.

What do images do? Do they illustrate? (It was a New Year's Eve party in the country and one of them had written a philosophical book and was searching for a picture that would illustrate a particular point but was having difficulty. Another was knitting, following the rules from a book she had in front of her. The rest were talking, trying to be helpful. The suggestion was made that the picture in the knitting book would illustrate the point. On examination it was found that everything on the page was relevant, including the number.) But do we not already have too much to look at? (Generosity.) Left to myself, I would be perfectly contented with black pictures, providing Rauschenberg had painted them. (I had one, but unfortunately the new room has a slanting ceiling and besides the wall isn't long enough for it. These are the problems that have no solution, such as the suit wearing out.) But going along, I see I'm changing: color's not so bad after all. (I must have been annoyed by the games of balance and what-not they played with it.) One of the simplest ideas we get is the one we get when someone is weeping. Duchamp was in a rocking chair. I was weeping. Years later but in the same part of town and for more or less the same reason, Rauschenberg was weeping.

(The white paintings caught whatever fell on them; why did I not look at them with my magnifying glass? Only because I didn't yet have one? Do you agree with the statement: After all, nature is better than art?) Where does beauty begin and where does it end? Where it ends is where the artist begins. In this way we get our navigation done for us. If you hear that Rauschenberg has painted a new painting, the wisest thing to do is to drop everything and manage one way or another to see it. That's how to learn the way to use your eyes, sunup the next day. If I were teaching, would I say *Caution Watch Your Step* or Throw yourself in where the fish are thickest? Of course, there are objects. Who said there weren't? The thing is, we get the point more quickly when we realize it is we looking rather than that we may not be seeing it. (Why do all the people who are not artists seem to be more intelligent?) And object is *fact,* not symbol. If any thinking is going to take place, it has to come out from inside the Mason jar which is suspended in **Talisman,** or from the center of the rose (is it red?) or the eyes of the pitcher (looks like something out of a movie) or—the farther one goes in this direction the more one sees nothing is in the foreground: each minute point is at the center. Did this happen by means of rectangles (the picture is "cut" through the middle)? Or would it happen given this point of view? Not ideas but facts. (pp. 98-108)

John Cage, "On Robert Rauschenberg, Artist, and His Work," in his Silence: Lectures and Writings, *Wesleyan University Press, 1961, pp. 98-108.*

Rauschenberg on his art:

It has never bothered me a bit when people say that what I'm doing is not art. I don't think of myself as making art. I do what I do because I want to, because painting is the best way I've found to get along with myself. And it's always the moment of doing it that counts. When a painting is finished it's already something I've done, no longer something I'm doing, and it's not so interesting any more. I think I can keep on playing this game indefinitely. And it *is* a game—everything I do seems to have some of that in it. The point is, I just paint in order to learn something new about painting, and everything I learn always resolves itself into two or three pictures.

> *Robert Rauschenberg, in an excerpt from* The Bride & the Bachelors: The Heretical Courtship in Modern Art *by Calvin Tomkins, Viking Press, 1965, p. 236.*

Henry Geldzahler (essay date 1963)

[*Reviewing Rauschenberg's retrospective exhibit at the Jewish Museum in New York, Geldzahler describes the merits of the artist's technique and asserts that "it is . . . impossible to conceive of a stronger, more consistently inventive and searching exhibition by any artist of his generation."*]

The Robert Rauschenberg retrospective exhibition at the Jewish Museum last Spring was the most impressive one-man show of the year in a New York gallery or museum. It is, in fact, impossible to conceive of a stronger, more consistently inventive and searching exhibition by any artist of his generation. The eighty-seven works in the show, paintings that surprise by the absolute rightness of apparently arbitrary elements, confirm both the historical position and the contemporary vitality of Rauschenberg, who, at thirty-eight, continues with each new work to meet the challenge he himself has set.

His use of disparate elements within a composition stuns us not because everything is unquestionably where it belongs, which is so, but because each element retains exactly its uniqueness and qualities as object and yet combines to form a painting; the goat remains a goat and the coke bottles are allowed to remain aggressively that, without diminishing the possibilities and complexities of their relationships within the painting (or combine). Whatever Rauschenberg uses brings to its new context the fullness of the context from which it has been ripped, enriching the associative value of his work without devitalizing it by an overly specific content.

The breadth of possibilities, subject matter and materials, within which Rauschenberg moves is the widest and freest ranging of any artist now working. His latitude in working is restricted only by what he has already applied to the canvas. The question is never whether or not something is suitable; only whether it is usable. The separable elements in his work are direct quotations from his experi-

ence, which must be very like our experience, for they have a logic and inner consistency which we cannot quite grasp but by which echo a sense of the organization of life and the relationship between things which we, too, feel. The shock is that of recognition, but *what's* been said is embedded only in the work and cannot be translated out of it. A clock, large and solid and square, is fixed to a painting, just below it a shirt with its arms spread out; or four coke bottles stand side by side in an opening at the top right of a painting, below it an exultant bull. There is no doubt that little stories and meanings, connections, can be made between these objects, but they will serve only to deaden the work, to cut off its possibilities. It is vain to attempt a literary equivalence of any work by Rauschenberg because far from exhausting its meaning, the story will not bear comparison with the painting. In a painting all the elements are visual and visible at once; in literature they, necessarily, follow one another in time. Thus the openness of painting is not the openness of literature. We can relate each object in a Rauschenberg in several combinations and directions *at the same time,* leaving room to breathe and to move in more than one direction. In Gorky the organization is fluid, each form exists in many possible combinations and relations and all is one unending continuum; the elements in a Rauschenberg suggest as many and more possible relations and combinations, but instead of merging into fluidity, they remain discrete and themselves. The difference is largely the difference between Surrealism (Gorky) and Cubism (Rauschenberg). Rauschenberg posits the plane of the canvas, most often breaking it down into subsidiary planes, all more or less rectangles and all lying on the surface, or forcefully projecting from it. The space is not the dream space of Surrealism, floating and endlessly continuous; it is the concrete space of the picture which is undeniably a two-dimensional painting and works its variations within those limitations.

Rauschenberg has said, and it has become famous, that "Painting relates to both art and life. Neither can be made. (I try to act in the gap between the two.)" Artists' statements are dangerous, for in our eagerness to simplify their work, to write away their complexities, we quote them and think we've said something. They are repeated ("I see in nature the cube, the cylinder and the cone.") until they become equivalents to the work itself, and are easier to think and lecture about than the densities of the paintings in question. Rauschenberg's statement is particularly revealing; he does work in the gap between art and life. He appropriates rude blocks of life and uses them in his art. He presents us not with the interpretation of an experience (a ladder, umbrella, tire, glass or chair), but with the experience itself. The tragedy, or rather the reality that so often looks like tragedy, is how rapidly we come to accept what Rauschenberg has given us; his best work is always fresh and mind-twisting on first confrontation; we turn it rapidly into art, into something we can deal with. We do not allow a work of art to throw us very often; we tame it and domesticate it. We do not allow it to put us at a permanent disadvantage. Rauschenberg's triumph is that his work continues to function as art even after we have drained its life as rapidly as we possibly can. The shock of life it first presents us pales, and we are left with a work that has lost its brutality but retains its challenge and gains, increasingly, elegance. Rauschenberg works in the gap between life and art, but his work, as the work of all artists, moves always toward art and away from life.

The problem of focus in Rauschenberg's work is a crucial one. We can take in an entire painting or combine at one glance, see the over-all pattern, the composition and organization, but the richness of incident and detail demand a different kind of looking. Within one picture, *Rebus,* painted in 1955 and in the artist's collection, we find what is close to an anthology of the techniques of contemporary painting, dripped paint, hard rectangles of primary color, collage cloth, torn poster, comic strip, news photo, children's drawing, graffiti, mass reproduction of art (Botticelli); and this anthology is organized with an uncanny aptness and discretion into an harmonious composition that, in spite of its complexities, remains somehow spare. In one year Rauschenberg moved from the densities and happy excesses of *Charlene* to the spareness of *Rebus;* as if he had to put down everything in 1954 in order to know what he could safely leave out in 1955. Both are great pictures, but the ellision of *Rebus* makes it the greater.

In order to take in the richness of these pictures, and this is true also of the latest black and white silk screen paintings, we must be willing to examine them more carefully than the abstract aspect of their nature would make it seem necessary. The incidents and details that go to make up the whole differ greatly in size, in compositional prominence, in color and, in the earlier pictures, in medium; their choice is never a casual one; yet the juxtapositions are never obvious. We must, as it were, stand different distances from the picture to focus clearly on its parts; or, rather than move forward and back, we must re-focus our vision, for the minutely detailed photograph three inches square affixed to a painting twelve feet long demands, certainly, another kind of attention than the entire painting. In Flemish art of the fifteenth century we see the foreground, the middle ground and the background as separable but continuous planes, each viewed with remarkably sharp focus and clarity. The result is an enhanced vision, the ability to see details in the background with clarity and without changing focus. Rauschenberg fragments this across his work; that which is smallest lies directly next to the largest element in the work; color lies next to black and white; a loose, abstract handling of the paint is directly juxtaposed to an aggressively presented three-dimensional object—a wheel, or an electric fan, a chair or an umbrella. What we are presented with is not the ordered reality of Flemish art, with everything at a pre-arranged distance from everything else; that is the art of a society assured of its hierarchies and its values. Rather Rauschenberg produces all the confusions of focus and relation that Joyce and Pound have expressed and educated us to in literature, and like them through his art, he raises the apparent disorganization of his material to a level of intuitive comprehensibility.

The relationships of photography to the painting of the past hundred and twenty years are meaningful in the context of Rauschenberg's work. The early photographs, as we know, had compositional influence on the work of Ingres and Degas; we are also told, and it seems sensible, that the photograph took certain of art's functions away from art; especially the idea of art as a record of appearances, portrait, landscape, historical event. Thus much of the impetus to abstraction in art is laid to the move away from the function of photography. It is curious that with Schwitters and the Surrealists, and now with Rauschenberg and Warhol, the photograph has re-entered art; not as a compositional influence, or as something to be copied and altered (as in Cézanne) but as exactly itself. So much of our awareness and our information comes to us through newspapers and magazines, through movies and television, that the appropriation of the photograph into contemporary art does not surprise. In the Rauschenbergs of the mid-fifties photographs and reproductions act as short-hand indications of both their subjects and the context from which they have been drawn.

With the White Paintings of 1951 Rauschenberg apparently wiped out the history of painting; after that he was free to invent art all over again; that his work has continued to reflect a wide knowledge and use of the history of art does not negate the purity of the gesture. It merely makes it more ironic. With the black and red paintings of 1952 and 1953 he rediscovered texture, brushstroke, value, color and collage. Then came the tremendously rich and varied period of *Charlene, Rebus, Hymnal, Odalisk, Curfew Monogram, Trophy I, Winter Pool* and *Pilgrim* (1954-1960); through these years the collage elements became bolder and more spare, the abstractly brushed areas larger and more beautiful. In 1961 and 1962 it seemed as if the combines were becoming increasingly aggressive toward the viewer and his space; the tension and balance of paint and collage on the surface of the painting was broken in piece after piece (*First Landing Jump, Coexistence, Third Time Painting, Pantomime*) by the physical presence of the three-dimensional object.

The Mona Lisa drawing (and others) of 1958 pointed the way to a break in style, although it was impossible to know it at the time. These rubbings with abstractly configured hatching are of course based on familiar photographic material juxtaposed, as in all of Rauschenberg's work, according to his own non-literal logic. They led to his ambitious and successful major work, the drawings illustrating Dante's *Inferno* (1960). It is curious that at just the moment the combines were becoming so sculptural, Rauschenberg's greatest energy was directed toward these highly original two dimensional works, works which combined through the frottage technique Rauschenberg's characteristic specificity of image with the abstractness of meaning, organization and overall handling.

Rauschenberg had been talking and thinking about the possibility of translating photographic material directly onto canvas for some time. In 1961 Andy Warhol began using the silk screen to reproduce the popular image exactly on canvas. This technical possibility, indicated by Warhol, made it clear to Rauschenberg that he could translate the specificities and ambiguities of the drawings onto canvas. He ordered many screens made, some from photographs he had taken himself. It is obvious that Rauschenberg's use of the silk screen for his own purposes differs tremendously from Andy Warhol's. Warhol lays the screens down in repeated series, emphasizing the reiteration of our popular images. Rauschenberg uses the screens exactly as he used the rubbed newspaper photograph in his drawings of 1958, to produce his floating, yet anchored images.

The black and white character of the silk screen paintings is a happy reduction of means. The effect of the very large (thirty-three foot long) *Barge* is very much like sitting in the first row of a black and white, large screen movie. The images flash by and we make connections; we end up with-

out a story, but with something much richer—the associative and imaginative leaps that Rauschenberg's works open up for us. (pp. 62-6)

Henry Geldzahler, "Robert Rauschenberg," in
Art International, *Vol. VII, No. 7, September
25, 1963, pp. 62-7.*

Max Kozloff (essay date 1963)

[*Kozloff is a highly esteemed art critic and author and
the winner of a Pulitzer Prize for his work in the* Nation
magazine. His writings include, among others, Photography and Fascination *(1979) and* The Privileged Eye
*(1987). In the following excerpt from his review of a
1963 exhibition of Rauschenberg's works, Kozloff discusses Rauschenberg's silkscreened compositions, singling out his originality and the poetic quality of these
works for special notice.*]

Robert Rauschenberg will continue to be dismissed by
many as a belated Abstract Expressionist, one whose dribbles and splatters of paint have merely thinned and shrunk
to give way to objects or reproduced images of daily life.
Others consider him to be a decorative practitioner of the
collage technique originated earlier in the century in the
Merzbilder of Kurt Schwitters. Perceiving that he is neither the one nor the other, a third group—one could already have guessed—makes him out to be a compromised
talent that vitiates none too original ideas by sheer facility.
This, however, still leaves those spectators, among them
myself, who find something far more poetic than additive
in Rauschenberg's sensibility and who are kindled by an
inventive genius they would never confuse with mere
slickness. I am convinced that his is the most significant
art now being produced in the United States by anyone of
the younger generation.

It has only recently become evident that Rauschenberg is
using his famed concept of "combine painting" (in which
there had been a dialogue between actual objects—Coke
bottles or pillows and the easel picture) as a point of departure for a whole new field of inquiry. Or rather, it is a
frame of reference for an imagery that now recedes into
the fibers of the canvas, from which it once had protruded.
This is accomplished by the silk-screen transfer to the canvas of photographs, originally black-and-white, and now
filtered by as many as four colors. That the new presences
do not have the immediate, yet enigmatic, impact of real
things is as obvious as that their range in time, space, and
memory is infinitely greater. Even while surrendering a
good deal of physical substance, the artist remains faithful
to his original premise that formal relationships alone are
an insufficient reflection of reality; at the same time, he refines his intuition that raw artifacts need some further projection into the pictorial life of the work of art.

The difference between what Rauschenberg now does
(which was anticipated by his rubbings, *frottages,* illustrating Dante's *Inferno,* 1959) and his earlier bipartite constructions is like the difference between the cinema and the
theater. Only two years ago, in **Pantomime,** two opposed
fans, plugged into the picture, "blew up" gusts of paint between them. But at his present show at the Castelli Gallery
the air currents have been cut off, the sound of motors has
ceased, and there is only a flickering, grainy, shadowy bal-

let of newsprint ephemera, colliding bodilessly with one
another on a surface whose continuity their disruptions refuse to acknowledge. Compared to the behavior of these
vicariously perceived figurations (which are the traces of
things rather than the things themselves—not even such
things as pasted photographs would be as palpable), the
once complex tactics of collage seem primitive and simpleminded indeed.

Initially one is aware not so much of the contained, visually recorded objects as of their baffling removal by reproductive means from the sensing eye. The echoing series of
negative, print, plate, and rephotograph almost duplicate
the infinity effect of anything caught between faced mirrors, and there are at least seven (and conceivably ten)
stages between Rauschenberg's image and the object "out
there." It is doubtless as a comment on the way we receive
news of the outer world, on how we have automated all
communications as mechanized afterimages—the kinescope, the delayed broadcast—that Rauschenberg presents these works, which are neither graphics, paintings,
nor collages, but a piquant composite of all three.

And yet his statement is not unfriendly toward our technological packaging of sensations, but rather welcomes
the inherent language possibilities of the mass media. He
wants to make one aware of interference, of visual static
for its own sake (just as in **Broadcast,** with its two radios
concealed behind the surface, he once did the same with
aural static). But now the effect is not cacophonic, because
the spectator has long been inured to the conventions of
photography in tabloids, films and television and has come
to accept them as adequate substitutes for reality. Rauschenberg takes advantage of this comfort but refreshes and
vivifies it by coarsening the visualization and changing its
context. If our vision is attuned to photography, even to
the extent of expecting to experience paintings in that medium, then, by reconstituting the photograph within his
opened-up perimeters, Rauschenberg ironically arrives at
a new work of art. What was once the echo has become
the substance—but a substance exquisite because, and yet
despite the fact that, it is fossilized.

More than in any of his previous paintings, reality fades
from sight, literally and figuratively. But it is the great paradox of the latest work that its physical energy is kept
whole. Each of these tableaux is part of a continuing badinage between the assertion of paint and the claims of the
outside world, now carried on through the mediation of
reproductive processes. Thus, in **Windward** there is the
following rather breathtaking archetypal sequence: among
color-photographed oranges, the sudden appearance of a
painted orange circle; beneath are black-and-white transferred photographs of oranges, the same orange circle, and
then a painted black-and-white orange, modeled in gray.
Furthermore, all this is done in extremely close values, so
that one is forced to discriminate hues optically with great
finesse, as well as to identify the actual level of existence
among the competing artifacts. In assimilating the recreated matter, naturally, one is compelled to absorb the
paintings both visually and logically, processes that yet
here go at two quite different speeds in the mind.

Far more dramatic are the analogies, say, between drips
and the feathers of a photographed eagle (which recalls
the real, stuffed one in **Canyon,** 1959), or between frequent
rainbows and the four-color separation process. Like an

oblique reference to Abstract Expressionism, these analyses and syntheses reveal how a "painting" is made. But even further, they go back, past Schwitters, to the discipline of Cubism, with its suggestion of multiple points of view. Finally, a black-and-white orange is inconceivable without Surrealism and, behind it, Dada. Hence this Rauschenberg exhibition is a tribute to the insights of all the great movements of twentieth-century art, but it is also a remarkable extension of them.

Within this general framework, whose implications are inexhaustible, Rauschenberg elicits some very particular associations of his own. Scenes of flag-waving patriotism, the Statue of Liberty, vignettes of sports events, the rooftops and water tanks of New York, aircraft instrument panels, capsules and nose cones, and interspersions of fluttering birds evoke the excitability of a mind agog with a welter of current events and vulnerable to the relentless pressure of the urban environment. But it is no inchoate mentality that presents us, in a daring stroke, with a clocklike electrical diagram superimposed upon Michelangelo's Sistine *Last Judgment.* This is, after all, the artist who has illustrated Dante, who punctuates his imagery with stop signs, and who shows the light going out in a series of four photographs of a glass of water (almost like a lamp dimming behind a film strip). It may be too vulgar to think of the overall mélange as hellish, but bright hints of disaster and dissolution are certainly not excluded from Rauschenberg's iconography.

Even the format he chooses—fragments, bleedouts, separations, repeats, superimpositions—mocks the integrity of any object that is caught within the field of attention. One has glimpses of the same image in different sizes and colors, scattered over the surface in a Marienbad simile of *déjà vu.* In fact, the whole procedure is reminiscent of the flashbacks, subliminal blips, filters, cut-ins, pan shots and dissolves of the modern film, so that the spectator is forced to "read" the picture as if it were on a screen, its narrative consistency perhaps shattered but its nostalgic poignance thereby heightened.

Other than Rauschenberg, no artist I know (even including Jasper Johns) takes such a polyvalent and imaginative inventory of modern life. It is this fullness of response that gains respect and is deeply moving. Ultimately he stands aside from the Pop art that owes so much to him, not by his methodology—the interjection of a banal motif into a new context—but by his ambition to derive as much sensuous profit from it as he can. One never feels in his work the complacent sentimental attachment to a subject, however evocative, that so easily degenerates into the frequent sado-masochism of what one apologist has recently called "antisensibility" painting. Such are the beauties of Rauschenberg's new colors, eliciting a chromatic transparency midway in effect between Titian and color television, that it would take another article merely to do justice to them. He satisfies an appetite for the contemporaneous, for an explicit crystallization of what art must respond to at this moment, which few can claim even to excite. He does so in a way that is not only far from self-defeating but gives every evidence of becoming a classic of our time. (pp. 212-16)

Max Kozloff, "Robert Rauschenberg," in his Renderings: Critical Essays on a Century of

Modern Art, *Simon and Schuster, 1969, pp. 212-16.*

Andrew Forge (essay date 1964)

[*In the excerpt below, Forge reviews an exhibit at London's Whitechapel Gallery, commenting on individual paintings and noting that Rauschenberg's "imaginative range is colossal."*]

Robert Rauschenberg's famous ***Bed:*** a real quilt with patchwork squares and a stripey border, mounted on a stretcher the size of a single bed; canvas, a real pillow. The upper part, the part that would be occupied by a person's trunk and head, is painted. Colour zig-zags rough-shod over the folds where the quilt is turned back, cooler on the 'sheet', darkly shadowing the sleeper's side of the pillow. The far side of the pillow is white—turned out, as it were, towards the room or the daylight. Elsewhere the quilt is undisturbed, lying quiet and flat, its rather faded pattern intact. It's not an ironic gesture like Duchamp's bottle-rack nor a magic transformation like Picasso's bicycle-bull. Rauschenberg's bed is just what it says it is.

One's eye goes back to the painted part: one has the sense of looking at a picture. But never of looking at a picture painted on an eccentric kind of canvas. There is no antagonism at all between the paint and the bed, no ironic or aggressive pose. What the painted part seems to be doing is bridging a gap between the general and the particular, making a bed into this bed. But not by embellishing, quite. One doesn't think that it is an extraordinary bed (how would you like to sleep in that?), any more than one thinks that Giacometti's heads have been run over by a steamroller. Rauschenberg endows it with the kind of specificity that belongs to a work of art without displacing it from its given position in the world.

A painter I was with objected: 'But he doesn't make anything.' It's true we miss the sense of shared in-fighting that we are tuned for when we approach freely executed art of this imaginative order. Rauschenberg proposes a new and unfamiliar relationship between the artist and his material. If a figurative painter tends to think in terms of a triangular relationship (Nature, the paint and canvas, and Me) and certain abstract painters of a relationship between themselves and the canvas, paint and canvas acting as a kind of idealised surrogate for external subject-matter, Rauschenberg seems to think of the paint and canvas in the same terms as any other class of object in the outside world. Everything in his pictures remains itself, and a large measure of his strength lies in his capacity for what seems like endless development of his material while still preserving the simple identity of the parts.

'I would like my pictures to be able to be taken apart as easily as they're put together—so you can recognise an object when you are looking at it. Oil paint really does look like oil paint . . . ' All his attention is focused on what is: 'Kerouac had written that he drank a sad cup of coffee. Damn it, a cup of coffee is a cup of coffee.' And somewhere he remarks approvingly of plumbing that, as an image, it leaves 'little room for aesthetic disagreement.'

He does use a lot of highly allusive material—stuffed birds, old-fashioned fabrics and so on. Indeed some of his earlier combines have more than a touch of the Portobello

Road. With them there is room for aesthetic disagreement. But he preserves his curious coolness in his dealings with them. His stuffed bird remains a stuffed bird and doesn't become a character in a nostalgic *mise en scène*. No extra life or weirdness is attributed to it. Nor does he aim at surrealist transformations. If the chimney cowl mounted on a trolley (***Empire I***) had become an emperor it would perhaps have been an easier work, but it would have been at the expense of the chimney cowl and the trolley.

His work is cool, reflective, unrhetorical, never violent, the opposite of weird. The tone of voice is at variance with everything that we expect of 'crazy' materials or the splashes and swipes of Abstract Expressionism. If his juxtapositions blared out at us it would be easier: he could be seen to be making points. But they do not ('I don't consider shock as a possible ingredient in art') and they demand a lot of slow looking, and a willingness to unlearn certain responses. What is he doing with the paint? Certainly not hurling it around in a fine spontaneous frenzy: 'I don't think you should slop around with the paint and emote.' He has the deliberateness of a virtuoso, a marvellously rich vocabulary and command of scale. Whether working broadly with a dripping rag or marking small accents there is no pretence that he is under the sway of some inner compulsion. He knows that his seriousness is not something to strike attitudes about. And yet he has been called slick. Perhaps his detractors cannot accept the fact that the morality of a certain way of painting is not immutable. Rauschenberg calls into question the cult of the unique creative act, the very basis of Abstract Expressionism. He has more than once painted replicas: there is a second and almost identical version of ***Factum*** in the Whitechapel exhibition, drips, 'accidents' and all. 'When you finish a picture and people like it they say, "It's just perfect," or, "It couldn't be any different" . . . I think that's a lot of bull because it could, it obviously could be some other way.'

At first this attitude might suggest nothing but cynical iconoclasm. In fact, it means a great deal more: behind it there is a remarkable modesty, or rather an indifference to the swollen self-projection that sustains the run of modern art, the assumption that the painter justifies himself only by claiming the subjugation of the world to his own world of form. The nightmare of all such painting is its own success: the more complete and consistent it is, the more it verges on self-parody. Rauschenberg questions the very root of it. He broaches its consistency and places himself at a distance from the expressionist situation, while at the same time making full use of the vivid particulars of its vocabulary. He introduces a multiplicity of means, never allowing the parts of the picture to lose their outward, worldly identity.

However incongruous the constituents of his pictures—a necktie buried in paint, a rusty can, a painted-over photo of Eisenhower or an Old Master—one doesn't have the sense of something violated or wrenched out of context. One isn't conscious of discords in his colour—nor of harmonies either, as such. Colour doesn't claim a decorative or idealistic role. The tonality of his pictures is more like the tonality of Whitechapel High Street than it is like any kind of picture, abstract or naturalistic. So too are their

rhythms, or rather the rhythms with which one gets to know them or find one's way about in them.

Montage, which is the fundamental technique on which his work is based, is the activating factor. It allows him to build up complex and sensitive relationships on many levels, to explore counterpoints between formal relations and psychological ones, nuances of feeling which are as broadly based as if the work was both painting and sculpture, book and thing, movie and real life. In looking at a work one finds oneself always on the move. For all the stillness and wholeness of individual parts—a row of coke bottles, a red letter—there is no status quo, no fixed limit within which the thing is read. Rauschenberg will not let the picture rest within familiar boundaries, is always exposing it to the outside world. A flashing light bulb gives a new character to the notion of pictorial light—it also makes us see the picture as we see any other kind of thing that is subject to shifting light. A hole cut in the canvas through to the wall makes us see the picture plane as more than a mere artistic convention. A radio inside a picture gives a random accompaniment, an outwardly shifting ambience for one's communion with the picture. A chair screwed to a painting provides a radical connection with the picture: we are 'in' the picture, as they say, not only because we are caught up in its internal relationships but also because we want to sit in the chair.

Although Rauschenberg is working all the time with realistic images he does not draw in the realistic sense. To draw is also to postulate a viewpoint, to make a claim, which in turn is to cut the draughtsman off from the actuality of what he is drawing. Rauschenberg insists on a relationship which is in a sense less pretentious and also closer to things as they are given. Photographic images have taken an increasingly important place in his work. Their value to him is obvious: they are neutral, yet highly evocative; they can be handled coolly as objects belonging to the outer world, yet they are susceptible to an infinity of imaginative choices. He has explored many ways of using them, sticking them on, rubbing transfers off them, painting over them, printing from them via silk-screens, continually enriching the relationship between them and the total organisation of the work yet never masking the outward, contingent character that photographs always have. They are always active, often engaging us by their topicality, or by their infinite invitations (*pour l'enfant amoureux de cartes et d'estampes*): others are broodingly themselves, a New York skyline, a key. And everywhere birds, birdmen, swimmers, runners, dancers, helicopters, rockets, the flies they carry past the Van Allen belt, images of flight, exhilarating complements to his darknesses, the black material chaos that his paint so often evokes.

But there is no neat scenario. Often the juxtapositions are inscrutable—Rubens nude, helicopter, eagle, street. It is as if one found oneself in a high oddly-shaped room with windows dotted around. At first the sights from each window are so different that one is at a loss to make sense of the total view. Each window seems to reveal a new place: down onto a street, a blank wall, a far horizon with ships, another room with things happening. As time passes the experience becomes unified and it is harder to recapture that mysterious concentrated singularity that each view once had. So Rauschenberg's disparate images slowly come to terms as one's experience of them deepens. But

it is a measure of his imaginative investment in the picture that however at home the parts become they never altogether lose their arbitrariness nor their own vivid character. Of course, his play with the arbitrary goes hand in hand with an iron control of pictorial space that has its roots in Cubism, and of pictorial movement that connects with Klee. There is a picture here called **Studio Painting** which is like a curt demonstration of his resources. Nearly square, it is made of two panels running vertically. Each is covered with broad areas of paint which overlap downwards and open out in scale, setting up a dense space like a bas relief. The left panel is all cool, earthy colours and white, the right fiery reds and yellows, sky-blue and white. A cord is screwed to the left-hand panel about half way down, runs through a pulley on the right-hand panel and is held taught by the weight of a half-filled sandbag that hangs at the bottom right. Opposite the bag at the top left of the picture, in the darkest area, is a photograph: pylons and telegraph poles against the sky and a huge veiled sun. The downward drag of the sandbag is irresistible. It seems to weigh tons. One wonders that the screw can support it. The photograph is exactly related to it, an equal and opposite form, the pylons making a reverse echo with the folds of the bag, the sun with its rounded corners. For the bag's palpable sacky weight, there is the sky, an infinite release. Neither sack nor photograph is anything like the painted areas, but they are not antagonistic either. The sack and cord close a series of firm rectangles that articulate the relief in the paint. The photograph is like a terminal, or an escape, for a line that runs from the real sack through the half-real, half-illusion-making paint. Then also photograph and sack are themselves making the kind of movement, pressing forward below and driving back behind, that the paint is making in its own special terms. If you block out the photograph the sack looks silly; if you block out the sack the photograph looks mute. There is no question here of a surrealist shock juxtaposition. He is handling real experiences, a whole complex of physical and imaginative apprehensions of mass and infinity, of weight and weightlessness, of here and away (although to put it in these abstract terms is foreign to the experience of the picture), and bringing them together in a single organism that we can see and touch and measure with our hands.

Not least of the breaches that Rauschenberg has made in the conventions of his time is in the matter of scale. 'What price a section of an action painting,' Adrian Stokes has asked, 'one section rather than another?' Think by contrast of the role of fingers in *Bacchus and Ariadne* or the elephants' trunks in Turner's *Hannibal*. Such details are not just small pieces of the whole but belong to organisms within the whole. They yield a special range of feeling that is distinct from the larger meaning of the picture, although the larger meaning is unimaginable without them. Rauschenberg's compositions have a similar richness.

In a recent picture called **Kite** there are four silk-screen images, a parade of soldiers and crowded banners extending like a frieze along the bottom; a giant helicopter over jungle surges diagonally above; much smaller than anything else, half way up at the right, a distant beach scene, a line of sand and sky; and dominating the top, a perching eagle. Each image has a distinct scale and spatial movement. These differences are essential: we find ourselves bound up with the character of each and the counterpoint between them. But there is none of that spatial disparity

that makes most photo-montage so boring. He projects them actively into the total picture space: a tall white rectangle supports the eagle as though on a gigantic column, for which the parade below is like a podium. The same white form becomes the sky that the helicopter is flying out of, but also it is a plane between it and its jungle background, locating the machine over the frieze of the parade below. A pale transparent blue soars up to the right of the picture, projecting the sky over the beach, attributing a further vastness to the eagle. But the eagle is in turn scaled exactly against the broad swipes of paint alongside it, which don't evoke anything except paint. They, and the drips that splash down from them, return it again to the actual size of the picture. The four images are now like Cubist planes, hammered out into a tight relief, a carved picture surface. The shadowy bars that project across the photo images seem to be at one with the painted parts, also bar-like, vertical or twisted slightly out. And yet, to say it again, the photo-images lose nothing of their integrity: each is as distinct and mysterious as ever. Rauschenberg has said 'I don't like to take advantage of an object that can't defend itself.'

The two major works here are the illustrations to *Il Purgatorio* and the 30-foot canvas **Barge** completed last year. Both indicate Rauschenberg's breadth and ambition. He is a world-painter, but the opposite of Napoleonic. I can think of no other artist of his age and stature who is so free of aggressive hunger or stridency, or of the primitivism which is the current posture for evading the tragic issues. Rauschenberg approaches his material with unparalleled clarity of feeling, and his imaginative range is colossal. He contemplates chaos without evasion or despair: think of Venus and the truck in **Barge,** and the black, streaming city. Think of his soaring releases, the outstretched winglike aerials, the swimmers driving forward, the constant sky. Freedom too is contemplated without evasion. (pp. 304-05)

Andrew Forge, "Robert Rauschenberg," in New Statesman, *Vol. LXVII, No. 1719, February 21, 1964, pp. 304-05.*

Nicolas Calas (essay date 1964)

[Calas was an author, art critic, and educator who frequently contributed to prominent art magazines and who was best known for his focus on young artists and avant-garde movements. In the following excerpt, he provides a survey of Rauschenberg's works, techniques, and themes.]

Some painters say that the sea is blue; others say that it is not blue; for others, blue is spelled out in red, and there are painters who replace blue by an enigma. Ten years ago Robert Rauschenberg glued, stretched, or crumpled like a hide, newspapers dyed black. Whenever the hide did not cover the whole canvas he painted the naked portion black as well. Ever since the palette gave up shielding him the artist was mercilessly exposed to the blankness of the canvas. For the painter who is a poet, and therefore familiar with darkness, purity is offensive: *We now see darkly.* For RR blackness is not so much a color as a condition in which paper, paint, ink, canvas are to be found. Careful not to confuse painting with action, RR assembles different blacks, placing a glossy one alongside a rough one, a

thick one, or a torn one, and fits them over the surface of the canvas. *We now see in enigmas* and do not know whether we shall ever see *face to face.*

From the blacks that do not form a single black we turn to a painting composed of seven identical white canvases. Inescapably the question poses itself: Which one is the whitest white? It is like asking oneself when facing one's image reflected in seven mirrors: Which one is me? *Seven Whites* is a self-portrait, yet even a self-portrait is the image of another. The poet's function is to spread doubt and create illusions. The illusion of greater whiteness or blackness is essentially no different from the illusion of a third dimension. But is the less white still white? Is the glossy black still black when it is next to a dull black? The relationship between illusionists in tridimensionality and color illusionists is analogous to that between priests and magicians. The worshippers of the third dimension, among whom should be included lyrical Abstractionists, such as Soulages and Rothko, are idealists, while artists who exploit differences between colors, as do Hans Hoffman, Kline, and de Kooning, are explorers in quest of disturbing results. RR will not accept that creasing paper is not a matter of color and that the combination of a creased black next to a stretched black is not as palatable as bread and butter. RR sets his seven white surfaces next to each other to show that they are as different as three apples by Cézanne.

(Since when did RR become a poet who explored differences? I am unable to answer this, as all ante-white and ante-black paintings were turned into ashes by two successive fires.)

Color being no more than a quality of paint, paper, or cloth, these materials are not to be subtracted from the painting, and must be treated as part of the pictorial content. Matter, as the ancients conceived it, is under the sign of dualism; for to comprehend it it must be divided. In this sense a painting which consists in splitting a given whole into fragments is a materialist one. To proceed by splitting is to follow an empirical method. It is this schismatic quality that distinguishes modern art from the art which is an imitation of nature. This non-Euclidian revolution started when the Impressionists interpreted colors instead of copying them. Painting has now become a process which includes the artist's handwriting as well as colored material. Painting is no longer a colony of nature and does not have to fit either into the Ptolemaic universe of the Laocoön or into the Copernican universe of Lessing. Painting is its own universe of discourse. Unlike imitative art, which sought to create the illusion of reality (human, divine, or satanic), modern art develops a series of relations that convince us of the illusory character of the appearance of physical reality. The art that does not imitate nature cannot have sublimation as its function; its role is to increase our awareness of the existence of other alternatives. Otherness is more important than beauty. "Je est un autre" (I is another) said Rimbaud. Modern art is schismatic, and all that it proposes is heresy. RR is an unquiet artist and he extends paper's creases and the white's or black's split personality to the very earth we tread on when he makes of dirt the content of a painting.

Dirt is loaded with hidden meanings. A painting, in the last analysis, is nothing but a surface that has been isolated from its surroundings for the benefit of our perception, in much the way a surface of the earth is isolated for the benefit of a landowner. As life springs from the earth, so meanings explode from paintings. RR created a new picture instead of destroying it, when he retained the green shoot that sprang out of *Dirt*'s soil into our field of vision. *Dirt* with its shoot is a new work in the sense that the ruin of the Parthenon is new because different from the original building. Today the Parthenon is a window open to the past, but a painting hanging on the wall should be a window open to views that have been walled out.

RR went on to a series of pictures which included plants, and during their exhibition would water them daily. To see a painting as a window requires insight, an awareness of what lies beyond our walled self. The identification of paintings with a wall is for house-painters who are in no position to cultivate our minds. Paintings, like plants, must live; they are alive when we let them change us and allow ourselves to accept our changed view of them.

The color quality of ink, paint, tar, paper, or metal is to modern painting what the object quality of iron, lead, wood, or stone is to modern sculpture. While RR's paintings are based on the division of the field, his sculptures come into being by the establishment of a continuity between two separate fields. One of his early objects consists of a stone lying on the ground and a vertical wooden pole, the two united by a length of slack string; another consists of a stone hanging at the end of a taut string, just above a little wooden platform slightly raised above the level of the floor.

Division may seem painful through its association with loss resulting from separation. When by means of a heavy stone and stout rope looped over a metal nail, RR anchors a block of wood, or when he lets a stone hang freely at the end of a string in a narrow box on a wall, we are able, through the missing image of boat and clock, to pre-empt departures and the passing of nostalgic time. No strings are attached to the stones that tumble among nails when we rock the container of the ***Musical Box.*** It is a sculpture, in the sense of a violin—baroque, feminine, and conversational; or a stone gong—magic, somber, mountainous, and authoritative. RR's musical box rattles secrets crushed in old chests, in the world of junk, where magic has taken refuge in this age of ready-mades.

The materialist doctrine, according to which all that happens is in the last instance due to chance, was refuted by its opponents on the grounds that if in a game of chance the lucky number came out four hundred times in succession this could only be due to the will of God. These arguments now seem puerile because, through the study of chance, man learned, in his heliocentric era, of the existence of laws of probability. But RR lives in the era of relativity. When he composes a sculpture consisting of a heavy rough block of wood and of twenty-one smooth rounded pebbles in a heap on the block, and affirms that the position of the stones can be interchanged at will without altering the aesthetics of the whole, he is asking us to re-examine the relation of chance and art. He appears to be denying that aesthetic pleasure depends on a strict order (in contrast to those who see the beauty of mathematical formulas when they fall into a neat pattern), for he has made use of the notion that uncertainty is part of our delight. The indeterminacy in art, the *je ne sais quoi* that was seen as an attribute of human beauty, has been extended,

through Abstract Expressionism, to the pattern, intentedly unidentifiable. The artist who is sensitive to the indeterminate is a poet and, hence, essentially different from both the worker and the gambler who are one in their faith in tangible results.

To return to the paintings: Having extorted new meanings from black, RR attacked red. Red has an emphasis which both black and white totally lack. Red is the most dramatic of colors, bloodstained, regal; orange is a detail of red. In *Traffic Yellow & Green* stripes of red alternate with stripes of yellow fabric dotted with luminous green. Red paint drips across the lines, traffic-wise colors clash with an accident-prone art.

A detailed narrative is touched on in *Hymnal.* An old-fashioned worn-out hanging, sparsely painted, has been turned into an abstract painting through the addition of a few squares of material. A glossy red, reduced to a few square inches, fights for our attention with velvet, once lush, now faded, dusty, and intricately curvilinear, as were the events which may have taken place in the parlor, too red for its size; for a family too red, for their guests too red. It is the pin-up red of a Valentine heart. The murky middle-class interior has been tuned to murder: pasted in a square in the lower left corner are the traits and finger-prints of a young man WANTED by the FBI. The crime may have been the outcome of a love affair, for in one of the patches the name of a boy and girl have been scribbled upon a heart. Bleeding paint is pointed to by an arrow. Above, a photograph records the victim fallen to the ground. Framed in an opening cut in the hanging there hangs a mutilated copy of the Manhattan Telephone Directory, the hymnal of those addicted to the mysteries and perils of sex. *Hymnal* is a detective story, or rather those elements of one which do not reveal what actually took place in the room with the omitted telephone. How small this room with walls the size of a nightmare must have been when the telephone rang and there was no answer.

RR's collages have been said to derive from Schwitters, probably the most aesthetic-minded of the Dadaists, who was interested in dramatizing forms, and "shows very conventional attachment to the values of art," according to Lawrence Alloway. RR, who shows no attachment to the conventional values of art, is able to dramatize the relation between form and content, thereby giving a Surrealist touch to his collages. But while the Surrealist compositions are riddles posed for the detectives of the soul, RR's are dramas for diviners.

Gloria, Gloria, Gloria . . . without Vivaldi! Gloria, long-necked like Botticelli's Venus, Gloria Vanderbilt thrice a bride with her third man and his happy eyeglasses. We have come to attribute a tabloid quality to fortune, good or bad, and a fabulous heiress is not compared to a Sibylla, as might have been the case in the Renaissance, but is given to occupy a square in a sensation-packed nickel's worth of news. Why does RR reproduce the clippings of the fortunate newlyweds four times? They gloriously occupy the upper left corner of the painting, heading a new chapter in the game of life.

This theme of Fortune opens with the lucky draw of four, the Venus throw of the ancients. The Diviner pursues his game: to the four he draws the ace, represented by a champion jumper, just below the fourth clipping. In the center

of the painting there is an opening, a square hole cut in the canvas, for a snare holds together the isolated players. To its left we have deuces in letters, bold as advertisements, standing perhaps for BI (sexuality) and CO (pulation). To its right we see but a solitary gloomy face card amid non-matching oblongs. It is the clipping of a nurse turned kid-naper. But enough of this dangerous game!

When we have learned not to perceive the difference between Vermeer and Mondrian, all signs are turned into images. *Painting with the Red Letter S* is actually a portrait of S reclining in a red dress. S, the clue to serpents and secrets, is all that remains of the forgotten name on a can which secreted red. The artist who buys his paints cut-rate runs the risk of getting a wrong red, one too thick for canvas or too white for blood. Trade names, whether of vitamins or paints, are the Dada words of Manhattan's Babel towers. RR takes his chances with canned goods while trying them out as in this painting. Canned colors stop or cross or run into one another like cars and pedestrians. There is no way of knowing when encounters will be fertile or fatal. Tanguy discovered himself on his way to Damascus when he jumped from a tram at his first sight of a Chirico. But mystery does not necessarily lie in over-turned Palladian perspectives of metaphysical painters. RR finds it in sweating walls of the wreckers' houses, on billboards with ads as mutilated as Babylonian tablets, in the ever-broadening gap between the lost and its remains. The artist defaces the handwriting on the wall. No reminders of legal consequences have ever prevented street urchins from adding moustaches to Miss Rheingold. Paints that come in cans with meaningless names are colors defaced, colors toneless.

Tonality is for nature, its sunsets, its waters, and its Impressionists. Atonality is in the hiatuses, in streets and blocks, in our skin and blockings. Empirical, unpredictable, magic is in the encounter of a green stain with a dark-eyed child. Images and non-images, squares and neckties are swept into the windblown path of paint, often angular, always expressionist. RR's style in painting and pasting remains too personal to permit a pattern, whether classic or baroque, to emerge.

This is equally true of his "Combines," as he calls his constructed works. A follower of Mondrian had once attempted to interpret the Master's work in terms of square pillars, forgetting that in so doing he was regressing to the sixteenth century, when the statue's mass made a hole in space. An abstract sculpture will fit into its surroundings by interpreting volume in terms of planes. RR did something else again when he translated volume into illustrated planes. He did it with the four vertical sides of the Combine named *Odalisk.* The pillar upholding the box—which is made of the lightest material, a transparent washing—rests on a cushion, as would an odalisk. The collage includes a photograph of two maidens bathing in the sun, giving nude body to an orange rectangle, an electric-chair candidate kissing his wife goodbye, an "Easter envelope," and a harp. Above is the symbolic cock. Easter the feast of love.

Unlike Surrealist objects that, however weird, always form a whole, RR's Combines give the impression of growing up distorted. RR distorts patterns, tattoos reality, vivisects hallucinations.

What has happened to the three beds of Plato, the ideal, or God's bed; the real, or craftsman's bed; the illusory, or painter's bed? Rauschenberg gives the empiricist's answer: "A bed is a bed is a bed." His bed is like a real bed, accidentally isolated from a line of ready-made beds, and like the painter's bed, for it has been defaced by an artist. In a face a beautiful scar is more beautiful than a Greek nose, Paul Eluard once remarked. Now that we know that man is not in the image of God, to the inapplicable divine laws and golden means the artist opposes accidents wrought with significance. The "what happened to that bed?" permits me to enjoy my bed and to forget that in my soul I'm closer to Raskolnikov than to Plato.

As accident is the devil's true name, in the world of art and accidents we need not fear the ghosts of Freudian castles, and can again reappraise the symbol. RR treats the accident as a lost object in need of a new identity. "Une porte reste ouverte ou fermée." ["A door is open or closed"] RR presents a variant: we may alternate in folding the past and the future he suggests in the Combine *Interview,* a triptych whose two shutters can be closed but one at a time.

In *Monogram* the goat and tire are locked in a monogram. We think of an animal jumping through a hoop, of a sacrifice reinterpreted in terms of motor accidents, of the crowning of garlands, of Argonauts of the world of painting in quest of exotic masks. But these are bad habits of the mind. This goat and the defaced cock of *Odalisk* are objects whose symbolic identity has been rejected; they are to be treated as sphinxes, not as photographs of the unconscious.

In *Canyon* the stuffed eagle with a box for springboard spreads its powerful wings over its victim: the feathers of our dreams suffocated in a pillow. Now that RR has made a combine named *The Pail of Ganymede,* one may ask will Ganymede be the eagle's next prey? In *Canyon,* an infant, his arm outstretched, summoning, is lost in the artist's personal mythology. Jupiter metamorphosed into an eagle could well be the patron saint of kidnapers. (A nurse kidnaper was included in *Gloria.*) The key to the solution is in the white and black keyboard framed above the eagle. Black for weight, 360 lbs. of it stamped on a vast field of darkness (upper right side), white for purity. The Statue of Liberty raises its hand like a helpless child whose name is Christopher. Will Christopher grow up to be free in the land of the free? The answer does not have to be given in terms of Jupiter, the bearer of Ganymede; or Christopher, the bearer of Christ; or of the critic, the kidnaper of meanings.

In *Inlet* a white heron takes refuge among outlets of electricity. Oh, the folly of white upon white! Above the heron is a minute seascape with a road running along the periphery of idle coastal land and then, the sea. Another detail is a photo of an eighteenth-century hero—migration into the past—set next to a pair of real-life work pants.

The heron of *Inlet,* the eagle of *Canyon,* the rooster of *Odalisk,* the goat, are we to see these as private totems?

Since 1958 RR has been in full control of his means of expression; he knows how to beat the life out of an umbrella and how to replace a rainbow by a necktie. He was taught that colors are not adjectives but has not forgotten that images too are words. There is no need for Expressionism to be either figurative or abstract for it can also be atonal. RR is one of the very few younger artists of the New York school who have not succumbed to the temptation of reducing mannerism to an empty gesture or to the lynching of colors on canvas. Modern art is a series of absolute beginnings, and artists who were brought up in an iconoclastic world have now brought about the desegregation of images.

When RR asked himself "What is black? What is white?" he plunged headlong into the world of painting. He emerged from this experience strong enough to include the world in his painting. Surfaces become denser, events more crowded. Temperamentally RR is at the opposite pole of those who reduce the world to an archetypal image, a square filled with deodorized or vaporized colors. RR's squares are earthy, but his colors are not plowed into patterns; his prototype is not a worker, farmer, or housepainter, but an actor, prototype of the imitator.

Art for art's sake came into being at a time when painters dropped the heroes of Church and State for the imitators of villains, for actors treated as performers performing, so that their gestures could be included with the analysis of light, form, or expression. But in an atonal frame of reference there is no way of dissolving the act of performing into a series of Impressionist, Cubist, or Expressionist gradations. "Performing" must instead be isolated and treated as a unique whole to be contrasted to other isolated wholes, such as the color "red" or the word "caution." In *Trophy for Merce Cunningham* RR juxtaposes a photograph of Cunningham performing on the stage floor to a gap between planks of wood, one of which bears the printed inscription "Caution, watch your step." If paint can be contrasted to a piece of cloth why not "performing" to danger? The accident that brings to an unexpected ending the series of steps the dancer has watched himself doing over and over again is a kind of event that can also interrupt the performance of a policeman's duty, as is indicated by the photographed fall of a mounted policeman and his horse. What the words of warning are to the photograph of the policeman's accident the Social Security card studded with polka dots is to the dancer.

The world of the stage, although a closed one, is not immune to accidents. The aesthetic value of *Trophy for Merce Cunningham* does not lie in the obvious contradiction between performance and accident but in the treatment of an event, the accident, as a unit in a series which includes items such as printed letters and painted colors. In atonality the musicality of colors has been replaced by interruptions of colors and events.

In *Wager* RR traced his body faintly on the right board while standing with his back against the canvas. This way he contrasts the artist to the world of painting with its accidents, as denoted by the clipping of the sinking ship (central section). Politicians and sports fall within the field of the gamble. We have the photo of the Capitol (lower left corner) and of a KKK member (center), plus a football goal (middle foreground). The artist's portrait is hardly visible even in the original. Perhaps it is a reference to the fact that the painter had once included in his show a drawing of de Kooning which he had erased, implying that not to imitate an older artist whom he admired was

the goal that he had set himself. How well de Kooning understood the meaning of RR's gesture is attested by his selection of a very good drawing for the purpose of erasure, thereby making the sacrifice more painful for RR.

By faintly tracing the outline of his body RR indicates his stand against imitation exemplified by the self-portrait—viewed as a copy of the mirror's copy of reality. This is the meaning of **Wager:** the artist versus the accident. RR gambles with patterns. The clipping of the ball game's goal serves as scale for measuring the proportions of the other squares. Seen in relation to its own square, the goal is a miniature version of the larger square formed, in the upper left corner, of a wood frame and a necktie. What a parody of the artist's goal! And repeated again with the horizontal line attached to a small black square set between the legs of RR's tracing of himself as a naked young man.

A true looking glass included in a work of an artist who does not believe in imitation offers the beholder an excellent opportunity to reflect upon the meaning of reflections. In **Allegory** a mirror has been turned into a pillar bearing the twisted member of an automobile's carcass. RR overcame the uncomfortable sense of volume produced by the protruding mass of crumpled metal by shading parts of the mirror with a dull paint so that only the concave aspect of the bulging form would be reflected. It is as if the mirrored shapes drew back the car's Expressionistic bumper.

This veiled rectangular mirror is pictorially balanced by the circular veil of light, a red parasol flattened like a sun dial against a wall with one section sliced out in Matisse-like fashion. The parasol's missing piece, stiffened with paint, clings like a giant moth upon the wall of a private life. There hang too a pair of blue jeans which have lost their tight grip on the flesh, khaki pants isolated through emptiness, and letters of forgotten words and colors of forgotten yellows. The savagery of demolition has been retained, but the savor of the conflict between work and play has not been entirely lost.

In his paintings of this period RR guides the eye with the movement of brushstrokes. He is able thereby to preserve the isolation of pictorial units in a field that becomes more and more crowded. What is worse than an artist bound to his subject, crucifixion, square, or collage, unless it be the critic who reduces art to the squaring of crucifixions or collages? The artist's mission is to adulterate, and save us from boredom. In **Gift for Apollo** the god's heavenly chariot is chained; art is no longer carried away on romantic flights, it is held by the concrete as the pail's content indicates. In **Pail for Ganymede** Jupiter's cupbearer is replaced by a robot water cooler. When we turn its handle, in lieu of a fountain of water rising, a useless tin can ascends awkwardly up the ratchet. In **Pilgrim,** a chair forms part of the Combine to provide rest for the worshipper with his back to the picture. In **Winter Pool** a ladder, leading to nowhere, forms the central panel. "What do you know about water?" says the painter of the pool to the painter of parlors. "What do you know about red?" says the painter of parlors to the painter of pools.

Gift for Apollo, Pail for Ganymede, Pilgrim, Winter Pool; art must be useless.

Wager, Allegory, Charlene are city scapes: "Where are we?"—Our New Amsterdam like the old one sees itself in squares. The carefully irrigated flats of the Netherlands

modeled Mondrian's ideal city the way Jerusalem modeled the Heavenly City. But New Amsterdam is Babylon. All is confusion in Babylon. RR precipitates, multiplies confusion, his thoroughfares littered with wreckage of cars, debris of patterns; squares bewildered by lights and sordid fetishes; squares black, square blocks, square rooms visited by vice squads; all the griefs Mondrian so neatly avoided are included in RR's polyglot squares. In the red delirium of an interior, color goes round and round like an umbrella. Charlene! Fortune turns. Charlene! Degas, Goya, Vermeer, seen through cheap reproductions become as tasteless as adult education.

In **Trophy for Tiny and Marcel Duchamp** the right panel with its aluminum reflector must be for Marcel, the dandy, while the left, with T & Y is dedicated to Tiny. The glass of water with the spoon, the elixir of water, is an allusion to the Duchamp glass and *The Bride Stripped Bare by the Bachelors.* The middle letters of Tiny's name have stepped into the central panel between the necktie and the trousers. Visually this triptych is a sheer delight with its patches of resplendent red, with its intense sky blues and clouds of white, with its yellow-white clouds and orange-white clouds; clouds in skies, in mirrors, rainbows in ties, clouds in sunsets.

RR is the painter of undecorated reality.

Half a century has elapsed since Futurism turned velocity into the subject of painting, but from the vantage point of supersonic speed how childishly slow is the movement of the Futurist image! If man is not to overreach himself in his attempt to conquer the universe, he must balance discoveries in outer space by the rediscovery of that *now* wherein Parmenides isolated the individual man. In turn he now can be isolated from the before and after. Painting is admirably equipped to free man from all associations with cause and effect. With cold precision RR abstracts objects from the here and there to make room for indeterminacy, so that another may participate in the happenings. Absurdity then becomes manifest. (pp. 169-85)

Nicolas Calas, "Robert Rauschenberg," in his Art in the Age of Risk and Other Essays, *E. P. Dutton & Co., Inc., 1968, pp. 169-93.*

Andrew Forge (essay date 1972)

[*In the following excerpt from his introduction to the Harry N. Abrams monograph on Rauschenberg, Forge emphasizes the eclectic and autobiographical aspects of the artist's works.*]

Nothing that Rauschenberg has done has been detached from an immediate context. He carries his work with him. He is the opposite of the kind of artist whose studio is like a hermit's cell or a laboratory, the only place where things are "right" and work can get done. Rauschenberg has worked in front of audiences and in museums, backstage in theaters, and in hotel bedrooms. If the situation has been intimidating or inconvenient, that in itself has been accepted as a formative ingredient, not as an excuse for stopping. Life has penetrated his work through and through, and each work, rather than imposing a definition of art, springs from a question about the possible contexts in which art can happen.

"Ideally I would like to make a picture [such] that no two people would see the same thing," Rauschenberg has said, "not only because they are different but because the picture is different." John Cage has spoken of a music which envisages "each auditor as central, so that the physical circumstances of a concert do not oppose audience to performers but disperse the latter around-among the former, bringing a unique acoustical experience to each pair of ears."

"Is a truck passing by music?" Cage asked in the same text. Are shadows passing by or sprouting bird seed painting?

Rauschenberg has used chance not as a blind antidote to order but as a way of handling the streaming autobiographic current that is his subject matter. Chance has meant selection, in fact, not chaos. Nor has he used it to exclusive ends, disguised as a system with its own rules and its own internal determinants. It has been a concrete alternative to the problematic confrontations of the studio, an open horizon. If something just happens it is, from his point of view, more convincing than something longed for or willed that doesn't happen.

When he was building one of the sections of the Amsterdam *Dylaby* he was offered the run of a junk yard for material; he was nonplussed. He had not realized until then how much it had meant to him that his objects had just turned up—if not today, then tomorrow. He was not keen on having to select.

When he first worked on silk screens with color he had found it difficult to reconcile himself to the blatant unpleasantness of the silk-screen inks, until he had established that there were only certain colors available, that they were the only ones to do the job, and that, raucous as they were, they could not be improved upon. Then even the screaming pink became possible, because it had taken on the status of a thing.

Whatever stratagem is used to court the unknown, there comes a point at which random material becomes polarized by the particular energy that is brought to bear on it. This is the paradox that fascinates him. He is equally sensitive to both extremes, to what he has called the "uncensored continuum" and to the finest aesthetic precipitation of it. His nonchalance is anything but evasive: it signifies a determination to accept *total* responsibility for what he does and to allow no prejudice, no *parti pris* to scatter this allegiance.

Of course there are preferences, favorite preoccupations, both formal and iconographic. The trailing horizontal line that wanders across so many canvases, a certain crispness around the edges of things, dearly held icons—birds, umbrellas, the Statue of Liberty—and to some extent these favorites threaten the freshness of his contact with material. More than once his obsession with biographical honesty has landed him in a seriocomic dilemma. A certain project involved the juxtaposition of a fountain and a clock. How was the clock to be kept dry? The obvious solution seemed to be some form of umbrella. But its obviousness was suspect. Was it more truthful to accept the personal cliché for the sake of the objective function, or to go on searching for a more recondite solution? Similar scruples surrounded his use of silk screens of President Kennedy, after Dallas had charged that likeness with an unforesee-

able weight. He came to the conclusion that it would have been just as affected to have dropped it at that point as it would have been to have started to use it then.

Making or performing has for Rauschenberg the value of a kind of giving. Many of his works have a personal direction, and are, so to speak, addressed like presents. There was an occasion when a combine was made for an exhibition which secretly incorporated works by two other painters who had been rejected from that exhibition; his own work served both as a sheltering vehicle for them and as a voice raised on their behalf. The idea of collaboration with others has preoccupied him endlessly, both through the medium of his own work and in an open situation in which no single person dominates. In ***Black Market*** he invited the onlooker to exchange small objects with the combine and to leave messages.

Painting is autobiographical, "a vehicle that will report what you did and what happened to you." Several works of the mid-fifties bear out this claim; for instance, the second version of ***Rebus,*** called ***Small Rebus.*** Above the row of color samples that divides the canvas laterally, is a photograph of a single runner curving past an audience of figures in suits seated on a rostrum. Below, three athletes perform on a rope. Related to them is a photograph of what appears to be an ancient brooch representing a dog, its coiled limbs echoing the coiling athletes, and to the extreme left, a fragment of another gym picture just showing a handstand. At the right edge of the canvas is a family group, a snapshot, the father in shirt sleeves and hat, his feet apart, his shoulders high; the mother craning forward with her hands on the shoulders of a bare-footed eight-year-old girl. Beyond are trees and an open prairie.

The center of the canvas is pale, with pasted papers and overlapping gauzes and sparse scribbles of paint. One element is a map, or rather two maps, a section of Central Europe and a section of the Middle West, pasted up to make one. Left of it, eight postage stamps. On the left edge is a detail from Titian's *Rape of Europa,* Europa herself, and above is a bullfight photograph, a corrida, and a child's drawing of a clock face with no hands.

One doesn't have to strain the material in the least to read it as a meditation on his own youth, his family past, his sense of identity. The family group is the only image which is unbroken by paint or anything else. It has peculiar sharpness. The single runner, at full stretch in front of his audience of judges, is ringed in black. The implications of identity are inescapable. Geography and history are implicit; athletic performance takes on the value of an individual life. (pp. 13-16)

Andrew Forge, in his Rauschenberg, *Harry N. Abrams, 1972, 87 p.*

Brian O'Doherty (essay date 1973)

[*O'Doherty was an artist (under the pseudonym of Brian Ireland), writer, editor, and the director of visual arts programs of the National Endowment for the Arts. His works include* Museums in Crisis *(1972) and* American Masters: The Voice and the Myth *(1973). In the following excerpt from the latter, O'Doherty identifies one of Rauschenberg's major achievements as the exploitation of a mode of perception O'Doherty calls the "ver-*

nacular glance," wherein the viewer "scans, sorts, recognizes, briefly wanders . . . , and moves on."]

At Rauschenberg's Jewish Museum retrospective in 1963, the work wouldn't let me settle down, and I remember feeling uncomfortable that I'd brought my street reflexes in with me. You wanted to look over your shoulder to see if you were going to be run over. Rauschenberg had introduced into the museum and its high art ambience not just the vernacular object but something much more important, the *vernacular glance.* While this could be played down as an episode in the history of perception, I believe it was an important moment in the history of sixties art, which, more than most art, made modes of perception its subject and their history its art history.

The sixties made us aware of a history of *seeing* pictures, and Rauschenberg was the first to make this an issue by forcing his idea of perceptual decay. Traditional ways of seeing pictures could roughly be fitted into two categories: the additive and the overall. The additive relates part to part in larger and larger units which eventually add up to the entire painting (a classical and academic habit that de Kooning modernized). Systems of checks and balances inflect each other until the "right" moment halts the process and freezes the picture. The general effect—the additive synthesis—then clarifies the picture, within which little pictures happily reside. Instructed by the parent picture, the eye is invited to make its own compositions within, finding pictures within pictures, details within details, before withdrawing to lock everything in again with the full glance. Nineteenth-century academic discourses are full of discussion of detail and effect, the split-level perception of academic art. "How-to-see" books, an academic hangover dressed up in educational finery, litter the first half of this century, crowded with diagrams and arrows guiding the visual traffic on everything from Cézanne to the Old Masters.

But also in the nineteenth century, the effect rather than the detail was the subject of a tenacious quest, arising out of the esthetics of the sublime. The overall field (and Caspar David Friedrich seems to have had a vision of this) emphasized effect, as various excuses—distance, atmosphere, light, time of day—are used to blur detail, eliminate relational perception and present a single, immediate experience. It was Miró as much as Matisse who later translated atmospheric and tonal subterfuges into areas of pure color and immediate response, thus putting the habits of additive perception out of work and in need of the reassurance Cubism still gave them. From this we can trace a history of a certain mode of perception, or at least the consciousness of it, becoming included in esthetic discourse: Pollock, Rothko, Newman, Louis, Noland, Olitski—at which last point the marginal detail is introduced not to suggest any additive future, but to check the overall glance—now codified as a mode of making art as well as of perceiving it. The marginal inflection of the overall field also avoided one of the sixties' most interesting blind alleys, the monochrome canvas, which failed to enter the historical dialogue in any effective way because it limited options to two major alternatives: total isolation of the canvas when displayed—to protect its absolutism; and a heavy emphasis on facture and staining. The problem here was to delay perception, as Ad Reinhardt learned

to do. Another way out was to develop canvases in series, a return to additive perception of a sort.

All through the sixties perceptual matters were high on the agenda. The theme of invisibility—literal or by inference—cut across such diversities as conceptualism and painting. The urge toward it, encountered around the same time (middle sixties) in many parts of the art world, derived from a complicated impulse. Absolutism, impatience with the condition of art, drugs and mysticism, a hostility toward the audience and toward the perceiving organ, the eye itself, as well as a radical anger at closed options, were all part of it. This impulse, at large in quite contradictory quarters, gave rise to the idea of the death of painting, the irrelevance of tradition, the end of art. Or perhaps, one might say, such matters donated energy to the desire for invisibility. Anyway, modes of perception became as codified as styles of art, in fact perception developed its own "styles," or the facts of style included the modes of their perception. As the first in the sixties to make perception his major theme, Rauschenberg had an interesting relation to all this, though his most upsetting efforts were over by the time this theme became manifest.

His early black and white series touched on the themes of abrupt perception in the offhand way of someone in rapid transit who saw opportunities he didn't have time to take. But he did tag them. He didn't detain himself long enough to give them the kind of serious certification the New York scene demands from an artist assembling a history. In the mid- and late fifties Rauschenberg's mind leaped around with such preposterous ebullience that it was, for the rest of the art community, like living with an ocelot. It leaped on everything from garbage to grass. He planted grass in a box, exhibited it, watered it every day. The seventies, which use the real world to describe art instead of the other way around, have made such daftness prescient, though the results hardly build an imposing edifice on the original insight. When Rauschenberg shuffled his signposts, however, the fallacies of the future were still hidden.

His white canvases were more "airports for the light particles," as John Cage described them, than formal forecasts of the esthetics of minimalism. As palimpsests of the fluctuating environment, they have a kind of short-term function, something done "to see how it would work," and for no further purpose. This vulgarizes the idea of formal esthetic inquiry, and there has always been a cheery vulgarity about Rauschenberg's work that hasn't helped because it isn't *intellectualized* vulgarity, but a genuine liking that is as suspect as his good taste. That his is a coarser and more ardent sensibility than Johns's has led to unfortunate judgments based on Johns's superb accomplishments. But Johns, it should be added, has everything that Rauschenberg has not: a reflective sense of his own history, a brilliant ability to turn esthetic meditation into provocative formal enigmas, a more cultivated gift of paradox created by internal rather than external systems. In other words, Johns provided everything the New York critical intelligence requires to requite its own narcissism. It would be irresponsible to use either of these two artists to expose the flaws in the other, but they have too often been paired in a way pejorative to Rauschenberg. Partly this is because Rauschenberg's work doesn't need criticism the way Johns's does. Johns's work takes the critic very seriously. In the early sixties, Rauschenberg made it no secret that

he thought neither criticism nor its practitioners very interesting. Indeed, the critic's grim orders of priority, pursuit of intention, fabrication of "issues," and so forth, are shadows cast by a self-consciousness Rauschenberg, temperamentally, cannot bear.

For these reasons Rauschenberg's vulgarity and facile taste have been misinterpreted. To the window dresser, whose material is fashion, that is, modes of perception bizarrely jogged, vulgarity and taste are matters to be flirted with. He levels hierarchies by bringing in worthless chunks of the secular world—rocks, twigs, junk, objects of nostalgia—and giving them equal importance to the dress or *object* they surround. A fruitful comparison can be made between the language of Fifth Avenue window dressing and Rauschenberg's assembling habits. And windows are seen not by the museum public, but by the man in the street with the casual eye.

Rauschenberg's esthetic of the unrepeatable glance—the second time you look, the work has changed—is connected to the kind of instantaneous overall perception clarified later by a vastly different kind of art. But once the Rauschenberg work broke down, that is, on the second glance, it lapsed into a kind of additive dementia. The only time it held together was at first glance. It takes years to put it together again for the museum audience, and of course the past decade has more or less accomplished that. Works such as Rauschenberg's thus have a lost mode of perception buried in them, as the esthetic of "museum perception" instructs academic modes of looking quite alien to the original. Every work, of course, is cued differently by succeeding ages, but Rauschenberg's art of the early-sixties called these processes of perceptual codification into question, or at least made them part of the issue.

The task for anyone writing about Rauschenberg now is to construct, from the museum-broken residues of his work and intentions, a rationale that does not ignore this perceptual history but which does ignore the myth of careless superficiality that disqualifies his work from the strenuous examinations of high seriousness. This will not be accomplished here, for the way must first be cleared of numerous misconceptions. It must be done without the cues usually given by artists eager to assist their work into the historical dialogue. Some artists have a gift for this and some don't, just as some are good at conning curators and some are not. Rauschenberg hasn't been very shrewd in assisting iconographic examinations of his work which put it on the art-historical couch and plumb matters irrelevant to its function. So we find ourselves in the peculiar position, unthinkable with, say, Johns, of acknowledging the artist's original intent and ignoring him as a faulty witness thereafter.

The artist's myth is also a form of "witnessing" the work, of inducing reactions to it consistent with the artist's ambitions, if not always with the work. Apart from the early rhetoric of delight, followed by puzzlement and withdrawal, one has difficulty discerning in Rauschenberg's myth any focus—and myths to be effective must focus disparities into a single state of feeling that can be easily recognized, if not necessarily understood. In Rauschenberg's case there is a kind of failure of self-interest, unique in the New York art world, which leaves his career dispersed. Though the attitudes and ideas Rauschenberg has held to with undoubted consistency—the collaboration with ma-

terials, animate and inanimate, as part of a continuum of activity—are still interesting, they are somewhat outdated through acceptance. This happens to all "original" thinkers, but the outdating has negatively affected the way Rauschenberg's work is historicized.

Though Rauschenberg anticipated many of the newer ideas which have displaced his, no strings have been tied to his work that would pull them into significance now. Yet consider how much Rauschenberg contributed to these subjects: perceptual history, the uses of photography, cross-media insemination, the nature of objecthood, replication and duplication, permutation of images, the use of language, organic literalism, collage, disposability, the body image and kinesthesia, lithography, the limits of museum culture, process, popular culture, the vernacular glance. Considering this wide swath of territory, now much inhabited, one can only conclude that Rauschenberg's spendthrift attitude showed little understanding of the ways in which the New York scene processes historical contributions. This is further confirmed by his innocent transgression of "permissions"—the limits of what an artist is allowed by his colleagues to do, a subject hardly spoken of among artists, and certainly remote from popular discourse.

The extension of his activities into dance, performances and theater—and his happily obtuse ambitions in these areas—lost him former friends. Indeed, the mid-sixties are a distinct benchmark in Rauschenberg's career, when the permissions he had transgressed reformulated themselves to define the territory to which he had to confine himself. Again, one cannot avoid reading Rauschenberg as one who donated to others his own lack of envy, who presumed, as idealistic social reformers do, that programs for the greater good would be welcomed by everyone. He did not realize that members of the art community frequently act against their own interests, are thus unpredictable, and that this whimsy is connected as much to self-destruction as to personal definitions of freedom. For this innocence he paid dearly. He misunderstood the powers of the system of checks and balances that obtains in any scene where the stakes are high—whether it is Florence in the 1440s or New York in the 1960s. It takes time for work to survive not just its period, but the limits a scene places on it, which is why art history is subject to continual revisions. Long-term history is usually more generous than we have a right to expect, seems indeed to have a bumbling sense of fair play. Rauschenberg will, I believe, eventually dominate the sixties in a way that seems unlikely now. Maybe the reasons will be wrong—historical reasons often are—but that is part of the hazard of a work surviving its contexts, part of what we are pleased to call its "many-sidedness." Rauschenberg's work now *includes,* as part of its content, the mode by which it was originally perceived—the vernacular glance. It can still tell us a lot.

The vernacular glance is what carries us through the city every day—a mode of almost unconscious or at least divided attention. Since we are usually moving, it tags the unexpected and quickly makes it the familiar, filing surplus information into safe categories. Casually self-interested, it accepts the miraculous as routine. Its self-interest becomes so habitual that it is almost disinterested. This is the opposite of the pastoral nineteenth-century "walk," where habitual curiosity provoked wonder, but

found nothing except ugliness in the city. The vernacular glance doesn't recognize categories of the beautiful and ugly. It just deals with what's there. Easily surfeited, cynical about big occasions, the vernacular glance develops a taste for anything, often notices or creates the momentarily humorous, but doesn't follow it up. Nor does it pause to remark on unusual juxtapositions, because the unusual is what it is geared to recognize, without thinking about it. It dispenses with hierarchies of importance, since they are constantly changing according to where you are and what you need. The vernacular glance sees the world as a supermarket. A rather animal faculty, it is pithy, shrewd and abrupt, like slang.

Its directions are multiple. Up and down (elevators, overpasses, bridges, tunnels, activity above the street and below it) are as much a habit as side to side. The one direction it doesn't have is distance, or the perspective distance gives. Everything is close up and in transit. Its disorder needs no order because it doesn't require thinking about or "solution." What relationships it perceives are provisional and accidental. The vernacular glance is dumb in terms of what it can't do, but extraordinarily versatile in dealing with experience that would be totally confusing otherwise. It can tolerate everything but meaning (the attempt to understand instead of recognize) and sensory deprivation (voids and absences). It is superficial in the best sense. It is very appropriate for looking at Rauschenberg's work. Indeed, it is possible to see all his work as a vernacular continuum. The chair, the goat, the tire, the ladder, the eagle, the Statue of Liberty, Kennedy, the Rokeby Venus, the helicopters, the birds, the keys, charts, diagrams all stutter by like scenes from an unedited day. For the fundamental emphasis in Rauschenberg's work is process. Its implicit, often explicit medium is time, an emphasis that increased as his work gained maturity around 1955-56, leaving behind the early sense of a diary (orthodox collage of personal material) for lumps of information, globs and drips of paint, and common objects, which remain open, refusing to close the psychological gestalt. It is this lack of closure that indicates process. The slight discomfort in perception, refusing to settle, is exactly what deposits the work in its most appropriate context—something one scans, sorts, recognizes, briefly wonders at, and moves on. What museum display does is check this process or impede it by modes of what we can call museum perception. Indeed, the history of Rauschenberg's work in the past decade is the perceptual wrestling match between the modalities of vernacular and museum perception.

One accepts anything in a museum because one sees it with one's glance, as it were, in quotes. Specimens of past perceptual shock are fossilized, not because they are in a museum, but because of the fallacies of fifty years of art education. The problem in a museum now is to see disparity, disorder, varieties of order, that is, the conventions of "art display," as clearly as we see those of the individual work. We used to be instructed in the etiquette of vision, on how to purge ourselves of the everyday to become sensitive to the dialectics of form. Indeed, this idea of "purification" is carried through in the immaculate spaces of the modernist gallery. Returning to life, outside the museum door, we could become esthetes *manqué* by civilizing the raw with our perceptual idealism. Now this mode of perception, inevitably connected with social and esthetic elitism, has been mugged by the competing modes of vernacular perception—movies, television, advertising, etc. Rauschenberg's work attempted to bring these modalities of perception into the museum, and he couldn't get them very far past the door. The museum took on all the "swinging" trappings, but maintained its essential conservatism. Not that that was a bad thing. But that is another issue. The point is that more than most art in a museum, Rauschenberg's work requires a strenuous effort for recovery.

But this is simply part of the task of recovering art for each generation, the perpetual salvage without which neither history nor the present is properly served. That this is not fully understood draws on museums a lot of criticism, but then museums hardly understand it themselves. There's nothing fundamentally wrong with the idea of a museum; you have to keep things somewhere. Caught in the midst of this process, however, Rauschenberg's works reveal predictable paradoxes and some unpredictable themes. Unrewarding to full contemplative regard, they are best apprehended by the casual glance. Seen that way, their internal relationships hardly exist, though the museum-trained eye invents these relations when given time. As the first glimpse is lost, the work unashamedly begins to proclaim its Cubist origins, and at this point formalist interest begins to wane.

But the unresolved images and objects begin to force a struggle against this reading, for they refuse to reside easily within the Cubist context. The images and/or objects do not suggest propositions to be solved, but appear as aspects of process. They contain, or indicate, no solutions, engender no enigmas. Nor are they absorbed into the picture as shapes or forms; indeed they continually resist any such transformation. They force a steady back pressure against the Cubist readings in which they reside. We are presented not with a criticism of a style, but its relegation to just "doing something," like the nail holding the picture up. Cubism is as cavalierly treated as the objects themselves. It's just to hold the picture together. This is just as much a demythification of a high style as the far more frequently cited Abstract Expressionism. Abstract-Expressionist facture here just "does something" too: it inserts the literal signatures of process, cueing the objects, linking up with their dissociative version of process, its drips frequently locking in components of the surface in such a mundane way that Jasper Johns calls them Rauschenberg's "hinges." In a dissimilar but related way, Davis also gave Cubism this vernacular accent.

Rauschenberg's usage of Cubism signifies a theme we have been unwilling to recognize. Formalist history is based on the persistence of Cubist readings. But it is virtually impossible to use multiple forms without putting one thing in front of another, or at least setting up figure-ground relationships. After the achievements of color-field painting, this issue is no longer an urgent artistic "problem." Problems in philosophy and art share this: they remain problems only so long as they are a rewarding source of energy. They lose their influence not because they are solved—they never are—but because they go out of date. Cubism, as a point of reference in "relational" painting, no longer, as Irving Sandler pointed out, carries the rhetoric it once did. It has simply been absorbed as an art historical "given," and the modes of perception it encouraged are somewhat anachronistic when applied to much post-

color-field art. Rauschenberg's handling of Cubism remains one of the most important hidden aspects of his work. Just as the museum-broken eye ignored the modes of vernacular perception his art introduced, it remained blind to the fact that the same vernacular had been extended to Cubism itself. (pp. 82-6)

Brian O'Doherty, "Rauschenberg and the Vernacular Glance," in Art in America, *Vol. 61, No. 5, September-October, 1973, pp. 82-7.*

Philip Smith (essay date 1977)

[*In the following essay, Smith discusses some of Rauschenberg's activities during the 1970s, most notably his involvement in the founding of Experiments in Art and Technology, a collective devoted to catalyzing "the inevitable active involvement of industry, technology, and the arts."*]

As blatantly as [Rauschenberg's] work incites our sensibilities, it does so with incredible politeness and gentility. This generous and cordial invitation/reception for participation in and of the world has always been, but is more so now, a reflection of an individual's need to confront and, at the same time, work with the world. There seems to be more of a willingness to address oneself in terms of tender subtleness rather than disturbing confrontation, which has caused the impact to become more effective and thereby more far-reaching. This invisible and undefinable effect remains immeasurable in its breadth and scope. The implications of the activity of Robert Rauschenberg on the culture has yet to be ascertained.

More than ever before the work annotates those seemingly vacant moments in our perceptual operations which strongly yet invisibly alter and effect our decisions, opinions, and behavior. What is at work here is not strictly objectness of pictorial representation but a literal flow of perceptual moments and events. Simultaneous occurrence: the presence of all things, of all people in our lives at all times; human history: the casual notation of the events which pass through our lives and irrevocably intertwine and interconnect us all in various degrees to an invisible yet essential network which produces and maintains humanity, its society, its culture. Even though extremely momentary, the work also functions as a calendar upon which social as well as personal events and memories are fixed. This calendar is not based on any mathematical system of thirty days or twenty-four hours, but on human myth and practice in the late twentieth century. It is this source which supplies the work its importance as well as its power and enables it to exist and function in an incredible number of realms. The art of Robert Rauschenberg provides an enormous range of tools with which we may examine, reconstruct, and enjoy our activity and movement.

The magic and perpetual applicability of the work to our lives stems from its founding in the concept of change. Its intended result is the subtle transformation of the individual through the creation of yet another point of reference. Only through a flexible framework can one respond to the continual current of events which collectively and individually comprise our lives. "I am, I think, consistently involved in evoking other people's sensibilities. My work is

about wanting to change your mind. Not for the art's sake, not for the sake of that individual piece, but for the sake of the mutual co-existence of the entire environment."

The creation and exploration of such an environment was the fundamental cause for the founding of Experiments in Art and Technology. At some point there was the entrance of information and technology into and around and about our lives. New ideas, energies, and materials appeared, completely unknown in the history of the world. And as part of the world their potential and application needed experimental study and expansion to ends other than those originally specified. Basically the questions raised were: what is this, how does it work, and how can it work for us? At the time of E.A.T.'s founding the impact of these new forms was so pervasive and overwhelming that the mere acknowledgment of their presence was an enormous job. Even now in the late seventies our approach to the subject remains somewhat unsophisticated and artless. The beauty and applicability of a new information/technological civilization is first becoming apparent.

Rauschenberg's assistance in E.A.T's. founding formalized two major concerns in regard to the production of art, namely working with the unknown both in materials and concepts and working in community with other artists and the world at large.

I struggled seriously with technology. Artists were fossilizing going to the art store. It was the same brushes, you want a cheap brush or you want a good brush, you want medium cadmium or deep cadmium. I think a lot of the interest came out of that mutual curiosity that we were all having; we established the problem. I'm sure that there are future possibilities that no one has been able to digest yet.

The undertaking of an assessment of industry and technology in terms of aesthetic possibilities with larger ramifications for practical and, in an indirect sense, political applications to the receiving social system has created attitudes of concern and curiosity not only toward technology but also toward other disciplines and sciences which affect and direct our lives. Logically I could see from working in E.A.T. and with industry and technology that there was no aesthetic and a resulting lack of conscience. They were in control of a lot of materials, mediums, and ideas that ought to have been public property long before the princess telephone was invented. E.A.T. was a complete failure because of the terror that industry felt by these foreigners in their midst. The most rewarding part of E.A.T. was working with the engineers and scientists and traveling from profession to profession. Industry has tried to continue the interest, particularly on the research level which they are completely dependent on because there is a certain point where you don't need any more money, you don't need any more pension plans, you don't need any more golf courses or tennis courts or swimming pools or hi-fi sets and they don't know what to bribe this curious human being with. We wanted their access to information and miraculous materials.

"Access to information and miraculous materials" was an aggressive attempt at working art and aesthetic consider-

ations into the population at large. For the first time there was (and still is) the possibility of having art a part of everyone's lives from both specific as well as anonymous sources. Much of the ideas, energy, and excitement that was generated in connection with E.A.T. has been refined and applied on a smaller scale to his individual work in the last few years. As with E.A.T. Rauschenberg has continued his examination of different materials as well as the "search for the possibility of working more or less in community. Encouraging, inviting, the best aspects, the most involved aspects of different people to possibly eliminate the idea of the one man football team."

Underlying these operational innovations remains his willingness to promote and accept change. "I've nearly always made changes, sometimes exaggerated changes in the way that I'm working because I'm beginning to feel comfortable in it. Otherwise I'm not being surprised myself, as the artist. I would rather keep on a pitch with myself so that when I do a piece I can say, 'you did *that!*' The pieces that don't work are actually the anatomy and muscles of the successful ones. That's why so often a successful piece is a bore. I can't work with preconceptions. I trust my immediate response. It's awfully hard not to do something that you already know. I am not interested in proof because if you can prove something, then you are imposing another restriction on that individual. Franz Kline once said that one of the most uninteresting things you can be is right." This respect for the inherent identity of the art and its making is an integral part of his approach to his job and responsibility as an artist.

Robert Rauschenberg continues to set and work toward seemingly unattainable and as yet unestablished aesthetic goals. The existence of an artist fully realizing intention and potential is not only overwhelming and humbling but truly astonishing. His prolificness stems from his reaction to and respect for our expansive and bountiful civilization as well as the unique worth and importance of each individual in the creation and advancement of every human community.

It is really not necessary nor very satisfying to specifically list and superficially describe and discuss what works. Robert Rauschenberg has presented for public viewing over the last few years. Their range in material and content has been enormous. Some have been more successful than others. Underlying each exploration has been the consistent and honest commitment to the actuality of events and the creation of an art that will not "tell you something that you already know." His concern with the realities and dimensions of human being in all its aspects from hunger to celestial navigation celebrates and comments on the enormous and continual human drama of which we are all a part.

The most simplistic yet profound comment that can be made about the work of Robert Rauschenberg is that it is human. Human in the most complete and fundamental sense:

> The most important reason I'm interested in art is, I know this sounds corny, its power to communicate. I think that concept has been very misused. I mean it very literally in the most direct, simple terms. I feel selfish in the sense of being so interested in art because of that reason. I'm doing it because I'd like to encourage a more flexible and rea-

sonable reaction to the actual moment itself. I think that if I were ever successful, completely successful in my work, then there would be no need for art.

(pp. 120-21)

Philip Smith, "To and About Robert Rauschenberg," in Arts Magazine, *Vol. 51, No. 7, March, 1977, pp. 120-21.*

Roger Cranshaw and Adrian Lewis (essay date 1981)

[*In the excerpt below, Cranshaw and Lewis discuss the significance of Rauschenberg's work, concluding that he was negatively influenced by too much early praise, with the result that his most recent works are "little more than bland combinations of pseudo junk and scenic mush."*]

One of the most difficult things for a living artist to cope with is to become an object of hagiography in some quarters, vicious critical dismissal in others. Either approach misses the target of explaining qualitative distinctions within the artist's oeuvre to date in terms of its creative tensions. One of the worst things for its audience is a closure of the terms of critical discourse. Both have happened in Rauschenberg's case.

The bulk of Rauschenberg criticism has been devoted to seeing his work as capturing the picturesque potential of the American urban scene. Rauschenberg's work lends itself to a culturalist interpretation, but this tends to obscure any fundamental reading of the works themselves. In brief, the standard critique casts Rauschenberg in the role of a youthful, infinitely naive, Walt Whitman, encouraging us to participate in seeing the world as if for the first time, subscribing, that is, to the myth of the American Adam. From this viewpoint, the Combines, produced in the seedier parts of downtown Manhattan, are seen to sustain the myth of the artist as urban savage promoted by [Harold] Rosenberg, the ingredients of Rauschenberg's 'soup' being the debased fragments of this dilapidated area. The Combines are seen to celebrate Rosenberg's mythical 'Tenth Street'.

Rauschenberg's way of working in and on that milieu is described as being essentially Whitmanesque. He doesn't transform, he inventorizes, he 'names'. Rauschenberg 'names' however, not through poetic utterance, but literally by taking up the objects of his environment, which take on indexical value insofar as they measure the passage of the artist through a particular situation. Rauschenberg's creative process in producing the Combines takes the form of a stroll around town in which the artist's sense of idle curiosity is given free play to engage, on the basis of unpremeditated chance encounters, with the environment. Brian O'Doherty [see excerpt dated 1973] described it as the city-dweller's rapid and roving way of looking, the "vernacular glance". The kinetic morphology of the artist's creative process becomes more extended and diluted than the Action Painters', a process of quasi-performance with objects rather than de Kooning's internalization of this same 'no-environment', followed by an explosion of gestural activity. De Kooning's problem is to get his 'objects' out, and the answer is a Dodge-City shoot-out. Unlike de Kooning, whose 'act' is based on the gestural trans-

formation of his 'objects', Rauschenberg's 'act' is simply one of placement.

Given this dominant culturalist interpretation, descriptions of Rauschenberg's work tend to emphasize the formal attributes of decomposition rather than composition, discontinuity rather than continuity (both in individual works and between works). John Cage [see excerpt dated 1961] wrote, for example, that a combine was not a composition but "a place where things are" and compared its layout to "two roads" which cross. An implicitly extendable and nonhierarchical grid-like organization of the picture plane is seen to imply a totally uncritical openness to the environment such that the picture-plane is described as an essentially "egalitarian" surface of randomly appropriated forms. While not wishing to deny either the culturalist or formal interpretations of Rauschenberg's work, we intend to challenge the exclusivity of these two readings. Our position is that they have proved to have been too complementary, too symmetrical, to the extent that the possibility of other readings has been denied. By infusing specific formal characteristics of both Rauschenberg's works and his working methods with over-generalized and highly conventional cultural meanings, the impression has been given that Rauschenberg's work is a closed book—a closed book which could be opened at will to provide, when called for, ritualistic critical incantations. In a sense, Rauschenberg was read too completely too soon. The text has taken on more significance than the objects it was supposedly describing.

Where the culturalist/formalist reading of Rauschenberg falls short is in its dismissal of the significance of imagery. Characteristic of almost any text on Rauschenberg is the fact that at a certain point it degenerates into a listing of recurring imagery. But nothing is made of this. Nothing *can* be made of it (apart from ritualistic invocations of the Whitmanesque model) so long as naivety of vision and randomness of choice are seen to be central to Rauschenberg's aesthetic. Thus over nearly three decades, we have received no substantive insight whatsoever into the semiological intelligence which animates so much of his work.

However, a major challenge to normal Rauschenberg criticism is to be found in Charles Stuckey's 1977 article 'Reading Rauschenberg' [see Further Reading, section III]. Stuckey argues that Rauschenberg's work is indeed susceptible to a literal reading, to the extent that he provides us with a linear translation of **Rebus** (1955), which he refers to as a 'diagram'. Stuckey's univalent reading of **Rebus** is vitiated by his own listing of a large number of additional verbal-visual linkages, which implies the essential multivalency of the work. His misapplication of iconographical exegesis to modernist art is based on a fundamental misunderstanding of the nature of modernism. One of the first things, after all, to disappear with the advent of modernism was a collectively legible narrative and symbolic content. In contrast to Stuckey, we would argue that Rauschenberg's work emulates the process of signification without actually being reducible to stable linear 'meanings'.

It is a mistake to assign fixed meaning to Rauschenberg's imagery. However, a simple look at the works does reveal, not a series of discontinuities, but rather an exploration of a limited range of images throughout his career. We can assert, then, that we are dealing with what becomes a closed system of signification, subject to what becomes similarly a closed system of operations. The problem is that, because the artist has not supplied us with any means of decoding these interpenetrating systems, we are denied the possibility of ever penetrating beyond the screen of signifiers to the signified core. Hence the misinterpretation of his work as the representation of an undifferentiated visual flux.

What in fact is happening is that the works invite decodification but frustrate its operation. This invitation to find meaning is made explicit in the titles of some works (**Rebus, Allegory, Decoder**), the instructions of sometimes incomplete linguistic signs ('That Repre . . . ' in **Rebus**, 'Order, View' in **Hazard**), and the reproduced image of a key. But despite the invitation to unlock the signification of the imagery, we are denied a purchase on the work. In some works, however, we *are* supplied with a text or stated theme, as, for example, in the **Dante Drawings** (1959-60), **A Modern Inferno** (1965), the **Stoned Moon** series (1969-70), **Currents** (1969-70), or thematic posters like **Earth Day, April 22** (1970). It is understandable that we feel most comfortable when we are provided with such a code.

We are not able to penetrate to any implied 'meaningful' essence in Rauschenberg's work. So the most we can do is to describe the workings of the system as a whole. The most straightforward way is to trace the history of a particular image through a range of operations. The image of the tyre, for example, proves particularly fertile in this regard.

The tyre first appears as a direct print on a scroll of paper (1951). There are three basic states in which the tyre appears to us, of which this example is the first—a direct trace. This reappears as the dirt and resin cast of a tyre track impressed in clay in **Hound (Tracks)** (1976). A reversal of Rauschenberg's normal way of working, the tyre-print occurs first as a 2-D image and much later as a 3-D image. The second state in which the tyre appears is 'as itself' in the combines from **Monogram** (1955-9) onwards, 3-D works, and the performance **Map Room II** (1965). The third state is the tyre as a photographic image, appearing in a straight photograph as early as 1951, as transferred from a pre-printed image using solvent (transfer drawing) from at least 1959-60, as a silkscreened photograph on paper, plexiglass and canvas in the sixties, on satin and silk in the seventies.

A tyre used once or twice might merely signify itself. A tyre used in several different states, and subject to so many different usages, obviously implies a degree of significance which belies the claim that Rauschenberg's choice of imagery is either arbitrary or uncritical. However, when it comes to describing his use of the object as a signifier, we are faced with an abundance of competing semantic possibilities. We should emphasise here that we are not making, or claiming to make, any kind of traditional iconographic analysis. We do not wish to be accused of the kind of literalism of which we accuse Stuckey. We are merely saying that Rauschenberg's imagery invites speculative interpretation of the kind which we offer. For example, the tyre's most appropriate significations are related to circularity and motion. Furthermore, an unmounted tyre could also be read as all-orifice, waiting to be (ful)filled. As an imprint it is a direct indexical record of time and motion.

Monogram is a particularly excellent example of the semantic loading of the tyre as signifier. The bizarre silhouette of the goat is contrasted with the geometric regularity of the tyre. The goat's static rootedness is contradicted by its dynamic associations. At another level, exoticism (goat) is compromised by banality (tyre). The tyre itself has its treads painted white. Thus it is a reversal of the normal white-walled tyre, an inversion which emphasizes its precious disfunctionality. At another level, the goat penetrates the tyre as orifice. Again, however, we are faced with an inversion of the norm, since the goat, clad in its shaggy fleece, appears soft relative to the erect rigidity of the tyre. We have suggested that the goat inside the tyre can be read as a sign of sexual penetration. In other works, this reading is made more explicit. In the 1965 performance *Map Room II,* a man is inserted into a short tunnel constructed of tyres.

The dynamic implications of the tyre as part of a wheel appear fully embodied in the literally mobile combine called *Gift for Apollo* (1959), where a bucket (yet another recurrent image) acts as a sheet anchor. In a sense, then, the chariot is grounded in its imaginative flight by a female sign (bucket/receptacle). This frustration of the possibility of movement reappears where wheels are suspended, encased, or upturned à la Duchamp. A tie is also appended to Apollo's 'chariot'. The tie appears quite often in the combines of the late fifties, early sixties. A tie, of course, could be read as a phallic symbol but, in order to emphasize the semantic richness of Rauschenberg's choice of imagery, we might also tentatively, if playfully, mention that 'tie' sounds like 'tyre', while 'a tie' *is* 'attire'. Furthermore, a tie has a sharp pointed end. It can act as, or echo, the form of a directional sign, an arrow, a frequent Rauschenberg motif. In *First Landing Jump* (1961), a tyre seems to act as a buffer between the picture and the spectator. The title invokes another key image of movement, the parachute. The parachute appears as a child's toy in the 1956 combine owned by Jasper Johns, as a silkscreened image in paintings, and as a prop in the 1963 performance *Pelican.* It is associated with the umbrella, which appears in *Charlene* (as a sort of colour chart), *Tower* (1957), *Allegory* (1959-60) and the 1978 *Mollusk (Scale)* series, and as a photoreproduction alongside the parachute in the lithograph *Autobiography* (1968). We also note in passing that a parachute is associated in shape with, but functionally the inverse of, a balloon, a less frequently recurring image, but part of a whole range of flight imagery in Rauschenberg's work—birds, helicopters, airplanes, space rockets, etc. The parachute is a kind of windjammer, and Rauschenberg called a group of 1975-6 works his *Jammer* series.

As we have already said, the most significant formal characteristic of a tyre is its circularity. From a formal point of view, then, we can suggest a range of associated images based on the circle—dishes, plates, hats, buckets, dustbins, fruit, doilies, rosettes, breasts, balls, head-lamps, paint-cans, also images eliciting ideas of change (barometer), motion (speedometer), and time (clock). In *Autobiography,* in fact, Rauschenberg depicts his life as an open-ended spiral motion, presented alongside an image of literal motion, a motorcycle wheel circling an occult life-chart overlaid by a vanitas-like X-ray image.

For R. W. Emerson, the circle was the 'primary figure' repeated throughout nature, and the natural world, fluid

and impermanent, could be seen as a 'system of concentric circles'. "This surface on which we now stand is not fixed, but sliding." Nothing is secure by the energizing spirit, in which the artist participates. Rauschenberg, internalizing this impermanency, vitalistic energy and artistic 'unsettling', makes of contingency upon time a major theme. It would require a separate article to broach this subject, involving his throwing of the rope and box objects made in North Africa into the river in 1953, his interest in performance, the literal motion of his experiments with E.A.T. like his *Revolvers Series* (1967), screened images on revolving plexiglass discs half-held in a box. Here the works themselves were literally impermanent. The last example depended on the viewer switching on the rotating mechanism. Hence dependence on spectator participation involved temporal contingency, from the 1951 *White Paintings,* which picked up spectators' shadows, dust and light variations in the exhibited environment; through *Black Market* (1961), where spectators were allowed to exchange objects in a case, while recording the exchange on clipboards attached to the painting; to *Soundings* (1968), where screened images of chairs on plexiglass panels were variously illuminated according to gallery noises.

Temporal contingency could also involve process through a number of works, cutting extra lines in the c.1948 woodcuts bound in book-form, adding an additional colour to each of the *Summer Rental* series (1960) or using previous lithographic stones or screens in new works. The literal incorporation of clocks involves an awareness of the act of placement over a particular time-span as measured by the clocks set at the start and finish of the fabrication of *Reservoir* (1961), though the information is not retrievable because of the twelve-hour time-span of a clock. Imagery and format were dependent on time in a deeper sense. Rauschenberg's silkscreen images were highly topical or, at least, of the moment. None more so than the 1969-70 newspaper collages and two silkscreen editions called *Currents,* drawn from newspapers over a period of two months, presented factually (or in transfer reverse occasionally) with no painterly connecting passages. As regards format, the act of placement was an analogy of the contingency of urban configurations, the complex 'random order' Rauschenberg saw in urban life: "trucks mobilize words and broadside our culture by a combination of law and local motivation." Truckloads of images and objects shuffle across Rauschenberg's work as separate units of experience.

The box, like the circle, acts as both sign and form, depicted image and literal object. His earliest Cornell-like boxes literally contain objects of experience, later to be locked as rectilinear compartments inside the combines. The box-form is an analogue of Renaissance pictorial space. The way that the interior space totally subsumed and became identified with the picture-space was a peculiarly Western European development from the Renaissance onwards. Yet the projections from the picture-plane and the compartmentalization of the combines deny this unified illusionism. Indeed, *Inferno XXXIII* depicts a box containing a single eye, referring to the centralized viewpoint of perspective construction, which conflicts with the dispersal of focus that typifies Rauschenberg's work. In the silkscreen paintings the external rectangular format is reasserted but scale and space relationships between the images clash. The box becomes a diagram which carves out an area of

illusionistic depth yet creates spatial contradiction by its very diagrammatic quality, its generally axonometric projection and its forcing recognition of the ground-relatedness of the screen images. We are in a world of illusions and contradictions, in which a geometric box can seem more real than a silkscreened image. The gap between art and life has narrowed to a play with reflections of reality on the picture-surface. Rauschenberg emphasizes this by repeatedly screening two old master images involving mirror reflections, Rubens' *Venus at Her Toilet* after a Titian original and Velazquez' *Rokeby Venus,* indebted to Titian and Rubens. The return to a direct use of materials in the early seventies initially seems to remove this chasing after ambiguity. In the 1971 *Cardboards* the box becomes literal again, though often bearing screened labels or images, yet the picture-format becomes a total box, though with irregular outline, literally splayed out on the wall. In line with the theme of this article, we must stress the multivalency of the box. The box as image, for example, can be read both as spatial diagram and as container or confinement, literal or imaginative. In *Autobiography,* a metaphoric level may be suggested in the way that Rauschenberg glides freely on skates, a parachute on his back, above an image of (mental?) confinement.

Does paintwork also become multivalent? Certainly. It is often said that Rauschenberg reduces paint to the status of object or material alongside other stuff. This is wrong. Paintwork acts both as sign and form. Developing from the Red paintings onwards, Rauschenberg begins to use a particular paint-sign, a short stroke with calculated dribbles sometimes lengthened to a trailing line. This is not actually a critique of the Abstract Expressionist gesture. It works formally holding the surface to prevent spatial piercing, inducing movement, linking or suggesting compartments (Johns calls it Rauschenberg's 'hinge'). However, it also reads as sign, runaway stains, frayed edges, horizon line. It can mimic the eagle's feathers in *Canyon* or become like a shock of hair in *Chariot for Apollo.* It develops into the painterly swatches that link the images of the silkscreen paintings, where again these connective passages obviously play a formal role but also suggest non-pictorial motion and speed, photographic effects and atmospheric conditions. A sweep of grey can create a bank of rain cloud. His paintwork does not normally have body (except marginally in certain early combines, when tubed on directly), but it does have a signifying (as well as formal) function.

The central problem in Rauschenberg criticism, today as much as ten years ago, is to explain the obvious decline in the quality of his work. We would not deny any of the answers proffered to date—early recognition, financial success, creative enervation, detachment from the urban milieu (particularly since 1971, when he began spending more time in Florida). We would simply note that such answers are extrinsic to the development of the works of art which they are claiming to explicate. Any explanation grounded in Rauschenberg's actual creative process must draw attention to the closure of his systems of images and operations.

If we compare an early work like *Monogram* (1955-8) with a later one such as *Phoenix* (1977), in both of which a tyre is used, it is evident that the latter lacks the energy or quality of the former. Contrasting the way the works were constructed, we can begin to find reasons for this degeneration of imagery. In *Monogram,* it is clear that Rauschenberg was still in the process of constituting his system of imagery. In retrospect, we are aware that the tyre has occurred before, and will occur again, whereas the goat (as indeed the use of stuffed animals generally) will not recur with any significant frequency. Rauschenberg, then, was still operating in the gap between art and life, open to new encounters with his environment. He was still the Whitmanesque *flâneur,* literally taking up objects and struggling to incorporate them into his work. The obduracy of the found object forces the paint-surface to lie down. In the three-round contest between the goat and the painting, the painting is floored, and the goat stands victorious in the ring. It should be added that the objects in the early combines had their own history, and a significance divorced from the artwork before they became part of the cycle of artistic production. In *Phoenix,* the tyre appears to be brand new, with no hint of previous usage. The post-MacLuhan *flâneur* sits in his studio armchair and lets his fingers do the walking, ordering up his materials according to preordained aims. The tyre is deliberately chosen out of Rauschenberg's personal stock of images in a self-curating move. This becomes self-parody rather than the fresh rebirth of an old image. A nose-dive instead of a rising from the ashes.

We can't say exactly when Rauschenberg's system of images became closed, though we could suggest that it was around the time when he created a pool of reproducible silkscreen images for the paintings of the early sixties. It would appear, however, that the closure of his system of operations came somewhat later. In a sense, once the stock of images was complete, much more weight had to be put on the search for new modes of operation. In *Solstice* and *Revolvers,* for example, screened images on transparent stacked surfaces move in relationship to one another. Actualizing the kinetic suggestions (and transparency/opacity fluctuation) of the silkscreen paintings, these works really represent the destruction of the deeper tensions of his earlier work by the glamour of a technological toy. The conceptual confusion generated by his early works, oscillating between invitations to meaning and surface banality, is trivialised into perceptual confusion. The semantic interpenetration of images is loosened irrevocably in an optical babble.

The search for a new range of operations has led to the dominance of qualities of reflection and transparency in Rauschenberg's recent work. However, the results are once again junk. Rauschenberg's sense of strain finds release in an increasing preciousness, since the operations have been employed earlier—in a c.1953 muslin-covered cube placed within a wooden box, certain combines, and the transfer drawings. Experientially, the increase in transparency and reflection also becomes a sign of his increasing distance from the origins of his own imagery. Rauschenberg certainly used reproductions alongside objects in his combines, but in terms of a unique application. The transfer drawings are transitional. Objects became reproduced photographs conjured into ghostly being by an aesthetic operation of rubbing, distanced in their visual positions behind the graphic rubbing, lacking surface-integrity on firm edges. (The edges of the drawing do not conform to the edges of the image.) The transparency of the imagery denies it forceful illusionistic quality. The im-

ages in the transfer drawings are one-off by nature but, given a stock of identical source-photographs, imply infinite reproducibility. His silkscreen works finally take up this implication in the repeated use of a pool of screened reproductions. His **Cardboards** (1971) and **Jammer Series** (1975-6) involved him in a return to a direct use of materials, though vitiated by a stylish aestheticism, since there is no sense of struggle to resolve the contradiction between the picture-plane and obdurate forms. The presentation of the materials themselves constitutes the condition of planarity. Tacking unstretched canvas directly on the wall, a gracious nod to anti-form, is allied to the immaterial quality of transfer images printed onto satin, silk or cotton gauze in his **Hoarfrost** series (1974-5). The strangeness of this union is even more apparent in the 1970's combines, with their dissatisfying gap between simple physical construction, itself often subverted in its bulk or weight, and fussy screened images. In **Pawky Cascade** (1978) for example, a bulky wall-structure like a magazine shelf is lit underneath by two fluorescent strip-lights and seems to hover. Paint transfer images on fabric collage cover the under-surface and are seen from a normal viewing position only reflected in the polished metal mirror-surfaces.

Rauschenberg now sees the world through a veil, transparently. Compare **Bed** (1955) with the 1974 **Gush** (**Hoarfrost**). The early bed is a real object of experience literally seized upon and appropriated, in lieu of other materials. (The quilt itself had been used over his car-hood to prevent freezing and was transferred to his bed when his car failed to work). **Gush** is that world of the 1950's turned upside down, rendered in de luxe materials and shimmeringly insubstantial. The confrontation between paint-marks and found object in **Bed** is totally lacking in the later work. The daintily transferred images, including tyres, are almost embarrassed to be found in such surroundings. The strategies, though, are stale and had all been developed separately as early as 1958. The closure of Rauschenberg's systems of imagery and operations here forces the artist, in order to maintain a semblance of incremental innovation, into a flirtation with daintily rococo taste.

Perhaps unwittingly, critics have punished Rauschenberg for his vaunted precociousness. Openness has long been noted to be the fundamental feature of Rauschenberg's work and character. It is obvious, then, that feedback in the sense of sensual and intellectual involvement with his works, implying above all the need for dialogue, was seen by the artist as an absolute aesthetic necessity. This dialogue has always been denied Rauschenberg. Rauschenberg's work has never been formally sophisticated. Therefore a certain kind of criticism was not prepared to take him sufficiently seriously to involve itself in what might have been a mutually beneficial dialogue with the artist. No other body of critics was prepared to consider seriously Rauschenberg's semiological ability, his capacity, that is, to manipulate and transmute the signs and meanings that were available to him. What filled the critical vacuum was a highly generalised and conventional type of cultural discourse, concerned only with promoting the essential 'Americanness' of Rauschenberg's work taken as a whole. This lack of specific critical feedback was lethal for Rauschenberg, as is all too apparent now, leading to a progressive deterioration in the depth of his involvement with the issue of communication through imagery. As a result,

his work has developed into *mere* playfulness celebrated somewhat tediously as 'boyishly fresh' and 'enthusiastically naive'. Stranded on his desert island by insensitive criticism, we find Rauschenberg, over the last decade, producing little more than bland combinations of pseudojunk and scenic mush. In the final analysis it is tragic that criticism which, in Rauschenberg's particular case, was invited to share in the creative process has been a significant factor in closing it down. (pp. 44-50)

Roger Cranshaw and Adrian Lewis "Re-Reading Rauschenberg," in Artscribe, *No. 29, June, 1981, pp. 44-51.*

FURTHER READING

I. Interviews

De Antonio, Emile, and Tuchman, Mitch. "Art Comes from Neither Art Nor Life." In their *Painters Painting,* pp. 87-102. New York: Abbeville Press, 1984.
> Transcript of a conversation taped in 1970 between De Antonio, Rauschenberg, Jasper Johns, and several art critics.

Perry, Arthur. "A Conversation between Robert Rauschenberg and Arthur Perry." *Artmagazine* 10, No. 41 (November/December 1978): 31-5.
> Rauschenberg discusses the genesis of some of his works, including *Bed, Monogram, Odalisk, Soundings, Hoarfrost,* and *Jammers.*

Rose, Barbara. *Rauschenberg.* Vintage/Random House, 1987, 169 p.
> Rauschenberg reflects on his life and aims.

Seckler, Dorothy Gees. "The Artist Speaks: Robert Rauschenberg." *Art in America* 54, No. 3 (May-June 1966): 73-85.
> An interview with Rauschenberg in which he touches on various events in his career as well as his philosophy of art.

II. Biographies

Tomkins, Calvin. *Off the Wall: Robert Rauschenberg and the Art World of Our Time.* Garden City, N.Y.: Doubleday & Co., 1980, 324 p.
> Biography which concentrates on tracing Rauschenberg's relationships with other artists and intellectuals.

III. Critical Studies and Reviews

Ashton, Dore. "Rauschenberg's Thirty-Four Illustrations for Dante's *Inferno.*" *Metro 2* No. 2 (May 1961): 52-61.
> Praises Rauschenberg's drawings of the *Inferno* and discusses his handling of Dante's ideas.

Baro, Gene. "Some London Galleries." *Arts Magazine* 36, No. 6 (March 1964): 15, 75.
> Very positive review of Rauschenberg's exhibit at the Whitechapel Gallery. Baro writes that "at the moment, London is under the spell . . . of Robert Rauschenberg's retrospective."

Calas, Nicolas. "ContiNuance." *ARTnews* 57, No. 10 (February 1959): 36-9.
> Comments on several of Rauschenberg's paintings in the context of a new kind of symbolism in American painting. Calas concludes that Rauschenberg's objects "are to be treated as sphinxes."

Dorfles, Gillo. "Rauschenberg, or Obsolescence Defeated." *Metro 2,* No. 2 (May 1961): 32-5.
> Suggests that the ultimate value of Rauschenberg's paintings transcends the meaning of particular symbols, lying instead in their celebration of the ephemera of contemporary life.

Feinstein, Roni. "The Unknown Early Robert Rauschenberg: The Betty Parsons Exhibition of 1951." *Arts Magazine* 59, No. 5 (January 1985): 126-31.
> Reconstructs Rauschenberg's first exhibition and notes that "the seeds of his later art . . . were already there."

————. "The Early Work of Robert Rauschenberg: The White Paintings, the Black Paintings, and the Elemental Sculptures." *Arts Magazine* 61, No. 1 (September 1986): 28-37.
> Focuses on the role of Rauschenberg's early, minimalist works in his career, concluding that they represented "a moment of (relative) discipline and control."

Forgey, Benjamin. "An Artist for All Decades." *ARTnews* 76, No. 1 (January 1977): 34-6.
> A highly positive review of Rauschenberg's retrospective at the National Collection of Fine Arts in Washington, D.C.

Gruen, John. "Robert Rauschenberg: An Audience of One." *ARTnews* 76, No. 2 (February 1977): 44-8.
> A discussion of Rauschenberg's life and career incorporating comments by the artist.

Johnson, Ellen H. "The Image Duplicators—Lichtenstein, Rauschenberg and Warhol." *Canadian Art* XXIII, No. 1 (January 1966): 12-19.
> Discusses Rauschenberg's works in the context of the use of ready-made images in modern art.

Kostelanetz, Richard. "Robert Rauschenberg: Painting in Four Dimensions." In his *Master Minds: Portraits of Contemporary American Artists and Intellectuals,* pp. 251-69. Toronto: Macmillan, 1967.
> Commentary on Rauschenberg's life and career, stressing his avant-garde point of view and versatile technique.

Kotz, Mary Lynn. "Robert Rauschenberg's State of the Universe Message." *ARTnews* 82, No. 2 (February 1983): 54-61.
> Recounts a visit to the artist's home on Captiva Island in the Gulf of Mexico, incorporating Rauschenberg's observations regarding his more recent artistic, social, and political activities.

Krauss, Rosalind. "Rauschenberg and the Materialized Image." *Artforum* XIII, No. 4 (December 1974): 36-43.
> Examines Rauschenberg's imagery in the light of various techniques and styles of art he invented.

Larson, Philip. "Robert Rauschenberg." *Arts Magazine* 49, No. 8 (April 1975): 78.
> Positive review of Rauschenberg's exhibit of his *Hoarfrost* series at Dayton's Gallery.

Perrone, Jeff. "Robert Rauschenberg." *Artforum* XV, No. 6 (February 1977): 24-31.
> A reevaluation of Rauschenberg's career on the occasion of his exhibition at the National Collection of Fine Arts in Washington, D.C.

Silverthorne, Jeanne. "Robert Rauschenberg." *Artforum* XXI, No. 8 (April 1983): 75-6.
> A complimentary review of Rauschenberg's exhibit at the Museum of Modern Art in New York.

Solomon, Alan. *New York: The New Art Scene.* Milano: Holt, Rinehart, Winston, 1967, 337 p.
> Contains scattered critical commentary on Rauschenberg and the Pop-Art circle.

Stuckey, Charles F. "Reading Rauschenberg." *Art in America* 65, No. 2 (March-April 1977): 74-84.
> Laudatory review of Rauschenberg's exhibition at the Museum of Modern Art in New York. Stuckey also examines the impact of Rauschenberg's work on modern art and explores the meaning of several of his works.

Swenson, G. R. "Rauschenberg Paints a Picture." *ARTnews* 62, No. 2 (April 1963): 44-7, 65-7.
> Traces the evolution of Rauschenberg's painting entitled *Inside-Out.*

Thomsen, Barbara. "Robert Rauschenberg at Castelli." *Art in America* 61, No. 5 (September-October 1973): 112-14.
> Praises Rauschenberg's paintings exhibited at New York's Castelli Gallery, noting that though "he is no longer in the vanguard," Rauschenberg has continued to pursue new directions in his art.

Tomkins, Calvin. "Robert Rauschenberg." In his *The Bride & the Bachelors: The Heretical Courtship in Modern Art,* pp. 189-237. New York: Viking Press, 1962.
> A detailed overview of Rauschenberg's life and career.

Welish, Marjorie. "Texas, Japan, Etc.: Robert Rauschenberg's Sense of Place." *Arts Magazine* 60, No. 7 (March 1986): 52-4.
> Commentary on the influence of Rauschenberg's travels on his art.

IV. Selected Sources of Reproductions

Forge, Andrew. *Rauschenberg.* New York: Harry N. Abrams, 1969, 230 p.
> Reproduces many of Rauschenberg's works, some in black-and-white, and some in color. Also contains a critical essay by Forge (excerpted above), an autobiography written by the artist, and a comprehensive bibliography.

————. *Rauschenberg.* New York: Harry N. Abrams/ Meridian Books, 1972, 87 p.
> A concise paperback version of Forge's 1969 book (see entry above). Contains fifty-one plates, some in color, as well as the critical essay, autobiography, and bibliography that appeared in the original publication.

Institute of Contemporary Art, University of Pennsylvania. *Rauschenberg: Graphic Art.* Philadelphia: Institute of Contemporary Art, University of Pennsylvania, 1970, 36 p. + 99 plates.
> Includes reproductions of Rauschenberg's graphics, as well as an introductory essay by Lawrence Alloway.

National Collection of Fine Arts, Smithsonian Institution.

Robert Rauschenberg. Washington: Smithsonian Institution,
1977, 216 p.
 Catalog of a 1977 exhibition includes numerous photo-
 graphs of the artist, reproductions of his works, a chro-
 nology, an extensive bibliography, and an essay by Law-
 rence Alloway.

Garry Winogrand

1928-1984

American photographer.

Winogrand is considered one of the most important American photographers of the post-World War II era. Working primarily in urban street settings, he excelled at capturing spontaneous moments that demonstrate the complexity, chaos, and incongruity of modern life. Winogrand is also esteemed for his unorthodox yet highly effective approach to visual composition, and critics have praised in particular the dynamism created by his tendency to crowd his pictures with varying images, as well as his habit of frequently aligning the camera along the vertical rather than the horizontal axis of the composition, which produces a vertiginous effect now known as the "Winogrand Tilt."

Winogrand was born and raised in New York City and first began taking photographs while serving in the Army Air Force during World War II. Following the war, he took courses in painting at the City College of New York and at Columbia University. However, after working briefly in the students' photography lab at Columbia, he decided to devote all of his energies to photography. In 1949, Winogrand studied with noted photographer Alexey Brodovitch at the New School for Social Research, and he was greatly influenced by Brodovitch's documentary style. Throughout the 1950s, he worked as a free-lance advertising photographer and photojournalist, achieving sufficient recognition to have his work published in such national magazines as *Sports Illustrated* and *Redbook*. Although Winogrand's early photographs are considered for the most part unremarkable, critics note that a well-known 1955 series shot in New York nightclubs presages the satirical and frenetic qualities of his later work.

In 1960, Winogrand presented his first one-man show at the Image Gallery in New York City. Three years later his work was featured in the exhibition "Five Unrelated Photographers" at the Museum of Modern Art, contributing to his growing reputation as an artist of note. While continuing to accept photography assignments, Winogrand concentrated increasingly on his own works during the 1960s, and in 1969 he published his first book, *The Animals*. An often disturbing study of humans and animals juxtaposed within the artificial environment of the zoo, *The Animals* was neither a popular nor a critical success at the time of publication. However, writing in 1988, John Szarkowski noted: "For coherence of style and meaning, for its achievement of simplicity in bedlam, *The Animals* seems to me the most fully successful of [Winogrand's] books."

Shortly after the publication of *The Animals*, Winogrand abandoned commercial photography in order to devote all of his time to his own work and to teaching. In 1975, he published a second book, *Women Are Beautiful*, which reflects his life-long fascination with women and celebrates their energy, complexity, and self-assurance through crystallized images of their everyday activities. Many critics

acknowledged Winogrand's sincere admiration and respect for women—demonstrated in his own comments and in Helen Gary Bishop's overtly feminist preface to the book—but denounced *Women Are Beautiful* as exploitive due to its exclusive concern with the appearances of women. Some also maintained that the collection as a whole lacked coherence, a criticism that persisted in estimates of his later works. However, a number of critics insisted that Winogrand had taken the art of documentary photography to new heights by adapting its forms to reflect his content and by selecting powerfully evocative images. Winogrand's next book, *Public Relations* (1977), was a largely ironic look at "media events": press conferences, society parties, political rallies and other planned gatherings staged primarily for the benefit of the media. His final collection was *Stock Photographs* (1980), a sometimes humorous, often poignant record of American middle-class culture as reflected in the events of the Fort Worth Fat Stock Show and rodeo. In 1978, after completing the shooting for *Stock Photographs*, Winogrand moved to Los Angeles, and commentators suggest that during his stay there, his exuberant drive to capture images appears to have become an obsession: when he died of cancer in 1984, he left nearly 300,000 unprinted negatives.

Despite some resistance to his candid, loosely composed style, Winogrand has become one of the most revered and imitated photographers of his generation. Critics agree that his evocative portraits of American society during the 1960s will remain among the most significant documents of the era, his multivalent, enigmatic images reflecting the open-ended feeling of the period while conveying its frenetic pace and patent absurdities. Summarizing Winogrand's achievement, Szarkowski has written: "[He] has given us a body of work that provides a new clue to what photography might become."

ARTIST'S STATEMENTS

Garry Winogrand (essay date 1974)

[*In the following comments, Winogrand describes his understanding of the photographer's art.*]

"The fact is the sweetest dream that labor knows." *Robert Frost*

There is nothing as mysterious as a fact clearly described.

What I write here is a description of what I have come to understand about photography, from photographing and from looking at photographs.

A work of art is that thing whose form and content are organic to the tools and materials that made it.

Still photography is a chemical, mechanical process. Literal description or the illusion of literal description, is what the tools and materials of still photography do better than any other graphic medium.

A still photograph is the illusion of a literal description of how a camera saw a piece of time and space. Understanding this, one can postulate the following theorem:

> Anything and all things are photographable.
>
> A photograph can only look like how the camera saw what was photographed. Or, how the camera saw the piece of time and space is responsible for how the photograph looks.
>
> Therefore, a photograph can look any way. Or, there's no way a photograph has to look (beyond being an illusion of a literal description). Or, there are no external or abstract or preconceived rules of design that can apply to still photographs.

I like to think of photographing as a two-way act of respect. Respect for the medium, by letting it do what it does best, describe. And respect for the subject, by describing it as it is. A photograph must be responsible to both.

> Garry Winogrand, "Understanding Still Photographs," in Garry Winogrand: Grossmont College Gallery, 15 March to 2 April 1976, edited by Gene Kennedy, n.p., 1976, 23 p.

Garry Winogrand with Barbaralee Diamonstein (interview date 1981)

[*In the following interview, Winogrand and Diamonstein discuss numerous aspects of Winogrand's career and art.*]

[Diamonstein]: *Garry, the New School is not unfamiliar ground to you. As I recall, you studied here for a short time in the early part of your career.*

[Winogrand]: Yes. It might have been 1949.

You began to photograph just at that period when you were less than twenty years old. How did it all begin?

Cameras intrigued me.

You started out studying painting, though, didn't you?

Yeah, well, cameras always were seductive. And then a darkroom became available, and that's when I stopped doing anything else.

How does a darkroom "become available"?

There was a camera club at Columbia, where I was taking a painting course. And when I went down, somebody showed me how to use the stuff. That's all. I haven't done anything else since then. It was as simple as that. I fell into the business.

You started out supporting yourself with commercial work—advertising photography and such things.

Yes, and magazine work, industrial work. I was a hired gun, more or less.

Why did you decide to give all that up?

I enjoyed it until I stopped. You could travel and get around. I can't really explain why, I just didn't want to do it anymore.

That wasn't very long ago . . .

Well, it was 1969 when I got out of it, more or less.

And then you turned to teaching, as well as your own work?

Well, it was strange, because the phone rang and a teaching job turned up that sounded interesting. And I always did my own work. **The Animals** and a lot of **Public Relations** were done while I was doing commercial work.

When you refer to **Public Relations,** *you're really talking about the title of a book that describes a very extensive body of material you started in 1969 on a Guggenheim Fellowship. During that period, you decided to photograph the effect of the media on events. And you studied ritual public events that very often were planned for the benefit of those who were recording them. What did you find out about that period, and what were you trying to tell us in your photographs?*

I don't think anything happens without the press, one way or the other. I think it's all done for it. You saw it start, really, with Martin Luther King in Birmingham. He did the bus thing. And I don't think anything that followed would have happened if the press hadn't paid attention. As far as my end of it, photographing, goes, all I'm interested in is pictures, frankly. I went to events, and it would have been very easy to just illustrate that idea about the

relationships between the press and the event, you know. But I felt that from my end, I should deal with the thing itself, which is the event. I pretty much functioned like the media itself.

But weren't you the media then?

I was one of them, yeah, absolutely. But maybe I was a little slyer, sometimes.

How so?

Well, at times people in the press were also useful to me, you know.

As subjects?

Oh, yeah, absolutely.

I'm reminded of a picture of Murray Kempton and Norman Mailer in that series at Mailer's 50th birthday party, that has been widely reproduced and discussed in critical essays. Are any of those events ever held just for fun or for the sheer relief of the participants? Are they always done to promote an idea, a cause, a person, or a product?

In my experience, I think it's the latter. I mean, people are going to have a good time, you know. One can go have a good time at these big openings in museums. And people go to have a good time. But the thing has another purpose.

What is the larger purpose?

In the case of museums, it's always got to do with money, people who donate and things like that. And I believe a certain kind of interest has to be demonstrated. The museums want large crowds coming to the shows—it's the same thing. It's hype. Absolutely. But there's nothing evil about it.

Are you really saying that it's marketing?

A lot of it is. And then, of course, you have politics, the Vietnam war and all that monkey business. There are all kinds of reasons. At every one of those demonstrations in the late Sixties about the Vietnam war, you could guarantee there'd be a series of speeches. The ostensible purpose was to protest the war. But then somebody came up and gave a black power speech, usually Black Muslims, then. And then you'd have a women's rights speech. It was terrible to listen to these things.

How was it to look at?

Well, it was interesting; it's an interesting photographic problem. But if I was doing it as a job, I think I'd have to get paid extra. If I ever hear "Power to the people" again, I'll . . . I just found out that John Lennon wrote that song, "All we are saying is give peace a chance." I couldn't believe it. I thought it was terrible; I hated that song. They used to bring out the Pete Seeger wind-up toy to sing it. Tiresome.

I hope that what I'm going to bring up won't be tiresome for you, too . . . The term "street photography" and your name have been synonymous for quite some time. But the streets are not the only place where you've worked over the last twenty-five years or so. You've worked in zoos and aquaria, Metropolitan Museum of Art openings, Texas rodeos. There must be some common thread that runs through all of your work. How would you describe it?

Well, I'm not going to get into that. I think that those kind of distinctions and lists of titles like "street photographer" are so stupid.

How would you prefer to describe yourself?

I'm a photographer, a still photographer. That's it.

If you don't like "street photographer," how do you respond to that other "tiresome phrase," "snapshot aesthetic"?

I knew that was coming. That's another stupidity. The people who use the term don't even know the meaning. They use it to refer to photographs they believe are loosely organized, or casually made, whatever you want to call it. Whatever terms you like. The fact is, when they're talking about snapshots they're talking about the family album picture, which is one of the most precisely made photographs. Everybody's fifteen feet away and smiling. The sun is over the viewer's shoulder. That's when the picture is taken, always. It's one of the most carefully made photographs that ever happened. People are just dumb. They misunderstand.

That's an interesting point, particularly coming from someone who takes—or rather, composes and then snaps—lightning-fast shots.

I'll say this, I'm pretty fast with a camera when I have to be. However, I think it's irrelevant. I mean, what if I said that every photograph I made was set up? From the photograph, you can't prove otherwise. You don't know anything from the photograph about how it was made, really. But every photograph could be set up. If one could imagine it, one could set it up. The whole discussion is a way of not talking about photographs.

Well, what would be a better way to describe that?

See, I don't think time is involved in how the thing is made. It's like, "There I was 40,000 feet in the air," whatever. You've got to deal with how photographs look, what's there, not how they're made. Even with what camera.

So what is really important . . .

Is the photograph.

. . . is how you organize complex situations or material to make a picture.

The picture, right. Not how I do anything. In the end, maybe the correct language would be how the fact of putting four edges around a collection of information or facts transforms it. A photograph is not what was photographed, it's something else.

Does it really not matter what kind of equipment you use?

Oh, I know what I like to use myself. I use Leicas, but when I look at the photograph, I don't ask the photograph questions. Mine or anybody else's. The only time I've ever dealt with that kind of thing is when I'm teaching. You talk about people who are interested in "how." But when I look at photographs, I couldn't care less "how." You see?

What do you look for?

I look at a photograph. What's going on? What's happen-

ing, photographically? If it's interesting, I try to understand why.

And how do you expect the viewer to respond to your photographs?

I have no expectations. None at all.

Well, what do you want to evoke?

I have no ideas on that subject. Two people could look at the same flowers and feel differently about them. Why not? I'm not making ads. I couldn't care less. Everybody's entitled to their own experience.

You describe very complex relationships photographically, in a very sympathetic way, but a very humorous one. Often you do that with juxtaposition, whether in zoos or rodeos or museum celebrations. Let's talk about your animal project. There, as in so much of your work, juxtapositions and gestures that usually pass unnoticed are very significant. You find them worth recording. Here you were, a city boy, how did you come to do a project that involved spending so much time in zoos? Do animals interest you that much?

Well, zoos are always in cities. Where else can they afford them, you know? When I was a kid in New York I used to go to the zoo. I always liked the zoo. I grew up within walking distance of the Bronx Zoo. And then when my first two children were young, I used to take them to the zoo. Zoos are always interesting. And I make pictures. Actually, the animal pictures came about in a funny way. I made a few shots. If you could see those contact sheets, they're mostly of the kids and maybe a few shots where I'm just playing. And at some point I realized something was going on in some of those pictures, so then I worked at it.

Consciously?

Yes. Then at some point I realized it made sense as a book. So that's what happened.

How important are humor and irony in your work?

I don't know. See, I don't get involved, frankly, in that way. When I see something, I know why something's funny or seems to be funny. But in the end it's just another picture as far as I'm concerned.

When you looked at those contact sheets, you noticed that something was going on. I've often wondered how a photographer who takes tens of thousands of photographs—and by now it may even be hundreds of thousands of photographs—keeps track of the material. How do you know what you have, and how do you find it?

Badly. That's all I can say. There've been times it's been just impossible to find a negative or whatever. But I'm basically just a one man operation, and so things get messed up. I don't have a filing system that's worth very much.

But don't you think that's important to your work?

I'm sure it is, but I can't do anything about it. It's hopeless. I've given up. You just go through a certain kind of drudgery every time you have to look for something. I've got certain things grouped by now, but there's a drudgery in finding them. There's always stuff missing.

You sold your very first work to the Museum of Modern Art. How did Edward Steichen come to know your work?

I had an agent. When Steichen was doing "The Family of Man," I went up to the office one day. I think Wayne Miller, who assisted Steichen with "The Family of Man," was up there and pulled out a bunch of pictures. So I got a message: "Take these pictures, call Steichen, make an appointment and take these pictures up there." And that's how I met him.

Did the museum buy any?

Yes, they bought some for that show.

How many did they buy? That was about 1960.

I don't remember.

Do you remember how much they paid for them?

Ten bucks each. Nobody sold prints then and prices didn't mean anything. In terms of earning your living, it was a joke.

Did you ever expect the public to celebrate the works of photographers either aesthetically or economically?

No. First of all, I don't know if they're celebrating. But yeah, I'm shocked that I can live pretty well, or reasonably, or make a certain amount of my living, anyway, off of prints. I guess it's nuts. I don't believe in it. I never anticipated it; I still don't believe it.

How do you explain the current rise of interest in photography?

Oh, I'm sure some of it has to do with taxes, tax shelter things. There are all kinds of reasons. There are people who like photography; there are people who are worrying about what's going to happen with the dollar. They want to get anything that seems hard. I don't know, but I think it's got to do with economics. Now and then you get somebody who buys a picture because he likes it.

What about all those young people who are so interested in photography?

They don't *buy* pictures. Young people don't have money to buy pictures. I don't really have any faith in anybody enjoying photographs in a large enough sense to matter. I think it's all about finances, on one side. And then there are people who are socially ambitious. If you go back aways, the Sculls, for instance, had a lot of money and they were socially ambitious. If you get an old master, it's not going to do you any good socially.

Besides, you can't get enough of them.

And likewise even French impressionists. So the Sculls bought pop. It was politics, and they moved with it. And I think that could be happening, to some degree, with photography, too. It doesn't cost as much to do it, either.

Then you don't have much faith in the longevity of the surge of interest, either economic or aesthetic, in photography. Do you see it as something typical of this moment?

I don't know what you mean by aesthetic.

Well, we're assigning the surge of interest to economic rea-

sons, rather than the fact that more and more people think of photography as a legitimate art form.

I don't care how they think of it. Some of these people are acquiring some very good pictures by a lot of different photographers.

For whatever motivation . . .

Right. Who cares?

But if their interest is economically engendered, then photography could be a short term pursuit.

Possibly. I'll take one day at a time; that's enough! I have no idea what's going to happen. Who knows—if they can't afford to buy a boat, maybe they buy a print. Who knows what happens with their buck?

When I was taking your photograph earlier today, with well-intended whimsy I tilted my camera in an attempt to make my own Winogrand. From what I understand, that's not how it's done. What is the meaning of the horizontal tilted frame that you often use? And is your camera tilted when you make the picture?

It isn't tilted, no.

What are you doing?

Well, look, there's an arbitrary idea that the horizontal edge in a frame has to be the point of reference. And if you study those pictures, you'll see I use the vertical often enough. I use either edge. If it's as good as the vertical edge, it's as good as the horizontal edge. I never do it without a reason. The only ones you'll see are the ones that work. There's various reasons for doing it. But they're not tilted, you see.

How do you create that angle, then?

You use the vertical edge as the point of reference, instead of the horizontal edge. I have a picture of a beggar, where there's an arm coming into the frame from the side. And the arm is parallel to the horizontal edge and it makes it work. It's all games, you know. But it keeps it interesting to do, to play.

There is another photograph that has an arm coming in from that edge, in almost Sistine Chapel fashion. That arm and the hand on the end of it are feeding the trunk of an elephant.

Oh, you mean the cover of the animal book. That has nothing to do with what I'm talking about now. It's just that I carry an arm around with me, you know. I wouldn't be caught dead without that arm!

Has teaching affected the way you take photographs?

I really don't know.

Do you learn a great deal from your students? Do you have any new ideas, any reactions to their reactions?

No, the only thing that happens when I'm teaching is that I hope there are some students out there in the class who will ask questions. Teaching is only interesting because you struggle with trying to talk about photographs, photographs that work, you see. Teaching doesn't relate to photographing, at least not for me. But now and then I'll get a student who asks a question that puts me up against the wall and maybe by the end of the semester I can begin to deal with the question. You know what I mean. It's not easy.

Several years ago a student did ask you which qualities in a picture make it interesting instead of dead. And you replied with a telling statement describing what photography is all about. You said you didn't know what something would look like in a photograph until it had been photographed. A rather simple sentence that you used has been widely identified with you, and that sentence is: "I photograph to find out what something will look like photographed." That was about five or six years ago. And I know there are few things that displease you more than being bored. So I would hope that you have since amended or extended that idea. How would you express it now?

Well, I don't think it was that simple then, either. There are things I photograph because I'm interested in those things. But in the end, you know what I'm saying there. Earlier tonight, I said the photograph isn't what was photographed, it's something else. It's about transformation. And that's what it is. That hasn't changed, largely. But it's not that simple. Let's put it this way—I photograph what interests me all the time. I live with the pictures to see what that thing looks like photographed. I'm saying the same thing; I'm not changing it. I photograph what interests me. I'm not saying anything different, you see.

Well, what is it about a photograph that makes it alive or dead?

How problematic it is. It's got to do with the contention between content and form. Invariably that's what's responsible for its energies, its tensions, its being interesting or not. There are photographs that function just to give you information. I never saw a pyramid, but I've seen photographs; I know what a pyramid or a sphinx looks like. There are pictures that do that, but they satisfy a different kind of interest. Most photographs are of life, what goes on in the world. And that's boring, generally. Life is banal, you know. Let's say that an artist deals with banality. I don't care what the discipline is.

And how do you find the mystery in the banal?

Well, that's what's interesting. There is a transformation, you see, when you just put four edges around it. That changes it. A new world is created.

Does that discreet context make it more descriptive, and by transforming it give it a whole new layer of meaning?

You're asking me why that happens. Aside from the fact of just taking things out of context, I don't know why. That's part of a mystery. In a way, a transformation is a mystery to me. But there is a transformation, and that's fascinating. Just think how minimal somebody's family album is. But you start looking at one of them, and the word everybody will use is "charming." Something just happened. It's automatic, just operating a camera intelligently. You've got a lot going for you, you see. By just describing well with it, something happens.

There are a number of photographers who have things happen in their work that you have responded to over an extended period of time. Whose work have you found was of importance to, or influenced, yours?

Well, we could talk about hope, that's all. I hope I learned something from Evans and Frank and . . . I could make a big list . . .

In what way did they inform your work, your vision, or your life?

I'll just talk about Evans' and Frank's work. I don't know how to say easily what I learned. One thing I can say I learned is how amazing photography could be. I think it was the first time I was really moved by photographs.

Did you know Walker Evans?

No, not really. We weren't friends.

Cartier-Bresson and Kertész?

I met Bresson once in Paris. Kertész I probably know a little better. But I'm not friends with those people. I'm not friends with Robert. I've known Robert for a long time.

But you are closely associated with a number of contemporary photographers, your contemporaries.

Oh sure. Lee Friedlander, Tod Papageorge.

Tod Papageorge, a first rate photographer in his own right, was the curator of an exhibition of yours called "Public Relations." How did that come about, that one photographer not only is the curator of another's exhibition, but also writes the introduction to his work?

Ask John Szarkowski. It wasn't my idea. I mean, he did ask me if it was okay with me, and I was delighted.

Did you all stalk the streets together?

No, we don't work together. We might meet for lunch or something, and maybe happen to saunter around a bit in the process. But we don't do expeditions.

Just exhibitions. In 1967 your work was exhibited at the Museum of Modern Art, with Lee Friedlander's and Diane Arbus'. Do you feel that the three of you were a likely combination? Or were there important differences? Were you part of the same school?

Oh, we're all radically different. John gave the show a title, "New Documents," and there was a little bit of written explanation. I would go by that. I don't remember what was written, though.

Has the Museum of Modern Art been very influential in your own career?

I don't know. I mean, it doesn't have anything to do with what I do. Probably has made some differences in my sales, I wouldn't be surprised. Again, you have to ask other people, because I don't have a measuring device. There are photographers whose shows I try to make it my business to see, if I'm in the city. There are photographers I have no interest in at all.

Tell me about the ones that interest you.

Tod or Hank Wessel, Bill Dane, Paul McConough, Steve Shore. Robert Adams, for sure. I'm ready to see what they do. Nicholas Nixon, also, I would make it my business to see. There's a lot of people working reasonably intelligently.

How important is that much criticized aspect of photogra-

phy—the mechanical, duplicatable printing aspect—to the quality of the work? How much time do you spend in your darkroom? Do you develop your own work?*

I develop my own film. And I work in spurts. I pile it up.

How far behind are you?

There's two ways I'm behind, in developing and in printing. It's not easily measurable. I'm a joke. That's the way I am; I mean, that's just the way I work. I've never felt overwhelmed. I know it gets done.

Do you have any assistants who work with you?

Well, I have a good friend who's a very good printer. And he does a certain amount of printing for me. I do all the developing. If somebody's going to goof my film, I'd better do it. I don't want to get that mad at anybody else.

How often does the unexpected or the goof happen when you work? And how often does it turn out to be a happy surprise?

I'm talking about technical goofs. I'm pretty much on top of it. The kind of picture you're referring to would have to be more about the effects of technical things, technical phenomena. And I'm just not interested in that kind of work at all. I've goofed, and there's been something interesting, but I haven't made use of it. It just doesn't interest me.

Are there any of your photographs that you would describe as being key in the development and evolution of your work?

No, I don't deal with them that way either.

How do you deal with them?

I don't know. I don't go around looking at my pictures. I sometimes think I'm a mechanic. I just take pictures. When the time comes, for whatever reason, I get involved in editing and getting some prints made and stuff. There are things that interest me. But I don't really mull over them a lot.

Well, what interests you the most? What's the most important thing to know about your work?

I think there's some stuff that's at least photographically interesting. There are things I back off from trying to talk about, you know. Particularly my own work. Also, there may be things better left unsaid. At times I'd much rather talk about other work.

*Your work, particularly in **Public Relations**, has often been compared to the work of that master press photographer, Weegee. Do you see any comparisons or similarities?*

No, I think we're different. First of all, he dealt with very different things. I don't know who makes that comparison. It doesn't make sense to me at all.

Tell us about your new book.

It's called **Stock Photographs.** It was done at the Fort Worth livestock show and rodeo. I was commissioned to shoot there by the Fort Worth Art Museum for a show. You shoot one year and the show is the next year, when the rodeo is in town. It was a big group show. I was the only photographer. There was a videotape guy and some sculptors: Red Grooms, Rauschenberg, Terry Allen. And

I think I hung some, I forget, sixty or so pictures in the show. And at the opening, somebody asked me if I was going to make a book out of it. And I knew I wouldn't. I mean, if I was going to make a book, I'd want to shoot more. You know, you do a book, and you want it to be a crackerjack of a book. Anyway, this person gave me the idea, the next year I went and did some shooting, and then the following year I did some more. And that was it. I probably shot a total of fourteen days, give or take.

You were teaching in Texas then, so you had some familiarity with cowboys and the West. It's been said that those rodeo pictures don't tell very pleasant truths. The image of the cowboy hero is somewhat deflated. Was that your intent?

My intention is to make interesting photographs. That's it, in the end. I don't make it up. Let's say it's a world I never made. That's what was there to deal with.

But one does select what one photographs, and what one doesn't . . .

Well, if you take a good look at the book, it's largely a portrait gallery of faces. Faces that I found dramatic. And some of those turned out to be reasonably dramatic photographs. But that's all it is, I think. They're in action; there's people dancing. Plus some actual rodeo action and some other animal pictures, livestock stuff. That's the way we're living. It's one world in this world. But it's not coverage; it's a record of my subjective interests.

There is another record that you made of one of your interests, at least at the time! I'm referring to the book on women. How did you assemble that collection?

It's the same thing, you know. I'm still compulsively interested in women. It's funny, I've always compulsively photographed women. I still do. I may very well do *Son of Women are Beautiful*. I certainly have the work. I mean, I have the pictures if I wanted to try to get something like that published. It would be a joke.

Do you intend to?

No. That's all we need, another book like that! The thing that was interesting about doing that book was my difficulty in dealing with the pictures. When the woman is attractive, is it an interesting picture, or is it the woman? I had a lot of headaches with that, which was why it was interesting. I don't think I always got it straight. I don't think it was that straight, either. I think it's an interesting book, but I don't think it's as good as the other books I've done.

Which book did you enjoy most? Are there any projects that were more satisfying to you, while you were putting them together or when they became public, in books or exhibitions?

No. I enjoy photographing. It's always interesting, so I can't say one thing is more fun than another. Everything has it's own difficulties.

When Tod Papageorge was the curator of one of your exhibitions at the Museum of Modern Art, he observed that you do not create pictures of significant form, but rather of signifying form. What does that phrase mean?

I think that's what photographic description is about. That's how a camera describes things.

Throughout your work, there is a narrative voice, and an active one at that. Do you agree?

I generally deal with something happening. So let's say that what's out there is a narrative. Often enough, the picture plays with the question of what actually is happening. Almost the way puns function. They call the meaning of things into question. You know, why do you laugh at a pun? Language is basic to all of our existences in this world. We depend on it. So a pun calls the meaning of a word into question, and it upsets us tremendously. We laugh because suddenly we find out we're not going to get killed. I think a lot of things work that way with photographs.

In much of your work you've described contemporary America. Do you find any recurring themes, or any iconography that either engages your attention or should engage ours?

Well, you said it before, women in pictures. Aside from women, I don't know. My work doesn't function the way Robert Frank's did.

What are you working on now?

I've been living in Los Angeles and photographing there. That's it.

Any particular subject matter?

No. I'm all over the place. Literally.

And then you're going to look at those contact sheets and realize once again that the work comes together—as a book, or something else . . .

I really try to divorce myself from any thought of possible use of this stuff. That's part of the discipline. My only purpose while I'm working is to try to make interesting photographs, and what to do with them is another act—a later consideration. Certainly while I'm working, I want them to be as useless as possible.

What made you move to Los Angeles?

I wanted to photograph there. But I'll come back to New York. I think I'll start focusing in more on the entertainment business. I have been doing some of that already, all kinds of monkey business. But I'm all over the place, literally.

When you say the entertainment business, do you mean things that relate to movies?

Yes, movies. You know, the lots, et cetera.

Rather than the "stars"?

Whatever. I may very well move in. I just don't know. I can't sit here and know what pictures I'm going to take.

Is environment—location—a very important influence on your photographs?

Well, Los Angeles has interested me for a long time. I was in Texas for five years, for the same reason. I wanted to photograph there. And the only way you can do it is to live there. So I'm living in Los Angeles for a couple of

years. I've been a gypsy for quite a while. It'll come to an end. I'm going to come back to New York. I'm a New Yorker. Matter of fact, the more I'm in places like Texas and California, the more I know I'm a New Yorker. I have no confusions. About that.

We've talked about the influence of people like Walker Evans and Cartier-Bresson and Robert Frank, of course, on your work. How would you contrast your work to theirs?

I wouldn't. We're different, I think. With Evans, if nothing else, it's just in terms of the time we photograph. And my attitude to a lot of things is different from Evans'. Let's say I have a different kind of respect for the things in the world than he does. I have a different kind of seriousness. This might be misunderstood, but I certainly think that my attitude is different. And generally the cameras I use, and how I use them, are different. The things that he photographs describe a certain kind of exquisite taste. And let's say the things I photograph may describe a lack of that. You know what I mean? He was like a very good shopper.

And you?

I think the problem is different. I was thinking about him and Atget. The things they photographed were often beautiful, and that's a hell of a problem, to photograph something that's beautiful to start with, you see. The photograph should be more interesting or more beautiful than what was photographed. I deal with much more mundane objects, at least. I don't really; actually, I deal with it all. I can't keep away from the other things, but I don't avoid garbage.

Do you think that some of those mundane objects are a holdover from your early commercial work?

No, no, I don't.

You worked in advertising for a long while. Did that influence your work?

I doubt it. I mean, I was able to work with two heads. If anything, doing ads and other commercial work were at least exercises in discipline.

Would you advise a young photographer who had to earn a living to turn to teaching or to commercial work like advertising?

You'd have to deal with a specific person. There's all kinds of people teaching who don't do anything worth a nickel. Likewise in advertising. Then there are some people who do get it together, so I wouldn't make any generalizations. You know if a specific person was asking me such questions, I might think I could tell well enough to say. Or I might say nothing. I don't know.

What general advice would you give to young photographers? What should they be doing?

The primary problem is to learn to be your own toughest critic. You have to pay attention to intelligent work, and to work at the same time. You see. I mean, you've got to bounce off better work. It's a matter of working.

Do you photograph every day?

Just about, yes.

But you don't develop every day?

Hell no! No way.

John Szarkowski called you the central photographer of your generation. That's very high praise.

Right. It is.

But it's also an enormous burden.

No, no problem at all. What has it got to do with working? When I'm photographing, I don't have that kind of nonsense running around in my head. I'm photographing. It's irrelevant in the end, so it doesn't mean a thing. It's not going to make me do better work or worse work as I can see it now.

Did you ever expect your life to unfold the way it has?

No, of course not. I mean, it's ridiculous. I had no idea. How can you know?

What did you have in mind?

Surviving, that's all. That's all I have in mind right now.

Flourishing, too?

That's unexpected. But I'm surviving. I'm a survivor. That's the way I understand it.

What are you going to do next? Do you have any exhibitions or books planned?

No, nothing cooking, not at the moment. Just shooting, that's enough. It's a lot of work organizing something, whether it's a show or a book, and I don't want to do it every day.

You have enormous curiosity that propels you from one project to the other.

I don't think of them as projects. All I'm doing is photographing. When I was working on **The Animals,** I was working on a lot of other things too. I kept going to the zoo because things were going on in certain pictures. It wasn't a project.

Do you think that's the way most photographers work?

I don't know. I know what happens. I have boxes of pictures that nothing is ever going to happen to. Even **Public Relations.** I mean, I was going to events long before, and I still am.

Have you ever had any particularly difficult assignments or photographic moments?

No, the only thing that's difficult is reloading when things are happening. Can you get it done fast enough?

You obviously have some secret because you are known as the fastest camera around . . .

Well, I don't know if I'm really the fastest. It doesn't matter. I don't think of it as difficult. It would be difficult if I were carrying something heavy, but I carry Leicas. You can't talk about it that way. I'm not operating a shovel and getting tired.

You said earlier that you sometimes think of yourself as a mechanic. Do you also think of yourself as an artist?

I probably am. I don't think about it, either. But, if I have to think, yeah, I guess so. (pp. 179-91)

Garry Winogrand and Barbaralee Diamonstein, in an interview in Visions and Images: American Photographers on Photography *by Barbaralee Diamonstein, Rizzoli International Publications, Inc., 1981, pp. 179-91.*

INTRODUCTORY OVERVIEW

Kenneth E. Silver (essay date 1988)

[*In the following essay, Silver surveys the characteristic features of Winogrand's art.*]

Garry Winogrand's New York is as complete and developed a representation, and is as internally coherent, as Louis Auchincloss's New York, only inside out: Auchincloss's tales of Manhattan unfold in the clubs and boardrooms of the privileged, while Winogrand's instantaneous narratives are blurted out on the street and in the parks that nominally belong to everyone else. In a photograph of 1968, a black man, tipping left owing to the angle of the camera, puts out his hand to accept the change offered by the anonymous white hand which extends itself from the four perfect buttons of the arm of a suit jacket. Thrust into the picture from the lower left, the still closed white hand, which somewhat resembles a clenched fist, has not yet relinquished its gift. The rushing, receding orthogonals of the perspective, which find their horizon line just to the right of the beggar's head, are dizzying—they may be an echo of the panhandler's inebriation, or of our presumption of his inebriation. But the pictorial vertigo is surely the sign of our discomfort, a visual emblem of our knowledge that the scales of American society are so terribly tipped in the direction of the white bourgeoisie. Of course, there is more than a bit of irony here: not only does the beggar make a much less vigorous effort to extend his hand to the donor than the donor does to him, but the two hands cannot help but make us recall those most famous reaching hands—those of God and Adam on Michelangelo's Sistine ceiling. All the more indelible, then, is this image of the unblessedness of those who receive. As the moving white pedestrian makes a lateral pass of his charity, the black beggar—for whom nothing much will ever move—remains a fixture of the street. All donors are alike, the picture seems to tell us; every unhappy recipient is unhappy in his own way.

Even when Winogrand wandered indoors, which usually meant to an art opening, he found his way to the teeming multitudes: his photograph of the Metropolitan Museum Centennial Ball of 1969 looks like a black-tie rendition of rush hour in Times Square as a peroxide-blond Venus—surrounded by the boozers of the charity ball circuit—sways to the rhythms in her head as she listens to those of Lester Lanin. Not for Winogrand the space and silence that only money can buy; the world of his pictures is crowded and noisy, and when it is neither, it is either peculiar or melancholy. When Winogrand photographed out-side New York, especially in Texas and California after 1973, he usually put himself in the crush of humanity that is the natural habitat of native New Yorkers.

The famous "Winogrand Tilt," much imitated but also much maligned, was in large part the photographer's solution for problems posed by the New York street. For not only is the use of the diagonal the first law of two-dimensional pictorial dynamics—it creates movement, where the typical verticals and horizontals of the New York street establish stasis—but it also represents a gravity-defying act. In order to depict a gridded city of rapidly receding perspectives, Winogrand had to make a choice with his wide-angle Leica: either get his horizontals level (as it says in the "good photography" manuals) or his verticals straight, and he idiosyncratically chose the latter. Yet, like all highly instinctive human beings, great artists make great choices, and Winogrand's willingness to tilt his camera—like Balanchine's decision to simply "speed up" classical ballet—turned out to be a powerful metaphor that was soon invoked by the artist even when not dictated by circumstance: as the very ground beneath their feet seems to toss and heave, the passengers on Winogrand's drunken boat of a picture miraculously keep their balance.

Gratia sub pressu ["grace under pressure"], these photographs tell us, is the motto that should be inscribed beneath the seal of the City of New York. The compositional balance and visual rhymings of Henri Cartier-Bresson, the Flaubert-like spareness of Walker Evans or the Romantic colorism of a Robert Frank—and we cannot imagine Winogrand's work *without* these precedents—is eschewed in favor of the fast-talking, wisecracking style of Charles MacArthur's and Ben Hecht's journalists in *The Front Page.* "Grace under pressure" for Winogrand means that one can chew gum, walk *and* take pictures all at the same time.

Indeed the "Winogrand Tilt" has its origin in earlier New York art, although the sources are in painting rather than photography. The slashing diagonals and vertiginous crisscrossings of direction that we rightly think of as characteristic of Winogrand's pictures are analogous to, and surely made (if unconsciously) under the influence of, the painterly slashes of the Abstract Expressionists. More generally, the adjectives by which we would characterize Winogrand's art are applicable both to New York City itself and to its so-called Action Painters: impetuous, turbulent, energized, dense, chaotic, direct. In strictly formal terms we feel the presence not only of Franz Kline and Willem de Kooning, but also of Jackson Pollock in both the "all-over" quality of the dispersal of incident across Winogrand's visual field (with its implied New World democratic expansiveness and lack of hierarchy), and in the role which "chance" plays in the art of Pollock and Winogrand. When Pollock said, "I don't use the accident—'cause I deny the accident," he was asserting what Winogrand shows us in almost every photograph, that great art is as much a matter of harnessing the higher-order "accidents" of esthetic endeavor (which are thus transformed into intentions) as it is a question of eliminating the accidents that result from the fumblings of the neophyte.

As demonstrated by the retrospective exhibition of Winogrand's art, "Figments from the Real World," Garry

Untitled

Winogrand was an artist for whom esthetic "accidents" were not merely a way of life (for that is true for every photographer of the "documentary" variety, the medium's Realists), but for whom the appearance of accident—its trace—was, as it was for Pollock before him, a sign for freedom. The power of the seemingly haphazard, underdesigned look of a Winogrand photograph is to catch us unawares—to recreate for us the "accidents" with which Winogrand was continually confronted, and over which he had to gain control. Again, he seems close to Pollock here: in Winogrand's art, photographic mastery over the contingent takes on the quality of an existential reckoning.

In fact, the element of surprise that makes itself so evident in Winogrand's first book of photographs, *The Animals,* of 1969, has its origin in popular culture, in the candid camera images, "Antics at the Zoo," that are still published in the *Daily News*—the elephant that snatches the toupee off the head of some visiting dignitary; the starlet who poses beside the peacock with the attendant caption: "Suzy and Feathered Friend Both Strut Their Stuff "; the monkey that makes a gesture that looks identical to one that Ed Koch made at a recent press conference (headline: "Hizzoner Has Voter Support in the Bronx!"). As Szarkowski tells us in his excellent essay in the show's catalogue, Winogrand, before receiving his first Guggenheim Fellowship in 1964, worked for years as a photojournalist. A protegé of the legendary Alexey Brodovitch, photographer and art director of *Harper's Bazaar,* Wino-

grand was soon taking pictures for that magazine, as well as for *Collier's, Argosy, Redbook* and *Sports Illustrated.* Among his photo essays were **"Whitey the Goat and Her Kids"** and **"Cat Meets Dog."**

The Animals is at once an homage to and a correction of the "human interest" genre, except that what results is poetry. A young couple leans against the railing outside the coyote cage; the man, whose face is in shadow apart from the forehead and one eye that is picked out by bright sunlight, stares with rapt attention and sexual desire into the woman's eyes (which we cannot see, since her head is turned towards him and away from us) as she talks to him in the relaxed but defensive pose of crossed arms and legs. Meanwhile, in the cage, unbeknownst to them but apparent to us, on a direct line created by the diagonal of a shadow which points directly to the couple, walks the white figure of a lone coyote. Caption? "Love is a game of mutual entrapment"; or "Our desire for love is like the wild animal we must keep contained until the right moment"; or "Those who are beautiful, young and in love, like this couple, are oblivious to the hazards that lie ahead"; or "A wild beast lurks in every human heart and every human relationship." Et cetera. Whatever we finally conclude about the meaning of a Winogrand picture, and it is likely to be less prolix than the above, it will *not* make a headline, although it often makes a profoundly moving story.

We might even go so far as to say that Winogrand's art

is built on a misplaced expectation: working not only in the medium but even in the style of the photojournalist, and seeming to stalk the photojournalist's prey, Winogrand leads us to the threshold of the "one-liner," anticipating—not wrongly—the salient caption which will explain and limit the meanings of the image. Instead, the meanings of his images seem to multiply before our eyes; the interpretations become unfixed; the points of view point us in so many directions, and demand so many conflicting sympathies, it is no wonder that Winogrand's art has been, for the last two decades, one of the primary battlefields of photographic intention.

One might well ask what kind of caption could be devised for one of Winogrand's greatest and most famous pictures, an image made at the Central Park Zoo in 1967. A superbly handsome couple—a blond, white woman and a black man—are captured on what appears to be a brilliant autumn day at the zoo: their noble features and serious expressions (both are focused on something outside the frame) give them the slightly unreal appearance of perfect "specimens" of their respective races. Yet their racial difference is not the only fact for which we are unprepared in this realm of Platonic ideals, for in their arms are two monkeys—clearly playing the role of progeny, dressed as they are in children's clothes and clinging to their "parents" with proprietary grip. As if to make even more emphatic the contrast between our expectations and what we see, Winogrand gives us an almost archetypal image of childhood at the lower right, a little white boy in a double-breasted chesterfield coat and matching hat. Is this couple aware of their incongruous appearance? Or is it only *our* uneasiness that creates this incongruity? Are they incapable of having children? Perhaps they simply don't want children. Or perhaps they have children at home. Yet, as the photographer Paul McDonough has said of this picture, what is an incongruity for one viewer here "may be just the opposite for another—a confirmation, or fantasy fulfillment, for those bigots who had always claimed that a polluting of the races would be the eventual outcome of manumission," a cockeyed world view that also recalls the arguments against the teaching of evolution at the Scopes trial. It is not that the words which we use to come to terms with the image are beside the point, they are very much *to* the point; they are nonetheless incapable of exhausting the original power of, or in any real sense "explaining," what we see. It is a picture that, by turns, makes us laugh and brings us close to tears. In the beginning there was . . . the gaze.

But if Winogrand is an artist of place—specifically, of the concrete jungle—he is also an artist of time, which yet again betrays his beginnings in photojournalism, with its twin gods of the City Desk: Where and When. Leo Rubinfien [see excerpt below] wrote in 1977: "As a photographer, Winogrand owns the 1960s in the special sense in which it is commonly said that Robert Frank owns the 1950s, or Walker Evans the 1930s." Not surprisingly, Winogrand's New York of the 1960s—which extends back at least to 1955 and forward to 1973—has a period flavor; what is perhaps less readily apparent is that the quality of life on the New York street was in the midst of a radical change.

Winogrand began photographing in earnest on the sidewalks of New York just at the moment when gentlemen ceased to wear hats and ladies to wear white gloves on our grimy pavements. (As late as 1957, my father, who was neither particularly fashionable nor especially old-fashioned, still wore a straw boater to the office during the summer.) Winogrand came of age along with that king of style, John Fitzgerald Kennedy, who, after first going hatless on the campaign trail, proceeded to become our hatless, youngest president in 1960. JFK was the incarnation of the vast middle-class dream of self-betterment, which could not prevail, or so it seemed, if the system of elite social prerogatives—symbolized by hats and gloves—were not abolished. Even if there has been no discernible withering away of the classes, the wearing of hats and gloves as pure symbols vanished into thin air. Simultaneously—and it is not clear which is the chicken and which is the egg—the main thoroughfares of midtown Manhattan were transformed from corridors of more-or-less decorous behavior into vast, outdoor, public stages for the representation of an ongoing, modern passion play. The quintessence of the new New York street of the 1960s was traffic commissioner Henry Barnes's attempt to choreograph The New Chaos: how many recall the so-called "Barnes Dance," whereby pedestrians at heavily used midtown intersections would no longer cross the street when alternating streams of traffic stopped, as is normal, but instead were given a moment in which all lights went red at once, and they could swarm any which way—even diagonally across the intersections? It was every man for himself, as pedestrians rushed for the distant shores of the other side. I don't recall any longer Barnes's rationale for this plan or how long this new "freedom" for the pedestrian lasted; it could not have been more than a few weeks. But the die was cast: henceforth the energies that were coursing so rapidly through American culture would make themselves felt everywhere, all the time and in public. And Winogrand was there stage-managing it for posterity.

Winogrand was especially interested in political demonstrations—street theater par excellence—although his representation of politics in late '60s America is rather more non-partisan than was typical of the era: he was not averse to photographing a right-wing counterdemonstration against the anti-Vietnam War Left in Central Park in 1969. Not only does he orchestrate a remarkable abundance of visual information, including waving flags, bare branches of trees and a mass of humanity near and in the background, but he creates a surprisingly sympathetic portrait of a fat park employee who, as he converses with New York's Finest, holds to his heart a correctly folded stars-and-stripes. Does this mean that Ralph Kramden was a real patriot? Maybe and maybe not, because the previous year Winogrand made a ghastly image of a peace demonstration outside Madison Square Garden, in which a young man who stares straight into the camera has almost certainly been the victim of those same New York City cops: the entire left-hand side of his face bleeds profusely and we can also see the dried blood on his hands. This image may not be the stuff of which great modern art is usually made—such direct observation of the passing political scene is usually considered detrimental to high esthetic ambition—but if that is so, then Francisco Goya will have to be removed from the honor roll as well.

But perhaps it is only that I have not evoked well enough the picture's resonances. Because it is probably fair to say that if all Winogrand had done in this picture was to set

down a record of police brutality, he ought *not* be admitted into art's Valhalla. Yet this is not the case, for what he has given us—with a clarity and an intensity that is astonishing—is also a picture of the dangers of sight, of the enormous burden of trying to see clearly. With the instincts of a master chef at the green market, Winogrand picks out five perfect young characters (left to right: a tall white man, a black man, the bloodied central character, another white man in woven vest and a final black man), all of whom wear glasses. The blood of the protagonist drips down his face *under* his eyeglasses. Is he some modern Oedipus, tragically cursed, and who, knowing of his double sin, gouges out his own eyes? Is this not also the photographer who, Pandora-like, cannot stop himself from looking, whatever the cost? At the very least we can say this: five individuals now see what they may not have seen before. And if we include the viewer of the photograph as well, that makes six.

The above reference to Goya is not, by the way, altogether incidental to a discussion of Winogrand's art. For Winogrand does indeed assume his place not only in a printmaker's tradition of political imagery—which of course includes Goya, along with Hogarth, Daumier, Grosz and many others—but also in a tradition of representations of street life, a venerable European practice, of which both Eugène Atget and August Sander were, in their own ways, late inheritors. I am referring specifically to what were known as the "Cries of the City," which began to appear at the end of the 15th century but which proliferated during the 17th, 18th and 19th centuries. Annibale Carracci in the 16th century and Jacques Callot in the 17th are probably the two best-known draftsmen to depict what was in effect a visual lexicon of the various "cries" of the urban street vendors. Paris, London, Rome, Bologna, Vienna, Berlin and many other cities not only had their vernacular town criers—who announced everything from the latest news to the availability of leeks, cocoa and porcelain repair—but also had an almost simultaneous folk tradition of depicting the various *petits métiers de la rue* in a gridded format, which showed, usually in etched form, but also in woodcut and later lithography, the individual vendors, their wares and sometimes the actual words they cried on the street. (The vegetable vendors of modern-day Paris who still call out their produce at the market are probably aware of the venerability of their cries; the hot dog vendor at the American ball park, on the other hand, is probably less well informed about his antecedents.) When Atget shows us his great picture of an organ grinder and serenading urchin, or his lampshade vendor, or his street sweeper, he is at once recording a fact of European street life that survived into the first decades of our own century and renewing a tradition of *depicting* that street life which was nearly as powerful and time-honored as the things depicted.

All by way of saying that, without discounting the modernity of Winogrand's photography, it is important to recognize that the roots of his art go deep into the soil of European consciousness; if some have claimed that his "candid" images of modern urban existence look dated in the light of postmodernism, it is probably equally true to say that they were not so utterly new even when they were new. Although it is difficult to imagine Winogrand's art as having emerged at any other time than when it did—his interest in popular culture is very much an interest he shares with the Pop artists (and, like Warhol, Winogrand began as a commercial artist)—we nonetheless find that a great deal of art history, whether consciously alluded to or unconsciously summoned forth, is writ large across these seemingly unprecedented pictures. His bench-full of suburban girls, who have been a bit too long at the 1964 New York World's Fair, with their interlocking gestures of fatigue, complicity and late-afternoon vanity, remind us of nothing so much as the goddesses from the east pediment of the Parthenon. The couple on the Circle Line boat (misidentified in the catalogue as the Staten Island Ferry), 1971, who are rather better dressed and more attractive than most of their fellow passengers pressing against the railings alongside and above, stand together, isolated in the center of the picture; they have the air of two saints, or of Adam and Eve, on the panels of a Northern Renaissance altarpiece. A mother and her two children are suddenly mesmerized, stopped short on a cold, wintry day along a cross street on the upper west side of Manhattan, by the sight of a fire burning in a trash can. Is this the Three Ages of Man—curious infant, anxious child, melancholy woman—as it might be depicted by a modern-day Wright of Derby, except that in place of the effects of a near-vacuum on animate objects, we find that it is mere combustion which reveals the onlookers' emotional life to us?

And richest in allusion and most visionary of all is Winogrand's photograph of Los Angeles, California, 1969, which turns out to be, on close inspection, a picture of the city's most famous intersection: Hollywood and Vine. Here are Three Graces who remind us of those in Botticelli's *Primavera* or Ingres's *L'Age d'Or,* or Roger de la Fresnaye's *Ville de Paris,* lit from behind like the stargazers and sunset-worshipers in Caspar David Friedrich. They cast long intersecting shadows, as dramatic as Tintoretto's or Tanguy's, as they move along the highway of dreams. We can read gossip-monger Louella Parsons's name affixed to the terrazzo star on which they are about to tread, in a deep perspective that makes us think of Caillebotte's *Le Pont de l'Europe.* But that is not all, for at the left foreground in shadow sits a severely crippled man or woman (it is difficult to tell which) in a wheelchair with a cup for taking donations wedged between his/her knees. The Graces all look in the cripple's direction and seem to step just ever so slightly away, in an arc that any of us might make in order to distance ourselves, instinctively, from what we want to avoid. Yet, in this wondrous play of light, one's mind wanders towards other miracles—and so the Graces begin to look like Magi, and the poor creature on the Los Angeles public assistance rolls takes on some of the mythic quality of the paralytic that, as both Mark and Matthew tell, Christ saw fit to miraculously heal. But then again this is Hollywood and Vine, and it is easy to believe in miracles in such proximity to those sound stages where Cecil B. De Mille asked Charlton Heston to part the Red Sea.

Be that as it may, Winogrand seems always to have believed, at least for much of his adult life, in the redemptive powers of unclouded vision. In a picture he made in the mid-'70s at the Fort Worth Fat Stock Show, we find again one of his favorite themes: the odd coupling of man and beast. Here a big man, a Texan whose belt buckle displays a longhorn steer, holds an enormous—it must be a championship-size, Texas-size!—rabbit in his arms. Both the

man and his prize rabbit look oddly becalmed; the human stares down, avoiding the camera's eye and the flash gun, while the rabbit looks straight ahead at us. The animal is so enormous and Winogrand gives him such attention that it makes us think of Dürer's depictions of the fauna of Paradise. But to claim this for the picture is in fact to glorify the image in terms that are ultimately inappropriate. For there is almost no pictorial rhetoric here at all—by all standards it is not a good picture, not even by the standards that Winogrand himself had already set. Yet it is a great work of art in precisely the way that Winogrand made great pictures from the earliest days—it testifies, and that alone seems to constitute a miracle. (pp. 148-57)

> *Kenneth E. Silver, "The Witness," in* Art in America, *Vol. 76, No. 10, October, 1988, pp. 148-57.*

SURVEY OF CRITICISM

Helen Gary Bishop (essay date 1975)

[*Bishop explores Winogrand's approach to his subject matter in* Women Are Beautiful.]

When I look at Garry Winogrand's women I am very moved. I see assertive, young bodies moving forward. Whether they are rushing in the streets of the city toward some exciting appointment, hailing a taxi or bus, waiting for a date or walking in the park, they seem confident of purpose and great expectations. They are women who are aware of the place they occupy in space and time.

They are especially aware sexually. The tight curve of the blue-jeans on a bicycle seat, a lean thigh under a wind-blown skirt are points of pride. But the proudest possessions of the Winogrand women are their breasts. These are not subtle, suggested contours; they are thrust forward, nipples erect, barely covered when not totally exposed. For these women, acutely conscious of the powerful appeal of the feminine attributes, the mammaries are still the most potent message.

And yet there is more to them than that. When I went from their bodies to observing their faces I was fascinated. I saw something so tenuous, so in need of reassurance, be it a frankly sexual remark or glance or an admirer's camera, that again I was moved. For the truth is there can be no real self-confidence for the woman who defines herself through her physical presence: there will always be someone else younger, more attractive or just different.

For the few Winogrand women who grow older, their bodies thickening from children had or still to come, the thrust is gone and an air of resignation prevails. The wistful look of a matron as a drum majorette briskly leads her baton-twirling group down the street sums it up: the parade has passed her by . . . at least until she reexamines who she is.

Garry Winogrand has done more than record artful compositions of beautiful breasts and bodies. I believe he is genuinely attracted by the dynamics of the female being. But with the unerring instinct of the artist he has caught the conflict of the feminine creature: the body as object vying with the self as person.

I wanted to enter the world of the Winogrand Women. I tried to conjure up childhood, girlhood, marriagehood. First it was "they" then it was "she" and then it was "I." There is a Winogrand Woman in all of us.

> *Helen Gary Bishop, "Winogrand Women," in* Women Are Beautiful, *by Garry Winogrand, Farrar, Straus and Giroux, 1975, p. 9.*

Winogrand on *Women Are Beautiful:*

Whenever I've seen an attractive woman, I've done my best to photograph her. I don't know if all the women in the photographs are beautiful, but I do know that the women are beautiful in the photographs.

By the term "attractive woman," I mean a woman I react to, positively. What do I react to in a woman? I do not mean as a man getting to know a woman, but as a photographer photographing. I know it's not just prettiness or physical dimensions. I suspect that I respond to their energies, how they stand and move their bodies and faces. In the end, the photographs are descriptions of poses or attitudes that give an idea, a hint of their energies. After all, I do not know the women in these photographs. Not their names, work, or lives.

Women Are Beautiful is a good title for this book because they are.

> *Garry Winogrand, "Winogrand on Women" in his* Women Are Beautiful, *Farrar, Straus and Giroux, 1975, p. 9.*

Dan Meinwald (essay date 1976)

[*In the following review of* Women Are Beautiful, *Meinwald praises Winogrand's photographic style and laments that his work has received less attention than it merits.*]

The importance of Garry Winogrand's photographic work is undisputed—certainly, whenever the list of significant contemporary workers is trotted out, his name is included—yet it seems odd that our esteem is based upon a sparsity of published material. There has been, before now, only one book devoted exclusively to his photographs (***The Animals,*** Museum of Modern Art, 1969) and only two of significance which have reproduced a substantial number of them (*Toward a Social Landscape,* Horizon Press, 1966, and *The Snapshot,* Aperture, 1974), the first being a catalogue for a group exhibition and the second, a loosely organized collection of photographs by picture

makers whose work could only have been collected in that way. Even in exhibition, Winogrand's work has rarely been given the kind of exposure that a one-man show can give. This has inhibited comprehensive appraisal of his work, since the evidence of even a tiny number of the photographs will reveal that they do not depend upon a limiting set of instances but upon Winogrand's ceaseless involvement with an ever-changing social arena. One of those rare one-man shows, at Light Gallery in New York last summer, covered a large room nearly floor to ceiling with only a fraction of his recent photographs. With his understanding, humor, and clarity of observation evident in every one of such a large number of pictures, the show provided a startling insight into the extent of his involvement.

This one instance, no matter how illuminating, is, however, hardly more than a half-measure in the face of such prolificacy. Although the show satisfied a great need, it was inaccessible to a major portion of the burgeoning photographic audience, and Light Gallery has taken a step which should help to alleviate the situation. The gallery, which handles exclusively not only Winogrand's work but that of a number of the other notables on the aforementioned "list," has moved into publishing, and Winogrand's second book, **Women Are Beautiful,** is their first.

It's a marvelous book. Devoted, as might be expected from its title, to pictures of women, it is a complex and incisive panorama of feminity in contact with itself and with its social environment. Most evidently, also, of Winogrand's contact with it.

Winogrand himself has been somewhat of a paradox to photography critics—even less critical attention has been devoted to his work, in relation to his large reputation, than exposure by publication of his photographs. His fate has been to be lumped together with a number of other contemporaries whose work is in some way linked to the influence of the snapshot, and left at that. This is not to say that viewing his photographs with reference to snapshot imagery is not useful to the experience of them, but that the interrelationships have not been clearly defined. That this is a difficult proposition is, for instance, made unboundedly clear by the publication of **Women Are Beautiful.**

The most famous of his photographs—the ones most often reproduced, and which form the basis for commonly-held opinions of his work—are those which, although obviously clearly-seen distillations of moments which the photographer had no part in causing to occur, resound with implications which are based upon, but which go far beyond, the elements of the moment. The picture on the cover of this book, and also on the last page, is a case in point.

In it we see a well-dressed young woman standing in front of a storefront window. What little can be seen beyond it is recognizable, to New Yorkers, as Sixth Avenue in midtown Manhattan, and to anyone else as a busy city street. The woman, isolated by the camera, is laughing unreservedly and holding a half-eaten ice cream cone. A manikin—a headless chest stuck on a pole—models shirt, tie, handkerchief, and suit coat in the window, on which the photographer can be seen, in faint reflection.

The inevitable question here is, of course, why the young lady is laughing. The most immediate suggestion is that

the manikin, which, in its brainless embodiment of traditional male garb could easily be taken to stand for the great majority of men, is the source of her mirth. But on the other hand, it's not at all obvious that she is even aware of the manikin's presence in the situation, and we must conclude firstly that it is something else she is laughing at, and secondly that it is something not within the context of the photograph.

Or at least not within the context of the photograph as a transcription of the original situation. The question of her laughter is unanswerable if the photograph is conceived of in this way, but is, in fact, the entire issue of the photograph—itself—as situation. The laughing lady might not be aware of the manikin, but we, through Winogrand, are. The two are linked in the context of the photograph, and everything within that context reinforces the connection.

She *is*, therefore, laughing at the manikin, and at Winogrand as well, since his head could by its presence serve for the absent one, and at the ice cream cone, which could serve the same purpose, and at herself, since in laughter her head is thrown back in a position which makes it look like it could roll off on her shoulders and onto the dummy's.

This photograph, like many of Winogrand's others, is very much in antithesis to the dominant notions of photograph-as-fact which inform the amateur snapshot. Since the inception of the hand camera, the snapshot has been thought of and used for a kind of visual note-taking ("this is the new baby," or "this is our summer vacation"), answering a need so fundamental that the primary response of many people to the important events of their lives has become the act of recording them with the family camera. This urge has, with crushing inevitability, led to the engendering of billions of photographs by people who, in their relentless pursuit of a "good shot" of something or other, ignore virtually every other consideration, and introduce into the picture space any number of objects which would, except by their physical proximity to the subject of the photograph, be considered irrelevant.

In Winogrand's photographs, however, nothing is irrelevant. Elements often enter the picture frame much as they do in an amateur's snapshot, but in what is not the case of most snapshots, every element of his composition is supportive of the experience of the photograph; Winogrand consciously generates a response to the photograph which the amateur could only do unconsciously. When Winogrand makes a photograph of a woman on a beach in which he tilts his camera and creates a sloping horizon line, it is for a specific purpose. What the amateur would accept as a valid, if marred, piece of reality (". . . tilted the camera on this one, but so-and-so looks great in her new swimsuit . . .") is in Winogrand's photograph a function of a chosen photographic reality.

The amateur, then, in seeking to record "fact" with his camera, has unconsciously obscured facts which he thinks he observes, and obtains facts which are entirely photographic. Winogrand, with real powers of observance, and an understanding of their translation into photography, can truly make what he sees into photographs. Indeed he probably eats, thinks, and sleeps photographs. In the case of the ones in this book, he might just have a satisfying social/sexual relationship with them as well.

Among other things, what Winogrand sees when he hits the streets are all kinds of women acting in all kinds of ways. His responses are honestly masculine. Each woman is different, and strikes him differently; the resulting photograph is evidence that he has been struck. Often the images are not, like the cover photograph, realities carefully constructed by Winogrand, but are simply descriptions of events that he finds revealing of the characters of these women in his momentary contacts with them. To be sure, the contacts are entirely visual. Winogrand himself states, in his brief preface to the book: "I do not know the women in these photographs. Not their names, work, or lives." His brief glimpses of these women are not of the sort which led Dante through hell and back; they are the kind every man past puberty encounters whenever he goes out in public. They range from wistful appreciations of beauty to nearly-ribald vignettes of pure lust.

What this book is, therefore, is a phantasmagoria of feminity. There is, in Winogrand's view, no real definition of what makes a woman attractive—it is something prescribed by social environment, and responded to by each individual in her (and his) own way—and Winogrand's response to its various manifestations is to make photographs that illustrate its effect. "Whenever I've seen an attractive woman," he says in the preface, "I've done my best to photograph her. . . . By the term 'attractive woman,' I mean a woman I react to, positively."

There are, for example, cheerleaders, and Winogrand's photograph of five of them thrusting their bodies into the air at a basketball game is the quintessence of that rather primitive display of female sexuality—checked bloomers and all. There are numbers of women who define themselves almost solely by their sexual attractiveness, like the young lady who draws a crowd of starers and camera-bearers by means of her metal-studded leather clothing and see-through blouse. Women who understand and enjoy their attractiveness, like the one who smiles at the stares of male passersby. And women who don't. Women who buy totally the prevailing image of beauty sold to them by advertising, like the young black girl who clutches a fashion magazine emblazoned with a picture of a blond white one. Or the pair of huge-breasted women wearing tight sweaters and slacks and walking two poodles—was the picture taken in the '50s or are they throwbacks? Or women by no means beautiful by society's standards, but made so by Winogrand's appreciation. All sizes, colors, shapes, and ages of women. This is a celebration.

If, in their transcription of very real situations, many of the photographs seem more in line with the striving-after-fact of amateurs, in some sense they are. Just like every other joker with a Brownie, Winogrand photographs everything he considers important, everything he loves. If the amateur snaps his family, so does Winogrand. It so happens that all people are members of his family, and he is constantly among them, snapping pictures of vital moments in their lives, even if they themselves undoubtedly do not consider those moments to be so.

The essential difference, however, between Winogrand and his less accomplished fellows, is Winogrand's awareness of something the snapshooter never troubles himself about. Winogrand understands the place of the photograph in its reference to the situation at which he points

his camera, while the snapshooter never really does. Photographs are never mere records; in some sense they are more significant experiences than the ones they are meant to signify ("this *is* the new baby," or "this *is* our summer vacation"), a quality which makes them so incredibly important to their makers. Understand this, and photographs are much more than snapshots (even if they *are* snapshots). Winogrand understands very well. *How to make Good Pictures* holds no answers.

That critics have thus far failed to categorize Garry Winogrand's work is only indicative of his value as a photographer. Winogrand himself is reluctant to discuss his work, yet his introduction to the selection of pictures included in his section of *The Snapshot* speaks to this very issue: "Neither snapshot, document, landscape, etc., are descriptions of separate photographic aesthetics. There is only still photography with its own unique aesthetic." He would obviously prefer to be making photographs than talking about them—there is so much constantly going *on* out there—but he has one final word about the photographic process: "This process is Perception (seeing) and Description (operating the camera to make a record) of the seeing."

This reticence on Winogrand's part may well have much to do with the fact that so few of his photographs, out of what must be quite an extensive body of work, have been published. For whatever reason, Winogrand has little to do with the production of his books. The selection of pictures for **Women Are Beautiful** was not made by him, but by Light Gallery. He stipulated that certain photographs be included, but final editing and sequencing were done by the gallery. They have done an excellent job, but since they are now exclusive dealers for Winogrand, they have more work to do. In 20 years Winogrand has done far more than photograph zoo animals and women, and although breakdown by subject is a convenient and effective method of creating photographic books, a thematically-organized sequence of a wider variety of subjects could much better represent him. The man must have *tons* of photographs in his closet, or somewhere. Let's see 'em. (pp. 6-7)

> *Dan Meinwald, "Winogrand's Women," in* Afterimage, *Vol. 3, No. 7, January, 1976, pp. 6-7.*

Leo Rubinfien (essay date 1977)

[*Rubenfien focuses on Winogrand's work as a reflection of the social, political, and artistic trends of America during the 1960s.*]

As a photographer, Garry Winogrand owns the 1960s, in the special sense in which it is commonly said that Robert Frank owns the 1950s, or Walker Evans the 1930s. These artists' photographs are distinguished from equally accomplished work produced in the same periods by an extraordinary conjunction—the conjunction of a form that comes to mirror, and stand for, the dominant sensibility of a time with a content comprising the major symbols and events of that same time. While Edward Weston's nudes belong clearly but allusively to their decades, it was Evans who made sharecroppers, impoverished shacks and crude, popular art central concerns of his own fine art. These are

things we have taken, 40 years after, as quintessential symbols of the Great Depression.

Of course, Evans and Frank have themselves had a great deal to do with forming our conventional notions of what symbolizes their milieux. Thus with time we forget that they pictured their periods selectively, that they offered no more than fictional versions of the Depression years and the complacent '50s: we take them as speaking truth. What was an opaque collage of objects—mundane objects that spoke out loud to these photographers of generous perceptivity—becomes a transparent glass through which we think we may return to history.

"Public Relations," Winogrand's current show at the Museum of Modern Art, comes at a time when the '60s have begun to be reckoned with publicly. The last two years have seen an abundance of '60s memoirs. That frantic, flamboyant decade, which no one any longer lives, is presently being negotiated into some form of myth by which we will retain it in the future. Yet the '60s were recent enough, if one counts all the Nixon years as part of the era, to leave an image in memory that is still fresh. We now see Winogrand's work at a stage where it is in the process of attaining transparency, where it is no longer esoteric or difficult (as many once thought it to be) but where it has not yet come to dominate the way we see its times.

"Public Relations" consists of pictures Winogrand made at various kinds of public events. It only partially represents an extensive and enormously varied oeuvre, although there is no formal discontinuity between the pictures in this show and others the photographer made at the same time. All are wide, 35mm camera frames, voluminously filled with ranges of details and small incidents. One might think that these details and incidents stand in no hierarchical relation to each other, so fascinating do they all seem to be. Winogrand has become famous for this style, which Tod Papageorge, guest curator of "Public Relations," describes as "discursive." Even once one has recognized which objects and events are preeminent in each picture, these photographs never cease elaborating. In those which were made by the light of a flash, tangential glances, marginal faces, extra lapels and spells of pleated drapery only fade out in the blackest corners of a scene.

This much has been said by Papageorge and other writers on the subject of Winogrand's form: that it descends from tradition via the work of Robert Frank, who was the first small-camera photographer to turn a consistent esthetic from the wide-angle lens; that the virtuosity with which Winogrand balances galaxies of detail is tremendous; that this discursive form reflects and comments upon what is perhaps photography's signal quality as a medium—its prodigious ability to describe cornucopious minutiae. Papageorge also implies a connection between the prolific manner of Winogrand's frames and the equally prolific manner of his personal speech. We are left asking how this visual voracity extends from, fictionalizes, and actually characterizes the subject of Winogrand's work—which, in sum, is no less than life in the United States during a crucial measure of its history. Abstractly put, this is the question of how Winogrand's form itself makes up a large part of the content of his pictures.

I am speaking of a time in which people of all classes and kinds, many of whom had never before led public lives to any degree, adopted postures, made statements and donned symbols that were aimed entirely at public effect. Perhaps more than at any time in America's past it was felt that to participate in *society*—not just in the specialties of governmental and cultural politics—it was necessary to make oneself publicly visible. And to be visible in the '60s meant to behave, to costume oneself, to pontificate in ways that would be positively conspicuous, even ostentatious, in the subsequent decade.

Slang terms of the period, "outrageous," "far-out," and "out-of-sight," referred directly to the extent to which a thing, a gesture, a style or a statement made public waves, and to how it did so. And one had the sense, whether truly or falsely, that everyone was talking, and flamboyantly too; only the general bombardment of speech made it seem, at times, that there was not very much difference between what different people said. Perhaps this is why Nixon's appeal to the "great silent majority" provoked such fury, and why an angry poster of the time placed that infamous slogan beneath a photograph of Arlington National Cemetery. It seemed inconceivable that anyone could be keeping silent who had not been silenced.

Winogrand placed himself in the midst of this crowd, and his photographs mimicked its loquacity. Why, one might ask, did Winogrand not choose to operate as did some of his contemporaries, who picked out and displayed the most bizarre or touching details of the scene? Editing from the fluctuating world of fact as all photographers do, he selected what appears in each picture to be the whole vista—the whole flood of overlapping arguments.

One of many photographs Winogrand made at Norman Mailer's 50th birthday party gives us the famous writer besieged at a dais. Mailer is surrounded by a chorus of eyes and hands—one of which belongs to a young woman who is gesturing at him with splayed fingers. While it would be false to say that this picture had no center of attention—everything does revolve around this woman's urgent profile—nothing escapes our notice, not even the disembodied hand aiming an electronic flash toward the back of Mailer's head. It is as if one had gotten drunk at this party: not "blind" drunk, but just drunk enough so that one could not keep pace with the dense conversation, finding himself repeatedly turning to the intriguing trivia that bedecked the surrounding crush. One returns intermittently to this picture's dominant motif as one would hasten to recover the thread of conversation he had so innocently dropped.

We touch here on the symbiosis that exists between Winogrand's form and the visage of the era to which it was being addressed. It was the phenomenon of a whole flood of arguments, rather than any one among them, that was most significant during the '60s. Winogrand has said that public events of the period seemed to be organized for the benefit of the news media which covered them; in fact, gratification of their participants' newfound talent for parading became at least as much of the motive. The movement against the war (can a mass effort that collapsed into an idiosyncratic motley still be called a movement?) found demonstrations as valuable for morale-building as for scaring the opposition. Spectators and spectacle became one of a piece.

Thus, to make pictures that emphasized, took seriously,

and lent dignity to each individual posture that surfaced from the crowd, would have been to ignore the inherent irony of the times. The form one used would have to be able to simulate the general drum of speech and to leave room, at the same time, for the urgency of each individual gesture. Other artists of the period, especially Robert Rauschenberg, took note of this necessity. Winogrand managed to turn it to consummate use, in part because of his medium's enormous appetite for fact.

There are no adjectives in photographs, only nouns. The items that populate a given photograph appear replete with all their descriptives; modifier and modified are fused. Where a writer might easily spend a paragraph reconstructing the feathery boa one Winogrand woman wore to the Met's Centennial Ball, a photographic picture makes the boa and its connoted qualities inseparable. Meaning resides in every object and every quality, and the outcome—the general meaning—of that picture is almost untranslatable.

Doubly crammed with detail, Winogrand's pictures are among the most extreme illustrations of this compaction that photography has produced. At the same time they take an ironic stance toward their own medium. Commonly photographers use larger cameras and finer films to extract more detail from their subjects. Winogrand shoves the detail in from around the edges. His pictures challenged other '60s artists (in painting, collage and prose) to portray a social scene which was confused by the breadth of its own multiplicity. Photography also seems to have been suited to that scene for the illusion of immediacy that accompanies the camera's illusory literalness. The '60s gave scant time to recollect in tranquility; but photography did not require that one do so.

Let me phrase my point about the '60s in terms of the Vietnam War. The war was, of course, the determining event in American consciousness at the time. Yet the war is paramount as fact only if one marks out history according to episodes of human conflict. True, new technology was used to pursue the war in Vietnam, but the war's motives, as many contestants in the '60s agreed, did not differ tremendously from American motives in Korea 15 years earlier. What *was* novel about Vietnam, and what may have been far-reaching in effect, was the stridency of the various reactions the war produced at home. Traces of this stridency are visible in the nipple-revealing boa Winogrand's character wore to the Met, in the attention a phalanx of hardhats lavishes on an eight-year-old wearing flags and a sign reading "Little Miss Patriotism," in the desperate eyes of a crazed man who rushes among the bystanders in Central Park, in the loony wallpaper of which one goggle-eyed dancer at the Met seems almost an extension, even in the American disregard for dress or decor that amounts almost to a kind of haughtiness on the part of Winogrand's NASA technologists.

The decade's stridency is evident above all in the degree to which Winogrand's subjects seem so often to be performing for, and responding to, each other. This is so even in Winogrand's book *Women Are Beautiful* (1975), where single characters dominate many frames: three times out of four these women act for the photographer himself, who weaves them into a continuous story of the dynamics of mutual lust and distrust. We may note the fact that the cowboys, provincials and small-time politicians of Wino-

grand's precursor, Robert Frank, also perform. But the dominant sense Frank's *The Americans* gives is that these people have been thoroughly deprived of an audience. Here lies a major difference between the two decades, at least as they have been rendered and handed to us in myth.

There is in Winogrand's photographs a cycle of attitudes that neither conflict nor merge. His pictures have most often been recognized for their comedy and for their attention to the grotesque, but they also contain bitterness, a great delight in physical grace, and a degree of desperation. These various emotions coexist in many frames, maintaining the plural ways one has to see a time in which one was too much a part of the crowd to have any objectivity toward it. Thus the sneering, misshapen lips on one of Winogrand's Met guests will paradoxically become graceful, as a comical and simply lustful incident will be tinged with despair in another picture from the same party. The feather-boaed woman has here found her way to the lap of a tuxedoed gent who is pulling the garment away to examine her breast, while she clutches him by the back of his neck and grins with fierce approval. The wantonness that this couple shares with a shiny young man dancing wildly a few feet away—and with Winogrand whose tilted frame is also wanton (not *actually* wanton, but calculatedly and precisely so)—carries the feeling, the fear, that time is running out. The viewer of this photograph is left free to determine whether it is simply that the night has grown late and the party is expiring frantically, or whether this is the quality of a society that appeared to be coming apart at the seams—or both.

That Winogrand's pictures are so much addressed to the visual shibboleths of the '60s does not mean his work is devoid of more abstract reference. The hardheaded verisimilitude of all photographs does not prevent them from operating metaphorically. But metaphor is less a summit at which we have finally deciphered a photograph's prolix language than a pressure that informs a camera image from underneath, affecting the way we read it at each turn. Consider Winogrand's desperate, naked man in Central Park.

He moves amid a crowd of intrigued, amused, astonished and embarrassed people, with his arms upraised in a gesture half hortatory, half pleading. Indeed, it is with the benedictional pose of a priest that he closes in behind a young man and woman, his hands almost pressing their heads; his eyes are lost in the inward and distant stare of someone possessed. We cannot know what brand of lunacy goads this man, but he is stamped with the frustration of someone who bears an arcane and urgent message and yet cannot form the words with which to preach it. Naturally this man recalls, and may well have been, one type of his times—the drugged visionary. But we do not fail also to read him as a Coleridgian artist of flashing eyes and floating hair, whose private yet guiseless obsession compels him to grasp for articulation before an audience that is irked by his frenzy—that, absorbed in its own trials, couldn't care less. Once one has admitted such resonances into his reading of Winogrand's pictures, they are half-removed from history, into the territory of continuing myths. One has removed the '60s as well, shaping them as they may well stand when their specifics have been forgotten, as a time of buoyancy and decadence, filled with prophecies.

For the time being, however, Winogrand's photographs bring us back to their pungent specifics, and we wonder at the generosity of his vision in a time when so much of America was manufacturing propaganda. To have described hardhats, radicals, hustlers, the elites of art and science, exhibitionists, clowns, and those who themselves purported to describe, the ubiquitous reporters and cameramen—to have described all these evenhandedly, with the same mixture of comedy, cruelty and respect, might well have outraged the typically partisan citizen of the '60s. That Winogrand's photographs *are* respectful should go without saying: they evidence what may be the most mature form of respect—the permitting of one's contemporaries to display their glories and follies free from one's own interference.

This amounts to a form of liberalism that was scarce in the decade. Not "bleeding-heart" liberalism, of which there was plenty, and for which there was plenty of derision, but a ruthless liberalism, lenient and strict, that would at once give everyone an ear yet hold all to themselves. It is a view that would seem to be possible only from a safe position of great power. Of course it was not the view of those who were powerful in the '60s: warmakers, didacts and rock-and-roll musicians. Perhaps its explanation lies in an earlier period, the ebullient time when America had survived the Depression triumphantly, when it was winning World War II and achieving world power, and when Winogrand was growing up.

It is worth speculating that Winogrand's sensibility survives from that brief spell when—so popular art and film would tell us—the United States rightfully thought of itself as democratic, and the V-J Day sailor in Times Square—the man in the street—could be authentically heroic. The generation whose violent youth had been relieved by this euphoric passage went on to create and incite the 1960s, blowing our self-assurance all out of proportion, until our sense of noblesse oblige came to be expressed with napalm. It seems that Garry Winogrand became estranged, however, and brought that man in the street back as the fictional describing persona of his art: the artist himself as the man in the crowd. Those whom Winogrand held to themselves in his photographs of the '60s must have been, above all, the parents of that period, the men and women of his own generation.

History, *histoire,* is not made while events are being enacted. It is made after the fact, in the telling and retelling. Gradually, of course, events that once occurred will blur and seem—as the Vietnam War and the movement against it already do seem—flip sides of the same coin. It should be clear that I do not use "history" to mean documentation, and that, in any case, a photograph does not straightforwardly document, but distorts, its moment of inception. The charm and satirical paradox of Winogrand's telling is that it attends to fact selectively, yet holds its chosen facts down with a vengeance. His subjective eye may prove to be one of the best historians we have. (pp. 33-7)

Leo Rubinfien, *"The Man in the Crowd,"* in Artforum, *Vol. XVI, No. 4, December, 1977, pp. 33-7.*

Pepe Karmel (essay date 1981)

[*In the following excerpt, Karmel discusses Winogrand's approach to photography as exemplified in the collections* The Animals, Women Are Beautiful, *and* Public Relations.]

Photography critics raised on the classical elegances of Stieglitz and Cartier-Bresson still consider Garry Winogrand's photographs haphazard snapshots, much as 19th-century academic critics saw the first Impressionist canvases as mere sketches, lacking the finish, composition and clear drawing essential to "good" pictures. To neoclassical photography critics, Winogrand's photographs appear deliberately uncomposed. Janet Malcolm writes that Winogrand "embraces disorder and vulgarity like long lost brothers." He has abandoned Cartier-Bresson's criteria that a photograph should achieve "the appearance of a formal work of art," and that the photographer should capture the "decisive moment" of a gesture or event. Since Winogrand's canonization in 1977 by the Museum of Modern Art's mammoth show of his pictures of "media events," he has become a major scapegoat for those who disliked the experimental photography of the 1960s and '70s.

Winogrand's first comprehensive retrospective, at New York's Light Gallery last April, made it clear that this photographer, like the Impressionists, simply has a new idea of what constitutes the appearance of a formal work of art, and of what kind of gesture constitutes a decisive moment. Winogrand's predecessor in exploring the limits of photographic form and content was Robert Frank. In his superb catalogue essay for Winogrand's 1977 show, "Public Relations," Tod Papageorge pinpointed in Frank's photographs from *The Americans* three devices that influenced Winogrand: the tilting of the picture frame, the use of a wide-angle lens, and the particular way Frank tested the limits of scale—by, in Frank's words, seeing "how small a thing could be in a frame and still sit as its nominal subject." The tilted frame is a metaphor for an off-balance experience of reality. At the same time, it declares the esthetic independence of the photograph from the reality which it depicts by twisting the frame away from the "natural" verticals and horizontals of buildings and horizons. In addition, Winogrand often tilts his camera to get into the picture everything he sees as part of the scene.

Winogrand's 28mm, extremely wide-angle lens serves the same purpose, only more so. Getting as much stuff in as possible is his imperative. Winogrand's pictures are usually packed with astounding quantities of incident and "information," a catchword popular among practitioners and students of street photography during the early '70s. It is on the city street that every human action is likely to be surrounded by a maximum of buildings, signs, shop windows, shopping bags, policemen, cars, and other people. In this setting, "testing the limits of scale" becomes a virtuoso game. Photography rulebooks are full of instructions on getting close to a subject, framing it carefully so it dominates the picture, and cutting out distracting detail. Winogrand deliberately breaks all these rules. Jacob Javits's face, buried in a sea of other faces at the Metropolitan Museum's 1969 Centennial Ball, emerges as a compositional nexus, successfully balancing the figures of the young couple in the left foreground. Of course, the photo-

graphic egalitarianism implicit in the aggrandizement of nearby figures is a mechanical consequence of using a wide-angle lens; Winogrand's accomplishment is to take advantage of this effect while at the same time situating the "nominal subject" in such a way that it remains the pivot of the image. (pp. 39-40)

His first solo show at the Modern, and first book, **The Animals** (1969), was represented in the Light retrospective by several pictures which have become classics: the walrus staring from its pool at the photographer while a family peers through the pool's railing at it, the lupine young man courting a blond woman while an actual wolf paces in its cage behind them, and other images from New York zoos exposing an animal world full of depression, frustration, and rage, not unlike the modern world around it. In using animals to comment on the human condition, Winogrand continued a long tradition, running from Aesop's Fables to Walt Kelly's Okefenokee Swamp. Winogrand's work insists on the humanity of animals as well as the bestiality of humans. His photograph of an interracial couple, holding chimpanzees, has been attacked by leftist critic Victor Burgin as a racist joke, a photographic depiction of the white fantasy that the children of "miscegenation" would be monkeys. But the joke, of course, belongs to the couple: they, after all, have chosen to confront and parody racist antagonism toward their relationship by carrying their pet chimps around in public. Winogrand becomes an accomplice in their joke by including in the picture a small white boy whose anxiety contrasts with the contentedness of the simian "children".

Winogrand's next book collection, **Women Are Beautiful,** appeared in 1975. Winogrand had photographed women everywhere—in swimming pools, in cafeterias, at society parties—but most of all he photographed them in the streets and parks of New York. Avoiding the posed nude or portrait, Winogrand explored how women express their sexuality in social settings, through dress, dancing, sunbathing, flirting and gossiping. In Winogrand's photographs, sex becomes an individualizing force—not, as it usually is in photographs, a depersonalizing one. Indeed, it is the sexual connection that defines the complicated relationship between this photographer and his subjects. Winogrand's pictures express both his desire and his frustration, most eloquently entwined where he has simply confronted a woman on the street, sometimes in midstride, sometimes pausing for his lens. The cover image from **Women Are Beautiful** . . . shows a laughing woman holding an ice cream cone, standing in front of an Atget-style shopwindow that displays a male mannequin. The woman's laugh can be read as a laugh of joy—joy in life, pleasure in her melting ice cream cone (the melting of the phallic cone symbolizing sexual release?), pleasure in the photographer's desire for her. But her laugh might also be read as rejection, as if to say that she finds the photographer's courtship (his desire to photograph her) merely laughable. Perhaps the elegant mannequin in the shopwindow is the photographer's tacit rival—an appropriate suitor, attired to complement the elegance of her simple white dress, her black handbag, the gloves in her hand, the satin lining of her coat. Winogrand's own reflection in the window reveals, by comparison, a rather rumpled Lothario.

The largest group of images in the Light retrospective came from the 1977 "Public Relations" show at MOMA.

The **Public Relations** project originated with a 1969 Guggenheim Fellowship to photograph "media events." These images place the photographer in an ambiguous position. He may scorn those who demean themselves before the lens, but he envies their power to command his camera's attention. At first glance, Winogrand's photograph of a 1973 press conference given by Elliot Richardson gives the eerie impression that no human beings are present to listen to Richardson, isolated at a bare table loaded with microphones; tape recorders cluster like mechanical disciples at his feet. American politics in the electronic age have come a long way from the rabble-rousing of Huey Long. What is remarkable is that the man who can command so much attention is so ordinary.

Opposed to Elliot Richardson's (and Richard Nixon's) catatonic chic was the hyperenergetic youth culture of rock-and-roll, long hair, and antiwar demonstrations. This milieu fascinated Winogrand as well, and it is easy to characterize him as a 1960s sensibility, a photographic equivalent of the New Journalist Tom Wolfe. But the era's public sensibility was not Winogrand's own. Winogrand was 40 in 1968, when the generational slogan was: "Don't trust anyone over 30." Feelings of empathy and estrangement compete in his photograph of Bethesda Fountain plaza on Easter Sunday, 1971. The naked young man approaching the camera seems possessed like a Dionysian figure, his face mingling ecstasy and alarm. The amused, incredulous crowd behind him manifests the conjunction of the youth of different backgrounds around common ideals and fantasies. But the two foreground figures flanking the naked Dionysus are full of anxiety and indecision. Strangely, they are looking away from him, beyond the camera, as if into the future towards which he is advancing, unsure whether Dionysian ecstasy will be adequate to contend with it.

A similar fervor appears in Winogrand's party pictures of the "glitterati," at the height of "radical chic," doing the twist while Rome—or Detroit—burns. These pictures derive from Weegee's The Critic, with the poor woman tramp glaring fiercely at two bubble-headed, jewel-bedecked dowagers. (Winogrand's use of flash also owes much to Weegee.) But Winogrand basically has an indulgent, even admiring attitude toward the rich, powerful, and renowned: he seems to feel at heart that they are awfully lucky to be able to make such fools of themselves, without worrying about the consequences. As the reporter Mike says in The Philadelphia Story, "there's no finer sight in this fine world than the privileged classes enjoying their privileges." If anything, Winogrand grants the old and privileged an assurance and respect he denies the young. At the Metropolitan's 1969 ball, Jacob Javits wears a self-assured smile of pleasure, while the young couple in the left foreground seem anxious and preoccupied. To paraphrase Yeats: the young lack all conviction, while the old are full of passionate intensity. One can't help feeling that Winogrand's sympathies are, finally, on the side of passionate intensity, wherever he finds it. (pp. 40-1)

Pepe Karmel, "Photography: Garry Winogrand, Public Eye," in Art in America, *Vol. 69, No. 9, November, 1981, pp. 39-41.*

Ben Lifson (essay date 1982)

[*Concentrating on* Stock Photographs, *Lifson examines Winogrand's unique vision of American life.*]

Garry Winogrand is one of the few American photographers of this century to have photographed America. Winogrand takes seriously the far-flung breadth of the continent and the look of its unblended masses; our size and diversity are the basic physical facts he starts with and the sources of his art. His pictures have become part of our myth of ourselves and of the eras and regions they photographed. Although he learned his style—as much a set of hypotheses about his medium as a style—in the streets and public spaces of Manhattan during the 1960s, his appetite for subject matter, his curiosity about what lies west of the Hudson, and his questions about what may be photographed (answer: anything) kept him heading for the territory. (Commercial assignments, workshops, and his own cross-country trips—one sponsored by the Guggenheim Foundation in 1964—kept him moving.) When he left New York in 1971 to earn his living as an itinerant teacher, his route retraced our nineteenth-century westward trek: Chicago and the Midwest, Texas and the Southwest, and now, Los Angeles.

The energy that drives him is a version of the partly historical, partly mythical restlessness that drove us from frontier to frontier in the last century. Winogrand's cast of characters is equally American—that is, motley, democratic. His crowded pictures are like visual town meetings, open to everyone, with no previously assigned seats; if you have something to say, you'll be heard; if it's vivid enough, you'll get center stage. But since photographs can only describe a character's surface, not his opinions, Winogrand's America is a democracy of appearance and behavior; it's because of their physical singularity, of costume, hairstyle, grimace, gesture, and outburst, not because of their social status, that his men, women, and children stand out from the crowd, can't be assimilated. They flirt, parade, snarl, beg, stare, laze, and wonder in their own ways. Let three brunettes contemplate and briefly pity a young man in a wheelchair, let an interracial couple (she white, he black) take their chimpanzees for a stroll, or let a man at a formal ball pull back his girlfriend's gown to expose and stare at her breast—in Winogrand's photographs, each character is unique, irreducible. Winogrand sees and describes his subjects so specifically that they become physical anomalies; like the dwarfs, midgets, and amputees who occasionally people his photographs, their shapes are unimaginable until come upon and limned. And if, in this photographer's collection of American originals, there were names like Pecos Bill, Fatty Arbuckle, Bo Jangles Robinson, Stonewall Jackson, Catfish Hunter, Gypsy Rose Lee, Natty Bumppo, Pudd'n'head Wilson, Stella Dallas, Sparkle Plenty, or Sam Spade, I wouldn't be surprised.

Winogrand's hunger for plethora, his eye for particularity, and his delight in simply showing us what he's seen have never been greater than in this group of pictures from the Fort Worth Fat Stock Show and Rodeo. In every photograph Winogrand transmutes photography's descriptive capacity into an occasion for making a fascinating and sometimes intoxicating list. Boots, flags, bunting, lights, hands, faces, cows, sheep, and pigs are strewn across his frames like confetti; on page 36 stand three women whose breasts create a shining visual passage that you wish would go on forever, if it weren't for the counterpoint of their hands.

Stock Photographs is a wonderful catalogue of sights: arabesque cowboy hats; checkered, powdery-wool engineer caps; styles of makeup, from porcelain thin to thick and greasy; hair like spun fiberglass and hides like pale, freckled skin and silver mesh; bulls with necks like sculpted lard; clods of earth flying through the ring like shrapnel; cows' eyes as cold as marble and horses' eyes as hot as flares. . . . How we move (strut, glide, dance, surge, lope) and how we stand; greetings, flirtations, preenings, smiles (this book would be remarkable if only as a warehouse of smiles); the way children hold their animals, dancers hold their partners; the way pigs run, sheep rear, horses buck, and shadows fall. . . . But most of all, it's the faces that astonish. The book is an inventory of American faces that's dazzling in its variety and apparent endlessness. It's enough to make you giddy.

Our teeming world is at once photography's source of richness and its problem. The medium depends on the world's bounty for its own vitality. At the same time, photographs are so descriptive and detailed that their very factualness can deaden their raw material by keeping it raw. When this happens, a photograph's subject can overwhelm its form. But form in photography is complicated by the world's variety and obduracy; a photographer has no easy way of making a round face when he has a narrow one in front of him; there are no synonyms for a face that will let it echo the shape of another face the way another word for ocean rhymes with lea.

When it comes to organizing the world into a picture, the photographer has little to go on. A poet, even today, when his breath is his principal measure, can work inside repetitive stanzas, shaping thought to form; twelve-tone composers frequently plumb the recesses of ancient structures like the fugue, the canon, the motet, or the sonata; a painter has any shape his brush can execute. Prose is the closest analogy to still photography, but photography is a language without syntax. A photographer's only constraining form is his frame. Inside those four edges there are no structural traditions, only space. Others have entered it, but, because the world changes with every picture, you can't follow their footsteps, you can only emulate their pioneering. The frame is a territory without maps and a test of virtuosity.

The long narrow field of the 35-mm. frame (its proportions are $1 \times 1\frac{1}{2}$) is the second frontier Winogrand explores as he surveys America. He has no preconceived ideas about how to divide up that field; rather, for him, its life depends on its being uncharted. How it can be broken up and filled—the structures it can discover, the rhythms it can start, the spaces it can describe—obsesses him. In ***Stock Photographs*** Winogrand's investigation of the visual territory that draws him, that he invades, uncovers a world of structure and space as startling as the faces that help create it. Two enormous heads in a dance hall bite eccentrically into the frame, while they in turn frame and define the cavernous space and the small dancing figures behind them. Hundreds of faces in a corner of the stands seem to have just tumbled into the trough they have made down the center of the frame; in several photographs, huge heads of bulls and cows loom into the frame from the left, from below, testing the picture's ballast.

The more crowded the scene, the more Winogrand's structural virtuosity is at play. Spectators rising in their seats fill half the frame with a shape like a skyrocket's explosion, leaving the rest of the picture space to the random pattern of the seated crowd. Girders, hindquarters of sheep, FFA signs hanging above stock pens, legs, arms, and hats are worked into arbitrary rhythmic patterns creating themes and variations that recur throughout the book. People milling around in a corridor weave together in a configuration as intricate and inventive as anything in a rococo chapel. When too much detail threatens formal coherence, Winogrand tilts his frame, setting everything aright. The variety of form and structure from picture to picture is so great that, finally, the frame is the only constant uniting these disparate performances. That predictable device, page after page, is like the patterned introductions punctuating long rapturous spiels—halfway between the circus master's "and in the center ring . . ." and the Apostle's "Behold . . ." But what follows is anybody's guess. Except that it will be superbly drawn.

Photography means, literally, drawing with light. The first published book of photographs—by William Henry Fox Talbot—was *The Pencil of Nature* (1844). Winogrand, like other masters of 35-mm. photography, understands that with the camera drawing is as important as light. In a way, **Stock Photographs** is a virtuoso set piece, a display of how variously Winogrand can draw the world, from the etchinglike precision of white stitching in white leather, to the visionary, sketchlike rendering of a boy and his sheep. He can then splash light across the frame, as if he were working in water colors, to create sumptuous bodies of cows and bulls or can build a whole photograph (the audacity of it!) around a toothpick that's merely a blunt, broomstraw-thin bright line. He can draw running pigs that look like torpedoes, bucking horses tapered like pears, and, perched on a woman's shoulder, a narrow, claw-like, female hand that outshines the gleaming breasts below.

But again, it's in the faces that Winogrand's drawing astonishes most. A blonde is drawn like a cartoon character: all profile, with no features (not even a nose), yet we know she's smiling. The cartoonist's technique often swells into the caricaturist's when Winogrand creates a buck-toothed laughing cowboy, a long-jawed woman with a concave face, or a cowboy whose profile, from where Winogrand stands, looks as flat as if the man's prize calf had just stepped on his face. There are profiles hung improbably on dark shadows where heads should be and mock heroic faces whose subdued expressions are inappropriate to their monumentality. Hat brims, parka hoods, paper cups, and long tresses cut into scores of other faces, giving them shapes and structures not found in artists' anatomy books or Renaissance compendia of grotesques. And there are a number of faces, especially women's, whose flatness, eccentricity, asymmetry, and disproportion of feature recall the visual program of Cubist portraiture.

The flood of light from Winogrand's flash helps create these strange, flat, almost deformed images; throughout this book light is as important to Winogrand's drawing as contour. A dark horse in a darker corner is all shadow and brilliance; a woman's blouse is a delicate passage of tiny designs against deep blackness—a small galaxy; in the stock pens, intersecting panels of chainlink fences dissolve into luminous cross-hatching unimaginable in any visual medium other than photography.

In fact the book is so much about the way things look when they're photographed, and about Winogrand's exploration of his medium, that we might be distracted from the problem of meaning were it not for the pictures of the rodeo riders and their animals. In the ring Winogrand is confronted with a myth of the frontier past. Although the rodeo is now professional entertainment, where it used to be a ritual reenactment of the skills and courage it took to tame the West, it demands the same skills and courage; it's still a contest between determined men and furious animal nature. The book's meaning emanates from that timeless conflict.

Winogrand respects both the wild energy and the frontier courage of the men who enter the ring. The cowboys' faces are drawn realistically now, without exaggeration or flourish; the riders are full of grim concentration, their bodies tense and purposeful, as they must be, for the animals, with their glowing eyes, metallic hides, and open-mouthed fury, are terrifying. In their bucking, they can hold still, dig in, and lurch all at once. Because of Winogrand's expressionistic drawing, these radically foreshortened, sometimes legless, always massive, improbably buoyant animals are worse than terrifying; they're alien, unknowable.

Everything in the rodeo pictures is drawn to enhance its strangeness. Clowns, animals, even the riders with their fragile human faces, have slight, ghostly auras around them; the blurred earthen surface of the ring swirls like the desert floor in a sandstorm, pitching and tossing like a squalling sea; the crowd is a collection of faceless staring ghouls. These effects are what Winogrand calls "photographic phenomena," the results of using flash on rapid action, of panning the camera to follow movement. The "phenomena" are inevitable, unintentional consequences of Winogrand's methods; they aren't indulged in for their own sake and never overwhelm description. Yet, their poetry dislocates the rodeo slightly, takes it out of the world of entertainment and places it in the realm of American myth.

Those pictures (even, coincidentally, the shape of the frame) recall an older artistic performance—Goya's bullfight etchings. This allusion to Goya's savage vision augments the atmosphere of crucial, even mortal, struggle in Winogrand's rodeo, but it also reminds us of the equally dangerous contention between Winogrand and his medium. In his etchings, Goya never denies that his brilliant light is just blank areas on the plate, his shadows crosshatching, and his bulls, crowds, matadors, horses, spears, and capes, mere line. Yet he virtuosically persuades us that all these draftsmanlike gestures create a perfectly transparent, unmediated vision of dreadful conflict between man and beast, the way Winogrand's virtuosity creates out of photographic phenomena a nostalgic, lyrical, and immediate vision of a contemporary sport with its roots in an older struggle.

Outside the ring, however, only the trappings of the frontier past remain; fake cowboys, city folk in shiny clothes and dry-look haircuts, fragile, overdressed women, and pampered children are figures in a social comedy. Out of the ordinary Texans flocking to the stock show and rodeo

Winogrand has created a gallery of comic stereotypes who move us to laughter because they so perfectly resemble not what they are in life, but their prototypes in art and thought. Like stock characters from all artistic history—from Plautus's wily servants to Mr. Tambo and Mr. Bones of the minstrel show, from Hogarth's gin-soaked mob to Daumier's wizened lawyers—Winogrand's chortling hicks, blasé city slickers, earnest farm kids, dandyfied gentleman farmers, city women with greasy makeup, hardened carnival girls, and beauty queens with clockwork smiles come into view full-fledged, in all their predictable, one-dimensional glory. And when we see a black cowboy shaking hands with a drunken Indian, we see the extent of Winogrand's powers of transformation. In one stroke, he creates one character who appears all too little in our fictions of the West and another who appears all too often. Winogrand has done this before. In his 1960s New York photographs, an interracial couple strolling with their chimpanzees unwittingly embody an ugly racial joke; four gossiping old women on a sidewalk full of garbage bags unwittingly personify a derogatory epithet. There, as with these Texans, our laughter is complex. We laugh at the world's ability to produce such literal metaphors, at our own capacity to become such characters, and at Winogrand's comic mastery.

In **Stock Photographs** Winogrand's comedy of ideas contains a comedy of manners, and we also laugh at what we assume to be an accurate recording of a social truth. This is Texas, we think—this vision of a sophisticated American center of wealth and power hankering after its frontier past. Because Winogrand's characters don't appear in earlier versions of the West, they seem to epitomize this modern regional civilization that is so uneasy about its identity, flagrant with its money, nostalgic for ruder times. Families in matching fleece-lined suede jackets and cowboy hats fall short of the past they imitate. Characters with hard-bitten frontier faces look foolish in their citified hairdos and brand new polyester shirts. In dance halls, couples perform country dances with awkward exuberance; and in the corridors, pale-faced city boys in shiny leather jackets fall short of the tanned, lined rodeo riders they flock around.

And trotting through this book from time to time like a satirical chorus come animals who resemble people. A far cry from the little dogies and Ole Paints of cowboy songs, these disgruntled creatures give us baleful looks, mocking us for taking the whole thing seriously. As a gentleman farmer tips his hat to receive his prize, his bull calmly and irreverently licks snot from its nose.

It's not just a western tradition Winogrand's Texans yearn for and sometimes betray, but an American one as well. Despite their physical singularities, many of Winogrand's characters turn from their own excellences, squeeze their remarkable bodies into clothes that are too tight, drape themselves in leather jackets that are too loose, and smoothe out their character-lined faces with pasty makeup. Despite the carnival, they are often weary and stilled. Parades bore them, crowds oppress them, and even their flirtations are self-conscious and restrained. Uneasy about themselves, they seek and fear attention. They brighten at a joke and come alive when they see a familiar face that may rescue them from solitude. The exuberance we associate with our common past has dried up; our fabled individualism has shrunk to conformity; these Americans are bland, their passions subdued.

Winogrand's photography quickens them. Tilting his camera, exaggerating the scale of a face, blitzing them with light, the photographer shakes life into his subjects by dragging them into the uncivilized world of his frames where his own passions are engaged. A boy's tenderness toward his sheep would be an incidental detail if the boy's face weren't so large; the glint of delight in a woman's eye needs all Winogrand's light to shine; the feral urgency of two boys straining against their father's grasp is the stronger for the way Winogrand's photography shoves them against the edge of the frame and attenuates their already long, narrow faces.

Sometimes Winogrand attacks just to see what will happen, to see if he can create vital human beings entirely through visual bravado. The strategy pays off in characters like the spectators at the parade in the most radically tilted photograph here, who brace themselves against the photographer's coming as they might against the wind and, in the process, disclose something about their nature because of Winogrand's presence. There is generosity in this. Winogrand assumes that people have the makings of vitality and character. The flagrant visual liberties he takes with them are also acts of generosity toward his audience.

Winogrand's art is neither private lyricism nor meditation nor theoretical exploration; like the rodeo he photographs, his mode is public spectacle. He handles his characters the way an impresario handles his performers, hectoring them to exceed themselves and inventing increasingly more splendid structures to house them and to delight us. When we first see the tilted picture of the crowd at the parade, or first come upon the fat boy whose face is drawn to look like his sheep's, our response must surely have something of the audience's gasp when the curtain goes up on the second act of Swan Lake to reveal an enchanted wood of surpassing delicacy and charm.

Winogrand's spectacle is wild. While he animates his characters he frequently creates harsh truths. His emphasis on any display of energy or spirit magnifies everything else about his characters, including their physicality. In Winogrand's comedy of manners, part of the stage is reserved for burlesque.

At this recognition our laughter takes on an edge of derision which is disturbing; we find ourselves laughing at caricatures. But bad skin, concave faces, a dancing woman's pear-shaped ungainliness, are nature's doings, not moral failings. Our laughter distances us from characters who began as our fellow beings. If we remind ourselves that human beings aren't always responsible for the spectacle others see in them, if we argue that a character in a photograph isn't the same as moral character, then we have identified the key to our dilemma in a truth about photography.

Winogrand's photography is Winogrand's fiction; these Texans are his creatures. He may draw them from life, but his drawing points to their fictional existence, to their roles in the world of these pictures. With his huge head and oversize teeth, the laughing cowboy may be the country bumpkin come to the fair, but only because Winogrand has drawn him thus. Winogrand's Texans are as distant from the Fort Worth audience as Julia Margaret Camer-

on's madonnas are from the housemaids who posed for her.

Winogrand's comic art, moreover, doesn't moralize; it presents no villains and makes no judgments. In the comedy of manners, laughter may deflate a character or a society, but doesn't slander; it leads to discomfiture, perhaps, but not to perdition. Winogrand's social laughter is an aspect of his democracy. Like Mark Twain's, Ring Lardner's, Bill Mauldin's, or Charlie Chaplin's, Winogrand's comedy respects no hierarchies, stands on no ceremony. It can, however, create momentary heroes and heroines who can take their place in this book beside the riders in the ring. Here, Winogrand's contemporary heroes are creatures of excess and self-awareness, like the fat farmer who struts across the show ring good naturedly exaggerating the connection between his girth and his bull's; or like the three women on page 36 who turn the act of being photographed into an outrageously burlesque flirtation with the photographer, while, with their hands, they carry on an even wilder and equally self-mocking flirtation among themselves. If people are energetic, like the self-absorbed women tending to their hair, Winogrand notices them; if they're passionate, like the cowboy whose eyes start from his head as if he's just survived a stampede, he makes them stars. In the stock pens, men, women, and children tend to their animals with care. Absorbed in activity that takes them out of themselves, they receive our respect; as they bend and stretch to curry and calm their beasts, they are beautiful, and our laughter turns to wonder.

But even as it brings forth creatures as marvelous as the trio of vamping beauties, bulls who are darkness incarnate, and balletic pigs, Winogrand's comedy has its rough side; it spawns a crowd of grotesques. We find ourselves gaping at what looks like a drunken Indian, gawking at a man whose arms have been amputated above his elbows, holding a paper cup between his stumps. Like Goya and Fellini, also masters of the grotesque, Winogrand understands that the self-indulgent and the misshapen are part of the real world upon which all art draws.

Winogrand's fictionalized rodeo is ultimately an imaginary democracy based on the original American assumption of every being's worth; it enfranchises all. It treats its citizens unceremoniously (this is the nation whose third president, Thomas Jefferson, walked back to his boarding-house alone after his inaugural address to find that his landlady hadn't kept supper waiting for him); but it gives everyone a chance to be amazing—and even a second chance: the fat boy whose blank face sparks our laughter returns at the end of the book as a minor character in a crowd of children driving their sheep through the ring; there he stands out again, an image of sheer concentration, urging his animal to excellence.

Still, it's a risky business, this effort to breathe life into the world by means of art, for it leads to satire and satire can breed resentment. It's riskier still because it takes Winogrand to visual outposts at the edge of incoherence where eyes accustomed to a tamer, more polite photography might see only wildness and miss the art. It also means that as Winogrand works without preconceived visual restraints, he works without social taboos, staring at everything—failed lives, a failed society in an abundant world—in order to create his own world of possibilities.

And this means he has to contend with his own conflicting responses to life as he stirs ours and entertains us.

This book ends with three pictures of rodeo clowns, metaphors for Winogrand's comic, risky adventure into the complex arena of our society, his own emotions, and the photographic frame. It's an adventure few take, for the possibility of being thrown by any of the forces in contention is great; even the professional cowboys run as the bulls charge and toss the clowns. But the clowns, even the one suspended in midair, don't fall in these pictures. Rather, they achieve buoyancy as they perform their controlled antics. They appeal to our laughter, fear, and wonder in the empty floodlit ring whose governance they share with the convulsive bulls. Winogrand is at the height of his powers.

Garry Winogrand has left Texas. Now, in Los Angeles, he's photographing, as always. No one has seen what he's done there. *Stock Photographs* is his latest dispatch. It is also some of the most intelligent, passionate, and sophisticated photography we have seen from one of the most significant photographers of the century. (pp. 33-9)

> Ben Lifson, "Garry Winogrand's American Comedy," in Aperture, No. 86, 1982, pp. 32-9.

FURTHER READING

I. Critical Studies and Reviews

Badger, Gerry. "Recent Books." *British Journal of Photography* 125, No. 6137 (10 March 1978): 214-15, 217.
> Discusses the collections *The Animals, Women Are Beautiful,* and *Public Relations.* Badger judges *Women Are Beautiful* disappointing but finds the subject matter of *Public Relations* perfectly suited to Winogrand's snapshot technique.

Blum, Caroline. "Facts of Life." *Art International,* No. 4 (Autumn 1988): 101.
> Positive review of the 1988 retrospective exhibition "Figments from the Real World."

Coleman, A. D. "Slim Pickings in Hog Heaven." *Camera 35* 26, No. 8 (August 1981): 20-1, 80.
> Negative review of the collection *Stock Photographs.* Coleman objects in particular to Winogrand's style—describing it as "a jumble of haphazard images"—and to the lack of focus and conviction in his satirical intent.

Davis, Douglas. "The Medium Is the Message." *Newsweek* 90, No. 19 (7 November 1977): 106-07.
> Review of the exhibition "Public Relations." Davis notes that Winogrand's technique can produce both strikingly good and completely ineffective images.

Edelson, Michael. "A Mosaic of Mediacracy." *Camera 35* 21, No. 12 (January 1978): 22-3.
> Negative review of "Public Relations." Edelson writes: "Winogrand fails in his purpose of demonstrating the premise of 'Public Relations' because he tries to prove

his point with ordinary party pictures and second-rate press photography."

Edwards, Owen. "Garry, Garry, So Contrary." *American Photographer* XXI, No. 2 (August 1988): 14, 16.
A review of *Winogrand: Figments from Real Life* that focuses on the enormous number of undeveloped negatives the photographer left behind at his death.

Grundberg, Andy. "Life Seized on the Fly." *New York Times* (23 December 1984): 29.
Appreciative overview of Winogrand's work.

Lifson, Ben. "Winogrand: De Tocqueville with a Camera." *Village Voice* XXII, No. 45 (7 November 1977): 74.
Positive review of the exhibition "Public Relations."

———. "Winogrand: The Pleasure of What's There." *Village Voice* XXIV, No. 29 (16 July 1979): 66.
Discusses Winogrand's photographs of Greece.

———. "About Garry Winogrand." *Artforum* XXIII, No. 1 (September 1984): 65-9.
A personal recollection of Winogrand.

Malcolm, Janet. "Photography." *New Yorker* 51, No. 24 (4 August 1975): 56-9.
Includes a discussion of Winogrand's style. Malcolm notes his affinities with photographer Robert Frank and comments: "Each picture is touched with the element of risk that Winogrand courts . . ., and not every picture is a photograph . . . But when a picture works, it is potent indeed."

Patton, Phil. Review of *Women Are Beautiful,* by Garry Winogrand. *Artforum* XIV, No. 6 (February 1976): 65-6.
Applauds Winogrand's photographs of women.

Whelan, Richard. "Garry Winogrand." *ARTnews* 78, No. 9 (November 1979): 190.
A brief review of a 1979 exhibition at the Light Gallery in New York City.

Wilcox, Beth. "Winogrand/Bonfils at The Burton Gallery." *Artmagazine* 13, No. 57 (February, March, April, 1982): 40-1.
Includes a critique of Winogrand's work, which Wilcox judges uneven in quality.

Woodward, Richard B. "Garry Winogrand." *ARTnews* 87, No. 8 (October 1988): 168, 173.
Discusses the retrospective of Winogrand's works held at the Museum of Modern Art in 1988, lamenting the show's "cold-eyed" documentation of his diminished capabilities during the later years of his life.

II. Selected Sources of Reproductions

Winogrand, Garry. *The Animals.* New York: Museum of Modern Art, 1969, unpaged.
Winogrand's first book.

———. *Women Are Beautiful.* New York: A Light Gallery Book, Farrar, Straus & Giroux, 1975, unpaged.
Winogrand's best-known collection of photographs.

———. *Garry Winogrand: Grossmont College Gallery 15 March to 2 April 1976,* edited by Gene Kennedy. n.p., 1976, 23 p.
Reproduces photographs shown at an exhibition in El Cajon, California. Includes an introductory essay by Leo Rubinfien and comments by Winogrand excerpted above.

———. *Public Relations.* New York: Museum of Modern Art, 1977, 110 p.
Winogrand's often sardonic look at the world of "media events."

———. *Stock Photographs: The Fort Worth Fat Stock Show and Rodeo.* Austin: University of Texas Press, 1980. 117 p.
Winogrand applies his approach to a distinctively American institution.

———. *Winogrand: Figments From the Real World.* New York: Museum of Modern Art, 1988, 260 p.
A collection of Winogrand's photographs published to accompany a retrospective exhibition at the Museum of Modern Art. Includes some previously unpublished photographs and a lengthy biographical essay by John Szarkowski.

Frank Lloyd Wright

1869(?)-1959

American architect.

Considered one of the most important American architects of the twentieth century, Wright achieved international fame for his unique vision of modern architecture. Rejecting both the rationalist ideology and rigid machine aesthetic propounded by the leaders of the Modern Movement in Europe, Wright sought to accommodate social, environmental, and technological considerations through the creation of what he called "organic architecture." Wright's architectural philosophy found expression in both his public and private buildings. Of the former, his early office buildings, in particular, are considered advanced for their bold integration of functional and social considerations. However, Wright's numerous designs for private houses are generally thought to constitute his greatest and most enduring work. Acclaimed for their innovations in planning, expressive use of materials, and subtle integration with their natural setting, both the early Prairie houses and the later Usonian concept were extremely influential in the formation of post-war attitudes towards the design of the American house.

Wright was born in Richland Center, Wisconsin. His childhood years were spent travelling with his parents, as his father, a Unitarian minister, constantly sought to improve the family's precarious financial position. In 1877, the Wrights finally settled in Madison, Wisconsin, near Mrs. Wright's family, the Lloyd Joneses, prosperous farmers of Welsh extraction. For several years Wright spent his summers assisting in farm work on property owned by his uncle James, and he learned to appreciate the importance of a close interrelationship with the natural world. Wright attended high school in Madison from 1879 to 1883 but never graduated. Nonetheless, in 1885 he was admitted to the University of Wisconsin, where he studied engineering for two years. His introduction to the architectural profession also occurred in 1885, when he met J. Lyman Silsbee, a successful architect who had recently designed All Souls Church for Wright's uncle Jenkin Lloyd Jones. Beginning in 1887, Wright assisted Silsbee as a junior draughtsman. However, he soon became dissatisfied with Silsbee's conservative approach to design and in 1888 he joined the firm run by Dankmar Adler and the noted commercial architect Louis Sullivan, who advocated an expressive functionalism that greatly influenced Wright. Wright stayed with Adler and Sullivan until 1893, by which time he was already accepting independent commissions to design houses, primarily in Oak Park, a suburb of Chicago.

Wright's early houses (1889-99) were largely derivative in style. However, the Winslow house (1894) and the house Wright designed for himself in 1889 were notable for their rigorous simplification of architectural elements, hinting at his later style. The period from 1900 to 1914 marked the apotheosis of Wright's early career. He designed a great number of houses for upper-middle class clients in and around Chicago that defined what has become known as the Prairie style, characterized by an open, asymmetri-

cal plan, interpenetrating spaces, long horizontal planes, and an unprecedented transparency, which brought the house into an intimate relationship with its surroundings. Another notable feature of the Prairie house was its expression of the ideal of a *Gesamkunstwerk,* or "total work of art," which originated in the German Arts and Crafts movement and involved the harmonious integration of all decorative elements into the functional design of the house. In many cases, Wright himself designed the furniture and decorative motifs for his Prairie houses. The most notable houses from this period include the Willits house (1902), the Dana house (1903), the Martin house (1903), and two masterpieces, the Coonley house (1908), considered by Wright his most successful Prairie house, and the Robie house (1909), his most abstract design of the period. Wright also designed a number of public buildings before the First World War, most importantly the Larkin Building (1904) and Unity Temple (1906) in Oak Park. The Larkin Building was distinguished by its open plan and monumental exterior, while Unity Temple was the first example of monolithic reinforced concrete construction in the United States. By 1909, Wright's reputation as a leading avant-garde architect was solidly established in America. Yet he felt that he had nearly exhausted his creative powers, and, frustrated as well by his domestic situation,

he left his wife and family in 1909 and went to Europe, accompanied by Mamah Borthwick Cheney, the wife of a client.

Wright's return to Oak Park in October 1910 initiated the second period of his architectural career. Alienated from the professional classes that had previously supported him by the scandal of his continuing affair with Cheney, Wright retreated to Spring Green, Wisconsin. On property owned by his mother, he built a home, which he named Taliesin. Tragedy struck in 1914 when a deranged servant set the main house on fire, killing Cheney, two of her children, and four of the staff. Immediately thereafter, the house was rebuilt as Taliesin II. (Completely destroyed by fire in 1925, it was rebuilt as Taliesin III.) Wright completed only two other important projects during this time: Midway Gardens (1914), an outdoor entertainment complex in Chicago which was demolished only fifteen years later, and the Imperial Hotel (1916-22) in Tokyo. A synthesis of Western and Japanese traditions, the Imperial Hotel survived the 1922 Tokyo earthquake intact due to Wright's foresight in employing a sophisticated type of reinforced concrete frame construction. In the twenties, Wright's attention turned to California, where he designed a series of innovative houses. Unlike the Prairie houses, these were formal and monolithic in appearance, typified by the Barnsdall house (1920), a lavish villa designed for a Hollywood aesthete, and the Millard house (1923), considered his finest essay in concrete-block construction. The 1929 stock market crash and ensuing depression deprived Wright of significant commissions for many years. Partly in order to alleviate growing financial difficulties, Wright founded the Taliesin Fellowship, an integrated training program for aspiring architects, in 1932. He also concentrated increasingly on writing during this time, publishing his *Autobiography* and a book on urbanism, *The Disappearing City,* in which he advocated a radical decentralization of the traditional city and the creation of a quasi-rural utopia he called Broadacre City.

In the mid-thirties, Wright's fortunes changed dramatically when he received a number of important commissions. The first of these was a weekend house for the Edgar Kaufmann family known as Falling Water, completed in 1936. Dramatically cantilevered over a wooded stream near Bear Run, Pennsylvania, Falling Water demonstrated Wright's mastery of reinforced concrete construction and great subtlety in the integration of natural and man-made elements. The same year, Wright received a commission for the S. C. Johnson and Son Company administration building (1936-39). Concerned with providing a unified, stimulating work environment, Wright created a large, open work space, punctuated by slender mushroom-shaped columns that terminated in large lily-pad capitals, the interstices of which were interwoven with pyrex glass tubing. The year 1936 was also notable for the completion of Wright's first Usonian (derived from the term U.S.A.) house, the Jacobs house, designed as efficient, low cost housing for the lower-middle class. Shortly after the completion of the Jacobs house, Wright also designed a new home for himself in Arizona, calling it Taliesin West. The climax of Wright's postwar career, however, was the construction of the Solomon R. Guggenheim Museum, intended to display Guggenheim's renowned collection of non-representational art. Like Falling Water, the Guggenheim Museum exploited the dramatic spatial possibilities of reinforced concrete, and was deliberately designed as a free-standing monument in order to set it apart from the surrounding urban fabric of New York. Completed shortly after Wright's death in 1959, the Guggenheim's eccentric design immediately raised a critical controversy.

While Frank Lloyd Wright's work, considered as a whole, is no longer held in universal regard, particular monuments like the Guggenheim Museum, as well as the early Prairie houses, are still considered important, innovative contributions to twentieth-century American architecture. Moreover, his influence on architectural theory in America persists, given the general acceptance of the open plan as well as the widespread use of natural building materials, both hallmarks of his architectural credo.

ARTIST'S STATEMENTS

Frank Lloyd Wright (essay date 1932)

[*In the following excerpt from his autobiography, Wright outlines the five basic components of his theory of organic architecture, focusing on what he considers the proper, rational use of materials in the "New Machine Age."*]

Our vast resources in America are yet new, new only because architecture is old. "Rebirth" (perennial Renaissance) has, after five centuries of decline, culminated in the imitation of imitations as seen by our Mrs. Plaster-built, Mrs. Gablemore and especially now by Miss Flat-top. In general, and especially officially, our architecture is at long last completely significant of insignificance. We do not longer have an architecture. At least no buildings with artistic integrity. We have only economic crimes in its name. Our greatest buildings are not qualified as great art. . . .

If you will be patient for a little while—a scientist, Einstein, asked for three days to explain the far less pressing and practical matter of "Relativity"—we will take each of the five new resources in order, as with the five fingers of the hand. All are new integrities to be used if we will use them to make living easier and better today for us all.

The first great integrity is deeper, more intimate sense of reality in building than was ever pagan—that is to say, than was ever "Classic." More human than any building realized in the Christian Middle Ages, although the thought that may ennoble it now has been living in civilization for more than twenty centuries. Innate in the simplicities of Jesus as it was organic five hundred years earlier in the natural philosophy, Tao (The Way) of the Chinese philosopher, Laotze. But not only is the new architecture sound philosophy. It is true poetry.

Said Ong Giao Ki, Chinese sage, "Poetry is the sound of the heart."

Well, like poetry, this sense of architecture is the sound of the "within." We might call that "within," the heart.

Architecture now becomes integral, the expression of ever new-old reality: it lies in the livable interior space of the room itself. In integral architecture the *room-space itself must come through.* The *room* must be seen as architecture, or we have no twentieth-century architecture. We have no longer an outside merely as outside. No longer an outside and an inside as two separate things. Now the outside may come inside, and the inside may, and does, go outside. They are *of* each other. Form and function become one in design and execution if the *nature* of materials and method and purpose are all in unison.

This interior-space concept, the first broad integrity is [the] first great resource—true basis for general significance of form. Add to this for the sake of clarity that (although the general integration is implied by the first integrity) it is in the nature of any organic building to grow from within on its site: come out of the ground an organism into the light—the ground itself held always as a component part of the building itself. We have then primarily the new ideal of building as Organic. A building dignified as a tree in the midst of Nature. (pp. 362-63)

Now consider the second of the five new resources: glass. This second resource, new, a "super-material" only because it holds such amazing means to modernize life for awakened sensibilities. It amounts to a new qualification of life itself. If known in ancient times glass would then and there have abolished the ancient architecture we know, and completely. This super-material GLASS as we use it is a miracle: air in air to keep air out or keep it in. Light itself in light, to diffuse or reflect, or refract Light itself.

By means of glass, the first great integrity finds prime means of realization. Open reaches of the ground may enter the building and the building interior may reach out and associate with these vistas of the ground. Ground and building thus become more and more obvious as directly related to each other in openness and intimacy, not only as environment but also as good pattern for good life lived in the building. Realizing the benefits to human life of the far-reaching implications and effects of the first great integrity: let us call it the interior-space concept. This interior realization is possible and desirable in all the vast variety of characteristic buildings needed by civilized life in our complex age today.

By means of the miracle, glass, something of the freedom of our arboreal ancestors living in their trees becomes a more likely precedent for freedom in twentieth-century life than the cave.

Savage animals "holing in" for protection were characteristic of life based upon the might of feudal times or based upon the so-called classical in architecture, both in turn based upon labor of the chattel slave. In a free century, were we ourselves free, organic thought in building might come out into the light without animal fear; come entirely away from pagan ideals of Form we dote upon and teach as "Classic." Or what Freedom have we in America?

Perhaps more important than all beside it is that by way of glass the sunlit space as a reality becomes most useful servant of a higher order of the human Spirit. It is first aid to the sense of cleanliness of line, form and idea when directly related to free living in fresh air and sunlight. It is this freshness that is coming in the new architecture with

the integral character of extended vistas gained by marrying buildings with ground levels, or blending them with slopes and gardens. This new sense of earth as a great human *good* we will call the move forward in building our new homes and great public buildings. Works of great Art.

I am certain we will desire the sun, spaciousness and integrity of means-to-ends more and more, year by year as we become aware of the possibilities I have outlined. The more we desire the sun, the more we will desire the freedom of the good ground and the sooner we will learn to understand it. The more we value *integrity,* the more securely we will find and keep a worthwhile civilization to set against prevalent abuse and ruin by education. (pp. 363-64)

This dawning sense of the *Within* as *reality* when it is clearly seen as *Nature* will by way of glass, steel and concrete make the garden be the building as much as the building will be the garden: the sun and sky as treasured a feature of daily indoor life as the ground itself.

Even now see walls vanishing. The cave for human dwelling purposes is disappearing.

Walls themselves because of glass become windows and windows as we used to know them as holes in walls will be seldom seen. Ceilings will often become as window-walls. The textile may soon be fit to be used as a beautiful overhead for space; textiles an attribute of genuine architecture instead of mere decoration by way of hangings and upholstery. Modern integral floor heating, gravity-heat, will follow integral lighting and standardized unitary sanitation. All these make it reasonable and good economy to abolish building as either hyper-boxment or super-borough. (p. 365)

As third resource, now the resource essential to modern architecture destined to cut down this outrageous mass-waste and lying-mass, is the principle of *continuity.* I have called it tenuity. Steel is its prophet and master. You must come with me for a moment into so-called engineering. This an unavoidable strain upon your kind attention. Unfortunately, gentle reader, you cannot understand architecture as *modern* unless you do come, and—paradox— you can't come if you are too well educated as an engineer or as an architect yourself either. Your common sense is needed more than your erudition but is in your way.

However, to begin argument: classic architecture knew only the post as an *upright.* Call it a column. Knew only the beam as a *horizontal.* Call it a beam. The beam resting upon the upright, or column, was to them structure throughout. Two things, you see, one set on top of another in various materials. Put there in various ways. Ancient, and nineteenth-century buildings science too, even building *à la mode,* consists as it consisted in simply reducing the various stresses of all materials and their uses to these two things: Post and Beam. Really, construction used to be just sticking up something in wood, steel or stone and putting something else in wood or stone (maybe iron) on top of it: simple super-imposition, you see? You should know that is all "Classic" architecture ever was. Still is some such form of direct super-imposition. The arch is a little less so, but even that must be a load so "figured" by the structural engineer if you ask him to "figure." (pp. 365-66)

Of course this primitive post-and-beam construction will be still valid, but both support and supported may now by means of inserted and welded steel strands or especially woven filaments of steel and modern concrete casting be plaited and united as one physical body: ceilings and walls made one with floors, reinforcing each other by making them continue into one another. This "Continuity" is made possible by the tenuity of steel.

So the new order wherever steel or plastics enter construction says: weld these two things, post and beam (wall and ceiling) together by means of steel strands buried and stressed within the mass material itself, the steel strands electric-welded where steel meets steel within the mass. In other words, the upright and horizontal may now be made to work together as one. A new world of form opens inevitably with the appearance of the cantilever.

Where the beam leaves off and the post begins is no longer important nor need it be seen at all because it no longer *is* actual. Steel in tension enables support to slide into supported, or the supported to grow into the support somewhat as a tree-branch glides out of its tree-trunk. Therefrom arises the new series of interior physical reactions I am calling "Continuity." As natural consequence the new esthetic or appearance we call *Plasticity* (and plasticity is peculiarly "modern") is no longer a mere appearance. Plasticity is actually the normal *countenance,* the *true esthetic expression* of genuine structural reality. Interwoven steel strands may so lie in so many desired directions in any extended member of structure that extensions may all be economical of material and much lighter, be safer than ever before. In the branch of the tree you may see the cantilever. The cantilever is simplest of the important phases of this third new structural resource demanding new expression. It has yet had little attention in modern architecture. It can do remarkable things to liberate space as twentieth-century Architecture. (pp. 366-67)

To further illustrate this magic simplifier "plasticity": see it as *flexibility* similar to that of your own hand. What makes your hand expressive? Flowing continuous line and continuous surfaces used continually flexible as mobile, part of the articulate articulated structure of the hand as a whole. The line is seen as "hand" line. The varying planes seen as "hand" surface. Strip the hand to the separate structural identities of joined bones (post and beam) and plasticity as the flesh expression of the hand. We would be then getting back to the joinings, breaks, jolts and joints of ancient, or "Classic," architecture: thing to thing; feature to feature. But plasticity is the reverse of that ancient agglomeration and is the ideal means behind these simplified free new effects of straight line and flat plane architecture we call organic. (p. 367)

Architecture is now integral architecture only when Plasticity is a genuine expression of actual construction just as the articulate line and surface of the hand is articulate of the structure of the hand. Arriving at steel, I first used Continuity as actual stabilizing principle in concrete slab construction also and in the concrete ferro-block system I devised in Los Angeles. . . .

In the cantilever or as horizontal continuity this new economy by means of steel-tenuity is what saved the Imperial Hotel from destruction during the great earthquake of 1922. It did not appear in the grammar of the building for

various reasons, chiefly because the building was to look somewhat as though it belonged to Tokio, Japan. (pp. 367-68)

As the first integrity and the two first new resources appeared out of interior nature in the kind of building I call Architecture—so now—naturally interior to the true nature of good building comes the fourth resource. This is found by recognizing the nature of materials used in construction.

Fascinating different properties, as many as there are different materials that may be used in building, will continually, and naturally, qualify and change all architectural forms whatsoever as design and purpose change.

A stone building will no more *be* nor will it *look* like a masonry or steel building. A pottery, or terra-cotta building, will not nor should it look like a stone building. A wood building will look like none other, for it will glorify the stick. A steel and glass building could not possibly look like anything but itself. It will glorify steel and glass. So on and on all the way down the long list of available riches in materials: Stone, Wood, Concrete, Metals, Glass, Textiles, Pulp and Plastics: riches so great to our hand today that no comparison with Ancient Architecture is at all sensible or anything but obstruction in Modern Architecture.

In this particular, as you may see, architecture going back to learn from the natural source of all natural things—Nature.

In order to get Organic Architecture born, intelligent architects will be forced to turn their backs on the antique rubbish heaps with which Classic eclecticism has encumbered our practice of Architecture. So far as architecture has gone in my own thought it is first of all a character and quality of *mind* that may enter also into human conduct with social implications that might, at first, confound or astound you. But the only basis for any fear of them lies in the fact that they are all sanely and thoroughly *constructive.* Truth is a double-edged sword and can cut both ways, but why cowardice?

Instinctively all forms of pretense fear and hate reality.

THE HYPOCRITE MUST ALWAYS HATE THE RADICAL because radical is of the root. The radical is a root man always alert to why and how, where and when.

This potent fourth new resource—the Nature of Materials—gets at the common center of relation to the work it is required to do. The architect must again begin at the very beginning. Proceeding according to Nature now he sensibly goes through with whatever material may be in hand for his purpose according to the methods and sensibilities of a man of this Machine Age. When I say Nature, I mean inherent interior *structure* seen and unseen by the architect as complete design. Good design is in itself, always, intrinsic *nature-pattern*. This profound interior sense of materials that enters our new world as Architecture now. It is this fifth new resource that must captivate and hold the mind of the modern architect to creative work. The fifth will give life to his imagination if it has not been already killed by school of one sort or another.

Inevitable implication! New Machine Age resource requires that all buildings do *not* resemble each other. But

new ideals do *not* require that all buildings be of steel, concrete or glass. Often that might be idiotic waste.

Nor do the resources even *imply* that mass is no longer a beautiful attribute of masonry materials genuinely used. We are entitled to a vast variety of form in our complex age so long as the form be genuine—serves Architecture as Architecture serves life.

But in this land of ours, richest on earth in old and new materials, architects must exercise well-trained imagination to see in each material, either natural or compounded plastics, their own *inherent style* for the purpose in hand. All materials may have beautiful consequence. Their beauty much or entirely depending upon how well they are used by the Architect.

In modern building we have the Stick. Stone. Steel. Pottery. Concrete. Glass. Yes, Pulp, too, as well as Plastics. And since this dawning sense of the "within" is the new reality, these will all give *"motif"* to any real building made from them. The materials of which the building is built will go far to determine its appropriate mass, outline and, especially, proportion. *Character* is criterion in the form of any and every building or industrial product we can call Architecture in the light of this new ideal of the new order we call Organic. (pp. 369-70)

Frank Lloyd Wright, in his An Autobiography, *1932. Reprint by Horizon Press, 1977, 620 p.*

Frank Lloyd Wright (essay date 1932)

[*In the following excerpt from* The Disappearing City, *Wright indicates the individualistic, democratic basis for the social and physical structure of Broadacre City, asserting that its opposite, the finite, traditional city, is as ethically unsound as it is technologically outmoded.*]

We are concerned here in the consideration of the future city as a future for individuality in [the] organic sense: individuality being a fine integrity of the human race. Without such integrity there can be no real culture whatever what we call civilization may be.

We are going to call this city for the individual the **Broadacre City** because it is based upon a minimum of an acre to the family.

And, we are concerned for fear systems, schemes, and "styles" have already become so expedient as civilization that they may try to go on in Usonia as imitation culture and so will indefinitely postpone all hope of any great life for a growing people in any such city the United States may yet have.

To date our capitalism as individualism, our eclecticism as personality has, by way of taste, got in the way of integrity as individuality in the popular understanding, and on account of that fundamental misunderstanding we, the prey of our culture-monger, stand in danger of losing our chance at this free life our charter of liberty originally held out to us.

I see that free life in the **Broadacre City.**

As for freedom; we have prohibition because a few fools can't carry their liquor; Russia has communism because

a few fools couldn't carry their power; we have a swollen privatism because a few fools can't carry their "success" and money must go on making money.

If instead of an organic architecture we have a style formula in architecture in America, it will be because too many fools have neither imagination nor the integrity called individuality. And we have our present overgrown cities because the many capitalistic fools are contented to be dangerous fools.

A fool ordinarily lacks significance except as a cipher has it. The fool is neither positive nor negative. But by way of adventitious wealth and mechanical leverage he and his satellites—the neuters—are the overgrown city and the dam across the stream flowing toward freedom.

.

It is only the individual developing in his own right (consciously or unconsciously) who will go, first, to the **Broadacre City** because it is the proper sense of the dignity and worth of the individual, as an individual, that is building that city. But after those with this sense the others will come trailing along into the communal-individuality that alone we can call Democracy.

But before anything of significance or consequence can happen in the culture of such a civilization as ours, no matter how that civilization came to be, individuality as a significance and integrity must be a healthy growth or at least growing healthy. And it must be a recognized quality of greatness.

In an organic modern architecture, all will gladly contribute this quality, as they may, in the spirit that built the majestic cathedrals of the middle-ages. That medieval spirit was nearest the communal, democratic spirit of anything we know. The common-spirit of a people disciplined by means and methods and materials, in common, will have—and with no recognized formula—great unity. (pp. 17-19)

.

Let us turn, now, to these forces that are thrusting at the city to see how they will, eventually, return such human nature as survives . . . festering acceleration, body and soul to the soil, and, in course of time, repair the damage cancerous overgrowth has wrought upon the life of the United States.

As one force working toward the destruction that is really emancipation, we have . . . the reawakening of the slumbering primitive-instinct of the wandering tribe that has come down the ages and intermingled with the instincts of the cave dweller.

The active physical forces that are now trained inevitably against the city are now on the side of this space loving primitive because modern force, by way of electrical, mechanical and chemical invention are volatilizing voice, vision and movement-in-distance in all its human forms until spaciousness is scientific. So the city is already become unscientific in its congested verticality and to the space loving human being, intolerable. The unnatural stricture of verticality can not stand against natural horizontality.

As another force—a moving spiritual force—the fresh in-

terpretation to which we have referred as a superb ideal of human freedom—Democracy comes to our aid. Our own new spiritual concept of life will find its natural consequences in the life we are about to live. We are going to move with that new spiritual concept the nation has been calling Democracy only half comprehending either ideal or form. This ideal is becoming the greatest subconscious spiritual moving force now moving against the city with new factual resources.

Surviving instincts of the freedom-loving primitive; these new instruments of civilization we call the machines working on new and super materials, together with this great new ideal of human freedom, Democracy: these are three great organic agencies at work, as yet only partly conscious but working together to overthrow the impositions and indirection that have fostered and exaggerated the city as an exaggerated form of selfish concentration. No longer do human satisfactions depend upon density of population. (pp. 23-4)

> *Frank Lloyd Wright, in his* The Disappearing City, *William Farquhar Payson, 1932, 90 p.*

Frank Lloyd Wright (essay date 1952)

[*In the following essay, Wright discusses his "organic" conception of the Guggenheim Museum, emphasizing the originality and sophistication of its structural logic.*]

The building for the **Solomon R. Guggenheim Museum** on Fifth Avenue will mark the first advance in the direction of organic architecture which the great city of New York has to show. Of modern architecture there are a number of examples; of organic architecture, none. It is fortunate that this advanced work appears on the Avenue as a temple of adult education and not as a profit-seeking business-venture.

Here for the first time architecture appears plastic, one floor flowing into another (more like sculpture) instead of the usual superimposition of stratified layers cutting and butting into each other by way of post and beam construction.

The whole building, cast in concrete, is more like an egg shell—in form a great simplicity—rather than like a criss-cross structure. The light concrete flesh is rendered strong enough everywhere to do its work by embedded filaments of steel either separate or in mesh. The structural calculations are thus those of the cantilever and continuity rather than the post and beam. The net result of such construction is a greater repose, the atmosphere of the quiet unbroken wave: no meeting of the eye with abrupt changes of form. All is as one and as near indestructible as it is possible for science to make a building. Unity of design with purpose is everywhere present and, naturally enough, the over-all simplicity of form and construction ensure a longer life by centuries than could be sustained by the skyscraper construction usual in New York City. The building was intended by Solomon R. Guggenheim to make a suitable place for exhibition of an advanced form of painting wherein line, color and form are a language in themselves . . . independent of representation of objects animate or inanimate, thus placing painting in a realm enjoyed hitherto by music alone.

This advanced painting has seldom been presented in other than the incongruous rooms of the old static architecture. Here in the harmonious fluid quiet created by this building-interior the new painting will be seen for itself under favorable conditions.

There are many innovations in the building all on the side of convenient exposition and enjoyable social experience. Accommodation for the pictures, comfort for the visitors come to view them, their refreshment and social intercourse meantime encouraged, should they wish to have them.

The paintings themselves are in perfectly air-conditioned chambers, chambers something like those of "the chambered nautilus," and are all well lighted by natural daylight as well as artificial light. Thousands of paintings are thus provided for. As air-conditioning is complete, glass is not needed.

A pleasant, quiet theater appropriate for chamber music, and a special new kind of exhibition in light, motion and sound projected in various spontaneous patterns is all provided for in this underground feature of the building.

The structure itself, extremely light and strong, will consist of a monolithic casting of glistening white plastic-aggregate formed of white cement and crushed white marble in various sizes—in general a matte-finished surface, polished wherever desired. Glass tubing, long glass tubes laid up like bricks in a wall, will form top-lighting surfaces like the central dome and ceiling lighting of the ramps. Interior insulation, ceilings, wall-linings and floors will be of thin cork slabs stained pale grey; or floors may be grey rubber tile.

As the building will be completely air-conditioned, there need be no movable windows.

The nature of the building design is such as to seem more like a temple in a park on the Avenue than like a mundane business or residential structure. The side streets are left far more wide open than usual and the whole presents an almost unbroken garden-front to the Avenue itself.

Every building signifies a state of affairs, social, therefore political. This building signifies the sovereignty of the individual: Democratic. Instead of the solidarity of the mass led by one: Fascist.

Therefore this building is neither Communist nor Socialist but characteristic of the new aristocracy born of Freedom to maintain it.

The Reactionary, though perhaps fascinated by it, will not really like it. It will scare him. (pp. 16-18)

> *Frank Lloyd Wright, in an excerpt in* The Solomon Guggenheim Museum *by the Solomon R. Guggenheim Foundation, Solomon Guggenheim Foundation and Horizon Press, 1960, pp. 16-18.*

INTRODUCTORY OVERVIEW

Vincent Scully, Jr. (essay date 1960)

[Scully is a leading American art historian, educator, and author whose works propound the view that architecture must be understood as a highly sophisticated form of cultural expression. His most prominent works include American Architecture and Urbanism *(1969),* The Shingle Style Today; or, The Historian's Revenge *(1974), and* The Earth, the Temple, and the Gods: Greek Sacred Architecture *(1979). In the following excerpt from his introductory study of Frank Lloyd Wright, Scully provides an overview of Wright's architectural credo, stressing his commitment to nineteenth-century liberal ideology and concomitant aversion to classicism. Scully also analyzes Wright's method of design.]*

In his London lectures of 1939, Frank Lloyd Wright said: "Every great architect is—necessarily—a great poet. He must be a great original interpreter of his time, his day, his age." Wright himself was exactly this, as he well knew when he said it. The prose of architecture—the background buildings which attempt only a little and are content to serve as neutral settings for any kind of human thought and action—did not interest him. Instead, it was his life-long intention to form human life into rhythmic patterns which seemed to him poetic and to embody those patterns in buildings which were in every case specific and unique poetic works themselves. In this double need he was the child of his time, but his extraordinary ability to carry his intentions through made him in fact its "great original interpreter."

Wright's long life's work spanned two vastly different cultural periods, and it did more than a little to bring the second of them, that of the mid-twentieth century, into being. Yet, throughout all its unique invention, it continued to recall the objectives of the first. Wright's "time, his day, his age" was that of late nineteenth-century America. He was the embodiment of its most tenacious attitudes: of its supreme confidence in the common future, and of its desperate, complementary yearning for pre-industrial, sometimes pre-civilized, images and symbols to root itself upon. This double attitude had been characteristic since the late eighteenth century of the modern world in general and of the uprooted American in particular. As such, Wright was the heir, in architecture—and regarded himself as being so—of a tradition, in part Jeffersonian, which had previously found its best expression in the works of Melville, Whitman, and Mark Twain. As they, in their writing, had celebrated at once the flux and flow which characterize modern times and the compulsion toward unity which is the democratic will, so he, in his architecture, sought to make the images of flow a fact, to celebrate continuous space, and to bring all together into shapes which were unified by his will. He himself stated the basic principle well: "Space. The continual becoming: invisible fountain from which all rhythms flow and to which they must pass. Beyond time or infinity." This image of "continuous becoming," as of the river, the sea, or the prairie, was a constant in Wright's work, as it had been in that of his literary predecessors. Many streams of nineteenth-century thought, historical, biological, and philosophical, fused in

it as well. To its pursuit Wright brought another nineteenth-century quality, a kind of Nietzschean individualism, not unknown in Whitman and certainly intrinsic to Wright's friend and avowed master, Louis Sullivan. This characteristic, instinct with an arrogance Wright freely admitted, and revealing a loneliness he did his best to conceal, finds expression in one of the quotations from Whitman's *Leaves of Grass* which Wright most admired and upon which he formed his life:

> Going where I list, my own master, total absolute, listening to others, considering well what they say, pausing, searching, receiving, contemplating, gently, but with undeniable will, divesting myself of the holds that would hold me. I inhale great draughts of space. The east and the west are mine, and the north and the south are mine . . . Beware of the moral ripening of nature. Beware what precedes the decay of the ruggedness of states and men. Beware of civilization.

This is the mobile individual, estranged from all that is not himself, who must go forward forever, continuously forward alone, beyond both nature and civilization, which are the two major "holds" upon him. It is a most persuasive image of modern man, Auden's poets of the sea symbols, Camus' *L'Homme Révolté*.

But Wright was an architect, and there were certain solid things that he loved. First, he loved the land. An examination of his work must lead us to believe that he loved it not in Whitman's way, primarily as a vast setting for the display of one's own questionable virility, but for itself, in its variety and its fact. In this love he faced a special problem, because, as Sybil Moholy-Nagy has pointed out [see Further Reading], he was the first architect in history who was required to take on a whole continent alone. Such projection of the individual into the necessity for making many and massive identifications with the world was itself appropriate and special to Wright's time. In the end he built almost everywhere on the North American continent without relinquishing his attempt to celebrate in architectural form the specific landscapes with which he happened to be involved. Characteristically, he attempted this through methods which related in principle to those which had been pursued in Bronze Age Crete, in Japan, and in Pre-Columbian America, and he admitted his admiration for the architecture of those cultures. He disliked the Hellenic way and its principles, which he refused to regard as architectural. That is, he tried, though in abstract form, to echo the shapes and dominant rhythms of the landscapes in which his buildings were set. He avoided introducing into the landscape that especially lucid image of human isolation in the world which was one of the elements of Greek architectural expression and which only a few modern architects of a later generation, most particularly Le Corbusier, have understood. The Hellenic method grew out of a complex set of religious speculations concerning the laws of nature and the life of man—a tragic perception for which Wright, along with the rest of his generation, was not prepared. It involved a recognition of separateness between things that was alien to Wright and to his time as a whole, which, as noted above, preferred to view men and nature as flowing together in a kind of evolutionary flux, like the semi-Darwinian "morphology" that Sullivan loved so well.

Wright's own way was complex enough. He would at once

merge with nature like a Cretan or a Japanese while, at the same time, like a Mayan, he marked off and built up abstract platforms and sculptural masses which compacted nature's shapes through human geometry and numerical control. Late in life, also, when his drive to encompass the whole of things had accelerated with the "mortal ripening" of his years, he seems to have come to understand the objectives and methods of Roman Imperial space and of the whole non-Greek Mediterranean tradition that lay behind it.

Wright's work was directly and indirectly influenced by all the architectures mentioned above, but, unlike LeCorbusier with his own influences, Wright consistently refused to acknowledge that fact. His refusal to do so was partly based upon his own tragic need, which was to keep the romantic myth of the artist as isolated creator and superman alive in himself. It also had something to do with his contempt for the generally uncomprehending and superficial use of forms from other periods (or from the magazines) which was practiced by most of the architects around him throughout his life. Yet, more deeply, his refusal to admit the help that came to him from across time grew out of his own profound loves as an architect, ideal loves which made it difficult for him to admit that he could not engross them entirely alone. Among these we have already noted his reverence for the landscape—which seemed to him to mean that each building should, ideally, be uniquely suited to its special place. We have also mentioned his desire to give precise and appropriate abstract form to the human action of his time. To these preoccupations should now be added another: his love for materials and for their expression in structures ideally appropriate to their specific natures. In this realm, which has received so much attention in the critical appreciation of Wright, he actually experienced some of his greatest difficulties, and knew that he did so.

This occurred because of a certain system of priorities—certainly not fixed, but pervasively present—which seems to have directed Wright's process of design. Looking at his developed buildings and reading his writings, we may feel that his primary interest was abstract: first, usually, in the abstraction of the space, taking shape as it did out of his double will to embody its use and to form it into a rhythmically geometric pattern. Secondly, he wished both to enclose the hollow so created and to extend it or the expression of it to the exterior through the sculptural massing of the building as a whole. Sometimes, as in the earliest works of his several phases, a concern for the exterior massing may have preceded that for the interior space. Having made his building visually integral in both its voids and its solids, he then wished to build it of such materials and in such a way as to make it structurally integral as well. In some of his later projects the structural principle may come first in the process, but when we survey his work in general we find that structural integration tended to come last at any stage in his development and that he himself was most specifically pleased with any building when its structural rather than simply its spatial and sculptural aspects were intrinsic to the whole. This helps explain Wright's admiration for buildings such as the early **"Romeo and Juliet"** windmill and the **Imperial Hotel,** which otherwise seem either of small importance or of doubtful success. Conversely, he was always willing to force or conceal the structure when he had to in order to achieve his spatial and sculptural ends. Yet he never relinquished his ideal of integration, and his pleasure at his successes is indicative of his deepest intent. He clearly believed that, when a building built by men to serve a specifi-

Philip Johnson on Wright:

I would pick the three great works [of modern architecture] as the Marseilles apartments of Corbusier, **Taliesin West** of Wright, and the 860 Lake Shore Drive towers of Mies van der Rohe. . . .

[With *Taliesin West*], I think, the essence of his house is the human element: the procession through the building. I once counted the turns that you make as you approach the building until you get into what he calls the cove, and the number of turns, I think, was 45. Now, he is playing with you as you walk through that place. He stops your car, as any good architect should, 200 or 300 feet from the entrance. It doesn't rain enough to make any difference. Then you start down steps, up steps, to the left, to the right, down the long, very long pergola and you turn to the right to get out under that famous prow, and you take those few steps down onto the magnificent view that has been concealed from you for two or three hundred feet of walking. Then you see Arizona stretched out as he meant you to, and then you turn and go into a little tent room. The man, of course, understands light better than anybody in the world, and he has this tent light that trickles, filters down through into this private room. Before he opens any flaps, you are just bathed in this canvas light. Then when he opens the flap onto the little secret garden, you say there are no more surprises. There can't be any more unfolding of space, but there is. And you get into the private courtyard with the green grass and the falling water, which I notice he has since changed. He now has round circular paths surrounding the seats. Then you finally get into the cove. And just when you're used to Frank Lloyd Wright's six foot ceiling, it has a fourteen foot ceiling and the fireplace runs the full length of the building—there are no windows all of a sudden and no canvas. You're entirely enclosed in the middle of this experience. And by the time you get there you realize that you've been handled, and twisted very much as a symphony will, until you get to the crisis. That, perhaps, is not even architecture in the same sense that the Corbusier Building is, but they both have something to tell later architects.

Philip Johnson, in an extract from a conversation in Print, *Vol. XI, No. 1, February-March, 1957, pp. 37-9.*

cally human purpose not only celebrated that purpose in its visible forms but became an integrated structure as well, it then took on the character of an organism which existed according to its own complete and balanced laws. In this way it dignified by its wholeness and integrity the purely human intellect and hand which had created it. This is what Wright meant by "organic." Few architects have attempted so much and have been willing to ignore so little in order to achieve it. (pp. 11-14)

Vincent Scully, Jr., in his Frank Lloyd Wright, *George Braziller, Inc., 1960, 125 p.*

SURVEY OF CRITICISM

Meyer Schapiro (essay date 1938)

[*An American art historian of Russian origins, Schapiro was associated with New York's left-wing intelligentsia in the decades before and after World War II. Considered a classical Marxist, Schapiro believed that the cultivation of the arts would best be achieved in a socialist state. In the following excerpt, he reviews* Architecture and Modern Life—*written by Wright and Baker Brownell—questioning the legitimacy of the economic, political, and social views Wright expressed in his plans for Broadacre City.*]

Frank Lloyd Wright believes that only "organic architecture" or primitive Christianity—"Jesus, the gentle anarchist"—can solve the crisis [of modern humanity]. This was also the theme of his earlier book, *The Disappearing City,* written in the depths of the depression. If we forget the undergraduate poetizing of the great architect, now seventy years old ("the earth is prostrate, prostitute to the sun"), and his no less profound philosophizing ("what, then, is life?"), and if we strip his argument of the grand, neo-Biblical and neo-Whitmanesque theogonic jargon of "integral," "organic" and the man "individual," we come at last to a familiar doctrine of innocence and original sin and a plan of redemption by rural housing. According to Wright (and this is developed in detail by Brownell) a primitive state of democratic individualism in the Eden of the small towns and the farms was perverted by the cities. A privileged class arose which did not know how to administer its wealth in the common interest; and what remained of the native culture was corrupted by the immigrants. But by an internal law that regulates the fortunes of mankind, swinging life back to its healthy starting-point when it has gone too far toward decay, salvation comes through the evil itself. As the city grows, it is choked by its own traffic and reawakens the nomadic instincts of man. Its own requirements of efficiency gradually bring about decentralization. And the insecurity of life in the city forces people back to the soil where their living depends on themselves alone and a healthy individualism can thrive. In the **Broadacre City,** already designed by Wright in his earlier book, the urban refugee will have his acre of ground on which to grow some vegetables; he will work several days a week in a factory some miles away, accessible in his second-hand Ford; the cash income will

supplement the garden; and through these combined labors he will enjoy a balanced life in nature. The new integrity of the individual will bring about the end of speculation and commercial standards.

The deurbanizing of life, the fusion of city and country on a high productive level, is an ideal shared by socialists and anarchists. But when presented as in Wright's books as an immediate solution of the crisis, it takes on another sense. It is the plan of Ford and Swope, a scheme of permanent subsistence farming with a corvée of worksharing in the distant mill, of scattered national company villages under a reduced living standard. The homes of **Broadacre City** may be of the most recent and efficient materials; they may be designed by the ablest architects—"integrated" and "organic" as Wright assures us they will be; but all these are perfectly consistent with physical and spiritual decay. Social well-being is not simply an architectural problem. A prison may be a work of art and a triumph of ingenuity. The economic conditions that determine freedom and a decent living are largely ignored by Wright. He foresees, in fact, the poverty of these new feudal settlements when he provides that the worker set up his own factory-made house, part by part, according to his means, beginning with a toilet and kitchen, and adding other rooms as he earns the means by his labor in the factory. His indifference to property relations and the state, his admission of private industry and second-hand Fords in this idyllic world of amphibian labor, betray its reactionary character. Already under the dictatorship of Napoleon III, the state farms, partly inspired by the old Utopias, were the official solution of unemployment. The democratic Wright may attack rent and profit and interest, but apart from some passing reference to the single-tax he avoids the question of class and power.

The outlines of Wright's new society are left unclear; they are like the content of his godless religion for which he specifies a church in **Broadacre City.** After all, he is an architect telling you what a fine home he can build you in the country; it is not his business to discuss economics and class relations. (pp. 42-3)

The contradictions and naivetés of [*Architecture and Modern Life*] are so numerous that the informed reader can have little confidence in the authors. He is struck again and again by the contrast between their reverence for technique and science and their complete failure to analyze the social mechanism they have in mind and the means for realizing their goals. They are obsessed by modern life as an expression of something peculiar to the moment, but are wholly unable to make an historical explanation. The idea that society is known through its reflections permits a crude analogical thinking and the flattest impressionist substitutes for a rounded historical study. The pages devoted by Wright to architectural style are no better; he says little that is precise about the forms of contemporary building, and his survey of past architecture is a grotesque parody of the views of the 1880s, a home-made affair based on old readings and the artistic propaganda of the pioneers of the modern movement. All architecture after the fourteenth century is regarded as decadent, and post-mediaeval painting as merely photographic.

The social imagination of Wright should not be classed with that of the great Utopians whom he seems to resemble. Their energy, their passion for justice and their con-

structive fantasy were of another and higher order and embodied the most advanced insights of their time. The thought of Wright, on the other hand, is improvised, vagrant and personal at a moment when the social values and relations he expounds have already long been the subject of critical analysis and scientific formulation. He is not in the direct line of the Utopians, but his social criticism as an architect is in many ways characteristic of modern architectual prophecy and has its European parallels, though addressed to an American middle class. During the last fifty years the literature of building has acquired a distinctive reformist and prophetic tone. The architects demand a new style to fit a new civilization, or if the civilization has become problematic, they propose a new architecture to reform it. In either case, the architect, unlike the poet or the painter, is a practical critic of affairs. Even his aesthetic programs are permeated with the language of efficiency, and underneath his ideals of simplicity and a flexible order we can detect the emulation of the engineer. As a technician who must design for a widening market, he can foresee endless material possibilities of his art, and by the existing standards he can judge the wretchedness of the average home. The whole land cries out to be rebuilt, while he himself, inventive and energetic, remains unemployed. But his social insight is limited by his professional sphere; in general, the architect knows the people whom he serves mainly in terms of their resources and their tastes. Their economic role, their active relation to other classes, escape him. His certainty that architecture is a mirror of society does not permit him to grasp the social structure. The correspondences of architecture and "life" by which he hopes to confirm the historic necessity of his new style, these are largely on the surface, reflections of reflections: architecture, for Wright, is "a spirit of the spirit of man." (pp. 45-6)

This blindness to the facts of social and economic power makes possible the visionary confidence with which architects like Wright correct society on the drawing-board. Accustomed to designing plans, which others will carry out and for which the means of realization already exist, they assume for themselves the same role or division of labor in the work of social change. The conditions which inspired their architectural inventiveness are more like those which preside over reforms than over revolution. Through their designs they have effected the almost daily transformation of the cities, and when society has to be rebuilt, their self-assurance as prophetic forces is strengthened by the current demands for housing and public works as the only measures against ruin. Their reformist sentiments are echoed by the architectural metaphors of planning, construction, foundations, bases and frameworks in the language of economic and social reform. Advanced architects who have only contempt for the grandiose, unrealistic projects of academic architectural competitions, relapse into social planning of the same vastness and practical insignificance. They are subject especially to the illusion that because they are designing for a larger and larger mass of people they are directly furthering democracy through their work; Mumford, for example, supposed that the use of the same kind of electric bulb by the rich and the poor was a sign of the inherent democratic effects of modern technology. The existence of fascism is the brutal answer to such fantasies.

To the degree that the crisis is judged psychologically as

the result of "restlessness" and is neurotically laid to a "faulty environment" or to mistakes of the past, the architectural utopia of Wright, the specialist in new environments, must seem really convincing to those from whom the economic reality is hidden. Around the private middle-class dwelling cluster such strong and deep memories of security that the restoration of the home appears in itself a radical social cure. Throughout his books Wright insists that architecture is the art which gives man a sense of stability in an unstable world, and that of all styles of building the modern is the most "organic." "The old is chaos, restlessness"; the new, "integral, organic, is order, repose," he writes,—like the modern mystics of the state and church. In his survey of modern architecture—otherwise so meagre—Wright tells in detail how he built the **Imperial Hotel** of Tokyo on marshy ground, and how this building alone withstood the earthquake of 1923. But social earthquakes are not circumvented by cantilevers and light partitions.

In spite of the exaggerations and errors of Wright in giving architecture an independent role in shaping social life, the experience of his profession has a vital bearing on socialism. But it is just this bearing that Wright and Brownell, as spokesmen for the middle class, ignore. They have failed to recognize—what must be apparent on a little reflection—that the progress of architecture to-day depends not only on large-scale planning and production, but also on the continuity of this production and on a rising living standard of the whole mass of the people—conditions irreconcilable with private control of industry. It is only when all three conditions are present that the architect can experiment freely and control the multiplicity of factors which now enter invariably into his art. (pp. 46-7)

Meyer Schapiro, "Architect's Utopia," in Partisan Review, *Vol. IV, No. 4, March, 1938, pp. 42-7.*

Henry-Russell Hitchcock (essay date 1942)

[*Hitchcock was a highly regarded American architectural historian and an influential critic of the avant-garde. His prolific writings addressed a broad range of architectural styles, but he was especially interested in the development of modern architecture and is well known for his studies* The International Style: Architecture since 1922 (*1932*), Architecture: Nineteenth and Twentieth Centuries (*1977*), *and* In the Nature of Materials, 1887-1941: The Buildings of Frank Lloyd Wright (*1942*). *In the following excerpt from the latter, Hitchcock analyzes the abstract composition of verticals and horizontals displayed in the Kaufmann house, emphasizing Wright's skill in juxtaposing the controlled, artificial realm of humanity with nature.*]

The **Kaufmann house** combines two sorts of romanticism, the romanticism about nature, which has flourished since the eighteenth century, and the romanticism about scientific feats of construction, often considered of quite opposite character. A house over a waterfall sounds like a poet's dream. A house *cantilevered* over a waterfall is rather the realized dream of an engineer. Through the forest trees, the long horizontals of slabs and parapets seem to float in space. The metal sash enclosing the rooms are hardly visible and offer no such sense of support as the

The Kaufmann house (1936; also known as Falling Water)

wooden and masonry mullions of the Prairie houses. The strength of the structure is patently in the rigidity of the slabs alone and in the solidity with which they are anchored at the rear. They are anchored not only to the rock of the waterfall edge itself, but also to the solid core of masonry at the rear of the house, built up in great rough pylons of native stone. This stone-work offers the sharpest visual contrast of striated naturalistic surfaces and mottled colour to the clean, precise, light-coloured forms of the concrete. Thus, as from the beginning of Wright's mature work, there is a sort of plaiting in space of horizontals and verticals; light tenuous horizontal planes, here more abstract than the sloping eaves of the prairie houses; and sturdy, massive, articulated verticals, rock of nature's rock, core and heart of the whole construction. But the composition is now at once very complex and very free. Although some hint of a cross form above a square remains, the organic order is rather that of a natural product than of geometry, regularly modular like a crystalline structure, but beyond any simple description in geometrical terms.

Although this was a rather large house, it was not expensive for its size. As it was intended for a week-end retreat an openness of plan such as has hitherto been used only in small houses was possible. The living area was unified,

although the many breaks in the basically square shape suggest the functional differentiation of the different parts. Even in the sleeping quarters above, which provide accommodations more in the nature of bed-sitting rooms or private suites than ordinary bedrooms, there is a remarkable openness. In them it is due more to the way in which each suite opens upon its own terrace than to any loss of interior privacy.

As in the block houses of the twenties, inside and outside are essentially one in treatment. In each room both the solid mass of the vertical masonry core and the rigid suspension of the reinforced slabs is evident, while built-in fittings of wood humanize the scale and the surface textures. Outside steps, actually starting within the living room, lead down into the stream. Pools hold the water for bathing purposes. Projections of the concrete slabs are pierced to form pergola-like grilles over which plants may hang. Yet nothing is done to interfere with the lush natural growth of the woods, or to dam the flow of the torrent. Never, even in Wright's work, has architecture as the product of man been so perfectly balanced and contrasted with the natural setting. For never has the natural setting been wilder or more superb in its original condition, and never has the work of man been bolder or in a sense more arbitrary in its placing. But so perfect, so apparently inevi-

table, is the juxtaposition that one cannot imagine such a house in a different setting or a different house in this setting. Ordinary questions of functionalism receive new answers, not because this is not a practical house to live in, but because it is so pre-eminently a comfortable house to live in over a waterfall.

There are no projects leading up to the **Kaufmann house** unless it be the **House on the Mesa**. It seems to have sprung as suddenly from the brow of Wright as did the **River Forest Golf Club** more than a generation earlier, with the difference that the world was now prepared to appreciate it, and to receive with loud acclaim a building that seemed to epitomize the aspirations not of Wright alone, but of all modern architects. After the twenties, in which the direction of the European leaders and the direction of Wright seemed sharply opposed, despite all the coincidences which we now recognize, now in the later thirties as new countries, Finland and England, came to achievement in modern architecture equalling that of France and Holland and Germany in the previous decade, architecture could be seen to be advancing on a deeper and broader, if less "international" front. And the **Kaufmann house** was one of the first and most striking demonstrations that a new cycle of world architecture had opened, a cycle, alas, destined within two or three years for a premature end in Europe with the coming of war. (pp. 90-2)

> *Henry-Russell Hitchcock, in his* In the Nature of Materials, 1887-1941: The Buildings of Frank Lloyd Wright, *Duell, Sloan and Pearce, 1942, 143 p.*

Mies van der Rohe (essay date 1946)

[*Mies van der Rohe is considered, along with Le Corbusier, one of the great masters of modern architecture. Born in Aachen, Germany, he was an active proponent of avant-garde architectural thought in Europe in the period between the wars. A director of the famous Bauhaus school of art and architecture from 1930 until it was closed by the Nazis in 1933, Mies emigrated to the United States in 1938, settling in Chicago. In the postwar era he established his architectural canon of "less is more," designing a series of meticulously proportioned apartment and office buildings whose steel skeletons were sheathed in transparent glass curtain walls. In the following excerpt, Mies comments on the historical significance of the Wasmuth portfolio published in Germany in 1910, asserting that Wright's designs had a profound impact on the first generation of European architectural Modernists.*]

Toward the beginning of the twentieth century, the great revival of architecture in Europe, instigated by William Morris, began to grow over-refined and gradually to lose its force. Distinct signs of exhaustion became manifest. The attempt to revive architecture from the standpoint of form was apparently doomed. Even the greatest efforts of artists could not overcome the patent lack of any usable convention. Then, however, these efforts were limited to the subjective. But the authentic approach to architecture must always be the objective. Accordingly, the only valid solutions at that time were in cases such as industrial building, where objective limitations made subjective license impossible. Peter Behrens' significant creations for the electrical industry are a vivid illustration. But in all other problems of architectural creation, the architect ventured into the dangerous realm of the historical; to some of these men the revival of classic forms seemed reasonable, and in the field of monumental architecture, even imperative.

Of course this was not true of all early twentieth-century architecture. Van de Velde and Berlage especially remained steadfastly loyal to their own ideals. Once a way of thinking had been accepted as essential, Van de Velde's intellectual integrity and Berlage's sincerity and almost religious faith in his ideal allowed no compromise. For these reasons the former won our highest respect, the latter our special veneration and love.

Nevertheless, we young architects found ourselves in painful inner conflict. We were ready to pledge ourselves to an idea. But the potential vitality of the architectural idea of this period had, by that time, been lost.

This, then, was the situation in 1910.

At this moment, so critical for us, there came to Berlin the exhibition of the work of Frank Lloyd Wright. This comprehensive display and the extensive publication of his works enabled us really to become acquainted with the achievement of this architect. The encounter was destined to prove of great significance to the development of architecture in Europe.

The work of this great master revealed an architectural world of unexpected force and clarity of language, and also a disconcerting richness of form. Here finally was a master-builder drawing upon the veritable fountainhead of architecture, who with true originality lifted his architectural creations into the light. Here, again, at last, genuine organic architecture flowered.

The more deeply we studied Wright's creations, the greater became our admiration for his incomparable talent, for the boldness of his conceptions, and for his independence in thought and action. The dynamic impulse emanating from his work invigorated a whole generation. His influence was strongly felt even when it was not actually visible.

After this first encounter, we followed the development of this rare man with eager hearts. We watched with astonishment the exuberant unfolding of the gifts of one who had been endowed by nature with the most splendid talents. In his undiminishing power he resembles a giant tree in a wide landscape, which, year after year, ever attains a more noble crown. (pp. 41-2)

> *Mies van der Rohe, "A Tribute to Frank Lloyd Wright," in* College Art Journal, *Vol. VI, No. 1, Autumn, 1946, pp. 41-2.*

Bruno Zevi (essay date 1950)

[*Zevi is an Italian architectural critic and historian who has written extensively on the subject of modern architecture. Few of Zevi's numerous works have been translated into English, but he is well known in America for his controversial study* Saper vedere l'architettura (*1948;* Architecture as Space, *1957*), in which he denied the significance of conventional stylistic distinc-

tions, asserting that architecture is defined by its spatial qualities rather than by structure and ornament. In the following excerpt, Zevi analyzes the concept of "continuous space" in Wright's architecture, asserting that his organic functionalism must be seen as more humane than the reductive, mechanical functionalism of his European contemporaries.]

Had someone been writing an essay on Frank Lloyd Wright in 1910-12, he could have defined him in one way only: as a genial architect who had applied to the theme of the single dwelling those spatial elements which were later to be called the free plan. Around 1925, one would have added that Wright had subsequently become an expressionist architect. Even in 1930, Henry-Russell Hitchcock (who after 1940 was to become his apologist and apostle) wrote of Wright as one among many pioneers of modern architecture, such as Berlage, Perret, Garnier, Van de Velde, Mackintosh or Behrens. When in 1932 a great exhibition of contemporary architecture was organized at the Museum of Modern Art, some neophyte of the European functionalist doctrine proposed excluding Wright; already pigeon-holed, critically speaking, why show him? In 1938, a biographer of Wright would have included works like **Falling Water** and the **Johnson Wax Company** but would certainly not have been able to foresee the production of Usonian houses. Even as late as 1946, no critic could have presented Wright so comprehensively as to encompass the creative possibility of the new museum designed to house the Solomon R. Guggenheim collection of Non-Objective Paintings.

Each author on Wright . . . has added new criticism, expanded definitions and enlarged the horizon of his subject, precisely because Wright himself by the creation of new forms has continually burst the chains with which scholarly criticism would encompass him. And almost certainly, despite Wright's seventy-nine years, he will within a matter of months or perhaps even days create other buildings and thus once again escape the critical framework I shall attempt to establish here.

Is recognition of this extraordinary creative elasticity, this continual capacity for invention and innovation, a value judgment? Not necessarily. It is surely part of our cultural tradition to love coherence, to feel close to those artists whose formal means of expression are limited and precise and whose works develop out of fundamentally stable themes. We are pleased when we recognize in a new house of Le Corbusier or of Gropius a familiar compositional achievement and elements already prepared in preceding works. In a sense Wright irritates precisely because his volcanic mind demands that his critical position be left undetermined. To speak of him in intellectual terms is as fallacious as to speak logically of love; his is a different reality, and there is no sense inquiring whether it is a better or a worse one, for infinite are the roads which lead to architectural redemption. To those whom Wright displeases, I would say that his is the reality of the pioneer American acting in the post-expansionist industrial era.

"What is the significance of the **Museum of Non-Objective Paintings?**" I asked Wright in 1946 during a long discussion in which I took the part of the devil's advocate in order to stimulate him to talk. "This Museum," he replied, "will be a great building. For the first time in the history of architecture we will have broken the habit

of building thus and so,"—these words were accompanied by a gesture in which one hand was placed above the other, then the lower one withdrawn and placed above to symbolize the floors of a house, one over the other, inert and discontinuous—"and we will have a work which is continuously this,"—the last word, pronounced slowly, was accompanied by an ascending spiral motion of the hand signifying continuous space, flowing, freed of any rigid concept of volume.

The esthetic judgment of his buildings apart, Wright's exceptional merit is in posing the problem of space as the fundamental problem of his work. Every building can be analyzed schematically into void, volume—that is, the box of walls that encloses the void—and decoration. All three factors are essential in a work of architecture, but the internal space, the void, takes the role of protagonist; it is the substance of architecture. The volume and the decorative elements, unless organically connected with the internal space and almost derived from it, become merely sculptural, plastic, planar or three-dimensional, but are never spatial in the architectonic meaning of the word.

The story of modern architecture is the story of structural techniques, modern social theories, modern taste. But, more specifically, it is also the story of a new concept of continuous space. Wright's passion for building is well known, and his position in regard to social problems as they relate to architecture has been made clear through his writings and speeches; here, therefore, we may dwell on his conquest of space, since it is in this that the tendency of organic architecture finds its real justification. Organic architecture, and modern architecture in general, would have no reason to exist, any more than have the infinitude of "modernistic" examples that plague our new suburbs, were it not based on a spatial concept—that of continuous space.

How was this concept born? First of all, from social considerations; second, at least as regards its formulation, from psychological insight. "Architecture for the people," "everyman's home," are the quasi-sacred phrases we hear repeated *ad nauseam,* and which have an historic significance. The work of contemporary architects is focused on houses for the middle-class family and the worker with as much intensity as was once devoted to public and monumental buildings. Given this program, how can it be resolved in terms of architecture? The ordinary house today, whether built by civic authorities or by corporations, does not even contemplate the problem. The nineteenth-century suburban villa took a grandiose edifice and reduced it in scale. The imposing salon shriveled into a tiny sitting-room; the monumental hall was reduced to a minuscule vestibule, arteriosclerotic in its congestion; the windows became peepholes, the pediments ridiculous little triangles. Once the relation between human dimension and the building scale was changed, the house became a parody of the palace. Current pseudo-modern architecture, by shaving off superficial decoration, has revealed in its nudity the spatial bankruptcy of the traditional house. We live in cubicles that open on either hand into other cubicles, while above and below are still more cubicles. The smaller the house, the more suffocating the cubicles. The juxtaposition of rooms, each geometrically autonomous, could be legitimate if these rooms were monumental or at least sufficiently large to allow men to breathe; reduced in

scale, they entail moral degradation and the sense of imprisonment between four inert walls, nameless and isolated.

To bring to the homes of workers or the middle classes some of the amplitude, dignity and freedom of the great architecture of history has been (and still is) the intent of all the modern movement, whether functionalist or organic. In this sociological quest, Wright is historically at both the point of departure and the point of arrival, as the Prairie Houses and the Usonians document.

It is psychological motive that differentiates the organic trend of today from the rational architecture of about twenty years ago, without opposing one to the other. Rationalism was rational and scientific especially with regard to social considerations, utilitarian requirements and technical construction. The organic movement, a kind of second functionalism, is functional in these respects and also psychologically: more precisely, it is not technically functional in relation to modern industry nor, in its social aspects, is it functional in relation to abstract social theory; but it is functional technically, socially and economically in terms of human living and of man's spirituality. The organic movement is conscious of the inherent differences between robots and human beings; it recognizes that if man has a soul and a free will, the problem of architecture will be one of quality, not only of quantity, that people are not file cards to be housed in boxes, and that to define habitations as "machines for living" [Le Corbusier] is ridiculous if not criminal. Is the quest of the organic movement therefore a romantic one? I do not think so, even though it includes irrational impulses among its aims. for the notion of science as the unique, immutable explanation of unrelated phenomena has been vanquished, and the scientific spirit now projects its light on the whole field of human psychology; the irrational world is studied, liberated and expressed through scientific knowledge and methods. In this quest, Wright's works represent a fundamental intuition, a guide, a direction.

Look at the **Warren Hickox house** at Kankakee, Illinois, dated 1900, or the **Bradley house** of the same year, or those first masterpieces like the **Willitts house** or the well-known **Robie house** in Chicago, of 1909; then skip to 1931, to the **House on the Mesa;** to the **Willey house** in Minneapolis (1934), which could be called the first of the Usonians; study the plans of **Falling Water** of 1936 or **Taliesin West** of 1938, or finally the **Museum of Non-Objective Paintings.** Everywhere the same tendency is apparent: to amalgamate the rooms, to animate the building as if it were a continuous spatial discourse rather than a series of separate words, to break with geometry—often even with the right angle—for the sake of forms more adequate for human use and movement. Above all, to feel interior space as a reality, as the substantive, pulsating reality of architecture—that reality which, through the artist's intuition, expresses and transforms all practical requirements. Apart from problems of taste in regard to volume and decoration, which are perhaps debatable, this is the true meaning of Wright's work.

The concept of continuous space cannot actually be experienced without visiting a Wright building. Works whose esthetic has been concentrated in their decorative patterns, and especially works in which the solution of problems of volume predominates, can be illustrated photographically. But Wright's architecture, where the entire secret lies in the powerful vitality of the interior space, of the voids, is incomprehensible unless one walks through those spaces, free to be influenced by the atmosphere, the vivacity of multiple indications of scale and the repose emanating from those vast concepts which Wright employs even in his most economical architectural themes. Views of Wright's interiors show that his spatial freedom is not expressed in plan alone, but also in elevation; the soffits of his houses are frequently the dialectic crown of a spatial drama, just as the exteriors are the projections of the interior space. In contrast, flat white soffits and habitable boxes seem either to be the result of building based on speculation serving corporations, and hence incapable of giving form to an individual expression, or else the consequence of a great poverty of invention and formal vocabulary.

After its dissemination through Le Corbusier's propaganda and his excellent examples, the free plan became a sort of captive of modern architecture, even a cliché. As with every mannerism, its meaning was finally lost, together with the reason and purpose of its discovery. The free plan as generally used is certainly a step ahead of the traditional cubicles, but it has no visible connection with the free plan as used by Wright, which is not an initial formula but results from the concept of continuous space.

The most difficult thing in architectural criticism is to see, to feel, to know how to relive and judge spaces. Thus much criticism has confined itself to judging Wright's work merely from a plastic point of view and has continued to play around with solids and spaces, with relationships of mass in projections and recesses, with stylistic preferences, without regard to the words of Wright himself, who is perhaps the worst propagandist of his own work, despite the fact that he is a brilliant and stimulating writer, speaker and conversationalist. Seen in this way from outside, as if one were judging a sculpture or a sketch, Wright's architecture cannot be understood, and thus it has been defined as romantic, naturalistic and arbitrary by those who have not perceived that—in so far as an artist has any consistency or any rule—there is a rule in Wright, but it is applied not to the volume or the decoration, but to the interior space.

In defining Wright's architecture as organic, we mean essentially two things: first, that his buildings are entities like living organisms, and secondly that they are functional in relation to mankind. (pp. 186-89)

A Wright house is an organism in that its fundamental and substantive theme is space, the voluminal enclosure is the projection of this space, and the decorative patterns, the choice of materials and ornamentation, are designed to give value and accent to the spatial concept.

No one but a maniac with hallucinations could in one lifetime have created the Prairie houses, **Falling Water** and the **Museum of Non-Objective Paintings,** if these were considered from the exterior as plastic phenomena. Instead, they are the results of a method of spatial creation applied to diverse themes under different conditions. In the light of this spatial interpretation, Wright's architecture, seemingly so manifold and arbitrary, is more coherent than that of any of the functionalists who betray the real problems of architecture with a coherence that is en-

tirely formal and extraneous. The vitality of Wright's structure, the power of his buildings, his unbelievable technical daring, the permanent fecundity of his genius are explicable in the light of this conception of a building as a living reality, growing and organic.

This man, who built functional buildings before the birth of functionalism, has nevertheless always refused to accept the utilitarian and technological descriptions of functionalism as they were formulated in Europe. On that continent functionalism had the merit of awakening architecture from its nineteenth-century slumbers and bringing it into contact with the actualities of the industrial era and the collective elements of modern society. It posed the problem of adherence to the technique and purpose of the building; if other requirements of a formal nature were added, this was after the researches of such movements in modern painting as purism, constructivism, neoplasticism and other derivatives of cubism. Such additions were never thoroughly integrated with architectonic vision, and so even today the majority of modern architects base themselves on technological and utilitarian theories, knowing that these are neither inflexible nor complete, and solve their other problems as suits their taste. But technique plus utility plus taste propound all over again the traditional triad of architecture, leaving unsolved the problem of social integration.

Wright is called romantic by those who prefer the easy scheme of a triad which is only seemingly clear, and who do not wish to subject themselves to the far vaster complications of contemporary architectonic culture. They prefer to talk of standardization, statistics and formulae—all things which seem precise but are infinitely vague—and to avoid the central problem of architecture posited by Wright. This is the problem of social man for whom buildings are built—man integrated and alive, not the cadaver vivisected into the intuitive man, the logical man and the economic man. It is the total problem of culture in which art, science and religion, to use Wright's words, find an organic synthesis.

The statement that there is no opposition between functionalism and the organic movement, but only the development of the second from the first, is also historically accurate. The organic architecture of Wright, it is true, stated its case before European functionalism, but this was possible because functionalism was born in America long before it was in Europe, finding its cultural center in the Chicago School of 1880-90 (witness, besides Burling and Adler, Burnham and Root, Martin Roche, W. A. Holabird and John Edelman and the prophet of modern architecture, Louis H. Sullivan). In Europe functionalism arose later, more completely and extensively, as an international movement, and it is understandable that only now is the organic movement being born on an international plane; hence only now can Frank Lloyd Wright be understood, not as an esoteric genius, but as an initiator of a movement in which one finds Aalto and the Swedes, the English city planners, and the young Italian architects and critics like Carlo L. Ragghianti and Giulio C. Argan.

Two facts, seemingly contradictory, exist today: social collectivism arising from the industrial revolution and from the arrival of the masses on the political scene, and individualism which refuses to abandon the illuminating liberal conquests of the past centuries. In architecture,

too, the field is divided: on the one hand are the pure functionalists, entirely dedicated (at least in theory) to resolving quantitative problems of technique and utility, based on numbers and charts; on the other, the nostalgic traditionalists who recall the creative thrill that came from bastardizing a "darling little" renaissance capital or from crowning an eighteenth-century window with a "sweet little" baroque pediment. They share one thing—their aversion to Wright: the former because he is too individualistic, the latter because he is too modern. Between these two permanently opposed groups a son was born to functionalism—the modern movement. This movement no longer needs to hate the traditionalists and the monumentalitarians, both already buried, so far as cultural significance is concerned, by the previous generation; thus it can even listen more benevolently to the profound reasonableness hidden beneath the absurd and antihistorical position of conservatism. The problems are, in fact, considerably more complicated than the technologists estimated, and more varied.

Modern architecture must satisfy not only social requirements but also those of the human personality; both the masses and the individual make demands regarding the appearance of the town and of the home. Underlined by the disasters of war and destitution, there arises a new need for spirituality or, as some say, for religion, and in the light of this need materialist functionalism, even embellished with formal lyricism, seems inhuman and insufficient. The complex of human demands, material, psychological and spiritual, poses for organic architecture and its culture the problem of integration. That is why the organic architecture of Frank Lloyd Wright, his moral appeal, his spatial conquests seem today, against the horizon of contemporary efforts, not only the seal of greatness of one architect but almost the marker of a road to be traveled with confidence and of a work to be prosecuted with passion and belief. (pp. 190-91)

> *Bruno Zevi, "Frank Lloyd Wright and the Conquest of Space," in* Magazine of Art, *Vol. 43, No. 5, May, 1950, pp. 186-91.*

Grant Carpenter Manson (essay date 1958)

[*In the following excerpt, Manson discusses three of Wright's most important Prairie houses, considering their ingenuity in planning, spatial characteristics, harmonious aesthetic, and careful integration into their natural setting.*]

[There] are three Prairie houses whose size or quality or circumstance place them in a class by themselves: the **Coonley house,** the **Robie house,** and the **McCormick house project.** They are roughly contemporary, falling in the years 1907-1909. Two were executed, and [they are] the "terminal masterpieces" of the Oak Park period—although the **Coonley** and **Robie houses** are very different from each other, they are a summation of Wright's principles of domestic architecture to their date. The third, the **McCormick project,** tragically abandoned at the eleventh hour, had a decisive effect upon the course of Wright's career; had it been built, it would have outranked the **Coonley** mansion as the *palazzo* of Prairie houses. Judging by frequency of publication, the **Coonley** and **Robie houses** are the general favorites among executed Prairie House

designs; Wright's own avowed preference is for the Coonley house, about which he remarks, "[it is] the most successful of my houses from my standpoint."

The **Coonley house** is the product of that rare set of factors in architectural history, a liberal client, a great designer, and perfect trust between the two. There is evidence on all sides that Mr. and Mrs. Avery Coonley were a most unusual and enlightened couple, seeking all the best that advanced thought and accomplishment in the new century afforded. They approached the task of erecting a house reflectively and rationally, determined to find the most progressive architect in practice and, having made their requirements plain, to interfere thenceforth in no way whatever with the creative processes which they had set in motion. Of the first meeting of clients and architect which led up to the famous **Coonley house,** Wright says: "About this time Mr. and Mrs. Avery Coonley came to build a home at Riverside, Illinois. Unknown to me they had gone to see nearly everything they could learn I had done before coming. The day they finally came into the Oak Park workshop Mrs. Coonley said that they had come because, it seemed to them, they saw in my houses 'the countenances of principle.' This was to me a great and sincere compliment. So, I put the best in me into the **Coonley house.** I feel now, looking back upon it, that building was the best I could do then in the way of a house." (pp. 185-88)

In the *parti* [plan] of the Coonley design, two of Wright's most convinced beliefs had their greatest opportunity for expression: the centrifugal plan and the raised basement. With the exception of a large, centrally located childrens' playroom, all principal rooms of the house are on the second level above grade; every room devoted to common enjoyment thus looks out over lawns and garden from a calculated height, although, by the magic of Wright's horizontal style, there is no sense of height on the exterior. The house fuses intimately with its setting, and its great length, bent like the letter U and intricately jointed, is given variety by articulation of wall-surfaces and by the whole repertory of Wrightian ornamentation. Oddly enough, it is frame construction, but there is no forced economy in the use of wood this time; everything is solidly and durably built. The treatment of exterior walls produces a banded effect: the lower registers are coated in fine sand-plaster of a creamy shade, the upper are faced with tilework in a simple geometric pattern whose subdued colors blend into a bronze tonality.

The view of the **Coonley house** most frequently published is the garden front, with its terraces, huge Wrightian urns, and reflecting pool. From this angle, the elements of the composition seem to reduce themselves to the plane of the water, the geometric solids of the ground story, the endless ribbons of casements in their deep band of shadow at the second level, the hovering, protecting roofs, and the low mass of the central chimney. The overriding impressions are those of a building with minimal head-heights and so perforated with openings everywhere beneath the eaves that it does not enclose space at all. It is only when we begin to move around the perimeter of the great house that we realize that it has many strongly defined space-blocks and that its plan is not symmetrical—that it is far more complex than it first seemed. The house is zoned within the confines of its U-shaped form. The living room, dining room and service quarters occupy the western half of the

U; the bedrooms occupy the eastern. But, so that not only the communal rooms, but the master bedrooms as well, shall enjoy the south, or garden, exposure, the central bar of the U is again divided in its function between living and sleeping accommodations; this accounts for the off-center placement of the main, or reflecting pool, elevation which, at first glance, seemed to be the exact center of the composition. The three blocks of the U are long, narrow and loosely connected; the length of the central block is projected at each end by pavilions, the western one containing the dining room, the eastern one containing the principal bedroom suite. The service wing and the guest-bedroom wing, the secondary blocks of the plan, are pierced at grade level by a driveway; the resultant isolation of the northern ground-floor spaces of these wings confirms the relative unimportance of the part which they play in the functioning of the house. In fact, almost the entire ground floor of the house is an extravagant substructure for what is essentially a one-level dwelling. Wright takes every aesthetic advantage, however, of this luxury. It is a fascinating experience to walk up one of the twin staircases from the entrance lobby into the great living space with its spatial surprises and its fantasy of moving, sloping ceilings emphasizing the fact that we are now under the great hovering roof itself. Here and there are leaded skylights set in separate peaked ceilings where the roofs have broken their flow to adjust themselves to the narrowed spots in plan caused by the joining of one element to another. In all this geometry of space and form, nature is constantly glimpsed through batteries of open casements in the distance, and is introduced into the room by jars of bittersweet and living plants. Across the long north wall, interrupted only by the raked brickwork of the enormous fireplace, there is a dim, painted frieze of a birch forest. These main spaces of the **Coonley house** combine to make what one is tempted to call a "noble apartment," for they have an undeniable grandeur, with their long vistas and their air of moneyed ease. Yet, the term conjures up the vision of monumental height, and there is no height here; on the contrary, everything is consciously scaled down to man. Wright replaces a senseless lavishness of height with a complete freedom of lateral movement, a luxury that human beings can *use.*

The harmony of shape and texture in the **Coonley house** is also due to the fact that all of the furniture and fittings were custom-made to Wright's designs. The color scheme of the decorations is expectedly autumnal: natural oak, brown, tan and gold stuffs, accents of verdigris. On the exterior, the tonality is established by the creamy tan of the plaster, the bronze of the tilework, and the russet terracotta roofing, with brown-stained trim providing sharp lineal definitions of breaks-of-plane. Richness of interest is accomplished by the prismatic gleam of the leaded casements and the constant, casual interruption of the strong lines of the architecture by vines and flowering plants in earth-pockets.

The word "harmonious" constantly comes to mind in connection with the **Coonley house.** It emerges first in the harmonious relation of client and architect and culminates in the perfectly harmonious relation of house to site—the poetic statement of innermost meaning of that entire segment of Wright's creativity for which the term Prairie house has come to stand. Perhaps it is this thought which causes him to single out the **Coonley house** as the best. But its harmony is more than a thing of spirit; it is the sum-

The Coonley house (1908)

total of its material parts. Beginning with the shapes of the plan itself, the very *poché* [structural infill] of the drawings, harmony spreads to every detail of the superstructure and to every material of which it is made. Study will reveal that shapes in lead, in glass, in wood, in copper, in terra-cotta, in concrete are mirror-images, large or small, of each other and of the whole. In this very real sense, the **Coonley house** is an organic growth in which all cells are determined by and obedient to the central, ruling idea. Of very little architecture today can such be said.

Shortly after the house was completed, a major alteration was made. It was discovered that the playroom, the space directly beneath the living room, was too difficult of direct access to the outdoors, having only two lateral entrances from the terrace. Hence, a row of French doors, giving directly onto the pool, was installed where originally there had been three low windows under a continuous lintel. At the same time, two additional trellises were incorporated into the garden facade, one free and running across the entire width of the terrace, the other at the second-story level, just under the eaves, acting as an additional protection for the living room casements. The altered garden facade is thus somewhat overburdened, and loses the clear definition of the original design; but, to compensate, the terrace is a true outdoor living area, and as arresting in its

spatial varieties as the rooms above. The added features are full of Wrightian decorative touches, both applied and inherent. With what sophisticated effect the shadowbands of the upper trellis fall across the mullions and casements beneath!

The setting of the **Coonley house** recalls that of the **Winslow house,** its ancestor. Riverside, which was laid out in 1869 by Frederick Law Olmsted at the instigation of the Chicago, Burlington and Quincy Railroad as a model suburb, is perfectly flat but was given interest by an irregular, winding street plan. The Coonley property is a roughly triangular area at one edge of Olmsted's plan, nearly surrounded by the meanders of the Desplaines River. The casual quality of the site is reflected in the flowing plan of the house, which presents no definite facades and which, with its garages and outbuildings, rambles as freely over the land as the little river around it. The choice prairie scenery, the ample sweep of grounds, the impressive size of the building, and its fascinating summation of all that went into the evolution of the Prairie house make it the first object of pilgrimage for those who travel to the western suburbs of Chicago to study in actuality Wright's early domestic work. (pp. 188-97)

A terminal masterpiece of a different order is the **Freder-**

ick **Robie house** in Woodlawn Avenue on Chicago's South Side. This is a city house, built upon an average-sized city lot, though it must be remembered that when the house was erected in 1908 this part of Chicago still had something of the leafy quality of the open prairie. The amazingly long, dynamic lines of the house did not have to struggle in those days against the huddle of anomalous buildings which now crowds it. The **Robie house** is the culmination of those directional qualities in Wright's design which had been growing ever since the 1890's. Unlike the **Coonley house,** it is a massive structure of brickmasonry and concrete whose volumes are disposed along a single axis, parallel with the long dimension of the corner lot; the garage is integral, perhaps for the first time in the history of American architecture. Advanced concepts of function, such as this, together with a precision of edges which we associate with the machine, give to the design a technological spirit as great as that of the public structures, the **Larkin Building** and **Unity Church.** Strong planes, reliance upon the cantilever, and an uncompromising treatment of fenestration dominate the design in a way never before equalled in Wright's domestic work. Granted the validity of the ideal of horizontal flow in a dwelling, the design achieves its purpose without deviation or vagary.

Again, the *parti* is based upon a masterly adaptation of the raised basement theme, but the insertion of a long, sunken areaway at the center of composition, above which the main mass of the house seems suspended, gives it a subtlety and drama which are unprecedented. By this device and by the great prolongations of exterior masses of brick at the ends of the composition, terraces and parapets, we are almost confused by the relationship of level to level and house to site. It is as if everything were held in place by levitation. The one vertical, and the one fixed point in the entire complex of horizontal planes, is the huge chimney, which achieves an occult balance with the rest of the mass somewhat in the manner of a ship's stack. In fact, an analogy can be drawn between the **Robie house** and marine architecture; we begin to think of its levels as decks and of its topmost room as a bridge and of its projecting terraces as prows. It is no wonder that the **Robie house** was nicknamed "the Battleship."

The floor plan of the main level is a miracle of fluid spaces. Those areas which, by their function, demand the privacy of compartmentation—guest bedroom, kitchen, servants' quarters—are relegated to a parallel block at the rear that has a sliding relationship to the main block. The living room, the central stairwell, and the dining room are a unit, separated but not divided by the pylon of the chimney, and defined by the long walls of the house. Within this area, there is not a single cross-partition, nor do the walls themselves return at their ends. The two chief spaces terminate in diamond-shaped bays which are independent of the walls, and around which the spaces flow outward to open porches. The south wall is not exactly a wall; it is a parapet upon which rest the series of brick mullions between casements, and this glazed plane makes no acknowledgement whatever of the change in function from living to dining spaces—its rhythm is unbroken. The master bedrooms are contained within the reduced area of the third level of the house, a sort of glazed loggia seemingly composed of a low, umbrella-like roof resting upon panels of glass. Every major space has its access to the out-of-doors; but, because there can be no sweep of lawn and garden around the

house, out-of-doors is man-made: porches and balconies, their brick parapets strongly demarcated by uninterrupted limestone cappings.

It is an absorbing exercise in the progress of Wright's style over fifteen years to compare the **Robie house** with the **Winslow house.** There are manifold changes; but perhaps the chief difference is in the degree of penetration of mass with surrounding atmosphere. Wall is important in the **Winslow** design, and the vertical planes are clear and unambiguous. Wall, as a supporting element, is non-existent in the **Robie** design. The effect is as of a loosely associated pile of horizontal planes, through and around which air flows uninhibitedly. The west front of the **Winslow house** is unified, self-contained; the **Robie house** is a temporary halt in a continuum which has neither beginning nor ending. It is part of some larger scheme of mass-in-space.

The biggest private house that Wright has ever designed was intended as the Lake Forest residence of Harold McCormick, principal heir of the great reaper and farm-implement fortune which was an inheritance to be favorably compared with the Carnegie and Morgan holdings. That the project ended in failure was, as has already been indicated, a severe blow to Wright's early career and, indeed, the lowering of the curtain on the whole Chicago School. Mr. McCormick had apparently been interested in Wright for some time, and in 1907 proposed that he should present some ideas in sketch form for a new Mc-Cormick family seat in Lake Forest, some thirty miles north of Chicago. The site for this project was a large tract of land bordering the bluffs which rise there from the beaches of Lake Michigan. It was a dramatic setting similar to that of the **Hardy house** at Racine; in addition, there was a brook cascading to the Lake through a deep ravine at the southern edge of the property.

As the **McCormick project** gathered force in the favorable atmosphere of the client's approval, a *parti* for the huge complex of main house and ancillary buildings began to emerge. Wright planned to reinforce and regularize the natural bluffs by means of a series of retaining walls, deeply articulated, which would also act as a great running base for the house proper. The levels of these walls were to be so varied that no one dominating horizontal would impose itself upon the natural landscape or make the scheme too rigid when seen from offshore; it would be a happy fusion of nature and Wright. Upon this partly synthetic platform, some fifty feet in height, the house would range itself in a long composition of freely associated pavilions and galleries. But the plan, of course, had an organization even though it was not obtrusive; a certain formality is necessary, even in a Prairie house, to a baronial way of life. The McCormick plan has its main axis along the bluff, jointed and staggered at places; extending westward and at right angles were two major wings and a minor one, forming landscaped courtyards open to the west. In its centrifugal, flowing quality, it resembles the plan of the smaller but equally luxurious **Coonley house,** with which it is contemporary. The *poché* of the plan indicates that the superstructure is carried on isolated masonry supports, with walls reduced to an absolute minimum. It is a complex of cantilevered hip roofs riding over vertical planes of glass. The long, free spans of covered verandahs, of which there are many, heighten the impression of a structure whose horizontal parts are rather mysteriously

maintained in place. The extreme openness of plan is calculated to induce intimate living with nature—the Japanese ideal—and the extent to which client and designer were willing to go in approximating the quality of a gigantic gardenhouse is seen in the open gallery through which one must pass to reach the suite of master bedrooms. The owner's bedroom is somewhat recessed from the edge of the bluff for the sake of extra privacy, but it commands a wonderful view across the limitless expanse of the Lake and down into the wooded ravine. The great living and dining rooms are at the center of mass, projecting forward on bastions of masonry, and enjoying through their transparent outer skin a majestic seascape.

The McCormick design, had it been executed, would have placed Wright in the vanguard of successful American architects, and as the apostle of a new architecture to which the most serious attention must be given. It would have done even more: it would have placed the stamp of social approval on the whole progressive movement in Chicago and extended its scope immeasurably. It might have turned the tide of eclecticism. The rejection of the design marks a pivotal point in the history of a trend toward modern design in America which, as it was, went down in *débacle,* not to rise again until the late 1920's. The story

Eero Saarinen on Wright:

Wright has given us the greatest inspiration about the use of space, has also shown us the plastic form of architecture; architecture in relation to nature, architecture in relation to the material, and to a certain degree to structure. And he has shown us, also, the dramatization of architecture, which I think is a very important thing. You know, some try in their work to be influenced by him directly. I could never do that and I think that is wrong. His influence on one is, and should be, much more not through the form itself but through the philosophy, the principles, and maybe the enthusiasm behind his forms. And I think it may well be that fifty years from now we will sort of feel him stronger amongst us than right now. We live too close to him now. That is the way I look at Wright, and I think of Wright as the greatest living architect. Well, I might add one little thing to that: that so much of Wright's forms are really from a different era and the young architect and the student who isn't aware of that sort of slides right into that and wrongly so. But, boy, don't ever underestimate Wright. Then Wright hasn't really been integrated into architecture yet. And I think that's the wisest statement I've said today: that I think Wright's contribution has not yet been integrated into modern architecture.

> *Eero Saarinen, in an extract from a conversation in* Print, *Vol. XI, No. 1, February-March, 1957, pp. 37-9.*

of the rejection of the McCormick design has never been fully revealed. It has been suggested that it was Mrs. McCormick who refused it, saying that her mode of life simply could not be suited by a Prairie house. In any case it was she who suddenly went to New York in August, 1908, and placed the commission for the house which she eventually occupied in the hands of a master of traditional architecture, Charles Augustus Platt, who gave her a handsome Italian villa that is as knowing a piece of archaeology as can be seen in the Middle West. That it was erected upon the ruins of the Chicago School was, for him, unimportant. (pp. 197-202)

> *Grant Carpenter Manson, in his* Frank Lloyd Wright to 1910: The First Golden Age, *Reinhold Publishing Corporation, 1958, 228 p.*

Lewis Mumford (essay date 1959)

[*Mumford was an American sociologist, historian, philosopher, and author whose primary interest was the relationship between the modern individual and his or her environment. Influenced by the work of Patrick Geddes, a Scottish sociologist and pioneer in the field of city planning, Mumford worked extensively in the area of city and regional planning, and wrote several important studies of cities, including* The Culture of Cities (*1938*), City Development (*1945*), *and* The City in History (*1961*). *All of these works examine the interrelationship between cities and civilization over the centuries. In the following excerpt from a review of the Guggenheim Museum written shortly after its official opening, Mumford elaborates on the conflict inherent in Wright's design between the architect's desire to express his abstract artistic vision and the practical necessity to fulfill programmatic requirements.*]

Wright dared greatly in all that he undertook, and above all he dared to be himself. Loving Emerson, he must have recognized a special personal blessing in Emerson's statement that "whoso would be a man must be a nonconformist." Wright lived to see the confident, self-reliant America of Emerson and Whitman, even the mugwump America of Howells, turn into that meek, tame, glossily corrupt totalitarian "democracy" which now lives—or half lives—in the shadow world of the television screen. To one who had the audacity to sin against the conventions of this society in almost every way except its love for exhibitionism and publicity, much may be forgiven. Wright was a chip off the old American block. In the sense in which the term still applied before the Civil War, he might be called one of the last Americans—a distinction he shared with such a profoundly different personality as Robert Frost. In his unique development, both the good and the bad qualities one associates with that role were exaggerated: on one hand his isolationism, his anti-Europeanism, his belligerence, his lightly triggered arrogance, his colossal self-admiration, but over against this his originality, his freshness, his gay generosity, his boundless affirmation of life, his belief that the world need not remain decayed and corrupt but might be made over anew in the morning.

These thoughts on his life and character temper all that I am bound, out of my respect for Wright's greatness as an artist, to say about the **Guggenheim Museum,** the only example of his architecture in New York. If I have occa-

sion to speak severely, remember that I am talking about a true artist, one of the most richly endowed geniuses this country has produced—an artist who has no need for the apologetic leniency one might accord to a lesser talent. For the most serious flaws in Wright's work, it may be that our country fully shares reproof with the artist. Had we had the proud understanding, when he was in mid-career, to encourage him with great commissions, we would have earned the right to challenge his narcissism and his complacent egocentricity and to require a more sober perfection than he, in the sheer willfulness of his genius, was prepared to achieve. Wright was at his best with appreciative but self-reliant clients, and in an equally appreciative America he might have risen to more searching demands and thrown away the shallow showmanship that on too many occasions marred his architecture no less than his public relations.

The **Guggenheim Museum** is a formidable, ponderous, closed-in concrete structure of almost indescribable individuality; the main element, the art gallery, might be called an inverted ziggurat that tapers toward the bottom—not the Mesopotamian kind, which stood on a square base, but Bruegel's round version in his *Tower of Babel*. Functionally, this museum, which occupies a whole block front on Fifth Avenue, from Eighty-eighth to Eighty-ninth Street, divides into two parts—at the south end a low, telescoped tower (the ziggurat) crowned by a wired-glass dome visible solely from the air, and at the north end an attached administration building only half its height, a combination of rectangular and circular forms, with portholes for windows, opening on viewless balconies with solid parapets. The ground floor of the tower is recessed under the overhanging second floor to create a deep shadow, so that the tower appears to be set on a strong horizontal base formed by the continuous concrete hand of the second-floor wall, which seems, because of the shadow, to float in space. In many of Wright's later designs, such as the unexecuted group of funeral chapels in San Francisco, such a broad horizontal base serves both to bring together separate elements and to set the building apart from the immediate landscape, as was done in such Renaissance designs as the villas in Frascati. In the Museum, the base seems wholly detached and aesthetic—not functional, as in the case of Wright's early prairie houses, which rested, without the usual cellar and foundations, on a low pedestal. The main mass, the tower, is set back from the building lines at the southwest corner, where the second-story wall bulges out into a bay that emphasizes, in profile, the wider curve and sloping sides of the ziggurat.

Despite its dull color, a sort of evaporated-milk ochre, this great monolith stands out boldly from the flat, anonymous apartment houses in the neighborhood, the positiveness of the form offsetting the all too congenial mediocrity of tone. The building is so definitely a thing apart, so different from every other one on Fifth Avenue, that the sprawling, pale-green letters (along the lower edge of the second-story wall) that identify it may almost be forgiven for their feebleness because they are actually not needed at all. As an external symbol of contemporary abstract art, this building has a genuine fitness in its severe rationality of form. But Wright had, out of respect for the materials and constructive elements he chose, denied himself the more enlivening resources of which he was master. This building is non-traditional, non-representational, nonhis-

torical abstract art in its own right; indeed, it not merely coincides with the contents, it supersedes them. You may go to this building to see Kandinsky or Jackson Pollock; you remain to see Frank Lloyd Wright.

From the moment I examined the preliminary drawings I was disturbed and puzzled by its design, and I am still disturbed, though further reflection and observation have revealed a little of Wright's intentions and decisions. At that, almost every part of this design leads to a critical question mark. Let us first consider the exterior, and, to begin with, the choice of monolithic concrete. Whether it is in the raw state imprinted by the mold, or whether it is smoothed and painted, concrete remains a sullen material. If left in the rough, as in Le Corbusier's Maison d'Unité d'Habitation, in Marseille, or in Louis Kahn's Yale Art Gallery, it is tolerable only at a distance; if it is smooth, no matter how carefully it is poured, cracks and splotches are bound to show from the beginning, and if the smoothness is covered with a cement paint, as in this case, it lacks texture and character. Worst of all, the flawed surface denies the solidity of the material, as if it were hastily done in plaster over canvas. Wright was a master of texture, in brickwork no less than in stone. Yet in this building, by its nature a showpiece, he was content to emphasize the sheer elephantine solidity of the heavy concrete walls. Is it possible that this structure, seemingly designed from the foundations up as if it were a fortification, was meant to be precisely that—as indestructible as he could make it? There would be at least a strong subjective justification behind this folly. Two of Wright's early buildings, among the best of his first twenty-five years as an architect, were prematurely demolished—the **Midway Gardens** in Chicago and the **Larkin office building** in Buffalo—and now the **Imperial Hotel** seems doomed. Did he design the **Guggenheim Museum** as a super-pillbox that would resist vandalism or demolition as effectively as those surviving concrete bunkers Hitler's minions built along the Channel coast? Wright is reported to have said that if a nuclear bomb destroyed New York, his building, on its cushioned foundation, would merely bounce with the shock and survive. Thus Wright would be left, in effect, surveying the ruins, ironically triumphing over the city that had waited till the end of his life to give him this one opportunity. He may have been consoled by the thought, but, apparently to insure that triumph, he sacrificed the purposes of the Museum and created an empty monument as the sole prospective occupant of an untenanted world. In his plan for the **Baghdad Opera House garage,** Wright turned an embarrassment—the need for motorcar parking—into a magnificent opportunity, but in the **Guggenheim Museum** he turned an opportunity into an obstacle. Even as a fortress, even as a bomb shelter, it falls short of perfection.

His seeming decision to leave behind an indestructible monument should perhaps enlist our sympathy, but the result does not merit our approval. From this error all the worst features of the exterior design spring. It is formidably *im*pressive, but it is not *ex*pressive of anything except the desire for monumental solidity. Montgomery Schuyler, the nineteenth-century architectural critic, said that H. H. Richardson's overponderous buildings were defensible solely in a military sense, and the gibe applies equally to Wright's museum. Only in the intimate touches do the more lovable features of Wright's imagination emerge, such as the banks of green foliage that provide a flare of

living color and texture along the Fifth Avenue approach. There is nothing else in this exterior to reduce the sense of grim military self-sufficiency, and the office wing is just as massive and as sparing of windows as the main structure. Except for the wealth of greenery—particularly effective in the motor court, which is framed by the entrance—there is nothing of Wright's specific imprint in the outward structure but the circular form. In using rounded forms, he shares honors with Eric Mendelsohn, who first suggested the special plastic quality of concrete in the imaginative architectural sketches he published after the end of the First World War. Ever since Wright designed the **Ralph Jester house,** in Palos Verdes, California, back in the thirties, he was fascinated by rounded forms, curving ground plans, and circular enclosures, and he continued, with increasing felicity, to explore these architectural resources. His circular houses, such as the one he designed for his son, David, are among the best examples of his later work. But in accenting the massiveness of monolithic concrete by replacing windows with mere narrow horizontal slots between the floors of the Museum tower, Wright introduced an inflexible element into his design, for he proposed to make the amount of natural illumination, as well as the inner space, unalterable.

Again one searches for some reason besides Wright's assertion of his own ego. His circular tower creates an exhibition room whose dimensions in no way can be modified to suit the needs of a particular showing. This is an all-or-nothing building; one takes it on Wright's terms or one does not take it at all. In planning it, what Wright did was to redesign his **V. C. Morris shop building,** in San Francisco, which has the same system of interior circulation, but he hollowed out the interior and replaced the flat Morris façade with an exterior that would properly correspond with the circular interior of the Museum. Unfortunately, his interior scheme, a brilliant one for a shop, because it increases the temptations to buy by spreading all the merchandise before the eye, is a ruinous one for a museum, in which the works of art, surely, should impose their needs on the building. But Wright never had a place for the painter in any of his buildings, and it was perhaps too much to hope that there would be a place for him even in an art museum.

For all that the exterior of the Museum is contemporary abstract art, in creating it Wright hid his light, so to speak, under a concrete funnel, and it is only in the interior that one may see it burning—in such a dazzling fashion, in fact, that it negates its function by obscuring all the other works of art that a museum supposedly exists to display. If the outside of the building says Power—power to defy blast, to resist change, to remain as immune to time as the Pyramids—the interior says Ego, an ego far deeper than the pool in which Narcissus too long gazed. On the outside, Wright's composition puts this architecture under the wing of the New Brutalist school; on the inside, he is the old Romanticist, singing—as if he were alone in the wilderness—the Song of Myself, but without communicating the sense of speaking for all other men and inviting their contributions, and enhancing their personalities, too, that made Whitman's swelling ego so lovable.

Thus, though the exterior of the Museum is far from negligible as "building," it is a feat for which the contractors and workers deserve heartier congratulations than the ar-

chitect. More than one builder shied away from this difficult task, and the architectural pleasure evoked by the massive concrete forms is unduly small when one considers the immense effort and expense involved. For while, as in all of Wright's buildings, the interior and exterior are conceived as organically one, in this case the outer expression is mere "building" or "engineering," while Wright's special gifts—and his sometimes defiant weaknesses as an architect—do not come to life until one gains the interior. In lesser degree this is true of many other domed structures—like the Pantheon, in Rome, and Santa Sophia, in Istanbul—but this distinction particularly applies to the **Guggenheim Museum.**

Yet once you come close to the **Guggenheim Museum,** Wright has you in his hold. From the time you scrape your feet on the unmistakably Wright grating in the vestibule and grasp the bronze bar that, serving as handle, stretches from top to bottom of the glass door, you are under his enchantment. Entering, you are in a monumental hall of exalted proportions. The form is circular, and the spiralling ramp that ascends it—broken by a bulging bay on each floor—creates a rotating band of light and dark, of solid and void, that terminates in the opaque, almost flat wired-glass dome. This dome, a combination of broken-spider-web space divisions and strong supporting forms, is in Wright's characteristic manner, though, uncharacteristically, it closes out the sky as completely as the concrete structure closes out the landscape. As for the strong curve of the bays, it not merely enhances the dynamism of the helical ramp, which widens with each floor, but makes it psychologically overpowering—indeed, physiologically almost unbearable. For the abrupter fall of the ramp on this sharp curve adds to the muscular tensions created by the form of the structure and its dizzy impact on the eye. This is not a tall building—only six stories—but it gives the effect of great height. Without ornament, without texture, without positive color, in a design as smoothly cylindrical as a figure by Fernand Léger—this is how Wright shows himself here a master of the abstract resources of modern form. Here is the freedom that Mendelsohn dreamed of and first brought into existence in the Einstein Tower, in Potsdam, but here, too, is the disciplined movement that the Baroque architects sometimes weakened in the exuberance of their ornament. In the very restraint of this composition, Wright, like a good disciple of Lao-tse, dramatizes its essential element—the central void, filled with light. It takes an effort to turn away from this striking composition, modelled with such boldness yet with such discipline and with such a vivid interplay of form between the curving ramp and the circular "utility stacks," which house the closets and lavatories on each level, rising against the wall on either side of the elevator to visually tie all the floors together. As an object by itself, the **Guggenheim Museum** interior is, like the exterior, a remarkable example of abstract sculpture; indeed, it is a new kind of mobile sculpture, whose dynamic flow is accentuated by the silhouettes of the spectators, who form a moving frieze against the intermittent spots of painting on the walls. Thus Wright permitted the requirements of his composition to dominate both the works of art and the freedom of the viewer. They are needed to complete it, but apart from this they do not signify. Those who respond to the interior do proper homage to Wright's genius. If the purpose of the Museum is solely to exhibit Wright, the interior has magnificent justification for its existence. And

if the spectator forgets the other works of art it contains, the building is—for him if not for the neglected artists—a compensation and a unique reward. What other monumental interior in America produces such an overwhelming effect?

But architecture is not simply sculpture, and this building was meant also to serve as a museum. Wright has allotted the paintings and sculptures on view only as much space as would not infringe upon his abstract composition. It is an open secret that he paid no attention to the program set before him and overrode every attempt to make this great shell workable as a museum. The dominating conception would have needed complete revision if the building were to be anything but a display of Wright's virtuosity. With all the willfulness of genius, he created the minimum amount of gallery space at the maximum cost and the all but complete sacrifice of the Museum's essential requirements. This architect who stood for organic forms, who continually preached the lessons of life and growth and change, created a shell whose form had no relation to its function and offered no possibility of any future departure from his rigid preconceptions. Except for a single high-ceilinged, triangular side room opposite the main entrance, on the first floor, the sole exhibition space is that great circular wall within the tower. The continuous ribbon of promenade that winds along this wall has, for a museum, a low ceiling—nine feet eight inches—so only a picture well within the vertical boundaries thus created can be shown. The wall provided by Wright slanted outward, following the outward slant of the exterior wall, and paintings were not supposed to be hung vertically or shown in their true plane but were to be tilted back against it. The interior, under Wright's direction, was painted the same dull cream as the rest of the Museum. To make matters worse, he interposed a sloping shelf between the wall and the spectator, so that anyone interested in a closer view—whether because of myopia or a curiosity about brush stroke and treatment—could not get near a canvas. Nor could he escape the light shining in his eyes from the narrow slots in the wall. Only on the first two floors, where there are no light slots, did he forgo this embarrassing embankment.

Short of insisting that no pictures at all be shown, Wright could not have gone much further to create a structure sublime in its own right but ridiculous as a museum of art. The most pretentious Renaissance palace could hardly have served a modern artist worse. There is not a mistake in rigidity of plan, in scale, or in setting made by the pompous academic temple museums of the past that Wright did not reproduce or actually cap. Even the sculpture on view has difficulty in surviving Wright's treatment; it is in hopeless competition with the overwhelming sculptural force of the building itself. It is as if Wright had only one condition to impose on rival artists—unconditional surrender.

With infinite labor, the Museum has since sought to neutralize Wright's blunders and to salvage the concept of the Museum as a public place for viewing works of art. But there are errors that no ingenuity can overcome, and one of them is the ramp. With it, the whole building is in motion, and the spectator must be in motion, too—part of a moving procession of people, with no place to sit down except a side bench at each floor, no place to retreat to, no

possibility of changing his relation to the object viewed, except by viewing it at a distance, from the opposite side of the hall. The worst feature of the old-fashioned museum was the continuous corridor, and it is not improved here by being made a spiral. It remains only for some pious machine-minded disciple of Wright's to go one step farther and place the pictures on a moving belt, so that the spectator may remain seated. The sloping ramp and ceiling, and the slanting vertical members that divide the wall into segments, magnify the problem—the annoying distortion of view—by destroying parallels and right angles for anyone who has come to look at pictures. Who has not felt an excruciating necessity to readjust a picture when it is hung even slightly out of kilter? In short, in the state Wright left the Museum in, it was magnificent but unusable, and the very worst service James Johnson Sweeney, its director, could have done Wright's reputation would be to open the Museum without making any changes. (pp. 106-22)

On a plot as generous as this one, with Central Park to provide both a contrasting outer view and the maximum of natural light, [Wright] had a rare chance to evolve a solution that would do full justice to the art, to the museum visitor, and not least to his own imagination and invention. But by committing himself to the continuous ramp and the closed shell of the building he turned his back on that open landscape and the varied natural light that were his for the asking. As if to emphasize this perversity, he wasted half the imposing frontage on the administration offices and enclosed them in a wall as nearly windowless as the gallery. The fact that Wright threw away such advantages—which lent themselves to many alternative solutions in forms just as bold as the present one—is the bitterest pill this box holds for at least one of his admirers. Even in creating a place in which to exhibit himself as supreme master of abstract art, he hardly did justice to himself, for the self he put on display was his worse self, the exhibitionist and the autocrat, not the poetic creator of form who could evolve a hundred fresh architectural images while his rivals were painfully trying to evolve a single one.

In every aspect of architecture, except as an abstract composition in interior space, one's final judgment of Wright's **Guggenheim Museum** must, then, be a sadly unfavorable one, such a judgment as only an old friend may in fear and trembling impart to the living and only a lifelong admirer feel free to deliver over the work of the dead. In coming to this verdict, I pass over the minor flaws—the absence of sufficient storeroom space, so that one whole floor of the spiral must be devoted to storage, and the lecture hall, too wide for its purpose, too lacking in facilities to serve as a little theatre, since it has none of the flexibility of function and seating that such a room might easily have had—for in some degree they are all counterbalanced by many ingratiating touches. So, too, I ignore the administration building, with faults as flagrant as those in the Museum itself, and I blame the city's building code, rather than Wright, for the lowness of the balustrade that lines the outer edge of the ramp—a lowness that seems scarcely adequate to its protective function. There are two dominant types of architecture today, both anti-functional, both meretricious—that of the package and that of the Procrustean bed. This museum is a Procrustean structure; the art in it must be stretched out or chopped off to fit the bed Wright prepared for it. The building magnifies Wright's

greatest weakness as an architect—the fact that once he fastened on a particular structural form (a triangle, a hexagon, a circle), he imposed it upon every aspect of his design, with no regard for the human purposes it presumably served. He thus sometimes turned a too strict logic into a hollow rhetoric. Despite all the sculptural strength the interior of the **Guggenheim Museum** boasts, the building as a whole fails as a work of architecture. And it is ironic to find that this failure is of exactly the same order—and because of the same kind of arrogance and willfulness—as that of Le Corbusier's equally ambivalent Maison d'Unité d'Habitation. In both cases the plan is arbitrary, the interior space is tortured, and the essential functions are frustrated in order to comply with the architect's purely formal aesthetic choices. This is not architectural originality but academicism.

The architects who pursue their formal aims so intently without consideration of all the public functions they serve are really claiming the privileges of the painter and the sculptor without fully accepting the responsibilities of their own profession. And they do this to their own disadvantage, for they forget that even minor irritations arising from functional deficiencies may seriously lower the aesthetic vitality of their form. In the case of the **Guggenheim Museum,** the lapses are not minor, and Wright's hollow triumph is all the worse because he was lending the weight of his genius to the fashionable aberration of the moment—the curious belief that the functional aspects of architecture are unimportant. Instead of showing, as he well might have, how a great modern architect does justice to every aspect of a building, and not least the aesthetic—without making timid compromises or irrational sacrifices or frivolous omissions—Wright turned his back on that challenge. He thus defeated his own purpose by producing a building that in order to function at all could not remain what he had planned it to be long enough to be formally opened. The old should not set such a bad example to the young, and the greatest of our architectural masters should not, while still hale and of sound mind, have added such a codicil to his last will and testament.

I can think of only one way of fully redeeming Wright's monumental and ultimately mischievous failure—that of turning the building into a museum of architecture. This would be in keeping with the form of the building and would cover up most of its mistakes. Could it be that it was this, and not abstract painting, that Wright had in mind, at least unconsciously, all the time? (pp. 127-30)

> *Lewis Mumford, "The Sky line: What Wright Hath Wrought," in* The New Yorker, *Vol. XXXV, No. 42, December 5, 1959, pp. 105-30.*

James Marston Fitch (essay date 1961)

[*Fitch is a prominent American architectural historian whose research on restoration and preservation of historic world architecture has earned him international recognition. He has also written widely on the subject of American architecture, most notably in his two-volume study* American Building *(1966-72). In the following essay, Fitch discusses the technical and aesthetic innovations Wright introduced into the design of the middle-class American home, praising the democratic spirit that determined his approach to domestic architecture.*]

Frank Lloyd Wright did his most prescient work at what was really the very dawn of our present era, but in his approach to the problem of industrialization and modern technology, he established certain criteria in design which are still extremely viable. When Wright first appeared on the scene, science, technology, and industry were highly advanced, placing in solution all the old verities of Jefferson's republic. A new world was waiting to be born, and with it, a new architecture.

To its creation, Wright contributed as much as any man alive. He has been called the inventor of the modern American house. And, certainly, during a long and fruitful life, he brought to it a level of comfort and amenity which, before him, could have been found only in Newport or Fifth Avenue, and a kind of domestic beauty which was entirely new. His houses have made available to the ordinary middle-class American family an environment of spacious ease and luminous urbanity such as only the rich could have afforded before him. Like Jefferson, whom he admired immensely, albeit in a quite different context and on a much higher level, he took the burgeoning material accomplishments of his world and put them to work for the enrichment of our people generally.

When Wright began his architectural practice in Chicago in the early 1890's, a basic change had already occurred in American life. The old self-sufficient family of Jefferson's republic which produced most of the food it ate, the clothes it wore, the furniture it lived with, the very house that sheltered it—this family and this way of life were already declining. In that family's place was appearing a new kind of family—a family of consumers, which, instead of producing what it ate and wore, bought it with earned wages from the stores. Today, beset with contemporary problems, we may tend to regret this change when we look back at this pre-industrial way of life with a nostalgia not always very firmly bedded in fact. Today, the very word homemade and handmade are terms of praise, trademarks of chic. But, fifty or seventy-five years ago, these same words were terms of disparagement, reproach, and contempt. Now, there are doubtless real merits to homemade, home-baked bread, home-cured meats, and home-woven cloth. But the hard, often noisome labor connected with their preparation was not one of them. Here we must take the word of our own grandmothers who had to do this work and only too gladly gave it up. For them, housework meant the stupefying heat of the kitchen on a July day, the squalid labor of the washtub, the stench and flies from the pigpen. The fact was that most homes were little factories, and most wives were slaves to a sweatshop schedule.

Under such conditions, most houses were uncomfortable to live in and unbeautiful to look at. Here again, we must take the testimony of the women. Why did they labor so hard to create *front* yards, *front* doors, *front* rooms, if not to conceal the ugliness of the rear? Why this effort to create little islands of peace and beauty? Why, if not for occasional escape from the grinding routine of the pre-industrial household?

For these women, cleanliness meant a constant struggle. Comfort was sometimes won, beauty almost never. No wonder they were turning with such enthusiasm to the labor-saving, comfort-making devices which American factories were turning out in the decade that Wright began

to work. Thanks to industrialization, the never-ending drudgery of housekeeping was being lifted from the housewife's shoulders. The most degrading and stultifying processes of family sustenance were being removed from the home. The ordinary housewife was becoming able to join the human race, to enjoy the comfort, leisure, and self-respect which had hitherto been the prerogative of rich, slave or servant attended women.

But there was another, and for architects an even more important side to this phenomenon: the same process which had been removing from the house the causes of most of its hard labor, inconvenience, and discomfort, was also removing the cause of most of its ugliness. For the first time in history, the home of the average family could be a thing of beauty; not just the front parlor, or the front yard, but all of it, inside and out, could be an object of pleasure and delight. We can say—I think without fear of contradiction—that Wright was the first American architect fully to understand this new fact, fully to explore its possibilities. It would be nonsense, of course, to claim that Wright, in those early days of the new American house, was the only, or even the first, architect to use central heating, plumbing, electricity, or all the host of new structural materials. His contemporaries used all these things enthusiastically. But they forced them into old, conventional designs. They employed steam radiators, but they meshed them behind Renaissance grilles; steel columns and beams, but they sheathed them to look like wood and marble; modern plumbing fixtures, but they patterned them to look like bishop's chairs.

Wright's role was of quite another order. He saw that all these developments taken together demanded nothing less than a totally new system of architectural expression. The old traditional forms simply could not contain the new order—a new kind of beauty was called for.

The technology which had wrought such profound changes in family life had also given the architect a whole new palette of building materials: steel, reinforced concrete, plywood, huge sheets of rolled plate glass. And Frank Lloyd Wright, almost alone in those early days, argued that these should be employed boldly and honestly in new forms and not tortured into traditional ones. As a result of his independent approach, Wright was able to make very important architectural contributions to design—contributions which became standard elements in the modern house. Only consider: by 1900 everybody who could afford it demanded central heating, either hot-air furnaces or steam heat. All the architects were including these in their new houses, but only Wright understood their ultimate implications, for they made obsolete the old honeycomb plan of boxy, airtight rooms strung like beads on a string. This had been a logical arrangement in cold climates so long as fireplaces and stoves were the only ways of heating rooms. But Wright was quick to see that, if all rooms could be kept equally comfortable with almost invisible heat sources, rooms could flow freely one into the other. Doors and whole walls could be eliminated. Rooms could dissolve into one another. The open plan was the result, the instrument which enabled Wright to create those splendid interior vistas for which his houses are justly famous.

Or again, by 1900 everyone was aware of the therapeutic value of sunshine, and was demanding more of it in his houses. Plate and rolled glass made possible windows of unprecedented size. But while other architects used more glass, they used it in conventional patterns, cutting up their sash into little Colonial rectangles, Elizabethan diamonds, or leaded Medieval bullseyes. Only Wright saw the dramatic possibilities of these huge transparent sheets. He saw that with them he could destroy the iron boundary between indoors and out. Here was another instrument of great power and beauty at his disposal. With it he could extend the living area to include not merely the enclosed space, but the terraces, porches, and gardens beyond. He thereby brought his interior space into a new and exciting proximity with nature.

Or, finally, by 1900, everyone was demanding electric lighting in his house. Its advantages over oil lamps and gas were obvious and immense. But electricity was not merely a substitute for coal gas and kerosene: it made possible a totally new concept of illumination. Instead of the niggardly pin-points of earlier light sources, electricity made it possible to flood whole areas with light. Spaces could be modeled, forms dramatized, textures enhanced. Who besides Wright, in those early days, understood this? While the rest of the profession continued to mask their Mazda bulbs in fixtures of conventional form—candelabra, chandelier, and sconce—Wright went boldly ahead building the anatorg bulb into the very fabric of the house. Light itself, and not just the fixture, became the source of pleasure and delight.

Wright always insisted upon his absolute independence from the esthetic forces of his time. He seemed to consider it an affront to his integrity as an artist to suggest that he might be influenced by his contemporaries. Influence was, for him, synonymous with plagiarism. He had spent so many arduous years fashioning his own idiom of expression, years in which his contemporaries were the most shameless eclectics, that he could not tolerate the suggestion of a connection, no matter how remote or indirect, with the men around him. He denied all such connections, and this sometimes led him into absurd semantic difficulties as when he called Sullivan "lieber Meister" and simultaneously asserted that he owed nothing to the older man. The fact is that Wright, like all truly great artists, was extremely sensitive to the world around him. Verbally he might deny the influence of Sullivan, of Japanese art and *art nouveau,* of cubism, of the North American Indian, and pre-Columbian art; artistically his buildings contradict him. They show beyond a shadow of a doubt how responsive he was. Like a seismograph, his work registers every insignificant tremor in the world of art. But unlike a seismograph, his great creative talent always transformed these external stimuli into forms inescapably his own.

It is sad to think that he ever felt it necessary to assert his originality; his work itself proves him to be, like Picasso and Corbusier, among the greatest artistic inventors of all time. Nor was the miracle of Wright's response to these stimuli exclusively a matter of esthetics. Nontechnical problems always underlay them, and Wright's mastery of them is the evidence of the uniqueness of this contribution.

This process is very clear, for example, in the lovely **Millard** and **Ennis houses** in California, both of which belong to his so-called Mayan period of the early 1920's. They are clearly influenced by pre-Columbian architecture, whose

acquaintance he had first made long ago at the Columbian Exposition. But these houses are not copies. The shining gravity of the Mayan temples sprang from their sculpture-encrusted limestone masonry. Wright could not, in fact, have copied these even if he had wanted to: the budget would not have permitted either carved sculpture or limestone, and the building codes of a California often shaken by earthquakes would have advised against rubble masonry walls. We can see instead the Wrightian process of transmutation; the special alchemy by which he extracted beauty from his cheapest building material, concrete, fabricated in its commonest form, cast block. Some of these blocks are plain, some are cast in geometric pattern. For all their basic simplicity, these create a rich and intricate fabric when woven into a wall. And this wall was simultaneously made as strong as it is handsome by an earthquake-resistant system of integral reinforcing ribs. The apparently effortless way in which Wright solved such problems lends an air of deceptive simplicity to his solutions. One needs almost to be an expert to understand the complexity beneath him. (pp. 84-9)

In the catalog for his 1954 exhibition house at the **Guggenheim Museum,** Wright said wryly that he would be accused of arrogance if he claimed that his early houses were the first "truly democratic expression of our democracy." Yet it is true that a distinguishing mark of his houses had, from the start, been their modesty. Even large and expensive ones such as the **Coonley** or the **Kaufmann** houses lacked that browbeating pretentiousness which was always the trade mark of the homes of the wealthy.

Big or small, Wright's houses have always had the grace and urbanity of a mansion, but this is never the result of just shrinking the mansion down to cottage size, as the Amazon headhunter does his trophies. Many of his contemporaries tried that, but not Wright. Even his own house at **Taliesin East,** actually one of the largest country houses in America, is so demurely fitted into its terrain that its real size is never apparent. It is, on the contrary, deliberately concealed. There are impressive, even majestic vistas in these houses, but they are designed to delight the inhabitants, and not to overawe the passerby.

All elements of a house were to Wright equally important and hence equally beautiful. It had no front and consequently could have no back. Wright's houses were also, from the start, democratic in their choice of materials. The cost or rarity of a building material was never for him an argument either for or against it. He could create interiors of magnificent warmth, of stunning luxury, with the simplest materials—wood, brick, plaster—while his contemporaries were using imported marbles, cut velvets, and gold leaf with much less effect. How can one explain this? Wright said it was because these other architects had no real feeling for the nature of their materials. Because of this, they cut, carved, chiseled, clipped, painted, and stenciled. He, on the contrary, extracted from each material, no matter what it was, its peculiar properties, and then expressed them clearly in the way he used them. The result was a lack of bombast and pretension which had not been seen since Jefferson's day.

It is strange indeed that men who should have known better could have misunderstood Wright's principles, could have attacked them as "un-American" (as the American Legion did in the United States Air Force Academy case).

A more typical American than Wright never lived. His strengths and his weaknesses are ours. His artistic declaration of independence was at the esthetic level the precise equivalent of our noblest social and cultural perspectives. Both envisioned the fullest development of the individual in a new kind of society, free of the fetters of the past, the hierarchies of king and clergy, of hereditary power and privilege. Just as the Bill of Rights denies them power, so Wright's architecture rejects all of their iconography of caste, power, and privilege. His houses, like those of Jefferson, even the largest and most expensive, are democratic in spirit. The analogy, of course, is not accidental; Wright greatly admired Jefferson, and like him he was persuaded that democracy is the best forcing bed of ability, talent, and genius. Its function is to produce for each generation a cadre of true leaders, an aristocracy of intelligence and ability, not of inherited wealth and title.

Wright's youth had been spent in threadbare parsonage parlors, whose genteel, constricting poverty had provoked an allergic response of pride and arrogance from a thin-skinned and sensitive young man. Most of his adult life, on the other hand, was spent against a background of beauty and physical ease. But this never led to snobbery in Wright; he was entirely unlike the typical self-made man, that parvenu American who uses democracy merely to climb to the seats of power, and then, by denying his origin, dons the traditional accoutrements of power. It was precisely this American whom Wright detested as a climber, who in a desperate bid for a prefabricated background, bought geneology, coat-of-arms, period furniture, and an eclectic house.

The architectural expression of Wright's response to democracy and industrialism took the form of two of the loveliest houses in the world. To his **Taliesins** in Arizona and Wisconsin, he brought a real splendor, the excitement of a presence larger than life, a touch both passionate and gentle, and a composition at once both lyrical and strong. No one who ever had the privilege of visiting his **Taliesins** when Wright was in residence could fail to feel himself ensconced in a special kind of oasis, in which the raw and hostile forces of surrounding life had somehow or another been reorganized into a landscape of blessed peace and plenty. In these two wonderful houses, of all the wonderful buildings he designed, we can most clearly see the sort of world his genius would have built for us, had we but fully used it. (pp. 89-92)

James Marston Fitch, "Wright and the Spirit of Democracy," in Four Great Makers of Modern Architecture: Gropius, Le Corbusier, Mies van der Rohe, Wright *by James Marston Fitch and others, Columbia University, 1963, pp. 84-92.*

Sigfried Giedion (essay date 1967)

[*Giedion was a Swiss engineer and art historian best known for his influential history of modern architecture* Space, Time, and Architecture (*1941*), *in which he stressed the profound impact of industry and engineering on twentieth-century design. In the following excerpt from a revised edition of that work, Giedion discusses Wright's career to the beginning of the Second World War, identifying the key architectural principles ex-*

*pressed in his designs for Prairie houses and office build-
ings and assessing his overall contribution to the develop-
ment of architectural Modernism.*]

Of all contemporary architects whose span of work reach-
es back into the nineteenth century, Frank Lloyd Wright
was without doubt the most farsighted, a genius of inexpli-
cably rich and continuing vitality. He ranged the wide ex-
panse of historical interrelations, drawing particularly
upon the architecture of the Far East—not, however, in
the manner of the last century, as a substitute for creative
impulse, but, like Matisse with Negro or Persian art, from
an inner sympathetic relationship. At the same time he
sprang out of the American soil and the American tradi-
tion more directly perhaps than any other of the great
American architects. True insight into his work demands
a somewhat subtle approach, for Wright's dominating
personality, present in every touch of what he did, was not
at all simple. He bore in himself the marks of the late nine-
teenth century; yet isolated and singlehanded, without aid
from his contemporaries among painters and sculptors, he
introduced the beginnings of a new conception.

When he began work in 1887, he was—in Chicago—at the
very center, the fountainhead, of architectural develop-
ment. He was apprentice in the atelier of two of the best
men, Louis Sullivan, "lieber Meister," he called him, and
Dankmar Adler, "the grand old chief," at the very time
when they were on the ascendant creatively, working on
the Auditorium Building. He had as the principal influ-
ence of his youth the culmination of the Chicago rena-
scence. And yet when he began to work independently,
Wright did not continue directly in the Chicago school;
he did not carry over the use of the new materials—the
iron skeleton and the great glass surfaces of the office
buildings—into his own sphere: housing. Instead he was
rather conservative; in many respects he followed Rich-
ardson more than Sullivan. It was not until as late as the
thirties, when European architects were already utilizing
the inherent possibilities of ferroconcrete to the fullest,
that Wright, as he said himself, used it for the first time
to any great extent for one of his houses. This was due not
to any lack of technical ability but to his own will and
character. (pp. 396-97)

What is the explanation of the fact that Wright was the
only architect so far ahead of his own generation, a man
who built works of great influence right up to his life's
end? The answer is rather simple: he had less debris to
clear away than the Europeans. He had been born in the
Middle West, within the shadow of the place possessing
the greatest architectural vitality of the period: Chicago.

From the outset Wright devoted himself to the problem
which was to be his life interest—the house as a shelter.
He had at his disposal the anonymous American tradition,
the example of Sullivan, and the conscious artistry which
Richardson had cultivated in home building. The secret
of Wright's work is that he saw in the tradition of the
American house those elements which could be used as a
basis for the future. He took these basic elements and
added new ones, enlarging—with all the force of genius—
the structure of the house delivered to him. (pp. 397-98)

.

Before I had seen any of Wright's houses, I stopped once
for a rest in a hunting lodge in the Vermont hills. It had

an immense stone chimney which stood massively in its
center, rising the entire height from the ground up
through the roof. The interior space was undivided, except
for a partition which cut off the kitchen and the sleeping
room. There was no ceiling, but simply open rafters from
which hung fox and bear skins. At that moment I began
to understand the way Wright conceived his interior
spaces. He worked fundamentally and as far as possible
with the house as one room. Its inner space is differentiat-
ed to meet special needs. As he pointed out, he "declared
the whole . . . floor as one room, cutting off the kitchen
as a laboratory, putting servants' sleeping and living quar-
ters next to it, semi-detached, on the ground floor, screen-
ing various portions in the big room, for certain domestic
purposes—like dining or reading, or receiving a formal
caller."

In organizing his plans Wright went back to the seven-
teenth century in the use of the large chimney in the center
of the house as starting point for the whole layout. He
spread out the different rooms from this massive kernel.
What first impressed European architects was his "wind-
mill" plan, so called because of the way the rooms were
extended outward from the center like the vanes of a wind-
mill. This "windmill" plan is really cruciform, an inter-
penetration of two parts of the house, which cut each
other transversely to form a cross. Often they are of differ-
ent heights; then the effect is of one crossbar superimposed
upon and penetrating the other. (pp. 400-01)

Most of Wright's houses, especially the smaller ones, are
based on the cruciform plan issuing out of and produced
by this interpenetration of two volumes of different
heights. Such are the **Hickox house,** Kankakee, Illinois,
1901; the **Ward house,** Willett Park, Illinois, 1901; the
Willitts house, Highland Park, Illinois, 1901; the small
country house of Charles Ross at Lake Delavan, Wiscon-
sin, 1902; the **Robert Evans house** in Longwood, Illinois,
1904; the **Isabel Roberts house,** 1907; the **Horner house,**
Birchwood, 1908.

Of these, the **Isabel Roberts house** in River Forest, Illi-
nois, one of the most charming of Wright's smaller houses,
shows an interesting employment of the interpenetration
of two volumes of different heights, in which Wright used
the higher volume to mold, not the hallway, but the space
of the living room from the ground up through the whole
height to the inner planes of the roof. It represents an ef-
fort to satisfy the feeling of a need for the full height as
living space. This feeling finds expression not only in the
houses of American settlers of the seventeenth century but
in many early civilizations, and it has reappeared in our
own period. Wright was one of the first to recognize this
feeling, to formulate it and give it expression. In the **Isabel
Roberts house** the living room dominates, rising up to the
gently sloping roof, and divided in height by a gallery, so
that there are recessed spaces both above and below. This
gives an unaccustomed and new plasticity to the whole
room, which is enhanced by the use of various planes in
different materials—the brick face of the chimney, the sev-
eral wall surfaces, and the slope of the roof. (pp. 401-04)

Wright himself never abandoned the idea of the house
spread out from a central core. When in 1939 he built a
low-cost four-family housing unit (**Suntop Houses,** Ard-
more, Pa.), he separated the different apartments by brick
walls crossing at right angles. At the central core he put

not a chimney but all the utilities—plumbing, heating, electricity, and ventilation—so that they were concentrated in the darkest spot in the building.

When possible, Wright liked to spread his structures out freely over the ground. In the introduction to the study of his work published in Berlin in 1910, he points out that the first floor was often built principally as a cellar. The main living quarters lie in the upper story on one floor, as in the **Coonley house** (1911), where only the entrance hall and the game room are on the ground floor; in **Taliesin,** his own house, they are set into and connected with the ground. This led him to the flexible and informal ground plan so deeply embedded in the American architectural development from its beginning. As a consequence of this development Wright now let the different rooms flow out horizontally, just as, in houses like the **Isabel Roberts house,** he had molded them vertically.

By 1910 Wright had achieved a flexibility of open planning unapproached hitherto. In other countries at that time the flexible ground plan and the flexibly molded interior and exterior were almost unknown. Wright's realization of a flexible treatment of the inner space of a building is probably his greatest service to architecture. It brought life, movement, freedom into the whole rigid and benumbed body of modern architecture.

.

The Japanese house impressed Frank Lloyd Wright as "a supreme study in elimination—not only of dirt, but the elimination, too, of the *insignificant.*" For the American house he accomplished just such an elimination, a rejection of the confused and the trivial. But he did more than this. He took up those elements lying about everywhere unobserved—elements arising from purely utilitarian solutions—and discovered in this raw material its hidden expressiveness, just as the following generation was to discover the hidden expressiveness in engineering and construction. Wright brought forward these elements and changed them, opened our eyes to their secret potentialities and their inherent beauty, revealing their symbolic strength as a poet does in showing forth what inner content of feeling the trees and mountains, the rivers and lakes, of his native land hold for him and for us.

In the treatment of the house as a spatial unit he seized upon these elements wherever he could find them. He also sought to shape the whole house in terms of its own period. The earliest American houses—those of the settlers along the frontier—had to afford protection against attack, and consequently were meagerly supplied with openings on the first floor, being without rows of windows and open galleries like those that have given the peasant houses of Switzerland and southern Germany—at any rate since the early seventeenth century—so distinctive an exterior. Much later, with the appearance of the porch on the houses of southern rice and cotton planters, there was a corresponding opening up of the American house in the southern part of the country. In nineteenth-century America the porch was used much more extensively as the recreation area of the home than the veranda of the European peasant house, even becoming a decisive element in the appearance of suburban and country houses. Sometimes it stretched out in long, unbroken horizontal lines, covered with a slightly sloping roof. The appearance of the

Central Park Casino, New York, 1871—one of many anonymous examples—is due to an extension of this peculiarly American employment of the porch. Apparently Americans like a strong and unbroken horizontal line equally in their houses and in the Pullman car.

Wright adopted the porch for his houses—not, however, encircling his buildings with it, but pushing it forward, in keeping with his cruciform or elongated plans, as an extension of the wings. Very often it thrusts out into space as a pure cantilever hovering above the earth. Such a treatment had never been attempted before. True, it is the old element of the porch, but it is not simply something attached to the house; rather it is an essential part of the structure, molded as an inseparable part of it. For several reasons, explained in his writings, Wright used overhanging eaves. He treated them, too, as horizontal planes— "broad protecting roof shelters," as he called them—just as Burnham, before he turned classicist, roofed his Reliance Building (1894) with a thin slab.

To these hovering horizontal elements Wright added the plane of vertical surfaces. When he built the **Charnley house** in 1892, he used the clean-cut level surfaces of the American tradition. But soon he became more daring, especially in his elongated schemes, such as the **D. D. Martin house** in Buffalo (1904), and in the house which has had perhaps the most far-reaching influence of all his works, the **Robie house,** a town villa on Woodlawn Avenue, Chicago. It is a sad example of the misunderstanding of architectural merit that the University of Chicago wished to pull it down to make room for a student dormitory. It was only saved from destruction at the last minute by a New York realtor. In the nineteenth century the exterior of the American house was not up to the level of the floor plan in quality and artistic expression. Wright brought about a change. He took the plane surfaces presented to him and organized them variously, multiplying them, intersecting them or placing them in different depths one behind another, incorporating the plane of the garden wall with the different advancing and receding planes of the house itself so that often its solid volume is not at all apparent. To speak of these houses as in the "prairie style," as inspired by the long lines of the prairie, does not go to the root of the matter. The forms of the **Robie house,** the long horizontal bands, the series of windows, the garden walls, are sharply cut as if by a machine. These houses are a pure artistic expression which is deeply connected with the anonymous aims of their period. This handling is not without relation to what was being explored at that time in space conceptions in France. (pp. 404-10)

From the beginning Wright treated the inner as well as the outer wall as a plane surface. It never occurred to him to do what European architects did about 1896—replace rococo decoration with the serpentine lines of the *art nouveau.* In his interiors, too, there is a constant endeavor to find interrelations between the various separate elements—walls, ceilings, windows, and door openings. Different ceiling heights are sometimes introduced into the same room, a treatment which parallels Wright's use of horizontal planes at different heights, such as cantilevered porches, overhanging eaves, and levels varying according to the grades of the site.

Correlative with the use of abstract plane surfaces is the

use of various materials and contrasting structures. The broad brick wall of a chimney and light-colored walls with wooden partitions are often juxtaposed. Very early Wright introduced the rough structure of a rusticated wall into the house, bringing it unbroken from the outside, as in primitive times. In this feeling for different materials and the search to find a new quality of lighting, Wright developed an even greater refinement as he grew older. The buildings of the **Johnson Wax Company** at Racine, Wisconsin (1937-39), are lighted by means of Pyrex glass tubes. In the winter home of the Taliesin fellowship in the Arizona desert (1939) many contrasting materials are used—desert stone, walls of rubble concrete, wooden trusses, and inclined canvas planes forming in one surface windows and ceilings, creating, as in the **Johnson Wax Company** buildings, a specific quality in accordance with the existing circumstances.

To use plane surfaces, on the one hand, and to give them force and expression by the frank use of undisguised materials, on the other, is to employ, as we shall soon see, one of the means of painting, which at this time in France was opening the way for our new spatial conceptions.

Wright had around him no painters and sculptors who were inspired by the same spirit. He was one of those rare exceptions, the architect who is in advance of the contemporary painter in his optical vision. In Europe, where the new spatial conceptions flowered about 1910, the case was just the opposite; there the painter showed the way. But Wright had to do his work alone, design his own stained-glass windows, architectural details, and pictorial ornamentation. He did the capitals of the **Larkin Building** as "straight-edged and sharp-cornered groups of ornaments at the top of the great piers and directly below the skylights . . . strange masses of square-edge patterning." The fresco of the **Midway Gardens,** a restaurant in Chicago, now lost with the tearing down of the building, he designed out of interpenetrating circles of different sizes and different colors. In its pictorial intention this fresco stands midway between the designs of the English group around Mackintosh and the new spatial treatments which Wassily Kandinsky was undertaking in Munich at about the same time.

In his houses Wright takes the traditional flat surfaces and dissects them in strips horizontally organized and in a juxtaposed play with solid volumes, his vertical chimneys penetrating the roof in opposition to the horizontal planes of the cantilevered porches and overhanging eaves, thus giving the exterior of the American house an expression synonymous with its plan. He dissects the wall and puts it together again with an unprecedented—after all, we are in the first decade of the twentieth century—keenness of imagination. He is impelled unconsciously by the same forces that worked in Europe about ten years later; there, however, the concern was to explore new penetrations of inner and outer space rather than, as with Wright, to treat the house as an enclosed spatial unit. (pp. 411-13)

· · · · ·

Throughout history there persist two distinct trends—the one toward the rational and the geometrical, the other toward the irrational and the organic: two different ways of dealing with or of mastering the environment. These contrasting approaches to the problem have been evident in all cultures, both early and late. Since the beginning of civilization there have been cities planned according to regular schemes and cities which have grown up organically like trees. The ancient Greeks put their mathematically proportioned temples on the top of rocky acropolises, outlined against their southern skies; the villages of the Greek islands, whitewashed on the crests of hills, are easily distinguishable far out at sea because of their clearly marked and periodically rewhitened walls.

The difference between organic and geometrical perceptions is present even today in contemporary painting and contemporary architecture. They are constantly recurrent ways of approach; one cannot be considered superior to the other. The artist has the right of choice, of saying according to his own point of view which pleases him and which he will follow. From the beginning Frank Lloyd Wright faced toward an organic perception of the world.

Wright's whole career was an endeavor to express himself in what he called "organic architecture," whatever that may be. He liked to work within the shadow of this feeling. When, on January 25, 1940, he lectured in Jackson Hall, Boston, he devoted his entire discussion to this problem of his life. He tried by a sort of Socratic dialogue, a give-and-take between himself and his audience, to define and explain it. But his effort was futile. It was clear, finally, that no explanation was possible in words, that what he meant by organic architecture could be revealed only in his work.

Around 1900 Louis Sullivan, in his *Kindergarten Chats,* sought to arrive at "the true meaning of the words 'Organic Architecture' " through contrast, by exploring "what the word 'organic' doesn't mean." Organic, he said, means living, means development, and not, as in the reigning American architecture of 1900, "pitiful in its folly, . . . functions without forms, forms without functions; details unrelated to masses, and masses unrelated to anything but folly. . . ." Of this he adds: "Organic it is not. Inorganic it is becoming." "Organic" means for him the "searching for *realities,*—a word I love because I love the sense of life it stands for, the ten-fingered grasp of things it implies. . . ." "Organic," in the sense of Sullivan and of Wright, is a protest against the split personality, against a split culture. It is identical with "the ten-fingered grasp of reality" or with that development in which thinking and feeling approach coincidence. (pp. 414-15)

This urge toward the organic may partly explain why Wright preferred to use materials taken directly from nature, rugged stone walls, rough granite floors, and heavy unfinished timbers. Throughout his Chicago period he made no use of the skeleton either of iron or ferroconcrete; he was most reticent in the use of glass and of white, and so cautious with openings that it is sometimes difficult even to find the entrance door. Likewise his urge toward the organic accounts for his developing his flexible, open plan—in the age of central heating—from the huge chimneys of the early colonial house.

The usual criticism of the houses of his Chicago period—the **Martin house** in Buffalo (1904), for example, and even the **Robie house** (1908)—is that they are rather dark. They have overhanging eaves and deep, low rooms. It is not completely clear what he was trying to express with them, nor what his real motives were. It may be that, having

grown up in Chicago's most vigorous period, he reacted against the big city and its heavily glassed-in areas. In his houses and even his administration buildings he sought to make a spatial unit of the structure, but to seal it rather than to open it up.

Behind this cautiousness in the use of new materials and this hesitation about opening up the house with glass walls, as was done in the Chicago office buildings of the eighties and the European houses of the twenties, seems to lie a special conception of the needs of human nature. Wright bound the human dwelling to the earth as intimately as possible, introducing the earth into the house in the form of rough walls, and attached to it as if, in the words of Louis Sullivan, by "the ten-fingered grasp of reality." For Wright the house was a shelter, a covert into which the human animal can retire as into a cave, protected from rain and wind and—light. There he may crouch, as it were, in complete security and relaxation, like an animal in its lair. Is there back of this the desire for shadowed dimness that prevailed in the late nineteenth century, or is it an urge toward primitive eternal instincts which sooner or later must be satisfied? This we do not know. Always in the study of Wright's personality a distinction must be made between his use of elements belonging to his generation, on the one hand, and, on the other, his own genius, overleaping its natural frontiers. (pp. 416-17)

.

Frank Lloyd Wright's distinctively individual feeling for the house as a shelter and his handling of it as an enclosed spatial unit are reflected in his two office buildings—the **Larkin Soap Company administration building** in Buffalo (1904) and the **Johnson Wax Company administration building** in Racine, Wisconsin (1939). Though they were erected more than thirty years apart and are very different in appearance, they show the same spirit and give an equal insight into Wright's architectural treatment. Both are treated primarily as *one room;* both are separated from the outdoors; both are enclosed by massive walls and receive their light through skylights and high-placed windows or glass tubing. They are shells shutting out the outer world, isolated and self-contained units, and thus in the strongest contrast, on the one hand, to the buildings of the Chicago school of the eighties with their wide open glass areas and, on the other, to the designs of the European movement of the twenties.

The **Larkin Building** stands a resolutely independent mass embraced by the extended wings of the much larger factory building of the company. There is an interplay between the volume of its spatial unit and the square towers at either end and flanking the entrance. These towers, which encase the stairways and rise starkly without interruption upward over a hundred feet, were the despair of contemporary critics, who protested that they thrust up so strongly that there was no play of light and shadow, and who thought that they should be relieved by moldings or softened by glazed tiles in a variety of color patterns. The building itself had for these critics a grimness of aspect which repelled them. It was for them an "accumulation of strange sharp-edged solids, offering no modulation of surface," its features "the square corner, the right angle, the straight edge, the sharp arris, the firm vertical and horizontal lines, unbroken, unmodified, uncompromising in their geometrical precision." Curiously, this is much the

same attack which Wright later made upon the right angles, flat surfaces, and triangles of the European architects of the twenties. This uncompromising precision was taken further in 1960 by Louis Kahn's science laboratories for the University of Philadelphia, which seem closely related to the **Larkin Building.**

No skeleton was used in the **Larkin Building.** Just as in his small dwelling-houses, Wright employed brick; the towers are square brick shafts; the walls are a massive brick shell closed above by a flat roof pierced by skylights. The architect himself characterized the structure thus: "Building sealed. . . . Furnishing and filing systems built-in of steel. . . . First air conditioned office building. . . . First metal bound plate glass doors and windows. . . . " Its inner core is a large space five stories high surrounded by galleries, forming a great nave open to the skylight. Square, sand-colored brick piers, rising with a Gothic strength, divide the nave from the galleries. That the owners later on placed an organ in this vast room is an indication of the serenity of the whole. Standing on the uppermost floor and looking down into the nave and the galleries, we can observe how the light falls upon the metal desk tops from high-placed windows. It is hardly believable that this masterpiece of American craftsmanship no longer exists. In 1949 the same firm that built it ordered its destruction.

The administration building of the **Johnson Wax Company** (1937-39) is also treated as a spatial unit, but primarily in one story. It soon became famous on account of its unusually formed columns. But the accent here again is on the manner in which the lighting is achieved. I had occasion to see the building just before it was completed, and I should like to give here my first impressions:

> We come to Racine, thirty miles north of Chicago, one of those places which have neither an end nor a beginning. In the middle of the town is the Building Office for which we are looking, and in front of us there is a curved brick wall with strange, long glass strips let into the top, just visible in the winter light. . . . From a dark entrance, we arrive in a big hall filled with mushroom pillars. All the engineers have shaken their heads over these pillars which taper toward their bases and are fitted into steel shoes. At the top there are widespreading circular discs which seem to float like leaves of the *Victoria regia* among the tubes of heat-resisting (Pyrex) glass. Most of the pillars carry nothing but the air above them. This glass is manufactured in small lengths, and it is very difficult to fix. But it does not discolor, and that is what Wright wanted. The pillars are a luxury, and so is the special glass, but why should not an administrative building, which is a work building, for once be based on poetry? The light that shimmers through the tubes is of a marvelous quality. The impression of the hall is magic. We look up into the light, like fish from the bottom of a pond, and the plates seem to swim in the flowing glass. The hall is the most fantastic thing that has been conceived in the architectural imagination for a long time. Its apparent pointlessness irritates many people—one could have spanned the whole space with a single truss. But the magic effect would have been lost.

> This building is said to have cost double the amount originally contemplated, but the firm is able and willing to afford this luxury. There have

always existed buildings which satisfied this need for luxury, and they will exist again. The point that matters is what we are to understand by luxury. Luxury does not simply mean waste of material, but only makes sense when *it broadens emotional experience by means of new discovery.* Only a few can fulfill this. Frank Lloyd Wright achieves in this building by means of silver light and plasticity of form, a new spatial sensation without which it is not possible to think of architecture. He shows us here, after half a century of building, how luxury can still be creative in architecture.

The building for the **Johnson Wax Company** introduced the last twenty years of Wright's work, in which he departed from the right angle and with increasing vigor emphasized circles and curves.

.

Frank Lloyd Wright was not only an architect. He belongs among the great preachers of his country; he had by nature the will and the courage to protest, to revolt, and to persevere. He carried on in architecture that tradition of sturdy individualism of which in the middle of the last century Walt Whitman and Henry Thoreau were the literary spokesmen. He regarded this tradition as part of himself. As prophet, preacher, and agrarian individualist, he preached hatred of the city and return to the soil and to the productive, self-sufficient community—in a land where man's relation to the soil is too often remote and impersonal; where at the same moment, according to the varying demands of the economic trend, forests are being changed into farms and acres of growing grain changed back into forests; and where food to a great extent comes to the table out of tins. (pp. 419-24)

The foundation bearing Wright's work is a strong tripod: the American tradition, his urge toward the organic, and his power to find an artistic language for his own period. By the time the definitive publication of his buildings appeared in Berlin in 1910, all this had been realized. At forty years of age Wright had already achieved a body of work great enough and influential enough to assure him his place in history.

What is to be grasped, what can be observed of his direct influence, is often only superficial and leads to misunderstanding. Whoever as an architect has tried to imitate or even to follow him, whether in Europe or America, has misused his work and misinterpreted his spirit. Much more important perhaps than Wright's direct influence was his significance as an index, as a sort of signpost of new directions, for no equivalent could be found for his work in Europe between 1900 and 1910. (pp. 425-26)

> *Sigfried Giedion, "American Development: Frank Lloyd Wright," in his* Space, Time and Architecture: The Growth of a New Tradition, *revised edition, Cambridge, Mass.: Harvard University Press, 1967, pp. 396-428.*

Giorgio Ciucci (essay date 1973)

[*In the following excerpt, Ciucci investigates the philosophical and socio-economic basis of Wright's design for Broadacre City.*]

Like Taliesin, [**Broadacre City**] was created outside the current institutional structure of America. As a result of the vicissitudes of his personal life, Wright's outlook in the early 1930s was closer than ever to the spirit of Thoreau, except that Thoreau's anarchism, the result of the translation of transcendentalist individualism into political terms, was transformed by Wright into a proposal for new and different institutions. The concept of moral law as the fundamental law, superior to statutes and constitutions, which lay at the base of Thoreau's "Civil Disobedience," made sense to Wright only in terms of new institutions. While Thoreau had affirmed the right to follow the dictates of one's own judgment without restrictions and to break the laws of society whenever they proved inferior to such dictates, Wright proposed new social laws; they, too, however, were based on subjective judgment. In the **Broadacres** program, for instance, banks, which had been responsible for Wright's precarious situation in the late 1920s, had to become disinterested institutions and their architectural forms, modest and simple; universities "should not be large but be qualified and qualifying. Why not somewhat like the old monastic institutions?" The courts of law, where Wright had appeared as a defendant, would be "greatly reduced by the simplification of a true people's government" in **Broadacres.**

Broadacres was, in fact, a proposal for a place in which man could live a life based on the Jeffersonian concept of self-government. Attenuating Thoreau's "extremism," which had modified the Jeffersonian maxim to the point of declaring, "That government is best which governs not at all," Wright affirmed his own anarchic individualism by proclaiming the necessity of rejecting life in the capitalist city and regaining man's innate "natural" condition. Uncontaminated, wild nature, which for Thoreau could be understood and enjoyed only by isolating oneself from the world in a hut in the midst of the woods, was now to be recaptured by means of the most advanced technology. It was no longer the inhabitant of the city who would seek the reason for his own existence in nature, as Thoreau had advocated or as Wright had done in first taking refuge at **Taliesin** in 1911; now it was the inhabitant of the country, the man who lived in nature, who would extract from the city the undeniable advantages it offered. This was the great difference in Wright's position in the 1930s from that held at the time he had founded Taliesin.

Broadacre City Project (1934-58)

Wright had always remained outside the official management of the city, had never served on commissions dealing with urban problems or participated in movements for civic betterment. As noted earlier, the development of city planning in the 1910s had had no interest for Wright, who was completely dedicated to his position as an architect of homes for the upper-middle-class American. Instead, **Broadacres** was generated from the consideration of problems involved in an industrial and technological restructuring of the rural areas and, even if it was utopian, was intended as a solution to the delicate problem of developing the agrarian world in relation to that of industry. Although **Broadacres** had no relation whatsoever to the projects for a new territorial organization that were under study in America in the 1930s, it was nevertheless a typical expression of the post-1929 atmosphere, which gave rise to a proliferation of programs for restructuring rural areas and creating new, self-sufficient communities. Wright, however, disregarded the scientific attempt of the regionalists to achieve a new scale of operation by treating the complex problems of costs, transport, zoning, and park programs as a whole, just as he disregarded the attempt to integrate planning with the rationalization of building production that government intervention now offered in this field. These were developments ignored by Wright, who remained totally absorbed in the vision of a "new urban era" that would come about through man's good will.

Although **Broadacres** was a step backward in comparison not only with regionalist efforts but even with earlier concepts, it cannot be said that Wright did not sense the new terms of the problem. The fact is that while **Broadacres** could only have been conceived at this moment of intense concern with the relations between rural life and industry, with model establishments for living and working, and with regional development, it was nevertheless actually identifiable with the "section," in Turner's sense of the term, an entity separate from the rest of the country. Even if Wright believed his proposal overcame and went beyond sectionalism and regionalism, **Broadacres** and Usonia remained isolated, autonomous, and individualistically closed within a single cultural perspective, which was that of Wright himself; surrounding them was an indifferent territory, regulated and controlled by extraneous laws.

Despite the new scale of Wright's proposal, it was completely unrelated to any real program of economic and social research and stemmed instead from a subjective hypothesis formulated solely on an intuition. Based on this intuition, formed over a period of time from various sources and previously made analyses, **Broadacres** was imbued with concepts and ideas directly suggestive of parallel experiments. Thus **Broadacres** appears to converge with the policies of the New Deal, the back-to-the-land movement, the TVA, soil-conservation programs, and decentralization. Actually, however, Wright's views on the problem of restructuring agriculture were wholly divorced from any consideration of a more general solution to the economic crisis. For Wright, all endeavor was still concentrated on the search for a balance suitable to a prebourgeois society, in which agriculture represented the absolutely fundamental element of the economic and social structure. His position coincided in this respect with that of the Southern Agrarians, but not with their regionalism; with the movement of the painters of the American scene,

but not with their critical realism; with the self-sufficient communities of Borsodi, but not with Borsodi's involvement with the Division of Subsistence Homesteads.

In **Broadacres,** what Wright ultimately proposed was quality for all. During his Oak Park years, and to a certain extent even in those that followed, Wright had held the opinion that the city, urban life, and the world of business excluded quality, which could be attained only within the family and the clan, who counterbalanced the brutality of the city. The two worlds could coexist; they were complementary and, indeed, appeared inseparable, but when the city's "lack of quality" overtook the world of the family and clan, coexistence was no longer possible. Completely shaken by this event in his own life, Wright began the search, first in Europe and then wherever he was, for a new quality that would make possible his own existence as an artist. . . . [It] was the desert that offered the possibility of recovering values and opened a perspective on a new life, a life that rose from the world of nature, the only reality unchangeable in its continuous changing.

Broadacres was not only a proposal of quality; more important, it was a demonstration of quality, expressed in the opposite of urban largeness: small homes, small industries, small schools, a small university, small laboratories, and small farms. General decentralization had to be accompanied by architectural reintegration, however; thus "architecture would necessarily again become the natural backbone (and architects the broad essential leaders) of such cultural endeavor." In this way, Wright fully restored the image of himself that urban America had so thoroughly shaken and had long since relegated to the sidelines. He could no longer be the architect of the American home, once the life in that home had been completely subordinated to an industrial social structure that was opposed to the institution of the family as the basis of prosperity.

Wright's book written with Brownell [*Architecture and Modern Life*] quotes the address given by O. E. Baker at the conference on integral society. After stating that only the preservation of the rural home and family and the rural institutions could preserve the prosperity of democratic American agriculture, Baker concluded, "It is becoming clear that the land is the foundation of the family, and that the family is the foundation of the democratic state." At this point Wright's identification with the agrarian world was complete; it was made possible by the technical means the Southern Agrarians also recognized as the only hope for the renascence of the agricultural South.

For Wright, three principle inventions made **Broadacres** possible: the automobile, and thus the general mobility of the individual; electrical intercommunication, and thus the end of traditional rural isolation; and, finally, standardized machine-shop production, bringing together machine invention with scientific discovery. He believed these inventions had extracted too high a price from America, however, because three inherent rights of man had been overlooked in the course of their development:

> 1. His social right to a direct medium of exchange in place of gold as a commodity: some form of social credit.
> 2. His social right to his place on the ground as he has had it in the sun and air: land to be held only by use and improvements.
> 3. His social right to the ideas by which and for

which he lives: public ownership of invention and scientific discoveries that concern the life of the people.

Broadacres was the complete expression of these three assumptions, which contain the essence of Wright's entire thought on social organization. George R. Collins has carefully examined these three "rights" and identified their sources: C. H. Douglas's social credit, Henry George's right to land ownership, and the publicity of discoveries asserted by Edward Bellamy. As always, Wright accepted ideas from any source so long as they could contribute to reinforcing the vision of an agrarian society structured on political and social systems that opposed those of the city and favored minimal forms of government. Thus, although Bellamy had based his own model of society on the regimentation of work and the government of the Great Trust, Wright could still draw upon him for some particular aspect of his thought. Wright's most direct source, however, was Henry George, whose influence and ideas can be continually discerned in **Broadacres.**

Wright's "countrywide, countryside city" depended directly on concepts contained in *Progress and Poverty:* the use of electricity ("All the currents of the time run to concentration. To resist it successfully we must throttle steam and discharge electricity from human service"); the right to land ("The equal right of all men to the use of land is as clear as their equal right to breathe the air—it is a right proclaimed by the fact of their existence"); the integration of city and country, apart from the single tax, which Wright rejected ("The people of the cities would thus get more of the pure air and sunshine of the country, the people of the country more of the economics and social life of the city"); the annulment of government and laws ("Society would thus approach the ideal of Jeffersonian democracy, the promised land of Herbert Spencer, the abolition of government"); and the opportunity for all to be "capitalists" ("The more equal diffusion of wealth would unite capitalist and laborer in the same person"). These and many other of George's ideas are encountered in **Broadacres** and, indeed, form its basic ideology.

For Wright, the form of **Broadacres** reflected the function it had to serve: "Form and function are one in **Broadacres.**" The model he prepared with the help of his student-apprentices, who flocked to the old master after the founding of the Taliesin Fellowship in September 1932, represented four square miles of a typical countryside development that summarized all the architect's proposals for a new social organization. The model was conceived for 1,400 families, with an average of five or more members per family, and thus for more than 7,000 inhabitants. Created for conditions in a temperate zone, it was adaptable with a few changes to northern or southern climates. The basic elements of the plan were services and civic installations, including the parks; transportation, with a differentiated traffic system; and dwellings, which also included the laboratories and workshops. Thus industry was directly connected with the home, and only a limited area was dedicated exclusively to small industries.

Regardless of the fact that Wright configured the site occupied by the settlement as a square, the structure of **Broadacres** goes back to the linear city. The direct line of descent from the linear city of Soria y Mata—who became a staunch supporter of Henry George at the end of the

nineteenth century—to Ford's city at Muscle Shoals was continued in Wright's **Broadacres.** Even Wright's scheme is, in fact, based on a principal road axis, to which all the automobile services and the industries are connected, and from which a secondary road network accommodates the dwellings, services, and civic functions. Wright's linear city could, however, be extended over the territory in any direction by the introduction of a new means of transport, the helicopter, or aerotor as Wright called it, which does not require a markedly directional structure; only the ground traffic, automobiles and monorail, must maintain a precise directionality, to which the organization of the whole is invariably related.

Parallel to this principal artery is a strip of vineyards and orchards, bounded at one end by a large parking lot and at the other by a commercial complex. This filter strip separates the noisier and more "urban" part of **Broadacres** from the residences. The residential area occupied the broad center strip of the model, and within it the dwellings are sparsely distributed around the school, which thus becomes the focal point of the composition. Situated in the strip beyond and parallel to this residential area are the county seat, with a large lake in front of it, the sporting clubs, the professional offices, and the stadium; farther along this same strip are located the aquarium, zoo, arboretum, and the scientific and agricultural research building. These latter points are situated at the foot of a hill on which rise the more elaborate dwellings: the "luxurious dwelling (**House on the Mesa**)," "Taliesin (equivalent)," and "luxurious homes." These are the terms Wright himself used to describe these residences, which were obviously destined for those at the apex of the "broad-based pyramid" that for Wright represented the "true capitalist system."

In **Broadacres,** houses are no longer classified according to the number of rooms but according to the number of cars the family owns, so that the dwellings are distinguished as one-car, two-car, three-car, or five-car houses. The automobile becomes the measure of individual liberty and indicates the make up of the family unit. Indeed, it was the cardinal element in the physical and spatial organization of **Broadacres,** a fact that reflected the unprecedented development in the use of the motor car in these very years; the 5,360,000 cars produced in 1929 was a level that would not, in fact, be surpassed until 1953.

The continual mixture of reality and utopia, of the acceptance of the facts as given and proposals for the future, is the prime characteristic of **Broadacres.** On the one hand, it embraces many of the utopian ideas of the nineteenth century; on the other, this proposal foreshadows the endless development of the American suburbs, themselves real linear cities organized along the roads leading out from the cities. The plan of **Broadacres** shows once again the grid of streets that characterized the first Jeffersonian towns, such as Jeffersonville, or the towns of the frontier, particularly those of the Mormons. In Wright's town, however, the grid has been transformed by the overriding desire to channel its unlimited expansion along principal directional routes. The result is a representation at the same time of both the immense American territory to be occupied in all directions and the directionality of a principal artery that, according to the scheme of a linear city, theoretically connects the points of concentrated activity.

Within this scheme, which rationalizes the territory and makes it real and ready for use, Wright could insert his past projects. The context organized in this way justified their existence. As part of **Broadacres,** they become, in fact, no longer projects for individual patrons but works created for a society that has behind it all the "values" of the American frontier. What **Broadacres** was intended to signify was the existence in the America of the 1930s of a *real* possibility, given the means available, of organizing society in a different way. When reintegrated with healthy and uncorrupted nature, American life would reacquire the old spirit of the pioneer, of the man who, living a life of complete individualism, could only be healthy and uncorrupted. The nature of man was such; centralization, concentration, the city destroyed his innate, genuine values.

The spirit that animated the Ocotillo Camp was no longer employed to create a resort for millionaires from the desert wilderness but, instead, to invent a proposal for rescuing Wright's own experience as an artist from failure. In **Broadacres,** Thoreau and Emerson, Whitman and Carlyle, Lane and Belloc, Borsodi and the Southern Agrarians were all brought together in a mythical place where the "mob" is eliminated: "Spirit only can control it. Spirit is a science mobocracy does not know." **Broadacres** was Wright's declaration that there was no break with the past, not even with his own past. His "countrywide, countryside city" was valid precisely because it demonstrated this continuity. Writing his autobiography and contemporaneously developing his proposal for **Broadacres** was Wright's way of affirming that his own life experience was the logical outcome of a century of American culture. Thus backed by the implicit validity of assumptions elaborated over time, all the contradictions of that experience were cancelled out; the autobiography was the irrefutable demonstration that **Broadacres** was formed over time in a wholly positive process.

Taliesin, inserted in **Broadacres,** was no longer the center of an isolated world but, instead, the leading house of the city. Next to it on the **Broadacres** plan is the **House on the Mesa,** the luxurious dwelling of the ideal Usonian. Unlike the **Robie house** or **Taliesin,** the **House on the Mesa** was conceived not as a grottolike refuge from the world but as a space open on nature, the new nature created by the architect-demigod. With its broad expanses of glass and its interiors free of any weighty historical reminiscences, this prototype of the Usonian houses was actually the exact opposite of the Prairie houses. Their difference did not mean that they could not coexist, however. Indeed, they had to coexist, because Wright had to introduce his past into **Broadacres** if it was to assume the significance of a total experience. (pp. 352-66)

The **Broadacres** program of providing an acre for every man and integrating work in the fields with work in small industries led back to Ford's idea for Muscle Shoals. In a review of *Architecture and Modern Life* in the *Partisan Review* in 1938 [see excerpt above], Meyer Shapiro noted this relationship:

> "The deurbanizing of life, the fusion of city and country on a high productive level, is an ideal shared by socialists and anarchists. But when presented as in Wright's books as an immediate solution of the crisis, it takes on another sense. It is the plan of Ford and Swope, a scheme of permanent subsistence farming with a corvée of worksharing in the distant mill, of scattered national company villages under a reduced living standard."

What Wright's ideal community proposed was the transformation of the middle class, "the real subject of his anxiety," into conservative farmers, with the aim of recovering their "human integrity."

This primeval integrity still existed in Spengler's "centers of landscape," the "meeting-points of rural life-interests" precedent to the cities. Like Spengler, Wright saw in the "earthboundness" of the farmer the means of escaping the social disintegration of the city. The farmer who works his own land, Spengler's "man [who] himself becomes plant," and for whom "the earth becomes Mother Earth," submits to the laws of nature, following her rhythm and slow transformations, and his dwelling, "itself plant, thrusts its roots deep into its 'own' soil." Such an integral life was still feasible in the United States South and West, in those areas not yet corrupted by "modern civilization," where it was still possible to found a new way of life and development based on traditional American culture. **Broadacres** became the model of a new ideal community, which contained the whole past, present, and future of both Wright and America. In three or four generations, Wright predicted, the cities would be abandoned, for the people would be completely won over by this new way of life.

General decentralization would be made possible through electricity and new technological innovations; architectural reintegration would be provided by the architect. As Shapiro observed, "The social imagination of Wright should not be classed with that of the great Utopians whom he seems to resemble." In fact, **Broadacres** was not a utopia, not an organic construction of a new society; rather, it was the organization in a formal key of a series of contributions and conceptions recovered for the purpose of reforming civilization by means of a new architecture. At the same time it provided a general context into which to insert the salient points of the architect's own experience. As Shapiro rightly concluded, however, "Even under more prosperous conditions, the great mass of architects have no chance for original artistic creation; they are salaried workers submerged in a capitalist office, with little possibility of self-development."

It was precisely this dependent relationship that Wright refused. He had to be and to remain free and individual; his clients had to submit to his vision of life. It is characteristic that Wright's one and only professional relationship with a government agency failed, even if not through his own fault. The architect, the unique creator of **Broadacres,** not only made his world concrete by means of a new architecture, but even conjured up its tomorrow; the helicopters that resemble flying saucers, the automobiles of a new design that dart along multilevel roads, and the ultrarapid monorails essentially already existed, but in Wright's drawings they become symbols of the future. In Wright's view, man was still the slave of the machine, but it was nevertheless technology that would grant him the maximum individual liberty by making possible the unlimited occupation of the territory. The tradition of the West and the myth of the nomadic pioneer were revived and brought up to date in **Broadacre City.**

For many today, Wright represents the image of the architect in its original artistic totality. The unswerving, unitary character of his life experience as architect and the absence of any contradictions, both fictive qualities, are coupled with his authentic inventive individuality and raised up as a model. In the struggle against the general "crisis" of the discipline, Wright has become a symbol, and his example appears to be the only one offering a way out. The concept of the architect as "the broad essential leader" signifies the artist-technician capable of designing an architectural masterpiece and planning the territory as well.

Wright's territory was outside of time, however, and his buildings, the focal points from which life radiates, have become lost in the immense American suburb. The houses, the cantilevered towers, and the service stations were the three elements that formed the nodal points of the **Broadacres** road network, and the **House on the Mesa,** designed in 1931, the **St. Mark's Tower,** designed in 1929, and the **Standardized Village Service Station,** designed in 1928 were all actually built in later years. The America that accepted these and other masterpieces, however, had become a place in which Wright's "quality" and the value on which it was based were absorbed and transformed.

The frontier and the technological future, nature and science, were to be stripped of the quality with which Wright endowed this twofold conception. Wright's ideal city would be realized only in the grotesque and preposterous form of Disneyland and Disney World. Not merely the realm of Mickey Mouse and his friends, nor only for children, Disneyland has become a place where the great public finds its realm. Today **Broadacres** is proposed again by critics as an alternative to urban chaos and thus to the consequent loss of values and traditional roles; Disneyland, with its popular appeal to the American dream, succeeds in fusing the values of tradition with the future of the country and transforms the "lack of quality" it expresses into a "new quality." (pp. 367-75)

> *Giorgio Ciucci, "The City in Agrarian Ideology and Frank Lloyd Wright: Origins and Development of Broadacres," in* The American City: From the Civil War to the New Deal *by Giorgio Ciucci and others, translated by Barbara Luigia La Penta, The MIT Press, 1979, pp. 294-388.*

FURTHER READING

I. Writings By Wright

An Autobiography. New York: Horizon Press, 1932, 620 p.
An account of Wright's early life and architectural career, focusing on the formation of his architectural philosophy.

Frank Lloyd Wright on Architecture: Selected Writings, 1894-1940. Edited by Frederick Gutheim. New York: Duell, Sloan and Pearce, 1941, 275 p.
Collection of Wright's essays, compiled largely from original manuscripts. Contains a complete bibliography of Wright's published writings up to 1940.

When Democracy Builds. Chicago: University of Chicago Press, 1945, 131 p.
Wright expresses his abhorrence of the centralized, industrialized city and proposes a quasi-rural alternative. This volume is a revised, expanded edition of *The Disappearing City* (1932), excerpted above.

The Future of Architecture. New York: Horizon Press, 1953, 326 p.
Anthology of lectures and broadcasts by Wright from 1930 to 1953.

An American Architecture. Edited by Edgar Kaufmann. New York: Horizon Press, 1955, 269 p.
Compilation of Wright's statements about architecture published between 1894 and 1954, including previously unpublished material from the Taliesin archives.

Frank Lloyd Wright: Writings and Buildings. Edited by Edgar Kaufmann and Ben Raeburn. New York: Horizon Press, 1960, 346 p.
Collection of the architect's writings arranged by subject. Contains a comprehensive list of Wright's buildings extant in 1960.

In the Cause of Architecture. New York: Architectural Record/McGraw-Hill, 1975, 246 p.
Reprint of the series of articles, "In the Cause of Architecture," that appeared in the *Architectural Record* between March 1908 and May 1952. Includes eight essays by friends and associates of Wright addressing various aspects of his work.

II. Bibliographies

Sweeney, Robert L. *Frank Lloyd Wright: An Annotated Bibliography.* Los Angeles: Hennessey & Ingalls, Inc., 1978, 303 p.
Comprehensive list of primary and secondary sources.

III. Biographies

Farr, Finis. *Frank Lloyd Wright: A Biography.* New York: Charles Scribner's Sons, 1961, 373 p.
The first full-length biography of Wright.

Twombly, Robert C. *Frank Lloyd Wright: An Interpretive Biography.* New York: Harper & Row, 1973, 373 p.
Biographical and critical study emphasizing the impact of Wright's complex personality on his architectural designs. Features an extensive bibliography.

Wright, John Lloyd. *My Father Who Is on Earth.* New York: G. P. Putnam's Sons, 1946, 195 p.
Noncritical biography by Wright's second son.

Wright, Olgivanna Lloyd. *The Shining Brow: Frank Lloyd Wright.* New York: Horizon Press, 1960, 300 p.
A laudatory account of the latter portion of Wright's architectural career.

IV. Critical Studies

Brooks, H. Allen. *The Prairie School.* Toronto: University of Toronto Press, 1972, 373 p.
Critical history of the Prairie school, a group of progressive architects working in the Midwest from 1870 to 1920, emphasizing the influence of Wright's early work on the development of the Prairie house style.

————. *Frank Lloyd Wright and the Prairie School.* New York: George Braziller, 1984, 119 p.

A brief synopsis of the halcyon days of the Prairie school (c. 1890-1914), stressing the importance of Wright's position as a leader of the movement. Includes annotated illustrations of buildings and decorative designs by Wright and other members of the movement.

Buitenhuis, Peter. "Aesthetics of the Skyscraper: The Views of Sullivan, James, and Wright." *American Quarterly* IX, No. 3 (Fall 1957): 316-24.

Compares the views of Louis Sullivan, Henry James, and Wright on the aesthetic and socio-economic problems caused by the proliferation of the skyscraper in American cities in the early twentieth century.

Cranshawe, Roger. "Frank Lloyd Wright's Progressive Utopia." *Architectural Association Quarterly* 10, No. 1 (1978): 3-9.

Analyzes the social and theoretical implications of Wright's work, linking Wright's ideas with those of the Progressive party.

Doremus, Thomas. *Frank Lloyd Wright and Le Corbusier: The Great Dialogue.* New York: Van Nostrand Reinhold, 1985, 192 p.

Comparative analysis of Wright and Le Corbusier, stressing underlying similarities in their work.

Fishman, Robert. "Frank Lloyd Wright." In his *Urban Utopias in the Twentieth Century: Ebenezer Howard, Frank Lloyd Wright, and Le Corbusier,* pp. 91-162. New York: Basic Books, 1977.

Concise biographical and critical essay focusing on Wright's contribution to modern urban planning.

Fitch, James Marston. "Frank Lloyd Wright's War on the Fine Arts." *Horizon* III, No. 1 (September 1960): 96-103; 127-28.

Explains Wright's adversarial stance toward the traditional uses of the fine arts and his method of incorporating functional decorative elements in his early buildings.

Frampton, Kenneth. "Frank Lloyd Wright and the Myth of the Prairie 1890-1916" and "Frank Lloyd Wright and the Disappearing City 1929-63" In his *Modern Architecture: A Critical History,* rev. ed., pp. 57-63, 186-91. London: Thames and Hudson, 1985.

Two-part summary of Wright's architectural career, emphasizing the sociological ramifications of his work.

Goodman, Paul, and Goodman, Percival. "Frank Lloyd Wright on Architecture." *The Kenyon Review* IV, No. 1 (Winter 1942): 7-28.

Examines Wright's theory of organic architecture.

Kaufmann, Edgar, Jr. "Centrality and Symmetry in Wright's Architecture." *Architect's Yearbook* 9 (1960): 120-31.

Study of Wright's centrally planned public buildings, focusing on those designed after 1945.

Levine, Neil. "Abstraction and Representation in Modern Architecture: The International Style of Frank Lloyd Wright." *A A Files,* No. 11 (Spring 1986): 3-21.

Analyzes the relationship between abstraction and representation in Wright's buildings, arguing that Wright must be classed as a Modernist along with the European leaders of the International Style.

Moholy-Nagy, Sibyl. "F. Ll. W. and the Ageing of Modern Architecture." *Progressive Architecture* XL, No. 5 (May 1959): 136-42.

Summarizes Wright's contribution to modern architecture.

Mumford, Lewis. "Frank Lloyd Wright and the New Pioneers." *The Architectural Record* 65, No. 4 (April 1929): 414-16.

In a review of Henry-Russell Hitchcock's French language monograph *Frank Lloyd Wright* (1928), Mumford defends Wright, asserting that his work represents a modern synthesis of art and science.

Pevsner, Nikolaus. "Frank Lloyd Wright's Peaceful Penetration of Europe." *The Architect's Journal* 89, No. 2311 (4 May 1939): 731-34.

Discusses the influence of Wright's architecture on the Modern Movement in Europe from 1910 to 1939.

Pyron, Bernard. "Wright's Small Rectangular Houses." *The Art Journal* XXIII, No. 1 (Fall 1963): 20-24.

Compares the development of the Usonian house in the forties and fifties to that of the early Prairie house.

Read, Herbert. "Against the Betrayal of Architecture." *New Republic* 129, No. 14 (2 November 1953): 20-21.

In a review of Wright's *The Future of Architecture* (1953), summarizes Wright's theory of organic architecture as well as his ideas on architectural education.

Rowe, Colin. "Chicago Frame." In his *The Mathematics of the Ideal Villa and Other Essays,* pp. 89-117. Cambridge: The MIT Press, 1976.

Affirms that Wright's preoccupation with organic form set him apart from the functionalist aspirations of the Chicago School.

Scully, Vincent J., Jr. "Conclusion: Frank Lloyd Wright." In his *The Shingle Style: Architectural Theory and Design from Richardson to the Origins of Wright,* pp. 155-64. New Haven: Yale University Press, 1955.

Explores the connections between the early work of Wright and the final development of the shingle style, an avant-garde mode of domestic design that flourished in the late nineteenth century.

Sergeant, John. *Frank Lloyd Wright's Usonian Houses: The Case for Organic Architecture.* New York: Whitney Library of Design/ Watson-Guptill, 1975, 207 p.

Critical survey of the Usonian house type developed by Wright, accompanied by plans and illustrations of individual houses.

Smith, Norris Kelly. *Frank Lloyd Wright: A Study in Architectural Content.* Englewood Cliffs, N.J.: Prentice-Hall, 1966, 332 p.

A survey of Wright's career, focusing on the theoretical aspects of his designs.

Tselos, Dimitri. "Frank Lloyd Wright and World Architecture." *Journal of the Society of Architectural Historians* XXVIII, No. 1 (March 1969): 58-72.

Describes the synthesis of traditional and modern European motifs and pre-Columbian elements in Wright's mature work.

Weisburg, Gabriel. "Frank Lloyd Wright and Pre-Columbian Art—The Background for His Architecture." *The Art Quarterly* XXX, No. 1 (Spring 1967): 40-51.

Traces the influence of pre-Columbian architecture on Wright's early work.

White, Morton, and White, Lucia. "Architecture Against the City: Frank Lloyd Wright." In their *The Intellectual Versus the City: From Thomas Jefferson to Frank Lloyd Wright,* pp. 190-99. New York: New American Library, 1962.

Examines the historical and theoretical basis of Wright's anti-urban polemic and its final expression in the plan for Broadacre City.

V. Selected Sources of Reproductions

Hanks, David A., ed. *The Decorative Designs of Frank Lloyd Wright.* Washington, D. C.: United States Government Printing Office, 1979, 18 p.

Catalogue from an exhibition held at the Renwick Gallery of the National Collection of Fine Arts, with full color reproductions and a brief historical survey.

Heinz, Thomas A. *Frank Lloyd Wright.* New York: St. Martin's Press, 1982, 96 p.

Full-page illustrations, in color, and photos of buildings spanning Wright's entire architectural career.

Pfeiffer, Bruce Brooks. *Treasures of Taliesin: Seventy-Six Unbuilt Designs.* Carbondale: Southern Illinois University Press, 1985, 72 p.

Catalogue of 106 architectural projects designed by Wright, reproduced in color, and accompanied by explanatory notes.

Storrer, William Allin. *The Architecture of Frank Lloyd Wright: A Complete Catalog.* Boston: The Massachusetts Institute of Technology, 1974, unpaged.

Comprehensive directory of Wright's extant works; provides small-format photographs and a short historical précis for each entry.

Wright, Frank Lloyd. *The Early Work.* New York: Horizon Press, 1968, 140 p.

A reissue of the 1911 version of the Wasmuth folio, *Ausgefürte Bauten,* a photographic survey of the first twenty years of Wright's architectural career; with an introduction by the noted Wright scholar Edgar Kaufmann, Jr.

MODERN ARTS CRITICISM

Indexes to Volume 1

Medium Index

Title Index

Title Index